Circa 1492

Art in the Age
of Exploration

Circa

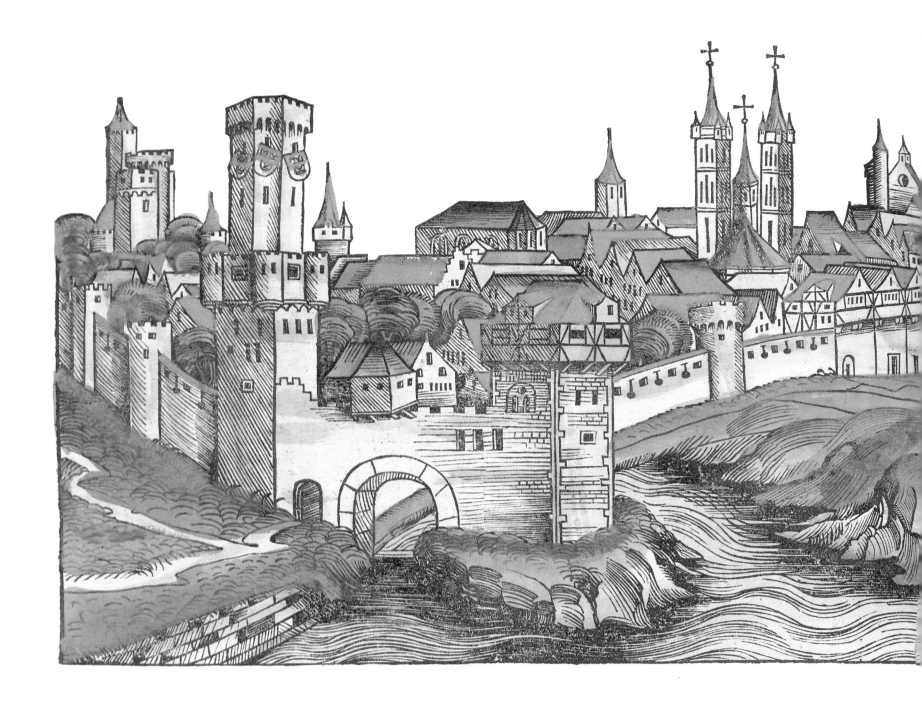

1492

Edited by Jay A. Levenson

National Gallery of Art, Washington

Yale University Press, New Haven and London

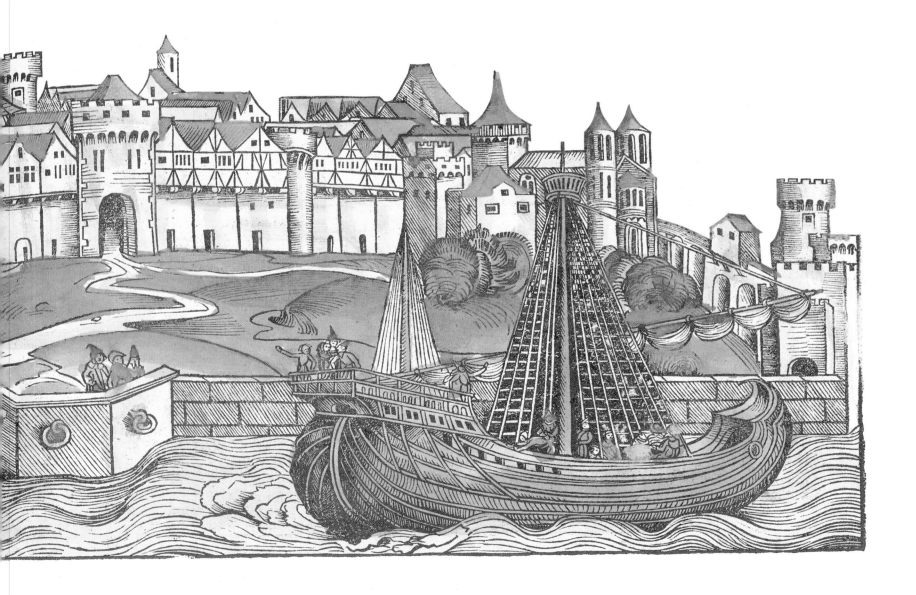

The exhibition is made possible by generous grants from

Ameritech

and

The Nomura Securities Co., Ltd. and
The Mitsui Taiyo Kobe Bank, Ltd.

and

Republic National Bank of New York.

The National Gallery of Art
is grateful for additional support provided by

The Rockefeller Foundation

and

Banco Exterior de España (Grupo CBE).

Exhibition dates at the National Gallery of Art: October 12, 1991 — January 12, 1992

Front cover: cats. 143 (foreground) and 359 (background)
Back cover: cat. 311
Endpapers: cat. 451
Title page: adapted from *Liber chronicarum*, Nuremberg, 1493, National Gallery of Art

Text for cat. 27: adapted with permission from *Renaissance Painting in Manuscripts: Treasures
from the British Library* by Thomas Kren. Published by the J. Paul Getty Museum (1983).

LIBRARY OF CONGRESS CATALOGING IN PUBLICATION DATA
Circa 1492: art in the age of exploration / edited by Jay A. Levenson. p. cm.
 Catalogue for a major quincentenary exhibition to be held at the
National Gallery of Art, Washington, D.C.
 Includes bibliographical references and index.
 ISBN 0-300-05167-0 hardbound
 ISBN 0-300-05217-0 softbound
 1. Fifteenth century — Exhibitions. I. Levenson, Jay A.
II. National Gallery of Art (U.S.) III. Title: Circa fourteen
ninety-two. IV. Title: Circa fourteen hundred ninety-two.
CB367.C57 1991

909'.4074753 — dc20 91–50590
 CIP

Printed in Italy

Contents

I. ﷽

EUROPE AND THE MEDITERRANEAN WORLD

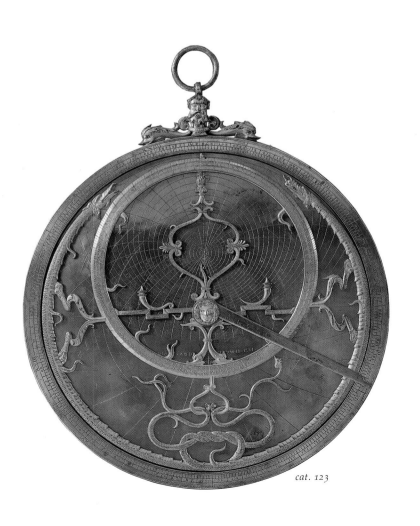

cat. 123

cat. 231

II. ❧

TOWARD CATHAY

III.
THE AMERICAS

THE AZTEC EMPIRE:
REALM OF THE SMOKING MIRROR 499
Michael D. Coe

THE AZTEC GODS — HOW MANY? 507
Miguel Léon-Portilla

THE TAÍNOS: PRINCIPAL INHABITANTS
OF COLUMBUS' INDIES 509
Irving Rouse and José Juan Arrom

EARLY EUROPEAN IMAGES OF AMERICA:
THE ETHNOGRAPHIC APPROACH 515
Jean Michel Massing

SIGNS OF DIVISION, SYMBOLS OF UNITY:
ART IN THE INKA EMPIRE 521
Craig Morris

THE FALCON AND THE SERPENT: LIFE IN
THE SOUTHEASTERN UNITED STATES
AT THE TIME OF COLUMBUS 529
James A. Brown

EMBLEMS OF POWER IN THE
CHIEFDOMS OF THE NEW WORLD 535
Warwick Bray

cat. 488

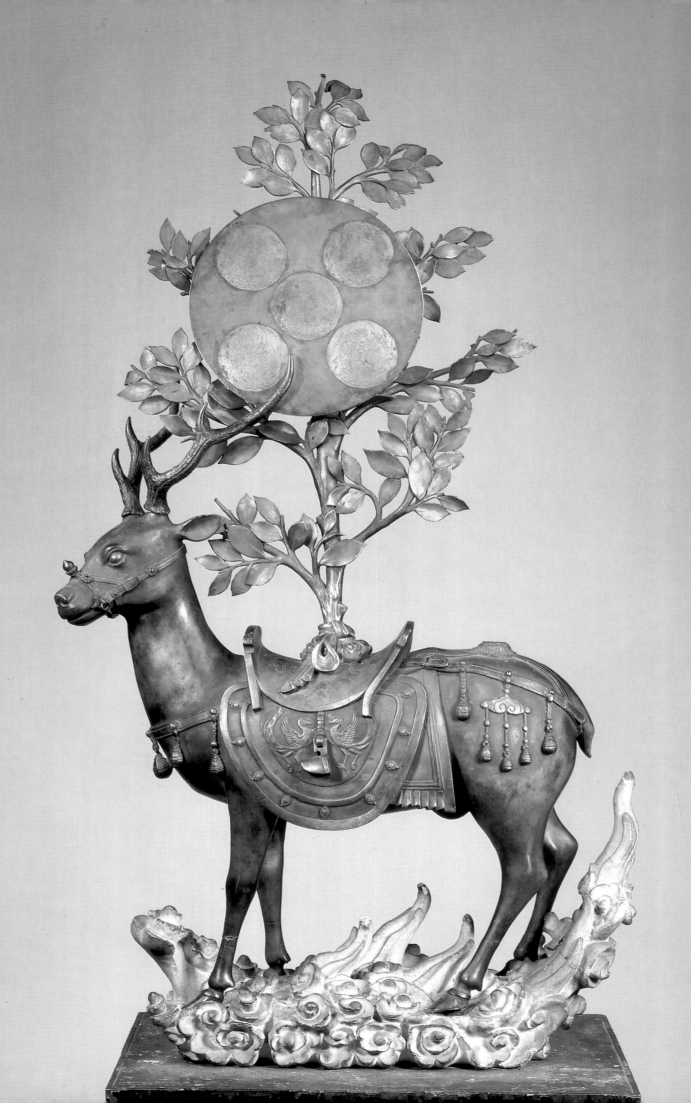

Foreword

If the date 1492 has been drilled into the consciousness of generations of American school children, it has, until recently, been largely from the single viewpoint of a European civilization transported to a "New World."

Now, with a 500th anniversary, we have an opportunity to pause and reflect on the significance of a milestone in human history that, however it may be interpreted from diverse points of view, must be considered a watershed in the history of our globe. The meeting of worlds that took place around 1492 has, in fact, been called "the most significant secular event in human history," a statement with which even partisans of a revisionist view concur. One opportunity this anniversary affords is to hold an exhibition that attempts, from the lasting perspective of art and cultural achievement, to assess what we have loosely termed the "Age of Exploration"; what it has meant, and by inference, could, and even must mean to our present world.

E pluribus unum. Pluralism is at the very root of the American tradition. Globalism is increasingly becoming recognized, in a country that is not without its isolationist past, as a necessity for survival. While Americans search out their specific cultural identities and roots, globalism pleads for awareness, sensitivity, and a new sympathy for the cultural identities of others. The single epoch in human history that can be said to have made possible the idea of globalism is the Age of Exploration, an age that began in the fifteenth century with the voyages of the Chinese admiral Zheng He, and, for the Western world, with the Portuguese voyages down the coast of Africa.

Circa 1492 examines, first of all, the ethos of a Mediterranean world in which, with a new vibrancy and energy, mankind was searching to understand its place in relation to this earth, bringing to bear a new consciousness, a new humanism growing out of centuries of concentration on other-worldliness. The measuring and mapping that led to the navigation of unknown seas sprang from the same impulses that helped define spatial perception through perspective, the structure of the human body, and even the attempt to chart what Leonardo called "the motions of the mind."

The first section of this exhibition begins with a prologue that sketches in the Europeans' mounting curiosity about what were, for them, distant worlds. It then takes the Mediterranean littoral as an entity. It examines the Portugal that gave contemporary navigation its start, the Spain that sent Columbus and so many others on their epoch-making voyages, and the Italy from which Columbus and the humanist tradition sprang. Not limiting itself to these, it goes on to make reference to the lands and cultures that were connected with them, such as the kingdoms of western Africa, linked by their trade routes northward, and the world of Islam, which made many astronomical and other intellectual contributions to Mediterranean culture and played a particularly crucial role in the early interchange between East and West.

Then, as now, the world of the intellect knew no national boundaries, and among the personalities reflected in this section are a Polish astronomer, a German cartographer who worked in Lorraine, as well as the greatest artist-scientist from north of the Alps, Albrecht Dürer. The section closes with the most protean explorer of them all, born within a year of Columbus — Leonardo da Vinci.

The show then takes a bold leap into the imagination. It invites the visitor on an imaginary voyage, to explore the European search for "Cathay," the Indies, "Cipangu" (Japan), moving into the subjunctive mode to reveal, with the hindsight of 500 years, some of the extraordinarily rich cultures that existed in Asia, in the order in which Columbus would have encountered them if he had been able to complete the voyage that he thought he had made until his dying day.

Finally, the reality of the American continents unknown to Europe and Asia before Columbus is presented, selectively, with the impact of their highly developed civilizations. We are left to marvel at the achievements and diversity of these cultures and the aesthetic power of their arts.

Our hope is that, by attempting an exhibition that for once goes horizontally through space rather than vertically through time, we can help sensitize our visitors to the significance of world culture at a particular moment, in its multiform variety. The period of human achievement surrounding the year 1492 was a truly epochal one, with repercussions, positive and negative, that inform our own age. Certain objects selected for this show, as explained in the introduction, illustrate specific historical points. But the essence of our exhibition is to go beyond illustration, to embodiment. This show is not about a man called Christopher Columbus; his name does not even appear in the title. It is about the extraordinary age in which he played his part. The worlds of visual art and artifact communicate so much more than the dry facts of historical events and do it, bridging time and space, without words, directly. It is the thesis of this exhibition that to grasp the lasting significance of an epoch, there is nothing quite so illuminating as the experience of an original object made in that time. When that object is a work of art, the experience can be unforgettable. The juxtapositions provided here will generate, we hope, a newer, keener understanding, both intellectually and affectively, of this historic era, and cannot but help give new resonance to the very concept of a Quincentennial commemoration.

Begun at the time of our *Treasure Houses of Britain* show in 1985–1986 as the Gallery's next large-scale undertaking, the project has been unusually complex, involving loans from some 210 collections and individuals in 34 countries. We are fortunate to have secured the services for this project of Dr. Jay A. Levenson, a specialist in late fifteenth-century art who had started his career at the National Gallery and then became a mergers and acquisitions lawyer in New York. He is chiefly responsible for the articulate formulation and organization of the exhibition's many diverse elements. He has been ably assisted by a talented staff here at the Gallery and a team of some fifty scholars with expertise in all the various fields on which the exhibition touches. The contributions of many of these gifted people are recognized in more detail in the acknowledgments. We are grateful for the early help of the Renaissance authority Professor Sydney J. Freedberg before his retirement as the Gallery's chief curator, and to the many other distinguished scholars throughout the world who have contributed to the exhibition and to this catalogue. A special word of thanks is owed to our editors office, and our colleagues at the Yale University Press, Marsilio Editori in Venice, and at National Geographic Society, all of whom had to work under extremely tight deadlines.

We wish in particular to thank our museum colleagues and all those in the various countries who have taken a special interest in our quest. They are listed in greater detail farther on, but we would like to mention especially, for the personal interest they have taken in this exhibition, His Majesty King Juan Carlos of Spain; President Francesco Cossiga and Prime Minister Giulio Andreotti in Italy; President Lech Walesa of Poland; President Mario Soares of Portugal; and President & Mrs. Turgut Özal of Turkey. Her Majesty Queen Elizabeth II of England is an especially generous lender. The following members of the cabinets of several governments have been instrumental in assuring that the most important works of art from their countries be included in our exhibition and they deserve our sincerest thanks: Erhard Busek, Minister for Knowledge and Research in Austria; Zhang Deqin, Director of the State Bureau for Cultural Relics in the People's Republic of China; Gianni de Michelis, Foreign Minister, and Francesco Sisinni, Director-General for Cultural Affairs in Italy; Victor Flores-Olea, President of the National Council for Culture and Arts in Mexico; Pedro Santana Lopes, Secretary of State for Culture in Portugal; Marek Rostworowski, Minister of Culture and Arts in Poland; Jordi Sole Tura, Minister of Culture and Jorge Semprun, former Minister of Culture in Spain; Chin Hsiao-yi, member of the Cabinet in Taipei; and Gökan Maras, Minister of Culture and Namik Kemal Zeybeck former Minister of Culture in Turkey. In addition, we were particularly favored by interest at the highest level in the Mexican government in this special opportunity to consider their Aztec treasures in a context of unprecedented breadth, and by the high-level attention paid in Beijing and Taiwan, the latter Parliament changing a twenty-five-year-old law against lending in their enthusiasm for this exhibition. In the United States, we have been gratified by the personal interest in this undertaking shown by President Bush; our trustee, Secretary of State Baker; and Chief of Protocol, Ambassador Joseph V. Reed. Space does not permit citing the many other supporters of this exhibition in the federal government, but it is impossible not to mention, with warm appreciation, our appropriations chairman in the House, Congressman Sidney R. Yates.

Needless to say, an exhibition of this complexity requires substantial funding. We were pleased that the Congress, acting on a specific recommendation in the President's budget, saw fit to award a supplement to our exhibitions funding in recognition of this special situation. Nonetheless, Congress has consistently indicated that it expects the Gallery to raise a substantial portion of its exhibition expenses from the private sector. In a climate of business uncertainty and reordering of corporate priorities, we consider ourselves extremely fortunate to have enlisted the generosity of a consortium of corporations who have understood the extraordinary nature of this undertaking.

Ameritech, which is based in Chicago and is the telephone company for a large section of the central United States, was the first to come aboard, and helped make the early development of this project possible. Next came The Nomura Securities Co., Ltd. and The Mitsui Taiyo Kobe Bank, Ltd. in Japan, helping symbolize the global reach of the exhibition's theme. Similarly, the Safras, with their South American and Lebanese roots, brought further symbology with the welcome support of Republic National Bank of New York. The specific inter-American aspect of the exhibition was underscored by the ancillary participation of The Rockefeller Foundation. Last, Banco Exterior de España (Grupo CBE), representing Europe and particularly Spain, graciously funded the gala opening dinner. The exhibition is supported by an indemnity from the Federal Council on the Arts and Humanities.

Augmenting an exhibition program that produces each year many small and highly focused exhibitions, and occurring in the Gallery's fiftieth-anniversary year, during which a reinstallation of the permanent collection has been a high priority, this exhibition has only gone from dream to reality thanks to the extraordinary support, generosity, and efforts of what is, for us, an unprecedented number of people, both on the Gallery staff, and around the globe. Our heartful thanks go to them all. The dream of a globe wholly knowledgeable of and sympathetic to its multi-form cultural components may still be beyond us; however, it can only be our hope that undertakings such as this can contribute their small part to *that* long-dreamt-of realization.

J. Carter Brown
Director
National Gallery of Art

Lenders to the exhibition

Ackland Art Museum, Chapel Hill, on extended loan from Gilbert J. and Clara T. Yager

Aichi Prefectural Ceramic Museum, Seto City

Alfonso Jiménez Alvarado

American Museum of Natural History, New York

Archeological Museum, Bijapur

Armeria Reale, Turin

Arquivo Nacional da Torre do Tombo, Lisbon

The Asia Society, New York

Asian Art Museum of San Francisco

Askeri Müze, Istanbul

Bayerisches Nationalmuseum, Munich

Berlin EKU; Museum für Kunst und Kulturgeschichte der Hansestadt Lübeck

Biblioteca Estense, Modena

Biblioteca Nacional, Madrid

Biblioteca Nazionale Marciana, Venice

Biblioteca Nazionale di Napoli

Biblioteca Palatina, Parma

Biblioteca Reale, Turin

Biblioteca Universitaria di Bologna

Bibliothèque Nationale, Paris

Bibliothèque de l'Institut de France, Paris

The British Library Board, London

The Trustees of the British Museum, London

The Brooklyn Museum

Roger Brunel

The John Carter Brown Library, Providence

Excmo. Cabildo Catedral, Burgos

Ente Casa Buonarroti, Florence

The Trustees of the Chester Beatty Library, Dublin

Church of Nossa Senhora da Ourada, Aviz

Church of San Domenico, Gubbio

Church of the Ognissanti, Florence

Chuson-ji, Iwate

The Cleveland Museum of Art

Viscount Coke and the Trustees of the Holkham Estate, Wells, Norfolk

Convento de Santo Domingo el Real, Segovia

Daiō-ji, Kyoto

Daisen-in, Kyoto

The Denver Art Museum

The Detroit Institute of Arts

Dōjō-ji, Wakayama

Dumbarton Oaks Research Library and Collections, Washington

Eisei Bunko, Tokyo

H. M. Queen Elizabeth II, Royal Library, Windsor Castle

R. H. Ellsworth Ltd., New York

En'ō-ji, Kamakura

Etowah Mounds State Historic Site — Georgia Department of Natural Resources, Atlanta

Fogg Art Museum, Harvard University, Cambridge

Fujita Art Museum, Osaka

Fundación García Arévalo, Inc., Santo Domingo

Gallerie dell'Accademia, Venice

Galleria Nazionale delle Marche, Urbino

Galleria degli Uffizi, Florence

Germanisches Nationalmuseum, Nuremberg

The Thomas Gilcrease Institute of American History and Art, Tulsa

Graphische Sammlung Albertina, Vienna

Haags Gemeentemuseum

Hakutsuru Museum of Fine Art

Hamburger Kunsthalle

Hasebe Yasuko

Hessisches Landesmuseum, Staatliche Kunstsammlungen Kassel

Hinohara Setsuzo

Ho-Am Art Museum, Kyunggi-do

Arthur Holzheimer Collection

Hong Kong Museum of Art, Urban Council

Honolulu Academy of Arts

Horim Art Museum, Sungbo Cultural Foundation, Seoul

Hosomi Minoru

Huaian County Museum

Institut de France, Musée Jacquemart-André, Paris

The Israel Museum, Jerusalem

Muzeum Uniwersytetu Jagiellońskiego Collegium Maius, Cracow

Jan Mitchell and Sons

Jōfuku-ji, Kyoto

José Maria Jorge

Kagoshima-jingu

Kenchō-ji, Kamakura

Kimbell Museum of Art, Fort Worth

Koho-an, Kyoto

Kunsthalle Bremen

Kunsthistorisches Museum, Vienna

Kuromori-jinja, Iwate

Kyoto National Museum

Library of Sint-Baafskathedral, Ghent

Linden-Museum, Staatliches Museum für Völkerkunde, Stuttgart

The London Gallery Ltd., Tokyo

Los Angeles County Museum of Art

Brian and Florence Mahony

Matsudaira Yasuhara

Matsuo-dera, Nara

The Metropolitan Museum of Art, New York

Mitsui Bunko, Tokyo

Musée des Arts Decoratifs, Paris

Musée de l'Homme, Palais de Chaillot, Paris

Musée du Louvre, Paris

Musée National des Arts Asiatiques-Guimet, Paris

Musées Royaux d'Art et d'Histoire, Brussels

Museo de América, Madrid

Museo de Antropología, Historia y Arte, Universidad de Puerto Rico, Río Piedras

Museo di Antropologia e Etnologia, Florence

Museo degli Argenti, Palazzo Pitti, Florence

Museo e Gallerie Nazionali di Capodimonte, Naples

Museo Civico, Turin

Museo Diocesano Catedrálicio, Valladolid

Museo del Hombre Dominicano, Santo Domingo

Museo Nacional de Antropología, Mexico City

Museo Nacional de Costa Rica, San José

Museo Nacional de Escultura, Valladolid

Museo Nacional de Historia Natural, Santiago

Museo Naval, Madrid

Museo Nazionale Preistorico e Etnografico Luigi Pigorini, Rome

Museo Nazionale del Bargello, Florence

Museo del Oro, Banco de la República, Santa Fe de Bogotá

Museo Pachacamac

Museo Parroquial de Pastrana

Museo Parroquial de Santa Eulalia, Paredes de Nava

Museo de Santa Cruz, Toledo

Museo Templo Mayor, Mexico City

Museos del Banco Central de Costa Rica, San José

Museu de Grão Vasco, Viseu

Museu Nacional de Arte Antiga, Lisbon

Museum of Art and History, Shanghai

Museum of Fine Arts, Boston

Museum für Kunst und Gewerbe, Hamburg

Museum of Natural History, University of Alabama, Tuscaloosa

Museum für Ostasiatische Kunst, Köln

Museum Rietberg, Zurich

Museum für Völkerkunde, Basel

Museum für Völkerkunde, Vienna

Muzeum Narodowe W Krakowie, Oddzial Zbiory Czartoryskich

Nanjing Museum

National Gallery of Art, Washington

National Gallery of Canada, Ottowa

National Museum of African Art, Smithsonian Institution, Washington

National Museum of the American Indian, Smithsonian Institution

National Museum of Ireland, Dublin

National Museum of Korea, Seoul

National Museum of Natural History, Smithsonian Institution, Washington

National Museums and Galleries on Merseyside, Liverpool Museum

National Palace Museum, Taipei

Navin Kumar Gallery, New York

The Nelson-Atkins Museum of Art, Kansas City

The Warden and Fellows of New College, Oxford

The New York Public Library

The Newberry Library, Chicago

Nezu Art Museum, Tokyo

Nigerian National Museum, Lagos

Ohio Historical Society, Columbus

The Okayama Prefectural Museum of Art

George Ortiz Collection

Palace Museum, Beijing

Palácio Nacional da Ajuda, Lisbon

Patrimonio Nacional, Madrid

Peabody Museum of Natural History, Yale University, New Haven

Percival David Foundation of Chinese Art, London

Philadelphia Museum of Art

Pinacoteca di Brera, Milan

Private Collections

Sze Tak Tong

The Rabenou Charitable Settlement Number One

Rautenstrauch-Joest Museum für Völkerkunde der Stadt Köln

The John and Mable Ringling Museum of Art, Sarasota

Röhsska Konstslöjdmuseet, Göteborg

The Royal Library, Copenhagen

Ryūkoku University Library, Kyoto

Saidai-ji, Nara

Sata-jinja, Shimane

Seikado Bunko, Tokyo

Rifaat Sheikh El-Ard

Shinagawa Yoichiro

Shinju-an, Kyoto

Shirayamahime-jinja, Ishikawa

Shōnen-ji, Kanagawa

José da Silva Lico

Saint Louis Science Center

Staatliche Museen Preussischer Kulturbesitz, Kupferstichkabinett, Berlin

Staatliche Museen zu Berlin, Skulpturensammlung

Staatliches Museum für Völkerkunde, Munich

Sterling and Francine Clark Art Institute, Williamstown

Städtische Museen Konstanz, Wessenberg-Gemäldegalerie

Suntory Museum of Art, Tokyo

Suwasugi-jinja, Fukui

Sé Patriarchal de Lisboa

Taima-dera, Nara

Tesoro di San Marco, Venice

The Textile Museum, Washington

Teylers Museum, Haarlem

Tokyo National Museum

Tokyo University of Fine Arts and Music

Topkapı Sarayı Müzesi, Istanbul

Türk ve İslam Eserleri Müzesi, Istanbul

The University Museum of Archeology and Anthropology, Philadelphia

The University of Arkansas Museum, Fayetteville

The Board of Trustees of the Victoria and Albert Museum, London

Visual Equities Inc., Atlanta

Fürstlich zu Waldburg-Wolfegg'sche Kupferstichkabinett

The Walters Art Gallery, Baltimore

Yamato Bunkakan, Nara

Yōhō-ji, Kyoto

Contributors to the catalogue

| | | | | | | |
|---|---|---|---|---|---|
| C.A. | CANDACE ADELSON | I.F | IRIS FISHOF | G.O. | GEORGE ORTIZ |
| L.D.A. | LUÍS DE ALBUQUERQUE | H.Y. | HIROI YŪICHI | C.P.I. | CRESCENCIO PALOMO IGLESIAS, O.P. |
| R.E.A. | RICARDO E. ALEGRÍA | R.L.K. | RICHARD KAGAN | C.P. | CLEMENCIA PLAZAS |
| G.C.A. | GIULIO CARLO ARGAN | R.K. | RONDA KASL | J.R. | JULIAN RABY |
| J.J.A. | JOSÉ JUAN ARROM | M.K. | MARTIN KEMP | H.R. | HOWARD ROGERS |
| E.B. | EZIO BASSANI | K.K. | KUMJA KIM | J.M.R. | J. MICHAEL ROGERS |
| C.B.-S. | CHRISTIAN BEAUFORT-SPONTIN | F.K. | FRITZ KORENY | M.A.R. | MARY ANN ROGERS |
| E.P.B. | ELIZABETH P. BENSON | G.L. | GARI LEDYARD | I.R. | IRVING ROUSE |
| C.B. | CLAUDE BLAIR | S.E.L. | SHERMAN E. LEE | M.J.S. | MICHAEL J. SNARSKIS |
| D.J.B. | DANIEL J. BOORSTIN | J.A.L. | JAY A. LEVENSON | F.S. | FELÍPE SOLIS |
| W.B. | WARWICK BRAY | F.M. | FRANCIS MADDISON | S.S. | SUZANNE STRATTON |
| J.A.B. | JAMES A. BROWN | J.J.M.G. | JUAN J. MARTÍN GONZÁLEZ | J.T. | JOSÉ TEIXEIRA |
| J.B. | JONATHAN BROWN | T.K. | THOMAS KREN | D.T. | DORA THORNTON |
| M.D.C. | MICHAEL D. COE | J.M.M. | JEAN MICHEL MASSING | J.U. | JAMES ULAK |
| M.C. | MARTIN COLLCUTT | L.L.-M. | LAURA LAURENCICH-MINELLI | S.C.W. | STUART CARY WELCH |
| E.C. | EGIDIO COSSA | M.L.-P. | MIGUEL LEÓN-PORTILLA | D.W. | DAVID WOODWARD |
| J.E. | JOHN ELLIOTT | E.M.M. | EDUARDO MATOS MOCTEZUMA | D.Z. | DANIELA ZANIN |
| A.M.F. | ANA MARIA FALCHETTI | C.M. | CRAIG MORRIS | | |
| C.F. | CHRISTIAN FEEST | F.W.M. | FREDERICK W. MOTE | | |

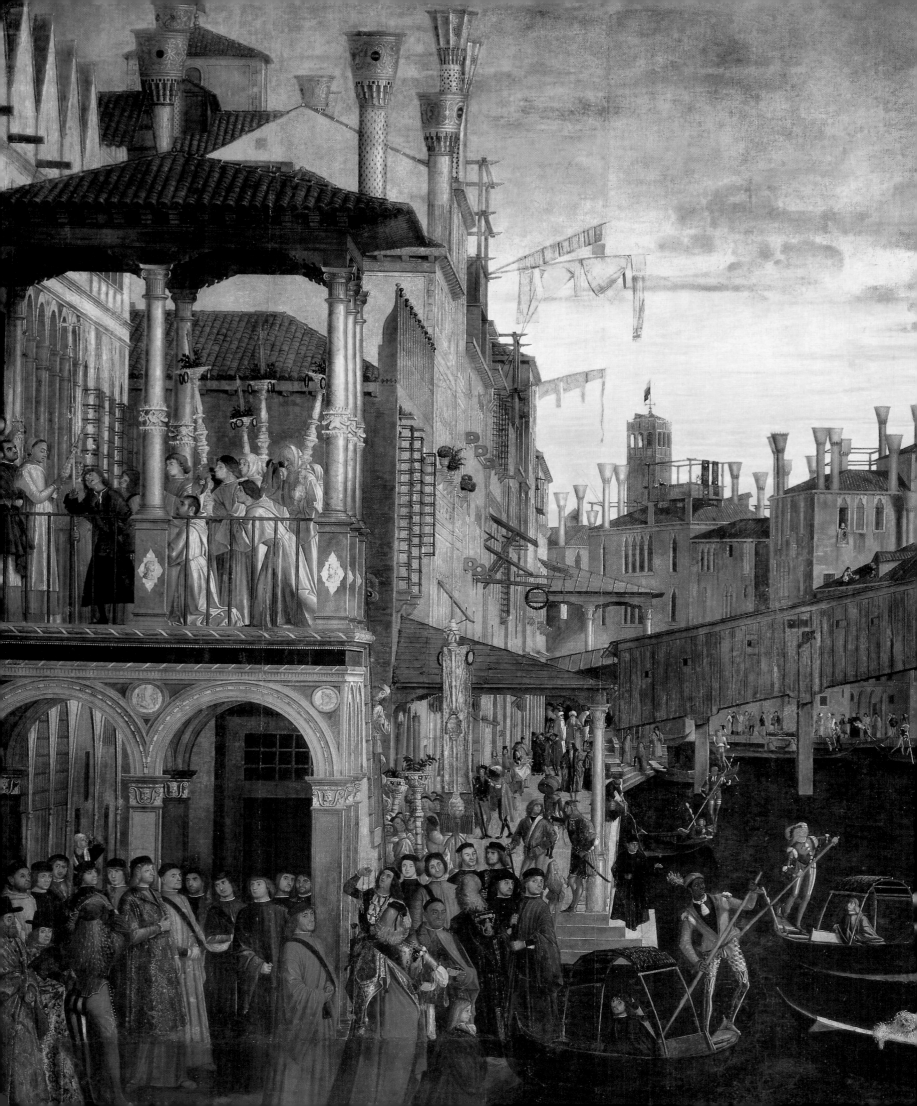

The Realms of Pride and Awe

by Daniel J. Boorstin

In our age of overweening pride in man's power over the physical world, this exhibit can balance our view of human nature and be an antidote to the contagion of science. By opening our eyes to art in the Age of Exploration, *Circa 1492* can remind us how much of the world that we enjoy and admire lay outside the Discoverer's ken, even when man's discovering energies were at full flood. Here we bring together some of the best mementos both of Man the Discoverer and Man the Creator, the Realms of Pride and Awe. Seldom have these two realms of human fulfillment been so richly displayed in one museum, and perhaps never before have they been so gloriously shown in a single exhibit.

In both the sciences and the arts the Age of Exploration was an era of spectacular achievement. But the usual rituals of the quincentennial year of Columbus' voyage are liable to be a festival only of pride in man's ability to brave the unknown, to increase his knowledge and mastery of the world. Our National Gallery exists to show us that such a celebration would recognize only one side of man's adventuring nature. Neither then nor now could man live by science alone.

Here we have an opportunity without precedent to see how disparate, though sometimes complementary, are the Culture of Discovery and the Culture of Creation. The Discoverer's work is often the prosaic charting and measuring and extrapolating, to define where man has already reached. The exhilaration of his work requires the artist or poet. It took Keats to remind us of the "wild surmise" awakened in

> . . . some watcher of the skies
> When a new planet swims into his ken;
> Or like stout Cortéz when with eagle eyes
> He stared at the Pacific . . .
> Silent upon a peak in Darien.

This exhibit, too, can remind us of the oceans of ignorance, the vistas of human creation still unknown to Europeans in the Age of Exploration. And so help us reflect on the scope and promise of these two ways of fulfillment.

Columbus' life and work offered an allegory of the Culture of Discovery—international, collaborative, and progressive. The Genoese Columbus had sought support from several other sovereigns before he allowed himself to be enlisted by Ferdinand and Isabella. The maps he relied on had their origins in the cartographic efforts of Jewish mapmakers at least a century before, and of the Greek Ptolemy long before that. His voyages were conspicuous feats of organization and command, holding the crews together and keeping up their morale under threats of mutiny. Columbus relied on the best manuscripts and printed books of his time to impress Isabella's experts. Despite the limits to his information, and the misinformation which made his voyage seem possible, it was the community of scientific knowledge of his time, the accumulating heritage of centuries, that sent him across the ocean.

The other grand voyages of the Age of Exploration were also products of international collaboration. In 1498 Vasco da Gama might not have succeeded in his voyage around Africa to India, proving the error in the Ptolemaic maps that had made the Indian Ocean into an enclosed sea, had he not been able to enlist an Arab pilot at Malindi to guide his fleet the twenty-three days across the treacherous Arabian sea to Calicut. An unsung godfather and catalyst of all these voyages had been the sedentary Prince Henry the Navigator of Portugal. Though a reluctant navigator himself, he had marked the adventuring paths for European sailors and cheered them on their way. Henry, too, had found clues for the design of his miraculous "caravels" which rounded Africa, in the Arab "caravos" long used off the Egyptian and Tunisian coasts, and modeled on the ancient fishing vessels of the Greeks. The printing press, which had come to Europe only decades before Columbus' voyage, was an unprecedented vehicle for sharing knowledge, spreading information (and misinformation) to people who earlier had been grateful for only a trickle.

Geographic knowledge, a product of discovery, was a precious international currency, coveted by everyone, easily stolen, and valuable to hoard. Anybody's new bit of information about an easy passage or a treacherous shore could be added to anybody else's in the race for gold and glory. The secrecy rigorously enforced on the fruits of discovery must have cost the lives of many an indiscreet sailor. The Portuguese "policy" of secrecy was itself so secret that some have even denied that it existed. On the other hand, recent champions of Portuguese primacy in the American voyages have dared to use the very absence of documentary evidence as proof that the Portuguese discoveries must have been too valuable to share.

In the long run secrecy could not prevail. For Discovery, this realm of science, was by its very nature collaborative and cumulative. Europe's community treasurehouse of geographic knowledge from the past was inevitably international. Columbus was a young man of seventeen at the death of Gutenberg, in 1468. Now printed books, themselves potent products of this Age of Exploration, made knowledge even more fluid, more mobile, more difficult to confine. The barriers of language, multiplied by the change from Latin to the vernaculars of emerging nations, threatened to be more obstructive than rivers and mountains. But these barriers, too, were soon penetrated by the newly-flourishing arts of translation. And the vernacular languages became widening currents of exchange.

Despite all obstacles, news of Columbus' first voyage spread speedily across Europe. Columbus' "letter" describing what he thought he had accomplished, first written in Spanish and printed in Barcelona about 1 April 1493, was translated into Latin as *De Insulis Inventis* and published in Rome before the end of that month. By the end of that year there were three more editions in Rome, and within the next year six different Latin editions were printed in Paris, Basel (cat. 136), and Antwerp. Soon there was a translation into German, and by mid-June 1493 the Latin Letter had been translated into a 68 stanza poem and published in Tuscan, the dialect of Florence. The Aldine Press in Venice and others across Europe prospered by diffusing knowledge.

Discovery was obviously a progressive science. How to add your bits of new knowledge to others' in the never-ending battle against ignorance? In this exhibit we see the many ways in which Circa 1492 was an epoch of scientific advance and climax. Cartography, the protoscience for explorers, was making great progress. Ptolemy was still the patron saint of astronomy and geography. But by 1459 the Venetian Fra Mauro's planisphere map for the King of Portugal made in his workshop near Venice revised Ptolemy's version which had

made the Indian Ocean inaccessible by water from Europe, and bore the first mention of "Zimpago" or Japan on a European map. Wald-seemüller's world map of 1507 was the first to put the label "America" on the new world and his new edition of Ptolemy's Geography came to be known as the first modern atlas.

In the fifteenth century, as David Woodward explains in his essay, a new way of looking at the earth was coming into being. In place of the legendary and theological maps which had placed Jerusalem at the center, the earth was being measured, and mapmakers were offering new aid to navigators. Now the portolano pilot books, a product of the newly extensive use of the magnetic compass, aimed to provide accurate maps of limited regions. And the portolan (harbor-finding) charts, first designed to help Mediterranean sailors find their way along the surrounding coastlines, began to be drawn for the west coasts of Europe and of Africa.

The famous Catalan Atlas of 1375, seen in our exhibit (cat. 1), though ornate by modern standards, was a monument to the new empirical spirit. Though a quarter-century after the return of Nicolò, Maffeo and Marco Polo, it is the first map to show the informative influence of their travels, and the first to give Europeans a reasonably accurate description of East Asia. Notable for what it omitted, it showed the courage to leave out mythical and conjectural data that had populated maps for the Christian centuries. And, in an impressive feat of self-control, the cartographer actually left parts of the earth blank, in the spirit of the harbor-finding portolan charts which gave only information useful for reaching a known destination. Vast regions once embellished by anthropophagi and mythical monsters remained vacant, waiting to be filled in by the reports of hard-headed sea-captains. And now at last geographic spaces were shaped into the sterile geometry of latitude and longitude. Even before 1501, the era of "incunabula" when printing was still in its cradle, there were seven folio editions of Ptolemy's classic Geography (cat. 127) which had finally been translated from the Greek and was continually being revised from the latest travel reports. The rediscovered Ptolemy provided a framework on which geographers could hang the new bits of discovery.

And navigators were continually improving their instruments. The earlier Islamic astrolabes, like the one seen in the exhibit, were models for the elegant late fifteenth-century astrolabes of Martin Bylica and Alphanus Severus (cats. 121, 123), which show us how far the instrument-makers had come from the primitive wooden disk suspended by a ring that was familiar to the ancients. One of the oldest

of scientific instruments, the device had been used to observe and chart the heavenly bodies. Now the astrolabe had become an instrument of navigation accurate enough to help mariners find their latitude. In the next centuries it would be displaced by the quadrant and the sextant. In 1484, Martin Behaim was said to be the first to adapt the astrolabe to navigation. He is best remembered for the terrestrial globe he constructed in Nuremberg, which is more notable for its beauty than for its verisimilitude.

In this grand universal enterprise of Discovery all scientists, explorers, and navigators were collaborating willy-nilly, intentionally or unintentionally. All knew that they were working toward the same end, a more accurate map of the earth. And their efforts bore fruit. The European "discovery" of America not only provided new destinations for Western civilization. It enlarged and redefined European knowledge of the whole earth. Whatever ills feudalism, chivalry and the crusades may have visited on the peoples of the West, the new centuries never failed to improve cartography.

Still, inherited "facts" had a dignity and a prestige that made them hard to displace. They had become the basis not only of myth and lore but of commercial hopes and political ambitions. Discarding the old geographic knowledge for the new was always painful, and often resisted. Columbus found it hard to doubt that what he saw on the shores of the Caribbean was the Terrestrial Paradise. When Vespucci showed these figments of ancient desire to be unimagined real continents, he shocked learned Europeans, but he nourished pride in the advances of their "modern" science. Reports of pagan temple sacrifices and cannibal feasts, documented by sacrificial knives like those in this exhibit (cats. 389–395), impressed Europeans with their superiority over the heathen. The greatest discovery of an age of discoveries was to realize how little of the earth was known to Europe. Never before had such vast areas of ignorance been so suddenly unveiled.

Discoverers everywhere focused their vision on the same object—the physical, sensible world that all shared. They brought the unknown down to earth. All were marching in the same direction. Ptolemy advanced along the lines marked by Aristotle, Vespucci on the lines marked by Ptolemy. Discovery reinforced faith in human collaboration and human progress. And it sparked the sense of being born again in a Europe-wide Renaissance.

In this brilliant Age of Exploration European man flexed his scientific muscles. When had there been more reason for pride in what man could do? Or in his capacity to discover new areas of his ignorance? This age, "Circa 1492,"

was a tonic for man's belief in his power to master wind and wave, to find and then conquer terra incognita. "The Measure of All Things" in this exhibit brings together the maps, astrolabes and navigating instruments with which explorers added to this increasing stock of knowledge.

A steady forward march against the unknown is only one sort of human effort. And not the kind to which our National Gallery is a special monument. What our National Gallery celebrates is the Culture of Creation. The happy coincidence that in Europe the epoch-making Age of Exploration was also an epoch-making Age of Creation gives us now the dramatic opportunity in our exhibit to compare the two Cultures. Renaissance belief in the inspired unique creator gradually elevated the painter, equipped with a newly rediscovered science of perspective, from craftsman to artist. No longer paid by the hour like other skilled laborers, he began to be liberated from guild traditions. By the end of the period covered by the exhibition, the artist himself was being sought after by Kings and Popes who left him free to conceive and execute his personal vision. And we must not allow glib attacks on the Philistinism of scientists to blind us to the real gulf between the two Cultures. Surveying not just the European arts but the whole world of the arts, mostly still unknown to Europeans, Circa 1492 can remind us of the limits of the pride-nourishing Culture of Discovery.

Peoples competing and collaborating in the search for knowledge are inevitably converging. Discovery is what men everywhere have found on our same earth. But Creation is what men have added to the world. Its hallmark is autonomy, the freedom to make the new. While there are of course traditions and styles and schools in the arts, every act of Creation is a kind of personal declaration of independence. Which makes the story of art infinitely more confused and confusing than the story of science, with countless communities of artists, each daring to be a community of one. The diversity, the diffuseness, the chaos is what makes representative works of art.

In this exhibit the works of artists in Portugal, Spain, Florence, and Venice give us glimpses of Europe's variegated Culture of Creation "Circa 1492." Artists on the other side of the world richly embellish the fantasy. From Japan the delicate brushwork of Sesshū Tōyō and the masks and ceramics of the prolific Muromachi era, from China the monumental paintings of the Ming imperial palaces, and from India sculptures of the still-flourishing Hindu traditions. These many worlds of the arts show us a kaleidoscope of visions and of

styles—African bronzes and ivories, Brazilian featherwork, Mississippian stone effigies, Aztec codices, Costa Rican and Colombian works in gold.

If we are puzzled and startled by this miscellany, still mostly hidden from Columbus' European contemporaries, it is because we have begun to see the distinctiveness of the two Cultures and the unique message of this exhibit. Here we can correct our myopia in this year of Discovery-Pride. We become aware of the limits of the kinds of fulfillment that dominate our consciousness in an age of science. The Culture of Discovery, an invisible community forged in the spirit of quest, focused on the same object, an earth to be mastered and mapped, winds and ocean currents to be harnessed, accumulating and sharing fragments from everywhere. But the Culture of Creation was a host of countless independents. Their only limits were their inherited styles and materials. Each was aiming at a personal target. Their heterogeneous and chaotic worlds, instead of nourishing our pride in a generalized mankind, inspires our awe at the infinite capacities of atomic individuals. We see an astonishing, even bewildering, array. We must be struck by the diffuseness and disconnectedness of man's efforts in different places to express himself. The subtle masks of Nō players contrast spectacularly with the monumental palace paintings of Ming artists and the massive rotundity of Aztec sculpture. It is folly to try to put them in a line. Not progress, surely, but endless variety! In this fertile chaos we see individual artists, and mankind, moving infinitely in all directions. We see every artist inventing an artist. As uncanny as the inevitable collaboration of Discoverers is the uncanny uniqueness of Creators.

Sometimes of course traditions converge or compete, and often artists learn from other artists, just as the Japanese painter Sesshū Tōyō learned from his visits among the artists of Ming China, or as Dürer learned from Italian painters in Venice. Then each does much more than translate. He transforms these predecessors.

While Discoverers are marching, or trying to march to the same tune, the world of Creators tells us no such simple story. Each is his own compass, not finding but making his directions. This exhibit can remind us of how random and diffuse were man's efforts to create in an era when, more effectively than ever before, leaders of Western Europe were competing for the common currency of discovery. Creations are the strange fruit of diverging imaginations. Vasco da Gama might not have reached India without that Arab navigator. But there was no Arab apprentice or mentor in Leonardo da Vinci's studio. The earlier maps were displaced

by the later, and Columbus' compass itself was an improved model. His voyage was promptly excelled by later navigators. So, too, the anatomy and physics of Leonardo and Dürer would be displaced. But Leonardo's *Lady with an Ermine* (cat. 170) and Dürer's *Knight, Death and Devil* would never become obsolete. The designs of Ming China and Inka stonework remain treasured originals. Textbooks can arrange maps in a clear line of progress, from Ptolemy and T-in-O medieval versions, advancing through Juan de la Cosa's planisphere, Waldseemüller's world, and Battista Agnese's portolan world atlas—and endlessly on into the future .

In the Culture of Creation there is no correct or incorrect, and in the long run no progress. Works of art reveal no linear direction but experiments radiating in all directions. While the post-Columbian maps of the world make their predecessors obsolete, works of art are always additive. They provide the pleasures of novelty and addition without pains of subtraction. Pre-Columbian arts only gain from modern comparisons.

The two Cultures differ too in the roles they assign to the individual. Oddly enough, though Discovery is the arena of collaboration, it offers its historic prizes for individual priority. There is something decisive and exclusive about every first discoverer. Although great discoveries, including those of Columbus, are a team product, it is somehow always *the* "Discoverer" who gets the credit. Columbus has no peer. While cities and nations are named after him, historians still debate the Portuguese claims, some seeking the laurels for Leif Ericson or an Irish Saint Brendan. And the laurels that go to the one are lost to all the others. Discovery seems to be a history of firsts, as we see illustrated in this exhibit.

But the Culture of Creation offers no superlatives or absolutes. While the arts celebrate the unique and the original, the uniqueness of the artist, even the greatest, is usually incremental. The individual differences between the works of Piero della Francesca and Leonardo da Vinci are minute, but they add up to reveal the works of different artists. These works can easily be distinguished, and the pleasures of the art historian come from the irrelevance of "firsts" and "bests." We can speak of the style or "school" of a Leonardo or a Dürer which can diminish the value of a work claimed for the master. But we do not speak of the "School" of Copernicus, Columbus, or Magellan. The Culture of Creation is full of minor variants and near misses, but the Culture of Discovery insists on naming the winner of first prize. The scene of Discoverers, then, is dominated by a star system,

with each idol displacing idols of the last generation and destined to be displaced in turn. Yet hero-artists like our Leonardos and Dürers never lose their starring role.

The great civilizations produce their own special triumphs of both Discovery and Creation. And each offers us its own distinctive large area of overlap. Technology, bastard offspring of the two Cultures, uses the fruits of past discoveries for surprising future creations. And Technology can mislead us into the illusion that there is progress in art and that somehow the findings of science can be made immortal, immune to displacement. The portable, durable, and accessible works of craftsmen put their stamp on our popular notions of other civilizations. In this exhibit we will be impressed by the skills of Flemish weavers, Portuguese silversmiths, Spanish ceramicists, Turkish swordsmiths, and Colombian jewelers, by the makers of Chinese lacquer and Korean porcelains. Every triumph of craftsmen has been made possible by earlier discoveries of the properties of wool, silver, jade, bronze, steel, or glass. The achievements of sculptors and painters become possible by discovering the special qualities of marble, of tempera and oil. The Cultures of Creation and of Discovery meet in a fertile limbo.

"Circa 1492" was an era of awesome achievements in the three hybrid arts of Cartography, Perspective, and Anatomy. In these years European cartography probably made more progress than in the millennium before. Even after explorers on the real earth ceased to be satisfied by the theological symmetries and mythological embellishments on their maps, they still expected their maps to be decorative objects. Accustomed as we are to the antiseptic schematic newspaper maps of our time, we can especially enjoy the elegance of the Islamic celestial globe of 1275, the whimsies of camels and elephants and giraffes, of sultans and emperors, that still adorn the *Catalan Atlas* of 1375, the many-handed monsters and monstrosities of the Nuremberg Chronicle of 1493. We see science translated onto a tapestry seen in this exhibit of the *Mechanism of the Universe* (cat. 111). The navigator's instruments, his globe and astrolabe, attain a filigreed elegance to equal that of the silver for communion or for the royal table.

In the years of our exhibit, "Perspective," a medieval synonym for the science of sight or optics, became a name for a rediscovered ancient art. "Circa 1492" reveals epochal progress in man's capacity to capture space on paper or on canvas, to translate the three-dimensional world into persuasive two dimensions. We see the fruits of this rediscovery in the studies of Uccello, the treatise of Piero della Francesca,

and delightfully idealized plans for Italian cities. And we see that Dürer himself took the trouble to show us how a draftsman could use the new perspective device. The technique which Giotto had applied by rule-of-thumb became a science in the hands of Leonardo or Dürer.

"Anatomy," originally a name simply for dissection or cutting up, "Circa 1492" was beginning to mean the science of bodily structure. Leonardo and Dürer, both pioneers of anatomy (as illustrated in our exhibit) made it the ally and handmaid of their painting and sculpture. Leonardo da Vinci used what he had learned at the dissecting table (seen in his drawings of sections of a human head and of the urinogenital system of a woman), while the mathematically-minded Dürer constructed his *Adam and Eve* with a compass and ruler. Artists felt new need for the science of anatomy when they made nudes a focus of their Renaissance vision. In the history of science and of art, rarely have the talents for both kinds of human fulfillment been so brilliantly embodied in the same artist, as we see in Leonardo da Vinci and Albrecht Dürer.

In our age of triumphant science, we are inordinately proud of the progressive powers of discovery. Knowledge is still the most precious international currency. The triumphs of technology, too, still bring the world together in the marketplace and on the battlefield. Both science and technology, but especially technology, assimilate the ways of life of people everywhere. Photography, television, the airplane, and the computer erase time and space. And in the long run technology becomes the enemy of cultural distinctions, extinguishing cultural species.

So today we are more than ever in need of the impulse of the arts for the variety of creation. Salesmen assure us of the progressive improvements in every new model, every latest "generation" of their devices. Research and Development laboratories confidently and deliberately chart the course of the future. Refugees from the extrapolations of statistics and the certitudes of advertising, we must welcome the wonderfully random unpredictable arts.

For us living in "Circa 1992" this exhibit of *Circa 1492* should be an especially illuminating and chastening experience. Here we can take ourselves off the speedy tracks of Progress and enjoy the fertile chaos of the arts. Just as the Europeans of the Age of Exploration were ignorant of the creations of most of the world in their time, so our confident lines of discovery can give us no hint of the spectrums of creation. This exhibit of the world-wide creations unknown to Europeans in one of the great ages of European exploration can remind us of the still vast continents of our own ignorance. While knowledge is a moving target and old maps are discarded for new, works of art hold their place in expanding constellations with richly iridescent afterlives. As every generation and every great scientist displaces predecessors, the stature of a scientific work is measured by how many earlier works it makes obsolete. But the artists only add. They are the re-creators of the world. Later artists help us discover the earlier, just as they will acquire new interest from the works of artists still unborn. *Circa 1492* can inspire our awe and caution us against the conceit, bred by all Ages of Discovery including our own, that by mastering more of the world we can ever encompass the mysterious vagaries of the human spirit, of Man the Creator.

(Copyright 1991 by Daniel J. Boorstin)

Circa 1492: History and Art

JAY A. LEVENSON

"It needs to be painted by the hand of a Berruguete or some other excellent painter like him, or by Leonardo da Vinci or Andrea Mantegna, famous painters whom I knew in Italy."

In this passage written in the 1530s, Gonzalo Fernández de Oviedo, author of the *Historia General y Natural de las Indias*, an early compendium of knowledge about the Americas, was trying to describe a strange plant, unlike any he had ever seen in Europe. Yet his remark not only evokes the excitement over the wonders of this "New World" that quickly spread among the more perceptive European observers of his generation; it also vividly reminds us that the Age of Exploration was a period as celebrated for the achievements of its artists as for those of its explorers.

The remarkable circumstance that the years around 1492 were a period of artistic excellence in so many different parts of the globe has made possible the exhibition which is the subject of this catalogue. That fact is one that is easily overlooked. Art history traditionally takes as its focus a single visual tradition, and so our timelines of artistic development tend to be one-dimensional, oriented toward a particular country or style. We recognize that certain movements cut across national boundaries. Albrecht Dürer, to take an example, is frequently discussed as a contemporary of Leonardo da Vinci—but that is because the Italian master influenced specific works by the German artist, who consciously set out to transport the achievements of the Italian Renaissance north of the Alps. We rarely stop to think that the two lived at the same time as Hieronymus Bosch in the Netherlands or the painters Sesshū Tōyō in Japan and Shen Zhou in China, that some of the best-known early sculpture from Benin is likely to have been cast during the lifetimes of these same masters, and that the finest surviving works of art from the Aztec and Inka empires originated during this period.

It is especially appropriate to take 1492 as the point at which to make this horizontal survey of the visual arts, for it was in the Age of Exploration that links among continents were created that changed the character of the relationships between the world's cultures forever. We need not adopt the uncritical enthusiasm for the exploits of Columbus and his contemporaries that has for so long been a part of the European tradition to recognize that their voyages brought about a metamorphosis in international communications. Admittedly, we may exaggerate the degree to which society before 1492 was fragmented if we look at the world solely from a European perspective. While there had been little direct contact between western Europe and eastern Asia since the time of Marco Polo, the picture is quite different if we take into account the Islamic world, whose merchants carried on a profitable East/West trade throughout the period. A mere glance at the *Transport of the Porcelains* miniature from the Topkapi Saray Library (cat. 100) makes it clear that the Islamic knowledge of China was of a completely different order of magnitude from the European. Moreover, Arab travelers had written extensively about Africa hundreds of years before the first Portuguese ventured down the coast, while Zheng He's Chinese fleets, described in F. W. Mote's essay in this catalogue, sailed majestically across the Indian Ocean to the east coast of Africa nearly a century before Vasco da Gama reached it. Still, for all practical purposes the Americas remained completely outside this network of trade and tribute, and by any standard the new connections that were established, from about the middle of the fifteenth to the end of the sixteenth century, were revolutionary indeed. If we are looking for a symbolic date of birth for the modern world, 1492 is clearly the most appropriate year to choose.

This exhibition includes over 600 paintings, sculptures, prints and drawings, maps, scientific instruments, and works of decorative art from four continents, most of them created during the late fifteenth or early sixteenth century. It makes no claims to completeness, either from the point of view of history or of art history. A survey that included, in acceptable depth, every significant culture that existed in the world of 1492 would be beyond the scope of any exhibition or catalogue. Difficult choices had to be made in each of the major sections of the show, and if a particular culture is not represented, that is likely to be because it is less central to the theme of that segment of the exhibition rather than because of any shortcomings in its artistic creations.

We have specifically tried to present each civilization on its own terms, not as it might have appeared to visiting Europeans of the period. As a result, each of the sections of the exhibition has its own special focus and individual point of view. Homogeneity was not a feature of the world of 1492, and under no circumstances could a single theme have done justice to the amazing variety that characterizes the cultures that are represented in the show.

"Europe and the Mediterranean World" focuses on the lands in which the Culture of Discovery, as Daniel Boorstin has termed it, had its origin. After a prologue, "Distant Worlds," that examines the curious image that had evolved in Europe of the unknown realms to the south and east, the section explores the reflection in the visual arts of the religious and political forces that underlay European expansion. Bosch's unforgettable *Temptation of Saint Anthony* (cat. 18) evokes the unsettled spiritual climate that prevailed at the end of the fifteenth century, when many, including Columbus himself, thought the end of the world was approaching, and the evangelical spirit ran high. The presentation then concentrates on those parts of the Mediterranean world that played special roles in the historic events of the time. Portugal comes first, as the sponsor of voyages down the coast of Africa that inaugurated the Age of Exploration in Europe and led to the opening of the sea route to Asia. Spain, itself an early crossroads of cultures, sent Columbus on his voyage west; though he failed to reach the Indies, he laid the foundation for his sponsors' rapid rise to world power. The Islamic empires formed serious counterweights to European might in the eastern Mediterranean. It was also in this period that the kingdoms of western Africa, which had long been part of the Islamic trading network, entered the European ambient as well. During this period African ivory carvers created some of the earliest cross-cultural works of art, combining their traditional artistic vocabulary with new subject-matter introduced from abroad (cats. 67–78). The last part of the Mediterranean section ranges across political boundaries, from Iran, to Egypt, to Spain, Italy, Germany and Poland. It examines the advance of scientific knowledge—particularly cartography, that specially characteristic science of the age. It also surveys those

branches of the visual arts that have the most pronounced intellectual and theoretical stamp: the mathematically-structured rendition of space and the revival of the classically-inspired human figure. It concludes with presentations of works by Leonardo and Dürer, the two masters whose wide-ranging intellectual curiosity—which centered on man but ranged across the entire natural world—makes them particularly characteristic embodiments of the period's aspirations.

"Toward Cathay" presents the lands of eastern Asia, the goal of the early European voyagers. Except in the case of India, there were few real connections between the European states and these countries until much later in the sixteenth century. This section consequently deals not with the encounters that were to come but rather with the civilizations of Japan, Korea, China and India as they existed in the late fifteenth and early sixteenth century, reflected in their visual arts. What is most striking about Asia in this period is how far its culture surpassed Europe's in precisely that technological dimension with which the Europeans were already so enamored. China, administered by an efficient bureaucracy that had already perfected a civil service system, was the archetype of the great world empire. The emerging European kingdoms seem paltry indeed by comparison, despite the ambitious titles which their rulers were fond of adopting. Far Eastern porcelains were regarded as almost miraculous objects in Europe, and printed books were in wide circulation in both China and Korea centuries before Gutenberg's press. While European maps of the fourteenth and early fifteenth century, prior to the rediscovery of Ptolemy's *Geography*, present a fantastic image of the East, Korea's world map of 1402, which is discussed in Gari Ledyard's essay, was systematically compiled from the best available models and actually included a reasonably accurate account of Europe. Major advances in technology in eastern Asia had taken place long before this period, and the development there was more gradual, the consequences less revolutionary. That may be why there are no real parallels in the Far East at this time to works like Uccello's studies in perspective (cats. 139–140), which embody the artist's exultant fascination with his discovery of the possibilities of mathematics. The early development of technological expertise in Asia had obvious political consequences: the principal countries were formidable powers circa 1492. Several essays in this catalogue speculate on the reception Columbus might have received had his voyage actually taken him to southeastern Asia; they make it clear that this was not a propitious moment for

successful European expansion into the area.

The final section of the show, "The Americas," provides a sampling of the extraordinary diversity that characterized civilization in the Americas during this period. Like the other sections, it represents a limited selection. The Aztecs and Inkas had created great empires by any standard, and their rulers were capable of employing art for political ends with all the subtlety of Renaissance princes. And yet the extraordinary skill evinced by the works in gold produced in the more modest societies headed by caciques, or chiefs, in what are now Costa Rica and Colombia indicate that the visual arts also flourished in less complex political settings. Chiefdoms of this sort were characteristic of much of the Americas at this period, and the works in the exhibition created by the Taínos in the West Indies, the Tupinamba in Brazil, and the Woodlands peoples in what is now the southeastern United States document other cultures of this type. The work of archaeologists and ethnographers has given us substantial insight into the often intricate systems of meaning in which such works of art figure. In the case of the Aztec religion, which absorbed subsidiary faiths as the empire expanded, theological thought achieved particular complexity. The exhibition includes a veritable pantheon of Aztec deities; as Miguel Léon-Portilla explains in his essay, however, these were in reality subordinated to more inclusive spiritual concepts.

Although the occasion for the exhibition is a historical anniversary, *Circa 1492* was conceived as an exhibition of works of art, not of historical documents. Even the objects like maps and scientific instruments that appear in the show were chosen for their aesthetic quality as well as for their historical importance. It is our belief that works of art can bring this period alive in a way that no other artifacts can. That premise also required us to make decisions, a process which is most easily explained by specific examples.

Fortunately for the organizers of an art exhibition, visual beauty was remarkably pervasive in the material culture that has survived from the fifteenth and early sixteenth century. In the societies of 1492, artistry could be lavished on the most utilitarian objects, particularly if they were crafted for the wealthy and powerful. Just to take an example, while few art museums would exhibit contemporary weapons, the splendid parade armor made in Innsbruck for the young Charles v (cat. 36), or a Muromachi *daimyō*'s colorful lacquered armor (cat. 257–258), or an Aztec ruler's carved and gilded spear-thrower (cat. 384) are objects of great beauty by anyone's definition.

There is no guarantee, however, that each

point of historical or cultural interest in the period will be reflected in a work of aesthetic interest. Throughout the late fifteenth-century world, patrons generally determined the subject-matter of the works they commissioned, and the achievements of royalty and the nobility were more likely to be commemorated than those of people of more modest origins, however famous they may ultimately have become. Some of the historical events that to us seem the most crucial found no expression whatsoever in works of art in the period. Columbus' landfall was depicted in only a few modest woodcuts (cat. 136) in early editions of the letter he wrote upon his return. Admiral Zheng He's voyages, which in many ways were far more extraordinary than Columbus', are also known primarily from texts rather than images.

The major European artists of the period, like those for whom Fernández de Oviedo yearned, often traveled, but generally within Europe, staying close to the principal centers of patronage. Venice's special relationship with the Islamic world enabled some of her masters to travel to and work in the Near East; the *Reception of the Ambassadors* (cat. 106) is the most impressive visual document of this fascinating episode. The New World in this period, however, attracted far more adventurers than artists; the latter knew it principally through the artifacts that were shipped back to Europe. It was on his trip to the Low Countries that Dürer was able to view and admire the Aztec treasures that Cortés presented to Charles v. Maddeningly enough, although Dürer appears always to have had a sketchbook with him, no drawings of his are known of the now-lost masterpieces which he described.

Sometimes art and history combine serendipitously in a single object. That is particularly true of the celebrated *Catalan Atlas* of 1375 (cat. 1), the centerpiece of "Distant Worlds." This map of the world, produced by the Jewish cartographer Abraham Cresques in Majorca, is both our principal image of Europe's vision of the East, which was still based largely on Marco Polo's *Travels*, and a spectacular work of illumination in its own right. Its famous representation of a caravan along the Silk Route splendidly illustrates the early land-based trade with the East. It was indeed fortunate that the *Atlas* entered the French royal collection soon after it was created, remaining there and ultimately entering the Bibliothèque Nationale.

Accidents of survival are particularly critical for our image of the art of the Americas. The widespread destruction that accompanied the sixteenth-century wars of conquest effectively eliminated whole categories of works of art. The Inkas' large-scale works in precious metals, for

example, completely disappeared. Contemporary inventories describe objects such as human and animal figures made of pure gold and weighing over fifty pounds. What have survived are relatively small votive figurines recovered in modern times from archaeological sites (cats. 442–448). Sometimes still wearing their miniature clothes, they tell us much about Inka religious practices and give us as good a sense as we will ever have of the much larger works that were turned into gold and silver ingots nearly 500 years ago.

We can also be thankful that a small number of pre-Hispanic religious manuscripts survived early colonial attempts to suppress the Aztec religion. These books, on pages of deerskin covered with gesso and assembled into screenfold codices, communicate through a beautiful pictographic language that can still be read. Represented in the exhibition by the *Codex Fejérváry-Mayer* (cat. 356) and the *Codex Cospi* (cat. 359) (a work that had entered a celebrated Bolognese *Kunstkammer* as early as the seventeenth century), they are the source for much of our primary knowledge of the Aztec religion and calendar. The depiction of the baneful influence of the planet Venus on different classes of mankind that appears in the *Codex Cospi* strikingly parallels representations of the "Children of the Planets" in astrological manuscripts from Renaissance Europe, like the Este *De Sphaera* (cat. 116).

Works of art from such diverse cultural traditions have rarely been included in the same exhibition, and that, too, is reflected in the selection of objects. Large-scale secular paintings designed for public display, like the *Miracle of the Relic of the True Cross* of 1494 by Vittore Carpaccio (cat. 150), which is included in "The Rationalization of Space," are very characteristic of European art late in the century. The Chinese paintings of this period that are best known, on the other hand, are subtle landscape scrolls intended for a scholar's study. While such works are well represented in the show, the presence of monumental European paintings made it an excellent opportunity to focus attention on the much less familiar paintings produced by Chinese court artists for display in the imperial palace. Shang Xi's splendid hanging scroll depicting *Guan Yu Capturing Pang De* (cat. 287), nearly eight feet wide, which portrays a battle scene from a novel of the early Ming period, shows the Chinese master, like Carpaccio, responding to the demands of composing for large public spaces.

The selection of specific masters to be included in the exhibition also reflects its special themes. Sesshū and Shen Zhou are pivotal figures in their respective artistic traditions, but they also form marvelous parallels to the artists that have been singled out in the Mediterranean section, Leonardo and Dürer. Sesshū was a great artist-traveler, who journeyed to China, much like Dürer to Italy, to learn the Chinese painting tradition at its source. And Shen Zhou's remarkable range of artistic interests included the rendering of humble plants and animals, drawn from life. At about the same time as Leonardo and Dürer executed their famous studies (cats. 184, 203, 204), Shen Zhou produced an equally astonishing album of his own (cat. 314).

Today's world, which is rapidly approaching 1992, is dramatically different from the world of 1492. And yet, as John Elliott explains in his essay, the same could be said of the world of 1592. The changes set in motion by the Age of Exploration were immediate and profound, bringing together parts of the globe that had never before been in direct contact. It is difficult for us to imagine a world in which communications between cultures were as restricted as they were *circa* 1492. This fact makes it all the more remarkable to find such consistent creative excellence in so many widely separated lands. Even Dürer, who lived in Columbus' age, was struck—and moved—by this phenomenon, when he saw the Aztec works in Brussels: "All the days of my life I have seen nothing that rejoiced my heart so much as these things, for I saw amongst them wonderful works of art, and I marvelled at the subtle *ingenia* of people in foreign lands." We hope that sense of wonder emerges clearly from the works of art assembled in this exhibition. From our vantage point in a world in which cultural interchange and mutual interdependence are almost taken for granted, there is much to be learned from looking back to the remarkable moment in history when the world first began to grow smaller.

Acknowledgments

The distinguished scholars who contributed essays and entries to this catalogue are identified on the following page. We are indebted to them not only for their writing but also for the crucial role they played in the organization of the show and the choice of works to be exhibited. Among them several must be singled out for the extent of their contributions — in "Europe and the Mediterranean World" Martin Kemp and Jean Michel Massing, who were responsible for the largest of the subsections; in "Toward Cathay" Sherman E. Lee, who masterminded the entire presentation of Asian art; and in "The Americas" Michael D. Coe, who conceived the overall scholarly program, and David Joralemon, who worked selflessly to ensure the excellence of each subsection. I would also like to extend special personal thanks to Mr. and Mrs. Paul Mellon and their staff, who graciously made their offices available to me during my work on this project.

J.A.L.

AUSTRIA
Christian Beaufort-Spontin, Armand Duchateâu, Sylvia Ferino-Pagden, Fritz Koreny, Manfred Leithe-Jasper, Hans Manndorff, Johann Marte, Konrad Oberhuber, Matthias Pfaffenbichler, Karl Schütz, Wilfried Siepel

BELGIUM
Ludo Collin, Dora Janssen, Sergio Purin, F. Van Noten

CANADA
Glenn Lowry, Shirley Thompson

CHILE
Luis Capurro

COLOMBIA
Mauricio Obregon, Clemencia Plazas, Juanita Saenz

COSTA RICA
Louise Crain, Eduardo Faith Jiménez, Alfonso Jiménez-Alvarado, Melania Ortiz

DOMINICAN REPUBLIC
Manuel Antonio García Arévalo, Fernando Morbán Laucer

DENMARK
Erland Kolding Nielson, Erik Petersen

ENGLAND
Alain Arnould, Tony Campbell, Elizabeth Carmichael, Andrew Ciechanowiecki, Viscount Coke, Prince Adam Carlos Czartoryski-Borbon, Annabel Dainty, Martin Davies, Michael Evans, Oliver Everett, Anthony Griffiths, John Hale, Peter Jones, Jill Kraye, Kristen Lippincott, John Mack, Annie Massing, Ian McClure, Malcolm McLeod, Theresa-Mary Morton, John Murdoch, Richard Preece, Andrew Prescott, Jessica Rawson, Jane Roberts, Michael Saunders-Watson, Yvonne Schumann, Rosemary Scott, Anthony Shelton, Sarah Tyacke, Christopher White, Roderick Whitfield, Adam Zamoyski

FRANCE
Dorothy Alexander, François Avril, Claude Baudez, Gilles Beguin, Florence Callu, Monique Cohen, Walter Curley, Jacques Fabries, Jean Guiart, René Huyghe, Michel Laclotte, Emmanuel Le Roy Ladurie, Dominique de Menil, Monique Pelletier, Andrée Pouderoux, Pierre Rosenberg, Françoise Viatte

GERMANY
Prinz Franz von Bayern, Gerhard Bott, Alexander Dückers, Bernhard Heitmann, Johann Georg Prinz von Hohenzollern, Gerhard Holland, Rainer Kahsnitz, Michael Knuth, Lothan Lambacher, Hans Mielke, Mary Newcome, Anne Röver, Siegfried Salzmann, Eckhard Schaar, Walter Scheel, Helmut Schindler, Erich Schleier, Eberhard Slenczka, Peter Thiele, Hildegard Vogeler, Erbgraf Johannes zu Waldburg-Wolfegg, Prinz Max Willibald zu Waldburg-Wolfegg, Johannes Willers

HONG KONG
Quincy Chuang

IRELAND
Joan Duff, Mairead Dunlevy, Michael Ryan

ISRAEL
Martin Weyl

ITALY
Francesca Abbozzo, Giovanni Agnelli, Susanna Agnelli, Marcella Anselmetti, Franca Arduini, Giovanna Giacobello Bernard, Luciano Berti, Lionello Boccia, Letizia Boncampagni, Leonard Boyle, Mauro Broggi, Gilbert Callaway, Claudio Cavatrunci, Sara Ciruzzi, Luigi Covatta, Paolo Dal Poggetto, Cesare De Michelis, Sabine Eiche, Andrea Emiliani, John Fleming, Maria Antonietta Fugazzola, Pietro Furieri, Giovanna Gaetà Bertelà, Paolo Galluzzi, Luisella Giorda, Hugh Honour, Elisabetta Kelescian, Venanzio Luccarini, Angelo Macchi, Daniella Masci, Francesco Negri Arnoldi, Giovanna Nepi Sciré, Fabienne-Charlotte Oräzie Vallino, Antonio Paolucci, Anna Maria Petrioli-Tofani, Silvana Pettenati, Cristina Piacenti, Pina Ragionieri, Fiorella Romano, Sante Serangeli, Francesco Sicilia, Nicola Spinosa, Rosalba Tardito, Paolo Emilio Taviani, Francesco Valcanover, Alessandro Vattani, Umberto Vattani, Paolo Venturoli, Paolo Viti, Marino Zorzi

JAPAN
Akashi Eikan, Hosomi Minoru, Ikeya Sadao, Inai Keijiro, Kamei Seiji, Kanazawa Hiroshi, Katsu Takako Yokokawa, Kobayashi Yosoji, Kono Tetsuro, Morisada Hosokawa, Okabe Osamu, Ono Shyunjo, Ono Jyokan, Shibagaki Isao, Shimosaka Mamoru, Shiraki Setsuko, Sugahara Hisao, Tabuchi Setsuya, Tajima Mitsuru, Tsuchiya Yoshio, Washizuka Hiromitsu, Watanabe Akiyoshi

KOREA
Chong Kiu-Bong, Chung Yang Mo, Han Byong-sam, Kim Gwon Gu, Kim Hwan Soo, Rhi Chong-Sun, Park Shinil, Yun Jang-Sub

MEXICO
Bertha Cea, Celia Chavez, Marysol Espina, Roberto García Moll, Miriam Kaiser, Ricardo Leggoretta, Sonia Lombardo de Ruíz, Eduardo Matos Moctezuma, John Negroponte, Pedro Ramirez Vazquez, Mari Carmen Serra Puche, Felipe Solis, Rafael Tovar Y De Teresa, Mario Vazquez

NETHERLANDS
E. Ebbinge, Rudi Fuchs, Carel van Tuyll

NIGERIA
Emmanuel Arenze, Robert Lagamma, Ade Obayemi, Lannon Walker

PEOPLE'S REPUBLIC OF CHINA
Du Fu Ran, Huang Xuanpei, Liang Bai-Quan, Michael McCary, Sheng Wei-Wei, Song Beishan, Zhang Zhongpei

POLAND

John Brown, Bruce Byers, Tadeusz Chruscicki, Isabel Cywinska, Kazimierz Jaszczyk, Aleksander Koj, Joseph McManus, Agnieszka Morawinska, Andrzej Rottermund, Thomas W. Simons, Jr., Krzysztof Jan Skubiszewski, Janusz Walek, Stanislaw Waltos, Zdzislaw Zygulski

PORTUGAL

Simonetta Luz Afonso, Martinho de Albuquerque, Maria Manuel Godinho de Almeida, José Bouza Serrano, Anna Brandao, Maria de Fatima Ramos, Antero Ferreira, Marie Teresa Gouveia, Maurílio Gouveia, Duarte Cabral de Mello, Vasco Graça Moura, Inácio Guerreiro, José Maria Jorge, António Martins da Cruz, Joao Deus Pinheiro, John Shippe, José Teixeira, Margarida Veiga

PUERTO RICO

Ricardo Alegría, Juan Fernandez, Annie Santiago de Curet

SAUDI ARABIA

Rifaat Sheikh El-Ard

SPAIN

José Delicado Baeza, Paz Cabello Carro, Sabino Fernandez Campo, Mª Rosa García Brage, Manuel Gomez de Pablos, Carmen González López-Briones, Marcelo González Martín, Luis Luna Moreno, José Luzón Nogué, Agustin Lázaro López, Crescencio Palomo Iglesias, Conchita Romero, Angel Sancho Campo, Piru de Urquijo, Jaime Carvajal Urquijo, Joseph Zappala, Julio de la Guardia García

SWEDEN

Christian Axel-Nilsson, Thomas Baagøe

SWITZERLAND

Gerhard Baer, Eberhard Fischer

TAIPEI

Leslie Chang, Kung Huang, Dan Sung, Richard Wang

TURKEY

Morton Abramowitz, Nurhan Atasoy, Ermine Bilirgen, Ismet Birsel, Filiz Çagman, Marjorie Coffin, Nejat Eralp, Metin Göker, Mehmet Akif Isik, Ahmet Mentes, Nazan Tapan Olçer, Günsel Renda, Turgei Tezcan, Hüoya Tezcan

UNITED STATES

Stephen Addis, Gordon Anson, Susan Arensberg, Anne von Arentschildt, Esin Atil, Paul Baker, Silvio Bedini, Egbert Haverkamp Begemann, Joseph Bell, Stephanie Belt, Arthur Berger, Robert Bergman, Elizabeth Boone, Suzanne Boorsch, Ruth Boorstin, Bill Bowser, Piergiuseppe Bozzetti, Yanna Brandt, Nancy Breuer, David Alan Brown, David Bull, Agostino Cacciavillan, Mauro Calamandrei, Allen Carroll, Cameran Castiel, Carroll Cavanagh, Marjorie Cohen, Annie Cohen-Solal, Wendy Cooper, James Cuno, Joseph Czestochowski, Susan Danforth, Thatcher Deane, Sandro Diani, Ding Mou-Shih, Christopher Donnan, Jack Dorr, Kazimierz Dziewanowski, Colin Eisler, Anita Engel, Eugene Enrico, Athala Morris de Estes, Kate Ezra, Gonzalo Facio, Diana Fane, Norman Fiering, Michelle Fondas, Bryna Fryer, Jorge Fuentes, Jaime Garcia Parra, Joseph Gore, Diane de Grazia, Antonio Guizzetti, Michael Hall, Immaculada de Hapsburgo, Pamela Harriman, Timothy Healy, Linda Heinrich, Lena Hernández, Genevra Higginson, Gretchen Hirschauer, Nancy Hoffman, Peggy Hsia, Colta Ives, Andrzej Jarecki, Helen Jessup, William Johnston, Julie Jones, William Jordan, Michael Kan, Nuzhet Kandemir, Ruth Kaplan, Walter Karcheski, Jr., Shinohara Katsuhiro, Thomas Kaufmann, Kim He Beom, Joseph Krakora, Marcia Kupfer, Donna Kwederis, Lewis Larson, Thomas Lawton, Lee Ching Ping, Mark Leithauser, Catherine Levenson, Claire Levenson, Li Chun, Constance Lowenthal, Colin MacEwan, Vivian Mann, Pablo Marentes, Gail Martin, Sartaj Mathur, Edward McBride, William McNeill, Susan Milbrath, Charles Moffett, Margarita Moreno, Frank Mowery, Kenneth Nebenzahl, Helmut Nickel, John Nicoll, Jeannine O'Grody, Jaime de Ojeda, Michon Ornellas, Carlo Pedretti, David Penney, Mirtha Virginia de Perea, Elizabeth Perry, Rinaldo Petrignani, Michael Pierce, Stuart Pyhrr, Orest Ranum, Gaillard Ravenel, Philip Ravenhill, José Ramón Remacha, Mervin Richard, Naomi Richard, David Robinson, Graça Almeida Rodrigues, Maria Cecilia Rosas de Brito, John Rosenfield, Nancy Rosoff, Morris Rossabi, Vuka Roussakis, Ann Rowe, Sara Sanders-Buell, Enid Schildkraut, Mary Schuette, Juergen Schulz, Thomas Settle, Alan Shestack, Akiko Shiraki, John Shupe, Roy Sieber, Ray Silverman, Marianna Shreve Simpson, Joaneath Spicer, Thomas Spooner, John Stevenson, William Sturtevent, Sally Summerall, Mary Suzor, D. Dodge Thompson, Richard Townsend, Carlo Trezza, Elaine Trigiani, Evan Turner, Susan Vogel, Dean Walker, Immanuel Wallerstein, Wang Ying Min, Anne Wardwell, James Watt, Laurie Weitzenkorn, Richard West, Jr., Alice Whelihan, Reinhard Wiemar, Johannes Wilbert, Lucy Fowler Williams, Sylvia Williams, Marc Wilson, Martha Wolff, Yang Heyun, Tomas Ybarra-Frausto, Deborah Ziska

I

Europe and the
Mediterranean
World

le vergine.

S. peru jri castello.

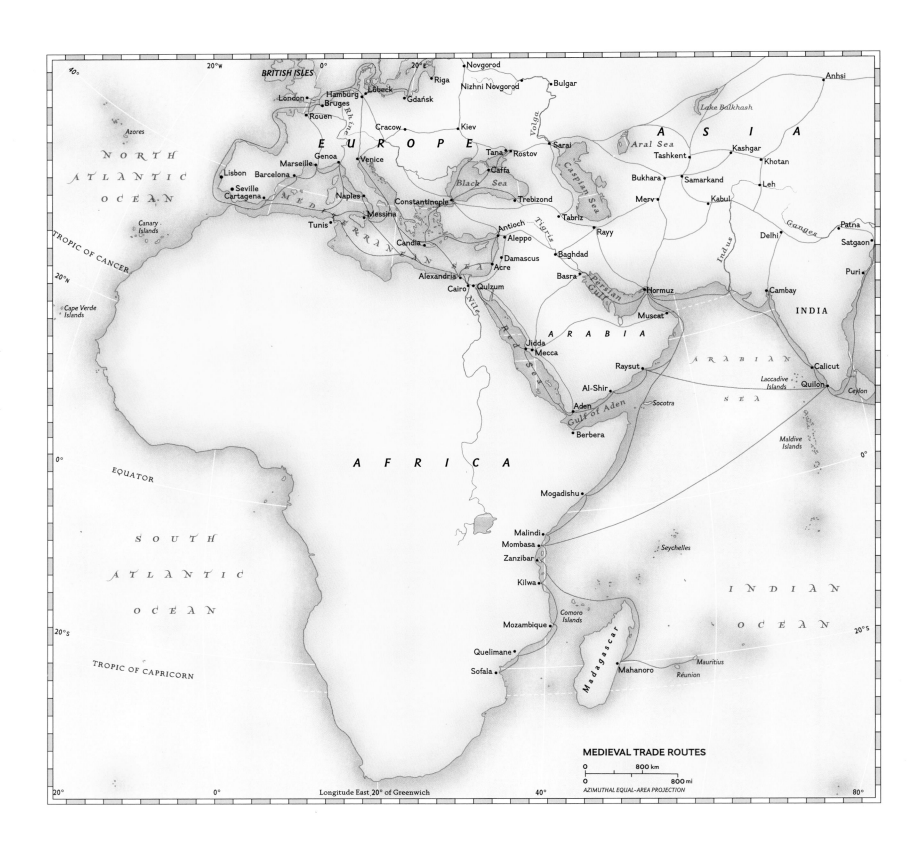

BRITISH ISLES

40° 20°W 0° 20°E

Novgorod

Riga

Nizhní Novgorod

Bulgar

Anhsi

London
Hamburg
Bruges
Lübeck
Rouen
Gdańsk

Cracow

Kiev

ASIA

Lake Balkhash

Rhine

EUROPE

Genoa
Venice
Marseille

Tana
Rostov
Caffa
Sarai

Aral Sea

Tashkent

Kashgar

Volga

Black Sea

Khotan

Lisbon
Barcelona
Seville
Cartagena

Caspian Sea

Bukhara

Samarkand

Leh

NORTH
ATLANTIC
OCEAN

Azores

Naples

Constantinople

Trebizond

Merv

Kabul

Canary Islands

Tunis

Messina
Candia

Antioch
Aleppo

Tigris

Tabriz
Rayy

Ganges

Patna

Satgaon

TROPIC OF CANCER

M E D
I T E R R A N E A N S E A

Damascus
Acre

Baghdad

Delhi

Puri

20°N

Alexandria
Cairo
Qulzum

Basra

Persian Gulf

Hormuz

Cambay

INDIA

Cape Verde Islands

Nile

Muscat

Red Sea

A R A B I A

A R A B I A N

Jidda
Mecca

Raysut

Laccadive Islands

Calicut

Quilon

EQUATOR

Al-Shir

Aden

Socotra

S E A

Ceylon

0°

Gulf of Aden

Berbera

Maldive Islands

0°

A F R I C A

Mogadishu

SOUTH

Malindi
Mombasa
Zanzibar

Seychelles

I N D I A N

ATLANTIC

Kilwa

O C E A N

OCEAN

Mozambique

Comoro Islands

20°S

Quelimane

Madagascar

Mauritius

20°S

TROPIC OF CAPRICORN

Sofala

Mahanoro

Réunion

MEDIEVAL TRADE ROUTES

20° 0° Longitude East 20° of Greenwich 40° 80°

0 800 km
0 800 mi

AZIMUTHAL EQUAL-AREA PROJECTION

OBSERVATIONS AND BELIEFS: THE WORLD OF THE *CATALAN ATLAS*

Jean Michel Massing

The exotic world of the Far East, which tantalized Columbus in the years he spent organizing his "Enterprise of the Indies," is the world of Marco Polo's famous narrative. Polo, along with several other European travelers who reached China in the years of Mongol dominance, before the borders were again closed to Westerners in the second half of the fourteenth century, left vivid accounts of their experiences that remained, nearly two hundred years later, the best available sources of information about the Far East. One extraordinary historical and artistic document, the so-called *Catalan Atlas* (cat. 1), integrates the information provided by these travel accounts with medieval geographical knowledge and lore into a complete view of the then-known world, stretching from the newly discovered Atlantic islands to the China Sea. It is an indispensable summary of late medieval Europe's geographical knowledge, one of the last great *mappaemundi* (map of the world) created prior to the rediscovery of Ptolemy's *Geography* in the early fifteenth century, and the closest we have to an image of Columbus' Cathay.

The *Catalan Atlas* was drawn in 1375 by a Majorcan mapmaker, probably Abraham Cresques.[1] By 9 November 1380[2] it had entered the library of Charles v of France. The map of the world proper is preceded by two sheets of cosmological information in the Catalan language, which reveal a mixture of ancient and medieval conceptions of the world: that it takes the form of a globe or sphere or, again, is a flat disk. The first of these preliminary sheets deals with the days of the month from the first to the thirtieth. To the right, from top to bottom, is a diagram of the tides; another lists the movable feasts, and a third drawing represents a bloodletting figure. The latter is accompanied by a long text describing the world; it deals with its creation, the four elements of which it is composed, its shape, dimensions, and divisions. Then come geographical accounts of countries, continents, oceans, and tides, as well as astronomical and meteorological information.

The second sheet presents a spectacular diagram of a large astronomical and astrological wheel. The earth at its center is symbolized by an astronomer holding an astrolabe. The other elements (fire, air, water) are incorporated into the next three concentric circles; then come the seven planets, the band of the zodiac, and the various stations and phases of the moon. The next six rings are devoted to the lunar calendar and to an account of the effect of the moon when it is found in the different signs of the zodiac. Three more rings show, respectively, the division of the circle into degrees, while the last gives an account of the Golden Number. The four seasons, finally, are shown in the corners as personified figures bearing scrolls.

The world map itself combines the basic form of a sea chart of the Mediterranean and the Black Sea[4] with a traditional *mappamundi*.[5] The origin of portolan or sea charts is still obscure, but they seem to have appeared at the end of the thirteenth century. Portolan charts have rightly been considered one of the most important developments in the history of mapmaking, providing a relatively accurate image of the Mediterranean based on firsthand navigational knowledge, "a living record of Mediterranean self-knowledge undergoing constant modification" in the interest of greater accuracy.[6] As in most portolans, the rendering of the Mediterranean is especially accurate: the harbors are clearly indicated and almost always placed in the right order, at least in the best-known areas. Flags specify, although not always correctly, the political allegiances of the various towns, crescents often being used for Muslim cities. However, the farther the detail is from the coast, the less reliable the rendering becomes—portolan charts are, after all, navigational maps. This is especially true for areas outside the Mediterranean, even for Northern Europe. The empiricism of the sea chart contrasts strongly with the medieval tradition of world mapping, which relies mainly on biblical, classical, and medieval lore known through literary sources. In the *Catalan Atlas*, Southern Europe, the area bordering the Mediterranean, is carefully recorded. Abraham Cresques, or rather the anonymous author of the map he used as his model,[7] was familiar with the political divisions, even in eastern areas under Muslim control. In the Near East both the Ottoman and Mamluk

powers are clearly symbolized by images of their rulers. The Ottoman state, originally a small power nestling between the Byzantine and the Seljuk empires, had already greatly expanded at the expense of Byzantium. Progressive Ottoman control over the Balkans was to culminate in the siege and final conquest of Constantinople by Mehmed ii, the Conqueror, in 1453. The Catalan map does not make much of Ottoman power. The Cilician kingdom of Armenia Minor is more clearly indicated. Founded at the end of the twelfth century, it fell to the Turks in 1375, the very year in which the *Atlas* was made.[8] There is some interest in the cities of the Near East, but the emphasis, here as elsewhere, is on the coastal area.[9] Egypt is symbolized by its sultan, curiously shown with a long-tailed green parrot on his arm: "This Sultan of Babylon [i.e., Cairo] is great and powerful among the others of this region."[10] The Mamluks (1250–1517) controlled Egypt and Syria until Selim i conquered Aleppo and Damascus in 1516 and Cairo a year later.

The compiler of the prototype used by Cresques for the *Catalan Atlas* had recourse to different, sometimes even contradictory sources. The legendary *Insula de Brazil*, for example, which is found on various medieval maps of the North Atlantic and later gave its name to Brazil, is shown here twice, once west of Ireland and a second time farther south.[11] The Islands of the Blest, located in accordance with the specifications of Isidore of Seville in his great seventh-century encyclopedia, the *Etymologiae*, are called both *iles Beneventurades* and *yles Fortunades*: "The Islands of the Blest are in the Great Sea to the left . . . Isidore says in his 15th book [in fact the 14th] that these islands are so called because they possess a wealth of all goods. . . . The heathens believe that Paradise is situated there, because the islands have such a temperate climate and such a great fertility of the soil." Here, too, the text informs us, is the island of Capraria, full of goats, and the Canary Isles called after the dogs (Latin: *canes*) that populated them.

The text adds that, according to Pliny the Elder, "there is one island on which all the gifts of the earth can be harvested without sowing

and without planting.... For this reason the heathens of India believe that their souls are transported to these islands after death, where they live for ever on the scent of these fruits. Thus they believe that their Paradise is there. But in truth it is a fable."[12] In this case, classical and medieval tradition is not borne out by experience and is accordingly rejected by the mapmaker; the Canary Islands had been discovered in 1336 and appear on Angelino Dulcert's chart of three years later.[13] Elsewhere, however, the weight of received opinion is still felt, as, for example, in the various islands with fabulous names; they cannot represent the Madeiran group, as these islands were discovered only in 1418–1419. Nor can they be the Azores, which are first mentioned in 1427, or the Cape Verde Islands discovered only in 1455–1456.[14] The *Catalan Atlas*, in fact, marks the progress in the gradual discovery of the Atlantic and the west coast of Africa with an illustration of Jaime Ferrer's ship, which, we are told, set sail on 10 August 1346 bound for the fabulous Rio de Oro (River of Gold) in Africa.[15]

Scarcely any place on the west coast of Africa is identified—only one name, perhaps a mythical spot, is found south of Cape Bojador in the former Spanish Sahara—but we are told that Africa, land of ivory, starts at this point and that by traveling due south one reaches Ethiopia.[16] Only a few cities in mainland Africa, such as Timbuktu and Gao, are indicated,[17] and yet the map is full of information. For here, as is often the case in other maps of the period, the cartographer compensated for the dearth of known geographical points by including historical facts.[18] We are told, for example, that merchants bound for Guinea pass the Atlas mountain range—shown here in its typical form of a bird's leg with three claws at its eastern end—at Val de Durcha.[19] More geographical information is given on the Maghreb, which, after all, is part of the Mediterranean. The Sahara, however, is shown with a lake in its center—a traditional medieval error. The text beside a Touareg riding on a camel and also a group of tents informs us that this land is inhabited by veiled people living in tents and riding camels. The crowned black man holding a golden disk is identified as Musse Melly, "lord of the negroes of Guinea"—in fact, Mansa Mūsā, of fabulous wealth. "The King," we are told, "is the richest and most distinguished ruler of this whole region, on account of the great quantity of gold that is found in his land."[20] Mansa Mūsā, who reigned over the kingdom of Mali, probably from 1312 to 1337,[21] is known for having encouraged the development of Islamic learning. His pilgrimage to Mecca, including a visit to Cairo, was famous

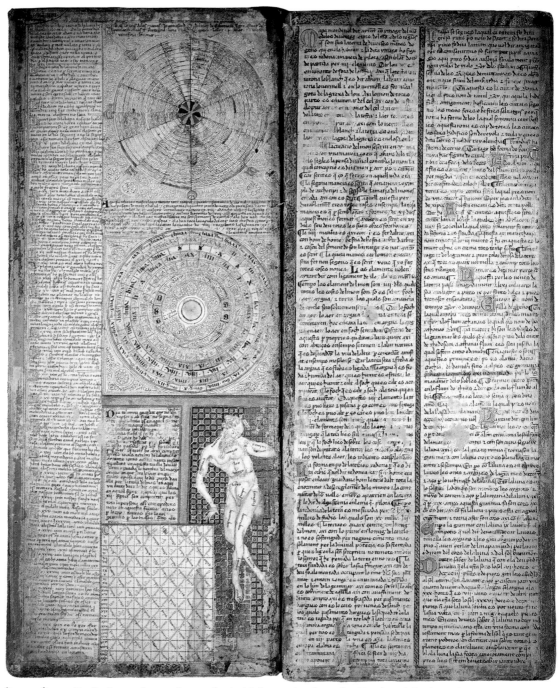

fig. 1., fig. 2. *Preliminary sheets of cosmological information* from the *Catalan Atlas* (cat. 1)

for the enormous amount of gold he spent on that occasion. This is plausible enough, for he controlled a large part of Africa, from Gambia and Senegal to Gao on the Niger, and had access to some of its richest gold deposits.[22] Reports of the fabulous wealth of this African ruler—whose first appearance on a European world map is on that of Angelino Dulcert of 1339—did much to encourage an interest in the exploration of Africa and certainly had something to do with Jaime Ferrer's voyage.[23]

East of the Sultan of Mali appears the King of Organa, in turban and blue dress, holding an

oriental sword and a shield. He is, we are told, "a Saracen who waged constant war against the Saracens of the coast and with the other Arabs."[24] Still farther to the east is the King of Nubia, "always at war and under arms against the Nubian Christians, who are under the rule of the Emperor of Ethiopia and belong to the realm of Prester John."[25] A number of portolan maps mention and sometimes even illustrate the mythical figure of Prester John.[26] The legend of this Christian ruler living somewhere in the east originated with a letter purporting to have been sent by him, around 1165, to the pope

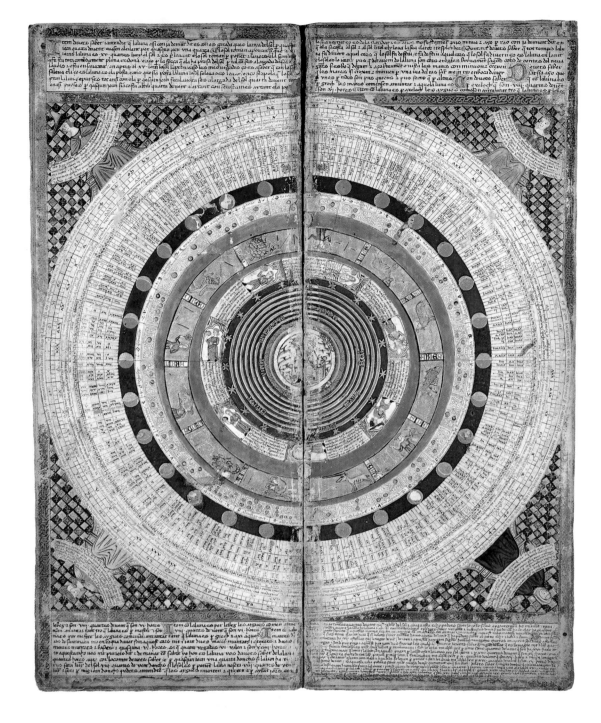

Quseir is clearly marked, and the accompanying text specifies that it is here that spices are taken on land and sent to Cairo and Alexandria.[31] In Arabia, between the Red Sea and the Persian Gulf, is located the kingdom of Sheba; the queen, who came to visit King Solomon, is shown crowned and holding a golden disk as symbol of her wealth.[32] Today, we are told, the area "belongs to Saracen Arabs and produces many aromatic substances, such as myrrh and frankincense; it has much gold, silver and many precious stones and, moreover, it is said that a bird called phoenix is found here."[33] This passage is altogether typical of the approach of late fourteenth-century cartographers, who freely mix biblical information with later accounts of foreign countries, in this case based on Isidore of Seville's *Etymologiae*.[34]

Mecca and Medina are clearly marked, although they are placed too close to the coast.[35] Between the Persian Gulf and the Caspian Sea appears the King of Tauris (Tabriz) and north of him Janï-Beg, ruler of the kingdom of the Golden Horde, who died in 1357.[35] The importance of Baghdad as a center of the spice trade is emphasized; from there, precious wares from India are sent throughout the Syrian land and especially to Damascus. Navigational information is also recorded: "From the mouth of the river of Baghdad, the Indian and Persian Oceans open out. Here they fish for pearls, which are supplied to the town of Baghdad." We learn that "before they dive to the bottom of the sea, pearl fishers recite magic spells with which they frighten away the fish"—a piece of information that comes straight from Marco Polo, who mentions that the pearl fishers on the Malabar coast are protected by the magic and spells of the Brahmins.[37] Various trading stations are indicated on the shore of the Indian Ocean from Hormus, "where India begins," to Quilon in Kerala.[38] There, pearl fishers are mentioned again with reference to magic spells. So are boats (called *nichi*) with a length of keel of sixty ells (a unit of measurement that in England was equal to 45 inches) and a draft of thirty-four, with "at least four but sometimes as many as ten masts, and sails made of bamboo and palm-leaves." One of these boats is illustrated next to the text and another east of the Indian peninsula: with their transom bow and stern, rails on the stern galley, portholes, and as many as five masts with unmistakable mast and batten sails, they are undoubtedly Chinese junks such as Marco Polo had described.[39] From the Persian Gulf and the Red Sea, from the African coast to Sumatra and China, maritime trade developed considerably in the thirteenth and fourteenth centuries; with the improvement in maritime technology, Arab and Persian, Gujarat and

and to two lay rulers of Christendom. Marco Polo, among many others, searched in vain for Prester John throughout Central Asia. As a result, mapmakers began to locate his kingdom in East Africa instead—for the first time, it seems, in 1306—and thereafter he was often confused with the Emperor of Ethiopia.[27] On the *Catalan Atlas*, Africa is also symbolized by a nude black man with a camel and a turreted elephant. Camels were first used for the trans-Sahara trade sometime between the second and fifth century A.D., after being introduced from Arabia. Thanks to their notorious capacity to

travel long distances without water, they completely transformed African trade, opening sub-Saharan areas to Islam.[28] The elephant, which inhabits the area south of the Sahara, signifies the fact, as the text puts it, that Africa is the land of ivory "on account of the large numbers of elephants that live there."[29]

In Asia the Red Sea stands out, being shown as red—a characteristic that derives, we are told, less from the color of the water than from that of the sea bed.[30] It is cut in two by a land passage, a conventional allusion to Moses' miraculous crossing (Exodus, 14:21–22). The port of

Chinese boats sailed the South Asian seas, carrying pepper and spices, dyes and drugs, as well as porcelain and the other exotic wares that were so valued in the West.[40] This is the world that Vasco da Gama finally reached in 1498 and explored with the assistance of local pilots, opening the area to European influence.[41]

The Indian powers are represented on the *Catalan Atlas* by the Sultan of Delhi and the Hindu King of Vijayanagar, who is wrongly identified as a Christian.[42] Farther north appear the Three Wise Men on their way to Bethlehem[43] and at the top (or bottom) of the map a caravan; all of the latter figures are drawn upside down, as the map was probably meant to be laid horizontally and viewed from both sides. Camels laden with goods are followed by their drivers; behind them various people, one of them asleep, are riding horses. Next to this group is a mass of fascinating information based once more on Marco Polo's travel account: "You must know that those who wish to cross this desert remain and lodge for one whole week in a town named Lop, where they and their beasts can rest. Then they lay in all the provisions they need for seven months." Farther on we read that "when it happens that a man falls asleep on his camel during a night-ride or wanders away and loses his companions for some other reason, it often happens that he hears the voices of devils which are like the voices of his companions and they call him by his name and lead him in all directions through the desert, so that he can never find his companions again. A thousand tales are told about this desert."[44] The scene thus clearly refers to the Silk Road, the overland route to China. The caravan is crossing the Sinkiang desert through the Tarim Basin. The province and town of Lop mentioned by Marco Polo can be connected with the modern town of Ruoqiang (Charkhlik) south of Lop Nor.[45]

For more than a thousand years trade with the Far East had been conducted not only by the sea route but also, whenever possible, overland. The Greeks traveled as far as India, while the Romans developed economic relations with the Chinese empire.[46] The land road linked Europe directly to China but was more prone to political turmoil. The Mongol conquest, which united large areas of Central Asia in the mid-thirteenth century, led to the reopening of the route from the Black Sea to the Far East and China, especially after 1264 when Kublai Khan moved his capital to Beijing. Marco Polo's father and uncle, Nicolo and Maffeo, must have been among the very first Europeans to take advantage of this development when, sometime after 1260, they set out for Cathay, where they were received by Kublai Khan. They returned to

Europe in 1269 but revisited China only two years later with the young Marco. Marco Polo's *Description of the World* (also called *Il Milione*) is the most comprehensive account of China to be written by a Westerner before the sixteenth century, for he described in great detail his life and travels in the service of Kublai Khan. Marco Polo left China in 1292, returning by the sea route from Zhangzhou to Sumatra, Ceylon, and India, and providing a firsthand account of these countries.[47] The *Catalan Atlas*, in fact, presents the Far East as he described it, but without much geographical accuracy. Historically it illustrates the political disintegration of the Il-Khanid state after the death of Genghis Khan (Chingiz-Khan), with Janï-Beg (here called Kaniebek) ruling the Golden Horde from 1340 until his death in 1357, Kebek Khan leading the Middle Horde from 1318 to 1326, and Kublai Khan (1215–1294), who founded the Yuan dynasty, reigning over China.[48] In the areas that these rulers controlled and the bordering lands, towns and cities are not often correctly located; towns such as Bukhara and Samarkand in western Turkestan, for example, are shown south rather than west of the caravan. Cities are often located simply in the order in which they appear in lists rather than according to their relative geographic position.

Quite a number of harbors are indicated on the eastern coast of India, a few of them still identifiable, while a sailing junk testifies to trading activity, especially with the island of Iana (?), which is here associated with the legendary isle of the Amazons (*regio femarum* [*sic*]) and symbolized by its queen.[49] The text describes the richness of the area: "on the island of Iana are many trees of aloe, camphor, sandalwood, fine spices, garenga, nutmeg, cinnamon trees, from which the most precious spice of all India comes, and here are also mace and leaves."[50] The mention of a *regio femarum* and of two of its cities, Malao and Semescra, seem to refer to Marco Polo's Malaiur and Semenat (Sumatra).[51] The location of this land "in India" and its geographic position, however, suggest it is instead Ceylon.

In mainland India, King Stephen has been represented: the text beside him indicates that this Christian ruler is "looking towards the town of Butifilis," Marco Polo's kingdom of Mutifilis.[52] The notion that there were Christian rulers east of the Islamic world stems largely from the legend of Prester John; also important, however, were the real Christian minorities in India and the fact that the tomb of Saint Thomas was thought to be in Mailapore, a suburb of Madras, the Mirapore of the map.[53] Farther north is the realm of Kebek Khan, a historical figure who reigned from 1309 to

1326: "Here reigns King Chabeh, ruler of the Kingdom of the Middle Horde. He resides in Emalech."[54] Next to him, between India and the Chinese empire, is a group of pygmies fighting cranes: "Here are born men who are so small that they do not grow to above five spans in height, and although they are so short and incapable of hard work, they are strong enough and in a position to weave and herd cattle. And know that these people marry at the age of about twelve years and generally live to be 40 years old. But they are happy and defend themselves valiantly against the cranes, which they hunt and eat." The ancient writer Pliny had already described pygmies who lived in the remotest mountains of Asia, and he commented on their antagonism to cranes; they were later mentioned in the travel accounts of Odoric de Pordenone and Mandeville, but Marco Polo doubted their existence. They are, however, also shown on the Ebstorf map of 1284.[55]

Above, upside down, is a curious scene of the cremation of an old man to the accompaniment of music: "Know that the men and women of this region, when they are dead, are carried away to be burnt, to the sound of instruments and in ecstasies of joy.... And it sometimes happens though rarely, that the widow of the dead man throws herself into the flames," a practice that recalls widow-burning (*sutti*) of India.[56] Here the text conflates information from Marco Polo's account of how in the province of Malabar the death of criminals, who are compelled to commit suicide, is celebrated by their relatives with his observation on the custom of widows immolating themselves on the pyres of their dead husbands, mentioned a few lines later.[57] Also upside down, as it is on the upper half of the map, are people seeking diamonds. Their rather peculiar method of doing so is explained at length: "As they cannot get between the mountains where the diamonds are, they ingeniously throw lumps of meat to the place where the stones are lying, and the stones adhere to the meat and come away from their original site: then the diamonds that are attached to the pieces of meat are carried away by the birds and thus obtained by the men."[58] Alexander the Great, we are told, was already familiar with this method: it is illustrated on the map by two men cutting off pieces of meat and a bird flying over the mountains of Baldasia [Badakhstan], from which flows the stream that marks the eastern border of India (*finis indie*). Abraham Cresques has shown snakes in the crevices of the rock: Marco Polo, after all, tells us that the diamonds are found in deep valleys with "so many serpents" that "he who should go down there would be devoured immediately."[59]

Alexander the Great is shown in the upper right half of the map. There we are told that Satan came to his aid and helped him to imprison the Tartars Gog and Magog. Alexander then had two bronze figures made by which to bind them with a spell. The reference is to the gate that Alexander is supposed to have built in the Caspian Mountains to exclude Gog and Magog, who are here equated with various Central Asian tribes. The text on the map specifically refers to the "various tribes who have no scruples about eating any kind of raw flesh..., the nation from which the Antichrist will come forth," but which will ultimately be destroyed.[60] There is a further allusion to Alexander having erected two trumpet-blowing figures in bronze; these, according to various medieval legends, resounded with the wind and frightened the Tartars until the instruments were blocked up by various nesting birds and animals.[61] The text freely combines the medieval legend of Alexander with biblical traditions. This applies equally to the corresponding scene, where the great lord and ruler over Gog and Magog is shown with his men, the devil painted on their banners: "He will march out with many followers at the time of the Antichrist" but will ultimately be defeated as predicted in the Book of Revelation (20: 7–10).[62] To the south are those who will be sent to declare his glory among the Gentiles. The text here refers to Isaiah 66:19: "I shall send those who are saved to the peoples of the sea, to Africa and Lydia"; and further, "I will send to the isles afar off, that have not heard my fame, neither have seen my glory; and they shall declare my glory among the Gentiles."[63] To this prophetic inscription is added a text about the Antichrist.

Farther south, the supreme ruler of China (CATAYO on the map) is identified as Kublai Khan, grandson of Genghis Khan: "The most powerful prince of all the Tartars is named Holubeim [i.e., Kublai Khan], which means Chief Khan. The emperor is far wealthier than any other monarch in the whole world. This emperor is guarded by 12,000 horsemen."[64] The *Catalan Atlas* contains the names of various towns placed apparently at random, some of them mentioned twice; this reflects the fact that the map was evidently composed with the help of various sources. It emphasizes the importance of the capital, Chanbalik, the modern Beijing, in an account once more based on Marco Polo's text: "This town [Beijing] has an extent of 24 miles, is surrounded by a very thick outer wall and has a square ground-plan. Each side has a length of six miles, the wall is 20 paces high and 10 paces thick, has 12 gateways and a large tower, in which hangs a great bell, which rings

at the hour of first sleep or earlier. When it has finished ringing, no one may pass through the town, and at each gate a thousand men are on guard—not out of fear but in honor of the sovereign." The description emphasizes the richness and urbanity of the Chinese capital at the edge of the civilized world.[65] This contrasts strongly with the people of the islands farther east who are described as savages living naked, eating raw fish, and drinking sea water.[66] They are obviously to be identified with the Ichthyophagi, one of the fabulous races traditionally placed in Asia or in Africa.[67]

Farther south is the island of Trapobana already found on maps attributed to Ptolemy. For Pliny and classical authors it was evidently Ceylon,[68] but it was later associated with Sumatra, as it is here, described as "the last island towards the east."[69] Altogether, we are told, there are 7,548 islands in the Indian Ocean; they are rich in gold, silver, spices, and precious stones, so much so that "great ships of many different nations" trade in their waters. Here again the information is from Marco Polo, who, however, spoke of 7,448 islands.[70] There Cresques placed some of the fabulous and monstrous races legendary in classical antiquity and the Middle Ages: "On this island are people who are very different from the rest of mankind. In some of the mountain-ranges... are people of great size, as much as 12 ells, like giants, with very dark skins and without intelligence. They eat white men and strangers, if they can catch them." The reference is to giants familiar from the medieval Alexander legend, specifically defined here as Anthropophagi.[71] To these far-distant waters are also relegated mermaids, some of them probably the traditional half-woman and half-fish, the others more siren-like half-birds. The one illustrated has two fishtails, in accordance with one of the most common medieval conventions.[72]

At the center of the world is Jerusalem, more or less as in the tradition of medieval *mappaemundi*.[73] But in contrast with the *mappaemundi*, Europe and the Mediterranean form only the western half of the world. To the east is an enormous region whose importance is clearly understood but whose exact form is to a large extent still unknown. This is the world of spices, of precious wares, of silver and gold that Marco Polo so tantalizingly described. This is the world that Columbus had in mind when he conceived his "Enterprise of the Indies," and that he set out to reach by the western path.

NOTES

1. See especially *El Atlas catalán de Cresque Abraham. Primera edición completa en el sexcentésimo aniversario de su realización 1375–1975* (Barcelona, 1975); H.-C. Freisleben, *Der katalanische Weltatlas vom Jahre 1375* (Stuttgart, 1977); G. Grosjean, *Mappa mundi. Der katalanische Weltatlas vom Jahre 1375* (Zurich, 1977) (The quotations are based on Grosjean's translations of the texts found on the *Catalan Atlas*). For serious doubts about the identification of the author of the *Catalan Atlas* see Campbell 1981, 116.

2. For its provenance see Jean Alexandre C. Buchon and J. Tastu, "Notice d'un atlas en langue catalane manuscrit de l'an 1375," *Notices et extraits des manuscrits de la Bibliothèque du Roi* 14 (1841), 3: François Avril, Jean-Pierre Aniel, Mireille Mentré, Alix Saulnier, and Yolanta Zaluska, *Bibliothèque nationale. Manuscrits enluminés de la péninsule ibérique* (Paris, 1982), 97–98.

3. For these sheets see Grosjean 1977, 35–50; also *Atlas catalán*, 1975, 23–36.

4. For portolan charts see Tony Campbell, "Portolan Charts from the Late Thirteenth Century to 1500," in [eds. J. B. Harvey and David Woodward,] *The History of Cartography 1 (Cartography in Prehistoric, Ancient and Medieval Europe and the Mediterranean)* (Chicago and London, 1987), 371–463; for a more general account see Michel Mollat du Jourdain and Monique de La Roncière, *Sea Charts of the Early Explorers. 13th to 17th Century* (Fribourg, 1984).

5. For medieval *mappaemundi* see David Woodward, "Medieval *Mappaemundi*," in Harvey and Woodward 1987, 286–370.

6. For this conclusion see Campbell 1987, 373.

7. For the making of portolan charts see Campbell 1987, 428–438. Raleigh Ashlin Skelton, "A Contract for World Maps at Barcelona, 1399–1400," *Imago Mundi* 22 (1968), 107–113, discusses the division of work between the *maestro di charta da navichare* and the *dipintore*.

8. Grosjean 1977, 75. For the Armenian kingdom see Gérard Dedeyan, *Histoire des Arméniens* (Toulouse, 1982), 307–339.

9. For medieval maps of Palestine and the Near East see Kenneth Nebenzahl, *Maps of the Bible Lands. Images of Terra Sancta through Two Millennia* (London, 1986), 8–69, especially 46–49 on the *Catalan Atlas*.

10. Grosjean 1977, 78. Parrots first appear on the Ebstorf map; see Wilma George, *Animals and Maps* (London, 1969), 30 (also 35 and 42); *Atlas catalán*, 1975, 46–47.

11. Grosjean 1977, 52

12. Grosjean 1977, 52–53. For the authors mentioned in the *Catalan Atlas* see Pliny, *Natural History*, VI, XXXVII.202–204 (also IV, XXII.119) and Isidore of Seville, *Etymologiarum libri*, XIV, VI:8–9; also Thomas Johnson Westropp, "Brasil and the Legendary Islands of the North Atlantic: Their History and Fable. A Contribution to the 'Atlantis Problem,'" *Proceedings of the Royal Irish Academy* 30 (1912), 223–260 and William Henry Babcock, *Legendary Islands of the Atlantic. A Study in Medieval Geography* (New York, 1922). For Isidore's sources see Hans Philipp, *Die historisch-geographischen Quellen in der Etymologiae des Isidorus von Sevilla*, 2 vols. (Berlin, 1912–1913), 2:135.

13. Armando Cortesão, *History of Portuguese Cartography*, 2 vols. (Lisbon, 1969–1971), 2:72. For the map-

ping of the Atlantic islands see Cortesão 1969–1971, 2:55–60; see also Charles Bourel de La Roncière, *La découverte de l'Afrique au moyen âge. Cartographes et explorateurs*, 2 vols. (Cairo, 1924–1935), 2:1–41. For an up-to-date account, Campbell 1987, 410–411.

14. See Campbell 1987, 410; see also Samuel Eliot Morison, *The European Discovery of America. The Northern Voyages, A.D. 500–1600* (Oxford, 1971), 81–111.

15. Grosjean 1977, 53.

16. For this part of Africa see Grosjean 1977, 62–63.

17. Grosjean 1977, 62–63. For the discovery of Africa see La Roncière 1924–1935.

18. For the representation of unknown lands in cartography see Wilcomb E. Washburn, "Representation of Unknown Lands in XIV-, XV-, and XVI-century Cartography," *Revista de Universidade de Coimbra* 24 (1971), 305–322.

19. For the Val de Sus or Val de Durcha on portolans see Youssouf Kamal, *Monumenta Cartographica Africae et Aegypti*, 5 vols. (Leiden, 1926–1953), 4.4:1474–1475. On the depiction of Africa on Catalan maps see La Roncière 1924–1935, 1:129–141 (for the *Catalan Atlas*, see also 121–129, pl. XI). On the characteristic form of the Atlas Mountains, Campbell 1987, 393.

20. Grosjean 1977, 63.

21. For Mansa Mūsā, see Basil Davidson, *Old Africa Rediscovered* (London, 1959), 90–95; Raymond Mauny, "Le Soudan occidental à l'époque des grands empires," in *Histoire générale de l'Afrique noire*, ed. Hubert Deschamps, 1 (Paris, 1970), 193–195; Nehemia Levtzion, "The Western Maghrib and Sudan," in *The Cambridge History of Africa*, ed. Roland Oliver, 3 (Cambridge, 1977) 380–382. He is also shown on various portolans: Kamal 1926–1953, 4.4:1475.

22. For a map of his empire see Mauny 1970, 194, map 8. For the control of gold, Levtzion 1977, 488–491.

23. Grosjean 1977, 53. For Angelino Dulcert's chart of 1339, Mollat du Jourdin and La Roncière 1984, 201, pl. 7.

24. Grosjean 1977, 70.

25. Grosjean 1977, 78. For the Kings of Organa and Nubia on portolan maps see Kamal 1926–1953, 4.4:1475–1476.

26. Kamal 1926–1953, 4.4:1476. He is also sometimes placed in Asia; for his location there on maps see Ivar Hallberg, *L'Extrême-Orient dans la littérature et la cartographie de l'Occident des XIIIe, XIVe et XVe siècles* (Göteborg, 1906), 281–285. On Prester John, see, for example, Robert Silverberg, *The Realm of Prester John* (New York, 1972).

27. On Prester John in Ethiopia see Silverberg 1972, 163–192.

28. For the importance of camels for African trade see Richard Williams Bulliet, *The Camel and the Wheel* (Cambridge, Mass., 1975), esp. 7–27 and 111–140; Philip D. Curtin, *Cross-cultural Trade in World History* (Cambridge, 1984), 21.

29. Grosjean 1977, 54. For the camel and the elephant on the *Catalan Atlas*, see George 1969, 42–43; *Atlas catalán*, 1975, 46.

30. Grosjean 1977, 76; *Atlas catalán*, 1975, 35, n. 19; see also Kamal 1926–1953, 4.4:1475.

31. For the importance of Quseir, Albert Kammerer, *La Mer Rouge, l'Abyssinie et l'Arabie depuis l'antiquité. Essai d'histoire et de géographie historique*, 3 vols. (Cairo, 1929–1952), 1:81–82. On the whole area of the Red Sea, Abyssinia, and Arabia in the Middle Ages see Kammerer 1929–1937, 1.

32. For Sheba and its queen in geographical literature see Hallberg 1906, 437–440.

33. Grosjean 1977, 82; Pliny, *Natural History*, X, II.3–4, already linked the phoenix with Arabia; for this tradition see Heimo Reinitzer, "Vom Vogel Phoenix. Über Naturbetrachtung und Naturdeutung," in *Natura loquax. Naturkunde und allegorische Naturdeutung vom Mittelalter bis zur frühen Neuzeit*, eds. Wolfgang Harms and Heimo Reinitzer (Mikrokosmos. Beiträge zur Literaturwissenschaft und Bedeutungsforschung 7) (Frankfurt, 1981), 17–72, and Christoph Gerhardt, "Der Phönix auf dem dürren Baum (Historia de preliis, cap. 106)," in Harms and Reinitzer 1981, 73–108.

34. Isidore, *Etymologiarum libri* XII, 7:22.

35. For European accounts of Mecca and Medina in the Middle Ages, see Kammerer 1929–1952, 1:esp. 136–144.

36. Grosjean 1977, 79, 81. For Janï-Beg see J. A. Boyle, "Dynastic and Political History of the Il-Khāns," in *The Cambridge History of Iran*, ed. J. A. Boyle, 5 (Cambridge, 1968) 408, 420; for Tauris and its king see Hallberg 1906, 518–522; Paul Pelliot, *Notes on Marco Polo*, 3 vols. (Paris, 1959–1973), 2:847–848; and Alfons Gabriel, *Marco Polo in Persien* (Vienna, 1963), 69–76.

37. Grosjean 1977, 81; see also 84–85; *Atlas catalán*, 1975, 52–53. For Marco Polo's *Description of the World* see Marco Polo, *The Description of the World*, eds. Arthur Christopher Moule and Paul Pelliot, 2 vols. (London, 1938), 1–2. For an Aragonese version see Juan Fernández de Heredia, *Aragonese Version of the Libro de Marco Polo* (Madison, 1980). For various studies see Leonardo Olschki, *L'Asia di Marco Polo. Introduzione alla lettura e allo studio del Milione* (Venice and London, 1957) and Pelliot 1959–1973; also the various articles in *Oriente Poliano. Studi e conferenze…in occasione del VII centenario della nascita di Marco Polo (1254–1954)* (Rome, 1957).

38. For Hormus in the Persian gulf, Pelliot 1959, 1:576–582; for Quilon see 399–402. The *Periplus of the Erythrean Sea*, a Roman text written in Greek c. 50 A.D., lists the towns on the coast of India from the Indus to the Ganges: see Wilfred Harvey Schoff, *The Periplus of the Erythraean Sea. Travel and Trade in the Indian Ocean by a Merchant of the First Century* (London, 1912).

39. Grosjean 1977, 84. For the boat see Joseph Needham with collaboration of Wang Ling and Lu Gwei-Djen, *Science and Civilisation in China 4.3 (Civil Engineering and Nautics)* (Cambridge, 1971), 4.3:471–473, fig. 977b; I have used their description verbatim. For Marco Polo's description of Chinese ships see Polo 1938, 1:354–357 (chap. 158).

40. Curtin 1984, esp. 109–135, for example.

41. For a summary of the early explorations, John Horace Parry, *The Age of Reconnaissance* (London, 1963), 131–145.

42. For information on these figures see Grosjean 1977, 84.

43. Polo 1938, 1:113 (chap. 31) specifies that it is from Sava that "the three Magi set out." And it is in that city that they "are buried in three sepulchres or tombs very great and beautiful." For Sava and its association with the Magi, Hallberg 1906, 438–440; Pelliot 1959–1973, 2:826; Gabriel 1963, 86–88.

44. Grosjean 1977, 80: for the source of this account see Polo 1938, 1:148–150 (chap. 57).

45. Hallberg 1906, 316–318; for the identification of the town, Pelliot 1959–1973, 2:770.

46. See, for example, Donald F. Lach, *Asia in the Making of Europe. The Century of Discovery*, 2 vols. (Chicago and London, 1965), I.1:5–19. On the

relations of the Roman world with the Far East see John Ferguson, "China and Rome," *Aufstieg und Niedergang der römischen Welt*, eds. Hildegard Temporini and Wolfgang Haase, 2.9.2 (Berlin and New York, 1978), 581–603, and Manfred G. Raschke, "New Studies in Roman Commerce with the East," in Temporini and Haase 1978, 604–1378.

47. For Marco Polo's travels see n. 37, above. For a short account see Lach 1965, I.1:34–38. On the Silk Road see, for example, Hans-Joachim Klimkeit, *Die Seidenstrasse. Handelsweg und Kulturbrücke zwischen Morgen und Abendland* (Cologne, 1988).

48. For a history of the Mongols see Boyle 1968, 303–421.

49. For the various references to Amazons in the Far East see Hallberg 1906, 20–23; for the Island of Women see also Pelliot 1959–1973, 2:671–725.

50. Grosjean 1977, 88–89.

51. Grosjean 1977, 89; Pelliot 1959–1973, 2:771–773, 830. On the *Catalan Atlas* Malao is shown, a second time on the Island de Trapobana: Grosjean 1977, 93.

52. Pelliot 1959–1973, 2:787–788.

53. For the tomb of Saint Thomas in India see Hallberg 1906, 355–356; Leslie Wilfried Brown, *The Indian Christians of St. Thomas. An Account of the Ancient Syrian Church of Malabar* (Cambridge, 1956), 54–59. For early European reactions to Indian art, Partha Mitter, *Much Maligned Monsters. History of European Reactions to Indian Art* (Oxford, 1977).

54. Grosjean 1977, 87. For Kebek Khan of the *Chaghatai* Khanate see Boyle 1968, 405, 408, 421.

55. Grosjean 1977, 88; *Atlas catalán*, 1975, 53. See Pliny, *Natural History*, VI, XXII.70, VII, II.26, and X, XXX.58; for classical and medieval texts see Hallberg 1906, 418–421.

56. Grosjean 1977, 86; *Atlas catalán*, 1975, 53. Megasthenes was the first to mention this practice.

57. Polo 1938, 1:387 (chap. 174).

58. Grosjean 1977, 87–88; *Atlas catalán*, 1975, 52.

59. Polo 1938, 1:396 (chap. 175).

60. Grosjean 1977, 86; also *Atlas catalán*, 1975, 51–52. For Gog and Magog and Alexander's gate see Andrew Runni Anderson, *Alexander's Gate, Gog and Magog, and the Inclosed Nations* (Cambridge, Mass., 1932); Hallberg 1906, 225–230, 260–265. For this subject on maps see Jörg-Geerd Arentzen, *Imago mundi cartographica. Studien zur Bildlichkeit mittelalterlicher Welt-und Ökumenekarten unter besonderer Berücksichtigung des Zusammenwirkens von Text und Bild* (Munich, 1984), 180–182, 215–216.

61. Grosjean 1977, 86, for the inscription. For the various accounts of the legend, Anderson 1932, esp. 83–85, 101.

62. For that scene see Grosjean 1977, 86.

63. Grosjean 1977, 90.

64. Grosjean 1977, 90; Polo 1938, 1:216–217 (chap. 86): "his…honor has himself guarded day and night with twelve thousand paid horsemen." We are also told, as on the *Atlas*, that they are led by four captains each commanding three thousand of them. For the Far East in the *Catalan Atlas* see also Henri Cordier, "L'Extrème-Orient dans l'Atlas catalan de Charles V, Roi de France," *Bulletin de géographie historique et descriptive 1895* (1896), 19–63. For Kublai Khan see Pelliot 1959–1973, 1:565–569.

65. Grosjean 1977, 90–91; see Polo 1938, 1:212 (chap. 85). For Cambaluc (Beijing) see Hallberg 1906, 102–106, and Pelliot 1959–1973, 1:140–143. For Christians in China in the Middle Ages see Arthur Christopher Moule, *Christians in China Before the Year*

1550 (London, 1930).

66. Grosjean 1977, 92.

67. Hallberg 1906, 257–258. "Ichthyophagi piscibus tantum aluntur et salsum mare bibunt" was how they were described on the Ebstorf world map; see Konrad Miller, *Mappaemundi. Die ältesten Weltkarten*, 6 vols. (Stuttgart, 1895–1896), 5:49. See also the many references in John Block Friedman, *The Monstrous Races in Medieval Art and Thought* (Cambridge, Mass. and London, 1981).

68. For example, Pliny, *Natural History*, VI, XXIV.82–91; for Trapobana according to Ptolemy, André Berthelot, *L'Asie ancienne centrale et sud-orientale d'après Ptolémée* (Paris, 1930), 357–371.

69. Grosjean 1977, 92. For Trapobana in the Middle Ages see also Hallberg 1906, 509–514 and Marie-Thérèse Gambin, "L'île Trapobane: problèmes de cartographie dans l'océan Indien," in *Géographie du monde au Moyen Age et à la Renaissance*, ed. Monique Pelletier (Paris, 1989), 191–200.

70. Grosjean 1977, 92; Polo 1938, 1:365 (chap. 161).

71. Grosjean 1977, 92. On Anthropophagi in the east see Hallberg 1906, 30–32; for giants see 220. See also various references in Friedman 1981.

72. For mermaids see Georges Kastner, *Les sirènes* (Paris, 1858), 1–83; also Gwen Benwell and Arthur Waugh, *Sea Enchantress. The Tale of the Mermaid and Her Kin* (London, 1961).

73. For Jerusalem on medieval world maps see Arentzen 1984, 216–222.

PORTUGUESE NAVIGATION: ITS HISTORICAL DEVELOPMENT

Luís de Albuquerque

Navigation made spectacular progress in Europe during the fifteenth century. In the course of that period, it became a technique rather than an art. This change was brought about not through any conscious decisions made by its leading practitioners, but rather by their responses to the external conditions with which they had to contend.

At the beginning of the fifteenth century, the European navigators who sailed the longest routes were exclusively Mediterranean peoples, the Genoese and Venetians in particular, and also the Aragonese. Their vessels followed the existing trade routes, from termini in the Near East all the way to the coast of Flanders, the location of the large European spice fairs which were the main incentive for this trade. This maritime traffic had taken a major step forward at the end of the thirteenth century, when the ships plying the route had begun regularly to sail around the Iberian Peninsula and to unload their goods at the ports of Flanders, rather than ending their voyage in southern France and consigning their cargoes to overland transport to their final destination. This change had dramatic economic consequences, for it brought irremediable decline to the principal crossroads of the land route, such as Cahors, which had previously been an important financial center. It had little effect on methods of navigation, however, since the ships still kept as close as possible to the coastline from the point they entered the Atlantic until they reached the English Channel.

Sailing conditions in the Mediterranean had made it possible to use coastal routes, and this is what had been done in most cases. There were clearly some navigators who did not hesitate to sail in a north-south direction—the frequency with which ships traveled to Cyprus and to Malta proves this—but one could almost say that the Mediterranean was a landlocked sea "especially navigated lengthwise." In fact the difference in latitude between any two points on the Mediterranean coast never exceeds six degrees.

It is clear that the new practice of sailing around the Iberian Peninsula to Flanders did not significantly change the art of navigation, which remained coastal. This is demonstrated by the fact that ships, especially Italian vessels, would often stop on the way to and from Flanders at Portuguese ports, principally Lisbon. The Portuguese ports were practically en route, and stopping there enabled captains and merchants to open up additional opportunities for trade. The continued increase of these visits led to the enactment of legislation in Lisbon to regulate the life of foreigners, their rights, their trade, and the taxes they were required to pay. There was some conflict with locals who were interested in the same activities, but the royal government knew how to handle these difficulties so as not to frighten away the foreigners; they provided a good income for the royal coffers.

Not all the ships in the Mediterranean sailed from Genoa, Venice, or Aragon; there were of course others engaging in maritime trade, including the Portuguese. However, the routes sailed by these other vessels were not as long, and they knew the art of navigation only by adoption. The Genoese, the Venetians, the Aragonese and perhaps navigators from other Italian provinces had created the art of navigation to suit the requirements of their own shipping; the others applied the techniques as best as they could.

A primary tool for navigation was the portolan, a written description of the course along which the ships sailed, indicating bays, capes, coves, ports, magnetic rhumb-lines, and the distances between these places. These writings had their antecedents in the so-called *peripli* of classical antiquity, some of which are still known, the principal one being the *periplus* of the Red Sea. One essential difference between the classical *periplus* and the medieval portolan is that the information in the former was mainly commercial whereas in the latter it was primarily nautical. Today more than ten portolans survive, all written in Italian. Motzo published and studied the most important, which circulated under the name of *Il Compasso da Navigare* (*The Navigational Compass*). Kretschner analyzed and edited the rest, almost all of which are known now by reference to the collection or library to which the particular manuscript belongs. The texts employ a direct and little-varied language and provide no commentary beyond the nautical information for which they were used.

I believe that the idea of representing maritime information graphically can be traced back to the written portolans. They gave rise to nautical charts, which in the nineteenth century came to be called portolan charts. The oldest known portolan chart is the anonymous *Carta Pisana* of the late thirteenth or early fourteenth century, so called because it was found in Pisa. It is in the collection of the Bibliothèque Nationale, Paris, but is not well-preserved. Motzo related it to the particular portolan he published; however, a portolan can always be related to a chart, since the chart is simply the graphic equivalent of the written text.

What is certain, however, is that the nautical charts inevitably improved in tandem with the improvement of the textual portolans. We even have written proof that there were nautical charts before the familiar portolan chart; the pilots were able to mark their location when they were in open sea. The gradual improvement of the nautical charts is particularly obvious when one examines the progress of the representation of northern Europe or the Canary Islands on the portolan charts. These eventually emerged fully indicated, with their relative positions very accurately depicted. The Canaries, along with Cape Bojador on the African coast, virtually to their east, marked the southern limit of the area of the Atlantic which was represented. Some charts continued the African coast to the south of that cape, sometimes giving it a different name ("river of gold," for example), but the coastline is shown as being so even that it soon becomes obvious that no navigator had ever seen it. So when Gomes Eanes de Zurara wrote in his *Chronicle of the Discovery and Conquest of Guinea*, dated 1453, of the addition beyond Cape Bojador made to the traditional nautical chart by order of Prince Henry the Navigator (1394–1460), he indicated specifically that this addition corresponded to the truth as "something that had been seen."

Even before the nautical chart, however, the so-called mariner's needle (the magnetic needle or compass) had been introduced into naviga-

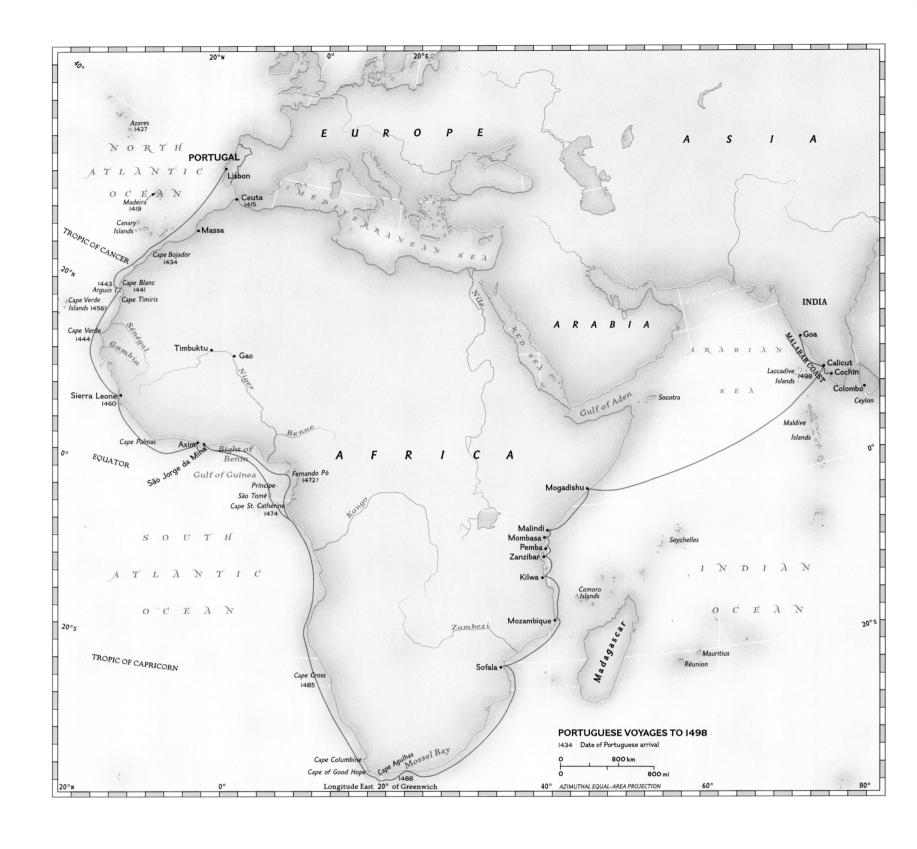

PORTUGUESE VOYAGES TO 1498

1434 Date of Portuguese arrival

0 800 km

0 800 mi

Longitude East 20° of Greenwich AZIMUTHAL EQUAL-AREA PROJECTION

tion. The magnetic properties of iron when rubbed against natural magnets was a phenomenon that had long been known. At about the time the needle was introduced, there are various written references to it, the most important of which is that of Pierre de Maricourt (or Petrus Peregrinus). The needle was first used on ships in a rather rudimentary manner: after being dipped in oil it was set to float in a pan of water. Over the years this elementary device was greatly modified, and when the pilot João de Lisbon described it in 1514, it had already become an effective nautical instrument. The origin of the magnetic needle and its introduction to navigation are still obscure. A dubious and late suggestion, repeated by Father Francisco da Costa in the seventeenth century in his *Arte de Navegar* (*Art of Navigation*), is that its use in navigation originated with an Italian from Amalfi named Flavio Gioia. The origin of the device may be Chinese (although when historians do not know the origin of a technical innovation in the Middle Ages they show a great tendency to attribute it to distant China!).

There are thirteenth-century Arab texts that refer to the magnetic needle, and it is therefore very probable that it reached Europe through the Islamic world.

Whatever the history of the magnetic needle itself, the rhumb-lines mentioned in the portolans and later represented graphically on the nautical charts were magnetic and not geographical. The phenomenon later known as magnetic declination (that is, the angular deviation of the compass needle in relation to the meridian line, which changes from place to place) was then unknown, and observers believed that the line indicated by the compass needle was identical to the geographic one. This is proved irrefutably by the nautical charts themselves, since they always distort, for example, the shape of the Mediterranean basin, because the magnetic declination varies from place to place. It is noteworthy, nonetheless, that the nautical charts of the Mediterranean remained unaltered until the eighteenth century; this is to be expected, because recent studies of magnetism in earlier periods show that the degree of magnetic declination itself was practically unchanged for about four centuries.

This, then, was the knowledge and equipment to which a pilot in the early fifteenth century had access. Alfonso X of Castile (r. 1252–1284), in his *Partidas* (*Ships' Crews*), required of the pilot some additional knowledge, such as an understanding of maritime currents. He did not refer to the traverse board, which allows a pilot to return to the straight course if he has had to leave it because of winds, currents or natural obstacles such as islands or shoals. Its invention has been attributed, without sufficient foundation, to Ramon Llull of Majorca. If it was Llull's contribution to the art of navigation of his time, it is the only one he made. The Aragonese did have a school of cartography partly under the influence of Majorcan Jews, and in documents mentioning the fifteenth-century Aragonese court, there is reference to an *Arte de Navegar* (*Art of Navigation*), a text which unfortunately has since been lost.

The growing nautical traffic in the Atlantic in the course of the fifteenth century did not completely change the methods of navigation described above. Since Prince Henry encouraged navigation beyond Cape Bojador, his ships having reached Sierra Leone at the time of his death, it is often stated that he surrounded himself with scholars of different origins, who came together at some kind of academy at Sagres at the southwestern tip of Portugal, where he set up some sort of meteorological observatory. There, it is said, he resolved all the problems posed by the navigation of the Atlantic.

Although the idea of the "School of Sagres" is widely accepted, it must be a fallacy for several reasons. First, neither Prince Henry nor any European, Arab, or Jewish scholar could foresee the geophysical conditions that would be encountered in the Atlantic and find adequate solutions for them in advance. Second, there is no evidence of any such group of scholars having been assembled, except for Jaime of Majorca, who was simply a cartographer, the son of Abraham Cresques (see cat. 1). Moreover, it would not have been possible to set up a meteorological observatory at Sagres, as the science itself did not exist in the fifteenth century. Furthermore, we know that Prince Henry did not spend much time in Sagres until the last two years of his life, when decisive progress in the new techniques of navigation had already been made as a response to the demands of Atlantic navigation. Until 1458 he visited Sagres only occasionally and did not stay long enough to direct a school. The idea of the "School of Sagres," which is as fallacious as it is famous, goes together with the idea that advanced studies in astronomy were necessary to develop a new manner of navigation, as well as the idea that the Prince took a great personal interest in these studies. The romantic historian Oliveira Martins even hypothesized that he had read the works of the German astronomers Peuerbach and Regiomontanus, which were not in print until 1460, the year Prince Henry died!

While extremely important, the fifteenth-century change in the art of navigation did not require specialized scientific training, and the little astronomy that was necessary was so simple that pilots were able to find the solutions by their own means. When this was not possible, they consulted astrologers, who had no difficulty in responding because the required information was recorded in a variety of books. We can still speak of a "school of navigation" metaphorically, because it was the navigators who departed from the Algarve who contributed their experience to resolving the difficulties in an unprecedented way, thereby bringing about the developments in technique. In this school, so to speak, each pilot was both apprentice and master. As Luciano Pereira da Silva wrote: "the school of Sagres was the planks of the caravels"—the practice of navigation rather than theory dictated the nautical solutions the pilots developed.

Let us look at the essential points of this new method of navigation. Sailors returning to the Algarve and later to Lisbon from their voyages, which reached increasingly farther south along the African coast, met with serious difficulties because of unfavorable currents and winds. Since it was not easy to overcome these obstacles, even when they used ships such as caravels that were able to sail close to the wind, the pilots tried out new ways of dealing with them. They would sail out into the Atlantic until, at about the latitude of the Azores, they encountered winds that would take them home to Portugal. This maneuver, which took more time the farther south the point of departure was, meant that for several weeks, sometimes for up to about two months, the ships had to navigate in open sea without any land as a point of reference. The pilots therefore needed to establish their approximate location so that they could proceed with some security, a process that led to increasingly more effective navigation techniques.

Initially, the navigator would estimate his north-south distance from a place of reference based on the difference in altitude of the polestar—or any other easily identifiable star—on the transit of the same meridian. The result would be the number of leagues, counted on a meridian, that separated the parallel of the observer's location from the parallel passing through the place of reference. For example, if the navigator took as his point of reference the parallel of latitude passing through Lisbon, where the upper meridian passage of the polestar was at the astronomical altitude of 42°, and at sea he measured the equivalent transit of the polestar at 35°, he could conclude that the parallel of his location was separated from that of Lisbon by 7° (that is, the meridian distance between these two parallels was 7 times 16 ⅔ leagues, the value then used for the unit of one degree of latitude).

This idea must have originated through the influence of Joannes de Sacrobosco's thirteenth-century treatise *Da Esfera* (*The Sphere*). This book was well known in Portugal and served as an instruction manual for pilots. In a passage at the end of Chapter I the cosmographer gives instructions on how to measure the distance encompassed by one meridian degree of the earth by measuring the distance separating two points along a single meridian, and more precisely by observing the altitude of the polestar at points one degree apart from each other. In the context of *Da Esfera* this information was merely theoretical, because it required measuring the distance between the two points without the observer's leaving the meridian where he happened to be, which made the technique impracticable.

The instrument used in these observations was the quadrant, and we know from a remark made by Diego Gomes that it was customary to write the name of the place where the star was

observed on the altitude marked on the graduation of the instrument. Since it was not always possible to observe the polestar's meridian transit—sometimes, for example, clouds darkened the sky at the moment of observation— it was then noted that other positions in the polestar's movement could be used. The star appears to trace a circular movement around the pole (the angular distance of the star to the pole was then estimated at 3° 30′). In addition to the two transits of the meridian, the positions chosen for observations corresponded to the other two main cardinal points (east and west) and also to the intermediate cardinal points (northeast, southeast, southwest, and northwest). Of course only altitudes observed under the same conditions could be compared.

At this stage it was not possible to engrave directly on the quadrant the eight altitudes of the polestar to be used. Instead, their values for Lisbon and other places of reference were written at the end of the radii of a circle corresponding to the eight bearings indicated, so that the circle would thus represent the apparent daily movement of the star in the sky. This manner of calculating was then known as the "Polaris Wheel," and such wheels are reproduced in early sixteenth-century nautical texts. This procedure was of decisive importance for the development of navigation. Knowing the latitude of Lisbon—then estimated at 39° north—it was not difficult to conclude that it would be sufficient to add or subtract certain quantities to the altitudes marked on the wheel for Lisbon in order to obtain the latitude at a particular place; and it was believed that what was valid for Lisbon would always be valid. With the value of these constants properly applied, the altitude of a star was no longer simply observed, but rather the latitude of a place was calculated directly by making the corresponding proportionate adjustment.

This ability to determine the geographical coordinates of latitude on board ship was the major step toward the modern art of navigation. Naturally the longitude of a place still had to be calculated, and a practical shipboard technique for that calculation was not developed until the second half of the eighteenth century, even though several astronomical processes, including procedures based on the movement of the moon, were previously known for determining the coordinate. In observations made by some of these astronomical processes, however, even as practiced by navigators of great skill, errors of up to 20° or more are common. The rules that indicate those constants (constituting the so-called "rule of the north") were also often represented in "wheels" (not with altitudes, but by indicating the correct numbers of the eight

fig. 1. "Polaris Wheel" based in Valentim Fernandes, *Reportório dos Tempos* (1518)

rules). In an analysis to which Pedro Nunes (who was appointed cosmographer-major of Portugal in 1547) submitted this rule, he wrote that the regulatory numbers varied with the latitude. While this is true, Nunes did not calculate this variation. Had he done so, he would have found that within the latitudes of 45° north and 45° south (limits that the navigators of the fifteenth century rarely exceeded and frequently did not reach), the variation was insignificant, particularly in view of the much greater and inevitable errors of observation on shipboard.

The three early phases of navigation, leading to the measurement of latitude by solar observation, probably began around 1455 and concluded in 1485. It was in the latter year that the groundwork was laid for determining latitude by means of the sun, as can be seen in a note in the margin of a book that was said to belong to Christopher Columbus. This note was written in an impersonal manner, and today serious doubts have been expressed as to whether it was actually written by Columbus, but the information is consistent with other sources and should be accepted.

The southward progress of the Portuguese voyages made it necessary to find a replacement for the polestar, for when ships began to approach the equator, it became impossible to observe the polestar. While navigators evidently tried to use other stars for their observations, they clearly preferred the polestar, for they tried unsuccessfully to find a star that fulfilled an equivalent role in the southern hemisphere; this is clear from a letter to the Portuguese king Dom Manuel II written in Brazil on 1 May 1500 by Mestre João, a member of Pedro Alvares Cabral's fleet.

The solution was at hand in astrological writings. Since at least the ninth century, astrologers had rules for determining latitude

based on the altitude (or zenithal distances) of the sun at its meridian transit (the moment when it reaches its highest point in the sky). These frequently appeared in treatises dealing with the use of the astrolabe (less frequently, the quadrant), but they were generally incomplete. The authors lived in latitudes north of the Tropic of Cancer and were interested only in rules of observation that applied to their own situations. They did not consider the case of an observer situated between the tropics and the equator, or observing the sun to the north of his zenith. These cases were of interest to the maritime navigators, and so it was necessary to enlarge upon the traditional rules and then try them out in practice. For this reason, Dom João II, as we know from a letter that is still generally attributed to Columbus, decided to send his physician Mestre José (doubtless the Jewish scholar José Vizinho) to Guinea to observe the altitude of the sun and thus verify in practice the effectiveness of the rules that he himself had established. One of these "rules of the sun" survives in its entirety; it is found in the *Livros del Saber de Astronomia* (*Books of Knowledge of Astronomy*), which also contains a second incomplete version.

Unlike the stars, whose altitudes remain fixed throughout the year, the declination of the sun changes from day to day. To find their latitude on the basis of solar observations, therefore, navigators needed to know the sun's declination on the day in question. Abraham Zacuto, a Jewish astronomer, had prepared a set of solar tables before he left Spain in 1492. In Portugal Zacuto's tables were put into use while he was still living in Spain; they were published in Latin in 1496 at Leiria after he had arrived in Portugal. The determination of the declination of a celestial object using this work was a task which presented some difficulties. In the first place, the book includes monthly tables for four consecutive years, which it calls a complete revolution of the sun. In one of these tables one could read the "place of the sun" in the determined number of degrees, minutes, and seconds covered from the sun's entrance into a given zodiacal sign. The place tables of Zacuto were calculated for the period 1473–1476 (1472 was said to be its "root year"); for dates later than 1476 it was necessary to add 1′ 46″ to the value given in the tables for each complete revolution beyond that period of four years. This reflects the fact that the true tropical year did not coincide with the average year of 365 days and 6 hours of the Julian Calendar then in use, with the result that the sun advanced and the value of the coordinate would have to be corrected, once the correct place was obtained; reference was made therefore to a fifth table,

where, based on that coordinate, the solar declination was read. But this table of Zacuto referred only to entire degrees of "places," which he subjected to mathematical operations that, given the ignorance of adequate logarithms at that time, were complex and certainly beyond the understanding of a pilot.

Therefore, mathematicians already able to undertake such calculations were commissioned to provide tables with solar declinations for the use of pilots at sea. At first they were prepared roughly and for only one year at a time (only one of these tables is known). Later they were prepared for four-year periods, that is, for complete revolutions of the sun, and with greater accuracy. Such quadrennial tables of solar declinations existed in the fifteenth century, of which some remains are found in the *Livro de Marinharia* (*Book of Seamanship*) by Andre Pires, which includes a series of tables covering the period 1497 to 1500. These must have been used by Vasco da Gama's pilots. It is not known who calculated these tables, but Gaspar Correia suggests in the *Lendas da India* (*Legends of India*) that it was Abraham Zacuto himself.

The most famous and most widely disseminated quadrennial tables of solar declinations cover the period 1517 to 1520. These were published (with printing errors) in the so-called *Guia Nautico de Evora* (*Nautical Guide of Evora*), and later copied many times. It is known that Gaspar Nicolas calculated them, because Valentim Fernandes so states in his 1518 edition of the *Repertório dos Tempos* (*Repertory of the Times*), which contains a transcription of the tables. Gaspar Nicolas was the author of the first treatise on arithmetic published in Portugal, in 1519.

* * * * *

This historical summary of the development of the art of navigation during the second half of the fifteenth century leads us well into the realm of modern navigation. This progress was widely recognized as such throughout Europe. Indeed, at least since the beginning of the sixteenth century, it was recognized within nautical circles in Lisbon that it would be useful to combine rules to be used by mariners with the Portuguese version of Sacrobosco's treatise *Da Esfera*, to shed some light on elementary cosmography. At least two known publications did just this, the second constituting an improvement on the first. These pamphlets, each known from a unique copy, are today called *Guia Nautico de Munique* (*Nautical Guide of Munich*) (1st edition, copy in the Bayerische Staatsbibliothek, Munich) and the *Guia Nautico de Evora* (2nd edition, Biblioteca Pública e Arquivo Distrital de Evora); some believe that the Munich edition is in fact a reprint. It is certainly surprising that this pamphlet, which does not bear a date but can be dated to 1509, presents only a one-year solar table, when better quadrennial tables with the declinations of the sun had already been calculated. The material in these Portuguese pamphlets was translated or adapted into Spanish, French, Italian, English, Flemish, and German. The knowledge they contained was recognized as new and was widely disseminated.

SPAIN IN THE AGE OF EXPLORATION: CROSSROADS OF ARTISTIC CULTURES

Jonathan Brown

Isabella of Castile and Ferdinand of Aragon, the Catholic Monarchs, are best remembered today as the sponsors of Christopher Columbus' daring enterprise of 1492.[1] However, they loom even larger in world history as the founders of a Spanish empire whose territories were to encircle the globe. In keeping with this potent historical role, Isabella and Ferdinand are given credit for opening the way to the golden age of art that was soon to dawn over their Spanish realms. Indeed, a special term—*arte* or *estilo Isabel*—has become a conventional way to describe Spanish art of the late fifteenth and early sixteenth centuries.[2] However, although Isabella was a major patron (Ferdinand was a negligible figure in the arts), she was only one player in the drama of Spanish art during this crucial phase of its development.

The practice of naming artistic styles after reigning monarchs first seems to have been applied to French art of the seventeenth and eighteenth centuries, when much artistic production was centered in the royal workshops. This form of systematic patronage, a byproduct of the absolute monarchy established by Louis XIV, could not be achieved by the less powerful monarchs of the late medieval and Renaissance period who bartered with their subjects for power. Thus in Spain, as elsewhere in fifteenth-century Europe, uniformity was the exception in art as in politics. The artistic mixture in the Isabelline period, moreover, was exceptionally rich, reflecting three influences: a late Gothic style from Germany and the lowlands, a classicizing style from Italy, and an Islamic style from the Muslim (*mudéjar*) and morisco (Muslim converts to Catholicism) populations of the Iberian Peninsula. Often coexisting in the same monuments, these stylistic traditions were utilized in the creation of complex, idiosyncratic works of art.

The late Gothic style characterizes the patronage of Isabella, although it was by no means unique to her. In fact, Isabella's patronage might be called "adoptive," in the sense that she appropriated a fully developed model and applied it to her own ends. During the fifteenth century the crown of Castile had rested upon the indecisive heads of the Trastámara dynasty, whose members were manipulated by ambitious noblemen eager to expand their wealth and influence at the expense of the king. A singular expression of the rising power of these aristocrats is the group of sumptuous funerary chapels they constructed to proclaim their fame, perpetuate their memory, and promote the redemption of their souls. Two important chapels exemplify the phenomenon and set a standard for what might be called conspicuous salvation.

One of these is the chapel of Alvaro de Luna in the Toledo cathedral.[3] Luna, like many of his powerful peers, was a recent arrival to the ranks of the nobility. In 1420 he became the favorite of the father of Isabella, Juan II, who ruled from 1419 to 1454, during much of which time Luna actually held the reins of power. However, he finally reached too far and fell victim to a rival faction, which persuaded the king to order his execution in 1453.

Luna may have died in disgrace, but he was buried in splendor. At the height of his career he had appropriated three chapels in the cathedral of Toledo, the primatial see of Spain, which he converted into a large-scale family funerary monument. The work began in 1430, but was partly destroyed a decade later when the populace rose up against Luna and vented its wrath on this symbol of his glory (proof that its intended meaning was widely understood). By 1448 the monument was rising again with the participation of an architect newly arrived from the north, Hannequin of Brussels, who designed one of the earliest examples of flamboyant tracery in Spain in the spaces above the cornice.[4] The present tombs, the originals of which were destroyed in the uprising of 1440, were not completed until 1489. By its sheer size and rich ornamentation the Luna chapel established the criteria for new-rich opulence and, as such, was bound to inspire competition.

The undoubted winners in the race for earthly glory were Pedro Fernández de Velasco, who bore the title of constable of Castile, and his wife, Mencía de Mendoza. Around 1482 the constables took possession of a chapel in the Burgos cathedral and commenced the construction of a sizable edifice known as the Capilla del

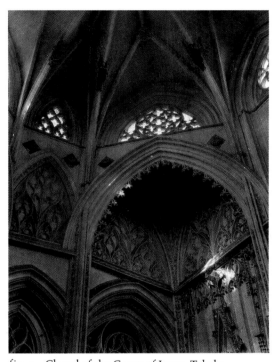

fig. 1. Chapel of the Count of Luna. Toledo Cathedral

Condestable.[5] The architect was Simón de Colonia (Simon of Cologne), whose father, Juan, had come from Germany in the 1440s and been appointed master of works of the cathedral. Juan introduced a German late-Gothic style into the region, which was perpetuated by his family workshop well into the sixteenth century. The interior of the constable's chapel is an unabashed exercise in aristocratic ostentation. Flanking the altarpiece (which was executed, after the constable's death, between 1522 and 1532) are the coats of arms of husband and wife, repeated twice on a mammoth scale to remove every doubt about the identity and importance of those interred within the marble tombs at the foot of the altarpiece. Outsize family escutcheons are also displayed on the exterior of the chapel. The Velasco, like certain egocentric American billionaires of the 1980s, spared no expense in trumpeting their wealth and position of power over lesser mortals.

Rich chapels required rich furnishings, and here again the constables were equal to the occasion. They acquired numerous devotional

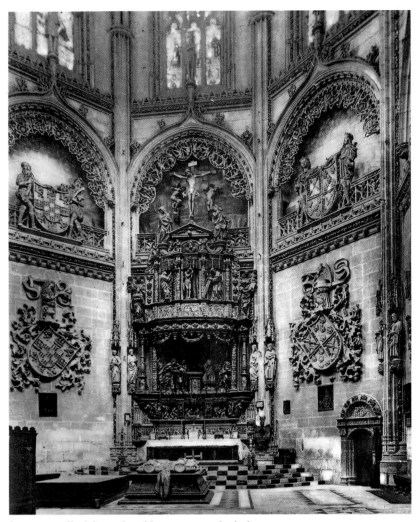

fig. 2. Capilla del Condestable. Burgos Cathedral

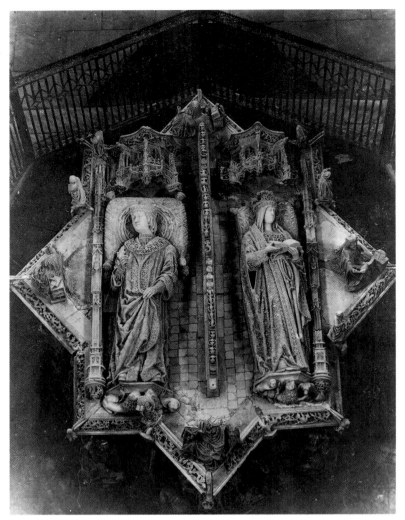

fig. 3. Gil de Siloe, Tomb of Juan II and Isabella of Portugal. Cartuja de Miraflores, Burgos

paintings, which were displayed in the sacristy, and also donated dozens of liturgical vessels made of gold and silver and decorated with precious stones. Most of these have vanished over the centuries, their high intrinsic value having tempted impecunious institutions and unprincipled individuals. But while intact the chapel constituted a brilliant display of the family's power.

These late Gothic chapels were the principal models available to Queen Isabella when she began her career as a patron of the arts, and would determine her involvement with the arts of architecture and sculpture. The goals of royal patronage were manifold. Isabella and Ferdinand needed to assert their hegemony over the nobles, and of course they were equally concerned with displaying their zeal as defenders of the Christian faith. They were also preoccupied with an issue that was especially charged during this period—dynastic legitimacy and continuity. A final desire was to signal the dominant presence of the monarchy throughout the kingdom. All these elements were conjoined in

what was to become the characteristic Isabelline foundation, the funerary chapel, examples of which were built in the prevailing Gothic idiom by the same artists already employed on important projects for patrons in the nobility.

The earliest of the queen's commissions was the church of the Carthusian monastery of Miraflores, on the outskirts of Burgos.[6] Miraflores was founded in 1442 by her father, who had intended to be interred at the site, but he died before much work had been done. After assuming the crown of Castile in 1474, Isabella at once turned her attention to Miraflores, undoubtedly with the idea of shoring up her claim to legitimacy as a monarch as well as honoring the memory of her parents. Establishing what would become her usual pattern, she sought out the leading local masters to complete the building and to provide the tombs and the adjacent altarpiece. Thus Simón de Colonia became the architect in succession to his father and brought the building to completion in 1488, even while still engaged in finishing the Capilla del Condestable in the cathedral.

Colonia's severe design, a prerequisite of churches built for the Carthusian order, makes an effective foil for the extravagant sculptural ensemble in the major chapel, where Juan II and Isabella of Portugal are buried in a freestanding tomb that is complemented by the wall tomb of the queen's brother, Alfonso.[7] These tombs, completed in 1493 and carved in alabaster, are the work of Gil de Siloe, who also designed the altarpiece, executed in polychromed wood and finished in 1499.[8] Like Simón de Colonia he was employed by the Burgos cathedral and thus was on hand when Isabella required the services of a sculptor for the monastery.

The tombs and the altarpiece are among the masterpieces of late Gothic sculpture and constitute a worthy reply to the Capilla del Condestable. Gil de Siloe's aesthetic is akin to a medieval goldsmith's and depends on the accretion of finely wrought details to produce the sensation of overwhelming magnificence. Splendor, achieved by intricate surface effects, is the byword of the Isabelline period, and here it is proclaimed loud and clear.

The next significant architectural project sponsored by the queen was again prompted by a mixture of religious, political, and dynastic considerations. This is the chapel of San Juan de los Reyes in Toledo, which was founded in the first instance to commemorate the victory at Toro in 1476.[9] San Juan, however, was also intended to serve another purpose, the funerary chapel of the Catholic Monarchs. Therefore every effort was made to endow the edifice with grandeur and majesty.

As at Miraflores, Isabella once more chose an architect and a sculptor employed by the nearby cathedral. Juan Guas, the designer, and Egas Coeman, the sculptor, were both connected to Hannequin of Brussels, who had become master of works at the Toledo cathedral following his participation in the reconstruction of the Luna chapel. Coeman was Hannequin's brother and Guas, a native of Brittany, had begun his career as a member of Hannequin's team of sculptors.

San Juan, which was substantially complete by 1496, was never to fulfill its destiny as the royal funerary chapel. After the conquest of Granada in 1492, Isabella changed her mind and decided to be buried in the city where the reconquest of Spain from Islam reached its glorious conclusion. Isabella then dedicated San Juan to the service of the Franciscans and installed the order there. However, by that time the seal of royal patronage had been stamped everywhere on this building. A dedicatory inscription in stately Gothic lettering runs along the cornice of the nave and proclaims the glory of "Ferdinand and Isabella, king and queen of Castile, León, Aragon and Sicily, who, through blessed matrimony, united the said realms." The program reaches a resounding climax on the walls of the transept, where the royal shield, held in the talons of an eagle (symbol of Saint John the Evangelist), is repeated five times on each side in monumental high relief, heralding the royal presence in this key city of Castile.

The final building project of the monarchs was their ultimate place of burial, the royal chapel of Granada.[10] By a royal decree of 13 September 1504, Ferdinand and Isabella ordered that their remains be interred in the city that, according to Ferdinand's testament, was "conquered and taken from the power and subjugation of the faithless Moors, enemies of our holy Catholic faith." The queen died two months later (26 November 1504), but the work proceeded as if she had been alive to direct it. The architect, Enrique Egas, was the nephew of Hannequin of Brussels and the son of Egas Coeman. He had also worked with Juan Guas at San Juan de los Reyes and became his successor as master of the works at the cathedral at Toledo. Conse-

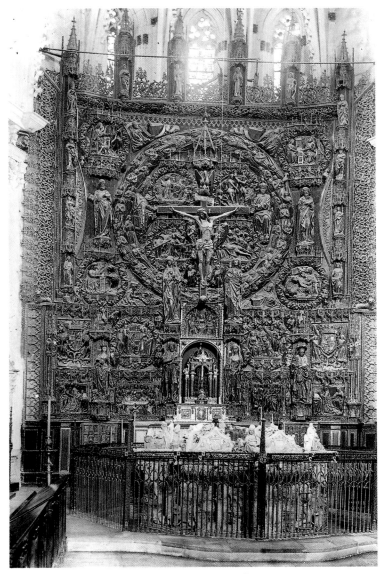

fig. 4. Gil de Siloe, Altarpiece. Cartuja de Miraflores, Burgos

fig. 5. Interior. San Juan de los Reyes, Toledo

quently his design for the chapel follows the norms of the Toledan late Gothic favored by the queen. Construction began in 1506 and terminated in 1519, by which time the emperor Charles v, grandson of the Catholic Monarchs, had ascended the throne of Spain. He was decidedly unimpressed by what he saw, dryly characterizing the chapel as a "meager sepulcher for the glory of my grandparents."[11] His remark reflects the major change in artistic taste from Gothic to Renaissance that began in the early sixteenth century, and his orders to adorn the chapel paid little heed to the existing style.

Although Isabella was to die without seeing her final resting place, she was concerned from the start that it be suitably decorated with impressive liturgical objects and devotional paintings. Ferdinand respected her wishes and, in due course, transferred numerous objects to the royal chapel. These objects came from the extraordinary art collection that the queen had accumulated during the thirty years of her reign, a collection that was one of the most important in Europe at the time.

Isabella's collection comprised four parts: illuminated manuscripts, tapestries, paintings, and decorative objects including gems and jewelry.[12] Although only a small percentage of the collection has escaped destruction and depredation, numerous inventories evoke the impressive size and extent of her holdings.

In assessing the queen's collection it may seem perverse to focus initially on its size and not on its contents. By modern criteria, which are highly selective and emphasize exemplary works, a large collection is not necessarily a great collection. But in Isabella's period, art was a means to display magnificence, the unmistakable hallmark of powerful rulers. It was also a time when the intrinsic value of objects— precious metals, rare gemstones, expensive cloths—counted at least as much as exquisite craftsmanship or artistry. Thus Isabella owned impressive quantities of gold and silver objects and tapestries which, to her contemporaries, would have overshadowed her nonetheless significant collection of paintings.

Isabella's taste in tapestries, paintings, and illuminated manuscripts, as in architecture and sculpture, leaned heavily toward the Netherlands. The important commercial ties between Castilian sheepherders and Flemish cloth manufacturers furnished the perfect conduit for works of art, especially tapestries.[13] Isabella may have owned as many as 370 of them, a truly enormous collection for the time. She acquired some of them from merchants involved in the cloth trade.[14]

The importance of this sizable accumulation is difficult to overestimate. In this period tapestries were the most esteemed and valued medium of the pictorial arts, far surpassing paintings as treasured objects. Collectors admired not only the intricate workmanship but also the sumptuous effect produced by what were actually portable mural decorations capable of transforming even the humblest surroundings into appropriate settings for royal majesty. For an itinerant court tapestries were an indispensable component of political stagecraft. Unfortunately their inherent fragility made them susceptible to damage, and all but a few panels of this enormous collection have disappeared (see cat. 33).

The illuminated manuscripts have fared somewhat better, although again only a small portion of the original holding survives. Isabella, who had a serious interest in languages and learning, amassed a library of some 393 books and manuscripts, mostly kept in the Alcázar of Segovia.[15] The majority were religious texts, but there were several grammars as well as romances, chronicles, histories, and juridical treatises. Her small but choice collection of illuminated manuscripts featured several exquisite examples from Flemish workshops, notably, in addition to the manuscript from Cleveland in this catalogue (cat. 34), the *Book of Hours of Isabella of Castile* (Biblioteca de Palacio, Madrid) and the *Breviary of Isabella of Castile* (British Library, London), the latter being one of the richest manuscripts produced in the late fifteenth century. In addition the queen patronized Spanish miniature painters such as Juan de Tordesillas, who illuminated the text of the *Missal of Isabella the Catholic* (Capilla Real, Granada). The royal account books list a number of illuminators, both Spanish and foreign, who illustrated books for the library.

The northward bias of the queen's taste naturally extended to the art of painting. During the middle years of the fifteenth century Castile virtually had become an artistic province of Flanders. As early as 1428–1429, Jan van Eyck, renowned as the artist who had renewed late Gothic painting in the lowlands, had visited the Iberian Peninsula and been received by Juan II. Copies after his works are known to have existed in Spanish collections of the period. Thereafter each new wave of Flemish painters found markets and imitators in Castile, giving rise to the distinctive adaptive style known as Hispano-Flemish.

Isabella inherited several important works by northern masters and avidly acquired others, and these composed the majority of her collection of more than two hundred paintings. Fate has been somewhat kinder to them. A representative sample is preserved in the royal chapel, Granada, where some were sent in response to a stipulation in the queen's last will and others later by her family.[16] Paintings by or attributed to Rogier van der Weyden, Hans Memling, and Dirk Bouts attest to Isabella's refined taste in Flemish painting.

Such was her admiration of this art that she hired two excellent Flemish masters to work at her court. In 1492 Michel Sittow, a native of Estonia trained in the Ghent-Bruges school, was appointed court painter at the elevated salary of fifty thousand maravedis, which placed him fifth on the pay scale of all court servants.[17] Sittow had an excellent reputation as a portraitist, a skill apparently lacking among his Spanish contemporaries. The survival rate of his portraits is fairly low, but the few extant works bespeak his excellence in the genre.

Four years later Sittow was joined by an artist known as Juan de Flandes, who was also a product of the Ghent-Bruges school.[18] A painter of exquisite sensibility, he collaborated with Sittow on what has become the best-known work of the Isabelline period, the so-called *Polyptich Altarpiece of Queen Isabella* (cats. 43–46). This ensemble was left unfinished at Isabella's death, at which time it consisted of forty-seven small panels depicting scenes from the life of Christ and the Virgin. Sittow is thought to be the author of some of the extant panels, including the *Assumption of the Virgin* (cat. 45), a work of great refinement and delicacy. Juan de Flandes, who did the major share of the work, is no less an artist, even surpassing his colleague in the creation of limpid light effects that wash gently over the landscape.

Sittow and Juan de Flandes ceased to work for the Spanish court after the death of Isabella, further proof that she was the driving force behind the monarchs' artistic policy. While Sittow returned to the north, Flandes decided to remain in Castile and worked for a succession of ecclesiastical patrons until his death in 1519.

Sittow and Flandes were undoubtedly the most refined painters in Isabelline Spain, but their activities account for only a tiny part of the pictorial production of the period, most of which was in the hands of Spanish artists. The demand for paintings from the ecclesiastical sector was far greater than from the court, and this demand was satisfied by practitioners of the Hispano-Flemish style.[19] These masters have fallen into oblivion, in large measure because the quality of their work pales compared to their models, the masters of fifteenth-century Flanders. The problem is further complicated because the most successful of these painters tended to take an artisanal approach to their practice, establishing workshops that absorbed their personal identities.

The problems in assessing these artists are

exemplified in the work of Fernando Gallego, a painter from Salamanca who was a leading Castilian painter from about 1475 to around 1507.[20] Gallego's stock in trade was the *retablo*, a large ensemble of panel paintings set within an architectural framework and erected behind the altar. Retables lent themselves to corporate execution; the master designed the compositions and then delegated much of the execution to his assistants. The collective labor of these works and the patrons' apparent indifference to the master's personal touch need to be kept in mind, even if they make a mockery of our concern for the division of artistic responsibility. This approach was taken because retables did not invite or permit close inspection of their constituent parts; the distance between viewer and object was too great, the illumination too marginal for this sort of studied contemplation. Thus the painters had to simplify and exaggerate their models in order to ensure a modicum of legibility for the worshipper. The term legibility is intentional, for these images were meant to be read: to provide instruction to the faithful and not to be admired solely as aesthetic objects. With these considerations in mind Gallego's intentions become obvious. He set out to remake his sources of inspiration, which were mainly works by Rogier van der Weyden, Dirk Bouts, and their followers.

This process can be observed in Gallego's *Pietà*, datable perhaps to around 1470, which can be compared to a version of the composition by Rogier van der Weyden executed some thirty years earlier and owned by Isabella of Castile. It is immediately evident that Gallego was thoroughly indebted to his Flemish model for his pictorial vocabulary: the bony, angular bodies, the studied, chiseled drapery, the composition of foreground figures set against the expansive landscape all are appropriated from this source. However, Gallego systematically schematized Rogier's composition, compressing the space, exaggerating the expression, and heightening the linearity of the Virgin's drapery. The colors are also transposed into a different key, with tawny yellows and dusky tans replacing the rich reds and lush greens employed by Rogier. Finally, the landscape is altered to conform to local conditions and building styles. Thus the delicacy of emotion and execution in Rogier's work is converted into a sterner, starker image. Gallego stripped away the adornments of simulated architecture and sculpture and focused attention on the image of the dead Christ and his grieving mother.

This hardy, emphatic interpretation of Flemish painting spread into every corner of Castile, where it remained dominant until the second decade of the sixteenth century. However, in

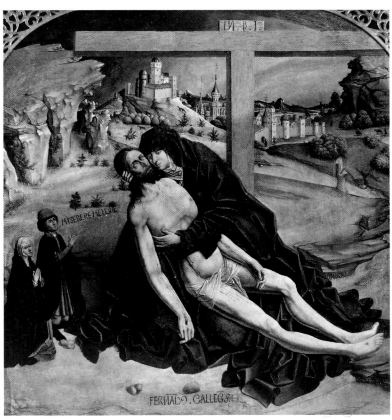

fig. 6. Fernando Gallego, *Pietà*. Museo del Prado, Madrid

the 1480s it was enriched by the addition of Italianate elements introduced in the work of Pedro Berruguete.[21] Berruguete was born at an unknown date in the agricultural town of Paredes de Nava, near Palencia, and was trained in the Hispano-Flemish tradition. It is almost certain that he traveled to Italy in the 1470s, although the trip is not recorded. In 1483 he was employed in the cathedral of Toledo executing a work in fresco, a technique he could only have learned in Italy. From then until his death in 1503 he received important commissions in Toledo and Avila, including three altarpieces in Santo Tomás, Avila, which was patronized by Ferdinand and Isabella and was the site of the tomb of their son, Prince Juan.

Berruguete represents the leading edge of Italianism in Castilian painting, although he is clearly a hybrid artist. His experience in Italy imposed a veneer of Renaissance style on his panels, but at the core he was faithful to his Hispano-Flemish origins. In the splendid series of portraitlike biblical prophets executed for an altarpiece in his native Paredes de Nava (cat. 46), Berruguete aligned himself with the vigorous realism of northern European art.

Throughout much of the fifteenth century, Castilian artists and patrons were little informed or inspired by the renascent classicism and innovative naturalism of Florentine art, which came into being as a response to the ideas of Italian humanism. The lack of interest in

Italian art at the Spanish court is particularly baffling because the queen did patronize Italian scholars, notably Peter Martyr d'Anghiera, who was brought to Castile from Milan to establish a school of humanistic studies. Yet Isabella remained faithful to her northern artists until her dying day.

However, toward the end of her reign and especially during the regency of Ferdinand (which ended with his death in 1516), the Italian Renaissance style began to make itself felt in Spain. Some of the principal sponsors of this importation were members of an important noble family, the Mendoza, who deserve to be counted among the great European art patrons of the fifteenth century.

The Mendoza family originated in the province of Alava and came to prominence in Castilian politics after around 1400.[22] A few years earlier they had been granted privileges in Guadalajara, which became the family seat and the locus of some of their most important artistic enterprises. They negotiated their way through the turbulent politics of fifteenth-century Castile with shrewdness and agility, culminating in somewhat tardy but nonetheless effective support of Ferdinand and Isabella. Under the rule of the Catholic Monarchs they enjoyed royal favor and grew exceedingly rich and powerful.

The rise of the Mendoza to political prominence was attended by their increasing presence in the world of arts and letters. Iñigo López de

Mendoza, first marquis of Santillana (1398–1458), is renowned as one of the important Spanish poets. He initiated a family literary tradition that reached its pinnacle in Garcilaso de la Vega (1501–1536), the first important Italianate poet in Castile.

As patrons of the visual arts the Mendoza were even more conspicuous. Much of their patronage was centered in Guadalajara, where they sponsored building projects that dominated the city and its surrounding territory. Of these the most important is the Palacio del Infantado, built for Iñigo López de Mendoza, the second duke of Infantado (d. 1500).

In its original state the Palacio del Infantado was a building of unstinting magnificence.[23] (The structure was extensively remodeled in the later sixteenth century, and then gradually fell into disrepair. It was seriously damaged in the Spanish Civil War and has since been reconstructed.) With a prodigality accessible only to the very rich, the duke decided to demolish the existing palace and build anew. A lapidary inscription in the courtyard explains his purpose. "The illustrious Señor don Iñigo López de Mendoza [his several titles follow] in 1483, having [inherited] a sumptuous house, built at great expense by his ancestors, destroyed it entirely, and to increase the glory of his forebears and of himself, ordered a new one built to honor the greatness of his line." The palace was completed thirteen years later.

Infantado was unencumbered by modesty, and in his palace he left no stone undecorated. The architect was Juan Guas, who designed the facade in the manner of a conventional late Gothic townhouse,[24] but turned the courtyard into a decorative fantasy emblazoned with the escutcheons of the duke and his wife, María de Luna. Richer still were the principal rooms, adorned with carvings and crowned by intricate gilt ceilings in the Moorish style (artesonado).

As the construction documents show, numerous artisans of Muslim origin participated in the decoration, executing ceramic tilework, fountains, and decorative carvings. The exotic blend of Hispano-Flemish Gothic and Islamic elements was in fact a commonplace in Castilian architecture. Christian patrons were understandably impressed by the inventive designs and superb craftsmanship of Islamic architecture, which were perfectly suited to enhance the intricate surface effects considered indispensable to the expression of magnificence. This architecture of ostentation reached new heights in the Infantado Palace.

Infantado, in this display of visual magnificence in the service of the glory of the Mendoza, seems to have been rivaled by his brother, Pedro González de Mendoza, cardinal of Santa Croce and archbishop of Toledo (1428–1495).[25] Although the youngest of the ten children of the marquis and marchioness of Santillana, Cardinal Mendoza became the head of the family and with true dynastic instinct provided money and position for the numerous members of his clan as well as for his three illegitimate sons. Mendoza owed his fortune not so much to inheritance as to political acumen. At just the right moment he threw his support to Ferdinand and Isabella and was rewarded with a series of dignities, culminating with the archbishopric of Toledo, the richest see in Spain.

Part of the wealth derived by Cardinal Mendoza from ecclesiastical rents was spent on art. He appears to have been a voracious collector, although only the inventory of his precious objects has come to light.[26] The line between art and investment was almost entirely eradicated in this part of the cardinal's collection. The inventory lists some 3,844 coins and medals, sixty-one cameos, and precious stones almost beyond measure. At his death he owned more than nine thousand pearls, not to mention impressive quantities of gems and gold- and silversmith's work.

His sponsorship of architecture is more difficult to assess, although much has been claimed for it.[27] Cardinal Mendoza had a superficial knowledge of central Italian architecture, probably obtained from his nephew, the second count of Tendilla. As his architect the cardinal employed Lorenzo Vázquez, who was versed in the ornamental vocabulary of the new classicism but almost completely ignorant of its syntax. The only important remains of their collaboration, the central panel of the facade of the Colegio de Santa Cruz, Valladolid (1486–1492), was altered in the eighteenth century and in any case was superimposed on an existing Gothic structure. The entrance portal affords a good idea of how Vázquez spoke the language of the Renaissance with a thick Gothic accent. Cardinal Mendoza, then, is at best a transitional figure in the introduction of the Italian Renaissance to Spain.

The true protagonist of this momentous story is the aforementioned second count of Tendilla (1442–1515) who, as if to confound historians, was one of at least a dozen members of the family to be called Iñigo López de Mendoza.[28] Even to his contemporaries Tendilla was the perfect gentleman — wise, witty, brave, and cultured. In 1458 he accompanied his father to Rome on an embassy to Pope Pius II, and the experience left him a devoted admirer of Italian art and culture. He returned to Italy in 1486 as an emissary of Ferdinand to Pope Innocent VIII, stopping first in Florence where he initiated a friendship with Lorenzo de' Medici. Then he traveled to Rome and successfully completed his mission. Tendilla returned for good to Spain once his work was done, but managed to keep informed about artistic developments in his beloved Italy.

Tendilla's sponsorship of Renaissance style is associated with a group of funerary monuments for his own and the royal family, which were executed in Italy and assembled in Spain. The first of these is the tomb of Cardinal Mendoza, which was erected in the major chapel of the Toledo cathedral in 1503.[29] The history of this monument, much but not all of which was made in Italy, is beset with problems that becloud the identity of both the sculptor and patron, although the latter in all probability was either Tendilla or the cardinal's son Rodrigo, marquis del Cenete (c. 1466–1523).

A second Mendoza tomb clarifies the pattern of Tendilla's patronage. Diego Hurtado de Mendoza, the cardinal of Seville who died in 1502, had nominated Tendilla, his brother, to provide a suitable funerary monument in the cathedral. For this purpose the count contracted with the Tuscan sculptor Domenico di Alessandro Fancelli (1469–1519) to carve the tomb of Carrara marble in Italy and then send it to Spain where he assembled it.[30] This was soon to become established procedure. It explains how a first-class work of Italian sculpture came to be situated in the cavernous Gothic setting of the Seville cathedral.

Presumably with Tendilla's backing Fancelli obtained a new and even more prestigious commission, the tomb of Prince Juan, the only son of Ferdinand and Isabella, who had died suddenly in 1497 just months after his marriage to Margaret of Austria. In July 1511 the sculptor was in Granada for consultations with Tendilla, after which he returned to Italy to carve the tomb. The work was finished by December 1512 and was shipped to Avila for installation by the sculptor in Santo Tomás the following year. Prince Juan's tomb is a horizontal monument executed in Carrara marble and modeled on the bronze tomb of Pope Sixtus IV, which had been executed by Antonio Pollaiuolo for the basilica of Saint Peter's in Rome.

The procedure was repeated a third and final time for the tombs of Ferdinand and Isabella, which were commissioned in 1513. Fancelli returned to Carrara and worked on the tombs until the spring of 1517. He then packed up his sculptures and sent them along to the Royal Chapel, Granada, supervising their placement in the summer of 1518. The indefatigable sculptor was given yet another set of tombs to execute — those of Philip the Fair and Joanna the Mad — but the hardships of his career as a commuter-sculptor finally took their toll. He died in Zaragoza in 1519, en route to his native

fig. 7. Salón de Linajes. Palacio de Infantado, Guadalajara

fig. 8. Domenico Fancelli, Tombs of Ferdinand and Isabella. Capilla Real, Granada

Italy. As far as is known the tomb sculptor par excellence was buried in an unmarked grave.

The arrival—or outbreak as it has suggestively been called—of the Renaissance in Spain is an extraordinary phenomenon. In central Italy the Renaissance evolved over time from a body of theoretical concepts; in Spain the Renaissance arrived in wooden crates. And not only tombs but entire architectural ensembles were sent, the most notable of which is the magnificent courtyard of the Castle of la Calahorra, ordered by Cardinal Mendoza's son Rodrigo and largely executed by the Genoese workshop of Michele Carlone between 1509 and 1512.[31] Such works must have seemed like extraterrestrial beings to the artists and patrons of Spain, who slowly and only with difficulty began to assimilate their novelty.

Yet these new arrivals from Renaissance Italy had to be given a home, and home was a Gothic structure with Gothic furnishings. This phenomenon is by no means unique to Spain. The Genoese workshop of Pace Gagini, which also fabricated Renaissance tombs for Spanish clients, produced, for instance, the double sepulcher of Raoul de Lannoy and Jeanne de Poix (1508–1509),[32] which was installed in a Gothic niche in the parish church of Folleville in Picardy.[32] A more renowned example is Pietro Torrigiano's tomb of Henry VII and Elizabeth of York (1512–1519),[33] which is set in the Lady Chapel of Westminster Abbey, famous for its extravagant fan vaults.

In Spain, however, a third ingredient was added to the brew, the Islamic style, resulting in creations of awe-inspiring heterogeneity. The best-known examples of these hybrid combinations are found in the Toledo cathedral and are associated with the name of Cardinal Mendoza's

successor, Francisco Jiménez de Cisneros (c. 1436–1517).[34] Cisneros' ascent to power in the religious and political life of Castile was secured in 1492, when he became the queen's confessor. By then Cisneros, who had entered the Franciscan order in 1464, had acquired a considerable reputation for austerity and devotion and become a leading advocate for the reform of Spanish monasticism. However, following his elevation to the see of Toledo in 1495, he became increasingly enmeshed in the affairs of state. He twice served as regent of Castile (Ferdinand could not inherit the crown of Castile) and personally led a military campaign against the Muslims in Oran, Morocco, in 1509.

Historians are currently debating the legitimacy of a special term—estilo Cisneros—that was coined to describe the cardinal's artistic patronage (see cat. 35).[35] He sponsored several important buildings in Alcalá de Henares, including its famous university as well as the Franciscan convent and church of San Juan de la Penitencia in Toledo. Most of these works combine Hispano-Flemish Gothic with Islamic elements, and this has been taken to be the hallmark of the style Cisneros preferred. Yet there is nothing distinctive about this aspect of his patronage; he simply appropriated the prevailing aristocratic fashion (as in the Infantado palace) and adapted it to ecclesiastical foundations. This said, it would be a mistake to dismiss Cisneros as a mere imitator of the secular elite. As his taste and his career developed he came to feel increasingly comfortable with the exercise of power and with the employment of the Italian Renaissance style as the appropriate way of emphasizing his position.

Cisneros' first significant project was the monumental high altar of the Toledo cathe-

dral.[36] In 1498 a design competition was won by an otherwise unknown French master called Peti Juan, who produced a standard if elaborate late-Gothic plan. Most of the carving was done by established local masters of northern origin. Yet even as this Gothic extravaganza was taking shape, Cardinal Mendoza's Renaissance tomb was being erected right in front of it, much to Cisneros' displeasure. As one of Mendoza's executors he proposed substituting a tomb of Gothic design for the Renaissance creation, but was overruled by the queen. Thus to this day Mendoza's Italianate effigy gazes on the lacy pinnacles and spiky gables of Peti Juan's altarpiece.

Fortunately Cisneros' taste was not immutable, and little by little he integrated the Italian Renaissance style into his choices, although not always abandoning his earlier preferences. From 1508 to 1511 he undertook the renovation of the chapter room of the cathedral, where Italianate and Islamic features are improbably but unselfconsciously mixed. The chapter room is a rectangular space with an impressive fresco cycle by Juan de Borgoña, a northern painter who is first recorded in Toledo as an assistant of Pedro Berruguete.[37] He continued to be employed at the cathedral until 1504, when in all probability he traveled to central Italy for a stay of some three years. Upon his return his style had been transformed from that of a Burgundian to that of an Italianate painter, fully in tune with an artist like Pinturicchio (1454–1513), who worked in Rome at the time of Borgoña's supposed visit. Borgoña's frescoes, with their elaborate, sophisticated perspectives, sculpturesque figures, and measured compositions, represent a drastic break with the prevailing Hispano-Flemish style. Yet the ceiling above them is a typical

fig. 9. Juan de Borgoña, Anteroom of Chapter Room. Toledo Cathedral

example of *artesonado*, carved in a geometric pattern and covered with gilding and bright colors. The anteroom, executed slightly later, is another inspired melange of two cultures. The frescoes, designed by Borgoña but executed by assistants, represent an illusionistic landscape of fruit trees and flowers populated by fluttering birds. However, the door leading to the chapter room is framed by a low-relief Islamic design carved in plaster (*yesería*).

In the final work commissioned by Cisneros for the cathedral his transformation into a Renaissance prince of the church is complete. This is the Mozarabic Chapel, so-called because it is reserved for the celebration of the mass according to the medieval Mozarabic rite. In 1514 Borgoña executed three frescoes of the battle of Oran, in which the saintly prelate Cisneros is depicted as a victorious military commander. On the vault Borgoña painted the illusion of a coffered ceiling in correct antique form, making

no concession to the Gothic or the Islamic.

By the time of Ferdinand's death in 1516 the Renaissance style had established a beachhead in Castile, although a few more decades would pass before it conquered Spanish art. The triumph of classicism was secured by Philip II (r. 1555–1598), the great-grandson of Ferdinand and Isabella, who grasped the potential of harnessing the style to express the formidable power and faith of his Catholic monarchy. Before the middle of the sixteenth century, however, Spanish art was caught up in the play of contradictory forces that were shaping the society itself. As the geographical frontiers of Spain expanded, its mental world began to turn inward. In that elastic moment many kinds of artistic expression, both traditional and innovative, native and imported, were possible. The resulting heterogeneity makes the period one of the most fascinating in the history of European art.

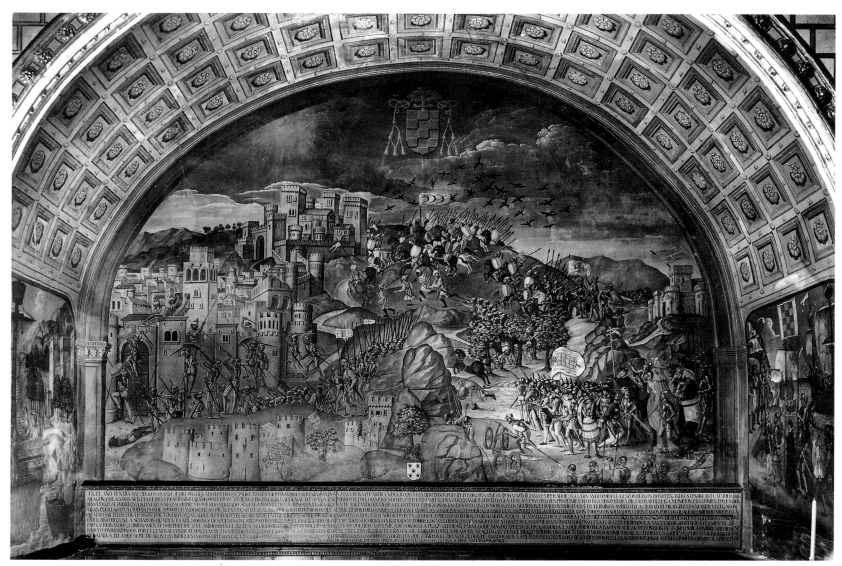

fig. 10. Juan de Borgoña, Mozarabic Chapel. Toledo Cathedral

NOTES

1. The present discussion is limited to the geographical region of Castile. A complete survey would encompass the equally rich provinces of Aragon, Valencia, and Andalusia.

2. The term *estilo Isabel* was introduced by Emile Bertaux, "L'Art des rois catholiques," in André Michel, *Histoire de l'art*, vol. 4, part 2 (Paris, 1911), 821–852, where it is used to describe the fusion of northern late Gothic and Islamic art, which the author considered to be the essential characteristic of the style. It is still employed in this sense by José M. de Azcárate, "Sentido y significación de la arquitectura hispano-flamenca en la corte de Isabel la Católica," *Boletín del Seminario de Estudios de Arte y Arqueología* 37 (1971), 210–233. As will be seen below, I regard the Islamic element (usually called *mudéjar* by Spanish art historians, although the religious convictions of the practitioners are not always easy to discover) and the northern late Gothic style as parallel, not convergent phenomena. The art of the Isabelline period has been little studied in the last twenty-five years and is badly in need of new thinking and research.

3. For the chapel and tombs, see C. González Palencia, "La capilla de don Alvaro de Luna en la catedral de Toledo," *Archivo Español de Arte y Arqueología* 5 (1929), 109–122, and Beatrice G. Proske, *Castilian Sculpture: Gothic to Renaissance* (New York, 1951), 181–182.

4. See G. Conrad von Konradsheim, "Hannequin Coemans de Bruxelles, introducteur de l'art flamand du siècle XV dans la region toledane," *Mélanges de la Casa de Velázquez* 12 (1976), 127–140.

5. For a summary history of the chapel, see Teófilo López Mata, *La catedral de Burgos* (Burgos, 1950), 227–255.

6. See Francisco Tarín y Juaneda, *La Real Cartuja de Miraflores* (Burgos, 1925). I am grateful to Ronda J. Kasl, who is preparing a doctoral dissertation on Miraflores, for sharing her information and insights on the project.

7. See Harold E. Wethey, *Gil de Siloe and His School* (Cambridge, Mass., 1936), 24–55.

8. A contemporary document published by Teófilo López Mata, *El barrio y la iglesia de San Esteban de Burgos* (Burgos, 1946), 102–106, refers to a certain Gil de Urliones as sculptor of the main retable (no longer extant) of San Esteban, Burgos, and reasonably suggests that he is Gil de Siloe. Although "Urliones" is thought to be a corruption of the French city Orléans, I believe that it refers to the town of Lens. The same word is used in the documentation (1591) of the Hall of Battles, El Escorial, where it unmistakably refers to this town.

9. See José M. de Azcárate, "La obra toledana de Juan Guas," *Archivo Español de Arte* 29 (1956), 11–31.

10. See Antonio Gallego Burín, *La Capilla Real de Granada* (Granada, 1931), and "Nuevos datos sobre la Capilla Real de Granada," *Boletín de la Sociedad Española de Ecursiones* 57 (1953), 9–16.

11. "Estrecho sepulcro para la gloria de mis abuelos...." Cited by Gallego y Burín 1931, 23.

12. Isabella's collection requires a new study. The inventory is published by Francisco J. Sánchez Cantón, *Libros, tapices y cuadros que coleccionó Isabel la Católica* (Madrid, 1952). However, as is pointed out by Roger van Schoute, *La Chapelle Royale de Grenade, Les Primitifs Flamands* I, 6 (Brussels, 1963), 2–7, Sánchez Cantón based his

transcription on faulty copies of the original documentation. I am grateful to Natalia Majluf for assistance on this discussion of the queen's collection.

13. See Valentín Vázquez de Prada, "Les rélations commerciales hispano-flamandes et l'importation de tapisseries en Espagne," in *Tapisserie de Tournai en Espagne. La tapisserie bruxelloise en Espagne au XVIe siècle* (Tournai, 1985), 54–87.

14. This estimate is provided by Juan J. Junquera, "Le gôut espagnol pour la tapisserie," in *Tapisserie de Tournai 1985*, 22.

15. See Sánchez Cantón 1952, 17–38.

16. See Van Schoute 1963.

17. See Jazeps Trizna, *Michel Sittow. Peintre revalais de l'école brugeoise (1468–1525/6)* (Brussels, 1976), and Fernando Marías, *El largo siglo XVI* (Madrid, 1990), 151–156.

18. See *Juan de Flandes* [exh. cat. Museo del Prado] (Madrid, 1986), and Marías 1990, 156–160.

19. The standard work by Chandler R. Post, *A History of Spanish Painting. Vol. IV, The Hispano-Flemish Style in Northwestern Spain* (Cambridge, Mass., 1933), is fundamental but out of date.

20. In addition to Post 1933, 4:87–147, see R. M. Quinn, *Fernando Gallego and the Retablo of Ciudad Rodrigo* (Tucson, 1961).

21. In addition to Chandler R. Post, *A History of Spanish Painting. Vol. IX, part 1, The Beginning of the Renaissance in Castile and León* (Cambridge, 1947), 17–161, see Marías 1990, 171–181. A new monograph on this important painter is long overdue.

22. See Helen Nader, *The Mendoza Family in the Spanish Renaissance, 1350–1550* (New Brunswick, 1979).

23. See Francisco Layna Serrano, *El Palacio del Infantado en Guadalajara* (Madrid, 1941).

24. See José M. de Azcárate, "La fachada del Infantado y el estilo de Juan Guas," *Archivo Español de Arte* 24 (1951), 307–319.

25. For his biography see Nader 1979, 118–123. His artistic patronage is summarized by Rosario Díez del Corral Garnica, *Arquitectura y mecenazgo. La imagen de Toledo en el Renacimiento* (Madrid, 1987), 19–47.

26. See José M. de Azcárate, "El Cardenal Mendoza y la introducción del Renacimiento," *Santa Cruz* 17 (1962), 7–16.

27. The case for Cardinal Mendoza as protagonist in the Spanish Renaissance is made by Manuel Gómez-Moreno, "Hacia Lorenzo Vázquez," *Archivo Español de Arte y Arqueología* 1 (1925), 7–40. For another vision of the question, see Marías 1990, 254–257.

28. For his biography see Nader 1979, 150–179. His role in the transmission of the Italian Renaissance to Spain was first signaled by Elías Tormo, "El brote del Renacimiento en los monumentos españoles y los Mendoza del siglo XV," *Boletín de la Sociedad Española de Excursiones* 25 (1917), 51–65, 114–121; 26 (1918), 116–130.

29. See Rosario Díez del Corral, "Muerte y humanismo: la tumba del Cardenal don Pedro González de Mendoza," *Academia* 64 (1987), 209–227.

30. The tombs by Fancelli discussed below are described by Jesús Hernández Perera, *Escultores florentinos en España* (Madrid, 1957), 10–11 (Cardinal Hurtado de Mendoza); 11–12 (Prince Juan); 12–13 (the Catholic Monarchs). A new study of Fancelli's career would be welcome.

31. Miguel Angel Zalama, *El Palacio de la Calahorra* (Granada, 1990).

32. See Hanno-Walter Kruft, "Genuesische Skulpturen der Renaissance in Frankreich," in *Evolution Générale et Développements Regionaux en Histoire de l'Art*, Actes du XXIIe Congrès International d'Histoire de l'Art (Budapest, 1972), 1:697–704, and "Pace Gagini and the Sepulchres of the Ribera in Seville," in *España entre el Mediterráneo y el Atlántico*, Actas del XXIII Congreso Internacional de Historia del Arte (Granada, 1977), 2:327–338.

33. See John Pope-Hennessy, *Italian Renaissance Sculpture* (London, 1958), 320–321.

34. There is no recent biography of Cisneros. For a summary of his life and references to the earlier literature, see Díez del Corral Garnica 1987, 49–59.

35. For a lucid summary of Cisneros' career as a patron, see Díez del Corral Garnica 1987, 60–77. Also important is Miguel Angel Castillo Oreja, "La proyección del arte islámico en la arquitectura del primer renacimiento: el estilo Cisneros," *Anales del Instituto de Estudios Madrileños* 12 (1985), 55–63.

36. See Proske 1951, 202–210.

37. Much remains to be learned about the career of Juan de Borgoña, especially the problematic early years. See Post 1947, 162–234; Diego Angulo Iñiguez, *Juan de Borgoña* (Madrid, 1954); Adele Condorelli, "II problema di Juan de Borgoña," *Commentari* 11 (1960), 46–59; and Charles Sterling, "Du nouveau sur Juan De Borgoña: son tableau le plus ancien connu," *L'Oeil* 401 (1988), 24–31.

SCULPTURE IN CASTILE c. 1492

J. J. Martín González

The Age of Exploration, a great historical era for the Spanish nation, coincides with a fascinating period in the history of Spanish art. The Gothic style, which remained a dominant influence in Spain right up to the very end of the fifteenth century, began to lose ground to the emerging Renaissance manner, which was imported from Italy. And yet there was also a marked conservatism on the part of some patrons: Gothic could still be considered "modern," and Renaissance thought of as "ancient" or "Roman."

The demand for sculpture in the later fifteenth century was high and fueled both by religious patrons — cardinals, bishops, and cathedral chapters — and by the crown and the powerful nobility. Much of this sculpture was created by artists from northern Europe. Importing works of art from abroad or bringing in foreign sculptors was an obvious sign of the patron's wealth. Most of the Gothic sculptors were Flemish, while others came to Spain from Germany. As Spanish taste shifted to the Renaissance style, Italian sculptors, or Spanish artists who had trained in Italy, came to the forefront.

Political and economic power in Spain in this period centered in the great cities of Burgos, Toledo, Seville, and Barcelona, which were also the principal centers of the visual arts. The selection of Spanish sculpture that has been assembled in this exhibition (cats. 46–51) centers on works from Castile, which is also the focus of this essay. It should, however, be understood that parallels to the developments outlined here can be found elsewhere in Spain at this time and that it is impossible to do justice to the many different strands of this history in a brief survey.

Egas Cueman (active c. 1450–1495) and his brother Hanequin, both from Brussels, brought the Flemish sculptural style to Toledo.[1] Shortly before 1454 they were commissioned to execute the choir stalls of the cathedral of Cuenca (now in the Colegiata of Belmonte), with Hanequin responsible for the architectural framework and Egas for the carving. These were the first stalls to be executed in Spain in the Flemish style.

The Lion's Door of Toledo Cathedral was built under Hanequin's supervision after 1452.[2] The inner part of the door portrays the Tree of Jesse; the outer part includes works by several

different hands, one of whom can be identified from documents as Juan Aleman or Juan "el Alemán (the German)," whose drapery is clearly in the Germanic style.[3]

Egas Cueman executed several tombs for the Monastery of Guadalupe — which had been built under royal patronage — including the magnificent tomb of Alfonso de Velasco and his wife Isabel de Cuadros, commissioned in 1467. Egas also participated in the architectural projects of Juan Guas, including the Palace of the Infantada in Guadalajara of about 1483, the transept of the church of the Monastery of San Juan de los Reyes in Toledo, and the screen around the nave of Toledo Cathedral (1490–1493). Egas' workshop continued after his death under the direction of his sons Anton and Enrique.

Sebastián de Toledo has been called the finest tomb sculptor in Spain in the late fifteenth century.[4] He created the lavish tombs in Toledo Cathedral for Don Alvaro de Luna and his wife Doña Juana de Pimentel, countess of Montalbán,[5] which were commissioned from this "entallador de imaginería" in 1489. Don Alvaro, at that time Grand Master to the Order of Santiago, had endowed a funerary chapel in the cathedral and had the chapel built to exalt that Order. A kneeling knight is shown at each corner of the free-standing tomb.

The great tomb in Sigüenza Cathedral of "El Doncel de Sigüenza" has been convincingly attributed to Sebastián de Toledo.[6] This masterpiece honors Don Martín Vázquez, known as "El Doncel," a knight of the Order of Santiago who died on the battlefield near Granada at the age of twenty-five. It was inspired by the design of Egas Cueman, Sebastián's master, for the tomb of Don Alfonso de Velasco. At El Doncel's feet is a weeping page holding his helmet. The young knight is shown leaning on one elbow and reading a book, a new kind of image inspired by Etruscan and Roman funerary models.[7]

Rodrigo Alemán of Toledo (active between 1489 and 1512) is celebrated for the series of choir stalls he carved. Though his surname suggests Germanic ancestry, he must have come from the Lower Rhine region, and his style is clearly Flemish.[8] The choir stalls he carved for Toledo Cathedral between 1487 and 1489 celebrate the Spanish military offensive against Granada. The program was probably devised by

Cardinal Mendoza, archbishop of Toledo and a close adviser to the Reyes Católicos, who actively participated in the campaign. Each scene portrays a siege or a surrender, although the compositional variety maintained is remarkable. Its purpose was propaganda for the crown.

Maestro Rodrigo subsequently worked on the choir stalls of Plasencia (Cáceres), a royal commission awarded in 1497 with the stipulation that Egas Cueman would first approve the models.[9] The stalls are remarkable for the considerable number of secular themes they contain, some erotic in nature, evidently intended to represent sins and vices, some of which are quite amusing.[10] The Plasencia stalls show the influence of the choir stalls of Seville Cathedral and indicate that Rodrigo had been there. In 1498 Rodrigo contracted to execute the stalls for the cathedral of Ciudad Rodrigo (Salamanca), which were not finished until after 1503. It is clear that by this time a sculptor's fame could be quite widespread and that important masters could travel far from their places of origin in connection with their work.

The most important sculptural work in Toledo during this period was the *retablo mayor*, begun in 1498,[11] which was the work of a team of artists. Peti Juan, probably a French carver, an *ensamblador*, contributed to the design, worked on the architectural frame, and probably executed some of the sculptures.[12] Rodrigo Alemán worked on the predella reliefs, while a certain Diego Copin "de Holanda," clearly of Dutch origin, together with Sebastián de Almonacid, executed most of the reliefs. The project even involved Felipe Bigarny from Burgos, a major Renaissance sculptor who will be discussed later in this essay, who in 1500 was paid to carve a figure of Saint Mark and to design *historias*.

Burgos' fame as an artistic center in this period rests with the achievements of two families of foreign artists: a German family from Cologne (Colonia) and the Siloe family from Flanders. Juan de Colonia, the earliest of these artists, is supposed to have come to Burgos in the service of archbishop Alonso de Cartagena in 1436, when the latter returned from the Council of Basel. Juan is reported to have been at work on the towers of Burgos Cathedral in 1442, serving as chief master.[13] His Spanish

wife, María Fernéndez, bore him a son named Simón, who also became a gifted architect and sculptor. Juan de Colonia supervised the building of the towers of the cathedral and the sculptural program of the west facade. He died in 1480.

Other works of sculpture executed in Burgos during this period indicate that there was a flourishing local school. Archbishop Alonso de Cartagena died in 1456, and his tomb is an extravagant example of the florid Gothic style.[14] Although the sculptor is unknown, the work seems to have been executed in Burgos, since several saints especially venerated in the province of Burgos are included in the program. Moreover, the numerous tombs from this period in Burgos Cathedral which differ in manner and style from those executed by Gil de Siloe — the most important of which is the tomb of Alonso Rodriguez de Maluenda[15] — record the presence of masters working outside his sphere of influence.

Simón de Colonia, Juan's son, was born in Burgos, and his style developed under the influence of the sculptors with whom he worked in Burgos and Toledo. In 1481 he was appointed chief master of the works at Burgos Cathedral. He was in charge of building the great Capilla del Condestable, sponsored by Don Pedro Fernández de Velasco, Constable of Castile and husband of María de Mendoza, the daughter of the marquis of Santillana. The sculptural decoration includes statues at the entrance to the chapel and, on the walls, wild men holding coats of arms. The manner of these works is tranquil, the drapery elegant, though rather stiff, and the whole suggests the participation of Simón's workshop.

Simón is also responsible for the facade of the church of San Pablo in Valladolid, completed in 1500.[16] Although the contract no longer exists, it is referred to in a document dated 1501: "contrato sobre la portade que se habia de hacer en el dicho monasterio…entre el obispo de Palencia Don Alonso de Burgos y Maestre Ximon, vecino de la dicha ciudad de Burgos."[17] Another document of 1503 indicates that Simón de Colonia and his son Francisco had carved several statues for the monastery of San Pablo. The available documents show that Simón was in charge of the construction of the facade and of the inner doors, and we know that it was he who set up the workshop for the project. There is no way of determining, however, how much of the sculpture is directly attributable to him. It is clear that special care was taken with the execution of the central relief of the *Coronation of the Virgin*, which includes the patron, bishop Don Alonso de Burgos, portrayed kneeling in prayer. The facade was constructed like a *retablo*,

and the sculptural decoration was essential to it. We can better appreciate Simón's style on the inner doors. The entrance to the funerary chapel of Don Alonso (in the adjacent Colegio de San Gregorio) depicts San Ildefonso receiving the chasuble from the Virgin, with the bishop shown, as in the facade, kneeling in prayer.

Francisco de Colonia assisted his father in the works in San Pablo and also executed the high altar of the church of San Nicolás in Burgos, in polychromed marble, between 1503 and 1505. This *retablo*, with its small-scale figures, is related in design to the facade of the church of San Pablo. Its completion marks the end of the Gothic style in Burgos; it is contemporary with Felipe Bigarny's earliest Renaissance works in the cathedral.

Gil de Siloe headed the other great family of sculptors in Burgos. There are two hypotheses with regard to his origins. One identifies him with a certain "Gil de Emberres (Antwerp)" mentioned in a lawsuit concerning the Monastery of San Pablo in Valladolid.[18] Another proposal is that he is to be identified with the "Gil de Urliones" (perhaps a reference to Orléans),[19] who is referred to in the contract commissioning the *retablo* of the church of San Esteban in Burgos. We know that Gil de Siloe lived in Burgos, where he married a Spanish woman, who bore him four children; one of them, Diego, himself became a prominent architect and sculptor.

Gil de Siloe's first known work was the altarpiece for the chapel of the Colegio de San Gregorio in Valladolid, since destroyed. Old descriptions of it emphasize its quality. He also created marvelous works in the monastery of Miraflores outside Burgos, a building under royal patronage. Between 1496 and 1499 he executed the high altar, which presents an allegory of the Eucharist, a polychromed wooden *retablo* which still shines like a jewel. Its geometrical composition, with a great circle at the center surrounded by a number of smaller ones, recalls the German *Rosenkranzaltaren* (Rosary altars). King Juan II and his wife, Isabel of Portugal, appear on the *retablo*, kneeling as donors.

Gil de Siloe also executed the high altar of the Chapel of Santa Ana in Burgos Cathedral, which was commissioned by bishop Don Juan de Acuña, who appears kneeling in prayer in one of the reliefs. The central motif is the Tree of Jesse. Gil also worked on a second altar dedicated to Santa Ana, this one in the Capilla del Condestable, Flemish rather than Spanish in type and similar to altarpieces actually executed in Flanders and then brought to Spain. In its present form it combines sculptures by Gil with others by his son Diego (cat. 50), creating vivid

contrasts between their respective Gothic and Renaissance styles.

The facade of the Colegio de San Gregorio in Valladolid displays some of the principal features that characterize Gil de Siloe's style.[20] It is a posterlike composition, symbolizing royal power. Wild men appear near the door. At the very top, surrounded by a pomegranate emerging from a fountain that symbolizes the Tree of Life, is the coat-of-arms of the Catholic monarchs. It has been suggested that the pomegranate is intended as a reference to the conquest of Granada in 1492. It is equally possible that it is meant to symbolize theology, a discipline of central importance to the Colegio de San Gregorio.

Gil de Siloe's talent achieves its highest expression in his funerary monuments. King Juan II had very generously endowed the monastery of Miraflores, where Henry III had previously erected a palace adjoining the church.[21] The church itself was built at the command of Queen Isabella, who commissioned tombs to be erected for her parents, Juan II and Isabel of Portugal. Gil de Siloe's preliminary sketch for the tombs dates from 1486.[22] Isabella, who visited Miraflores in 1483 to view the body of Juan II, had doubtless heard of Gil — quite possibly from bishop Alonso de Burgos, who was her confessor — before commissioning such an important work. There is a key precedent for Gil de Siloe's free-standing composition in the tombs of the dukes of Burgundy, originally in the Carthusian monastery of Champmol at Dijon. With the help of several assistants, Gil de Siloe completed the alabaster tomb in 1493. It is one of the great masterpieces of Gothic funerary sculpture in Spain (see cat. 48). He did not hesitate to draw heavily on the *mudéjar* style of ornament. The effigies are in a recumbent position, although they are sculpted as though standing. Isabel of Portugal is portrayed reading a book, resting on a lavishly embroidered pillow. The garments are shown richly brocaded and bejeweled. The tomb is an important document of official court taste and the sense of luxury and wealth that were favored in its commissions. The tomb of the Infante Don Alfonso, which shows him kneeling in prayer, is located in a wall niche in the church. The garments are again richly embroidered, with an openwork collar. The carving shows great technical virtuosity and is clearly the work of Gil de Siloe himself.

Gil de Siloe also carved the tomb of Juan de Padilla, a page in the royal service who was killed in 1491, at the age of twenty, in a battle fought near Granada. This tomb was created at the request of the monastery of Fresdelval and is now displayed in the Museo Arqueológico

Provincial in Burgos. The quality of the carving is as fine as that of the Infante Don Alfonso; the youth's face is idealized, and his garments are sumptuously embroidered.

Palencia, Valladolid, and León also developed sculptural workshops, but none comparable to those in Burgos and Toledo. When an important work was required, patrons in Valladolid did not hesitate to invite artists from the more important centers. This was the case with Juan Guas' work at the chapel of San Gregorio and with Simón de Colonia's work on the facade of the monastery of San Pablo.

In 1505 the cathedral chapter of Palencia commissioned Alejo de Vahia to carve statues of Mary Magdalene and of Saint John the Baptist for the high altar.[23] The document refers to him as "Alejo de Vahía, imaginero, vecino de Becerril." The Gothic statue of Mary Magdalene is still in place on the altar, and Alejo's manner is discernable in many other figures in the cathedral, suggesting that he had set up his own shop. His style is archaic, belonging to the final stage of Gothic art. Alonso de Portillo was a tomb sculptor who worked in the Flemish style, signing his works "Portillo me fecit."[24] Valladolid also had a local workshop, which produced the wooden doors of the Collegiate church that are displayed in the exhibition (cat. 41), richly ornamented with branches twined around scrolls and the figures of wild men. The Master of San Pablo de la Moraleja, author of the *Lamentation* (cat. 49) was also a sculptor of distinction of this period.

Another important category of Gothic carvings consists of choir stalls. Exotic figures appear amid the vegetal ornamentation of the stalls in Santa María de Dueñas.[25] The choir stalls of the cathedrals of Zamora, León, and Oviedo are the work of Flemish carvers. We know that Zamora Cathedral commissioned its stalls from Juan "de Bruselas (Brussels)," who lived in León.[26] Juan de Malinas, another Flemish sculptor, was the author of the stalls of León cathedral between 1476 and 1481 and afterward carved the stalls at Oviedo Cathedral.

The introduction of the early Renaissance into Spain was brought about by the actual import of Italian sculpture, by works executed in Spain by Italian and French sculptors, and by those created by Spanish sculptors trained in Italy.

Tombs were an especially important category of patronage; symbols of eternity and of earthly fame, they were usually commissioned by forward-looking patrons. Thus Cardinal Mendoza had his Renaissance-style tomb erected in the presbytery of Toledo Cathedral, following a design created in 1494; the work was finished in 1504 and is thought to be by the Florentine sculptor Andrea Sansovino. The tomb's formal inspiration is a Roman triumphal arch.[27] Other tombs were carved in Italy and then shipped to Spain, like those commissioned in 1520 by Don Pedro Enríquez and his wife Catalina de Rivera from Antonio Maria Aprile and Pace Gaggini, now in the University church in Seville. Other examples are the tomb of Don Francisco Ruiz, bishop of Avila, in the church of San Juan de la Penitencia in Toledo, commissioned in 1524 from Giovanni Antonio Aprile and Pier Angeli della Scala,[28] and the tomb of Ramón de Cardona, viceroy of Naples, executed by Giovanni Merliano da Nola in Naples in 1524 and then shipped to the church of Bellpuig (Lérida),[29] which like Cardinal Mendoza's tomb follows the form of a Roman triumphal arch. Various tombs executed by Domenico Fancelli of Florence are discussed by Jonathan Brown in his essay in this catalogue.

In Burgos the starting point of the Renaissance style was marked by the arrival of the French sculptor Felipe Bigarny, who came from Langres in Champagne. His Spanish name appears to be an adaptation of his French surname, Bigarne,[30] and he may well have been born in Marmagne. His training appears to have taken place in Dijon, and his Renaissance style could well have been formed in France, which was already deeply influenced by the Italian manner; it certainly does not require us to hypothesize an actual trip to Italy. Bigarny was in Burgos by 17 July 1498, as is indicated by the document in which he agrees to execute reliefs of the "trasaltar" in Burgos Cathedral: "Tomó asiento Felipe Bigarny, Borguiñon, diócesis Lingonen."[31] He had been recommended by Simón de Colonia, who thereby, as the scholar Proske put it, "signed the death warrant for his own kind of art."[32] Bigarny's work shows clear Renaissance elements, like the city gate that appears in the relief of Christ bearing the Cross, designed in quattrocento-style perspective. His work quickly won acceptance not only in Burgos, but also in Toledo, in Salamanca, where in 1503 he was requested to execute an altarpiece for the chapel at the University, and in Palencia, where the cathedral chapter in 1505 asked him to execute the sculpture for the high altar. This marked the end of Alejo de Vahia's style of sculpture.[33]

The Mendoza family were especially noted patrons of the Renaissance style; the facades of their family palaces were richly ornamented with Italianate forms and subjects, among them the Palace of Santa Cruz in Valladolid and the Castle of La Calahorra (Granada), whose sculpture was designed by Michele Carlone for Rodrigo de Vivas y Mendoza, marquis of Zenete. The doorway of the "Salón de las Marquesese" in the castle is decorated with marble reliefs made in Genoa in 1509. The Mendoza family were also the patrons of the Hospital of Santa Cruz in Toledo; the tympanum over its main doorway contains a relief showing the Cardinal kneeling before Santa Elena.

In Burgos Diego de Siloe, son of Gil, and Bartolomé Ordóñez, both trained in Naples, worked in the Renaissance style. Diego returned to Burgos in 1519, where he was commissioned to execute the tomb of Bishop Don Juan de Acuña in Burgos Cathedral. It was modeled after the tomb of Pope Sixtus IV in the Vatican by Antonio Pollaiuolo. Diego also added several statues to the altar of Santa Ana in the Capilla del Condestable, including the splendid *Lamentation* displayed in this exhibition (cat. 49).

A key figure in the development of Renaissance style in Castile was Alonso Berruguete, son of the painter Pedro Berruguete (see cat. 46). Alonso was born in Paredes de Nava around 1488 and trained in Italy. Vasari tells us that around 1510 Bramante ordered Jacopo Sansovino to model in wax the classical sculptural group of *Laocoön*, which "Alanso Berugetta Spagnuolo" and other sculptors were also modeling.[34] Berruguete brought back with him to Spain the influence of such classical masterpieces as the *Laocoön*, as well as that of Renaissance masters like Ghiberti, Donatello, and Michelangelo. In 1523 he was commissioned to execute the altarpiece of the Monastery of La Mejorada, now in the Museo Nacional de Escultura in Valladolid.[35] On 8 November 1526 he received the commission to carve the altar of the church of the monastery of San Benito of Valladolid.[36] It is also preserved in the Museo Nacional de Escultura and is his most famous work; the impressive *Sacrifice of Isaac* in this exhibition (cat. 51) forms a part of this masterpiece. In the altarpiece architecture, sculpture, and painting form a unified ensemble, and all are the work of Alonso Berruguete.

The years around 1492, then, marked the conclusion of one important stylistic phase in the history of Spanish sculpture and the successful launching of another. In both phases artists of the most diverse national origins — the Low Countries, Germany, Italy, and France, in addition to Spain — made important contributions to a cultural heritage that was to become uniquely Spain's own.

NOTES

1. José María de Azcárate, *Arte gótico en España* (Madrid, 1990), 243; María González Sánchez Gabriel, "Los hermanos Egas, de Bruselas, en Cuenca. La sillería de coro de la Colegiata de Belmonte," *Boletín del Seminario de Estudios de Arte y Arqueología de la Universidad de Valladolid*, V (1936–1939), 32.

2. José María de Azcárate, "Análisis estilístico de las formas arquitectónicas de la Puerta de los Leones de la catedral de Toledo," in *Homenaje al professor Cayetano de Mergelina* (Murcia, 1961–1962), 97–122.

3. Manuel R. Zarzo del Valle, *Datos documentales para la historia del arte español, II, Documentos de la catedral de Toledo*, 1 (Madrid, 1916), 3, 4.

4. Azcárate 1990, 245.

5. José María de Azcárate, "El Maestro Sebastián de Toledo y el Doncel de Sigüenza," in *Wad-al-Hayara*, 1 (1974), 7–34.

6. Azcárate 1974, 33.

7. Fernando Checa, *Pintura y escultura del Renacimiento en España, 1450–1600* (Madrid, 1983), 48.

8. Héctor Luis Arena, "Las sillerías de coro del Maestro Rodrigo Alemán," *Boletín del Seminario de Estudios de Arte y Arqueología de la Universidad de Valladolid*, XXXII (1966), 89–123.

9. José Ramón Mélida, *Catálogo Monumental de España, Provincia de Cáceres* (Madrid, 1924), 284.

10. Isabel Mateo Gómez, *Temas profanos en la escultura gótica, las sillerías de coro* (Madrid, 1979); Dorothy and Henry Kraus, *Las sillerías góticas españolas* (Madrid, 1989), 149.

11. Zarzo 1916, 30–68.

12. Beatrice Gilman Proske, *Castilian sculpture: Gothic to Renaissance* (New York, 1951), 203.

13. Manuel Martínez Sanz, *Historia del Templo Catedral de Burgos* (Burgos, 1866), 186.

14. Proske 1951, 11.

15. María Jesús Gómez Bárcena, *Escultura funeraria en Burgos* (Burgos, 1988).

16. Filemón Arribas Arranz, "Simón de Colonia en Valladolid," *Boletín del Seminario de Estudios de Arte y Arqueología de la Universidad de Valladolid*, II (1933–1934), 165.

17. Julia Ara Gil, *Escultura gótica en Valladolid y su provincia* (Valladolid, 1977), 259–286.

18. Arribas 1933–1934, 157.

19. Proske 1951, 83.

20. Ara Gil 1977, 239–251.

21. Fernando Chueca, *Casas reales en monasterios y conventos españoles* (Madrid, 1982), 99.

22. Harold E. Wethey, *Gil de Siloe and his School: a Study of Late Gothic Sculpture* (Cambridge, Mass., 1936), 122.

23. Ignace Vandevivere, "L'intervention du sculpteur hispano-rhénan Alejo de Vahia dans le Retable Mayor de la Cathédrale de Palencia (1505)," in *Mélanges d'Arquéologie et d'histoire de l'Art offerts au Professeur Jacques Lavalleye* (Louvain, 1970), 305–318; Clementina Julia Ara Gil, *En torno al escultor Alejo de Vahia (1490–1510)* (Valladolid, 1974).

24. Clementina Julia Ara Gil, "El taller palentino del entallador Alonso de Portillo (1460–1506)," *Boletín del Seminario de Estudios de Arte y Arqueología de la Universidad de Valladolid*, LIII (1987), 211–242.

25. J.J. Martín González, "La sillería de la iglesia de Santa María de Dueñas (Palencia)," *Archivo Español de Arte*, XXIX (1956), 117–123.

26. Guadalupe Ramos de Castro, *La catedral de Zamora* (Zamora, 1982), 594.

27. Maria José Redondo Cantera, *El sepulcro en España en el siglo XVI: Tipología e iconografía* (Madrid, 1987), 112.

28. Marqués de Lozoya, *Escultura de Carrara en España* (Madrid, 1957).

29. Redondo Cantera 1987, 111.

30. María Isabel del Río de la Hoz, "Felipe Bigarny: origen y formación," *Archivo Español de Arte*, 57 (1984), 89–92.

31. Martínez Sanz 1866, 282.

32. Proske 1951, 224.

33. J.J. Martín González, "La introducción del Renacimiento en la escultura de Castilla la Vieja," in *Actas do Simpósio Internacional "A introdução da arte da Renascença na Peninsula Iberica"* (Coimbra, 1981), 53–77.

34. Giorgio Vasari, *Le Vite*, edited by Gaetano Milanesi, 7 (Florence, 1881), 489.

35. José María de Azcárate, *Alonso Berruguete: Cuatro ensayos* (Valladolid, 1963).

36. Isidro Bosarte, *Viaje artístico* (Madrid, 1804), 359.

THE SPAIN OF FERDINAND AND ISABELLA

Richard L. Kagan

By his own account, Christopher Columbus left Portugal and arrived in Spain sometime in 1485. He came in search of royal support for what he later described as the "enterprise of the Indies."[1] Columbus' enterprise was to journey to India, China, and Japan by sailing westward from the Canary Islands into the Atlantic. This scheme was both risky and expensive. For one thing, Columbus' cosmographical calculations challenged traditional notions about the size (if not the shape) of the world. He believed that the circumference of the globe was much smaller than geographers generally accepted. Furthermore, he had an exaggerated notion of the extent of the Eurasian landmass and was convinced that the "ocean sea" separating Europe from Asia could be easily crossed.

Born in the Italian maritime republic of Genoa in 1451, Columbus already had a decade's experience sailing in the Atlantic by 1485. Under Portuguese auspices he had ventured as far south as the Cape Verde Islands and the coast of Guinea and as far west as Madeira. Columbus had proposed his enterprise to John V, king of Portugal, but had generated little interest. The Portuguese had already established important trade links with southern Africa and were seemingly committed to reaching India via what would soon be named the Cape of Good Hope. Columbus also may have explored the possibility of English and French backing for his seaborne adventure, but as we now know, the mariner's future actually lay with the Spanish monarchs, Isabella I of Castile (1474–1504) and Ferdinand V of Aragon (1482–1516).

The Spains

Strictly speaking, Spain did not exist in the fifteenth century except as a geographical reference to the ancient Roman province of Hispania. Columbus himself addressed Ferdinand and Isabella as "king and queen of the Spains," a term that referred to the crown of Castile and León, Isabella's domain, and the crown of Aragon, an amalgam comprising the inland kingdom of Aragon, the principality of Catalonia, the Levant kingdom of Valencia, and the Balearic Islands, together with Aragonese dominions in the south of Italy. "The Spains" also encompassed the small Cantabrian states

stretching along Iberia's northern coast: Galicia, Asturias, and the Basque country, all of which owed allegiance to the crown of Castile. Each of these kingdoms maintained its own identity, a situation that the union of Isabella and Ferdinand did not alter. The monarchs had no intention of constructing a unified realm and even rejected a suggestion to adopt the title of king and queen of Spain. Instead they called themselves in traditional fashion: "King and Queen of Castile and León, Aragon, and Sicily, Toledo, Valencia, Galicia, Mallorca, Seville, Sardinia, Corsica, Murcia, Jaen, Algarve, Algeciras, Gibraltar, Count and Countess of Barcelona, Lords of Vizcaya and Molina, Dukes of Athens and Neopatria, Counts of Rousillon and Cerdagne."

Within the monarchs' extensive domains, the kingdom of Castile and León enjoyed pride of place. Its five million inhabitants outnumbered the population of the crown of Aragon by almost five to one. Castile's economy was also the most dynamic of all the Spains. Its economic

strength derived from the production of wool. Its arid climate and mountainous terrain were ideal for grazing, and sheep raising had dominated the economy of Old Castile since the eleventh century, when Berbers from North Africa introduced the merino, a species known for its fine, long-staple wool. Most of these sheep—estimated at more than three million in 1492—were herded in flocks whose long annual migrations from winter to summer pasture and back again were conducted under the supervision of the Mesta, the royal sheepherders' guild. Wool from these flocks was then shipped to northern Europe in exchange for finished textiles and other manufactured goods. The wool trade was Castile's golden fleece, enriching various sectors of society: the nobles and monasteries owning large flocks; the merchants of Burgos, the commercial capital of Old Castile; the shippers of Bilbao, the Cantabrian port through which much of this cargo moved; and the crown, which taxed the transhumant flocks as well as the trade fairs in Medina del Campo

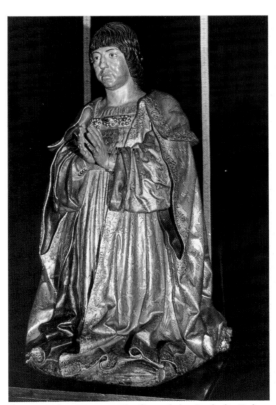 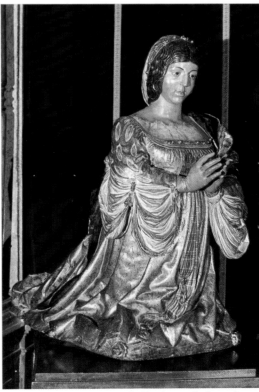

fig. 1. Felipe Bigarny, *Ferdinand the Catholic*. Polychromed wood. Capilla Real, Granada Cathedral

fig. 2. Felipe Bigarny, *Isabella the Catholic*. Polychromed wood. Capilla Real, Granada Cathedral

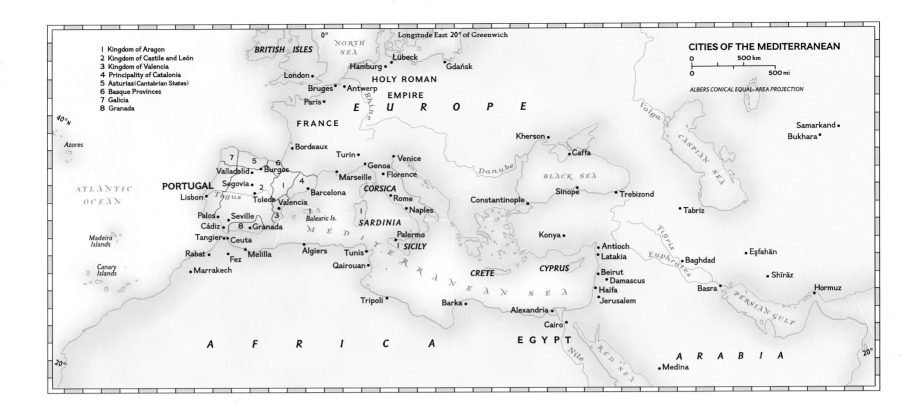

where foreign merchants gathered annually to buy Spanish wool.

The economy of Andalusia in southern Spain was even more prosperous. The former Islamic caliphate of al-Andalus had been incorporated into the crown of Castile following the conquests of Ferdinand III in the mid-thirteenth century. The region's principal city, Seville, with a population of almost forty thousand in 1492, was a major entrepôt with trade links to North Africa and the Mediterranean as well as northern Europe. Its principal exports were olive oil and wine, along with hides, soap, salt, and pickled tuna produced in one of the many fisheries lining the coast around Cádiz. Andalusia also had an important offshore economy that extended far into the Atlantic, as fishermen from Palos, Sanlúcar de Barrameda, and other ports plied the waters as far south as Cape Bojador and the Canaries. It was this important maritime tradition, much of it financed by Genoese merchants in Seville, that attracted Columbus to Andalusia and encouraged him to present his enterprise to the king and queen of the Spains.

Ferdinand and Isabella

"Although they are monarchs, they are human beings."[2] Such was the judgment of Fernando de Pulgar, one of several chroniclers employed by Ferdinand and Isabella. Such platitudes aside, contemporary descriptions of the two monarchs depict them as paragons of Christian virtue:

pious, charitable, prudent, temperate in both food and drink. This image actually better suits Isabella than Ferdinand, who was something of a philanderer known to have fathered at least four illegitimate children, including two after his marriage. Yet Isabella had her weaknesses too, including a fondness for fine clothing and jewels and a love of luxury partly conditioned by her elevated notion of monarchy and her desire to endow the Castilian throne with the dignity and majesty it previously lacked. In Pulgar's words, "She was a woman who was very ceremonious in her dress and adornments, in the choice of her daises and thrones, as well as in the service of her person; she only wanted great men and nobles to attend them and then with humility and respect. One has never read about any previous monarch who had so many great men as their servants."[3] Unlike most women of her era, Isabella learned to read and write, and even studied Latin. She carefully cultivated an image of piety and chastity, going so far, it was said, as to sleep surrounded by chambermaids whenever Ferdinand was away in order to preserve her reputation.

Isabella was born in 1451, the third child of Juan II (d. 1454). She was raised by her mother in Arévalo, a small town in Old Castile. Her older brother Henry inherited the crown in 1454, but as a child Isabella had only limited contact with the royal court. Henry IV was a weak, unpopular monarch whose alleged impotence prompted rumors that Juana (b. 1463), his infant daughter and designated heir, was in fact

Juana "la Beltraneja," fruit of an illicit union of Henry's queen with Beltrán de la Cueva, a prominent courtier. Whatever the truth of this rumor, it placed the royal succession in doubt. The infante Alfonso, Isabella's younger brother, was supported by one noble faction, Isabella by another. Alfonso's premature death at the age of fifteen in July 1468 favored Isabella's cause, and in a treaty signed later that year King Henry finally agreed to name Isabella his successor on the condition that she marry his ally, Alfonso V of Portugal. The independent Isabella, afraid that Henry might change his mind, preferred an Aragonese alliance and arranged to marry Ferdinand, the young son of John II of Aragon. Born in 1452 and one year her junior, Ferdinand, the very model of a Renaissance prince, cut a dashing figure. Isabella's choice of a husband was not primarily dictated by affection, but by politics. Isabella needed Aragonese support against Henry and his Portuguese allies. For his part the ambitious Ferdinand hoped to utilize Castile's resources in order to defend traditional Aragonese interests in Italy and the Mediterranean.

The young couple's marriage, celebrated secretly in Valladolid, immediately plunged Castile into a bitter war of succession involving the intervention of French and Portuguese troops loyal to Henry IV. Ferdinand and Isabella had a number of powerful allies, including Alonso Carrillo, archbishop of Toledo and primate of the Spanish church, but most of the Castilian nobility held aloof. Henry IV's death in Decem-

ber 1474 marked the beginning of the new regime, and Isabella deliberately used the occasion of the deceased monarch's obsequies to demonstrate her new authority. Immediately after the funeral ceremony she changed out of black mourning clothes into a richly jeweled dress and proceeded to the cathedral, riding majestically on horseback and attended by noble footmen who held her train and elevated a canopy above her head. At the forefront of this stately procession one of Isabella's courtiers brandished an unsheathed sword, a symbol of royal authority and a sign that the new queen would no longer tolerate opposition to her rule.[4]

Despite this charged symbolism, critics alleged that the queen had no business displaying attributes that rightfully belonged to her husband. Such reservations exemplified the new monarchs' continuing lack of support, and in fact the couple remained relatively isolated until February 1476, when Ferdinand defeated the Portuguese at a battle near Toro. Interpreting this victory as a sign of divine favor, the monarchs later celebrated it by founding the monastery of San Juan de los Reyes in Toledo, an imposing structure whose church they designated as their tomb. The victory at Toro also helped Ferdinand and Isabella to persuade Castile's representative assembly, the Cortes, in April 1476 to create the Santa Hermandad, an urban league that provided them with both money and troops. Even more important for the monarchs' prospects was the birth of a male heir in June 1478. The Infante Juan promised the continuity of the double monarchy created by Ferdinand and Isabella's union and reassured Castile's anxious nobility that their kingdom would not be ruled by Ferdinand, a "foreigner," in the event of Isabella's death. One by one, previously hostile noblemen pledged their support, enabling Ferdinand to defeat enemies both foreign and domestic. In 1479 the Treaty of Alcaçovas ended hostilities with Portugal, and by 1480 Ferdinand and Isabella had begun to consolidate their regime and to restore royal authority. Their new monarchy, as Ferdinand himself later acknowledged, would be "constituted in the service of God" and dedicated to the "increase of our realms."[5]

"The Increase of Our Realms"

Scholars tend to describe Ferdinand and Isabella as two of the fifteenth century's "new monarchs," rulers who increased their power at the nobility's expense. In addition, they have been credited with the creation of new governing institutions that represented the nucleus of the modern bureaucratic state. Actually, Ferdinand and Isabella were rulers of a traditional stripe

whose principal policy—the assertion of royal authority—differed little from that of earlier Trastámara monarchs, the ruling dynasty to which Isabella herself belonged. What distinguishes Ferdinand and Isabella is the determination and the skill with which they pursued this traditional program.

Both rulers made the dignity of their office a prime concern. Ferdinand and Isabella cloaked themselves in an aura of majesty, spending unprecedented sums on court entertainments, the foundation of new churches and monasteries, the construction of a royal pantheon, as well as the patronage of artists, poets, and various men of letters. The distinguished Castilian grammarian Antonio de Nebrija was a member of their court, as were various Italian scholars, including Peter Martyr d'Anghiera, a Milanese whose palace school helped to establish an important tradition of humanist learning in Castile. Their entourage lacked the glitter of contemporary Italian Renaissance courts, but Ferdinand and Isabella won praise for cultivating what were generally described as the "arts of peace." Moreover, contemporaries generally regarded them as rulers who had initiated a period of unprecedented peace and prosperity, and this particular memory serves to explain why they are commonly credited with the inception of Castile's golden age in both literature and art.

Yet no fifteenth-century ruler, not even the pope, could hope to govern by artistic patronage alone. The assertion of royal authority also required money—lots of it. In fifteenth-century Castile most of the crown's ordinary revenues came from a sales tax known as the *alcabala*. Owing to the kingdom's buoyant economy, the income Ferdinand and Isabella derived from this tax tripled during the course of their reign, but their spending, most of which was earmarked for war, grew at an even faster rate. The monarchs' search for additional revenues began at the Cortes of 1476 when the cities of Castile voted to establish the Santa Hermandad and continued at the Cortes of 1480, when the cities voted additional support in exchange for promises of certain governmental reforms. The king and queen also used this gathering to recover certain royal rents alienated by previous rulers along with others usurped illegally by the nobility during the war of succession. Historians have interpreted this particular episode as if Ferdinand and Isabella won a great victory over the nobility, but in fact the monarchs were anxious to avoid a confrontation with the nobles, particularly the sixty or so magnates who controlled much of the Castilian countryside. Ferdinand and Isabella successfully worked out a compromise that allowed

the nobles to retain most of their landed income together with other privileges but also increased the crown's revenues.

The rulers struck a similar deal with the church. Not all of Castile's clergymen were as wealthy as the archbishop of Toledo, a prelate whose income far exceeded that of any Castilian grandee. But together the clergy constituted a privileged group whose income, derived principally from tithes paid by the faithful, was largely exempt from royal taxation. Ferdinand and Isabella, however, skillfully used the crusade they launched against the Moorish kingdom of Granada in 1482 to ask the clergy for additional financial support. After considerable prodding, the church agreed to a special subsidy of a hundred thousand gold florins in 1483 and was subsequently persuaded to provide similar grants in later years. Similarly, the monarchs used the war in Granada to obtain a papal bull granting them revenues derived from the sale of indulgences. In theory, the *cruzada* was a voluntary contribution to be employed solely in the struggle against Islam, but it quickly evolved into a tax the monarchy used for other purposes. The money Ferdinand and Isabella invested in Columbus' 1492 voyage, for example, came from this particular levy.[6]

Ferdinand and Isabella's continuing search for new sources of revenue was complemented by various governmental reforms, particularly in the realm of finance and the administration of justice. The latter was essential to their policy of reasserting royal authority because justice was considered the highest of the monarchy's temporal prerogatives. During the civil war, however, royal justice had deteriorated considerably, prompting the Cortes to complain about the independence and quality of the crown's magistrates. In theory, rulers were expected to render important decisions personally, and Ferdinand and Isabella attempted to live up to this ideal by holding regular weekly audiences as they moved their court, in traditional fashion, from town to town. Yet they also recognized the need for competent judges and consequently reorganized the Royal Council, formerly an aristocratic preserve, into a body composed principally of university-trained jurists. Meanwhile, other legal tribunals, notably the *Real Chancillería de Valladolid*, the monarchy's principal court of appeals, were reformed and expanded and new ones established in order to make royal justice more accessible. Efforts were likewise made to improve the education of magistrates and to make royal law more comprehensible and easier to use. Compared to the administrative programs of previous monarchs, these reforms were not particularly innovative and served

only to make marginal (and in some cases temporary) improvements in the overall quality of royal justice. Yet the reforms helped Ferdinand and Isabella establish a reputation for being just rulers who successfully ended the "anarchy" and "tyranny" of previous regimes.

Even more important for the monarchs' reputation was their success at what contemporaries labeled the "arts of war." Like other medieval rulers, Castile's were expected to be warriors, and for all practical purposes this meant personal participation in the liberation of the peninsula from Islam. Muslims first entered Iberia in A.D. 711, when combined Arab and Berber armies toppled the weak regime of the Visigoths and conquered the whole of the peninsula with the exception of some small Christian enclaves in the north. What is generally called the reconquest began in the late eleventh century as the westward leg of the Crusades and culminated in the conquest of Seville in 1248. Following the capture of Gibraltar in the mid-fourteenth century, however, a combination of weak kings and civil war brought the progress of the reconquest to a virtual halt. Granada, the last Moorish stronghold, survived by paying a regular tribute, usually in gold, to Castile's rulers, its nominal overlords. Hostilities continued along the frontier, but in the course of a century the two states developed a workable modus vivendi partially reflected in Castile's taste for Islamic decoration in architecture, pottery, and the minor arts, the so-called *mudéjar* style. Yet the dream of completing the reconquest and restoring Hispania to Christianity remained.

Ferdinand and Isabella revived this dream in January 1482 by announcing the start of a crusade to liberate Granada from the clutches of Islam. Granada's rulers had provided the monarchs an excuse for this war with a raid on the Christian enclave of Zahara, but the motivations for the crusade actually went deeper. Granada, a prosperous silk-producing region, was a tempting prize. The war also provided an opportunity for Ferdinand and Isabella to unite their kingdoms under the banner of a crusade. Religious considerations also played a part in their decision to restart the reconquest. The fall of Constantinople to the Ottoman Turks in 1453 had sparked growing fear of Islam throughout much of Christendom, and there were calls for a new crusade after the Turks captured the southern Italian town of Otranto in 1480. In view of Aragonese interests in the region, many looked to Ferdinand as their savior, and he responded by sending a fleet to Italy the following year. Thus Ferdinand had already emerged as the champion of Mediterranean Christendom when the monarchs announced the beginning of a "just and

holy war" against Granada.

Contemporaries considered Granada's surrender ten years later, on 2 January 1492, as Ferdinand and Isabella's greatest achievement, certainly one far surpassing their sponsorship of Columbus' voyage. Congratulations poured in from across Europe. Calling Ferdinand and Isabella "athletes of Christ," a grateful pope bestowed on the rulers the title of Catholic Monarchs. Others called Ferdinand a "new Charlemagne" and claimed that he should now embark on the liberation of North Africa and Jerusalem from Islam. "This triumph is reserved for you," wrote Hieronymus Münzer, a German traveler who urged the monarchs to follow in the footsteps of Louis IX of France and King Richard of England and to add "this jewel to your diadem."[7] Ferdinand never attacked Jerusalem, but his aspirations to increase his realms in North Africa were manifest, starting in 1493, in a series of crusades directed against Oran. In the end Ferdinand's imperial ambitions were thwarted, but his dream of a universal Christian empire under Spanish dominion lived on in the person of his grandson and heir, Emperor Charles V (1500–1556).

A Catholic Monarchy

Ferdinand and Isabella's idea of a monarchy "constituted in the service of God" did not end with the reconquest and the war against Islam. It accounts for Isabella's particular interest in monastic reform, a policy that led to the appointment of Fray Jiménez de Cisneros, her confessor and a member of the reformed or "spiritual" branch of the Franciscan order, as archbishop of Toledo in 1495. Once installed in this powerful office, Cisneros instituted a series of measures aimed at improving monastic discipline, and founded the University of Alcalá de Henares, an institution designed expressly to improve the clergy's education. Yet Cisneros was also a prelate whose intolerance for other faiths led to the forced conversion of the Muslims of Granada in 1498.

The idea of a monarchy dedicated to God also helps to explain why Ferdinand and Isabella sought to establish an inquisition to investigate heresy among Castile's converted Jews (conversos). The monarchy's so-called converso problem began after a series of violent pogroms had swept across Castile and Aragon during the summer of 1391. In the decades that followed as much as half the Jewish population—estimated at two hundred thousand in 1391—underwent baptism. Many Jews did so sincerely, one of the more famous New Christians being Salomón Ha-Levi (1350?–1435), chief rabbi of Burgos, who, after having been baptized Pablo de Santa

María, subsequently became archbishop of the same city. Thousands of other Jews converted solely to escape persecution and continued to practice Judaism secretly. Clergymen viewed them with increasing alarm and used their pulpits to denounce these *marranos* as dangerous heretics and apostates who threatened to subvert the faithful. Most Old Christians, however, failed to distinguish the judaizers from other conversos, and by the middle of the fifteenth century the entire population of New Christians in many cities was subjected to increasing discrimination and armed attack.

In order to resolve this particular dilemma King Henry IV in 1461 had asked for papal permission to establish an inquisition under royal control. This request represented a departure from the medieval inquisition, which was subject to episcopal jurisdiction, and the papacy refused. Ferdinand and Isabella renewed this request in 1477 after a visit to Seville, a city with a large converso community, convinced Ferdinand that a new inquisition was absolutely essential. Isabella's initial commitment to the inquisition is not entirely clear. Fernando de Pulgar, a converso himself, counseled the queen that education was the best way to resolve the converso problem since he believed that most judaizers were ignorant souls lacking basic instruction in the rudiments of Catholicism. But Ferdinand, a firm believer in religious orthodoxy, was determined to make religion the business of state. He pressed the issue, and in November 1478 Pope Sixtus IV authorized what is now known as the Spanish Inquisition.

This new inquisition began operation in Seville late in 1481. News of its coming spread panic among the city's conversos. Those who could—four thousand by one estimate—fled, but by 1486 six hundred heretics had been burned at the stake. By this date tribunals were functioning in other Castilian cities as well as in Aragon, where Ferdinand forcibly managed to overcome opposition to their establishment. In 1483 the monarchs also had named Fray Tomás de Torquemada as Spain's first inquisitor general.

The purpose of the Holy Office is frequently misunderstood. By law its authority extended only to Catholics; neither Jews nor Muslims were subject to its authority. In the sixteenth century its jurisdiction encompassed a variety of religious crimes, but initially the inquisition had only one mission: to try conversos suspected of judaizing and to reconcile these "heretics" to the faith at the *auto da fe*, the public ceremony at which the inquisitors solemnly pronounced penances that ranged from whipping and public humiliation for repentant judaizers to death by fire for those who proved

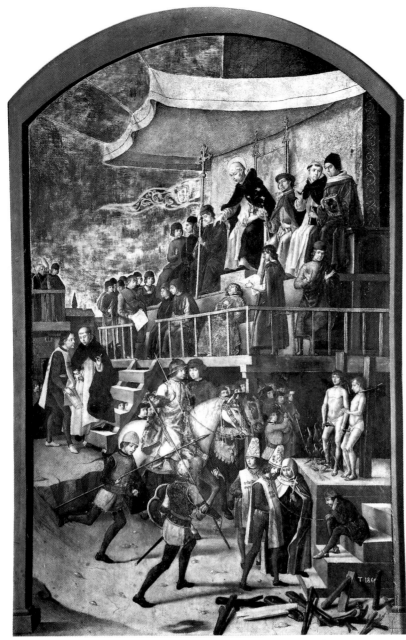

fig. 3. Pedro Berruguete, *Saint Dominic Presiding at an Auto da Fe.* Oil on panel. Museo del Prado, Madrid

justice."[11] The Jews' survival, however, depended totally on the monarchy. Royal sufferance alone guaranteed their existence and then only by virtue of a special concession granted in exchange for certain taxes and other services.

Notwithstanding the inherent precariousness of their situation, Jews came to occupy a relatively important place throughout the Spains. Most were small merchants, itinerant traders, small moneylenders, and shop owners; others worked as physicians; some even owned land, despite prohibitions to the contrary. On the other hand, Jews did not figure prominently either in industry or international commerce, although a few did manage to occupy high offices of state. Isabella, for example, named Abraham Seneor, grand rabbi of the Jewish *alhamas* (ghettos), treasurer of the Santa Hermandad in 1486.

Generally speaking, Jews in the Spains were tolerated, if not exactly loved. For all practical purposes they constituted a separate community, subject to their own law and officials. In the wake of the pogroms of 1391, however, Jews met with growing intolerance, much of it sparked by preachers belonging to one of the mendicant orders. Christians complained about the Jews' special legal position, pointing to their exemptions from imprisonment for debt, from serving in the militia, and the like. Municipalities enacted new and more restrictive measures against Jews, including limits on proselytizing (1455), prohibitions against the construction of new synagogues (1465), insistence that Jews wear special clothing (1476), as well as the requirement they live in walled ghettos (1480). The last measure was designed to minimize communication between Christians and Jews and was specifically aimed at separating conversos from their former brethren.

Ferdinand and Isabella generally attempted to protect "their" Jews from discrimination, but the monarchs' support began to waver shortly after the inquisition commenced operation. In January 1483 Seville's inquisitors expelled the Jews from that city on the grounds that their continued presence contributed to heresy and apostasy among local conversos. The Jews protested, but the monarchs did little to rescind the order. Nor did they intervene in subsequent years when other cities, again citing Jews as the source of apostasy among conversos, expelled their Jewish populations.

Similar reasoning may be found in the royal edict of 31 March 1492 that ordered the wholesale expulsion of the Jews from both Castile and Aragon. The document specifically faults "close communication between Christians and Jews" as the primary cause of "bad Christians [conversos] who judaize and apostatize." It also

recalcitrant. At one such *auto*, staged in Toledo on Sunday 12 February 1486, the local inquisitors, working diligently before what the event's chronicler described as a "great number of spectators," managed to dispatch the cases of no fewer than 750 male and female penitents in the course of a single morning.[8] Similar *autos* were held with terrifying frequency throughout most of the 1480s; nevertheless, many conversos escaped unharmed and were assimilated successfully into Castilian society. In 1484 one Polish traveler even reported that Isabella "has greater confidence in baptized Jews than in Christians. She entrusts them with her rents and revenues. They are also her counsellors and secretaries, and so are those of the king."[9] But the tendency to equate New Christians with heresy enabled overzealous inquisitors to perse-

cute thousands of innocent conversos and to confiscate their goods. In Aragon these abuses were so flagrant that even the papacy complained about the inquisitors' "love of lucre" and lack of concern with the salvation of souls. For Ferdinand the Holy Office was a means of increasing royal authority and there was no turning back: "no cause or interest, however great, will make us suspend the Inquisition."[10]

Ferdinand and Isabella's decision to expel the Jews from their kingdoms in 1492 represents yet another part of their effort to protect what they sincerely believed to be the true faith. By law, Jews belonged to the royal patrimony. "All the Jews in my kingdom are mine," Isabella once remarked, "and they are my Jews, and they are under my help and protection, and mine is the obligation to defend, help, and maintain them in

blames Jews for attempting "to subvert and to reduce Our Holy Catholic Faith" by instructing conversos in Jewish rites and laws. The edict stipulated that Jews had four months (or until 31 July 1492) to leave the kingdom. In the meantime they were guaranteed full legal rights and entitled to sell or otherwise dispose of their property. The Jews were further entitled to take with them all their possessions except gold, silver, and other items prohibited by royal law.[12]

Such an edict was by no means unprecedented; French monarchs and several Italian states had previously ordered the expulsion of their Jewish subjects on similar grounds. In the Spanish case, however, the edict, a product of euphoria created by the conquest of Granada in January 1492, represented the continuation of the monarchs' determination to unite their kingdom under one religion or law. Isabella may have hoped that the edict would spark a general conversion among "her" Jews, and by publicly celebrating Abraham Seneor's conversion on 15 June 1492 as a great victory it was probably hoped that others would follow the example of this prominent Jew. In the end, however, the edict had the opposite effect, serving to unite a Jewish community previously divided by sharp differences in religious outlook. Rabbis described the forced exile as a new Exodus comparable to the Jews' departure from Egypt, and one Christian chronicler left behind the following emotional description of the actual event.

The Jews left their birthplaces, children and parents, young and the old, on foot, riding on burros and other beasts, as well as in carts. They travelled to the ports of embarkation to which they were assigned, by way of the designated roads and places. They journeyed with great suffering and misfortune; some falling, some getting up, some dying, some being born, and some getting sick. There was hardly a Christian who did not feel sorry for them and wherever they went the Jews were invited to be baptized. Some converted and stayed behind, but very few. Instead, the rabbis went among them, urging them on and making the women and boys sing and play drums and tambourines to raise their spirits. Thus they left Castile.[13]

How many left? No precise figures exist, but a minimum of forty to fifty thousand Jews departed, primarily for destinations in Portugal (from which they would be expelled in 1496), North Africa, Italy, and Turkey. Some of the exiles converted and returned to reclaim their property, but most of these Sephardim abandoned their Iberian homeland for good.

The economic consequences of this exodus

have been frequently exaggerated, particularly among scholars who tend to regard the Jews as the nucleus of Castile's incipient bourgeoisie. Only a few Jews had actually been involved in large-scale economic enterprise. As in the case of Abraham Seneor, moreover, some of the kingdom's most prominent Jews opted for conversion rather than exile. The edict did not result in an economic windfall for the crown nor did it substantially diminish Castile's entrepreneurial skills, thus assuring, as often alleged, the kingdom's economic backwardness in subsequent decades. It is also a commonplace to attribute the expulsion to antisemitism, but the edict probably represents less an attack on Jews as an ethnic minority than a desperate attempt to defend Christianity against Judaism. As reprehensible as this decision now appears, it is best understood within the context of Ferdinand and Isabella's efforts to create a monarchy dedicated to the "servicio de Dios."

Columbus, God, and the Millennium

Is there a connection between these events and the monarchs' decision in April 1492 to sponsor Columbus' "enterprise of the Indies"?

At the beginning of Columbus' journal of his voyage to the New World appears the following entry:

This present year of 1492, after Your Highnesses had brought to an end the war with the Moors who ruled in Europe and concluded the war in the very great city of Granada . . . [on] the second day of the month of January I saw the royal standards of Your Highnesses placed by force of arms on the towers of the Alhambra, which is the citadel of the city, and I saw the Moorish king come out of the gates of the city and kiss the royal hands of Your Highnesses and the Prince, My Lord.[14]

Later in January Columbus claimed to have given the Catholic Monarchs information about India together with the "Great Khan's" interest in learning about Catholicism. He then wrote that the monarchs decided to send him to India to report on those lands and to see how "their conversion to the Holy Faith might be undertaken." The journal states: "So, after having expelled all the Jews from all of your kingdoms and dominions, in the same month of January Your Highnesses commanded me to go, with a suitable fleet, to the said regions of India."[15]

Columbus' chronology is confusing, but he clearly linked the expulsion of the Jews to the monarchs' decision to support his enterprise. As it turns out, little is known about the negotiations leading to the Capitulations of Santa Fe,

the agreements of April 1492 that stated the terms and conditions under which Columbus was to set sail.[16] Columbus had attempted to secure royal backing for his voyage as early as January 1486 but had been rebuffed, partly because of the royal preoccupation with the Granada campaign then approaching its final stages. Meanwhile Ferdinand and Isabella demonstrated their interest in Columbus with subsidies and grants of cash. After the fall of Granada Columbus renewed his request, appealing directly to the monarchs' messianic aspirations and particularly to Ferdinand's vision of himself as a great Christian champion.

It is now known that Columbus was a profoundly religious man much influenced by the Spiritual Franciscans, the order to which Cisneros, Isabella's influential confessor, also belonged.[17] In the late Middle Ages, Franciscan prophetic tradition envisioned the spiritual conquest of Islam, the liberation of Jerusalem, and the conversion of the Jews as preludes to the millennium and the second coming of Christ. Columbus' fascination with these subjects is demonstrated in his *Book of Prophecy*, written around 1498, a treatise in which he calculated the millennium as imminent, only several decades away. For Columbus, therefore, it appears that the fall of Granada and the expulsion of the Jews from Castile and Aragon appear to have marked the beginning of the millennial scenario that the prophecies outlined. His enterprise also belongs to this scenario, and should be interpreted, at least in part, as a spiritual quest pointing toward the millennium.

What is certain is that Columbus harbored messianic ambitions of his own. After 1493, for example, he regularly signed his letters "Christopher Columbus, Christ Bearer." In 1498 he even referred to himself as a messiah: "God made me the messenger of the new heaven and the new earth of which he spoke in the Apocalypse of St. John after having spoken of it through the mouth of Isaiah; and he showed me the spot where to find it."[18] To be sure, Columbus had other, more worldly desires including aspirations to nobility as well as to high office and honor. His letters also demonstrate his fascination with gold, a metal he clearly invested with spiritual meaning. "Gold is most excellent," he wrote. Yet Columbus also stated: "Gold constitutes treasure, and he who possesses it may do what he will in the world, and may so attain as to bring souls to Paradise."[19]

According to Columbus, Ferdinand and Isabella's view of this precious commodity was strikingly close to his own. On 26 December 1492, still aboard ship in the Caribbean, Columbus recalled in his journal having instructed Ferdinand and Isabella that they should spend

the gold to be derived from his voyage on "the conquest of Holy Places." The text reads: "I urged Your Highnesses to spend all the profits of this my enterprise on the conquest of Jerusalem, and Your Highnesses laughed and said that it would please them, and that even without this profit they had that desire."[20]

Historians have traditionally explained Ferdinand and Isabella's support for Columbus as the logical outcome of their interests in exploration and colonization. Competition with the Portuguese, and specifically the desire to profit from the spice trade of India and South Asia, are viewed as an additional rationale. Yet if Columbus is to be believed, royal support for his voyage was also predicated upon the monarchs' image of themselves as messianic rulers with a divine mission to conquer Jerusalem, release Asia and Africa from the grip of Islam, and establish universal Christendom as a prelude to the millennium. The adventure undertaken by Columbus led to what one of the monarchs' chroniclers would later describe as a New World. For Ferdinand and Isabella, however, Columbus' "enterprise of the Indies" heralded something even more momentous, the end of time itself.

NOTES

1. *Four Voyages of Christopher Columbus*, ed. Cecil James (New York, 1988), 2:2.
2. In Andrés Bernaldez, *Historia de los reyes católicos*, ed. Cayetano Rosell y López, *Biblioteca de autores españoles* 70 (Madrid, 1931), ch. 13. The original reads: "lo que mas grave se siente en los reales, es méngua estrema de las cosas necesarias." The translation is that of Felipe Fernández-Armesto, *Ferdinand and Isabella* (New York, 1975), preface.
3. Fernando de Pulgar, *Crónica de los Reyes Católicos*, ed. Juan de Mata Carriazo (Madrid, 1943), 1:78.
4. Alonso Fernández de Palencia, *Crónica de Enrique IV*, ed. A. Paz y Melia (Madrid, 1975), 2:154.
5. Cited in Fernández-Armesto 1975, 187.
6. Popular legend asserts that Queen Isabella was so committed to Columbus' voyage that she was willing to sell her jewels to pay for it, but the truth is that the monarchy contributed only a little more than one half the expedition's cost, with the balance coming from various Sevillian merchants as well as Columbus himself. Juan de la Cosa provided the flagship, the *nao Santa María*, while the caravels *Niña* and *Pinta* belonged to the port of Palos.
7. José García Mercadal, *Viajes de extranjeros por España y Portugal* (Madrid, 1959), 1:405.
8. Henry Kamen, *The Spanish Inquisition* (New York, 1965), 189.
9. Nicolas de Popielovo in García Mercadal 1959, 1:319.
10. Cited in Henry Kamen, *Spain 1469–1514: A Society in Conflict* (New York, 1983), 41.
11. Letter of 12 August 1490 cited in Luis Suarez Fernández, *Los Reyes Católicos: La Expansión de la Fe* (Madrid, 1990), 75.
12. For the complete Spanish text of the edict, see Luis Suarez Fernández, *Documentos acerca de la expulsion de los judios* (Valladolid, 1964), 391–395.
13. Bernáldez 1931, 653.
14. *Journal of Christopher Columbus*, ed. Oliver Dunn and James E. Riley, Jr. (Norman, 1989), 17.
15. Dunn and Riley 1989, 19.
16. The full text of Columbus' capitulations with the monarchs may be consulted in *The Spanish Tradition in America*, ed. Charles Gibson (New York, 1968), 27–34. The monarchs agreed to name Columbus "Admiral in all those islands and mainlands which by his hand and industry shall be discovered or acquired." He was also appointed perpetual viceroy and governor general with full authority over "all the said islands and mainlands," although the monarchs later revoked this particular privilege as the full extent of Columbus' discoveries became known.
17. For Columbus' spirituality, see Pauline Moffitt Watts, "Prophecy and Discovery: On the Spiritual Origins of Christopher Columbus's 'Enterprise of the Indies,'" *American Historical Review* 90 (1985), 73–102. For his connection to the Franciscans, John L. Phelan, *The Millennial Kingdom of the Franciscans in the New World* (Berkeley, 1970), 17–28.
18. *Voyages of Columbus* 1988, 2:48.
19. *Voyages of Columbus* 1988, 2:104.
20. Dunn and Riley 1989, 291.

THE ART OF WESTERN AFRICA IN THE AGE OF EXPLORATION

Ezio Bassani

The age of European maritime expansion coincided with an extraordinary period in the history of west African art. The brass sculptures cast in Benin (cats. 60–65) are the most famous of the works produced at this time, but that kingdom was by no means the only major center of artistic creativity in this part of the continent, as the works included in this exhibition indicate. Moreover, the late fifteenth century also marked the first direct contact between sub-Saharan Africa and Europe, as the Portuguese sailed down the west African coast on the route that was ultimately to take them to India in 1498. An early consequence of this encounter was the creation of the remarkable corpus of works known as Afro-Portuguese ivories (cats. 68–78), created for trade with Europe.

Mali

The successive empires of Ghana, Mali and Songhay, on the south flank of the Sahara, were inland civilizations. All their important cities — Niani, Walata, Jenne, Mopti, Timbuktu, Gao — were located in the interior of the continent, and their connections with North Africa and the Mediterranean were through the caravan routes that had long crisscrossed the desert.

The initial nucleus of Mali was a small kingdom of Mande population that took shape in the region of the present-day Guinea following the dissolution of the empire of ancient Ghana at the end of the eleventh century. It was only around 1230, with the reign of the legendary emperor Sundiata, that Mali began to make its mark as a great power. Because its ruler (known as *Mansā*, or king) controlled the gold of Bambuk and Bore and the trans-Saharan trade, he accumulated vast wealth. The empire's elite soon adopted Islam as its religion. The ruler's fame spread throughout the Arab world and reached Europe after the spectacular pilgrimage to Mecca undertaken in 1324 by Mansā Mūsā, with an imposing escort of courtiers and servants and a seemingly limitless supply of gold that was used for both expenses and gifts, in such measure as to make the value of the precious metal plummet in the markets of Egypt.[1]

It was from that point on that European maps began to include Mali as a place name. On the 1339 world map of Angelino Dulcert, a Genoese mapmaker active in Mallorca, "rex Melli" identifies the figure of an enthroned king, and on the *Catalan Atlas* of 1375 (cat. 1), drawn by another Mallorcan, Abraham Cresques, "Musse Melly" (that is, Mūsā of Mali) is identified by name.[2] Mali's empire at its peak in the mid-fourteenth century extended from the capital of Niani in the upper Niger valley westward to the coast, and eastward along the Niger valley to the borders of Hausaland. Its government was much admired by the famous traveler Ibn Battuta of Tangier, who visited the area in 1352–1353.[3] By the next century, however, its power was in decline. The vassal states of Mali included the strategically located kingdom of Songhay, which in the reign of Sonni ᶜAlī (c. 1464–1492) was finally able to defeat the emperor of Mali and begin to create an empire of its own. The Songhay empire ultimately became even greater than that of Mali.

Sonni ᶜAlī's successor, Askiyā Muhammad (1493–1528), who overthrew the former's son to establish the Askia dynasty, was a faithful Muslim (like Mansā Mūsā he made a pilgrimage to Mecca in 1495–1497) and an enlightened and tolerant ruler. He permitted the populations of his empire to preserve their traditional religions. As the emperors of Mali before him had already done, he encouraged an influx of learned Muslims from North Africa and the Middle East into his domains, promoting cultural exchange and the formation of a lively and complex civilization. Timbuktu, at the bend of the Niger River, became one of the most important marketplaces of sub-Saharan Africa. It was not only the point of arrival and departure of caravans to and from Morocco, Algeria, Tunisia, Libya, and Egypt, but also a great center of Islamic culture, said to house as many as 180 schools of Koranic learning.[4] Leo Africanus, a learned and wide-ranging Arab traveler who had converted to Christianity, wrote about 1523 that at Timbuktu there are "great store of doctors, judges, priests, and learned men, that are bountifully maintained at the king cost and charges. And hither are brought divers manuscripts or written bookes out of Barbarie, which are sold for more money than any other merchandize."[5]

If Timbuktu was the gateway to the Sahara, Jenne on the inland delta of the Niger was the center to which were brought the continent's products — gold, ivory, skins, pepper, kola, rubber — to be exchanged for goods from the North: fabrics, salt, glass beads, iron, copper, and manuscripts. In 1943 the French archaeologist Théodore Monod brought to light, in the vicinity of Jenne, along with numerous other archaeological finds, a terra-cotta human figure. In the course of the following years, other terra-cottas were found between Jenne and Mopti, in the triangle defined by the courses of the Bani and Niger Rivers, and in a few sites farther south, in the environs of Bamako. The corpus of terra-cottas from the inland Niger delta region of Mali is often called Jenne, after the site of the first discoveries, and those from around Bamako are often called Bankoni, after the village in which they were first found.

For the most part the terra-cottas are human figures portrayed in different positions, some apparently depicting mother and child, others horsemen (cat. 58), and others representations of serpents. According to the results of thermoluminescence testing, the terra-cottas were produced over a long period of time, stretching from the tenth to the sixteenth century.[6] Morphologically they differ a good deal among themselves, and stylistically they can be divided into two large groups based on the principal sites of the diggings: one from the Jenne-Mopti region, the other from the Bamako region. The figures in the second group are characterized by an exceptional elongation of the trunk and limbs.

In the absence of archaeological data for most of the terra-cottas, however, definitive elements for making stylistic distinctions are still limited. For the same reason we remain uncertain, at present, of the function of these works and of the culture within which they were created.[7] The ruling elite in this area had adopted Islam and clearly would not have used representations of the human figure in religious ceremonies, although traditional religious practices continued to be tolerated.[8] The reports of the Arab

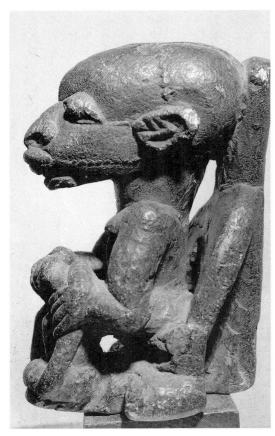

fig. 1. *Seated figure*, Sapi peoples, Sierra Leone. 16th century? steatite. Carlo Monzino collection.

travelers to Mali make no mention of any such terra-cottas. These uncertainties notwithstanding, the quantity and the artistic quality of the terra-cottas from Mali permit us to consider the region one of the great centers of early production of African earthenware, along with Chad, Ghana, and, above all, Nigeria.

Sapi

The earliest Portuguese accounts of what is now Sierra Leone suggest a social organization without the cosmopolitan character that prevailed in the large Sudanic cities. The Sapi or Çapes—the inhabitants of the coastal region and the immediate hinterland—lived in villages governed by chiefs who, more nominally than in fact, were subject to the authority of rulers of small kingdoms which, in their turn, formed a kind of confederation.

The Sapi were the ancestors of the Bullom, Temne, and Kissi peoples now living in this region. According to Walter Rodney, they constituted a loose community with a common culture more than a true ethnic entity or a unified state.[9] Early Portuguese accounts described the Sapi as a cultivated and peaceful people,

"given to feasts and pleasures"[10] and extremely gifted in the arts. The latter trait quickly led to trade with the European visitors, as we know from the reports written by Duarte Pacheco Pereira and Valentim Fernandes as early as the first years of the sixteenth century.[11]

It was around the middle of that century that the lands of the Sapi are thought to have been invaded by a warlike people of Mande stock, the Mani or Manes, who came down from the northeast. According to a late sixteenth-century account, the Mani "committed so many vexations on the indigenous peoples that the latter have become less and less concerned and have given up the exercise of their arts."[12] On the basis of thoroughgoing enthnolinguistic analyses, P. E. H. Hair has expressed doubts that a Mani invasion ever took place, at least on the scale and with the disastrous effects reported in the Portuguese chronicles which, in any case, were written several decades after the purported events.[13] Whatever the truth may have been, there seem to be grounds for thinking that the Sapi carvers ceased to produce ivory art objects on Portuguese commissions of the type discussed later in this essay sometime before the middle of the sixteenth century, an indication that some kind of traumatic event may indeed have occurred in the area.

In addition to these ivories that shall be considered later on, the corpus of Sapi art includes a relatively large number of sculptures in soft stone (steatite), the first of which were discovered by chance in the course of farming, while additional examples were unearthed through systematic explorations. For the most part these are human figures, in a few instances associated with animals, mostly the elephant or crocodile. There are also heads of considerable size, great expressive power, and notable sculptural quality.

The scholars who have researched these sculptures agree that they were produced at a time preceding and immediately following the arrival of the Portuguese.[14] The obvious formal analogies with the figures carved on the Sapi-Portuguese ivories support this hypothesis, and there is contemporary confirmation in the chronicle of Valentim Fernandes, written in the first decade of the sixteenth century, who noted that the inhabitants of Sierre Leone "love to make idols of wood and stone."[15]

Ife, Benin, Owo

Farther south, in what is now Nigeria, an extraordinary corpus of works of art, the most important in both quantity and quality in all of Africa during this period, records the existence of complex and highly developed civilizations.

These centered in Ife, Benin, and Owo, three great city-states surrounded by a large tributary territory.[16]

Ife, situated in the southwest of the country, some 90 miles from the coast, is the oldest of these cities. Its first settlement appears to date to the eighth century, but little is known for certain about how it developed. Although Ife has remained the most important religious center of the Yoruba people, its political power began to decline in the fifteenth century.

The known corpus of Ife sculpture—some thirty works cast in metal and a large quantity in terra-cotta—attests to an artistic production of extremely high quality that, as is indicated by the thermoluminescence analysis of some of the works, lasted from the twelfth to the sixteenth century. The dates for the terra-cottas appear relatively earlier than those for the works in metal and suggest that the artists of Ife may have worked in clay initially and only later, when artistic production had already developed and been refined, turned to metal. The metal, a copper alloy, is often generically called bronze, although since the copper is alloyed with zinc rather than tin, brass is the correct term.

Virtually the only subject of Ife art is the human figure and, in particular, the head, which is rendered with a sublime fusion of realism and idealization. It was precisely the exceptional formal perfection and the aristocratic realism of the facial features—unique in African art—that led the German scholar Leo Frobenius, who in 1910 discovered a group of Ife heads in terracotta and bronze, to propose the notion that the culture of Ife was to be linked to a hypothetical Mediterranean colony that settled in ancient times on the Atlantic coast of Africa.[17] The idea, of course, reflects the prejudices of the period and is entirely without basis in fact. More recently Frank Willett has discovered, through careful comparisons, a number of relationships between the art of Ife and that of the Nok culture which flourished between 500 B.C. and 200 A.D. on the upland plain of Jos in southern Nigeria, helping to confirm that the art produced in Ife was completely African in both origin and character.[18]

South of Ife was the kingdom of Benin, which had its capital, Benin City, some fifty miles inland. The origins of that kingdom are shrouded in myth. According to the Nigerian historian Jacob Egharevba, the first king of the Yoruba derived dynasty acceded to the throne of Benin, whose people belong to the Edo ethnic group, in the thirteenth century. R. E. Bradbury dates that event a century later.[19] What is certain is that at the time of the arrival of the Portuguese in 1485 there was a highly organized society in Benin, wealthy and militarily

powerful and governed by an absolute monarch, the *Oba,* supported by a court aristocracy and an efficient bureaucracy. Artists and craftsmen, such as the metal casters and ivory carvers, were organized into guilds and worked exclusively for the king, living in separate neighborhoods set aside for them.

Despite the transformations that came inevitably through contact with the Europeans, this system of organization lasted until 1897, when Benin City was occupied, sacked and destroyed by a British punitive expedition sent to avenge the death of an English consul who had been murdered, with his escort, en route from the coast to the capital for a visit to the *Oba.* It must be remembered, however, that the ruler had at the time been absorbed with ceremonies in honor of his ancestors, which rendered him unapproachable to foreigners, and he had explicitly forbidden the visit.

The booty from Benin, comprising thousands of works of art, was for the most part put up for sale in London in order to recover the costs of the expedition, and most of it found its way into the major museums of Europe. There were sculptures in ivory and terra-cotta but chiefly in brass, both figures in the round and plaques in relief that had decorated the pillars of the inner courts in the royal residence. The unexpected arrival of so many works of art of exceptional formal and technical quality (the works from Ife and Mali were not yet known) made an enormous impression in European cultural circles.

According to one oral tradition, the technique of metal casting was introduced into Benin by masters from Ife toward the end of the fourteenth century. Whatever its origin may have been, no other African artistic production is as well known as that of Benin; hundreds of studies have been devoted to it. William Fagg, the eminent specialist in Nigerian art, has divided the art of Benin into three broad periods. The first period is typified by the commemorative heads, which reveal a degree of naturalism which may have been derived from Ife art, and is thought to have extended from the end of the fourteenth century to the middle of the sixteenth. The production of the middle period, from the mid-sixteenth century to the end of the seventeenth, includes the cast plaques, which often contain figures of Portuguese. The late period, marked by an increasing decline, ran from the eighteenth century until the sack of Benin in 1897. Scholars have debated the chronology of the Benin sculpture at great length, without any consensus having yet emerged.[20]

The art of Benin is a court art, whose principal aim is the glorification of the ruler. For all its extraordinary formal perfection, it lacks the moving humanity of the art of Ife. That human quality also comes to the fore in the art of Owo, the Yoruba city-state located midway between Ife and Benin. Owo sculpture, as Frank Willett has shown, has points of contact with that of the two other capitals and shows the influence of both their cultures.

It was only with the excavations conducted by Ekpo Eyo between 1969 and 1971 that the terracottas of Owo were brought to light.[21] Although the works are still being studied, they have already shown their importance not only as major documentary materials of Owo culture but also as works of art of an intense expressiveness. Dating obtained through thermoluminescence tests indicates the fifteenth century as the period of manufacture.

Kongo

At about the time the Portuguese arrived in Benin they also established contact with another great African state, the kingdom of the Kongo. At that time it occupied roughly the strip running from the Atlantic to the Kwango River, bordered on the north by what is now Gabon and on the south by the course of the Kwanza. This area was inhabited chiefly by Bantu populations of the Kongo group. At the close of the fifteenth century much of the kingdom, divided into provinces, was directly governed by the Manicongo, the king of Kongo, through a hierarchy of chiefs and subchiefs, while a few vassal states flanking the kingdom were in the process of removing themselves from domination by the Manicongo or were striving to do so. The king kept a firm grip on the wealth of the country, on the activity of the mines and on commerce. He collected tribute from his subjects, and he was served by a monetary system, judged functional by the first European chronicles, which was based on a particular type of shell over whose gathering, on the island of Luanda, he held the monopoly.[22]

Between 1482 and 1488 Diogo Cão carried out three voyages into the region. On his

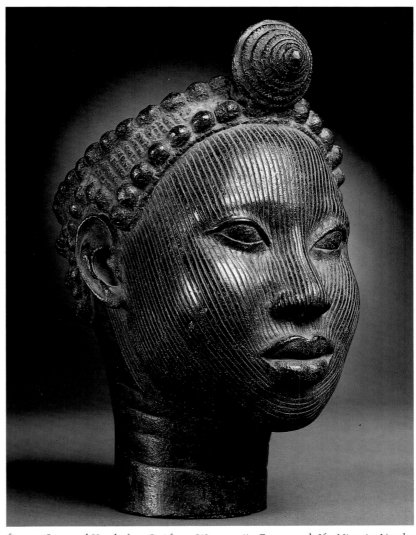

fig. 2. *Crowned Head of an Oni* from Wunmonije Compound, Ife, Nigeria, Yoruba peoples. 12th–15th century, zinc brass. Museum of the Ife Antiquities, Ife.

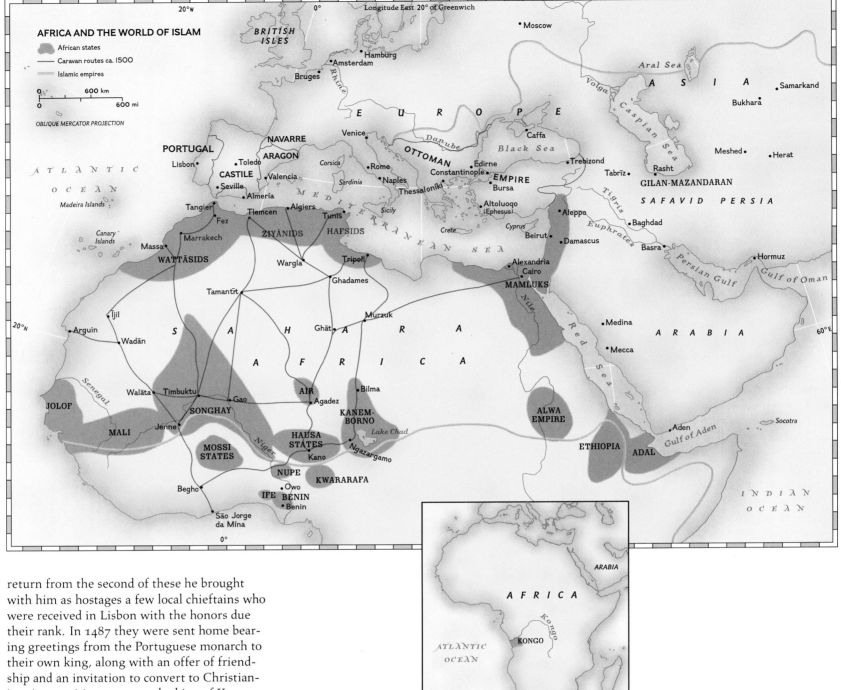

AFRICA AND THE WORLD OF ISLAM

- ▨ African states
- —— Caravan routes ca. 1500
- ▨ Islamic empires

600 km
600 mi

OBLIQUE MERCATOR PROJECTION

return from the second of these he brought with him as hostages a few local chieftains who were received in Lisbon with the honors due their rank. In 1487 they were sent home bearing greetings from the Portuguese monarch to their own king, along with an offer of friendship and an invitation to convert to Christianity. As a positive response the king of Kongo sent an embassy to Portugal headed by the noble Nsaku, one of the hostages who had been sent home, and a large cargo of gifts. In 1491, on the occasion of a new Portuguese expedition, the Manicongo and his family converted to Christianity and had themselves baptized, although as soon as the Portuguese left, the king resumed his traditional religious practices.

The case was different, however, with his eldest son, Nzinga Mvemba. Baptized as Afonso in 1491, he reigned as a Christian from 1507 until his death in 1543. His commitment to Christianity was sincere and profound; he changed the name of his capital to São Salvador, ordered the destruction of all the "idols," called insistently for missionaries to be sent to him,

and even sent his son Henrique to study in Lisbon. It was his wish to remodel his kingdom along European lines.

The Portuguese responded with an ambivalent policy to the African ruler's faith and eagerness to modernize his country. They interpreted the right of "patronage" over the African lands that Pope Alexander VI had granted to King Manuel I of Portugal in 1499 not as a privilege and a responsibility to spread the Christian faith but as a sort of exclusive right to exploit the lands included in the Act of Patronage. The *Regimento*—the rules for governing that the Portuguese king sent to his counterpart in the Kongo in 1512[23]—suggested a model of European organization for the African state but at the same time explicitly requested that the Portuguese ships returning to Lisbon be loaded to the maximum with slaves, copper, and ivory ("*asy descrauos como de cobre e marfim*") to compensate for the costs of spreading the Christian faith. It was thus inevitable that the relations between Portugal and the Kongo would soon degenerate.

Although there are no Kongo art works or craft objects known that can be attributed with

any certainty to the period before the arrival of the Portuguese, there is considerable support for the conclusion that artistic creation and a high level of artisanry flourished in the kingdom prior to contact with Europe. The Portuguese chronicles, in fact, record among the gifts received from Kongo in 1488 "objects in ivory well worked and many garments in palm fiber well woven and with delicate colors."[24] Such fabrics and ivory objects found their way into the European princely collections and curiosity cabinets in the sixteenth and seventeenth centuries.

Two splendid ivory oliphants, with their surfaces covered by an exquisite geometrical decoration using typical Kongo motifs, were among the possessions in 1553 of Grand Duke Cosimo I de' Medici, ruler of Florence (cat. 78). It can reasonably be supposed that these were gifts sent by the Kongo monarch, a convert to Christianity, to a pontiff of the great Florentine family, perhaps even Giovanni de' Medici—who was Pope Leo X from 1513 to 1521 and who appointed the Kongo prince Henrique bishop of Utica in 1518.[25]

The first explicit mention in a European source of palm fiber fabrics worked like velvet, using the same geometrical decoration that was carved on the ivory horns, is found in Duarte Pacheco Pereira's invaluable account, *Esmeraldo de Situ Orbis*, which is thought to have been written between 1506 and 1508. There the author states that "in this kingdom of Kongo they make fabrics with a nap like velvet, some of them worked in velvety satin, so beautiful that nothing finer is made in Italy,"[26] no mean compliment at that time.

The passage quoted is intriguing, as is the listing of some Kongo fabrics in the inventory of the estate of a Portuguese colonist who died in São Tomé in 1507,[27] where they are specified as *avjlotados*, "velvety." These demonstrate beyond any doubt that the procedure for making palm fiber textiles similar to velvet was an independent African achievement, the product of a textile industry that must have had roots far in the past, if it could produce cloth of such refinement. The chorus of European admiration for these textiles runs through the centuries. For example, in 1664, Paolo Maria Terzago noted that the Kongo textiles in the Museo Settaliano in Milan reflected "an art so great as to surpass our cloth of worked silk."[28]

Afro-Portuguese Ivories

In Sierra Leone, Benin, and perhaps Zaire, the encounter and resulting cultural interchange between the Portuguese and Africans produced a phenomenon unique in the history of African figurative arts at that time: the creation of works of art for export, those now known as Afro-Portuguese ivories.

The term, coined in 1959 by William Fagg,[29] covers a group of saltcellars, pyxes, spoons, forks, knife and dagger handles, and oliphants that were carved within the span of a few decades beginning at the end of the fifteenth century, either commissioned directly by the Portuguese visitors or created to be sold to them. Elements native to the two cultures are harmoniously integrated in these ivories, of which a corpus of about two hundred works has thus far been identified.[30] European models are particularly recognizable in the decoration of the saltcellars and liturgical vessels, and in many cases it is possible to identify the probable source of the designs (see Fagg and Bassani, 1988).

The records from 1504–1505 of the treasurer of the Casa de Guiné, the Portuguese administrative headquarters for overseas commerce,[31] along with statements from Portuguese chroniclers of the time, like Duarte Pacheco Pereira and Valentim Fernandes, are evidence that such ivory objects were indeed sent to Portugal from Africa. The chronicles are in accord in their admiration for the African carvers' skill. Fernandes, in his description of West Africa written between 1506 and 1510, states that "in Sierra Leone, men are very clever and make extremely beautiful objects as spoons, saltcellars, and dagger hilts."[32]

For the ivories from Benin, on the other hand, we have only a single and considerably later account. The English navigator James Welsh, in the report of his voyages that he wrote in 1588, stated that the inhabitants of Benin produce "elephant tooth spoons, curiously carved with different kinds of birds and animals on them."[33] It is clear, however, that the production of these ivories began before, for as early as 1560 five spoons from Benin figured among the possessions of the Florentine Grand Duke Cosimo I de' Medici (cats. 72–76).[34]

The reason such precious objects were produced—works destined in some cases for the kings of Portugal and Spain, as we know from the coats of arms carved on some of the saltcellars and oliphants (cats. 70 and 77)[35]—is readily explained by the abundance of ivory available at this time and by the proven professional capacity of the local carvers. It is inconceivable that objects of such sophistication and technical perfection could have originated only in response to a sudden demand from abroad. In any case, the ultimate proof that the origin of these works is connected to local artistic traditions lies in the stylistic characteristics we have described that relate the Afro-Portuguese ivories to works of art that do not presuppose contact with Europe, to the stone sculptures in the case of the Sapi and to the indigenous ivories and bronzes in the case of Benin.

This brief survey is meant to serve simply as an introduction to a broad and complex subject, as is the selection of objects included in the exhibition. The cultures described and represented are by no means the only art-producing cultures of the period. The Age of Exploration did not bring about this period of extraordinary artistic production. As we have seen, in each cultural area the indigenous roots of the techniques and styles are clear. Even the Afro-Portuguese ivories are a logical outgrowth of local traditions, although they also reflect the opportunities presented by the new European market. Taken as a whole, these West African works remind us of the exceptional artistic vitality that prevailed in the world around 1492, all the more extraordinary in that its manifestations were so often independent of one another.

fig. 3. *Raffia cloth*, Zaire or Angola. Seventeenth century. Nationalmuseet, Copenhagen

NOTES

1. See Nehemia Levtzion, *Ancient Ghana and Mali* (reprint ed., New York and London, 1980), 65–66.

2. See Massing essay "Observations and Beliefs: The World of the *Catalan Atlas*" in this catalogue.

3. See N. Levtzion and J. F. P. Hopkins, *Corpus of early Arabic sources for West African history* (Cambridge, 1981), 289–297.

4. See *The Cambridge History of Africa*, 3 (Cambridge, 1977), 415–462.

5. Leone Africano, "Della descrizione dell'Africa e delle cose notabili che quivi sono per Giovan Lioni Africano," in *Primo volume delle navigationi et viaggi nel qual si contiene la descrittione dell'Africa, et del paese del Prete Ianni, con vari viaggi...*, ed. Gio. Battista Ramusio (Venice, 1550); and Leo Africanus, *The history and description of Africa and the notable things therein contained done into English in the year 1600 by John Pory*, Robert Brown, ed. (London, 1846), 3:825.

6. Roderick J. McIntosh and Susan Keech McIntosh, "Terracotta Statuettes from Mali," *African Arts* XII 2 (February 1979), 51–53; Bernard de Grunne, *Terres Cuites Anciennes de l'Ouest Africain* (Louvain-la-Neuve, 1980); Susan Keech McIntosh and Roderick J. McIntosh, *Prehistoric Investigation in the Region of Jenne, Mali* (Oxford, 1980); Bernardo Bernardi and Bernard de Grunne, *Terra d'Africa, Terra d'Archeologia—La grande scultura in terracotta del Mali-Djenné VII-XVI sec.* (Rome, 1990).

7. Roderick L. McIntosh, "Middle Niger Terracottas before the Symplegades Gateway," *African Arts* XXII 2 (February 1989), 74–83.

8. René A. Bravmann, *Islam and Tribal Africa* (Cambridge, 1974).

9. Walter Rodney, "A Reconsideration of the Mane Invasions of Sierra Leone," *Journal of African History*, VIII 2 (1967), 218.

10. A. Alvarez de Almada, "Tratado Breve dos Rios de Guiné do Cabo Verde desde o Rio do Sanaga até aos Baixos de Sant'Anna" (Lisbon, 1594), in Rodney 1967, 238.

11. Valentim Fernandes, *Description de la Côte Occidentale d'Afrique (Sénégal au Cap de Monte, Archipels)*, T. Monod, A. Teixeira da Mota and R. Mauny, eds. and trans. (Bissau, 1951), 96; Duarte Pacheco Pereira, *Esmeraldo de Situ Orbis*, Augusto Epifanio da Silva Dias, ed. (Lisbon, 1905), 96.

12. Alvarez 1594, in Rodney 1967, 240.

13. P. E. H. Hair, "From language to culture: some problems in the systematic analysis of the ethnohistorical records of the Sierra Leone Region," in *The Population Factors in African Studies*, eds. Rowland P. Moss and R. J. A. R. Rathbone (London, 1974), 71–83; P. E. H. Hair, "An Ethnolinguistic Inventory of the Lower Guinea Coast before 1700: Part I," *African Language Review* 7 (1968), 47–73.

14. Kunz Dittmer, "Bedeutung, Datierung und Kulturhistorische Zusammenhänge der 'prähistorischen' Steinfiguren aus Sierra Leone und Guiné," *Baessler Archiv*, N. F. XV (1967); Aldo Tagliaferri and Arno Hammacher, *Fabulous Ancestors* (Milan and New York, 1974); Frederick J. Lamp, "House of Stones: Memorial Art of Fifteenth-Century Sierra Leone," *Art Bulletin* LXV 2 (1983), 219–237; Aldo Tagliaferri, *Stili del Potere, Antiche sculture in Pietra dalla Sierra Leone e dalla Guinea* (Milan, 1989).

15. Fernandes 1951, 75.

16. Ekpo Eyo and Frank Willett, *Treasures of Ancient Nigeria: Legacy of 2000 Years* [exh. cat., Detroit Institute of Arts] (New York, 1980).

17. Leo Frobenius, *The Voice of Africa* (New York, 1968), 1:323–349.

18. Frank Willett, *Ife in the History of West African Sculpture* (New York, 1967), 110–118; Frank Willett, "A missing millennium? From Nok to Ife and beyond," in *Arte in Africa—Realtà e prospettive nello studio della storia delle arti africane*, ed. Ezio Bassani (Modena, 1986), 87–100.

19. Jacob Egharevba, *A Short History of Benin*, 3d ed. (Ibadan, 1980); R. E. Bradbury, *Benin Studies*, ed. Peter Morton-Williams (Oxford, 1973); Henry John Drewal and John Pemberton III, with Rowland Abiodun, *Yoruba—Nine Centuries of African Art and Thought*, ed. Allen Wardwell (New York, 1989).

20. See *inter alia*, William Fagg, *Divine Kingship in Africa* (London, 1970), 12–20; Babatunde Lawal, "The Present State of Art Historical Research in Nigeria: Problems and Possibilities," *Journal of African History*, XVIII 2 (1977), 193–216; and P. T. Craddock and J. Picton, "Medieval Copper Alloy Production and West African Bronze Analyses—Part II," *Archaeometry* 28, 1 (1986), 3–32.

21. Eyo and Willett 1980, 14–17.

22. Georges Balandier, *La Vie Quotidienne au Royaume de Kongo du XVIe au XVIIIe Siècle* (Paris, 1965); Teobaldo Filesi, "Le relazioni tra il regno del Congo e la Sede Apostolica nelle prima metà del XV secolo," *Africa* XXII 3 (1967), 247–285; Teobaldo Filesi, "Le relazioni tra il regno del Congo e la Sede Apostolica nel XVI secolo," *Africa* XXII 4 (1967), 413–460.

23. The manuscript is preserved in the Archivo nacional da Torre do Tombo, Lisbon, *Leis*, maço 2, 25, and is reproduced in Antonio Brasio, *Monumenta Missionaria Africana, Africa Ocidental, 1471–1531*, 1 (Lisbon, 1952), 228–246.

24. Rui de Pina, *Chronica d'El Rey Dom João II* (Lisbon, 1792), 148. The same words are used by Garcia de Resende and Jeronimo Osorio in reports from the same period as Rui de Pina's chronicle.

25. Ezio Bassani, "Antichi Avori Africani nelle collezioni medicee," *Critica d'Arte*, 143 (1975), 68–80 and 144 (1975), 6–23.

26. Pacheco Pereira, 1905, 134.

27. Archivo nacional da Torre do Tombo, Lisbon, *Corpo Cronologico*, II, 15–77. The author is grateful to the late Admiral Avelino Teixeira de Mota for making this document available.

28. Paolo M. Terzago, *Musaeum Septalianum Manfredi Septalae Patritii Mediolanensis industrioso labore constructum* (Tortona, 1664), 131.

29. William Fagg, *Afro-Portuguese Ivories* (London, 1959).

30. Ezio Bassani and William Fagg, *Africa and the Renaissance—Art in Ivory* (New York, 1988); see also Kathy Curnow, *The Afro-Portuguese Ivories: Classification and Stylistic Analysis of a Hybrid Art Form* (Ph.D. diss., Indiana University, 1983).

31. Archivo Nacional da Torre do Tombo, Lisbon, *Nucleo Antigo*, 799, reproduced in A. F. C. Ryder, "A note of the Afro-Portuguese Ivories," *Journal of African History* V 3 (1964), 353–365 and in A. Teixeira da Mota, "Gli avori africani nella documentazione portoghese dei secoli XV-XVII," *Africa* XXX 4 (1975), 580–589.

32. Fernandes 1951, 96. See also Pacheco Pereira 1905, 96.

33. James Welsh, "A voyage to Benin beyond the countrey of Guinea made by Master James Welsh, who set forth in the yeere 1588," in *The Principal Navigation Voyages Traffiques and Discoveries of the English Nation*, ed. R. Hakluyt (London, 1904), 252.

34. Bassani 1975.

35. Bassani and Fagg 1988, 109.

'THE GORGEOUS EAST': TRADE AND TRIBUTE IN THE ISLAMIC EMPIRES

J. Michael Rogers

The Ottomans and Constantinople

In 1453 Constantinople fell to the Ottoman Sultan Mehmed II, "the Conqueror" (cat. 107). To Europe it appeared to be a catastrophe, but the city was in fact no great prize, little more than a collection of villages and virtually "the dead centre of a dead empire."[1] Mehmed II, who aspired to conquer all the lands that the Byzantines had formerly ruled, chose it as a fitting capital. To restore its economic prosperity he transferred populations from the provinces—wealthy Muslim merchants, skilled craftsmen, and notables from Bursa; Greeks from the Morea (1460–1462); Muslims and Armenians from central Anatolia and Karaman (1468–1474); and Armenians, Greeks, and Jews from the former Genoese colony of Caffa in the Crimea (1475)—simultaneously converting the city into a Muslim capital by encouraging the building of mosques and other pious foundations.

Already at the accession of Bayazid II in 1481, Constantinople/Istanbul had regained its status as a great metropolis. The conquest of Constantinople turned the Ottoman sultans' attention more than ever towards Europe. Beneath the city walls in 1452 Mehmed had discoursed on history and empire with the Italian antiquarian Ciriaco d'Ancona.[2] Mehmed's library[3] contained European classics as well as Arabic, Persian, and Turkish literature. He summoned to his court Italian medalists and portrait painters,[4] the most famous of whom was Gentile Bellini in 1479. And from the monasteries and churches of Constantinople, the Balkans, and Anatolia[5], Mehmed collected, not altogether impiously, remarkable Christian relics. His successor, Bayazid II, had no use for his father's Italian pictures, and the Italian merchant Angiolello, who wrote a history of Bayazid's reign, says that they were sold off in the bazaar and collected by Italian merchants.[6] The great Jewish diaspora following the fall of Granada in 1492, however, further strengthened the Ottomans' links to Europe, for, in addition to the fact that a community of Sephardic Jews settled at Salonike (transforming it into the most important commercial city of the eastern Mediterranean), Bayazid took as his physician Joseph Hamon, a Jewish refugee from Andalusia.[7]

Mehmed II did not neglect the East, however. Within ten years Trebizond, the last Byzantine stronghold, had fallen (1461) to his troops, and the capture of Caffa and other Genoese trading colonies on the Crimean coast in 1475 made the Black Sea an Ottoman lake. Mehmed's campaigns in Anatolia, on the other hand, brought him up against a complex mosaic of ruling dynasties of almost kaleidoscopic confusion. The Mamluks, in a last flash of glory under the Sultan Qā'it Bāy (r. 1470–1496) (cats. 85, 86, 95) controlled Egypt, Syria, and Southeastern Turkey; Baghdad to Tabriz was under the sway of the tribal confederation of the Aqqoyunlu (White Sheep) Turcoman, whose notable ruler, Uzūn Ḥasan (d. 1478) appears, anachronistically, in Christopher Marlowe's *Tamburlaine the Great*; and while the rest of Iran, up to the limits of Transoxania, was ruled by Timurid epigones in full decline, the court at Herat rivaled in splendor those at Tabriz and Istanbul. Within a decade, however, the Timurids had fallen to a new Turkish confederation, the Uzbeks; the Aqqoyunlu had fallen to the Safavids (Turks, but champions of Iranian nationalism); and in two decades the Mamluks were absorbed into the Ottoman empire.

The activities of Mehmed II's successor, Bayazid II (r. 1481–1512), on the European front were hampered by his younger brother, Cem[8] (cat. 91), with whom he had disputed the succession. Cem was defeated and fled straight to Cairo, but on his return to southeastern Turkey in 1482 Bayazid stood firm. Cem then turned to the Knights Hospitallers of Rhodes, to whom Bayazid agreed to pay a lavish annual subvention to keep him captive. He remained a prisoner of the Knights in France for seven years but in 1489 he reached Rome, where Matthias Corvinus of Hungary and Qā'it Bāy of Egypt, who had been at war with Bayazid since 1485, contended for his support. Bayazid was forced to buy off the pope with further largesse and some choice specimens from his father's collection of relics.[9] Notwithstanding, Cem was released into the hands of Charles VII of France, who took him off to Naples in 1493, where he died two years later. Further gifts of both relics and cash, as well as copious threats, were

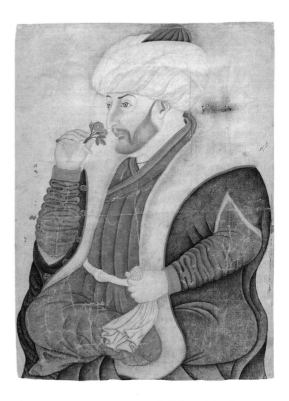

fig. 1. Sinan Beg, *Portrait of Mehmed*. Topkapī Sarayī Museum, Istanbul, Library JR-K

required before his body was returned to Bursa for burial. Cem's potential value in an anti-Ottoman crusade was in fact never realized, but Bayazid was made to regret bitterly that he had survived so long. The code of laws promulgated by Mehmed II had provided that, to avoid civil strife, a sultan on his accession should have his brothers killed. Selim I, who gained the throne in 1512, did not repeat Bayazid's mistake.

In the East, Bayazid II continued his father's campaigns against the Mamluks but with indifferent success. To counter this threat to their trade, Venice and Genoa had pursued alliances with the Aqqoyunlu ruler, Uzūn Ḥasan, in Tabriz, but these initiatives came to nothing because the essential artillery from Venice had failed to reach Uzūn Ḥasan in time to prevent his defeat by Mehmed II at Başkent near Erzincan in 1473. Although the Mamluks were favorably disposed to such an alliance, Uzūn Ḥasan had been no less anti-Mamluk than anti-Ottoman. The struggle with Iran continued

under the Safavid Shah Ismāʿīl, who seized the throne in 1501, but by Bayazid's death in 1512 most of eastern Anatolia was definitively under Ottoman control.

In conquering these new and largely tribal provinces the Ottomans invoked the traditions of the great Turkish conqueror and destroyer, Tamerlane, whose legendary exploits had inspired the Aqqoyunlu no less than his numerous descendants, both in war and, paradoxically perhaps, in learning and the arts. Tamerlane had outdone his predecessors in despoiling the lands he conquered of artists, craftsmen, and scholars to adorn his capital, Samarkand, though, as with the workers of enameled glass he deported from Aleppo and Damascus, sometimes without any practical result. His successors followed his example, and the booty of the later fifteenth-century Turkish states from victorious campaigns was henceforth not merely of luxuries, heirlooms, and cash but also of craftsmen and scholars.

Not all the Eastern scholars who reached Istanbul had been conscripted.[10] Some were attracted by the growing reputation of the Ottoman sultans as patrons of learning. After Ulugh Beg's death in 1449, ʿAlī Qushjī, the head of his observatory in Samarkand where a new, radically revised set of star tables had been compiled, found his way to Istanbul after some years at the court of Uzūn Ḥasan at Tabriz. On his arrival there in 1471 he was appointed, at the colossal stipend of 200 akçe (rather more than 4 ducats) per diem, to the staff of the

fig. 2. Master of the Vienna Passion. *Il Gran Turco.* engraving. Topkapı Sarayı Müzesi, Istanbul

mosque of Ayasofya. On his death in 1474, the bequest of his large library, which included works from the observatory at Samarkand, completely transformed Ottoman astronomy. The earlier works of the great Herati poet, ʿAlīshīr Nevāʾī, who singlehandedly transformed the local Turkish dialects of Central Asia into classical Chaghatay,[11] were in Mehmed II's own library. And on his arrival in Istanbul in 1474–1475 the jurist ʿAlī b. Yūsuf Fenārīzāde, who had studied at Samarkand, Bukhara, and Herat and who was to reach high office under Bayazid II, brought with him a copy of the famous early Turkish work of counsel for kings, the *Kutadgu Bilik*, executed in Uyghur script at Herat in 1439–1440.

These scholars were welcomed, and the works they brought with them to Istanbul made a fundamental contribution to Ottoman learning and literature. But Mehmed II and his successors actively acquired artists and their works from the East as well as from Europe. In 1472 Mehmed captured the Aqqoyunlu prince Yūsuf-cha Mīrzā and demanded as part of his ransom albums of prized drawings, paintings, and calligraphy from the Aqqoyunlu collections in the Royal libraries of Tabriz, Shiraz, and Herat. These are still for the most part in the libraries of Istanbul. More of this material came to Istanbul after Mehmed's victory at Başkent in 1473 and after Selim I's sack of the Hasht Bihisht palace at Tabriz in 1514. Although some of the albums were already bound,[12] they were reviewed in Istanbul and Ottoman heirlooms were added, including a portrait of Mehmed after Costanzo da Ferrara and a miscellaneous collection of Florentine engravings dating from the 1460s and 1470s.[13] Among these was a hand-colored male portrait in profile wearing a tournament helmet, now attributed to the Master of the Vienna Passion after Antonio Pollaiuolo and in later states entitled, picturesquely but groundlessly, *Il Gran Turco* (actually "The Sultan").

Palace registers state that many of the Muslim painters working for Süleyman the Magnificent in the 1520s were conscripted from Tabriz[14] by Bayazid II, while the Tabrizi painters sent to Istanbul after Selim I's victory at Çaldıran in 1514 included a certain Shāhqulī[15] (d. c. 1556), who was to become the head of Süleyman the Magnificent's studio. Bayazid II, who, according to the historian Spandugino,[16] inaugurated pomp at the Ottoman court, conscripted other craftsmen, prisoners of war, and slaves for his palace workshops,[17] including embroiderers in gold thread, swordsmiths, boot-makers, tailors, and furriers, but above all jewelers and goldsmiths. These were divided into two groups, *Rūmī* (Anatolian) and ʿ*Acemī* (Persian),

not on the basis of their origins but by their styles and the materials in which they worked. Menavino,[18] who himself had been a slave of Bayazid II, states that they numbered seventy. In their virtuoso work the fashions of Herat and Tabriz were brilliantly adapted to Ottoman taste.

Recruitment of foreign craftsmen by conscription presupposed a careful check of their qualifications, but since an important function of the Ottoman palace workshops was to furnish gifts for the sultan on the great feasts of the Muslim year, inferior work would not go undetected. In any case, the benefits of conscription far outweighed the disadvantages. Conscription on a massive scale was the means used to provide the skilled labor for Bayazid's occasional building works such as his great foundations at Edirne (inaugurated 1487–1488) and in Istanbul (inaugurated 1505).

The Mamluks and the India trade

Trade with India placed the Mamluks in a pivotal position in the Mediterranean world in the waning years of the fifteenth century. From the India trade the Mamluks acquired luxuries primarily for their own consumption—Chinese porcelains, Indian cottons, ivory and ambergris, gemstones and pearls. Far more important economically, however, was the export trade for the northern Mediterranean in spices, drugs such as Indian opium, preservatives, incense from Somalia and Oman, and Indian dyestuffs, particularly lac, which gave the finest crimson for the velvets of northern Italy.[19] Sultan Barsbāy (d. 1432) had transformed the export trade into a state monopoly, and although the Italian documents inveigh against its extortions the monopoly also protected European merchants from piratical exactions and corsairs in the Red Sea and off Alexandria.[20]

Immensely profitable as the monopoly was to the Mamluks, they were, like all middlemen, highly vulnerable, requiring enormous amounts of silver for the settlement of accounts in India and a large and efficient seagoing fleet. Egypt, however, depended abjectly upon imports of both raw metals, including copper and brass, and of timber, down to the minutest details of naval equipment, though contraband largely frustrated the periodic papal embargoes on timber exports to Egypt from the northern Mediterranean. In the later fifteenth century the supply of silver, which came in payment by European merchants for spices, was threatened by growing demand in the sea trade with India and by a growing shortage of silver resulting from Ottoman control of the Bosnian silver-mines in the hinterland of Dubrovnik. Critical

disturbances to shipping in the northern Mediterranean also occurred. Venetian hostilities with Bayazid II in the 1490s led to the virtual suspension of the spice trade: in 1500 so many ships had been diverted to the defense of the Venetian possessions in the eastern Mediterranean that only three ships to Beirut and three to Alexandria could be raised, and that only on condition that the Serenissima, already almost bankrupted by the cost of equipping galleys, provide armed convoys at its own expense. In Mamluk Egypt the increasingly heavy commitments in the east and the shortage of silver from the north brought catastrophic inflation, which was an obvious cause of Mamluk weakness[21] that made Egypt such an easy prey to the Ottoman Sultan Selim I in 1516.

The Mamluk spice monopoly confined foreign merchants to Alexandria,[22] and only exceptionally did foreign embassies reach Cairo. Among these were embassies from the Bahmanids, the Muslim rulers of the Deccan, who also maintained diplomatic relations with the Aqqoyunlu and the Ottomans.[23] The purpose of the Bahmanid embassy received at Tabriz in 1471[24] was evidently commercial, for from the Bursa archives[25] we learn that in 1479 the Bahmanid vizier, Maḥmūd Gāvān Gīlānī (executed 1481) had three agents in Bursa and that in 1481 there were another six. Some of these were from Gilan, a principal producer of raw silk for export to Europe on the Bursa market, and may well have been wholesale merchants; but some had come from the Hijaz, where they had doubtless traded at the great fairs attending the annual pilgrimage to Mecca. This may well explain Ludovico di Varthema's observation[26] that the Hijaz in 1503 abounded in cottons, as well as the appearance of fine Indian cotton stuffs in early sixteenth-century Ottoman palace inventories.

Mamluk relations with the Indian subcontinent were, however, much stronger with Gujarat, an important entrepot and textile manufacturing center. Abundant finds of Gujarati block-printed cottons at Fusṭāṭ and Quṣayr al-Qadīm on the Red Sea also argue for large-scale imports for a mass market, and popular Gujarati figural scenes also evidently found a ready sale.[27] In the general panic in the Mediterranean following the Portuguese discovery of the Cape route to India, which briefly united the Mamluks, the Ottomans, and the Italian trading republics, embassies from Cambay in Gujarat were also received in Cairo,[28] and in 1505 Sultan Qānṣūh al-Ghawrī dispatched an expeditionary force to drive the Portuguese out of Gujarat. On its annihilation by the Portuguese he ordered munitions and timber from Turkey, and in 1511[29] Bayazid II presented him with three hun-

fig. 3. *Fragment of Printed Cotton.* The Textile Museum, Washington

dred pieces of artillery, and powder, ropes, oars, and rigging to re-equip the fleet. Strangely, the Mamluks did not think to use this arsenal in their own defense against Selim I in 1516, and it remained to be used by the Ottoman governors of Egypt, who continued the Mamluks' anti-Portuguese struggle in the Red Sea and the Indian Ocean.[30]

For the Italian trading republics diplomatic relations with the Mamluks and Ottomans were no sham, for they guaranteed the security of their shipping, which had a virtual monopoly in the eastern Mediterranean and was the mainstay of their economies, and of the Italian factories at Alexandria and Beirut, Damascus, and Aleppo. War, like the sixteen-year Venetian War with Mehmed II (1463–1479), was a catastrophe, permanently weakening Venetian power overseas and fatally depriving the Republic of European allies, who had always piously reprehended its accommodations with the Infidel.[31]

Magnificent diplomacy: from Italy to China
Despite the Muslim threat, the East in the Italian Renaissance remained the land of the Magi, of gold, frankincense, and myrrh. Long after

Marco Polo, whose account of his travels was, as Paul Pelliot demonstrated, an attempt to follow the legendary journeys of Alexander the Great in the *Alexander Romance*, the persistence of books of travelers' tales and marvels of the East, the science fiction of the time, demonstrates the extreme disinclination of the Renaissance public to abandon its view of the East as a source of entertainment.

Reality also nourished fiction. The magnificence of Qāʾit Bāy's embassy to Florence in 1487[32] with a draft treaty was still vividly remembered when Vasari depicted it sixty years later in the Palazzo Vecchio. It brought balsam, musk, benzoin, and aloeswood; finer porcelain than any hitherto seen in Florence; colored stuffs, cottons, and muslins; sweetmeats, myrobalans, and ginger; and a grand ceremonial tent. Lorenzo de' Medici's secretary, Pietro di Bibbiena,[33] also lists a bay horse, long-haired goats, and a fat-tailed sheep, to which Landucci[34] adds animals that even the Mamluks would have found exotic, a lion and a giraffe. Although, to judge from the final text of the treaty, it was not intended as a move against the Ottomans, the lavishness of the gifts certainly might have suggested an ulterior motive, and it was the

animals on which the Commune of Florence prudently chose to dwell in its report of the embassy submitted to Bayazid II.[35]

Such dazzling embassies were, however, a commonplace of Muslim diplomacy. That from the Safavid Shah lsmāᶜīl to Qānṣūh al-Ghawrī in Cairo,[36] in a last-minute attempt to bring the Mamluks into an anti-Ottoman coalition, brought seven cheetahs with silk jackets; horses and horse-trappings; fine arms and armor; gold cups and silver basins and ewers; gold brocades and satins from Bursa; Turkish prayer rugs and runners; and fine cottons and velvet robes. The Bahmanid embassy of 1471 to Aqqoyunlu Tabriz described by the Venetian Josafà Barbaro[37] brought a whole menagerie—a lion, a tiger, a giraffe, civet-cats, and parakeets; as well as fine muslins and calicoes; sandalwood, aloes-wood, and gems; and porcelains to add to Uzūn Ḥasan's already fine collection. A charming scroll fragment in the Topkapi Saray Library[38] showing a gamboling giraffe in a deep blue embroidered jacket may be a record of this embassy. Nor were the Ottomans excluded. Among the gifts of the Bahmanid embassy of 1485 to Istanbul were elephants and a giraffe.

While at Tabriz Barbaro also learned, from an ambassador of "Tartarie" (probably from Far-ghana),[39] of an overland route to Cathay, east-ward from Tana on the Sea of Azov. This was the route traveled by Western merchants and missionaries during the "pax mongolica" of the first half of the fourteenth century, and by it Europe obtained chinoiserie silks from Īl-Khānid Iran, as well as Chinese silks, which strongly influenced the design of northern Ital-ian silks of the later fourteenth century. By the early fifteenth century the sea route had taken over, when the great Ming naval expeditions reached Arabia and the Gulf[40] with enormous war junks in which celadons and blue and white porcelains evidently formed a substantial ele-ment of the ballast.

Overland trade with China was from Central Asia: Barbaro's informant rightly gave him to understand that Western merchants would not get beyond Samarkand—if they got even that far. This trade was, moreover, much complicated by the fact that in Chinese eyes trade was trib-ute. In the Confucian tradition the emperor was the divinely appointed ruler of the world, graciously accepting the humble tribute of his vassals and their ambassadors, even if the "dip-lomats" were actually merchants. This elaborate make-believe perhaps gave the Chinese court a better pick of merchandise than if foreign traders had sold their wares on markets at the frontier, and counterfeit embassies with coun-terfeit credentials were thus continually wel-comed in Beijing. Provision for them was

lavish, for the system admitted only those for-eigners whom the Chinese court was prepared to impress, while tribute intervals could, theo-retically at least, be adjusted to suit its own demand.[41]

By the mid-fifteenth century, however, this pseudo-diplomacy was getting out of hand. Faced with an annual horde of merchants from Central Asia, the Ming administration in 1456 reduced the official scale of exchanges to four pieces of variegated silk and eight garments of cheap silk for each Turcoman horse (the most highly prized steeds in the Ming cavalry); ten garments of cheap silk for three camels; and for each Tatar horse only a piece of hempen cloth and eight pieces of cheap silk.[42] The exotic animals presented by foreign embassies, even when they were from foreign rulers, were much more critically received. When an embassy from Sultan Aḥmad (1468–1493),[43] the Timurid ruler of Samarkand, arrived with two lions, it was objected that lions were useless beasts that were expensive to keep but which could neither be sacrificed nor even, bizarre thought, be harnessed to a carriage. In 1489 when another embassy arrived from Samarkand with parrots and a lion, the emperor, quite against the Confucian imperial tradition, declared that he disliked both rare birds and strange beasts. The following year yet another lion and an Asiatic lynx were brought by an embassy from Turfan. Their pictures were drawn at the northern capital and sent to the emperor who this time, though against his ministers' advice, deigned to accept them.[44]

The lists of gifts and the commodities exchanged for them clearly show that unless merchants surreptitiously succeeded in striking profitable bargains in the Chinese cities they passed through on their way to or from Beijing, trade was small-scale and rather trivial and could scarcely have been the basis of a Chinese export trade westward from Samarkand. In the early sixteenth century the Ottomans were nev-ertheless informed of the overland route to China, though their political concerns probably reached no further eastward than the Uzbeks in Transoxania. In 1516 a certain Sayyid ᶜAlī Akbar presented a work on the China trade, the *Khiṭāynāme*[45] to Selim I, though his advice to offer gifts of cheetahs, lions, and lynxes sug-gests that he was unaware that for decades the Ming court had been suffering from a glut of unwanted animals. Though the Ottoman sources say nothing of any embassies to China, the Chinese annals mention two embassies from "Rum" (Anatolia) that could conceivably have been official.[46] One in 1524 arrived with a lion and a Western ox, but the envoy was arrested as a spy. The second embassy arrived

in 1526, but when the envoy claimed twelve thousand gold pieces for his expenses it was indignantly dismissed.

The menageries that the Muslim rulers of India and the Middle East presented to each other, and the lions and other animals that they believed were acceptable to the Ming court at Beijing, make exotic animals a surprisingly important item of international trade across Asia. How the trade worked is unknown, but the animals may have been obtained as a by-product of the enormous traffic in thoroughbred horses exported annually from the Gulf ports[47] for the cavalries of the warrior states of north-ern India and East Africa. Albuquerque's rhinoceros, which was to be commemorated in Dürer's famous woodcut (cat. 206), may have added a new dimension to Renaissance pag-eantry, but it was in a well-established Muslim diplomatic tradition.

An oriental obsession

The spectacle of Muslim embassies fueled the Venetian idea of the East as the source of all benefits and luxuries, to the exclusion of north-ern and western Europe. Unfortunately, the Venetians wilfully ignored the most conspicu-ous drawback of trade with the East, bubonic plague. For more than a century after the Black Death first arrived, it reappeared annually[48] with the galleys from Alexandria, whose crews were constantly reinfected through the Mam-luks' importation of slaves from the Crimea and the fur trade from the Black Sea and the Volga to Cairo.

An Eastern import that added conspicuously to the comfort and splendor of Renaissance furnishing was the carpet. Those that reached the northern Mediterranean were for the most part nomad weaves from western Anatolia and large carpets from Cairo.[49] The "Holbein" pattern of small Turkish carpets used to cover tables (*tappeti di tavola*), not for the floor, goes back to the 1450s.[50] The pattern was most prob-ably traditional, uninfluenced either by Italian demand or by the Ottoman court.[51] They were exported by Italian merchants resident at Alto-luogo, the medieval port of Ephesus, and by merchants on Rhodes who acquired them from agents in the hinterland.

Carpets from Cairo arrived via Alexandria and Damascus, in such numbers that there must have been a large, uncontrolled market in them, though they were much prized by the Mamluk Sultans and later by the Ottomans too. They were also large, sometimes enormous. In 1515 the Sultan Qānṣūh al-Ghawrī rode in state through Cairo to the Citadel, and the whole way from the entrance of the Hippodrome at its

base to the great tent erected for him, a distance of at least a hundred meters, was spread with silk carpets.[52]

In Venice too, the Signoria had a collection of Cairene and other carpets (Marino Sanuto [1466–1535] more than once describes them as *caiarini et cimiscasachi*, the latter evidently from Çemişgezek on the Upper Euphrates[53]) for state occasions: they appear in pictures of processions in the Piazza San Marco, thrown over the balconies of the Ducal Palace and the Procuratorie Vecchie. Cairene and Turkish carpets were also, though briefly, woven in northern Italy. A letter from Barbara of Brandenburg dated 1464 asks for a Turkish slave to weave carpets for her at Mantua, and Rodolfo Signorini's recent publication of the Camera Dipinta in the Ducal Palace there suggests that the carpet Mantegna painted was the work of this slave. From 1490 onward, there was a carpet workshop at the ducal court at Ferrara, run by a Muslim from Cairo, Sabadino Moro.[54] Though the Ferrara workshop remained active until c. 1530, these initiatives did not lead to the establishment of any permanent carpet manufacture in Renaissance Italy.

Many of the objects in the Treasury of the Cathedral of San Marco in Venice were also believed to have come from the East. Such was definitely the case with some of the rock-crystals from the Fatimid Treasury (cat. 13) which reached Venice via Acre or Jerusalem in the mid-thirteenth century. These were, evidently, diverted booty from the sack of Constantinople in 1204 — though this was not demonstrated until the nineteenth century.[55] It was not the actual provenance but the Venetian belief that objects coming from the East thereby gained glamor that is so striking, and this remains as strong as ever.[56] One of the more remarkable cases is a bowl of heavy opaque glass of Fatimid type in the Treasury of San Marco, with molded lobes and panels of stylized hares datable to c. 1000 AD, which is almost certainly also from the Fatimid Treasury. This has long been believed to be a gift to San Marco from the Aqqoyunlu ruler, Uzūn Ḥasan, in Tabriz, even though that is ruled out by the mounts, which include Byzantine cloisonné enamels and northern Italian medieval filigree plaques of far too early a date to be connected with that ruler.[57]

Though the Venetians were not to know it, however, Uzūn Ḥasan, or one of his immediate predecessors, must have owned Western hardstones, notably the famous classical sardonyx cameo made for Ptolemy Philomeator of Egypt, known as the Tazza Farnese, now in the Museo Nazionale in Naples. This was acquired by Lorenzo de' Medici in 1471 from Pope Sixtus IV, to whom it had been bequeathed by Paul II. The piece appears in an accurate drawing attributed to Muḥammad Khayyām in an album of fifteenth-century graphic material from Herat and Tabriz, which was presented to Johann Gottfried von Diez, the Prussian ambassador at the Sublime Porte in the 1770s.[58] The absence of modeling gives the drawing a misleadingly neoclassical appearance, but Muḥammad b. Maḥmūdshāh (al-)Khayyām is known from signed drawings in Berlin and Istanbul that are attributable on the basis of their style to Tabriz c. 1460, and stylistically the Tazza Farnese drawing fits with these very well. The Tazza Farnese must thus have come from Tabriz: how and when it reached that city is unknown, but the drawing of it shows that if it was a chance acquisition it was a highly esteemed curiosity.

Classical cameos, improbably perhaps, are nevertheless not difficult to fit into an Aqqoyunlu context. A developed taste among Tamerlane's successors for vessels in eastern Asiatic jade brought with it a fashion for objects in agate, onyx, and chalcedony, all of which materials were readily procurable from the Deccan and are listed in late fifteenth- and early sixteenth-century Ottoman Palace inventories: of these an agate cup survives, dated 1470–1471, made for the Timurid Sultan Husayn Bayqara, ruler of Herat.[59] The jades subsequently traveled westward, as well as toward India, where their Timurid associations made them prized by the Mogul emperors. A cup[60] bearing the name of Tamerlane's grandson, Ulugh Beg, has a silver plug at the rim with an Ottoman Turkish inscription indicating that at some time, very probably in 1514 (a partial inventory of booty from Tabriz in the Topkapi Saray archives, D. 10734, lists jade vessels, without however describing them in detail), it came into the Ottoman Treasury: if, as suggested here, it came from Tabriz it may well have been in Uzūn Ḥasan's Treasury as well. And a dark green jade pot inlaid in gold with scrollwork and the name of the Safavid Shah Ismāᶜīl, now in the Treasury of the Topkapi Saray[61] and clearly booty from Tabriz as well, is so similar in profile to a white jade jug bearing the name of Ulugh Beg[62] that it too must also have been of Timurid origin, appropriated by Shah Ismāᶜīl and elaborated to his own taste when he seized the throne in 1501. The histories of these pieces and the list of treasuries through which they passed are thus remarkably similar to the history of the Tazza Farnese, and to those of many of the Antique hardstones in the great Italian Renaissance collections. In that at least, East and West were one.

NOTES

1. Halil Inalcık, "The Policy of Mehmed II Towards the Greek Population of Istanbul and the Byzantine Buildings of the City," in *Dumbarton Oaks Papers* 23–24 (1969–1970), 231.
2. Julian Raby, "Cyriacus of Ancona and the Ottoman Sultan Mehmed II," in *Journal of the Warburg & Courtauld Institutes* 42 (1980).
3. Julian Raby, "East & West in Mehmed the Conqueror's Library," in *Bulletin du Bibliophile* 3 (1987).
4. Julian Raby, "Mehmed II Fatih and the Fatih Album," in *Between China and Iran. Paintings from Four Istanbul Albums*, ed. Ernst J. Grube and Eleanor Sims (Percival David Foundation, London, 1985); Julian Raby, "Pride and Prejudice: Mehmed the Conqueror and the Italian Portrait Medal," in *Studies in the History of Art*, ed. Graham Pollard (National Gallery of Art, Washington, 1987), no. 21.
5. Franz Babinger, *Reliquienschacher am Osmanenhof im XV. Jahrhundert* (Munich, 1956).
6. The pictures appear to be mentioned in a partial Treasury inventory, dated 1505, of objects that were evidently to be donated to, endowed upon, or disposed of for the mosque of Bayazid in Istanbul, which was inaugurated in that year. J. Michael Rogers, "An Ottoman Palace Inventory of the Reign of Bayazid II," in *CIEPO, VIᵉ Symposium, Cambridge, 1st-4th July, 1984*, ed. Jean-Louis Bacqué-Grammont and Emeri van Donzel (Istanbul, Paris, Leyden, 1987). Angiolello's report, which has often been dismissed as ill-informed gossip, is thus very probably true.
7. Uriel Heyd, "Moses Hamon, Chief Jewish Physician to Sultan Süleyman the Magnificent," in *Oriens* 16 (1963).
8. "Djem," *Encyclopaedia of Islam*², 6 vols. (Leyden, 1960–1990), vol. 2.
9. Babinger 1956.
10. Hanna Sohrweide, "Dichter und Gelehrter aus dem Osten im Osmanischen Reich," in *Der Islam* 46 (1970).
11. Osman F. Sertkaya, "Some New Documents Written in the Uigur Script in Anatolia," in *Central Asiatic Journal* 18 (1974); Eleazar Birnbaum, "The Ottomans and Chagatay Literature. An Early 16th Century Manuscript of Nava'i's *Divan* in Ottoman Orthography," in *Central Asiatic Journal* 20 (1976).
12. Filiz Çağman, "On the Contents of the Four Istanbul Albums, H. 2152, 2153, 2154 and 2160," in *Between China and Iran. Paintings from Four Istanbul Albums*, ed. Ernst J. Grube and Eleanor Sims (Percival David Foundation, London, 1985); Zeren Tanındı, "Some Problems of Two Istanbul Albums, H. 2153 and 2160," in *Between China and Iran. Paintings from Four Istanbul Albums*, ed. Ernst J. Grube and Eleanor Sims (Percival David Foundation, London, 1985).
13. Raby 1985 suggests that they may have reached Istanbul with the Florentine Benedetto Dei, but they could equally well have been brought from Tabriz.
14. Ismail Hakkı Uzunçarşılı, "Osmanlı saray' ında ehl-i hiref 'sanatkarlar' defterleri," in *Belgeler* 11 (Ankara, 1986), 26–32.
15. Banu Mahir, "Saray nakkaşhanesinin ünlü ressamı Şah Kulu ve eserleri," in *Topkapı Sarayı Müzesi. Yıllık* 1 (Istanbul, 1986).
16. Nicola Iorga, *Geschichte des Osmanischen Reichs* (Gotha, 1909), 2:440.
17. Uzunçarşılı 1986, 29–61.
18. Giovanni Antonio Menavino, *I costumi, et la vita de' Turchi* (Florence, 1551), 121.

19. Frederick C. Lane, "The Mediterranean Spice Trade: Its Revival in the Sixteenth Century," in id. *Venice and History. Collected Papers* (Baltimore, 1966).

20. Frederick C. Lane, "Pepper Prices before Da Gama," in *Journal of Economic History* 28 (1968).

21. J. Michael Rogers, "To and Fro. Aspects of Mediterranean Trade and Consumption in the 15th and 16th Centuries," in *Villes au Levant. Hommage à André Raymond*, ed. Jean-Paul Pascual (Aix-en-Provence, 1990).

22. Eliyahu Ashtor, "La découverte de la voie maritime aux Indes et les prix des Epices," in *Mélanges en l'honneur de Fernand Braudel* 1 (Toulouse, 1973).

23. Joseph von Hammer-Purgstall, *Geschichte des Osmanischen Reiches* (Pest, 1828), 2:289–291.

24. Charles Grey, ed., *A Narrative of Italian Travels to Persia in the Fifteenth and Sixteenth Centuries* (Hakluyt Society, London, 1873), 57.

25. Halil Inalcık, "Bursa and the Commerce of the Levant," in *Journal of the Economic and Social History of the Orient* (1960) 3:2; Halil Inalcık, "Osmanlı idare, sosyal ve ekonomik tarihiyle ilgili belgeler: Bursa kadı sicillerinden seçmeler. II. Sicil 1 Safar 883 — Muharrem 886," in *Belgeler* 13 (Ankara, 1988).

26. Ashtor 1976.

27. Mattiebelle Gittinger, *Master Dyers to the World: Technique and Trade in Early Indian Dyed Cotton Textiles* (Textile Museum, Washington, D.C., 1982); G.M. Vogelsang-Eastwood, *Resist-Dyed Textiles from Quseir al-Qadim, Egypt* (Paris, 1990).

28. Ibn Iyās, *Badā'iᶜ al-Dhuhūr*, trans. Gaston Wiet in *Journal d'un bourgeois du Caire*, 2 vols. (Paris, 1955, 1960), 1:81, 1:176.

29. Ibn Iyās 1955, 1960, 1:195.

30. Cengiz Orhonlu, "XVI. asrın ilk yarısında Kızıldeniz'de Osmanlılar," in *Tarih Dergisi* (1962), 12, no. 16.

31. Victor L. Ménage, "Seven Ottoman Documents from the Reign of Mehemmed II," in *Documents from Islamic Chanceries*, first series, ed. Samuel M. Stern (Cassirer, Oxford, 1965).

32. John Wansbrough, "A Mamluk Commercial Treaty Concluded with the Republic of Venice 894/1489," in *Documents from Islamic Chanceries*, first series, ed. Samuel M. Stern (Cassirer, Oxford, 1965).

33. A. Fabroni, *Laurentii Medicis Magnifici Vita* (Pisa, 1784), 2:337.

34. L. Landucci, *Diario fiorentino 1450–1516* (Florence, 1883), 52–53.

35. Giuseppe (Joseph) Müller, *Documenti sulle relazioni delle città toscane coll'Oriente cristiano e coi Turchi fino all'anno 1531* (Florence, 1879), 237, n. 202.

36. Ibn Iyās 1955, 1960, 1:249.

37. Grey 1873, 57.

38. H.2153, f. 95b.

39. Grey 1873, 75.

40. Ma Huan, *Ying-yai Sheng-lan. The Overall Survey of the Ocean's Shores*, ed. J.V.G. Mills (Hakluyt Society, Cambridge, 1970). The quantities in which they arrived in the Gulf explain the remarkable fact that Middle Eastern demand for Chinese porcelains long remained fixated on the products of the Yuan and the early Ming dynasties. In the late fifteenth century the Jindezhen kilns even manufactured copies of these earlier pieces specially to satisfy Middle Eastern demand.

41. Joseph F. Fletcher, "China and Central Asia, 1368–1884," in *The Chinese World Order*, ed. John K. Fairbank (Cambridge, Mass., 1968).

42. E. Bretschneider, 2 vols. *Mediaeval Researches from Eastern Asiatic Sources* (London, 1888; 1967), 2:263.

43. Bretschneider, 2:265.

44. Bretschneider, 2:266.

45. Charles Schéfer, "Trois chapitres du 'Khitay Nameh.' Texte persan et traduction française," in *Mélanges Orientaux* (Paris, 1883); Yih-Min-Liu, "A Comparative and Critical Study of Ali Akbar's *Khitaynama* with Reference to Chinese Sources," in *Central Asiatic Journal* 25 (1983), no. 1, 2. It is a compilation from earlier sources, some of them out of date, which leads Liu to question its authenticity. The perennial Muslim tradition in geographical literature has, however, invariably been to draw on earlier sources, not to compile Baedeker's guides; and many widely used contemporary Italian merchants' guides and trading manuals were based on out of date sources too.

46. Bretschneider, 2:306–330.

47. Simon Digby, *War-Horse and Elephant in the Dehli* (sic) *Sultanate. A Study of Military Supplies* (Oxford-Karachi, 1971); Jean Aubin, "Le royaume d'Ormuz au début du XVIᵉ siècle," in *Mare Luso-Indicum* 2 (Geneva, 1973).

48. Michael W. Dols, *The Black Death in the Middle East* (Princeton, 1977).

49. A contemporary Italian description of the short-lived Aqqoyunlu ruler Yaᶜqūb Beg's palace at Tabriz, the Hasht Bihisht (Grey 1873, 175) describes a great round carpet placed beneath the dome of the central audience hall, which may well have been of local manufacture. But mentions of *Persian* carpets in late fifteenth century Italian inventories or depictions of them in contemporary Italian paintings are extremely rare; nor do they figure conspicuously in early sixteenth century Ottoman palace inventories.

50. John Mills, "Near Eastern Carpets in Italian Paintings," in *Carpets in the Mediterranean Countries 1400–1600*, ed. Robert Pinner and Walter B. Denny (London, 1986).

51. There were carpet weavers, mostly Balkan, on the Ottoman palace staff as early as the reign of Mehmed II (Bige Çetintürk, "Istanbul'da XVI asır sonuna kadar hâssa halı sanatkârları. I. Türk san'at eserleri ve halı hakkında mutalealar," in *Türk san'atı tarihi. Araştırma ve incemeleri*, 1 [Istanbul, 1963]) who could have been weaving Holbein pattern rugs too, though scarcely to cover tables, while embroidered or appliqué felts, or even rich silk brocades, not carpets, remained the most highly esteemed floor-coverings at the Ottoman court until well into the sixteenth century. But the manufacture of very much larger carpets in the Uşak area, with designs based on bookbindings of the period 1470 to 1490 (Julian Raby in Pinner and Denny 1986) was an initiative of the Ottoman court, since it involved both a radical change in design and redesigned looms too. Such Uşak carpets were reaching Italy by the 1530s, but they may have been made for the Ottomans as much as three or four decades earlier.

52. Ibn Iyās, 1:393.

53. Marino Sanuto, 58 vols. *Diarii* (Venice, 1881–1901), 13:131, 21:46; (J. Michael Rogers in Pinner and Denny 1986).

54. Alberto Boralevi in Pinner and Denny 1986.

55. Le Comte Riant, *Dépouilles religieuses enlevées à Constantinople au XIIIᵉ siècle par les latins*, off-print from *Mémoires de la Société Nationale des Antiquaires de France* 36 (1875); Le Comte Riant, "La part de l'évêque de Bethléem dans le butin de Constantinople en 1204," in *Mémoires de la Société Nationale des Antiquaires de France* 46 (1885).

56. Until very recently, for example, it has been maintained that the Lion of Venice, which is most probably Romanesque and from northern Europe, had been brought from Tarsus in southeastern Turkey (Bianca-Maria Scarfi, *The Lion of Venice. Studies and Research on the Bronze Statue in the Piazzetta* [Venice, 1990]).

57. Tesoro 140. Margaret Frazer and Carolyn Kane (in *The Treasury of San Marco* [exh. cat. British Museum] (London, 1984), 29) needlessly complicate matters by their assumption, for which there is little evidence, that the glass is of early medieval Persian manufacture. The base of the bowl bears an undotted Kufic inscription the letters of which, HRSAN, can be vocalized in numerous ways, none of them giving, however, an appropriate sense. The final two letters AN are either an Arabic dual, giving two of some masculine noun, or possibly a Persian plural in -ān, which may or may not be significant. Conceivably some Venetian antiquarian misread the inscription, omitting the r, which would then have given a possible reading of Ḥassān not Ḥasan however, and therefore nothing at all to do with Uzūn Ḥasan. If so the wish to attribute it to him was obviously father to the error.

58. Now Berlin, Staatsbiblothek Preussischer Kulturbesitz, Diez A Fol 72, Seite 3:2; Horst Blank, "Eine persische Pinsel-Zeichnung nach der Tazza Farnese," in *Archäologischer Anzeiger* (1964); H.-P. Bühler, *Antike Gefässe aus Edelsteinen* (Mainz, 1973), 41–43; Nicole Dacos, A. Giuliano and U. Pannuti, *Il Tesoro de Lorenzo il Magnifico I. Le gemme* (Florence, 1973), 69–72.

59. Now A. Soudavar collection. Armenag Sakisian, "A propos d'un coupe à vin en agate au nom du sultan timouride Hussein Baicara," in *Syria* 6 (1925); Thomas W. Lentz and Glenn D. Lowry, *Timur and the Princely Vision. Persian Art and Culture in the Fifteenth Century* [exh. cat. Sackler Gallery, Smithsonian Institution] (Washington, 1989), 150.

60. British Museum, OA 1959 11–20 1 (36), Brooke Sewell Fund. Washington 1989, 124.

61. Hazine 1844. Cengiz Köseoğlu, *The Topkapi Saray Museum. The Treasury*, ed. J. Michael Rogers (London, 1987), 196, no. 48.

62. Calouste Gulbenkian Foundation, Lisbon, no. 328.

PICTURING THE LEVANT

Julian Raby

In 1492 two paintings that were to depict scenes set in the eastern half of the Old World, in the Levant, were commissioned in Italy. Both paintings were to take as their subject a saint associated with the city of Alexandria in Egypt, both used oriental figures in an attempt to convey an Egyptian setting, and both based their depictions of Muslims from studies drawn from life. In this sense the two paintings reflect a fundamental change and significant development; for the first time, Europeans had begun to acquire realistic images of the Muslim world.

In most other respects the two paintings differed greatly, and their differences can tell us much about how Europe had acquired these new images of the East and how it reacted to them. One was Gentile Bellini's *Saint Mark Preaching in Alexandria* (Brera, Milan), for the Scuola di San Marco in Venice, to which we shall return later. The other was Pinturicchio's fresco of the *Disputation of Saint Catherine* in the Sala dei Santi in the Borgia Apartments in Rome.[1] Pinturicchio's fresco was painted for Rodrigo Borgia, Pope Alexander VI. As a saint of Alexandria, who is said to have disputed the mysteries of the faith with fifty philosophers so

successfully that they converted to Christianity and were prepared to die for their new belief, Saint Catherine became the protectress of those with the name Alexander. She is also the protectress of bastards, and, in Corrado Ricci's words, "Alexander had good reason to commend his sons to her."[2]

Such explanations trivialize, however, the role that the *Disputation* plays in the program of the frescoes of the Sala dei Santi. The frescoes depict instances of how the Lord rescued His saints in times of need. The saints are emblematic of the Church, and the *Disputation*, which is the culminating scene, appears to refer to Pope Alexander's concern at the threat that the Church faced from the Muslims. As a Spaniard himself, Pope Alexander perhaps made the particular choice of Saint Catherine because it was on her feast day that the capitulation of Granada, the last Moorish Kingdom of Spain, took place.

But above all Rodrigo Borgia, like his uncle Pope Calixtus III before him, was concerned with the threat to Christianity from the Ottoman Turks, and he had long advocated a crusade against them. This helps explain why Turkish

figures are so prominent in Pinturicchio's fresco: several members of the crowd wear quasi-oriental outfits that look no more convincing than fancy dress, but there are also three more accurately attired oriental figures, who can be identified as Ottoman Turks, one of them wearing the tall felt hat of the Janissaries.

Pinturicchio thus conveyed the contemporary concerns of his patron rather than an historicist interest in conveying an idea of Alexandria, where the disputation took place. In this respect his approach differed fundamentally, as we shall see, from that of Gentile Bellini. Pinturicchio made no attempt to indicate an Alexandrian locale for the incident. The major element of architecture was a triumphal arch based on the Arch of Constantine, but it served not as an indication of place, but as a symbol of Constantine's victory, which took place a few years after Saint Catherine's supposed disputation.[3]

Pinturicchio was better able to convey Pope Alexander's Ottoman concerns because he had recently acquired realistic depictions of Turks. Two Turkish figures are depicted flanking the Tetrarch Maximinus' throne. That they are borrowings is clear because the accuracy of their

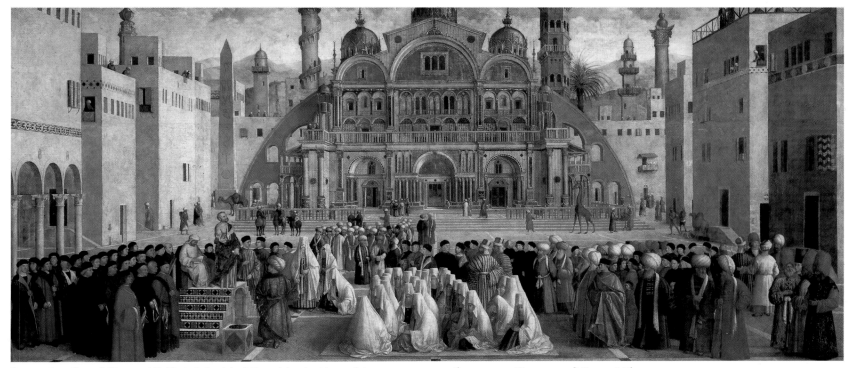

fig. 1. Gentile and Giovanni Bellini, *Saint Mark Preaching in Alexandria*. c. 1504–1507, oil on canvas. Pinacoteca di Brera, Milan

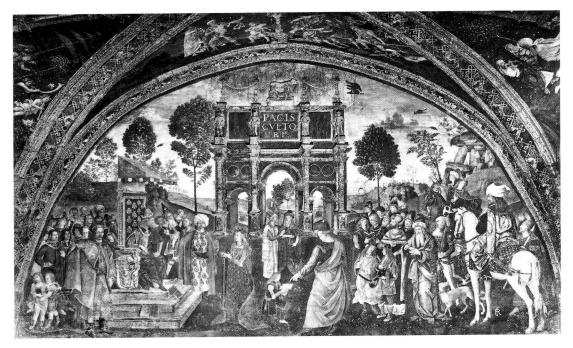

fig. 2. Pinturicchio, *Disputation of Saint Catherine*. Fresco. Sala dei Santi, Appartamenti Borgia, Vatican

costume, their solid presence, and the directness of gaze contrast with the winsomeness of Pinturicchio's customary figures. Pinturicchio's source is traditionally thought to have been Gentile Bellini, who visited Istanbul between 1479 and 1481, but the models are more likely to be by another artist who was in Istanbul in the 1470s, Costanzo da Ferrara (cat. 108). Another Turkish figure is the rider on the extreme right of the scene. He is probably to be identified as a historical figure whom Pinturicchio could have seen in Rome—the Ottoman Prince Cem Sultan (cat. 91), son of Mehmed the Conqueror, who spent his last years as a fugitive in the West and arrived in Rome in 1489.[4]

As the first Renaissance artists to work in the Muslim East, Gentile and Costanzo were able to bring back the earliest empirically observed studies of the Levant, and their visits mark the beginning of Europe's pictorial documentation of the East. We can best appreciate their importance and the reason why they visited Ottoman Turkey if we take a brief glance backward.

In the early fourteenth century painters such as Ambrogio Lorenzetti and Giotto had made attempts at realistic depictions of orientals, but the figures were mostly Mongol in derivation, who were easily distinguished by their facial characteristics as well as apparel. The Mongol type survived into the second half of the fourteenth century and the early fifteenth century as a symbol of cruelty and anti-Christian beliefs. Stereotypes of turbanned Muslims with less well-defined racial features but identifiable apparel and accouterments also abounded.

These stereotypes were the visual counterparts of the literary fictions of eastern travel then in vogue, of which the most popular was Sir John Mandeville's travel fantasy (cat. 124).[5]

In fifteenth-century painting, the Muslim figure expressed three traditional conceptions of the East—its wealth, its cruelty, and its wisdom. Quasi-Muslim figures did service in the retinue of the Magi, conveying the notion of eastern luxury in paintings such as Gentile da Fabriano's *Strozzi Adoration* (Uffizi, Florence) and Benozzo Gozzoli's frescoes in the chapel of the Medici Palace.[6] Others served as pagans in scenes of the Crucifixion or Christian martyrdom. Often, particularly in northern Europe, the warrior pagan was identified with a scimitar and pointed hat;[7] in Italy the eastern sage Avicenna was characterized by a turban, kaftan, and long beard.[8]

These exotic types were based on long-standing exempla and literary images, and bore little relation to reality. New models based on studies from life became available only around the middle of the fifteenth century, as one reflection of a growing concern in European art with empirical observation. The earliest instance was not, however, of Muslim Arabs or Turks but of Byzantine Greeks. In 1438 the Byzantine emperor John VIII Palaeologus visited Italy for the Councils of Florence and Ferrara. John VIII himself cut a striking figure: he wore a tall Timurid hat with pointed brim, and his robe was apparently embroidered with an inscription in the name of an Egyptian sultan.[9] His entourage was equally picturesque: his

ecclesiastics wore huge stove-pipe hats and shovel-hats, and he was accompanied by a Tatar or Kalmuck, possibly his groom, whose Mongol features, exotic costume, and weaponry caught the eye of Pisanello. Pisanello used the Tatar figure in his fresco of Saint Anastasia (San Zeno, Verona). This was not a continuation of the fourteenth-century topos of Tatar images but the reworked gleaning from an actual incident.[10]

Pisanello also produced a portrait of Emperor John VIII that served as the basis for the first portrait medal of the Renaissance. The visit of the Byzantines to Italy was commemorated by other artists such as Filarete, and Byzantine figures continued to appear in works of art for several decades, whether for political commentary, as in Piero della Francesca's *Flagellation*, or as classical figures, as in the work of Apollonio di Giovanni.[11] The costume of the Byzantines appealed to an observer such as Vespasiano da Bisticci on two counts: it was grand in appearance and antique in origin, unchanged, or so he believed, for 1500 years or more. In reality Vespasiano was mistaken, because late Byzantine costume was under strong influence from the Muslim world to the East.[12]

fig. 3. Pisanello, *Portrait of John VIII Palaeologus*. National Gallery of Art, Washington, Samuel H. Kress Collection

The Byzantine image, however, was doomed by the advance of the Ottomans. Like a balance, Christendom's push down against Islam in the West, in Spain, was matched by the rise of the Ottomans in the East, as they drove into the Balkans and Hungary. The Ottomans' military impact should have been clear to the West at least as early as 1396, when Ottoman forces routed a combined Crusader army at the battle of Nicopolis. But it was with the conquest of Constantinople in 1453 that they entered into the consciousness of all of Europe. The year marks a turning point in European images of the Levant for several reasons.

Following 1453, Ottomans replaced Byzantines as the principal Near Eastern type in European visual imagery. The change can be summarized by comparing Pisanello's medal of John VIII, the penultimate emperor of Byzantium, with Costanzo da Ferrara's medal of Mehmed the Conqueror, first Ottoman Sultan of Istanbul (cat. 107). It represented more than a mere change of costume. Whereas the image of the Byzantine emperor resulted from John VIII's visit to Italy, the figure of the Ottoman was based upon sketches by Italian artists who had visited Istanbul. However, it must be stressed that these visits to the Levant were not occasioned by a European spirit of enquiry but by the patronage of a Muslim potentate, Mehmed the Conqueror. The artists traveled East because they had been invited, and the scope of their work in Istanbul was dictated by their patron's interests.

The conquest of Constantinople in 1453 made the twenty-one-year-old Mehmed II master of an empire that straddled East and West, giving political justification to interests he shared with the humanist princes of Italy—in geography and cartography, for example, in military matters from advances in artillery to star-shaped fortresses, and, most pertinently, in history and portraiture. Mehmed sustained an interest in medallic portraiture throughout his life so that he became, in quantitative terms at least, the most active patron of Italian medalists in the Quattrocento. He was depicted by a greater number of medalists than any other patron, though he was never, as far as we know, depicted more than once by the same artist.[13]

The most famous Italian artist to visit Mehmed's court was Gentile Bellini. When he arrived back in Venice, dressed in Ottoman costume, he was greeted on the quayside by the Doge, as well as his brother Giovanni, and "half the populace of the city."[14] The legend of his oriental adventure had already begun. Although Gentile Bellini benefited greatly from this visit, receiving fame and official honors in his lifetime and being credited by scholars as the father

of late Quattrocento orientalism, the truth is more complicated.[15] In the first place, Gentile Bellini was not the only artist of talent to visit Mehmed's court. The mistake has been to credit him uncritically with each and every late-fifteenth century portrait of an oriental. His influence has been exaggerated and the contribution of his fellow visitors underestimated. Bellini's influence, as we have seen, was believed to have spread beyond his native Venice, for he was thought to be the source of the Ottoman types in Pinturicchio's frescoes in Rome and Siena. As a consequence, the artist to whom this group of drawings of Ottomans is here attributed, Costanzo da Ferrara, has languished in obscurity, even though his talent should have been obvious from the quality of his medal of Mehmed the Conqueror, which Hill justly described as one of "the finest portrait medals of the Renaissance."[16]

Gentile Bellini's Ottoman studies had far greater impact outside Venice than in his native city. By influencing the young Dürer during his first trip to Venice in 1494–1495, Bellini even achieved an influence, by proxy, in northern Europe. Ever receptive to exotica, Dürer seems to have responded with enthusiasm to the Ottoman figure studies he saw in Venice in 1495. He copied a group of *Three Orientals* (cat. 110) after Gentile Bellini's model either from a now lost preparatory drawing or directly from the background of Gentile's *Procession in Saint Mark's Square* (Academia, Venice), a painting that is dated 1496 and which was presumably in progress during Dürer's visit. Dürer made other copies of Turkish figures, as well, and in the decade between his first and second visits to Venice his graphic work was filled with Ottoman types wearing either the turban wound around a ribbed cap or the tall felt hat of the Janissaries.[17]

Dürer transformed the northern European visual platitude of a Muslim into a more specific Ottoman image that mirrored contemporary reality. In almost all cases, though, Dürer's Ottomans continued to fill the traditional role of the oriental in European art, as the epitome of despotism—the emperor Domitian ordering the torture of Saint John in one of the images from his woodcut *Apocalypse*, for example—or as a symbol of corruption kneeling before the Sea Monster of the Apocalypse.[18] Dürer also placed Ottomans in attendance on the Three Kings. This was appropriate since, according to a tradition that began in Cologne, the coat-of-arms of the Magus Caspar was the Crescent and Star, and Europe associated that symbol with the Turks in particular.[19] Dürer used other Ottoman types for sages of the East such as the astrologer al-Sufi ("Azophi Arabus") (cat. 118).[20] Only rarely did he depict them specifi-

fig. 4. Attributed to Gentile Bellini, *Seated Scribe.* Pen and gouache on paper. Isabella Stewart Gardner Museum, Boston

cally *qua* Ottomans.[21] In short, Dürer affected the appearance rather than the function of the oriental in northern European art.

Gentile Bellini can take credit for being one of the main sources of the "Ottoman mode" in European art of the late fifteenth century, but, as we have seen, he was not the only direct source. Moreover, the "Ottoman mode" was not the only expression of orientalism in European art of the period. Another drew not on the world of the Ottomans but on that of their great rivals, the Mamluks of Egypt and Syria. The "Mamluk mode" is evident in the other painting that was commissioned in 1492, Bellini's *Saint Mark Preaching in Alexandria.*

For the Mamluk figures in this painting, Bellini had to rely on someone else's models, because Gentile himself never visited Egypt or Syria. In 1492 Gentile agreed with his confraternity, the Scuola di San Marco, to renew the paintings of the life of Saint Mark that had been destroyed in a fire of 1485, though in fact the cycle was not completed until long after his death in 1506.[22] Saint Mark had been the first Bishop of Alexandria, which made an Egyptian setting for the paintings appropriate.

Gentile's concern with place was greater than Pinturicchio's. His primary concern was to suggest Alexandria. His method was, first, to provide a synopsis of the city's best-known monuments, producing a pictorial equivalent of the literary encomium. His church, based on the Basilica of Saint Mark in Venice, would

stand for the Church of Saint Mark in Alexandria, his pillar, for the Pillar of Pompey, his obelisk for the "needles of Cleopatra," and so forth.[23] Second, the inhabitants of Bellini's Alexandria were not Pinturicchio's motley crowd, but rather based upon the actual inhabitants of fifteenth-century Alexandria, the Mamluks.

The Mamluk elite could easily be distinguished from the Ottomans by their costume. The most distinctive contrast was in turbans. As portraits of Mehmed the Conqueror show, late fifteenth-century Ottoman taste ran to turbans wound horizontally around a red, gadrooned hat; the Mamluks, on the other hand, favored turbans with a distinct vertical emphasis. These were often extravagantly tall and sometimes equipped with "horns."[24] Such differences explain why Bellini and his colleague Giovanni Mansueti made limited use of Bellini's Ottoman studies for the Scuola di San Marco cycle. If the city was to be Alexandria, its inhabitants should be Egyptians.

Gentile Bellini's work thus parallels Pinturicchio's in adopting both Ottoman and Alexandrian themes, but in contrast to Pinturicchio, Gentile does not combine the two. In general Venice had a greater understanding than other European cities of cultural differences in the Levant, and such distinctions were deemed important in the context of history paintings, because the Venetians regarded the historical testimony of the visual arts as equivalent to that of the written word. As a record of an historical event in Alexandria, Gentile's painting, by Venetian standards, should convey the peculiarities of at least the place. What enabled Gentile and his colleague Giovanni Mansueti to observe this principle was the arrival in Venice in the mid-1490s of a painting that accurately portrayed the Mamluk world.

The importance of this painting—the *Reception of the Ambassadors* (cat. 106)—transcended its novelty appeal. It was the first realistic European portrayal of Mamluks, but more than that, it was the first European attempt to depict an exotic locale in all its detail, from the fauna and flora to the architecture and inhabitants.

Accustomed as we are to photography, it is difficult for us to imagine the impact that this panorama must have had on contemporaries. Artists such as Gentile Bellini and Costanzo da Ferrara had brought back portraits and figure studies from their sojourns in Istanbul, but these were characters abstracted from their environment. The *Reception* depicted not just Mamluks, but Mamluks in a Mamluk habitat. The military elite and a handful of common folk, including women, were shown against a backdrop of the Damascus skyline, dominated by the Great Umayyad Mosque. The details were rendered exactly—from the black and white marble decoration of the arches and minarets to the blazon of the Mamluk sultan Qā'it Bāy.

The *Reception of the Ambassadors* spawned derivatives in painting and in tapestry, and elements were freely plundered by artists such as Carpaccio and Mansueti. On his second trip to the city in 1505, Dürer adopted the Mamluk type the *Reception* had introduced to Venice and for a few years he abandoned Ottoman figures in his graphic work in favor of Mamluk, though the change was cosmetic, not functional. The *Reception*'s greatest influence, however, was in inspiring the "Mamluk" setting of Gentile's Scuola di San Marco cycle which represented a new consciousness in the use of oriental figures for Christian themes.[25]

The *Reception* seems also to have encouraged the use of oriental settings for comparable cycles commissioned by other *scuole*. Carpaccio's series of paintings for the Scuola di San Giorgio was ostensibly set in North Africa, but he had no single source comparable to the Louvre *Reception* and resorted to a composite Near East drawn from a variety of sources. One was the Louvre *Reception*; another the first printed travel book with illustrations, the record of a pilgrimage to Egypt and the Holy Land by Bernhard von Breydenbach, Bishop of Mainz, which was published in 1486. The woodcuts in this volume provided Carpaccio with models for human and animal figures, as well as architectural ideas. Carpaccio combined these disparate sources with such an easy grace that he has deceived many into believing that he had visited the Near East.[26]

To return to the comparison between Bellini and Pinturicchio's paintings of 1492, we may note that the artists conveyed their eastern themes in different ways and with differing intentions. Pinturicchio's effort was directed to contemporary concerns at the expense of geographical accuracy: the Ottomans were not to be masters of Alexandria for another twenty-five years. *Vice versa*, Bellini's concerns were historical, which led him to emphasize topography and regional costume. Pinturicchio's orientalism was excerptive; Bellini's was more sustained and better informed. The paradox was that it drew on another Italian painting, the Louvre *Reception*, rather than the artist's firsthand experience in Istanbul. Geography was the main factor, but there was also a marked contrast in the character of Gentile's Istanbul oeuvre and the Louvre *Reception*. The manner in which the artist of the *Reception* combined a historical scene with a panorama was designed to satisfy a Venetian patron. Gentile's work in Istanbul, however, was circumscribed by Mehmed's tastes. As Mehmed's patronage focused on portraiture, there were limitations to the range of images brought back from the East by artists such as Costanzo da Ferrara and Gentile Bellini, which in turn affected the way their models could be employed in Europe. Bust portraiture could only be adapted with difficulty to a figural scene; full-length studies were more easily included but they were not placed in an architectural or environmental setting that was Eastern.

In the 1490s, as Europe made its first contact with the Americas, Europe—or rather Venice "the eye of all the West"—produced the first dispassionate record of an exotic locale. Yet this did not lead immediately to similar records. In concept, style, and historical connections the Louvre *Reception* was peculiar to the Venice of the 1490s. In historical terms it reflected the close mercantile and political ties between Venice and the Mamluks in this decade, but the "Mamluk mode," like the Byzantine fashion before it, was doomed by the Ottoman advance.[27] The first two decades of the sixteenth century were not propitious times for European artists and travelers in the Levant.

The Louvre *Reception* owed its conception to the fact that the Venetians believed that paintings had a testimonial value analogous and equal to that of the written word. Stylistically, the studied realism of details in the Louvre *Reception*, such as the body harness of the monkey or the wooden armature of the adobe housing, expressed and confirmed the painting's role as attesting to a historical event. This style of "inventory" painting was the visual equivalent of the chronicle style of Venetian historical writing, but both were to be superseded in the early sixteenth century. Just as Giorgione and Titian displaced the generation of "inventory" *istorie* painters led by Gentile Bellini, Giovanni Mansueti, and Carpaccio, so the last great example of Venetian chronicle writing was Marino Sanuto's *Chronache*.[28]

These are some of the factors that explain why the precedent of the Louvre *Reception* was not taken up by Venetian artists until well into the sixteenth century. The next phase in Europe's visual documentation of the Levant was in the 1530s, but then the initiative came—as it had under Mehmed the Conqueror—from the Ottoman court rather than from Europe itself.[29] It was only in the late 1550s that a European artist—Melchior Lorck of Flensburg—working for a European patron, produced a comprehensive record of Istanbul that ranged from portraits to costume studies and from city views to architectural and archaeological studies.[30]

The fall of Constantinople in 1453 provoked many reactions in Europe, but for a decade or so

scholars such as Nicholas de Cusa and Aeneas Sylvius attempted to view the world of Islam with reason and clarity. Sir Richard Southern has termed it "The Moment of Vision."[31] The drawings of Costanzo da Ferrara and the painting of the *Reception of the Ambassadors* lacked the intellectual horizons of such scholarship, but they were based on experience and dispassionate in tone, devoid of Christian or Classical glosses, and free of the emotional overtones of popular illustration; *mutatis mutandis,* they can be regarded as "a moment of vision." By the end of the fifteenth century, however, Europe was becoming increasingly concerned with apocalyptic visions. It was a fitting commentary on Europe's perception of the Levant that, in Dürer's woodcut series of the *Apocalypse* of 1496–1498, it was the Ottomans who served as the Emissaries of the Bottomless Pit.[32]

NOTES

1. Corrado Ricci, *Pinturicchio (Bernardino di Betto of Perugia), His Life, Work and Times,* trans. Florence Simmonds (London, 1902), 103–119.

2. Ricci 1902, 111.

3. N. Randolph Parks, "On the meaning of Pinturicchio's *Sala dei Santi,*" in *Art History* 2 (September 1979), 291–317.

4. Ricci 1902 expresses severe doubts about the value of such identifications, but the identification of Cem is much older than Ricci realized, and was given credence by Paolo Giovio, who put together his portrait collection in the 1530s and 1540s: *Gli Uffizi. Catalogo Generale* (Florence, 1979); compare to Franz Babinger, "Dschem-Sultân im Bilde des Abendlands," in *Aus der Welt der islamischen Kunst. Festschrift für Ernst Kühnel zum 75.Geburtstag am 26.10.1957* (Berlin 1959), 254–266. On Giovio and the Turks, Linda Klinger and Julian Raby, "Barbarossa and Sinan: A Portrait of Two Ottoman Corsairs from the Collection of Paolo Giovio," in *Venezia e l'Oriente Vicino. Primo Simposio Internazionale sull'Arte Veneziana e l'Arte Islamica,* Ateneo Veneto (Venice, 1989), 47–59.

5. An example is Lorenzo Monaco's *Adoration* of 1420–1422 in the Uffizi; Gustave Soulier, *Les Influences orientales dans la peinture toscane* (Paris, 1924), 166, pl. xi. In general, Donald F. Lach, *Asia in the making of Europe. II. A Century of Wonder, Book One: The Visual Arts* (Chicago and London 1970); Maria G. Chiappori, "Riflessi figurativi dei contatti Oriente-Occidente e dell'opera poliana nell'arte medievale," in *Marco Polo. Venezia e l'Oriente,* ed. Alvise Zorzi (Milan, 1981), 281–288; Götz Pochat, *Der Exotismus während des Mittelalters und der*

Renaissance, Voraussetzungen, Entwicklung und Wandel eines bildnerischen Vokabulars, Stockholm Studies in History of Art 21 (Stockholm, 1970), chapter 4.

6. Soulier 1924, 161–174, 274–281; Sylvia Auld "Kuficising Inscriptions in the Work of Gentile da Fabriano," in *Oriental Art* 32 (1986), 246–265; on the Magi, Hugo Kehrer, *Die »Heiligen Drei Könige« in der Legende und in der deutschen Kunst bis Albrecht Dürer* (Strassbourg, 1904); H. Zehnder, *Die Heiligen Drei Könige. Darstellung und Verehrung* [exh. cat. Wallraf-Richartz-Museums] (Cologne, 1982).

7. For example, Martin Schongauer's engraving of *The March to Calvary,* c. 1475–1480, in *Bartsch VI,* 21: R.A. Koch, in "Martin Schongauer's Christ Bearing the Cross," *Record of the Art Museum, Princeton University* 14 (1955), 22–30; on the Figural Alphabet of the Master E.S., Pochat 1970, 142–144.

8. For example, *Europa und der orient 800–1900,* ed. Ge-eon Sievernich and Hendrik Budde [exh. cat. Berliner Festspiele] (Berlin, 1989), 131, pl. 149; compare pl. 153.

9. Michael Vickers, "Some Preparatory Drawings for Pisanello's Medallion of John VIII Palaeologus," in *Art Bulletin* 60 (September 1978), 417–424. A textile origin seems more likely than Reich's proposal that the inscription was derived from an enameled lamp: S. Reich, "Une Inscription mamlouke sur un dessin italien du quinzième siècle," in *Bulletin de l'Institut d'Egypte* 22 (1940), 123–131; compare to Josef von Karabacek, *Abendländische Künstler zu Konstantinopel im 15. und 16. Jh.* (Vienna, 1918), 37–42.

10. George F. Hill, *Pisanello* (London, 1905), 87, 92. G.A. Dell'Acqua and R. Chiarelli, *L'opera completa del Pisanello* (Milan, 1972), pls. 18–19, 26. On the steppe origin of the Emperor's horses, Vickers 1978; Leo Olschki, "Asiatic Exoticism in Italian Art of the Early Renaissance," in *Art Bulletin* 26 (1944), 95–106.

11. Vickers 1978; Roberto Weiss, *Pisanello's Medallion of the Emperor John VIII Palaeologus* (London, 1966); Soulier 1924, 168. For Apollonio, Ernst Gombrich, "Apollonio di Giovanni. A Florentine Cassone Workshop Seen Through the Eyes of a Humanist Poet," in *Norm and Form. Studies in the Art of the Renaissance* (London, 1966), 11–28, reprinted from the *Journal of the Warburg & Courtauld Institutes* (1955); Ellen Callmann, *Apollonio di Giovanni* (Oxford, Clarendon Press, 1974); compare to Olschki 1944, 101–102.

12. Vespasiano da Bisticci, *Vite di Uomini Illustri del secolo XV,* ed. Paolo D'Ancona and Erhard Aeschlimann (Milan, 1951), 14–16.

13. Julian Raby, "Pride and Prejudice: Mehmed the Conqueror and the Italian Portrait Medal," in *Italian Medals. Studies in the History of Art,* ed. J. Graham Pollard (Washington, D.C. 1987), no. 21, 171–194.

14. Klinger and Raby 1989.

15. Louis Thuasne, *Gentile Bellini et Sultan Mohammed II. Notes sur le séjour du peintre venitien a Constantinople (1479–1480) d'après les documents originaux*

en partie inédits (Paris, 1888); Josef von Karabacek 1918; compare to Jürg Meyer zur Capellen, *Gentile Bellini* (Stuttgart, 1985), 87–102; Klinger and Raby 1989.

16. George F. Hill, *A Corpus of Italian Medals of the Renaissance before Cellini* (London, 1930), 80, cat. nos. 321–322. On Costanzo, Maria Andaloro, "Costanzo da Ferrara. Gli anni a Costantinopoli alla corte di Maometto II," in *Storia dell'Arte* 12 (1980), 185–212 and Andrea S. Norris "Costanzo," *Dizionario Biografico degli Italiani* 30 (1984), 394–396.

17. Julian Raby, "Venice, Dürer and the Oriental Mode," in *Hans Huth Memorial Studies I,* ed. Ernst J. Grube and David Revere McFadden (London, 1982).

18. In his woodcut *Apocalypse* of 1496–1498: Willi Kurth, *The Complete Woodcuts of Albrecht Dürer* (London, 1927; reprinted New York, 1963), pl. 106, 117, compare to pls. 119, 122–123.

19. Kehrer 1904, 110; Zehnder 1982, 101–105, cat. no. 112.

20. Dürer made Plato wear the headgear of an Ottoman Janissary in his woodcut illustration to Konrad Celtis' *Quatuor libri amorum,* Nuremberg 1502: Fedja Anzelewsky, *Dürer-Studien* (Berlin, 1983), 119.

21. Compare to Washington 1971, 113–114, cat. no. 4 ("Five Soldiers and Turk on Horseback," 1495–1496).

22. P. Paoletti, *La Scuola Grande di San Marco* (Venice, 1929), 137–142; Meyer zur Capellen 1985, 24–26, 87–94, 112–113.

23. Phyllis W. Lehmann, *Cyriacus of Ancona's Egyptian Visit and its Reflection in Gentile Bellini and Hieronymus Bosch* (New York, 1977); Meyer zur Capellen 1985, 87–94.

24. Raby 1982.

25. Raby 1982. The Renaissance architecture of Giovanni Mansueti's paintings may seem to contradict the idea of an Alexandrian setting; but Mansueti repeated the Mamluk blazon in his paintings as a clear reference to the Mamluk domains. On western interpretations of Qā'it-Bāy's blazon, O. Kurz, "Mamluk Heraldry and *Interpretatio Christiana,*" in *Studies in Memory of Gaston Wiet,* ed. M. Rosen-Ayalon (Jerusalem, 1977), 297–307.

26. Raby 1982.

27. Raby 1982.

28. Patricia F. Brown, "Painting and History in Renaissance Venice," in *Art History* 7 (1984), 264–294.

29. Klinger and Raby 1989.

30. Maria-Magdalena Müller-Haas, "Ein Künstler am Bosporus. Melchior Lorch," in (Berlin, 1989), 239–244.

31. Richard W. Southern, *Western Views of Islam in the Middle Ages* (Cambridge, Mass., and London, 1962; second printing 1978), 67–109.

32. Kurth 1927, 1973, 20–21, pl. 119; Washington 1971, 171, cat. no. 105; W. Waetzoldt, *Dürer and his Times* (London, 1950), 37–38; compare to Kenneth M. Setton, "Lutheranism and the Turkish Peril," in *Balkan Studies* (Thessalonica) 3, (1962), 133–168.

MAPS AND THE RATIONALIZATION OF GEOGRAPHIC SPACE

David Woodward

Modern historians have emphasized that both the abruptness and significance of the change from the medieval to the modern world have been grossly exaggerated.[1] Rather than focusing on the fifteenth century as a time of dramatic transition between the two ages, as earlier historians had done, they point backward to the several renaissances that took place in the Middle Ages and forward to the medieval and occult character of much sixteenth- and seventeenth-century science. Although this caution is also appropriate when discussing the specific case of the conceptual shift between medieval and Renaissance cartography, the overwhelming conclusion is still that a rapid and radical change in the European world view took place during the fifteenth century.

In retrospect we can see that in the late Middle Ages there were several fundamentally different ways of looking at geographic space and representing geographic reality. One relied on the concept of consistent physical measurement and scale, another on the notion of varying scale depending on perceived importance or the affective qualities of iconography, and another stressed qualitative topological relationships of adjacency and connectedness rather than those of measured distance and area. It is not unusual to find side by side, and often in the same manuscript, maps drawn on different structural frameworks and with widely different functions. In many fifteenth-century world maps, the various structures appear even within the confines of the same map: a frame and center of an iconographical medieval *mappamundi* (world map), the configuration of a measured nautical chart for the Mediterranean, and towns, rivers, and regions topologically fitted in between.

The medieval *mappaemundi* were derived from two fundamentally different sources. On the one hand, there were the maps of the known world (sometimes known as T-in-O maps, from their layout), derived from Roman sources in which the world was divided into the three known continents: Asia, Africa, and Europe. This concept was readily adapted by the Christian church to accommodate the biblical notion of the world as divided among the three sons of Noah—Shem, Ham, and Japheth—and thus to

illustrate the three great races of the world—the semitic, hamitic, and japhetic. These T-in-O maps, of which early typical examples appeared in the *Encyclopedia* of Saint Isidore of Seville (seventh century), were, with important exceptions, usually circular, oriented to the east, and centered on the Holy Land. Well-known large examples based on this model included the Ebstorf map (1239) and the Hereford map (c. 1290). The frame and center of these maps are rigidly predetermined, and the scale naturally changes in proportion to the relative familiarity of the area being represented. These maps reflect a blending of history and geography, a projection of history onto a geographical framework, emphasizing the spiritual rather than the physical world. On them could be represented the symbols of the deepest Christian truths: the earth as a record of divinely planned historical events from the Creation of the world through its salvation by Jesus Christ in the Passion to the Last Judgment. *Mappaemundi* were themselves epitomes of the earth and the cosmos, showing the physical relationships among earth, man, and God.

Similar in function, but quite different in structure, were the zonal maps, in which the medieval church adopted the Hellenistic Greek model of the earth divided into five climatic zones. This concept, which can be traced back to the ancient Greek philosophers Aristotle and Parmenides, postulated two temperate and habitable zones (the *oikoumene* and the *antipodes*), a torrid uninhabitable zone at the equator and two frigid uninhabitable zones at the poles. It was transmitted to the medieval world largely through manuscripts of Macrobius' *Commentary on the Dream of Scipio* (fifth century) and dramatically illustrated the Christian dilemma of incorporating into Christ's flock a potential fourth race of people to the south in the antipodean temperate zone that could not be reached through the impassable equator. The zonal maps were circular, like the T-in-O maps, but were usually oriented to the north. Combinations of the two types appeared in many forms.

In the thirteenth century, a completely different kind of map appeared, based on maritime measurements of distance and direction. The

Mediterranean sea charts—the so-called portolan charts—are technological marvels whose origin has still not been fully explained. They seem to have been based on books of sailing directions (statements of sailing distances with a traditional wind direction). The earliest surviving example is the *Carte Pisane* (c. 1275). Their structure could therefore be said to be route-enhancing. Their frames result from the natural shape of the sheepskin that was the source of the vellum, and their centers are arbitrary, based on the geometry of the radiating directional lines. Although at first confined to the Mediterranean and Black seas, the scope of such maps was soon expanded to encompass the known world, as in the *Catalan Atlas* of c. 1375 (cat. 1).

At the beginning of the fifteenth century, a new concept of ordering geographic space was introduced to the Christian West. Although Roger Bacon in his *Opus maius* (c. 1265), had already proposed mapping the earth with coordinates of latitude and longitude, it was a cen-

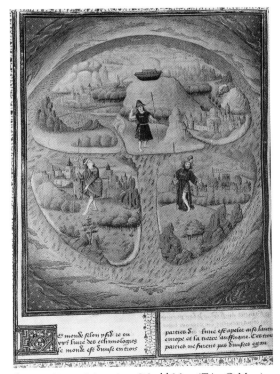

fig. 1. Simon Marmion, *World Map (T-in-O Map)*. From Jean Mansel, *Fleur des Histoires*, MS 9231. Bibliothèque Royale Albert 1er, Brussels

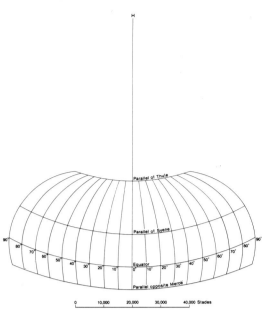

fig. 2. *Ptolemy's Second Projection*. From *History of Cartography: Cartography in Prehistoric, Ancient, and Medieval Europe and the Mediterranean*, eds. J. B. Harley and David Woodward (Chicago, 1987), 1:187

tury and a half later, with the translation into Latin of the *Geography* of the second-century Alexandrian Greek geographer Claudius Ptolemy, that abstract, geometric and homogeneous space began to be used for mapping. In Greek mathematics, this concept had been necessary for the theorems of Euclidean plane geometry, and without it the achievements of Apollonius and Hipparchus on the concepts of mathematical projection could not have taken place. By plotting points of known location from perpendicular axes intersecting at an artificial origin, the cartographer could fit existing surveys into the synthetic whole; the measurements would thus be less subject to cumulative errors. It was a shift in thinking away from piecing together local surveys in order to create a whole—a change from inductive to deductive cartographic thinking.

Ptolemy's *Geography* provided a coordinate structure for such a synthesis. This work had been part of the classical scholarly inheritance in the Arab and Byzantine worlds, but its concepts had not been fully implemented there in terrestrial mapping. As Byzantium was increasingly subjected to attacks by the Turks at the end of the fourteenth century, the Greek scholar Manuel Chrysoloras was sent to Venice to enlist help. He and other scholars rumored the existence of the *Geography* and other manuscripts that Italian humanists were eager to examine and translate. The Latin translation of the Greek text of the *Geography* was completed by Jacopo d'Angelo in Florence in 1406, and manuscript and printed versions with and without maps appeared throughout the fifteenth century

(cats. 126, 127), establishing Ptolemy's prime authority as a geographer.

The practical application of the idea of coordinates for geographical maps did not take effect either in the Islamic or the western world until sufficient observations had been gathered and a clear need was felt. Thus, despite Bacon's impassioned plea that a framework of locations was essential "for the conversion of unbelievers and for opposing unbelievers and the Antichrist and others," neither the data nor the demand were ready for the concept.[2]

Ptolemy explained that his proposed scheme of mapping places by their longitude and latitude was intended to preserve the correct proportion of small areas (chorography) to the whole earth (geography), working as a painter might sketch in the broad strokes before filling in the detail. The abstract, numbered graticule (that is, the network of lines of latitude and longitude) could thus theoretically be applied to the whole earth as well as the known world. But the map projections that he described to transform systematically the spherical surface of the globe to the plane surface of the map could not contain this global view. To show it all, he said, an actual globe was necessary.

Ptolemy's second projection, which he regarded as his most advanced, curved the meridians to imply the sphericity of the earth but only covered 180° of longitude. It was not conceived as a projection, in the sense of being geometrically projected from a model sphere onto a developable surface, but was constructed to preserve scale along certain parallels and meridians in an abstract coordinate space. Its geometry is thus unrelated to the projective geometry of perspective.

The construction of Ptolemy's third projection, however, appears at first glance to be a bona fide geometrical projection of the armillary sphere on a plane passing through the earth's center. Upon closer inspection, however, the graticule of the earth's surface is not drawn on a true geometrical projection but is adjusted so that it can appear unimpeded between the rings of the equatorial and summer tropic on the armillary sphere from an observer's viewpoint at a given distance from the earth. The timing of the appearance of Ptolemy's manuscript in Italy in the early fifteenth century and its similarity to Brunelleschi's concept of vanishing point perspective have led some scholars to postulate that the map projection had a crucial role in forming the new ideas of how pictorial space could be ordered, but it is difficult to establish any direct causal relationship.[3]

Even if precise associations between cartography and the emergence of perspective in its early years cannot be proven, there was demon-

strably a community of scholarship and practice that grew up later in the fifteenth century around the idea of measured space. There was a common interest in geometrically proportioned representations of nature among artists and engineers of the fifteenth century that is the hallmark of the "universal man" of the Renaissance.[4] Surveying and mapping the earth were at the very heart of this activity. Similar instruments were designed for observing angles and distances in astronomy (see cats. 120, 123), artillery range finding, building construction, land surveying, and navigation. Methods of calculating the position of inaccessible points using similar and congruent triangles were developed as the precursors of triangulation.

One result for cartography of this infatuation with measurement was the blending of cartographic traditions that had remained distinct in the Middle Ages. The *mappaemundi*—previously structured on a strictly religious and symbolic space—started to incorporate the information and methods of Ptolemy: Andreas Walsperger's *mappamundi* of 1448 bears the note that it was "made from the cosmography of Ptolemy proportionally according to longitude, latitude, and the divisions of climate" and it bore a graphic scale as if to confirm this statement.[5] Likewise, the portolan charts—previously structured solely on a network of lines of constant compass bearing for the aid of the navigator—also began in the early sixteenth century to bear latitude scales derived from the idea of Ptolemaic coordinates.[6] Local maps and town plans, too, saw a profound change in their geometrical structure. The tradition of Roman planimetric representations of land holdings, buildings, and cities—as demonstrated most

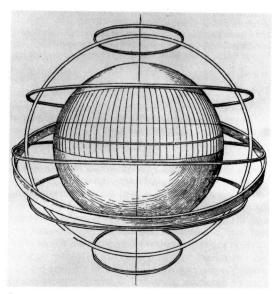

fig. 3. *Ptolemy's Third Projection*. Harley and Woodward 1987, 1:188

dramatically by the *Corpus agrimensorum* and the *Forma urbis Romae*—was not apparently sustained in the Middle Ages (although the ninth-century *Plan of Saint Gall* is an obvious exception). The rediscovered importance of representing cities in measured proportion is strikingly shown by comparing fourteenth-century city views, in which the position of buildings is shown topologically, with the scaled plan of Vienna and Bratislava, the content of which dates to 1421–1422.[7]

For geography, cartography, and the associated practical mathematical arts in the western world, therefore, the fifteenth century was crucial in forming "the first coherent, and rationally cumulative pictures of the world since antiquity."[8] A key ingredient was that a transition took place in the way people viewed the world, from the circumscribed cage of the known inhabited world to the notion of the finite whole earth. The transition began with the concepts of the universality and interconnectedness of knowledge, neo-Platonic ideas that the circle of thinkers that included Leon Battista Alberti, Paolo Toscanelli, and Nicolas of Cusa was to share. For geography, this meant a movement away from local topological concepts toward those of a finite, spatially referenced

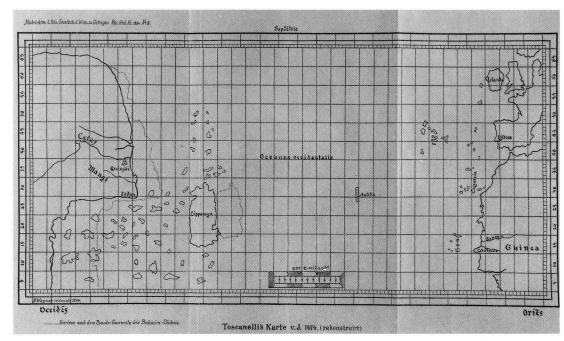

fig. 4. Hermann Wagner, *Reconstruction of Toscanelli's Map*, "Die Rekonstruktion der Toscanelli-Karte vom Jahre 1474...." From *Nachrichten der K. Gesellschaft der Wissenschaften zu Göttingen*, Phil. Hist. Kl. (1894), 313

spherical earth, a *tabula rasa* on which the achievements of exploration could be cumulatively inscribed. Robert Thorne, merchant and geographer, boasted in 1527 that "there is no lande inhabitable nor sea innavigable."[9] The circumnavigation of the world in 1522 had made everything possible.

Columbus could not have made his voyage

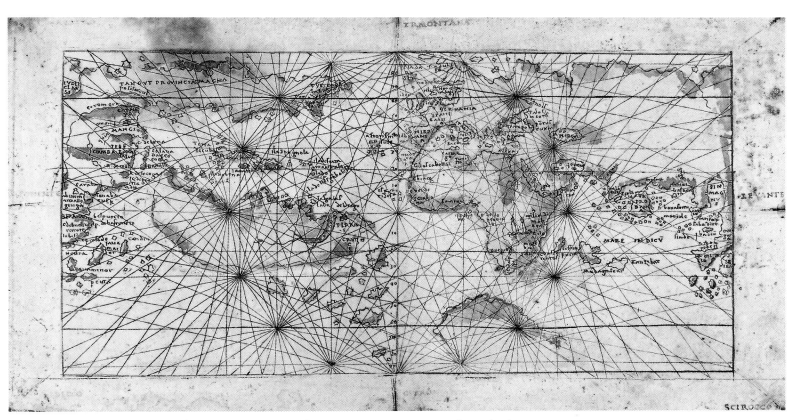

fig. 5. Francesco Rosselli, *Marine Chart*, engraving. National Maritime Museum, Greenwich, England

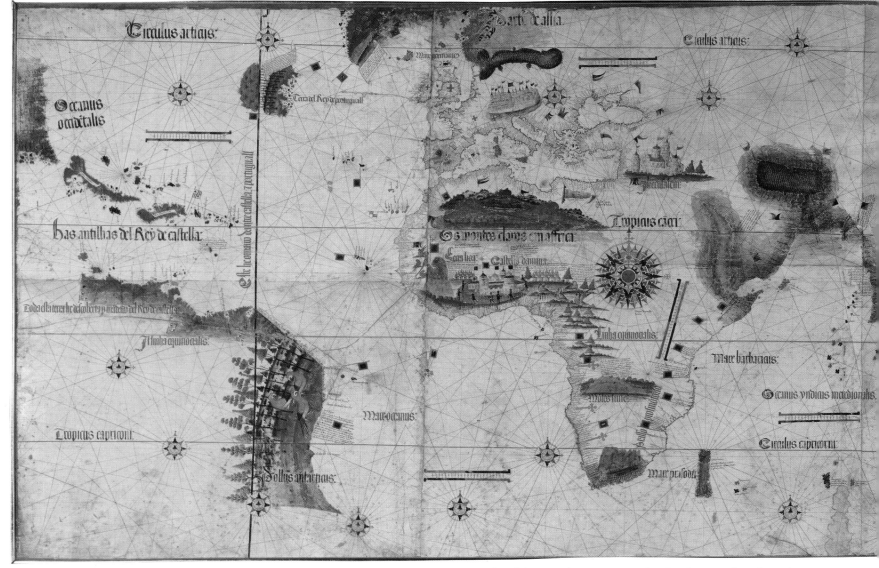

fig. 6. *Cantino World Map.* 1502. Biblioteca Estense, Modena. The anonymous Portuguese compiler of this portolan *mappamundi* refused to speculate about the westward extension of the lands reached by Columbus, Cabral, and Corte-Real

across the Western Ocean thirty years earlier without such global thinking. Calculations of the size of the earth, the disposition of its continents, and the distance westward from Europe to Asia were necessary for the Enterprise of the Indies, erroneous though Columbus' actual calculations were. Although he claimed that maps were of no use to him in the execution of the enterprise (how could they be?), it is believed that maps as well as written descriptions of the width of the Western Ocean influenced his decision. A copy of a letter dated 1474 from Paolo Toscanelli intended to urge Afonso v, king of Portugal (r. 1438–1481), toward the goal of westward exploration came into Columbus' hands. It described an accompanying map: "And although I know from my own knowledge that the world can be shown as it is in the form of a sphere, I have determined . . . to show the same route by a chart similar to those which are made for navigation. . . . The straight lines which are shown lengthwise on the said chart show the

distance from west to east; the others which are across show the distance from north to south . . . "[10] The map is lost, but it was clearly intended to show the distance from Lisbon to Quinsay in China (26 spaces of 250 leagues each) using the coordinate space of parallels and meridians. As Toscanelli himself suggests, a globe would perhaps have provided even more dramatic evidence of the modestly perceived distance to be traversed on the Western Ocean, but there are few references indeed to such artifacts in the late fifteenth century. There is not even any solid evidence that Columbus saw the famous globe which Martin Behaim had been contracted to produce for the city of Nuremberg in 1492. Nevertheless, clear references are made to globes and large printed and manuscript maps of the world in circulation during the 1480s, such as those prepared by Henricus Martellus for the Vatican Library.[11] One of these maps may have formed the model for Behaim's globe. Martellus' large 1489 manuscript map is the

only extant example, although other smaller world maps by him survive (cat. 129). It is quite possible that Columbus saw such a globe or map which was graduated in latitude and longitude and implied that only 90 degrees needed to be crossed between the Canary Islands and Japan.

The Martellus maps — or at least those that have survived — did not show the whole earth. But they explicitly extended the world beyond the 180° of Ptolemy's second projection to 275°. Martin Waldseemüller in 1507 extended it further to 360° in his *Cosmographia universalis* (cat. 132), again using Ptolemy's projection as the core, but did not extend it to both poles. The process was taken to its logical conclusion in 1514 when Johannes Werner extended Ptolemy's projection to cover the globe.[12] No maps of the whole earth survive from the fifteenth century, but interest in the concept of showing the earth as a globe was obviously present. The references to globes before Behaim's globe of 1492 attest to it. It is curious, therefore, that the

rather modest map made around 1508 by Francesco Rosselli (cat. 133)—graduated with 360° longitude and 180° latitude—is the earliest extant map of the world in the pure sense of "map" and "world." It takes on special significance as being drawn on an oval projection into which every point on earth could theoretically be plotted and on which every potential route for exploration could be shown. If ever there was a geographical idea of elegant simplicity since the realization that the earth was a sphere, this was it.

Rosselli's coordinate world map was accompanied by a navigation chart on a rhumb-line structure; the pairing of these two fundamentally different map structures symbolizes a mathematical puzzle of how properly to represent the spherical world on a plane. Rosselli was a commercial printmaker in Florence—one of the first to be independently successful—and although he was working in one of the most active humanist centers, it is unlikely that he

was at the cutting edge of geographical knowledge. Representations of the world such as his must have catered to the taste for mathematical and cosmographical puzzles. There was a fascination with the notion of measurement and measuring instruments; maps, globes, and armillary spheres became graphic symbols of scholarly learning. Later in the sixteenth century, manuals of surveying practice and instrumentation became fashionable for the educated classes, long after such mundane pursuits had become part of common life in the fifteenth century.[13] Likewise, the survival of Rosselli's simple map may well reflect an earlier broad and pervasive interest in representations of the whole earth.

In fifteenth-century Europe, therefore, a fundamental change took place in geographical thinking. The ideas for a measured, coherent, global map presented in Ptolemy's *Geography* were not new, but they were received in a scholarly climate that valued the universality and interconnectedness of knowledge. Despite the potential of the Ptolemaic coordinate system, it was not always fully understood at the practical level and was certainly viewed with much suspicion by navigators hardened by experience. Even after Gerardus Mercator showed in 1569 that geographical coordinates and straight compass courses could be reconciled in the same map, the suspicion continued.[14] But cosmographical scholars had by then long admired and accepted the elegance of the global system. Navigational practice was ultimately to catch up with the great hypothesis of looking at the world in global terms.

The record presented by the maps shows an emergence from the medieval center/periphery frame of mind, in which places in the world were accorded widely different levels of importance. As the ideas in Ptolemy's *Geography* took hold, the more abstract notion developed that space could be referenced to a geometrical net of lines of longitude and latitude and could thus everywhere be accorded the same importance. The idea of a finite globe was implicit in Ptolemy's *Geography*, but the projections he proposed could not explicitly show it. In the course of the fifteenth century, the map frame expanded little by little and at times literally burst to accommodate a discovery, such as the rounding of the Cape of Good Hope in Martellus' maps. A map projection such as Rosselli's, intended to solve the puzzle of showing the globe on a flat piece of paper, apparently had to wait until the early years of the sixteenth century. Such an image of the whole earth allowed the idea of a finite world over which systematic dominance was possible, and provided a powerful framework for political expansion and control.

NOTES

1. Joan Kelly Gadol, *Leon Battista Alberti: Universal Man of the Early Renaissance* (Chicago, 1969), 200–201, usefully summarizes the debate among historians such as Lynn Thorndike, Pierre Duhem, Leo Olschki, Ernst Cassirer, and Alexander Koyré.
2. David Woodward, "Roger Bacon's Terrestrial Coordinate System," in *Annals of the Association of American Geographers* 80(1) 1990, 109–122.
3. Here is not the place to enter into this complex question in detail, but Ptolemy's third projection is superficially similar to vanishing-point perspective, as Samuel Y. Edgerton, Jr., "From Mental Matrix to Mappamundi to Christian Empire: The Heritage of Ptolemaic Cartography in the Renaissance," in *Art and Cartography: Six Historical Essays*, ed. David Woodward (Chicago, 1987), 10–50, has argued, although the plane on which the image is projected is not between the viewer and the object, as in Leon Battista Alberti's *velum*, but passes through the object. Svetlana Alpers is correct to claim that "what is called a projection in this cartographic context is never visualized by placing a plane between the geographer and the earth" (see Alpers, "The Mapping Impulse in Dutch Art," in Woodward 1987, 51–96, especially p. 71), but there are plenty of examples of azimuthal projections in which this plane is visualized as touching the earth or passing through it. There is a danger in pressing the similarity of Ptolemy's projection to vanishing point perspective and inferring a cause-and-effect relationship because other azimuthal projections, such as the stereographic, had already been in common use for astrolabes throughout the Middle Ages without a similar causal effect (J. V. Field, "Perspective and the Mathematicians: Alberti to Desargues," in *Mathematics from Manuscript to Print, 1300–1600*, ed. C. Hay [Oxford, 1988]).
4. Gadol 1969, 143–211, especially 157–195.
5. David Woodward, "Medieval *Mappaemundi*," in *History of Cartography: Cartography in Prehistoric, Ancient, and Medieval Europe and the Mediterranean*, eds. J. B. Harley and David Woodward (Chicago, 1987), 286–370, especially 316.
6. Tony Campbell, "Portolan Charts from the Late Thirteenth Century to 1500," in Harley and Woodward 1987, 371–463, especially 386.
7. Paul D. A. Harvey, "Local and Regional Cartography in Medieval Europe," in Harley and Woodward 1987, 464–501, especially 474.
8. Gadol 1969, 201.
9. Richard Hakluyt, *Divers Voyages Touching the Discovery of America and the Islands Adjacent*, ed. John Winter Jones (London, 1850), 50.
10. From Columbus' copy of Cardinal Piccolomini's *Historia rerum ubique gestarum*, now in the Biblioteca Colombina, Seville.
11. Józef Babicz, "The Celestial and Terrestrial Globes of the Vatican Library, Dating from 1477, and Their Maker Donnus Nicolaus Germanus (c. 1420–c. 1490)," *Der Globusfreund* 35–37 (1987), 155–168.
12. Johannes Keuning, "The History of Geographical Map Projections until 1600," *Imago mundi* 12 (1955), 1–24.
13. Gadol 1969, 171.
14. W. G. L. Randles, "From the Mediterranean Portulan Chart to the Marine World Chart of the Great Discoveries: The Crisis in Cartography in the Sixteenth Century," *Imago mundi* 40 (1988), 115–118.

TRADITION AND INNOVATION: COLUMBUS' FIRST VOYAGE AND PORTUGUESE NAVIGATION IN THE FIFTEENTH CENTURY

Francis Maddison

Ó mar salgado, quanto do teu sal
Sao lagrimas de Portugal!
. .
Valeu a pena? Tudo vale a pena
Se a alma nao é pequena.
. .
Deus ao mar o perigo e o abismo deu,
Mas nele é que espelhou o céu.

Pessoa[1]

Pero nada que toque a Colón puede ser simple y diáfano.

Varela[2]

So viele Berichte.
So viele Fragen.

Brecht[3]

The Manueline architecture of Lisbon and Coimbra uses, as a motif, an armillary sphere; the same instrument appears on the *meia esfera* (half sphere), a gold coin minted for Portuguese India during the reign of King Manuel I (r. 1495–1521). It was often depicted in medieval and Renaissance art as a symbol of astronomy— as for instance to identify the fine limewood bust of the Hellenistic astronomer Claudius Ptolemy, set up around 1470 by Jörg Syrlin the Elder on a choirstall in Ulm cathedral.[4] The armillary sphere was an appropriate device to be given to Dom Manuel by his uncle, King João II (r. 1481–1495),[5] because it was during the reigns of these two kings of Portugal that navigation developed from almost pure seamanship, which has its limitations, into a practice that, as Fontenelle recognized in 1699, "hath a necessary connection with Astronomy."[6] The armillary sphere could not have been of much direct use to seamen, except as a model from which to learn cosmology and elementary astronomy: "the figure of the [celestial] sphere, because mathematicians represent [with it] the form of the machine of the sky, and the earth, with all the other details," as the sixteenth–century historian Damiao de Goís described it.[7] Rather, it was an appropriate device because it was an astronomical instrument, which derived from the same conceptual, historical, and technological sources as the essential instruments on which an astronomical navigation had to rely.

When, on 3 August 1492, Columbus sailed with a *nao* (the *Santa María*) and two caravelles (the *Pinta* and the *Niña*) from the port of Palos de Moguer (Huelva), on the Atlantic side of the Pillars of Hercules, on his first voyage—a voyage westwards in order to reach the East— he was aware of furthering the expansion of Castile. At the beginning of the previous Janu-ary, the Castilians had completed the Christian *Reconquista* of Spain by the capture of the Moorish city of Granada, an event Columbus had witnessed. He was not ill-equipped for his journey across a scarcely explored ocean, because his career, from his childhood in Genoa to his present service under the Spanish crown, encompassed training as a Portuguese seaman, with knowledge and some application of the new Portuguese astronomical navigation. In the journal of his first voyage, he recorded: "I have spent twenty-three years at sea and have not left it for any length of time worth mentioning, and I have seen everything from east to west, [by which he means that he has been to the north, that is, to England] and I have been to Guinea".[8] Though it was not until the latter part of 1575 that the master of a Spanish ship was required to keep a daily log book,[9] Columbus fortunately did so. We know from his journal that he took with him marine compasses, quadrant, "*astrolabio,*" and sandglass; also that most ancient of nautical instrument, the lead and line; and possibly some charts of the hither oceanic coastline, a traverse table, and some form of solar declination table. Columbus was, in fact, participating in the second of three important revolutions in the technology of navigation, even though his successful thirty-three-day voyage to the island of Guanahaní, whose identity is still debated, where he arrived on 12 October, no doubt owed much more to his seamanship than to accurate use of instruments.[10]

Much fantasy has been written about the use of instruments (for example, the planispheric astrolabe) by early navigators, and the value of remembered observation of natural phenomena often ignored. It is quite clear that in early medieval times the Vikings traversed vast areas of inhospitable and featureless ocean, with the ability to return to their port of departure, and there is little evidence that they made even occasional use of any instrumental aid.[11] The Islamic navigators in the Indian Ocean, when first encountered by Europeans at the end of the fifteenth century and the beginning of the six-teenth, though equipped with a simple instru-ment, the *kamāl*, relied on oral *rutters*. These were long poems containing navigational instructions, which the navigators could learn and remember because of the meter and set phrases, much like the epic poems recited by Homer and later rhapsodes.[12] More recently, there is the evidence of the extensive skills of Pacific peoples who navigate without charts or instruments, using traditional lore concerning star positions, waves, and birds.[13]

The direction of stars rising on the horizon would hardly be of use in overcast northern latitudes; and other geographical constraints would have influenced the evolution of naviga-tional procedures in different regions of the world. Possible connections between naviga-tional practices in the distant past are forever obscure; even the medieval contacts between the Atlantic sailors of northern and southern Europe remain undetermined. However, this substratum of inherited knowledge, passed on from masters to apprentices, concerning sea-sonal variation of observed celestial bodies, of winds, of the directions of bird flight,[14] of the saltiness or other flavors of areas of ocean, of warm or cool currents, and of the nature of the seabed, lies at the basis of all navigational activ-ity from antiquity to the early medieval period and even later when charts and nautical instru-ments had become available in Europe. Naviga-tional practice off the Atlantic coast of southern Europe and northwest Africa, the *Maghrib*, was no doubt a combination of the experience and

folklore of two traditions, that of the west-facing Atlantic coast and that of the "inland sea," the Mediterranean, from which sailors rarely ventured voluntarily into the Atlantic. During antiquity and the early Middle Ages, sailing in the virtually tideless Mediterranean was concentrated in the summer months and was mostly coastal or "island hopping." It required an ability to judge the speed of the ship and to estimate distance,[15] a knowledge of seasonal wind directions and their relationship to ports of departure and destination, visibility and identification of the polestar, and the use of lead and line to avoid shoals and to sample the seabed as a means of determining locations.[16]

A transformation of basically coastal navigation, whether in the Mediterranean or off the Atlantic coasts of Europe, into a technique that would permit venturing out of sight of land in the open ocean, with the expectation of return to the port of departure, requires an ability to determine position on the globe accurately, in modern terms, to be able to find the ship's latitude and longitude in a coordinate system. This transformation is as much sociological as technological. Any early astronomer, for instance Ptolemy of Alexandria (c. A.D. 150) or az-Zarqellu (Arzachiel) in eleventh-century Toledo, could have instructed a sailor in the use of an astrolabe to find his latitude at sea but, practical difficulties apart, the question would not have been asked, because sailors belonged to a craft and so did not mingle with learned astronomers. The traditions of classical, Byzantine, and Islamic craft navigation in the Mediterranean, and the contemporary navigation on the Atlantic coast, were, in fact, eventually developed by three infusions of "scientific" and "technological" knowledge. The first of these occurred in the late twelfth and thirteenth centuries with the introduction of the marine (magnetic) compass and the creation of sea charts,[17] using a network of lines that enabled courses to be set using the compass to navigate by azimuth. The second took place during the fifteenth and early sixteenth centuries, when a form of astronomical navigation was evolved, enabling latitude to be determined.[18] The third important development came in the eighteenth century, when the invention of the marine chronometer provided a practical method of finding a ship's longitude.

The use of lodestone, or a needle magnetized by it, to determine direction derives from China, but how knowledge of its use was transmitted remains obscure, although presumably it passed through Islam, to medieval Christian Europe. A stage in the development of the marine compass was the technique of floating a magnetized needle embedded in a straw on a bowl of water. There is a thirteenth-century Arabic description of the use of such a compass on a voyage from Tripoli (Lebanon) to Alexandria, but by the end of the twelfth century, the English writer Alexander Neckam had already referred to the use of the compass at sea, and to a needle placed on a pivot. He is followed in the thirteenth century by references in the works of Guy de Provins, Jacques de Vitry, and King Alfonso x, the Wise (el sabio), of Castile, and most notably in the famous treatise of Petrus Peregrinus de Maricourt, the Epistola de magnete of 1269.

By the fifteenth century, the compass had been greatly improved for nautical use by the substitution of the "fly" for the simple pivoted needle. A fly is a disk of pasteboard under which is attached the needle (or a metal frame) and its pivot cup; the diameter of the disk is such as to make it move closely within the confines of the compass-box. The disk was painted with the design and lines of the wind- and compass-roses familiar from early sea charts and bore a circumferential scale of degrees and eight "winds," subdivided into "quarter winds" of eleven and one quarter degrees each. The transference of the scale from the rim surrounding the needle to the fly made possible a direct reading of a course to be set.[19] Possibly the earliest detailed illustration of a compass with a fly is the allegorical drawing by Leonardo da Vinci, dated about 1515–1516 (cat. 189), in which a wolf, seated in a sailing boat, is looking at a fixed compass that clearly has a fly. The ship's course would have been set first according to "wind" directions given in written sailing directions,[20] and later according to the rhumb lines drawn on the sea charts, which were in use by the end of the thirteenth century.[21] The rhumb lines radiated from wind- or compass-roses and showed directions from port to port across the Mediterranean. If, for example, a ship's master wished to sail from Tunis to Genoa, inspection of a chart would show that the angle from the meridian (the north-south line) was so many degrees or "quarter winds"; then, with the compass placed in a case, called a binnacle, with its north-south line aligned on the longitudinal axis of the ship, the master would seek to sail keeping the fly positioned so that the appropriate angle marked on it remained opposite the fiducial mark on the compass box.

This combination of marine compass and sailing directions or sea chart constitutes the first important technological advance in navigation beyond the traditional Mediterranean techniques, scarcely changed since antiquity. The French, Italian, Spanish, Catalan, and Portuguese navigators who, from the late thirteenth century, explored down the west coast of Africa and its island archipelagos were equipped with compasses and gradually with coastal sailing directions and charts, as well. They would not voluntarily have sought to sail far from land.[22] The political, religious, and economic factors that pushed the Europeans to explore the west coast of Africa as a possible entry to the fabled tropical Africa are beyond the scope of this essay, but the distinction must be made between fortuitous or involuntary discovery and deliberate voyaging for power or financial gain, implying colonization. The Portuguese, who developed a fishing monopoly in the African Atlantic, were backed by policies at home. "O plantador de naus" (the planter of ships), the poet Fernando Pessoa called King Diniz of Portugal (ruled 1279–1325), who around 1300 ordered the planting of the pine forest of Leiria, which later supplied wood for the royal shipyards.[23] In 1415, the Portuguese took Ceuta; in 1434, under Gil Eanes, they passed Cape Bojador, probably preceded by the Vivaldi brothers in 1291—Genoese merchants who apparently perished in the first recorded European voyage to the Indies—and others after them. From this date the voyages there and beyond become regular, and that required a solution of the problems of returning to Portugal. These problems arose from the nature of the winds and currents in the Atlantic off the Guinea coast, which forced returning ships to sail into the open sea in a wide northwestward arc. To reach Lisbon, or any other Portuguese port, while sailing northwards, the mariners observed the altitude (angle above the horizon) of the polestar until its observed altitude matched that of the pole-

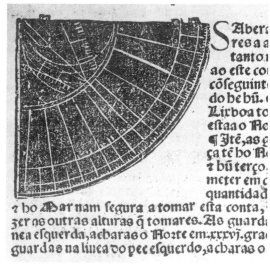

fig. 1. Quadrant. Two sight-vanes are shown on the top radial edge. Near the apex is a diagram of unequal hours and possibly a solar declinations scale, which enabled the quadrant to be used as a sundial. From Valentim Fernandes, Reportório dos tempos (Lisbon, 1563), 140

star at the port of destination; they then set course eastward.

This technique was first adopted about 1460 and is associated with the Portuguese navigator, Diogo Gomes. The navigators used a simple altitude-measuring instrument known as a quadrant, which consists of a small plate of wood or brass in the form of a quarter disk with a scale of degrees engraved along the curved edge, a plumb-line and bob suspended from the apex, and a pair of pinhole sight vanes attached at either end of one of the radii.[24] By sighting the polestar through the pinhole sights, holding the quadrant as near to the vertical as possible, and letting the plumb-line hang freely, navigators could read the altitude of the star from the degree scale. This was difficult on board a moving ship, particularly in adverse weather, although a series of observations made at short intervals could be averaged to improve accuracy. Furthermore, an overcast sky might render the polestar invisible for long periods, and rough seas and winds might make keeping a set course impossible. In the fifteenth century, the polestar was not, as it is today, displaced from the celestial pole by about a degree of arc; owing to the constant shift of about one degree in seventy years, it was several degrees off and appeared, like the other stars, to rotate about the pole. This problem was resolved by the use of mnemonic diagrams, called *rodas* ("wheels"), giving the altitude in degrees of the polestar at successive positions during this apparent rotation. To use a similar form of altitude navigation in daylight, it was necessary to measure the altitude of the sun at noon and to use tables giving solar declination (*regimentos*) throughout the year in a particular latitude. Because it is not safe to look through sight vanes directly at the sun, navigators measured its altitude by holding the quadrant so that the sunlight passing through the pinhole in the foresight fell exactly on that in the backsight (or so that the shadow of the foresight fell squarely on the backsight).[25]

The altitude in degrees of the celestial pole above the horizon at a given place is, of course, the latitude of that place. The primitive altitude navigation was soon developed to "run down" the latitude and use latitude data more generally; diagrams and tables were improved and instruments specially devised for mariners. Possibly the earliest such instrument was the mariner's astrolabe, although it is not known exactly when it was first used; the earliest and rather crude illustration occurs in Alessandro Zorzi's letter of 1517, and the oldest surviving mariner's astrolabe is Portuguese and dated 1540.[26] The mariner's astrolabe resembles most closely a simple circular altitude-measuring

fig. 2. *Mariner's Astrolabe.* Shown being used to determine the meridian altitude of the sun. From Pedro de Medina, *Regimiento de navegación* (Seville, 1563), fol. 16

instrument, apparently used by medieval astronomers, but is broadly inspired by the shape and construction of the well-known planispheric astrolabe. In the mariner's astrolabe this is reduced to a simple measuring device for altitude (or zenith distance) suitable for shipboard use, and there is no stereographic projection of the celestial sphere, or rotatable star map (*rete*). From the suspension rings hangs a cast, wheel-shaped body, sections of which are left open to offer the least wind resistance and made heavy to help it hang vertically; there is an alidade (sighting rule) movable over a scale of degrees, with the sight vanes placed near the center to facilitate solar observations.[27]

On the voyage which took him to India, Vasco da Gama brought with him, as well as small brass astrolabes of unknown type, a large wooden astrolabe, which may have resembled those used by medieval astronomers. This he used for the determination of latitude in 1497 at the bay of Saint Helena (southern Africa), where it was suspended from a tripod on land because of the difficulties in making accurate solar observations at sea. From such rough beginnings, commented the Portuguese historian João de Barros (c. 1496–1570), began the technique that became so valuable for navigation.[28] The following year, at Malindi on the east coast of Africa, Vasco met a *mu'allim* (ship's captain) from Gujerāt who was to pilot him across the Indian Ocean. Even if this mariner was not, as has often been claimed, the famous navigator Ahmad b. Mājid (fl. 1460–1550) himself, he had no doubt learned oral *rutters* (sailing directions) similar to those for which Ahmad b. Mājid is well known.[29] Barros described Vasco's encounter with the mariner.

And when Vasco da Gama showed him the large astrolabe of wood that he had with him, and others of metal with which he measured the altitude of the sun, the Moor [that is, the *mu'allim*] was not impressed, saying that some navigators of the Red Sea used brass instruments of triangular shape and quadrants with which they measured the altitude of the sun, and especially of the star which they most used in navigation. But he, and the mariners of Cambay and of the whole of India, because their navigation was by means of certain stars, both of the north[ern] and of the south[ern hemispheres], and other important [stars] which moved along the middle of the sky from east to west, did not measure its distance [that is, the altitude of a star] by instruments like those, but by one which he himself used; which instrument he took the opportunity to show, which was of three tablets. And because we describe the shape and use of these in our *Geography*, in the chapter on instruments of navigation, it is only necessary to know here that they use them for the technique which among us is now done with the instrument that mariners call a cross-staff, which will also be explained and [an account given of] its inventors in the chapter we have referred to.[30]

This instrument "of three tablets" is now usually referred to as a *kamāl*.[31] It was a simple altitude-measuring device consisting of three small rectangular wooden boards of different sizes, each with a central hole to which was attached a string. The string was knotted at intervals, the position of the knots representing altitudes in *isbā'* (finger [breadth]) or, alterna-

fig. 3. Instrument used to ascertain altitude. From Gabriel Ferrand, *Introduction à l'astronomie nautique arabe* (Paris, 1928), 26

tively, the altitude of the polestar in a particular place. Choosing the most appropriately sized board, the navigator held it so that the lower edge appeared to lie on the horizon and the upper to touch the celestial body to be observed, then held the string taut against his nose or between his teeth. The knot nearest to his face indicated the altitude. The origin and history of the *kamāl* is obscure, but it may derive from a similar Chinese device. Its importance in the history of European navigation lies in its possible influence on the development of the cross-staff for nautical use. *Kamāls* were brought back to Portugal and are mentioned, together with conversions of the *isbā'* to degrees of arc, in the sixteenth-century navigational treatises of Andre Pires and João de Lisboa.[32] The cross-staff was an old instrument; it was probably invented by Levi ben Gersom (1288–1344), a Jewish philosopher and scientist from southern France, whose treatise was translated from Hebrew into Latin in 1342. Although popular with astronomers—it was, for example, used by Bernhard Walther, patron of the astronomer Regiomontanus, for observations in Nuremberg from 1476 to 1504—nothing suggests that it was used at sea before the sixteenth century, although it was certainly in use by 1524. The cross-staff was usually of hardwood, sometimes of brass, and consisted of a square-sectioned rod (the "staff") with a sliding cross-bar (the "transversary"). It could be used vertically or horizontally to measure angular distances, by holding the end of the staff to the eye and sliding the transversary until its extremities appeared to touch the objects between which the angle was to be measured.[33]

By the end of the fifteenth century, then, instruments were being adapted or invented for the purposes of the new astronomical navigation. There was no nascent instrument-making industry in Portugal or Spain, so the manufacture and certification of instruments for navigators was controlled by the cosmographers, unlike in the Netherlands and in England. There instrument-making workshops existed to fill the demand that arose later in the sixteenth century, when the navigators of those countries came to adopt astronomical techniques and instruments, first based on the Iberian experience and then on their own technical contributions. The appointment in 1529 of Pedro Nunes (1502–1578) as royal cosmographer introduced into Portuguese navigation a truly mathematical overview of the colonial enterprise.[34] Nunes became professor of mathematics at Coimbra by 1544 and chief royal cosmographer in 1547; among his pupils were the astronomer Christoph Clavius and also the naval commander João de Castro, who tested Nunes' newly devised

fig. 4. Cross-staff used for determining the altitude of the Polestar, when the Guards are in a particular position. From Pedro de Medina, *Regimiento de navegación* (Seville, 1563), fol. 36

"shadow instrument" (*estormento de sombras*) during his voyage to Goa in 1538—a culmination, indeed, of the application of science to navigation.[35]

The first voyage of Columbus in 1492 places him at the midpoint in this technological development. He had with him a number of instrumental aids. Their value to him, as revealed in the journal of his first voyage, appears ambiguous, his instinctive seamanship often in conflict with the data he obtained from the instruments. The journal includes many observations of flocks of birds (and in one place notes that he knew that the Portuguese had discovered most of the islands they held by observing the flight of birds) and records how Columbus changed course because of these observations. Sticks floating in the sea are also noted as evidence of land, and the presence of rock weed and reeds is mentioned; the lesser saltiness of the sea near land is commented upon. Columbus' use of the lead and line is evidenced by references to the seabed being sandy, not rocky, at a depth of fifteen or sixteen fathoms; to the existence of a good entrance to the mouth of a river found by taking soundings; and to the sea bottom being beyond a forty-fathom plumb-line.[36] He apparently used half-hour sandglasses: "Here the Admiral measured the length of the day and night in hours, and found that from sunrise to sunset was 20 half-hour glasses, although he says that there could be an error either because they do not turn the glass soon enough or because some of the sand has not passed through"; and "he sailed for about 14 half-hour sand-glasses or a little less until the end of the first quarter watch, and made about 4 miles an

hour, which is 28 miles."[37] Columbus had with him more than one marine compass, and it is possible that the peculiar behavior of these compasses recorded in an entry in the journal resulted from his crossing the agonic line (line of zero magnetic declination; the declination at the time was about eleven and one quarter degrees in northwestern Europe), and that other problems Columbus had with his compasses arose from his having brought with him Flemish and Genoese compasses whose makers adopted different values for the declination in setting the fly.[38] For the early part of his voyage, Columbus had some sort of chart, and he proposed to make a new navigational chart.[39] To this extent, he had not progressed beyond the first technological revolution in navigation.

But Columbus did notice the apparent rotation of the polestar about the celestial pole, and may have used a mnemonic diagram of the positions of α and β *Ursae minoris*,[40] and he thus joins his Portuguese contemporaries at the beginnings of astronomical navigation. Of astronomical instruments, we read that "he has suspended the use of the quadrant until he reaches land and can repair it"; later, that "he found from his quadrant that he was 34 degrees [in fact nearly 20° N] from the equinoctial line"; and then that the "north star seemed to him to be as high as at Cape St Vincent... [but he] could not measure its elevation with the astrolabe nor the quadrant because the waves would not let him."[41] What sort of astrolabe this was remains unknown.

"The American," wrote the philosopher Georg Christoph Lichtenberg, sometime between 1779 and 1783, "who first discovered Columbus made a bad discovery."[42] This awareness of the interaction and conflict of cultures as a result of European mercantile and missionary expansion is a dominant theme of this exhibition. This brief essay has not sought to trace in time or space the stages of Portuguese or Spanish colonial enterprise along the coast of Africa, to farther Asia, or to the Americas, but rather to consider the intellectual endeavor engaged, to borrow the words of Borges, in "deciphering the magical alphabet of the stars in other latitudes."[43]

NOTES

1. Fernando Pessoa (1888–1935). "Mar portugues," *Mensagem* xxx: 'O salty sea, how much of your salt / Are tears of Portugal/ . . . Was it worth it? Everything is worthwhile / If the soul is not mean. / . . . God gave the sea danger and depth / But in it mirrored the sky", quoted from F. E. G. Quintanilba, ed. & trans., *Fernando Pessoa. Sixty Portuguese Poems* (Cardiff, 1971), 46–47.

2. Consuelo Varela, *Cristóbal Colón: Textos y documentos completos. Relaciones de viajes, cartas y memoriales*, 1st ed. (Madrid, 1982), LII: "But nothing which concerns Columbus can be simple and clear."

3. Bertolt Brecht (1898–1956), "Fragen eines lesenden Arbeiters": "So many reports. / So many questions.", quoted from *Die Gedichte von Bertolt Brecht*, 6th ed. (Frankfurt am Main, 1965), 656–657; and John Willett, Ralph Maheim, and Erich Fried, *Bertolt Brecht. Poems*, 2d ed. (London, 1981), 252–253.

4. Jörg Syrlin der Ä. (c. 1425–1491), Ulm. Ptolemy holds a demonstrational armillary sphere in his left hand, a measuring device in his right. The carving is full-round, stained brown, height 44 cm.

5. See Francis Maddison, *Medieval Scientific Instruments and the Development of Navigational Instruments in the XVth and XVIth Centuries* (Agrupamento de estudos de cartografia antiga 30) (Coimbra, 1969), 4 and note 2. To avoid expanding unduly the footnotes, reference will be made, where possible, to this publication, which has extensive bibliographical references. Most of the instruments mentioned in this essay are discussed and illustrated in Anthony Turner, *Early Scientific Instruments: Europe 1400–1800* (London, 1987), which includes a good up-to-date bibliography.

6. Maddison 1969, 4 and note 4. It was, however, King João II who rejected Columbus' project before the Spanish court supported it.

7. Maddison 1969, 4 and note 1; author's translation.

8. B. W. Ife, ed. and trans., with an essay on Columbus' language by R. J. Penny, *Christopher Columbus: Journal of the First Voyage (Diaro del primer viaje) 1492* (Warminster, Wiltshire, 1990), 2–5, notes on 242–243, 142–145 (Friday, 21 December; the gloss in italics is that of Bartolomé de Las Casas); Varela, 89.

9. Ife 1990, 243 n. 7.

10. References to instruments in Columbus' journal are given below. The drawing of divisions on a trigonometrical quadrant in a manuscript of Pierre d'Ailly's *Ymago mundi*, in the Biblioteca Colombina, Seville, no. 3,122, may be evidence of Columbus' theoretical interest in instruments, or merely a diagram for the graphical determination of solar declination; the drawing is conveniently reproduced in Björn Landström, *Columbus*, Eng. trans. (London, 1967), 30; and compare Luís de Albuquerque, *Curso de história da náutica*, 2d ed. (Coimbra, 1972), 123–125.

11. See G. J. Marcus, *The Conquest of the North Atlantic* (Woodbridge, Suffolk, 1980).

12. See G. R. Tibbetts, *Arab Navigation in the Indian Ocean Before the Coming of the Portuguese, Being a Translation of* Kitāb al-Fawā'id fī usūl al-bahr wa'l-qawā'id *of Ahmad b. Mājid al-Najdī* (Oriental Translation Fund, n.s. vol. 42) (London, 1971).

13. See, for instance, Stephen D. Thomas, *The Last Navigator* (London, 1987).

14. For instance, the seventeenth-century examples from Alexander O. Exquemelin (Cayman Islands, before 1678) and Martin Martin (Hebrides, before 1698) in Maddison 1969, 5–6, note 8. For references to Columbus' observation of natural phenomena, see below.

15. To ascertain the ship's position by "dead-reckoning," Vitruvius, the Roman engineer and architect, writing in 25 B.C. proposed an impractical version of his hodometer, for use in ships; see A. G. Drachmann, *The Mechanical Technology of Greek and Roman Antiquity* (Copenhagen, 1963), 157–159.

16. See generally for the history of European navigation, E. G. R. Taylor, *The Haven-Finding Art: A History of Navigation from Odysseus to Captain Cook*, new ed. (London, 1971). For the background, see J. R. S. Phillips, *The Medieval Expansion of Europe* (Oxford, 1988).

17. Often called portolan charts, but a thirteenth-century use of the word *compasso* means "sailing directions," comprising the *portolano* (the *written* guide) and the nautical chart. On nautical instruments in the time of Columbus, see the individual entries in Silvio A. Bedini, ed., *The Columbus Encyclopedia* (New York, forthcoming).

18. On the development of an astronomical navigation, see Albuquerque 1972, and Vitorino Magalhaes Godinho, "Navegaçao oceânica e origens da náutica astronómica," reprinted in his *Ensaios* (Lisbon, 1968), 1:179–227.

19. *Columbus Encyclopedia*, forthcoming, under "Compass, Marine," where bibliographical references will be found. See also J. J. L. Duyvendak, *China's Discovery of Africa* (London, 1949), 19–20, for the Chinese use of the marine compass; and Taylor 1971, 91–92, 97, for the traditional association with Amalfi of the development of the marine compass in Europe. On twelfth-century science, see Tina Stiefel, *The Intellectual Revolution in Twelfth-Century Europe* (London & Sydney, 1985), who mentions Neckam on page 101.

20. *Compasso da navigare*, in Italian.

21. See David Woodward's essay in this catalog.

22. For the political and economic background, see Pierre Chaunu, *L'Expansion européenne du XIIIᵉ au XVᵉ siècle*, Nouvelle Clio 26 (Paris, 1969). The basic study of the early African west coast voyages is Raymond Mauny, *Les Navigations médiévales sur les côtes sahariennes antérieures à la découverte portugaise (1434)* (Lisbon, 1960). See also Luís de Albuquerque, *Introduçao à história dos Descobrimentos* (Coimbra, 1962).

23. Quintanilha 1971, 33: "D. Diniz," *Mensagem* XX.

24. The quadrant was not a recent invention. Most medieval quadrants were engraved with lines showing the planetary (unequal) hours and used for telling time in conjunction with an adjustable bead sliding on the plumb line. See *Columbus Encyclopedia*, forthcoming, under "Quadrant."

25. The earliest illustration of a quadrant for use at sea is comparatively late: in the 1563 (posthumous) edition of Valentim Fernandes' *Reportório dos tempos*, 1st ed. (Lisbon, 1518); see figure 1. Other mnemonic diagrams served to assist the determination of the time at night by showing the midnight positions throughout the year of ß Ursae minoris; see Maddison 1969, 32, 35.

26. See Nan Stimson, *The Mariner's Astrolabe: A Survey of Known, Surviving Sea Astrolabes* vol. 4 of HES Studies in the History of Cartography and Scientific Instruments (Utrecht, 1988). The planispheric astrolabe was not a mariner's instrument. Its flat solid disk made it unsuitable for use on board ship, it was fragile because of the delicate tracery on the *rete* (star map) and separate latitude plates, and its stereographic projection of the celestial sphere made it a complex instrument to understand and to use. See *Columbus Encyclopedia*, forthcoming, under "Astrolabe"; Maddison 1969, 11–13; Turner 1987, 11–16, 27–45.

27. Pedro de Medina, *Regimento de navegación* (Seville, 1563).

28. João de Barros, *Asia...Dos fectos que os Portugueses fizeram no descobrimento e conquista dos mares et terras do Oriente*, 1.a década (Lisbon, 1552), livro 4, cap. vi, folio 41v.: "sayo em terra por fazer aguáda & assy tomar a altura do sol. Porgue como do vso do astrolabio pera aquelle mister da naueguaçam, auia poco tempo *que* os mareantes deste reyno se aproueitauá, & os nauios era*m* pequenos: nam confiáua muyto de àtomar dentro nelles por causa do seu árfar. Principalmente com hu*m* astrolábio de pao de tres pálmos de diametro, o qual armáua*m* em tres páos a maneira de cábrea por melhor segurar a linha solar, & mais verificáda & distinctame*n*te poderem saber a veradeira altura daquelle lugar: posto *que* leuássem outros de latam mais pequenos, ta*m* rusticamente começou esta árte que tantó fructo tem dádo ao nauegar." The 1946 edition of Barros' massive history is now available on computer disk from the Center for the Study of the Portuguese Discoveries, Linacre College, Oxford.

29. See Tibbetts 1971, generally; and, on the identification of Vasco's pilot, 9–12.

30. Barros 1552, fols. 46v–47v: "E amostrandolhe Vasco da Gama o grande astrolábio de pao que leuáua, & outros de metal com que tomáua a altura do sol, nam se espantou o mouro disso: dizendo que alguu*n*s pilótos do már roxo vsáua*m* de j*n*strumentos de latam de figura triangular & quadrantes com que tomáua*m* a altura do sol, & principalmente da estrella de que se mais seruiam a naue*g*acam. Mas que elle e os mareantes de Cambaya & de toda a India, peró que a sua nauegácam éra per cértas estrellas assy do nórte como do sul, & outras notauees *que* cursáua*m* per meyo do céo de oriente a ponente: nam tomáua*m* a sua distancia per j*n*strume*n*tos semelhauces áquelles mas per outro de *que* se elle seruia, o qual j*n*strumento lhe trouxe lógo amostrar, *que* éra de tres tauáas. E porque da figura & uso dellas tratámos em a nossa Geografia em o capitulo dos j*n*strume*n*tos de nauegacam, báste aquy saber *que* seruem a elles naqu*e*lla operacam *que* óra acerca de nós sérue o j*n*strume*n*to aque os mare*a*ntes chama*m* balhestilha, de que ta*m*bem no capitulo *que* dissemos se dará razam delle & dos seus j*n*uentores" (author's translation). Unfortunately, Barros' *Geography* has apparently not survived.

31. This Arabic term, meaning "perfection, completion," is not attested before the nineteenth century; perhaps better is *khashaba* (a piece of wood), used by the Arab *mu'allims* Ahmad ibn Mājid and Sulaymān al-Mahrī (first half of the sixteenth century). See Tibetts 1971, 315–318; and *Columbus Encyclopedia*, forthcoming, under "Kamāl." See figure 3, reproduced from H. Congreve, "A Brief Notice of Some Contrivances Practiced by the Native Mariners of the Coromandel Coast, in Navigating, Sailing and Repairing Their Vessels," in *Madras Journal of Literature and Science* 16 (January–June 1850), 101–104, reprinted in Gabriel Ferrand, *Instructions nautiques et routiers arabes et portugais des XVᵉ et XVIᵉ siècles* (Paris, 1928), 26.

32. See Albuquerque 1972, 195–199.

33. *Columbus Encyclopedia*, forthcoming, under "Cross-staff"; Albuquerque 1972, 189–195. See figure 3, reproduced from Medina 1563.

34. See J. M. López de Azcona, "Nuñez Salaciense, Pedro," in Charles Coulston Gillispie, ed., *Dictionary of Scientific Biography* (New York, 1974), 10:160–162.

35. Armando Cortesão and Luís de Albuquerque, eds., *Obras completas de D. João de Castro* (Coimbra, 1968), 1:115–179.

36. For example, Ife 1990, 12–13 (Tuesday, 18 September) Varela 1982, 22; Ife 1990, 24–25 (Sunday, 7 October), but the passage is not in Varela 1982, 27–28; Ife 1990, 26–27 (Thursday, 11 October) Varela 1982, 28–29; Ife 1990, 12–13 (Monday, 17 October) Varela 1982, 21–22; Ife 1990, 82–83 (Thursday, 15 November) Varela 1982, 58; Ife 1990, 108–111 (Tuesday, 4 December) Varela 1982, 72; Ife 1990, 112–115 (Thursday, 6 December), compare also the following Friday, 116–117 Varela, 73–77.

37. Ife 1990, 126–127 (Thursday, 13 December) Varela 1982, 81; Ife 1990, 200–201 (Thursday, 17 January) Varela 1982, 119. Columbus uses the word for sand-glass, *ampolleta*, also to mean "the time which the sandglass measures" (Varela 1982, 338).

38. Ife 1990, 10–11 (Thursday, 13 September) Varela 1982, 20; compare also Ife 1990, 12–13 (Monday, 17 September) Varela 1982, 21. See *Columbus Encyclopedia*, forthcoming, under "Marine Compass."

39. Ife 1990, 16–17 (Tuesday, 25 September) Varela 1982, 24; Ife 1990, 4–5; Varela 1982, 17.

40. Ife 1990, 20–21 (Sunday, 30 September) Varela 1982, 26.

41. Ife 1990, 88–89 (Wednesday, 21 November) Varela 1982, 61; Ife 1990, 126–127 and note 147 (Thursday, 13 December) Varela 1982, 81; Ife 1990, 208–209 (Sunday, 3 February) Varela 1982, 123.

42. Georg Christoph Lichtenberg, *Schriften und Briefe*, ed. Franz H. Mautner, 4 vols. in 6, "Sudelbücher / Fragmente / Fabeln" (Frankfurt am Main, 1983), 1:359; "Der Amerikaner, der den Kolumbus zuerst entdeckte, machte eine böse Entdeckung," 2:84,1; Georg Christoph Lichtenberg, *Aphorisms*, ed. and trans. R. J. Hollingdale (London, 1990), 110, no. 42.

43. Jorge Luis Borges (1899–1986), "Susana Bombal," *El Oro de los tigres* (1972), reprinted in *Obras completas* (Buenos Aires, 1974), 1094: "...descifrando el mágico alfabeto / de las estrellas de otras latitudes..."; trans. Arthur McHugh in *Oxford Magazine* 68 (1991), 16.

THE MEAN AND MEASURE OF ALL THINGS

Martin Kemp

The old and much criticized cliché that the "spirit" of the Italian Renaissance can be identified with a new attitude toward man may still possess some value in our quest to characterize the arts of this period. The great humanist Leon Battista Alberti, in his innovative dialogues on private and public life entitled *Della famiglia*, which he composed between 1433 and 1441, provided a classic formulation of what we have come to see as the archetypal Renaissance attitude to man: "The Stoics taught that man was by nature constituted the observer and manager of things. Chrysippus thought that everything on earth was born only to serve man, while man was meant to preserve the friendship and society of man. Protagoras, another ancient philosopher, seems to some interpreters to have said essentially the same thing, when he declared that man is the mean and measure of all things."[1] Alberti quotes the same tag from Protagoras in his seminal treatise *Della pittura* (*On Painting*, 1435), when he explains how the human figure provides the essential frame of reference for the scale of all other forms in a perspectival picture.[2]

Alberti's neo-Stoic ideas appear to reveal a heightened and extended definition of man as the "purpose" of nature—as the being for whom nature was created and through whom the order of God's creation becomes apparent. Without man as a rational observer, such order would remain unseen. The perception of nature and intellectual command over its rules place human beings in a position of potential mastery within the physical world, giving them the means to make nature serve their purposes—even if these purposes are ultimately dependent upon God's decrees. The exploitation of knowledge within the context of such admirable pursuits as scholarship and the various arts permits human beings to cultivate *virtù* (worth, talent, and will) as the means of combating *fortuna* (the whims of fate).

The expression of such ideas in the writings of Alberti and his fellow humanists provided the basis for the famous characterization of "Renaissance man" in Jacob Burkhardt's *Civilization of the Renaissance in Italy*, the classic study by the great Swiss historian, first published in 1860. At the start of the key section, "The Development of the Individual," Burkhardt painted a beguiling picture of the new consciousness. "In the Middle Ages both sides of human consciousness—that which was turned within as that which turned without—lay dreaming or half awake beneath a common veil. The veil was woven of faith, illusion, and childish prepossession, through which the world and history were clad in strange hues. Man was conscious of himself only as a member of a race, people, party, family, or corporation—only through some general category. In Italy this veil first melted into air; an *objective* treatment and consideration of the State and of all the things of this world became possible. The *subjective* at the same time asserted itself with corresponding emphasis; man became a spiritual *individual*, and recognized himself as such."[3] His equally crucial section, "The Discovery of the World and of Man," opens with a short essay on the "journeys of the Italians," which are epitomized by the adventures of Columbus. In Burkhardt's view, the voyages of discovery are prime symptoms of the Renaissance spirit. "Freed from the countless bonds which elsewhere in Europe checked progress, having reached a high degree of individual development and been schooled by the teachings of antiquity, the Italian mind now turned to the discovery of the outward universe, and to the representation of it in speech and form. . . . Columbus himself is but the greatest of a long list of Italians who, in the service of Western nations, sailed into distant seas. The true discoverer, however, is not the man who first chances to stumble upon anything, but the man who finds what he has sought. . . . Yet ever we turn again with admiration to the august figure of the great Genoese, by whom a new continent beyond the ocean was demanded, sought and found."[4]

Leaving aside the question of whether it was accurate to say that what Columbus found was the new continent he sought, modern historians no longer accept Burkhardt's characterization of the Renaissance enterprise even on its own terms. The polarities of attitude he used to demarcate the medieval and Renaissance periods have been crucially blurred, both by a greater understanding of medieval culture in its own right and by a greater awareness of the amount of medieval baggage carried by even the most progressive Renaissance thinkers. Moreover, there is a growing tendency to see the voyages of exploration themselves as a continuation of the travel and expansion that had begun to characterize Europe's relationship to Asia and Africa in the course of the preceding centuries.[5] Even more seriously, the underlying assumption—that "man" and "nature" were in some sense waiting to be "discovered"—can be shown to be untenable, since every age has articulated its own special relationship to the world through selective perceptions that have disclosed that period's own "man" and "nature." This is not to say that we should necessarily expect the full range of these perceptions to be expressed in a transparent way in the works of art from each age, since the functional contexts for what we call the arts do not necessarily provide vehicles for their expression. Thus, the fact that perceptions of man and nature may be less striking in much of medieval art by no means indicates that such perceptions were not present in the consciousness of medieval thinkers.

Although we may no longer share Burkhardt's confidence in the picture he painted of Renaissance man, his intuition that profound changes were taking place in fifteenth-century Europe has not been entirely superseded. In the present context, it is worth emphasizing that not the least important of these was the changing scope of the arts, which came to articulate the relationship of man to nature in new ways through the transformation of their communicative means. Nor is Burkhardt entirely wrong in his conviction that shared aspirations can be discerned behind the geographical ambitions of those explorers who regarded the surface of the earth as a space for conquest and behind the representational endeavors of those authors and artists who disclosed "real" people in "real" space and "real" time. What may be outdated is Burkhardt's notion that a shared spirit connects artist with explorer. We should think instead of a complex series of interlocking social, political, imperial, religious, and cultural motivations, all of which used related tools in the service of the geographical and intellectual extension of the scope of individuals and institutions—tools like the splendid scientific instruments included in this exhibition and the more prosaic devices used by architects such as Brunelleschi and Alberti and which probably lay behind the invention of perspective by Brunelleschi in or before 1413. We can glimpse the shared motivations by considering the careers of some

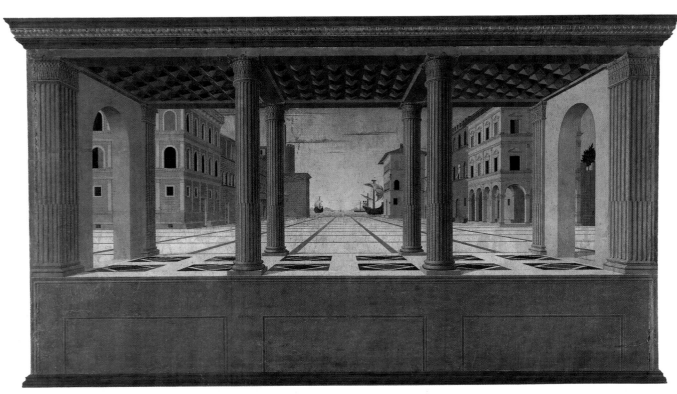

fig. 1. Unknown Italian artist, *Ideal City*. c. 1500, oil on panel. Staatliche Museen, Berlin

outstanding individuals. Aeneas Sylvius Piccolomini, who became Pope Pius II, is a perfect example and was recognized as such by Burkhardt. As a geographer and an ambassador, he recorded vivid eyewitness accounts of people and places in such distant lands as Scotland. As a humanist, he wrote autobiographical *Commentaries,* in which he acts as a sober observer of himself and others. As captain of the Church and proud leader of the Sienese family of the Piccolomini, he transformed his native village of Corsignano into an exemplary new town of the Renaissance, renamed Pienza in his honor. Yet this exemplar of Burkhardt's Renaissance man determined that the internal disposition of the cathedral in Pienza should follow the medieval pattern of a "hall church" with Gothic windows.[6] In a sense, the human figures represented in the works of art in the section of this exhibition devoted to the human body are fleshly Pienzas—amalgams of medieval and modern, laid out according to the new measures and in accordance with the empirical scrutiny of forms and functions, yet deeply imbued with Christian traditions about sin and grace, body and soul.

Albrecht Dürer and Leonardo da Vinci are the perfect Burkhardtian figures in the visual arts, attesting in their closely related yet highly individual ways that genuinely new manners of representing man and nature developed in the years on either side of 1500. Both men played exceptional roles in forging new tools of visual communication—tools that could illustrate the known world with fresh analytical force and summon up unknown worlds (whether the inner regions of the human body or the exotic regions of the earth) with such illusionistic skill that spectators suddenly became privileged eyewitnesses. This is not to say that the new techniques of representation automatically lifted what Burkhardt called the medieval "veil . . . of faith and illusion." Indeed, the very illusionist power of the new techniques could make the completely imaginary seem to have been taken from life. A case in point is Dürer's famous *Rhinoceros* (cat. 206), which for generations of natural historians came to embody the essence of "rhinocerosity" more truly than the beast itself. Armor-plated and—as the medieval bestiary required—the constitutional enemy of the elephant, Dürer's invention may be regarded as another parallel of Pienza in the sphere of visual representation, bearing compelling witness both to the new visual techniques for the construction of a world of rational understanding and to the necessary retention of important elements from established frameworks of meaning.

In its double-edged nature, the visual weapon forged by the Renaissance revolution is perhaps no different from any other truly revolutionary agent. The direction in which any such weapon cuts into the prevailing notions of reality can only be determined by a complex series of mutually reinforcing and sometimes contradictory motivations in the participants' mental and political lives. The works gathered in this exhibition under the general heading of "The Mean and Measure of All Things" have been selected to bear suggestive witness to some of the more Burkhardtian of these motivations in the period around 1492. These motivations also provide the underlying theme of the following discussion of the rationalization of space, the human body, and Leonardo and Dürer.

THE RATIONALIZATION OF SPACE: GEOMETRY AND THE MAN-MADE ENVIRONMENT

Renaissance thinkers did not hesitate to connect the ordering of space with the highest organizing principles of the universe. The humanist Alberti, who was an architect and theorist of art as well as a writer, wrote a Latin satire, *Momus* (*The Prince*), in which Jove searches, at first unavailingly, for a means to bring order into the chaos of earthly existence. This chaos had been orchestrated by Momus, the wayward son of Night, who had been expelled from the heavens and was now reveling in his capricious rule on earth. The contradictory and sophistic opinions of the philosophers Jove consults in his quest provide him with no clear guidance on the best model for a new world order. The first signs of enlightenment come when he sees a stupendous architectural creation, a great Colosseum-style theater, whose harmonious design signals the rational system that should underlie the cosmos as a whole and its component parts. Jove laments his own earlier stupidity in "not having turned to the constructors of such an extraordinary work, rather than the philosophers, to plan the model of the world of the future."[7]

Alberti makes it equally clear in his short but seminal treatise *Della pittura* (*On Painting*), written in Latin in 1435 and translated into Italian a year later, that painters play no lesser a

role than architects in revealing the inherent order of nature as created by God.[8] The means through which painters were to effect this revelation was the acquisition of rational understanding and systematic skills. Alberti considered these attributes essential if their possessors were to have any hope of resisting the vagaries of fortune in human affairs. The kind of enlightenment that Alberti sought was disinterested, in that the philosopher-creator was to be detached from corrupting entanglements in the hurly-burly of politics and commerce, but it was not completely separate from society, since it could be applied to the creation of actual structures for the benefit of human life. The vision of order formulated by Alberti, founded on the neo-Stoic doctrines of the Roman authors he admired, above all Cicero and Seneca, was very much that of the new urban intellectual class, for whom monastic withdrawal from society seemed as undesirable as unreserved commitment to the unprincipled outer world where human beings struggled for supremacy.

The new visions of space that appeared in the late Middle Ages and the Renaissance, above all in Italy and most especially in Florence, arose within urban societies and were expressed through new conceptions of the human environment—not only the environment that was actually constructed for the conduct of human affairs, but also the imagined worlds depicted by practitioners of the figurative arts. Perhaps in no other period were developments in constructed and depicted space more profoundly united. If it is true to say in the final analysis that the fourteenth-century developments in the rendering of human space in painting, as in Ambrogio Lorenzetti's superb depiction of the well-governed city, were dependent upon actual spaces in cities and the manner of their use, it is nonetheless apparent that the depiction of imagined space, especially after the invention of linear perspective in or before 1413, played an active role in transforming the fifteenth-century vision of urban space.

This development appeared first in the construction of actual urban spaces. The late Middle Ages witnessed the building of planned new towns in a number of European centers, but those initiated in Tuscany from 1299 onwards by the government of Florence were of special significance in the development of urban geometry.[9] The commission that reported in 1350 on the proposed new town of Giglio Fiorentino made the following recommendations: "In the middle of the town shall be a piazza ninety *braccia* [about 50 m] long and seventy *braccia* [about 39 m] wide. In the piazza shall be a well. And flanking this piazza, on one side, shall be a house of the *comune* [the local government] with a loggia.... And on the other side... shall be built the church of the parish of St. Peter.... Inside the town shall be nine streets.... [There follows an account of the widths of the streets and dimensions of the properties, according to a carefully graded mathematical order, diminishing in size from the central axis.] The main street shall run the length of the town and another street, similar to it, shall be made across it in the middle of the town."[10]

One of the best surviving examples of the new towns is San Giovanni Valdarno, the birthplace of Masaccio, a town where axial streets of calculated widths flow into and out of a fine double square. At the center stands the Palazzo Pretorio, the seat and symbol of civic rule, surrounded by places of worship and of business and domestic life, arranged according to a carefully ordered hierarchy of functions. The visual elements are controlled in a rigorous manner through a series of calculated alignments and vistas that make manifest the rationality of form and function in the new urban settings for the theater of life.

Such regular planning, which required skill in practical mathematics, including surveying, lay in the hands of sophisticated architect-masons, who were drawn largely from the workshop of the cathedral in Florence. In the city of Florence itself, the scope for the establishment of systematic town spaces and proportional design

fig. 2. Piero della Zucca, *Plan of San Giovanni Val d'Arno*. 1553, pen and ink. Archivio di Stato, Florence

fig. 3. Church of San Giovanni viewed along the south arcade of the Palazzo Pretorio, San Giovanni Val d'Arno. 1299 onwards

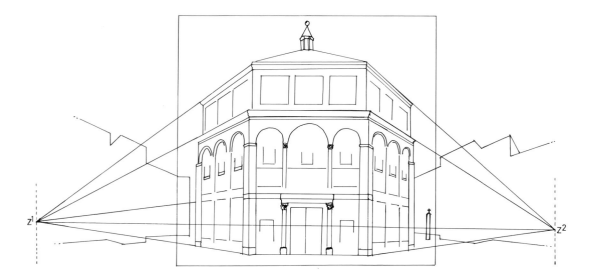

left: fig. 4. *Diagrammatic Reconstruction of Brunelleschi's Perspective Panel of the Baptistery* (z^1, z^2, are points of convergence of sides of Baptistery at maximum possible width for the panel)

below: fig. 5. North-east side, main square, Pienza. c. 1459–64

was limited by the piecemeal growth of the old city and the multitude of private property interests, but during the course of the fourteenth century the Florentine government made strenuous and largely effective efforts to reorder the most important civic and religious-civic spaces. The greatest effort was devoted to the creation of the huge L-shaped piazza beside the Palazzo dei Priori (or dei Signori, the current Palazzo Vecchio), which grew in stages to reach its present dimensions. The documents that record the compulsory acquisition of properties and the regulation of rebuilding lines reiterate the social and aesthetic motives of the commissioners—defense and security, utility, regularity, prestige, and beauty—in a way that anticipates the principles Alberti was to enunciate in the next century. Considerable effort was also devoted in 1389–1391 to the widening and regularizing of the Via de' Calzaiuoli, the main thoroughfare between the Piazza della Signoria and the important space in front of the cathedral in which the magnificent Baptistery was located. It was from the vantage point at which the Via de' Calzaiuoli opens onto the Piazza della Signoria that Brunelleschi painted his famous view of the Palazzo Vecchio in one of the two panel paintings (now lost) which he created to demonstrate his invention of linear perspective. His other demonstration panel showed the Baptistery from the central doorway of the Cathedral, thus depicting another building that was a focus of civic pride in an orderly urban space.[11] Later in his career, Brunelleschi himself would conceive projects to open up new urban spaces in Florence.[12]

The humanist chancellor, Leonardo Bruni, writing his *Panegyric of the City of Florence* during the early years of the fifteenth century, bears witness to exactly the kind of effect the

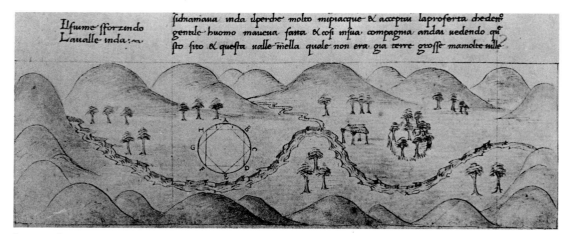

fig. 6. Filarete, *Geometrical City Plan* from *Trattato d'Architettura*. c. 1464, pen and ink and wash. Biblioteca Nazionale, Florence

city fathers intended the physical organization of the city to convey: "This palace (the Palazzo Vecchio) is so immense that it must house the men who are appointed to govern the state. Indeed it was so magnificently conceived that it dominates all the buildings nearby."[13] This nodal building is set in progressively broader perspectives as Bruni, in his description, moves away from the center of the city, until he sees Florence, its surrounding walls, its corona of villas, and its encircling hills and orbital towns as a manifestation of a supreme spatial order.

In the middle of the century Alberti, in his treatise *De re aedificatoria (On the Art of Building)*, laid down the ideal order as a set of theoretical principles. The same combination of social and aesthetic factors governed his axioms, according to the premise that "the range of different works depends principally on the variations within human nature."[14] Thus, appropriate provision—appropriate both functionally and visually—must be made for the various governmental, public, private, and religious activities within the city. For example, different kinds of rulers needed different kinds of buildings: "Whereas a royal dwelling might be sited next to a show-park, a temple or the houses of noblemen, that of a tyrant should be well set back on all sides from any buildings."[15] Similar differentiations were to be made between types of religious buildings: "There are two main types of temple: major temples where a great prelate solemnly conducts established ceremonies and sacraments, then those presided over by a lesser priest, such as chapels in built-up areas.... Perhaps the most suitable site for the main temple would be the centre of a town."[16] The paintings of ideal townscapes from later in the century, particularly those now in Urbino and Baltimore (cats. 147, 148), can be analyzed in terms of such functional and visual hierarchies. All the diverse elements in a city should be held together in a rational order: "The principal ornament to any city lies in the siting, layout, composition and arrangement of its roads, squares and individual works; each must be properly planned and distributed according to use, importance and convenience. For without order there can be nothing commodious, graceful and noble."[17]

The kind of order envisaged by Alberti's immediate successors as architect-theorists, Filarete and Francesco di Giorgio, was far more complex and all-embracing than even that of the fourteenth-century town planners.[18] Everything from the design of a capital at the top of a column to the overall plan of the city was to be governed by a rigorously proportional geometry. The visual effect of such calculation is as apparent in the finest of the painted ideal townscapes, that now in Urbino, as in the appearance of the most coherent piece of actual fifteenth-century town planning from the middle of the century, the main square of Pope Pius II's Pienza.[19] The various buildings around the square—the cathedral, the pope's family palace, the residence of the archbishop, the seat of the local government, and other, more modest structures, including a beautifully designed well—are arranged in a highly coherent visual and social ensemble.

The theorists, of course, could be even more uncompromising in adopting geometrical plans than the builders of actual projects, who had to confront the range of practical problems connected with each individual site. When laying out his imaginary city of Sforzinda for the duke of Milan, Filarete uncompromisingly drops his geometrical scheme for the city into a virgin landscape—one free of preexisting structures and conflicting property rights. Such overarching geometrical designs drew their justification not only from the cultivation of order for beauty's sake (or even for the sake of function), but also from their symbolic associations.[20] The regular geometrical forms, particularly the so-called Platonic solids, were thought to correspond to the building blocks of the cosmos.[21] These archetypal forms governed the design of man, the microcosm, as much as they determined the scheme of the heavens, the macrocosm. In the Renaissance, this view of man as the microcosm came to be associated particularly with the so-called Vitruvian man, based on a set of ideal proportions laid down by the Roman architect Vitruvius and expressed in the image of a human figure, arms outstretched, inscribed in a square and a circle. Both Francesco di Giorgio and Leonardo (see cat. 175) made drawings of this subject.[22]

The later fifteenth century saw the flowering of an appreciation of the regular geometrical bodies in terms that can justifiably be called aesthetic. The leading figures in this movement were the painter Piero della Francesca and the mathematician Luca Pacioli (cat. 143), the latter of whom published an important work, *De divina proportione (On Divine Proportion)*, in 1509. The brilliant perspectival illustrations of the regular geometrical bodies in their solid and skeletal forms in the original manuscript were designed by Leonardo da Vinci, Pacioli's colleague at the court of Milan in the late 1490s (see cat. 142).[23] The ubiquitous "divine proportion" upon which the beauty of the bodies was dependent was the harmonic division of a line according to the ratio of the so-called golden section (such that the ratio of the smaller part to the larger equals the ratio of the larger part to the whole). The attraction of these forms

fig. 7. Intarsia Decorations in the *Studiolo* in the Palazzo Ducale, Urbino

in Renaissance theory was so compelling that Pacioli prefaced his treatise with a verse hymn in praise of their ubiquitous significance in the construction of the world. For Leonardo, as for Luca Pacioli, the cerebral abstractions of geometry corresponded to elements that were embedded in reality rather than separate from it. The conceptual spaces in the human mind and the realized spaces in which Renaissance man pursued his social and intellectual life existed in a continuity. This continuity is perhaps best symbolized by the decoration of aristocratic scholars' studies *(studioli)*, particularly those designed for Federigo da Montefeltro in his palaces at Urbino and Gubbio.[24] The designs of inlaid woodwork in the *studioli* and in other items of domestic and church furniture (cat. 145) use the new science of perspective to evoke the orderly disciplines of the liberal arts through details such as books, mathematical solids, and scientific instruments, and not infrequently include images of well-ordered townscapes akin to those on the painted panels. The intellectual base underlying this vision of harmony was, in theory at least, formed by contemplative philosophers of the kind imagined by Botticelli in his *Saint Augustine* (cat. 144), depicted as a Renaissance scholar who sits in a study equipped with a treatise on geometry, a modern clock, and an armillary sphere that represents the design of the celestial orbits.[25]

In creating the images through which this vision of geometrical order in space was disseminated, the artistic technique of perspective was crucial. The close association between Brunelleschi's invention of perspective and the "squaring up" of Florence's public spaces has already been noted. Indeed the techniques through which the town planners achieved their ends, involving precise techniques of mensuration,

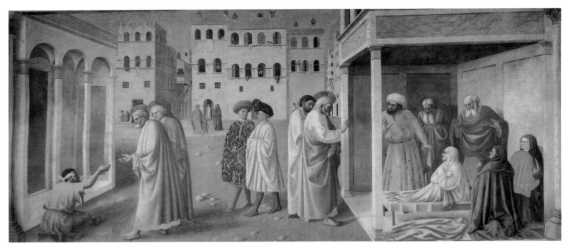

fig. 8. Masolino, *Healing of the Cripple and Raising of Tabitha.* c. 1427, fresco. Brancacci Chapel, Santa Maria del Carmine, Florence

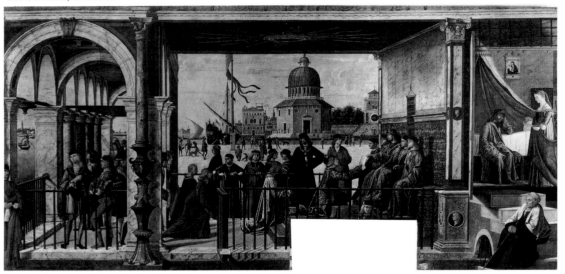

fig. 9. Vittore Carpaccio, *Reception of the Ambassadors* (*Legend of St. Ursula*). c. 1496–1498, oil on canvas. Gallerie dell'Accademia, Venice

are those Brunelleschi is most likely to have used in achieving the perspectival projection of the Palazzo Vecchio and Baptistery onto the flat surfaces of his two demonstration paintings. Although it is likely that the techniques of surveying—rather than the map-making methods of Ptolemy, as has sometimes been suggested—provided the direct means for Brunelleschi's achievement, the nature of his skills exhibits a deep affinity with those pioneers who were reviving Ptolemaic techniques for the charting of the heavens and earth.[26] It may even be that charting land and sky presupposed the control of space on a smaller scale, that the rational mastery of local space in the man-made environment is a prerequisite for the systematic exploration of spaces lying beyond man's immediate visual compass. Such a thesis is strongly supported by Jacopo de' Barbari's remarkable *View of Venice* (cat. 151), in which the systematic description of the city in space positively invites speculation as to what lies beyond.

However close were the links between perspective and the new conceptions of civic space,

these links do not on their own explain the invention and development of perspective within the art of painting. Brunelleschi's precocious townscapes could have remained as visual curiosities, given that purely topographical representations were not required of painters in the fourteenth and fifteenth centuries. His invention could be taken up—and even, I believe, conceived—only within an art whose new functions made the basic techniques for the depiction of realistic space relevant to the needs of both painters and their audiences. The new kind of narrative art, pioneered by Giotto and his successors, was immediate, accessible, human, and even anecdotal. It was further developed in the 1420s by Masaccio and Masolino in their frescoes in the Brancacci Chapel, which depicted solid, highly individualized human actors placed within convincingly characterized spaces that make direct reference to the urban environment. Most striking in this respect is the large fresco that portrays Saint Peter healing a cripple and raising Tabitha, in which key elements in contemporary city plan-

ning—the expansive piazza flanked by properties along a single building line, the wide roads, and the open loggias—provide a convincing setting for the participants in the human drama.

The real climax of these painted civic dramas occurred not in Florence but in Venice, where painters and their patrons developed a large-scale form of art in which the demands of religious narrative and triumphant civic ritual are conjoined within panoramas of the teeming life of the city.[27] It is with images of the maritime, mercantile city-stage of Venice that we arrive at one of the stepping-off points for the actual exploration of the world. The city has become a stage designed and depicted through the rational mastery of techniques for the mensuration and control of space. On this stage a rich human story is acted out, involving the ceremonies of civic business, the insinuation of religious ritual into everyday life, and the imperatives of expanding commercial and imperial concerns. Of course, Venice, mistress of the established eastern Mediterranean trading routes, did not herself sponsor the new voyages south to India and west to the Americas, but the type of commercial organization the city had pioneered was a prerequisite for the formation of the Portuguese and Spanish maritime empires. In this commercially oriented urban environment, abstract mathematics and practical techniques go hand-in-hand. Perhaps it is worth remembering that Luca Pacioli, the intellectual author of *On Divine Proportion*, the book on the "abstract" beauty of geometry, also played a seminal role in the codification and dissemination of one of the practical necessities of European commercial expansion—double-entry bookkeeping.[28]

THE HUMAN BODY: NEW ANATOMIES AND OLD IDEALS

The portrayal of the human body, naked or semi-naked, assumed a central role in the ambitions of major artists in northern and southern Europe during the Renaissance. By 1500 a German artist like Dürer felt compelled to master the portrayal of the nude, just like his Italian contemporaries, such as Leonardo. Not since classical antiquity had artists accorded such significance to the beauty, corporeal presence, and expressive power of the unadorned human form. Although the art of ancient Rome played a conspicuous part in firing the ambitions of Renaissance artists, the formal and emotional range of images of the human body around 1500 far exceeded anything achieved in antiquity. Renaissance representations of the body in a variety of private and institutional

contexts established a complex set of meanings, of which we remain the heirs. Indeed, this range of meanings is so great that it seems at first sight to preclude the definition of any common ground across the varied European traditions within which the expressive potential of the human body was reinvented or invented anew.

The extremes of this range are represented by Antico's suave *Apollo* and the figure of Christ in Grünewald's harrowing *Crucifixion* (cat. 152). The one is luxurious, polished, idealizing, hedonistic, entirely secular, and emotionally bland, appealing to the connoisseur of classicizing beauty. The other is tortured, discomfiting, terrible, graceless, and deeply expressive, functioning as a stark reminder to the believer of Christ's suffering on behalf of a sinful mankind, whose corrupt flesh is burdened with the guilt of Adam and Eve. The comparison is almost a *reductio ad absurdum* of the conventional contrasts of stylistic features in northern and southern European art.

Between these poles are works of art that combine classical form and Christian meaning, like Mantegna's monumental *Saint Sebastian*. Mantegna's heroic figure is deeply imbued with the grandeur of ancient sculpture, from which Antico, too, was drawing inspiration. It follows in a tradition of Apollo-like Saint Sebastians in Renaissance art, a reference that is clearly appropriate for Sebastian as a Roman soldier in Maximian's and Diocletian's First Cohort. But Mantegna's saint, pierced with arrows, is primarily a Christian martyr whose bodily suffering makes him an ideal intermediary between man and Christ. The story of the failure of the arrows to kill Sebastian—he was later clubbed to death—led to his cult as the patron saint of plague victims, who offered him their prayers in hopes of relief. This meaning resides not only in the obvious expressiveness of the image—Mantegna's striking depiction of the anatomy of suffering—but also in the presentation of the saint as a devotional icon rather than as an actor within an overtly narrative context. This meaning is underscored by the guttering candle, a reminder that "nothing is stable other than the divine; everything else is smoke," and by the swags in the form of rosary beads, a reminder of the ritualistic incantation of prayers.

Grünewald's great masterpiece, the *Isenheim Altarpiece*, which was commissioned for an Anthonite monastery devoted to healing, also appropriately includes an image of Saint Sebastian. The Christ Child in another panel of this altar fingers a rosary, a reminder that the rules of the Order of St. Anthony stipulated that "each patient be required for every canonical hour to say twelve Our Fathers and as many Hail Marys."[29] In this instance, it is the German

artist who has created a Saint Sebastian who is an image of calm piety, emphasized by the allusions to paradise conveyed by the figures of angels, while the Italian Mantegna has vividly portrayed painful emotion.

To understand this apparent paradox, we must remember the differing functions of the two paintings. Grünewald's Saint Sebastian, mirrored in his holy calm by the image of Saint Anthony on the corresponding wing on the right of the altarpiece, provides the suffering

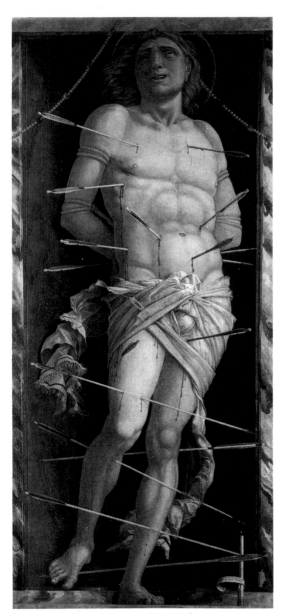

fig. 10. Andrea Mantegna, *Saint Sebastian*. c. 1505–1506, tempera on canvas. Galleria Giorgio Franchetti, Ca' d'Oro, Venice

fig. 11. Matthias Grünewald, *Saint Sebastian*. 1512–1516, oil on panel. Musée d'Unterlinden, Colmar

inmates of the hospital with the hope of a release which can be realized through Christ's assumption of human sin and suffering, so coruscatingly illustrated in the central image of the altarpiece, a monumental predecessor of the Crucifixion now in the National Gallery of Art, Washington. This calming and intercessory role was commonly assigned to images of Saint Sebastian. Mantegna's saint, by contrast, dramatically assumes within his own person the sufferings of our sinful world—sufferings that

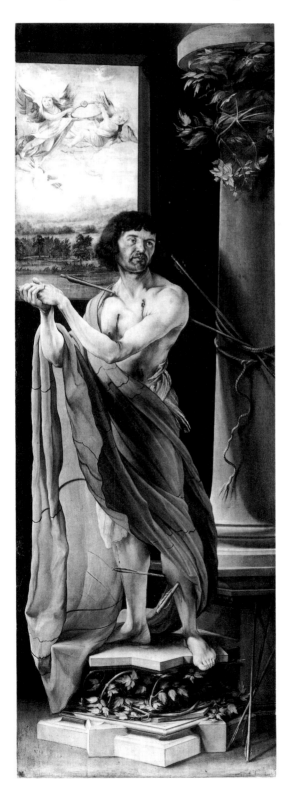

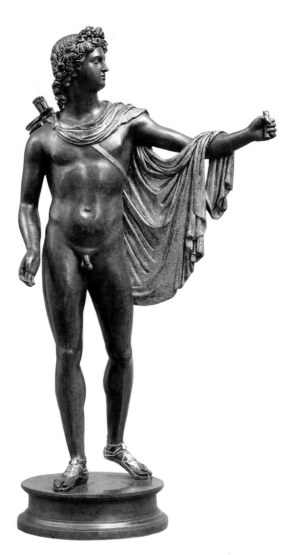

fig. 12. Antico, *Apollo Belvedere*. c. 1498, bronze. Liebieghaus, Museum alter Plastik, Frankfurt

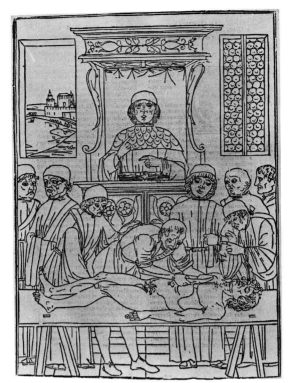

fig. 13. *Dissection of a Human Body*. Woodcut. From J. Ketham, *Fasciculus medicinae*, Venice, 1493

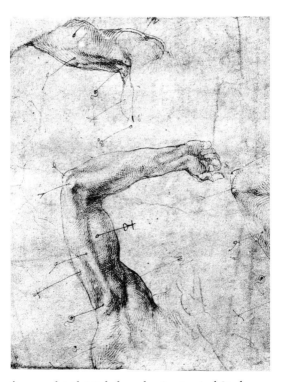

fig. 14. detail, Michelangelo, *Anatomical Study*. c. 1505, pen and ink. Graphische Sammlung Albertina, Vienna

a churchman, but we should remember that Bishop Lodovico was also an important patron of Antico. The series of bronzes by Antico that Isabella d'Este sought to obtain in 1519 were to be based on models and molds that had been used by the artist twenty years earlier to cast statuettes for Lodovico.[30] When Mantegna was in financial difficulties towards the very end of his life and reluctantly decided to sell his prized antique bust of *Faustina*, Bishop Lodovico was considered to be a likely purchaser, since "he delights in such things, and is a spender."[31] The actual buyer was Isabella, who obtained an expert opinion on its high valuation from none other than Antico. Moreover, while Mantegna painted the anguished *Saint Sebastian* during this period, he continued to work right up to the end of his life on elegant and erudite *all'antica* allegories for Isabella's *studiolo*.

Such patronage illustrates the elasticity of the patrons' taste in responding to the different frameworks for viewing the various types of works, and the artists' virtuosity in responding to such widely divergent demands. The full range of possibilities for the naturalistic portrayal of the human figure—from highly idealized to directly anatomical, from hedonistically beautiful to brutally expressive, from classically erudite to piously devotional—could coexist in infinitely variable permutations in works of art associated with the same period, country, locality, building, patron, or artist, or even within an individual image. It is this richness of potential, rather than a single, easily definable quality, that best characterizes the Renaissance discovery of the human figure.

In the course of the fifteenth century, theorists articulated the demand that the artist must master the anatomical structure of the human figure in order to realize its potential. In his *Della pittura*, Alberti recommends "when painting living creatures" the draftsman should "first contrive to lay in the bones, for, as they bend least, they always occupy a certain definite position. Then locate the tendons and muscles, and finally clothe the bones and muscles with flesh and skin."[32] Lorenzo Ghiberti recommends that the sculptor who wishes to make a *statua virile* should "have witnessed dissection [*veduto notomia*] in order... to know how many bones are in the human body, what are the muscles in the human body, and similarly the tendons and sinews in it."[33] When he refers to witnessing anatomy, Ghiberti is probably alluding to the formalized dissections performed under the professor's eyes in a medical school, as illustrated in Johannes Ketham's book. Donatello's bronze relief, *The Miracle of the Miser's Heart* (Sant'Antonio, Padua) suggests that he had witnessed just such a set-piece dissection.[34]

are a necessary prelude to salvation. This may be a far more personal statement, and we can well believe that this image was painted in 1505–1506, during an epidemic of plague at Mantua, at a time when the great artist himself was only months away from death.

The idea that there is a continuous spectrum of meaning regarding the expressive potential of the human body, within which one can place images by artists belonging to very different national schools, is also confirmed when one looks at patronage and ownership of works of art in the Renaissance. The same patron was evidently capable of appreciating images that stand at opposite ends of this spectrum. For example, from a letter written by one of Mantegna's sons shortly after the artist's death, we know that Mantegna intended the *Saint Sebastian* to be given to Cardinal Lodovico Gonzaga, bishop of Mantua, who was also trying to obtain Mantegna's painting of the *Lamentation over the Dead Christ* (cat. 154). Both these images, we may think, would be appropriate choices for

Opportunities for artists to gain direct, hands-on experience of dissection were strictly limited in the fifteenth century, and there is no unequivocal evidence that any painter or sculptor before Leonardo and Michelangelo conducted his own voyages of discovery into the

inner regions of the human body. The paintings and engravings of Antonio Pollaiuolo from 1460 onwards reveal his ambition to become what Leonardo was to call an "anatomical painter," but it is impossible to demonstrate that his depictions depend upon any deeper knowledge than that obtained by surface inspection of the body and the making of casts. His understanding, which was considerable, appears to blend direct scrutiny of living figures with the keen adoption of certain conventions from Roman sculpture. In his famous *Battle of the Nudes* (cat. 160), he may also have drawn upon anatomical texts such as *De usu partium* by the ancient philosopher, Galen.[35]

Sixtus IV's bull in 1482 helped to clarify the Church's attitude towards dissection, and specifically sanctioned the dissection in medical schools of the bodies of executed criminals.[36] It may have been within a climate of greater tolerance that Leonardo and Michelangelo were able to receive their earliest direct experiences of dissection in the monastic hospitals of Florence. The best documented of the dissections is Leonardo's autopsy of a "centenarian" in the hospital of Santa Maria Nuova in the winter of 1507–1508.[37] During the same period Michelangelo's drawings exhibit an understanding of the surface configurations of the human body that presupposes a developed understanding of the attachments and course of each muscle. This increased knowledge was accompanied by a reexamination of the way in which the artist should use anatomical information. Its overt display in all circumstances, making every figure look like a "sack of nuts" (to use Leonardo's term), was not to be sanctioned.[38] Looking back from his vantage point in the mid-sixteenth century, Vasari criticized artists of the generation of Pollaiuolo and Verrocchio for demonstrating their knowledge in too direct and dry a manner; he praised Leonardo, Michelangelo, and Raphael for showing how anatomical understanding could be placed in the service of the overall character, motion, and emotion of each subject. The revered works of classical antiquity, such as the Apollo Belvedere and the Belvedere Torso, provided some guidance, but the three High Renaissance masters each achieved his own particular way of integrating the fruits of his study into the general framework of his compositions. The contrast between the wiry, calculated detail in the re-creation in bronze of a Roman sarcophagus relief by Michelangelo's master, Bertoldo di Giovanni (cat. 164), and the rhythmic power of Michelangelo's own *Battle of the Centaurs* (see essay by Argan in this catalogue) already signals the transformation in figure style acclaimed by Vasari, even though Michelangelo's relief was undertaken at the

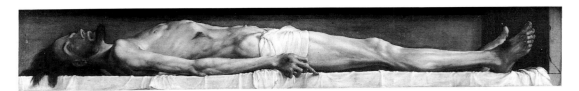

fig. 15. Hans Holbein, *Dead Christ*. 1521, oil on panel. Öffentliche Kunstsammlung Basel Kunstmuseum

very start of his career when working under the wing of the older sculptor.

One of the key requirements for Italian Renaissance artists was to use anatomical knowledge within the context of a system of proportional beauty for the human figure. They knew well enough that the revered Greek artist, Polykleitos, had demonstrated the theory of harmonic proportions by means of his *Canon* (the name of both his treatise and one of his statues).[39] In the absence of detailed information about the *Canon*, however, Renaissance theorists beginning with Cennino Cennini looked both to the Roman scheme outlined in Vitruvius' *Ten Books on Architecture* and to the surviving legacy of a proportional system in Byzantine art. Confirmation of the canon was increasingly sought through direct measurement of the human figure. Typically, Alberti in his *De statua* did not attempt to describe individual human specimens as such, but rather tried to define the underlying ideal, searching for "not simply the beauty found in this or that body, but, as far as possible, that perfect beauty distributed by nature, as it were, in fixed proportions in many bodies."[40] His research resulted in a head-length in a ratio of 1:7.5 to the full height of a man, which departs both from Vitruvius' 8-head norm and the Byzantine 9-face system. This program of research was sustained and extended by Leonardo (cat. 177) and Dürer (cat. 194), and the latter devised alternative systems for figures of inherently different types and ages. It is difficult to know whether artists actually used specific proportional modules in the making of figures, or whether their designs should be seen as responding in a more general way to the idea of proportional beauty. Dürer certainly thought that the Italians owed the superior beauty of their figure style to their adherence to precise measures, and he keenly sought initiation into the "secret" from his Venetian colleague, Jacopo de' Barbari.[41] On the other hand, a number of artists raised their voices to caution that proportional measures should not be used in a mechanical, slavish way. Donatello, when asked to demonstrate his "abacus," is reputed simply to have made a freehand drawing, and Michelangelo was repeatedly credited with the injunc-

tion that the artist should have "compasses in his eyes" rather than in his hands.[42] This does not mean that Michelangelo denied the ultimate existence of musical proportions in the human figure, and in fact his drawings show evidence of his own research into modular systems.[43] Rather, he wished to emphasize that the artist's understanding should have become so naturalized as to transcend the need for laborious constructions. It was on this basis that he was so critical of Dürer's elaborate formulas.

The sense of natural mastery of anatomy and proportion in even the most complex poses, which in the hands of Michelangelo looks so easy, had been hard won by generations of artists. Equally hard won had been the patrons' own growing sense of ease and comfort regarding depictions of the nude human figure. Paradoxically, the acceptance of nakedness in art was harder to achieve in domestic than in religious settings. The portrayal of the *naked* body (to draw upon Clark's distinction between the "naked" and the "nude")[44] had specific meaning in certain religious subjects, such as the Expulsion of Adam and Eve. And the nakedness of the Christ Child in Renaissance paintings of the Madonna and Child was intended to emphasize the idea that "the Word had become flesh."[45] The near-naked dead Christs of Mantegna (cat. 154) and Holbein dramatically illustrate how the new resources for the portrayal of the corporeality of the human body could be used to transform the impact of religious images. Using the technique of foreshortening, Mantegna lays his Christ on the unyielding stone of unction, composed of veined marble, which, according to legend, was stained forever by the Virgin's tears. His feet, the "lowest" part of Jesus, with their open wounds, are thrust assertively into our space and our view. The realism of their wrinkled soles is precisely of the kind that would disconcert Caravaggio's patrons over a century later. Holbein, for his part, uses resources of a realism that was no less uncompromising if different in emphasis. Whereas Mantegna uses his sculptural synthesis of forms in perspective to provide a selective assertion of Christ's mutilation, every inch of Holbein's figure bears eloquent witness to the unbearable strains to which Christ has been subjected. The

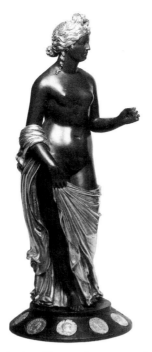

fig. 16. Antico, *Venus Felix.* c. 1519, bronze. Kunsthistorisches Museum, Vienna

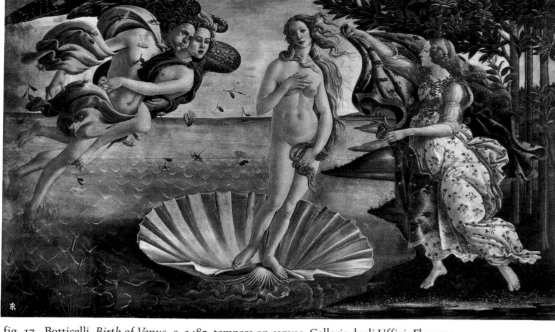

fig. 17. Botticelli, *Birth of Venus.* c. 1485, tempera on canvas. Galleria degli Uffizi, Florence

artist's skill in handling oil paint allows him to achieve a sense of the reality of dead flesh over ravaged muscles and tortured joints which none of the Italian masters could rival. Both artists use their varieties of realism fully to exploit the resonant meaning of Christ's body for those worshipers who celebrate the real presence of his flesh in the wafer of the Eucharist.

In a secular context, by contrast, a naked figure had to become a *nude,* acceptable within a changed framework of assumptions governing the role of art. Only in the generation that included Antonio Pollaiuolo, whose great Hercules cycle for the Medici was apparently painted as early as 1460, and Botticelli, who was working for the Medici in the last quarter of the century, was the new figure style united with classical subject matter on a grand scale, which had not been seen since Roman times. These images reveal a complex set of motivations on the part of the patrons. At the center of the aspirations of patrons like the Medici was the desire to transform the styles and mores of antiquity into forms relevant to contemporary needs. Specially commissioned works of literature and the visual arts were intended to suggest that the patron shared in the valor of ancient heroes (not least in deference to Florence's traditional devotion to Hercules) and to shape a poetic ideal of womanhood as immaculate yet ultimately available to the hero. Botticelli's *Birth of Venus,* in which the emerging goddess has been idealized to the point at which she has become "de-anatomized," is an expression of hedonism, no less than Antico's *Venus.*

Since Antico's bronze was made for Isabella d'Este, we should not necessarily think of such images as exclusively oriented to the male, but they clearly function most powerfully within a social system in which a beautiful young woman is expected to assume a role defined by men. Large-scale pictures of nude or sensuously attired female figures were often commissioned to celebrate an event such as a betrothal or marriage and convey through their philosophical allegories an ideal vision of transcendently harmonious relationships—in contrast to the rougher realities of domestic life. Botticelli's graceful *Primavera* (Uffizi, Florence), for example, appears to have been painted for the youthful Lorenzino de' Medici to perform just such a function, conveying the hope—in the words of a letter Lorenzino received from the philosopher, Marsilio Ficino—that "a nymph of such nobility" should be "wholly given into your power. If you were to unite with her in wedlock and claim her as yours, she would make all your years sweet and make you the father of fine childen."[46]

In other contexts, however, the unclothed female figure as an object of beauty bore less comforting messages for male patrons, and it could readily become charged with ambiguous feelings and anxieties. A good example is Hans Baldung Grien's *Eve, the Serpent, and Death.* Baldung, who shared so many of his northern contemporaries' fascination with the Italianate Venus figure, could with the minimum of adjustments transform the beloved ideal of the Italian courts into a threatening temptress, the

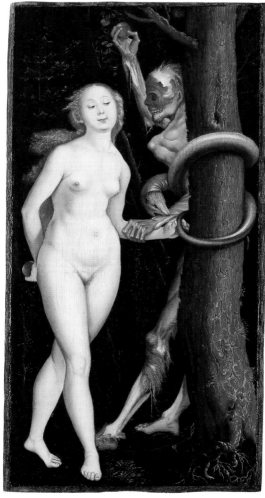

fig. 18. Hans Baldung Grien, *Eve, the Serpent and Death.* c. 1520, oil on panel. National Gallery of Canada, Ottawa

siren who haunts man's imagination and who as Eve was the intermediate agent of man's fall from grace.

This discovery of the evocative power of the human body across such a broad range of functions in the secular and spiritual worlds has a counterpart in Renaissance philosophy. Pico della Mirandola, the philosopher who is often taken as epitomizing the era of Lorenzo il Magnifico, in a famous passage characterized the diverse potential of the human spirit: "You shall have the power to degenerate into the lower forms of life, which are brutish. You shall have the power, out of your soul's judgment, to be reborn with the higher forms of life which are divine."[47]

LEONARDO AND DÜRER: MAN, NATURE, AND THE ART OF UNDERSTANDING

When Albrecht Dürer was in Venice in 1506 on the second and last of his trips to Italy, he sent a series of letters to the learned humanist, Willibald Pirckheimer, his close confidant in their native city of Nuremberg. Towards the end of a long letter written that October, Dürer responded to Pirckheimer's inquiry about the date of his return to Germany: "I shall have finished here in ten days; after that I should like to ride to Bologna to learn the secrets of the art of perspective, which a man is willing to teach me. I should stay there eight or ten days and then return to Venice. After that I shall come with the next messenger. How I shall freeze after this sun! Here I am a gentleman, at home only a parasite."[48] The last remark reflects one of the most notable aspects of the Italian Renaissance revolution in the visual arts, namely the high social status attained by a select group of major artists, who now expected to be ranked with the gentlemanly practitioners of the so-called liberal arts—those arts (like music) that could lay claim to an intellectual basis in rational theory. Leonardo was prominent among the theorists who began to insist that artists were not rude craftsmen but rather intellectuals, deserving of high rank in society. Hence the coupling in Dürer's mind of the acquisition of theoretical knowledge—in this case, the painters' science of perspective—with the perception of his social standing. Although there is evidence of criticism and jealousy directed against Dürer by his fellow painters in Venice, he was generally accorded the status of a celebrity on his second visit. He shared a mutual admiration with the aged Giovanni Bellini, the father of Venetian Renaissance painting, and he was greatly respected by the most celebrated painter of northern Italy, Andrea

Mantegna, who was Bellini's brother-in-law. Joachim Camerarius, another of Dürer's learned German friends, tells a revealing story in the preface to his Latin translation of Dürer's *Four Books on Human Proportion* (cat. 194). "While Andrea was lying ill at Mantua he heard that Albrecht was in Italy and had him summoned to his bed at once, in order that he might fortify Albrecht's facility and certainty of hand with scientific knowledge and principles. For Andrea often lamented in conversation with his friends that Albrecht's facility had not been granted to him nor his learning to Albrecht."[49] Unfortunately, much to Dürer's regret, before he could reach Mantua Mantegna died, so he was unable to pay direct homage to the artist who had provided him with some of his earliest knowledge of Italian Renaissance style.[50]

Camerarius' anecdote, whose truth we have no reason to doubt, precisely reflects Dürer's conviction that natural gifts of hand should be cultivated through the "science" of theory, so that the full glory and rationale of God's creations might be demonstrated through art. The typical young painter in Germany, Dürer lamented, "has grown up in ignorance, like a wild and unpruned tree," lacking access to the theoretical principles through which he could gain true "understanding" and become a *kunstreicher meister* (a master rich in artistry).[51] To rectify this deficiency, Dürer planned to write a comprehensive treatise on art, embracing such topics as the proportions of the human figure, perspective, light and shade, colors ("how to paint like nature"), and composition.[52] His unrealized ambition to write such a work resembles that of Leonardo, and this resemblance is not coincidental. Not only were the two masters looking toward the same sources, such as the writings of the ancient Roman architect Vitruvius and Alberti's *Della pittura*, but also there is ample evidence that Dürer had direct knowledge of Leonardo's art and ideas.

There is no record of direct personal contact between the two men, but neither is there any shortage of possible intermediaries. Galeazzo Sanseverino, son-in-law of Ludovico Sforza and one of Leonardo's patrons in Milan, stayed at Pirckheimer's house in Nuremberg in 1502.[53] One of Leonardo's colleagues in the employ of the Sforza, the military architect Lorenz Behaim, returned from Milan to Nuremberg in 1503.[54] Emperor Maximilian I, a notable patron of Dürer, married the Milanese princess Bianca Sforza, who was accompanied to Germany by Ambrogio da Predis, a collaborator of Leonardo. And whomever Dürer may have met in Bologna to learn perspective, it was someone whose ideas were closely associated with those of Luca Pacioli, if not Pacioli himself. Pacioli had been

Leonardo's close companion in Milan and Florence and, as mentioned earlier, his geometrical treatise, *De divina proportione*, was illustrated by Leonardo with perspectival diagrams of the Platonic solids and their derivatives. The treatise would have been known to Dürer in the Florentine edition of 1509 (cat. 142).[55] Dürer's own works contain plentiful indications that these or other contacts bore fruit—not only echoes of Leonardo's creations in his own works of art but also, more compellingly, direct records in Dürer's notebooks of some of the Italian master's artistic inventions and theoretical investigations. The most notable of these occur in Dürer's so-called Dresden Sketchbook, which contains drafts for his book of human proportions.

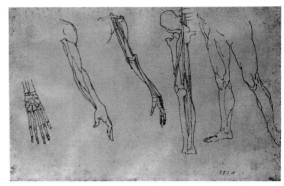

fig. 19. Albrecht Dürer, *Studies of the Hand, Arms and Legs*. c. 1517, pen and ink, fol. 130v, Dresden Sketchbook. Sachsische Landesbibliothek, Dresden

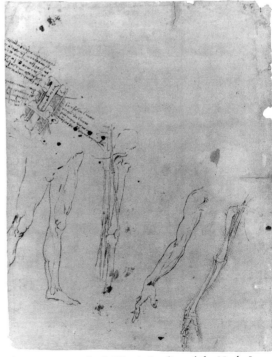

fig. 20. Leonardo da Vinci, *Studies of the Neck, Legs and Arms*. c. 1489, pen and ink. Her Majesty Queen Elizabeth II, Royal Library, Windsor Castle

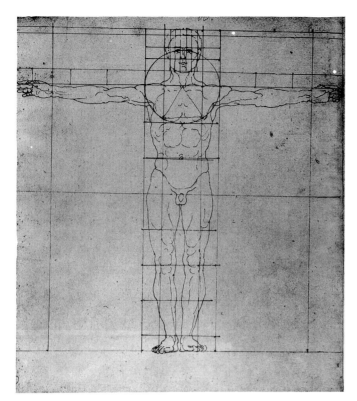

fig 21. Albrecht Dürer, *Proportion Study of Man with Outstretched Arms*. c. 1513, pen and ink, fol. 123v, Dresden Sketchbook. Sachsische Landesbibliothek, Dresden

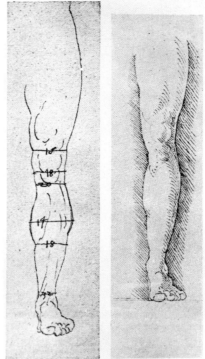

fig. 22. Albrecht Dürer, *Study of the Proportions of the Left Leg of a Man*. c. 1513, pen and ink, fol. 102v, Dresden Sketchbook. Sachsische Landesbibliothek, Dresden

The most surprising evidence of Dürer's knowledge of Leonardo's drawings appears on two folios of this sketchbook, which precisely copy, in reverse, a group of Leonardo's anatomical studies devoted to the skeleton and nerves.[56] There is no indication that the drawings by Leonardo in question ever left his possession, and by the time Dürer made his versions in 1517, these particular studies had been rendered obsolete by Leonardo's own far more sophisticated later research. It is likely, therefore, that Dürer was copying rare, and now lost, engraved "facsimiles" of Leonardo's drawings—hence the reversal of the images— perhaps made by the new process of "relief etching," which Leonardo himself wrote of using for anatomical illustration.[57] Leonardo's studies were part of an early series executed around 1490 in which he investigated the way the network of "hollow" nerves communicated with the ventricles of the brain, within whose cavities the various faculties of mental activity were thought to occur (cat. 179). Dürer himself, in 1498, illustrated this traditional view of the mental faculties in a woodcut of the *caput physicum* for a treatise by Pruthenius. These forays into the inner anatomical and physiological mechanisms of body and mind were exceptional in Dürer's work, in marked contrast to Leonardo's obsessive search for cause and effect in the

operation of all aspects of the human body, which he regarded as nature's supreme creation. For Leonardo, a complete understanding of man the microcosm, in whom the universal principles of natural order were mirrored, was necessary if the artist was to depict human beings in his works of art in such a way that their appearance accorded perfectly with their characters and situations. Although Dürer was as keenly interested as Leonardo in the doctrine of the four human temperaments—sanguine, choleric, phlegmatic, and melancholic—he was more concerned with characterizing their effects on human appearance and behavior than with inquiring into the mechanisms through which the four humors give rise to the temperaments.

In one of their areas of mutual concern, the rules governing human proportion, Dürer succeeded in pursuing his research farther than Leonardo. Dürer initially sought advice on the "secret" of human proportions from Jacopo de' Barbari, the Venetian painter who worked in Germany beginning in 1500. However, Jacopo did not offer him adequate guidance, so Dürer subsequently turned to a variety of written sources. He went directly to Vitruvius, as had Leonardo, and to those theorists who had worked variations on Vitruvian ideas. The latter surely included Alberti, whose writings were certainly accessible to Dürer, and Pomponius

Gauricus, whose treatise *De sculptura* of 1504 is known to have been in Pirckheimer's library.[58] Dürer also gained detailed knowledge of Leonardo's investigations. Some of the Dresden studies, such as that of the left leg of a man, are so close to Leonardo's surviving drawings of the 1490s as to indicate that they are based directly upon the kind of lost studies or engravings that were later copied by Carlo Urbino, the author of the Codex Huygens.[59] The system used by Dürer expresses the widths of the limbs as aliquot fractions of the total height of the figure, whereas Leonardo uses a system of fractions of face-lengths. In both systems, the basic idea—that there were fixed proportional relationships between each part of a human body and the whole—is fundamentally similar, and both men regarded such proportional harmonies as akin to those of music.[60] Dürer also shared Leonardo's belief that a single canon of beauty was not adequate to reflect the varied types of the human figure in nature. However, he took this idea much farther than did Leonardo, conducting a painstaking analysis of the different proportional systems in a wide range of figures, from short and fat to tall and thin, and showing how the "mean" proportions of those figures which he regarded as closest to "true beauty" might be systematically compressed and stretched to produce other bodies consistent within themselves.[61] Dürer's system was accused, particularly by Michelangelo and his followers, of being overly doctrinaire and mechanical, but Dürer himself stressed that his system was directed toward achieving a comprehensive understanding of the design principles of divine nature rather than toward providing precise formulae for the creation of particular works of art: "If you have learnt well the theory of measurements and attained understanding and skill in it, so that you can make a thing with free certainty of hand, and know how to do each thing correctly, then it is not always necessary to measure everything."[62]

Dürer also applied his method of progressively transforming the geometrical "mean" to the human head, with remarkable results. He showed how the differential compression and skewing of the geometrical modules of the ideal head could result in astonishingly varied physiognomies, giving systematic expression to the kind of grotesque heads that had become Leonardo's specialty. No picture better demonstrates Dürer's ambition to emulate Leonardo as a *kunstreicher meister* in the field of physiognomic expression than the *Christ among the Doctors* in the Thyssen-Bornemisza Collection. This is probably the picture he described to Pirckheimer in 1506 as a "*Quadro* [using the Italian term] the like of which I have never

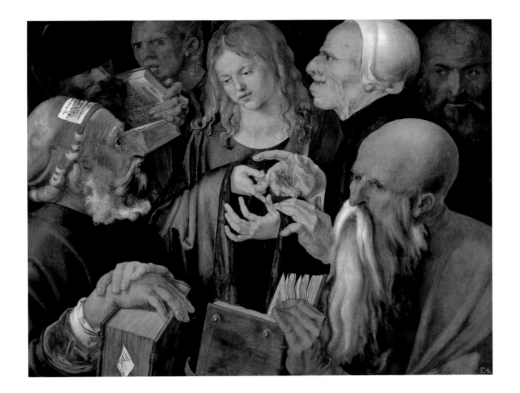

painted before."[63] The piece of paper protruding from the book of the doctor on the left indicates that it was the *opus cinque dierum* (work of five days). Dürer challenged the Italians, and especially Leonardo, on their own territory. He employed facial expressions and manual gestures to convey the temperaments and "motions of the mind" of each participant in what Alberti would have called a *historia*. He consciously enhanced Christ's youthful beauty in juxtaposition to the gnarled heads and hands of the older disputants, precisely in the manner recommended by Leonardo: "I say that in narrative paintings you should closely mingle direct opposites, because they offer a great contrast to each other, and the more so the more they are adjacent. Thus, have the ugly next to the beautiful."[64] To the "learning" of the Italians, Dürer consciously added his own manual gifts, demonstrating his unmatched graphic facility with descriptive and expressive line, the skill Mantegna had so envied.

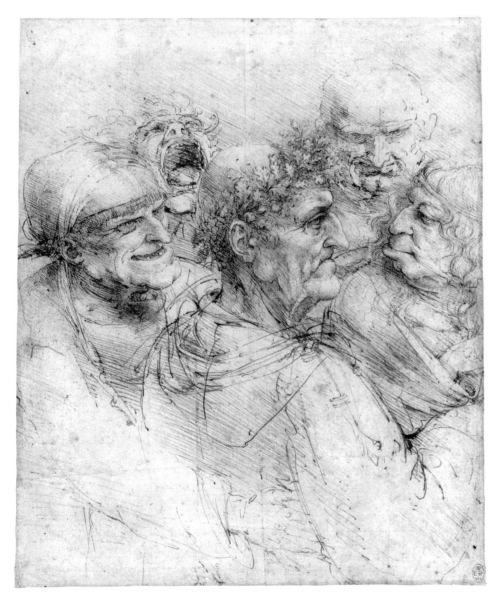

left:
fig. 23. Leonardo da Vinci, *Five Grotesque Heads*. c. 1495, pen and ink. Her Majesty Queen Elizabeth II, Royal Library, Windsor Castle

above right:
fig. 24. Albrecht Dürer, *Study of Fifteen Constructed Heads*. c. 1513, pen and ink, fol. 97r, Dresden Sketchbook. Sachsische Landesbibliothek, Dresden

above left:
fig. 25. Albrecht Dürer, *Christ among the Doctors*. 1506, oil on panel. Thyssen-Bornemisza Collection, Lugano

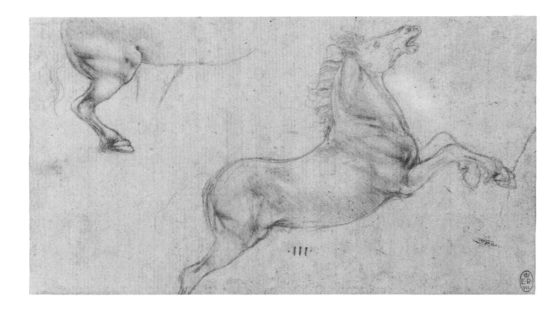

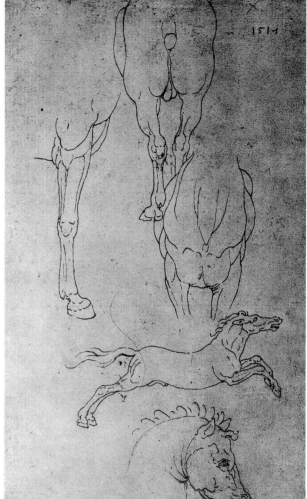

above left:
fig. 26. Leonardo da Vinci, *Study of a Leaping Horse*. c. 1481, metalpoint. Her Majesty Queen Elizabeth II, Royal Library, Windsor Castle

center:
fig. 27. after Leonardo, *Horse's Head*. Engraving. Her Majesty Queen Elizabeth II, Royal Library, Windsor Castle

right:
fig. 28. Albrecht Dürer, *Studies of Horses*. 1517, pen and ink, fol. 175v, Dresden Sketchbook. Sachsische Landesbibliothek, Dresden

In Dürer's view, the artist with true "understanding" should not stop with a mastery of the human figure; he was to comprehend all nature. Like Leonardo, Dürer intended to extend his studies of proportions to horses, and the Dresden Sketchbook again indicates his direct familiarity with Leonardo's designs. In this instance, early engravings of Leonardo's horse studies have survived and provide examples of the kind of prototypes that were accessible to Dürer. The result of his studies was to combine the kind of proportional control exercised by Leonardo with his own graphic vigor and with the remarkable sense of surface detail exhibited in his master-engraving, *Knight, Death, and Devil* (cat. 196).

Dürer applied an equally intensive scrutiny to the inanimate and most modest parts of God's creation. He devoted no less an effort of concentrated attention to an apparently unprepossessing tuft of grasses and plants in his *Piece of Turf* than to his own facial features in one of his self-portraits. His intensity of observation yields nothing to Leonardo's closely focused studies of plants, such as the *Star-of-Bethlehem*

(cat. 184), but the motivating forces behind the portrayals are rather different. Dürer's analysis is dedicated to describing the formal irregularities that arise in this particular corner of nature, with its tangled stems, mingled roots, and soggy mud. Leonardo, by contrast, characteristically uses his graphic representation as a way of expressing the general laws of plant structure and patterns of growth that lie behind the effects visible in the particular specimen. Dürer's studies of nature, whether of minute details or complete scenes, speak of the artist absorbed in the textures of nature, responding with astonishing freshness to the transitory beauties of the passing times of day and seasons. Leonardo was similarly fascinated by the fleeting effects of atmospheric phenomena (cat. 169), but we can always sense his obsession with the *processes* involved and with the optical laws governing their appearance. For Dürer, the ravishing effects speak eloquently of the "meaning" of the world, and the artist's role is to act as an informed individual conduit for God's painting of nature. For Leonardo, on the other

hand, the artist-scientist's role is to extract the underlying causes of natural law behind the effects and to remake nature according to these absolute and impersonal principles.

Nowhere are the two artists' different views of the role of the individual artist more vividly apparent than in their representation of "visionary" scenes. If we set Dürer's watercolor of one of his "dreams" beside one of Leonardo's so-called Deluge Drawings (cat. 188), the divergence is clear. The signed note beneath Dürer's drawing describes how he saw in his sleep on Whitsunday night a terrifying vision of "great waters" falling from heaven: "When the first water that touched the earth had very nearly reached it, it fell with such swiftness, with wind and roaring, and I was so sore afraid that when I awoke my whole body trembled and for a long while I could not recover myself. So when I arose in the morning I painted it above here as I saw it. God turn all things to the best."[65] Dürer was much taken with the interpretation of natural phenomena as portents—as signs of God communicating through nature—

and on another occasion he carefully recorded a miraculous rain of crosses that was experienced in Nuremberg in 1503, depicting a specimen Crucifixion as a guarantee of the authenticity of the miracle.[66] He also, as was common at that time, gave great credence to the doctrines of astrology.

Leonardo, by contrast, was highly suspicious of the extravagant fantasies of dreaming and distrusted the attribution of natural phenomena to the direct agency of the supernatural. His deluges are no less "visionary" and apocalyptic than the storm of Dürer's dream, but their fury is described in the formal terms of a vortex motion that is expressive of natural law. Leonardo's instructions for how to portray a deluge are couched in impersonal terms: "Let there first be represented. . . ." And his account leaves no doubt that the deluge is to be described in accordance with the laws of dynamics and optics: "The waves that in concentric circles flee the point of impact are carried by their impetus across the path of other circular waves moving out of step with them, and after the moment of percussion leap up into the air without breaking formation. . . . The air was darkened by the heavy rain that, driven aslant by the crosswinds and wafted up and down through the air, resembled nothing other than dust, differing only in that this inundation was streaked through by the lines that drops of water make as they fall. But its color was tinged with the fire engendered by the thunderbolts that rent and tore the clouds apart."[67]

The two artists developed distinctively different conceptions of their own presence as subjective participant and objective observer in relation to the subjects they portrayed. This difference is reflected in their writings on the theory of art. Both men subscribed to the view that every painter tends to "paint himself" in his own works, that is to say, to create images that reflect his personal idiosyncrasies, physical and mental.[68] Both viewed this tendency as undesirable, since the deformities of the individual lead the artist away from an understanding of true beauty. Dürer, however, was not prepared to go as far as Leonardo in subordinating individual response and subjective impulse to the rule of law. Leonardo disparaged inventions and ideas that "begin and end in the mind," setting "experience" of the action of law in nature above personal insight and far above the kind of transcendental speculations on divine truth that were characteristic of a certain kind of neo-Platonism.[69] He did not ignore the artist's powers of invention; indeed, he gloried in the ability of the artist's *fantasia* to devise new forms through the infinitely variable compounding of natural features.[70] But the artist's inventions were no less subject to the necessities of natural law than were the creations of nature. Although Dürer by no means approved of an artist relying upon his unaided imagi-

nation—which he believed must always be nourished by the informed study of nature, as Leonardo insisted—he did delight in the inherent ability of someone "naturally disposed" toward art to "pour forth and produce every day new shapes of men and other creatures, the like of which was never seen before nor thought of by any other man."[71] He gives social, theological, and philosophical justifications for this ability: "Mighty kings. . .made the outstanding artists rich and treated them with distinction because they felt that the great masters had an equality with God, as it is written. For, a good painter is inwardly full of figures, and if it were possible for him to live for ever he would always have to pour forth something new from the inner ideas of which Plato writes."[72] Such access to God-given (or "Platonic") ideas within the mind was not something that Leonardo sought.

It is consistent with the greater scope Dürer permitted the artist's individuality, whether as an impassioned observer of the signs of nature or as a font of endless ideas, that he was prepared to acknowledge the special qualities of the artist's "hand." Although we see Leonardo's works, particularly his drawings, as full of his personal "handwriting," just as they teem with his individual powers of invention, his own theoretical injunctions left no room for the individuality of the artist's touch. But Dürer was fascinated by the gifted artist's "hand," both as

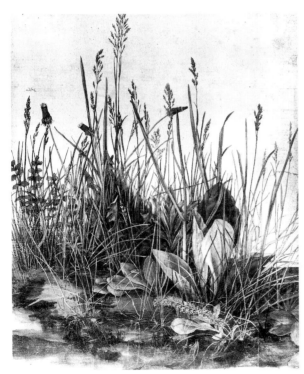

fig. 29. Albrecht Dürer, *Piece of Turf*. 1503, watercolor and body color. Graphische Sammlung Albertina, Vienna

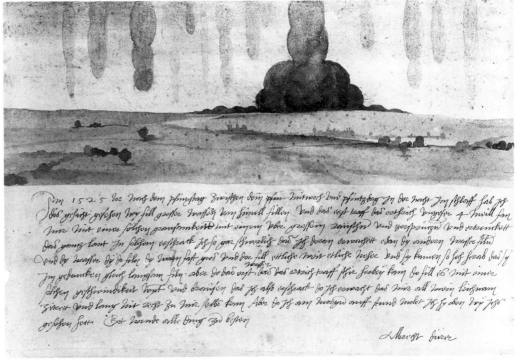

fig. 30. Albrecht Dürer, *Dream of Waters Descending from the Sky*. 1525, pen and ink and watercolor. Kunsthistorisches Museum, Vienna

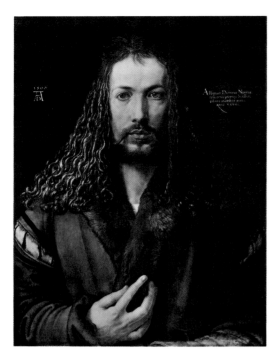

fig. 31. Albrecht Dürer, *Self-Portrait*. 1500, oil on panel. Bayerische Staatsgemäldesammlungen-Alte Pinakothek, Munich

a general concept and in individual cases. In his view, a slight sketch, "roughly and rudely done," by a "powerful artist" will have its own special value: "A man may often draw something with his pen on a half-sheet of paper in one day or engrave it with his tool on a small block of wood, and it shall be fuller of art and better than another's great work on which he has spent a whole year's careful labor."[73] He refers to this, earlier in the same passage, as the ability of the artist "to make himself seen in his work." This concern explains Dürer's wish to acquire examples of the "hand" of other masters. Having obtained a drawing by Raphael, he added an inscription that was clearly addressed to posterity: "Raffahell de Urbin who is so highly esteemed by the Pope made these naked figures and sent this to Albrecht Dürer in Nuremberg in order to show him his hand."[74]

The scope Dürer allowed to individuality was part of his highly developed sense of his own individual presence and his relationship to others. In his diaries, notebooks, drawings, and watercolors, he intentionally provided a greater personal insight into his life (both circumstantial and emotional) than survives for any other artist of his time, although he seems to have resisted any detailed characterization of his relationship with his wife, whom we largely know through the ungenerous assessment of Pirckheimer.[75] The autobiography preserved in his art even extends to a drawing of himself in the nude to record a malady: "The yellow spot which I point out with my finger is the place where it hurts."[76] Although Leonardo left a vast

legacy of notes, including numerous memoranda about his daily life, he never willingly dropped the mask of objective recording and analysis, and such personal insights as do emerge either arise inadvertently or must be discerned beneath the surface. Leonardo recorded even his father's death dispassionately, in a dry memorandum, whereas Dürer wrote movingly about the illness and death of both his father and mother.[77] Not surprisingly, it is Dürer who left behind a great series of drawn and painted self-portraits, which reflect the astonishing range of his physical, social, and mental attributes. Although a degree of self-characterization has been discerned behind some of Leonardo's portrayals of bearded "seers," direct self-portraiture as such appears to have been of little interest to him. Even the famous red chalk drawing in Turin, generally taken to be Leonardo's only authentic self-portrait, is probably an idealized type and not a direct representation of Leonardo himself.[78] It is difficult to imagine Leonardo painting the equivalent of Dürer's astonishing self-image of 1500 in Munich, in which the theological injunction to "imitate Christ" is translated into the specific terms of the artist who is inwardly full of divine ideas.

Thus, for all their apparent affinities in establishing the most ambitious conception of the artist as a man of universal "understanding," for all their shared concerns as theorists, and for all the common motifs in their art, the ultimate targets of the two masters were distinctly different. Leonardo was interested in extending absolute understanding into every corner of the created world outside himself, searching for the laws of form and function that would bring nature's apparent diversity within the embrace of common causes. Dürer's great concern was to act as a visual spokesman for God's multitudinous signs in nature, and he exploited his full measure of acquired learning and highly personal insight toward this divine end. In their respective discoveries of man as an integral part of nature's awesome system of cause and effect and of men as the individual conduits for the perception of God's creation, Leonardo and Dürer embody the two Renaissance conceptions of art that were to dominate future generations of creators over at least the next four centuries.

NOTES

1. *I Libri della famiglia*, trans. R. N. Watkins, *The Family in Renaissance Florence* (Columbia, S.C., 1969), 133–134.
2. Martin Kemp, ed., *Leon Battista Alberti on Painting*, trans. C. Grayson (Harmondsworth, 1991), 53.
3. Jacob Burckhardt, *The Civilization of the Renaissance in Italy*, trans. S. Middlemore (London, 1960), 81.
4. Burckhardt 1960, 171–172.
5. J.R.S. Phillips, *The Medieval Expansion of Europe* (Oxford, 1988).
6. C. R. Mack, *Pienza, the Creation of a Renaissance City* (Ithaca, N.Y., 1987).
7. Leon Battista Alberti, *Momo o del principe*, ed. R. Consolo (Genoa, 1985), 234–235.
8. Kemp 1991.
9. D. Friedman, *Florentine New Towns: Urban Design in the Late Middle Ages* (Cambridge, Mass., 1988).
10. Friedman 1988, 341.
11. J. White, *The Birth and Rebirth of Pictorial Space*, 2d ed. (London, 1967), 113–121; S. Y. Edgerton, Jr., *The Renaissance Rediscovery of Linear Perspective* (New York, 1975), 143–145; Martin Kemp, *The Science of Art: Optical Themes in Western Art from Brunelleschi to Seurat* (New Haven, 1990), 11–15, 344–345.
12. I. Hyman, "Notes and Speculations on San Lorenzo, Palazzo Medici, and an Urban Project by Brunelleschi," *Journal of the Society of Architectural Historians* 34 (1975), 98–119.
13. Leonardo Bruni, *Laudatio Florentinae urbis*, trans. B. Kohl, in *The Earthly Republic: Italian Humanists on Government and Society*, ed. B. Kohl and R. G. Witt (Manchester, 1978), 141. See also H. Baron, *The Crisis of the Early Italian Renaissance*, 2d ed. (Princeton, 1966), 199–211.
14. Leon Battista Alberti, *On the Art of Building in Ten Books*, trans. J. Rykwert, N. Leach, and R. Tavernor (Cambridge, Mass., 1988), 92.
15. Alberti 1988, 121.
16. Alberti 1988, 126.
17. Alberti 1988, 191.
18. For Filarete (Antonio Averlino), see J. R. Spencer, ed. and trans., *Filarete's Treatise on Architecture* (New Haven, 1965), and the edition by A. M. Finoli and L. Grassi (Milan, 1972); for Francesco di Giorgio, see *Trattati di architectura civile e militari*, ed. C. Maltese and L. Maltese Degrassi, 2 vols. (Milan, 1967).
19. M.G.C.D. Dal Poggetto, "La 'Città ideale' di Urbino," in *Urbino e le Marche prima e dopo Raffaello* [exh. cat., Galleria Nazionale delle Marche] (Urbino, 1983), 71–78; and Mack 1987.
20. P. Marconi, ed., *La Città come forma simbolica*, Biblioteca di storia dell'arte 7 (n.p., n.d.); E. Garin, "La Cité idéale de la Renaissance italienne," and R. Klein, "L'Urbanisme utopique de Filarete à Valentin Andreaé," in *Les Utopies à la Renaissance* (Brussels, 1963), 11–37, 209–230; and L. Gambi, "La Città da imagine simbolica e proiezione urbanistica," *Storia d'Italia: Atalante* 6 (1976), 217–228.
21. M. Dalai Emiliani, "Figure rinascimentali dei poliedri Platonici: Qualche problema di storia e di autografia," in *Fra Rinascimento, manierismo e realtà*, ed. P. Marani (Florence, 1984); and Martin Kemp, "Geometrical Bodies as Exemplary Forms in Renaissance Space," in *World Art: Themes of Unity in Diversity*, Acts of the 26th International Congress of the History of Art, ed. I. Lavin, 3 vols. (London, 1989), 1:237–242.
22. R. Wittkower, *Architectural Principles in the Age of Humanism*, 3d ed. (London, 1962), 14–15, pls. 2–3.
23. Luca Pacioli, *De divina proportione* (Florence, 1509). For Pacioli, see P. L. Rose, *The Italian Renaissance of Mathematics* (Geneva, 1975), 143–144.
24. L. Cheles, *The Urbino Studiolo* (Wiesbaden, 1986). For Federigo and mathematics at Urbino, see Rose 1975, 54–55.
25. Martin Kemp, "The Taking and Use of Evidence;

with a Botticellian Case Study," *Art Journal* 44 (1984), 207–215.

26. Edgerton 1975, 91–123.

27. P. Fortini Brown, *Venetian Narrative Painting in the Age of Carpaccio* (New Haven, 1988), especially chap. 10.

28. B. Yamey, *Art and Accounting* (New Haven, 1989).

29. H. Chaumartin, *Le Bal des ardents* (Paris, 1946), 100. For the context of Grünewald's altarpiece, see Andrée Hayum, *The Isenheim Altarpiece: God's Medicine and the Painter's Vision* (Princeton, 1989). For the rosary, see G. Ritz, *Der Rosenkranz* (Munich, 1963).

30. Umberto Rossi, "I Medaglisti del Rinascimento alla corte di Mantova, II: Pier Jacopo Alari-Bonacolsi detto l'Antico," *Revista italiana di numismatica* 1 (1888), 161–194, 433–438; and Anthony Radcliffe, "Antico and the Mantuan Bronze," in *Splendours of the Gonzaga* [exh. cat., Victoria and Albert Museum] (London, 1981), 46–49.

31. Paul Kristeller, *Andrea Mantegna* (Berlin, 1902), 577.

32. Kemp 1991;

33. Lorenzo Ghiberti, *I Commentarii*, ed. Julius von Scholosser (Berlin, 1912), 6.

34. Bernard Schultz, *Art and Anatomy in Renaissance Italy* (Ann Arbor, Mich., 1985), 49–51, and more generally for artists' involvement in anatomical investigations.

35. Schultz 1985, 57.

36. Schultz 1985, 61–63.

37. Martin Kemp, *Leonardo da Vinci: The Marvellous Works of Nature and Man*, 2d ed. (London, 1990), 257.

38. Martin Kemp, ed., *Leonardo on Painting*, trans. Martin Kemp and Margaret Walker (New Haven, 1989), 130, no. 333.

39. For the *Canon* and proportions generally, see Erwin Panofsky, "The History of Human Proportions as a Reflection of the History of Styles," in *Meaning in the Visual Arts* (Harmondsworth, 1970), 82–138.

40. Leon Battista Alberti, *"On Painting" and "On Sculpture,"* ed. and trans. Cecil Grayson (Oxford, 1972), 132–135, citing Zeuxis as his precedent.

41. Hans Rupprich, *Dürer: Schriftlicher Nachlass*, 3 vols. (Berlin, 1956–1969), 1:102.

42. Pomponius Gauricus, *De scultura* (1504), ed. André Chastel and Robert Klein (Geneva, 1969), 183–187; and David Summers, *Michelangelo and the Language of Art* (Princeton, 1981), 332–379.

43. Summers 1981, 380–396.

44. Kenneth Clark, *The Nude* (Harmondsworth, 1960), 1: "To be naked is to be deprived of our clothes and the word implies some of the embarrassment which most of us feel in that condition. The word nude . . . carries, in educated usage, no uncomfortable overtone."

45. Leo Steinberg, *The Sexuality of Christ in Renaissance Art and in Modern Oblivion* (London, 1983), 141–143.

46. E. H. Gombrich, "Botticelli's Mythologies," in *Symbolic Images* (London, 1972), 42. The letter was probably written c. 1477–1478 when Lorenzino was fourteen or fifteen years old.

47. Pico della Mirandola, *Oration on the Dignity of Man*, trans. Forbes, in *The Renaissance Philosophy of Man* (Chicago, 1948), 224–225.

48. Rupprich 1956–1969, 1:58; W. M. Conway, trans., *The Literary Remains of Albrecht Dürer* (Cambridge, 1889), 58.

49. J. Camerarius, preface to Dürer's *De symmetria partium humanorum corporum* (Nuremberg, 1532);

Rupprich 1956–1969, 1:307–308; Conway 1889, 139.

50. For Dürer's copies after Mantegna prints in 1494, see W. Strauss, *The Complete Drawings of Albrecht Dürer*, 6 vols. (New York, 1974), vol. 1, 1494/12 to 13; Erwin Panofsky, *The Life and Art of Albrecht Dürer* (Princeton, 1971), 31–32; and F. Anzelewsky, *Dürer: His Life and Art* (New York, 1981), 50–51.

51. *Underweysung der Messung* (Nuremberg, 1525); letter of introduction in W. L. Strauss, ed., *Albrecht Dürer: The Painter's Manual* (New York, 1977), 37; Conway 1889, 171, 188.

52. British Library, MS Sloane 5229, 36v; Sloane 5230, 102r; Rupprich 1956–1969, 2:92.

53. Leonardo was involved with architectural projects for Galeazzo; see Carlo Pedretti, *Leonardo da Vinci: The Royal Palace at Romorantin* (Cambridge, Mass., 1972), 16–18. Galeazzo was the dedicatee of the major manuscript of Pacioli's *De divina proportione* (Ambrosiana, Milan), which contains illustrations designed by Leonardo. See Anzelewsky 1981, 102–104, for Galeazzo and Pirckheimer.

54. Anzelewsky 1981, 104–106.

55. See Martin Kemp, in *Leonardo da Vinci* [exh. cat., Hayward Gallery] (London, 1989), 184.

56. The other Dresden drawing after Leonardo's anatomical studies is fol. 133v, based on Windsor 12613r. See W. Strauss, ed., *The Human Figure by Albrecht Dürer: The Complete Dresden Sketchbook* (New York, 1972), nos. 131–132; Kenneth Clark and Carlo Pedretti, *The Drawings of Leonardo da Vinci in the Collection of Her Majesty the Queen at Windsor Castle*, 3 vols. (London, 1979), no. 12613r-v. Dresden 130v contains four of the five drawings from Windsor 12613v and the hand from 12613r, while 133v contains three of the six drawings on 12613r. Dürer's copies are not identical in size to Leonardo's drawings, but the labored line of the copies suggests that they were traced or directly replicated from Leonardesque prototypes. Dresden 131r is also clearly copied directly from Leonardo, although the original has been lost.

57. L. Reti, "Leonardo da Vinci and the Graphic Arts. The Early Invention of Relief Etching," *Burlington Magazine* 113 (1971), 188–195.

58. Alberti's ideas were adapted in a book published in Nuremberg in 1511, *Das Buch von der Malerei*, and Dürer himself acquired a manuscript of *De statua* in 1523. See Strauss 1972, no. 85; also no. 31, for Pirckheimer and Gauricus. For the adaptations of the "Vitruvian Man," see F. Zollner, *Vitruvs Proportionsfigur: Quellenkritische Studien zur Kunstliteratur im 15. und 16. Jahrhundert* (Worms, 1987).

59. For the knowledge of Leonardo's proportional studies by Dürer and the author of the Codex Huygens, see Erwin Panofsky, *The Codex Huygens and Leonardo da Vinci's Art Theory* (London, 1940), 115–122; Panofsky 1971, 264–268; and F. Zollner, "Die Bedeutung von Codex Huygens und Codex Urbinus für die Proportions- und Bewegungstudien Leonardos da Vinci," *Zeitschrift für Kunstgeschichte* 52 (1989), 334–351; and Zollner, "Leonardo, Agrippa and the Codex Huygens," *Journal of the Warburg and Courtauld Institutes* 48 (1985), 229–234. There is also evidence that Dürer knew the new kind of compasses for the drawing of ellipses that appear in one of Leonardo's studies; see O. Kurz, "Dürer, Leonardo, and the Invention of the Ellipsograph," *Raccolta Vinciana* 17 (1960), 15–26.

60. Codex Urbinas, 16r-v, trans. in Kemp 1989, 34, no. 59; Sloane 5231, 114; Conway 1889, 250; included at

the end of Book 3 in the *Vier Bücher von menschlicher Proportion* (Nuremberg, 1528).

61. For Dürer's *verkehrer* (converter), see Dresden fols. 106v, 103r-v; Strauss 1972, nos. 72–74.

62. Sloane 5231, 114; Conway 1889, 249; Dürer 1528.

63. Letter of 23 September 1506; Conway 1889, 56.

64. Codex Urbinas, 61r-v; trans. in Kemp 1989, 220, no. 568.

65. Rupprich 1956–1969, 1:214–215; Conway 1889, 145.

66. In Albrecht Dürer, *Gedenkbuch* (Kupferstichkabinett, Staatliche Museen Preussischer Kulturbesitz, Berlin); Rupprich 1956–1969, 1:36; Anzelewsky 1981, 16, pl. 6.

67. Windsor 12665r and MS G 6v; trans. in Kemp 1989, 234, no. 583, and 237, no. 586.

68. Codex Urbinas, 44r-v, 107r, 157r; trans. in Kemp 1989, 203, no. 529, and 120, nos. 306–307; Sloane 5230, 14v; Rupprich 1956–1969, 2:100–101; Conway 1889, 180, 199. See Martin Kemp, " 'Ogni dipintore dipinge se': A Neoplatonic Echo in Leonardo's Art Theory," in *Cultural Aspects of the Italian Renaissance: Essays in Honour of Paul Oskar Kristeller*, ed. C. Clough (Manchester, 1976), 311–323; and Kemp, " 'Equal Excellences': Lomazzo and the Explanation of Individual Style in the Visual Arts," *Renaissance Studies* 1 (1987), 10–12.

69. See particularly the texts in Kemp 1989, 10, nos. 4–8.

70. Martin Kemp, "From 'Mimesis' to 'Fantasia': The Quattrocento Vocabulary of Creation, Inspiration and Genius in the Visual Arts," *Viator* 8 (1977), 376–384.

71. Sloane 5231; Conway 1889, 243.

72. Sloane 5230, 68; Rupprich 1956–1969, 2:109–110; Conway 1889, 177, 197. See Erwin Panofsky, *Idea: A Concept in Art Theory*, trans. J. S. Peake (New York, 1968), 123–125, for the classical sources of Dürer's views. See also Martin Kemp, "The 'Super-Artist' as Genius: the Sixteenth-Century View," in *Genius*, ed. P. Murray (Oxford, 1989), 32–53.

73. Sloane 5231, 20r; Sloane 5321, 123r; Conway 1889, 244.

74. Albertina, Vienna, Bd. V.17575, a drawing for two figures at the left of the *Battle of Ostia*; see P. Joannides, *The Drawings of Raphael* (Oxford, 1983), no. 371; Conway 1889, 33.

75. Pirckheimer, letter to Johann Tscherte on Dürer's death in 1528; in Conway 1889, 38.

76. Kunsthalle, Bremen (now lost); Strauss 1974, 1519/2; see also the drawing, *Self-Portrait as the "Man of Sorrows,"* Kunsthalle, Bremen; Strauss 1974, 1522/8.

77. Codex Arundel, 272r, 9 July 1504; in J. P. Richter, ed., *The Literary Works of Leonardo da Vinci*, 2 vols. (Oxford, 1970), 2:344, no. 1372; Conway 1889, 40–41, 77–79 (1504 and 1513 respectively).

78. A. E. Popham, *The Drawings of Leonardo da Vinci* (London, 1964), no. 154; Carlo Pedretti, ed., *Disegni di Leonardo da Vinci e della scuola alla Biblioteca Reale di Torino* (Florence, 1975), no. 1. I am inclined to date the Turin drawing to the later 1490s, which would exclude it as a self-portrait. The only reliable image of Leonardo is the studio drawing in Windsor 12726; see London 1989, no. 1.

MICHELANGELO 1492

Giulio Carlo Argan

Michelangelo's debut has a date, 1492; and his career was a long one, lasting beyond the midpoint of the following century. We know that he always worked with and for the highest civil and religious powers; no other artist had such authoritative influence on the dramatic historical conditions of his time. Before him Leonardo had thought to make of art the method and instrument of knowledge, thus opening for it new and unlimited horizons. Michelangelo, twenty years younger, did not follow in that progressive direction; radically opposing Leonardo, he denied that the purpose of art was the knowledge of the objective world and devoted himself to the study of the thought of the human being, its reason for existence, and its final destiny. His aim was not progress, but rather a return to that humanism which, moving out from Dante and the great artists of the fourteenth century, gave Florence a cultural superiority that then became political supremacy. In 1492 he was seventeen years old and was living in the palace of the Medici; he had studied sculpture technique with the older Bertoldo and was in direct contact with Lorenzo il Magnifico, Botticelli, and Poliziano.

His activity in sculpture began with two marble reliefs: the *Madonna of the Stairs* (cat. 168) and the *Battle of the Centaurs and Lapiths*. His *Madonna* was an analytic and methodical, almost philological study of the projection of perspective in the *rilievo schiacciato* of Donatello. The *Battle*, done slightly earlier, can be dated precisely: Condivi said that it had just been finished when Lorenzo il Magnifico died in April 1492. From that moment Michelangelo did no more reliefs.

Immediately after his *De pictura* (1436) Alberti had written a brief treatise called *De statua*. He did not discuss relief there: relief represented actions (*historiae*) by projection onto a plane, and for him its only difference with painting lay in technique. This nature of relief as *historia* concisely narrated on a perspectival plane is demonstrated paradigmatically by Donatello's *Banquet of Herod* of 1437. However, a statue in the round was not *historia* but *elogium*, the superposition of an ideal eternal figure onto an earthly mortal one. After 1492 Michelangelo did only statues, ideal figures, but they were imbued with a pathos that

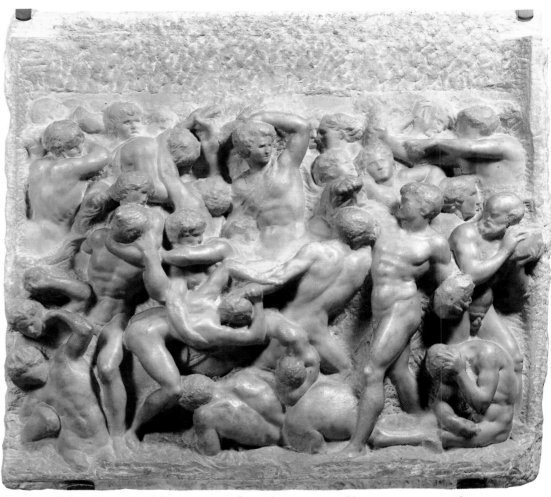

fig. 1. Michelangelo, *Battle of the Centaurs and Lapiths*. c. 1492, marble. Casa Buonarroti, Florence

was the sublimation of human drama. His unfinished modeling thus presupposed the *historia* of the relief: the moment of passage from the relief on a plane to the statue and statuary group is clearly evident in his *Pietà* in Saint Peter's of 1498.

Vasari and Condivi agreed on the subject of the 1492 relief, and their source was Michelangelo himself. Almost certainly it was suggested by Poliziano. No figure, however, shows the features of a centaur, half man and half horse: the relief is a tangle of nudes clinging to each other in tight muscular knots. The subject is ancient, but the energetic plastic idiom comes directly from Giovanni Pisano: the ancient was transmitted to the modern through the Tuscan

language of the fourteenth and early fifteenth century, which restored its life and vigor. Brunelleschi, Manetti recounted, thought that in the Middle Ages the great culture of Rome was providentially transposed to Tuscany: in Rome the ancient had been handed down through time. Florence had deliberately chosen it as a model and was thus its legitimate heir. Not the inert liturgical and curial Latin, but that of the great ancient writers, was fused by Dante and Petrarch with the lively Tuscan vulgate, giving it literary dignity. What had happened in the field of spoken language had also happened in the field of art: shortly after theorizing about the art of the masters of the early fifteenth century, Alberti became the sponsor of the *Cer-*

tame Coronario, which was to sanction the literary dignity of poetry in the vulgate.

Events in Florentine culture in the last two decades of the fifteenth century can seem to be a movement backward, a sort of reaction to the dissipation not only of the doctrine but also of the moral force of early humanism: Savonarola understood that Florentine liberty was ending and blamed Lorenzo il Magnifico, but in the Medici circle itself there was also a return to the past, and precisely to Dante. Remember Landino's monumental edition and Botticelli's illustrations of Dante's work. Later Michelangelo himself became enthusiastic about Dante and, according to Vasari, Leonardo ridiculed him for it.

Much earlier his dissension with Botticelli had been one of the motives for which Leonardo left the learned Florence for the more technological Milan: this polemic was at the origin of Michelangelo's anti-Leonardism. Aiming toward the direct and unprejudiced experience of the real, Leonardo denied the authority of history as a teacher. Michelangelo idealized history, positing it as the necessary reference for realizing his own modernity but excluding any form of imitation. In his first relief, the only thing taken from the antique is the theme; the plastic text is in the Tuscan line of Giovanni Pisano and Donatello. Similarly, around this same time Botticelli was redoing a famous painting by Apelles, *Calumny*, of which no figurative memory existed. For the elderly Botticelli as for the young Michelangelo, history was not something that was handed down, but was a resurrection of the past. With his 1492 relief Michelangelo posited explicitly the problem of the relationship between ancient and modern. He was still troubled by the experience, on one hand flattering and on the other bitter, of his *Cupid*, which had been mistaken for an ancient piece and sold as such. It was the same problem that was being faced in language: the ancient was Latin, the modern the vulgate. This was a crucial problem from a political point of view also, Machiavelli had explained. Michelangelo faced it by writing his *Rime*, which he did as a way of integrating with the word his formal investigations of art. The problem of the language was political also because Italy was a group of states in conflict with each other and threatened by France. The fulcrum for stronger political cohesion, albeit not true unity, could be furnished by Rome for its apostolic authority or Florence for the cultural supremacy expressed by its language. Tuscan speech, at the same time noble and popular, would and in fact did become the national language of Italy. In the Medici circle at the end of the fifteenth century the question of language was given highest priority by Poliziano, the poet and philologist. He showed that it was possible to write poetry in the vulgate, in Latin, and even in Greek. Poetry was therefore a vital value that took form through language but went beyond it. This too represented a return to an intrinsic vitality that had been lost: Donatello inserted learned quotations from the ancient in his figurative plastic realism, especially in the last phase of his work, the two pulpits in San Lorenzo on which Bertoldo collaborated so extensively. And Bracciolini had warned that in poetry things "non enarrari sed agi videantur"(things should not seem to be narrated, but [made] to happen).

The deplorable deviation from the sources of early humanism was blamed at least in part on Leonardo: on his interest in knowing, his experimentalism, his religious scepticism, his lack of interest in the ancient. In 1500, in his *Nativity* now in London, Botticelli had greeted the new century with apocalyptic invective. But already in 1492, Michelangelo's relief had opposed to the poetics of the universal harmony of nature a violent realism that could not achieve catharsis. Michelangelo had not yet met Leonardo and therefore his opposition could not have been as strong as it was, ten years later, to the Leonardo who returned in triumph from Milan to Florence. But the antithesis was already clear from that earliest moment: Michelangelo was fighting against what seemed to be a renewed and more extensive feeling about nature, a new spirit of investigation, a progressive and promising marriage between art and science.

Was Michelangelo's beginning, then, regressive or reactionary? The gravest problem facing society between the end of the fifteenth and beginning of the sixteenth century was not the problem of a new image of the cosmos: it was religious conflict, the crisis of the Church, the rise of a new concept of Christianity. Even before Luther's proposals regarding doctrine, Savonarola's moral furor had troubled the young Michelangelo as much as it had the elder Botticelli. Beyond condemnation of the corruption of the clergy and the contrast between orthodoxy and heresy, an idea was gaining ground that the ontological problem of human being and action preceded the gnoseological problem of knowledge of the objective world. The need for a different basis for speculation about science did not arise for another century, with Galileo, who to be sure strongly affirmed the experimental nature of scientific research but also understood that in order to give birth to a new science it was necessary to define clearly its relationship with religion. Galileo was aware of what was going on in literature and art — certainly he knew of the opposing meanings assigned to art by Leonardo and Michelangelo; we could say paradoxically that for him Michelangelo's strength in speculation was a stronger force than Leonardo's interest in knowledge.

Parronchi correctly considers the 1492 relief not a later work, but slightly earlier than the *Madonna of the Stairs*, a work that is in fact a profound critical reflection on Donatello's *rilievo schiacciato*. Everything is concentrated into the limited depth between the plane of the Madonna's chair and the gradually receding planes of the steps. The relief of the Madonna is minimal yet the matronly figure is statuesque, in the ancient style. In the flattened space the figures do not represent action but create a rhythm; this is the same concatenation, but more relaxed and open, as that seen in the 1492 relief. The crux of the problem is still the relationship between relief and statuary, that is between action and figure. In the *Madonna of the Stairs* the space has neither a real nor illusory depth; it is as though it were completely contained within the figures. As in the *Battle*, where the centaurs are not really centaurs, all that is left of the *historia*, or action, is the rhythm, the essence. From that moment on, the statuary figure will absorb within itself the dramatic action and with it the spatiality of relief; and its extraordinary intense pathos will depend on just this absence of any complementarity, that is of any reference to physical space.

THE QUEST FOR THE EXOTIC:
ALBRECHT DÜRER IN THE NETHERLANDS

Jean Michel Massing

Albrecht Dürer is the best-known artist/traveler of the Renaissance. His two visits to Italy, in 1494–1495 and 1505–1507, were essentially pilgrimages to the wellsprings of the Renaissance, study trips for an artist who was anxious to acquire a thorough grounding in classical art theory and practice. His year-long journey to the Netherlands, undertaken in the last decade of his life, was quite different. The principal purpose for the trip was to convince Charles v, who was traveling to his coronation in Aachen, to continue the pension that Dürer had been awarded by Maximilian i. Dürer clearly saw the journey, however, as a chance to mix business with pleasure, for he took along his wife and her maid and brought with him a large supply of works of art to sell and barter. His personal diary of the trip has come down to us, yielding a vivid picture of the daily life of this by-now celebrated artist. What is most striking from our perspective is Dürer's inexhaustible curiosity for the unfamiliar animals, plants, peoples, and products that he encountered in the Low Countries. The amazing variety of exotica he was able to examine was a direct consequence of the voyages of exploration.

By 1520–1521, when Dürer visited the Netherlands, Antwerp had become one of the principal centers for the spice trade; the other was Lisbon, since Portugal now controlled the new maritime sea routes, especially those to Africa and Asia.[1] For Dürer this development meant direct contact with all sorts of exotic wares, including imports from America.[2] In Brussels Dürer admired the Aztec treasures sent by Cortés to Charles v and subsequently exhibited in the Coudenberg Palace.[3] Dürer also noted in his diary that "I saw behind the King's house . . . the fountains, labyrinths, and animal-garden; anything more beautiful and pleasing to me and more like a Paradise I have never seen."[4] He made a sketch of the park, the famous Warande, which he identified, as he did so often, with an inscription: "This is the animal park and the pleasure grounds behind, at Brussels, seen from the palace."[5] The park was large, with special areas for wild boar and hares, shelters for deer, wild goats and ibexes, as well as various aviaries; in 1517, some 150 deer of all kinds could be seen there. Exotic animals were kept in the Nederhof. Lions are first mentioned in 1446, monkeys in 1462, and in 1507, it included wild cows, camels, ostriches, and other exotic animals brought from Spain.[6] It was probably in Brussels, but in the next year (1521), that Dürer drew on one sheet six animals and two landscape scenes (cat. 205): a Barbary lion, two depictions of a lioness, a lynx—the only native animal—a young chamois, as well as a baboon, the latter heightened with blue and pink washes. According to an inscription now partly lost through the sheet's subsequent trimming, this was "an extraordinary animal . . . , big, one and a half hundredweight."

Dürer does not seem to have seen—or in any case to have sketched—real lions before his travel to the Netherlands.[7] For the lion in his small panel of *Saint Jerome in the Wilderness*,[8] painted c. 1497–1498, he used a study in watercolor made during his first trip to Venice. There, however, the animal was not drawn from life, but rather based on the lion of Saint Mark as it appears in the coat-of-arms of Venice.[9] From Dürer's diary of his trip to the Netherlands, we also know that on 9 April 1521 he saw the lions kept in Ghent and drew one of them. In fact he added the words *Zw Gent* (at Ghent) on a silverpoint drawing of a crouching lion. He studied two further poses of the animal on another sheet and sketched its head on a third.[10] In Dürer's time the Ghent lions were kept at the *Leeuvenhof*, descendants of the four animals recorded a hundred years before as in the charge of a local butcher, Jacques de Melle. His job was taken over by Henri van den Vyvere, who seems to have started the tradition of showing new-born cubs to the town councillors (*échevins*) for a small fee. The same was done by his successors, who also kept bears; in 1497 a fight was even organized between a bear and bulls, in the manner of classical Roman spectacles.[11] It may have been in Ghent rather than in Brussels that Dürer made the two splendid gouache studies on vellum of a lion and a lioness.[12]

Lions came from Asia and Africa but they were known in Europe during the Middle Ages and depicted in religious and even secular art.[13] More remarkable was the rhinoceros, which Dürer had recorded in his famous woodcut of 1515 (cat. 206). The animal that sultan Muzafan ii, ruler of Gujarat, gave to Alfonso de Albuquerque, governor of Portuguese India, who then sent it to King Manuel i, was the subject of intense interest, no rhinoceros having been seen in Europe since classical times.[14] The Greek geographer Strabo seems to have been the first to mention fights staged between rhinoceroses and elephants, a tradition that was briefly revived less than a month after the rhinoceros' arrival in Lisbon, as we know from various testimonies: "The native keeper . . . led the rhinoceros by its chain to a place behind the tapestries covering the passageway, where it remained well hidden. Then the elephant, a young one with short tusks, was brought into the arena. When the tapestries were pulled aside revealing the rhinoceros, the elephant took flight and sought refuge in the shelter where it was usually kept."[15] The mutual antipathy of the two animals was duly recorded on Dürer's preparatory drawing:

> In the year 15[1]3 [*recte* 1515] on 1 May was brought to our king of Portugal in Lisbon such a living animal from India called Rhinocerate. Because it is such a marvel I considered that I must send this representation. It has the color of a tortoise and is covered all over with thick scales, and in size is as large as an elephant, but lower, and is the deadly enemy of the elephant. It has on the front of the nose a large sharp horn: and when this animal comes near the elephant to fight it always first whets its horn on the stones and runs at the elephant with its head between its forelegs. Then it rips the elephant where its skin is thinnest, and then gores it. The elephant is greatly afraid of the Rhinocerate; for he always gores it whenever he meets an elephant. For he is well armed, very lively and alert. The animal is called rhinocero in Greek and Latin but in Indian, *Ganda*.[16]

King Manuel i sent the rhinoceros to Pope Leo x. According to Paulo Giovio,[17] it was meant to repeat the combat with an elephant, in this case the famous elephant Hanno drawn by Raphael, which Manuel had sent to the Pope the year before. The fight never took place, as the rhinoceros drowned in a shipwreck off the Italian

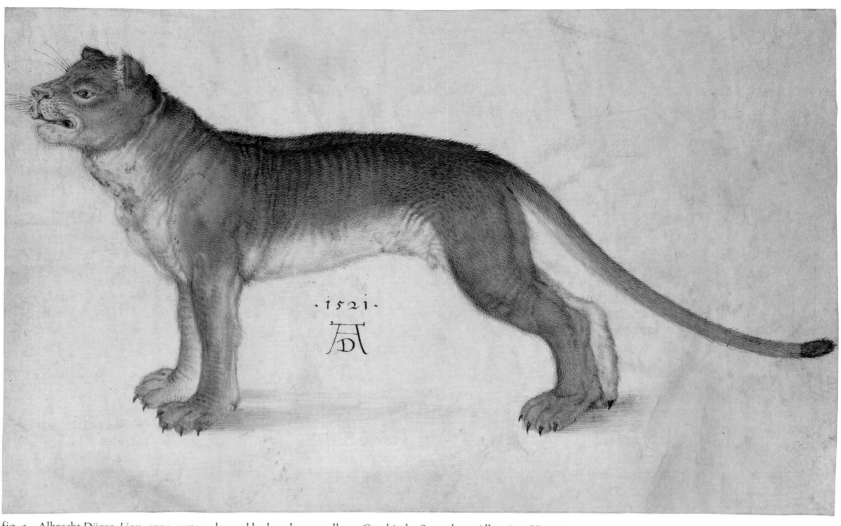

fig. 1. Albrecht Dürer, *Lion*. 1521, watercolor and body color on vellum. Graphische Sammlung Albertina, Vienna

coast in February 1516; Hanno, incidentally, died a few months later.[18] Both animals had caused a sensation whenever they were seen. The French king Francis I traveled to an island off Marseilles to view the rhinoceros, while Hanno was a constant source of delight for the inhabitants of Rome, so much so that Luther used that fact to mock the papacy for its frivolity.[19] Both rhinoceros and elephant were sent to Portugal from India; the newly established sea route allowed, for the first time since antiquity, direct contacts with the heart of Asia.

Almost as curious as the rhinoceros must have been the walrus, an animal so strange that Dürer adapted it for the dragon of Saint Margaret in one of his compositional sketches of 1522 for a *Sacra Conversazione*.[20] On that occasion, Dürer used his drawing of a walrus, a beautiful study in pen and brown ink with washes, which he had done the year before, according to an autograph inscription (cat. 207): "That stupid animal of which I have portrayed the head was caught in the Netherlands sea and was twelve Brabant ells long with four feet." In

Europe walruses are found mainly in the Arctic sea and on the northern coast of Norway, where they used to be hunted for their ivory and skins. Even in Dürer's time they were extremely rare in Netherlandish waters and completely unknown in southern Europe. They were so fabulous that the Norwegian bishop Erik Walkendorf sent the head of a walrus, preserved in salt, to Pope Leo X in 1520,[21] to show him the animal's physiognomy. That specimen was duly painted by an anonymous artist on a panel that used to hang in the *Curia Argentinae* in Rome. A German epigram added and later published in Gesner's *Icones animalium aquatilium* of 1560 starts with Albertus Magnus' erroneous statement that the walrus is the female of the whale; we are also told that the animal is found in oriental seas, where it frightened Alexander the Great and his army. This legendary and, of course, totally inaccurate information appears beside precise details about where and when the particular animal had been killed; we also learn that the head sent to the pope was exhibited in Strasbourg on its way to Rome.[22]

From Antwerp Dürer traveled to Zeeland, probably in the hope of seeing a stranded whale. He recorded in his diary that: "At Zierikzee in Zeeland a whale has been stranded by a high tide and a gale of wind. It is much more than 100 fathoms long and no man living in Zeeland has seen one even a third as long as this is. The fish cannot get off the land; the people would gladly see it gone, as they fear the great stink, for it is so large that they say it could not be cut in pieces and the blubber boiled down in half a year." When Dürer arrived at Zierikzee on 10 December 1520 he "tried to get sight of the great fish, but the tide had carried him off again."[23] From the sixteenth century the dramatic stranding of whales was recorded by many artists, so much so that it became a familiar subject of Netherlandish and northern German art, especially in the last quarter of the sixteenth and in the seventeenth century when it was often charged with moral or political meaning.[24] For Luther, the stranding of a whale near Haarlem in 1522 was a clear sign of God's wrath.[25]

In the second half of March 1521, Dürer

bought a little tortoise in Antwerp.[26] The painter and his wife had previously been presented with parrots by Rodrigo Fernandez d'Almada, the Portuguese factor: "Rodrigo has given my wife," wrote Dürer in his diary, "a small green parrot," for which she bought a birdcage. Rodrigo gave them a second parrot a few days later. In June or July 1521, Dürer recorded another gift from the Portuguese, a parrot from Malacca for which Dürer bought a new cage.[27] Dürer had sketched a parrot as early as the very first years of the sixteenth century and used it for his drawing of the Madonna with a multitude of animals and for the *Fall of Man*, his famous engraving of 1504.[28] African and Indian parrots were bought in Antwerp by German merchants at the beginning of the sixteenth century. We know from a letter written by the Nuremberg city council in 1505 to Anton Tetzel and Dürer's friend, the humanist Willibald Pirckheimer, that agents of the Nuremberg merchants had been robbed of a basket load of parrots.[29] Slightly later, in 1511, grey African parrots were sent by the Fugger of Augsburg to the Bishop of Breslau, Johann Turzo,[30] while Konrad Peutinger, the famous Augsburg scholar, had talking parrots from India.[31] Feathers of parrots and macaws were also brought back from Brazil—so many, in fact, that a Venetian spy reported from Lisbon that Cabral had discovered "a new land they call the land of the Parrots."[32] Bright red macaws, in fact, symbolize South America on the Cantino map.[33]

Like lions, apes were known in Germany during the Middle Ages. Dürer engraved his well known *Madonna with a Monkey* as early as 1498.[34] Long-tailed monkeys, however, became relatively widely available only with the maritime discoveries. Lucas Rem, the agent of the Welser in Lisbon between 1503 and 1508, acquired "strange, new parrots, long-tailed monkeys, and other rare and curious things" to be sent to Augsburg.[35] Dürer also bought a little monkey for four gold florins in Antwerp. The poor creature probably did not last long. At any rate, when Dürer sent a drawing of a dance of monkeys to Felix Frey, of Zürich, in 1523, he commented "in regard to the dance of the monkeys that you asked me to draw, I am sending you an awkward sketch, for I have not seen monkeys in a long time. Please be understanding."[36]

The Antwerp that Dürer visited was one of the most cosmopolitan cities in Europe and, as we have seen, a major center for the spice trade, especially between Portuguese and German merchants. Apart from spices, the main imports were sugar in various forms, most of it to be resold to Germans. Sugar products came mostly from the Canaries and other Atlantic islands.

Such delicacies are mentioned throughout Dürer's diary, as for example when Rodrigo Fernandez d'Almada gave him two boxes of quince electuary and many sweetmeats of all kinds, or when he received from João Brandão two fine large white sugar-loaves, a dish-full of sweetmeats, and two green pots of preserves.[37] In Antwerp Dürer spent time with the wealthy Genoese silk merchant Tomaso Bombelli, as well as with various members of the Portuguese community, especially the Portuguese factors. Thomé Lopes, Portuguese ambassador and factor in Antwerp from 1498 to 1505, invited Dürer "to a great banquet on Shrove-Tuesday 1521 which lasted till 2 o'clock and was very costly . . . To the . . . feast very many came in costly masks and especially Tomasin and Brandão."[38] Dürer in fact saw more of Thomé Lopes' successors, João Brandão, factor from 1509 to 1514 and again from 1520 to 1526, and his Secretary Rodrigo Fernandez d'Almada, who later became factor, who seem to have been his best friends in Antwerp. In return for their exotic gifts such as those mentioned above, he gave them prints and paintings and made their portraits. The famous painting of *Saint Jerome* (Museu Nacional de Arte Antiga, Lisbon) was a gift to Rodrigo, who took it with him to Portugal.[39] Dürer also portrayed João Brandão's black servant, Katherina (cat. 193): the silverpoint drawing inscribed *Katherina alt 20 Jar* can be related to a passage in Dürer's diary in which he wrote: "I drew a portrait of this moor with met-

alpoint."[40] Dürer had already sketched a black man (cat. 192) in charcoal, perhaps for use in a composition of the Adoration of the Magi. Although the two drawings—at any rate that of the maid—do not seem to have been done to be given to the sitters, they are among the first portraits of black people made in Renaissance Europe.

The Portuguese traded with Brazil and also controlled the sea route to Africa and India via the Cape of Good Hope; this trade bought immense wealth and the influx of many new products to Lisbon and Antwerp. Among the rarest objects acquired by Dürer in the Netherlands were probably ivories and Chinese porcelains: from his diary, we know that Dürer received "three pieces of porcelain" from Brandão and "a beautiful piece of porcelain" from Lorenz Sterck, Treasurer of the Provinces of Brabant and Antwerp.[41] Although Chinese porcelain is occasionally mentioned in fourteenth- and fifteenth-century inventories, it was extremely rare until the opening of the Portuguese sea route to India in 1498, when Vasco da Gama sailed to Calicut;[42] it appeared in large quantities only at the beginning of the seventeenth century.

Dürer also acquired objects in ivory: altogether he bought four combs, a button, a small ivory skull for a florin, and two saltcellars from Calicut for three florins.[43] The saltcellars may in fact have been Afro-Portuguese ivories (see cats. 67–71) which are among the finest African

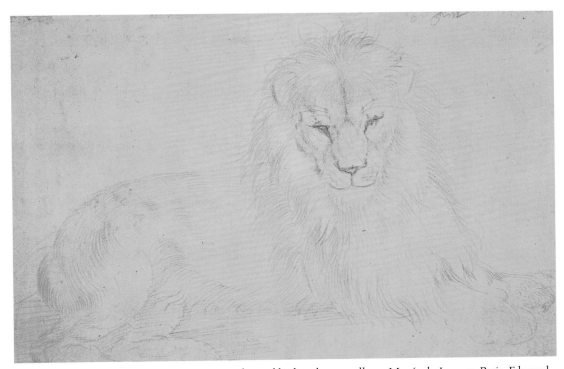

fig. 2. Albrecht Dürer, *Lioness*. 1521, watercolor and body color on vellum. Musée du Louvre, Paris, Edmond de Rothschild Collection. Photo Réunion des musées nationaux

works of art of the early sixteenth century, as the term Calicut was used generically for all the newly discovered countries.[44] "Calicut objects" are mentioned all through Dürer's diary. There we read that Lorenz Sterck gave Dürer a wooden shield from Calicut and one of light wood reeds.[45] Sterck had probably acquired, or rather been given these objects by Portuguese merchants; the same is true for the "ivory whistle and a beautiful piece of porcelain," which, as we have seen, he also gave to Dürer.[46] Rodrigo Fernandez d'Almada presented Dürer with Calicut feathers and six Indian nuts (coconuts). Later Dürer also received from him "two Calicut cloths, one of them in silk . . . , an ornamented cap, a green jug with myrobalans, and a branch of cedar tree, worth ten florins altogether." On another occasion (16 March 1521) Rodrigo have him six large Indian coconuts, a very fine stem of coral, and two large Portuguese florins.[47] Even Dürer's host, Jobst Plankfelt, offered him exotica, an Indian coconut and an old Turkish whip.[48] From the diary we also learn that a Herr Gilbert, of whom we know nothing else, gave him "a small Calicut round shield made of fish-skin, and two gloves with which the natives there fight."[49] A plaited hat of alder bark(?) may have come from some foreign land; the Turkish cloth which he received from Tomaso Bombelli certainly did.[50] In Zeeland, Dürer recorded that Master Hugo, Alexander Imhof, and Friedrich, the Hirschvogels' servant, each gave him an Indian coconut that they had won at play; from his host he received a sprouting bulb. Others, such as the commercial agent of the Hochstätter in Portugal, provided *naturalia*: "In return for the three books which I gave him, Herr Lazarus von Ravensburg has given me: a great fish-scale, five snail-shells, four medals of silver, five of copper, two little dried fishes, a white coral, four cane arrows, and another white coral."[51] Dürer also bought various drugs—some of them probably to cure the illness contracted in the Low Countries—dyes and perfumes. He acquired various textiles, including calico and silk, furs, even fishskins, which were used as a high-quality substitute for leather. As for the shells, dried fishes, squid, and possibly some of the buffalo horns, these must have been for his collection of curiosities, his *Wunderkammer*; also the more precious items, the glassware rings, precious stones, and the sprouting bulb. Dürer may have resold some of these items; buffalo horns were probably not kept with hunting trophies[52] but mounted as drinking horns (see cat. 8) or even used as raw materials for items such as the ring purchased by Dürer in Brussels and the ink stand he sent to Pirckheimer. Coconuts, which were imported by the Portuguese, were often

carved and mounted as cups (see cat. 11);[53] so were shells (see cat. 9). Altogether Dürer gathered a formidable collection of curiosities, most of them probably from Africa and Asia— so many that he had to ask Wenzeslaus Lind, Vicar-General of the Saxon congregation of the Augustines, to help him bring them back to Nuremberg: "I gave the new Vicarius the great turtle shell, the fish shield, the long pipe, the long lance, the fish-fins, and the two little casks of lemon and capers to take home for me."[54]

Dürer's activities in the Netherlands, sketching people from foreign countries[55] as well as exotic animals, collecting any testimony he could find of the newly discovered lands, reflects an interest quite unique in its intensity and breadth among artists of his time. It indicates that he was as much a man of his time as any of the explorers, and it helps to explain why he is the only artist known to have recorded his admiration for the Aztec treasures sent by Cortés from Mexico.[56]

NOTES

1. For Antwerp and its role in the spice trade, see Jan Albert Goris, *Etude sur les colonies marchandes méridionales (Portugais, Espagnols, Italiens) à Anvers de 1488 à 1567* (Louvain, 1925), who discusses the imports and exports, including many exotic products; for medieval trade with the East, Wilhelm Heyd, *Histoire du commerce au Moyen-Age* (Leipzig, 1885); for exoticism in the arts, Götz Pochat, *Der Exotismus während des Mittelalters und der Renaissance* (Stockholm, 1970).
2. Jan Veth and Samuel Muller, *Albrecht Dürers Niederländische Reise*, 2 vols. (Berlin and Utrecht, 1918), 182–201, have a very thorough chapter on Dürer as a collector.
3. Hans Rupprich, *Dürers schriftlicher Nachlass*, 3 vols. (Berlin, 1956–1969), 1:155; Jan Albert Goris and Georges Marlier, *Albrecht Dürer. Diary of His Journey to the Netherlands. 1520–1521* (London, 1971), 64; see also my essay "Early European Images of America," note 1, in this catalogue.
4. Rupprich 1956, 1:155; Goris and Marlier 1971, 63.
5. Walter L. Strauss, *The Complete Drawings of Albrecht Dürer*, 6 vols. (New York, 1974), 4:1932–1933, no. 1520/15; Fedja Anzelewsky, "A propos de la topographie du Parc de Bruxelles et du Quai de l'Escaut à Anvers de Dürer," *Musées Royaux des Beaux-Arts. Bulletin* 6 (1957), 87–107.
6. Paul Saintenoy, *Les arts et les artistes à la Cour de Bruxelles. Leur rôle dans la construction du Château ducal de Brabant sur le Coudenberg de 1120 à 1400 et dans la formation du Parc de Bruxelles* (Mémoires publiés par la Classe des Beaux-Arts de l'Académie royale de Belgique, 2ᵉ série, II) (Brussels, 1932), 72–77.
7. Harry David, *Die Darstellung des Löwen bei Albrecht Dürer*. Inaugural-Dissertation . . . Halle-Wittenberg (Halle, 1909), 79; Fritz Koreny, *Albrecht Dürer and the Animal and Plant Studies of the Renaissance* (Boston, 1988), 160. For lions kept in Germany in Dürer's time, Gustave Loisel, *Histoire des ménageries de l'antiquité à nos jours*, 3 vols. (Paris, 1912), 1:231–236.

8. Nuremberg, Germanisches Nationalmuseum, *Albrecht Dürer. 1471–1971* (Nuremberg, 1971), 304–305, no. 569; Jean Michel Massing, "Dürer's Dreams," *Journal of the Warburg and Courtauld Institutes* 49 (1986), 242, n. 26.
9. Strauss 1974a, 1:232–233, no. 1494/17; also Nuremberg 1971, 302, no. 560.
10. Strauss 1974a, 4:2018–2023, nos. 1521/11–1521/13; Fedja Anzelewsky and Hans Mielke, *Staatliche Museen preussischer Kulturbesitz. Albrecht Dürer. Kritischer Katalog der Zeichnungen* (Berlin, 1984), 101–103.
11. Loisel 1912, 1:222–225.
12. Koreny 1988, 170–171, nos. 58–58a (see also 160–161).
13. Camels and dromedaries are also commonly found in scenes of the Adoration of the Magi. Dürer drew an oriental with a dromedary in the *Book of Hours of Maximilian*: Strauss 1974a, 3:1538–1539, no. 1515/32; Walter L. Strauss, *The Book of Hours of the Emperor Maximilian the First* (New York, 1974), 84.
14. Abel Fontoura da Costa, *Deambulations of the Rhinoceros (Ganda) of Mizüfar, King of Cambaia, from 1514 to 1516* (Lisbon, 1937); Donald Frederick Lach, *A Century of Wonder: The Visual Arts*, vol. II.1 of *Asia in the Making of Europe* (Chicago and London, 1970), 158–172; T. H. Clarke, *The Rhinoceros from Dürer to Stubbs. 1515–1799* (London, 1986), 16–23; also L. C. Rookmaker, *Bibliography of the Rhinoceros* (Rotterdam, 1983), 15–17.
15. Angelo de Gubernatis, *Storia dei viaggiatori italiani nelle Inde Orientali* (Livorno, 1875), 389–392; Lach 1970, 2.1:161–162.
16. Strauss 1974a, 3:1584–1585, no. 1515/17; John Rowlands, *The Age of Dürer and Holbein: German Drawings, 1400–1550* (London, 1988), 92–94, no. 65, ill.; Günther Pass, "Dürer und die wissenschaftliche Tierdarstellung der Renaissance," in *Albrecht Dürer und die Tier- und Pflanzenstudien der Renaissance: Symposium (Jahrbuch der kunsthistorischen Sammlungen in Wien 82/83, 1986–1987)* (1989), 59–64.
17. Paolo Giovio, *Elogia virorum bellica virtute illustrium, veris imaginibus supposita* (Florence, 1551), 206.
18. For Hanno, see Lach 1970, 2.1:136–144.
19. Martin Luther, *Werke, kritische Gesamtausgabe, Briefwechsel*, 18 vols. (Weimar, 1930–1985), 6:289; G. Scheil, *Die Tierwelt in Luthers Bildersprache in seinen reformatorisch-historischen und polemischen deutschen Schriften* (Bernberg, 1897), 19.
20. Strauss 1974a, 4:2180–2181, no. 1522/1.
21. Valentin Kiparsky, *L'histoire du morse* (Annales Academiae Scientiarum Fennicae, Ser.B.73,3) (Helsinki, 1952), 46–48.
22. Konrad Gesner, *Icones animalium aquatilium* (Zurich, 1560), 178–179; Kiparsky 1952, 46–48. It cannot be excluded that Bishop Walkendorf sent it via Antwerp, where Dürer could have sketched it. Dürer's indication that the walrus "was caught in the Netherlands sea," however, seems to imply the contrary.
23. Rupprich 1956, 1:162–163; Goris and Marlier 1971, 76–77 and 79.
24. Werner Timm, "Der gestrandete Wal, eine motivkundliche Studie," *Staatliche Museen zu Berlin. Forschungen und Berichte* 3–4 (1962), 76–93; Carus Sterne, "Walfischstrandungen in ihrem Einfluss auf Kunst und Poesie," *Pan* 1 (1895–1896), 165–171; Van der Grinten 1962, 149–156.
25. Luther 1931, 2:559–560; Timm 1961, 82.

26. Rupprich 1956, 1:166; Goris and Marlier 1971, 84. He also received a tortoise shell from Bernard Stecher.

27. Rupprich 1956, 1:154, 156, 157, 175; Goris and Marlier 1971, 63, 65–66, 67, 97–98 (Malaca here refers to Malacca, not the Spanish Malaga).

28. Strauss 1974a, 2:604–605, no. 1502/7; also Koreny 1988, 116, fig. 35.9; *Renaissance Drawings from the Ambrosiana* (Notre Dame, 1984–1985), 192–193, no. 84. For the symbolism of parrots, Emil Karel Josef Reznicek, "De reconstructie van 't Altaer van S. Lucas' van Maerten van Heemskerck," *Oud-Holland* 70 (1955), 238–241; Lach 1970, 2.1:179–180. On parrots and exotic birds in the Middle Ages and the Renaissance, Adolf Rieth, "Papageiendarstellungen in der mittelalterliche Kunst Südwestdeutschlands," *Nachrichtenblatt der Denkmalpflege in Baden-Württemberg* 7 (1964), 53–55; Lach 1970, 2.1:178–183.

29. Emil Reicke, *Willibald Pirckheimers Briefwechsel*, 2 vols. (Munich, 1940–1956), 1:257–258; Lach 1970, 2.1:179–180.

30. Goetz, Freiherr von Pölnitz, *Jakob Fugger . . .* 2 vols. (Tubingen, 1949–1951), 179; Lach 1970, 2.1:180.

31. Erich König, *Konrad Peutingers Briefwechsel* (Munich, 1923), 77–78; Lach 1970, 2.1:22.

32. John Hemming, *Red Gold. The Conquest of the Brazilian Indians* (London, 1978), 5.

33. Hugh Honour, *The New Golden Land. European Images of America from the Discoveries to the Present Time* (New York, 1975), 8, pl. 1; also Wilma George, *Animals and Maps* (London, 1969), 60.

34. Walter L. Strauss, *The Complete Engravings, Etchings, and Drawings of Albrecht Dürer* (New York, 1972), 42–43, no. 21; Walter L. Strauss, *The Intaglio Prints of Albrecht Dürer. Engravings, Etchings and Drypoints* (New York, 1976), 69–70, no. 21.

35. B. Greiff, "Tagebuch des Lucas Rem aus den Jahren 1494–1541," *Sechsundzwanzigster Jahres-bericht des historischen Kreis-vereins . . . von Schwaben und Neuburg* (Augsburg, 1861), 31; Lach, 1970, 2.1:22.

36. Rupprich 1956, 1:106–108, no. 51; Strauss 1974a, 4:2246–2247, no. 1523/11. On monkeys in the Middle Ages and the Renaissance, Horst W. Janson, *Apes and Ape Lore in the Middle Ages and the Renaissance* (London, 1952), and Lach 1970, 2.1:175–178.

37. Rupprich 1956, 1:166; Goris and Marlier 1971, 83.

38. Rupprich 1956, 1:165; Goris and Marlier 1971, 82. For the Portuguese factors, see Veth and Muller 1918, 251–260; Goris 1925, 215–236.

39. Veth and Muller 1918, 254–259; Goris 1925, 231–232. For the Saint Jerome, Erwin Panofsky, *Albrecht Dürer*, 2 vols. (Princeton, 1943), 211–213; Fedja Anzelewsky, *Albrecht Dürer. Das malerische Werk* (Berlin, 1971), 122–123, no. 14, figs. 12–13.

40. Strauss 1974a, 4:2012–2013, no. 1521/8; Jean Devisse and Michel Mollat, *Africans in the Christian Ordinance of the World. Fourteenth to the Sixteenth Century*, vol II.2 of *The Image of the Black in Western Art* (Lausanne, 1979), 253, fig. 263. For blacks in Antwerp, Goris 1925, 31–32.

41. Rupprich 1956, 1:156 and 166; Goris and Marlier 1971, 65 and 83.

42. For the import of Chinese porcelain in Europe, see Lach 1970, 2.1, 104–109; and David Whitehouse, "Chinese Porcelain in Medieval Europe." *Medieval Archaeology* 16 (1973), 63–78. For their representation in Italian paintings of the late fifteenth and early sixteenth century, A. I. Spriggs, "Oriental Porcelain in Western Painting. 1450–1700," *Transactions of the Oriental Ceramic Society* 36 (1967), 73–74, pls. 57–59: two of the earliest examples are Francesco Benaglio's *Madonna and Child* and *Feast of the Gods* by Giovanni Bellini and Titian, both in the National Gallery of Art. For an interesting but problematic link between a drawing from Dürer's circle and Chinese porcelain, see Robert Schmidt, "China bei Dürer," *Zeitschrift des deutschen Vereins für Kunstwissenschaft* 6 (1939), 103–108. (For porcelain in Europe in the Middle Ages, see also cats. 15–16).

43. Rupprich 1956, 1:160, 162, 163, 165, and 168; Goris and Marlier 1971, 72, 77, 79, 83, 86.

44. Ezio Bassani and William B. Fagg, *Africa and the Renaissance: Art in Ivory* (New York, 1988), 53; for the saltcellars, 62–81 and 225–231.

45. Rupprich 1956, 1:152 (also 181, ns. 132–133); Goris and Marlier 1971, 59.

46. Rupprich 1956, 1:166; Goris and Marlier 1971, 83.

47. Rupprich 1956, 1:156, 162, 165, and 166; Goris and Marlier 1971, 65, 76, 81, 84.

48. Rupprich 1956, 1:156 (also 185, no. 225); Goris and Marlier, 1971, 66.

49. Rupprich 1956, 1:166; Goris and Marlier 1971, 84.

50. Respectively Rupprich 1956, 1:152 and 164; Goris and Marlier 1971, 59 and 80.

51. See respectively Rupprich 1956, 1:163 (191, n. 412) and 163–164; Goris and Marlier 1971, 79.

52. For a sixteenth-century collection in Nuremberg, see Detlef Heikamp, "Dürers Entwürfe für Geweihleuchter," *Zeitschrift für Kunstgeschichte* 23 (1960), 48–51.

53. Rolf Fritz, *Die Gefässe aus Kokosnuss in Mitteleuropa. 1520–1800* (Mainz, 1983), 13–18.

54. Rupprich 1956, 1:176; Goris and Marlier 1971, 100.

55. I have not discussed the studies of foreign costumes that Dürer made in the Netherlands. For his study of Irish warriors and peasants, see cat. 208; also Henry Foster McClintock, *Old Irish and Highland Dress* (Dundalk, 1950), 30–31. For the drawings of Livonian women, Strauss 1974a, 4:2066–2071, nos. 1521/37–1521/39; also Ursula Mende, "Dürers Zeichnungen livländischer Frauentrachten und seine sogenannte Türkin," in *Kunstgeschichtliche Aufsätze von seinen Schülern und Freunden des Heinz Ladendorf zum 29. Juni 1969 gewidmet* (Cologne, 1969), 24–40. See also Sebastian Killermann, *Dürers Werk. Eine natur- und kulturgeschichtliche Untersuchung* (Regensburg, 1953), 67–69.

56. See my essay "Early European Images of America," note 1, in this catalogue.

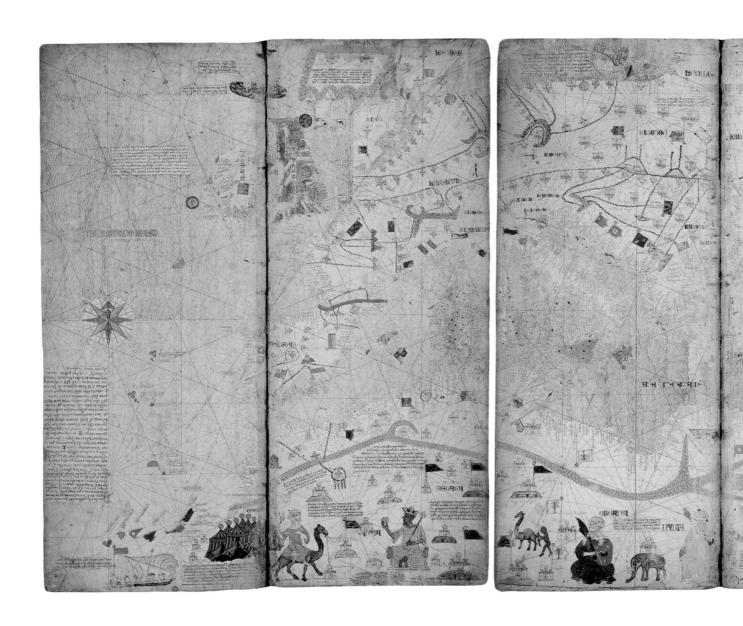

DISTANT WORLDS

*Tales of the splendors of Cathay had circulated
in Europe for centuries before Columbus'
voyage. The medieval world had inherited from
antiquity a bewildering variety of fact and fic-
tion concerning the lands of Asia, dating as far
back as the time of Alexander the Great and
preserved in romances and in the Christian
encyclopedias. In the late thirteenth and early
fourteenth century these sources were enriched by
the narratives of actual travelers to China, most
notably Marco Polo. Their journeys were made
possible by the opening up to Europeans of the
overland trade routes during the period of
Mongol rule over China and central Asia.*

*Late medieval Europe was fascinated by
these accounts of the marvels of the East, which
centered on its storybook riches and on the
strange humans and monstrous creatures that*
*inhabited it. The trickle of exotic goods—both
natural objects, like ostrich eggs and coconut
shells, and manmade products, like silks and
porcelains—that reached Europe from the far-
off lands of Africa and Asia fetched high prices,
as did the spices that were so vital to a society
that lacked effective means of refrigeration to
preserve food.*

*The few maps that have survived from this
period—most notably the* Catalan Atlas—
*present a world that looks familiar to us only in
its western reaches, where coastal navigation
had established the basic contours of land and
sea. To the east lay a vast, uncharted territory,
full of riches and wonders, whose luxuries
enticed the merchant and whose largely
heathen populations beckoned to the Christian
rulers of Europe, who also imagined new
opportunities for spreading the Gospel.*

1 𐂂

Abraham Cresques
Mallorcan, 1325–1387

CATALAN ATLAS

1375
*12 vellum sheets, 2 leather bindings, mounted on
7 wooden panels*
each panel 65 x 25 (25⅝ x 9⅞)
*references: El Atlas catalán 1975; Freisleben 1977;
Grosjean 1977; Campbell 1981, 116; Avril et al.
1982, 96–98, no. 110*

Bibliothèque Nationale, Paris, MS espagnol 30

The *Catalan Atlas* was originally made up of six
large rectangular panels; at the beginning of the
sixteenth century each of these was split length-
wise in two, and the vellum leaves were glued
onto the rectos and versos of seven panels which
were then backed onto one another so that the
map could be read as a book. The binding in

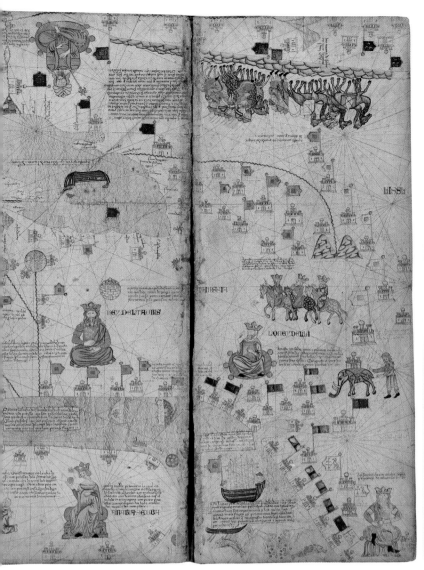
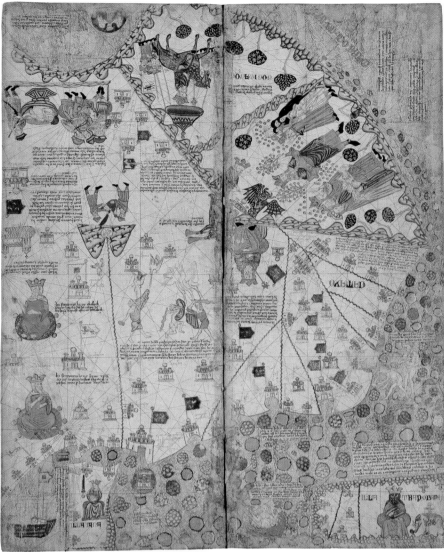

brown leather recalls the style of the so-called Atelier de Louis XII. Some of the inscriptions and most of the illustrations found in the northern half of the map are upside down. This, together with the fact that some inscriptions on the eastern edges are written at a ninety-degree angle, suggests that the map was intended to be placed horizontally and read from all sides, as a sort of table-top object. The *Catalan Atlas* is implicitly dated on the first sheet, where the compiler gives the method of finding the dates of the movable feasts of the year according to the Golden Number. Here he twice mentions in the same paragraph that for the year 1375 the Golden Number is eight, a piece of information that is repeated on the outer circle of the diagrammatic wheel of the second sheet.

The atlas was owned by Charles V of France; it appears as manuscript 201 in Jean Blanchet's inventory of the Royal Library compiled before 6 November 1380 ("Une carte de mer en tabliaux faicte par manière de unes tables, painte et

historiée, figurée et escripte"). It also appears, described in greater detail, in the inventories of 1411 and 1413. Since it was in the Royal Library by 1380, the *Catalan Atlas* cannot have been one of the world maps the Aragonese infante Don Juan asked Guillaume de Courcy to take to Charles VI, who succeeded to the throne of France in 1381. The two letters about this transaction, both dated 5 November 1381, also mention the author of the world maps in question—the Jew Cresques ("Cresques lo juheu"), who can be identified with Abraham Cresques (1325–1387), a leading "master of maps of the world and of compasses" of his time. He was not so much a cartographer in the modern sense as a copier of maps who sometimes added new material to them. Abraham Cresques and his son Jehuda were without doubt the most famous masters of the Catalan school of mapmakers, which was rivaled only by the Italian, and especially the Genoese, practitioners of the art. Abraham is probably responsible for the

Catalan Atlas (but for doubts about the authorship, see Campbell 1981, 116). He is perhaps also the illuminator of the famous Fahri Bible of 1381 (Letchworth, Sassoon Collection, MS 368), a Hebrew-Samaritan work by a scribe and illuminator who signed himself Eliça (Abraham) Cresques. The basis of the *Catalan Atlas* is a portolan chart of the Mediterranean and the Black Sea, to which are added representations of Asia and Africa; the information provided for the Red Sea and the Indian Ocean is noticeably less precise than that for Europe. Various traditions supplied the map's details: the Bible, of course, and also apocalyptic writings, ancient and medieval literature, and travelers' tales, especially those of Marco Polo. The lack of precise information for the eastern areas is particularly striking on the last sheet, where the features no longer have any connection with accurate geographical information and where place names are given at random, in the order in which they appear on medieval town lists. J.M.M.

ALEXANDER OBSERVING THE ICHTHYOPHAGI

from Jehan Wauquelin,
Histoire du bon roy Alexandre
c. 1448
French
manuscript on parchment, 227 fols.
43.5 x 30.5 (17⅛ x 12)
references: Omont 1895–1896, 1:383, no. 9342;
Ross 1963, 17 and 36; Ross 1971, 193; Husband
1980, 53, fig. 26.

Bibliothèque Nationale, Paris, MS fr. 9342, fol. 182

This illustration depicts one of the best-known adventures from the Romance of Alexander, showing the hero being lowered in a diving bell below the sea to observe the fish-eating people, the *ichthyophagi,* who can be seen on the right, hunting their prey surrounded by all kinds of aquatic animals. (For additional information on Alexander's submarine adventures, see Ross 1971, 193, index.) The Romance of Alexander has some factual basis in Alexander the Great's travels in Asia, but Alexander's actual adventures were eclipsed by legend. The oldest Greek Alexander legend was probably written by the author known as the Pseudo-Callisthenes sometime in the third century A.D. This text is known to us only indirectly, through various recensions that fall within three main lines of transmission. The present manuscript belongs to the tradition which dates back to a Greek version, of which the oldest surviving manuscript is Bibliothèque Nationale, Paris, MS grec 1711. This text is also known through various derivatives, such as the Latin version by Julius Valerius (*Res gestae Alexandri Macedonis*) and its epitomes; this was used by Alberic for his Old French *Roman d'Alexandre* in dodecasyllabic verse. Jehan Wauquelin of Mons, the author of the text in the manuscript exhibited here, used Alberic's text for his *Histoire du bon roy Alexandre* which he wrote, before 1448, for Jean de Bourgogne, Comte d'Etampes. The first part of this work is entirely based on the *Roman d'Alexandre* while the second is a version, sometimes quite literal, of the *Old French Prose Alexander,* a derivation of the *Historia de preliis.* Wauquelin's *Histoire* is found in four illustrated manuscripts, including the one exhibited here, of great quality, which was made for Philippe le Bon, Duke of Burgundy. MS fr. 9342 has eighty miniatures on 227 folios showing a great variety of narrative scenes; on folio 179 is found, for example, the story of Alexander the Great's visit to the Earthly Paradise, a legend of Jewish origin which was known in the Middle Ages through a short Latin text, the *Alexandri Magni iter ad Paradisum.*

J.M.M.

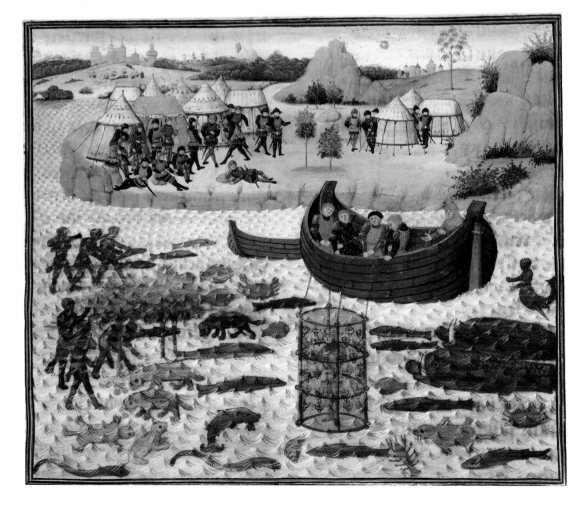

Boucicaut Master

THE PEPPER HARVEST IN COILUM

from Livre des merveilles
c. 1410
manuscript on parchment, 297 fols.
42 x 29.8 (16½ x 11¾)
references: Omont 1907; Bibliothèque Nationale 1955, 82–83, no. 169; Meiss 1968, 116–122, figs. 81–100; Wittkower 1977b, 76–92

Bibliothèque Nationale, Paris, MS fr. 2810, fol. 84r

The history of this splendid *Livre des merveilles* (*Book of Marvels*) is well known. From an inscription on a guard folio we know that the manuscript was presented by John the Fearless, duke of Burgundy, whose portrait, coat of arms, and devices appear on fol. 226, to his uncle Jean, duke of Berry. An inventory of the duke of Berry's possessions records that he received the gift in January 1413. The manuscript was later owned by Jacques d'Armagnac, duke of Nemours, and on his death it passed to the House of Bourbon before entering the Royal Library. The illustrations for the most part fall into three distinct stylistic groups. The first of these consists of works from the workshop of the so-called Boucicaut Master: The portrait of John the Fearless was probably painted by the master himself, while a few pictures are by one of his followers. The second group can be linked to the circle of the Bedford Master. The remaining pages are traditionally attributed to minor illuminators.

The manuscript is an important compilation of French translations of various texts describing voyages to the east, including Marco Polo's *Description of the World,* Odoric of Pordenone's *Itinerarium,* and William of Boldensele's *Liber de quibusdam ultramarinis partibus (On Certain Lands beyond the Sea),* an account of his pilgrimage to Palestine and Egypt in 1336. The volume also contains the letter from the great khan to Benedict XII (1338) and the pope's answer, as well as a description of the state of the great khan written by John of Cor, bishop of Sultaniyah. Finally there are Sir John Mandeville's *Travels,* Hayton's *Historia orientalis,* and Ricoldo di Montecorvo's story of his voyage to the East begun in 1288. Real travel accounts are thus mixed with spurious and imaginary material.

The inscription on the guard folio written by the duke of Berry's secretary Flamel indicates that the book contains 266 *hystoires,* by which he means illustrations of narratives. The miniatures present a visual counterpart, or rather complement, to the marvels described in the text. They depict, for example, fabulous creatures on the islands of the Indian Ocean (fol. 194v), or pygmies from the land of Pitan who live on the

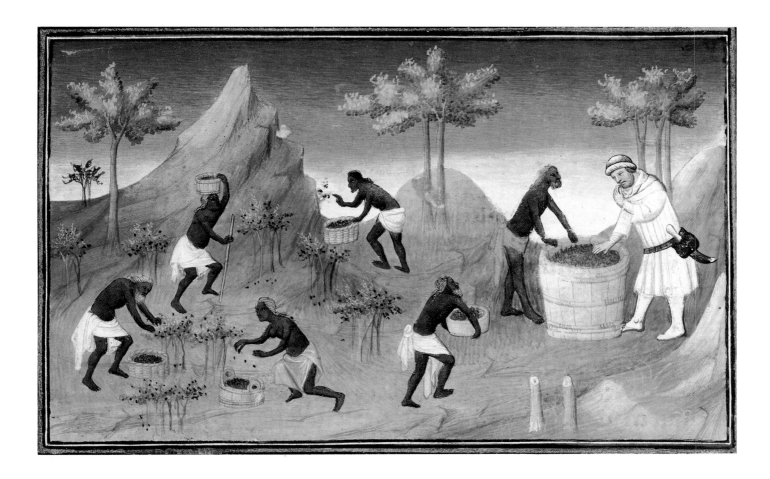

smell of fruit (fol. 219v). The best known pages, however, are probably those illustrating the pepper harvest in Coilum (fol. 84r), the dog-headed men of the Adaman Islands (fol. 76v), and the headless men (fol. 194v). J.M.M.

4 🐍

Strasbourg artist

WILD MEN STORMING A CASTLE AND OTHER SCENES

c. 1440
tapestry
100 x 490 (39⅜ x 193)
references: Concilium Basiliense 1904, 5:413;
Cavallo 1967, 47–49, no.1, pls. 1-1f; Husband 1980,
77–82, no. 14; Vandenbroeck 1987, 15, fig. 11; Rapp
and Stucky-Schürer 1990, 314–318, no. 96

Museum of Fine Arts, Boston

This tapestry shows various characteristic scenes of wild men — mythical figures who were supposed to have a human body covered with hair except on the face, hands, feet, and sometimes elbows (for wild women, also breasts). Wild men were believed to be creatures halfway between men and beasts, who lived roughly, close to nature, but often according to familiar social and familial patterns. On several upper Rhenish tapestries of the fifteenth century, they interact with fabulous animals as well as perform the everyday tasks of raising their children, working the land, hunting, and fighting.

The concept of the wild man could be extended to embrace social outcasts and people living in exotic or "fabulous" countries. For the famous Strasbourg preacher Geiler of Kaisersberg, "wild men" included anchorites, various types of satyrs, gypsies, pygmies, and devils. The wild men in the Boston tapestry seem to be inhabitants of faraway

countries and not, as has sometimes been claimed, embodiments of sexual desire. Andrea Gattaro, a Venetian envoy to the Council of Basel in 1435, recorded that he saw there twenty-two dancers dressed as wild men entertaining the guests of the council; the fact that the event took place on Epiphany (6 January, the day commemorating the coming of the Magi) suggests that they may have been meant to symbolize the eastern world from which the Wise Men had come (*Concilium Basiliense* 1904, 5:413).

The Greek writer Herodotus, in the fifth century B.C., provided the earliest known account of wild men in his *Histories* (IV, 191), where he writes of strange inhabitants of Libya, among them "dog-headed men and the headless that have their eyes in their breasts, as the Libyans say, and the wild men and women, besides many other creatures not fabulous." The fabulous races were discussed by many authors in classical antiquity

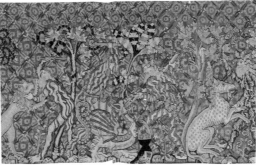

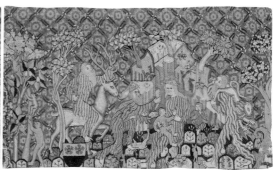

and the Middle Ages. Wild men are found, for example, in the legends that grew up around Alexander the Great (cat. 2); in these stories they dwell in the most remote areas of Asia and sometimes even Africa. It seems that the wild men took on only in the twelfth century the form in which they became familiar—with a hairy body as one of their identifying characteristics.

The Boston tapestry shows a succession of scenes. In the first, seven wild men armed with tree trunks and various rustic weapons attack a castle held by black people, an indication that the scene is set in a country far from Alsace. The fortress is defended by two archers wearing long tunics and, from the top of the towers and behind the crenelated walls, by soldiers; at the window the king and queen can be seen exhorting their troops. The following scenes show a wild man fighting a snarling lion; two wild men fighting a basilisk or a dragon, one of them thrusting a wooden pole down the animal's throat; then another who has caught a unicorn, which he holds by its horn. On the right sits a wild woman nursing two of her children. She is flanked by three wild men returning from the hunt; one rides a stag, another carries a dead lion on his back, while the third presents her with an animal's leg, which he has just torn from his prey.

The aim and the function of this tapestry are difficult to determine, but it is possible that by conjuring up these images of people of exotic lands, the tapestry may have been intended to reinforce, by contrast, contemporary Christian values.

<div align="right">J.M.M.</div>

5 🐍

MAP OF THE WORLD AND PEOPLE FROM FARAWAY LANDS

from Hartmann Schedel,
Liber chronicarum, *Nuremberg, 1493 (fols. 12v–13r)*
1493
46.9 x 31.6 (18½ x 12½)
references: Baltimore 1952, no. 44, pl. XII; Rücker 1973, 77–79, fig. 59; Wilson 1976, 115; Husband 1980, 48–50, no. 4, fig. 22; New York and Nuremberg 1986, 233–234, no. 87; Campbell 1987, 152–153, no. 219, fig. 33

National Gallery of Art, Washington,
Gift of Paul Mellon in Honor of the 50th
Anniversary of the National Gallery of Art

Hartmann Schedel's *Liber chronicarum* (*Book of Chronicles*) was first published in Latin on 12 July 1493; a German translation appeared the following 23 December. This survey of the history of the world from the Creation to the year 1493, with its 1,809 illustrations (actually 1,165 woodcuts, some of which are repeated at different places, in some cases more than once), was the most lavishly illustrated printed book of the fifteenth century. It must also have been one of the most widely diffused, since more than 1,200 copies of the Latin and German versions are still extant. The work was commissioned from the humanist Hartmann Schedel by two Nuremberg patricians, Sebald Schreyer and his brother-in-law Sebastian Kammermeister. The woodcuts were designed in the workshop of Michael Wolgemut and his stepson Wilhelm Pleydenwurff, and the printer was Anton Koberger.

In the *Liber chronicarum*, now commonly known as the *Nuremberg Chronicle*, the history of the world is divided into seven ages according to the scheme laid down by the seventh-century encyclopedist Isidore of Seville. The second age begins with Noah's ark and ends with the destruction of Sodom and Gomorrah. It is in this section, following a discussion of the Flood and Noah's drunkenness, that we find an account of the fabulous races of mankind, for which Schedel cites as his authorities Pliny, Saint Augustine, and Isidore of Seville. Some examples of those races are illustrated on the recto and verso of fol. 12; on the latter page are found, from top to bottom, a man with three pairs of arms, a wild woman, a man with six fingers on each hand, a centaur, a hermaphrodite, a man with four eyes, and finally a crane-man. They appear next to a map of the world that has Noah's sons at three of its corners, to represent Japhet's inheritance of Europe, Shem's of Asia, and Ham's of Africa. Schedel used as a model the *mappamundi* found in an edition of the *Cosmographia* of the Roman geographer Pomponius Mela published at Venice in 1488. Like Mela's, Schedel's world map is based on that of Ptolemy, but simplified and without indications of longitude and latitude; it is also shown as a segment of a globe in the conical projection, and surrounded by the twelve winds identified by name. The Indian Ocean is wrongly depicted as an enclosed sea, with Asia linked to Africa by a strip of land. Ceylon, now Sri Lanka, is unrecognizably large, and the shape of India is badly distorted. One of Schedel's very few improvements on the map in Mela's *Cosmographia* involves the definition of the southeastern bend of the coast of west Africa, as recorded by Portuguese navigators around 1470. By 1493, however, one would have expected a better understanding and a more accurate rendering of the whole west coast of Africa, since in 1487–1488 Bartolomeu Dias had circumnavigated the Cape of Good Hope, the most southerly point of the African continent. Even areas that were well known, such as western Europe and the Mediterranean, are relatively poorly rendered: they appear more accurately, for example, in the world map from the 1482 Ulm edition of Ptolemy's *Geographia*, and in nautical charts of the time.

The *Nuremberg Chronicle* is best known for its eighty-nine views of towns and cities; of these, thirty are more or less recognizable renderings, while the other fifty-nine are fanciful (and share only seventeen different woodcuts). The book also contains a map of central Europe by Hieronymus Münzer, based on a manuscript map made in 1454 by Nicolas of Cusa, which is probably the first map of the German Empire to appear in a printed book. The copy of the *Chronicle* from the National Gallery of Art is beautifully hand-colored and preserved in a fine binding made for Raimund Fugger (1489–1535) of Augsburg, a member of the famous banking family.

<div align="right">J.M.M.</div>

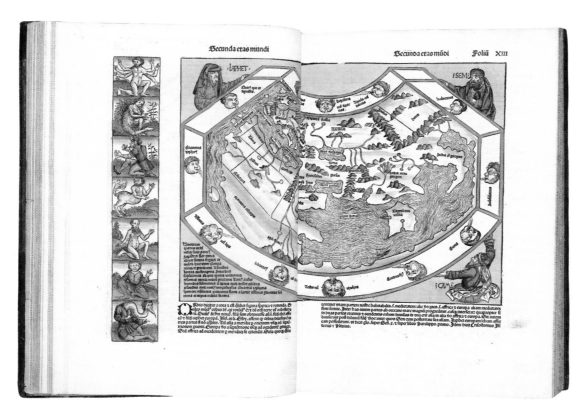

MARVELS OF THE EAST

from Liber de naturis rerum creatarum
1492
Flemish
manuscript on vellum, 280 fols.
41 x 29.5 (16⅛ x 11⅝)
references: Thomas Catipratensis 1973, 98–99;
Wittkower 1977a, 57, fig. 80; Derolez 1979,
168–175, no. 29; Oudenburg 1984, 281–282,
no. 166; Arnould 1991, forthcoming

Library of Sint-Baafskathedral, Ghent, MS. 15, fols.
1v–2r

Raphael de Mercatellis (1437–1508) is best known today as a collector of richly illuminated manuscripts. Raphael, a scion of the Venetian family Mercatelli di Mercatello, was probably born in Bruges. After joining the Benedictine Abbey of Saint Peter at Ghent, he studied theology in Paris. He returned to Flanders to serve as abbot first of Saint Peter's at Oudenburg, then of Saint Bavo's in Ghent. While serving as abbot of Saint Bavo's, Raphael built up a collection of manuscripts, which were mostly works commissioned by him. The present manuscript was made for him in 1492, as a Latin inscription records: "Hoc volumen comparavit Raphael de Marcatellis, Dei gratia episcopus Rosensis, abbas Sancti Bavonis iuxta Gandavum, anno Domini 1492." It includes a variety of texts: first a *Liber de naturis rerum creatarum* (*On the Nature of Created Things*), then a number of works mostly concerned with the history of eastern Europe. These include Jordanes' *De origine actibusque Getarum* (*On the Origin and Deeds of the Thracians*), Johannes de Thwrocz' *Chronica Hungarorum*, and Aeneas Sylvius Piccolomini's *Historia bohemica*.

The *Liber de naturis rerum creatarum* is divided into seven books. Essentially it is a bestiary, which discusses among other things the fabulous races of mankind; it is composed largely of extracts from Thomas of Cantimpré's *De natura rerum* (also called *Liber de naturis rerum*, or *On the Nature of Things*). The verso of fol. 1 and the recto of the next leaf illustrate fabulous inhabitants of faraway countries, including dog-headed people and cannibals (for the text illustrated, see Thomas of Cantimpré, *De naturis rerum*, 3.2–3.5, in Thomas Cantipratensis 1973, 98–99). The first column of fol. 2r contains some of the best known examples: a woman with one eye in the middle of her forehead, a kind of Cyclops; a "sciopod" resting on his back to shield himself from the sun with his large foot (note that here, as in other cases, "breeches" were added later to cover the nudity of the figures); a headless man with his face on his chest; an apple-smeller who lives on the smell of apples and would die from the effect of a bad odor; a man with six arms; and finally various exotic dangerous women.

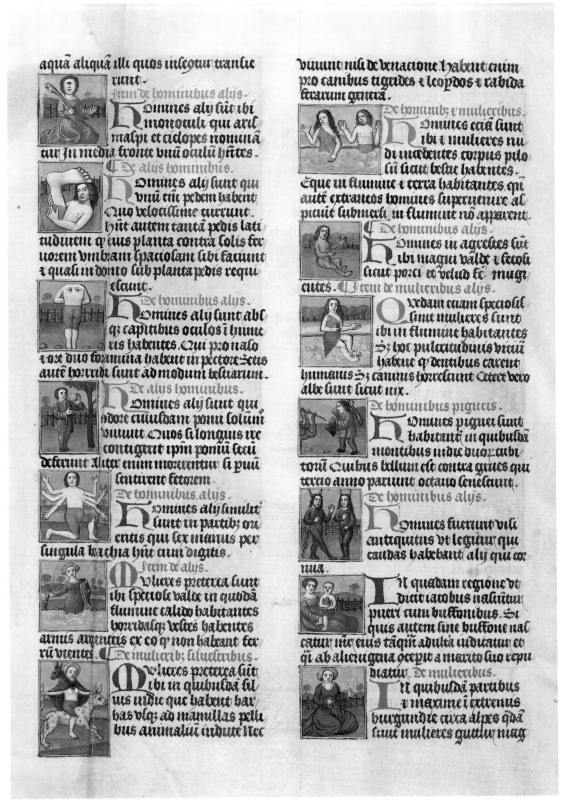

The Ghent manuscript can be linked to another, better known example that illustrates the same text: Bruges, Stadsbibliotheek, MS 411 (see Oudenburg 1984, 281–282, no. 166; for an illustration, Wittkower 1977a, 57, fig. 80). The two works are not closely related, but they clearly belong within the same tradition—as do some of the woodcuts that illustrate fabulous people in Hartmann Schedel's *Nuremberg Chronicle* (cat. 5).

J.M.M.

7 ᚶ

CEREMONIAL STAFF

c. 1125–1150
English
narwhal horn
length 117 (46⅛)
references: Schönberger 1935–1936, 164–247; Saxl
1954, 73n.24, fig. 25; Beckwith 1972, 135, no. 82,
ill. 198; London 1974, 67, no. 43; Einhorn 1976;
Freeman 1976, 29, fig. 9; London 1984, 223, no. 204

Victoria and Albert Museum, London

In medieval times, horns of the narwhal (*Monodon monoceros* L.), a small whale inhabiting the Arctic seas, were of great rarity and accordingly commanded high prices, for they were thought to be from unicorns. The Greek physician Ctesias was the first to describe this mythical creature; writing in around 398 B.C. he characterized it as a wild Indian donkey, larger than a horse, white, and with a single horn one and a half ells (about five and a half feet) long. He added that "those who drink from these horns, made into drinking vessels, are not subject, they say, either to convulsions or to the falling sickness. Indeed they are immune even to poisons if, either before or after, they drink wine, water, or anything else from these 'beakers'." Such an idea was widespread in classical antiquity and throughout the Middle Ages, when the horns were often seen as symbols of Christ. Many narwhal horns are found in treasuries, especially, but not exclusively, in those of churches: A horn in the Musée de Cluny, Paris, can be traced to the famous abbey church of Saint-Denis, while another, with runic inscriptions, is still in the Marienkirche in Utrecht. Narwhal horns in medieval mounts are found in the Treasury of San Marco in Venice. One of them has inscriptions in Arabic, while another must have come from Constantinople, as its mount carries the name of a Byzantine emperor, either John V (1341–1391) or John VI Paleologus (1425–1448). On the second piece, in addition to biblical passages and words in praise of Christ and the Virgin, there is a text in Greek on how the unicorn offers protection against poison (for the cultural history of narwhal horns, see Schönberger 1935–1936, 167–247).

This narwhal horn is splendidly carved into a ceremonial staff. The lower portion has straight bands, some of them plain, others with grotesque animals or naked figures intertwined with scrolls, while the long, spiraling end alternates straight plain bands with bands of leaf scrolls and scrolls with birds and animals. Another, unpublished, staff, which is said to be "similarly carved" and "probably from the same workshop and of the same date," is recorded in a private collection in England. Fritz Saxl compared the decoration of the present tusk to that of one of the columns from the central portal of Lincoln Cathedral, now

dated circa 1145. This date must be close to that of the ivory staff, even though it may have a quite different provenance. That tusks should be used as ceremonial staffs seems natural, given that Christians saw the unicorn as a symbol of Christ. For the theologian Tertullian, writing in the third century A.D., "Christ is meant by it and the horn denotes Christ's cross." This idea was elaborated by later theologians and mystically expressed in the image of the unicorn hunt, which ends with the animal tamed in the lap of a virgin (for the symbolism of the unicorn, see Einhorn 1976 and Freeman 1976). J.M.M.

8 ᚶ

Salzburg or Nuremberg craftsman
DRINKING HORN *(Greifenklaue)*

c. 1400
gilt silver, champlevé enamel, and horn
28 x 32 (11 x 12⅝)
references: Rossacher 1966, 122, no. 18, pl. 8;
Salzburg 1967, 55, no. 23, pl. III; Kohlhaussen 1968,
150, no. 229, fig. 243; Cologne 1978–1980, 3:166;
Fritz 1982, 257–258, no. 512, fig. 512; Wagner 1986,
66–67

Museo degli Argenti, Palazzo Pitti, Florence

Like the shell cup and the ostrich egg jug in the Museo degli Argenti (cats. 9, 10), this drinking horn comes from the silver chamber (*Silberkammer*) of the prince-archbishops of Salzburg. Both Salzburg and Nuremberg have been proposed as its place of manufacture. In Germany, drinking horns, usually made of the horn of an ox or an aurochs, were called *Greifenklauen*, or griffin claws. Our specimen is mentioned in an inventory of 1586 as having the coat of arms of Gregor Schenck von Osterwitz, who was archbishop of Salzburg from 1396 to 1403 ("Ain Greiffen Claw innwendig mit Silber ausgefüttert und mit ainem silbern Vogl und Khlaider eingefasst, mit den Schenggen von Osterwitz wappen"). In a later inventory compiled in 1612, it is simply described as a drinking horn with silver mounts, partly gilt and with a pelican ("Ain Greiffenklau mit silbern und verguldten beschlecht, darauf ein Pelican").

In Europe large horns were rare in the Middle Ages and were often mounted with the most precious materials. Dürer acquired a number of them while traveling in the Netherlands in 1520–1521. A medieval legend records how Saint Cornelius once cured a griffin of epilepsy; in gratitude, the fabulous animal gave him one of its claws. The origin of this story is probably related to the fact that the saint was invoked as protector from epilepsy and was often depicted with a mounted horn as his attribute. The griffin, a mythical animal with the body of a lion and the wings and head of an eagle, was sometimes depicted, appropriately, as part of the mount of such horns.

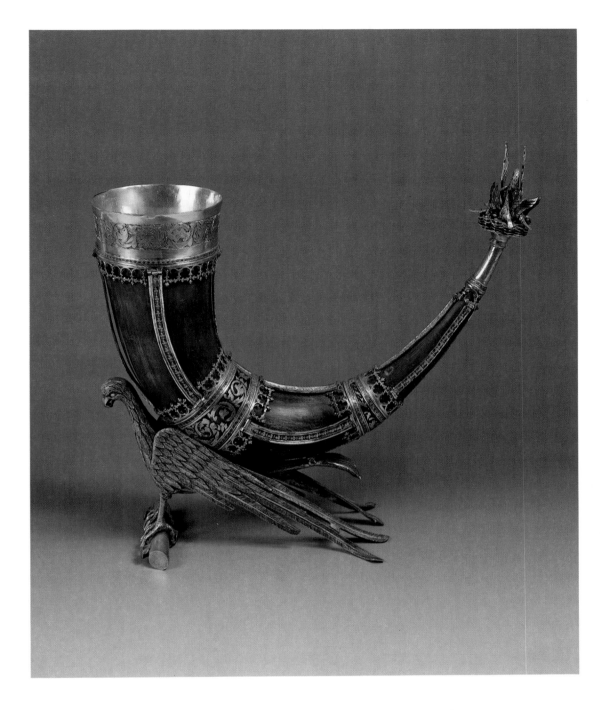

turned into a drinking vessel by the addition of a fluted stem with a hexafoiled embossed foot. The shell (*Dolium galea*) has deep whorls giving a rich surface texture, with clearly defined growth rings and a large siphon. The species is found in a wide geographical area, including the Mediterranean and the Indian Ocean.

The systematic collection of exotic shells seems to have begun in the Renaissance. Dürer bought a number of shells during his trip to the Netherlands in 1520–1521, but it seems to have been Erasmus who assembled the first real collection, probably for scholarly reasons; this was certainly the motivation of their younger contemporary, the Swiss zoologist Conrad Gesner (for the early collecting of shells, see Coomans 1985). The shell cup from Florence, like the drinking horn and ostrich egg jug also in the Museo degli Argenti (cats. 8, 10), was originally in the *Hochertzstüft-liche Silberkammer* in the palace of the prince-archbishops of Salzburg. This collection of precious objects was dispersed in 1805, two years after the secularization of religious institutions in Salzburg. In the 1586 inventory of the treasury, the shell cup is described as a mounted seashell ("Ain grosser Märschnegg mit ainem silberver-gulten Fuess und vergoldter Khlaidung").

J.M.M.

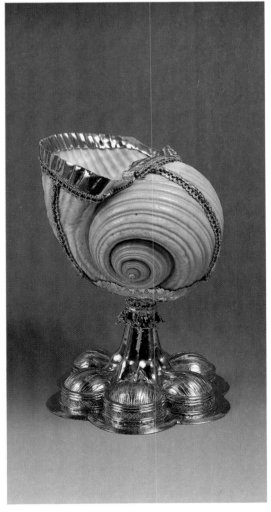

This horn, which appears to be that of a European bison (*Bison bonasus*), is beautifully mounted on a gilt eagle with long, finely incised wings. The horn is elegantly set with bands; on its tip is a pelican nourishing its young from its own breast. This was thought by Pliny and many writers after him to be characteristic behavior of the animal—a misunderstanding of the bird's habit of regurgitating the fish it had caught to feed its chicks. In the Middle Ages, the pelican's "self-sacrifice" was taken as an image or type of Christ's Passion. Yet the presence of the pelican on this drinking horn does not necessarily suggest a liturgical function for the vessel. Most such horns were used in a secular context, especially as luxurious drinking vessels at banquets.

J.M.M.

9 🐚

Nuremberg craftsman

SHELL CUP

c. 1480
silver, partly gilt, and shell
height 22 (8⅝)
references: *Rossacher 1966, 11, 130, no. 33, pl. 13; Kohlhaussen 1968, 155, 159, no. 244; Hernmarck 1977, 111, fig. 160; Fritz 1982, 307, no. 870, fig. 870; Loomans 1985*

Museo degli Argenti, Palazzo Pitti, Florence

Mounted by an anonymous silversmith from Nuremberg around 1480, this dolium has been

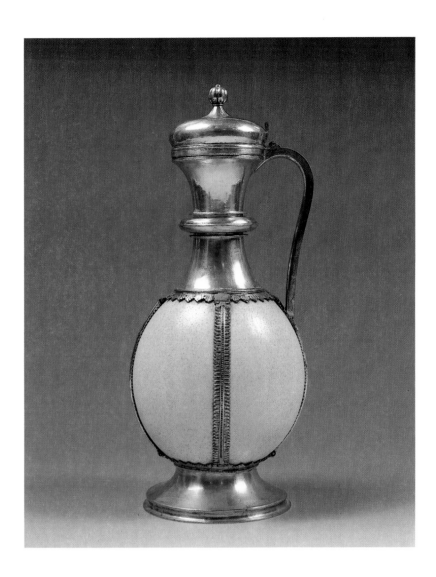

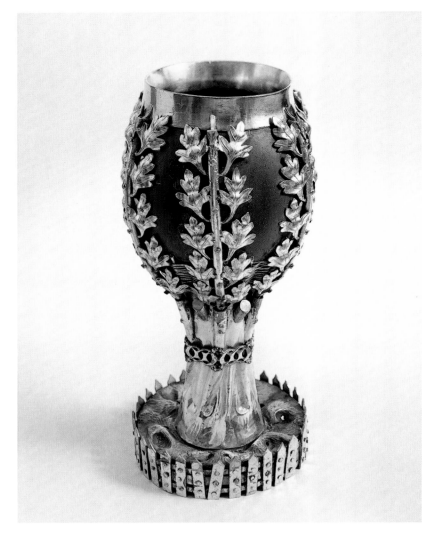

10 ঽ

Nuremberg craftsman

Ostrich Egg Jug

c. 1300–1350
ostrich egg and silver gilt
height 33 (13)
references: Rossacher 1962, 6–7, no. 6, fig. 8;
Rossacher 1966, 126, no. 26; Kohlhaussen 1968, 154,
no. 234, fig. 252; Meiss 1976, fig. 88; Lightbown
1978, 59; Wagner 1985, 36, fig. 4; Koreny 1988,
38–39, no. 5

Museo degli Argenti, Palazzo Pitti, Florence

This jug comes from the famous Silberkammer,
the treasury of the prince-archbishops of Salz-
burg; it is recorded in an inventory of 1612 as a
small jug made of an ostrich egg mounted in silver
and gilt ("Ain Kandl von einem Straussenayr mit
Silber und verguldt eingefasst"). Ostrich eggs
were still very rare objects in the fourteenth cen-
tury. Raoul de Nesle, marshal of France, had one
such egg mounted in gold, as we know from an
inventory compiled after his death in 1302, while

Charles v of France had three, although one of
them was broken (Lightbown 1978, 59). Ostriches
from North Africa and the Near East had been
brought to Europe in classical antiquity; Pliny the
Elder knew the animal well and provided a good
description of it. In the Middle Ages, however,
the ostrich was known mainly through literary
sources, such as bestiaries, and most images fail to
capture the characteristics of the animal. It is only
in the drawings of Giovannino de' Grassi (d. 1398)
and his workshop that we find a more accurate
rendering of the ostrich (Struthio camelus L.);
the best known among Renaissance images is per-
haps a Franconian drawing made c. 1500 and until
recently attributed to Dürer (Koreny 1988, 38–39,
no. 5). In the Middle Ages and later the ostrich
egg was sometimes seen as a symbol of the
Madonna's perpetual virginity. Such associations
encouraged the mounting of ostrich eggs as reli-
gious vessels. Eggs were also hung in churches as
a symbol of the Madonna; this is why Piero della
Francesca painted an ostrich egg hanging over
the Madonna in his celebrated altarpiece, now in
the Brera, Milan (Meiss 1976, fig. 88). J.M.M.

11 ঽ

Coconut Cup

c. 1475–1500
English
coconut, silver partly gilt
height 20.2 (7⁷/₈)
references: Jackson 1911, 2:649; Watts 1924, 28–29;
Oman 1979, 296, pl. 71; Fritz 1983, 93–94, no. 27,
pl. III

The Warden and Fellows of New College, Oxford

Seven coconut cups are mentioned in a 1508
inventory of the plate owned by New College,
Oxford. Two of these are still owned by the col-
lege today. The body of this cup, the earlier and
more unusual of the two, is fashioned out of a
coconut mounted in a silver oak tree. The base
represents a patch of ground enclosed by a pali-
sade. From the "ground," an area of plain white
silver displate, rises the trunk of an oak tree
encircled by a collar of intertwined Ds. From the
trunk, which is also the stem of the cup, spring a
dozen branches, six of which have been pruned
back, while the other six are covered in abundant

foliage; they hold the coconut and join the upper rim. The band of Lombardic *D*s linked back to back may refer to Robert Dalton, who was admitted to New College in 1472 and left in 1485; if so he was presumably the donor of the cup.

Coconuts (from the tree *cocos nucifera L.*) are found in most tropical areas. During the Middle Ages, when they were known as Indian nuts (*noix d'Indes*), they were imported from Islamic countries, but the opening of the Indian Ocean to Portuguese trade and the discovery of the Americas gave Europeans direct access to the areas where they grow. Dürer's diary of his trip to the Netherlands in 1520–1521 attests to the ready availability of coconuts, which he eagerly purchased. One of the earliest mounted coconut vessels still extant is a reliquary made circa 1250, now in the *Domkammer* in Münster, which also contains a Fatimid rock crystal lion on its cover. Others are documented in medieval inventories; for example, thirty such vessels are recorded between 1295 and 1371 in the papal treasury in Avignon. Coconuts were praised for their curative values; Marco Polo mentioned coconut milk as a panacea, while others, like the Islamic traveler Ibn Battuta, described the coconut as an aphrodisiac and as a medicine for various ailments, including "phlegm" (for the cultural history of the coconut, see Fritz 1983, 8–28). J.M.M.

12 ॐ

Nuremberg craftsman

"Serpent's Tongue" Table Ornament (*Natterzungenbaum*)

c. 1450
silver gilt, with fossil sharks' teeth and large topaz
height 27 (10⅝)
references: Pogatscher 1898; Kris 1932, 4, no. 7, pl. 6; Vienna 1964, 32, no. 80, pl. 43; Tescione 1965, 224–225; Kohlhaussen 1968, 162–163, no. 252, fig. 276; Oakley 1975, 15–21; Zammit-Maempel 1975; Rudwick 1976, 30–31; Hannsmann and Kriss-Rettenbeck 1977, figs. 252–257; Lightbown 1978, 29–30; Oakley 1985, 63–65; Schiedlausky 1989, 29–30, fig. 4

Kunsthistorisches Museum, Vienna, Sammlung für Plastik und Kunstgewerbe

Natterzungenbaüme (in French *espreuves* or *languiers*) still summon up a vivid image of the luxury of table decorations in the late Middle Ages. This piece has fossilized sharks' teeth— then called "serpents' tongues"—mounted as a bouquet. The four-lobed foot—a type that is also found on Gothic chalices and monstrances—is surmounted by a knob of foliage from which the leaves and "flowers" spring. Above these a large topaz is mounted. Part of the crowning bouquet

can be removed by lifting the topaz; this allowed the sharks' teeth to be dipped in wine or food to test for poison, for according to legend the teeth would sweat and change color upon contact with toxins. The piece is first recorded in 1526, among the possessions of the deceased Emperor Maximilian I, as a gilt table ornament with "serpents' tongues" mounted as a tree ("ain vergulte credenz mit viel natterzungen in gestalt wie ain paumb").

The triangular teeth come from chondrichthyes (*Lamna, Odontaspis,* etc.), which are marine fish with cartilaginous skeletons including sharks, rays, and skates; they were distinguished from

prehistoric times onwards for their shiny enameled surfaces, often stained by different minerals, which gave them a variety of hues: milk white, yellowish-brown, bluish-gray, and green. In the Middle Ages they were known as *glossopetrae* (tongue-stones) or as serpents' tongues. The Swiss zoologist Conrad Gesner, in 1558, was the first to notice their resemblance to sharks' teeth (Rudwick 1976, 30–31).

The identification with serpents' tongues could be explained by a simple process of visual association, but there is probably also a basis in biblical lore. Medieval sharks' teeth came mainly from Malta, the place where Saint Paul was bitten on

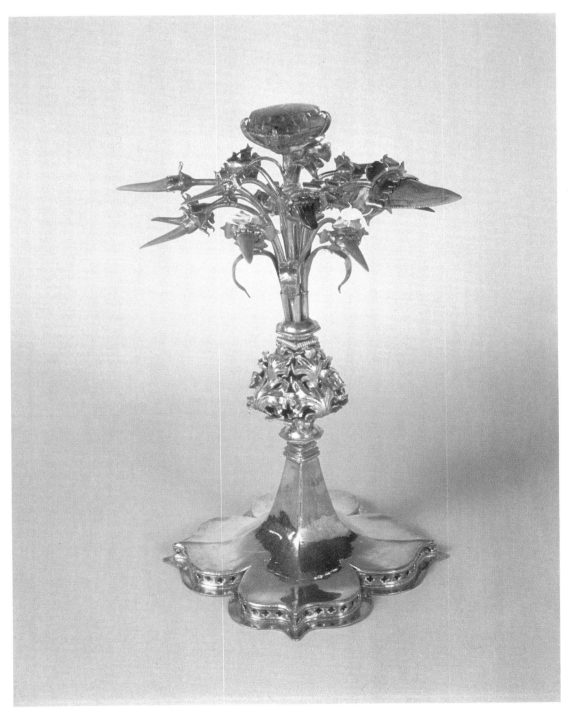

the hand without coming to any harm by an adder which he then threw onto the fire. The Maltese name for sharks' tongues is indeed *Ilsien San Paul* (Saint Paul's tongues), and legend has it that because of the saint no venomous serpent is now found on the island. The notion that the teeth have apotropaic power is rooted in sympathetic magic, though in the legend the idea has been given a religious rationale (see Oakley 1975, 15–21; Zammit-Maempel 1975; Oakley 1985, 63–65). In the thirteenth century, Arnald of Villanova wrote in his *Breviarium* that "certain nobles and barons, when they eat, keep on the table the horn or else the tongue of a serpent in a vessel on a piece of bread, and it is said that if any poison is set before it on the table, it at once begins to sweat" (Lightbown 1978, 29). Chinese porcelain and narwhal horns served a similar function on the medieval table (cats. 16, 7).

The oldest reference to *languiers* is in the inventory of goods made at the death of Odo, count of Nevers, in 1266. Under Pope Boniface VIII in 1295 the Holy See had fifteen "branches or trees with serpents' tongues." In the fourteenth and fifteenth centuries they appear in many inventories; for example, in 1318 Pope John XXII received from Philip the Long one that was described as "a beautiful *languier* of gold, covered with rubies and emeralds and fine pearls, with six serpents' tongues" (for the history of *languiers*, see mainly Pogatscher 1898; Tescione 1965, 224–225; Lightbown 1978, 29–30; Schiedlausky 1989).

Natterzungenbaüme are extremely rare today. Only two other medieval specimens are extant, one in the Schatzkammer des deutschen Ordens in Vienna and another in the Grünes Gewölbe in Dresden (Kohlhaussen 1968, 163, no. 253, fig. 277). To these examples, which have been preserved intact, can be added a few individually mounted teeth which, if not originally hanging on a *languier*, must have been worn as amulets to protect against poison, plague, and epilepsy (Hansmann and Kriss-Rettenbeck 1977, figs. 252–257). J.M.M.

13 ᴥ

CRUET MOUNTED AS A EWER

10th century (rock crystal), 13th century (mount)
Fatimid, mount possibly Venetian
rock crystal, silver gilt, and niello
height 28 (11)
references: Hahnloser 1971, 113–115 no. 125, pls.
C–CI; New York 1984, 222–227, no. 32; Berlin 1989,
544, no. 4/1, fig. 218

Tesoro di San Marco, Venice

According to the Arab scholar Biruni, who wrote at the turn of the first millennium, rock crystal was imported from Kashmir, Madagascar, and the

Laccadive and Maldive islands, while other sources mention North Africa, Afghanistan, Yemen, and the Red Sea as well. Of the 170 medieval works in rock crystal from the Islamic world that are still preserved, by far the largest number come from Fatimid Egypt. This is the case with the cruet now in the Treasury of San Marco, which was mounted as a ewer in the thirteenth century. The rock crystal receptacle, which has lost its handle, has a symmetrical decoration of two rams facing each other and separated by palmettes, which fill most of the remaining space. The style is close to that of another crystal vase, also in the Treasury of San Marco, which bears a Kufic inscription "Blessing from Allah for the Imām al-'Azīz billāh," referring to the Fatimid caliph al-'Azīz who ruled from 975 to 996. The Fatimid treasure must have been of fabulous wealth: Various sources mention between 18,000 and 36,000 items. It is not known when this vase reached Venice, but it was probably one of the three pieces mentioned in an inventory of 1325 ("Ampulletas tres de cristallo, varnitas argento"). It was probably mounted as a ewer in the thirteenth century, although for decorative purposes only, as the silver spout is not functional. The general effect of the mount has been described as orientalizing, and it must have

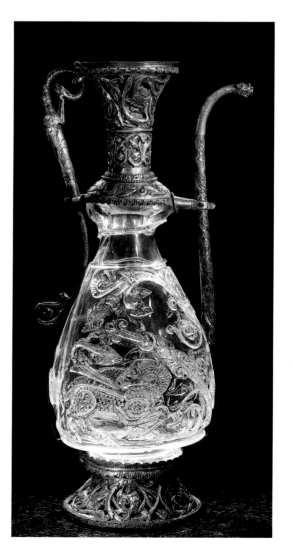

been intended to harmonize stylistically with the vase. The largest section of the neck is decorated with foliate scrolls populated by two men fighting dragons, while the foot of the cruet has scrolls enriched in two cases with lions and in a third with a dragon. Most impressive, however, are the handle, formed of an elegant dragon, and the spout, which ends in a dragon's head. The closest parallels to the mount are found in French works of the late twelfth and the first half of the thirteenth centuries; a Venetian origin, however, is not impossible. J.M.M.

14 ᴥ

ROCK-CRYSTAL ELEPHANT

late 15th century
Indian, Deccan Sultanate
rock crystal, with 16th-century European mounts in gold and enamel
height 7.3 (2⅞); length 9.4 (3¾)
references: Born 1936, 275, pl. IID; Lach 1970, 27, pl. 9; Welch 1985, 132–133; Jordan 1991

Kunsthistorisches Museum, Vienna, Sammlung für Plastik und Kunstgewerbe

This recumbent rock-crystal elephant is difficult to date, because of its uniqueness and the fact that rock crystal takes on no signs of age. It is clearly Indian in style and workmanship. The carving could only have been done by a lapidary aware of the way Indian elephants look and move. After studying the animal's exceptional—and very obliging—pose, he abstracted it, echoing the pleasing roundness of head and trunk in the almost circular space between trunk and chest. As there are no signs of the naturalism that is characteristic of Mughal Indian style, which would have lent the piece more individuality, suggestions of texture, and greater accuracy of proportion, it is almost certainly of Sultanate manufacture. The gold and enamel mounts were added in Europe during the sixteenth century, when the elephant was fashioned into a saltcellar.

Although the literature on this piece suggests that it once formed part of the famous *Kunstkammer* of Archduke Ferdinand of the Tyrol (1520–1595), in fact it belonged to Catherine of Austria (1507–1578), the younger sister of Charles V, who was queen of Portugal. Her collection of oriental and other exotic objects was one of the largest of the sixteenth century, next to that of Philip II of Spain. The mount for the *Elephant* was commissioned in 1552 (Jordan 1991 and forthcoming article). A splendid example of European enthusiasm for Asia during this period, the piece may have come through Goa, which enjoyed close relations with the Deccani sultans. This plump, benevolent pachyderm bears stylistic affinities to

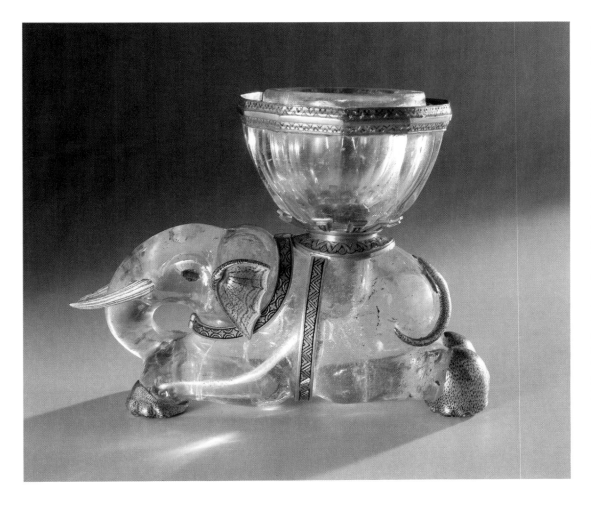

must have been exceedingly rare, acquired in diplomatic gifts from oriental rulers or, in a few instances, brought back from the East by travelers (Whitehouse 1973, 63–78).

The Gaignières-Fonthill vase had certainly reached Europe by 1381, when it was set in a now lost silver gilt and enameled mount. From various inscriptions, from heraldic evidence, and from the style of the mount, the ewer can be dated 1381, the year when it was given by the Hungarian king, Louis the Great to Charles III of Anjou-Sicily to celebrate the latter's accession to the kingdom of Naples (1381). The bottle itself is made of a hard, white *qingbai* (blue white, formerly known as *yingqing*) porcelain with a pale bluish-green glaze and can be dated c. 1320–1340. A drawing made for Roger de Gaignières in 1713 represents the bottle when it was still mounted as a ewer (Bibliothèque Nationale, MS fr. 20070, fol. 8). Four manuscript pages bound with the drawing describe its mounting at the time, when it was in the collection of M. de Caumartin. It had previously belonged to the dauphin and was recorded in a royal inventory of 1689. The ewer, which later came into the possession of William Beckford at Fonthill Abbey, was sold in 1822 to John Farquhar and resold by him a year later. When it reappeared in the Hamilton Palace sale in 1882, it had been stripped of its fourteenth-century mount to become again a simple "pear-shaped bottle"; today only the hole pierced for the spout testifies to the European additions. J.M.M.

later Deccani depictions of elephants, suggesting strongly that it should be assigned to one of the sultanates of the Deccan, perhaps to the Bahmanid dynasty that ruled from 1345 until the first quarter of the sixteenth century.

<div align="right">S.C.W.</div>

(Adapted with permission from India: Art and Culture, *published by The Metropolitan Museum of Art, New York, 1985.)*

15 ❧

GAIGNIERES-FONTHILL VASE

c. 1320–1340
bluish-white glazed Yuan-dynasty porcelain
height 28.3 (11⅛)
references: Mazerolle 1897; Moule and Pelliot 1938, 1:352; Pelliot 1959–1973, 2:805–812; Lane 1961; Whitehouse 1973, 63–78; Spallanzani 1978, 83; Lunsingh Scheurleer 1980, 4–5, figs. 1a, 1b; Ayers 1985, 260–261

National Museum of Ireland, Dublin

In his *Description of the World* written in 1298–1299, Marco Polo provided the first substantial account of Chinese porcelain to reach the European educated public: "And . . . I tell you that the

most beautiful vessels and plates of porcelain, large and small, that one could describe are made in great quantity . . . in a city which is called Tingiu [Tongan near Quanzhou], more beautiful than can be found in any other city. And . . . from there they are carried to many places throughout the world. And there is plenty there and a great sale, so great that for one Venetian groat you would actually have three bowls so beautiful that none would know how to devise them better (Moule and Pelliot 1938 1:352 [chap. 157]; Pelliot 1959–1973, 2:805–812).

In the Islamic world, porcelain was first described by Sulaymān, an Arabian traveler of the ninth century, and recent excavations in Sīrāf have revealed that large quantities of porcelain were reaching the Persian Gulf before 820. Rulers like Hārūn al-Rashīd (786–806) in Baghdad and the Fatimid caliph al-Mustansir (1036–1094) had large collections of Chinese porcelains. Chinese silks, as well as other Chinese objects, had already found their way to Europe as early as the Roman period. The oldest reference to actual examples of porcelain in a European collection seems to occur in 1323 in the will of Queen Maria of Naples and Sicily, but material from an archaeological excavation of the royal residence in Lucera in Puglie provides an indication that Chinese porcelain reached Europe before the fourteenth century. The evidence suggests, however, that porcelain

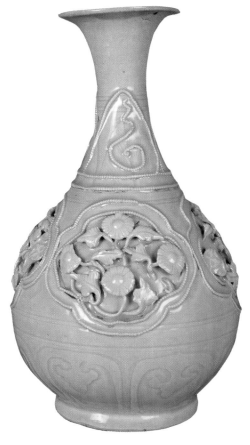

KATZENELNBOGEN BOWL

c. 1434–1453
bowl, late 14th/early 15th century celadon ware,
probably from Longquan
mount silver gilt, partly enameled
height (with cover) 20.6 (8⅛)
references: Pelliot 1959–1973, 808–809; Whitehouse
1973, 71; Spallanzani 1978, 83–84; Lunsingh
Scheurleer 1980, 9–10, fig. 4; Ayers 1985, 262;
Carswell 1985; Kassel 1990, 10–13, 215–218, no. 1

Hessisches Landesmuseum, Staatliche
Kunstsammlungen, Kassel

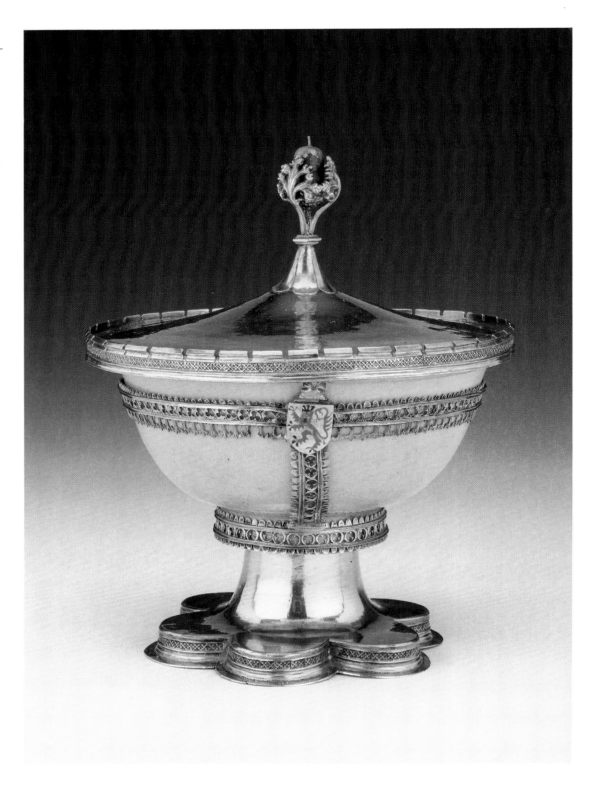

The Katzenelnbogen bowl is first mentioned in an inventory, compiled in 1483, of the possessions of Landgrave Heinrich III, where it is described as a gilt cup with cover and identified as an Asian ceramic ("Ein vergoldeter Pokal mit Deckel, genannt die Erde von Indien"; *Indian* in this case simply means Asian). In an inventory of 1594 we are told that the cup was brought back from the orient by one of the Katzenelnbogen counts ("ein Graff von Catzenelnbogen auss Orient Mitt sich in diese Landte brachtt").

The bowl is a typical example of Chinese celadon ware, probably from Longquan, of the late fourteenth or early fifteenth century. It was probably purchased by Philipp the Elder, count of Katzenelnbogen, during his pilgrimage to the Holy Land from 14 July 1433 to 3 May 1434; this would accord with the information given in the 1594 inventory. He may have bought it in Acre; an account of his life written by an anonymous author and later versified tells that merchants from all over the world could be found there. Chinese wares were relatively easy to obtain in the Near East, for they had been exported there for centuries (for the export of Chinese blue-and-white porcelain to the Islamic world, see Carswell 1985). In western Europe they were still of the utmost rarity. To set off his "Indian" treasure, Count Philipp had it mounted by a silversmith in a Rhenish workshop as a cup with a broad stem and a six-lobed foot; the cover was decorated with an enameled acorn, held by foliage, which originally (as we know from descriptions of the piece in two inventories of 1500 and 1502) was completely blue and surmounted by a pearl. The pearl has now disappeared. The enameled coats of arms have been identified as those of Philipp von Katzenelnbogen before he became count of Dietz in 1453.

The Gaignières-Fonthill vase (cat. 15), the Katzenelnbogen bowl, and another dish in Longquan celadon ware that was given by the sultan of Egypt Qā'it Bāy to Lorenzo de' Medici in 1487 (Spallanzani 1978, 85–86, pls. 21–22) are the only Chinese ceramics known today that can be shown to have been brought to Europe before 1500. The so-called Marco Polo Jar in the Treasury of San Marco in Venice may well have come to Europe at a later date (Whitehouse 1973, 71–72).

In medieval times, Chinese porcelains were believed to offer protection from poison. This belief is reflected, for example, in the *Libellus de notitia orbis* (*On Knowledge of the World*) of 1402: "Noblemen eat and drink from these vessels. Porcelain is said to be efficacious against poison, and whatever there may be inside, poison or anything drinkable, it absorbs all the impurities, etc. of the poison and purifies it entirely" (Pelliot 1959–1973, 808–809). Chinese ware, as we have seen (cat. 15), was still rare in Europe at the end of the fifteenth century. Only after Vasco da Gama opened the new maritime route to the Middle and the Far East in 1498 did porcelain become more common in European countries. J.M.M.

DALMATIC

c. 1350–1400
probably Gdansk
five silk textiles, three with gilt yarns;
blue linen lining
height 124 (48⅞); width with outstretched sleeves
133 (52⅜); width at hem 132 (52)
inscribed: (in rounded naskhī *script) as-sulṭān*
al- ᶜālim and as-sulṭān
references: Falke 1913, 2:62–63; Kendrick 1924, 67;
Mannowsky [1931]–1938, 1:6, 3:15–16, no. 111, pls.
122, 123; Nuremberg 1958, 11–12, cover
illustration; Atil 1981, 223, 228, n. 5; Wardwell
1988–1989, 100, 106–108, 127, n. 106, figs. 41–41A;
Berlin 1989, 172–173, figs. 186–187, 569–570,
no. 4/43

ᴇᴋᴜ, *Berlin; Museum für Kunst und*
Kulturgeschichte der Hansestadt Lübeck

The dalmatic is one of the three main outer garments used for Roman Catholic rites since the Middle Ages, along with the chasuble, which shrank over the years from a bell shape to a double-shield shape, and the large, half-circle cope. The dalmatic, which has sleeves but is open down the sides, derives in shape and name from an ancient garment of Dalmatia, now northwest Yugoslavia, which became a mark of important personages during the late Roman Empire.

This dalmatic is one of the hundreds of rich vestments originally used in the Marienkirche (Church of Mary) in Gdansk. The front and back are of a magnificent silk and gold lampas, in which dark blue, salmon, and light green stripes are separated by narrower white ones with salmon and beige outlines. On alternate wide stripes are palmettes, or the inscription "the sultan, the wise." The narrow stripes show crescents with a dot at the center, separating dotted florettes. The sleeves are of a slightly different lampas, with wide stripes of the same colors, but outlined in salmon and dark blue, and white and light blue narrow stripes. The wide stripes show alternately the same inscription, or palmettes and ovals of leaves, with parrots and birds in between. In the narrow stripes, the crescents with the dot separate running dogs, deer, and lions. The type of these two textiles, dated around 1270–1350, has sometimes been identified as Chinese, for the Mamluk market (Kendrick 1924, 67), but more often either Syrian or Egyptian or specifically Syrian. Most recently it has also been assigned on technical grounds to Khorasan, then a part of the vast Mongol Empire, and now northeast Iran. Various regions of the Mongol Empire are believed to have created such striped, inscribed silks for sale to Mamluk Egypt and Mesopotamia. The triangular insets down the sides of the dalmatic are of a red and green silk lampas showing an ogival trellis

outlined with tiny crescents, rosettes, and flowers, which frames ornate medallions inscribed "the sultan." It is thought to be Mamluk Egyptian or Syrian, from around 1300–1350. Around the neckline is an inset of red and green silk lampas, with a white and blue pattern of paired facing birds and palmettes, attributed to the Italian center of Lucca in the mid-fourteenth century. The left sleeve has a patch of Lucchese gold-brocaded red silk lampas of around 1350–1400. The visible part of the design is a leaping leopard in a large letter *S*. The blue linen of the lining may come from near Gdansk, where the dalmatic was presumably assembled.

Liturgical vestments were usually made in matching sets, to be used together. At least eight other vestments from the Marienkirche were primarily of similar striped lampasses: a cope, four chasubles, and three other dalmatics; along with two stoles and a maniple (Mannowsky [1931]–1938, nos. 3, 30–33, 112–114, 132, 132a, 133, pls. 5–6, 46–49, 122–125, 132). The cope, two chasubles, and one other dalmatic are also now in Lübeck (Nuremberg 1958, nos. 3, 18, 19, 52). The eastern silks of this unusually large set were considered so precious that every small bit was used; the gaps were filled with only slightly less precious Lucchese silks. Such a costly set was probably for only the most solemn occasions—the *missa solemnis* at consecrations, for instance—when there might be more celebrants than for usual masses. The textiles indicate that the dalmatic was made around 1350–1400. Gdansk was then ruled by the Teutonic Knights, who had close ties with the court of Emperor Charles ɪᴠ in Prague (r. 1346–1378), and hence to Venice, a major center for trade with the Mamluks (Mannowsky [1931]–1938, 1:6). ᴄ.ᴀ.

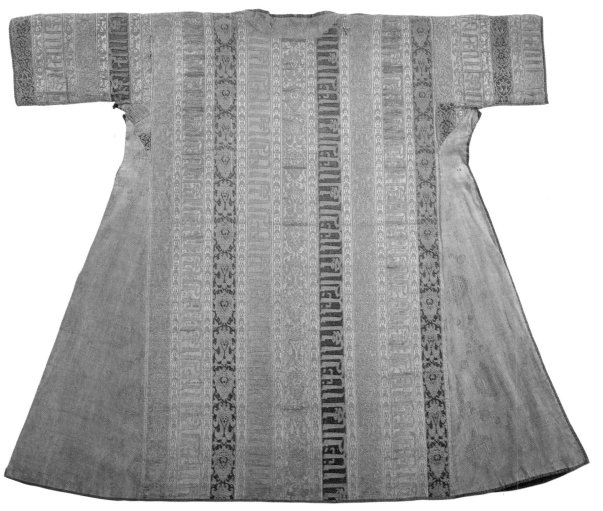

THE REALM OF THE SPIRIT

It is easy to overstate the extent to which the Renaissance in Europe brought about a revolution in man's outlook on the world. In numerous ways medieval concepts continued to influence many of the principal figures of our period, Columbus among them. Their view of history was not the secularized one that prevails today. They believed fervently in the coming end of historical time as foretold in the Book of Revelation, in a bitter struggle with the forces of evil and the establishment of God's kingdom on earth. They keenly felt the call of the Biblical injunction to effect the final conversion of all the world's races to Christianity.

Nowhere are these apocalyptic sentiments better reflected than in the art of northern Europe. There the circumstances that were to climax in the Reformation led to a heightened sense of religious anxiety. Thus Albrecht Dürer, though one of the major humanistic artists of the age, also published a famous series of woodcuts of the Apocalypse and, in a highly personal drawing, recorded his fearful dream of the destruction of the world. Perhaps the most gripping of all renderings of the struggle between the forces of good and evil occurs in Hieronymus Bosch's depictions of the Temptation of Saint Anthony.

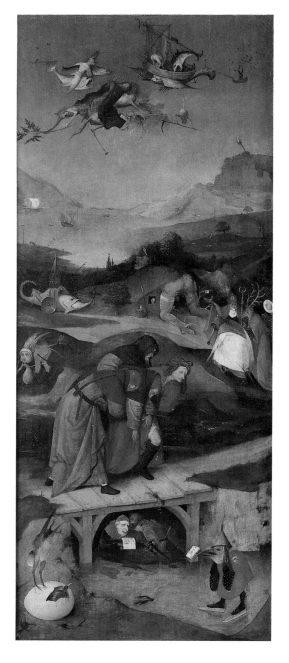

18 ཟ

Hieronymus Bosch
c. 1450?–1516

TEMPTATION OF SAINT ANTHONY

c. 1500–1505
oil on wood
center panel 131.5 x 119 (51¼ x 46½), each wing
131.5 x 53 (51¼ x 20⅝)
references: Cuttler 1957, 109–124; Baldass 1959,
240–241, figs. 86–98, 123–126; Cinotti 1966, no. 43,
pls. XLII–XLVII; Gibson 1973, 138–152; Snyder 1973,
28–41; Bax 1979, 1–178; Unverfehrt 1980, 309 (for
index); Gibson 1983, 105–109; Massing 1984;
Vandenbroek 1987

Museu Nacional de Arte Antiga, Lisbon

In the twentieth century, Hieronymus Bosch is perhaps as famous as he is misunderstood. He was born and spent his life in 's-Hertogenbosch, the town in Brabant from which he took his name. He was baptized Jeroen van Aken and was both the son and the grandson of painters. Not much is known about his life, but there are a few references to him in archival documents, especially those relating to the Brotherhood of Our Lady (*Lieve Vrouwe Broederschap*). It was in the chapel of Our Lady — the chapel of the brotherhood — that Hieronymus Bosch was buried, on 9 August 1516.

Many attempts have been made to unravel the "mystery" of Bosch's art. Some interpretations emphasize the influence of writings of the Dutch mystics, while others turn to astrology or alchemy to explain the artist's symbolism. A more productive approach, however, is to examine Bosch's painting in relation to iconographic traditions of the time and to consider the influence it had on his immediate sixteenth-century successors. Bosch's art becomes less perplexing when seen in the context of contemporary religious and sociocultural conventions, especially those of popular culture (see Bax 1979 and Vandenbroek 1987).

In the case of Bosch's imagery of the temptations of Saint Anthony, the meaning was clear to at least one sixteenth-century viewer, the critic Felipe de Guevara. In his *Commentaries on Painting* (*Commentarios de la pintura*) of around 1560, Guevara considered Bosch's interest in depicting devilish creatures, noting that the artist "painted strange figures, but he did so only because he wanted to portray scenes of Hell, and for that subject matter it was necessary to depict devils and imagine them in unusual compositions." A Spanish cleric, the learned Fray José de Sigüenza, gave a more extensive account of the nature of Bosch's art in his *History of the Order of Saint Jerome* (*Historia de la Orden de San Jeronimo*), published in 1605. Sigüenza found Bosch worthy of comment for various reasons: "first, because his great inventiveness merits it; second, because [his works] are commonly called...absurdities...by people who observe little in what they look at; and third, because...people consider them without reason as having been tainted by heresy." Sigüenza divided Bosch's works into three groups, which he characterized respectively as devotional subjects, various versions of the Temptations of Saint Anthony, and paintings of more complex iconography, such as *The Haywain* or *The Garden of Earthly Delights* (both Prado, Madrid).

Of all Bosch's versions of the temptations of Saint Anthony, the Lisbon triptych is the most extraordinary, testifying not only to the formal and iconographic inventiveness of Hieronymus Bosch, but also to his outstanding skill as a painter, for the triptych has come down to us in pristine condition. It is traditionally placed in the first decade of the sixteenth century, probably between 1500 and 1505 or slightly later. When the triptych came to Portugal is unknown; it is first recorded in the nineteenth century in the Palácio da Ajuda (Real Palacio das Necessidades) in Lisbon.

When closed, the triptych displays on its wings two scenes of the Passion of Christ, which are painted in monochrome except for some brown and bluish tones. On the left is the Capture of Christ in Gethsemane, including in the foreground the episodes of Judas fleeing with his money and Saint Peter cutting off the ear of Malchus. On the right-hand panel is Christ falling under his cross, with Veronica kneeling before him; in the foreground, amid the desolation of Golgotha, are the two thieves confessing their sins.

When opened, the triptych shows Saint Anthony subjected to a wide range of devilish delusions. On the left wing are scenes from the saint's life described by the early Christian writer Athanasius and found in abbreviated form in later works, such as Vincent of Beauvais' *Speculum historiale* (*Mirror of History*) and Jacopo da Vora-

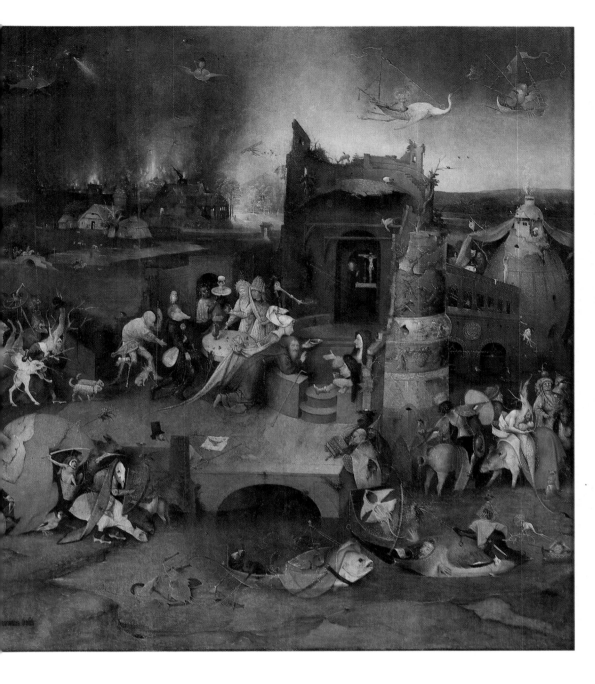

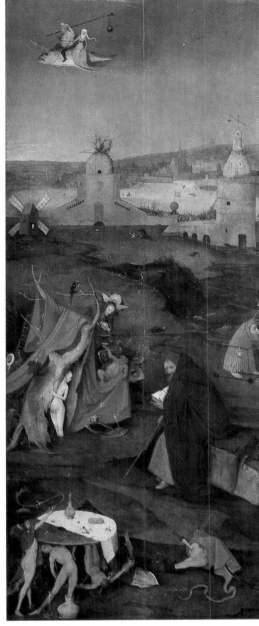

gine's *Legenda aurea* (*Golden Legend*). After having been attacked by devils and left half dead in the desert, Anthony was rescued by a friend who took him home. When he recovered consciousness, the saint asked to be brought back to the desert to fight the devil on his own ground. In the painting the saint is being carried by three companions back to his tomblike "cave," which has been taken over by the devil; a woman, clearly a prostitute, can be seen at the window. Up in the air, the saint is seen enduring another tribulation, usually described as the devil's second assault on the hermit. The Dutch translation of the *Legenda aurea* describes how "the fiends came again and tore him with their teeth and stabbed him with their horns and struck him with their claws. They cast him up into the air, then they hurled him down again, in such manner that they had almost brought him to death." It is more likely that Bosch

meant the aerial attack to represent a different scene in the life of the saint, namely his moment of ecstasy, when he saw himself struggling in the air with his enemies. Bosch was probably familiar with Martin Schongauer's engraving representing this scene (see Massing 1984, 220–236), and he must have known the text in which Anthony "felt himself carried off in spirit . . . Then he also saw loathsome and terrible beings . . . preventing him from passing through," thus trying to thwart his mystical experience. In the end, the devils had to set the saint free. In the painting the devils lurking under the bridge are probably compiling a list of sins supposedly committed by Anthony—their faked evidence for the accusations they make in the aerial scene.

On the right wing of the triptych is shown another episode of temptation, when Saint Anthony came upon a beautiful woman bathing

naked in a stream—the Devil, again, in this case disguised as a queen. As in the left-hand panel, the whole composition swarms with a crew of monsters and demons who take on the most extraordinary forms to bring the saint and the world to damnation.

The devilish temptations become almost overwhelming in the central panel, in which the oppressed saint kneels in front of an altar, set up inside a broken-down structure—a haven from the torments of sin, with Christ pointing to a crucifix. All around Satan triumphs, with devils enacting parodies of Christian practices and beliefs. These are the fantasies inspired by the devil in the saint's fevered mind. They are distinctly medieval fantasies, for in the psychological theory of the period, dreams suppress the rational powers that control both the *virtus imaginativa* (the power of imagination) and the images stored

in the *imaginatio* (imagination). These images then take rational forms and are submitted to the *sensus communis* (common sense), which accepts them as real. Fray José de Sigüenza was clearly thinking of some such process when he discussed the function of the temptations of Saint Anthony as painted by Bosch: "In one place one observes this Saint, the prince of hermits, with his serene, devout, contemplative face, his soul calm and full of peace; elsewhere he is surrounded by the endless fantasies and monsters that the archfiend creates in order to confuse, worry and disturb that pious soul and his steadfast love. For this purpose Bosch conjures up animals, wild chimeras, monsters, conflagrations, images of death, screams, threats, vipers, lions, dragons, and horrible birds of so many kinds that one must admire him for his ability to give shape to so many ideas. And all this he did in order to prove that a soul that is supported by the grace of God and elevated by His hand to a like way of life cannot at all be dislodged or diverted from its goal even though, in the imagination and to the outer and inner eye, the devil depicts that which cannot excite laughter or vain delight or anger or other inordinate passions." Moreover, Sigüenza appears to have considered Bosch's message especially relevant to him: "He made variations on this theme so many times and with such invention that it arouses admiration in me that he could find so much to deal with, and it makes me stop to consider my own misery and weakness and how far I am from that perfection when I become upset and lose my composure because of unimportant trifles, as when I lose my solitude, my silence, my shelter, and even my patience. And all the ingenuity of the devil and hell could accomplish so little in deceiving this saint that I feel the Lord is just as ready to help me as him, if I would only have the courage to go out and do battle." (For the various translations from Spanish, see Snyder 1973, especially pages 28–29 and 34–37.) Viewers such as Felipe de Guevara, Ambrosio de Morales, and Sigüenza would certainly have understood many of the details that Bosch included — for example, the burning houses in the background that refer to the *ignis sacer* or Saint Anthony's fire, an illness (ergotism) thought to be propagated by the devil and cured by the saint; both the desiccated foot and the cup of wine held by the woman next to the saint allude to this disease. They would also have recognized that the artist's general intention was moral, since Bosch illustrated in his work the devil's role in disseminating various vices and especially the Deadly Sins. J.M.M.

PORTUGAL AND THE SEA ROUTE SOUTH

The Age of Exploration began in Europe with Portugal's voyages down the African coast in the 1430s. In the century that followed, the Portuguese revolutionized navigation. They sailed as far west as Brazil and as far east as the Indian Ocean, which Vasco da Gama opened to European commerce in 1498. The small kingdom quickly developed into a major world power; in 1494 Portugal presumed to divide up the entire non-Christian world with Spain.

Portuguese artistic monuments of this period—whether produced in Portugal or commissioned abroad, in the Low Countries or Italy—reveal the deep religious faith that lay behind its expansionist foreign policy, as well as pride in the country's remarkable political and economic success.

19 ॐ

Nuno Gonçalves
Portuguese, active c. 1450–1491

PANEL OF THE INFANTE (FROM THE ALTARPIECE OF THE VENERATION OF SAINT VINCENT)

1471–1481
oil on oak panel
220 x 124 (86 ⅝ x 48¾)
references: Vasconcelos 1895; Figueiredo 1910; Saraiva 1925; Cortesão 1925; Motta Alves 1936; Jirmounsky 1940; Huyghe 1949; Lambert 1951; Santos 1955; Gusmão 1956; Bélard da Fonseca 1957–1967; Gusmão 1957; Botelho 1957; Vieira Santos 1959; França 1960; Sterling 1968; Cortesão 1971; Markl and Pereira 1986; Freitas and Gonçalves 1987; Osório de Castro 1988; Markl 1988

Museu Nacional de Arte Antiga, Lisbon

The polemic that has surrounded the celebrated altarpiece to which this panel belongs could be said to approach, in its intensity, the controversies that have long enveloped Leonardo's *Mona Lisa*. It has led to the publication of literally hundreds of books and articles, to violent fights, and even to one suicide. When the panels were discovered in 1882, at the monastery of S. Vicente de Fora in Lisbon, they were being used as scaffolding by workmen. Their recovery brought about one of the most complex debates in all of Portuguese art.

Sixty portraits confront us in the altarpiece, masks of the *dramatis personae* in a spectacle, calling upon us to interpret the action. The closed composition recalls Italian narrative frescoes of the Quattrocento. In the background are a series of faces, like the chorus in a tragedy. In the foreground the principal figures are singled out, in an exaggerated way, to emphasize their importance as protagonists. The strength of the composition stems from its unique combination of the religious and the worldly. It attests to a pivotal moment in the transition between sacred and secular, a time of great uncertainty. It represents the final moments of a world order defined by theology, which governs the iconic and architectonic structure of the work, but it also affirms secular references and a structure that is devoid of

sacred character. In fact, following the Council of Trent, the paintings were taken out of use because of what was judged to be the excessive number of laymen represented (Markl 1988).

In the panel displayed here, facing the figure of Saint Vincent, at the observer's right, is the benefactor—Dom Afonso v, shown on his knees. While the painting is influenced by religious themes, the presence of the court and lay figures shows the intention of communicating on a historical level, as well as of creating a true collective portrait of the age. While the votive intent of the composition is clear, there is also a secondary meaning, the king's loving dedication to his first wife. Though she had died in 1455, he had her represented in the panel (Dom Afonso v's motto—JAMAYS [never]—inscribed in the Pastrana tapestries [see cat. 20], stresses his intention never to forget her). This emphasis on family harmony is directed to the young Prince Dom João (later King Dom João II)—seen at the right as a delicate adolescent, his restrained seriousness characteristic of images of that period— a message made all the more important by the tragic struggles that had taken place during the regency, while Dom Afonso was a minor, which in 1446 cost the life of his uncle and father-in-law, the Infante Dom Pedro.

The altarpiece also celebrates the Discoveries, the project which galvanized the efforts of the entire nation, symbolized by the figure of the Infante Dom Henrique (Prince Henry the Navigator), seen in sober garb behind the prince at the right. Dona Isabel, the daughter of Dom João I, appears at the left in her widow's garb as a Franciscan nun or as a member of the order of Santa Clara. She focuses attention on the historic role of the House of Avis in the pursuit of navigation and conquest and on its international policies, which led to her marriage to Philip the Good of Burgundy.

The altarpiece consists of five other panels in addition to the Panel of the Infante: the Panel of the Friars, the Panel of the Relic, the Panel of the Archbishop, the Panel of Sailors and Fisherman, and the Panel of the Noblemen. The first two, though each half the width (61 cm.) of the Panel of the Infante, are related to it. The friars, in

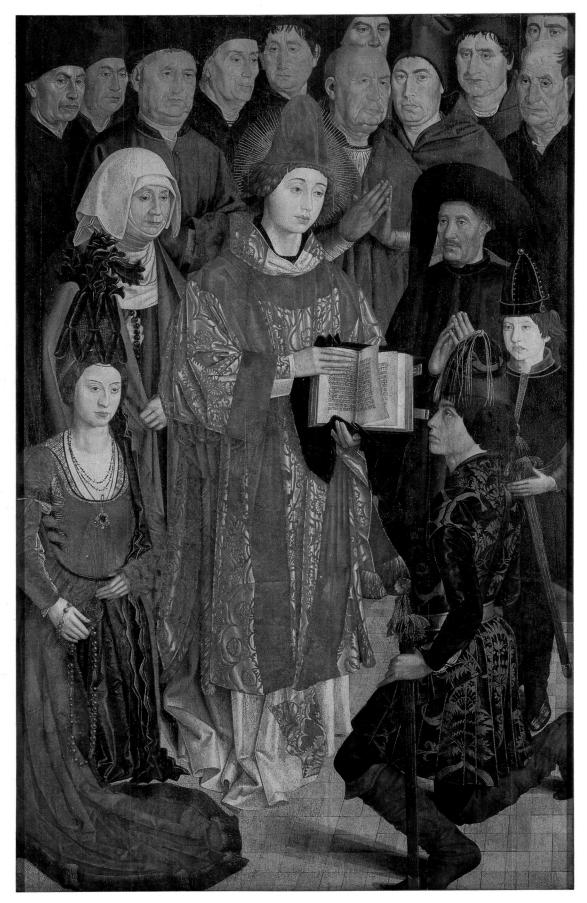

white robes, are from the monastery of San Vicente da Fora (or, according to some scholars, of Alcobaça), which was closely associated with the campaigns in Arzila. The kneeling figure is Nuno Alvares de Aguiar, the prior from 1464 to 1490, who accompanied Dom Afonso v's army during the occupation of Tangiers. There, on 20 August 1471, he celebrated a thanksgiving mass in a large mosque that had been transformed into a Christian chapel and was designated bishop of Tangiers.

The Panel of the Relic shows the fragment of a skull, part of the remains of Saint Vincent, preserved in the Cathedral of Lisbon. The coffin shown in the upper part of the panel is thought to be a reference to a knight, Dom Henry, a crusader against the Moors who perished in the siege of Lisbon in 1147. He miraculously appeared and healed two of his friends, and his relics were venerated by a growing number of pilgrims. Others believe that the casket represents the one in which the relics of Saint Vincent were transported, while others think that it is meant to be the casket in which the remains of Dom Fernando were found. The figure holding the Hebrew Bible is Isaac Abrabanel, whose significance is discussed below.

The Panel of the Archbishop (called by some scholars the Panel of the *Condestáveis* to indicate its relationship to the Panel of the Infante [also known as the Panel of the King]), shows Saint Vincent holding a staff, the symbol of military action, flanked on the left by the kneeling figure of Dom Fernando, brother of Dom Afonso v and strategist of the expedition to Arzila, who died days before the battle. On the right is the kneeling figure of Dom Henrique de Menezes, first count of Valença and the official bearer of the royal flag, who took Dom Fernando's place. To the rear is Dom Fernando de Menezes, who was appointed governor of the conquered city of Arzila because of his bravery. Dom João, the twenty-three-year-old son of Dom Fernando, is shown next to his father, in a visual parallel to the representation of Dom Afonso v and his son Dom João on the Panel of the Infante. The imposing ecclesiastical figure who appears at the upper left of this panel is Dom Jorge da Costa, archbishop of Lisbon from 1464 to 1500. He is flanked by canons of the cathedral and by the archdeacon, who holds the bishop's crozier. It is Dom Jorge da Costa, later to become Cardinal Alpedrinha, who is generally credited with the program for the polyptych (R. da Cunha 1642). At the upper right, the figure with a book may be the chronicler Gomes Eanes de Azurara.

The sailors and fishermen who appear in the fifth panel are ordinary people who have become actors in this drama. Their significance is historical as well as religious; their brotherhood was under the protection of the Holy Spirit, and they played a key role in furnishing the transportation that was essential to the Portuguese success at Arzila. The Panel of the Noblemen is usually thought of as homage to the noble house of Bra-

gança. The first duke, Dom Afonso (1385–1461), illegitimate brother of the Infante Dom Henrique, is the figure in the foreground, singled out for his role in defending the king's party in the crisis that led to the Battle of Alfarrobeira and for the part he played in the North African campaigns. In the background, to the right, is the second duke, Dom Fernando (1403–1483), who served as regent during the absence of Dom Afonso v in the African campaign. To the left is the third duke of Bragança, Dom Fernando (1430–1483), who served in the assault on Arzila, together with Dom João, his brother, the marquis of Montemor. The bearded, hirsute young man may be meant to represent Mohammed, son of the Sheikh of Arzila, who was kept in the custody of the court in Lisbon for two years following the battle.

The Portuguese cult of the martyr Saint Vincent is closely related to the drive for national independence and the Reconquest of Portugal from the Moors, symbolized by the victory of Dom Afonso Henriques, the first king of Portugal, in Lisbon in 1147. Above the grave of those who perished in that bloody battle, the King erected a Romanesque temple, dedicated to the Virgin as well as to Saint Vincent. Shortly before his death Dom João I arranged for the construction of the presbytery and the altar of Saint Vincent (1433). We know that in 1434 Dom Duarte donated six urns of oil for the lamps of the altar of Saint Vincent at the Cathedral of Lisbon, where the saint's remains were deposited soon after their arrival in the city in 1173. The Infante Dom Fernando, held prisoner in Fez, in 1437, left valuable religious works to the memory and honor of Saint Vincent, who became the patron of the royal house, of the city of Lisbon, and of the navigators.

Documents dating from 1451 (ANTT, *Chancelaria do Rei D. Afonso v*, Book 11, fl. 139, cited in Sousa Viterbo, 1899) describe the campaign to construct a chapel dedicated to Saint Vincent, under the direction of the master-architect João Afonso, who is described as "master of works of that chapel of the blessed." In the slightly earlier Niccolini Chapel in the Vatican Pope Eugenius IV commissioned an ensemble of frescoes in honor of the martyrs saints Lawrence and Stephen, the only deacons other than Vincent to be canonized, may have encouraged Dom Afonso's project. A document of 1469 indicates that Dom Afonso v offered "5650 reals to the cathedral chapter as alms for the altarpiece of the martyr Saint Vincent being made there."

The *Retrato dos Reis q Estãem Lisboa*, a codex of the late sixteenth or early seventeenth century in the Biblioteca Nacional of Rio de Janeiro, states that the figure of Saint Vincent has the features of the son of Dom João II, Prince Dom Afonso, who died tragically in 1491, suggesting that the face of the saint was repainted to commemorate the loss of the heir to the throne. This change further complicates the issues of dating and attributing the altarpiece. These historical sources were the

basis for assuming that Dom Afonso v commissioned the altarpiece for the chapel of Saint Vincent. It is thought that its execution took some time and that the historical events of the conquest of Arzila and Tangiers in 1471 determined its conceptual and symbolic framework.

We know that on 12 April 1471 Nuno Gonçalves, to whom the altarpiece is attributed, was appointed official painter of the city, replacing João Eanes. One of the most important references to him, and a basis for the attribution, is a quotation from Francisco de Hollanda's *Da Pintura Antiga* of 1548: "And this was Nuno Gonçalves, the painter of King Dom Afonso, who painted the altar of Saint Vincent in the Cathedral of Lisbon" (Book I, ch. XI).

We know little about Nuno Gonçalves. There is no stylistic tradition to support the attribution of the panels to him, nor do we know of any followers. We know nothing of his training. The influence of Jan van Eyck (c. 1390–1441) is often proposed. While it is thought certain that van Eyck visited Lisbon in 1428–1429 to paint a portrait of the future wife of Philip the Good, this date is too early for him to have exerted any direct influence on Gonçalves, who may not even have been born yet. The other Early Netherlandish master who is often mentioned is Rogier van der Weyden (c. 1400–1464). Gonçalves must have known of van der Weyden, as he was painter to the court of Burgundy, the home of Dona Isabel, who is represented in the Saint Vincent altarpiece. Her portrait appeared in a triptych which until the early nineteenth century was preserved in the monastery at Batalha.

Ultimately, one can speak only of the general inspiration of Flemish art, which was of broad influence in Portugal at this time. The same can be said about the influence of Catalan painting, whose principal exponent, Bartolomé Bermejo (1430–1498), shares stylistic features with Flemish art. Francisco de Hollanda also spoke of Gonçalves' innovative technique — "for in a very primitive time he wanted in some way to imitate the care and description of the ancient and Italian painters" — a statement which has caused scholars to look to the paintings of Gozzoli, Ghirlandaio, and Luca Signorelli (the latter above all in his anatomical modeling of figures — see, for example, his *Christ at the Column* [Museu Nacional de Arte Antiga, Lisbon]).

There is an especially fascinating correlation between the text of the book that Saint Vincent holds open to the observer in the Panel of the Infante and the Hebrew Bible which Isaac Abrabanel holds in the Panel of the Relic. The intention is evidently to convey a message through both the New and Old Testaments. The passage in Saint Vincent's Bible is chapter XIV, verses 30 and 31, of the Gospel according to Saint John: "Hereafter I will not talk much with you; for the prince of this world cometh, and hath nothing in me. But that the world may know that I love the

Father; and as the Father gave me commandment, even so I do." In the context of the New Testament, Christ, anticipating his Ascension, is encouraging the apostles in their coming struggle with the devil. The text is read in the mass for Pentecost, where it refers to the propagation of the faith by the apostles after the Holy Spirit has descended upon them. In the symbolic context of the altarpiece this Biblical quotation must refer to the Portuguese struggle with the Infidel, the forces arrayed against Christianity (Cortesão 1978).

Isaac Abrabanel (1436–1508), a powerful Jewish banker and the administrator of Dom Fernando's household, became the financial adviser to Dom Afonso v in 1472. In later years he helped finance the campaigns in Castile. He was also an important Biblical scholar. He holds his Hebrew Bible open to a passage from Isaiah 66:18–19, a text which medieval theologians had compared to passages in St. John's Gospel, seeing in it a prefiguration of the evangelical mission of the Apostles. Abrabanel thus appears as the bearer of Isaiah's prophecy, attesting to the mission of the Apostles and, by extension, to the crusade of Portugal and its soldiers, the new apostles, who have taken on the mission of combating the Infidel (Sterling 1971). J.T.

20 ✦

Attributed to the workshop of Pasquier Grenier
Tournai, active until 1493

TAKING OF TANGIERS

c. 1471–1475
365 x 1050 (143⁵⁄₈ x 413³⁄₈)
tapestry: wool and silk
references: Faria Y Sousa 1680; Raczynski 1846; Guiffray 1886; Viterbo 1920; Merchante 1923; Lopes 1925; Santos 1925; Figueiredo 1926; Dornelas 1926; Santos 1927; Mendonça 1949; Thompson 1980

Museo Parroquial de Pastrana

The splendid set of four Tournai tapestries of which this forms a part, preserved today in the Collegiate Church of Pastrana in Spain, celebrates an important military triumph in the Portuguese conquest of Morocco.

In 1471 Dom Afonso v (1432–1481) added a new epithet to the title he had inherited, one that was intended to glorify his expansionist foreign policy: *Rei de Portugal e dos Algarves daquém e dalém mar em África* ("King of Portugal and of the Algarves and on this side of, and beyond the seas in, Africa"). To underscore the ten years he spent in conquering Morocco, the Portuguese later dubbed him *o Africano* ("the African"), clearly indicating their approval of his own characterization.

The historical context of the Moroccan campaign was the conflict between Christianity and

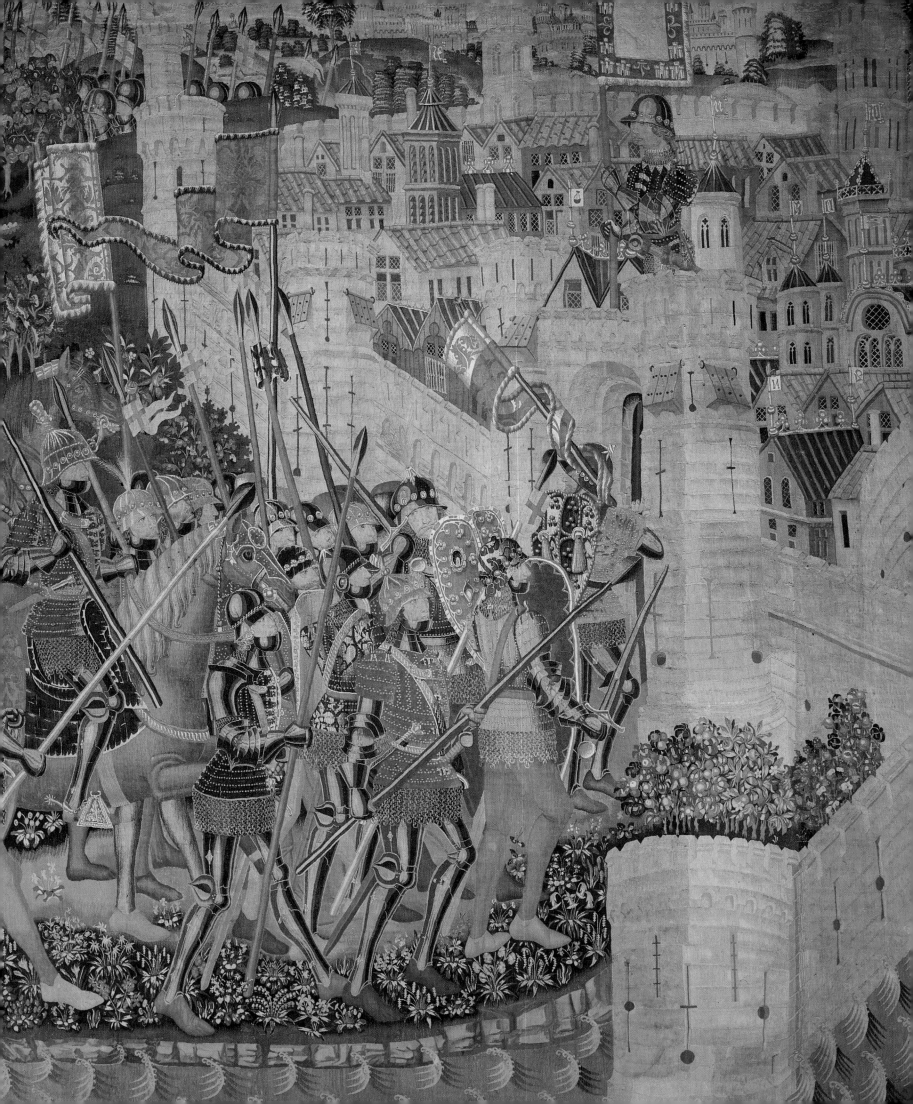

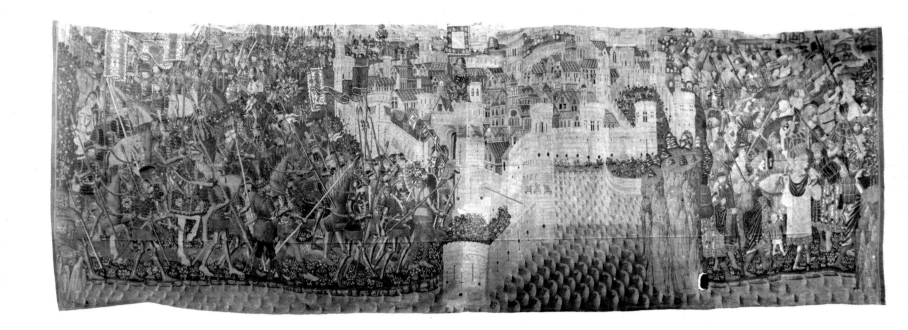

Islam in the Mediterranean world at mid-century. In 1457 Pope Calixtus II appealed to the princes of Christianity to unite in a crusade against the Infidel, a call that was in reaction to the fall of Constantinople to the Ottomans in 1453, regarded by the Catholic world as a catastrophe. In 1456, Dom Afonso V had ordered that the income of the Church in Portugal be used for the crusade "which we now undertake to serve God and defend the Holy Church against the renegade Turks" (*Monumenta Henricina*, vol. XIII). In 1457, in the midst of preparations for the Pope's crusade, the first gold *cruzados* emerged from the Casa da Moeda (Mint). Their production reflected the considerable quantities of gold that the Portuguese obtained from south of the Sahara through Ceuta and especially via their trading post at Arguim.

Portuguese support for this crusade did not go unrewarded. The Papal Bull promulgated by Nicholas V on 8 January 1455 legitimized the occupation of lands and the struggle against enemies of the faith, an undertaking regarded as serving the interests of God and of the Christian religion. A Bull of Pope Calixtus III of 13 March 1456 reiterated this pronouncement and granted to the Order of Christ, the special Portuguese order that had been founded in 1319 to fight the Muslims, spiritual jurisdiction over all territories discovered at present and in the future, "from Cape Bojador and Cape Não, along the coast of Guinea and beyond to the Indies."

After the Portuguese victory in 1458, which led to the annexion of the Moroccan town of Alcácer-Ceguer, the failure of the expedition to Tangier in 1463 persuaded Dom Afonso V to undertake a new Moroccan campaign. His military advisers determined that for strategic and commercial reasons, the most important objective on the Atlantic coast was the city of Arzila. It ultimately fell to Dom Afonso's troops in 1471.

The so-called *Taking of Arzila* tapestries depict the fierce battle in a format that reflects the great mythological narratives of classical antiquity. The intent was to glorify Portugal's ambitions in northern Africa and to celebrate its national achievements. The tapestries are thought to have been commissioned from the workshop of Pasquier Grenier in Tournai soon after the battle and to have been based on drawings made on the scene, as the accuracy of detail in the costumes and armor would suggest. This lifelikeness extends to the extraordinary gallery of portraits presented in the compositions. The drawings have been attributed to Nuno Gonçalves on the basis of similarities between the figures of Dom Afonso V and Prince Dom João in the tapestries with the corresponding figures in the Panel of the Infante from the Saint Vincent altarpiece (cat. 19).

The *Taking of Arzila* is recounted in three tapestries narrating the Disembarkation, the Siege, and the Taking of Arzila. The tapestry exhibited here celebrates the *Taking of Tangiers* immediately following the fall of Arzila. The king himself decided to attack this Moroccan town after learning that the inhabitants had been frightened by the fate of Arzila. A small expedition led by Dom João, son of the second duke of Bragança and later marquis of Montemor, took the city without encountering any resistance.

The tapestry reads like a triptych, from right to left: the flight of the Moors; the vacant city; and the arrival of the Portuguese. At the right the population of the city, in a compact group, is shown fleeing the arrival of the Portuguese troops. A woman in the foreground leads one child by the hand, holding a second on her back and a third on her arm. The tapestry captures the exotic style of the Moorish garments and their colors.

At the center of the composition Tangiers is depicted with such accuracy that it can easily be compared to the rendition in the engraved view of the city in the *Civitates Orbis Terrarum* by Georg Braun (1541–1622). Despite the schematization the essential features of the Muslim town emerge clearly, including the monumental mosque with its various towers and minarets.

To the left the Portuguese army approaches the town's main gate, led by a standard-bearer dressed in a magnificent blue doublet, carrying a leather shield on his back and holding a red and yellow standard. Dom João, Constable of Portugal since 1463, stands out in his splendid garments, with plumed helmet, damascened steel armor and pointed boots *à la poulaine*, riding a richly harnessed white horse with a red and gold brocade saddlecloth.

It is not known for certain how the tapestries made their way to Pastrana. A variety of theories have been proposed. One suggestion is that they were offered by Philip II to Rui Gomes da Silva (1517–1573) at the time of the union of the kingdoms of Portugal and Spain. Because of his influence on Philip II, Gomes da Silva was known popularly as *Rei* (King) Gomes; he was later Prince of Eboli and first duke of Pastrana. (He was descended from Dom João da Silva, Prince Dom João's *camareiro-mór* (steward), a circumstance that could account for the gift of the tapestries; moreover, he is portrayed with the coat-of-arms

of the Silva family (a lion rampant) on one of the tapestries of the *Arzila* series. Another suggestion is that the tapestries were presented to the second marquis of Santillana, later first duke of the Infantado, by Dom Afonso v himself, at the time he claimed the throne of Castile (1474–1479). According to this explanation, the tapestries later passed by inheritance to Dona Catarina de Mendonça e Sandoval who gave them to her husband, the fourth duke of Pastrana, at the time of their marriage in 1630. It is also sometimes thought that the Mendoza family, who supported the troops of Ferdinand and Isabella during this struggle over the Spanish succession, acquired the tapestries as a result of the victory over Dom Afonso at Toro in 1476. Yet another proposal is that Dom João II gave the tapestries, as a reward for important services rendered to the Portuguese crown, to Cardinal Pedro González de Mendonça, brother of the second marquis of Santillana, who accompanied the Infanta Dona Isabel to Portugal for her betrothal to Prince Dom Afonso in 1490.

Faria Y Sousa unmistakably described the tapestries in his *Epitome de la Historias Portuguesas* (1628) after seeing them in the palace of the dukes of the Infantado in Guadalajara. Indeed, we know that in 1664 they were donated to the Colegiata at Pastrana by a nephew of Don Frei Pedro González do Mendoza, archbishop of Granada, Zaragoza and Sigüenza (1564–1639) and son of Don Diego da Silva y Mendoza (d. 1630). J.T.

21 ᢒ

SALVER DEPICTING A BATTLE FROM THE TROJAN WAR

end of 15th century
Portuguese
silver-gilt, engraved and repoussé
diameter 30 (11¾)
references: Sousa 1739, 2:448; Braga 1870;
Vasconcelos 1951; Couto and Gonçalves 1960; Oman
1968; Smith 1968; Santos and Quilhó 1974

Victoria and Albert Museum, London

The scene in deep repoussé work on this salver depicts a battle from the Trojan war, set at the entrance to the city of Troy. The two knights in combat above the upper part of the coat-of-arms are identified in engraved inscriptions as the Trojan commander Hector on the left and the legendary Greek hero Achilles on the right. The story of the siege and attack of Troy, as narrated by Homer and Virgil, was a popular theme in classical antiquity as well as in medieval novels and Renaissance and Baroque decorative art. It was a popular subject for tapestries, as well. The city and fortifications depicted on the salver resemble those of Arzila, as depicted in the series of tapestries in Pastrana (see cat. 20). Other similarities to scenes on tapestries are the ships' rigging—note the ornament of the sails and the

crows' nests. The salver also recalls the great silver-gilt pieces of the Manueline period in the Palácio Nacional de Ajuda, both in the mythological narrative and in the style of the figural scenes.

The dowry that the Infanta Dona Beatriz of Portugal (1504–1538) took to Nice in 1521 at the time of her wedding to Charles III of Savoy (the Good) included many pieces of jewelry and gold work, including "four large silver cups gilded inside and outside and with relief work on the base and edges, that is, one of the *Story of Troy*, which has a city, a horseman and a tent" (A. Caetano de Sousa, *Provas*, 2:448). This description corresponds to various depictions of the Trojan War from this period and to the scene on the salver, though the work's provenance cannot be traced that far back. The central medallion on the salver was engraved in the seventeenth century with the coat of arms of the Pintos da Cunha family. In 1871, it was sold by Dr. Henrique Nunes Teixeira of Porto, to Francis Cook, a London businessman and investor with Portuguese connections. In 1863–1865, Cook had commissioned the architect James Knowles, Jr. to design a neo-arabic revival palace in Sintra. The salver was subsequently acquired in 1955 by W. L. Hildburgh, an American resident of London, who left it to the Victoria and Albert Museum. J.T.

22 ᢒ

Attributed to João Afonso
Portuguese, active 1402–1443

SAINT MICHAEL

limestone, with polychromy
79 (31⅛)
references: Humbert 1913; Santos 1948; Müller
1966; Bazin 1968; Quarré 1978; Almeida 1983;
Andrade 1983

private collection

If we follow the suggestions of Reinaldo dos Santos, this sculpture of *Saint Michael* should be attributed to the master João Afonso. Other works related to this piece are the sculpture from the collection of Ernesto Vilhena, now in the Museu Nacional de Arte Antiga, Lisbon; a very similar statue in the church of Golegã; and the sculptures that make up the altarpiece of the Corpo de Deus of 1443, now in the Museu Machado de Castro at Coimbra. All of these works have features in common, such as the stylized hairdos, encircled by an interwoven wreath ornamented with rosettes, and the garments with angular patterns of folds, decorated with geometrically shaped brooches (another recurrent element).

The ultimate iconographic prototype of this image is the famous *Ange au Sourire* of the west

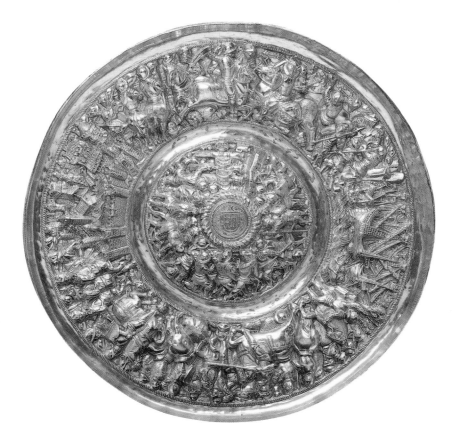

portal of Reims Cathedral, the high point of the attempt in Gothic sculpture to capture human expression in the representation of the divine. This led to the creation of hybrid sacred and profane examples, whose elegance appeals to an earthly taste, without emphasizing the religious dimension. In the case of *Saint Michael*, the sacred element is conveyed by the figure's spiritual restraint and by the very size of the wings, which are appropriate for this Biblical being. Another source of inspiration was small-scale French Gothic sculpture, works in ivory which were produced mostly for private devotion and which often depicted the Virgin and Child. They contributed their best-known characteristic, an effect of elegance. The third influence on this work came from Burgundian art. Burgundy had emerged in the fifteenth century as one of the most important commercial and cultural centers of Europe. It was there that the "International Style" gained momentum, with nuances that were different from the style prevailing in France. The marriage of the Infanta Dona Isabel, daughter of Dom João I, to Philip the Good of Burgundy in 1428 strengthened the ties between Portugal and Burgundy, leading to increased artistic influence.

Sculpture produced under Burgundian inspiration is distinguished by a certain archaic aspect, with features such as accentuated drapery folds, delicate mouths, and melancholy expressions. In *Saint Michael*, the schematic anatomical rendering of the figure's hands creates an incongruous effect, almost of coarseness, which is accentuated by the marked rigidity of the shield with its heraldic cross.

The devotion to the archangel Saint Michael (described in the Apocalypse of Saint John XII, 7–10 as the chief of the celestial militia arrayed against satan) has always been great in Portugal. According to tradition, Dom Afonso Henriques, the first king of Portugal, was baptized in the chapel of Saint Michael in the castle of Guimarães. He later dedicated to Saint Michael the private chapel of the royal palace in Coimbra, as well as other chapels, such as those in the monastery of Santa Cruz de Coimbra, in the fortress at Santarém, and in the Cistercian Abbey of Santa Maria de Alcobaça. When Dom Dinis began to spend more time in Lisbon and built his residence in the castle, he, too, erected a chapel (1299) dedicated to Saint Michael, like the one in the palace of Coimbra.

Dom Pedro's father, the infante Dom Pedro known as *das Sete Partides* because of his cosmopolitan manner and extensive knowledge, adopted as his emblem a pair of scales to which he added the motto DESIR (desire). One can discern a duality of purpose in this selection, on the one hand associated with ethical and proper conduct, and on the other with the scale, the symbol of justice, which is also the symbol of Saint Michael. The Infante Dom Pedro dedicated his altar in the Chapel of the Founder at the monastery of Batalha to Saint Michael. Dom Manuel I was also thinking of the archangel's patronage when he asked Pope Leo X to authenticate the feast of the Guardian Angel of the Kingdom, celebrated on the third Sunday of July. J.T.

23 🐂

RELIQUARY CHEST

Portuguese
c. 1460
silver-gilt, engraved and repoussé
38 x 15 x 29 (14 ⅞ x 5 ⅞ x 11⅜)
inscribed on the ledges of the cover: HESTA ARCA MANDOV FAZER HO CLARO E MVI NOBRE DOM PEDRO REGEDOR DO MESTRADO D. AVIS FILHO P:MOGENITO DO IFANTE DON Pº. DE CLARA MEMORIA REJENTE QVE FOI NOVE ANOS DESTE REINO E FOI FEITA PERA OS OSSOS DOS BENAVENTURADOS PEDRO E PAVLO APLLOS E PERA OUTRAS RELIQAS PRECIOSAS E PERA HO LENHO DO SENHOR *(THIS CHEST WAS MADE AT THE BEHEST OF THE ENLIGHTENED AND VERY NOBLE MAN DOM PEDRO*

ADMINISTRATOR OF THE MASTER MILITARY ORDER OF AVIS FIRST-BORN SON OF THE INFANTE DOM PEDRO OF BRILLIANT MEMORY WHO WAS FOR NINE YEARS REGENT OF THIS REIGN AND WAS MADE FOR THE BONES OF THE BLESSED PETER AND PAUL APOSTLES AND FOR OTHER PRECIOUS RELICS AND FOR THE RELIC OF THE LORD'S CROSS)
marks: caravel (assayer's mark of the city of Lisbon, Victoria and Albert no. 2535): "IM" *(unidentified goldsmith, Victoria and Albert no. 2733A);* "I" *(unidentified appraiser, Victoria and Albert no. 2706B)*
references: Estaço 1625; Roiz 1631; Keil 1938; Rego 1730; Martinez 1940, 1942; Chicó 1948; Santos and Quilhó 1953; Couto and Gonçalves 1960; Ferro and Avelar 1983; Marques 1987

Church of Nossa Senhora da Ourada, Aviz

While the shape of this object, as well as its lock, which is made up of two latches, indicate that it is a reliquary, its models are those cases that are miniature versions of gothic cathedrals. It resembles those architectonic reliquaries, a vestige of which remains in the border of battlements surrounding the top part of the cover. A crucifix originally was at the center of the cover, but it was removed in the seventeenth century and replaced by the rocky coping from which a skull emerges. The need to explain the contents of the reliquary and the teratological obsession of baroque culture led to the replacement of the crucifix. Crucifixes often appear atop thirteenth- and fourteenth-century enameled reliquaries from Limoges, which were very popular in Portugal. It is likely that they served as a source of inspiration for Portuguese artists.

This piece is described succinctly by Jorge Roiz in his *Regra da Cavalaria e Ordem Militar de S. Bento de Avis* (Rules of the Knighthood and Military Order of Saint Benedict of Avis, printed in Lisbon in 1631) as "a box of gilt silver" for keeping "the most Sacred Relic, which is in the convent of the Holy Rood of Christ, and the bones of Saints Peter and Paul." The inscription on the ledges of the cover confirms this function. The sides of the coffer are decorated elaborately with small rosettes, reminiscent of the ornamentation of the Limoges reliquaries. On the front of the reliquary, in relief, are the figures of Saint Catherine of Alexandria and Saint Benedict. Saint Catherine is depicted with her most common attributes: the wheel of knives, the instrument of her torture as ordered by the Emperor Maxentius in the early fourth century A.D., and the executioner's sword; the demon's head crushed under her feet seems instead to recall the attributes of quite a different saint, Catherine of Siena (c. 1347–1380). Saint Benedict (c. 480–547), the founder of the Benedictines, the oldest of the religious orders, appears as a bishop of the church wearing a dalmatic, decorated with a cross of Avis, and a mitre; in his right hand he holds the book and in his left the crozier. At the center is the

coat-of-arms of the kingdom of Portugal with a battering ram, an attribute of the infantes, above which appears the Biblical burning bush, on which are depicted the Virgin and Child on the crescent.

This reliquary was offered to the church of the Convent of Avis by Dom Pedro (1429–1466), generally called *o Condestável* ("Supreme Commander of the Army") to distinguish him from his father, the Infante Dom Pedro, son of Dom João I, the founder of the house of Avis. The Infante Dom Pedro is known as *o Regente, o das Sete Partidas* or *o de Alfarrobeira*. It was Dom Pedro *o Condestável* who at the age of fifteen, according to his contemporary, the historian Rui de Pina, when he was the handsomest youth of the day, was knighted in Coimbra by his uncle Prince Henry the Navigator. In his youth Dom Pedro served as a soldier, principally in Castile,

but he was also able to pursue his studies of the humanities, continuing the tradition of culture pursued by his father and uncles.

After the battle of Alfarrobeira (1449), in which Dom Pedro's father lost his life, the victors pressured Dom Afonso V, Dom Pedro's cousin and brother-in-law, to strip Dom Pedro of his title of *Condestável* and of his status as Master of the Order of Avis, of which he was the second title-holder. All his possessions were confiscated, and he was forced into exile. Until 1457 he lived as an unhappy wanderer in Castile and Aragon. His fatalistic motto — *PAINE POUR JOIE* (sorrow for joy) — appears in the ornamental border around the coat-of-arms on the front of the reliquary. It faithfully expresses his existence — prodigal in sorrows and sparing in joys. The title of one of his books, *Coplas do menospreço do Mundo* (Stanzas

of contempt for the World), underscores the misfortune that followed him. He was eventually reinstated in the military Order of Avis and served in the campaigns in Africa under Dom Afonso V, even though he pronounced himself opposed to the undertakings in Morocco (1460). Three years later, in Ceuta, in view of his great prestige as a knight and a man of culture, and the fact that through his mother he was a grandson of Don Jaime, the last count of Urgel, he was offered the crown of Catalonia, which had been vacant since 1462. Dom Pedro was made King of Aragon and Sicily, Valencia, the Mallorcas, Sardinia, and Corsica, and Count of Barcelona. His reign lasted only two years, but his interest in intellectual and artistic matters is reflected in his accomplishments: he extensively remodeled the royal palace of Barcelona, as well as the church of Giranolers. He also instituted the Archive of Catalonia and donated to its chapel of Santa Águeda the magnificent altarpiece by Jaime Huguet (today in the Museo de Historia de la Ciudad) and endowed the Cathedral of Huesca with a set of Flemish tapestries, on which his motto is inscribed.

This reliquary is one of the oldest works of Portuguese goldsmiths, if not the oldest, to be stamped with the mark of an appraiser of the goldsmiths' guild, the Brotherhood of Saint Eligius. This privilege was granted by the royal patents of Dom Afonso V of 1457 and 1460, the latter confirming the guild's obligation to mark the works produced in the Lisbon workshops. The reliquary should be compared with that belonging to the Museu Alberto Sampaio Guimarães, which came from the old collegiate church of Our Lady of Oliveira of Guimarães and is dated 1467. The two works have a similar shape, though the ornamentation of the Avis reliquary is more in the vernacular. J.T.

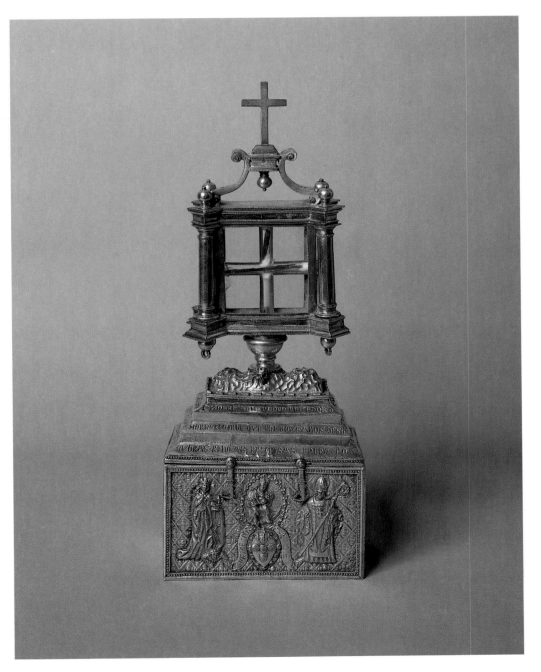

24 ❧

DALMATIC

first quarter of the 16th century
Italian (?)
silver and gold brocaded beige silk embroidered in silk, silver, and gold
133 x 117 (52³⁄₈ x 46)
references: Góis 1566; Belém 1750–1755; Correia 1953; Mayer-Thurman 1975; Gombrich 1984; Wieck and Zafran 1989

Sé Patriarchal de Lisboa

This dalmatic is complete and is part of a set of vestments which, according to tradition, were presented by Dom Manuel I to the Sé (Cathedral) of Lisbon immediately after he acquired them in

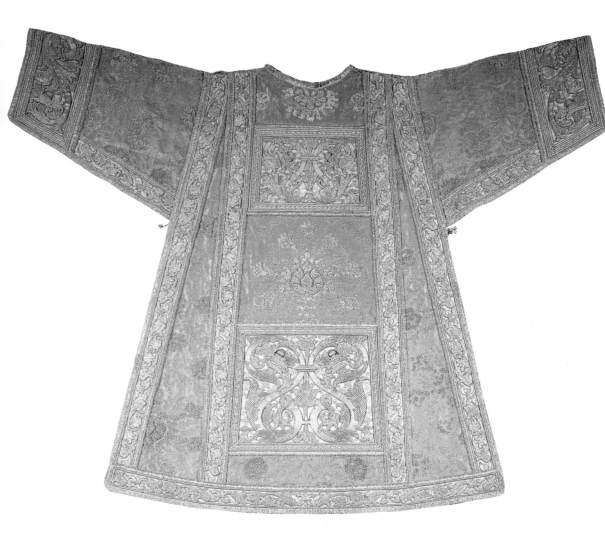

iv, ch. xxv). Queen Leonor, Dom Manuel's sister and the widow of Dom João II, bequeathed to the Convent of Madre de Deus in Lisbon beautiful sets of vestments, in particular a set for high mass "of crimson brocade, with a chasuble, dalmatics with their albs, stoles, maniples, and orpheries, and a large cope of the same brocade" (Fr. Jerónimo de Belém, book XIII, ch. XXI). J.T.

25 ❧

Andrea della Robbia
Florentine, 1435–1528

MEDALLION WITH THE ROYAL PORTUGUESE COAT-OF-ARMS

c. 1509–1517
polychromed terra-cotta
diameter 82 (32¼)
references: Belém 1750–1755, 4:85; Cavalucci and Moliner 1884, 115; Pope-Hennessy 1980, cats. 15, 27, 32, 48, 52

Museu Nacional de Arte Antiga, Lisbon

In 1868 the abbot of Castro e Sousa still noted the presence of "some ceramic medallions created in the sixteenth century by Luca della Robbia" in the upper part of the exterior of the south side of the church of the convent of Madre de Deus in Lisbon. He was evidently referring to the three terra-cotta medallions now in the collection of the Museu Nacional de Arte Antiga, which originally came from that church. In addition to the work exhibited here, one medallion depicts the bust of a helmeted warrior in the manner of Verrocchio, and another the *camaroeiro*, the black bow-net used on an emblem by Dona Leonor (1458–1525), the wife of Dom João II, who commissioned the church. In addition to a group with other shapes, such as a sanctuary door, there is also a second set of medallions in the museum's collection containing the figures of the Four Evangelists. In the course of the restoration of the church in 1872, these became part of the collection of Dom Fernando II and were later transferred to the Museu Nacional de Arte Antiga.

Dona Leonor founded the church on 25 May 1508, pursuant to a writ granted by Pope Julius II. Widowed in 1495, she had continued her support of the arts and charitable programs as actively as during her husband's reign, with a humanist outlook. She sponsored the translation of religious and moral texts, and commissioned numerous works of art. She also supported, with great conviction, the career of Gil Vicente, the talented dramatist and goldsmith.

The terra-cotta roundels appear to have been in place in the Madre de Deus church in 1517. In that year the queen's cousin, Emperor Maximilian I (son of Frederick III and Dona Leonor, the daugh-

Italy (as was the case with those offered by the same king to the Sé of Braga, which still have vestiges of their original coral decoration). The pomegranate motif of the silk and the rigidly symmetrical pattern in the embroidery of acanthus foliage, which was stylish during the Renaissance for its *all'antica* design, makes it possible to date the vestment to the early sixteenth century; in the absence of a detailed study of the garment, however, it is difficult to determine with precision where the silk brocade was manufactured.

During the Renaissance religious vestments—especially those used for the celebration of the mass—became ever more ostentatious, after the types had become fixed in the thirteenth century. In the Latin rite of the Catholic church, a total of eighteen different liturgical vestments and accessories were needed for interior and exterior ceremonials, requiring a considerable investment in such garments. Royalty, the nobility and great bankers and merchants, as well as high-ranking ecclesiastics, fostered the taste for increasingly sumptuous textiles, creating a demand to which the producers responded. As a consequence, however, sumptuary laws were enacted that attempted to suppress the use of exorbitantly priced garments, and in 1464 Pope Paul III promulgated a regulation concerning cardinals' vestments.

The main centers that supplied textiles to Portugal continued to be Flanders and England, but in the fifteenth century textiles were obtained in the Mediterranean area. Brocades, damasks, silks, and satins began to arrive from Lucca, Genoa, and Florence. Likewise, textiles from Aragon and Andalucia are registered in the records of merchandise entering the port of Lisbon.

The Portuguese court's notable patronage of religious art extended to vestments. In addition to those commissioned in Flanders to be presented to the kings of the orient, a particularly celebrated set was sent by Dom Manuel I with Tristão da Cunha to Pope Leo X, which were enthusiastically described to Emperor Maximilian I in Germany: "All these vestments were woven of gold and are so covered with precious stones and pearls that in few places could one see the gold; pearls and stones were placed and inserted with admirable skill, inlaid like the seeds in a pomegranate; this artful work was a great sight to behold, for the work was marvelous, sumptuous and magnificent" (Góis 1566, part III, ch. VII) Another set of vestments that deserves mention is the one which Dom Manuel I, on being awarded the Order of the Golden Fleece, commissioned in Flanders to be presented to the church of that name in Brussels, which were described by Góis as "made of cloth rich in gold, with tasseled edges" (Góis 1566, part

ter of Dom Duarte of Portugal), offered her, from his father's treasury, the relic of the body of Saint Auta, one of the 11,000 virgins martyred in Cologne. The naval cortege bearing the relic entered the Tagus estuary on 4 September 1517, and the body of Saint Auta was brought in pomp to Madre de Deus. A triptych depicting the *Arrival of the Relics of Saint Auta at Madre de Deus Convent* (Museu Nacional de Arte Antiga, Lisbon) records the appearance of the church at that time and shows, to the right of the helicoid counterfoils that frame the portal, the della Robbia medallions. This altarpiece is thought to have been commissioned at the time of the relics' arrival and completed around 1520. It indicates that work on the church had progressed relatively swiftly from the foundation in 1508 and that it was essentially complete in 1517.

This chronology indicates that the traditional attribution of the medallion to Luca della Robbia (1399/1400–1482) is mistaken. It must have been executed by Andrea, his nephew and successor in the workshop. The two angels bearing the coat-of-arms are strikingly analogous to those in a della Robbia roundel of the Madonna and Child in the Accademia, Florence (Cavalucci and Moliner 1884, 115), while the garland of fruit around the border recalls Andrea della Robbia's *Coronation of the Virgin* in the Church of the Assunta in La Spezia. A terra-cotta roundel of the Madonna and Child in the Museu Nacional de Arte Antiga, of great sculptural quality, appears to be by Luca himself. This piece was acquired by Dona Leonor's parents, the Infante Dom Fernando, master of the Order of Christ, duke of Beja and of Viseu, and Dona Bea-

triz, who offered it to the convent of Nossa Senhora da Conceição de Beja, which they founded in 1456. It is comparable to another medallion of the Madonna by Luca in which the child is seen with his arm around his mother's neck (Pope-Hennessy 1980, cat. 27), and to numerous other works by him, distinguished by the studied folds of the Virgin's cloak and their balanced composition (Pope-Hennessy 1980, cats. 15, 32, 48, 52). It would have been well known to Dona Leonor. The popularity of della Robbia terra-cottas in Portugal may also have been a consequence of the construction of the funerary chapel of Dom Jaime, Cardinal of Portugal, in San Miniato al Monte in Florence, by Antonio Rossellino; its decoration includes medallions by Luca della Robbia executed in 1462–1466. We know of Dona Leonor's interest in ceramics, as she had in her service a master tilemaker known as *Alle Azulejo Mouro da Rainha* (The Moor Tilemaker of the Queen). Her last will indicates that she continued to maintain relations with Rome, which began during her husband's reign, and with Florence. It mentions her intention to bequeath, in addition to the silver ampullas used in her oratory given to her by the archbishop of Lisbon and produced in Rome, "all things sent to me by the Mothers of Florence" (Belém 1750–1755, 4:85).

The medallion shows the royal Portuguese arms as modified in 1485 by Dom João II, who had the Cross of Aviz removed, the lateral escutcheons changed on the vertical level, and the number of castles fixed at seven. The pendant to this piece, which is also in the Museu Nacional de Arte Antiga, shows a pelican in his nest opening his

breast to feed his young, an emblem adopted by Dom João II; his motto was *pola lei e pola grei* (by the law and by the people). This image, symbolizing good will and brotherly love, corresponds to the changes Dom João II made in the coat-of-arms and reflects his intention to create a modern, centralized monarchy, as opposed to the previous medieval conception of royal power in a framework of feudal sovereignties. J.T.

26 🦎

PORTRAIT OF DOM MANUEL I

from Leitura Nova, *district of Além Douro I*
1521
Portuguese
tempera and gilding on parchment
53 x 38 (20⅞ x 14¾)
references: Baião and Azevedo 1905; Dornelas 1931; Santos 1932; Gusmão 1951; Campos 1967; Santos 1967; Deswartes 1977; Alves 1985

Arquivo Nacional da Torre do Tombo, Lisbon

The *Leitura Nova* (*New Reading*), a corpus of sixty-three books containing forty-three illustrated frontispieces, reproduces documents from the royal Portuguese archives. Ordered by Dom Manuel I in 1504, the series was continued under his son Dom João III until 1552. The project was described in 1566 by Damião de Góis, the chief keeper of the Torre do Tombo archives, in Part IV of the *Crónica do Felícissimo Rei D. Emmanuel* (*Chronicle of the Most Fortunate King Emmanuel*): "He ordered most of the documents of the Torre do Tombo to be reproduced in books of parchment well written and illustrated." The new

system of organizing the royal archives continued the initiatives begun by Dom Manuel I's predecessor, Dom João II, to centralize and modernize the archive. It put an end to the existing labyrinth of documents. The books were grouped in volumes according to administrative and juridical divisions (*districts*), military orders (*masterships*), miscellaneous (*mixed*), monarchs (*kings*), bulls, donations, payments, and others.

The first volume of the series was finished about six months before the death of Dom Manuel I and signed by the officials who reproduced the documents, Franciscus (fols. 1–240v) and Gabriel Gil (fols. 241–261). The splendid frontispiece to the volume is a compendium of the iconography of the Portuguese monarchy. The royal Portuguese shield is held aloft at the top of the page by four angels, recalling a passage in the *Tratado Geral de Nobreza* (*General Treatise on Nobility*) by Antonio Rodrigues, one of the three lords-in-arms who served Dom Manuel I and Dom João III in the reformation of the court bureaucracy. Explaining the origin of royal power as it was then understood, Rodrigues compared the functions of the angels and archangels of the divine court to those of the heralds and lords-in-arms who served the Portuguese king. Above them, the heavens part to reveal a patch of gold—part of the gold leaf that lies under the painting—behind a tiny figure of God the Father. His image gives visual expression to the rhetorical flourish with which the text begins: "*Dom Manuel por graça de Deus Rei de Portugal*" (Dom Manuel, King of Portugal, by the grace of God).

In the tondo on the right, a youth shown in slightly more than half length appears against a blue sky with golden stars. He points to the historiated initial of the portrait of Dom Manuel that begins the text. The sash he holds is inscribed REX PACIFICUS MAGNIFICATUS EST, part of a biblical proclamation from *Isaiah XI*, 2,3 ("The kingdom of the Messiah is peaceful and prosperous and the spirit of the Lord will repose over him"), another analogy between the greatness and benign nature of the monarchy and its parallel in the realm of religion. This imagery shows that the sovereign is indeed worthy of the impressive titles accorded him in the opening of the text: "Dom Manuel, by the grace of god King of Portugal and Algarve, on this side and beyond the seas in Africa, Lord of Guinea, of the conquest, navigation and commerce of Ethiopia, Arabia, Persia, and the Indies."

Although Dom Manuel I usually preferred sober everyday dress, he was also known to be fond of pomp and of the ceremonies and feasts that were part of the ritual of monarchy, a facet of his character that was also reflected in his artistic patronage. In his frontispiece portrait worked into the initial "D," he wears an ermine cloak and a velvet beret set with a jeweled pin. Brooches of rubies, diamonds, and pearls appear to adorn the angels surrounding the initial.

The armillary spheres, which Dom Manuel took as his emblem and which had been offered to him by his brother-in-law Dom João II, both implied that the planets had smiled on the foundation of the Portuguese maritime empire and suggested the important role played by science and astronomy in the Portuguese discoveries. Dom Manuel I's choice of the armillary sphere indicated his determination to continue the maritime exploration begun by his predecessors, which brought the Portuguese to India and to Brazil during his reign. The establishment of commercial bases in India was crucial in launching the empire in the East, and the arrival in Brazil consolidated Portuguese dominion over the Atlantic. It is small wonder, then, that historians accorded Dom Manuel I the soubriquet *Afortunado* (Fortunate). His motto, "hope in God and do good," taken from Psalm CXXXVI, *Spera In Deo Et Fac Bonitatem*, exploited the semantic play on the Latin word *spera* (hope), which in Portuguese at that time could refer either to *espera* (hope) or to *esfera* (sphere). J.T.

27 🐌

Simon Bening
Bruges, 1483/1484–1561
Antonio de Hollanda
Holland(?), c. 1510–after 1553

TWO LEAVES FROM THE
GENEALOGY OF THE INFANTE
DOM FERNANDO OF PORTUGAL

Genealogical tree of the later kings of Portugal
(Antonio de Hollanda, fol. 8)
Genealogical tree of John, Duke of Lancaster (Simon
Bening, fol. 10)
1530–1534
manuscript on vellum
55.9 x 39.4 (22 x 15½)
*references: Góis 1619, 65; Kaemmerer-Ströhl 1903,
1:9; Thieme-Becker 1907–1950, 1:595–596; Destrée
1923, 24–25, 89; Hollstein 1949–, 5:nos. 324–415;
Dos Santos 1950; Aguiar 1962, 78–79; Seguardo
1970, 12, 54, 142, 175–177, 228, 454, 460, 503–505,
512*

*The British Library Board, London, Additional MS
12531*

The artistic importance of the unfinished *Genealogy* of the Portuguese Infante Dom Fernando, brother of Dom João III (r. 1521–1527), rests mainly on the five magnificent leaves by Simon Bening, the finest Bruges illuminator of the sixteenth century. Like most Flemish illuminators of his period, Bening was a specialist in the execution of small devotional books; but the present leaves are much larger than a page from a typical book of hours and they comprise the only illuminated genealogy in the corpus of Flemish illumination.

The *Genealogy* of Dom Fernando contains a total of thirteen leaves, seven of which were illuminated by Antonio de Hollanda, an artist active in Lisbon, who designed all thirteen. Damião de Góis (1503–1573), a Portuguese humanist, historian, and diplomat who lived in Antwerp, records in his chronicle of Dom Manuel I the circumstances behind the creation of the *Genealogy*. He tells that while he was in Flanders in the service of Dom João III, Dom Fernando

ordered me to find whatever chronicles I could, either manuscript or printed, in whatever language, so I ordered them all. And to compose a Chronicle of the Kings of *Hispanha* since the time of Noah and thereafter, I paid a great deal to learned men: salaries, pensions, and other favors. I ordered a drawing of the tree and trunk of this line since the time of Noah to Dom Manuel I, his father. [Dom Fernando ordered it illuminated] for him by the principal master in this art in all of Europe, by name of Simon of Bruges in Flanders. For this tree and other things I spent a great deal of money (Góis 1619, 65 [trans. by Barbara Anderson])

Góis' Simon of Bruges is certainly Simon Bening, an identification supported not merely by the wide evidence of Bening's own fame but also by the style of some of the illuminations. Another contemporaneous source, the Portuguese artist Francisco de Hollanda's notation in his copy of Vasari, confirms that his father, Antonio de Hollanda, designed the *Genealogy* (Dos Santos 1950). Hollanda executed the drawings, which Dom Fernando sent to Bening one at a time. Góis wrote to Dom Fernando on 15 August 1530, describing the progress on the illumination and telling him that Bening was disappointed because only a single drawing had arrived (Destrée 1923, 24–25, 89). In 1539, five years after the death of Dom Fernando, Antonio still had not been paid for his work on the *Genealogy* and the project was never completed. In the end, Bening illuminated only five leaves, and Hollanda attempted to complete the remainder himself. In addition to the seven he illuminated, he drew another that was never completed.

The *Genealogy* begins with the Old Testament ancestors of the family, then jumps ahead to Favila, Duke of Cantabria (d. 700), and his descendants, described as the "Trunk of the Kings of León and Castile." That is followed by the lineage of the Kings of Aragon and by that of the ruling house of Portugal, beginning with Henry of Burgundy, first Count of Portugal (d. 1112), to which sequence folio 8 belongs. It was conceived as a pair of facing leaves with folio 7, as the head-

ing reads across the top of the two pages: "First Table: The Kings" on folio 7, and "of Portugal" on folio 8. The representation at the bottom of the page of sixteenth-century Lisbon, shown under siege, is one of the earliest known panoramic views of the city (Aguiar 1962, 104). The last two tables, on folios 9 and 10, represent the complex array of descendants of John of Gaunt, duke of Lancaster and Aquitaine (d. 1399), whose progeny included fifteenth-century kings and queens of the houses of Lancaster, Burgundy, Hapsburg, Portugal, and Castile (Kaemmerer-Ströhl 1903, 1:9). Visual and genealogical lacunae among various folios strongly suggest that the *Genealogy* was intended to be considerably more extensive than the existing thirteen leaves, and over thirty may have been planned. It has been argued persuasively that the genealogy, long considered that of the royal house of Portugal, is rather a genealogy of Dom Fernando himself (Aguiar 1962, 78–79).

The designs and illuminations for the *Genealogy* are Hollanda's most famous work. Probably

born about 1480, possibly in Holland, he was named by Dom Manuel I to the post of heraldic officer in 1518, a position he continued to occupy into the reign of Dom João III (Haupt in Thieme-Becker 1907–1950, 1:595–596; Seguardo 1970, 12, 142, 175–177, 228, 454, 460, 503–505, 512). He was alive in 1553, when his son Francisco wrote about him to Michelangelo, but he probably died a few years later (Segurado 1970, 142, 505, 54).

Hollanda's primary prototype for the genealogical tree was Hans Burgkmair's woodcut series of 1509–1512, *The Genealogy of the Emperor Maximilian I* (Hollstein 1949–, 5:nos. 324–415). However, Burgkmair's woodcuts depict only rows of single figures unrelated by arboreal motifs. The composition of the Hollanda design recalls Tree of Jesse imagery. Hollanda's draftsmanship was probably inspired by the technique of German artists, especially Albrecht Dürer. He modeled his figures in fine, closely placed parallel hatchings and crosshatchings. The hatchings are short and their arrangement gives the materials a velvety quality. His designs suggest that he followed the artistic

mainstream in Lisbon, which had absorbed recent developments in other European art. The quality of Hollanda's painting on pages which he illuminated lacks the refinement of his drawing. It appears competent but flat and dull—his characters lack expression—when compared to Bening's work.

The leaves by Simon Bening tell quite a different story. He has breathed life into the Portuguese artist's refined drawings. A range of lively personalities is apparent in the *Genealogical Tree of John, Duke of Lancaster*, one of the illuminator's most unusual and beautiful miniatures. Bening gives his illuminations a sculptural quality and places them in a deeper, more tangible space. The colors, blues and reds in particular, are richer and the textures of a leaf, a brocade, velvet, or armor are differentiated in an even light. He had beautiful drawings to work with here but his skill as an illuminator surpasses the draftsman's achievement. His leaves compare favorably with the work of the best painters of his day, including Bernaert van Orley and Joos van Cleve.

HOURGLASS

c. 1517
Portuguese
silver-gilt and glass
height 18.5 (7 ¼); diameter 10.7 (4⅛)
references: A. Caetanos de Sousa 1752; Raczynski
1846; Vasconcelos 1904; 1929; Wollf 1962; Panofsky
1967; Guye 1970; Couto and Gonçalves 1970; Attali
1982; Matoso 1983; Le Goff 1984; Markl and
Pereira 1986

Museu Nacional de Arte Antiga, Lisbon

Like the solar quadrant and the clepsydra, or
water clock, the hourglass is among the oldest
non-mechanical instruments for measuring time.
It consists of two conical glass bulbs, one of
which is filled with sand, connected by a small
channel, which in this example is adorned with a
filigree knot.

The gilt silver framework architecturally resem-
bles a circular miniature temple. Eight small col-
umns are sectioned half-way up the shaft, and
repeat the pseudo-capitals in the shape of a
cupping-glass. In the extremities of the frieze the
rims are adorned by a wreath accompanied by a
threadlike molding, which is followed by a hollow
panel of fleurs-de-lis. Also in the friezes, blending
with the concave frame, small double-S shaped
lizards rest upon the end of each small column.

At either end of the drum of the hourglass, the
royal Portuguese coat-of-arms and the armillary
sphere are engraved. The armillary sphere was
the emblem of Dom Manuel I, "because mathe-
maticians portray the shape of mechanism of
heaven and earth, with all the other elements,
which is astonishing" (Góis 1566, ch. v).

Used by sailors to measure the speed of their
ships and to mark the shifts of the watch, the
hourglass appears on the frontispiece of Lucas
Janzoon's *Spieghel der Zeevaerdt...*, published in
Leyden in 1584, together with the astrolabe, the
quadrant, the terrestrial and celestial globe, the
magnetic compass, and other instruments of navi-
gation. Given Dom Manuel's own association
with the maritime world, it is clear why the hour-
glass was chosen as an object to be presented to
him. It was during his reign that the most impor-
tant events occurred in the history of Portuguese
navigation and exploration.

During that period rare and precious objects of
this type formed part of the royal collection. A
similar instrument was part of the trousseau of
the Infanta Dona Beatriz (1504–1538) when she
married Charles III of Savoy in 1521. The list
given to her treasurer describes a number of gold-
smith's works, including "a white silver clock with
six staffs, and it has above and below it the
emblem of daisies in low relief with a knot in the
middle, also of silver" (A. Caetano de Sousa,
Provas, vol. II). The description suggests that this

hourglass is similar to that example. The presence
of the emblem of the "marvel-of-Peru" (Mirabilis
Jalapa) in low relief indicates that it belonged to
the second wife of Dom Manuel I, Queen Maria
(1482–1517). Her emblem, the bough of "marvel-
of-Peru," appears in several sculpted medallions in
the monastery of the Jerónimos in Lisbon. It is
therefore thought that the two hourglasses were
made for Dom Manuel and Dona Maria prior to
1517, the date of Dona Maria's death. The hour-
glass described as being in the trousseau of the
Infanta Dona Beatriz in 1521 was presumably the
one that had belonged to her mother, Dona Maria.

Just as cartography in the Renaissance changed
from rendering the symbolic and sacred space of
the Christian religion to the representation in the
portolan charts of the direct observation of the
world, so did the concept of time change from a
hierarchy of events related to divine history. The
new Portuguese chronicles reflected the actual
historical events of the monarchy and of the
nation, seen from a humanistic perspective.
Mechanical clocks came to replace the church bells
as regulators of social life. The hourglass itself
came to be associated with the philosophical con-
cept of Time, which was revived by Petrarch,
whose *Triumphs* were a popular theme in human-
istic illustration.

The fact that this Manueline hourglass seems
so similar to the instrument depicted in Albrecht
Dürer's *Melencolia 1* (cat. 199) may not be coin-
cidental. Dürer's engravings influenced Portu-
guese painting of the period, particularly the
works of Vasco Fernandes (see cat. 32), in whose
painting of *Jesus at the House of Mary and
Martha* the figure of Mary reflects the figure in
Melencolia 1. It may be that this hourglass also
reflects Dürer's model. J.T.

LISBON BIBLE

1482
Sephardi
illuminated manuscript on vellum, 184 + II folios
30.5 x 24.4 (12 x 9⅝)
references: Narkiss 1969, 80; Sed-Rajna 1970, 24–
29, no. 2; Narkiss 1982, 141–144, no. 42; Sed-Rajna
1988; Cohen 1988

The British Library Board, London, MS Or. 2626,
fols. 7b–8a

This illuminated Bible is one of the masterpieces
of a Hebrew manuscript workshop active in
Lisbon from no later than 1469, the year of its
earliest preserved dated work, until 1496. It was
presumably disbanded at the time of the enforced
collective conversion of the Portuguese Jews; the
official Edict of Expulsion was promulgated on 5
December 1496.

The volume displayed here is the first of a set of
three (MS Or. 2626–2628) containing all twenty-
four books of the Bible, as well as certain addenda.
According to the colophon at the end of the man-
uscript, the text, which is written in light brown
ink in square Sephardi script, was executed by
Samuel the scribe, son of Samuel Ibn Musa, and
completed in Lisbon between 12 November and 10
December 1482. The patron was Joseph, son of
Yehuda al-Hakim.

The manuscript is illuminated throughout with
a luxurious system of decoration that emphasizes
the major divisions in the text. The opening illus-
trated here is from an introductory section,
preceding the Biblical text, which lists the 613
precepts contained in the Bible in the order in
which they are mentioned in the Old Testament.
The decoration on these pages consists of full-
page frames filled with floral motifs, which can be
related to contemporary styles of Portuguese illu-
mination, panels of filigree penwork surrounding
the text, and burnished gold ornamental script.
Unlike scribes, the artists and craftsmen in charge
of the decoration rarely signed their work, and the
decoration in the *Lisbon Bible* in fact appears to be
the work of a team of artists, among whom several
different hands can be distinguished. The Lisbon
workshop's productions are characterized by the

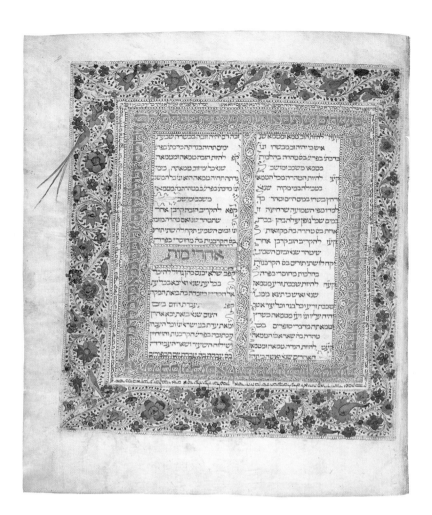

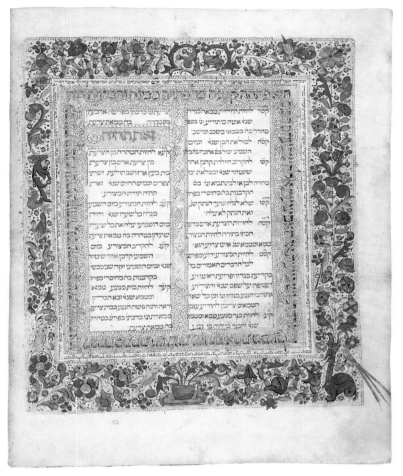

technical refinement of the decoration, especially the burnished lettering of the decorative script, and the very limited vocabulary of decorative elements employed (Sed-Rajna 1988).

Illuminated Hebrew manuscripts do not appear to have been common in Europe until the thirteenth century. Jewish manuscript illumination reached its peak in the following century, and while the tradition continued through the fifteenth century, the later manuscripts are known more for their highly refined technique than for any compositional innovations. By the latter part of the century, the manuscript tradition began to be displaced by the introduction of Hebrew printing. In fact, the first Hebrew book printed in Portugal is dated 1487, only five years later than the *Lisbon Bible*.

J.A.L.

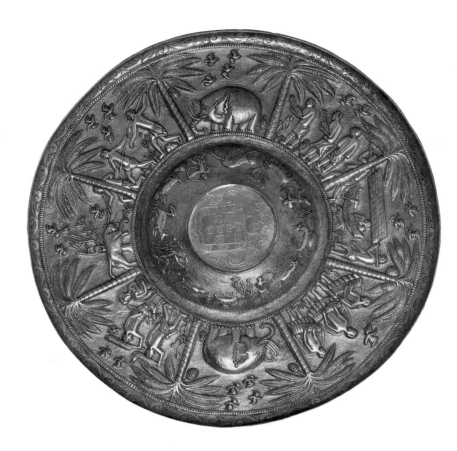

30 &

SALVER WITH AFRICAN MOTIFS

late 15th century–early 16th century
Portuguese or Afro-Portuguese
silver-gilt, engraved and repoussé
diameter: 32 (12⅝)
references: Resende 1596; Pina 1792; Simões 1882;
Viterbo 1882; Vasconcelos 1882; Mota 1975; Bassani
and Fagg 1988

Palácio Nacional da Ajuda, Lisbon

In the last century this salver was thought to be an Indo-Portuguese work. In 1882 Sousa Viterbo, describing the *Exhibition of Portuguese and Spanish Art* at the Palace of Janelas Verdes, which was to become the Museu Nacional de Arte Antiga, questioned the Indo-Portuguese classification of this salver, which at the time was in the collection of Dom Luis I, asking whether "these are scenes of Africa, or scenes of Asia?" A. Filipe Simões, who wrote a series of articles on the exhibition, unaware of Sousa Viterbo's reservations, described the salver as depicting "Indians armed with crossbows, elephant hunts, and palm trees; in the central medallion the royal Portuguese arms are engraved."

At that time the Indo-Portuguese works of art—furniture, ivory, bedspreads, and goldsmiths' works—were the subject of nostalgia for the maritime and mercantile grandeur of the Age of Discoveries. Charles Yriarte lamented that a special section had not been devoted to them in the exhibition. In 1882, the historian Joaquim de Vasconcelos, who had studied the goldsmiths' works of the fourteenth to sixteenth centuries in depth, considered this salver a work done in "Indian, semi-barbarian style, the work of some artist from the Portuguese colony of Goa." His attribution reveals the influence of the many sixteenth-

century works created as a result of the contacts with the orient. Vasconcelos noted, however, that the salver reflected a European decorative model: two concentric bands, the outer one divided into eight segments separated by palm trees rather than the traditional pilasters. He also suggested that the coat-of-arms of the central medallion was that of the Casa de Bragança (he assumed that the crown in the upper register belonged to a duke and that it was not the heraldic device at the top of an escutcheon indicating royalty). This coat-of-arms was frequently reproduced during the reign of Dom Manuel I, in the *Cartas de forais*, the volumes of the *Leitura Nova* (see cat. 26) and in the coinage of the "Perfect Prince." Dom João II changed the coat-of-arms of the Portuguese crown. He eliminated the cross of Avis and corrected the lateral escutcheons, placing them as pendants (they had previously been placed horizontally). In 1485 Dom João II was first called "the Lord of Guinea" (G. de Resende, 1596, ch. LVII). While still a prince he received from his father, Dom Alfonso V, the concession of the Guinea trade, and the rights to fish in its rivers and seas; it was prohibited for anyone to go there or send anyone there without the prince's authorization. On being elevated to the throne he knew from his own experience just how profitable was the African trade in gold, ivory, and slaves, which was the crown's recognized source of wealth.

Dom João's rights in Guinea were the basis for the claim he made in 1493, upon learning from Columbus of the newly discovered lands to the

west, that America belonged to the Portuguese crown by virtue of "believing that said discovery was made within the seas and terms of his lordship of Guinea" (Rui de Pina 1792). His controversy with the Catholic Monarchs led to the intervention of Pope Alexander VI and the Papal Bull of 4 May 1493, by which the Spanish were given the right to all lands found or to be found to the west of the meridian that ran 100 leagues west of the Cape Verde islands. The dispute persisted, however, and the Treaty of Tordesillas signed by Portugal and Spain on 7 June of the following year changed that distance to 370 leagues, at the suggestion of Duarte Pacheco Pereira. The objective was to specify an area that would include the coast of Brazil (reached just six years later).

The construction of the fort of Mina in Africa, which was essential for maintaining the monopoly on gold, led to the naval policy which, with the objective of reaching the orient, encouraged continued exploration along the African coast. In 1486 John Afonso of Aveiro reached the kingdom of Benin, opening the door to cultural contacts. This salver may have been created during the early phase of contact with Africa, to convey images of a world that was just beginning to be known in Portugal, a world in which the indigenous artists were creating, in response to Portuguese commissions, the fascinating Afro-Portuguese ivories (see the essay by Ezio Bassani in this catalogue and cats. 67–78). The unusual aesthetic of these ivories also seems to be present in this salver.

J.T.

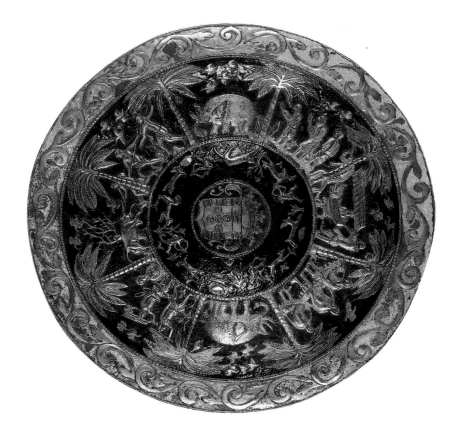

The gilt and enamel decoration is typical of this period. Objects in copper, enamel, and gold figure prominently in an inventory of armor and tapestries in the royal collections, dated 1505. The entries include "a sword one-third gold-plated, the handle and mace of gold-plated copper; two swords one-third gold-plated with *the edges and sphere all gold-plated*... and on the mace *the edges and sphere are enameled*; there is one *gold-plated and enameled* dagger." Prince Henry donated "two silver ampullas with enamels in his colors, that is, blue, white, and black" to the church of the Convent of the Order of Christ in Tomar. Salvers said to be Manueline often have enameled medallions, and such royal works as the *Belém Monstrance* and the *Reliquary of Dom Leonor* (both Museu Nacional de Arte Antiga, Lisbon) attest to the importance of enamels in Portuguese goldsmiths' work. J.T.

30B &

SALVER WITH AFRICAN MOTIFS

late 15th–early 16th century
Lisbon
diameter 25.8
copper-gilt and enamel, engraved and repoussé
references: Marques 1940; Blake 1940; Vasconcelos 1882; Campbell 1983; Godinho 1984; Bassani and Fagg 1988; Peres 1988

private collection

The program for the tapestries commissioned in Flanders by Dom Manuel I to celebrate the key events in the opening of the sea route to India includes a view of the Cape of Good Hope, which Vasco da Gama's fleet rounded on 22 November 1497. It called for an African scene with natives and local flora and fauna, including elephants and shepherds with their cattle emerging from their huts "in the style of that place" (Barreto 1880). This description is close to that of the African scenes reproduced on this salver, which reflects an effort to set a standard in this form of expression.

The first Portuguese accounts of Guinea and Sierra Leone indicate that most of the natives in fact went about without clothing; only a few wore cotton garments, which are portrayed on this salver, perhaps out of modesty or because the piece was likely to be presented to the king or to a member of his court. There was a great interest in fifteenth-century Portugal for genuine objects from the newly found lands. We know that Prince Henry the Navigator himself "much desired to have these strange things that came to him from different parts and countries discovered through his diligence" (Cadamosto e Sintra 1988, 168)

In Hans Burgkmair's woodcut *The Kings of Cochin*, published in Augsburg in 1509, the figures said to be from Guinea resemble those on the salver; one man holds a lance similar to those depicted in the salver. The famous engraving of the city of Benin included in Olfert Dapper's *Description de l'Afrique* (1687) shows the cortege of the *oba* or king, which includes leopard-trainers, recalling the leopard portrayed on the salver. The motifs on the salver also recall those depicted in the *Miller Atlas* of 1519 by Lopo Homem-Reineis (Bibliothèque Nationale, Paris), especially the palm trees, elephants, huts, and figures of natives (although there they are meant to represent India). Similar palm trees and elephants appear in the scene of the *Flight to Egypt* in the *Book of Hours of Dom Manuel I* of 1517–1538 (Museo Nacional de Arte Antiga, Lisbon). Despite the thematic similarities, however, the scheme of representation used in the salver is fundamentally different from that employed in these works; it shows affinities with the Afro-Portuguese ivories.

The materials used in the salver remind us of Portugal's foreign trade during this period. From the reign of Dom João I until the mid-sixteenth century, Portugal controlled several cities in Morocco, from which it obtained gold, copper, and cotton cloth (V. M. Godinho). The entrepot at Arguim served as an advance post for obtaining gold from the Sudan. Copper from the Maghreb brought high prices in Lisbon (in 1436 one hundred kilograms sold for 1,410 reals, and in 1506, in the reign of Dom Manuel I, for 6,240 reals). African copper arrived in Lisbon from northern Europe through Flanders. Copper also was exported through Cairo to India, where it was highly sought after, especially by the Casa da Moeda, or mint, at Goa. Copper was also used for liturgical ornaments, jewelry, and arms and armor, as well as for a great many works of religious art.

31 &

FESTIVE PROCESSION WITH GIRAFFES

early 16th century
Flemish, probably Tournai
tapestry, warp: wool; weft: wool and silk
references: Barreto 1800; Vasconcelos 1896; Keil 1919; Viterbo 1920; Castanheda 1924; Bottiger 1947; Chumovsky 1960; Asselberghs 1968, 13, 15; Digby 1980, 31; Águas 1987

Mr. Roger Brunel

This tapestry is part of a cycle of works commissioned to commemorate the establishment of the Portuguese presence in India, the crowning achievement of Portugal's Age of Discoveries. The momentousness of the event was recognized even at the time. When on 20 May 1498 Vasco da Gama arrived at the port of Calicut in India, he had learned through the contacts he had made during his voyage that he would have to respect cultural differences in India and give a clear explanation of the reason for his voyage so as to facilitate the exchange of goods. It was important to reinforce the image of the power of the Portuguese kingdom and yet also to indicate that the goals of his voyage were not pillage, looting, and oppression. According to the narrative of the

voyage, the *Roteiro da Primeira Viagem de Vasco da Gama* (Route of the First Voyage of Vasco da Gama), he declared to the king of Calicut that "he was ambassador of the King of Portugal, who was Lord of a vast territory, rich in all things, more than any other king of those parts" (although one of the sailors confessed plainly to two Muslims: "We came to look for Christians and spices"). According to this account the experienced Arab pilot who had guided da Gama's fleet on the voyage from Melinde to Calicut compared Portugal to the former Roman Empire and stressed the fierceness of the Portuguese. Da Gama himself, despite the dangers and the reservations of his crew, boldly decided to lead the party to meet the King of Melinde who resided five leagues inland. "Even though I may know how to die," he said, "I still wish to meet the King of Calicut to see if I can establish friendship and dealings with him, and to have spices and other things from his city, that they may serve as testimonies in Portugal to verify that the discovery of Calicut is true" (Castanheda, 1, ch. 16).

It is in this context of authentication that the commissioning of the tapestries "in the style of Portugal and India" should be understood. The Portuguese wanted to make known to all the exotic nature of the world they had encountered in order to draw attention to the leading role they had played. Da Gama's voyage and its aftermath had yielded a wealth of information about new peoples and lands, furnishing eloquent testimony of a larger world. Detailed maps of the routes were made, showing the location of coasts and ports, and inaccuracies in old maps were corrected. The cartographers who executed the new portolan charts attempted to systematize and update this knowledge and incorporate elements of local flora, fauna, and anthropological data.

There is no documentary evidence for dating the tapestry exhibited here. However, we do know that in 1516 Dom Manuel I (r. 1495–1521), an important patron of the arts, had his royal secretary António Carneiro send to craftsmen in Antwerp details of da Gama's voyage and other events related to the Portuguese in India. The document that was sent to Antwerp was called *Pera os pannos que El Rey nosso senhor quer hordenar* (For the tapestries the King our lord wishes to commission). This "order book" specified that the tapestries should faithfully portray images and events taken from nature (Graça Barreto 1880) and summarize twenty-five principal themes. Emphasis was placed on da Gama's leavetaking, with his audience before the king and the delivery of the regiment for Vasco da Gama's voyage, and the procession, including the monks of the convent of the Order of Christ in Tomar, who departed from the chapel of Our Lady of Belém to go to the Praia do Restelo that João de Barros called "shore of tears for those who depart, land of pleasure for those who arrive." The arrival of da

Gama in Calicut and the return of the armada to the port of Lisbon completed the cycle of the voyage. The *Conquest* portion of the cycle was to include the foundation of fortresses at Mozambique in 1507, at Cochin, erected by Francisco de Albuquerque on 27 September 1503 (this series of tapestries also depicted a baptism of native Indians in a Christian church), and at Cananor, constructed in the time of Dom Francisco de Almeida (1505). The cycle of *Contacts and Diplomacy* included the capture of Quíloa, showing the city with Portuguese flags flying on the walls, the ships in the foreground, and Dom Francisco de Almeida crowning the new king who accepts the swearing-in and the homage. The same ritual is portrayed in the "Act of Homage Rendered by the King of Cochin," in which a gold cup, a present from Dom Manuel I, is being handed over.

The "order book" emphasizes details when new territories, their peoples, and customs were to be represented. It pays specific attention to the adornments of indigenous women: "how they wear jewels on their toes and the way they wear them," which coincides with the text of the *Roteiro da Primeira Viagem de Vasco da Gama*. Another passage specifies the representation of the crafts and trades, depicting merchants selling jewels and spices. The third tapestry of the Cochin series is to portray the local prince, "the make-up of the people, color and dress and arms, true to nature with their litters, elephants, and hats (parasols)."

We also know that even earlier, in 1504, Philip the Handsome, who was married to Princess Isabel of Portugal, the sister of Dom Duarte, had acquired a tapestry "a la maniere de Portugal et de Inde" from the Tournai tapestry maker Jean Grénier. Emperor Maximillian I (1493–1515), the son of the Infanta Leonor of Portugal (daughter of Dom Duarte), had in 1510 bought a tapestry for his residence described as *une Histoire de gens et bestes sauvages a la maniere de Calicut* (a story of wild people and beasts in the manner of Calicut). Documents record numerous payments to Tournai craftsmen for tapestries on this theme, as well. A great range of scenes appears to have been available. The tapestry exhibited here comes from the Dreux-Brezé collection, which had the most extensive set of *Calicut* tapestries to survive into modern times. This particular piece, which originally was almost twice as wide as it is now, is one of three that constitute the *Cortejo Festivo* (Festive Procession). It depicts the exotic fauna of the Indies, as well as giraffes, which had been transported by the Portuguese from Africa to India.

J.T.

Not illustrated.

Attributed to Vasco Fernandes
Portuguese, c. 1475–1541/1542

ADORATION OF THE MAGI

c. 1501–1502
oil on oak panel
131 x 81 (51½ x 31⅞)
references: Moreira 1921; Cortesão 1944; Santos 1946, 1962; Cortez 1968; Foutora da Costa 1968; Santos 1970; Sampaio 1971; Honour 1976; Hemming 1978; Markl and Pereira 1986; New York Public Library 1990

Museu de Grão Vasco, Viseu

This *Adoration of the Magi* is unique in European painting for its depiction of a native American, a Tupinamba from Brazil, as one of the Three Kings paying homage to the Virgin and Child. There was an older tradition for portraying one of the Magi, Melchior, as an African, but no other picture is known that introduces an American figure into such an image. The artist apparently sought to suggest the growing knowledge of new worlds and new peoples brought about by the Portuguese voyages. Another contemporary element is the gold coin, brought by the Magi, which the Child Jesus holds, presumably a Portuguese coin from the reign of Dom Manuel I (1456–1521). This is evidently an allusion to the fact that the desire to spread the gospel had been a driving force behind the discoveries since the time of Henry the Navigator, as had the search for secular riches—*Em nome de Deus e do lucro* (In the name of God and gold), as it was sometimes put.

The Tupinamba Indian is placed at the center of the composition, dressed in a costume that is a composite of Brazilian elements—the feathers and the accurately depicted arrow—and European shirt and breeches (see essay by Jean Michel Massing, "Early European Images of America," in this catalogue). As his offering he holds a cup of coconut shell, mounted in silver, a detail that reinforces the exotic character of the representation.

This picture forms part of a polyptych painted for the high altar of Viseu cathedral, of which sixteen panels remain of an original eighteen. The *Adoration* is attributed to Vasco Fernandes (c. 1475–1541/1542), who probably also painted the panel of *The Agony in the Garden* from the same series. The altarpiece is the work of a group of painters who worked in the Flemish style, which also included Francisco Henriques, who painted the high altar of Évora cathedral (now in the Museum of Évora). The collaboration explains the uneven artistic quality of the polyptych.

Whoever commissioned this image must have had some special connection with Brazil and it is in fact believed that the kneeling Magus in the foreground is a portrait from life of Pedro Alvares

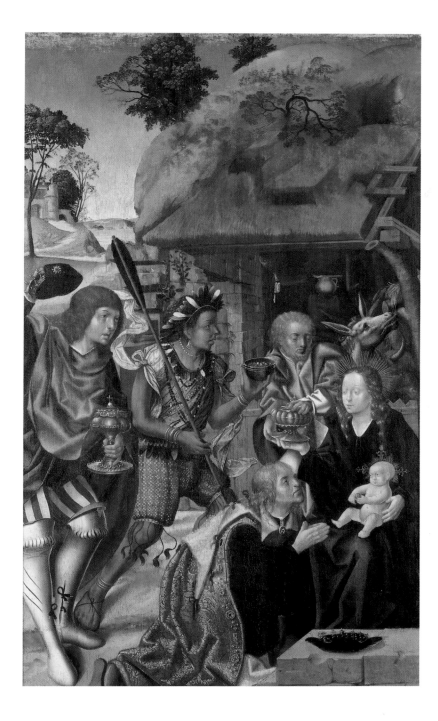

Cabral (1468–1519), who in 1500 commanded the first Portuguese fleet to reach Brazil. Cabral's portrait is known from a limestone medallion, surrounded with a garland of fruit in the style of della Robbia, that decorates the walls of the south wing of the cloister of the Jerónimos in Belém, where he is shown with a Renaissance helmet in the Florentine style (similar to those depicted in many frontispieces of the *Leitura Nova* [cat. 26]) and a Roman-style tunic fastened at the shoulder. The protruding jaw, accentuated by the long beard, in the image on the medallion is close to the facial structure of the figure in the painting. At the time the *Adoration* was painted, Alvares Cabral would have been about 35 years old. His personal history may explain his much older

appearance. He had spent his life in constant travel, participating in an expedition to Morocco when he was only eighteen years old, and soon thereafter in an expedition to Graciosa in the Azores, which resulted in his being knighted by Dom João II and receiving a handsome pension. The artist may also have made Alvares Cabral look older to emphasize his experience as a navigator.

Although there are no historical records of Alvares Cabral's participation in the commissioning of the altarpiece, we know from a document dated 22 September 1500 that Dom Fernando Gonçalves de Miranda, Bishop of Viseu from 1487 to 1491, was concerned that the costs of the painting had not been covered and was seeking to enlist the support of patrons of the arts. At that

time, soon after his return from the voyage to Brazil, it is said that Alvares Cabral spent some time in the city of Viseu or in the neighboring village of Azurara da Beira (today known as Mangualde), where his relatives owned property. His ancestors were buried in Viseu cathedral, and his grandfather had been a respected property owner in the city.

There are no references to any Tupinamba having been brought back to Portugal on Alvares Cabral's return trip, though it is known that Columbus had brought West Indian natives to Seville years earlier. The Portuguese first came ashore in Brazil at Porto Seguro on 21 April 1500. There they encountered members of the Tupinamba ethnic group, a nomadic culture characterized by its high degree of adaptation to the tropical forest. The natives spoke the Tupi language, which was in use all along the coast of Brazil in the sixteenth and seventeenth centuries, after which it was replaced by Portuguese as the area's lingua franca.

The specifics of this first encounter are preserved in a letter written by Pero Vaz de Caminha (1450?–1500) to be sent to Dom Manuel I (Foutora da Costa 1968). It emphasized the distinct characteristics and skin color of the native peoples: When the Portuguese boat arrived at the mouth of the river, there were nearly twenty "brown men all nude with nothing to cover their shameful parts. They had bows in their hands and their arrows.... And one of them gave him a hat of long birds' feathers with a small crown of red and brown feathers such as those of the parrot." Later the author adds: "their features are reddish brown with good faces and good well-formed noses." Short and robust (from 15.8 cm to 16.2 cm), the Indians had horizontal eyes and aquiline noses, straight, black, and short hair ("cut even above the ears"); they removed their facial hair, as well as body hair, eyelashes, and eyebrows.

The Portuguese observed the natives before proceeding to disembark. They had not appreciated the food the Portuguese offered them (bread, cooked fish, honey, and overripe figs). In the course of the letter Vaz de Caminha moves from emphasizing the Indians' humanity to describing them as "bestial people, with little knowledge ... they are like birds or mountain animals," in a statement affirming the Europeans' ethnic superiority. The author does, however, repeatedly emphasize the Indians' innocence, "such that Adam's could be no greater," a statement that contributed a good deal to the developing myth of the noble savage. J.T.

SPAIN: THE FOUNDATIONS OF EMPIRE

Two key events in the later fifteenth century consolidated Spain's position as an emerging world power: the union of the crowns of Aragon and Castile through the marriage of Ferdinand and Isabella and the victory of these "Christian Monarchs" in 1492 over the kingdom of Granada, the last stronghold of Islam, which had ruled large areas of Spain in the Middle Ages. It was no accident that Christo-

pher Columbus, the Genoese captain who had been peddling his vision of a sea route to the Indies throughout the courts of Europe, found his first sympathetic audience in the person of the Queen of Spain. Columbus' "Enterprise of the Indies" offered his patrons the prospect of a new route to the East, enabling Spanish merchants to compete with their Portuguese rivals and the established maritime trading cities of

Italy. It also was to provide direct access to the courts of Asia, allowing the Gospel to be preached to the ends of the earth.

Spain's geographical position had long made it the crossroads of Europe. In Columbus' day its culture was an amalgam of indigenous traditions, including important contributions from its long-established Islamic and Jewish communities, and more recent influences from the Low

Countries and Italy. As the monarchy of Ferdinand and Isabella developed into the Empire of Charles V, the Italian Renaissance emerged as the dominant influence in Spanish art.

Columbus' unexpected landing in the Americas gave Spain the opportunity to develop the greatest empire of early modern times, eclipsing the wealth of the Far Eastern powers, word of which had inspired his journey.

33 &

Workshop of Pieter van Aelst
Brussels

CORONATION OF THE VIRGIN

Tapestry from the series called Triumph of the Mother of God *or Paños de Oro*
c. 1500–1502
warp: wool; weft: wool, silk, silver and go
332 x 375 (130⅞ x 147⅝)
reference: Madrid 1986

Patrimonio Nacional, Palacio Real de Madrid

The series of four tapestries of the *Triumph of the Mother of God*, also known as the *Paños de Oro* because of the vast quantity of gold thread used in their manufacture, is the earliest set of its kind still in the Spanish royal collection.

The author of the designs for the *Paños de Oro* is unknown, but the sale of the tapestries from the shop of Pieter van Aelst in Brussels on 10 August 1502 is documented. They were bought by Juana *la loca* (Joanna the Mad), second daughter of Ferdinand and Isabella and wife of Philip the Handsome. Juana gave the set, along with another, similarly rich tapestry, *The Mass of Saint Gregory* (also preserved in the Spanish royal collection), to Isabella, who on her death in 1504 bequeathed them back to Juana.

Juana's life was tragically marred by the death of her young husband in 1506 and by a severe mental illness that led to her gradual deterioration. After Philip's death Juana took the tapestries with her to Tordesillas, where she lived in isolation and died in 1555 at the age of 75.

The *Paños de Oro* represent four key events in the life of the Virgin: *God Sending the Angel Gabriel to the Virgin Mary*, the *Annunciation*, the *Nativity* and the *Coronation of the Virgin* exhibited here. In the center of the *Coronation*, the Virgin Mary is crowned by the Trinity (in which the Holy Spirit is, unusually, pictured as an angel). They are surrounded by a choir of musical angels, saints, and representations of the Virtues with their attributes. In the four corners of the tapestry are scenes that represent subjects not

usually associated with the *Coronation of the Virgin* but all apparently related to royal or courtly marriages. In the upper left, the betrothal of David and Abigail, as told in *Samuel* 25:40–42, is pictured. The marriage of Solomon is in the upper right. The scenes in the lower corners show the coronation of a young woman and a young woman presented with the portrait of a young man.

The biblical stories and the image of the woman presented with the portrait may refer to Juana's own marriage in 1496 to Philip, son of Maximilian I and Mary of Burgundy. The coronation scene at the lower left, which reflects the subject of the *Coronation of the Virgin*, may refer to the historical event that took place in 1501, when Juana and Philip journeyed from Flanders to Spain to be recognized officially by the *Cortes* of Castile and Aragon as inheritors of the Spanish crown (Madrid 1986, 5). Ferdinand and Isabella's older children, Juan and Isabel, had already died, in 1497 and 1498 respectively. If this interpretation is correct, it would strongly suggest that Juana not only purchased the *Paños de Oro* but specifically commissioned them to celebrate her own marriage and coronation.

Pieter van Aelst, from whom the tapestries were bought, held the title of tapestry master to Emperor Maximilian I. These tapestries are typical of the finest Brussels weaving of the 1490s, the period in which, under the aegis of Maximilian, painters and weavers in Brussels collaborated to create this new style of luxury tapestries. s.s.

34 &

Master of the Older Prayerbook of Maximilian I (Alexander Bening)

CRUCIFIXION and DEPOSITION

from the Book of Hours of Queen Isabella of Castile
c. 1496–1504
manuscript, tempera and gold on vellum, 279 fols.
22.6 x 15.2 (8⅞ x 6)
references: de Winter 1981

The Cleveland Museum of Art, Purchase, Leonard C. Hanna Jr. Fund, fols. 72v–73r

Isabella inherited from her father a substantial, for her time, library to which she added books and illuminated manuscripts throughout her lifetime. The monastery of San Juan de los Reyes in Toledo was to include a library that would be the repository of Isabella's and Ferdinand's collection, though that plan was never implemented. This *Book of Hours* is a particularly fine example of the illuminated prayerbooks in the Ghent-Bruges style favored by Isabella; others that once belonged to her may be found in the Spanish national collections and elsewhere, including a breviary in the British Library, London (Add. MS 18851).

The shield on the armorial page of the Cleveland *Book of Hours* includes the pomegranate (*granada*), a symbol that Isabella and Ferdinand added to their heraldry after they expelled the Moors from Granada in 1492. The book therefore must have been commissioned afterward. Other inclusions indicate that the book was intended

for the queen herself; as she died in 1504, it was probably completed by that date (de Winter 1981, 343).

Isabella's taste for Netherlandish art was agreeably facilitated by her family connections in the region. Two of her children married into the House of Burgundy in 1496 (cat. 33). Those weddings occasioned the commissioning of the breviary now in the British Library by Fernando de Rojas, Ferdinand's and Isabella's ambassador to Flanders. The Cleveland *Book of Hours* was also probably commissioned as a gift for the Spanish queen, perhaps by Rojas as well (de Winter 1981, 347), though indications in that volume suggest it might have been begun for someone else.

A book of hours is exactly that: a selection of prayers to be read at the eight canonical hours of the day, along with other prayers to mark special feast days. The Cleveland *Hours* comprises 279 folios, which include ten three-quarter page miniatures and forty full-page miniature paintings. The text is written in black with red rubrics by a single hand throughout the volume and is illuminated with elegant initial letters in gray, blue, and white with gold on a brown ground. The framing elements surrounding the *Crucifixion* and the *Deposition* are representative of the brilliantly decorated borders painted throughout the manuscript. Irises and butterflies, strawberries and lilies are laid out as though in a shadow box: "Appealing and yet disquieting is the unruffled seclusion of this arrested microcosm observed as if through the magic of prismatic crystal" (de Winter 1981, 351).

The illumination of the *Crucifixion* and the smaller *Deposition* on the facing page have been convincingly attributed to the Master of the Older Prayerbook of Maximilian I (Kupferstichkabinett, Staatliche Museen Preussischer Kulturbesitz, Berlin); the master is now identified as Alexander Bening, father of the prolific sixteenth-century illuminator Simon Bening (de Winter 1981, 355). Alexander Bening evidently designed the layout of the manuscript and provided the majority of the illuminations.

The compositions of both the *Crucifixion* and the *Deposition* can be found in earlier manuscripts and both are, as is usual in manuscript illumination, ultimately dependent on large-scale compositions by early Netherlandish masters. In this instance, two paintings by Rogier van der Weyden were Bening's main sources of inspiration: a *Crucifixion* in the Kunsthistorisches Museum, Vienna, and the *Deposition* in the Museo del Prado, Madrid. The scenes are not mere copies, however; they are varied by elements that may be traced to paintings by Hugo van der Goes and to Dieric Bouts' *Deposition*.

Interestingly, both van der Weyden's and Bouts' paintings referred to here were later transferred from Flanders to Granada by Isabella's grandson Charles v. There they served as part of the decoration of the *Capilla Real* (Royal Chapel)

of the cathedral where Isabella and Ferdinand were interred. The remains of the *Reyes Católicos* lie in the city that their crusade liberated from the Moors. s.s.

35

THE RICH MISSAL (*Misal Rico*) OF CARDINAL CISNEROS

1503–1519
Spanish
manuscript on vellum
45.5 x 33 (18 x 13)
references: de Winter 1981; New York 1985, 71–72

Biblioteca Nacional, Madrid, MS 1546

This seven-volume missal *al uso de Toledo* is important not only because of the richness of its thousands of illuminated pages but also because it was made for one of the outstanding figures of the age, Cardinal Francisco Jiménez de Cisneros. Cisneros rose from a humble Franciscan friar to his appointment as Confessor to Queen Isabella in 1492. He succeeded Cardinal Mendoza as Archbishop of Toledo in 1495. In 1504, when Isabella died while Ferdinand was in Italy, Cisneros served as Regent of the Realm. He served in this capacity again on Ferdinand's death in 1516, while Spain awaited the arrival of its new ruler, the Emperor Charles v, from Flanders. Cisneros was a prodigious patron of artists and architects; his generous

support of the arts is particularly visible today in the Cathedral of Toledo (see the essay by Jonathan Brown in this catalogue).

Although the *Misal Rico* was finished during Cisneros' lifetime, it also bears the coat of arms of his successor as Archbishop of Toledo, Alonso de Fonseca. These precious volumes, which took fifteen years to complete, continued in use in the Cathedral of Toledo until the nineteenth century; here and there on its vellum pages are stains left by candles and oil lamps, attesting to its active role in the rites of the faith.

Records in the cathedral chapter show that Cisneros spared no expense in the production of the manuscript called the "rich missal." The lettering and illumination of the volumes were executed by Gonzalo de Córdoba, "Master of the Books of the Cathedral," between 1504 and 1510. The miniatures were painted by Bernardino de Canderroa, Alonso Jiménez, Fray Felipe, and Alonso Vázquez. Their styles represent the uniquely Spanish blend of Flemish and Italian Renaissance styles prevalent at this transitional moment.

The volumes contain 2,794 decorated bands in the side margins, 1,866 historiated initials, 1,316 miniature paintings, and 2,688 even smaller ones. Full-page borders illuminate the pages dedicated to the main feast days of the church; each page is decorated with a historiated initial related to that feast. In the ornamental borders, flowers, fruits, and insects glow against a golden field. In the first and second volumes there are also 322 miniatures with "banners," initials decorated with bands of flowers on a blue or gold background (New York 1985, 71–72). s.s.

36 &

Konrad Seusenhofer
Innsbruck, active 1500–1517

BOY'S DRESS ARMOR OF ARCHDUKE CHARLES, SUBSEQUENTLY CHARLES V

1512–1514
steel, silver gilt; velvet, leather
height 150 (59); width 70 (27½)
references: Primisser 1819, 52–53, no. 6; Sacken 1855, 115ff.; Sacken 1859, 16, pl. 8; Boeheim 1894, 2–3; Boeheim 1899a, 25; Boeheim 1899b, 296ff.; Vienna 1936, 42; Thomas 1949, 37ff.; Innsbruck 1954, 68–69, no. 62; Vienna 1958, no. 87; Vienna 1959, no. 622; Thomas-Gamber-Schedelmann 1963, pl. 16a; Thomas-Gamber 1976, 118–119; Vienna 1988, 395; Vienna 1990, 128ff.

Kunsthistorisches Museum, Vienna, Hofjagd-und Rüstkammer

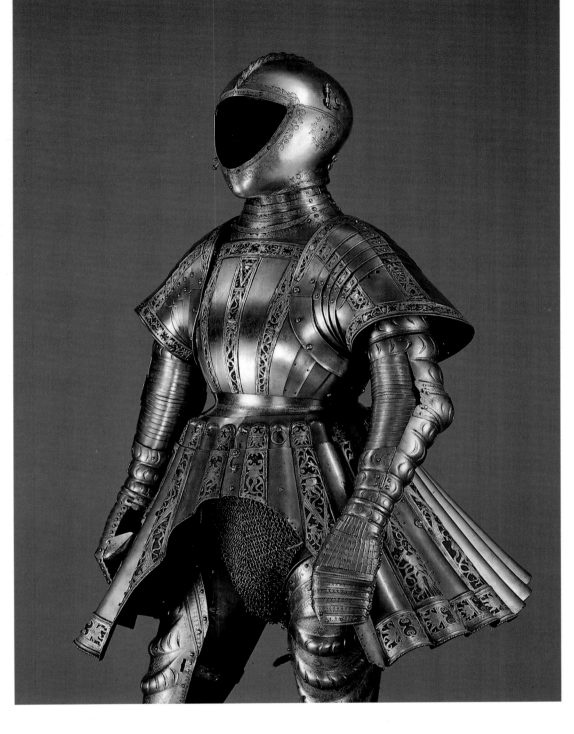

This armor, which does not appear in the old inventories, was catalogued in the Ambras collection in 1819 and attributed to Philip I. The validity of this traditional attribution was questioned (Sacken 1855) and it was later definitively proved that only the young Charles V (1478–1506) could have worn this dress armor (Boeheim 1899b). Maximilian I (1459–1519) ordered this magnificent armor for his twelve-year-old grandson in 1512 from his court armorer, Konrad Seusenhofer, who had run the court armory since its creation in 1504. He had an unusually gifted, versatile, and imaginative artistic personality, and this type of

armor could only be his creation. He undoubtedly enjoyed imitating such a work of fashion in steel, but it required unusual skill to do so. The armor is patterned after the pleated skirt of the Dutch man's costume, the so-called "long-cloak," which has appliquéd borders. To imitate this, recessed bands were affixed on the front and back, on the pleated skirt, the shoulders and the knees of the armor. Originally, black velvet was the background for these gilded interlaced bands. The emblems of the Order of the Golden Fleece, the cross of Saint Andrew, and the flint and sparks of Burgundy are constantly repeated. The cut-out

arched sections were necessary for riding and could be closed with inserts, now unfortunately missing, for foot combat.

The closely fitted vest, incised with half moons and with etched slits, emerges from under the wide cone-shaped shoulders. This motif resembles the then fashionable Landsknecht costumes, which reveal the slitted puff sleeves of the colored lining underneath. Partially gilded, partially blackened etching in the style of the Augsburg master Daniel Hopfer the Elder decorates the other pieces; foliage, star flowers, creatures of fable, and putti on a punched ground accompany

CABASSET OF FERDINAND OF ARAGON

late 15th–early 16th century, Aragonese (?)
steel, gilded copper
height 29 (11⅜); width 24.5 (9⅝); depth 32.5 (12¾)
references: Marchesi 1849, 2–3; Valencia de Don
Juan 1898, 127; Mann 1932, 296–297, 304; Vienna
1936, 22; Vienna 1976, 118–119

Kunsthistorisches Museum, Vienna, Hofjagd-und
Rüstkammer

Three half-sun marks are engraved on the side of
this bell-shaped helmet. Since the beginning of
the nineteenth century these markings have been
attributed to the previously unstudied armory in
Calatayud near Saragossa. The smooth helmet
inclines slightly toward a point at the back. This
incline ends in a small cross. The helmet is
encircled by a ribbonlike headband of gilt copper
with the engraved inscription *in hoc signo vincit*
(in this sign you shall conquer), on a punched
ground. The letters are separated by two lobed
leaves and a similar decorative band, covered with
vegetal climbers, adorns the brim. Crowned car-
touches with the emblem of Granada are affixed
to the middle of the forehead and on the nape. In
the front another cartouche with what is now only
a partial cross is affixed above the one with the
emblem. The cartouche in back was topped at
some later point with a plume holder. The decora-
tive inscription, undoubtedly based on Moorish
design, alludes to the conquest of Granada by Fer-
dinand, as do the emblems. The word *cabasset*
comes from the Spanish *cabeza* (head) and repre-
sents a local variation of the helmet. The receding
brim and the sharp ridge from front to back are
typical for the *cabasset*. C.B.-S.

edges of "sewn designs" and free-formed branches
of pomegranates. For etching and silver decoration
the armor was sent to Augsburg, where the best
artists for this work were to be found. The visor
displayed here is a contemporary piece thought to
be by Seusenhofer, but it did not originally belong
to the armor.

Maximilian I had many presentation armors
fashioned in his Innsbruck armory. In 1511 he
commissioned the armorer Hans Rabeiler (active
1501–1519) to make a body armor for his grandson
Charles, which was never completed. It was evi-
dently learned that the armor then in progress

would no longer have fit the growing Charles and
the project was abandoned. On 12 March 1512 the
chamberlain at Innsbruck informed the emperor
that a vest and pants of the young Charles had
been sent to the master armorer Konrad Seusen-
hofer as a basis of measure for the new armor. At
the same time Maximilian I ordered two addi-
tional parade armors in this style for his English
relation Henry VIII. At least a helmet, now in the
Tower of London (inv. no. IV 22), remains of this
gift, which the brother of Konrad Seusenhofer,
Hans, delivered to Antwerp in April 1514 for its
journey to England. C.B.-S.

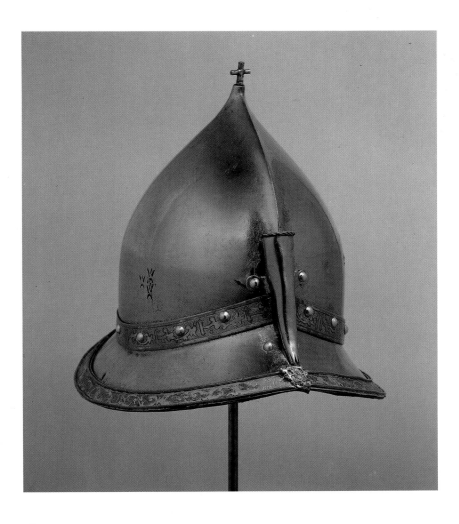

coat-of-arms on the chapel's screen (Burgos 1496).

Judging from the 1487 inventory, the reliquaries were not part of a series of apostles (apostolado), as has been suggested (Rico Santamaría 1985, 445), but were simply meant to house the relics of three saints especially venerated in Burgos. Santiago, patron of Castile, was particularly important. Burgos was not only at the time the unofficial capital of the kingdom, *la cabeza de Castilla*, it was one of the major cities on the pilgrimage route to Santiago de Compostela.

Luis de Acuña, the prelate who commissioned the reliquaries, was an important political figure during the years immediately preceding the reign

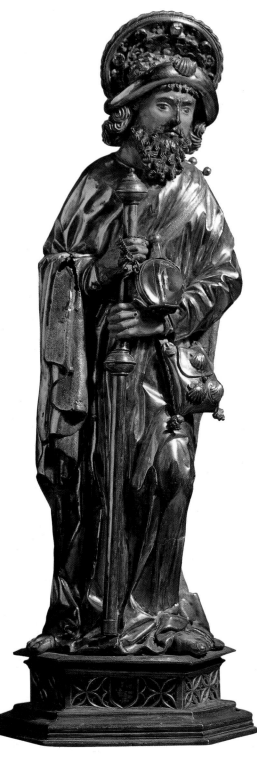

38 ꙮ

Master IF (possibly Juan González Frías)

RELIQUARY OF SAINT JAMES THE GREATER

1456–1457

Castilian
gilt silver, painted, with precious stones
height 67 (26⅝)
references: Burgos 1496; Martínez Sanz 1866, 270–272; López Mata 1950, 96, 98; López Martínez 1961, 309; Estepa Diez 1984, 287–288; Rico Santamaría 1985, 445

Excmo. Cabildo Catedral—Burgos

This silver gilt figure of Santiago, Saint James the Greater, is one of a set of three reliquaries in Burgos Cathedral in the form of standing figures of apostles, the others depicting Saints Peter and Paul. They date from the tenure of Luis de Acuña as bishop of Burgos (1456–1495); his coat-of-arms appears on the Santiago reliquary. The reliquary also displays the *Caput Castellae*, the crowned head of a king atop a castle, the mark of the Burgos silversmith's guild. The mark of the silversmith himself consists of two letters: IF. Burgos was one of the principal centers of silversmith's production in Castile in the fifteenth century, and its guild was one of the most prestigious

and among the first to be established (Estepa Diez 1984, 287–288).

Burgos Cathedral once possessed a large number of relics, which were kept in the sacristy until 1765 (Martínez Sanz 1866, 270–272). The reliquaries of Saint James, Saint Peter, and Saint Paul are almost certainly identical with the ones listed in a 1487 inventory of the sacristy:

b.I El pulgar de señor Sant Pedro apóstol está en el apóstol
b.II De los huesos de señor Sant Pablo apóstol está en el apóstol
b.III De los huesos de señor Santiago apóstol está en el apóstol
(López Martínez 1961)

The Roman numeral III is inscribed on the base of the Santiago reliquary, corresponding to the inventory number. The listing of these relics under the alphabetical headings *a–g* can probably be understood as a reference to the compartments within the reliquary cabinet in the sacristy in which the relics were stored. This arrangement may have been altered in 1495 upon the completion of Alonso de Sedano's "altar of the relics" (*retablo de las reliquias*). Significantly, it must have been Luis de Acuña who initiated this project, as the artisan responsible for the ironwork, the *rejero*, was later required to place the bishop's

of the Catholic Monarchs. Like several other members of his prominent family, he had opposed a matrimonial alliance between Castile and Aragon and, subsequently, Isabella's claim to the throne. As a result, Acuña spent the years 1476–1481 in exile from Burgos. Nonetheless, during his lengthy term as bishop, he intervened in favor of several major building projects in Burgos Cathedral. Successive masters (maestros de la obra) Juan and Simón de Colonia completed the north tower, the Gothic cimborium (which collapsed in 1539), and Acuña's own funerary chapel. Gil de Siloe and Diego de la Cruz executed the main altarpiece of Acuña's chapel. In addition, Acuña caused the silver image of Santa María la Mayor, patroness of the cathedral, to be remade on a larger scale between 1460 and 1464, providing the silver necessary for the undertaking. That anonymous work can be usefully compared with the Santiago reliquary (López Mata 1950, 96, 98).

R.K.

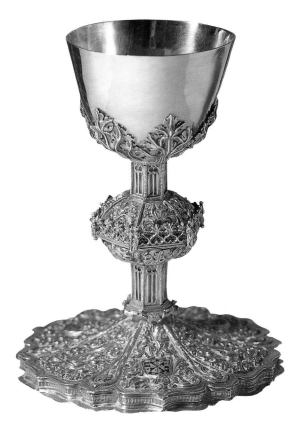

39 ❧

CHALICE OF THE CATHOLIC MONARCHS

late 15th century
Castilian
gilt silver, enamel
25 x 19 (9¾ x 7⅜)
references: Llorente 1961, 39; Palomo Iglesias 1970, 89; Arnáez 1983, 1:74–75, fig. 24

Convento de Santo Domingo el Real, Segovia

This chalice, bearing the coats of arms of Spain and of the Dominican order, attests to the special devotion of Isabella the Catholic for the order founded by Saint Dominic of Guzmán. The queen called upon a Dominican, Tomás de Torquemada, to undertake the reorganization of the Tribunal of the Holy Office (the Inquisition) and appointed him inquisitor general. Torquemada was the prior of the convent of Santa Cruz at Segovia, an institution of great tradition and importance. It was the first Dominican convent in Spain, founded by Saint Dominic himself in 1218 (Jordan of Saxony, *Libellus de principiis ordinis praedicatorum*, n. 59). For this and other reasons Isabella took the convent of Santa Cruz under her royal patronage. She had it completely rebuilt, sparing only the cave to which Saint Dominic had withdrawn at night for prayer and penitence. The queen entrusted this work to the royal architect Juan Guas.

Columbus' "Enterprise of the Indies" is itself connected with a prominent Dominican of the time. Before the queen agreed to finance Colum-

bus' undertaking, she sent him to Salamanca to discuss the feasibility of the voyage with the Dominican Diego de Deza, a learned cleric about whom Columbus wrote: "Ever since I came to Castile he has held me in favor and desired my honor" and if it were not for him "Their Highnesses would not possess the Indies and I would not have remained in Castile, since I was about to leave." In memory of this event, one of the cloisters in the Dominican convent of San Esteban of Salamanca is named after Columbus, and the stone lintel above the window of Deza's room is inscribed, "Diego de Deza and Columbus spoke together here."

Among the donations Isabella made to the convent of Santa Cruz was this chalice. It was kept with the most valued objects until the disentailment of 1834, when the clerics were forced to abandon their convent. At that time Prior Claudio Sancho Contreras took the chalice and kept it in his possession until his death in 1886. It then passed to the convent of Dominican nuns in Segovia, where it is still kept and used on the most solemn occasions. This chalice was one of the objects exhibited at the *History of the Americas Exhibition* on the occasion of the fourth Columbus Centenary.

Though the intervention of the queen's architect at Santa Cruz dates from at least as early as 1478, the chalice must have been commissioned slightly later, as the royal coat of arms includes the pomegranate of the kingdom of Granada, added in 1492. The base of the chalice is richly

worked with embossed and engraved foliate decoration, with the enameled coats of arms of the Catholic Monarchs and the Dominican order applied. The cup is likewise sustained by large, embossed, leafy forms. The hexagonal stem is decorated with Gothic fenestration, while the six-paneled central nodule is articulated with a like number of tiny figures of standing saints. The maker of the chalice is unknown, as is its place of origin. The goldsmith's marks are not clearly visible, though one of them appears to be that of the city of Avila (Arnáez 1983, 1:75).

C.P.I. and R.K.

40 ❧

CHALICE

c. 1500
Castilian
gilt silver, filigree, pearls, enamel
height 23 (9⅛)
inscribed: AVE MARIA GRATIA PLENA DOMINUS TECUM
references: Madrid 1893, no. 44; Villa-Amil y Castro 1893, 13; Chicote 1903–1904, 1:140–141; Martín González 1971, 322; Brasas Egido 1980, 117, fig. 67

Museo Diocesano y Catedralicio, Valladolid

Given that no goldsmith's marks can be distinguished on the chalice, it is impossible to identify its maker or to be certain of its place of origin. It

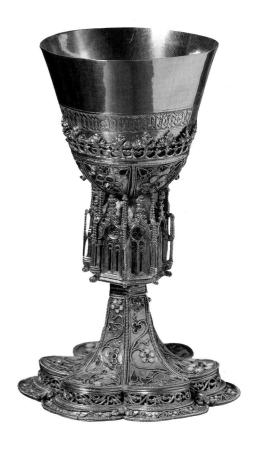

has been attributed to a Valladolid craftsman and dated to around 1500.

The base of the chalice is divided into five lobes and is decorated with an unusual floral pattern executed in filigree and enamel, repeated at the base of the bowl and enriched with tiny pearls. The broad uppermost part of the stem, just below the bowl, is articulated with gothic fenestration. The bowl itself is inscribed with the words of the angelic salutation from the Annunciation.

The chalice originally comes from the Valladolid church of La Magdalena, a parish that prospered under the patronage of the La Gasca family. It is traditionally said to have been a gift of the prelate and statesman Pedro de la Gasca (1485–1567), who was named President of the Audiencia of Peru by Charles V. La Gasca is known as "el Padre restuarador y pacificador" for his role in subduing the rebellion against the crown led by Gonzálo de Pizarro. Upon his return to Spain, he served as Bishop of Sigüenza and later, of Palencia.　　　　　　　　　　　　　　R.K.

41 ᢙ

PANELS FROM A DOOR

last quarter 15th century
Castilian
walnut
each upper panel 145.5 x 50.8 (57¼ x 20)
each lower panel 50 x 50.8 (19⅝ x 20)
inscribed: AVE GRACIA P and SALVE REGINA MA
references: *Ara Gil 1977, 371–372; Mateo Gómez, 1979, 219; Martin González 1985, 15*

Museo Diocesano y Catedralicio, Valladolid

This door, now placed at the entrance to the chapel of San Llorente in Valladolid Cathedral, is one of six late fifteenth century doors to survive from the no longer extant Collegiate church of Santa María la Mayor. The *Colegiata* was founded in 1095 by the Conde Ansúrez and was later elevated to the status of Cathedral in 1595 by Clement VIII at the request of Philip II.

The door is divided into four panels: the two lower ones are decorated with tracery while the two upper ones are decorated with a foliate pattern populated with birds. A jar of lilies, associated with the Virgin (to whom the *colegiata* was dedicated), is found in each of these two panels, accompanied by inscriptions which likewise refer to Mary: in the left hand panel, "AVE GRACIA P" and in the right hand panel, "SALVE REGINA MA." In the latter panel, the lilies are supported by a wild man and woman (see cat. 4), a rather common motif in Castilian art of the late fifteenth century, above all in heraldic contexts in architecture and the decorative arts, where such creatures often serve as guardians of portals or of a particular coat of arms. Two of the most prominent examples occur in the decoration of the façade of the Colegio de San Gregorio in Valladolid and the Capilla de los Condestables in Burgos Cathedral. The wild man and woman represented in the Valladolid door function similarly as the "heraldic" guardians of an emblem of the Virgin.

The author of the portal is unknown, though it is likely that all six doors were commissioned at the same time as a set of choir stalls, also from the Collegiate church, now found in the Cathedral. Although there appear to have been a certain number of *entalladores* (woodcarvers) active in Valladolid towards the end of the fifteenth century, only a few names are known: Fray Pedro de Lorena, Fray Pedro de Valladolid, Martín Sánchez, Pedro de Guadalupe. Among these craftsmen, few names can be connected with surviving works. Martín Sánchez, who is referred to as a resident of Valladolid, was active between 1486 and 1489 in the construction of the stalls for the monk's choir at the Cartuja de Miraflores near Burgos. Unfortunately, the Miraflores stalls have no figural decoration and it is not possible to draw any conclusions regarding the authorship of the Valladolid doors by analyzing similarities between the two works.　　　　　　　　　　　　　　　　R.K.

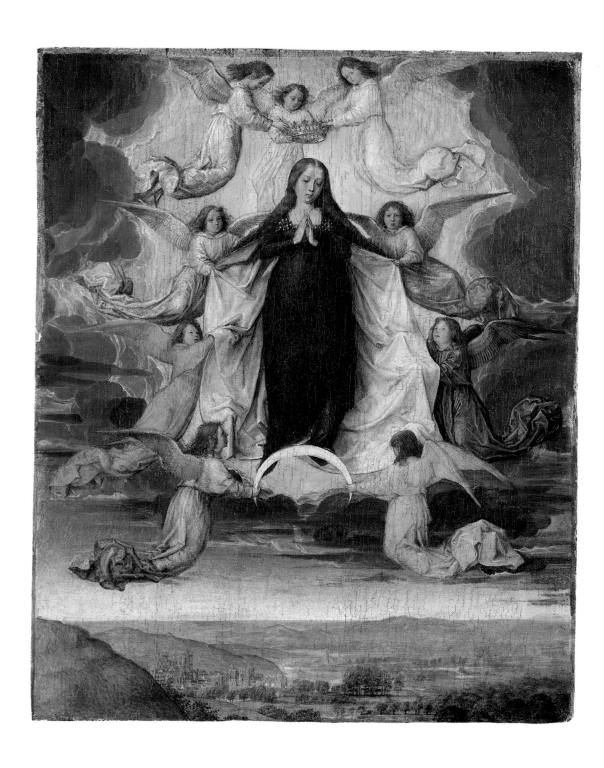

42–45 ❧

FOUR PANELS FROM THE POLYPTYCH ALTARPIECE OF QUEEN ISABELLA

c. 1496–1504

Michel Sittow
Hispano-Flemish c. 1469–1525 or 1526

ASSUMPTION OF THE VIRGIN

oil on panel
21.3 x 16.7 (8⅜ x 6⅝)

National Gallery of Art, Washington, Ailsa Mellon Bruce Fund

Juan de Flandes
Hispano-Flemish, active 1496–1519

TEMPTATION OF CHRIST IN THE DESERT

oil on panel
21 x 15.8 (8¼ x 6¼)

National Gallery of Art, Washington, Ailsa Mellon Bruce Fund

Juan de Flandes

MULTIPLICATION OF THE LOAVES AND FISHES

oil on panel
21 x 15 (8¼ x 6)

Patrimonio Nacional, Palacio Real de Madrid

Juan de Flandes

SUPPER AT EMMAUS

oil on panel
21.2 x 15.7 (8¼ x 6¼)

Patrimonio Nacional, Palacio Real de Madrid

references: Sánchez Cantón 1930, 99, 115; National Gallery of Art 1941; Vandevivère 1967, 35; Trizna 1976, 19, 39

Juan de Flandes and Michel Sittow began working on a miniature altarpiece for Queen Isabella in 1496. Listed in a 1505 inventory of Isabella's possessions in the castle at Toro are forty-seven small panels *(tablicas)*, which were stored in a cabinet (Sánchez Cantón 1930, 99). These (and probably others planned but not executed) were intended to be framed as a *retablo*, with a format like that of the enormous *retablos* in Spanish cathedrals, but greatly scaled down to serve for Isabella's personal devotions. Twenty-eight of the panels are extant today, fifteen of them in the Palacio Real, Madrid. Juan de Flandes painted the majority of the panels and probably served as supervisor of the project.

This miniature *retablo*, with its many individual scenes from the life of Christ, was privately commissioned by Queen Isabella. It thus reflects both her personal piety and, as was recently suggested by Chiyo Ishikawa, underlines the character of the religious reform undertaken during the reign of the Catholic Monarchs. The compositions are spare and simple, the stories told with impressive sobriety, the facial expressions showing the utmost seriousness. One of the panels even includes portraits of the king and queen; in the *Multiplication of the Loaves and Fishes* they are seen on the left, Isabella kneeling and Ferdinand standing behind her.

Michel Sittow was born in Reval, a Hanseatic port on the Baltic (now Tallinn, Estonia). His apprenticeship and early career as a painter were served in Bruges, from about 1484 to 1491, when Hans Memling was the most influential painter there. From 1492 to 1504 Sittow was in the service of Queen Isabella. Not yet twenty-five years old, he received an annual salary of 50,000 *maravedís*, more than twice as much as Juan de Flandes would receive four years later (Trizna 1976, 19). Although Sittow worked on the polyptych altarpiece of Isabella with Juan de Flandes, he was probably retained primarily as a portrait painter.

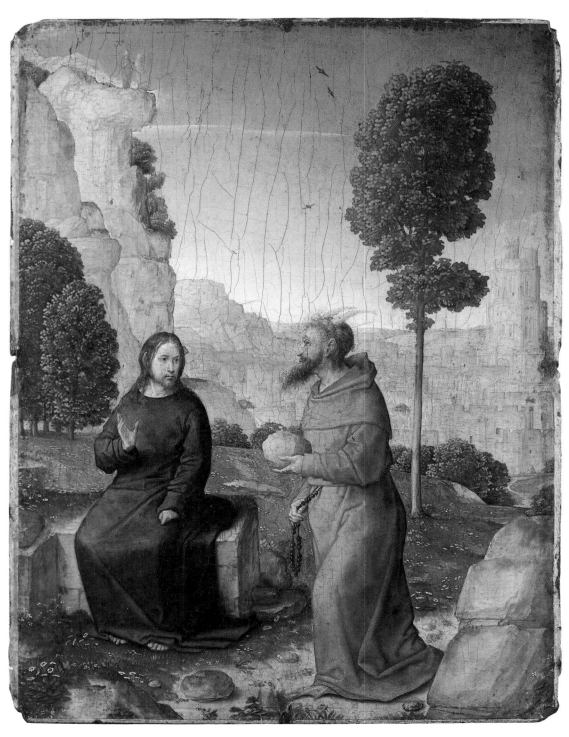

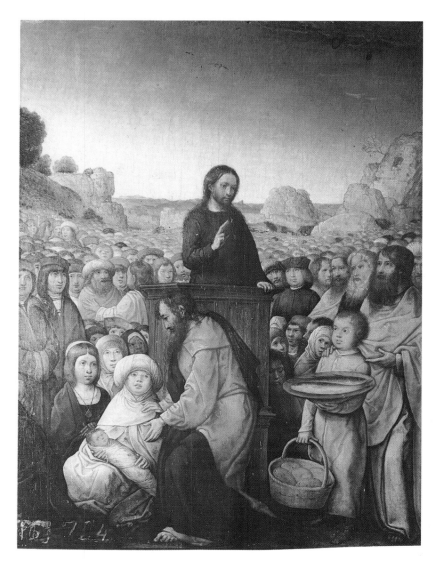

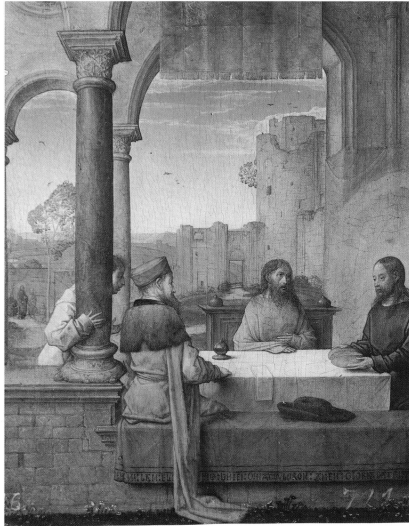

After Isabella's death in 1504, Sittow evidently returned to his native Reval to straighten out a matter of his inheritance (Trizna 1976, 39). In 1514 he traveled to Denmark, where he painted a portrait of King Christian II (Statens Museum for Kunst, Copenhagen). In 1516 he was in Malines, painting for Margaret of Austria and the future Charles V. His last years were spent in Reval, where he died in 1525 or 1526.

Sittow's work on Isabella's altarpiece is documented in a 1516 inventory of the panels made when they were in the collection of Margaret of Austria. The *Ascension of Christ* (Earl of Yarborough, Brocklesby Park, Habrough) and the *Assumption of the Virgin* are there attributed to "la main de Michel" (the hand of Michel). Sittow painted for Margaret and may well have been at her court in Malines to help with the inventory and thus identify panels that he himself had executed (Sánchez Cantón 1930, 115).

Juan de Flandes may have been trained as a miniaturist in his native Flanders; however, when Isabella died in 1504 and his tenure as court artist ended, he never again worked on such a small scale. In 1505 he was painting the main altarpiece for the chapel of the University of Salamanca. He established residence in Palencia in 1508 and began work on the main altarpiece of the church of San Lázaro in that city (four panels of which are now in the National Gallery of Art). In 1509 Juan de Flandes contracted to paint the immense altarpiece of the Cathedral of Palencia; he was still working on that project when he died in 1518 (Vandevivère 1967, 35).

Juan de Flandes also painted three of the panels exhibited here. Albrecht Dürer, who saw the panels in Margaret's collection on his trip to the Netherlands in 1520–1521, admired the small paintings for their "purity and excellence," qualities still prized today. Scene after scene quietly unfolds before us, picked out with the meticulous brushstrokes of a painter completely at ease with the miniature format. The figures move with studied serenity through simple architectural settings *(Supper at Emmaus)* or against atmospheric landscapes *(Assumption of the Virgin)* that sometimes reflect the rugged austere landscape of Isabella's Castile *(Temptation of Christ in the Desert)*. s.s.

46 ஓ

Pedro Berruguete
Spanish, c. 1450–c. 1504

THE PROPHET DAVID

c. 1480–1490
oil on panel
98.4 x 59.1 (38¾ x 23¼)
references: Laínez 1943, 46; Post 1947, 85, 86;
Angulo Iñiguez 1954, 12:89–90

Church of Santa Eulalia, Paredes de Nava

Pedro Berruguete was born in Paredes de Nava, a town northeast of Palencia, around 1450. We know nothing definite about his early life and training, but his style indicates that he may have served an apprenticeship in the Low Countries around 1470. He may have traveled from there directly to Urbino in the company of Joos van Gent, who worked between 1473 and 1475 for Federigo da Montefeltro, Duke of Urbino. For the *studiolo* of the ducal palace in Urbino, Berruguete painted allegories of the Liberal Arts, and completed with Joos van Gent a series of twenty-eight

portraits of famous men (Angulo Iñiguez 1954, 89–90).

In 1483, the year after Federigo da Montefeltro's death, Berruguete was back in Spain, at the Cathedral of Toledo, where he is recorded throughout the following decade, though little of his work there remains. After his patron, Archbishop Pedro González de Mendoza, died in 1495, Berruguete painted several important works for Cardinal Tomás de Torquemada, Grand Inquisitor during the reign of Isabella and Ferdinand, including the main *retablo* of the monastery of Santo Tomás in Avila and that of the Cathedral of Avila. Besides these important commissions, which are his masterpieces, Berruguete created altarpieces for a number of churches in the areas around Palencia, Burgos, and Segovia. Following Berruguete's death some time before 6 January 1504 (Laínez 1943, 46), his altarpiece for the Cathedral of Avila was completed by Juan de Borgoña.

The set of paintings in the church of Santa Eulalia in Berruguete's home town of Paredes de Nava, to which this panel belongs, must have been one of the earliest commissions he undertook upon his return to Spain from Italy. Those paintings are now ensconced in an altarpiece painted by Pedro's grandson Inocencio Berruguete, in collaboration with another artist, in the mid-sixteenth century (Post 1947, 85). Despite the considerable stylistic changes in Spanish art that had occurred between the 1480s and the 1550s, the contract for the new altarpiece explicitly required the inclusion of Pedro Berruguete's existing paintings.

The predella of the Santa Eulalia altarpiece includes six half-length Old Testament worthies by Pedro Berruguete—Jehoshaphat, Solomon, Uzziah, Ezra, and Hezekiah, in addition to *David*. All but Ezra are mentioned in the book of Matthew as ancestors of Saint Joseph and so are iconographically appropriate for the altarpiece, which is dedicated to the life of the Virgin (Post 1947, 86). The degree of idealization in these imaginary portraits reflects Berruguete's Italian experience and somewhat recalls the series of portraits that he painted in Urbino. However, it is clear that his experience in Italy did not turn Pedro Berruguete into an Italian Renaissance painter. He simply infused into his native Hispano-Flemish style a greater sense of monumentality and an interest in space and perspective. Much more striking in *The Prophet David* is Berruguete's masterful handling of those elements most characteristic of the Hispano-Flemish style: the dazzling gold brocade, the brilliant palette, and the precise rendering of details. King David is not overwhelmed by his rich trappings, however; his steady outward gaze conveys both a sense of his magisterial wisdom and a profound humanity. s.s.

47 🐚

Michel Sittow
Hispano-Flemish, c. 1469–1525 or 1526

PORTRAIT OF A MAN
(DIEGO DE GUEVARA?)

c. 1515–1518
oil on panel
33.6 x 23.7 (13¼ x 9⅜)
reference: National Gallery 1941, 185

National Gallery of Art, Washington, Andrew W. Mellon Collection

Sittow, who worked on *the Polyptych Altarpiece of Queen Isabella* (see cat. 45) with Juan de Flandes, was primarily a portrait painter. This modest portrait of a middle-aged man wearing a fur collar, seen in three-quarter view facing to the left, his left hand on the parapet and his right on his breast, indicates clearly the qualities that earned Sittow his importance in Isabella's entourage.

The painting has been tentatively identified as the portrait of Diego de Guevara, who worked for the court of Isabella's daughter, Juana "la Loca," and her husband Philip the Handsome. An inventory of 1548 of the estate of the Marquis of Zenete includes a reference to a diptych with one panel representing the Virgin and Child and the other "Don Diego de Guevara with a furred gar-

ment." About 1560, Diego de Guevara's son Felipe mentions a portrait of his father by "Michel." It is certain that this portrait has a pendant, the *Virgin and Child with a Bird* (Gemäldegalerie, Staatliche Kunstsammlungen Preussischer Kulturbesitz, Berlin, no. 1722), because the pattern of the oriental carpet on the parapet on which the Christ Child rests exactly matches its continuation in the foreground of the portrait.

These references are tantalizing, but ultimately inconclusive. The portrait could also be of a member of the entourage of Catherine of Aragon, painted when Sittow was in England (National Gallery 1941, 185). The brocaded pattern of the sitter's doublet could allude to the emblem of the Order of Calatrava—the cross and fleur-de-lis—which would suggest that the sitter was a knight of that military and religious order, established in the twelfth century. (Ferdinand and Isabella, to avoid the possible use of the order's resources against their monarchy, in 1489, with the approval of the papacy, took over the administration of the Order of Calatrava.)

Whoever the subject may have been, Sittow's own accomplishment in this portrait is clear. With precision and unflinching honesty played off against the values of light, shadow and volume, he has created a likeness that is small in scale but monumental in its sobriety and dignity. s.s.

Gil de Siloe

Netherlands or Lower Rhine (?), active 1486–1500

SAINT JAMES THE GREATER

1489–1493
alabaster with traces of polychrome and gilding
45.9 x 17.8 x 14.6 (18⅛ x 7 x 5¾)
references: Burgos 1500; Burgos 1501; Laurent C.
1577; Iglesia 1659, 3; Rada y Delgado 1874, 3:322;
Tarín y Juaneda 1896; López Mata 1946, 103;
Wethey 1936, 31, 130, nn. 116–118

The Metropolitan Museum of Art, New York, The Cloisters Collection, 1969

Like numerous other sculptors active in Castile during the second half of the fifteenth century, Gil de Siloe was from northern Europe, though his precise origin remains uncertain. A document describing him as a native of "urliones" (Orleans?), and another, recently discovered, in which

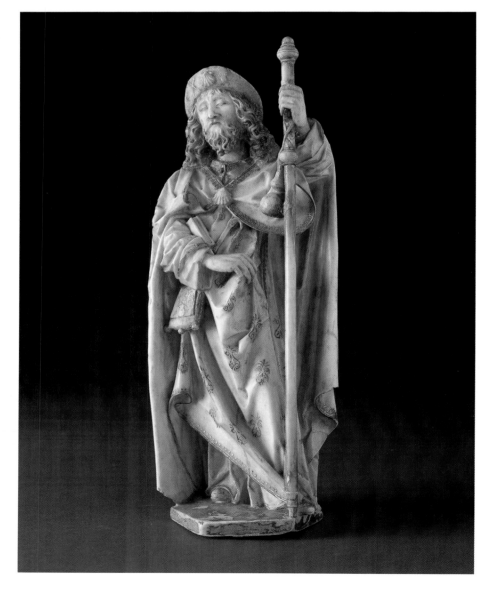

he is called "frances," cannot be easily reconciled with stylistic evidence that points to his origin in the Netherlands or the Lower Rhine region (López Mata 1946, 103; Burgos 1501). Nothing certain is known of Gil's activities prior to 1486, when he provided the designs for the tombs at the Carthusian monastery of Miraflores, near Burgos. These tombs were not begun, however, until 1489, and in the interim Siloe must have completed the *retablo* for the funerary chapel of Luis de Acuña in Burgos Cathedral, and another altarpiece, now lost, for the chapel of Alonso de Burgos at the Colegio de San Gregorio in Valladolid. Upon completion of the royal tombs in 1493, Siloe was commissioned to execute the main altarpiece for the church of San Esteban in Burgos (now destroyed). Between 1496 and 1499 he was once again at Miraflores, at work on the monumental main altarpiece. With the Miraflores altarpiece, the documented activity of Gil de Siloe comes to an end, though other works attributed to him such as the Saint Anne altarpiece in Burgos Cathedral and the tomb of Juan de Padilla (from

Fresdelval), are presumed to postdate it. He died in 1500 (Wethey 1936; Burgos 1500).

The alabaster tomb of Juan II of Castile and Isabel of Portugal, for which this figure of *Santiago* was sculpted, is one of the most unusual and extravagant funerary monuments of the fifteenth century. The Carthusian monastery in which it is situated was founded in 1442 by Juan II, who ceded the former palace of Miraflores for the purpose. However, the monastery was almost entirely destroyed by fire in 1452, less than two years before the death of its founder. It remained for Isabel la Católica to pursue the construction and decoration of her father's foundation. Work at the monastery came to a complete standstill during the troubled reign of Enrique IV and did not resume until 1477, shortly after Isabel secured the throne. Construction of the monastic church was directed by Simón de Colonia, who completed it in 1488. During the course of the next decade, Gil de Siloe and his shop executed the tomb of Juan II and Isabel of Portugal, that of Isabel's brother, the Infante Alfonso, and the polychromed wood *retablo mayor* (Tarín y Juaneda 1896). Significantly, the royal tombs at Miraflores distinguish and exalt the particular line of succession through which Isabel la Católica asserted her disputed claim to the throne of Castile. As a dynastic monument, Miraflores functions to affirm the legitimacy of Isabel's claims.

The alabaster figure of *Saint James the Greater*, the patron of Castile, is one of sixteen that once adorned the top of the star-shaped tomb of Juan II and Isabel of Portugal. The largest of these figures, the four Evangelists, remain *in situ* at the cardinal points of the eight-pointed star. The remaining points and interior angles were originally adorned with twelve standing figures of saints, including the *Santiago* and the eight statuettes still at Miraflores. It is possible that two of the latter originally belonged to the adjacent tomb of the Infante Alfonso. Although written descriptions of the monument have listed varying numbers of figures (Wethey 1936, 31, 130, nn. 116–118), there is no reason to doubt that there were originally twelve standing figures situated in the twelve available points and angles of the tomb. Moreover, the earliest description of the tomb specifically cites twelve figures: "en las quatro principales esquinas los quatro Evangelistas, y en los demas angulos, ay doze estatuas menores..." (Iglesia 1659, 3).

A lithograph and two early photographs show that this figure was formerly situated to the left of the figure of Saint Luke, near the head of the effigy of Isabel of Portugal (Rada y Delgado 1874, 3:322; Laurent C. 1577. It cannot be assumed, however, that this was its original location. Physical evidence suggests that the *Saint James* was singled out for special devotion and was at some point removed from the tomb for a period of time. The figure's gilding and polychromy cannot be considered original as formerly maintained

(Wethey 1936, 32). Early photographs show that it was the only figure on the tomb to be so embellished, and physical examination of the work reveals that the paint and gilding is in some instances applied over restorations. Parts of the back of the figure have been roughly cut away, apparently in an effort to accommodate its placement in a more restricted site, most likely an altar dedicated to Santiago. R.K.

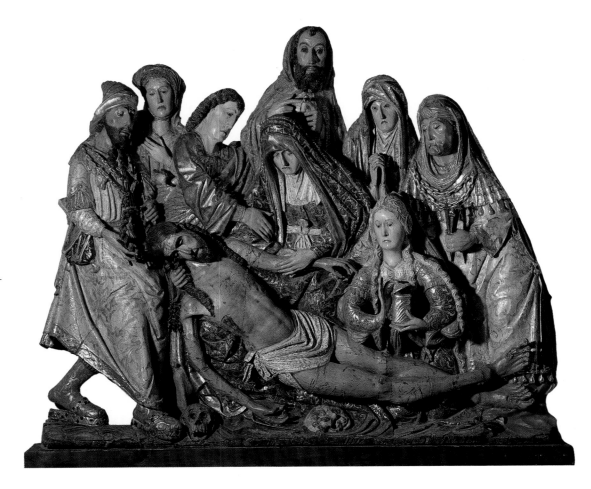

49 ॐ

San Pablo de la Moraleja Master
Netherlandish or German

LAMENTATION

c. 1500
polychromed wood
159 x 187 (62⅝ x 73⅝)
references: Buser 1974, 1; Valladolid 1988, 162–163

Museo Diocesano y Catedralicio, Valladolid

The anonymous author of this sculpture, who probably came to Spain from Flanders or Germany, has been called the "San Pablo de la Moraleja Master" after the parish church in the province of Valladolid from which the group came (Valladolid 1988, 162–163). The work is characteristic of the late gothic in Castile; in fact, it has much in common with polychromed sculptural groups throughout Europe at this time. Sculpture in marble and bronze was largely the specialty of the artists of central Italy, where classical examples were most reverentially recalled. Elsewhere in Europe the power of these narrative groups, composed of unidealized figures painted and gilded to emphasize their corporeality, reflected the immediacy of the medieval Passion play. This sculptural group in fact suggests a scene from a play of the Passion of Christ, performed by actors representing Joseph of Arimathia, Nicodemus, Saint John, the Virgin Mary, Mary Magdalen, and the "other Marys." As in the play, the actors are distinguished individually by their makeup and costumes, but they respond to the death of Christ almost in unison, as a tragic chorus.

The subject of the *Lamentation* is an extraordinarily apt one for an altarpiece, where the body of Christ is the all-important focus. The emphasis of the more contemplative image of the Virgin and her dead son, or Pietà, is on the compassion of the Virgin, and thus that image is more suitable for private devotion. In Spain it is often adapted for use in tomb sculpture (Buser 1974, 1). The Lamentation, on the other hand, is based on the narrative of the Passion of Christ, which is a public

scene with many figures, including by implication the viewer himself.

A comparison of the *Lamentation* with Alonso Berruguete's *Sacrifice of Isaac* (cat. 51) is extraordinarily instructive. Although created less than thirty years apart, the two Spanish polychromed sculptural groups represent entirely different stylistic worlds. In the *Lamentation*, the drama of the scene is brought to stylized life. The San Pablo de la Moraleja Master's awkward figures, wearing concave masks of tragedy, swoon melodramatically over the greenish flesh of Christ's scarred and bloodied body. Alonso Berruguete's finely wrought figures, on the other hand, reflect the idealization of the Italian Renaissance style in which the younger sculptor was trained. The two artists, however, are heirs to the same spiritual tradition. Both knowingly use tortured faces and compressed space to express the religious fervor of their respective subject in beautifully painted and gilded wood. S.S.

50 ॐ

Diego de Siloe
Spanish, active 1517–1563

MAN OF SORROWS

c. 1522
polychromed and gilt wood
height 54 (21¼)
references: Villacampa 1928, 25–44; Gómez-Moreno 1941, 17, 38–39

Excmo. Cabildo Catedral—Burgos

Diego de Siloe's *Man of Sorrows* forms part of the altarpiece of Saint Anne in the funerary chapel of the Constables of Castile in Burgos Cathedral. The dead Christ, supported on the edge of his tomb by a pair of lamenting angels, is an explicitly eucharistic subject. The figure is the central image of the *banco* of the altarpiece, a position that recalls, and refers to, the tabernacle in which the consecrated host was stored.

The altarpiece was left unfinished by Gil de Siloe around 1500 and was completed more than twenty years later by his son, Diego, who added four figures: the Man of Sorrows and three standing female saints. The polychromy of these figures can be attributed to Leon Picardo, the painter responsible for the polychromy of the main altar-

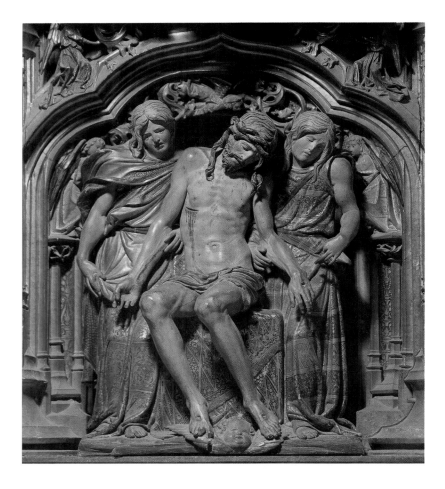

cipally active in southern Spain. In Granada, he was active as architect, designer, and sculptor at the Cathedral, and at the churches of San Jerónimo, San Gabriel, and San Gil. Likewise, he intervened in the construction of the Cathedrals of Sevilla, Málaga, Guadix, and Plascencia. R.K.

51

Alonso Berruguete
Spanish, c. 1490/1492–1561

THE SACRIFICE OF ISAAC

from the altarpiece of the church of the monastery of San Benito, Valladolid
begun 1526
polychromed wood
36.5 x 18 x 13 (14⅜ x 7⅕ x 5⅛)
references: Camón Aznar 1980, 20

Museo Nacional de Escultura, Valladolid

Alonso Berruguete, the son of the painter Pedro Berruguete (cat. 46), was born in Paredes de Nava, probably about 1490–1492 (Camón Aznar 1980, 20). Alonso Berruguete's early training took place in Italy, which he reached at a very auspicious moment. Michelangelo mentions him in a letter of 1508, and Vasari speaks of "Alfonso Berruguete espagnuolo" in his biographies of Michelangelo and Baccio Bandinelli. Berruguete is recorded as working in Florence and Rome. He probably returned to Spain before 1516.

Berruguete's first important commission in Spain was the tomb of Grand Chancellor Juan Selvaggio, a member of the court of Charles V, which was entrusted to him together with the French sculptor Felipe Bigarny. This opportunity gave Berruguete an early entry into high circles; in 1518 he was referred to as "pintor del rey" (painter to the king). In 1521 both Berruguete and Bigarny were commissioned to work at the Royal Chapel in Granada, which Charles V ordered decorated in a manner befitting the burial place of his grandparents Ferdinand and Isabella. Berruguete's contract for the work in Granada specified fifteen *historias pintadas*, and between 1520 and 1523 he was busy painting banners and standards for the Armada. Not until 1523 did he turn to the design of altarpieces and the combined arts of architecture-sculpture-painting.

Between 1523 and 1526 Berruguete created the main altarpiece of the Hieronymite monastery of La Mejorada (Olmedo). From then on Berruguete, who is now called a sculptor, both designed the architectural framework for the great altarpieces and carved and painted the sculpture. In 1526 he was commissioned to create the altarpiece for the church of the monastery of San Benito in Valladolid for which *The Sacrifice of Isaac* was created.

piece for the same chapel executed by Diego de Siloe and Felipe Bigarny.

The chapel within which the Saint Anne altarpiece is located, dedicated to the Purification of the Virgin, was founded by Pedro Fernández de Velasco and Mencía de Mendoza, Condes de Haro and Constables of Castile. Documents of the period, however, consistently refer to the "chapel of the Condesa," attesting to the primary role played by Mencía de Mendoza in the foundation of the chapel and her direct involvement in its construction. A member of one of the most powerful and influential families of Spain, Mencía was the daughter of Iñigo López de Mendoza, Marqués de Santillana, and the sister of Pedro González de Mendoza. The construction and decoration of the chapel, begun in 1482, seems to have stalled upon the death of the founder in 1500. It was only in 1522 that Iñigo Fernández de Velasco, Third Constable of Castile, secured the financial means and assumed the legal responsibility to finish the chapel in accordance with the testament of his mother, Mencía de Mendoza. The Saint Anne altarpiece, referred to in a document of 1522, must have been one of the first works in the chapel to be completed (Villacampa 1928).

As the son of Gil de Siloe, Diego would have customarily received his training as a sculptor in the shop of his father. Yet from the start of Diego's career, his Italian-influenced style diverges sharply from his father's manner. While there are certain stylistic anomalies in the later

works of Gil, such as the *Lamentation* relief from the tomb of Juan de Padilla, that are sometimes regarded as "Italianizing," these works cannot be convincingly attributed to the young Diego. Nor can the influence of the father's late Gothic manner be discerned in the earliest works of the son. The contrast between the two generations is nowhere more evident than in the Constable's chapel and, in particular, in the placement of Diego's *Man of Sorrows* within the flattened trefoil niche of Gil's canopied tabernacle-like altarpiece. The date of Diego's birth is unknown, but given that Gil died in 1500, it is entirely possible that Diego received, or at least completed, his training elsewhere.

Whatever the nature of Diego's training, his earliest works manifest a style that is thoroughly Italianate, and this was precisely what was required by his patrons. The contract for the tomb of Luis de Acuña is explicit: it should be executed in the "Roman" manner. Diego is first documented in 1517, in Naples, working alongside Bartolomé Ordóñez (who was from Burgos), in the chapel of the Caracciolo family in San Giovanni a Carbonara (Gómez-Moreno 1941). By 1519 he had returned to his native Burgos, where he was engaged in a series of important projects in the Cathedral: the tomb of Luis de Acuña (1519), the Escalera Dorada (1519), and the altarpieces of Saint Anne, Saint Paul, and the Purification for the Constable's chapel (1522–1526). In 1528 Diego left Burgos for Granada and thereafter was prin

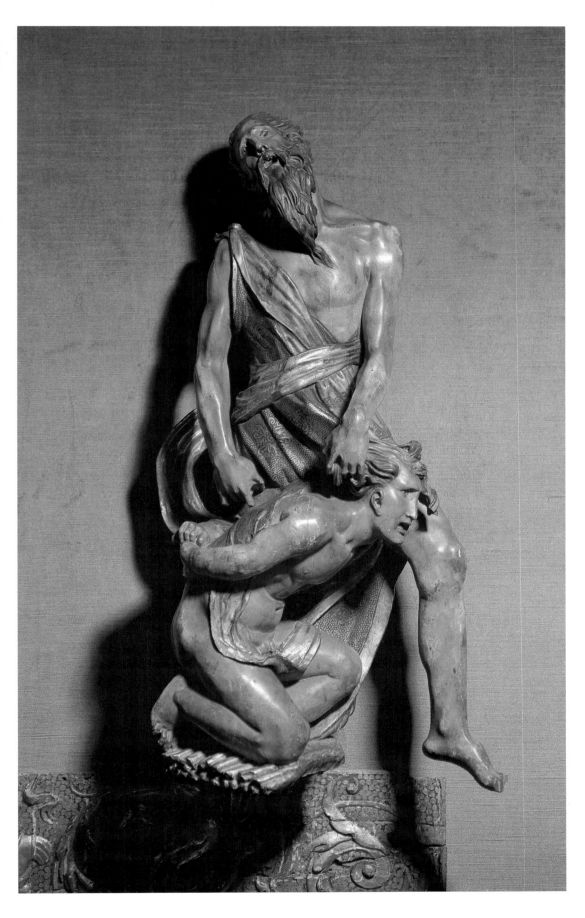

Alonso Berruguete was hardly alone among Spanish sculptors of his generation in adopting the aesthetics of the Italian Renaissance, but he was the only Spanish sculptor able to imbue those classical, idealized forms with a spiritual passion as intense as that of his Gothic forebears. *The Sacrifice of Isaac* shows Berruguete's sources, his inspiration from Donatello's late works, Michelangelo, and the sculpture of the *Laocoön*, which was discovered in Rome during his Italian sojourn. In terms of sheer emotional impact, Alonso Berruguete's sculpture recalls the late work created by Michelangelo after Berruguete left Italy for Spain.

The sculpture represents the moment when Abraham is about to slay his own son as an offering to his God, just before the angel stays his hand (Genesis 22). Berruguete has combined with great sensitivity the physical beauty of Isaac and his palpable fear with his father's ambivalent stance and yearning. These elements, bound within a highly compressed composition, express the passion and agony of Abraham's faith.

Berruguete remained active throughout the remainder of his career. In 1529 he provided sculpture and paintings for the altarpiece of the Colegio de Fonseca in Salamanca. Major works of the 1530s include altarpieces for the churches of Santiago in Valladolid, and Santa Ursula in Toledo, as well as some of the choirstalls in the Cathedral of Toledo. When Bigarny died in 1543, the commissions for the throne of the Archbishop of Toledo and for the huge alabaster *Transfiguration* in the choir went to Alonso Berruguete. In 1554 he began the sepulcher of Cardinal Tavera, modeled after that of Cardinal Cisneros in Alcalá de Henares by Bartolomé Ordóñez. Berruguete died in 1561. S.S.

52 ᢧ

"ADMIRAL" HERALDIC CARPET

c. 1429–1473
Hispano-Moresque
wool, Spanish knotting
581 x 267 (228⅘ x 105⅛)
references: Faraday 1929, 23; Ellis 1988, 247

Philadelphia Museum of Art, The Joseph Lees Williams Memorial Collection

Rug weaving, a craft brought to Spain by the Moors, became an important industry there in the twelfth century. Some of the oldest carpets in existence today were manufactured in Spain. When Queen Eleanor of Castile traveled to England in the late thirteenth century, she brought back carpets from Córdoba and Granada that provoked much interest, because rugs were hardly known in England at that time (Faraday 1929, 23).

The disassembled altarpiece is now exhibited in the Museo Nacional de Escultura. The contract for the altarpiece specified a mixture of paintings and sculpture, with the latter gilded, then painted (*estofada sobre oro*). *The Sacrifice of Isaac* was placed in a niche at the lower left of the altarpiece, where its considerable energy must have seemed only barely contained.

Spanish carpets, like all European hand-knotted carpets, are based on Persian techniques. However, Spanish designs reflect the unique contribution of the Moors, who absorbed design elements—Persian, Roman, Coptic—along every step of their nomadic journey to northern Africa and then to Spain, where Moorish elements often intermingled with Christian ones.

One of the most distinctive types of early Spanish rugs is the heraldic carpet, a long, narrow rug with coats of arms woven into the design. This example, which bears the arms of Don Fadrique Enríquez de Mendoza (c. 1390–1473), Lord of Medina de Rioseco and twenty-sixth Admiral of Castile, is one of half a dozen that were donated by the Enríquez family to the Convent of Santa Clara in Palencia. They are all called "admiral" carpets because they bear the coat of arms of Fadrique Enríquez, the second member of the Enríquez family to bear the hereditary title of Admiral of Castile. The device includes a lion rampant, two triple towered castles, and anchors.

Fadrique Enríquez de Mendoza and his first wife, Marina de Ayala, were the parents of Juana Enríquez, queen of Aragón and mother of King Ferdinand. The convent of Santa Clara was begun by Don Fadrique's father, Alfonso Enríquez, and continued by the son. It was to be the burial place of the Admirals of Castile. In 1910 the carpets donated to the convent were sold and dispersed. Besides this example in the Philadelphia Museum, one is in the Villa Vizcaya Museum (Miami), two in The Art Institute of Chicago, one in the Textile Museum (Washington), and one in the Instituto de Valencia de Don Juan (Madrid).

The carpet appears to have been woven by Muslim craftsmen, as is evidenced by the upper and lower borders of illegible Kufesque script (Ellis 1988, 247). Rugs belonging to another set of admiral carpets, donated to the Convent of Santa Isabel de los Reyes in Toledo, bear the legible Kufic inscription, "There is no God but Allah"— an inclusion that, if they understood it, evidently did not offend the Christian patrons.

Of all the surviving admiral carpets, this is perhaps the finest. An elaborate design in tones of ivory to brown is laid upon a dark blue background. The diapering surrounding the coats of arms contains, within myriad octagons, a lively array of peacocks, ducks, hawks, tiny heraldic lions, and stylized human figures with upraised arms. The borders along the length of the carpet frame a rich variety of scenes that have a narrative element—rampant bears under a tree wait for fruit to fall, a hound torments a stag, and bears are attacked by armed wild men, while ladies in impossible farthingales await the outcome. s.s.

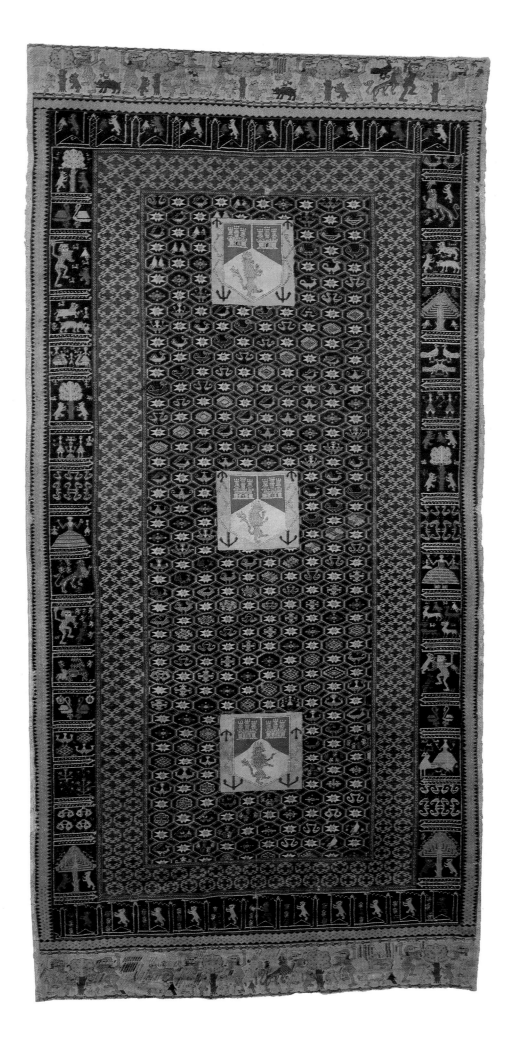

53 &

LUSTERWARE VASE WITH COAT OF ARMS OF THE MEDICI

c. 1465–1475
Hispano-Moresque
earthenware
height 57 (22²/₅)
references: Frothingham 1951, 2, 3; Caiger-Smith 1973, 7; Caiger-Smith 1985, 101, 107–108

The Trustees of the British Museum, London

This wing-handled vase (in the shape called a *terrás*), which bears the arms of the Medici family, was meant to hold a bouquet of flowers. Such vases were often used on altars and in shrines. This splendid example must have been commissioned by Piero "The Gouty" or his son and successor Lorenzo il Magnifico, because the shield bears seven balls (*palle*), one decorated with the French fleur-de-lis, an addition granted to Piero by Louis XI of France in 1465. The rest of the vase is covered in a delicate ivy pattern in lustered gold and cobalt blue.

Lusterware, along with other luxury items such as silk worked with gold, was brought to Spain from the Middle East as early as the late tenth century, as is evidenced by fragments of gold-lustered pottery found at sites around Córdoba where the Islamic Caliph himself once lived (Frothingham 1951, 2). When the difficult process of luster-glazing was employed by Muslim artisans in Spain, it was used as painted decoration on vessels that were first glazed in opaque white:

Either metallic copper and silver mixed with sulphur or the bisulphides of these metals … were calcined to form copper and silver oxides. The compound was ground and mixed with red ochre, which contained ferric oxide, and then fluxed with vinegar and painted on the white-glazed earthenware. The vessels were given another firing to reduce the oxides to the metallic state, this time at a low temperature and in a reduction kiln. When they emerged, they were blackened, but with rubbing, the coating was removed, and the decorated parts appeared as metallic silver, copper, or gold (Frothingham 1951, 3).

The earliest production of lusterware in Spain was in Andalusia, and it was long referred to as "Málaga-ware" in contracts and inventories. However, Moorish craftsmen also migrated north to practice their craft in the Christian kingdoms, and the fame of their skill soon spread; as early as 1362 a Moorish ceramist in Manises, near Valencia, was contracted to produce floor tiles for the papal palace at Avignon (Caiger-Smith 1985, 101). The number of ceramists in Spain, who were largely Moorish, multiplied during the fifteenth century, and their product was sought not only by

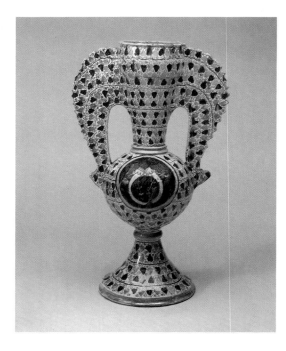

Spaniards, but by important persons in Italy, France, and the Low Countries. Entire sets of dinnerware were ordered for royal palaces, and Hispano-Moresque lusterware was also bought by merchants, apothecaries, religious communities, and churches. Lustered tiles decorated floors, walls, and ceilings. According to one fifteenth-century observer, Hispano-Moresque lusterware was so highly prized that "the Pope himself and the Cardinals and Princes of the world all covet it, and are amazed that anything so excellent and noble could be made from common clay" (Caiger-Smith 1973, 7). The Medici, arguably the most discerning artistic patrons of the era, evidently concurred.

Lusterware was originally developed in response to the Islamic *hadith*, which condemned the use of gold and silver vessels. Although it mimicked such sumptuous items in a more humble material, lusterware itself was certainly a luxury. It was never, however, merely decorative; each of the various shapes reflects a practical use. Goblets were drunk from, and even the most magnificent plates were designed to hold food. During a feast, the grand pieces bearing heraldic emblems, which ordinarily graced walls and sideboards, were pressed into action for service at table (Caiger-Smith 1985, 107–108).

Málaga, Manises, Paterna, and Valencia were the centers of lusterware during the fifteenth century, and the finest work was produced between 1440 to 1480. Not a single piece of lusterware from that golden age is known to have been signed by the artist who made it, but many pieces bear the heraldry of the high ranking individuals who commissioned them. These heraldic devices form the centerpiece of an overall design that often incorporates signs and symbols from Moorish tradition, which would have been unrecog-

nizable to the Christian patrons. This seems particularly remarkable in the cases in which such designs surround specifically Christian themes, such as the sacred monogram of pieces commissioned for use in a church or convent. Other patterns derive from plants and leaves and flowers; ivy, acacia, trumpet flowers, and bryony are often worked in gold and blue lusters over the primary glaze of creamy white. s.s.

54 &

LUSTERWARE PASSOVER PLATE

c. 1480
Hispano-Moresque
earthenware
diameter 57 (22³/₈)
references: Roth 1964, 110; Katz 1968, 160; Davidovitch 1975, 51–54; Avrin 1979, 27–46

Israel Museum, Jerusalem

This Passover plate is one of very few preserved Jewish artifacts that originated in Spain prior to the expulsion in 1492. Shaped and decorated in a way typical of contemporary Spanish lusterware plates, it has a wide rim, flat bottom, and an elevated umbo in the center. It is decorated with repeated motifs of gadroons and various floral and geometric designs in brownish-gold and cobalt blue. There is a hole in the brim, in which a clay peg was probably inserted to keep the large dish in an upright position during one of the firings, as was customary in the process of producing large Valencian plates.

Dr. Leila Avrin, who has published an extensive study on this plate, has hypothesized that it was commissioned by a Jewish lead merchant from the town of Murviedro, near Manises, in exchange for the merchant's ware, one of the ingredients of the glaze. This suggestion could explain the naive spelling mistakes that appear in the Hebrew inscription. According to Avrin "the client, who was not expert in spelling and who could not afford the quality of the plates made for royalty or nobility, provided the potter, possibly Jaime Murci, with the inscription, and the decorator did his best to write and space the unfamiliar letters aesthetically." (Avrin 1979, 45–56) The inscription refers to the three main elements of the Passover Feast, following Rabban Gamliel: *Pesaḥ* (paschal lamb); *maẓẓah* (unleavened bread); and *maror* (bitter herb). The word *seder* (order) refers to the special home ceremony on the first night of Passover. In Hebrew the inscription reads:

<div dir="rtl">

סור פסר מצע מרור

</div>

with mistakes both in spelling and vocalization. It was obviously intended to read:

<div dir="rtl">

סדר פסח מצה מרור

</div>

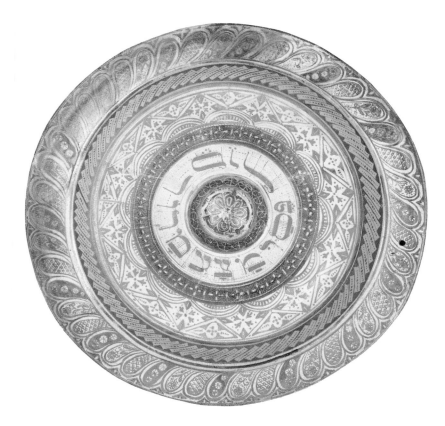

Although a special seder plate *(Ke'arah)* is mentioned as early as mishnaic times (around A.D. 200), no early examples have survived. Most seder plates known to us date from the eighteenth century onwards and are made of every conceivable material: pewter, brass, silver, faience, porcelain, and even wood. In medieval Ashkenazi illuminated Passover prayer books *(Haggadot)*, there is often a large round plate shown on the table, probably for ceremonial use during the seder, but in medieval Sephardi *Haggadot*, we usually see a special wicker basket for the pieces of unleavened bread *(mazzot)*. Avrin has assumed that the Israel Museum's plate was used in a pre-Passover ritual of the distribution of the *mazzot*, a popular custom at the time. In fact in most depictions of the distribution of *mazzot* and *harosset* (a paste made from almonds, apples, and wine) to the children, the round *mazzot* are kept in a wicker basket (see, for example, the Golden Haggadah [British Library, Add. MS 27210, fol. 15] and the Hispano-Moresque Haggadah [British Library, MS Or. 2737, fol. 89v]), making it questionable that this was actually the function of our plate. Yet there is at least one example, the *Sister to the Golden Haggadah* (British Library, MS Or. 2884, fol. 17), in which it is not clear whether the *mazzot* are kept in a basket or perhaps on a dish. Moreover, one must bear in mind that all the above-mentioned *Haggadot* are from the fourteenth century and the use of a special *seder* dish in Spain might have been introduced later. I.F.

55 &

HEADSTALL

late 15th–early 16th century
Granada
copper-gilt, ornamented with copper granulation
and cloisonné enamel
width and height (largest assembled piece) 38.6 x
21.4 (15¼ x 8⅜)
references: Fernandez y Gonzales 1872, 1875,
1:573–590, 5:389–400; Leguina 1898, 7–46; Dalton
1907, 376–378; Rosenberg 1918, 152–153; Laking
1920–1921, 2:15–18, 21–23, 261–267; Mann 1933,
301–302; Fernández Vega 1934–1935, 360, 364–367;
Hildburgh 1941, 211–231; Forrandis Torres 1943,
142–166; Rodríguez Lorente 1964, 68–70; Seitz
1965, 180–181; Pyhrr and Alexander 1984, 21–22

The Trustees of the British Museum, London

This headstall (the part of the bridle or halter that encompasses the horse's head) is made up of twenty-five flat sections of copper gilt through which the leather straps passed; the two medallions forming the junction for the bands pass behind the ears. The upper surface of each section of the headstall is divided into two compartments. One section is ornamented with a section of cloisonné enamel, in which translucent green and blue form the ground for arabesque patterns in opaque red and white. The other section is decorated with an arabesque set out in strips of wire on a gilded ground decorated with copper granulation. In each section, the relative position of the

enameled and gilded compartments is reversed, creating a rich decorative effect.

The headstall closely resembles an example depicted on an early sixteenth-century Venetian School painting, *A Warrior Adoring the Infant Christ and the Virgin* (National Gallery, London), attributed to Vincenzo Catena (d. 1531), and so was long regarded as Venetian-Saracenic in origin. W. L. Hildburgh pointed out, however, that it is clearly from the same source as a group of objects, principally sword-hilts and scabbard-mounts, that are decorated with similar enamels and, in some cases, similar granulated work. These are associated with the Nasrid Kingdom of Granada and apparently date from the second half of the fifteenth century. Outstanding among these objects are the hilt and scabbard-mounts of a sword and the scabbard-mounts of a dagger—now respectively in the Museo del Ejercito and the Real Armería, Madrid. They are traditionally said to have been taken from the last Nasrid king of Granada, Abū 'Abd Allāh Muhammad (Boabdil), after the Battle of Lucena in 1483, by an ancestor of the de Vieana family, Marqueses de Villasca, in whose possession they remained until recently. Enamels of the same type are also found on a late fifteenth-century helmet in the Metropolitan Museum of Art, New York, which has also been ascribed to Boabdil, though nothing certain is known of its history before the nineteenth century.

The style and decorative techniques represented on these objects belong to a tradition in Muslim Spain that goes back to a period long before the time of Boabdil, but, as Hildburgh pointed out (1941, 212), the actual designs on them are "a pure translation into metal-work of typical Granadan ornamentation . . . we may, indeed, see still in the stucco wall-coatings of the Alhambra just such designs, differing . . . only in their minor details." There can be no serious doubt that all of them were actually produced in Granada, though not necessarily exclusively for Moorish patrons, since several fifteenth- and early sixteenth-century Christian Spanish inventories include descriptions of what must have been similar *espadas moriscas* (or *ginetas*) and daggers mounted in enameled precious metals (Leguina 1898, 15–18; Fernández Vega 1934–1935, 365). The headstall and the Boabdil sword and dagger have every appearance of being the products of the same—presumably royal—workshop, to which the following pieces can also be attributed: three swords in, respectively, the Landesmuseum, Kassel, the Bibliothèque Nationale, Cabinet des Medailles, Paris (cat. 56), and the store of the Topkapi Palace, Istanbul (unpublished); a sword-scabbard mount, Victoria and Albert Museum (no. M58–1975, unpublished); harness (?) ornament, Musée Dobrée, Nantes; dagger-pommel (?) and a Jewish torah shield, Walters Art Gallery, Baltimore (nos. 44.248 and 44.151, unpublished); a necklace, a set of belt-mounts, and a pair of stirrups, Metropoli-

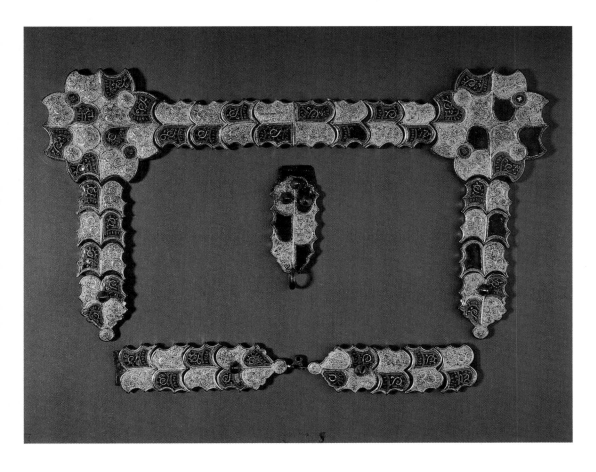

chasing, surface granulation, and filigree, enhanced with enamel and applied cloisonné enameled plaques. The pommel bears circular enameled plaques with the same inscription on the obverse (*wa lā ghā*) and reverse; one, however, is inverted. On the sides there were originally two longitudinal pointed plaques, one now missing, with the continuation *lib illā'llāh*. The script of all is a modified Maghribī *naskhī*. The inscriptions are in opaque white enamel on a ground of silver scrolling arabesques with traces of gilding that form the cloisons of a translucent green enamel ground. The grip has granulation forming an all-over star-polygon design.

Above and below are two *naskhī* inscription bands in opaque white, both between thin bands of opaque turquoise enamel: the inscriptions are in opaque white and are similarly on a scrolling ground of arabesques in silver, but the ground enamel appears to have decayed to black. The inscriptions above and below both read *wa lā*

tan Museum of Art, New York (nos. 17.190.161, 17.190.962, 17.190.641, 642, the second unpublished); a pair of stirrups, formerly in the collection of Lady Ludlow; a mount and tassel from a dagger-belt (?), Museo Arqueológico Nacional, Madrid (unpublished). Also, according to Mann (1933, 301), there are two "fragments of a bridle" similar to the headstall in the Museo Nazionale del Bargello, Florence.

The only information available about the actual maker of these pieces is the Arabic inscription "The work of Ridwan" damascened in gold on the blade of the Boabdil dagger. Unfortunately, nothing is known about Ridwan, though the name is one found in Granada at the period (Leguina 1898, 27), and it is even uncertain whether he was responsible for the whole dagger or merely for its blade. There appears to be no evidence to support the suggestion (Seitz 1965, 180–181) that he was the same person as Julian del Rey, King Ferdinand's swordsmith, a Moor who is said to have worked for Boabdil before converting to Christianity after the conquest of Granada in 1492.

C.B./D.T.

56 ᡒ᠍

SWORD OF BOABDIL

late 15th or early 16th century
Granada
steel; mount: gold or gilt silver and enamel;
scabbard: wood, leather, gold or silver-gilt and
enamel mounts
blade length 95 (37⅜)
references: Babelon 1924, 261–262; Paris 1971,
no. 179; Paris 1977, no. 388

Bibliothèque Nationale, Paris, Cabinet des Medailles

Like other related swords, including examples in the Museo del Ejército in Madrid and the Hessisches Landesmuseum in Kassel, this weapon is traditionally associated with Boabdil, the last Naṣrid ruler of Granada, who was defeated and expelled by Ferdinand and Isabella in 1492 (see cat. 55). The sword and its hilt are inscribed with numerous variants of the royal Schriftwappen of Granada, *wa lā ghālib illā'llāh* ʙᴍ (And There is no Conqueror but God [the sense of "ʙᴍ" is obscure]). The blade, which may have been pattern-welded, has on each side a stylized four-legged animal, somewhat like a bird-headed dachshund with open beak, inlaid in copper. The hilt—with pommel surmounted by a stemmed finial, grip, and down-turned quillons—is somewhat flattened in profile. It is of silver-gilt or gold worked in three dimensions with considerable

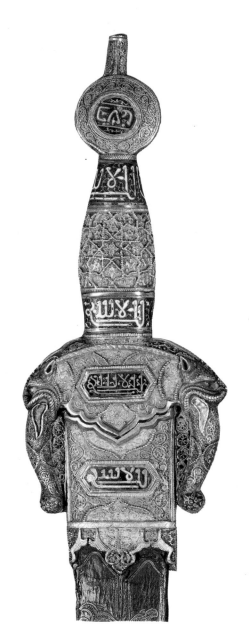

ghālib ilā'llāh. The lower one is broken at the sides in the usual way, *ghā:lib,* by medallions filled with a palmette or fleur-de-lis in opaque turquoise and black enamel on a translucent green enamel ground. The down-turned quillons are spewed from the mouths of dragons or felines, worked in relief and with chasing. Below their jaws on each side are small tonguelike panels, now rather damaged, of opaque white and translucent red enamel, possibly suggesting a forked tongue. The flattened obverse and reverse bear enameled medallions: on the obverse is a shield of European type with a diagonal bar from left to right bearing *wa lā ghā* in *naskhī;* on the reverse is a transverse bar with the usual continuation *ilā'llāh* BM in Kufic. The inscriptions are in opaque white enamel on a decayed black enamel ground; the ground of the bar is of scrolling arabesque in silver, with traces of gilding filled with translucent green enamel. The rest of the surface bears fine filigree and granulated ornament.

The sheath of the scabbard is of wood covered with dark brown leather heavily sewn with metal thread; the obverse has longitudinal *naskhī* inscription cartouches with variants of the inscriptions on the hilt, and three transverse bars. The cartouches are separated by knotted, winglike split palmettes enclosing a quatrefoil, with confronted palmettes on a plain ground. The reverse of the sheath is stitched down the center with rather more elaborate palmettes and small knots at each end.

The mounts are gold and silver-gilt, solid or cast. Worked in champlevé relief, they carry rather perfunctory chasing with considerable surface ornamentation in granulation and filigree, the latter mostly fine spiral scrolls. The granulation on the central, upper, and hilt mounts forms stylized Kufic *lām-alifs.* The enameled plaques, in the form of European shield blazons or transverse bars, are cloisonné with cloisons of fine foliate scrollwork showing traces of gilding. On the obverse mount at the tip, which ends in a small flattened knob, are three plaques and a transverse bar between two shields, the latter with a diagonal bar sloping from left to right bearing *naskhī* inscriptions. The reverse bears similar inscription plaques.

The *Schriftwappen* of the Naṣrid rulers of Granada was well known to the Spanish rulers of the Reconquest, and its appearance on the sheath and the enamel plaques is not therefore a guarantee of Naṣrid workmanship or even of a Naṣrid date. However, the break at *ghā:lib* seems to have been standard Naṣrid practice, so that it does not count against the sword's alleged provenance. Although the confused stitched inscription cartouche on the sheath certainly testifies to inept copying of an original, it could also have been the work of a well-meaning but not particularly literate Granadan craftsman. On internal grounds the sword appears to be late fifteenth- or early sixteenth-century. The absence of an owner's inscription,

moreover, may suggest that the sword was designed not for a ruler but possibly for presentation to an emir, or even a neighboring Christian prince. However, if it was indeed made for Boabdil, the style, in accordance with such ceremonial weapons, would have been becomingly conservative. J.M.R.

57 🐎

NASRID SHIELD (ADARGA)

before 1492
Granada
hide, silk embroidery
90 x 75 (35⅜ x 29½)
references: Boeheim 1888, 279; Boeheim 1890, 183;
Madrid 1898, 161; Nickel 1958, 98; Buttin 1960,
407, 447; Bruhn de Hoffmeyer 1982, 279;
Encyclopedia of Islam 1986, "Lamt," 651–652; Feest
1990, 7

Kunsthistorisches Museum, Vienna, Hofjagd-und
Rüstkammer

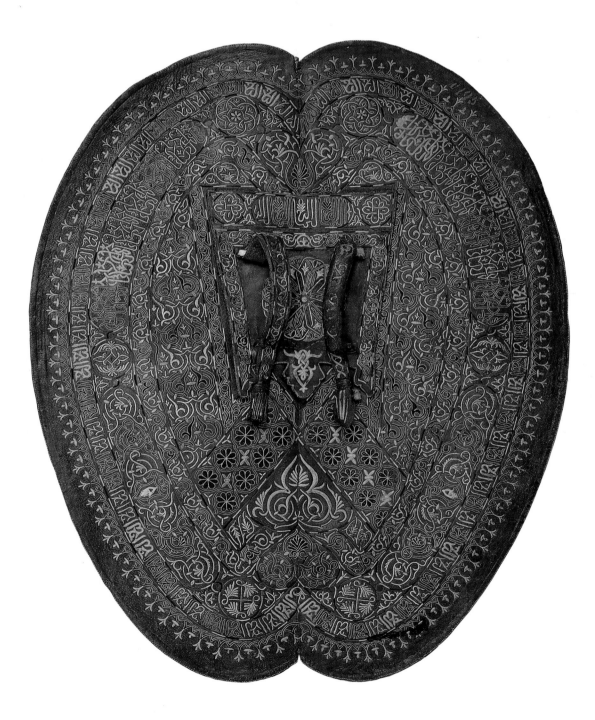

The shield consists of two ovals of thick hide stitched together, its middle axis strengthened by an attached bar. The light, originally white outerside is almost free from decoration and the eight embedded lines along the edge serve more as reinforcements than as decoration. Interwoven tasseled strap ends for the handle bindings are missing. The entire inner surface was originally dyed red but is now bleached brown and decorated with finely worked silk embroidery in red, blue, yellow, green, black, and white. The design divides the surface into four concentric bands which follow the shape of the shield. The remaining fields are determined by the trapezoidal slightly off centered cushioned handles which are also richly embellished. The densely worked design contains arabesques, stars, and flowers. Abstract trilobate lilies and plaited lines on the outer border are juxtaposed against an Arabic inscription in a stylized Kufic script. Inscribed on the second concentric band is "Allāh" in stylized Kufic script, while the cartouche at the top of the handle repeats "Allāh the Living One" three times.

Only one other adarga of this quality and from this period has been preserved (Real Armería, Madrid. The Vienna adarga is recorded in the 1596 inventory of Ferdinand II of Tyrol (1529–1595) at Schloss Ambras (RK Ambras, Reg 5556 fol. 346v) which reads "Ain Türggische tartsche, auswendig von weiszen, innwendig von rottem leder, darauf von allerlei gefarbten seiden Türggische buechstaben gestuckht, samt seinem fuetral" (Boeheim 1888, 279). Exactly how it

passed into the Archduke's collection at Ambras requires further research. It is generally presumed that it entered the armory of the Austrian Hapsburgs through the son-in-law of the Reyes Católicos, Philip I of Austria, King of Castile and Granada (1478–1506). However, it is equally possible that it was included in a gift of ten objects from "New Spain" presented in 1524 by the Emperor Charles V (1500–1558) to his brother Archduke Ferdinand I (1503–1564)(Feest 1990, 7). As early as the tenth century there is mention of a sahib adarca (inspector of adarga) in Cordoba (Madrid 1898, 161) but the earliest pictoral representations of such shields are to be found among the magnificent miniatures of the "Cantigas de Santa Maria" made for King Alfonso X of Castile (1221–1284) in which Muslim warriors are depicted protecting themselves with heart shaped adargas. During the fourteenth century, the form of the adarga changed from a simple heart shape to two ellipses with the longer sides overlapping. Such shields were introduced into Spain by the Muslims. The word adarga comes from the Arabic al-daraq which is also the origin of the English word targe and the French adargne. Islamic accounts of the Middle Ages mention that North Africa was famous for shields made from the skin of the Lamt (the orynx of the Sahara) and that these were made by a Berber tribe, also called Lamt, whose menfolk like the Toureg wore the veil. The ninth century geographer Ya'qübi notes that these shields which were exported to Spain were white in color—just as the Vienna shield originally was. They were said to be cured in milk

and so effective that a saber would rebound or stick so hard that it could not be freed. They were light yet solid and if hit, the arrow holes tended to close up by themselves (Encyclopedia of Islam 1986, "Lamt," 651–652).

The Muslim nobility used adarga such as this richly embroidered example for parade and combat games on horseback (furūsiyyah). In the late fifteenth century the adarga and richly decorated swords of the Boabdil type (cat. 56) (Bruhn de Hoffmeyer 1982, 279) were favored by the Christian nobility, and the fashion spread from Spain to France, Italy, and even to England. Several artists, including Hans Memling and Martin Schongauer, depicted individuals carrying adarga to lend an exotic flair to religious depictions (Nickel 1958, 98, n. 182; Buttin 1960, 407). The use of such a shield by Hernán Cortés (1519–1523) and his conquistadors to conquer the Aztecs has also been documented (Nickel 1958). According to the comments "x de iste fassesson" in the pictoral inventory of Charles V (Inventario Illuminado), the Emperor owned ten adarga (Buttin 1960, 447) and until the devastating fire of 1884 there were 40 in the Real Armería in Madrid. Most, including those remaining (D87–D95, D97–D106), are late Spanish works sometimes decorated on the inside with feathers, such as one made for Philip II (D88). Indeed, the adarga continued to be used by the nobility in Spain for combat games—the "juejos de caras" and "alancias"—until the 18th century (Boeheim 1890, 183; Madrid 1898, 161). C.B-S.

AFRICAN KINGDOMS

The works of figural sculpture cast in brass in Benin are the most famous west African objects to have survived from the Age of Exploration, a time of significant artistic production in a number of different centers. Other notable works of art include the terra-cotta figures unearthed in Mali and the exquisite terra-cotta heads from Owo, first excavated slightly more than thirty years ago.

Sub-Saharan Africa had long-standing links to the Islamic world across overland trade routes, and the ruling elite in the great empires of Mali and Songhay were Muslims. Contact with Europe, however, began only in the second half of the fifteenth century, as Portuguese ships progressed down the African coast. The burgeoning trade that developed as a consequence led to the creation of the so-called "Afro-Portuguese" ivories. These spoons and forks, saltcellars and horns, crafted in what is today Sierra Leone, in Benin, and in the kingdom of Kongo, are an extraordinary amalgam of European shapes and African decorative vocabularies.

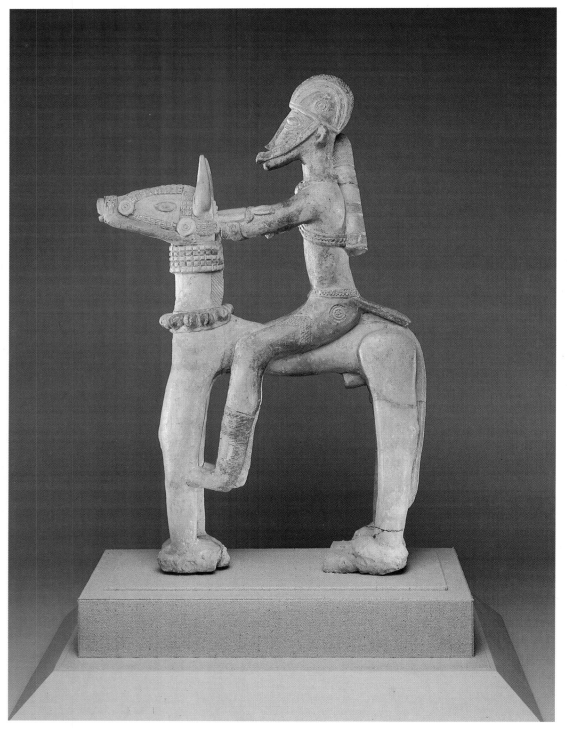

EQUESTRIAN FIGURE

13th–15th century
Jenne style, Mali
terra-cotta
height 70.5 (27¾)
references: de Grunne 1980; Vogel 1985; Ezra 1988; Kerchache, Paudrat, and Stephan 1988; McIntosh 1988; Cole 1989, 120–121; Robbins and Nooter 1989; Bernardi and de Grunne 1990

National Museum of African Art, Smithsonian Institution, Museum Purchase

This superb horseman is one of a handful of relatively complete equestrian figures that are outstanding objects in the corpus of ancient Malian terra-cottas because of their highly formal quality and imposing size. The average height of ninety intact statues examined by Bernard de Grunne (1980) is 27.8 cm. (11 in.) while that of the equestrian figures is close to 70 cm. (27½ in.).

The figures were modeled in clay, to which materials were added to decrease its plasticity and render it less delicate to firing. They were then smoothed and often covered with a fine reddish slip that gives them a finished appearance (de Grunne 1980, 46–47).

More or less identical in a number of these works are the horseman's features and his pose, as well as his clothing. With back held straight and arms outstretched, holding the reins, he wears short embroidered pants slit at the thigh to form a triangle, a rectangular cloth in back held by a decorated belt, a caplike helmet and ringed greaves, a heavy necklace, a dagger fastened to the arm, and a large closed quiver over the shoulder. Two other figures, in a private collection, also wear a heavy cloak (or armor) decorated in a geometric pattern. The other figures ride bareback, and the horses have only reins and a collar ringed with large crotals.

The monumental, hieratic figures are marked by a rigorous architectonic structure, accentuated by simplified volumes and a relief type of decoration that is as subtle as it is functional and refined. Seen in profile the various parts of the man and his mount, formed of cylinders of almost equal diameter, seem to come together at a right angle and define two sections of space. Herbert Cole (1989, 120–121) suggests that "this straight-legged, formal stance is preferred in equestrian icons, which serve to support and project the image of heroic leadership." The horseman's head is proudly erect, as is that of his mount, in a posture of archaic nobility well suited to the presumed member of a bygone warrior aristocracy.

No archaeological data is available for the figure exhibited here, as is the case with most of the terra-cottas from the region watered by the upper course of the Niger and Bani rivers. Even the precise location of its discovery remains unknown;

thus the subdivision into stylistic areas normally indicated for ancient Malian terra-cottas is for now limited to the two large regions of the inland delta of the Niger and Bamako.

For the above reasons, the date is also difficult to establish. Nonetheless, measuring the thermoluminescence has permitted us to place the group of horsemen between 1240 and 1460 A.D. Bernard de Grunne (Bernardi and de Grunne 1990) has suggested that they were made before the spread of Islam in the region. The presence of horses in the Sudanese savannah, which was not infested by the tsetse fly, is widely documented beginning in the eleventh century A.D.

De Grunne suggests that "the equestrian figures probably represent some of the Kamara Kagoro sacred ancestors, who were founders of clans, powerful sovereigns, great hunters, and important religious figures." He prudently reminds us, however, that "the debate on both the Soninke and Malinke origins of the Kagoro is still wide open."

One clue, even if only circumstantial, is present in the horseman's weaponry, the quiver and arm dagger, seen also in a standing figure attired similarly, possibly a product of the same workshop (de Grunne 1980, no. 1.14). A dagger is also attached to the arm of a reclining figure, characterized by a soft, vaguely androgynous body, excavated at Jenne-Jeno in 1981 by McIntosh (1988, ill. 6–8).

The arm dagger appears, sometimes together with the quiver, in certain sculptures of the Dogon, people who inhabit the cliff of Bandiagara and the underlying plain (Vogel 1985, no. 7; Ezra 1988, no. 6; Kerchache 1988, nos. 22, 23; Robbins and Nooter 1989, nos. 32, 34, 36). These horsemen also wear short pants open at the thigh. These similarities seem to suggest the existence of a relationship between the ancient inhabitants of the region of the inland Niger delta and those of the Bandiagara region, possibly confirming the Dogon oral tradition of a migration of peoples from the Jenne area after the Songhay conquest.

Given the few elements at our disposal, the function and meaning of the equestrian figures, as well as of the other terra-cottas, remain a mystery. However, the creative ability and technical skill of their makers are beyond doubt. E.B.

59 ᢒᗷ

FEMALE HEAD

15th century
Yoruba people, Igbo'Laja site, Owo, Nigeria
terra-cotta
17.4 (6⅞)
references: Eyo and Willett 1980, 30, 55; Willett 1986; Abiodun 1989, 99–103, 240, n. 23

Nigerian National Museum, Lagos

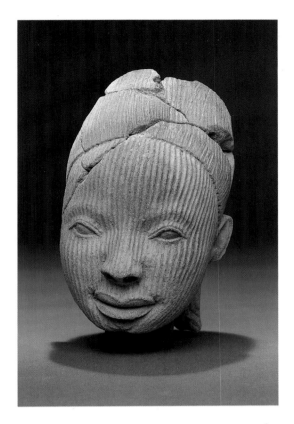

In the glorious panorama of Nigerian art, Owo, the Yoruba city-state halfway between Ife and Benin City, was known until a few decades ago only for its works in ivory and bronze.

Excavations conducted by Ekpo Eyo between 1969 and 1971 at Igbo'Laja, a location about five hundred meters from the current center of the city, near the palace of the *Olowo* (king), uncovered two deposits of interesting archaeological material. In the main deposit were the ruins of what is thought to have been a thatched-roof hut, some heads and incomplete small human figures, as well as important fragments of larger figures and groups.

Among the finds, all dated to the fifteenth century, were numerous terra-cottas relating to the theme of the sacrificial offering of small animals, and even the theme of human sacrifice, rare in African art, which was represented by a basket of severed heads (Eyo and Willett 1980, nos. 66–69 and 57).

Iconographically the Owo works have elements in common with the art of Ife and Benin and seem almost to be the connecting link between the two artistic traditions in the region before the arrival of the Europeans.

Analogies with Ife works are visible mainly in the heads: the upper eyelids marked by a sharp incision, the dimples at the sides of the mouth, the relief surrounding the lips, and the vertical striations lining the face. So evident are these similarities that scholars who have dealt with the question (Eyo and Willett 1980, 30, 55, and nos. 60–61, 64; Abiodun 1989, 101) have considered

the possibility that the terra-cottas were brought to Owo from Ife. Stylistic considerations and the type of clay used (Willett 1986), however, have led them to conclude that the works were created in Owo.

Analogies with Benin sculptures are fewer but no less significant. One may note, for example, the vertical keloids, or scars, on the forehead, typical of Benin heads of the early period, and those on a small fragment of a human head excavated at Owo (Eyo and Willett 1980, no. 75), which present the same motif.

Rowland Abiodun (1989, 99–103) believes that the head exhibited here, because of its royal attitude, could represent the legendary Oronsen, beautiful wife of the Olowo Renrengeyen. According to Owo tradition, she disappeared into the earth forever after a violent argument with her co-wives, leaving her head-wrapping in the hands of those who ran after her to detain her.

The head certainly shows extraordinary nobility, and beyond the indisputable iconographic analogies, it is conceived with a spirit that seems very different from that of the sublime, idealized portraits from Ife.

The oval face under the compact hairstyle, defined by a harmonious outline, has a strong but very gentle structure. The fluid modeling is ennobled by the light diffused by the carefully placed scarifications. The small wide-set eyes, without a pupil but with a profound, disturbing expression, the delicate nose, the very beautiful lips hinting at a smile, the dimples at the sides of the mouth and in the chin constitute an image full of sensitivity, a living figure with an intensely moving message, composed of a system of perfect curves and volumes.

Abiodun (1989, 240, note 23) has pointed out that "as pottery is traditionally a female occupation, there is a reason to believe that Owo terracotta sculptures were made by women." Perhaps this is the context for the human tenderness of this portrait. E.B.

60 ᢒᗷ

MALE HEAD

15th–early 16th century?
Edo peoples, Benin kindgom, Nigeria
cast copper alloy and iron
22.2 (8¾)
references: Elisofon and Fagg 1958, 62–65; Forman and Dark 1960, 21; Fagg 1963, 32; Dark 1973, 9, 18, 39; Ben Amos 1980, 18; Nevadomsky 1986; Freyer 1987, 1

National Museum of African Art, Smithsonian Institution Collection Acquisition Program, 1982

Ancient Benin art is almost synonymous with sculpture that is often generically called bronze.

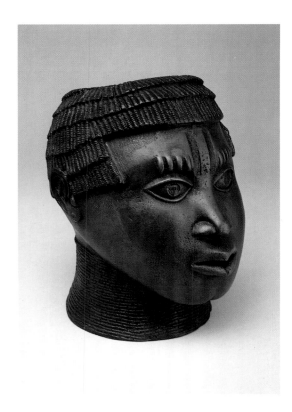

Of the approximately two thousand artworks taken from Benin after the British punitive expedition in 1897, the vast majority of works were metal objects made by the "lost wax" casting process. However, the word bronze, frequently used to describe ancient Nigerian sculptures, whether from Ife or Benin, is often incorrect, as most of these works were actually cast in an alloy of copper and zinc rather than copper and tin. Thus brass is really the more appropriate word, except in the case of the male heads of the "early period" (like the one exhibited), for which the designation low tin bronze is the most suitable.

The earliest efforts to cast cupreous alloys in Benin are enshrouded in myth (see Ben-Amos 1980, 15–18 for a discussion). According to one oral tradition, at the death of the Oba (king) the head of the dead sovereign was sent to Ife, where a commemorative image in bronze was made and then taken to Benin. This practice continued until Oguola, the sixth Oba (who reigned around 1400), sent for a master founder named Ighueghae, who came from Ife to teach Benin artists the casting technique. Thereafter the presumed commemorative heads were made in Benin by Ighueghae's followers, who belonged to a guild, the Iguneromwon, exclusively in the service of the Oba. Among the body of works found in Benin, no head can be attributed with reasonable certainty to Ife artists, so there is no material proof to confirm that oral tradition. However, Philip C. Dark (1973, 9) advances the hypothesis that because of the scarcity of metal before the Portuguese arrived in Benin, the heads brought from Ife could have been melted down to provide material for new works.

A number of heads slightly smaller than life and showing similar characteristics have been grouped together, including the head shown here (Freyer 1987, 1), which William Fagg has assigned to the early period of Benin art, from the early fifteenth to the mid-sixteenth century (Elisofon and Fagg 1958, 62–65; Fagg 1963, 32).

These heads are products of a refined, mature technology, differing from later works in several respects: the thinness of the metal (no more than a millimeter at certain points), the sober representation, and the superbly refined modeling. The nose and mouth are regular; the pupils of the open eyes are of iron inlay, as are the ethnic markings on the forehead flanked by four keloids above each eye (see Nevadomsky 1986, 42 for a discussion of these markings). The flattened ears are the most stylized feature of the heads. The only decorative elements are the hairstyle in the form of a cap of overlapping bands of tight parallel curls and the coral bead collar around the neck, with its insistent horizontality in harmonious contrast to the strong verticality of the hairstyle, all executed with great subtlety.

The heads from subsequent periods are more massive and imposing, and the collar becomes so important as to cover altogether the bottom part of the face; the hairstyle is covered by a cap of coral beads, and several decades before the arrival of the English this cap was enriched by two wings at the sides of the forehead. A large round opening at the top of the head, which cannot be explained on technical grounds (Dark 1973, 39), recalls a similar characteristic of Ife heads. In Benin heads from Fagg's "later" group, the openings allowed the heads to support carved ivory tusks.

Commentators have often remarked on the stylization of the Benin heads, as compared to the earlier Ife examples. According to Fagg (1963, 32), the heads of the early period show the Benin artists' attempt to adopt the spirit as well as the letter of the "sensitive naturalism" of Ife heads, even though in comparison the Benin heads "are in detail considerably more stylized and also rather less individualized. Those which appear to be by a single hand are very clearly similar to each other in expression and features, and may therefore represent the artist's 'ideal portrait' rather than an attempt to represent individuals."

Philip C. Dark (Forman and Dark 1960, 21), referring to a Benin head similar to this one, notes that it is not "close stylistically to the known examples of bronze heads discovered at Ife," since it is "stylized and generalized, showing no real evidence of an attempt at meeting the requirements of naturalistic portraiture." For example, the slight asymmetry that renders the Ife heads so expressive is missing completely in the Benin pieces, characterized instead by strongly symmetrical features.

R. E. Bradbury, in a personal communication reported by Dark (1973, 18), observes that the

male heads "are impersonal in character because they represent not the late king as an individual, but the authority which he transmits to his successors." This thesis presupposes, however, the use of the heads in succession rituals, but we have no conclusive proof of this, only conjectures that do not always agree.

Paula Ben-Amos (1980, 18) advances the fascinating theory that these are trophy heads, citing as support a tradition reported by a member of the caster's guild, Chief Ihama, according to which "in the old days they used to cut off the head of (conquered) kings and bring it to the Oba who would send it to our guild for casting. They did not necessarily cast heads of all the captured rulers, but just the most stubborn among them. If it happened that the senior son of a rebel king was put on the throne, the Oba would send him the cast head of his father to warn him how his father was dealt with." The close similarity between the hairstyle of the Benin heads of the early period and that of an Igbo man (photographed at the beginning of this century and published by Paula Ben-Amos) supports the hypothesis that the ancient male heads represent a foreigner and not the dead Oba. However, this explanation does not seem to account for the stylization and resulting impersonal nature of the heads.

Despite the mystery surrounding their origin and function, the early Benin heads are a valuable testimony to the skill of the Benin sculptors and to their ability to work creatively within the context of an authoritarian and highly formal court culture. E.B.

61 ও

QUEEN MOTHER HEAD

16th century
Edo peoples, Benin kingdom, Nigeria
cast copper alloy and iron
51 (20)
references: Dapper 1686, 311; Luschan 1919;
Underwood 1949, 20; Egharava 1953; Elisofon and
Fagg 1958, 64; Forman and Dark 1960; Fagg 1963;
Blackmun 1991, 59–60

Nigerian National Museum, Lagos

In the first half of the sixteenth century the Oba Esigye conferred the title of "Queen Mother" on his mother, Idia, who had helped him in his struggle for power. In giving her this title, he institutionalized the role of the king's mother and defined its position in the kingdom's complex hierarchy (Egharava 1953; Blackmun 1991, 59–60).

About a century later, in the monumental work on Africa by the Dutch scholar Olfert Dapper, a chapter on Benin, based on the report of an unknown author, confirmed the high status of the Queen Mother, her participation in affairs of state

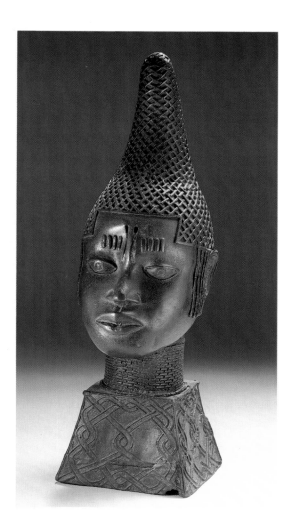

sculptor Leon Underwood notes (1949, 20), "is more that of a general concept of beauty than that of the individual." William Fagg has commented that these heads "have a remarkable formal abstract quality, as a drop of liquid, almost as if they had been influenced by Brancusi" (Elisofon and Fagg 1958, 64).

A limpid rhythm defines the synthetic structure of the work, which is articulated in two complementary blocks: the base in the form of a truncated pyramid and the egg-shaped volume of the head, joined together by the perfect cylinder of the neck enclosed in the regal collar of coral beads. The tall netted headdress, also made of coral and edged with stiff vertical hanging strands of beads that cover both sides of the face and neck, seems molded onto the head.

The face has a rounded, inert surface, large eyes close to the plane of the head (the pupils are of iron inlay, as are the scarifications across the forehead); nostrils and mouth are vigorously modeled to yield a remote, evocative mask.

This head is indeed distinguished by a "remarkable formal quality," without any uncertainty, to whose perfection any indication of humanity has yielded. These elements were the deliberate choice of the artist, who refused any attempt at specific characterization, as can be seen by comparing this work with similar heads — a fitting choice for a work whose purpose was to give shape to an abstract notion of royalty, to a "general concept of beauty," and to cast it in metal for eternity.

E.B.

and her relationship to the *Oba*. "This prince greatly honors his mother, and does nothing important without first asking her advice. Nonetheless, according to I don't know what law, it is not permitted that they see each other; for this reason the Queen Mother lives in a beautiful house outside the city, where she is served by a large number of women and young girls" (Dapper 1686, 311).

The first commemorative heads of queen mothers, recognizable by the tall pointed headdress which coincidentally recalls the "ducal horn," the insignia of office of the Doges of Venice, can thus be dated about the middle of the sixteenth century. They belong, both by chronology and style, to the early period of Benin art, according to the subdivisions proposed by William Fagg. The heads of queen mothers are fewer in number than the male heads. The group includes, along with this piece from the Lagos museum, two others in the Museum für Völkerkunde in Berlin (Luschan 1919, pls. 51 and 52 b,c), one in the Museum of Mankind in London (Forman and Dark 1960, nos. 65–67), and one in the museum in Liverpool (Fagg 1963, no. 13). The last two lack the base.

Compared to the male heads (cat. 60), those of the queen mother are more stylized and impersonal, as though isolated in their mysterious and haughty perfection. Their "physical beauty," the

62 🐍

DWARF

14th–15th century
Edo peoples, Benin kindgom, Nigeria
cast copper alloy
59.5 (23⅜)
references: Fagg 1963; Dark 1973, 23; Eyo and Willett 1980; Willett 1986, 95; Duchateau 1990, 13–17

Museum für Völkerkunde, Vienna

This and a second sculpture of a dwarf from the museum in Vienna (Duchateau 1990, 13–17) are considered by scholars of Benin art to be among the most extraordinary works created in the Nigerian city. William Fagg (1963, pl. 25) goes so far as to declare that "without doubt they are the finest of all Benin bronze figures, but they are so naturalistic that it is difficult to find points of style by which to date them, though the early date seems most likely.... It is even conceivable that they are Ife works."

The date of 14th–15th century, recently established by measuring the thermoluminescence of some traces of clay found in the cavity of the dwarf from Vienna not exhibited here (Duchateau 1990), confirms the keen intuition of the English

scholar, even if at present there is no strong basis for concluding that this work actually originated in Ife. It is clear that in style the *Dwarf* is far from a typical Benin work. Its deformed head, like a similar but fragmentary head preserved in the Museum für Völkerkunde in Berlin (Dark 1973, pls. 37, 38), shows a degree of expressiveness which, though very unusual in the stylized plasticism of Benin art, at the same time does not correspond to the balanced, Apollonian canons of Ife sculpture which exhibits a sublime fusion of realism and idealization. The details of the Vienna *Dwarf*, moreover, differ from those of classic Benin figures. Philip Dark (1973, 23) has noted that the facial features of the *Dwarf*—the deep-set eyes, flattened nose and mouth — "do not bear the stamp of Benin conventionalization," just as the necklaces and wide bracelets worn by the figure are not typical of Benin.

There are, moreover, interesting connections between this work and Ife art. Frank Willett (1986, 95, ill. 45, 47, 48) has drawn attention to

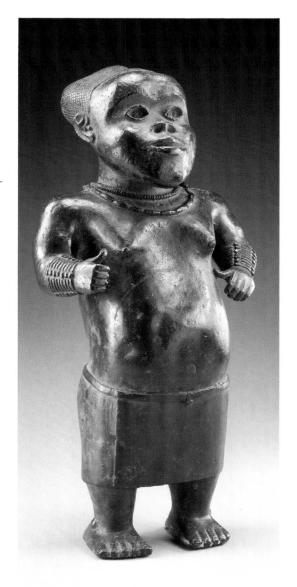

the accentuated deformity of the head in a series of terra-cotta sculptures excavated at Obalara's Land, Ife. In fact, a comparison of our piece with the full sensual volumes of the wonderful seated figure formerly in Tada (Eyo and Willett 1980, no. 92), recently restored conjecturally to Ife art, suggests the most convincing explanation: the Vienna *Dwarf* should be included among the works executed in Benin when Ife influence was significant and supports the hypothesis that there were indeed important relationships between these two art traditions, at least in the early period of Benin history. These relationships, which according to some oral traditions were very close, must now be substantiated by thorough formal investigations.

The features of the second Vienna dwarf (Duchateau 1990, 16–17) are stylized and substantially more impersonal, more in accord with the Benin figure canons epitomized in the *Queen Mother Head* (cat. 61). Dark nonetheless agrees with Fagg that, on the whole, both the Vienna figures and the related Berlin head can be considered works of Edo artists, albeit different sculptors, perhaps working in different periods. Disagreeing with Fagg, he suggests, however, that the figure represented here is a woman; while his arguments are ingenious, they do not seem conclusive for determining the figure's sex, especially if we accept that the two figures are not contemporary and did not originally form a pair.

The sculpture exhibited here, with its large body and admirably shortened limbs, has a compact structure, rounded, strongly sensual volumes, and smooth, gentle surfaces. The head, marked by sharp relief and deep furrows, conveys an extraordinary, moving humanity. The apparent contrast between the sluggish heaviness of the torso and the dramatic deformity of the head is reconciled by means of the sensitive modeling and fluid handling, resulting in a work of incomparable formal unity. E.B.

63 ɞ

HORNBLOWER

16th century
Edo peoples, Benin kingdom, Nigeria
cast copper alloy
height 62 (24½)
references: Dapper 1686, 311; Luschan 1919, pl. 72;
Forman and Dark 1960, 23–25; Fagg 1963, 36, 54a;
Dark 1973, 44; London 1974

The Trustees of the British Museum, London

Hornblowers served an important function in the complex ceremonials of Benin society. Along with

a few examples of sculpture in the round, including the one shown here, hornblowers appear fairly frequently on plaques next to the *Oba*, chiefs, or warriors. In court ritual a hornblower always accompanied the king and announced his presence.

The seventeenth-century Dutch scholar Olfert Dapper writes that the king of Benin "appears in public once a year, covered with his royal ornaments, accompanied by an entourage of three or four hundred gentlemen as infantry or cavalry and by a group of players of (musical) instruments, some preceding and others following the sovereign" (Dapper 1686, 311). In the very famous engraving appearing as a plate in that volume and illustrating the royal cavalry riding against a background of the royal palace and city of Benin, two hornblowers are clearly visible, along with men playing drums, tambourines, and triangles. The illustration is misleading, however, as the artist had as inspiration only Dapper's brief description and did not know that African horns, usually made of ivory, do not have the mouthpiece at one end like European instruments, but are played through a side mouthpiece like flutes. Instruments from Benin and Yoruba are further distinguished by the fact that the mouthpiece

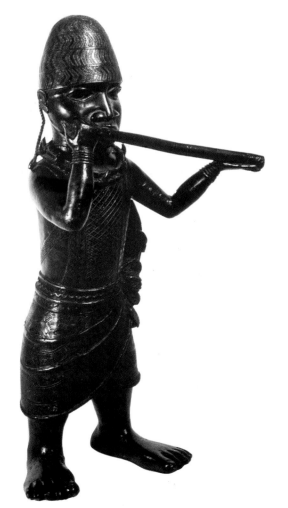

opens onto the convex side of the tusk rather than the concave side as is the case with all other African horns. This characteristic is readily evident in sculpture of hornblowers and is confirmed by the ivory horns that have come down to us, for example the magnificent example in the Museum für Völkerkunde in Vienna (Fagg 1963, 54a).

Besides the hornblower exhibited here, at least five other examples can be dated around the second half of the sixteenth century and thus assigned to the early period of Benin art: another in the Museum of Mankind (Dark 1973, 44), one in the Museum für Völkerkunde, Berlin (Luschan 1919, pl. 72), one in the National Museum of Scotland (inv. no. 1985.631), one in the Brooklyn Museum, and one in an unidentified collection (Sotheby's London, sale July 1974, lot 58, formerly S. R. Ingersoll Collection). The similarities among these six works are so strong as to suggest not only that they were executed at the same time but also that they were products of the same workshop; the piece shown here, the one in Berlin, and the one formerly in the Ingersoll Collection were probably even by the same sculptor.

The massive figure, set in a rigidly frontal pose, stands heavily on the ground with his huge feet, rendered with surprising realism, which, like his massive legs, are disproportionate to the height of the figure but functional to the solid balance of the piece. In contrast, the arms are thin and, like the torso, show no sign of muscles. The delicate gesture of the left hand holding the musical instrument and following its movement provides a contrast to the figure's overall severity. The large head is made even more imposing and compact by the cap pulled down to the eyes, over an impersonal face with stylized, stiff features.

The artist's attention is concentrated on the sumptuous costume: the fiber helmet (Forman and Dark 1960, 23–25), decorated with parallel bands of chevrons running in opposite directions; the thin, tight-fitting, finely chiseled armor, which contrasts with the rigid collar set with leopard's teeth; and the skirt of heavy precious cloth held by a belt decorated with the mask of a leopard.

The studied opposition between the very beautiful series of parallel horizontal bands and tapering oblique bands gathered together by the crescent-shaped, upward-pointing piece, typical of the costume of high Benin officials, introduces the only hint of movement into the otherwise rigid figure. The intricate ornamentation, with its subtle, virtuoso rendering of the dress that encloses the body of the musician like a precious wrapping and exalts its impersonal quality, is in perfect accord with the expressive canons of a court art whose purpose was the glorification of the sovereign.

Sculptures like this were placed on the altars to ancestors and were associated with the royal ancestor cult (Fagg 1963, 36).

E.B

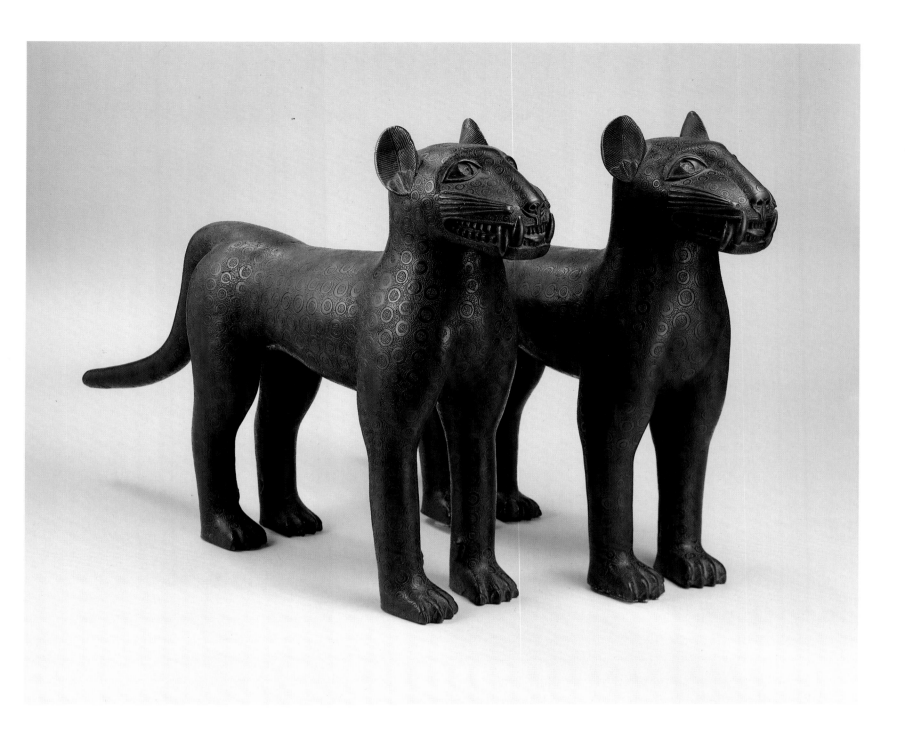

64–65 🐾

PAIR OF LEOPARDS

16th century (?)
Edo peoples, Benin kingdom, Nigeria
copper alloy
length 69 (27⅛)
references: Dapper 1686; Elisofon and Fagg 1958,
171, 172; Ben-Amos 1976, 246–247; Ben-Amos
1980, 20, 64; Eyo and Willett 1980, 81–82;
Quarcoopone 1983, 95

Nigerian National Museum, Lagos

The seventeenth-century Dutch author Olfert Dapper notes in his description of the ride of the *Oba* of Benin around the royal palace that the entourage included "some tame leopards and a goodly number of dwarfs and deaf people whose function was to entertain the king." The cats and dwarfs are also illustrated in the plate accompanying the text.

In Benin culture the leopard was the symbol of the *Oba*, a metaphor for royal power because of its combination of threatening force and prudent reserve (Quarcoopone 1983, 95; see also Ben-Amos 1976, 246–247). In the cosmology of the ancient African kingdom, the leopard was celebrated as "king of the bush," and only specialized hunters in the exclusive service of the king were allowed to hunt it. Leopards were sacrificed at the coronation of the *Oba* and on the occasion of the *Iguae*, the annual ceremony dedicated to the rein-forcement of the king's mystical powers. A pair of leopards in brass or ivory were usually placed on either side of the king when he sat in state (Ben-Amos 1980, 20, 64).

In Benin art the leopard is the most frequently represented animal, depicted in different contexts but always in some way connected with the *Oba*. Besides statues of this type, leopards appeared as ewers in imitation of European models, on bas-relief plaques, and on hip pendants. Often the head stands for the whole animal; in other cases the leopard's skin is worn by the warriors also shown on the plaques.

Brass was most often the medium, although we do know of leopard images done in ivory, notably an imposing pair (each animal is 83 cm. long) now

in the British Museum, on loan from Her Majesty Queen Elizabeth II. These are probably works from the nineteenth century, but they may have been carved as substitutes for two older pieces that were damaged and subsequently destroyed; the superb head in the Museum für Völkerkunde in Vienna could be the only fragment remaining of these earlier pieces.

The two leopards in the Lagos museum, which Eyo and Willett (1980, 81–82) have assigned to the middle of the sixteenth century, are considered by William Fagg to be among the most technically perfect works of Benin metalcraft (Elisofon and Fagg 1958, 171–172).

The imposing bodies in a watchful, proud pose, summarized with extraordinary success, are made up of muscular masses that vibrate and ripple under the smooth skin, evoking the beasts' capacity for sudden leaps. The rendering of the spotted pelt with concentric circles on a finely stippled ground does not interfere with the steady, precise modeling of the curves; on the contrary, the refined surface decoration seems to complement the superb structural balance.

The sculptures' plastic animation is concentrated in their proudly lifted heads. The strong canine teeth convey aggression. Their volumes are harmoniously integrated with the expressive head despite the fact that the different elements of the work are faithful to the canons of Benin sculpture. Note also the humanlike eyes with incised pupils, the beautifully molded ears decorated like precious leaves, the stiff whiskers in relief, similar in shape to the half-open mouth but pointing in the opposite direction: these are all signs of a deliberate search for a compositional balance that seems to have been the aim of the maker of these superb monumental representations of the power of the *Oba*. E.B.

66 ଈ

MASK

16th century
ivory, copper, and iron
24 (9½)
references: Fagg 1957; Forman and Dark 1960, 25;
Fagg 1963; Fagg 1968; Willett 1971, 108, 109; Dark
1973, 97; McLeod 1980, 133; Koloss 1982; Blackmun
1991, 59–60

The Metropolitan Museum of Art, New York, the
Michael C. Rockefeller Memorial Collection, Gift of
Nelson A. Rockefeller, 1972

Among the spoils of the conquered city of Benin in 1897, the members of the British punitive expedition found in the *Oba*'s bedchamber a group of ivory masks that are iconographically similar to one another and represent a human

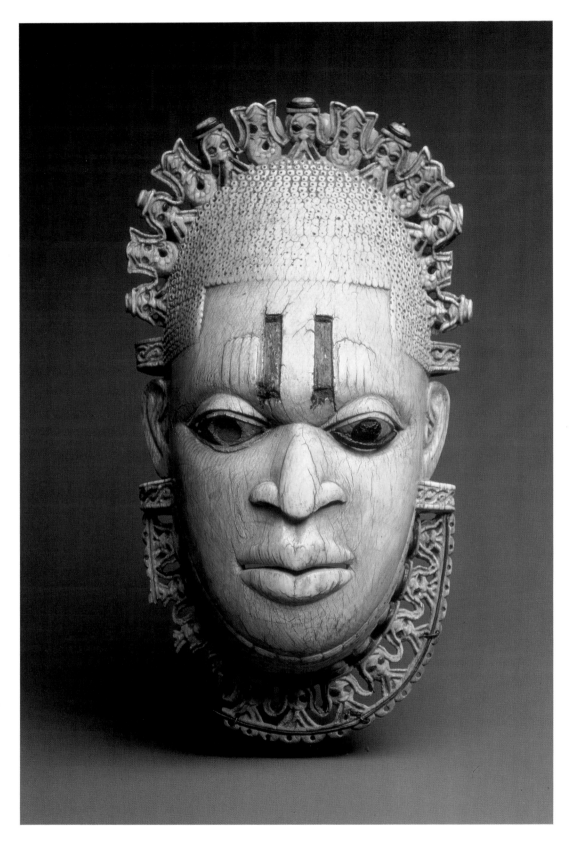

face. The two finest masks were taken by Sir Ralph Moor, civil head of the expedition, and subsequently entered the Seligman Collection: one is now in the Metropolitan Museum of Art (exhibited here), the other in the Museum of Mankind in London (McLeod 1980, 133). Two others were taken by other officers and are now in the Seattle Museum of Art (Fagg 1968, no. 141) and the

Linden Museum in Stuttgart (Koloss 1982, A8).

The four masks, according to Fagg, "should be regarded as contemporary and of the first half of the sixteenth century"; thus they belong to the early period of Benin art. Philip Dark (1973, 97) also believes that the four ivories are "relatively contemporary"; he suggests that it is reasonable to assign the London and New York pieces to the

Esigie epoch on the basis of the Portuguese heads forming a band above the forehead on both masks and the rich decoration below the chin on the mask in the Metropolitan Museum. The reign of the *Oba* Esigie (c. 1517–1550) witnessed numerous contacts with the Portuguese. *Oba* Akenzua II has in this century identified the masks as representations of Idia, the powerful mother of King Esigie, because of the presence of the Portuguese heads (see Blackmun 1991, 59–60 and note 7).

In the mask shown here the stylized Portuguese heads (a motif that recurs almost unchanged on Benin ivories and brass sculptures in later periods) alternate with mudfish, a symbol of the *Oba*, another recurrent motif in Benin art. Mudfish also form a band above the forehead on the Stuttgart mask; the decoration below the chin, as in the London and Seattle pieces, is an elaborate guilloche design. The ornament on the forehead of the Seattle ivory is composed of birds, which have largely been lost. These similarities, along with the almost identical treatment of facial features, indicate that the works were almost certainly executed at the same time.

The presence of lugs above the ears suggests that the masks were hung from a cord. Fagg (1957) therefore concludes that the masks were worn around the *Oba*'s neck and not hung from a belt like the smaller brass masks that decorated the king's costumes in more recent times. A brass mask similar to these ivory examples and of the same size, assigned to the early period of Benin art (Willett 1971, 108–109), belongs today to the Atah of Idah, sovereign of the Igala (a people who had contact, including warfare, with the Benin in the past); he wears it during official ceremonies. In support of Fagg's conjecture is a drawing dating from 1832–1833 depicting an ancestor of the Atah wearing this mask on his breast.

The facial features of the Metropolitan Museum's mask are rendered with the usual mixture of naturalism and stylization that characterizes Benin works of the early period, harmoniously placed to form a design that is rigorous and strictly symmetrical; the profile, at once delicate and strong, has a musical rhythm. The details are executed with great skill; the use of different materials, such as copper for the outline of the eyelids and iron for the pupils and the markings on the forehead, is discreet and functional, although, as Dark observes (Forman and Dark 1960, 25), quite different from the European treatment of ivory.

The mask shown here and the example in London, probably by the same hand, are among the most beautiful ivories carved in Benin; their maker, a master of his craft, was also an artist of great refinement and sensitivity. The slightly disquieting sense of impersonal coolness that pervades these pieces reminds us of the expressive conventions binding the *Igbesanmwan*, the powerful guild of carvers of ivory in the service of the *Oba*. E.B.

67 ❧

SALTCELLAR

late 15th — early 16th century
Sapi-Portuguese style, Sierra Leone
ivory
height 43 (16⅞)
references: Ryder 1964, 363–365; Dittmer 1967, 183–238; Teixeira da Mota 1975, 384, 580–589; Grottanelli 1975, 14–23; Grottanelli 1976, 23–58; Bassani and Fagg 1988, fig. 135, and 75, 78

Museo Nazionale Preistorico e Etnografico Luigi Pigorini, Rome

Of the more than fifty ivory cups or fragments of cups usually referred to as saltcellars that are known to date, made by artists in Sierra Leone in the late fifteenth or early sixteenth century, this example is among the most impressive, not only for its extraordinary size but also its refined execution and sophisticated conception of volumes. The decorative motifs and the iconography of the characters portrayed, which show unquestionable affinities of style with the production of stone *nomoli* figures from Sierra Leone — and, above all, its formal syntax, with elements carved in the round alternating with surfaces left undecorated — allow us to assign this work to the Bulom

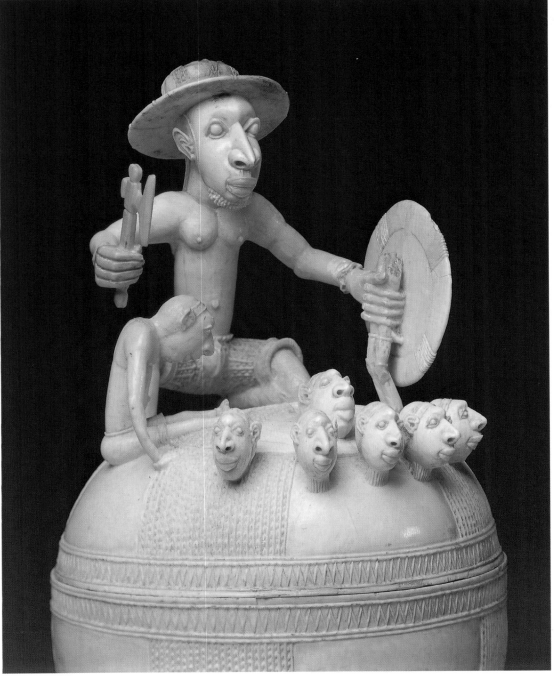

sculptural tradition in Sierra Leone, or, as was recently proposed by Ezio Bassani and William Fagg, to the Sapi (Çapes, Sapes). This collective term was adopted by the Portuguese during the Renaissance to indicate a group of populations including the Bulom, the Temne, and other bordering nations.

The cup illustrated here has a hollowed-out cylindrical base with figurative elements carved in the round inserted into an architectonic structure. Four human figures, male alternating with female, seated on the rim of the base, are separated by vertical elements, some decorated with crocodiles

in bas-relief, which modulate the rhythm of the carving on the basis of rectangular registers. The architectural structure is thus lightened by the skillful alternation of filled and empty spaces, which produces an openwork effect. The base supports a hemispherical cup whose lid is decorated with an execution scene carved in the round. The complex formal structure and the originality of the iconography combine to make this cup unique among works of its type.

The imperfect attempts at restoration—the head of the victim about to be sacrificed, the hand and ax of the executioner, the latter completed

according to the restorer's imagination—do not detract from the exceptional aesthetic quality of the object. The sophisticated structure and the clever formal devices—note the elegant alternation between carved masses with smooth surfaces, and areas decorated with simple incised geometric designs—show this to be the work of a great master. With the rhythmical modulation of volumes, the tension of line, and the sculptural precision of the surprising effects of balance, he shows that he is able to combine dynamism and a feeling for the essential with the most significant morphological elements of the great African sculptural tradition. E.C.

The Sapi saltcellars are mentioned in some of the earliest Portuguese accounts of ivories imported from Africa. The 1504–1505 account book of the Casa de Guiné refers to *saleyros* (saltcellars). Valentim Fernandes, in his report of 1506–1510, describes the Sapi as "very skillful in manual arts, that is [they create] ivory saltcellars and spoons and thus whatever work you draw for them they carve out in ivory." E.B.

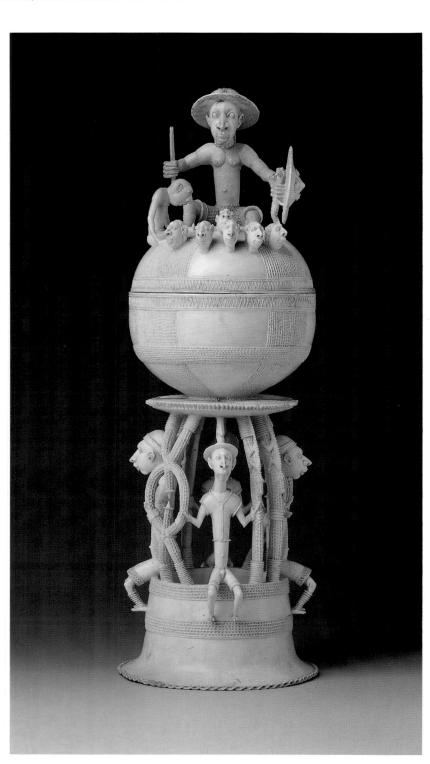

68–69 ✐

SPOON AND FORK

late 15th– early 16th century
Sapi-Portuguese style, Sierra Leone
ivory
spoon length 24 (9½); fork length 24.5 (9⅝)
references: Pacheco Pereira 1905, 134; Fernandes 1951; Ryder 1964; Teixeira da Mota 1975; Dam-Mikkelsen and Lundbaek 1980, 47, 48; Bassani and Fagg 1988

The Trustees of the British Museum

The virtuosity and exquisite taste of the carvers of ivory in what is today Sierra Leone attain their finest expression in these small masterpieces, the Sapi-Portuguese spoons and forks. Although the models are European—as is easily confirmed by a quick comparison with Portuguese examples in metal from the end of the fifteenth century—the choice of decorative motifs and their perfect integration into the finished works must be attributed entirely to the inventiveness and skill of the African artists.

Open and closed spaces are skillfully articulated throughout. Snakes and crocodiles, whose scales are rendered by means of cross-hatched incisions, slither along the slender handles, forming elegant loops, or confront small four-legged animals. Typical motifs of Portuguese Manueline decoration (rows of beads and zigzag transverse bands, which also appear on saltcellars and oliphants) are harmoniously integrated with the images of ani-

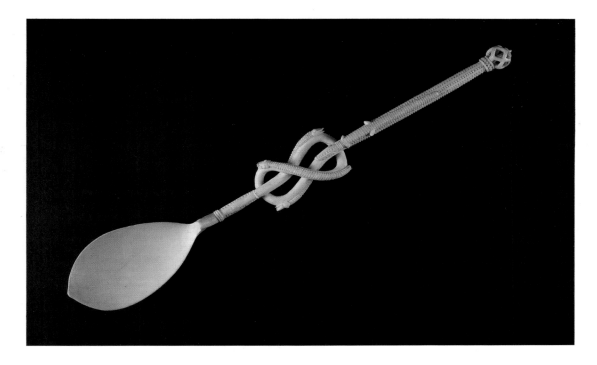

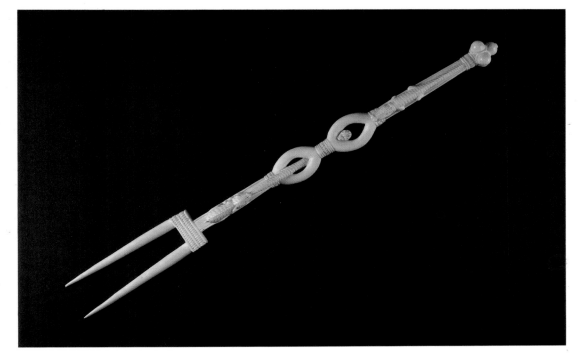

A spoon now in Copenhagen and another piece from Benin (Bassani and Fagg 1988, nos. 61, 161) were registered in a Danish manuscript inventory of 1689 as "two East Indian carved spoons with lizards and snakes on the handles" (Dam-Mikkelsen and Lundbaek 1980, 47, 48). It is beyond doubt, however, that the spoons are African, as analogies with other works from Sierra Leone and Benin have established.

From the very valuable account book of the Casa de Guiné, we note the importation into early sixteenth-century Europe of 114 spoons in ivory (*colhares de marfy*) and 22 in wood (*colhares de pao*). F. C. Ryder (1964) and Avelino Teixeira da Mota (1975) have analyzed the merchandise subject to tax besides spoons and saltcellars (in particular, rice and woven straw mats) and have concluded that the ships touched shore in Sierra Leone, where rice was abundant, indicating that the spoons also came from that part of Africa.

This conclusion is confirmed by the early report of Valentim Fernandes. His contemporary, Duarte Pacheco Pereira, is even more explicit in *Esmeraldo de Situ Orbis*, written between 1505 and 1508, where he affirms that in Sierra Leone "the finest ivory spoons are made, worked better than anywhere else and also they make palm mats that they call bicas, very harmonious and beautiful" (Pacheco Pereira 1905, 134). At the same time he lists ivory spoons and woven mats like those registered by the Casa de Guiné.

Not all of the 114 *colhares de marfy* on which a tax was levied in the year 1504–1505 correspond with the decorated examples ordered by the Europeans. If we take this number as a yearly figure, then their total would have reached several thousand. Yet only eight Sapi-Portuguese spoons and three forks have to date been identified. It is probable that for the most part the spoons recorded in the account book were simple and without decoration, valued for the material used to make them and, like the wooden spoons, their significance as souvenirs. Most of them have presumably been lost or confused with other objects imported in more recent times. E.B.

mals in lively and highly refined combinations.

The unequivocal manner of representing the crocodiles with blunt tails and transverse reliefs marking the juncture of the necks to the rest of the bodies leads us to attribute the London fork and spoon to the very talented author of four saltcellars (Bassani and Fagg 1988, nos. 27–30), which present an original solution. The container proper is attached to the conical base by a series of slender semicircular elements along which slide serpents and crocodiles, forming a spherical openwork cage.

The spoons and forks almost certainly served an ornamental rather than practical purpose, as was true also of the saltcellars. However, a practical use is suggested by the inclusion of what appears to be a Sapi-Portuguese spoon in the painting *The Death of the Virgin* by the Mestre do Paraiso of 1520–1530 (Museu Nacional de Arte Antiga, Lisbon), where it is shown immersed in a container of food. It is nevertheless possible that the object is actually a Portuguese metal spoon that by chance resembles a model used by an African carver.

70 ଛି

OLIPHANT

late 15th–early 16th century
Sapi-Portuguese style, Sierra Leone
ivory
length 63 (24⅞)
references: Pigouchet 1497; Bonanni 1709; Fagg 1981; Bassani and Fagg 1988

Armeria Reale, Turin

Oliphants do not appear in the lists of objects in the account book of 1504–1505 in the Casa de

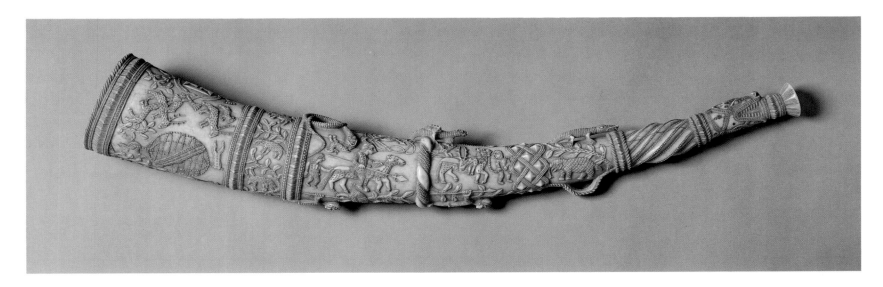

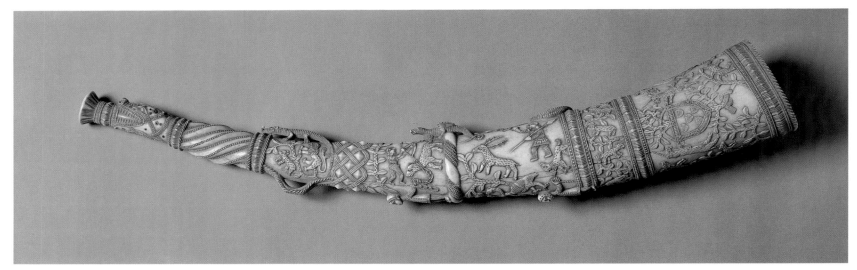

Guiné, nor are they mentioned among the creations of Sierra Leone artists in the early sixteenth-century reports of Duarte Pacheco Pereira and Valentim Fernandes, who describe "spoons, salt-cellars, and handles for daggers." Nonetheless, thirty-six ivory horns of quite large size (between 26 and 68 cm.) have come down to us (Bassani and Fagg 1988, nos. 75–110). The absence of any record in the Casa de Guiné could be explained by the assumption that the horns were destined for the royal palace, which would be supported by the presence of the royal coat of arms carved on the sides of many of the horns. This would account for the horns' exemption from tax.

An oliphant that was in the Collegio Romano, the museum of the Jesuits in Rome, and is now in the Museo Luigi Pigorini, is the only ivory identifiable as Afro-Portuguese whose African origin was recognized as early as the eighteenth century. Father Filippo Bonanni, director of the museum and editor of its catalogue in 1709, described the horn, probably on the basis of documents no longer in existence, as "*Cornu eburneum ex Africa alatum cum figuris variis elegantissime sculptis*" ("Winged ivory horn from Africa with

various figures very elegantly carved"), thus eliminating any doubt as to the object's origin.

Horns made from an elephant's tusk (and thus called "oliphants"), usually carved by Arabian artists, were common in Europe during the Middle Ages and the Renaissance. They must have been even more widespread in Africa, where ivory was abundant before the arrival of the Europeans. The horns used in Africa differ from those made for export, both in terms of shape and in the way they are played; the mouthpiece is on the side (on the inside of the curve of the tusk in instruments from Sierra Leone) instead of at one end. They also lack the rings for attaching a cord, which are always found on European horns.

The mouthpiece of the Sapi-Portuguese oliphants mimic the teeth and jaws of animals of prey. On some examples a winged dragon is sculpted in the round; both elements also can be seen in European objects, especially guns, dating from the beginning of the sixteenth century.

The bas-relief decorations on the sides of the horns are usually deer-hunting scenes, carved freely over the surface. The theme is common in many Franco-Flemish tapestries of the late fif-

teenth and first half of the sixteenth century, as well as in drawings, miniatures, and prints of the same period. Analogies with small images printed along the borders of some prayer books, particularly the small incunabulum *Horae Beatae Mariae Virginis*, printed in Paris in 1498 by Philippe Pigouchet for Simon Vostre and widely distributed, are so close as to suggest that the devotional books served as models for some of the ivories.

Some horns have carvings in high relief of hunters holding dogs on leashes or carrying their prey over their shoulders; the latter strongly recall images of the Good Shepherd in Christian iconography. Heraldic motifs such as the crowned lion, fantastic creatures such as unicorns, centaurs, and harpies, the sun and moon all make up part of the decoration. Oriental motifs also appear: the two birds with entwined necks on the Turin oliphant and on a few others, for example. This theme can be found in printed books from the same epoch, but it ultimately derives from Indian and, even more, from Islamic decorative traditions.

Elements common in Portuguese Manueline architecture are found on the oliphants as well as

the saltcellars; the transverse reliefs dividing the surface of the oliphants into registers are particularly analogous to the horizontal bands carved into the pilasters and capitals of many early sixteenth-century Portuguese monumental buildings, such as the monastery of Los Jeronimos in Lisbon.

The coats of arms of the House of Aviz, the armillary sphere, and the cross, symbol of the Order of Christ, all attributes of King Manuel I of Portugal, are carved, sometimes by themselves but more often together, on almost all of the oliphants and on two saltcellars.

Three oliphants and a powder flask made from a fragment of a fourth horn (Bassani and Fagg 1988, nos. 75–77, 79) have carving showing the coat of arms of Portugal, as well as those of Ferdinand V of Aragon and Isabella of Castile and the motto of the Spanish king *Tanto Monta* ("it amounts to the same thing," thought to refer to a remark made by Alexander the Great in cutting the Gordian knot). It is likely that Manuel I of Portugal, who had married in succession two daughters of the Catholic monarchs (in 1497 Isabella and in 1500, after her death, Maria), presented his father-in-law with these hunting horns created by an artist from Sierra Leone. The inscription *Ave Maria* carved on a transverse band of the oliphants could refer to the name of Manuel's second wife. The coat of arms of Ferdinand and Isabella also contains a pomegranate, the emblem of Granada, the kingdom in southern Spain that was liberated from the Moors in 1492; thus these works can be dated between 1492 and 1516, the year of King Ferdinand's death.

On the oliphant exhibited, the coat of arms of the reigning house of Portugal is shown hanging from the limbs of a leafy tree, flanked by two unicorns, a motif identical to that appearing in the device of the French printer Thielman Kerver, active in the last decade of the fifteenth century, whose shop was styled "at the sign of the unicorn."

All the European iconographical elements that we have identified in the Sapi-Portuguese ivories can be dated more or less between the last quarter of the fifteenth century and the first quarter of the sixteenth, allowing us to conclude that these works were carved in a relatively brief period by a small group of artists who worked for the export market as well as for African purchasers. This is confirmed by the oliphant in the Musée de l'Homme in Paris (Bassani and Fagg 1988, no. 201), which has a side mouthpiece and no rings for attaching a supporting cord—a typically African instrument. Careful comparison shows that it was carved by the same artist who executed the saltcellars now in the Museum für Völkerkunde in Vienna and the Bowes Museum in Barnard Castle (Bassani and Fagg 1988, nos. 16–17). E.B.

71 ᕲ

SALTCELLAR

16th century
Bini-Portuguese style, Nigeria
ivory
29.2 (11½)
references: Dark 1973; London 1980; Mendes Pinto 1983; Vogel 1985; Bassani and Fagg 1988

The Trustees of the British Museum, London

This saltcellar from the Museum of Mankind in London belongs to a group of fifteen Bini-Portuguese examples, most of which are incomplete (Bassani and Fagg 1988, nos. 114–128). Unlike the Sapi-Portuguese saltcellars, those from Benin have two spherical containers, one atop the other, divided exactly in half, so that the complete saltcellar is composed of three parts: a base with the lower half of the first container, a middle section comprising the upper half of the first container and the lower half of the second, and, in the few surviving complete pieces, a third part, which serves as the lid of the second container, usually topped by a group sculpted in the round. In each case a frieze of figures in European clothes—standing in five of the saltcellars and mounted on horseback in the other ten—encircles the base.

The saltcellar exhibited here belongs to the type with standing figures and is the work of an artist who, on the basis of this work, may be called the "Master of the Heraldic Ship." He also carved

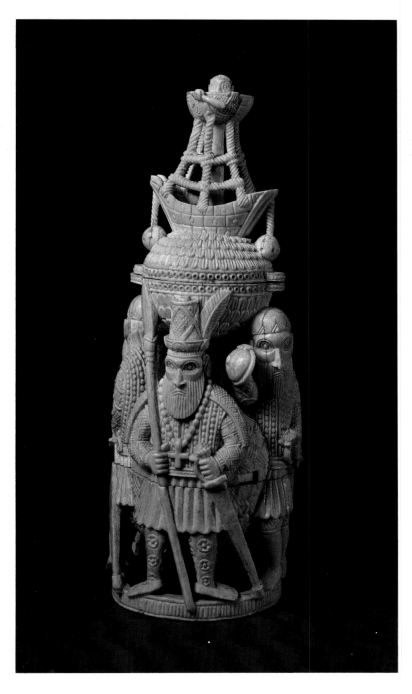

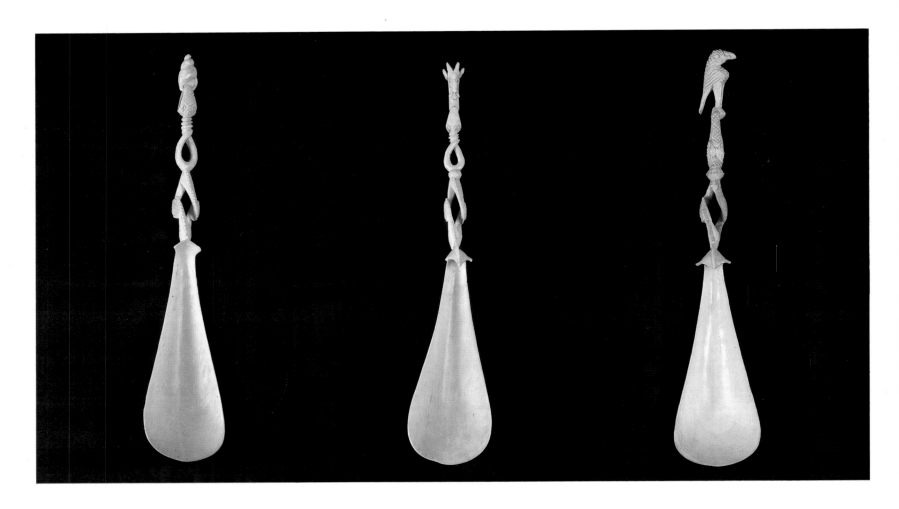

two incomplete examples, of which only the central sections survive (Bassani and Fagg 1988, nos. 114–116).

On this saltcellar the four human figures are skillfully alternated in frontal and three-quarter poses to emphasize movement. This is the most intriguing stylistic trait of the fifteen Bini saltcellars; most of the figures are represented in movement, unlike the figures on Sapi-Portuguese saltcellars as well as those in classic Benin art and in African art in general. This unusual manner of rendering the human figure, common only to the saltcellars and to a few Bini figures of crossbowmen and harquebusiers cast in brass, has suggested the possibility that a Portuguese "commissioner/teacher" could have introduced this convention to Bini figurative art. After his departure or death, this foreign motif would have been abandoned.

The double-chambered form of the saltcellars bears no resemblance to traditional works from Benin. The standing figures carved on them also have no precise iconographical equivalent in traditional sculpture from the ancient Nigerian kingdom, with the exception of some facial details (the eyes and mouth, for example) and some decorative motifs, such as the basket weave and lozenge patterns that were part of the artistic vocabulary of the *Igbesanmwan*. See, for example, the Portuguese figures carved on the ivory bracelets in the Museum of Mankind and the Monzino Collection

(Dark 1973, pl. 8 left, and Vogel 1985, no. 80). Attribution to Benin artists is possible not only because these stylistic details — particularly the similarities between the horsemen on some saltcellars of the second type and the figure of a Portuguese horseman on the surface of a tusk destined for the altar of the *Oba*'s ancestors, even though this piece is of later date (London 1980, lot 24) — but also because of the close correspondence of details of the saltcellars to traditional Benin works in ivory and brass, in particular the ears in the shape of leaves and the tack of the horses.

The frontal figures on the saltcellar shown here wear sumptuous costumes, and in their monumentality evince a close relationship to contemporary images of important figures in Portuguese society. See, for example, the portrait of Afonso de Albuquerque, viceroy of the Indies, painted in Goa in the sixteenth century and now in the Museu Nacional de Arte Antiga in Lisbon.

The three-quarter figures wear a kind of light armor with metal plates fastened by rivets, which was common in Europe beginning in the second half of the fifteenth century. The four figures hold swords with handles decorated with a large pommel, a type widely used in Europe between the end of the fifteenth and the first half of the sixteenth centuries. The lances, according to Claude Blair, could be an Indian style because of the way the blade is fixed to the shaft; also possibly of Indian origin are the daggers worn at the

belt by several horsemen carved on the saltcellars of the second type. Oriental weaponry was certainly common among the Portuguese, as Vasco da Gama had reached India in 1498.

The Bini-Portuguese saltcellars also show elements typical of Manueline decoration, for example, the rows of beads used to render the rivets of the armor and other details of costume and the lotus flowers carved on the stockings of the figures seen frontally. This is a typical Indian motif going back to Vedic tradition, adopted in Indo-Portuguese architecture to decorate teak beams (Mendes Pinto 1983, nos. 156, 157) as well as in Manueline decoration, as can be seen in the rich portal of the church of Viana in the Alentejo.

These elements suggest the first half of the sixteenth century as the period when these saltcellars were created.

The ship carved on the lid is not a caravel, the ship used by the Portuguese in the sixteenth century for ocean voyages, but an *urca*, a type of freighter common in Portugal and northern Europe until the middle of the preceding century — an identification that we owe to Admiral Vasco Viegas of the Marine Museum in Lisbon. The image must therefore have been copied from a drawing or print, but the detail of the sailor in the crow's nest, rendered in a narrative manner unlike the imposing figures of the lower register, has the character of an observed detail and could have been added by the carver. E.B.

THREE SPOONS

16th century
Bini-Portuguese style, Nigeria
ivory

72: length 25 (9⅞)

73: length 24.8 (9¾)

74: length 25.7 (10⅛)

Museo di Antropologia e Etnologia, Florence

TWO SPOONS

16th century
Bini-Portuguese style, Nigeria
ivory

75: length 24.8 (9¾)

76: length 26 (10¼)

Museo Nazionale Preistorico e Etnografico Luigi Pigorini, Rome

references: Zeiler 1659, 53; Dapper 1668; Heger 1899, 109; Welsh 1904, 452; Wolf 1960; Bassani 1975; Dam-Mikkelsen and Lundbaek 1980, 47; Eyo and Willett 1980; Bassani and Fagg 1988

Spoons are the most numerous category (forty-eight examples have been identified to date) of Bini-Portuguese ivories. A very large number of them must have been made since so many have survived despite their fragility. The three spoons in Florence and the two in Rome were listed among the possessions of Eleonora of Toledo, wife of the Grand Duke Cosimo I de'Medici in 1560 (Bassani 1975). Other groups of these valuable objects were part of the celebrated "cabinets of curiosities" amassed by various sixteenth- and seventeenth-century European collectors (Bassani and Fagg 1988, nos. 134–169).

Documents in Dresden and Ambras describe the spoons in those collections as "Turkish" (Wolf 1960) or of "Turkish shape" (Heger 1899, 109), an attribution curiously repeated in the Florentine inventories beginning in 1793; one of the spoons in the collection of the merchant Christof Weickmann of Ulm is described as "Indian" (Zeiler 1659, 53), while one from the Danish royal collection, now in Copenhagen, is called "Japanese" (Dam-Mikkelsen and Lundbaek 1980, 47). Such mistaken oriental attributions are typical of the early inventories. Iconographical and stylistic considerations prove beyond a doubt the Nigerian origin of the spoons. Carved in the round on the handles in various combinations are leopards and antelopes, birds, snakes, and crocodiles eating smaller animals, all belonging to traditional Bini iconography, as can be seen in the innumerable works in brass and ivory found in Benin. The antelopes carved on the spoons are always shown devouring leaves. This motif is common in the art of Owo, a Yoruba city about 100 kilometers from Benin (see, for example, the covered ivory cup in the Musée des Beaux Arts in Lille).

The concave bowl of the spoons, so thin as to appear translucent, is the most refined element. This may have led to the erroneous description of the pieces in Florence as "spoons of mother of pearl." The elongated shape, tapered toward the rib along the back, and toward the point at which it meets the handle, where it curves forward to form a three-sectioned hook, seem inspired by the form of a leaf. These motifs are rare in Benin art, whereas they appear frequently in the Owo figurative tradition. Some fifteenth-century terra-cottas excavated at Owo show leaves of the sacred *akoko* tree (Eyo and Willett 1980, nos. 70–71). Reference to the leaf shape and the marked absence of the *horror vacui* that characterizes Benin art suggest that the makers of the spoons may have been Owo artists working for the *Oba* alongside other Bini members of the *Igbesanmwan*, according to a tradition reported by R. A. Bradbury in his posthumously published notes.

This workshop could have been located outside the city of Benin, not far from the Portuguese port of entry. Possibly it was not far from, or even the same as, the shop that produced the Bini salt-cellars, considering the similarity between the only human figure carved on a spoon, perhaps a Portuguese apprentice sailor (now in the British Museum, London; Bassani and Fagg 1988, no. 171), and the figure represented in profile on a saltcellar now in Berlin (Bassani and Fagg 1988, no. 126).

The numerous examples that have come down to us and the relatively late (1588) but precise description by James Welsh, "In Benin they make spoons of Elephant teeth very curiously wrought with diverse proportion of fowls and beasts made upon them" (1904, 452), suggest that the creation of Bini-Portuguese spoons (and perhaps the horns and saltcellars) began later than that of Sapi-Portuguese spoons and lasted longer, until about the end of the sixteenth century, when Prince Christian of Saxony is recorded to have purchased a dozen of these objects (Wolf 1960).

The diminishing numbers of elephants that resulted from over-hunting due to the European demand for ivory may have ended the carving of larger works for export, such as saltcellars and oliphants, but small spoons continued to be produced. E.B.

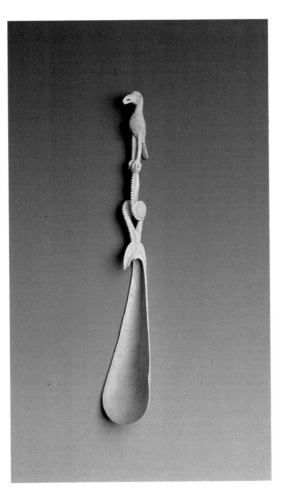

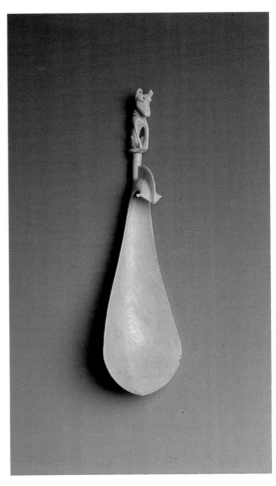

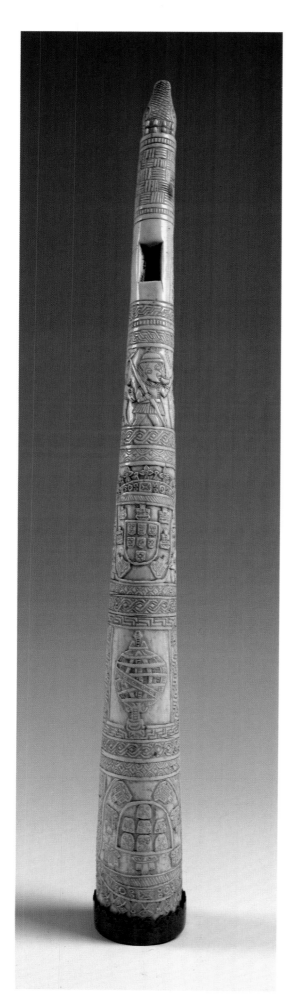

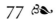

77

OLIPHANT

16th century
Bini-Portuguese style, Nigeria
ivory
length 57 (22½)
reference: Bassani and Fagg 1988

*Rautenstrauch-Joest Museum für Völkerkunde
der Stadt Köln*

This instrument belongs to a group of three extant Bini-Portuguese oliphants (Bassani and Fagg 1988, nos. 111–113). Their close similarity indicates that they were almost certainly carved by the same artist within a relatively brief period. Thus they represent a circumscribed episode in the cultural exchange between Benin and Portugal.

The oliphants differ substantially from the Sapi-Portuguese examples (cat. 70) in both form and decoration. They are more like native African instruments than those designed for export to Europe. The three Bini horns have no rings for attaching cords, and in each case the rectangular mouthpiece is placed on the outside curve of the tusk, a position that is documented only in indigenous Bini and Yoruba instruments. The oliphant exhibited here could be compared to a typical Bini horn like the one in Vienna, decorated with the figure of an *Oba* riding an elephant, a metaphor for power.

The head of an animal at the narrow end of the oliphant, from whose teeth the mouthpiece appears in Sapi-Portuguese instruments, serves here as a purely decorative element.

The bas-relief decorations that cover the entire surface of the oliphant are a skillful combination of geometric elements typical of the Bini figurative tradition—basket weave, lozenge, and guilloche patterns—and European motifs. The latter include the coat of arms of the House of Aviz, the ruling family of Portugal, surmounted by a rich crown, an armillary sphere, and small stiff figures of hunters with lance, sword, and dogs, confined to a narrow transverse band. In terms of both iconography and placement, the coats of arms of the reigning house of Portugal strongly recall those appearing in miniature in a manuscript volume, the *Livro Carmesin*, containing documents of the Lisbon administration from 1502 to 1796 (Arquivo Historico da Camara Municipal, Lisbon).

The evident *horror vacui* that characterizes this artist's work and the presence in two of the horns, among other traditional motifs, of a border design consisting of a single line of steps framing the armillary sphere (Bassani and Fagg 1988, nos. 111–112; on no. 113 the coat of arms does not appear)—a motif used only by carvers in Benin—enabled William Fagg to establish the Bini origin of the three horns.

Despite the presence of the Portuguese coats of arms and the figures of hunters, the typically African structure of the three oliphants makes one wonder whether they were carved for export or rather for the use of the sovereign of Benin himself, who might have requested the European motifs for their prestige and exotic nature. It is also possible and perhaps more probable that the oliphants were indeed commissioned in Benin by a European, but that the rigid academic training given to artists belonging to the *Igbesanmwan* (the guild of carvers of ivory who worked for the *Oba*) led them to conform to indigenous canons even when they were working for a foreign client.

E.B.

78

OLIPHANT

16th century
Kongo-Portuguese style (?), Zaire or Angola
ivory
length 83 (32⅝)
references: Brasio 1952, 113, vol. 1; Bassani 1975, 143; Bassani 1981; Bassani and Fagg 1988

Museo degli Argenti, Palazzo Pitti, Florence

The two splendid horns in the Museo degli Argenti in Florence, one of which is exhibited here, are the very earliest identifiable sculptures from Africa to have been registered in a European inventory. Other works mentioned in even earlier documents have either been lost or confused with objects found in more recent times. These two oliphants appear to correspond to the "2 ivory horns worked in intaglio" described in both the General Inventory and the Wardrobe Inventory of the possessions of Cosimo I de'Medici in 1553 (Archivio di Stato di Firenze, Guardaroba Medicea, vol. 30, c. 134r and vol. 36, c. 134v). This brief description fits the two instruments perfectly, although it does not completely guarantee their identity. Combined with my analysis of a series of archival elements, however (Bassani 1975, 143), the connection is highly probable.

The two ivories in the Museo degli Argenti are part of a group of seven known instruments, all having a very elegant line and a surface entirely covered with bas-relief decorations in a refined interwoven design based on Greek frets and lozenges. Analogies of shape and decoration are strong enough to attribute the seven oliphants to the same artist, a highly talented master from the Kongo, the great kingdom reached in 1482 by Diogo Cão.

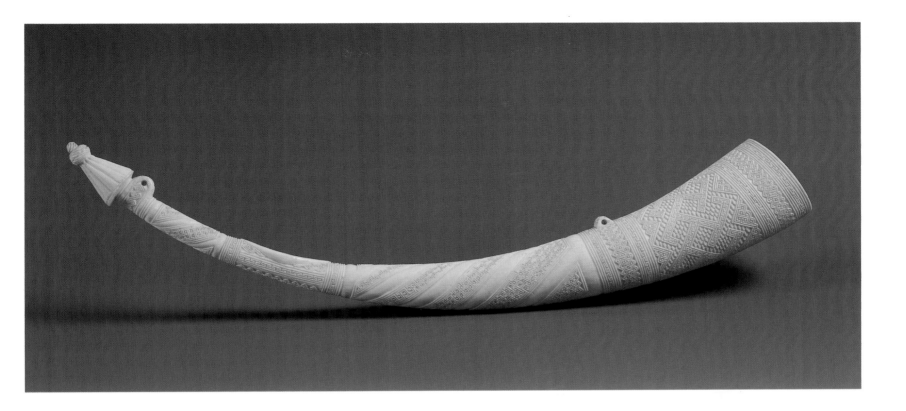

In these seven examples the mouthpiece is pierced into the concave side of the tusk following African usage, but, at the same time, one or two rings for attaching a cord have been carved (Bassani and Fagg 1988, nos. 181–187). As noted earlier, typical African horns have no rings, and the cord, when it exists, is wound around the instrument. We must therefore conclude that the artist who created these oliphants had seen a European horn. In that case they must have been carved between 1482, the year that Diogo Cão's ships entered the mouth of the Kongo River, and 1553, when they were registered in the inventories of the grand duke in Florence. The tradition that one of the seven oliphants belonged to the collection of the famous Spanish writer of Peruvian origins, Garcilaso de la Vega (1539–1616), is consistent with this hypothesis.

The rings could have been added by the maker in anticipation of the instruments' eventual ownership by some European prince or the pope. It is possible that the two Florentine ivories were sent by the king of the Kongo to one of the two Medici pontiffs (Leo x, who was pope from 1515 to 1521 or Clement VII from 1523 to 1534). Henrique, son of King Afonso I of the Kongo, a convert to Christianity, was appointed bishop by Leo x.

It is equally possible that all seven oliphants were carved for the king or another important leader of the Kongo people and that the rings were incorporated simply to imitate European models. Ivory horns, called *mpungi* in the Kikongo language, were part of the hereditary regalia of the appointed leaders, beginning with the king, and played an important role in court ceremonies. The earliest reports describing the arrival in April 1491 of the Portuguese delegation, led by Ruy de Sousa, in the capital of the Kongo notes that the king sent to meet them a group of nobles "with many ivory horns and drums, and many other instruments" (Brasio 1952, I, 113).

The decorative motifs on the horns belong to the traditional figurative vocabulary of the Kongo, elaborated before the arrival of the Europeans, and are seen not only in ivories but also in cloth made of palm fiber, headdresses, and woven baskets. They reveal a highly cultivated taste, a sense of rhythm and composition, and also a complete mastery of geometry. The design on the Kongo ivories is consistently regular and controlled. Note, for instance, the carver's skill in adapting the Greek fret motif to the narrowing spiral bands as the conical tusk becomes smaller. E.B.

ISLAMIC EMPIRES

The conquest of Constantinople by Mehmed II in 1453 sealed the Ottomans' rise to power. Mehmed's successors were ultimately to extend Ottoman hegemony over most of the Near East, but in the closing decades of the fifteenth century rival Islamic empires continued to flourish. The Mamluks under Qā'it Bāy controlled Egypt, Syria, and southeastern Turkey; the Aqqoyunlu (White Sheep) Turcomans ruled

from Baghdad to Tabriz; while in the East the Timurid court at Herat set the model for princely patronage.

The taste and extraordinary skill of the court artists and craftsmen are evident in all that they produced—religious manuscripts and paraphernalia, arms and armor, costumes, and precious objects designed for personal use. Contacts with China and Europe also had

consequences for the arts during this period. Enthusiasm for Chinese porcelains led to the development of Iznik blue-and-white ware, while Ottoman and Mamluk diplomacy occasioned visits to the Near East by prominent Italian artists, who on their return redefined the European image of the Islamic world.

79 ⊷

COMPOSITE STANDARD LAMP

c. 1470–1478
Aqqoyunlu Turcoman
cast or beaten brass, engraved and inlaid with silver
(the drip-tray, of a different alloy, may be
subsequent, though possibly contemporary addition)
height 121 (47⅝)
references: Encyclopedia of Islam 1960– , "Hādjdjī
Bayrām Walī"; Bayramoğlu 1983; Melikian-
Chirvani 1987; Grube 1989

The Rabenou Charitable Settlement Number One

This composite standard lamp (*chirāghdān*) has a bowl-shaped reservoir and a tall knopped shaft. Its candlestick-shaped base is in the form of a truncated cone. Such lamps, despite their improbable shape, are illustrated in a *Kalīla wa Dimna* manuscript (Topkapı Sarayı Library H. 362, folios 36b and 95a) made in 1431 for Baysunqur Mirza at Herat that includes miniatures of earlier date which have been pasted in.

The lamp bears a series of inscriptions in Arabic and Persian dedicating it as *waqf* to the shrine-mausoleum of an eminent Sufi Shaykh, Bayrām Bābā Valī, stipulating that it shall not be removed from the shrine and invoking God's curses upon anyone who replaces it or disposes of it by *istibdāl*—the buying out of the assets of an older *waqf* in favor of a new endowment, a practice forbidden by many Muslim lawyers. There follow praises of the twelve Shīʿī Imams and, on the candlestick-shaped base, brief prayers for the Sultan Abu'l-Naṣr Ḥasan Bahādur Khān, that is, the Aqqoyunlu ruler Uzūn Ḥasan (d. 1478). The earliest known coin of Uzūn Ḥasan's to bear these titles is dated 1470–1471, and this lamp evidently dates from between 1470 and 1478.

The exact extent of Uzūn Ḥasan's allegiance to Sufism is still under discussion; however, at least up to the extreme polarization of Shīʿism and Sunnism under the early Safavids in Iran, praises of the twelve Imams would not invariably have been regarded as incompatible with Sunnism.

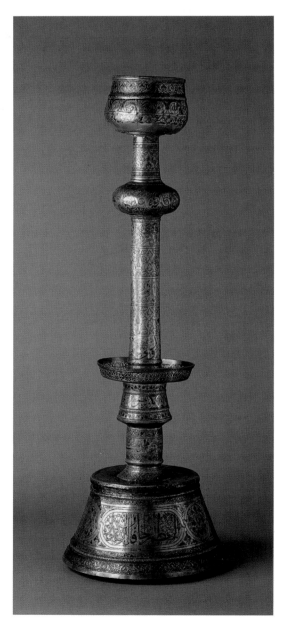

Melikian-Chirvani has argued that the Sufi shaykh to whom the lamp is dedicated must be Ḥājjī Bayrām Velī, the founder of the Bayrāmiyya order whose mausoleum-shrine is at Ankara.

Since, however, hostilities between the Aqqoyunlu and the Ottomans culminated in the defeat of Uzūn Ḥasan at Başkent in eastern Turkey in 1473, Uzūn Ḥasan may seem an unlikely donor to a Sufi shrine in the heart of Ottoman territory. Melikian-Chirvani has, therefore, suggested that the lamp, probably one of a pair, was dedicated to a presumed mausoleum of Ḥājjī Bayrām Velī, somewhere closer to Aqqoyunlu territory, popularly revered as such or deliberately encouraged for propaganda purposes by Uzūn Ḥasan himself.

J.M.R.

80 ⊷

LANTERN

c. 1470
Turkish, Ottoman
beaten silver
height 67 (26⅜); base diameter 40 (15¾)
inscribed: Koran XXIV, the Sūrat al-Nūr
references: Washington 1966, no. 254;
London 1982, fig. 6; Istanbul 1983, no. E21

Türk ve İslam Eserleri Müzesi, Istanbul

This hexagonal lantern, decorated with openwork and repoussé with chased detailing, was probably made for Mehmed II's mosque, Fatih in Istanbul.

Each facet of the lamp is decorated by lobed medallions—with split-palmette arabesque tracery—on a ground of dense chinoiserie foliate trails. On a scrolling ground above and below are fine, rounded inscriptions of Koran XXIV, the Chapter of Light, verse 35.

A tray or polycandelon, inserted into the base, is designed to hold seven oil lamps. In one of the sides, a door opens and provides access to the lamps from above.

J.M.R.

81

KORAN BINDING

late 15th century
Turkish, Ottoman
*stamped and gilded leather manuscript transcribed
by the calligrapher Ḥamd Allāh b. Muṣṭafā Dede,
known as Ibn al-Shaykh; quarto, 265 folios,
muḥaqqaq, fourteen lines to the page. The colophon
(folio 259b) is signed by the calligrapher. A note
below in an illuminated panel states that the
manuscript was completed by early Rajab 889 (early
August 1484). The illuminations include a double
frontispiece (folios 1b-2a), Sura I, and the beginning
of Sura II (folios 2b-3a), the colophon (folio 259b),
the headings of subsequent suras, and marginal
indications of five- and ten-verses.*

*boards, height 33.2 (13); width 22.5 (8⅞); width
with flap extended 62.5 (24⅝)*
*references: Çiğ 1971, figs. IV–V; Aslanapa 1982, 12–
17; Istanbul 1983, 3, no. E12*

Türk ve İslam Eserleri Müzesi, Istanbul, 402

The exquisite binding, which is contemporary
with the manuscript, is of pasteboard covered in
deeply stamped, red gilt leather. The decoration,
on a stippled black ground, is of floral scrolls, with
lotuses, split palmettes, and trefoils typical of the
International Timurid style, all in high relief and
with gilt detailing. The border is of alternating
lappets and lobed medallions filled with undulat-
ing scrollwork.

Instead of a title, the spine bears, in bold script,
the customary Koranic formula, "that this is
indeed the Koran most honorable, in a Book well-
guarded" ("Innahu 'l-Qur'ān karīm fī kitāb
maknūn") (Koran LVI, 77–78). The leather dou-
blures, of a pale coffee color, are deeply stamped
on a stippled background. The tooling is in silver
as well as gold, used for bold outlines within and
outside the panels. The designs of the outer and
inner covers are variations on similar themes; any
resemblances between them and the illumination
of the manuscript are, however, generic rather
than specific.

The Koran was endowed upon (made *waqf* to)
the library of Mahmud I (1730–1754) in the
mosque of Ayasofya, as noted in folio 1a.

J.M.R.

Koran Fragment
(Sura XVIII, 107, to Sura XX, 12)

late 15th century
Turkish, Ottoman
written in fine muḥaqqaq *or* rayḥān *script, seven*
lines to the page, with elaborate cloud contours
*(*abrī*) and interlinear Persian translation in*
small naskhī
height 36.3 (14¼); width 27.5 (10⅞)
references: Martin 1912, 102; Lisbon 1963, no. 115;
Arberry 1967, 57, no. 185; London 1976, no. 578
a-b; James 1980, no. 71; James 1981, no. 32

The Trustees of the Chester Beatty Library, Dublin,
MS *1492, fols. 1b–2a*

The first opening, folios 1b–2a, has fine panels of
illumination above and below the text with mar-
ginal hasps. The verse counts and Sura-headings,
which also include appropriate verses from other
Suras, are in spidery white, heavily stylized
Kufic on a dense scroll of split palmettes. These
palmettes are rendered in vividly contrasting
colors with finely serrated fronds. The layout,
owing much to Timurid prototypes, is somewhat
atypical of late fifteenth-century Ottoman illumi-
nation; but the motifs and their treatment are
from the period of Bayazid II (r. 1481–1512). The
binding is modern.

Another fragment from the same Koran is in
Lisbon in the Calouste Gulbenkian Foundation.
According to Frederic Martin, the Koran was orig-
inally in the library of the mosque of Ayasofya

in Istanbul. Since his evidence for this assertion
is not known, the Koran may have left the founda-
tion to which it was originally endowed some
time before the mid-eighteenth century, when
Mahmud I founded the library at Ayasofya.

J.M.R.

Koran Chest of Bayazid II

1505–1506
Turkish, Ottoman
walnut veneered with ebony, inlaid with ivory
height 82 (32¼); diameter 56 (22)
inscribed: (on body) Koran II, *255, the* Āyat al-Kursī
or Verse of the Throne; LIX, *22–24; (on lid) Koran*
XLVIII, *28–29;* III, *18–19; and* XXVII, *30*
references: Migeon 1903; Meriç 1957, 7–76; Meriç
1963, 764–786; Istanbul 1983, no. E19; Frankfurt-
am-Main 1985, no. 8/2

Türk ve İslam Eserleri Müzesi, Istanbul

It was doubtless in connection with the inaugu-
ration in 1505 of the mosque of Bayazid II
(r. 1481–1512) that this superb chest was created.
It is one of the finest extant examples of Ottoman
woodwork. The hexagonal body is decorated
with oblong panels of ivory carved with Koranic
inscriptions in fine *thuluth* on a deep blue
ground. The triangular ivory corner pieces are
embellished with carved arabesques and include
verses in Ottoman Turkish in praise of Bayazid II,

as well as the date 911 (1505–1506). The chest is
signed by Aḥmad b. Ḥasan *al-Ḳālibī* ("the inlayer
of firearm stocks"). The hinged lid, which is sur-
mounted by a twelve-sided pyramid and a carved
and turned ebony and ivory finial, is adorned
with ivory panels carved with Koranic inscriptions
and arabesques.

The interior is more sparely decorated with
small panels of minute inlay in fine woods, green-
stained ivory, and gilt brass. The three interior
compartments were to hold the parts of a thirty-
part Koran, a common format for mausolea, where
endowment deeds frequently stipulate that one
part of the Koran should be read each day in
memory of the founder. Although the Koran that
the box once contained has not been identified,
the dimensions are oblong, indicating that it
must date from the early centuries of Islam, when
such formats were standard. Such Korans, often
believed to be written by the early Caliphs, were
much treasured by the Ottoman Sultans. In fact,
the registers of palace expenses and disbursements
for the reign of Bayazid II contain numerous
entries of rewards to those who had given early
Korans for the inauguration of his mosque
(Meriç 1957).

As the inscription indicates, the craftsman's
specialty was the inlaying of firearm stocks (com-
pare Meriç 1963), an interesting indication of
craft specialization during the reign of Bayazid II.
This type of fine Ottoman woodwork has many
features in common with the products of the con-
temporary Embriachi workshops in Northern Italy
(compare Migeon 1903, pl. 8).

J.M.R.

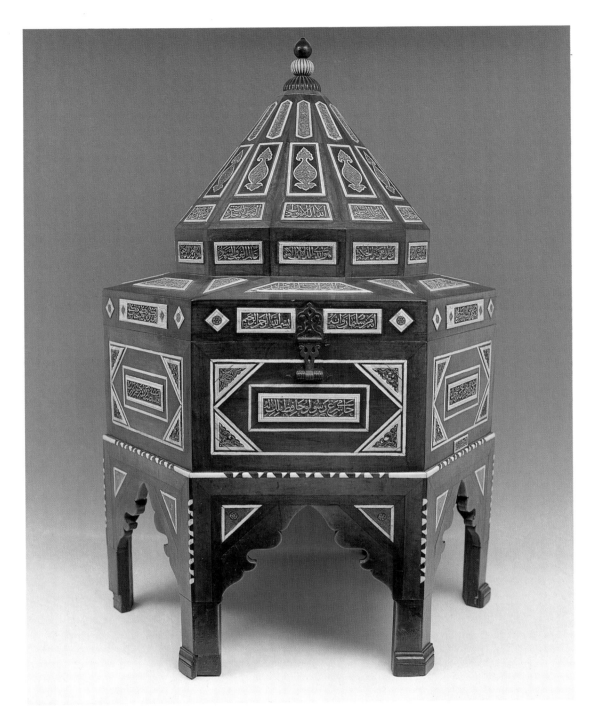

sorts of metalwork. The lower inscription includes the name of the Shirvanshah Farrukhyasār (1464–1501) best known for his victory over the Safavid leader Shaykh Ḥaydar in 1492–1493. Farrukhyasār was a refined patron of the arts of the book, as is shown by a splendid anthology in the Herati style (British Library Add. 16561), copied at Shamakha in Shirvan by Sharaf al-Dīn Ḥusayn al-Sulṭānī in 1468–1469. This inscription, which is surmounted by a lobed, scribbled border, is less carefully dotted than the former; and its arrangement and ungrammatical construction make it difficult to suggest the order and parts of words. Only a highly tentative reading can be proposed.

Turban helmets of this type, which seem to have been made in Dagestan and sold in Derbend, are associated particularly with the Aqqoyunlu Turcomans. (Another helmet also bears a rare legible dedication to the Aqqoyunlu ruler Yaᶜqūb Beg.) Shirvan, now modern Soviet Azerbaydzhan, was important both as a producer of raw silk and as a winter military bivouac, but though nominally independent by the later fifteenth century, the Shirvanshahs were little more than tributaries of the Aqqoyunlu.

Helmets and armor found today in Turkish collections must mostly have entered Turkey as booty. David Alexander has observed in conversation that the substantial number of such pieces in the Leningrad armories were almost certainly seized by Russian forces from the Ottoman arsenal at Erzurum, which they occupied in 1827–1828.

J. M. R.

84 ༄

Turban Helmet

late 15th century
Iranian, Aqqoyunlu Turcoman
iron, heavily overlaid with silver
height 34 (13³⁄₈); base diameter 23.4 (9¹⁄₄)
inscribed: (upper) al-dawla wa'l-iqbāl al-nuṣra
wa'l-ifḍāl li-ṣāḥibihi; (lower) Sulṭān ibn BSA
QTAFS wa āl wa ibn tāj ijlāl wa ᶜizz BR TIR AHSU
Farrukhyasār manbaᶜ BDhl majmaᶜ [?] abyār [?anbār]
al-muẓaffar al-manṣūr al-mu'ayyad.

Askeri Müze, Istanbul

This helmet, originally decorated at its apex with a plume, recalls early fourteenth-century stucco work in Īl-Khānid in Iran, rather than the International Timurid foliate or floral style fashionable in the late fifteenth century. The nose-piece is missing.

The helmet bears two inscriptions in handsome, rounded script. The upper one, placed between thin, lobed bands filled with traces of scribbled Arabic, reads, "Power and good fortune, victory and favors to its owner." These are a form of the standard prayers on arms and armor and other

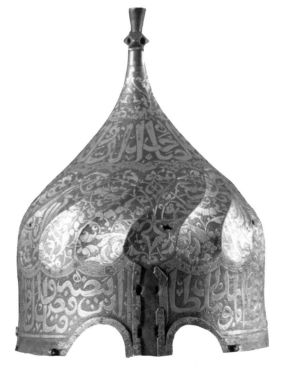

BATTLE STANDARD OF QĀ'IT BĀY

late 15th century
Egyptian, Mamluk
iron, with traces of gilding
length 225 (88⅝)
inscribed: ᶜIzz li-mawlānā al-Sulṭān al-Malik al-Ashraf, Qā'it Bāy

Askeri Müze, Istanbul

The forged, tonguelike blade, with cast gaping dragons' mouths below, has a spine or midrib with fretwork panels on either side, decorated variously with half-lozenges, half-circles, and curved leaves. Below is a lobed cartouche, across which is engraved the royal dedication: "Glory to His Majesty, al-Malik al-Ashraf, Qā'it Bāy." Both sides are inscribed in the name of the Mamluk Sultan of Egypt and Syria, Qā'it Bāy (r. 1472–1496).

These standards (ᶜalam) were evidently given out to the commanders of units on Mamluk military campaigns. A standard and a drum were also ceremonially presented to a Mamluk at manumission on the completion of his training, a ceremony comparable to the commissioning of an officer. The original appearance of these standards is difficult to reconstruct but, assuming they resembled Ottoman battle standards (tuğ), they would have been decorated with pennons, textile streamers, or animal hair. J.M.R.

BATTLE-STANDARD OF QĀ'IT BĀY

late 15th century
Egyptian, Mamluk
gilt steel with openwork
length
inscribed: (on one side) ᶜIzz li-mawlānā al-Sulṭān al-Malik; *(on the other side)* al-Ashraf, Abu'l-Naṣr Qā'it Bāy ᶜazza naṣruh

Topkapı Sarayı Müzesi, Istanbul

Like cat. 85, this standard is inscribed with the device of Qā'it Bāy, Mamluk Sultan of Egypt and Syria (r. 1472–1496): "Glory to His Majesty, al-Malik al-Ashraf, Qā'it Bāy, may his victory be glorious." The cast base is faceted, with a broad band of gilding, a pierced knop, and flattened dragons' necks, the heads of which appear to be biting the blade. The blade is flat with a recessed spine, semi-circular in profile. At the top are leaflike panels first pierced and then with gilt decoration. Below are two swordlike leaves, filled with tight scroll work, probably stencilled, of chinoiserie lotuses with a triangular indentation at mid-height and with two pierced pointed heptagons. Below is an eight-lobed rosette with a bar that contains the inscriptions held as though in a stand. J.M.R.

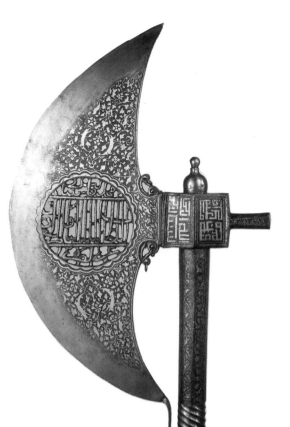

88

CEREMONIAL SCIMITAR OF MEHMED II THE CONQUEROR

*blade possibly late 15th century, hilt and quillons
possibly 16th century
Turkish, Ottoman
steel, gold, walrus ivory, with damascening
length 126 (49⅝); blade 106 (41¾)
inscribed: Sulṭān al-ghuzāh wa'l-mujāhidin and sayf
Allāh al-maslūl li'l-jihād
references: Yücel 1988, 106, no. 87*

Topkapı Sarayı Müzesi, Istanbul

The exceptionally long blade of this ceremonial scimitar (*yatagan*) is grooved and encrusted on the obverse in gold. A fine *thuluth* two-line inscription offers prayers for the victory of Mehmed the Conqueror, describing him as "Sultan of warriors for the faith" and his weapon as "the Sword of God unsheathed in the Jihad." His genealogy, going back to Sultan ᶜOsman, the legendary founder of the Ottoman dynasty, is also inscribed. The sword bears neither date nor craftsman's signature. The hilt and quillons could well be sixteenth-century replacements, as it was standard practice for later sultans to refurbish the swords of their famous ancestors. J.M.R.

87

BATTLE AXE

*late 15th century
Egyptian, Mamluk
iron damascened with gold
length 98.6 (38⅞); axe head 30.5 x 20.5 (12 x 8⅛)
inscribed: (on socket) in square Kufic formulae,
inter alia, Muḥammad (four times), al-ḥamdu
li'llāh (twice)
references: Munich 1910, no. 530, pl. 244*

Kunsthistorisches Museum, Vienna, Hofjagd und Rüstkammer

The axe bears the name and titles of the Mamluk Sultan al-Malik al-Nāṣir Abu'l-Saᶜāda Muḥammad (r. 1495–1498), son of Qā'it Bāy, and prayers for his victory in the usual late Mamluk heraldic form (*Schriftwappen*). It must have been Ottoman booty from the arsenal at Alexandria, sacked by Selim I (r. 1512–1520) on his conquest of Egypt in 1516. The square Kufic inscriptions read "Muhammad, Praise be to God." It evidently fell into Hapsburg hands after one of the defeats of the Ottoman armies by central European powers in the late seventeenth century. The shaft and the surface of the blade are richly ornamented with arabesques in gold. The shaft is partly faceted and partly fluted to give a better grip; however, the weapon may well have had a ceremonial rather than a practical purpose. J.M.R.

89

CEREMONIAL SCIMITAR OF HERSEKZADE AHMED

*court workshops of Bayazid II or Selim I,
c. 1500–1517
Turkish, Ottoman
inlaid with gold, silver, and rubies
length 81.2 (32); blade 67.8 (26⅝)
inscribed: (on spine) Rustam-i ᶜaṣr, yāre-i ᶜaskar,
Iskandar-i begān . . . Aḥmed b. Hersek Ḫān
references: Encyclopedia of Islam, 1960–,
"Hersekzade Ahmed"; Ettinghausen 1983, 208–222;
Uzunçarşılı 1986, 23–76; London 1988, no. 83;
Rogers 1988, 12–17; Melbourne 1990, no. 50;
Alexander and Kalus, forthcoming*

Collection Rifaat Sheik El-Ard

The long, inward-curving blade of this ceremonial scimitar (*yatagan*) is inlaid in gold on either side below the hilt, with a scaly dragon and phoenix locked in combat amid chinoiserie flowers. The monsters, forged separately and secured by pins to the blade, are depicted differently on each side. The teeth of the dragon are silver and the eyes of the animals are set with tiny rubies. The monsters and the foliage are gilded. The scimitar embodies a variety of virtuoso techniques, possibly requiring the separate skills of a swordsmith (*kılıçcı*),

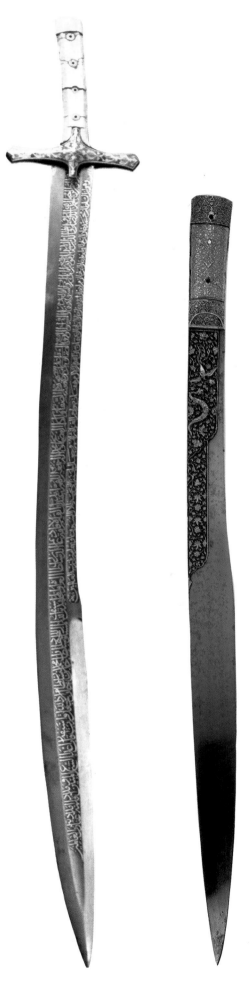

a damascener (*zerneşancı*), an inlayer in metal (*kuftekâr*), an inlayer in ivory or other precious materials (*hakkak*), a jeweler (*kuyumcu*), and a goldsmith (*zerger*).

Along the spine of the blade are four inscriptions, each separated by a floret. These consist of a distych in Persian praising the quality of the sword and a series of titles, including the name of the weapon's owner, "The Rustam of the age, the aid of the armies, the Alexander of generals...." This was Hersekzade Ahmed (1456–1517) (*Encyclopedia of Islam, 1960–*), who distinguished himself under Mehmed II, then served under Bayazid II and Selim I as commander-in-chief of Anatolia (*Anadolu Beğlerbeği*), admiral of the fleet (*Kapudan-i Derya*), and grand vizier.

The eulogistic inscriptions are appropriate for a great general (which would not exclude a grand vizier) but not for a naval commander. Although Ahmed was evidently a great administrator and politician, his success as a general was rather indifferent. A younger son of the Grand Duke of Herzegovina, he arrived in Istanbul in 1472. He was standard bearer (*mir-i ᶜalam*) on Mehmed II's Albanian campaign of 1478. In 1481 he married a daughter of Bayazid II, Hundi Hatun, and was appointed provincial governor (*sancakbeğ— subaşı* in the sources, however) of Bursa and then *beğlerbeğ* or commander-in-chief of Anatolia, in which capacity he led Bayazid's army in July 1483 against Bayazid's brother Cem Sultan (see cat. 91). In the spring of 1486 he commanded an expedition toward Karaman and Syria, but was captured and imprisoned in Cairo. On his release and return to Turkey he was made a vizier and Admiral of the Fleet (*Kapudan Paşa/Kapudan-i Derya*). In August 1488 the fleet was almost entirely destroyed at Aga Çayırı, but he was reappointed *beğlerbeğ* of Anatolia in the autumn of 1489 and commanded an expedition to Kayseri. It was not a great victory but at least he was not defeated. In 1497–1498 he was grand vizier, but was dismissed and reappointed admiral, capturing Lepanto in 1499. He was grand vizier from late in 1502 to 1506, and from 1512 to October 1514, taking part in Selim I's Çaldıran campaign. His dismissal so soon after the battle suggests that his performance cannot entirely have satisfied the sultan. However, in 1515–1516 he was again, briefly, grand vizier. At the time of Selim's Egyptian campaign he was governor (*muhafiz*) of Bursa. He traveled to Egypt to congratulate Selim and died on the way back, old and with many honors, in July 1517.

This somewhat checkered career suggests therefore, that certainly up to 1500, a splendid presentation sword with such grand titulature would have been wholly inappropriate for Hersekzade Ahmed. It would most appropriately have been awarded in 1517 on his congratulatory visit to Selim, who at the height of his glory could have recognized Hersekzade Ahmed as the architect of his Egyptian triumph. Such presentation swords

may have been customary; the close parallels to the sword made by Ahmed Tekelü in 1526–1527 for Süleyman the Magnificent suggest a workshop in continuous production over the course of several decades, and even the participation of Ahmed Tekelü himself, although Hersekzade Ahmed's sword is not signed. Ahmed Tekelü, however, may well have been an outsider. He is listed in the palace registers only once (Topkapi Saray Archives D. 9605; Uzunçarşılı 1986), yet his reward, 3000 *akçe* and a medallion brocade robe of honor, far outweighs any given to other specialist craftsmen.

Although the *yatagan* was not a Turkish invention it was adopted by the Turks at an early date: A Tang painting, probably ninth century (National Palace Museum, Taibei; Ettinghausen 1963, 208–222), depicts a Turkish chieftain girt with a long *yatagan*-like knife. This *yatagan* and one other (private collection), inscribed with the name and titles of the Ottoman Sultan Bayazid II (r. 1481–1512), are the earliest surviving Islamic examples of this type of weapon. Ahmed's sword can be dated by its hilt, which is of the style commonly found on Ottoman swords and sabers of the fifteenth century (see Alexander and Kalus and especially Alexander in Melbourne 1990).

J.M.R.

90

CALLIGRAPHIC SCROLL

c. 1457–1458, or later
Turkish, Ottoman
ink and color on paper
page 41 x 25 (16⅛ x 9⅞); total length 1,640 (645⅝)
references: Istanbul 1983, 3:E10; Richard 1989, 89–93

Topkapı Sarayı Müzesi, Istanbul

Calligraphed partly length-wise and partly across the width, this scroll appears to contain a random collection of text fragments, all dedicated to Mehmed II (r. 1451–1481). The texts are virtually all Arabic—Koranic *āyas*, prayers (*duᶜā*), or *hadīth*. The illuminated heading, in blue with gold chinoiserie lotus-scrolls, is characteristic of work from contemporary Shiraz. It originally had a crescent finial. The dedication follows in a pointed oval with grand *thuluth* in gold on blue. At the end of the scroll are panels of assorted scripts (*thuluth*, *taᶜlīq*, and *nastaᶜlīq*) in white on a black ground with eulogies in Persian of Mehmed's saintliness (*ᶜĪsā dūst*), wise judgment (*Āṣaf rayy*), and Salomonic justice.

A long Koranic inscription written lengthwise, which ends abruptly, must be the pattern for an inscription on a building. In later Islamic cultures architectural inscriptions were almost always written out by a calligrapher to scale, and often —though not in the case of the present scroll—in full size, before being executed in stucco, paint,

stone or tilework, as the case may be. This was to establish how the lines of text would break and to ensure accuracy; the texts were generally quotations from the Koran and would have been rendered invalid by errors in transcription. The calligraphic bird and lion in this scroll are the earliest known datable examples of this type. The square Kufic panel has below it a rather curiously composed craftsman's signature in *nastaᶜlīq*, of ᶜAṭā Allāh b. Muḥammad al-Tabrīzī, one of the Persian scribes in Mehmed II's chancery, and the date 4 Rabīᶜ I 862 (19 February 1458). While this is no indication that all the contents of the scroll are the work of this scribe, he very probably composed and wrote the final panels praising Mehmed's statesmanship. The bars of *thuluth* inscription strongly suggest that the scribe was trained in one of the Timurid chanceries of Iran.

J.M.R.

91

TALISMANIC SHIRT

late 15th century
Turkish, Ottoman
white glazed cotton
length: 120 (47¼); width 133 (52⅜)
inscribed: in black, blue, red, carmine, and gold with panels containing Koranic verses, magic figures, and magic squares filled with numbers; (in the four corners of the square on right shoulder) Innā fatahnā laka: fathan mubaynan: wa naṣara Allāh laka: naṣran ᶜazīzan; (below left shoulder, in nastaᶜlīq) Cem Sulṭān: Khallada Allāh dawlatuh; wa ayyada mamlakatuh
references: Herklots 1921, 247–263; Gökyay 1976, 93–112; Istanbul 1983, 3:E25; London 1988, 175–177

Topkapı Sarayı Müzesi, Istanbul

The talismanic shirt (camè-yi feth), designed to protect the wearer in battle, appears to have been in use in the sultanates of northern India in the fifteenth and sixteenth centuries. Such shirts may have been in widespread use in later Muslim cultures, but the best known examples are Ottoman Turkish, from the later fifteenth century and onward. Many talismanic shirts are preserved in the Topkapi Saray, some of them, like this one, with the hole for the neck uncut. This shows that the shirts must have been presents that were never used.

This shirt is almost sleeveless, without an opening at the neck. It is dedicated in two places to Şehzade Cem (1459–1495), brother of Bayazid II. At the bottom right of the shirt is a short Persian horoscope in two columns stating that this victory garment (came-yi feth) was begun on 14 Dhu'l-Ḥijja 881 (30 March 1476), in the fifty-seventh minute of the fourth hour when the sun was in the nineteenth degree, and that it was completed on 16 Muḥarram 885 (29 March 1480), on the thirty-sixth minute of the twelfth hour when the sun was also in the nineteenth degree. This is a valuable indication of the time it took to make the shirt, but the name of the craftsman-astrologer is not given.

On the chest is a large panel of sixteen magic squares framed by the Surat al-Fatḥ (Koran XLVIII), the so-called Victory chapter of the Koran. Other Koranic verses used on the shirt are from Suras III-V, VII, IX, XIV, XLVIII, LIV, LXI, CX, and CXII, as well as various of the "Ninety-nine" names of God. On the right shoulder is a large blue circle with silver at the center surrounded by eight asymmetrical gold hexagons with their points inward, each forming a compartment containing numbers. The upper inscription from Koran XLVIII, 1, reads, "Verily, we have granted thee a manifest victory" in fine gold thuluth. The lower inscription reads, "Prince Cem, may God prolong his good fortune and support his territory." A similar inscription appears on the square panel immediately to the right of the neck, with an asymmetrical six-pointed star. The back is a single, enormous magic square composed of 100 x 100 boxes with thin borders of columns of figures. Numerous digits have been erased and rewritten in gold, suggesting that the squares were checked and in some cases the numbers were found to be erroneous.

Though this talismanic shirt, like many others, was intended to bring victory to the wearer, a protective effect must also have been attributed to it. Thus Hürrem Sultan, the wife of Süleyman the Magnificent, in a letter to him accompanying the gift of a talismanic shirt, asks him to wear it for her sake, stating that it is inscribed with figures and will keep away bullets. J.M.R.

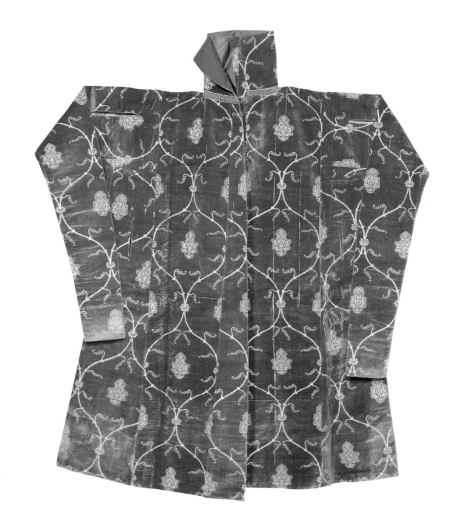

CEREMONIAL KAFTAN

c. 1500
Turkish, Ottoman
velvet with gold brocading and bouclé, with satin
and twill lining
length 142 (56); width across shoulders 86 (34);
sleeves 106 (41¾)
references: Barişta 1981, no.3; Istanbul 1983, 3:E26

Topkapı Sarayı Müzesi, Istanbul

This kaftan belonged to Şehzade Korkud (1473–1513), son of Bayazid II (r. 1481–1512). In its combination of magnificence and sobriety, it is an outstanding example of Ottoman tailoring. The Venetian velvet has a *ferronnerie*-type pattern of pointed oval medallions with tendrils and small, stylized thistles. The wide, flaring collar is characteristic of Ottoman fashion of the period. The arms are, as is usual, ornamental: the slits for the arms at the shoulders show no signs of wear, as the garment was very probably worn over the shoulders with the arms falling to the sides. Although the loops for fastening the pockets still remain, the corresponding buttons have been lost. Inside, down the back are three appliqué panels: two of palmettes in bold filigree, showing the blue satin lining beneath and hemmed in yellow silk; and a circle with an arabesque and split-palmette interlacing of deep pink on a yellow ground.

J.M.R.

93 ◈ not in exhibition

94 ◈

SOLOMON AND THE QUEEN OF SHEBA

from Sharaf al-Din Musa, known as Firdevsi Burūsevī, Süleymanname (The Solomon Romance)
before 1512
Turkish, Ottoman
332 folios, mottled cream polished paper, naskhī, autograph, mostly 39 lines sometimes in 5 columns, some pages blank, preface (2b–3a) with decorated borders bears Bayazid II's name in gold naskhī above and below
44.3 x 31 (17⅜ x 12¼)
references: Hammer-Purgstall 1836–1838, 1:276; McCown 1922; Goldschmidt 1923–1924, 217; Macler 1928; Neuss 1931; Deissmann 1933, no. 17; Wittkower 1942, 159–197; Minorsky 1958, 9–10; Kraus 1967; Miner 1967; Flemming 1968, 36–40, no. 52; Narkiss 1971; James 1981, no. 31; Bologna 1988

The Trustees of the Chester Beatty Library, Dublin

The *Süleymanname* of Firdevsi Burūsevī (Uzūn Firdevsī, b. 1453), dedicated to Bayazid II (r. 1481–1512), hence datable before 1512, even though it is incomplete, is a masterpiece of early Ottoman painting. It is executed in *naskhī* on 332 folios of mottled cream polished paper. Bayazid's name appears in gold, above and below, on the folios with decorated borders containing the preface (fols. 2b–3a). Firdevsi Burūsevī himself alleges that he drew upon *Süleymannames* written in Syriac by Luḳmān al-Ḥakīm and translated into Persian by Aflāṭun (both either apocryphal or pseudographic), as well as upon a certain unnamed work that had come his way at Niksar, to which his attention was drawn by the *shaykh* of the *tekke* of Melik Gazi Danişmend there. The text of his *Süleymanname* is in twenty books, divided into a hundred scenes or fits (*majlis*). The author states that it was originally to consist of 366 books and 1,830 fits—no such complete version is known, perhaps fortunately. The text shows, not surprisingly, considerable eclecticism—Koranic *ḳiṣaṣ* material; *ḥadīth* and sayings of the Imams; Biblical material from Genesis, Kings, and possibly the Apocrypha, drawn directly or via the Midrash scholia; the Alexander Romance; and Persian epic, that is, the heroes of Firdawsī's *Shāhnāme* from Gayūmarth to Rustam. The narrative begins with the Old Testament, with the Creation sequence and daimonomachy, but with Gayūmarth introduced as a son of Adam. There follows, as though anticipating Wagner's operatic epic, a series of wars between prophets or patriarchs and demons for possession of Solomon's ring, which allegedly preceded him by several generations. Solomon himself appears on the scene relatively late (his birth is recounted on fols. 158b–159a): thereafter his exploits are difficult to connect with the Old Testament narrative.

The splendid double frontispiece, the two sheets of which have been unbound from the manuscript and mounted separately, contains the only illustrations actually executed. On folio 1b Süleyman (Solomon) is shown as an elderly man, seated cross-legged in a domed pavilion with cylindrical side-towers and pointed turrets. To either side is a gathering of fowls, while behind the throne is a crowd of angels or peris, crowned, with wings springing from their shoulders. The moulding between the two tiers of the throne is irregularly decorated with repeating letter-forms possibly derived from Hebrew characters. Below Süleyman are six registers, the first three of which contain human figures. The turbaned figures in the first of these evidently represent Solomon's viziers. The next two registers contain supernatural figures, including animal-headed spirits (*jinns*), demons, and angels, while the last register contains what appear to be planetary figures, as well as exotic animals and other details.

Folio 2a shows the court of the Queen of Sheba (known as *Bilqīs*) flanked by angels holding the attributes of emirs (including cup, axe, sword, mace, bottle, and napkin) and female attendants. The most striking figures in this scene are the demons, thirty-six in all, many of them part animal, which stand on the next three registers, evidently the decan demons of the Egyptian Zodiac, which made their way into medieval Western astrology.

The total absence of other illustrations in the manuscript makes it difficult to interpret the double frontispiece. So crammed with detail is it that it may have been intended as a précis of the illustrations that were planned for the remainder of the manuscript. The identifiable elements, however, can be traced only to the Solomon romance ("Sulaymān b. Dā'ūd," *Encyclopaedia of Islam*), not to the *Shāhnāme* or the other works from which Firdevsi Burūsevī's poem draws. Moreover, it is difficult to explain why certain figures appear on one page rather than the other. For example, why should it be *Bilqīs* rather than Solomon who has the thirty-six decan-demons parading for her in their three rows? And if the three tiers of seated turbaned figures and crowned figures below Solomon are a sign of Solomon as King of Kings, the lowest registers on this page suggest no precise interpretation at all. It may be that the painter's principal aim was simply to fill the facing pages in a roughly symmetrical way.

The most intriguing figures in the frontispiece are, of course, the *jinns* and demons. The principal Muslim source for the natural history of *jinns* is the *ʿAjāʾib al-Makhlūqāt* of Zakāriyyā Qazvīnī, the earliest known copy of which, dated 1279–1280 (Bayerische Staatsbibliothek, Munich, Cod. ar. 464), depicts the various sorts of *jinn*. Some of the fourteenth-century manuscripts contain *jinn* features that are western European in origin (Bibliothèque Nationale, Paris, supp. pers. 332, 1388), though the demon pictures in general differ markedly from those in the small number of illustrated magical manuscripts recorded, notably the Seljuk Turkish *Kitāb Daqāʾiq al-Ḥaqāʾiq* of Nāṣir al-Dīn Siwāsī (Bibliothèque Nationale, Paris, pers. 174, dated 1271). The demons of Firdevsi Burūsevī's *Süleymanname* are, however, not in the *ʿAjāʾib al-Makhlūqāt* tradition at all. The demon with its head beneath its shoulders, for example, is the *akephalos daimon* of the *Testamentum Salomonis* (though going back, of course, as far as Herodotus; compare Pauly-Wissowa XXII c. 2346); while the enormous ears of other demons depend ultimately on Indian demonology, where the Karnapravarana (literally, "people who cover themselves with their ears") of the Mahābhārata, who were taken to typify the barbarian tribes of the epic period in India, are widely represented in medieval manuscripts of such texts as the *Speculum Historiale* of Vincent de Beauvais or the *Alexander Romance*. The musculature of the demons' stomachs, moreover, recalls the concentric ovals of Byzantine or Romanesque drapery and limbs.

Dog-headed demons, *cynocephaloi*, are also conspicuous: these spread from a Greek tradition

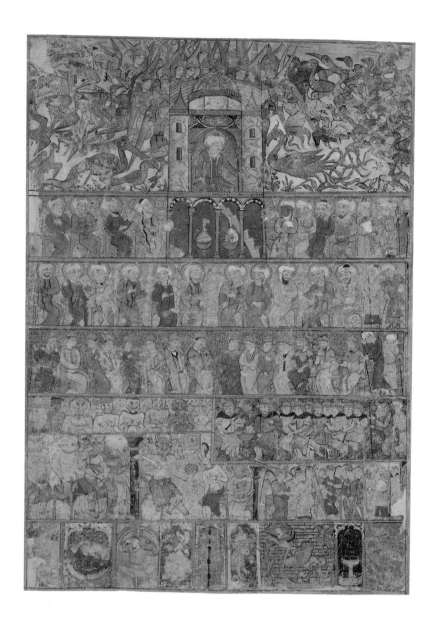

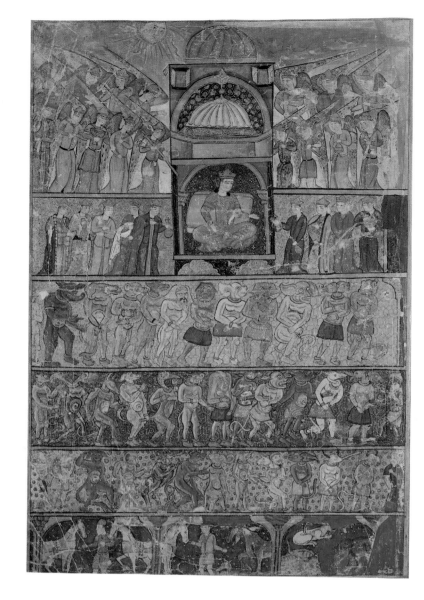

via Roman maps and possibly through Byzantine painting to the East. In the West, curiously enough, they were identified as giants, hence the common representation of Saint Christopher as a dog-head. As Wittkower has shown, the popularity of these monstrous races in Western art arose from their use as types of the pagan nations to whom the Church must preach the Gospel and, via the universally popular bestiaries, as types of virtues or vices. There is not the slightest evidence in the *Süleymanname* frontispieces of any indebtedness to Armenian demonology or magical texts.

Compositions showing figures arranged in successive tiers are practically unknown in Islam and many of the figures certainly presuppose Western sources; nevertheless, the tiered composition is also uncommon in medieval European manuscripts. The known examples fall into three groups. Two of these are too early on to have figured as direct sources for our *Süleymanname*: the early encyclopaedia of Hrabanus Maurus (for

example, MS Monte Cassino cod. 132, f. 16b, Italian, c. 1063) and Catalan manuscripts of the commentary of Beatus of Liébana on the Apocalypse (for example, that executed for Ferdinand I of Castile and Leon in 1047, Biblioteca Nacional, Madrid, MS Vit. 14–2, with a double page showing the Adoration of the Lamb) (Bologna 1988, 27); and still earlier medieval English or French manuscripts (for example, a copy of Saint Augustine's *De civitate Dei*, probably Canterbury and c. 1120, where the City of God is shown as an edifice with Christ in a *mandorla* and rows of angel-musicians, saints, and martyrs below, Biblioteca Medicea Laurenziana, Florence, MS Plut. 12.17, f. 2b) (Bologna 1988, 94), and a drawing by Ingelard, c. 1030–1060, showing the celestial hierarchies (Bibliothèque Nationale, Paris, MS Lat. 11751, f. 59b) (Miner 1967, 87–108).

The third group of Western manuscripts is, however, much more promising as a source; most of the works in this group are Southern Spanish and mostly with strong Sephardic Jewish connec-

tions. The "Golden Haggadah" (British Library, MS Add. 27210, compare Narkiss 1971) made, probably, in Barcelona c. 1320–1325, is not particularly similar in detail to our composition, but both it and a "Hispano-Moresque" Haggadah of c. 1310–1320 (British Library, MS Or. 27–37) are remarkably archaizing in style and hark back to Catalan manuscript painting of the tenth-eleventh centuries and the style of the Beatus Apocalypses. Directly comparable, however, are a historical manuscript of the fourteenth century from Castile, *Crónica de los reyes de Judea e de los gentiles* (Biblioteca Nacional, Madrid, MS. 7415) (Bologna 1988, 27), with kings shown enthroned in Gothic aedicules; and the Bible of the House of Alba (Palacio de Liria, Madrid, vit. 1), a translation from Hebrew into Spanish by Rabbi Moses de Arragel of Guadalajara, made for Luis de Guzmán, 25th Master of the Order of Calatrava, Toledo, 1422–1430 (Bologna 1988, 140). This manuscript shows a knightly figure enthroned in an elaborate Gothic aedicule with a hemispherical ribbed dome, and

below, in rows, the works of corporeal mercy alternating with figures of Dominicans, Franciscans, and members of the Order of Calatrava.

These Spanish manuscripts with their Sephardic connections harmonize strikingly with the elements from the *Testamentum Salomonis* and from the Jewish Midrash incorporated into the *Süleymanname* frontispieces; and the transmission could well be the result of the diaspora of manuscripts brought by Jewish scholars to Salonike and Istanbul from Granada after its fall to Ferdinand and Isabella in 1492.　　J.M.R.

95 ❧

BASIN

late 15th century
Egyptian, Mamluk
brass, inlaid with gold, silver, and black composition
rim diameter 36.2 (14¼); height 16 (6⅜)
inscribed: ᶜIzz li-mawlānā al-Sulṭān: al-Malik al-Ashraf Abu'l-Naṣr Qā'it Bāy ᶜazza naṣruh
references: Munich 1910, no. 3554 and pl. 158; Kühnel 1950; Ettinghausen 1967; Melikian-Chirvani 1969

Türk ve İslam Eserleri Müzesi, Istanbul

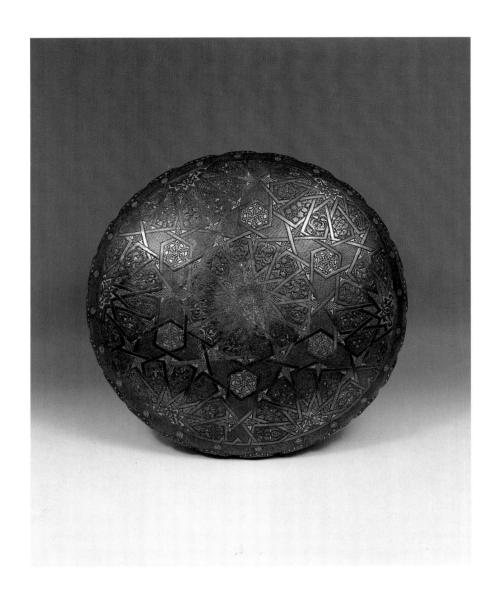

The outer sides of this celebrated basin are decorated with four bold, repeated, and blazoned *ṭūmār* inscriptions—"Glory to His Majesty, al-Malik al-Ashraf the victorious Qā'it Bāy, may his victory be glorious"—on a spiral scroll ground broken into two and repeated, broken by circular three-field inscription blazons with the same inscription. Between the inscriptions are complex knots on a dense arabesque ground with elongated split palmettes. At the rim is a band of chinoiserie lotus scroll typical of manuscript illumination during the reign of Qā'it Bāy, Mamluk Sultan of Egypt (r. 1472–1496). Above the base are beaten arcs, filled with minute meanders and y-shaped motifs and broken by small circles. The base is shaped as a roundel with a design of star-polygons, and other star patterns. It is one of the finest known examples of the so-called Mamluk *Kassettenstil* (angular interlacing ornament), which is otherwise more typical of stone and paneled woodwork of the period. The polygons are filled with arabesques, stylized chinoiserie lotus blossoms, and knot patterns. The basin's interior has the remains of lavish arabesques in silver.

Certain features of the decoration point to a deliberate revival of the fine inlaid Mosuli and Mamluk metalwork of the late thirteenth and early fourteenth centuries, particularly the chasing of the silver inlay, which stands proud of the surface, and the use of two highly unusual motifs for later fifteenth-century Egypt: pairs of back-

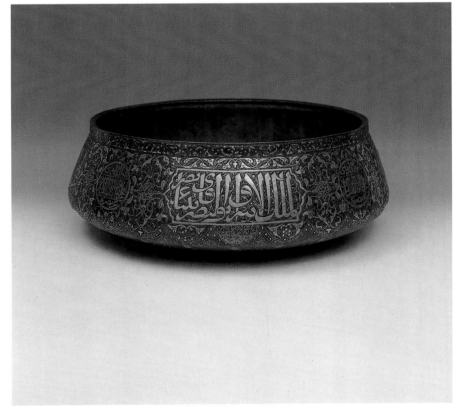

to-back ducks and a minute, undulating design. These features distinguish the piece, in both style and quality, from other Mamluk works in metal with star-polygon strapwork on their bases. It is also difficult to find parallels for the basin's other decoration in brasswork made for Qāʾit Bāy or in wares made for the Italian market. J.M.R.

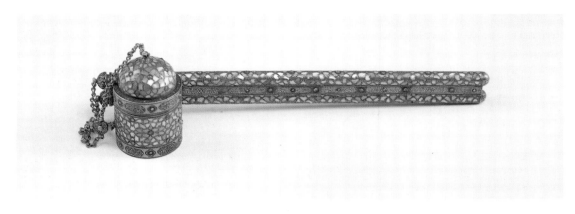

96 ❧

COLLECTED POEMS OF AMIR HIDAYATALLAH (HIDAYAT)

1478
Iranian, Aqqoyunlu Turcoman
73 folios, in Azeri Turkish, nastaᶜlīq on cream, semi-polished, gold-sprinkled paper, 2 columns of 11 lines; with a binding of contemporary brown stamped leather with filigree doublures over gold and blue
folio 17.5 x 12.7 (6⁷⁄₈ x 5); written surface 11 x 6.8 (4³⁄₈ x 2⁵⁄₈)

The Trustees of the Chester Beatty Library, Dublin, MS 401, fol. 70b

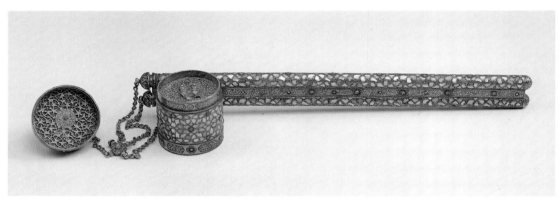

The Aqqoyunlu ruler Khalīl Sultan, son of Uzūn Ḥasan, to whom this volume is dedicated on the frontispiece (folios 1b–2a), was killed in a battle with his brother Yaᶜqūb Beg after a reign of only seven months. The manuscript has no colophon and was evidently left unfinished on the sultan's death.

The manuscript has a fine illuminated double-page frontispiece (folios 1b–2b) and opening text page (folio 2b). The four miniatures, in the finest

Turcoman Court style, are only vaguely related to the text of the poems and show a princely figure in a variety of pursuits: drinking by a stream (folio 3b); mounted with a falconer and shield-bearer (folio 19b); seated on a balcony (folio 38b); and drinking in an arbor (folio 70b). One or more of the images may be intended as portraits of Khalīl Sultan. J.M.R.

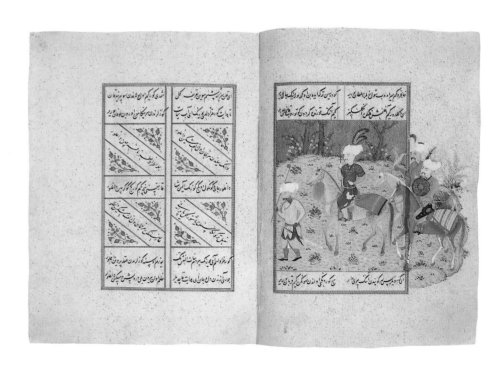

97 ❧

PEN CASE WITH INKWELL

c. 1500
Iranian, Aqqoyunlu Turcoman or Ottoman Turkey gold, silver, mother-of-pearl, turquoise, rubies, and amethysts
length 25 (9⁴⁄₅)
references: Menavino 1551, 121, 132–133; London 1982, 17–33; Uzunçarşılı 1986, 23–76; Köseoğlu 1987, no. 110

Topkapı Sarayı Müzesi, Istanbul

The minuteness, variety, and complexity of its workmanship make this pen case a masterpiece of the goldsmith's art. The two barrels, body, and cap of the inkwell are silver openwork with finely chased and nielloed split palmettes; the openwork supports a mosaic of mother-of-pearl, sliced turquoise (*firuzekâri*), rubies, and amethysts.

The gold stoppers of the pen case and the cover of the inkwell are attached by golden chains. This flat gold cover has a circular hole in the center with a lid attached to two small hinged bars of reddish gold with *champlevé* floral ornament. To judge from the bottom of the inkwell, the underlay of both it and the cover is silver with minute floret-scrolls strongly reminiscent of early sixteenth-century Ottoman illumination. The lid is decorated similarly on both sides with minute chinoiserie florets, each embossed with a tiny turquoise at the center. The cover has densely scrolling, heavily chased gold arabesques on a nielloed ground. The caps closing the barrels are

of gold with minutely chased arabesques on a nielloed ground, both originally embossed with a turquoise nipple. Along the bar that joins the two barrels at the base and on the body of the inkwell are inscribed verses in a fine rounded script.

The case bears no craftsman's name. The extensive use of nielloed gold suggests comparison with the zinc flask from Topkapi (cat. 98), which may confidently be assigned to Tabriz, around 1500, but certain features, like the finely worked silver cloisons of the openwork, recall traditions from farther East, for example the court of Ḥusayn Bayqara (r. 1470–1506) at Herat, even though the details of the floral ornament make it most probable that the place of manufacture was Istanbul. If crafted in Istanbul, the pen case must certainly have been the work of one of Bayazid II's so-called "Persian" (ᶜAcem) goldsmiths, whose work is described by Menavino, a slave in the Topkapi Saray for some years. In some later lists of palace craftsmen, these goldsmiths are stated to have been recruited in Tabriz in the 1480s. The verse cartouches by an unidentified author, in Persian but not easily legible, may well be the work of the patron who commissioned this pen case or perhaps the patron of a prototype from which this one was copied. This leaves the attribution wide open, however, for Ḥusayn Bayqara, the Safavid Shah Ismāᶜīl I, and Bayazid II's brother, Cem Sultan, were all noted poets, and their collected works survive in several versions. Identification of the patron must, therefore, await the decipherment of the verses. J.M.R.

98–99 ॐ

FLASK AND CUP

c. 1500
Iranian, Aqqoyunlu Turcoman
cast zinc, gold, turquoise, rubies, and (cup only) emeralds
cup height 4.3 (1¾); rim diameter 14.6 (5¾)
flask height 52 (20½); diameter 21 (8¼)
references: Köseoğlu 1987, no. 74 (cup), and no. 75 (flask)

Topkapı Sarayı Müzesi, Istanbul

The cup and the accompanying flask were very probably booty from Selim I's sack of Tabriz following his victory over the Safavid ruler, Ismāᶜīl I, at Çaldīran in 1514. The polished interior of the cup, with thin openwork gold plaques laid over a matt ground and encrusted with precious stones, is spectacular enough, but the workmanship of the exterior is even more virtuoso. The inlay consists of openwork gold panels, six lobed pointed ovals, and six oblong cartouches. The former are deco-

rated with seated drinkers or winged peris, the latter with pairs of animals, in silhouette but worked in relief, with heavy chasing emphasized by niello or black paste. At the rim and base are half-cartouches filled with peris and chinoiserie phoenixes.

The ground is of flowering Prunus branches inlaid in gold with flying birds, the blossoms inlaid with tiny emeralds and turquoises in now mostly missing claw mounts. The minuteness of the work and the extraordinary contrast between interior and exterior show the piece to be of the highest quality. Such vessels are represented in faithful detail in Aqqoyunlu and early Safavid paintings from Tabriz.

The convex cover and stopper of the drinking flask are both gold and finely engraved with arabesques on a nielloed ground. The neck is plated with beaten gold, with relief decoration enhanced with niello on a ring-punched ground and encrusted with turquoise and rubies in claw

settings. Below, the zinc shoulders are worked in relief, with panels filled with phoenixes and other animals, alone or in combat on ring-punched grounds, and encrusted with turquoise and emeralds, though many of the latter are missing.

The shoulders on the narrow sides of the flask are covered with openwork gold panels encrusted with turquoise and rubies with dragons, over a matt ground. On the broader sides the gold overlay is of oblong panels of finely chased arabesque on a nielloed ground. Similar plaques, also encrusted with turquoise and rubies, fill the narrower sides at mid-height. Below these are openwork gold panels with dragons and phoenixes, on a bluish ground and encrusted with turquoise and rubies. On the flattened sides are large pointed oval gold medallions with finely chased arabesque on a nielloed ground, similarly encrusted. At the foot are half-cartouches in gold.

The use of zinc for drinking vessels is at first surprising. There is little evidence for its use in

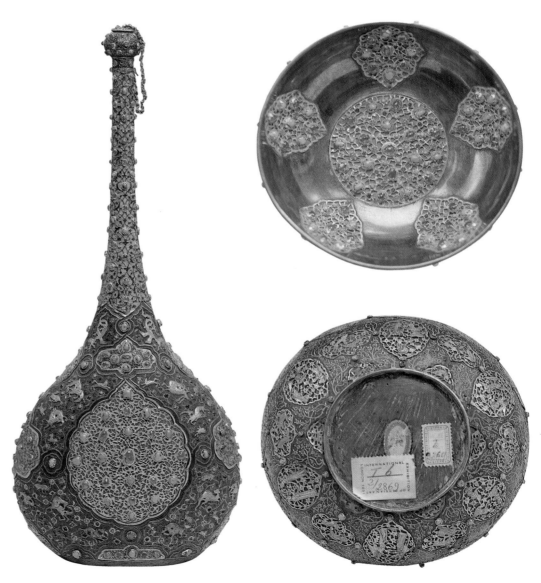

other Islamic cultures, nor can any particular astrological or medical value be attributed to the metal. A possible explanation is that since vessels of gold and silver were as forbidden in Islam as wine, pietistic concern to avoid sin on too many fronts favored crafting such luxurious specimens from a base metal, so that it could at least be argued that the vessels were "not really" gold.

J.M.R.

100 🐁

PROCESSION SHOWING THE TRANSPORT OF CHINESE BLUE AND WHITE PORCELAIN

c. 1470–1480
Iranian, Aqqoyunlu Turcoman
scroll fragment, gouache on silk
25 x 48 (9⅞ x 18⅞)
references: Yörukan 1965, 188–199;
Medley 1985, 157–159

Topkapı Sarayı Müzesi, Istanbul

The fragment is one of a group of images from album H.2153, all of different formats, representing a wedding procession. The porcelains are evidently part of the bride's dowry and probably meant to represent heirlooms rather than pieces of contemporary manufacture.

The taste of the Middle East had long remained fixated on blue and white Chinese porcelains of the Yuan and early Ming periods, to the extent that by the late fifteenth century the Jindezhen kilns found it profitable to manufacture copies of these for export to the Islamic world. The most striking feature of the porcelains shown here is not their quantity but the predominance of large covered jars, of a size and type that are difficult to parallel among extant pieces. These scroll fragments appear to illustrate a narrative recording the marriage procession of a Chinese princess sent off to marry a barbarian ruler on the north-western frontiers of China, an occurrence frequent enough in Chinese history to make it pointless to try to identify the present scene specifically. The miniatures were probably executed for the Aqqoyunlu court at Tabriz, and the artist would have

been far less familiar with the narrative than with the gifts of porcelains brought back overland from China by Muslim embassies to the Ming emperors on their return journey from Beijing.

The exaggerated contrapposto stances of some of the figures, though paralleled in popular Chinese woodcuts of the sixteenth and seventeenth centuries, are also highly characteristic of figure-painting at the Aqqoyunlu court at Tabriz under Uzūn Ḥasan (d. 1478) and Ya'qūb Beg (d. 1490), particularly in the style of the painter Shaykhi al-Ya-qūbi. The present scroll fragment bears no attribution, but a reversed repeat of a servant holding a bowl in another album in the Topkapi Saray Library (H.2160, fol. 89a) bears an attribution to Mehmed Siyah Qalem.

J.M.R.

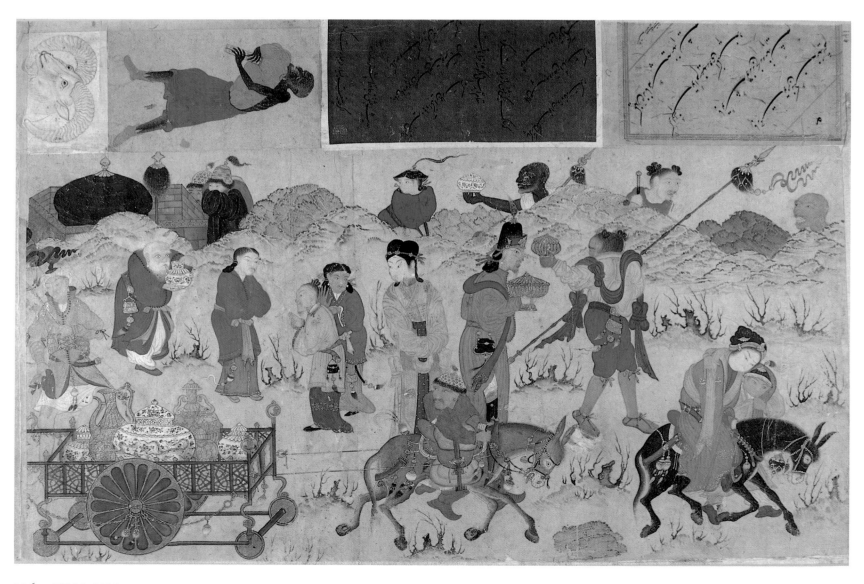

101

DISH WITH BRACKETED RIM

mid-14th century
Chinese, Yuan period
porcelain
diameter 46 (18⅛)
references: Washington 1966, no. 277; Krahl and
Erbahar 1986, 490, no. 553

Topkapı Sarayı Müzesi, Istanbul

White on blue designs decorate this dish, which is part of the celebrated collection of Chinese porcelains begun by the Ottomans in the fifteenth century. Its base — marked by a firing crack — is designed in concentric circles. The outermost circle consists of eighteen petal panels filled alternately with flaming pearls and a variety of auspicious objects — *lingzhi* mushrooms, conch shells, lozenges, bell, rhinoceros horn cups, and cash. Inside these panels are four *ruyi* panels on a wave ground enclosing chrysanthemum sprays. At the center is a single chrysanthemum blossom enclosed by six petal panels with flaming pearls.

The cavetto is filled with a peony scroll and the flat rim bears crested waves. On the reverse of the cavetto is a lotus scroll. The petal-panel motif may be an adaptation of the Arabic latters *lām* and *alif* with serifs joined above, which could indicate a Chinese response to demand from Middle Eastern markets. It is more likely derived from the lobed panels of fine Chinese metalwork of earlier periods, though, since the indiscriminate mixture of Buddhist and Daoist motifs enclosed by the petal panels scarcely points to a clearly focused Muslim market. J.M.R.

102

DISH

c. 1480
Turkish, Iznik, Ottoman
underglaze-painted fritware
diameter 44.5 (17½)
references: Ünver 1958; Raby and Atasoy 1989,
76–81, figs. 57 and 279

Gemeentesmuseum, The Hague

By 1400, Chinese blue and white porcelains were being widely imitated in the lands of Islam, and Yuan and early Ming prototypes remained in fashion for many decades thereafter. Apart from mass-produced imitations — many of which were crafted in named workshops in Mamluk Egypt that were active over several generations — little is known of where these early works were made. Tabriz may well have been an important market or kiln site in the fifteenth century.

Although evidence now suggests that much finer, almost convincing copies of early Ming blue

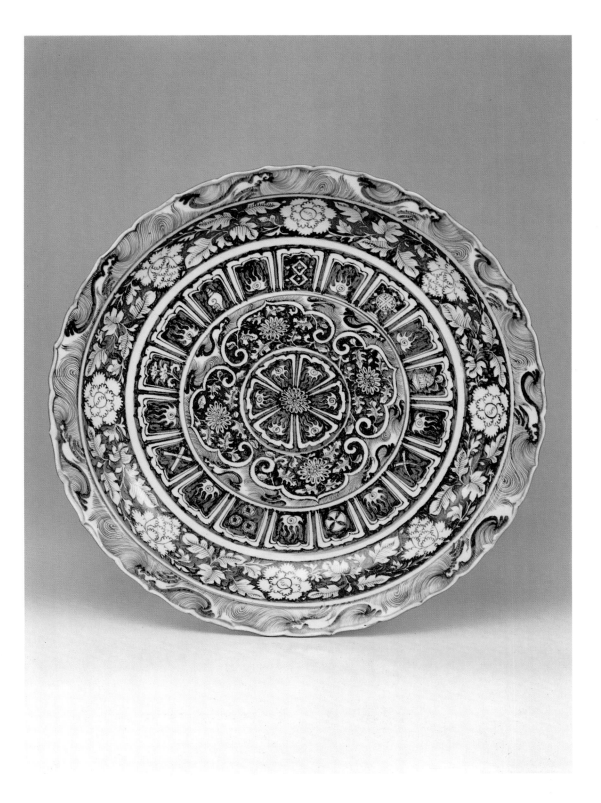

and white vessels were manufactured in late fifteenth-century Egypt, in general these craftsmen could not duplicate the Chinese process. They had no access to the porcelain-stone that produced the characteristic, much admired body of Chinese porcelains, and their kilns fired at far too low a temperature. The bodies are all silicon-enriched, making early blue and white wares from Muslim potteries rather breakable and generally small in size. The characteristic glaze was alkaline, a mixture of soda and lime.

In the Ottoman town of Iznik, however, revolutionary technologies made it possible to fire kilns at higher temperatures. Iznik ware was produced in an unparalleled range of shapes and in larger sizes than earlier Islamic ceramics.

This impressive dish, which compares in size with Chinese Yuan blue and white porcelain dishes (cat. 101), may owe its decoration in reserve to such a source, but is not markedly Chinese in shape. The arabesque interlace at the center is, moreover, adapted from the prints of

small silver-gilt Ottoman drinking bowls of the late fifteenth century.

The most important innovation, however, is the use of the chinoiserie lotus-scrolls on the flat rim as well as on the cavetto and on the ground of the center. Julian Raby (Raby and Atasoy 1989, 76–81) has traced this motif to drawings in an album, F1423, in the Istanbul University Library. This material is mostly datable to the reign of Mehmed II and has been tenuously associated with Baba Nakkaş, a high Janissary officer whose career continued under Bayazid II.

Baba Nakkaş served as one of the inspectors of the accounts (mu^ctemeds) for the building of Bayazid's mosque in Istanbul. He founded mosques of his own as well, the Dizdariye Camii in Istanbul and one at Çatalca in Thrace. Since Imperial decrees issued for him use the sobriquet nakkaş, meaning painter or decorator, it is possible that he could have also been a court painter who adapted the album drawings to this blue and white vessel.

J.M.R.

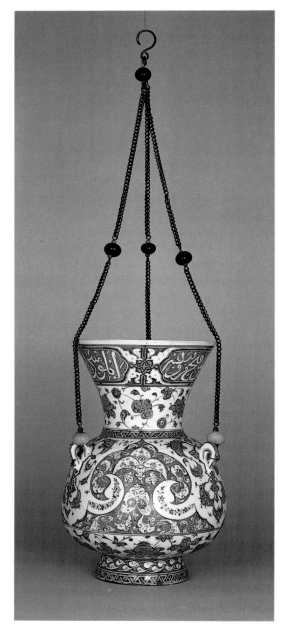

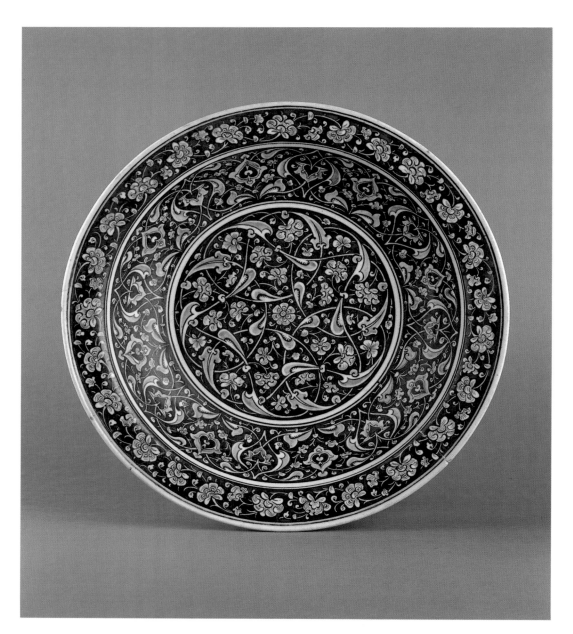

103 ❧

MOSQUE LAMP

c. 1505
Turkish, Iznik, Ottoman
underglaze-painted fritware
height 28.5 (11¼)
inscribed: (on the rim) Koran LXI, 13; yā
Muḥammad; Allāh, Muḥammad, ʿAlī
references: Meriç 1957, 7–76; Unal 1969, 74–111;
London 1976, no. 409; Frankfurt-am-Main 1985,
no. 7, 2; London 1988, no. 130; Raby and Atasoy
1989, no. 89

The Trustees of the British Museum, London

At the rim of this mosque lamp are three oblong panels separated by a knotted pseudo-Kufic motif with stenciled inscriptions in naive naskhī: part

of Koran LXI, 13; *yā Muḥammad*; and *Allāh, Muḥammad, ᶜAlī*.

This lamp and another from the mausoleum of Bayazid II (Çinili Köşk, Istanbul, 41/1) with similar inscriptions and some similar motifs have been dated to the reign of Selim I, 1512–1520 (Raby and Atasoy 1989, 94). An earlier date is however likely; in fact the lamps were most probably made for Bayazid's mosque, which was inaugurated in 1506. An entry dated 10 Şaᶜbān 910 (17 January 1505) in the palace registers of miscellaneous disbursements (Meriç 1957, no. 30) records a reward of 2000 *akçe* to a certain Mehmed Izniki, *ki ḳandīl āverd* "who brought lamps." Izniki must refer not merely to Mehmed's place of origin but to his trade, a maker of Iznik blue and white pottery (*çini-i Iznik*).

The extraordinarily varied profiles of the fourteen or so lamps associated with Bayazid II and the rich, somewhat incongruous use of decorative motifs shows that they must have been a trial order. The subsequent lack of Iznik mosque lamps until the mid-sixteenth century may indicate that the experiment was not judged particularly successful. J.M.R.

This lamp—from the mosque of Bayazid II in Istanbul, which was inaugurated in 1505—has a stiff profile. Like earlier Mamluk glass mosque lamps, it is designed as a standing vessel, though with three loops at the shoulders for suspension. The flaring neck bears a repeating pseudo-Kufic inscription between cable bands. The ground is sprinkled with florets, and the ascenders and some of the other letters terminate in split palmettes. Above these letter forms are traces of a second Kufic inscription, reduced to a horizontal line broken at intervals by pairs of ascenders. The shoulders have painted flutes, and below these is a broad band of feathery lotus scroll, perhaps derived from a Chinese blue and white porcelain of the Yuan Dynasty (1260–1368), with fat tadpolelike buds. The foot, which allows no light through, is painted with an eleven-petaled star-rosette.

Two other lamps from a group associated with the mausoleum of Bayazid II (Çinili Köşk, Istanbul, 41/4 and 41/3), with different profiles but identical inscriptions and other motifs, must be by the same hand (compare Raby and Atasoy 1989, nos. 105/107). J.M.R.

105 ᘓ

FOOTED BASIN

c. 1510–1520
Turkish, Iznik, Ottoman
underglaze-painted fritware
height 23.5 (9¼); rim diameter 42.3 (16⅝)
references: London 1983, no. 106; Raby and Atasoy 1989, no. 299

The Trustees of the British Museum, London

The exterior of this basin, painted in tones of cobalt, has a band of rounded script at its rim. The inscription, though carefully executed, appears to be wholly decorative. Foliate motifs of exquisite detail embellish the interior. Their composition is crowded into too small a space, however, for an obtrusive hexagon surrounding the center which suggests that stencils used to reproduce the panels fell short, so that the inner space had to be finished by hand. At the center are half-palmettes, very possibly derived from contemporary silverwork. In addition, they are distinctly, probably deliberately, reminiscent of swimming fish on fourteenth and fifteenth-century Mamluk inlaid metalwork. J.M.R.

104 ᘓ

MOSQUE LAMP

c. 1505
Turkish, Iznik, Ottoman
underglaze-painted fritware
height 21.8 (8½); rim diameter 16.7 (6⅝)
references: Unal 1969, 74–111; London 1976, no. 408; London 1983, no. 108; Yüksel 1983; Raby and Atasoy 1989, 98–100

The Trustees of the British Museum, London

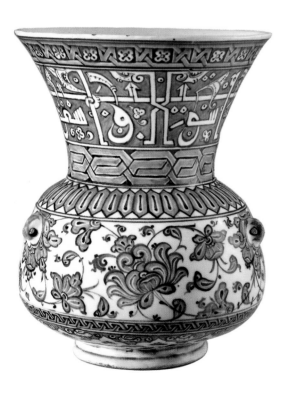

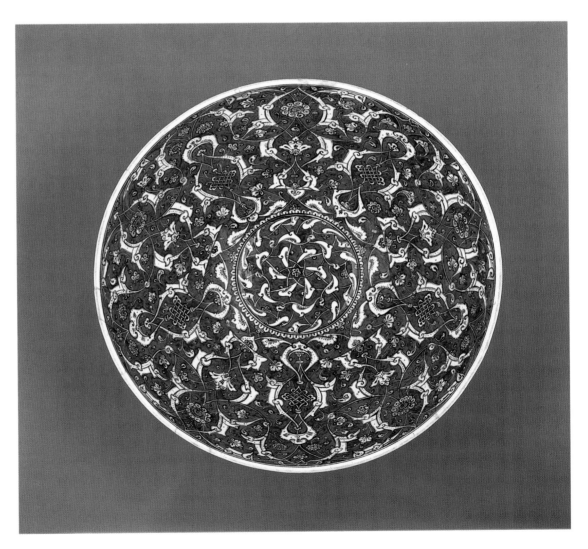

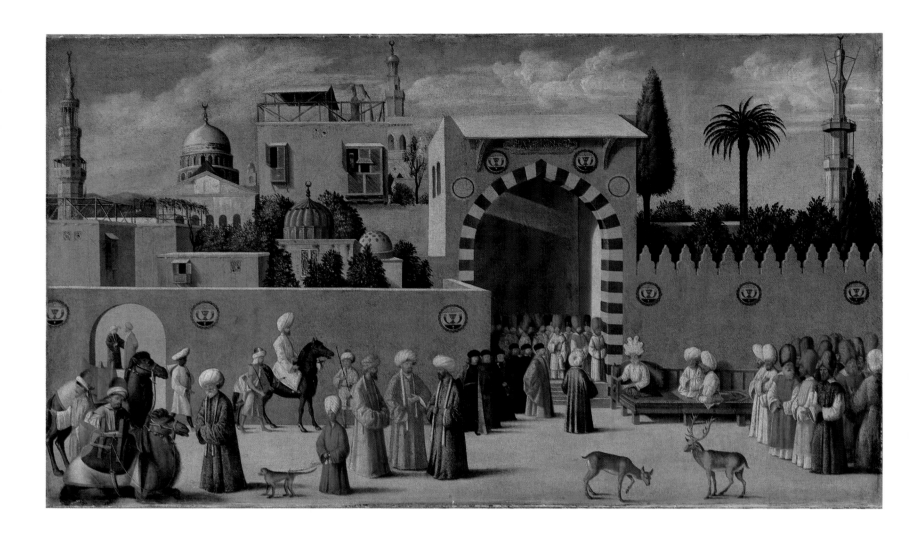

106 ❧

Circle of Gentile Bellini
Venetian

THE RECEPTION OF THE AMBASSADORS IN DAMASCUS

c. 1488–1499
oil on canvas
175 x 201 (68⅞ x 79⅛)
references: Sauvaget 1945–1946; Pallucchini 1966,
49–51; Raby 1982, 55–60, n. 51, 63, n. 86

Musée du Louvre, Paris, Département des Peintures

This painting is a landmark in Europe's visual record of the East, the earliest known attempt to represent a realistic panorama of an exotic location. The remarkable accuracy of its details makes it a valuable source for the architecture and costumes of late fifteenth-century Damascus.

The painting is divided into two registers: the upper shows the skyline of Damascus, dominated by the minarets, gable, and dome of the eighth-century Great Mosque. The lower register is a somewhat contrived juxtaposition of three scenes: on the right is a historical incident that depicts a Venetian deputation, perhaps the *bailo*, the Vene-

tian official resident in Damascus, being received by a senior Mamluk official, probably the *na'ib* or governor of Damascus. The *na'ib* is seated on a dais (*mastaba*), and his rank is confirmed by his curious "horned" turban, a type used only by the Mamluk Sultan and his top officials. The figure is flanked by members of the Mamluk military elite. The topicality of this tableau contrasts with that on the left of the picture, which is a generalized rendering of a street scene with a mounted Mamluk, armed attendant and two camel drivers with their beasts. The compositional link between the two scenes is provided by a third group which occupies the immediate central foreground. This depicts three figures in conversation, while a young boy nearby holds a monkey on a leash. A sequence of animals — camels on the left, a monkey in the center, and deer on the right — provides not only incidental interest, but also additional coherence by linking the parts of the immediate foreground.

The contrived composition of the lower register does little, however, to diminish the immediacy and realism of the painting as a whole. The city is minutely observed, even down to minor details such as the body-harness of the monkey and the Mamluk blazons on the walls. The architecture is

accurately rendered, from the wooden armatures of the brick housing of Damascus to the minarets of the Great Mosque, which are shown complete with their struts for hanging lamps; in fact, the painting provides the only extant visual record of the double tambour of the dome of the Great Mosque. The angle and distance from which the Great Mosque is depicted suggest that the painter had a view from the Venetian *fondaco*, or commercial center, which was situated to the south of the mosque (Sauvaget 1945–1946).

The identification of the setting as Damascus puts to rest a long-held belief that the painting was by Gentile Bellini and depicted the Court of Mehmed the Conqueror in Istanbul. This attribution can be traced back at least to the seventeenth century, when it was recorded by Boschini. There is no evidence that Gentile Bellini ever visited the Mamluk domains of Syria and Egypt, and the attribution is a clear example of how the legends that grew up around Gentile Bellini's visit to Istanbul influenced the understanding of almost all early European depictions of the East. It was effectively abandoned when in 1895 Charles Schefer correctly identified the setting as Mamluk rather than Ottoman.

Schefer, however, mistakenly identified the

scene as the Reception of the Venetian Ambassador Domenico Trevisano in Cairo in 1512. The choice of city was wrong, but Schefer's dating encouraged a spate of alternative attributions, as Gentile Bellini was known to have died in 1507. These have ranged from "School of Gentile Bellini" to Carpaccio, Vincenzo Catena, Antonio Badile, Vittore Belliniano, and most recently Benedetto Diana (Raby 1982, 63, n.86). None of these attributions is supported by stylistic, thematic, or circumstantial arguments that are convincing, however, and for the time being the painter must remain anonymous.

The date of the painting can no longer be fixed by reference to Gentile Bellini's visit to Istanbul in 1479–1481 nor by Trevisano's reception in Cairo in 1512. The work must, however, have been painted between 1488 and 1499. In 1488 the Mamluk Sultan Qā'it Bāy had the western minaret of the Great Mosque erected in the form in which it appears on the left of the painting, while Giovanni Mansueti's *Arrest of St. Mark* of 1499 contains numerous borrowings from the Louvre painting.

The Louvre *Reception* had a considerable impact when it arrived in Venice. For a decade or so it inspired an oriental mode in Venetian painting with specific reference to the Mamluks. It provided many of the details for the cycle of the life of Saint Mark that Gentile Bellini and Giovanni Mansueti painted for the Scuola di San Marco. Its influence can be felt even in the work of Albrecht Dürer, who visited Venice in 1494/1495 and again in 1505 (Raby 1982).

The painting's influence stems from the fact that it combined exotic picturesqueness with the meticulous attention to detail that characterized the late fifteenth-century "inventory school" of Venetian historical painting, which relied on the accumulation of gem-like detail. It was the first European picture to provide such a tangible record of the East, and no painter attempted a comparable scene until the mid-sixteenth century. The painting's charm was summarized by Boschini in the seventeenth century:

Se vede in prospetiva un'armonia
 De fabriche diverse, che inamora;
Ghe xe Cameli, Cervi, Simie e tante
 Diversità de cose curiose,
 D'abiti e de persone capriciose,
 Dele più bele che abita el Levante.
 (Pallucchini 1966, 49–51)

In perspective can be seen a harmony
 Of diverse buildings that enchants;
There are camels, deer, monkeys and such
 A diversity of curious things,
 Of costumes and of delightful people,
 Among the most beautiful that live in the Levant.
 J.R.

107 ஃ

Costanzo da Ferrara
Venetian

PORTRAIT MEDAL OF MEHMED II

c. 1460–1478
bronze
diameter 12.3 (4⅞)
inscribed, first state (on the obverse): SVITANVS
MOHAMETH OTHOMANVS TVRCORVM IMPERATOR; *(on the reverse)* HIC BELLI FVLMEN POPVLOS PROSTRAVIT ET VRBES *(and signed in a* tabula ansata) CONSTANTIUS F
references: Karabacek 1918; Hill 1926, 287–298; Hill 1930, 80, no. 321–322; von Pastor 1959, 3:259; Dizionario biografico 1960–, 30:394–396; Hill and Pollard 1967, no. 102; Andaloro 1980; Raby 1987

National Gallery of Art, Washington, Samuel H. Kress Collection

Costanzo's medal is the most powerful preserved portrait of Mehmed II, the Ottoman sultan who seized Constantinople in 1453 and thus ended the Byzantine Empire. It conveys an impression of considerable physical presence and awesome intensity, warranting the claim made in the inscription on the obverse that Mehmed was the "Thunderbolt of War." He not only fills most of the picture space of the medal, but his broad, sweeping collar rides up high from the surface, giving the medal a greater three-dimensionality than is usual for the period. On the reverse the sultan is shown riding in a rocky landscape with leafless trees, reminiscent of Pisanello's medallic compositions (see the essay by Julian Raby in this catalogue).

The medal serves to remind us of Mehmed's interests in Western culture in general and in portrait medals in particular. He was patron to a great number of medalists. He even attempted to obtain the services of Pisanello's leading follower, Matteo de'Pasti, but the Venetians arrested Matteo as he was *en route* to Istanbul. Before Matteo's visit was aborted, the sultan and Sigismondo Malatesta, the ruler of Rimini, corresponded on the subject of portraits and their role in ensuring a person's immortality. The medal by Costanzo certainly helped disseminate Mehmed's image; it is probably the medal referred to by the Mantuan ambassador in 1489 (von Pastor 1959, 3:259), and both Paolo Giovio and Vasari owned examples, though they attributed the authorship to Pisanello.

As the only surviving signed work by Costanzo, the medal is central to any attempt to reconstruct his oeuvre. It suggests a talent that deserves recognition; like Pisanello, Costanzo combined glyptic and graphic skills; Summonte, in a letter of 1524, describes him as "above all else an outstanding draughtsman."

He led a peripatetic existence: he was Venetian in origin and spent time in Lombardy and Ferrara before settling in Naples in the 1470s. The only recorded source for his trip to Turkey is a letter by the Este ambassador Battista Bendidio, dated 1485, in which he says that Costanzo went to Turkey *gia piu anni* (already several years ago), stayed there for *molti anni* (many years), and was made a *cavaliere* in recompense. Costanzo was sent to Istanbul by Ferrante of Naples, but political relations between Naples and Istanbul were so strained between 1471 and 1475 that the visit must have taken place either in the 1460s or between 1475 and 1478. The traditional date for the medal of 1478 is not, however, based on any firm evidence.

The medal is known in two versions, of which the earlier is that in the National Gallery of Art, a unique specimen. The second, which is signed *Opus Constantii*, is dated 1481. As this was the year Mehmed died, it was probably reissued on the news of his death and tells us little about the date of Costanzo's visit to Turkey. J.R.

After Costanzo da Ferrara

STANDING OTTOMAN

c. 1470–1480
North Italian
brush and brown ink
30.1 x 20.4 (11⁷/₈ x 8)
references: British Museum 1950, 1:5, 6, nos. 7, 8;
Babinger 1951, 349–388

Musée du Louvre, Paris, Département des Arts
Graphiques

This beturbanned Ottoman figure, wearing a calf-length kaftan and the long outer robe known as a dolaman, stands in a frontal posture, exuding confidence. Here is a fifteenth-century European depiction of an oriental that is dispassionately objective, untramelled by the legacy of classical scholarship or Christian propaganda. The sheet belongs to a series of seven such drawings, two of which are in the British Museum, three in the Louvre, and two in the Städelsches Kunstinstitut in Frankfurt. Three of the seven were used by Pintoricchio in frescoes he painted in the 1490s and early 1500s. Only this standing figure appears twice, however, once in the Disputation of St. Catherine in the Borgia Apartments in Rome, and once in a fresco in the Piccolomini Library in Siena. He occupies a prominent position in both, and there have been attempts to identify him as "Calixtus Ottomanus," the fugitive half-brother of Sultan Mehmed II (Babinger 1951, 349–388). There is no basis for this claim, however, and, as

Karabacek long ago pointed out, his costume, in particular his striped kaftan, suggests a character of more modest origins and means. When A. Venturi first published this series of drawings in 1898, he attributed them to Pintoricchio. An objection was soon raised, first by Frizzoni, and then by Ricci, that the figures had a physicality and presence which distinguished them from Pintoricchio's more winsome types. They were evident borrowings, and Frizzoni pointed out that whereas Pintoricchio was of Umbrian origin, the Seated Lady in the British Museum bears a color notation in Venetian dialect—arzento in place of argento (silver). Only the two drawings in the British Museum are generally accepted as originals, the others being regarded as later derivatives (British Museum 1950, 1:5, 6, nos. 7, 8). Nevertheless, as a group, they reflect a common source.

The Ottoman character of the series and the notation in Venetian on the London sheet seemed to most scholars to point to Gentile Bellini, who visited Istanbul between 1479 and 1481, as the author. This Louvre drawing even bears an inscription attributing it to Gentile's brother Giovanni Bellini, but it is in a later, eighteenth-century hand. Another argument in favor of Gentile was that in his final will of 1507 he bequeathed to his apprentices omnia mea designia retracta de Roma, which was taken to mean "all my drawings brought back from Rome"—a clear reference, it was thought, to the drawings which Pintoricchio had used in Rome. The case is not, however, so clear-cut. The meaning of retracta de Roma is ambiguous and could refer to views of the city. More important, the general style of the drawings bears little relation to Gentile's documented work. They are closely related, on the other hand, to a gouache drawing of a Seated Scribe in the Isabella Stewart Gardner Museum in Boston that bears a sixteenth-century Ottoman inscription in Persian. Attempts have been made to wrest Bellini's name from this inscription, but it can be shown that it refers instead to another European artist who visited Istanbul, Costanzo da Ferrara, the artist of the splendid portrait medal of Mehmed the Conqueror (cat. 107). The seven drawings are more reasonably attributed to Costanzo than to Gentile.

Although, as his name suggests, Costanzo lived for a time in Ferrara, he was in fact of Venetian origin, and doubtless would have written color notations in his native dialect. Costanzo was said by a contemporary Neapolitan critic, Summonte, to have been a draughtsman of consummate skill, and this group of oriental drawings shows that this was praise well deserved. J.R.

Albrecht Dürer
Nuremberg, 1471–1528

AN ORIENTAL RULER SEATED ON HIS THRONE

c. 1495–1496
pen and black ink
30.6 x 19.7 (12¹/₈ x 7³/₄)
references: Römer 1917, 219–224; Dodgson 1922, 17–18; Winkler 1932, 68–89; Winkler, 1936–1939, 1:57–58, no. 77; Tietze and Tietze-Conrat 1935, 213–223; Tietze and Tietze-Conrat 1937–1938, 2:143; no. W7a; White 1973, 365–374; Strauss 1974, no. 1495/18–18a; Strika 1978, fasc. 2; Berlin 1989, 236, pl. 280

National Gallery of Art, Washington, Ailsa Mellon Bruce Fund

The identity of this enthroned ruler has occasioned some controversy. In the early nineteenth century the subject was thought to be Charlemagne, but since the 1860s scholarship has increasingly favored an oriental, and more specifically an Ottoman, ruler. The figure lacks the Christian symbols one would expect in an image of a Western ruler; the orb, for example, is not equipped with a cross. As a "Sultan of Turkey," however, the figure belongs firmly in the realm of fiction. He wears a composite headgear—half-turban, half-crown—while his bejeweled chain and pendant, two-handed sword, robes, and footwear, as well as his throne, all derive from a European rather than an Ottoman context.

The drawing can be dated on stylistic grounds to Dürer's first trip to Venice in 1494–1495 (White 1973, 365). The figure, together with its shading, was traced through on the verso of the sheet, probably by Dürer himself, and served as the model for an unfinished engraving by Dürer of the same subject, known from a unique trial impression (Rijksmuseum, Amsterdam), which he appears to have begun shortly after his return from Venice. Despite the Western embroidery, details of the drawing are reflected in several Ottoman figures that appear in Dürer's graphic work shortly after his Venetian trip. The emperor Domitian, in the Martyrdom of Saint John from the woodcut Apocalypse of 1496–1498, wears a comparable chain, and his pendant, like that of the oriental ruler, has two flanking birds. The standing attendant to the left of Domitian bears a facial resemblance to the "Sultan of Turkey" and holds a similar sword. Both Domitian and the standing attendant, however, wear credible Ottoman turbans. As the drawing of the Three Orientals in the British Museum (cat. 110) proves, Dürer had access to accurate depictions of Ottomans through Gentile Bellini, who had been in Istanbul some fifteen years earlier.

Although the comparison with Dürer's Three Orientals makes it plain that this is not a realistic

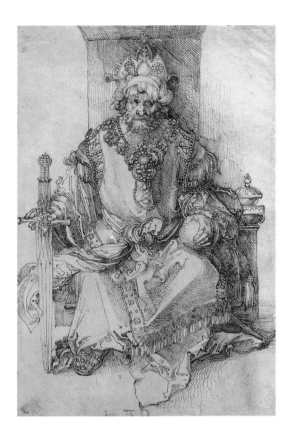

Albrecht Dürer
Nuremberg, 1471–1528

THREE ORIENTALS

*signed with Dürer's monogram and dated 1514
by another hand
pen and black and brown ink with watercolor
on paper*

*30.5 x 19.9 (12 x 7⁴/₅)
references: Janitsch 1883, 50–62; Winkler 1936–
1939, 1:58–59, no. 78–79; Tietze and Tietze-Conrat,
1937–1938, 1:87–88, no. w7; Washington 1971, no.
69; Strauss 1974, 1: no. 1495/12*

The Trustees of the British Museum, London

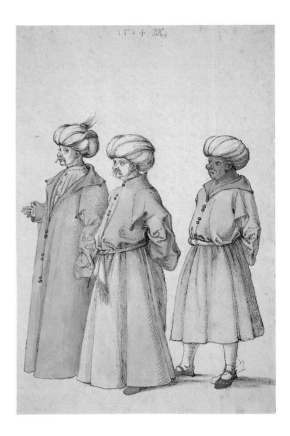

Dürer's three orientals are wearing Ottoman dress, and they have been modeled on a very similar trio that appears in the background of Gentile Bellini's *Procession in Saint Mark's Square* (Accademia, Venice), a monumental painting dated 1496. Dürer was in Venice on two occasions, first in 1494–1495 and later in 1505–January 1507; it has long been accepted that the style of this drawing is most appropriate to the first of these visits. He may therefore have seen Gentile's painting as it was in progress, though it seems more likely that he had access to Bellini's sketches. The Ottomans are a tiny detail in Bellini's painting, and their rendering is summary compared to Dürer's drawing. Moreover, in a related watercolor by Dürer in the Albertina, Vienna, an Ottoman rider carries a mace; he is not a figure who appears in Bellini's painting of the *Procession*, and Dürer presumably copied him from one of the lost studies from Bellini's trip to Istanbul (Winkler 1936–1939, 1, no. 79, compare to nos. 80–81). Salvini's thesis which suggested that Dürer drew the Ottomans while they were posing for Gentile in Venice has no merit. Dürer made ample use of these Ottoman types in both his paintings and his graphic work over the next decade. In the process he transformed the representation of orientals in northern European art, from a stereotype that might have been excerpted from a mystery play into a more substantial creature, with realistic details of Ottoman costume.

When Dürer returned to Venice in 1505, Gentile Bellini had almost completed a huge canvas of *Saint Mark Preaching in Alexandria* (see essay by Julian Raby in this catalogue), which included figures of Syrian and Egyptian Mamluks in place of Ottomans. Dürer responded by introducing Mamluks into his own work on his return from Venice. This "Mamluk phase" was relatively brief, and Dürer soon reverted to his use of the Ottoman type. Indeed, he continued to rely on the oriental material from his first trip to Venice—the central Turk in the British Museum drawing reappears as the lead figure in his etching of *The Cannon*, which is dated 1518. The pose and *kaftan* are similar, but the head of the Turk has

been replaced with Dürer's own features (Washington 1971, no. 69).

In copying from Bellini, Dürer did not feel constrained to retain every detail of the original. His drawing differs first in that his central figure wears only a moustache and not a beard as does the corresponding figure in Bellini's painting; second, and more important, the attendant on the right has been changed considerably. He has been turned into a black servant, and his stance has been altered so that he no longer walks tentatively forward but stands with his feet firmly planted on the ground, anchoring the composition on the right. The *pentimento* in the servant's left foot allows one to see how Dürer first copied, then modified Bellini's model. J.R.

depiction of an Ottoman ruler, it has been seen by some as an image of Mehmed the Conqueror. The suggestion was first made by the orientalist Friedrich Sarre, who also claimed that the throne was based on the Near Eastern throne known as the *Catedra di San Pietro*, which is preserved in the Church of San Pietro in Castello in Venice. Yet the face of the seated ruler is no more related to known portraits of Mehmed the Conqueror, such as Costanzo da Ferrara's medal (cat. 107), than the throne is to the *Catedra di San Pietro*. A less literal reading was proposed by the Tietzes: this was not the Mehmed of the cold light of history, but the conqueror of romantic fantasy. They linked the seated ruler to a drawing in Basel of a standing lady who is also heavily draped with jewelry. The two drawings, they argued, were companion items depicting Mehmed and his ill-starred companion, the Greek beauty Irene. Mehmed is said to have had her executed in order to disprove the rumor that she had an unhealthy hold over him. The story is a *topos* of despotism, and was first related of Mehmed by Gian Maria Angiolello, a Venetian who was a member of Mehmed's court in the 1470s. It passed into Venetian popular fiction when it was included by Matteo Bandello (1485–1561) in his *Novelle*. If Dürer intended a specific historical allusion in his drawing, however, he did not include sufficient detail for us to divine it. J.R.

MEASURING AND MAPPING

In the second half of the fifteenth century, the works of Claudius Ptolemy of Alexandria (c. A.D. 100 – c. A.D. 170) were of central importance to European astronomy and geography. His principal texts, the Almagest and the Geographia, were preserved in the Islamic world during the Middle Ages. The former, the crowning achievement of the Greek tradition of mathematical astronomy, became known in Christian Europe when it was translated into Latin in the later twelfth century. It presented the complicated formulae that were needed to describe the geocentric concept of the universe that prevailed in classical antiquity. Renaissance astronomers corrected the translation, revised some computations, made new celestial observations, and even noted inconsistencies in Ptolemy's system, but no one emerged to dispute his vision of the universe until Copernicus' heliocentric theory was published in the sixteenth century.

Ptolemy's Geographia reached Florence in the early fifteenth century and was avidly studied as the principal text of classical cartography and geography. It contained mathematical systems for representing the curved surface of the earth on maps, as well as tables of the cities of the classical world plotted by latitude and longitude and maps (probably added in Byzantine times) that had been based upon the tables. In this case, however, Ptolemy's authority was soon challenged by the new knowledge derived from the voyages of exploration. By the second half of the century, the Portuguese had traveled farther south down the African coast than Ptolemy's maps extended. With the first voyages to the Americas, the classical image of the world was revealed as incomplete. Early sixteenth-century cartographers had to struggle to integrate this revolutionary data into their maps.

111 &

THE MOVEMENT OF THE UNIVERSE

c. 1450–1500
Flemish, possibly Tournai
tapestry
415 x 800 (163⅜ x 315)
references: Madrid 1892–1893, 79, no. 167; Las joyas 1893, pls. 179–180; Toledo, Museo de Santa Cruz 1958, 256, no. 669; Firenze 1980, 327, no. I.1; Cortes Hernandez 1982, 27–28, 30 and 126–127; Revuelta Tubino 1987, 1: 55–56, no. 87, ills.

Museo de Santa Cruz, Toledo (on loan from Toledo Cathedral)

At the center of this tapestry, which represents the movement of the heavens, is the celestial sphere as an astrolabe activated by an angel who turns the *rete* with a crank. The *rete* shows a stereographic projection of the celestial sphere, with the extrazodiacal constellations of the Northern sky. The polar star is at the center: the inner and outer concentric circles represent respectively the polar circle and the tropic of Capricorn, the path of the sun being shown on the ecliptic circle. The extrazodiacal constellations (among them Andromeda, Pegasus, Orion, etc., with Draco round the polar circle; some are shown on a flowery meadow) are identified by inscriptions and depicted according to the tradition transmitted in illustrations to Hyginus' *Astronomica* (cat. 115). The image of the heavens is explained in a Latin text: "Thus adorned with the fixed stars the sky revolves under the pole both through the region of the North Wind and the South Wind; according to their different effects they are fitted to different figures of people and other signs and planets and the belt of the zodiac keeps under itself [that is, controls] their movement." (*Sub polo volvitur c[o]elum sic ornatum / stellis fixis tam per aquilonis*

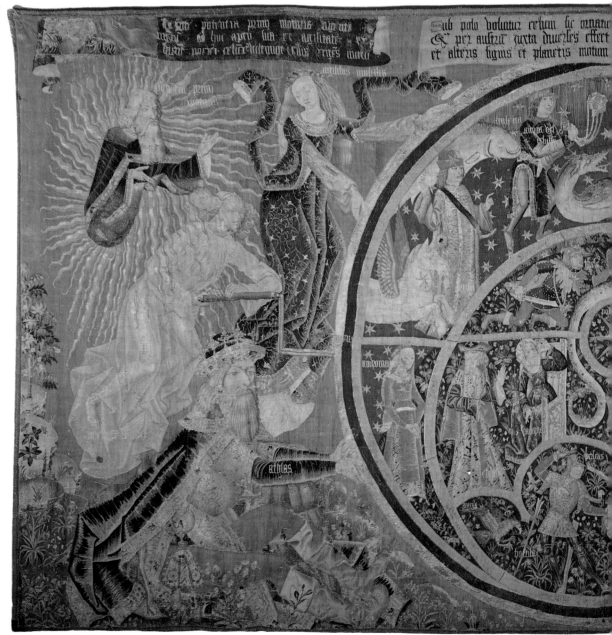

locum / quam per austrum. juxta diverses effectus / diversis aptantur figuris hominum / et alteris signis et planetis motum / circulus conservat sub se zodiacus.)

On the left, God himself is shown, identified as the power of the prime mover (*potentia primi motoris*). The personification holding the mother of the astrolabe supported by the kneeling Atlas (*Athlas*) stands for the agility of the world (*agilitas mobilis*). These figures are explained in another Latin inscription: "The poets say when the angel acts under the power of the prime mover the world is made fit for this by its own agility [and?] the sky revolves controlling its [the world's] motion." (*An[gelo?] sub potentia primi motoris agente / mentum [recte mundum] ad hoc aptu[m] sua esse agilitate / dicunt poetae in*

c[o]elum re....vat eius rege[n]s motu[m]). On the right is Philosophy with Geometry and Arithmetic (*aritmetica*) at her feet. On her left is Abraham (*Abram̃*) and above him Virgil (*Virgilius*), while Astrology (*astrologia*), who is next to the sphere, points with her finger to the heavens. This scene, too, is explained by a Latin text also written on a scroll: "Abraham understood through Philosophy and through Wisdom these facts of Astrology of which the poet Virgil speaks. Many other men now have this knowledge. The mathematics [of it] is explained through Geometry and Arithmetic." (*Abrachis co[n]gnovit per philosophiam / h[a]ec astrologie et per scientiam / under virgilius poeta loquitur / alij quam plures et hanc notitiam / jam habe[n]t homines per geometria[m] / et aritmeticam numerus panditur*).

The tapestry combines various iconographical traditions. The general formula is that of the wheel of Fortune turned with a crank, while the heavenly spheres are shown as an astrolabe, with the constellations depicted according to their traditional form.

This is probably one of the tapestries mentioned in a Toledo Cathedral document of 1503; this records three large tapestries with the story of Saul and David, but also three French astrological tapestries which were bought by Diego López de Ayala with money from the Marqués de Pliego ("Otros quatro paños franceses de la historia del rey Saul y del rey David y tres paños grandes franceses de astrologia que mandó comprar el senor Diego López de Ayala de la almoneda que se hizo en Toledo del marquéz de Pliego"). In 1541 they are recorded as "three old astrological tapestries," one of them depicting what was probably an allegory of death ("Numero tres, tres paños viejos de astrología que uno dellos es historia de la muerte").

J.M.M.

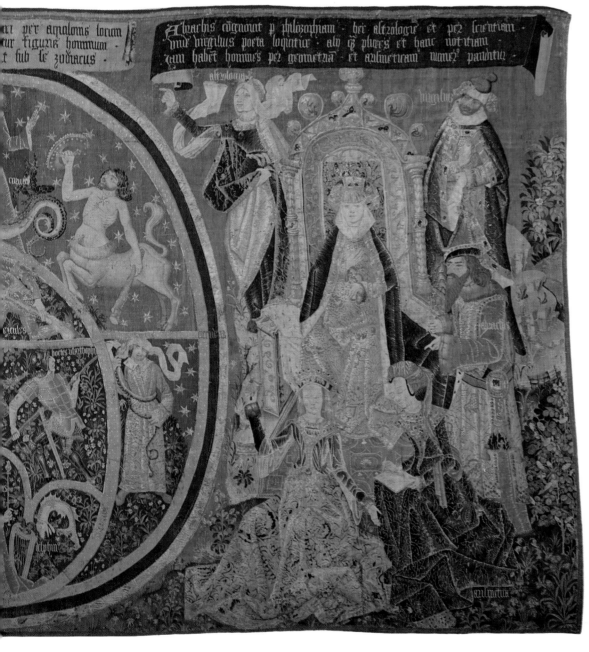

112 ॐ

ASTROLABE

1235–1236
Egypt or Syria
brass inlaid with copper and silver
height 39.4 (15½); diameter 33 (13)
inscribed: (engraved) ṣanaᶜhu ᶜAbd al-Karīm al-Miṣrī al-usṭurlābī; (underneath in lighter characters) bi-Miṣr al-Malikī al-Ashrafī al-Muᶜizzī al-Shihābī (dated abjad in letters) fī sanat KhLJ al-hijriyya (that is, 633/1235–1236)
references: Hartner 1939 3:2, 530–2, 554 (reprinted in 1968, 287–311; Mayer 1956, 29–30; Barrett 1949 19 ff; van Berchem 1978, 3:1814–1815; 1941, no. 4080

The Trustees of the British Museum, London

The astrolabe, the most important astronomical instrument of the Middle Ages, was designed to measure the altitude of the stars, moon, or sun without any mathematical calculation. It was used in much the same way as the astronomical quadrant or sextant, but in addition it bore various diagrams or scales which made it possible to determine immediately the positions of the sun, moon, and planets—most significant, the earth— in relation to the fixed stars (see cat. 121).

The instrument consists of a ring for suspension and a cast body, the *umm* or *mater*, into which fit a series of detachable plates for different latitudes, each with a stereographic projection of the heavens. Over the latitude plates rotates the openwork *rete* (Arabic ᶜankabūt, "spider") with a stereographic projection of the fixed stars on the plane of the equator. The revolution of the *rete* demonstrates the swing of the courses of the fixed

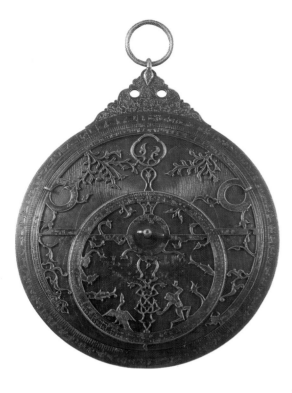

stars around the North Pole. On the reverse of the *mater* is fixed the alidade, a flat ruler that turns around the pole and which serves to set the instrument and read off the altitude of the stars.

The cast suspension plaque *(kursī)* of this instrument is lobed, indented, and inlaid on both sides with silver arabesques, chased and on a stippled ground. The two rings and the central pin keeping the instrument together all appear to be original. The *rete* is exceptional in showing many of the star-pointers as figural, including Scorpio, Taurus, Cygnus, Pisces, and Hercules *(en gonasin)*: they are heavily inlaid in chased silver and copper. On the inner ring of the *rete* are abbreviated Latin designations of the Zodiac signs in Gothic lettering. The three plaques and the inner face of the *mater*, which include readings for Cairo, Kufa, Damascus, and Baghdad, are also inlaid in silver and copper.

The back is elegantly inlaid with the signs of the Zodiac. Certain peculiarities of form—Capricorn is on its back with a fish tail, Aquarius and Taurus are both shown sideways, and Virgo is a bald giant—suggest that the figures were drawn without reference to either a star manual, like the tenth-century astonomer ᶜAbd al-Raḥmān al-Ṣūfī's *Kitāb Ṣuwar al-Kawākib al-Thābita* (cat. 114), or of a celestial globe (cat. 113). Engraved abbreviations of the Latin months were added later in Gothic letters. The remainder of the back is engraved with astrological tables, but only as two half-circles. Consequently, this example lacks the diversity of information on contemporary astolabes whose backs are engraved as quadrants. The alidade, which has an undulating trefoil scroll inlaid in silver, is a European replacement.

The engraved inscription tells us that this instrument was made by ᶜAbd al-Karīm al-Miṣrī,

the astrolabist, while underneath the remains of a lighter, probably earlier, inscription date the piece to 1235–1236 and explain that it was made in Cairo by the servant or client of *al-Malik al-Ashraf*. This lighter inscription may have been deliberately erased because it was becoming effaced through wear. The 1235–1236 date is corroborated by the star positions on the *rete*. In both inscriptions, the soubriquets al-Miṣrī and bi-Miṣr are not otiose as applied to the artisan, for the technique of ᶜAbd al-Karīm, even if he was born in Egypt as al-Miṣrī implies, shows that he was trained elsewhere, in an area very much influenced by the contemporary metalwork of Mosul in Iraq. He owes his title al-Malikī al-Ashrafī to his association with al-Malik al-Ashraf Mūsā, a nephew of Saladin who reigned in the Jazira and parts of Syria (1210–c. 1237) and for whom he had made an astrolabe dated 1227–1228 (Museum of the History of Science, Oxford, ex-Comtesse de l'Espinasse and Lewis Evans Collections). In 1235–1236, al-Malik al-Ashraf Mūsā ruled *inter alia*, at Damascus. The inscribed soubriquet *(nisba)* al-Muᶜizzī may well be associated with another of that ruler's titles, Muᶜizz al-Islam, "He who brings glory to Islam," though Shihāb al-Din was not his honorific title *(laqab)* and so the inscribed al-Shihābī may relate to someone quite different. Soubriquets *[Nisbas]* like al-Muᶜizzi were not necessarily drawn only from the Ayyubids' and Mamluks' "throne names," which they customarily took on their accession. Max Van Berchem, who did not realize this fact, argued that ᶜAbd al-Karim must have worked for two princes, al-Malik al-Ashraf and al-Malik al-Muᶜizz, and noted that the only occasion on which two rulers of these titles coincided was in Egypt 1250–1251, when the Ayyubid al-Malik al-Ashraf Muzaffar al-Din Musa II was deposed by the Bahri Mamluk Muᶜizz al-Din Aybak. Van Berchem's thesis, though ingenious, still does not account for al-Shihabi and is also difficult to reconcile with the date given in the inscription, 1235–1236, which is confirmed well enough by the position of the stars identified on the *rete*.

J.M.R.

113 ᴈ

CELESTIAL GLOBE

1275–1276
western Iran
brass, hollow-cast
diameter 24 (9⅖)
signed by Muḥammad b. Hilāl al-munajjim (astronomer) al-Mawṣilī
references: Dorn 1830, 2:2–371; Drechsler 1873; Repértoire chronologique 1941, no. 4708; Mayer 1956, 68; Pinder-Wilson 1976, 83–101; Savage-Smith 1985

The Trustees of the British Museum, London

This globe may well have been made for the Īl-Khānid observatory established by the Mongol ruler Hülegü (d. 1265) at Maragha in western Iran under the direction of the astronomer Naṣīr al-Dīn Ṭūsī. The surface is engraved with the pictures of the circumpolar constellations of the northern hemisphere, and is inlaid in silver with approximately 1,025 stars—those listed in the catalogue of the tenth-century astronomer ᶜAbd al-Raḥmān al-Ṣūfī. The globe's southern hemisphere is only sparingly engraved, with the oars of Argo and the hooves of Centaurus as the most southerly elements. Although the figure of the constellation Ophioucus has an odd pointed cap with three concentric rings, most of the constellation figures are very similar in details to the manuscript of al-Ṣūfī's star catalogue, the *Kitāb Ṣuwar al-Kawākib al-Thābita* (Bodleian Library, Oxford), which was illustrated by his son in 1009 (see cat. 114).

The equator and the ecliptic—that is, the apparent path of the sun in the heavens—are graduated in degrees, making longitudes and the right ascensions of the stars possible to determine. The great circles of longitude, corresponding to 0°, 30°, 60°, 90°, and so on, are engraved perpendicular to the ecliptic. Because the ecliptic is set at an angle to the equator, the globe appears to revolve on a slant as it shows the sun's apparent daily revolution around the earth.

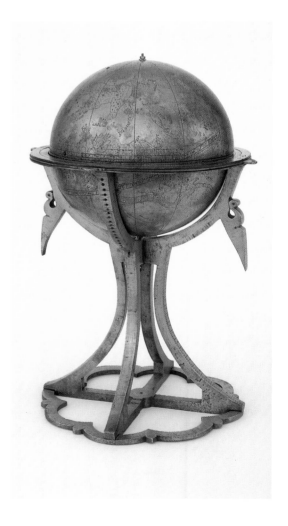

The brass stand, piece-cast and with an applied copper ring, is also graduated but is a later replacement. It is held together below the base by a half-melon shaped screw with a loop below, probably for a plumb-line. J.M.R.

114 ❧

THE CONSTELLATIONS CENTAUROS AND THERAN (LUPUS)

from Kitāb Ṣuwar al-Kawākib al-thābita (Book of the Fixed Stars) *by* ᶜAbd al-Raḥmān al-Ṣūfī
15th century
probably Timurid, Herat
247 folios, 74 illustrations in black line, colored washes and gold, text in Arabic, written in a spidery elongated nashkī, *13 lines to a page on yellowish unwatermarked paper*
23.5 x 16.5 (9¼ x 6½)
references: Ivanov 1977; Paris 1990

Bibliothèque Nationale, Paris, MS Arabe 5036, fol. 238b

Al-Ṣūfī composed the *Book of the Fixed Stars* around 960 for the Buyid sultan of Iran, Azududdawla. The text derives ultimately from Ptolemy's *Almagest* of the second century A.D., but in early versions of al-Ṣūfī, such as the manuscript in the Bodleian Library of 1009–1010, the Muslim artists reinterpreted the classical celestial iconography. The dedication and colophon of this copy state that it was ordered for the library of Ulugh Beg; this is generally thought to be the grandson of Tamerlane who was killed in 1448, although, as is discussed below, it could also have been a later Timurid ruler with the same name.

The book is a catalogue of the fixed stars — together with depictions of the circumpolar constellations of the northern and southern hemispheres and the zodiac. Despite its fairly careful layout, with narrower panels of text at the end of each section, this volume was very probably not a fair copy. The text contains numerous passages crossed out with corrections added in the margins, as well as omissions made good by the copyist. There is no illumination: the heading of folio 1b is, for example, blank, and the headings of each section in bolder script when present vary from the grand to the banal. At what point the illustrations were added is difficult to say, but space was clearly left for them, generally on two sides of the same folio, but the larger on facing pages, and in exceptional cases a double page was allotted for them.

The history of the book is unclear. The dedication and colophon state that the book was ordered for the library of the Timurid ruler of Samarkand, Ulugh Beg, who was killed in 1448. The manuscript contains no indication of the scribe, the

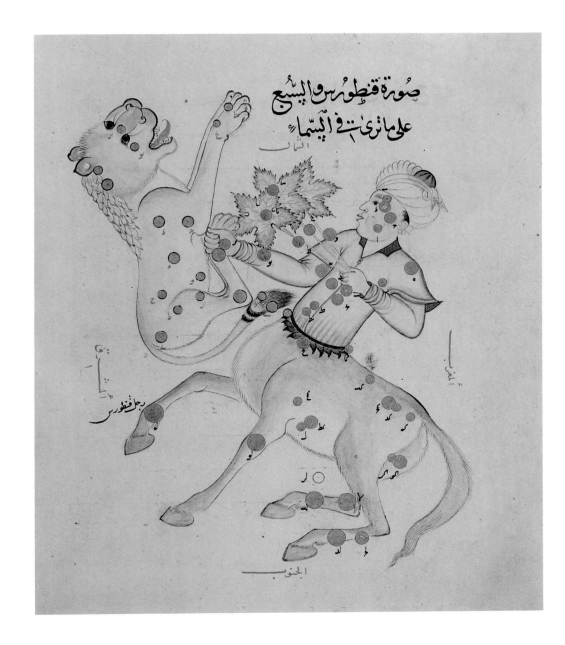

date, or the place of writing, and may conceivably have been booty worked up to the standards of a Timurid prince. Alternatively, a manuscript that was not ready for the library of Ulugh Beg may have been appropriated, and a dedicatory medallion (1a) and a colophon (247a), and grand titles for the sections and illustrations, or at least the coloring added to make it suitable. The disparity between the fine illustrations and the carelessly written text is otherwise difficult to explain. Compass points are in red or blue, while the stars in the figures that belong to other constellations (khārij al-ṣūra) are clearly shown in red.

Folio 1a bears an *ex libris* composed of nine lines of rounded script in gold with many unorthodox ligatures, in some respects approaching *taᶜlīq*. It reads, partly conjecturally:
1. Bi-rasm khizānat al-Sulṭān al-aᶜẓam
2. wa'l-Khāqān al- afkham mawlā mulūk al-ᶜarab wa'l-turk
3. wa'l-ᶜajam ẓill Allāh fi'l-arḍ al-mamlūʾ fīhā ᶜadlan bi'l-ṭūl

4. wa'l-ᶜarḍ wa mu'dhat ẓilāl dawlatihi mamdūda wa'l-ghassān
5. ashjār ᶜuẓmatihi ghayr maᶜdūda sulṭān ᶜaqd LQ T'D TNA
6. sar-idāqāt mimmatihi lā lukhsā wa ᶜumud ᶜurūsh rifᶜatihi la yuqsā
7. ᶜālim natāᶜij ᶜilmihi bi'l-aᶜmāl al-ṣāhha mujtamᶜuhu ᶜādil
8. aᶜlam imānihi fi baṣā'īt al-ᶜālam man/min tafᶜuhu al-Sulṭān Ulugh Beg
9. Gūrkān khallada mulkuhu. Amīn
Normally such a medallion would have been on an illuminated ground or surrounded by illumination.

The colophon folio 247a also bears a dedication to the library of Zahīr al-Dawla wa'l-Dunyā wa'l-Dīn Ulugh Beg, though this titulature is much simpler. A marginal note in a *nastaᶜlīq* hand, stating that the text and illustrations are from types determined by Ibn al-Ṣūfī (that is, the copyist of the Bodleian manuscript) but that the revisions and the numerical tables incorporated into the text by Khwāja Naṣīr al-Ṭūsī have been respected,

could well be later fifteenth-century in date and could therefore be attributable to Ulugh Beg's Astronomer Royal, ʿAlī Qūshjī, who ended his life as the astronomer attached to the Mosque of Ayasofya in Istanbul. Blochet's attribution of this manuscript to Samarkand c. 1437 is based merely on the fact that Ulugh Beg's observatory was located there and the height of its activity was probably around 1437. Although Samarkand has been claimed by various authors as a center of manuscript illustration under the Timurids or even earlier, these claims have been systematically demolished by A. A. Ivanov (Ivanov 1977). Significantly, the manuscript bears neither the seal of Ulugh Beg nor that of his son ʿAbd al'Laṭīf, who also had astronomical interests, nor of Abū Saʿīd, Ulugh Beg's successor as ruler of Samarkand. Instead it bears the seal of Muḥammad Sulṭān (d. 1452), the son of Baysunqur and governor of Central Iran (Fars). Later the manuscript was at Herat under Ḥusayn Bayqara and is believed to have reached Istanbul with his son Badīʿ al-Zamān Mīrzā following the Ottoman sack of Tabriz in September 1514. Ivanov states that it bears the seal of the Topkapi Sarayi Library, but this does not appear to be the case. It was acquired for the Bibliothèque Nationale in Cairo. The presence of the seal of Muḥammad Sulṭān, who expelled Ulugh Beg from Herat after his brief occupation of the city in 1448, may suggest that it came into his hands as booty there; and indeed, stylistically speaking, there would be no incongruity in supposing that the manuscript was written and illustrated there. Further evidence, of a negative kind, is that the illustration of the autograph of Naṣīr al-Dīn Ṭūsī's Persian translation of al-Ṣūfī (now Istanbul, Süleymaniye Library, MS Ayasofya 2595), dated 1249–1250, which came into Ulugh Beg's hands from the library of Sultan Aḥmad Jalāʾir (killed 1410), would have made a second illustrated copy for his library superfluous. In any case the illustrations in the present book are clearly not copied from it.

If the copy was made at Herat, when were the *ex libris* and the colophon added to it? The written text suggests that a rough draft, rather than a fair copy, was illustrated, and it is quite possible that the dedications were added some considerable time later. Ivanov remarks that Ulugh Beg's *laqab* is given here only in the colophon and as *Zahīr al-Dawla waʾl-Dunyā waʾl-Dīn*, whereas his attested *laqab* was *Mughīth al-Dunyā waʾl-Dīn*. This may well be an indication that it was added somewhere outside Ulugh Beg's domains, by a scribe unfamiliar with his Chancery titulature, and the markedly unofficial titles of the *ex-libris* certainly bear that out. Ivanov also notes that a second Timurid ruler by the name of Ulugh Beg was ruler of Kabul from 1469 to 1502. Though his *laqab* is not known, a finely illustrated *Shahname* made for him around 1500, volume III of a set of four, has recently come to light (compare Paris 1990) and is clear proof of the abilities of the

Herati artists working for him there. It could well be that the dedications were added for him rather than for the grandson of Tamerlane.

In the opening exhibited here, Centauros grasps Therion (Lupus) in the form of a crouching panther (al-Sabʿ) by the hind legs. The man's face, in profile, is grotesque. The club shaft is dissociated into three slim stems, the head being three serrated palmate leaves. His tunic is short-sleeved with an undervest creased at the wrists, with a narrow collar splayed out. Therion has two dark rings round the bushy tip of its tail. The headdress, the palmate leaves, the horse's tail and mane, and the right arm of the man have very little to do with the stars of the constellation. Apart from the color and wash the figure is remarkably close to the Bodleian manuscript.

Much has been made of the chinoiserie elements in the illustrations of this manuscript. These are attributed to the close relations between the early Timurids and their Ming contemporaries in China, who had such a pronounced effect on painting and drawing at the courts of Tabriz and Shiraz. However, in contrast to works illustrated for Iskandar Sultan (d. 1414) at Shiraz, the chinoiserie elements are not particularly like the Chinese fabulous fauna. They may trail cloud or flame scrolls, but the Mongol chinoiserie of Naṣīr al-Dīn Ṭūsī's autograph translation of al-Ṣūfī (Süleymaniye Library, Istanbul, Ayasofya MS 2595) is much more striking. Not only does the manuscript offered to Ulugh Beg's library exhibit

little in common with that copy; many of the illustrations (including that of Centaurus) are so close to the Bodleian al-Ṣūfī manuscript of 1009–1010 A.D. as to suggest that it or a common prototype was on hand when the present manuscript was illustrated. This seems all the more likely in that al-Ṣūfī's manual remained for centuries a standard work for any well-equipped observatory library in Islam and this may have led to the remarkable diversity of local illustrative traditions. It is also clear that the marked disparity between the skeleton of component stars and the elaborate complete illustrations were an incitement to innovation and variation of detail. J.M.R.

115 ༖

North Italian artist

SAGITTARIUS AND CAPRICORN

from Hyginus, Astronomica
c. 1480–1500
manuscript on vellum, 80 fols.
23.5 x 15 (9¼ x 5⅞)
references: London 1933, 123–124, no. 60, pls. 35–36; De Ricci 1935–1940, 2:1341, no. 28; Baltimore Museum of Art 1949, 69, no. 189, pl. 73

The New York Public Library, Astor, Lenox and Tilden Foundations, Spencer Collection, MS 28, fols. 52v and 53r

Hyginus' *Astronomica* is a compendium of knowledge probably written at the end of the first or at the beginning of the second century A.D. It is divided into an introduction and four parts. In Books II and III Hyginus names forty-two constellations, discussing the mythological stories associated with each and its place in the nighttime sky.

This beautiful fifteenth-century manuscript of Hyginus' work contains eighty vellum leaves, the last four blank, with thirty-eight illustrations of the constellations. The text on this opening, dealing with Sagittarius, Capricorn, and Aquarius, comes from Book III (26–28) of the *Astronomica*. The form and position of each constellation (at least as it appeared in Hyginus' time) is clearly indicated; then comes an account of the positions of individual stars within the constellation. The draftsman has carefully followed the textual indications, although he must have had recourse to a visual model as well. Each constellation is shown in its traditional form. Sagittarius, for example, is a bounding centaur shooting with a bow, while Capricorn combines the form of a goat (in its upper half) with fishlike hindquarters.

The grouping of the fixed stars into constellations stems from an impulse to project well-known images onto the unknown. When, for example, the configuration of some stars reminded ancient observers of the form of a lion, they gave the name lion (Latin *leo*) to that constellation. Among the constellations are the signs of the zodiac, which form the band of sky that seems, from the earth, to contain the paths of the seven planets. It was probably the Babylonians, in the sixth century B.C., who defined the zodiac in the form in which we know it, though of course the names and images familiar to us are those used by the ancient Romans (Aries, Taurus, Gemini, Cancer, Leo, Virgo, Libra, Scorpio, Sagittarius, Capricorn, Aquarius, Pisces). J.M.M.

116 ❧

The Moon and Various Occupations Associated with the Planet

from De sphaera
c. 1450–1466
Lombard
manuscript on parchment, 16 fols.
24.5 x 17 (9⅝ x 6⅝)
references: Orlandini 1914; Pellegrin 1955, 384; Ludovici 1958; McGurk 1966, 47–48; Alexander 1977, 32, 93–94, pls. 27–28

Biblioteca Estense, Modena, MS Lat. 209 fols. 9v–10r

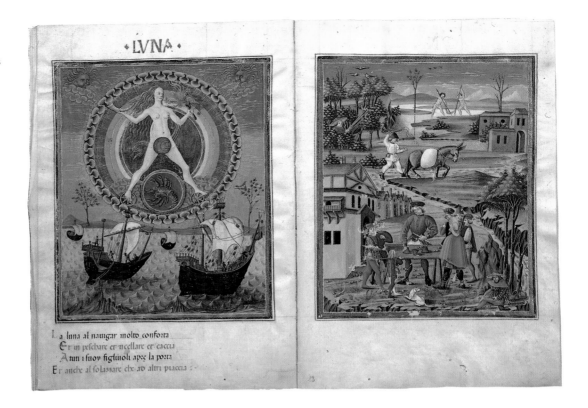

The Este *De sphaera*, perhaps the most beautiful astronomical manuscript of the Renaissance, was executed for Francesco Sforza and his wife Bianca Maria Visconti, daughter of the duke of Milan, whose coats of arms are shown on the verso of folio 4. As they were married in 1441 and Francesco died in 1466, the manuscript must have been produced between these two dates. It probably entered the Este library in 1491, when Anna Sforza married Alfonso d'Este. The miniatures have been connected with the illuminator Cristoforo de Predis or one of his direct predecessors.

The manuscript includes a number of pages with diagrams, but its most important feature is a group of illuminations, from folio 5v to folio 12r, each containing a personification of a planet and its influence on the lefthand page, with various occupations associated with that planet on the righthand page. This iconographic scheme had its origin in classical antiquity, when seven heavenly bodies were observed to move at different rates through a band of the sky and were identified as the "planets" (Moon [*Luna*], Mercury, Venus, Sun [*Sol*], Mars, Jupiter, and Saturn). The band of stars was divided into twelve constellations, which became the signs of the zodiac (see cat. 115). At this time, the sun and the moon were thought to be planets, like the other five, while the outer planets were still unknown. In the *De sphaera* the Moon (fol. 9v) is personified as a young woman, practically nude and holding a burning torch in one hand and a golden horn in the other. She stands on two small wheels, the *rotae fortunae* (wheels of fortune), an astrological notion. The zodiacal sign between Luna's legs is Cancer, her "house," that is, the sign in which the Moon was thought to exert its greatest power. Below is a seascape with four boats; the classical authority Ptolemy explained the Moon's connection with water (*Tetrabiblos*, I, 4): "Most of the moon's power consists of humidifying, clearly because it is close to the earth and because of the moist exhalations therefrom." The Italian text below the miniature explains the influence of the planet and mentions its beneficial influence on navigation: "La Luna al navigar molto conforta/Et in peschare et ucellare et caccia,/A tutti i suoi figliuoli apre la porta/Et anche al solazzare che ad altri piaccia."

On the next page (fol. 10r) are shown people born under the Moon and influenced by it, the Moon's so-called children; there are two fishermen, a hunter with a gluestick, a peasant beating his donkey, a group of players around a table, and, in the lower right corner, a tired pilgrim massaging his sore foot. J.M.M.

ZODIAC MAN AND VOLVELLE

from the Guild-Book of the
Barber Surgeons of York
probably 1486
English
manuscript on vellum and paper, 124 fols.
27.5 x 19 (10¾ x 7½)
*references: British Museum 1882, 334–335, no. Eg.
2572; Bober 1948, 25, pls. 8d–e; Pattie 1980, 31, fig.
8; Jones 1984, 71–74, fig. 30*

*The British Library Board, London, MS Egerton
2572, fols. 50v–51r*

The Guild-Book of the Company of Barber-
Surgeons of the city of York was begun in the
fifteenth century, but much material was added
subsequently; the last addition to the register
of members was made in 1786. The oldest part
consists of a Latin calendar for the use of York
(fols. 44r–49v), followed by a bifolium on thicker
vellum with drawings, partly in color, of a "blood-
letting man" (fol. 50r), a "zodiac man" (fol. 50v),
a revolving wheel (fol. 51r), and finally the Four
Temperaments (fol. 51v). The "zodiac man"
(*Homo signorum*) is intended to illustrate the
domination of the twelve signs of the zodiac over
various parts of the human body, a notion that
dates back to classical antiquity. For example, in
his *Astronomica* (2,453–465), the Roman poet
Manilius described the way in which the limbs are
subject to different signs: "the Ram, as chieftain

of them all is allotted the head, and the Bull
receives as his estate the handsome neck; evenly
bestowed, the arms to shoulders joined are
accounted to the twins; the breast is put down to
the Crab, the realm of the sides and the shoulder
blades are the Lion's, the belly comes down to the
Maid as her rightful lot; the Balance governs the
loins, and Scorpion takes pleasure in the groin;
the thighs lie to the Centaur, Capricorn is tyrant
of both knees, whilst the pouring Waterman has
the lordship of the shanks, and over the feet the
Fishes claim jurisdiction." A corresponding icono-
graphic tradition developed in the thirteenth cen-
tury and became increasingly popular, especially
in the late Middle Ages. The "zodiac man," as is
the case here, was usually illustrated in a medical
rather than a strictly astrological context, for he
readily indicated the part of the body which
should not be operated on or subjected to blood-
letting when the moon was located in the sign
ruling over it.

The volvelle on fol. 51r is surrounded by four
saints: John the Baptist and John the Evangelist,
the patrons of the barber-surgeons' guild, are
shown on the top; below are Cosmas and Damian,
well known as patrons of the medical arts. The
matrix itself shows, from the inside out, the band
of the zodiac with the twelve signs identified by
name, then an indication of the thirty degrees
occupied by each sign. Next come the twelve
months, also identified by name, and their respec-
tive number of days. The central movable disk,
known as the index of the sun, had its pointer set
at the sign and exact degree of the zodiac where

the sun stood on the day of the year an observa-
tion was made. Another disk, the index of the
moon, is now missing, but the user would have
set it on the number on the index of the sun that
corresponded to the phase of the moon in its
monthly cycle on the day of observation. With
the index of the moon in place, a doctor, for exam-
ple, could read the zodiacal sign and the degree
occupied by the moon on that day. This would
have enabled him to determine auspicious dates
for treatment and avoid days when the moon
was in signs related to the relevant parts of the
patient's body.

J.M.M.

Albrecht Dürer
Nuremberg, 1471–1528

CELESTIAL MAP OF THE NORTHERN SKY

1515
woodcut
42.7 x 42.7 (16¾ x 16¾)

CELESTIAL MAP OF THE SOUTHERN SKY

1515
woodcut
43.1 x 43.1 (17 x 17)

*references: Saxl 1927; Voss 1943, 89–150; Zink
1968, 121–127; Nuremberg 1971, 171–174, nos. 309–
310; Washington 1971, 190–191, nos. and figs. 198–
199; Strauss 1980, 488–492, nos. 171–172; New
York and Nuremberg 1986, 315, no. 134*

*The Metropolitan Museum of Art, New York, Harris
Brisbane Dick Fund, 1951*

In the diary of his journey to the Netherlands,
Dürer recorded that he gave to Agostino Scar-
pinello, secretary to the bishop of Tuy, Aloisius
Marliano, "the two parts of the *Imagines*," by
which he meant his woodcut maps of the northern
and southern sky (*Imagines coeli septentrionalis*
and *Imagines coeli meridionalis cum duodecim
imaginibus zodiaci*). The latter has an inscription
on a scroll indicating that Johann Stabius was
responsible for the general arrangement
("Joann[es] Stabius ordinavit"), that Konrad Hein-
fogel calculated the place of the stars ("Conradus
Heinfogel stellas posuit"), and that Albrecht
Dürer drew the figures ("Albertus Dürer imagini-
bus circumscripsit"); below are the coats of arms
of the three contributors, including Dürer's. The
two celestial maps, as well as a terrestrial map of
the eastern hemisphere made at the same time,
were dedicated to Cardinal Matthäus Lang of Wel-
lenberg, who had served Emperor Maximilian as
secretary. His arms appear in the upper left corner
of the map of the southern sky; in the upper right

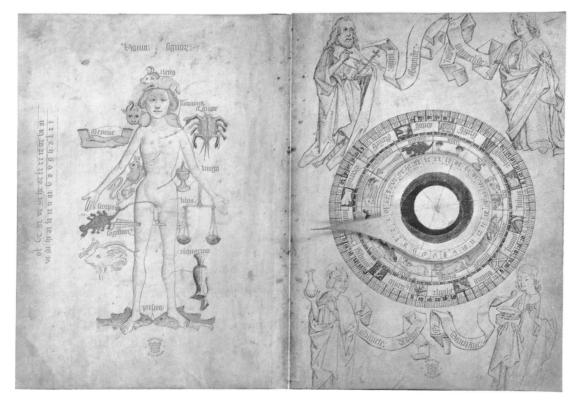

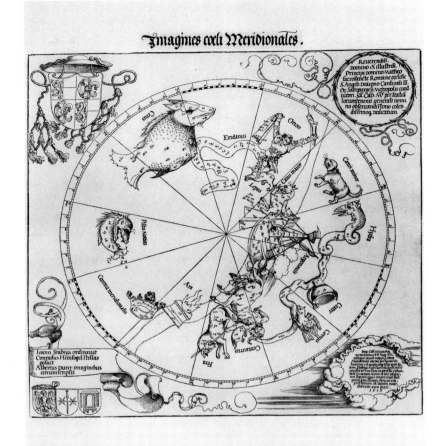

corner is a dedication to him, and in the lower right the imperial privilege granted to Stabius and the date 1515. The map of the northern sky has in its corners the most famous exponents of the four main astronomical traditions: the Greek Aratus (*Aratus Cilix*), Ptolemy the Egyptian (*Ptolemeus Aegyptius*), the Roman Manilius (*M. Manilius Romanus*) and the Arab al-Sūfī (*Azophi Arabus*). The woodcuts do not quite show the skies of the northern and southern hemispheres, as the dividing line is not the equator but rather the ecliptic, the band of the zodiac. Dürer's woodcuts are in fact based on two maps of the northern and southern skies drawn by an anonymous artist, presumably in Nuremberg in 1503, after the specifications of Konrad Heinfogel and Sebastian Prenz; Dietrich Ulsen composed the accompanying Latin verses (Zink 1968, 121–127, nos. 99–100). These maps stem from a tradition that dates back to the beginning of the fifteenth century and is best reflected in a pair of sky charts in the Österreichische Nationalbibliothek in Vienna (MS 5415, fols. 168r and 170r; see Saxl 1927, 150–155, pls. IX–X). The exact positions of the stars on the 1503 maps were not newly calculated. As a result, the northern sky is shown as it appeared at the spring equinox of 1424. For Dürer's woodcuts, however, the stellar positions were recalculated. The numbers next to the constellations refer to

those in Books VIII and IX of Ptolemy's astronomical treatise, the *Almagest*.

The two celestial maps of 1515 were the first ever published. They testify to the importance of Nuremberg not only as a major center of printing but also of the manufacture of scientific instruments. More than in any other European city, scholars there seem to have worked with craftsmen and artists, a collaboration Dürer commented on with enthusiasm in his theoretical publications.

J.M.M.

120 🐚

Attributed to Hans Dorn
Viennese, 1430/1440–1509

MARTIN BYLICA'S CELESTIAL GLOBE

1480
Buda?
brass
height 121 (47⅝); diameter of globe 39.9 (15¾)
references: Ameisenowa 1959; Rosińska 1974; Nagy 1975; Pilz 1977, 62–63; Schallaburg 1982, 339–340, no. 284; Turner 1987, 35–38

Jagiellonian University, Cracow

This celestial globe, the astrolabe (cat. 121), and the torquetum (cat. 122) were bequeathed to the Jagiellonian University by the cleric, astronomer, and astrologer, Martin Bylica of Olkusz (1437–1493). The three objects arrived in 1494 at the university—where Copernicus was a student from 1491 to 1494—and the rector excused all the students and masters from their work in order that they might see these exceptional instruments. Martin Bylica, a pupil of the Cracow astronomer Andreas Grzymala of Poznań, lectured at Cracow from 1459 to 1463. He met Regiomontanus in Rome in 1464, and both astronomers were summoned to Hungary in 1466. When Regiomontanus left Hungary to settle in Nuremberg, Bylica remained there and became the often-consulted astrologer to the king, Matthias Corvinus I. He was also a theologian and became Protonotary Apostolic (the insignium of which surmounts Bylica's coat of arms which are engraved on the horizon-plate, as well as the date, 1480, in a decorative scroll which gives instructions for the use of the sundial on this globe).

The globe and the associated instruments have been attributed to Hans Dorn because he was a member of the King Matthias, Regiomontanus and Bylica "circle," because there are no other known instrument makers as likely manufacturers

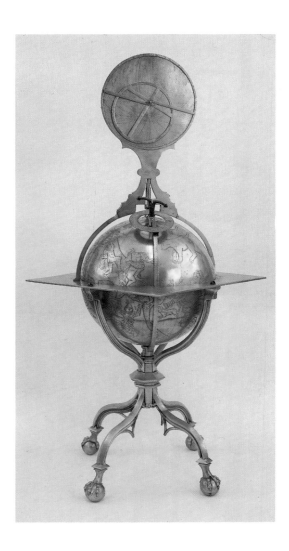

clutching small spheres. A meridian-circle permits the adjustment for latitude of the globe, and azimuths can be read from the 360° circular scale surrounding the globe on the horizon-plate, which also carries a small compass, for orienting the globe, and a horizontal sundial with a string-gnomon. A small circular scale of hours is at the north celestial pole on the meridian-ring. Over it moves an index fixed to the axis of the globe below the turning-handle. Once adjusted for latitude, rotation of the globe simulates the apparent rotation of the stars about the celestial pole at the place of use, thereby providing a didactic or analogue computing device. For the resolution of other astronomical or astrological problems, there is an astrolabe mounted vertically on an arc attached to the horizon-plate at right angles to the meridian. It includes a plate of the twelve astrological houses, with a *rete* consisting solely of the ecliptic circle, and a plate engraved with an orthographic universal astrolabe projection. This projection, known today as the Rojas projection—after Juan de Rojas who published an account of it at Paris in 1550—is very rare in medieval manuscripts and on medieval instruments. It was however used by the Andalusian astronomer, Ibn as-Zarqālluh, in eleventh-century Toledo. Dorn's use of universal projections on his globe and on his astrolabes is innovatory. (For explanations of the astrolabe terms used here, see Bylica's astrolabe, cat. 121).

The globe is engraved with the equator, the tropics, the polar circles, twelve meridians, the Milky Way, and thirty-six constellation images—indicating the magnitude of their constituent stars and the astrological nature of the planetary symbols. This information was derived from the thirteenth-century Latin translation of the Haly (the tenth-century Cairene astronomer, ʿAlī Abū Ḥassān b. Riḍwān) commentary on the *Tetrabiblos* of Ptolemy of Alexandria from the second century A.D. The iconography of the constellation images is sometimes unusual, using European and Arabic sources (Ameisenowa 1959). F.R.M.

and, more especially, because of the Roman antiqua capital letters in which the instruments are engraved. This style of letter was used in printing, for example by Regiomontanus for his *Kalender* of 1474, but is extremely rare on astronomical instruments, which in the medieval period are engraved in Gothic (Black Letter) script and later in standard Roman or italic lettering. The only known instrument signed by Hans Dorn, a silvered brass astronomical compendium, dated 1491 (British Museum), is engraved in Roman antiqua capitals.

Hans Dorn was born between 1430 and 1440; he became a Dominican and from 1491 he resided at the Dominican monastery in Vienna where he died in 1509 He was a pupil of the Austrian astrologer and mathematician Georg Peuerbach and of Regiomontanus between 1450 and 1460 in Vienna. From 1458 to 1490, he was in the service of King Matthias in Buda—where, presumably, Bylica's instruments were made. King Matthias sent Dorn to Nuremberg from 1478–1479 in an attempt, which proved unsuccessful, to buy the books, manuscripts, and scientific instruments left by the deceased Regiomontanus.

The globe proper, made from a hollowed-out sphere of brass, sits within a square horizon-plate, supported by a "Gothic" stand on four claw-feet

This accurately-engraved large planispheric astrolabe belongs, with cats. 120 and 122, to the group of instruments bequeathed in 1493 to the Jagiellonian University by Martin Bylica. It is dated 1486 on the alidade, six years after the celestial globe (cat. 120), and is attributable to the same maker, Hans Dorn. Like the other instruments, it is engraved in fine Roman antiqua lettering. It bears, on the back of the suspension piece, the coat of arms of Bylica, and the Latin words *MARTINI PLEBANI*, indicating Bylica's possession.

The astrolabe is the best known of the astronomical instruments of Islam (cat. 112) and medieval Europe; many have survived. It reduces the image of the celestial sphere to a plane surface using an ingenious geometrical procedure: stereographic projection as described in Ptolemy of Alexandria's *Planisphærium* from the second century A.D. The astrolabe was known early in Islam and transmitted from Muslim Spain to medieval Christian Europe no later than the twelfth century. The astrolabe is usually too small to make serious astronomical observations but was useful for teaching astronomy, in the practice of astrology, and for simple time-telling by night or by day. The upper cut-away plate, called *rete* in Latin and also in Middle English, on the front of the instrument is a star-map where the tips of the curly pointers represent the positions of selected brighter stars, which are named in engravings by the pointers. On the *rete*, the eccentrically placed circle represents the ecliptic, the apparent path of the sun through the stars in the course of a year, and is divided into the twelve signs of the zodiac, each sub-divided into thirty degrees. The outer circular band represents the Tropic of Capricorn,

121 𐌸

Attributed to Hans Dorn
Viennese, 1430/1440–1509

Martin Bylica's Astrolabe

1486
Buda?
brass
height 52 (20½); diameter 45 (17¾)
references: Rosińska 1974; Pilz 1977, 62–63;
Wattenberg 1980, 343–362; Schallaburg 1982, 338–
339, no. 283; Turner 1987, 35–37

Jagiellonian University, Cracow

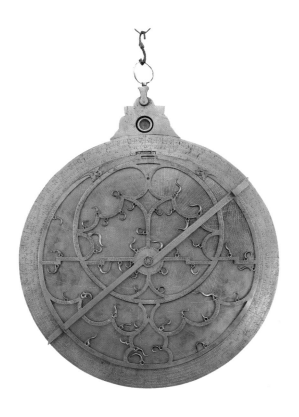

which bounds the projection. Although the *rete* resembles a modern planisphere made of transparent plastics, it is a mirror image because it shows the celestial sphere, not as seen from the earth, but as seen "externally"; for instance, as seen *on* a celestial globe. The *rete* can be rotated over a plate, designed for use in a specific latitude, on which are engraved the horizon for that latitude; circles of altitude at equal intervals between the horizon and the zenith (*almucantars*); lines showing unequal, planetary hours: hours determined by dividing the interval between sunset and sunrise into twelve equal divisions and the interval between sunrise and sunset into a further twelve divisions, six o'clock being at midnight and at midday, and the hour-length varying throughout the year; and sometimes lines delineating the twelve astrological houses. Usually a number of plates are provided for different latitudes, that for the place of immediate use being placed on top of the pile of plates which are, with the *rete* on top, placed in a recess, *mater*, in the body of the astrolabe. Together with a sighting-rule, alidade, the whole is held in place by a pin and wedge, horse, through the center of the astrolabe, which represents the celestial pole. Rotation of the *rete* over the plate—which is prevented from turning by a lug—simulates the apparent rotation of the stars about the pole, creating a form of analogue-computer.

Time-telling by night provides a simple example of one use of an astrolabe: The instrument is freely suspended by the ring and the altitude of a star represented on the *rete* is measured, using the alidade in conjunction with the scale of degrees. The *rete* is then turned until the pointer for the observed star lies on the circle of altitude corresponding to the observed altitude, east or west of the meridian as appropriate. This done, the *rete* shows the positions of the stars in relation to the horizon of the place of observation. A straight line taken with a rule from the center of the astrolabe through the position of the sun in the ecliptic, as marked on the ecliptic circle of the *rete* (that is, the declination on the day of observation, ascertainable from the zodiac calendar scale usually engraved on the back of European astrolabes) will indicate the time in equal hours on the scale of hours on the limb (circumferential border) or by an analogous procedure in unequal hours on the hour-lines on the plate below the *rete*.

Forty-eight stars are indicated on the *rete* of Martin Bylica's astrolabe. The bases of the pointers of the brightest stars are more elaborately decorated than the others (compare to the stars on the globe, cat. 120). This astrolabe is unusual in that the limb of the front bears the zodiac calendar scale correlating the solar declination with the date, as well as the customary scales of degrees and of equal hours (0–12, twice). The zodiac calendar scale was not engraved on the back because

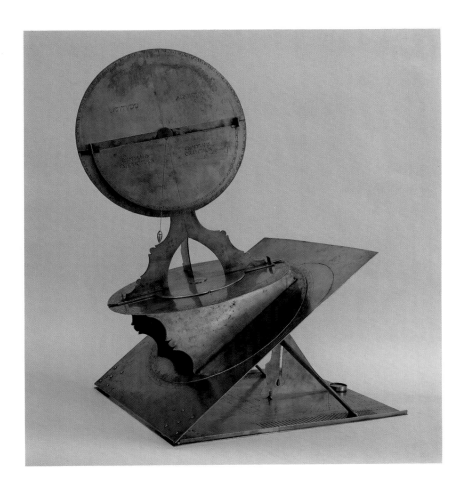

in it is a second recess for plates. These include a plate for latitude 48° and another of the twelve astrological houses. A small magnetic compass is inset in the front of the suspension-piece; this is an unusually early example of such practice.

The need for a different plate for every latitude led to the design of universal astrolabes requiring only a single plate; these instruments, however, were not always as convenient for the solution of certain problems. Such a plate is found at the back of this astrolabe: a stereographic projection of the celestial sphere from the vernal point onto the colura of the solstices, known in medieval Europe as *saphæa Azarchelis*, because it was devised by the astronomer, Ibn az-Zarqālluh, in eleventh-century Toledo. His Arabic treatise was translated into Hebrew first, then into Latin, ensuring its diffusion in the Christian West. Like the insertion of the small magnetic compass, a universal projection was innovative at this time because there are very few medieval examples outside the manuscript tradition (for example, orthographic projection on the astrolabe on the globe, cat. 120). A large, similar astrolabe, also attributed to Dorn, is equally innovative and dated three years earlier to 1483 (Museo di Storia della Scienza, Florence).

F.R.M.

122 &

Attributed to Hans Dorn
Viennese, 1430/1440–1509

MARTIN BYLICA'S TORQUETUM

1487
Buda?
brass
height 71 (27⅞); base 43.3 x 56 (17 x 22)
references: Rosińska 1974; Schallaburg 1982, 339–340, no. 285; Poulle 1983, 32–35; Turner 1987, 17–18

Jagiellonian University, Cracow

The torquetum "may rather be considered an example of conspicuous intellectual consumption than a much used instrument" (Turner 1987, 18). This perhaps explains, apart from the piece's obvious fragility, why only two known medieval examples have survived—although several more are known from the sixteenth century and the instrument is described in medieval manuscripts and early printed books. One of the two surviving torqueta was bequeathed to the Jagiellonian University by Martin Bylica (as were cats. 120, 121). The other belonged to Nicholas of Cues at the beginning of the fifteenth century and is now at Bernkastel-Cues.

The torquetum is an invention of the thirteenth century, devised in 1284 by Franco de Polonia or a little earlier by Bernard de Verdun, and perhaps ultimately inspired by an instrument invented by the twelfth-century Islamic astronomer, Jābir b. Aflaḥ of Seville. It represents schematically the several reference planes and circles of the celestial and terrestrial spheres and enabled mechanical solutions when converting coordinates between the equatorial, ecliptical, and horizontal planes. That is, it gave geometrical rather than mathematical solutions to astronomical problems, but not as with an astrolabe, which uses an analogue system.

The planes represented, from the base upwards, are: the horizontal; the equatorial, adjustable for the latitude of the place of use; the plane of the ecliptic, which is fixed to the equatorial plane at an inclination of about 23.5°, depending on the maker's data, and is engraved with a circumferential scale of degrees; and finally the vertical plane, which can be rotated on the ecliptical plane over which moves an alidade, with sighting vanes, bearing the support for the vertical plane.

Martin Bylica's torquetum is engraved, like his other instruments, in Roman antiqua script and is certainly by the same maker as the rest of the *instrumentarium*. The disc representing the vertical plane has a circumferential scale, which is used with an alidade equipped with sight-vanes; from the center hangs a plumb-line and bob. A horizontal sundial and a small compass are on the base-plate. On either side of the sundial are parallel racks for the adjustable supports of the equatorial plane.

This torquetum, which was probably made by Hans Dorn of Vienna, resembles another designed in 1467 by the astronomer Regiomontanus; he described its use in a brief treatise. F.R.M.

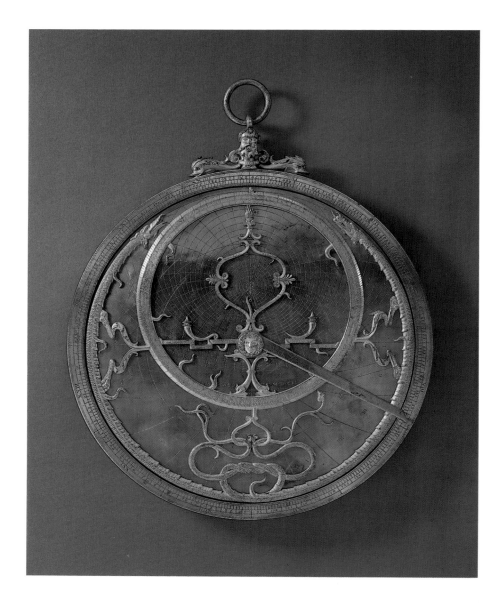

123 &

Astrolabe

late 15th century ?
Perugia ?
brass, partially gilt
diameter 27.6 (10⅞)
inscribed (on a scroll on the back): ALPHENVS: SEVERVS GENIO SVO: ET COMMODITATI ·F· *references: Danti 1579, Conestabile 1848, 14–15; Uzielli 1875, 300–304; Uzielli 1889; Rohde 1923, 90–92; Gunther 1932, 2:322–325, no. 171*

Museum für Kunst und Gewerbe, Hamburg

This planispheric astrolabe of the European Renaissance is highly ornate and untypical. The tracery of the *rete* (see cat. 121) is of zoomorphic design, worked in relief. Each end of the Capricorn band terminates in the head of an animal,

presumably a goat but much elongated. The "bodies" attached are of snakes and form the Capricorn band. One head holds what could be a fruit or the severed head of a snake between its jaws. The remaining tracery is based on what appear to be four goat's legs and hooves, an intertwined snake-pattern, possibly two rythons, a flaming torch, and two dolphins. A human head decorates the top of the central pin which holds the components of the astrolabe together.

The symbolism of the overall design has not been elucidated. As is usual, the tips of various pointed parts of the tracery represent the positions of a selection of apparently thirty stars. Their names are engraved close by and the ecliptic circle is divided into the zodiacal divisions. The limb of the *mater* is engraved with the customary scales of degrees and equal-hour divisions (0–12, twice) and is attached to a suspension-piece, modeled in relief, representing a bearded head between two dolphins, with a pivoted ring. There are six plates, engraved on either side, for a total of twelve different latitudes. The back of the astrolabe is engraved, conventionally, with a zodiac calendar scale (0° Aries, 10.5 March) within

the outer scales of degrees. Inside the zodiac calendar scale is a diagram of unequal hours, used in conjunction with the semi-diametrical rule—normally on the front of the instrument, but easily transferred to the back—as a sundial. Below the diagram is a "shadow-square" used to survey and reach observations and calculations which would otherwise require trigonometry.

Within the central, six o'clock hour-circle of the diagram is a coat of arms engraved with cornucopic decoration: the shield is charged with a doubled-tailed lion rampant, the arms of the Alfani family. There is a reference, as far back as the seventeenth century, to an astrolabe supposedly made by Piervincenzo Danti de' Rinaldi having been in the Alfani family collection. If the Hamburg astrolabe, which was acquired in 1893 from Frau Margarethe Gaiser and which had passed through the collection of Frédéric Spitzer, is indeed this instrument, then its eclectic nature and the fact that it surfaced in the later nineteenth century would not be cause for concern.

Prof. Thomas Settle has generously shared with us the following information concerning the astrolabe's history. Ottavio Lancellotti (1593–

1671), in a 1646 entry in his manuscript chronicle/diary (the original manuscript is preserved in the Biblioteca Augusta in Perugia), mentioned an astrolabe known by him to be in the house of Luzio Alfani as having been executed by Piervincenzo Danti de' Rinaldi. Piervincenzo had in 1498 completed an Italian translation of Joannes de Sacrobosco's treatise *La Sfera*, dedicating the work to Alfano Alfani and referring in this dedication to an astrolabe then under construction. Egnazio, Piervincenzo's grandson, published this translation, and in the *Proemio* to the three editions (1571, 1574, 1579) referred to an astrolabe still in the Casa Alfani made by his grandfather for Alfano (Danti 1579). What is possibly this same astrolabe was described in 1848 by Count Gian Carlo Conestabile (Conestabile 1848, 14–15), who was related by marriage and inheritance to the Alfani family. In 1875 Gustavo Uzielli published engraved illustrations of Conestabile's astrolabe (Uzielli 1875, 300–304 and plate), which were later reproduced in reduced form by Gunther (1932) in his discussion of the Hamburg instrument (the receipt which Uzielli gave to the conte Conestabile for the astrolabe "to be reproduced [*reprodotto*] . . . by the 'shop' of the Military Engineers of Rome," probably a reference to the production of the engraving plates rather than to a three-dimensional reproduction, still survives in the Biblioteca Nazionale Centrale di Firenze). By 1889 Uzielli reported that the astrolabe was no longer in Italy (Uzielli 1889). The inscription on the engraved scroll on the back of the astrolabe, which refers to Alfano Alfani, is somewhat ambiguous on the issue of authorship: *Alfano Severo, for his own inspiration and pleasure, made it [had it made (?)].* F.R.M.

124 ᕣ

WISE MEN ON MOUNT ATHOS

from a volume of illustrations to Sir John Mandeville, Travels
c. 1410–1420
Bohemian
silverpoint and pen and black ink with watercolor, body color, and gold leaf, on light green prepared vellum; manuscript, 16 fols.
22.5 x 18.1 (8⅞ x 7⅛)
references: Warner 1889, XLII, 9, pl. 18; Cologne 1978–1980, 3:106–107; Krása 1983, pl. 19; Deluz 1988; Rowlands 1988, 17, no. 1

The British Library Board, London, Add. MS 24189, fol. 15r

The *Travels* of Sir John Mandeville, a guide for pilgrims bound for Jerusalem that was written in 1356, was undoubtedly one of the most popular travel accounts of the Middle Ages. More than 250 extant manuscripts attest to its popularity. Nineteenth-century scholars, however, discredited it as

a firsthand account of the East, characterizing it instead as a mere compilation of earlier sources organized within the traditional framework of the *Imago mundi* (*Image of the World*) by an unknown author. In the narrative, classical and biblical sources are freely mixed with information from medieval encyclopedias as well as historical and pseudo-historical texts. Many earlier accounts of pilgrimages and travels to the East are quoted more or less verbatim.

This manuscript consists simply of twenty-eight miniatures carefully painted on both sides of fourteen folios. No accompanying text is present to help identify the subject matter, but recent studies have shown that the images are based on the Czech translation of the *Travels* made by Vavřinec of Březová. The miniaturist, undoubtedly a Bohemian artist, has been identified by Otto Pächt as the Master of the Dietrichstein Martyrology of Gerona, who worked on the famous Wenceslaus Bible of 1402. More recently Josef Krása proposed that the author of the present manuscript should be called the Master of the Mandeville *Travels* and that two illuminations in the last part of the Gerona manuscript should also be ascribed to him.

The illustration on folio 15r is based on Mandeville's account of Mount Athos, in chapter 5 of Vavřinec's translation: "There is also another hill which men call Athos; and that is so high that its shadow stretches to Lemnos, which is distant from it nearly seventy-eight miles. Upon these hills the air is so clear and so pure that no wind can be felt there; and so no animal can be seen there; and so no animal nor bird can live there, the air is so dry. And men say in those countries that once wise men went up on the hills and held to their noses sponges soaked with water to catch the air, for the air was so dry. And also up on those hills they

wrote letters in the dust with their fingers, and at the end of a year they went up again and found the same letters that they had written the year before as fresh as they were on the first day, without any defect. And therefore it certainly appears that these hills pass beyond the clouds to the pure air" (see also Warner 1889, 9). This account is basically a compilation of passages from, respectively, Vincent of Beauvais' *Speculum naturale* (VI. 21), Gervase of Tilbury's *Otia imperialia,* and another passage from Vincent of Beauvais based on Peter Comestor (Deluz 1988, 74–76). The illustrator portrayed wise men on Mount Athos observing the stars, while another three with long sticks write in the dust the letters that were still as fresh after a year as on the day they were made. For a fifteenth-century writer the scene would probably also have suggested geomancy. The astronomers in the background examine the heavenly bodies with quadrants and astrolabes. The carefully depicted quadrants are deployed in the proper fashion but the astrolabe is not—when used for observation, it would have been held by its ring. The position of the stars and thus of the heavens is found by aligning a star with the sight holes of the alidade and reading off its angles on the rim. J.M.M.

125 ᕣ

ASTRONOMY

c. 1520–1525
Flemish
tapestry, wool warp, 5 ends per cm
240 x 340 (94½ x 133⅞)
references: Burger 1950, 863–864, fig. 4; Strömberg 1965, 14–28, 46–47; Cavallo 1967, 1:79; Paris 1973–1974, 157–158, no. 64; New York 1974, 157–158, no. 69; Joubert 1987, 165, 167, fig. 162

The Röhss Museum of Arts and Crafts, Gothenburg

Astronomy is personified as a female figure who holds a scroll bearing her name (*Astronomie*): she points toward the stars, which are the object of study of two astronomers in the foreground. The first holds a rolled parchment in one hand and an armillary sphere (showing the zodiacal signs Pisces[?], Aries, and Taurus on the ecliptic) in the other. He observes the stars, especially the moon and an adjacent feature that may be a comet. His seated companion also notes his observations in a book. The scientific instrument on the lectern before him is probably meant to be a nocturlabe, an instrument used to determine time at night, or an astrolabe, the basic instrument used for calculating the position of the stars (see cat. 121). The heavens are observed by shepherds, too, a cirumstance that may allude to the Star of Bethlehem which announced the birth of Christ or to

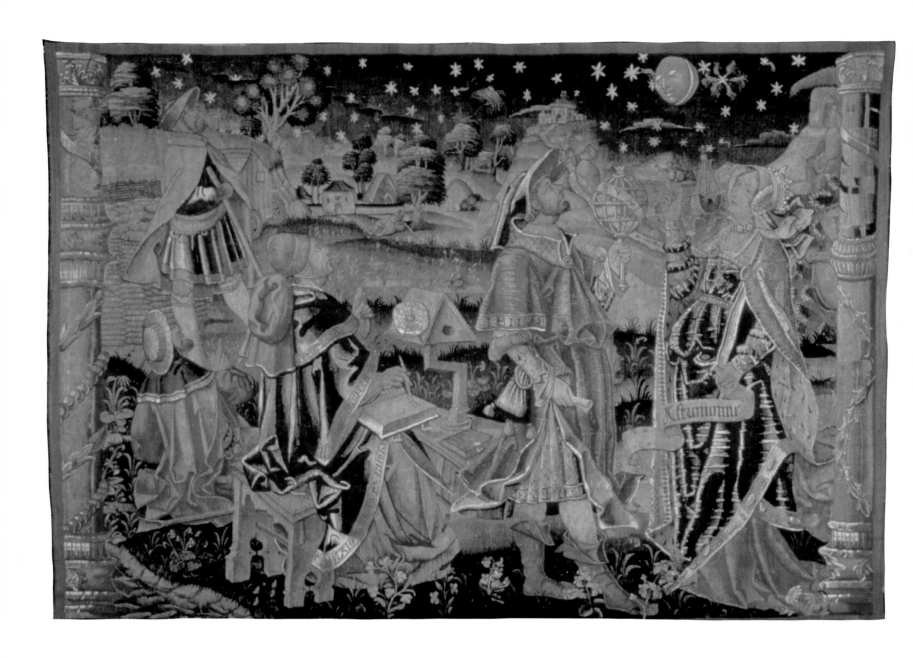

the fact that the first astronomer was said to have been Endymion the shepherd.

Traditionally the arts and sciences were classi-fied—and personified—as the Liberal Arts. The categories were already established by the fifth century A.D., in Martianus Capella's allegorical novel, *De nuptiis Philologiae et Mercurii*, in which he introduced the personifications of the *trivium* (Grammar, Rhetoric, and Dialectic) and the *quadrivium* (Arithmetic, Geometry, Astron-omy, and Music).

This extremely well-preserved tapestry was probably part of a set of seven illustrating the seven Liberal Arts. Other tapestries are known with related designs, showing *Rhetoric* (Musée des Arts Décoratifs, Paris), *Arithmetic* (Musée de Cluny, Paris), and *Music* (Museum of Fine Arts, Boston). *Rhetoric* and *Arithmetic* (which bears the date 1520) were probably both woven from a common series of full-scale cartoons. *Astronomy* has some similar design features, but different

side-column and costume types, and slightly more naturalistic figures and rendering of space. Though it has sometimes been dated earlier than these pieces, about 1510–1515, it is more likely from a slightly later copy series, of perhaps about 1520–1525. *Music* seems to come from still a third cartoon series, based on similar composi-tional models. It is uncertain where these tapes-tries were designed and woven. They appear to be Flemish, but may not all be from the same center. Both Tournai and Bruges have been suggested; but *Astronomy* might even come from some smaller center, perhaps with greater influence from Brussels. J.M.M. and C.A.

126 ❧

PORTRAIT OF PTOLEMY

from Claudius Ptolemy, Geography
c. 1453
Italian
manuscript on vellum, 104 fols.
58.5 x 43.5 (23 x 17⅛)
references: Wieser 1932, 211, 275–284; Ferrari 1939; Venice 1968, 52, no. 48; Zorzi 1988, 122–123, ill.

Biblioteca Nazionale Marciana, Venice, Cod. Gr. Z. 388 (coll. 333), fol. 6v

Claudius Ptolemy (c. 90–168 A.D.) is best known today for his *Almagest*, an astronomical work; the *Tetrabiblos*, an astrological compendium; and his *Geography* in eight books, in which he mapped the known world. While improving on an earlier, now lost, account of the world by Marinus of Tyre, Ptolemy proposed three systems of carto-

graphic projection: one in which the world is shown upon a conic graticule with converging meridians and semicircular parallels, another with curved meridians and parallels, and a third in which armillary rings surround the earth, which appears as a sphere seen in perspective. Especially important are the tables of coordinates giving the latitude and longitude of principal towns and cities, region by region, which provide the basic instruction for mapmakers. Ptolemy's *Geography* was not known in western Europe until the fifteenth century. The oldest Greek manuscript is Byzantine and dates from the thirteenth century, when the scholar Maximus Planudes realized the importance of Ptolemy's contribution to geography.

This manuscript in the original Greek, which was copied by Giovanni Rhosos in the fifteenth century for Cardinal Bessarion (as it appears in an early catalogue: "Geographia Ptolemaei optima cum picturis, liber B[essarionis] card[inalis] Tusculani. In loco 49") combines textual accuracy with artistic beauty. It is based on the so-called "A" recension of the *Geography* and includes twenty-seven maps, among them the well-known Ptolemaic planisphere, or map of the world. Of all the Greek manuscripts of the *Geography*, Cod. Gr. Z. 388 is the only one containing an imaginary portrait of Ptolemy himself. The scholar is shown outside his study, holding an astrolabe. Books and various scientific instruments can be seen inside, including another astrolabe, a quadrant, and two torqueta. Ptolemy is bearded, dressed in a rich coat lined with ermine, and wearing a gold crown. This portrayal reflects the widespread confusion of the Greek geographer, who was born in Ptolemaïs but lived either in Alexandria or in Canopus, fifteen miles east of that town, with one of the Ptolemies who were kings of Egypt. Below the illumination is a Greek epigram written in gold letters: "Ptolemy/I know that [I] am mortal, a creature of a day; but when I search into the multitudinous revolving spirals of the stars my feet no longer rest on the earth, but, standing by Zeus himself, I take my fill of ambrosia, the food of the Gods." These verses, from a collection of ancient and medieval Greek poems known as the *Greek Anthology* (IX, 577), are accompanied by Nicolò Perotti's Latin translation and are especially appropriate here, not just because they relate to Ptolemy but also because Maximus Planudes, who promoted a new interest in Ptolemy's *Geography*, was also famous as an anthologist of Greek epigrams. J. M. M.

WORLD MAP

from Claudius Ptolemy, Geography
c. 1466
manuscript on vellum, 124 fols.
44 x 29.5 (17¼ x 11⅝)
references: Fischer 1932, 215, 335–340, 344;
Fischer in Stevenson 1932, 3–15; Pagani 1975;
Dilke 1987, 268

Biblioteca Nazionale di Napoli, MS V.F. 32,
fols. 71v–72r

Ptolemy's *Geography*, written in the second century A.D., is in some ways the quintessence of classical cartographical knowledge. Its table of coordinates provided the basic information for mapmakers, giving the positions of major cities and towns according to their longitude and lati-

tude. In the absence of a thorough critical edition of the *Geography*, some aspects of the original text remain obscure and certain questions unresolved, especially as regards its cartographic illustration. The oldest Greek manuscripts known today date from the late thirteenth century. It seems to have been a Byzantine scholar, Maximus Planudes, who "rediscovered" Ptolemy's book. Because the manuscript he obtained had no maps, he had some drawn to illustrate the text. The result pleased the Byzantine emperor Andronicos II Paleologus (1282–1378) so much that he had the manuscript copied.

The illustrated manuscripts of the *Geography* can be divided into two groups: the "A" recension, which contains twenty-seven maps, and the "B" recension, with sixty-five. For Ptolemy, the known world occupied half of the northern hemisphere and extended south of the equator. Various

manuscripts have a note added to Book VIII that "Agathos Daimon, a technician of Alexandria, drew the whole world from Ptolemy's *Geography*." Although the historical Agathodaimon, as we would call him, probably lived in late antiquity, it seems improbable, for various reasons, that the world map found in the Byzantine manuscripts of the *Geography* copies a classical prototype; the Byzantine maps were probably drawn in the late thirteenth or fourteenth century based on the instructions found in Ptolemy's text.

About 1400 the Florentine merchant Palla Strozzi first brought a Byzantine manuscript of Ptolemy's *Geography* to western Europe and it was later translated into Latin by Emanuele Chrysoloras and Jacopo Angelo de Scarperia (Dilke 1987, 268). MS V.F. 32, which contains this translation, includes the twenty-seven maps of the "A" recension. The new interest in Ptolemy's *Geogra-*

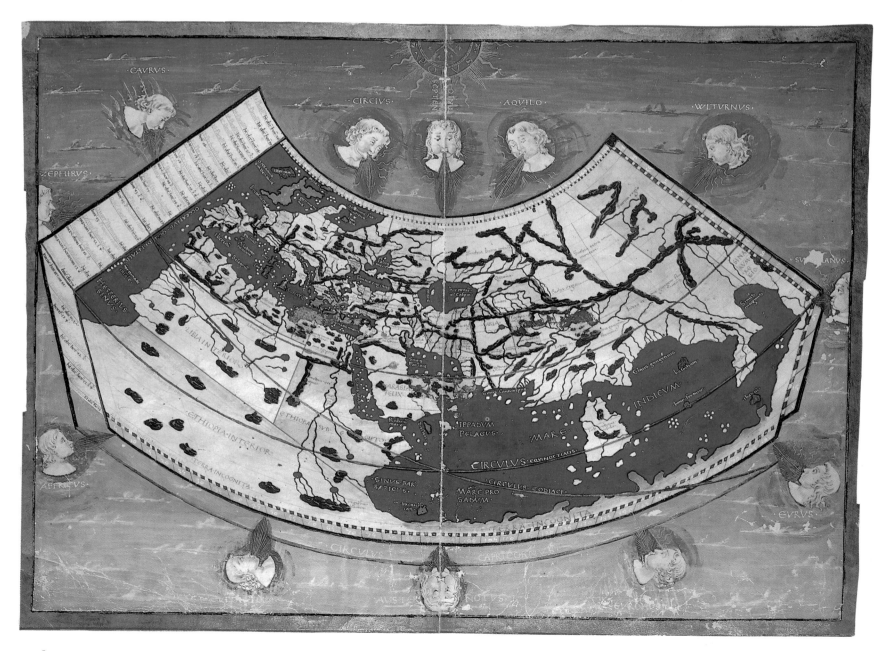

phy in western Europe was part of the rediscovery of classical antiquity that was fundamental to the Renaissance. In this case, however, the learning of antiquity was to some extent demonstrably out of date: The Ptolemaic image of the world was often difficult to reconcile with the more accurate portolan charts reflecting current navigational experience. In slightly later Italian editions of the *Geography*, three new maps, respectively of Spain, northern Europe, and Italy, are added to the canonical twenty-seven. The general reverence the Italian humanists felt for classical authority was thus qualified by the necessity to add new information, a process that also led to the gradual improvement of the original twenty-seven maps throughout the fifteenth and sixteenth centuries.

Especially notable among the Latin Ptolemy manuscripts produced in Italy were the maps drawn by the German Benedictine monk Donnus Nicolaus, who in 1466 presented an illustrated copy of the *Geography* to Borso d'Este, duke of Ferrara, which is preserved in the Biblioteca Estense, Modena. The present manuscript is very close in style to that copy and has been convincingly attributed to Donnus Nicolaus. It formed part of the Farnese library and was brought to Naples from Parma in the eighteenth century. The world map, on folios 71v–72r, follows a simple conical projection with straight meridians and curving parallels in a grid that is visible beneath the geographical features.

The world is set between the parallel of Thule to the north and the parallel opposite Meroë to the south. The equator, the parallel of Syene, and the Tropic of Capricorn (which runs below the southern border of the map) are drawn in gold, as is the diagonal band of the zodiac. The map largely follows Ptolemy, showing Africa linked to Asia by a narrow strip of land. The Mediterranean area is better defined but exaggerated in length. Farther east the configuration becomes increasingly less precise, being based mainly on travel accounts and lists of towns rather than on observation. This manuscript may have served as the prototype for the maps in the printed edition of the *Geography* produced in Bologna in 1477.

J.M.M.

128 &

Donato Bramante
Urbino, 1444–1514

DEMOCRITUS AND HERACLITUS

c. 1490–1499
detached fresco
102 x 127 (40¼ x 50)
references: Murray 1962, 29–31, fig. 7; Wolff-Metternich 1967–1968, 74–76; Woodward 1987, 357; Pinacoteca di Brera 1988, 121–130, no. and fig. 94a; Borsi 1989, 163–166

Pinacoteca di Brera, Milan

This fresco formed part of a cycle of famous men painted by Donato Bramante in the Casa Panigarola in Milan near the end of the fifteenth century—certainly before 1499 when the artist left the city. Various military heroes were shown in painted niches, while the two philosophers were placed over a doorway. The attribution of the frescoes to Bramante was first made by Giovanni Paolo Lomazzo, in his *Trattato dell'arte della pittura (Treatise on the Art of Painting)* published in Milan in 1584, and it seems completely convincing. The house came in to the possession of the Panigarola family in 1548; in the late fifteenth century—at any rate in 1486—Gasparo Ambrogio Visconti, a soldier, ducal councilor, and poet, was living there. Visconti, a friend of Bramante, probably commissioned the painting.

The image of the globe between the two philosophers was painted *a fresco*, in one working session (*giornata*). The configuration of the world still largely reflects Ptolemy's *Geography* (see cats. 126, 127), with Africa connected to Asia by a strip of land, so that the Indian ocean—in which Taprobana (the modern Sri Lanka) is found but Madagascar is not to be seen—becomes an enclosed sea. Despite some scholarly claims to the contrary, the globe does not seem to record the most recent Portuguese discoveries along the coast of Africa. As far as Asia is concerned, the closest analogy is with the *mappamundi* included in manuscripts of the *De cosmographia* of the first-century geographer Pomponius Mela, for example the map by Pirrus de Noha in the Vatican Library (see Woodward 1987, 357, fig. 18.79, pl. 19); the configuration of Europe, however, especially Scandinavia, seems to reflect a more recent source. In his *Ricordi*, first published in 1546, Fra Sabba Castiglione called Bramante a cosmographer; this may, of course, simply reflect a knowledge of Bramante's depiction of the globe in this fresco, but the possibility cannot be excluded that he was also involved in mapmaking, as quite a few artists of the period had an interest in cartography.

Democritus, now famous as an atomist, is mentioned as a laughing philosopher by Cicero and Horace, while Heraclitus is first characterized as the weeping philosopher by Sotion, the master of Seneca. Many ancient writers, particularly Lucian and Juvenal, make a contrasting pair out of the two philosophers, with Democritus laughing at and Heraclitus weeping about the stupidity of the world. Above the two philosophers can be seen a pseudo-antique relief, whose significance is not clear, nor is that of the monogram in the middle. On one side is an antique triumphal procession and on the other a scene of submission, both of which may relate to a passage in Juvenal. J.M.M.

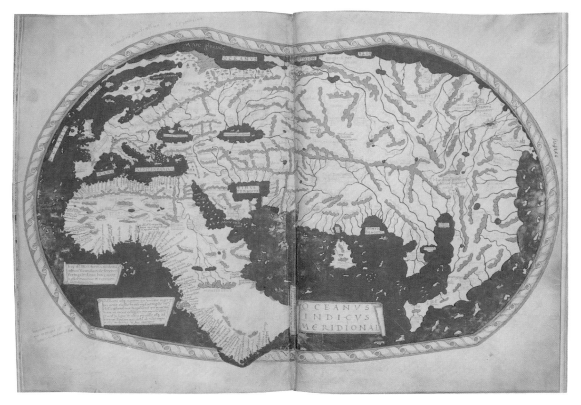

Juan de la Cosa

Spanish, c. 1450/1460–1510

WORLD CHART

1500
parchment
960 x 1830 (37½ x 72)
references: Vascáno 1892; Morison 1942, 1:186–
188; Skelton 1958, 71; Ganong 1964, 8–43, 469–
473; Morison 1974, 139–140; Parry 1979, 113–114;
Campbell 1982, p. 14–15; Nebenzahl 1990, 30–33

Museo Naval, Madrid

This large *mappamundi*—one of the most important of all cartographic records of the early European exploration of the Americas—bears the date 1500 and the signature of Juan de la Cosa, who sailed aboard the *Niña* on Columbus' second voyage (some scholars believe that the Juan de la

Henricus Martellus

German, active c. 1480–1496

WORLD MAP

from Insularium illustratum
c. 1489
manuscript on vellum, 75 fols.
30 x 47 (11⅘ x 18½)
references: Almagià 1940; London 1960, 19, no. 28,
pl. IIIa; Bagrow and Skelton 1964, 81–82, pl. LIII;
Destombes 1964, 230–232; Hamann 1968; Klemp
1968, no. 7; Campbell 1987, 72–74, 77–78, 213

The British Library Board, London, MS Add. 15760,
fols. 68v–69r

Henricus Martellus (Henry Hammer) was a German cartographer who worked in Florence in the late fifteenth century. He is best known today as the author of the maps that are included in two manuscripts of Ptolemy's *Geography* and three manuscripts of his own *Insularium illustratum*, as well as of the large world map now in the Beinecke Library at Yale. The *mappamundi* in the London manuscript of the *Insularium* still adheres for the most part to the Ptolemaic model for the eastern half of the world, but Asia is no longer linked to Africa by a narrow strip of land. The southern half of Africa, which had just been explored by Portuguese navigators, is somewhat exaggerated in length, literally outgrowing the boundary of the known world, as its southern tip had now been reached and even circumnavigated. The Cape of Good Hope (*capo d'esperanza*) is

clearly identified, while a few inscriptions the east coast of southern Africa testify to the most recent coastal voyages. The names on the African coast clearly reflect knowledge of the travels of Diogo Cão—his voyage as far as Cape Santa Maria in the Kongo (1482–1484) and his second voyage, to Cape Cross (1485–1487)—and also of Bartolomeu Dias' circumnavigation of the Cape of Good Hope (1487–1488). The farthest point reached by Dias, the great Fish River, is duly recorded (*ilha de fonti*). An inscription next to the Kongo mentions the commemorative stone (*Padrão*) Cão erected at Cape Negro during his second voyage (Hamann 1968, 195–199, fig. 15). Other sections of the map are not as accurate. Madagascar is not recorded, and Asia is still poorly depicted, while Scandinavia follows the configuration found in the second map of Claudius Calvus, with Greenland depicted as a peninsula linked to northern Europe.

The world maps of Martellus have often been associated with Martin Behaim's globe of 1492 (Germanisches Nationalmuseum, Nuremberg); both are non-Ptolemaic but graduated with degrees for longitude and latitude. (The present example, however, does not include such graduations.) The differences between the two, however, especially in their mapping of southern Africa, make a direct relationship improbable. J.M.M.

130 not in exhibition

Cosa who is recorded as the master-owner of the *Santa María* on the first voyage was a different person). In a celebrated incident that occurred on 12 June 1494 off the southern coast of Cuba, de la Cosa, together with all the other members of the expedition, signed a document prepared by Columbus stating that Cuba was part of a continent. Columbus had been sailing west and was less than fifty miles from rounding Cuba's southwestern edge, but he decided at that point to turn back, evidently satisfied that Cuba was indeed part of the so-called "Golden Chersonese," the elongated peninsula at the southeastern end of Asia that was represented on European maps of the period (see cat. 129). He pressured his crew into supporting this idea, which would have proven that he was close to the realms of the Chinese emperor, but his assertion was quickly challenged when he returned to Spain.

Juan de la Cosa's map shows Cuba as an island. Whether it depends on later information or repre-

sents de la Cosa's recantation of the coerced pledge is unclear. It has been suggested that the map, though dated 1500, was completed some years later. Some scholars believe that the map is an early copy of the lost original of 1500. Juan de la Cosa himself participated in three expeditions to the Caribbean coast of South America and was killed in 1510 by a poisoned arrow during a slave raid in Cartagena Bay, in what is now Colombia.

His impressive map grapples with the problem of representing the newly-known territories within the framework of the traditional portolan *mappamundi*. It is unclear whether the contours of the mainland that extend north and south of the Caribbean are meant to be seen as an extension of Asia, which runs off the map at the right. It is not even certain whether they are thought to be connected to each other—a representation of Saint Christopher bearing the Christ child covers the area to the west of the Caribbean. This presumably is meant to refer to Columbus, whose

signature read *Xp̃o Ferens* ("Christ bearing") and who increasingly saw himself in the role of carrying the divine word to foreign lands. The Virgin and Child are also depicted on the map, in the wind rose just to the left of the designation *Mare Oceanum* (Ocean Sea), another reference to the missionary character of Spanish sponsorship of the voyages.

As is the case with the *Catalan Atlas* (cat. 1), some of the inscriptions on de la Cosa's map appear upside-down or at an angle of 90°, suggesting that it was meant to be placed on a table and looked at from all sides. Although de la Cosa includes information based on the latest voyages to Africa, India, and the New World, the depiction of the eastern regions of Asia has changed little from the time of the *Catalan Atlas*, and the figures at the upper right corner of the map are still the legendary Gog and Magog (see Massing essay "Observations and Beliefs: The World of the *Catalan Atlas*" in this catalogue).

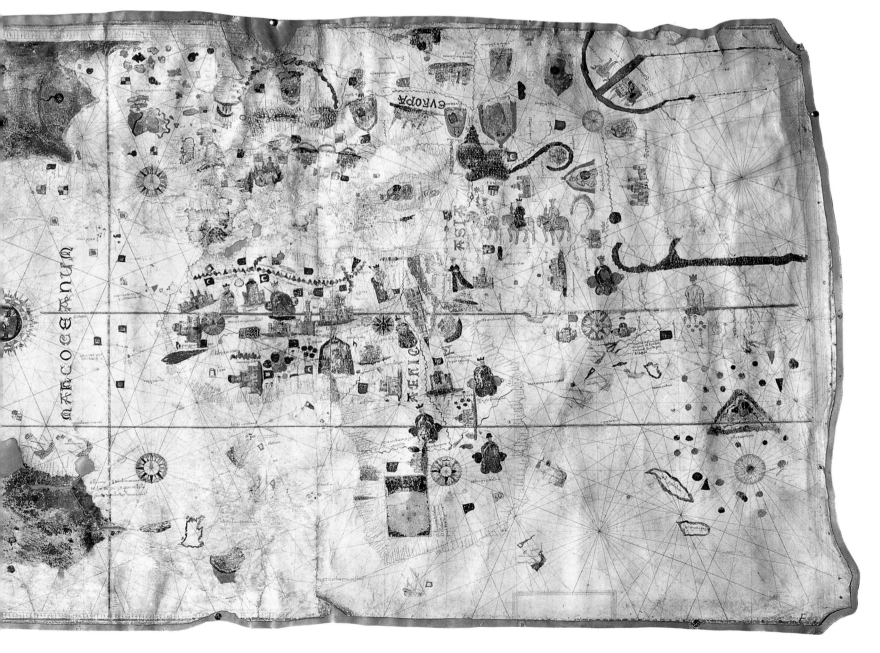

The Western Hemisphere is out of scale with the Old World on the map, either out of ignorance or a desire to show the details more clearly. The map is full of place names in the Antilles and along the South American and African coasts. The prominent vertical line that touches South America is the "line of demarcation" created by the Treaty of Tordesillas to separate areas of Spanish and Portuguese sovereignty. The detail of the coastline to the north, around Newfoundland and Cape Breton, is thought to reflect a lost map drawn by John Cabot. J.A.L.

132 &

Martin Waldseemüller
German, 1470–1518

WORLD MAP

1507
woodcut on 12 sheets
120 x 240, each sheet 45 x 60 (47¼ x 94½, each
sheet 17¾ x 23⅝)
references: Fischer and Wieser 1903, 1–18, 45–55,
pls. 1–13; Laubenberger 1959; Fite and Freeman
1969, 24–27, no. 8; Klemp 1976, no. 4; Harris 1985

Fürstlich zu Waldburg-Wolfegg'sche
Kupferstichkabinett

In his *Cosmographiae introductio* published in Saint-Dié in Lorraine in May and September 1507, Martin Waldseemüller (or perhaps Matthias Ringmann: see Laubenberger 1959) noted that the book was to constitute "a sort of introduction to the cosmographical configurations which we have depicted both on a globe and on a map." Today the map is known in only one impression, in the library of the prince of Waldburg-Wolfegg. It was discovered there early in this century in a large folio volume bearing the ex libris of Johann Schöner (1477–1557), the famous cartographer from Nuremberg. This remarkable volume contained Martin Waldseemüller's woodcut world maps of 1507 and 1516 (both unique examples) and Dürer's map of the heavens of 1515 (see cats. 118, 119), as well as gores of Schöner's celestial globe of 1517.

Martin Waldseemüller was born in Radolfzell in Germany in 1470 and died probably in 1518, in Saint-Dié. He settled at the court of René II, duke of Lorraine, where he produced various maps of Europe and of the world. Most important is his edition of Ptolemy's *Geography* published in Strasbourg in 1513, for its new maps brought the traditional Ptolemaic world view up to date. According to Waldseemüller's own account, his world map of 1507 was drawn and printed in the small town of Saint-Dié, although the woodcuts seem to have been made in Strasbourg. An

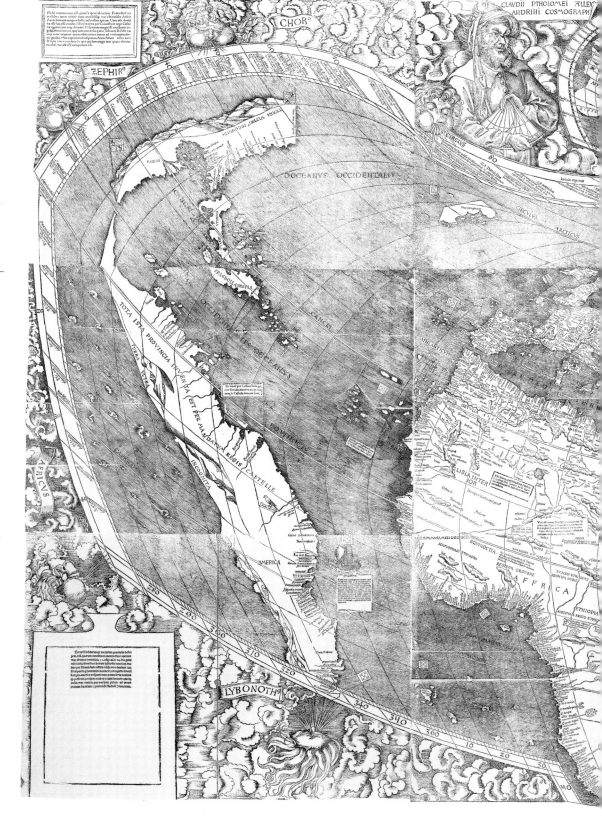

inscription on a later map indicates that the original printing was 1,000 copies.

The map's full title is *Universalis cosmographia secundum Ptholomaei traditionem et Americi Vespucii aliorumque lustrationes* (*A Map of the World According to the Tradition of Ptolemy and the Voyages of Americus Vespucius and others*).

Appropriately, representations of Ptolemy and Vespucci appear at the top at either side, emphasizing the fact that the configuration combines the traditional Ptolemaic vision of the world with the results of the latest geographical explorations. Africa is shown to be circumnavigable, but the topography of India and what is now Sri Lanka

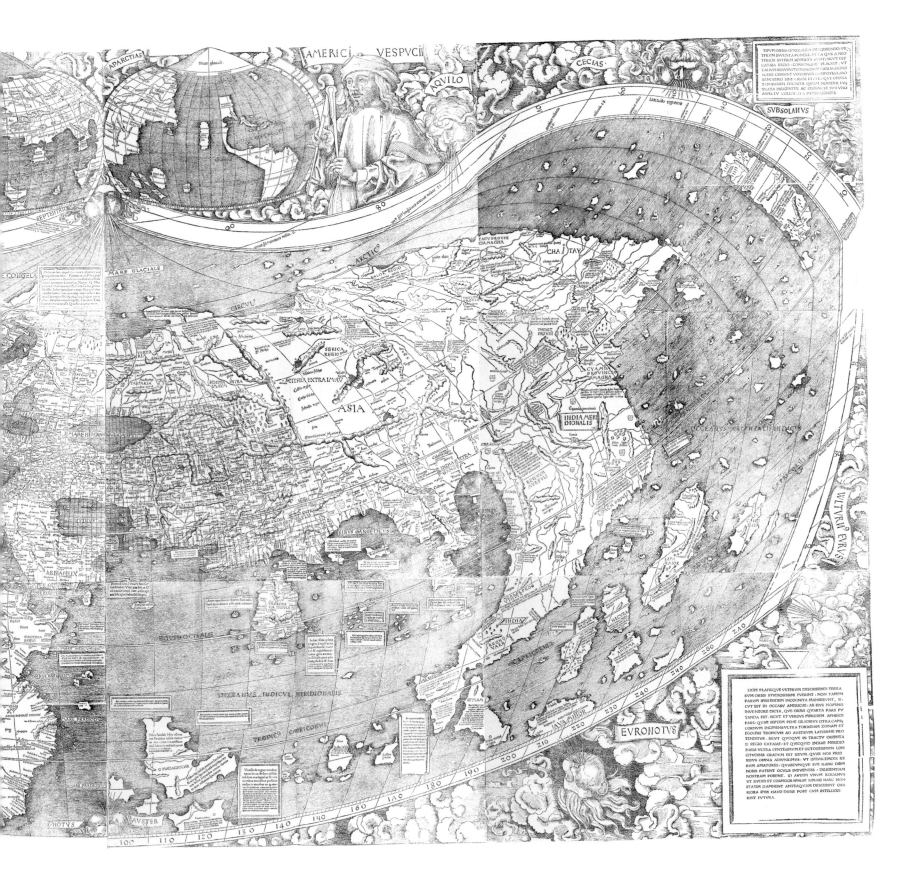

still follows traditional Ptolemaic models. The depiction of the Far East reflects medieval fiction more than fact. America is shown as a long, narrow strip divided into two sections. The islands of the West Indies are given suitable prominence, especially *Spagniolia* (Hispaniola), and *Isabella* (Cuba). On the slightly earlier Juan de la Cosa and Cantino maps, the land that was depicted west of these islands was probably meant to represent not America but China, since Columbus and his fellow navigators thought they had approached the coast of Asia—although the possibility cannot be excluded that the authors of these maps had some knowledge of the coast of Florida. Waldsee-müller, however, recognizes this land as a new entity, and he shows it, on the gores of his globe made the same year, as quite separate from either Japan (*Zipangri*) or China.

Brazil, discovered by Cabral in 1500, is here—for the first time ever on a map—given the name America. The *Cosmographiae introductio*

explains the rationale for this name, Waldseemüller's mistaken belief that it was Amerigo Vespucci (rather than Christopher Columbus) who first set foot on the continent: "the fourth part of the earth, since Amerigo discovered it, we may call Amerige, the land of Amerigo, so to speak or America." Waldseemüller continues, "Now, these parts of the earth have been more extensively explored and a fourth part has been discovered by Amerigo Vespucci, as will be set forth in what follows [Amerigo Vespucci's *Letters* were printed in the same volume]. Inasmuch as both Europe and Asia received their names from women, I see no reason why any one should justly object to calling this part Amerige, i.e. the land of Amerigo, or America, after Amerigo, its discoverer, a man of great ability."

Waldseemüller intended his map as a compendium of information about the findings of the voyages of exploration. In the lower left corner, an inscription states that the map includes: "A general delineation of the various lands and islands, including some of which the ancients make no mention, discovered lately between 1497 and 1504 in four voyages over the seas, two by Fernando of Castille, and two by Manuel of Portugal, most serene monarchs, with Americus Vespucius as one of the navigators and officers of the fleet; and especially a delineation of many places hitherto unknown. All this we have carefully drawn on the map, to furnish true and precise

geographical knowledge." The upper left corner contains more data on the "new" continent: "For there is a land, discovered by Columbus, a captain of the King of Castile, and by Americus Vespucius, both men of very great ability, which, though . . . it lies . . . between the tropics, nevertheless extends about 19 degrees beyond the Tropic of Capricorn toward the Antarctic Pole Here a greater amount of gold has been found than of any other metal." In addition to being graced with the name America, Brazil is also symbolized on this map by a red macaw as on the Cantino map (this time with the label *rubei psitaci*). J.M.M.

133 ✍

Francesco Rosselli
Florentine, 1448–before 1513

WORLD MAP

c. 1508
engraving
21 x 35 (8¼ x 13¾)
references: National Gallery of Art 1973, 47–59; Shirley 1983, 32, no. 28; Nebenzahl 1990, 56–57

Arthur Holzheimer Collection

News of the voyages of exploration first reached the educated community in Europe through books like Columbus' *Letter* (cat. 136) and Vespucci's *Mundus Novus* (New World), and then through printed maps such as this one. Signed by the engraver Francesco Rosselli, this oval projection was probably produced a few years after the coniform projection which Rosselli engraved after the design of a certain Giovanni Matteo Contarini in 1506, known from a unique impression in the British Library.

A brother of the painter Cosimo Rosselli, Francesco Rosselli was also active as a miniaturist and painter. An important group of early Florentine engravings executed in the so-called "Broad Manner" has convincingly been attributed to him. He is also the author of a famous engraved view of the city of Florence, known today only from a woodcut copy. He is recorded as having been in Venice in 1505 and 1508; in the latter year he was described as having been in the audience in Venice at a lecture on geometry given by Fra Luca Pacioli (cats. 143) in the Venetian church of San Bartolomeo. At the death of Francesco's son Alessandro in 1525, an inventory of the stock of the family print shop in Florence was prepared which listed a number of maps, prints by other contemporary artists, woodblocks, and engraving plates.

Rosselli's elegantly simple oval projection is graduated in 360° longitude and 180° latitude. Having determined to show the entire globe in

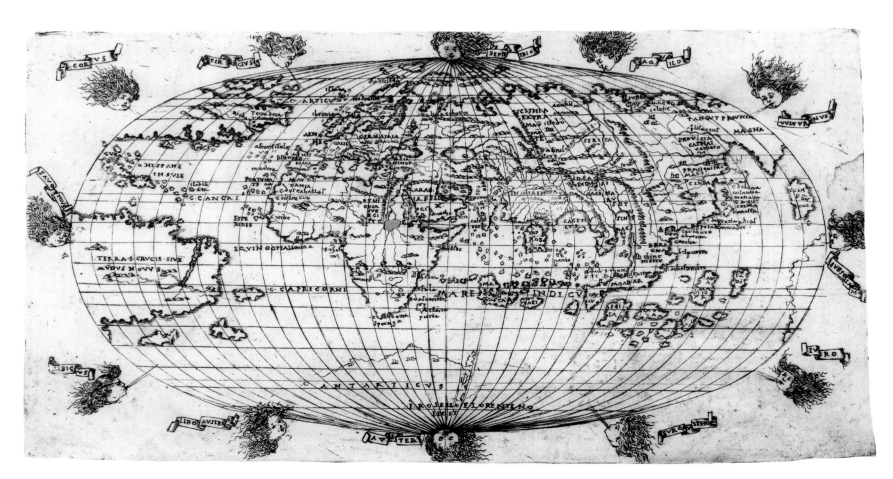

one image, Rosselli had to determine the relationship between the lands described by Columbus, Vespucci, and Cabot and the traditional image of Asia. Newfoundland appears at the upper left, as the easternmost limit of Asia. The West Indies are below, with Cuba shown as an island, and below that is a South American continent, labeled *Mundus Novus*. In his Fourth Voyage of 1502–1503, Columbus had explored the coast of Central America, designating many place names. These appear in Rosselli's map at the lower right, along the southeast Asian coast. The island at the extreme right edge of the map is Japan.

This map is known in only two other impressions, one in the Biblioteca Nazionale Centrale, Florence, and a hand-colored example in the National Maritime Museum, Greenwich, which was long thought to be a manuscript map rather than an engraved one. J.A.L.

134 ❧

Hunt-Lenox Globe

before 1507(?)
engraved copper globe
diameter 12.7 (5)
references: Harrisse 1892, 470–471, no. 87;
Stevenson 1921, 1:73–74, figs. 34–35; Fite and
Freeman 1969, 22–23

New York Public Library, Astor, Lenox and Tilden
Foundations, Rare Books and Manuscripts

The Hunt-Lenox globe was discovered in Paris in 1855 or 1856 by the architect Richard M. Hunt; he presented it to James Lenox, who donated it, with his collection of books, to the New York Public Library. The globe is an engraved pair of copper hemispheres joined at the equator. Two holes pierced for an axis provide evidence of a mount, which is now missing. Originally the globe may have been part of an astronomical clock, as was the case with the Jagiellonian globe in Cracow.

The old world, from Europe to Asia, occupies much of the sphere's longitude, leaving little space for the Atlantic and Pacific oceans. Europe is rather summarily delineated: We need only observe the shape of Portugal, France, or the British Isles. The proportions of Africa are not very accurate either, but its southern tip is at least separated from Asia, which had not been the case in Ptolemaic world maps. The Cape of Good Hope, circumnavigated by Bartolomeu Dias in 1487–1488, is clearly identified. The Indian Ocean is poorly recorded; similarly the depiction of Asia depends on traditional accounts, and the strip of land between Asia and Africa from the Ptolemaic world map has been fragmented into a string of unidentified islands. Most of the inscriptions on the globe look back to the medieval picture of

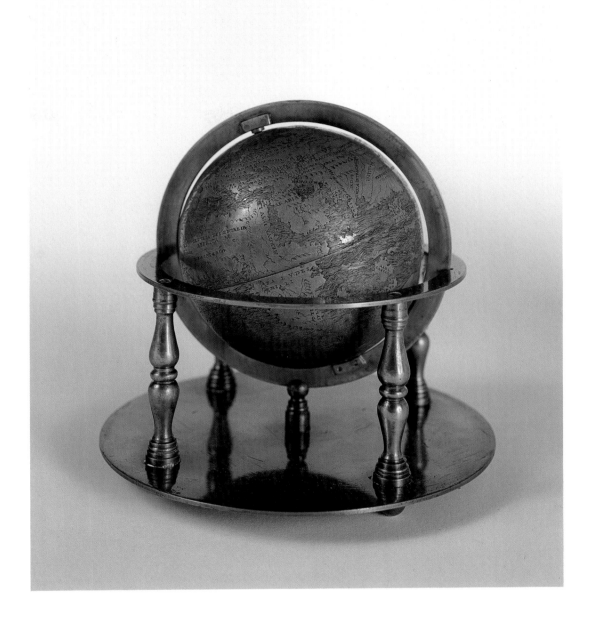

Asia, combining antique sources, travel accounts, and fabulous legends. The anonymous engraver filled the ocean with ships and sea monsters and stressed the dangers of navigation by illustrating a shipwreck off the coast of China. Most interesting is the depiction of America. The two main islands of the West Indies, Hispaniola and Cuba, are identified by inscriptions (respectively, *Spagnolia* and *Isabel*); the third, to the west, is probably meant to be Japan (*Zipancri*). The newly discovered continent is variously called *Mundus novus*, *Terra sanctae crucis*, and *Terra de Brazil*; this last is indeed Brazil, which was first reached by Pedro Álvarez Cabral on 22 April 1500. North America does not yet appear; nor indeed is the name America employed. This may suggest that the Hunt-Lenox globe was produced before 1507, when Waldseemüller published his map of the world (cat. 132) and the gores for his globe, the first documents to give that name to the new continent. J.M.M.

135 ❧

Battista Agnese
Genoese, active c. 1536–1564

World Map

from a portolan atlas
c. 1543–1545
manuscript, 14 fols.
21.6 x 28.2 (8½ x 11⅛)
references: Spitzer and Wiener 1875; Wieser 1876,
541–561; Collection Spitzer 1890–1892, 5:143–144,
no. 30; Wagner 1931, 74–75, no. 32; Fite and
Freeman 1969, 58–59, no. 17

The John Carter Brown Library at Brown University,
Providence

Battista Agnese, a cartographer and miniaturist born in Genoa, seems to have spent most of his life in Venice, where he produced atlases and maps of great beauty; those which are signed attest to

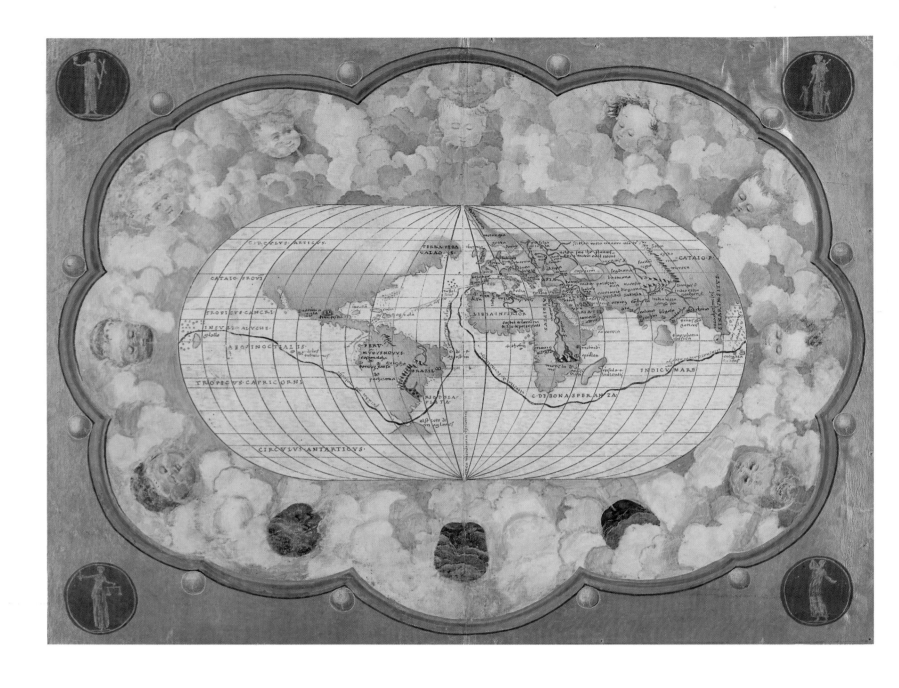

his activity between 1536 and 1564. In many ways his maps recall sea charts, but they seem never to have been used in navigation: rather, they convey, like a modern atlas, a global vision of the world as seen from a European perspective and through European eyes. More than seventy atlases by Battista Agnese are known today (see Wagner 1931, 1–110; 1947, 28–30), two of them in the John Carter Brown Library in Providence. The so-called Charles v atlas exhibited here is splendidly decorated. In fact it was made not for the emperor but for his son, the future Philip II of Spain. A frontispiece to the atlas shows Providence handing over a globe to the young prince, together with the arms of Castile and Aragon, and a dedication to Philip: "Philippo Caroli Aug[usti] F[ilio] optimo princ[ipi] Providentia" (Providence to Philip, excellent prince, son of Charles the Au-

gust). Next comes a double page with a representation of the zodiac, then declination tables, and a page with an illustration of Jupiter. This is followed by eleven maps, beginning with the world map. The others represent, respectively, Spain and northwest Africa, northwest Europe, the western and then the central part of the Mediterranean, the Black Sea, the Greek archipelago, the eastern Mediterranean, and finally, in three maps, the Indian, Atlantic, and Pacific Oceans. The atlas is undated but internal evidence, as well as a study of the chronology of Agnese's maps, suggests a date of 1543–1545. The world map is of the so called post-Californian type, showing California as a peninsula. This "discovery," made during Francisco de Ulloa's exploration of the Gulf of California in 1539, was first included by Agnese in his world map of 1542.

The world map itself is surrounded by the winds blowing from twelve directions, with four personifications (Faith, Charity, Justice, and another Virtue) at the corners. The world is superimposed on a projection constructed with curved meridians and straight parallels. There are large areas of unmapped territory, especially to the north of Asia and America. The shape of the Mediterranean, of Africa, and of Madagascar is more or less accurate, but as in so many other maps of this period Asia still depends on the world map of Ptolemy. The triangular form of the Indian subcontinent is not understood; the island that is now Sri Lanka (*Taprobana*) is still far too large; and China and the Malaysian peninsula are drawn without any direct knowledge of their configuration. America is depicted with more accuracy, although it is connected to the west with

China (*Cataio provi[ncia]* is written north of California, and *Cataio p.*, on China). North America is, however, linked to South America, which was not the case on the Cantino and Waldseemüller (cat. 132) maps. South America is identified as *Mundus Novus*; Peru is also indicated, having been conquered by Francisco Pizarro, who set out from Panama in 1530 and sacked Cuzco—which is shown on the map—in 1533. The Rio de la Plata and the Straits of Magellan are indicated, the latter with an uncharted land stretching towards the Antarctic circle. Especially interesting is the fact that the map records, with a continuous line, the route of Magellan, who left Seville in September 1519 with five ships, only one of which, the *Victoria*, completed the circumnavigation of the globe to return to Spain in 1522 with its captain Sebastian del Cano, a crew of fifteen men, and a precious cargo. The other sea course that is indicated in gold, running from the New World to Spain, is the route of the Spanish treasure fleet.

J.M.M.

136

COLUMBUS' LANDING

from Christopher Columbus, De insulis inventis Epistola, *Basel, 1493 (fol. 1v)*
woodcut
13.5 x 10.5 (5¼ x 4⅛)
references: Morison 1942, 1, 413–414; Hirsch 1976; Gerbi 1986, 45–49; Taviani 1984; Jane 1988, CXXIII–CXLIII and
1–19

The John Carter Brown Library at Brown University, Providence

In late January or early February 1493, during his homeward passage from the West Indies, Christopher Columbus composed a short letter describing his voyage. Not addressed to anyone specifically (it begins with the salutation "Sir" and bears the date 15 February), it was evidently intended as a general announcement of his achievement. It was enclosed with another letter, addressed to Ferdinand and Isabella and since lost, as well as a detailed *Journal* of the voyage (the original of which has long since disappeared); these documents were sent to the king and queen when he arrived in Lisbon. Ferdinand and Isabella had this general letter copied and distributed to various officials who had been involved in mounting the expedition, including to Luis de Santangel, who had arranged the financing of Columbus' fleet

(Santangel was treasurer of the Santa Hermandad, the urban league set up by Ferdinand and Isabella), and Gabriel Sánchez, treasurer of the crown of Aragon. One copy reached a printer's shop in Barcelona and appeared as a pamphlet in Spanish by the summer of 1493. A Latin translation by Leandro de Cosco, made from a better text than the manuscript used by the Barcelona printer, served as the basis for nine editions of the letter ("Letter concerning the newly discovered islands in the Indian Ocean") that appeared in 1493–1494 in Rome, Paris, Basel, and Antwerp and for an Italian verse translation by Giuliano Dati, of which three versions were printed in 1493 in Rome and Florence.

The numerous translations and printings indicate that the demand for news of Columbus' voyage was high. The literate public of Europe thus learned of the voyage essentially in the explorer's own words. He described the islands he had visited, the timid "Indians" he had encountered, who "go naked... as their mothers bore them," and his hope that they would be converted to Christianity and that Hispaniola would serve as a base for trade with the mainland belonging to

the Chinese emperor, the "Grand Khan." Columbus noted that he had not found the "human monstrosities" that many had expected to inhabit these distant regions, though he had encountered cannibals and had heard of an island inhabited solely by women. He promised to be able to supply "as much gold as [their highnesses] may need," spice, cotton, mastic, aloeswood, and slaves. Columbus' letter was soon eclipsed in popularity by the *Mundus Novus* ("New World"), a sensationalized adaptation of Amerigo Vespucci's account of his voyages to South America, of which sixty editions had appeared by the late 1520s, as compared to a total of twenty-two editions of the Columbus letter.

In this Basel edition of 1493, an anonymous woodcut labeled *Insula hyspana* represents Columbus' encounter with the timorous, naked natives. This woodcut depicts Columbus' ship as a galley with an auxiliary sail, a craft more suitable for use in the Mediterranean (a similar galley is visible at the lower right of (cat. 151) Jacopo de' Barbari's *View of Venice*). Other illustrations in this edition contain more appropriate representations of ocean-going sailing ships.

J.A.L.

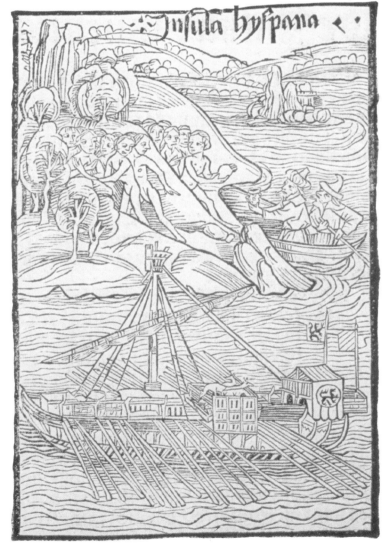

SCHLÜSSELFELDER SHIP

1503
Nuremberg
silver, partly gilt, enamel, and paint
79 x 43.5 (31⅛ x 17⅛)
references: Oman 1963, 18–19, 21–24, pls. XV–XVII;
Nuremberg 1971, 367, no. 660; Fusi 1977, 89–90,
95, pl. 9; New York and Nuremberg 1986, 224–227,
no. 81

Germanisches Nationalmuseum, Nuremberg, on
permanent loan by Schlüsselfeldersche Stiftung

Fifteenth- and sixteenth-century carracks are best known today from their representation in manuscripts (see Villain-Gandossi 1985), paintings, and engravings. The *Livro das Armadas* (Academia das Ciencias, Lisbon), for example, is an invaluable document showing the principal fleets of the Portuguese. More impressive still is a Netherlandish painting in the National Maritime Museum in Greenwich showing the arrival of the Infanta Beatriz of Portugal at Villefranche in 1522, with a squadron of Portuguese carracks; one of them, in the foreground, can be identified as the *Santa Caterina de Monte Sinai,* a ship built in Cochin (India) in 1511 (Greenhill 1982, 60–61). Three-dimensional ship models are rare. One such is the fifteenth-century wooden carrack that was made as an ex-voto for the church of Mataró in Catalonia (Maritiem Museum "Prins Hendrik," Rotterdam). Another is a more splendid object altogether—the Schlüsselfelder ship.

Completed in 1503, this ship was originally used as a wine container; the whole superstructure can be lifted off and the hull filled. The ship's utilitarian function is emphasized in an inscription on a colored drawing after the vessel (Kunstbibliothek, Berlin), made by Jakob Mores, a goldsmith from Hamburg: "The silvergilt ship weighs 26 marks. When you remove the upper part, the lower section becomes a drinking vessel that holds two measures of drink." More precisely, the ship can hold 2.33 liters. In the Middle Ages silver ships were used as table decorations, but generally to hold table utensils and napkins, as in the case of the *nef* (ship) described in a 1380 inventory of the goods of Charles V of France, which also contained the king's *languier* to test food for poison (see cat. 12), his spoon, and his little knife and fork. Other *nefs,* such as the vessel owned by Jean, duke of Berry, and illustrated in a miniature of his *Très riches heures* (1416), contained *tranchoirs* (dishes used for cutting and eating meat) in silver or gold (for *nefs* in medieval France, see Lightbown 1978, 30–31).

The ship is a carrack, a merchant ship "heavily built, with carvel planking, with large and well-developed castles, three-masted, square-rigged on fore and main with lateen mizzens" (Parry 1963, 64). It closely resembles the vessel shown in the engraving of a carrack (*kraeck*) by Master WA with an Anchor. The ship itself is supported by a double-tailed mermaid, cast in silver. Only the swelling foresail is inflated; the sails of the other two masts are furled. Various small flags fly in the wind; engraved on them are images of saints Catherine, George, Sebastian, and Nicholas, as well as a lion, the symbol of Saint Mark, and the enameled coat of arms of the Schlüsselfelder family. A dragon forms the figurehead, furnished with anchors and grappling irons. Both the forecastle and poop have battlement arcading. The boat is heavily armed and full of activity. The masts all support crow's nests with soldiers in them. Some sailors are on the rigging, probably unfurling the sails, while others are lifting ballast. Some are armed, while others are involved in various occupations—eating and drinking, making music, playing cards, or just standing around. Among the varied crowd can be discerned a cook, a monk, a fool, a washerwoman, and even an embracing couple.

The Schlüsselfelder ship was provided with a black leather case, ornamented on the front with a pattern of scrolls against a punched background and lined with red leather and velvet. The case bears the date 1503. The ship's first owner seems to have been Wilhelm Schlüsselfelder (1483–1549), who bequeathed it to his seven sons, who drew lots for it in 1567. In 1503 Wilhelm Schlüsselfelder was only twenty years old; since his father had died in 1493, it has been convincingly suggested that the ship may have been commissioned by Wilhelm's rich uncle, Matthäus Landauer, who died in 1515 and who is best known for having ordered Dürer's altarpiece, the *Adoration of the Trinity* (Kunsthistorisches Museum, Vienna). The ship was certainly made in Nuremberg, as a reversed *N,* a well-documented mark, has been punched on the foresail.

The name of the goldsmith who made the ship is unknown. One name that has been proposed is that of Albrecht Dürer the Elder (1423–1502), father of the famous painter. Not enough is known of the style of individual masters in Nuremberg at this period to identify the ship's maker on that basis; for example, Albrecht Dürer the Elder's only identified work is the little silver statuette which he is shown holding in a drawing in silverpoint (Albertina, Vienna) which is most probably a self-portrait. A more likely candidate would be another goldsmith, Hans Frey (1450–1523), who was the painter Dürer's father-in-law and was famous for constructing complex mechanical devices, especially table fountains. According to Johann Neudörffer's *Nachrichten von Künstlern* (*Accounts of Artists*) (1547), "he understood how to force water up by means of air. He made numerous figures of men and women out of hammered copper. These were then filled with water that emerged from their heads due to the pressure of the air. These ornamental fountains were portable and could be carried from room to room." Albrecht Dürer himself made a few drawings for such table fountains (Strauss 1974, 1:456–465, nos. 1499/1–1499/5); the most famous of them (British Museum, London) clearly indicates the action of the silver plunger, which is to force the liquid up through tiny pipes. Most interesting, however, are the painted silver figures, which recall the seventy-two tiny figures on the Schlüsselfelder ship. J.M.M.

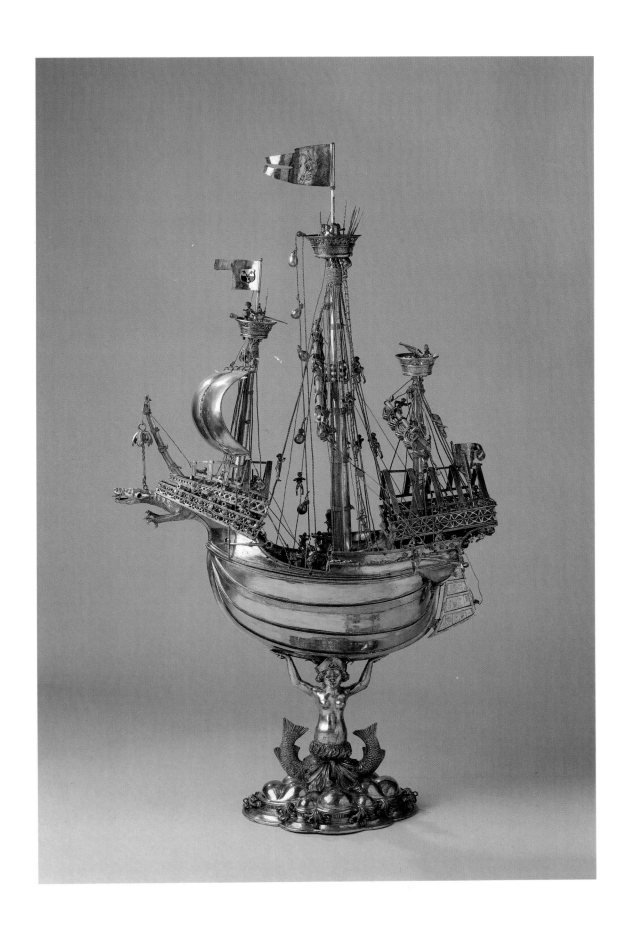

THE RATIONALIZATION OF SPACE

Renaissance faith in the power of the intellect to comprehend the universe and to order human life is nowhere more apparent than in the new visions of space that appeared in fifteenth-century Italian art. The humanists believed that man's only hope for deliverance from the chaos of earthly existence lay in the discipline of the liberal arts, epitomized by the rationality of geometry. Brunelleschi's invention of linear perspective in Florence early in the century provided theoreticians and artists with a potent device to express their belief in the ordering force of numbers.

Practical as well as theoretical concerns made the science of perspective a critical tool for the artist. From Giotto onward, religious and secular art in Italy emphasized the narrative, in which individualized human actors played their parts convincingly within a realistically conceived space. Perspective enabled the artist to create a mathematically-designed stage, the perfect setting for human action.

138 &

Follower of Filippo Brunelleschi

CHRIST HEALING A POSSESSED WOMAN

before 1462
cast silver relief with traces of enamel; silver-gilt and enamel frame
6.9 x 10.7 (2⅝ x 4⅛) (without frame); 17 x 20 (6⅝ x 7⅞) (including frame)
references: Pope-Hennessy 1965; Hyman 1981

Musée du Louvre, Paris, Département des Objets d'art

The miracle is set within an invented but overtly Florentine-style townscape that shows similarities to the background of Masolino's fresco of the *Healing of the Cripple and the Raising of Tabitha* in the Brancacci Chapel and, ultimately, to the famous lost panel showing the Florentine Baptistery which Brunelleschi created as one of his original demonstrations of linear perspective. Here the main building, dominating the spacious piazza, appears to be a centralized structure on a square base, with cruciform upper story and corner domes (presumably over chapels set between the arms of the Greek cross). Its architectural style is Brunelleschian only in the broadest sense. The pilasters and panels derive from the Florentine Baptistery, while the porticoes are closest to the door surrounds added by Donatello to Brunelleschi's Sacristy of San Lorenzo. The precise subject of the narrative remains obscure and cannot be definitely identified as one of the specific episodes of healing by Christ described in the New Testament. It is not even clear if the person from whom the devil is being expelled is male or female.

Despite its extremely small size, the relief reflects a high degree of ambition and achievement in the characterization of architectural space, and its figure composition makes knowing reference to a number of works by the pioneers of the early Renaissance, especially those by Masaccio and Donatello. The alarmed female figure throwing her arms in the air is a notably Donatellesque feature, while the ring of standing apostles makes reference to the composition of Masaccio's *Tribute Money* in the Brancacci Chapel. The relief has at various times been attributed to such important artists as Brunelleschi, Donatello, Castagno, and Filarete (Hyman 1981). It is likely to have been cast before 1462, when the background architecture was copied rather crudely on the reverse of a portrait medal of King René of Anjou by Pietro da Milano. It is also known in an inferior and marginally smaller bronze plaquette in the National Gallery of Art, which appears to have been cast from a mold taken from the silver original. The question of attribution remains intractable, largely because of the absence of a directly comparable work by any of the major Florentine sculptors. Of the proposed attributions, that to Filarete has most to recommend it but seems less than wholly convincing. It is possible that it is an unusually accomplished work by a specialist in precious metals, such as Maso Finiguerra or Baccio Baldini. The apparent contrast in style between the uncompromisingly Renaissance relief and the medieval filigree decoration of the frame might at first glance suggest that the relief and the frame were only united at a later date, but the traditional decorative motifs of the frame recur persistently in Italian metalwork throughout the fifteenth century, and it is likely that image and frame were made in the same workshop at the same time. The precious materials and rich appearance of the ensemble indicate that it was conceived as a prestige object for a wealthy patron like Piero de' Medici, who is known particularly to have treasured small-scale objects of rich workmanship for close inspection in his writing room (*scrittoio*).

M.K.

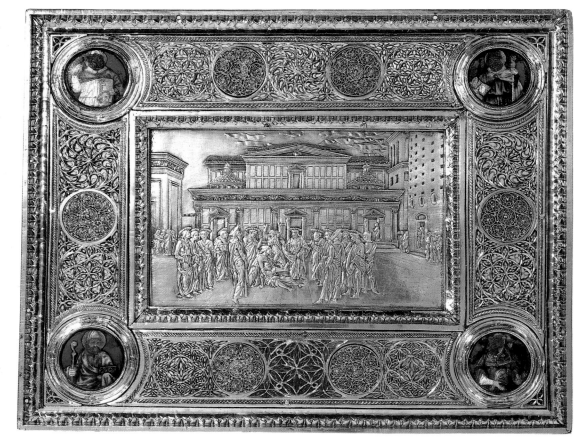

139–140 �

Attributed to Paolo Uccello
Florentine, 1397–1475

PERSPECTIVAL STUDY OF A CHALICE

1758A
29 x 24.5 (11⅜ x 9⅝)

PERSPECTIVAL STUDY OF A MAZZOCCHIO
1757A
9 x 24 (3½ x 9½)

c. 1450–1470
pen and dark brown ink
references: *Kern 1915; Arcangeli 1942; Chastel
1953; Rome 1959; Parronchi 1964; Pope-Hennessy
1969, 155–156; Florence 1978, nos. 76–78;
Himmelheber 1985; Cheles 1986; Rossi et al. 1986*

Gabinetto Disegni e Stampe degli Uffizi, Florence

Uccello's fondness for perspectival conundrums
is well affirmed both by paintings and by the
famous anecdotes in his biography by Vasari, who
claimed to own a drawing of "a *mazzocchio* traced
in line alone, so beautiful that without the pa-
tience of Paolo it would not have been possible to
accomplish." There are two drawings of a *mazzoc-
chio* in the Uffizi — no. 1756A also depicting a
"skeletal" *mazzocchio* but with different-shaped
outer facets — and two related drawings in the
Louvre — Cabinet des Dessins no. 1969 depicting a
faceted sphere and no. 1970 depicting a solid *maz-
zocchio* (Rome 1959). The *mazzocchio* was a
hollow wooden or basket-work frame that sup-
ported a fashionable male headdress of the period.
Examples appear in Uccello's paintings of the
Battle of San Romano and more unexpectedly
around the neck of a near-naked man and on the
head of a woman in the fresco of the biblical *Flood*
in the cloister of Santa Maria Novella, Florence.

Despite the obvious similarities among the
drawings and their relationship to Uccello's
known practice, their attribution to him is less
straightforward than is generally assumed. The
main feature that the Uffizi drawings have in
common is their basic constructional approach,
which involves a myriad of incised stylus lines on
the surface of the paper, which are fully visible

only in raking light. At each separate level of the
upper and lower edges of the facets, a "rosette" of
incised lines radiates outward from the central
axis. Even the relatively simple *mazzocchio* on
sheet 1756A necessitated five such "rosettes." The
positioning of the lines in the "rosettes" appears
to have been determined in relation to a series of
scaled points on horizontally (and possibly verti-
cally) incised lines, which had previously been
plotted on an unforeshortened plan of the polyg-

onal outline inscribed within a square. The loca-
tion of the relevant points on each of the lines in
the "rosettes" could have been obtained by refer-
ence to a foreshortened version of the square in
which the polygonal plan was inscribed, or by the
use of a foreshortened vertical scale at the side of
the drawing, as in book II of Piero della Frances-
ca's *De prospectiva pingendi* (see cat. 141) The
mazzocchio drawings, which have been trimmed
down, provide no unequivocal evidence regarding
this question, but the closely packed diagonal
lines incised at the left and right margins of the
drawing of the chalice favor the latter alternative.
Although Piero could have used this method for
the drawing of a *mazzocchio*, he reserved it in his
treatise for relatively simple forms, preferring to
use the technique of projection from plan and
elevation in his book III for more complex struc-
tures such as a *mazzocchio* or the capital of a
column. The plan and elevation technique would
not have necessitated the welter of incised lines
and speaks against any attempt to attribute one or
more of these drawings to Piero himself (Par-
ronchi 1964).

In other respects, however, the Uffizi drawings
are rather dissimilar. The *mazzocchio* exhibited

here (no. 1757A) exhibits freer pen work than the others and is the only one to exhibit the sharp diminution that results from a relatively close viewpoint. Although the *mazzocchio* not exhibited here (no. 1756A) is seen at a shallow angle similar to that in no. 1757A and to that illustrated in Piero's treatise, the viewing distance is very long, inasmuch as the far side of the *mazzocchio* is hardly diminished in size compared to the near side. The chalice is even more puzzling in this respect, in that the facets on the far side of the chalice are not diminished at all, and the viewing angle at the different levels of the chalice does not change. We do not appear to be looking down at the base of the chalice to a greater extent than at its mouth. The chalice is therefore depicted in nonconvergent or orthographic perspective, in which the notional viewpoint (according to a later formulation) may be said to be at infinity. The complex, see-through nature of the cage of confusing lines has tended to disguise the fact that the chalice is not constructed according to the laws of single-vanishing point perspective at all. The drawing of the chalice is also inconsistent in that only some features—the *mazzocchio*-like rings and flat central plane—are shown in a fully see-through manner.

These observations suggest the need for further investigation both of the constructional methods and the attributions. It is difficult to determine the extent to which the *mazzocchi* in Uccello's paintings are seen from a relatively close viewing point and fully foreshortened, since their far sides are not visible and the paint surface in the *Flood* is badly damaged. Such evidence as is visible suggests that they may have been drawn as if viewed from a distant point, as in no. 1756A. On the other hand, the nonconvergent perspective of the chalice corresponds to the technique used by some of the designers of *intarsia* decorations. Although the famous inlaid woodwork of the *Studiolo* in Urbino, which contains a *mazzocchio* among the other symbols of the liberal arts, appears to use convergent perspective throughout, other *intarsia* designs exhibit the parallel orthogonals of nonconvergent perspective (cat. 145). The popularity of perspectival *intarsie* in the period 1450–1520 and the geometrical expertise of the specialist craftsmen leave open the possibility that some or all of the surviving drawings may have originated in their workshops and certainly indicate that there is no need to attribute all such drawings to Uccello. On the other hand, Uccello himself may well have been involved in the design of *intarsia* decorations for chests and other furniture. Until more evidence comes to light, it is probably best to retain the traditional attribution of the drawings to Uccello, albeit in a very qualified manner.

Such drawings may well have served as templates to be used repeatedly in the workshops; the chalice has in fact been pricked through for transfer at the corners of each facet. This sheet shows obvious signs of wear and is repaired on the verso

with six patches. Like the two other sheets in the Uffizi, it has been laid down at the corners, but in this case the added paper at the bottom corners has been removed or come away. The lower edge of the sheet has been made up at a later date to complete the lower front edge of the chalice.

Whatever the attributional and technical problems posed by the studies of the *mazzocchi* and the chalice, they provide vivid testimony to the patient care with which designers in the Renaissance approached such perspectival tasks. The draftsmen of such objects were prepared to plot projections point by point in a laborious manner to achieve the kinds of results that were to become readily attainable only with the advent of computer graphics in this century. M.K.

141 &

Piero della Francesca
Umbrian, c. 1416–1492

THE CONSTRUCTION OF A VAULT OVER A SQUARE PLAN FROM De Prospectiva Pingendi (On the Perspective of Painting)

c. 1470–1480
manuscript on paper, 91 fols.
28.9 x 21.5 (11³⁄₈ x 8³⁄₈)
references: Pacioli 1494; Winterberg 1899; Nicco-Fasola 1942; Daly Davis 1977; Kemp 1990

Biblioteca Palatina, Parma, MS. Parm. 1576, fol. 29r

The two principal manuscripts of Piero's treatise *On the Perspective of Painting* are the Italian version of 91 folios in the Biblioteca Palatina, Parma, and the Latin text of 115 folios in the Biblioteca Ambrosiana, Milan (Cod. Ambr. C 307 inf). There is a second Italian version without illustrations in the Ambrosiana (D 200 inf), and three additional Latin versions in the British Museum (Cod. 10366), Bibliothèque Nationale, Paris (Cod. lat. 9337), and Bibliothèque de Bordeaux (Cod. 516), respectively. Although the attribution of precisely drawn diagrams to a particular hand is always difficult, the quality of the designs and careful humanist script in the Parma manuscript may reasonably be regarded as by Piero himself, as may the diagrams accompanying the Latin text in the Ambrosiana (Nicco-Fasola 1942). Relying upon the testimony of Piero's follower, Luca Pacioli, who indicated in his *Summa de arithmetica* that Matteo dal Borgo translated *De prospectiva* into Latin, one would think that the Italian text was the earlier, but there are signs that some elements in the Parma version, including the poems "to the author" at the end, are based on the Latin text. It is thus probable that the Latin codex in the Ambrosiana was prepared first from Piero's draft and that the Palatina manuscript was

subsequently produced by Piero himself as the model Italian version.

In addition to his treatise on perspective, Piero had already written a *Trattato del abaco*, an outline of mathematics as applied to such practical problems as calculating size, and was subsequently to write a *Libellus de cinque corporibus regularibus*, on the mathematics of the five regular (or "Platonic") polyhedra (Daly Davis 1977). When he offered his *Libellus* to Duke Guidobaldo da Montefeltro, Piero suggested that it should be placed next to his book on perspective, which he had presented to Guidobaldo's father, Federigo, who had died in 1482. The writing of *De prospectiva* could be assigned to either the 1460s or 1470s, with the balance of probability favoring the later decade.

Although Piero's treatise is highly technical in its mathematical outline of perspectival techniques, it is cast in the guise of practical instructions, working through the examples in a step-by-step manner, with a minimum of abstract theory. His introduction makes it clear that he is dealing with only the second of the three skills needed by the painter to imitate nature—*disegno* (the drawing of the shapes of objects), *commensuratione* (the proportional location of objects in measured space according to the laws of perspective), and *colorare* (the distribution of color, light, and shade). The prevailing tenor of the treatise may be described as "applied Euclid," exploiting basic geometry for the perspectival projection of forms onto a plane (or *termine*) rather than becoming involved in physiological optics.

De prospectiva is divided into three books. The first deals with basic geometrical terms and the foreshortening of a square plane onto which various flat figures, such as the plan of an octagonal building, are projected. The second extends this method to the erection of three-dimensional bodies on the foreshortened plane. The last book shows how to use the plans and elevations of an object to project that object point by point onto an intersecting plane established at a definite distance from the point of projection (or eye). It is this full technique of projection from plan and elevation that Piero uses for such complex forms as the *mazzocchio* (compare cat. 140), column base and capital, and human head. The diagram illustrated here is from near the end of book II and is the final demonstration of how to erect three-dimensional structures on the foreshortened square plane with a vanishing point at A. Piero explains that "the foreshortened [*degredato*] plane is BCDE, on which I intend to place a chapel with a cruciform vault, the square of the chapel being FGHI." The basic technique consists of the erection of a rectangular box in perspective projection within which the points necessary for the drawing of the vault are plotted. Piero takes the reader through the construction line by line, like a schoolmaster coaching a pupil for an examination. The end result is not unlike the structure of the

Although Pacioli was not a mathematician of great originality on his own account, he was an important author in terms of the early history of mathematics in print. A member of the Franciscan order, he spent a peripatetic career in a number of the major Italian centers of learning, including Venice, Urbino, Rome, Bologna, Milan, and Florence. Of particular significance for the production of *De divina proportione* were his contacts with Piero della Francesca in Urbino and with Leonardo da Vinci in Milan. His treatment of the geometrical solids is closely dependent upon Piero's treatises, to the extent that Pacioli has been accused of plagiarism, a charge hardly justified in light of the standard techniques of copy and commentary in the manuscript tradition of the late Middle Ages and early Renaissance.

Pacioli arrived in Milan in 1496 and persuaded Leonardo to draw the illustrations for his book on the five regular or "Platonic" solids and some of their semiregular variants. In his *De viribus quantitatis*, Pacioli indicated that the illustrations were "made and formed by the ineffable left hand" of the "most worthy of painters, perspectivists, architects and musicians, one endowed with every perfection, Leonardo da Vinci the Florentine, in Milan at the time when we were both in the employ of the most illustrious Duke of Milan, Ludovico Maria Sforza Anglo, in the years of our Lord 1496 to 1499, whence we departed together for various reasons and then shared quarters at Florence."

The illustration of the geometrical solids in previous geometrical treatises, including Luca's own *Summa de arithmetica* of 1494, gave little sense of the existence of real forms in measurable space and were difficult to read coherently. Pacioli stated that he had already constructed the Platonic bodies as actual solids, probably in various materials such as wood and glass (as depicted in his portrait in Naples [cat. 143]). He was later to be paid by the Florentine government for a set of geometrical solids (Kemp 1989). It is not known whether the brilliant idea of illustrating the polyhedra perspectively in both solid and skeletal forms should be credited to Pacioli or to Leonardo. Although the solids are depicted very convincingly in three dimensions, with carefully described cast shadows, their perspectival projection is not mathematically precise in every respect. This suggests that they were not drawn using the kind of point-by-point technique of mathematical projection described by Piero della Francesca, but rather that Leonardo used a drawing frame or "veil" or "glass," such as that he showed a draftsman using to depict an armillary sphere (Codice atlantico 5r). The illustrations in the treatises could have been produced by pricking through the corners of the facets of each body on the master drawing and transferring the prick marks to the intended page. Prick marks, incised lines, and pentimenti in the Milan manuscript bear witness to the care that went into its produc-

chapel in Masaccio's *Trinity*, though for the purposes of this basic demonstration Piero does not use Masaccio's low viewpoint. Piero does not intend this construction to be used as it stands for a particular painting; rather he provides the student with the resources necessary to tackle such a construction when the need arises, as, for instance, when painting a *sacra conversazione*.

The existence of four Latin manuscripts of Piero's treatise indicates that it was taken up in learned circles outside the artists' studios. It was known to, among others, Luca Pacioli, who extensively adopted ideas from Piero's other writings in his publications, to Albrecht Dürer (either directly or via an intermediary), to the mathematician Ignatio Danti, and probably also to Leonardo da Vinci. Its most direct influence was on Daniele Barbaro's *La practica della perspettiva* published in Venice in 1569. Barbaro relied heavily upon Piero's methods, although he avoided Piero's laborious line by line expositions, which he considered to be addressed to "idiots." Through Barbaro's well-regarded treatise, Piero's lucid methods entered the general currency of perspective theory during succeeding centuries. M.K.

142 🙐

After Leonardo da Vinci

DODECAHEDRON

from Luca Pacioli, De divina proportione,
Venice, 1509
28.5 x 19.5 (11¼ x 7¾)
references: Fontes Ambrosiani 1956; Rose 1975; Kemp 1989; Kemp 1989a; Dalai Emiliani 1984

Library of Congress, Washington

Pacioli's treatise was produced in two manuscript versions, the better of which was made for Galeazzo Sanseverino in Milan in 1498 and is now in the Biblioteca Ambrosiana (MS S.P. 6) . The second manuscript, in the Bibliothèque Publique et Universitaire in Geneva, has a fine frontispiece dedicating it to Galeazzo's father-in-law, Duke Ludovico Sforza, but it is otherwise a disorderly and inferior version and must be regarded as a later compilation. The text and illustrations were published in amplified form by the printer Paganini in Venice in 1509 and dedicated to the Gonfaloniere of Florence, Piero Soderini.

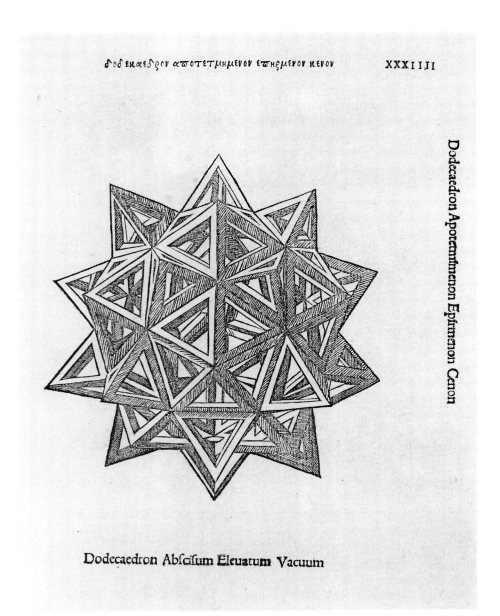

Dodecaedron Apocemmenon Eptimenon Canon

Dodecaedron Abfcifum Eleuatum Vacuum

Jacopo de' Barbari (?)
Venetian, active before 1495–died by 1516

Portrait of Fra Luca Pacioli with a Young Man

1494?
oil on panel
99 x 120 (39 x 47¼)
references: Pacioli 1494; Pacioli 1509; Gronau 1905, 28; Servolini 1944, 105–106; Rose 1975; Daly Davis 1977; Levenson 1978; Naples and Rome 1983, no. 79; Dalai Emiliani 1984; Kemp 1989, 1:237–242

Museo e Gallerie Nazionali di Capodimonte, Naples

The identity of the main figure as the Franciscan mathematician Luca Pacioli and the nature of the mathematical allusions are the only indisputable aspects of this remarkable picture. The inscription on the large volume to the right, "Li[be]r R[e-verendi] Luc[a] Bur[gensis]," indicates almost certainly that the book is Pacioli's *Summa de arithmetica, geometria, proportione et proportio-nalità*, the large compendium of pure and practical mathematics that was published in Venice in 1494. The open book is a printed edition of Euclid's *Elements*, of which Pacioli was to publish an Italian translation in 1509. The geometrical solids—the dodecahedron perched on the cover of the *Summa* and the semiregular polyhedron composed of squares and triangles (a rhombicuboc-tahedron) hanging in the upper left—allude to his special interest in the regular (Platonic) and semi-regular geometrical bodies. This interest had been fired by his contacts with Piero della Francesca and was to result in his most attractive book, the treatise *De divina proportione*, illustrated by Leonardo da Vinci and published in 1509. Pacioli is known to have constructed actual models of the polyhedra (Kemp 1989). The "crystal" polyhedron in the present picture, suspended from a cord that runs through the upper vertex to a point of attachment at the bottom of the solid, appears to have been constructed from glass faces, with a glass plane running horizontally across its center to stabilize the structure. The dodecahedron, an apparently humbler object for everyday teaching, is made from wood. The geometrical diagram on the writing tablet takes up the analysis of an equi-lateral triangle inscribed in a circle from book XIII of Euclid's *Elements*, open in front of the mathe-matician, while the lines and figures deal with the proportional ratios and sums that occupied a good deal of attention in Pacioli's *Summa* (Daly Davis 1977).

Other historical aspects of the portrait are far more problematic, including the identities of the author of the painting and of the young man beside Pacioli. Taken at face value, the signature on the cartellino beside the book—*jaco[po] bar-[bari] vigennis p[inxit] 149.*—would appear to

tion, whereas the illustrations in the Geneva manuscript are drawn far more casually. It is pos-sible that the Milan illustrations were laid in by Leonardo himself, although the attractive and skillfully disposed shading in colored washes seems not to be by his hand.

For Pacioli the interest of the solids extended far beyond the realms of pure geometry. Plato had regarded the five regular bodies—the tetrahedron (four equilateral triangles), the hexahedron or cube (six squares), the octahedron (eight equilat-eral triangles), the dodecahedron (twelve penta-gons), and the icosahedron (twenty equilateral triangles)—as the archetypal forms of the ele-ments and the quintessence from which the cosmos was constructed. Pacioli allied this cosmo-logical geometry with the "divine" harmony of the golden section (i.e., the division of a line AB at C such that AC:CB as AB:AC), which can be used to construct the 72-degree angle of the pen-tagon. Although Leonardo was not disposed to

identify the elements literally with the Platonic solids, he was wholly convinced of the mathe-matical base of harmonic beauty and accepted the idea that the underlying organization of nature conformed to proportional principles.

The folio reproduced shows plate XXXII, the truncated and stellated dodecahedron in its skeletal form. This solid is assembled from a regular body of twelve pentagonal faces, the corners of which have been truncated to produce equilateral trian-gles. Stellations with equilateral faces have been built out from each of the pentagonal and triangu-lar faces of the truncated body. Following the publication of Pacioli's treatise in 1509, such com-plex bodies became popular motifs in *intarsia* designs and provided generations of authors on perspective with one of their greatest challenges.

M.K.

indicate that the author was the much-traveled Venetian artist Jacopo de' Barbari at the age of twenty. However, there has been some difficulty in reconciling this picture with Jacopo's known style, and the status of the inscription has been doubted on technical grounds, since it does not appear in the X-ray of the panel and may have been a much later addition (Naples and Rome 1983). Against these doubts, we can point to the elusive nature of Jacopo's artistic personality, to the absence of any certain works before 1500 (the year of the great *View of Venice* (cat. 151) and the *Saint Oswald*), and to the fact that the white lead of the cartellino is impervious to X-rays and thus precludes any chance of the lettering's being visible. We know that Jacopo's intellectual propensi-

ties were consistent with the sophisticated content of the picture. In an address to Frederick the Wise of Saxony he insisted that an artist must be versed in the liberal arts: "first geometry and then arithmetic, which are both necessary for measurement and proportions, because there cannot be proportion wihout number, nor can there be form without geometry" (Servolini 1944, 105–106). The publication of Luca's *Summa* in Venice in 1494 would have provided both a reason and an opportunity for Jacopo to have painted the portrait in Venice, which in turn suggests that the damaged date on the cartellino originally read "1494." The best alternative suggestions of a painter for the Naples picture have drawn parallels with portraits by Alvise Vivarini and his Venetian circle (Leven-

son 1978), but it is possible that Jacopo's style some six years before his first certain works was itself similar to Vivarini's. On balance, the attribution to Jacopo seems acceptable.

The identity of Luca's young companion (and pupil?) has proved elusive. An inventory of 1631 records a lost inscription, "Divo principi Guido," referring to Duke Federigo da Montefeltro's son, Guidobaldo, who was born in 1472 and was to die in 1508. Guidobaldo was the dedicatee of Luca's *Summa* and the recipient of Piero della Francesca's treatise on the regular solids, the *Libellus de quinque corporibus regularibus* (Daly Davis 1977). However, it would hardly be fitting for a duke to play such a secondary role in the painting, and there is little reliable evidence of Guidobaldo's

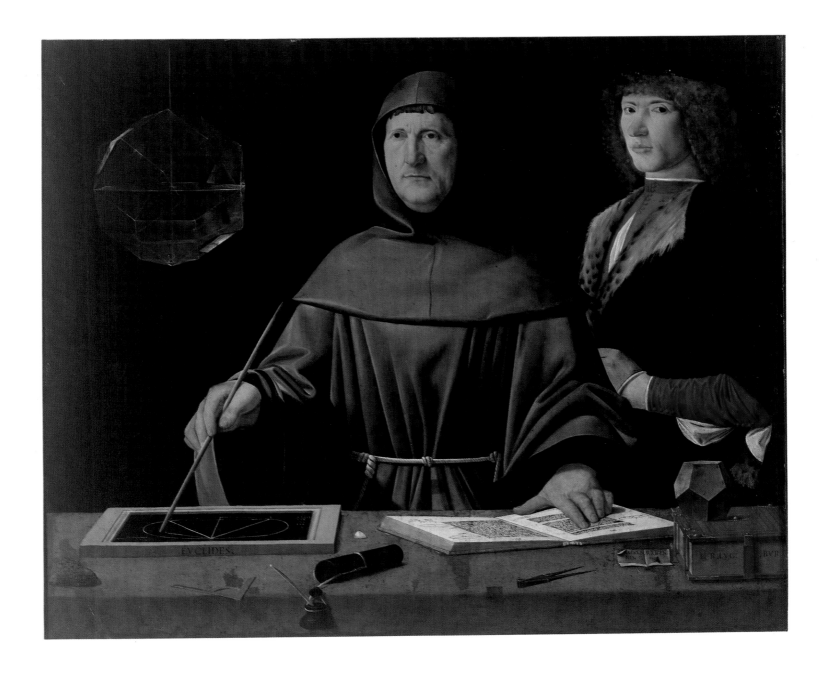

appearance in his early twenties. On the other hand, the young man's glove and rich costume indicate that he was someone of high status, so identification with the young duke is possible. There are records of a portrait of Pacioli in the ducal collection in Urbino from the late sixteenth century, when it was attributed to Piero della Francesca, until 1654 (Naples and Rome 1983). (It should be noted that the traditional identification of a portrait of Pacioli in the background of Piero's altarpiece of the *Madonna and Saints with Duke Federigo da Montefeltro* (Brera, Milan) should be treated with extreme caution, not only on chronological grounds but also in view of the improbability that a Franciscan monk would be portrayed as the notable Dominican saint, Peter Martyr.) Although it is unclear how and when the present panel arrived in Naples, there seems no need to presume the existence of two separate versions of the portrait.

There are numerous filled-in paint losses across the panel and an area of severe damage in the left corner. The main figurative elements have survived in reasonably reliable condition, although Pacioli's left eye shows signs of having been reworked. The most frustrating area of damage and retouching occurs around the last digit of the date. The paint is handled in a solid and unfussy manner, with restrained passages of textural description and beautifully observed reflections in the suspended polyhedron. The draftsmanship places considerable emphasis upon simple volumetric shapes and carefully observed cast shadows — characteristics that suggest the influence of Piero della Francesca, either directly or through Venetian intermediaries such as Antonello da Messina and Alvise Vivarini.

Whatever the remaining historical problems, the portrait of Pacioli in Naples is exceptional as the most substantial and evocative record of any man of science from the early Renaissance.

M.K.

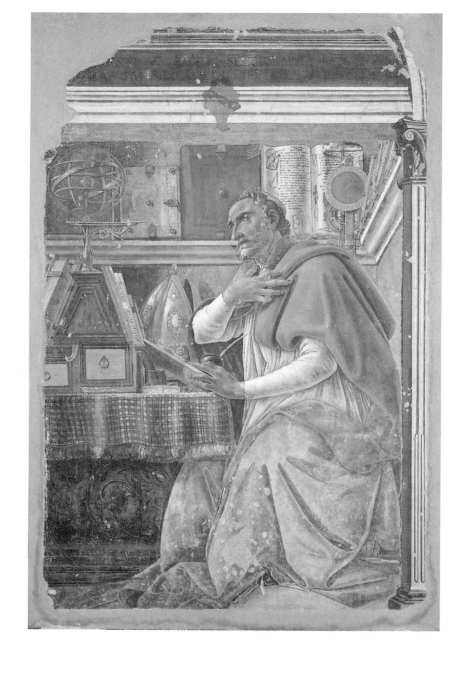

144 ða

Alessandro Botticelli

Florentine, 1444 or 1445–1510

THE VISION OF SAINT AUGUSTINE

c. 1480
detached fresco
185 x 123 (73 x 48½) (irregular)
references: Milanesi 1905–1915, 3:311; Horne 1908; Roberts 1959; Rotondi 1959; Meiss 1970; Lightbown 1978, no. B25; Kemp 1984

Church of the Ognissanti, Florence

In the 1560s Botticelli's fresco was detached from its original location on the screen wall (*tramezzo*) separating the nave from the choir of the Church of the Ognissanti and placed on the right wall of the nave. This occurred following the replacement of the Umiliati in the monastery associated with the church by the Minor Franciscan Observants and the consequent reorganization of the church interior, which included removal of the screen. The low viewpoint of the study represented in the painting — we are looking up from the level of the saint's ankles — may well have been chosen in relation to the original height of the choir and its screen above the level of the nave. Following the flood of 1966, the fresco was removed again and restored. Although its present condition shows clear signs of its adventures, the major areas of the composition are in surprisingly good condition. It was originally painted at the right of the door into the choir as a companion piece to Domenico Ghirlandaio's *Saint Jerome*, which stood on the left of the door. Ghirlandaio's fresco is dated 1480, and

Botticelli's is likely to have been painted at about the same time, before his departure for Rome in 1481 to work in the Sistine Chapel. The shield on the cornice above the saint indicates that his fresco was undertaken for a member of the Vespucci family, a number of whom patronized the church.

Although the images by Ghirlandaio and Botticelli both belong to the tradition of the contemplative scholar-saint in his study, a tradition that had been inspired in Florence largely by the presence of a lost painting of *Saint Jerome* by Jan van Eyck then in the Medici collection, Botticelli's depiction has exceptionally introduced a narrative element. With great eloquence he has illustrated a spurious but apparently popular story from the saint's life. A letter purporting to have been written by Augustine to Saint Cyril (which was probably a thirteenth-century invention) recounted

that at the very moment of Saint Jerome's death (A.D. 420) Augustine was writing a letter to him, seeking advice about the nature of the bliss of souls in paradise. Augustine's study was instantaneously flooded with light, which was accompanied by an "ineffable fragrance" and the voice of Jerome, who indicated that an understanding of the infinite mysteries of heaven was inaccessible to the finite, earthbound intellect of man without the aid of divine revelation. The miraculous rays of light that diverge from a point to the upper left of the armillary sphere in the fresco would have originally been more apparent when the work was freshly gilded, but the impact of the directional light on the saint's features retains its formal and expressive power. This same story was later illustrated by Carpaccio in the Scuola di San Giorgio degli Schiavoni in Venice (Roberts 1959). Ghirlandaio's *Saint Jerome* contains no narrative implications beyond his representation as translator of the Bible from Hebrew into Latin, and it is reasonable to suppose that the choice of subject for Botticelli's fresco was determined by a desire to make an explicit link with Ghirlandaio's already existing image.

Both saints have been fittingly depicted as humanist scholars, and Botticelli has provided Augustine with suitable equipment for cosmological speculation—an armillary sphere (showing the earth at the center of the sphere of the heavens in the Ptolemaic manner), a manuscript treatise on geometry, and an accurately portrayed clock. The time on the clock indicates the passing of the twenty-fourth hour of the day; that is to say (in the system used in this period), the hour of sunset, the supposed time of the miraculous appearance of Saint Jerome (Lightbown 1978). However, Botticelli has muddled the numbering of the dial, allowing for only three of the four divisions hidden by the shelf and subsequently having to jump from XVIII to XXI in order to finish on XXIIII (Kemp 1984). The saint's equipment is entirely consistent with that of actual Renaissance *studioli*, such as that depicted in the *intarsia* decorations in the *studioli* of Federigo da Montefeltro at Urbino and Gubbio. The clear depiction from the low viewpoint of the armillary sphere, lectern with open drawer, inkwell, and clock with crenellated foliot wheel recalls comparable details in the Urbino and Gubbio *intarsie* and lends support to the idea that Botticelli was involved in the design of inlaid decorations for Federigo (Rotondi 1959). It is unclear whether the cosmological paraphernalia were included as an allusion to the kind of speculations that Jerome was to criticize in the story, or, as is more probable, whether they were deemed by Botticelli to be the kind of equipment required by any serious philosopher-theologian (Kemp 1984).

The strange scribbled inscription in the geometrical treatise—"the house of St. Martin has collapsed, and where has it gone? It is outside the Porta al Prato"—may refer to the Church of San

Martino a Mugnone outside the Porta al Prato, but it is difficult to see why such an apparently trivial rhyme has been included. Lightbown's alternative reading—"where is brother Martin? He has slipped away. And where has he gone? He is outside the Porta al Prato"—poses even greater problems. The geometrical diagrams in the treatise are generically Euclidian rather than illustrative of recognizable problems of interpretation. The inscription on the cornice was added after the transfer of the fresco to the nave wall, since it tells us that the intensity of the saint's studies has made him oblivious to his change of location.

The best evocation of the essential meaning of Botticelli's image is still provided by Vasari's account in 1568:

> This work succeeds most admirably in that he has demonstrated in the head of the Saint that profound cognition and sharp subtlety which is only present in persons of wisdom who continually devote their thoughts to the examination of topics of the highest order and greatest difficulty.

M.K.

LECTERN

c. 1500–1515
Central Italian
walnut, carved and inlaid with numerous other woods
240.5 x 135 (diameter) (94⅝ x 53⅛)
references: *Arcangeli 1942; Chastel 1953; Chastel 1965; Pignatti 1967; Rotondi 1969; Cantelli 1973, figs. 28, 35–36, 38–39; Ciati 1980; Tosti et al. 1982; Haines 1983; Trionfi Honorati 1983; Cheles 1986*

Church of San Domenico, Gubbio

Since the grain of wood lends itself to being cut straight, the fifteenth-century Italian masters of intarsia, pictorial marquetry, quickly realized that the new techniques of geometrical perspective were particularly well suited to their art. Perspectival illusions in marquetry proved to be particularly attractive and compelling, not only because of the warmth and tonal contrasts of the various woods but also because of the way that wood, as a common structural material, conveys a sense of solidity. Masters soon vied to show their virtuosity in ever more complex vistas, geometric bodies, and other solid objects. The finest surviv-

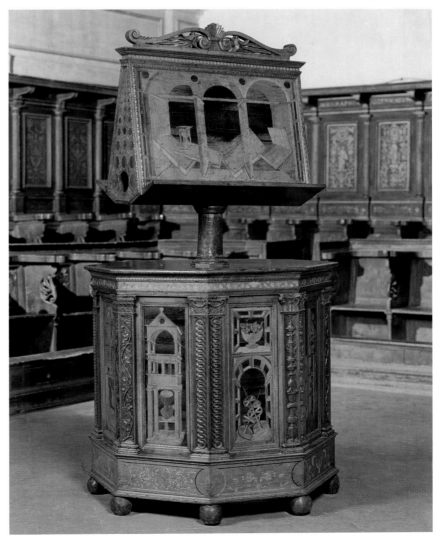

some knowledge of the single vanishing point system—as for instance in the three-arched loggias—but it is not applied consistently within all the panels. For example, the tiered palace in panel 4 of the base exhibits at least two vanishing points for the orthogonals. Some of the trickier forms, such as the circular well in the townscape (panel 1), have given the designer all too obvious trouble. And some of the assemblages of forms are illogically constructed, as is the case with the hourglass and books on one of the sloping faces of the stand, where the hourglass is placed on an inclined book but still manages to stand vertically. The impression is that variations on local themes have been worked ingeniously within the shop of a master-craftsman, to produce a splendid piece of display furniture encompassing the latest style, but without the detailed intervention of a master-artist who was learned in all the geometrical subtleties of perspective. M.K. and C.A.

146 ❧

Antonio and Paolo Mole?
CASSONE OF THE HERZOGIN JACOBÄA

c. 1500–1510
wooden chest with inlaid decoration
99.5 x 229 x 86.5 (39⅛ x 90⅛ x 34)
references: Bertolotti 1889; Arcangeli 1942; Chastel 1953; Chastel 1965; Rückert 1965; London 1981; Himmelheber 1985

Bayerisches Nationalmuseum, Munich

This magnificent and well preserved chest has traditionally been associated with the marriage in 1522 of Jacobäa von Baden and Herzog Wilhelm IV of Bavaria, and it appears in the inventory of the possessions of the Herzogin Jacobäa (Rückert 1965). However, the heraldic devices indicate that its origins are within the court of the Gonzaga at Mantua. The emblematic motifs at either end of the chest—a muzzled hound with a decorative leash and a turtledove seated above a coiled, burning tree trunk with the motto *"vrai amour nese chiange"* (true love does not change)—are both Gonzaga devices, featured on ceramic floor tiles in Isabella d'Este's *studiolo* at Mantua (London 1981). A legend stated that the turtledove would remain faithful to its deceased mate and would perch only on dead branches. The devices appear to have been associated with various members of the Gonzaga family, and Isabella adopted them for use in her own decorative schemes.

The fine *intarsia* decorations of the perspectival cupboards on the Munich chest have, not surprisingly, been connected with Baccio Pontelli, a Florentine master of marquetry, who is commonly said to have worked in Urbino and perhaps also in

ing examples of perspectival *intarsie* are the schemes of decorative paneling for the *studioli* of Federigo da Montefeltro in his palaces at Urbino and Gubbio (Rotondi 1969 and Cheles 1986). The *intarsia* patterns were probably executed by Florentine masters, though the artist-designer has not been identified with any certainty.

This octagonally based lectern normally stands at the center of the choir of the church of San Domenico (formerly San Martino) in Gubbio. Though its early history is unknown, it was almost certainly made for such a setting, where it would be used to support antiphonaries, the large books of oversized music from which the monks sang. It was restored in 1980–1981 (report in Tosti et al. 1982). Until recently, it was thought to be by Mariotto di Paolo Sensi, called Terzuolo, who is first recorded working in Rome in 1492. He was also active in Perugia and his native Gubbio, where he died in 1547 (Sannipoli, forthcoming). Terzuolo's one identified work, the *intarsie* in the sacristy in the Duomo, Perugia, of 1494–1497 (Cantelli 1973, fig. 28), are finer than the lectern, which should probably be attributed to another master working in Gubbio or elsewhere in the Marches. The presence of *grotteschi* on the base appears to reflect trends in neighboring Perugia and suggests a date for the lectern from the late 1490s at the earliest. The variously carved pilasters may reflect the choirstalls and similarly shaped lectern for Sant'Agostino, Perugia, executed by the Florentine master Baccio d'Agnolo in 1502–1532 (Cantelli 1973, figs. 35–36 and 38–39).

Within the three arched loggias represented in *intarsia* on either side of the antiphonal stands are books, an hourglass, a lamp with a lighted candle, and a box with an inkwell and quill pen. It is possible that the objects are symbols of worthy but transitory pursuits, while the three arches might allude to the enduring virtues of the Trinity. The contents of the panels on the base, beginning with the deftly concealed door, are (progressing to the right): (1) an architectural scene; (2) symbols of geometry (compasses, try square and *mazzocchio*) with architectural motifs; (3) books, an incense boat with its spoon, and a fan-like object, perhaps a *flagellum*; (4) tiered architecture; (5) an altar bell (?), an unidentified object, a holy water bucket with its *aspergillum* and a box with altar tapers; (6) a campanile-like construction containing two chalices; (7) a bowl of "eucharistic" grapes and a series of spiked objects (holders for processional candles?); (8) a censer, with a pomegranate (symbolic of the unity of the church) and three cherries. One of the pilasters is decorated with twining branches and foliage in a Germanic manner, while others display ivy bearing acorns or classical motifs (one strip of which is more exquisitely finished than the others). The acorns may allude to the della Rovere family, who were the heirs to the Montefeltro dynasty.

The lectern as a whole is a pleasing ensemble, but on detailed analysis it can be seen that the perspectival designs have not been not undertaken with the geometrical sophistication of the Urbino, Gubbio, and Perugia *intarsie*. The designer has

Gubbio for Federigo da Montefeltro (Himmelheber 1985). The fluted pilasters on the Munich chest are very similar to those in the Urbino *studiolo*. On the other hand, a close parallel for the perspective of the cupboard doors, which diminish so little in depth as to be almost in nonconvergent perspective, is to be found in the *intarsia* dado of the second *Grotta* of Isabella d'Este in the Corte Vecchia at Mantua. The masters Antonio and Paolo Mole worked on the Mantuan decorations in 1506, and it seems likely that they had previously designed the *intarsia* cupboards in the sacristy of San Marco in Venice (Bertolotti 1889, 17). The contents of the cupboards in the *cassone*, two of which contain musical instruments, also recall the enthusiasm for music manifested in the decorations of Isabella's *Grotta*, although such subjects had by this time become common motifs in such *intarsie*. The continuity of motifs in the workshops of the masters of *intarsie* makes dating based on style and content problematical. A date around 1500–1510 is as conceivable as Himmelheber's suggestion that the chest was made for the marriage of Federigo Gonzaga and Margaretha of Bavaria in 1470. Indeed, neither of the devices on the chest were particularly associated with Margaretha. It is more likely that the *intarsiatori* of the chest are Antonio and Paolo Mole, with Isabella as the likely patron. The Gonzagas had long fostered dynastic links with German houses, and there are a number of occasions on which the *cassone* might have traveled north as a gift, including Jacobäa's wedding in 1522. For the maker of *intarsie*, the advantage of the virtually nonconvergent perspective of the chest is that

many pieces of wood could be cut from the same template. For example, the parallelograms of the boards for checkers in the left cupboard appear not to diminish in size toward the rear. The distant viewpoint implied by such a technique does little to destroy the delights of the illusion and may indeed make it less vulnerable to "incorrect" viewing positions.

M.K.

147–148 🐚

Central Italian artist

IDEAL CITY WITH A CIRCULAR TEMPLE

c. 1500
oil on panel
67.5 x 239.5 (26½ x 94¼)

Galleria Nazionale delle Marche, Urbino

Central Italian artist

IDEAL CITY WITH A FOUNTAIN AND STATUES OF THE VIRTUES

c. 1500
oil on panel
77.4 x 220 (30½ x 86⅝)

Walters Art Gallery, Baltimore

references: Baldi 1724; Kimball 1927–1928; Quinvitalle 1964; Saalman 1968; Clark 1969; Krautheimer 1969; Shearman 1975; Sangiorgi 1976; Zeri 1976; Urbino 1978; Duprè dal Poggetto 1983; Trionfi Honarati 1983; Kemp and Massing 1991

These two magnificent panels are often associated with another large townscape in the Staatliche Museen (Gemäldegalerie), Berlin, and occasionally with a smaller painting built into a *cassone* formerly in the Kunstgewerbemuseum, Berlin (now destroyed). The former is similar in length (234 centimeters) to the Urbino and Walters panels but is nearly twice as high (124 centimeters), due to a strip of painted paneling below the perspectival view. Its foreground is occupied by a loggia or portico, through which the vista leads across a wide piazza to a distant seascape with ships. The origins, dating, attribution, function, and possible meaning of the panels have been much debated, with generally inconclusive results. The four known versions may be representative survivors of a kind of painting that was originally produced in some quantity for Renaissance interiors.

The depiction of ideal townscapes in forceful perspective as a motif for the decoration of princely interiors is particularly associated with Urbino, and the panel in the Galleria Nazionale delle Marche, in fact, has a provenance from the Church of Sta. Chiara in Urbino. The *intarsia* panels in the doors leading to the throne room, the audience chamber and dressing room in the Palazzo Ducale, which belong to the phase of decoration undertaken between 1474 and 1482, display grand buildings of a predominantly classical type flanking piazzas with conspicuous tiled pavements (Trionfi Honorati 1983). Inventories of the palace from 1582 and 1599 describe a painted *prospettiva* by Fra Carnevale above one of the doors (Sangiorgi 1976), while Bernardino Baldi, writing in 1588, mentioned that Luciano Laurana, the Slavic architect of the palace, had painted "certain small pictures in which several scenes are drafted according to the rules of perspective and coloring." An Urbino document of 1651 also mentions a long perspective by Fra Carnevale (Kemp and Massing 1991). There is no reason to think that such townscapes have any more specific meaning than to reflect the ideals of civic order and Neo-Stoic mores to which Duke Federigo da Montefeltro aspired in the administration of his state. The vision is closely founded upon that of Leon Battista Alberti in *De re aedificatoria* (*On the Art of Building*), and the various townscapes in the *intarsie* and paintings can be shown to realize Alberti's social, functional, spiritual, and aesthetic requirements for the component buildings in the cities of a well-ordered society. It is therefore unnecessary to suppose that the painted panels were early attempts to visualize stage sets in the Roman manner, as described by Vitruvius (Krautheimer 1969). Indeed, it appears that the *intarsie* and paintings provided the inspiration for the earliest perspectival scene designs.

The Berlin townscape is technically and stylistically somewhat different from the other two. In addition to its painted *basimento*, the lateral edges of the panel are painted in a way that suggests it

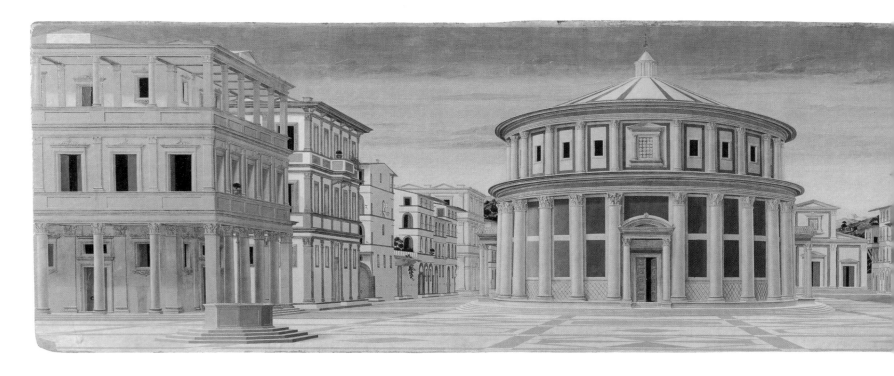

formed the upright back of a piece of furniture, such as a richly decorated bench, couch, or bed. Stylistically it is very close to the Urbino *intarsia* door panels, particularly with respect to the insistent orthogonals of the dark bands of tiles in the piazza and the depiction of ships in the distant seascape. Nothing in the architecture requires a later date for this panel than 1480, and it may be the best of all the candidates for attribution to the shadowy architect-painter Fra Carnevale (Bartolo-

meo di Giovanni Corradini), who died in 1484.

The Urbino and Walters panels have much in common. The raised and ragged lips of paint around the Urbino panel indicates that it was removed from an item of furnishing, where it would have been set within an integral frame. The filled and painted-in upper and lower borders of the Walters panel, which has been trimmed laterally, indicate a similar original setting, as do the nail holes in its right margin. The classicizing

architecture in both panels shares a strong affinity with the style and archaeological impulses of Giuliano da Sangallo, an affinity that suggests a date no earlier than 1490 and an origin in Florence. Zeri's reading of the incomplete date "149." on the tablet on the top of the right-hand palace in the Urbino panel would exclude an attribution to Fra Carnevale and also rule out the persistent association of the panel with Piero della Francesca. This tablet also contains traces of a hybrid

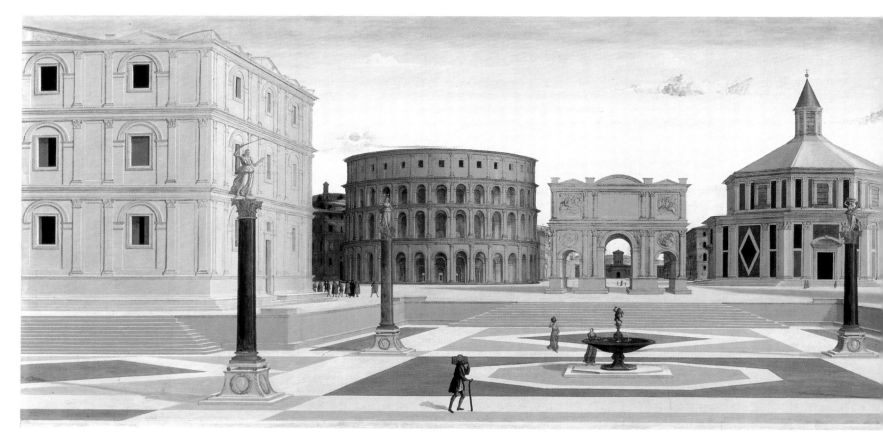

script that appears to mix Latin and Greek characters incoherently, while the tablet on the left-hand palace is indecipherable.

Despite the obvious similarities, the organization of the space in the Urbino and Walters panels is rather different in feel. The composition in the Urbino picture has an amplitude and unity that are absent in the Walters townscape, which appears to have been compiled additively from a repertoire of classicizing buildings. The subtle

mix of buildings in the Urbino painting, such as the juxtaposition of the grand centralized "temple" with the facade of a "parish church," gives a feeling of credibility to the ideal town center. The superbly controlled description of the three-dimensional bulk of the objects in space, such as the wellheads, and their integration into the perspective scheme explain the temptation felt by earlier commentators such as Kenneth Clark to attribute the Urbino painting to Piero della Francesca himself. The Walters townscape, by contrast, displays its exemplary buildings and decorative features in a more literal and less "naturalized" manner, not unlike the background in Perugino's fresco of the *Donation of the Keys* in the Sistine Chapel. The statues of the four Virtues atop the columns—apparently Justice, Temperance, Abundance, and Fortitude—allude directly to the characteristics of the political regime that would be conducive to the creation of such a cityscape, while the fountain from which the women (and the man?) draw water refers to the way in which the provision of fountains was regarded as a sign of a ruler's magnanimity in the Renaissance. The strange proportions of the figures recall those in the panels of the *Story of Griselda* (National Gallery, London) by an anonymous master in the orbit of Signorelli. The differences between the conceptions may suggest a different mind at work in the two paintings or indicate that the same artist was using two rather different approaches. Until a direct comparison of style and constructional methods can be made in the context of the present exhibition—the first time they have been brought together—the most likely attribution is to different artists working around 1500, one perhaps in the environment of Urbino and the other in Florence. M.K.

149 ❧

Piero di Cosimo
Florentine, 1462–1521

THE BUILDING OF A DOUBLE PALACE

c. 1510–1515
oil on panel
82.6 x 196.9 (32½ x 77½)
references: Morgan 1960; Fahy 1965; Frederickson and Zeri 1972; Panofsky 1972; Craven 1975; Bacci 1976; Ryknert et al. 1988

John and Mable Ringling Museum of Art, Sarasota

Piero di Cosimo's most famous works were series of *spalliera* paintings of mythological and allegorical subjects, that is to say, panels set into the furnishing of a room at a level above the dado or as upright elements in pieces of furniture. If such panels survive untrimmed, they show, as here, the ragged lip of paint and priming that once abutted an integral frame. Vasari refers to one

such series commissioned by Piero del Pugliese for the family house on the Via de' Serragli in Florence, which probably included the *Hunt* and the *Return from the Hunt* (both Metropolitan Museum of Art, New York), and possibly the *Fire in the Forest* (Ashmolean, Oxford), which show the early history of man. The Ringling painting has been associated with the Pugliese series (Fahy 1965), but differences in size and style seem to exclude this possibility. It may have belonged to an otherwise unknown series or on its own may have adorned a single piece of furniture. In 1510 Piero was collaborating with the famous woodworker Baccio d'Agnolo on the making of "cassoni con spalliere" for Filippo Strozzi (Craven 1975). Such *spalliere* would have formed the upright backs above the main body of chests.

Although this scene of building cannot be specifically associated with any of the known series by Piero, it does fit well with those that deal with aspects of the early history of human skills, such as the discovery of fire or the activities of Vulcan. The painting of Vulcan shows primitive men constructing the framework of a wooden building, at a stage of civilization at least two steps removed from the accomplished builders in the Ringling picture. The general source for Piero's visions of the origins and progress of human civilization appears to be the first chapter of book II in Vitruvius' *Ten Books on Architecture*. The Roman author describes how the discovery of fire

originally gave rise to the coming together of men, to the deliberative assembly and to social intercourse. And so, as they kept coming together in greater numbers into one place, finding themselves naturally gifted beyond other animals in not being obliged to walk with faces to the ground, but upright and gazing on the splendors of the starry firmament, and also being able to do with ease whatever they chose with their hands and fingers, they began in that first assembly to construct shelters.... And since they were of an imitative and teachable nature, they would daily point out to each other the results of their building, boasting of the novelties in it; and thus, with their natural gifts sharpened by emulation, their standards improved daily.

For Alberti in the Renaissance, the architect was of particular importance in shaping the ideal of civic order and could indeed take a lead in showing how a better social life might be achieved. Piero's picture of a great classical structure being erected by our ancestors in a virgin plane, like the eighth wonder of the world, is a vision of architectural optimism that aligns it in function with the *spalliera* paintings of ideal townscapes in Urbino, Baltimore, and Berlin (see cat. 147–148). Although the general tenor of Piero's representation is clear, it is not easy to interpret precisely what is happening. In particular, the building itself is not readily recognizable as any known kind of struc-

ture. It appears to consist of two identical palace blocks separated by a colonnaded forum and completely surrounded by a single-story colonnade with a horizontal architrave, which is topped by rows of statues. The flat platform between the architrave and the palaces provides an elevated walkway with access to the second-story doors. The function of the compound structure appears to be secular. Perhaps the closest parallel is provided by the forms of the forum and basilica described by Vitruvius in chapter one of his fifth book. He explains how

the Greeks lay out their forums in the form of a square surrounded by very spacious double colonnades, adorn them with columns set rather closely together, and with entablatures of stone or marble, and construct walls above in the upper story.

He later notes that the architect should "have the balconies of the upper floor properly arranged so as to be convenient, and to bring in some public revenue." Alberti paraphrased Vitruvius' account of Greek and Roman forums in the eighth book of his *De re aedificatoria* (*On the Art of Building*). However, no one closely reading Vitruvius would arrive at a structure like that depicted by Piero, and it is likely that he created a fantasy architecture designed to impress visually rather than to invite precise functional analysis. The style of the architecture is generally in accord with that of Giuliano da Sangallo, whose portrait Piero painted, together with that of Giuliano's father (Rijksmuseum, Amsterdam). The scattering of the workshop activities across the foreground plane is also designed more for pictorial effect than for realism, although the detailed portrayal of the laboring masons and carpenters is clearly based upon contemporary practice.

The chronology of Piero's career is less clearly charted than we might like, but the formal symmetry of the design points to a relatively late date, no earlier than his work for Strozzi in 1510.

M.K.

150 �

Vittore Carpaccio
Venetian, 1455/1465–1525 or 1526

MIRACLE OF THE RELIC OF THE TRUE CROSS

1494
oil on canvas
365 x 389 (143⅝ x 153⅛)
references: Lauts 1962; Muraro 1977; Pignatti 1981; Daly Davis 1980; Bergasconi 1981; Nepi Scirè and Valcanover 1985; Davanzati 1986; Fortini Brown 1988; Humfrey 1991

Gallerie dell'Accademia, Venice

The painting of large-scale narrative cycles for the Venetian *scuole*, the lay organizations that exerted so much influence on Venetian religious and civic life, is one of the most remarkable episodes in Renaissance art patronage. Venetian artists developed for these pictures a distinctive narrative and scenic approach centered upon the ceremonies and rituals through which Venetian society expressed some of its most important aspirations (Fortini Brown 1988). Carpaccio's painting is part of the cycle for the Albergo of the Scuola di San Giovanni Evangelista, one of the Scuole Grandi, which was undertaken by a team of artists, possibly led by Gentile Bellini, who executed three of the paintings himself. Giovanni

Mansueti painted two of the canvases, while Lazzaro Bastiani, Benedetto Diana, and Pietro Perugino completed one apiece. Carpaccio's contribution can be dated with some certainty to 1494 (Bergasconi 1981) and is among the earliest works in the cycle. The latest was painted by Gentile Bellini in 1500. With the exception of Perugino's painting, which was destroyed, the cycle is now preserved in the Accademia. In 1544, while Carpaccio's canvas was still *in situ*, a portion was cut from the bottom left edge to accommodate a door. The seventeenth-century repair of the lost portion is clearly apparent. In its original location, the picture was situated on the east wall of the Albergo, beside the altar on which the relic was housed, with Perugino's painting on the other side.

The stories in the cycle are concerned with a deeply revered relic that the Scuola guarded in its Albergo, a fragment of the True Cross. The authenticity of such a relic was thought to be confirmed by the miracles it facilitated, and each of the narratives in the cycle portrays one of the documented episodes of the relic in effective action. The event illustrated by Carpaccio occurred in 1494, the year in which he was commissioned to paint his picture, and concerns a man possessed of a demon who was cured when the Patriarch of Grado raised the relic above the deranged man's head. The procession of white-robed celebrants can be seen wending its way over the wooden Rialto Bridge and up to the handsome balcony where the Patriarch performs the miracle. As was the case in other of the paintings in this and comparable cycles, many of the figures were intended to be recognizable portraits, and the details of the costumes were carefully depicted, such as the robes of a member of the Cavalieri della Calza, with his back to us in the foreground, for which a

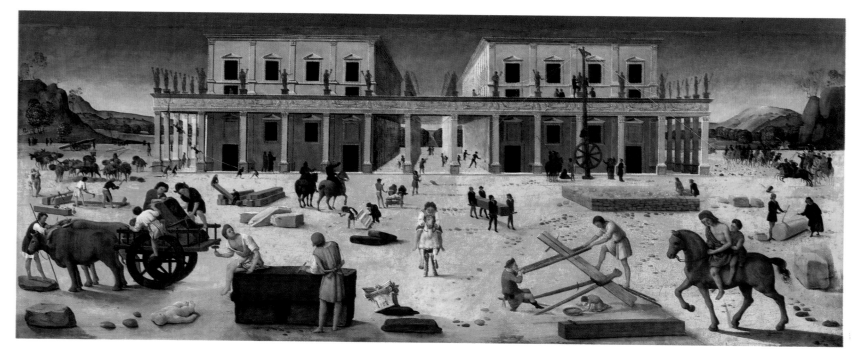

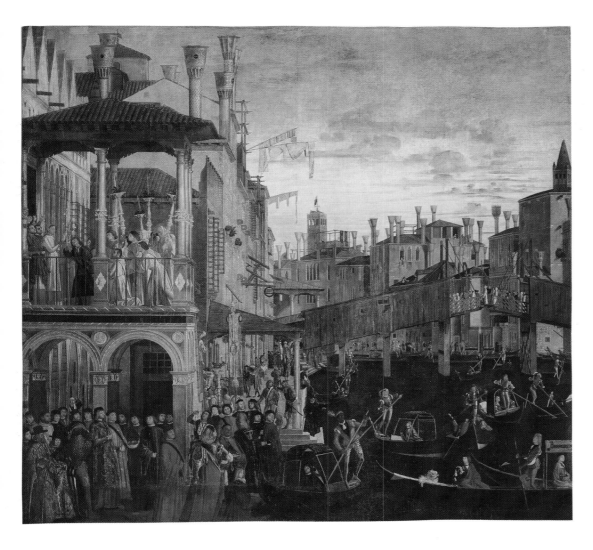

scale paintings, most notably in his *Reception of the Ambassadors* from the Saint Ursula cycle (Accademia, Venice), which included some set-piece demonstrations of geometrical forms in perspective in the manner of Uccello and Piero della Francesca (Daly Davis 1980). The great narrative view paintings by Carpaccio and his Venetian rivals represent a logical climax of one aspect of Brunelleschi's invention of perspective some eighty years earlier.

M.K.

151 🐍

Jacopo de' Barbari
Venetian, active before 1495 — died by 1516

VIEW OF VENICE

1500
woodcut on six separate blocks (first state)
143 x 309 (56¼ x 121⅝) (approx)
references: Kristeller 1896; Servolini 1944; Pignatti 1964; National Gallery of Art 1973; Levenson 1978; Schulz 1978; London 1983

Hamburger Kunsthalle

The authorship of the design of this most astonishing of all Renaissance map-views of a city is not in doubt, although the woodcut is unsigned — unless we read Mercury's caduceus as Jacopo's own device, for it appears on other of his works. In 1500 Anton Kolb, a German printer in Venice, applied successfully to the Venetian authorities for a four-year copyright and a license to export the print without paying duty, stressing the effort involved over a three-year period, the high price per copy (at least three florins) needed to recover his costs, and the fact that it had been undertaken chiefly for the fame of "this supreme city of Venice" (Schulz 1978). The print's emphasis upon the benefits that Mercury and Neptune bring to Venice — the former shining on "this above all other emporia" and the latter stilling the waters of "this port" — are clearly designed to appeal to the city's self-regard and to promote its image elsewhere.

Jacopo is known as an itinerant painter and engraver of high intellectual aspirations, who spent much of his career in the service of northern courts (Levenson 1978). He is not known to have been a woodcutter, and the question must remain open as to whether Jacopo himself cut the six blocks or whether Kolb hired the services of one of the Venetian specialists. The original blocks survive in the Museo Correr, Venice. Three states of the print are known (Pignatti 1964), of which twelve examples of the first state have been recorded.

There is evidence that maps produced during the cartographic revolution of the Renaissance — a revolution that centered on the study of Ptolemy's methods and achievements — were already attract-

preliminary study survives (Albertina, Vienna). The use of gold leaf to reinforce the decorative details, such as the splendid candelabra that have been carried up to the balcony, not only emphasizes the magnificence of the event but also attests to the fact that the Scuola spared no expense in its artistic competition with other Scuole. The combination of a particular and vividly topical miracle with the annual rituals that conferred a special status on the Scuola within Venetian society is brilliantly expressed by Carpaccio through an unrivaled depiction of the Grand Canal and its flanking palaces and warehouses.

The essential accuracy with which Carpaccio has depicted the buildings in the area of the Rialto Bridge can be confirmed both by reference to the same scene today — although the wooden bridge has long since been replaced by the present stone structure, to less picturesque effect — and by comparison with the relevant section of Jacopo de' Barbari's great *View of Venice*, which was published in 1500 (cat. 151). Barbari and Carpaccio agree on the basic structure of the bridge, with the four pylons from which the central span was suspended and could be raised. The boxed-in flanks of the bridge contained shops, much in the manner of the Ponte Vecchio in Florence. Barbari does not show the architecture of the Patriarch's

palace in the same detail as does Carpaccio, but his depiction of many of the other features tallies well with the painting, including the position of what Barbari labels as the "fontico dalamanj" on the right — the Fondaco dei Tedeschi — the German merchants' warehouse that was to receive the famous wall paintings by Titian and Giorgione.

The architecture on the left of the Grand Canal is carefully aligned so that the orthogonals all run to a common vanishing point halfway across the picture and at the level of the cornice above the arches of the balcony. It appears that to achieve this spatial coherence on the left Carpaccio indulged in some slight regularizing of the building lines. By contrast, the buildings visible on the right behind the bridge are arranged in a more erratic manner around the curve of the canal and were probably laid in by eye to give an impression of the variety of angles at which they were set. Although he has given a formal rigor to the portion of the canvas in which the main event takes place, the overall effect is one of daring asymmetry, perhaps sanctioned in part by the painting's lateral position beside the altar. The relative informality is obviously a matter of calculation rather than chance, since Carpaccio demonstrated a sophisticated command of perspective in orchestrating architectural settings throughout his large-

ing the attention of noble patrons before 1500, both as painted decorations for palaces and as collector's items. The relatively high cost of Jacopo's map indicates that it was aimed at such a market, appealing to those who had political and intellectual reasons for being interested in other territories and to those for whom maps, then as now, provided a form of vicarious travel. In a sense, the word "map" is misleading, since Jacopo's six large sheets were hardly designed to assist the visitor in finding his or her way around the maze of Venice's streets and canals. However, the anachronistic and popular title of the print, "bird's-eye view," is by no means preferable. The early docu-

ments simply refer to the fact that Venice had been "portrayed" or "printed." Perhaps it might best be called a "Portrait of Venice."

"Bird's-eye" views of cities had been published before Jacopo's. The Florentine graphic artist and printseller, Francesco Rosselli, appears to have played a pioneering role with multiblock prints of Florence, Rome, and Pisa in the 1480s and 1490s. However, what evidence survives of Rosselli's views suggests that they fell far short of the detail, coherence, and grandeur of Jacopo's. The basic principle observed in the design of his map is that the ground plan of the city has been tilted into space in such a way that we appear to be

viewing the solid forms of buildings at an angle from the south and from a considerable distance and height. The foreshortening is broadly consistent with the way the puffing heads of the winds are disposed around an imaginary ellipse, as if they are situated on a foreshortened equator whose poles are marked by Mercury and Neptune. However, as Schulz has shown in his fundamental analysis of the print, the perspectival rendering is not consistent either overall or in its individual parts. Although there is a general tendency for the plan to be more compressed toward the top, as it should be, there are also severe compressions on either side of the central join at the left. Some

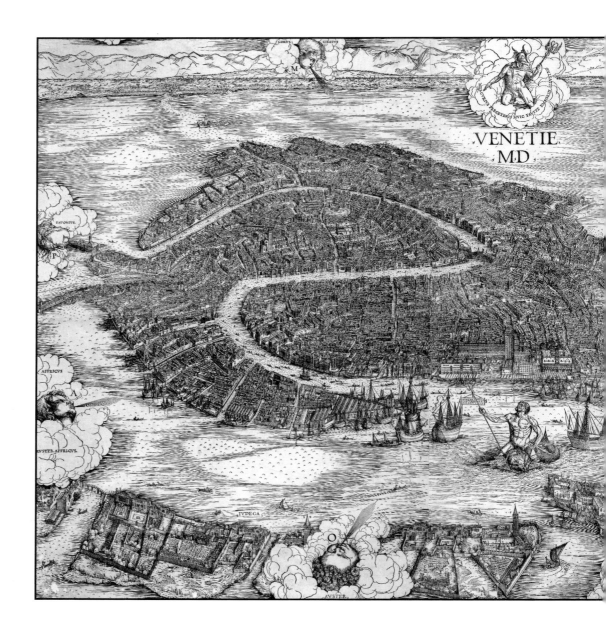

passages of groups of buildings, most notably those around the tiled area of Saint Mark's Square, are depicted in reasonably coherent perspective in themselves but are not coordinated with the perspective of the whole city, while other buildings have been set down by eye without much concern for measured recession. There is a tendency to exaggerate the height of those vertical features that provide suitable landmarks in various regions of the city.

The procedure followed in compiling the map is likely to have involved a complex compound of techniques. Jacopo must have made or had access to a reasonably accurate flat plan, but comparison with a modern map show that his tilted projection is markedly inconsistent throughout. There are two possible explanations: either he set the main outlines of the city into space by eye without precise calculation, or he systematically foreshortened a plan that was not accurately proportioned throughout. In view of the extreme difficulty in foreshortening such an irregular shape by eye, the latter alternative seems more likely. On the basis of the foreshortened outline, however it was achieved, he then would have laboriously drawn in details of the buildings, squares, canals, bridges, etc., using studies taken from high vantage points and from less readily adaptable locations at ground level. The area around Saint Mark's Square, for example, appears to have been taken largely from the tower of San Giorgio Maggiore in the middle of the foreground. Despite its inconsistencies if analyzed in the light of information and techniques available to us today, the *View* remains an achievement of astonishing visual and intellectual control, demanding incredible patience and a notable ability to visualize forms from inaccessible viewpoints. Its size and dramatically open horizons also give it a sense of grandeur—as a magnificent slice of the vast surface of the world—in a way provided by no equivalent view in the Renaissance. M.K.

THE HUMAN FIGURE

In the late fifteenth and early sixteenth century, first in Italy and then in Northern Europe, the nude figure became a central vehicle of artistic expression. The art of classical antiquity supplied the Renaissance masters with actual sculptural prototypes and with a theoretical ideal, the notion that perfect human beauty followed a mathematical canon of proportions. The most famous expression of this belief is Leonardo da Vinci's constructed figure of a man who conforms to the proportional schema laid down by the Roman architect Vitruvius. Renaissance theorists also required the painter and sculptor to master human anatomy, though evidently only at the end of the century did artists like Leonardo and Michelangelo actually begin to conduct dissections.

What is remarkable is the broad range of meanings with which the nude figure could be endowed in Renaissance art, a variety that far exceeded its expressive possibilities in antiquity. Artists like Pollaiuolo, in his series of paintings of the exploits of Hercules, reintegrated heroic classical form and subject matter. The nude could also serve the very different aims of Christian art, as is so eloquently attested by moving representations of the Crucifixion. This breadth of potential is reflected in renderings of the female nude, as well. An unclothed woman could represent a classical goddess, an alluring nymph, or even a threatening temptress, allied with the forces of evil in a Christian universe.

152 ஃ

Matthias Grünewald

German, c. 1465–1528

CRUCIFIXION

c. 1516
oil on limewood panel
61.6 x 46 (24 x 17¹⁵⁄₁₆)
inscribed: mg at top of cross
references: Sandart 1675, 82; Schönberger 1922; Zülch 1938; Fränger 1946, 11; Kress 1956, no. 36; Ruhmer 1958; Suida and Shapley 1975; Walker 1975, 144, no. 3152; Eisler 1977

National Gallery of Art, Washington, Samuel H. Kress Collection

Until comparatively recently, this image was known only through an engraving made in 1605 by Raphael Sadeler, through copies, and through Joachim von Sandrart's perceptive description of the painting when it was owned by Duke Wilhelm v of Bavaria: "He had a small Crucifixion with our Dear Lady and St. John, together with a kneeling and devoutly praying Mary Magdalen, most carefully painted by Grünewald's hand, and he loved it very much, even without knowing who it was by. On account of the wonderful Christ on the Cross, so suspended and supported on the feet, it is so very rare that real life could not surpass it, and certainly it is more true to nature and reality than all the Crucifixions when one contemplates it with thoughtful patience for a long time. For this reason it was, on the gracious order of the honorable duke, engraved half a sheet large on a copper plate in the year 1605 by Raphael Sadeler; and I greatly pleased His Highness, the Great Elector Maximilian of blessed memory, by making known the artist's name" (Sandrart 1675, 82). Sandrart correctly identified the painting as an autograph work by Matthias Grünewald (more properly, Mathis Gothardt Nithardt). His account conveys a clear sense of the way in which the contemplative spectator was expected to absorb the striking corporeality of Christ's suffering.

The composition of the painting is related to a drawing by Grünewald (Kunsthalle, Karlsruhe), which is close in scale to the painted image; X-rays of the panel show that in the underpainting the thumb of Christ's left hand was bent towards the palm, as in the drawing. The Karlsruhe drawing is in other respects closer to another painting by Grünewald in the Öffentliche Kunstsammlung, Basel. The monogram signature, *mg*, at the top of the cross in this painting seems not to be original and was probably added after Sandrart had identified the author of the panel. There have been numerous paint losses which have been infilled, but these are for the most part in subsidiary areas of the composition (Eisler 1977).

The Crucifixion, which became the archetypal Grünewald subject, probably first appeared in his art in the Basel painting, which can be dated, on stylistic grounds, to the early years of the sixteenth century. The Washington version appears to postdate the harrowing depiction on the outside of Grünewald's immense Isenheim Altarpiece (Musée d'Unterlinden, Colmar), where Christ's bodily ravages are extended to include the disfigured joints occasioned by "St. Anthony's fire" (ergot poisoning), the illness the Anthonite monastery that commissioned the altarpiece was particularly dedicated to treating. The dependence of the painting on the Isenheim image would suggest a date of 1516 or shortly thereafter for the Washington picture. The translation of the subject to a small panel for intimate devotion inevitably entailed some scaling down of the rhetoric—the grief of Mary Magdalen is notably less overt—but without compromising expressive intensity. No other artist has ever used an unremitting emphasis upon the physical description of injury more effectively for spiritual ends, providing a visual counterpart to Saint Bridget of Sweden's visionary descriptions of Christ's agonies (Eisler 1977). The other details of the composition, such as the torn clothes and jagged rocks, all reinforce the central meaning of the image. The eclipse of the sun, which ominously darkens the scene, has been related to an actual eclipse in 1502 (Zülch 1938), but can be seen in more general terms as referring to the Gospel accounts and the prophecy of Amos (8:9).

M.K.

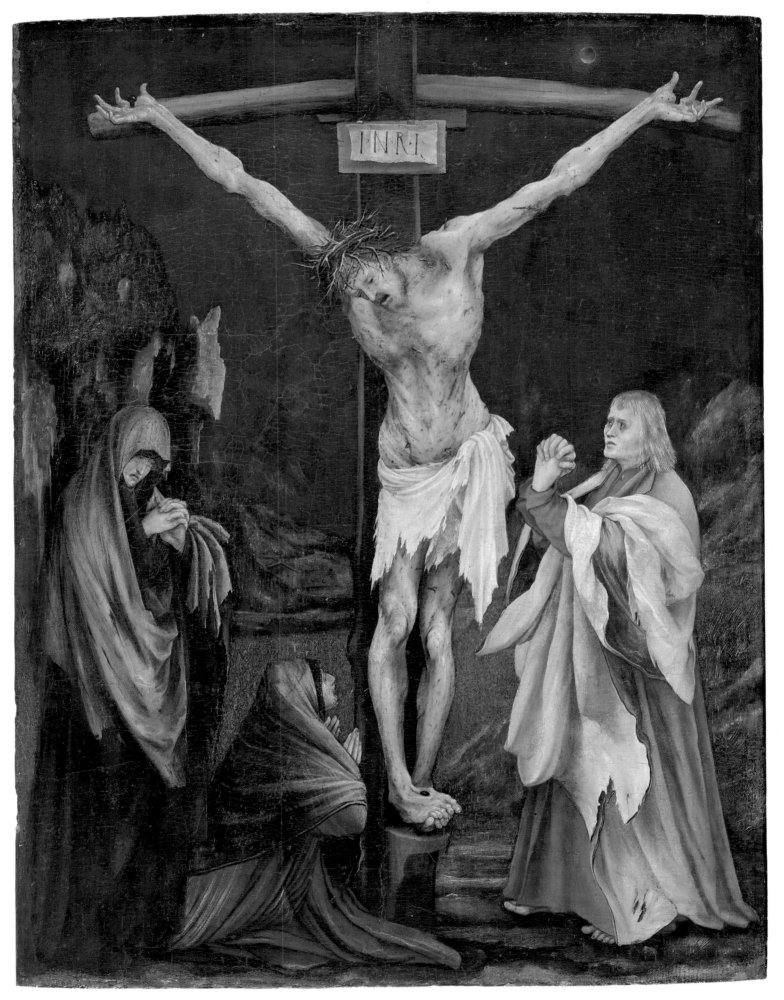

155 ❧

Donatello
(Donato di Niccolo di Betto Bardi)
Florentine, 1386–1466

THE SHOOTING OF SAINT SEBASTIAN

c. 1453
bronze, partially gilt
26 x 24 (10¼ x 9½)
*references: Kauffman 1935; Janson 1963; New York
1956, no. 46; Pope-Hennessy 1980, 93–95; Bober
and Rubenstein 1986, no. 34; Avery 1986, 14–18;
Boucher 1986; Florence 1986*

Institut de France Musée Jacquemart-André, Paris

The remarkably wide technical, formal, and
expressive range of Donatello's documented work,
reflecting his highly flexible responses to the dif-
ferent media, subjects, patronage, functions, and
settings of each project, makes the attribution and
dating of undocumented work a perilous under-
taking. Opinions about the authenticity of this
relief have varied widely, although its high quality
has generally been acknowledged. Following the
recent rediscovery of the *Chellini Madonna* (Vic-
toria and Albert Museum, London), which is
securely dated to 1456, there is now little reason
to hesitate in attributing the Jacquemart-André
relief to Donatello himself and dating it to the
period immediately after his return from Padua in
1453. The two bronze reliefs have in common a
compressed composition, a refinement of execu-
tion, and the use of gilding. Equally characteristic
of Donatello is the highly imaginative use of
antique prototypes. He has transformed the motif
of a bound Marsyas into the figure of the saint
(e.g., Bober and Rubenstein 1986, no. 34) and has
modeled the archers after the type of Roman war-
riors with braced legs commonly found on antique
sarcophagi. Vasari recorded that Donatello had
restored an antique Marsyas.

Saint Sebastian was especially revered as an
intercessor in times of plague, and this small relief
may have been made for a private patron as an *ex
voto* or as a kind of insurance policy. In no other
rendering of this subject—which, strictly speak-
ing, should not be called the "martyrdom" of
Saint Sebastian, since he miraculously survived
the archers' assault—are the injured saint and his
assailants so starkly juxtaposed. The remarkable
motif of the angel rushing forward to console
Sebastian with the martyr's palm recalls the
expressive characterization of the pairs of proph-
ets depicted by Donatello on his doors for the Old
Sacristy of San Lorenzo. As in the San Lorenzo
reliefs and statues for the high altar in the Santo
in Padua, the surface of the bronze has been
worked to give a marked sense of textural dif-
ferentiation between such features as the smooth
skin of the saint, the linear surface of the hair, the
feathery wings of the angel, the coiled strings of

the bows, and the "pock-marked" draperies. The
Apollonian character of the saint and the Hercu-
lean quality of the archers articulate similar
classical references in the bronzes by Bertoldo
(cat. 164) and Pollaiuolo (cat. 162). M.K.

157 ☙

Adriano Fiorentino
(Adriano di Giovanni de' Maestri)
Florentine, c. 1415/1416–1499

VENUS

c. 1492
bronze
height (including base) 42.2 (16⅝)
references: Fabriczy 1903; Florence 1986;
Washington 1986, 51–57

Philadelphia Museum of Art

Adriano's formative experiences as a sculptor occurred when he worked in Florence with Bertoldo di Giovanni (cat. 164), whose bronze of *Bellerophon Taming Pegasus* (Kunsthistoriches Museum, Vienna) he was responsible for casting (Washington 1986, 51–57). He was a specialist in bronze casting, working not only as a sculptor but also as a medalist and canon-founder. This statuette, cast solid with a hollow base, attests to his technical expertise. After 1486 he worked in Naples for Virginio Orsini, the *condottiere*, and for the Aragonese court, where he portrayed the poet Giovanni Pontano. He was well regarded in Gonzaga circles at Mantua and in Urbino and his small bronzes did much to promote the connoisseur's taste for nudes in the antique style, which Antico was to satisfy so effectively with his statuettes. In 1498, while at the court of Emperor Maximilian I, Adriano executed a bust of Frederick the Wise, Elector of Saxony (Grünes Gewölbe, Dresden). Adriano died the following year. Although a number of his bronzes are signed, the chronology of his works is unclear. The present statuette is likely to date from his employment in the Italian courts during the early and mid-1490s.

Unlike Antico's reduced replicas and reconstructions of known Roman statues, Adriano's figures are "antique" only in a general sense. The open and relaxed pose of his *Venus* does not seem to imitate any of the Roman statues of Venus known to the Renaissance, but, like Botticelli's pictures of Venus, remakes antiquity through the artist's imagination. Adriano probably followed the prototype of Botticelli's *Birth of Venus* in his portrayal of the goddess on a shell, while the motif of her wringing water from her wet hair was probably inspired by a description of the classical Greek artist Apelles' famed painting of the newborn Venus arising from the waves, her body glistening. Adriano's statuette is the finest early example of this genre of hedonistic art, which was to become so popular in courts throughout Europe.

M.K.

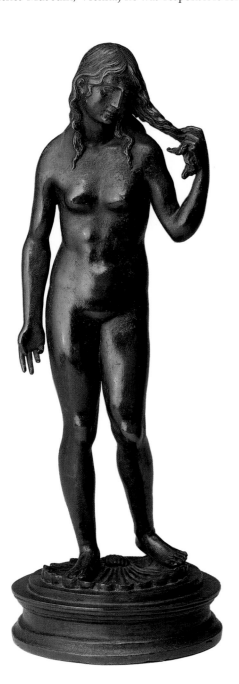
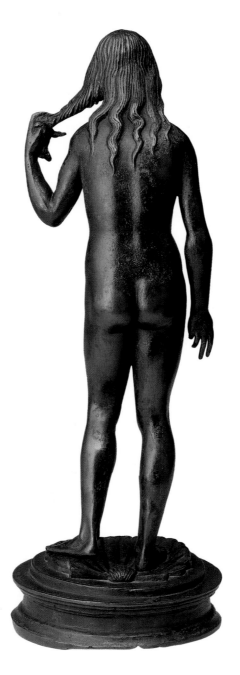

158 ☙

Lucas Cranach the Elder
German, 1472–1553

NYMPH OF THE SACRED WELL

c. 1537
oil on panel
48.5 x 72.9 (19 x 28½)
references: Kurz 1953; Liebman 1968; Basel 1974;
MacDougall 1975; Suida and Shapley 1975;
Friedländer 1978; Leeman 1984

National Gallery of Art, Washington

In 1504 Cranach entered the service of Frederick the Wise, Elector of Saxony, and he was to spend nearly fifty prosperous years in Wittenberg in the service of successive rulers of Saxony, producing a large number of altarpieces, smaller religious paintings, portraits, secular images, and prints. The first of his images of the female nude appears to be the *Venus and Cupid* of 1509 in Leningrad (Friedländer 1978, no. 22), in which the figures are more rounded and overtly Italianate than in his later and more characteristic images. Frederick employed the Italian artists Adriano Fiorentino (cat. 157) and Jacopo de'Barbari, both of whom portrayed graceful female nudes in the antique style, and they appear to have exercised a decisive influence on Cranach's conception of female beauty, although his translation of their vision was highly idiosyncratic. He later produced a substantial number of such subjects, including *Lucretia, The Judgment of Paris,* and *Venus with Cupid the Honey-Thief,* regularly working slight variations on the same theme. The Latin inscriptions on a number of the paintings reflect the humanist learning at the court of Saxony. The librarian of

the University at Wittenberg, Georg Spalatin, obtained many books from the leading Italian presses, and it was from one of the Venetian volumes, Francesco Colonna's *Hypnerotomachia Polifili* (1499), that Cranach derived the major visual inspiration for his reclining nymph. Like the inscription on the versions of *Venus with Cupid the Honey-Thief*, the Latin hexameter on the painting—"I am the nymph of the sacred font. Do not interrupt my sleep for I am at peace"—may be directly taken from one of the texts in the library (Leeman 1984). The nymph of the well became one of Cranach's popular subjects and exists in a number of variants. The earliest may be the panel in Leipzig (Museum der bildenden Künste; Friedländer 1978, no. 119), which is dated 1518, and there is a further dated version in the Walker Art Gallery, Liverpool (Friedländer 1978, no. 259), which is inscribed 1534 on the rim of the fountain. The Washington painting, which is clearly autograph, can be dated to 1537 or slightly later, since it was in this year that the dragon device from his coat of arms (which he had been granted in 1508) appears with its wings folded, perhaps in deference to the death of his eldest son and collaborator, Hans.

The motif of the sleeping nymph was well known in humanist circles in the early sixteenth century through what was widely assumed to be an ancient epigram, although it was actually a fifteenth-century invention. The epigram was said to have accompanied a carving of "a sleeping nymph in a beautiful fountain above the banks of the Danube." In Alexander Pope's picturesque translation it reads:

Nymph of the grot, these sacred springs I keep,
And to the murmur of these waters sleep.

Ah, spare my slumbers, gently tread the cave,
And drink in silence or in silence leave.
(Kurz 1953)

The general idea of Cranach's *Nymph*, with the condensed version of the epigram, clearly conforms to this type of "Danube fountain," but he has amplified and modified the basic image in ways that seem to enhance its amatory associations. The conjugal partridges at which the nymph casts a sleepy glance are associated with Venus (Liebman 1968), while the bow and quiver are more likely to belong to Cupid than to the chaste Diana. In the earliest version the nymph looks enticingly through half-closed eyes at the spectator, and in all the variants the erotic elements are underlined. In contrast to the inscriptions, her heavy-lidded eyes are never completely closed and give a teasing ambiguity to the injunction not to disturb her dreams. In the Washington painting, she not only possesses the customary jewelry and provocative veils but also reclines on a splendid velvet dress with slashed sleeves, which serves to emphasize her courtly accessibility rather than her mythological remoteness. In one late painting, *The Fountain of Youth* (1546, Gemäldegalerie Staatliche Museen Preussischer Kulturbesitz, Berlin; Friedländer 1978, no. 407), cartloads of stolid and aging women enter a pool filled by a fountain, subsequently to emerge on the other side as fashionable objects of desire. One of the metamorphosed ladies reclines on the side of the pool in the same pose as the nymph of the sacred well.

The marked emphasis on the doll-like delicacy and the exaggeratedly linear contours of Cranach's female nudes tend to make them appear to modern eyes curiously abstracted from fleshly

concerns rather than seductive, but German small-scale sculpture of comparable subjects suggests that the portrayal of women with this kind of mannered grace had a distinct appeal in court circles at this time. Indeed, the costumes in Cranach's more flamboyant images of clothed women speak a similar language of artifice and unreal promise. The language is less conspicuously multidimensional than the complex images of naked females by Hans Baldung Grien, in which the sensual vanity of earthly beauty is regularly undermined by premonitions of death. Even when the inscriptions in Cranach's pagan subjects suggest a moral, as in the story of Cupid the honey-thief, the actual portrayal of the theme exudes an air of playful delectation and humanist wit rather than heavy moralizing.

M.K.

159 ❧

Bernardino Luini
Milanese, c. 1480–1532

NYMPH OF THE SPRING (OR VENUS)

c. 1525
oil on panel
107 x 136 (42 x 53½)
references: Ottino della Chiesa 1956; Shapley 1968, 143; Luino 1974, 94; MacDougall 1975; Shapley 1979, no. 231

National Gallery of Art, Washington, Samuel H. Kress Collection

Of the Milanese painters who fell under Leonardo's spell, Luini retained the most distinct artistic personality. This painting appears to date from the 1520s, when his style was fully evolved, and is comparable to the frescoes he executed at Saronno, which are dated 1525. Although Leonardo's lost painting of *Leda* was one of the first depictions of a nude female figure in a luxuriant setting, Luini seems here to be influenced by the popular Venetian type of Venus reclining in a landscape as painted by Giorgione, Titian, Lotto, and Palma Vecchio. Luini shares with Palma a tendency to simplify and generalize female anatomy in keeping with the classical ideal. The mountains in the distance are quite Leonardesque, but the landscape as a whole and the minutely observed plants suggest the direct inspiration of northern art, perhaps even of Lucas Cranach, who had portrayed similar subjects at least as early as 1518.

The nude in this picture has, not surprisingly, been identified as Venus, but the water spouting into the pool in the front of the scene indicates that she is more likely to be a guardian nymph of a sacred spring, as celebrated in a supposedly ancient epigram (MacDougall 1975) and as depicted

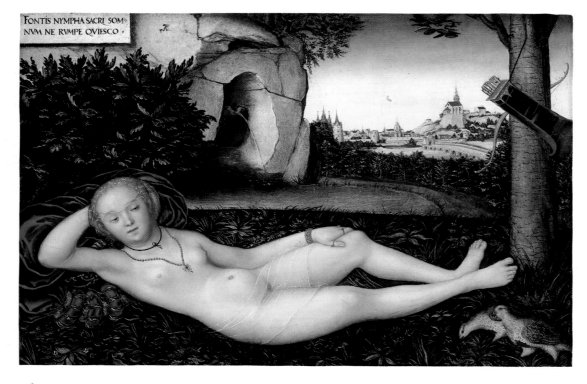

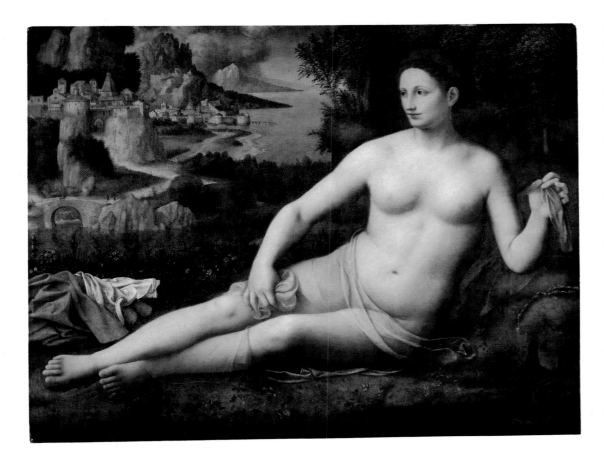

by Cranach (cat. 158). The association of nymphs with Diana, the chaste goddess of the hunt, does make it feasible that this is a portrait of an actual woman (Ottino della Chiesa 1956), but the facial features are typical of Luini's style and may not depict a particular person. Like so many of the Italian pictures that ostensibly deal with the theme of chastity, alternative aspects of the nymph's appeal seem to come to the fore. As in Cranach's pictures, the veils serve to draw attention to what they fail to conceal, and the hints of discarded clothing and jewelry suggest that the nymph belongs as much to our own world as to the distant realms of myth. M.K.

160 🦢

Antonio Pollaiuolo

Florentine, 1431/1432–1498

BATTLE OF THE NUDES

c. 1465
engraving
42.8 x 61.8 (16¹¹/₁₆ x 24⅛)
inscribed: OPVS ANTONII POLLA/IOLI FIORENT/TINI
references: Hind 1938, 1:9; Richards 1968; Fusco 1973; Ettlinger 1978, 15, 36, 37; Emison 1990; Kemp 1991, 43

Fogg Art Museum, Harvard University, Cambridge, Gift of Francis Bullard in Memory of His Uncle Charles Eliot Norton

Almost every aspect of this remarkable engraving—the largest of the Florentine fifteenth century—is open to dispute, except its authorship. Its date is problematic. Pollaiuolo's own testimony in 1494 indicates that he had painted three large canvases of the almost nude Hercules in violent action (now lost) for the Medici in 1460. The

Paduan painter, Squarcione, who died in 1469, possessed "a cartoon" by Pollaiuolo with nude figures, a fragment of which may survive in the Fogg Museum, Harvard University (Ettlinger 1978, 36). A date in the mid-1460s for the engraving is therefore plausible. Even if its correct date were in the next decade, it would still be notably precocious as an overt image of naked men. The Cleveland version of the engraving is a unique survival of the earliest state known, before the recutting of the plate (Richards 1968). The original engraving of the plate is a technical tour de force (Fusco 1973), and clearly owes much to the artist's expertise as a metalworker (including the chasing of incised decoration).

The subject of the engraving has occasioned much debate. Some have claimed specific literary sources, while others have seen it as a demonstration piece (either to promote Pollaiuolo's skills or to instruct aspiring artists). None of the textual sources (Ettlinger 1978, 15) seems to fit the image convincingly, and it is probably not an illustration of a known story. The idea that it was designed as an exemplary demonstration piece, to be copied by artists who wished to acquire an advanced figure style, has much to recommend it. A drawing by Pollaiuolo in the Louvre, Paris, showing a nude man from the front, side, and back, appears to have performed just this function (Ettlinger 1978, 37). A number of artists, including Verrocchio, Bertoldo, and Pollaiuolo himself, are recorded as having conceived compositions of fighting nudes in a variety of media; these seem to have been intended to show "anatomical" figures in stirring action. The engraving could almost serve as an illustration of the variety of positions demanded in Alberti's *De pictura* (1435): "Everything that

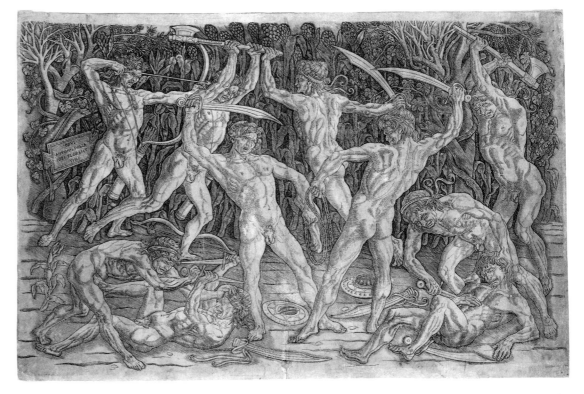

changes position has seven directions of movement, either up or down or to the left or right, or going away in the distance or coming towards us; and the seventh is going round in a circle. I want all these seven movements to be in a painting. There should be some bodies that face towards us, and others going away, to right and left. Of these some parts should be shown towards the spectators, and others should be turned away; some should be raised upwards and others directed downwards" (Kemp 1991, 43). Such an exemplary function would not exclude a specific meaning for the image, and Pollaiuolo may have been as keen to display his powers of *invenzione* ("invention" in the rhetorical sense of devising subject matter) as his prowess with the human body. In this respect, the engraving would be similar to Mantegna's engravings of *all'antica* themes, such as the *Battle of the Sea Gods* and *Bacchanals*.

The selection of the carefully characterized plants in the background appears to be deliberate. The corn and grapes may refer to the Eucharist, while the two olive trees may allude to the Christian peace, which is notably absent in the foreground. The chain—the possession of which does not seem to be the prime subject of dispute—can be read as a reference to the chaining of the soul to the unredeemed body of mortal man (Emison 1990). According to this reading, we see a conscious juxtaposition of the spiritual reality of Christ's flesh and blood in the Eucharist with the corporeal reality of man's sinful and untamed body. This line of interpretation suggests that it is not the heroism of the fighting warriors that is held up for admiration, but the artist's high achievement in combining the depiction of their beastly actions with the devising of a meaningful context. The artist could thus demonstrate not only his great command of anatomy but also an intellectual ability to invent significant content in a manner to equal the poet. M.K.

161 &

Antonio Pollaiuolo
Florentine, 1431/1432–1498

HERCULES AND THE HYDRA

c. 1460–1475
oil on panel
17.5 x 12 (6⅞ x 4¾)
references: Milanesi 1878, 3:293–295; Müntz 1888; Fusco 1971; Ettlinger 1972

Galleria degli Uffizi, Florence

When Antonio Pollaiuolo wrote to Gentile Virginio Orsini in 1494 seeking a favor from Piero de' Medici, the artist said Piero would "remember that 34 years ago I made the *Exploits of Hercules*

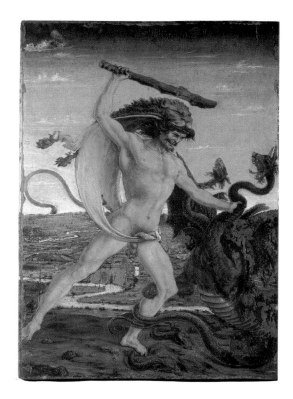

which are in the *sala* of his palace, made by me and my brother [Piero]." Three huge canvases depicting three of Hercules' exploits—overcoming the hydra, strangling Antaeus, and killing the Nemean lion—were recorded in the Medici inventory in 1492 in the *sala grande* of Lorenzo il Magnifico. A little over a year after the letter, following the expulsion of Piero de' Medici from Florence, the images were requisitioned by the government of the Florentine republic, and they have since disappeared. From Vasari's description of the Medicean paintings, it is clear that the composition of the figure groups in two of them—*Hercules and the Hydra* and *Hercules and Antaeus*—are closely reflected in two small panel paintings in the Uffizi, Florence. Vasari greatly admired the vitality of the former, describing it as "truly a marvelous thing, particularly the serpent; the coloring of which is so vividly done, and so appropriately, that it is impossible that anything could be more lively" (Milanesi 1878, 3:294). His assessment of the *Hercules and Antaeus* perfectly captures the "anatomical" quality of the portrayal: "Hercules...strangles Antaeus, a beautiful image; in which one can genuinely see the force of Hercules in the act of strangling, in that his muscles and tendons are all bunched up in the effort to finish off Antaeus; and in the head of this Hercules one can discern the gnashing of the teeth, in keeping with the character of the other parts of his body, right down to his toes, which turn up with the strain. Nor does the artist devote less attention to Antaeus, who, constrained by the arms of Hercules, is seen to be declining and losing all vigor, and with open mouth his spirit is departing" (Milanesi 1878, 3:294). The third of the paintings

recorded by Vasari, *Hercules and the Nemean Lion*, does not correspond to a surviving image.

There seems no reason to doubt Pollaiuolo's precise account of when he and Piero painted the large versions, and the smaller panels may have been executed around the same time (that is, c. 1460), though they could be as readily assigned to the 1470s on stylistic grounds. The handling of the Uffizi panel paintings suggests Antonio's sole authorship. Such small panels would most likely serve as integral decorations of an item of wooden furniture, probably something like a casket rather than a larger chest or *cassone*. The removal of the panels from their setting may have been partly responsible for the damage they have suffered, though the vertical cracking and paint loss are less severe in this panel than in its companion piece. The chief area of paint loss occurs in the body and wings of the hydra. The damage around the edges of the panel reflects an earlier but not original frame. The present edges of the two panels do not provide clear evidence of their mounting.

The lost paintings described by Vasari were of great historical significance, as the first recorded images in the Renaissance that depicted classical subjects on a large scale in an overtly Antique manner, drawing upon Roman relief sculpture for their figure style. The choice of subject, however, was not motivated solely by humanist antiquarianism. Hercules served as a kind of pagan guardian of Florence, appearing on the seal of the city and in the sculptural decoration of the Porta della Mandorla at the cathedral (Ettlinger 1972). The commissioning of large images of Hercules florentinus for the Medici palace either by Cosimo il Vecchio or Piero il Gottoso confirmed their wish to be identified with the virtues of the Florentine republic. The family's possession of Uccello's three patriotic panels, *The Rout of San Romano*, served much the same function. The smaller images, including the bronze version of *Hercules and Antaeus* (Museo Nazionale del Bargello, Florence), obviously can not have performed such a publicly rhetorical role and belong rather in the realm of humanist connoisseurship assssociated with Lorenzo il Magnifico. It is likely though not certain that the small panels, too, were painted for one of the Medici.

Even in its damaged state, the landscape of this panel exhibits Pollaiuolo's remarkable and characteristic use of a foreground "plateau," behind and below which a plain extends into the limitless distance. He may have gleaned this technique from Netherlandish painting, but his use of it as a foil for the monumentally sculptural description of near-naked figures is entirely his own. M.K.

Antonio Pollaiuolo
Florentine, 1431/1432–1498

HERCULES

c. 1480
bronze
40.5 (15⅞)
references: Müntz 1888; Bode 1923, 18;
Fusco 1971; Ettlinger 1972; Joannides
1977, 1981; Ettlinger 1978, nos. 18, 24, 27; Bober
and Rubenstein 1986, nos. 89, 129–130

Skulpturensammlung, Staatliche Museen, Berlin

Like the three large paintings of the exploits of
Hercules by Antonio and Piero Pollaiuolo, a
bronze sculpture of Hercules was listed in the
Medici inventories: "a Hercules who crushes
Antaeus, completely of bronze, half a *braccio*
high" (Müntz 1888). This entry refers to the
bronze group now in the Museo Nazionale del
Bargello, Florence (Ettlinger 1978, no. 18). No
comparably early record is known of the single
figure in Berlin, though Pollaiuolo's authorship
has not been seriously doubted since the original
attribution by Bode in 1902. The subject of Her-
cules seems to have been especially favored by the
Medici, but Hercules' more general association
with Florentine ideals—as *Hercules florentinus*
(Ettlinger 1972)—suggests that the Medici need
not necessarily be identified as the patrons of the
present statuette. There are no fixed points in the
chronology of Pollaiuolo's small bronze statuettes,
but the similarity of Hercules' facial features to
those of God the Father on the reliquary cross of
1478 for San Gaggio (Ettlinger 1978, no. 24)
suggests a date in the late 1470s or early 1480s.
The only conspicuous damage is the fracturing of
the lion's foot at the rear of the base, which may
have been the result of a casting flaw.

Like the Medicean bronze of *Hercules and
Antaeus*, this is a connoisseur's piece, made as a
virtuoso exercise in the "antique" manner. It not
only emulates the Roman statues of Hercules
known in the Renaissance (Bober and Rubenstein
1986, nos. 129–130), but also recalls the statue
described in Libanios' *Ekphraseis xv:*

> His head bends towards the earth and he seems
> to me to be looking to see if he can kill another
> opponent. Then his neck is bent downward
> along with his head. And his whole body is bare
> of covering, for Herakles was not one to care
> about modesty when his attention was directed
> toward excellence. Of his arms, the right one is
> taut and bent behind his back, while the left is
> relaxed and stretches toward the earth. He is
> supported under the arm-pit by his club...Of
> Herakles's two legs, the right one is beginning
> to make a movement, while the left is placed
> beneath and fitted firmly on the base (Pollitt
> 1965, 148–149).

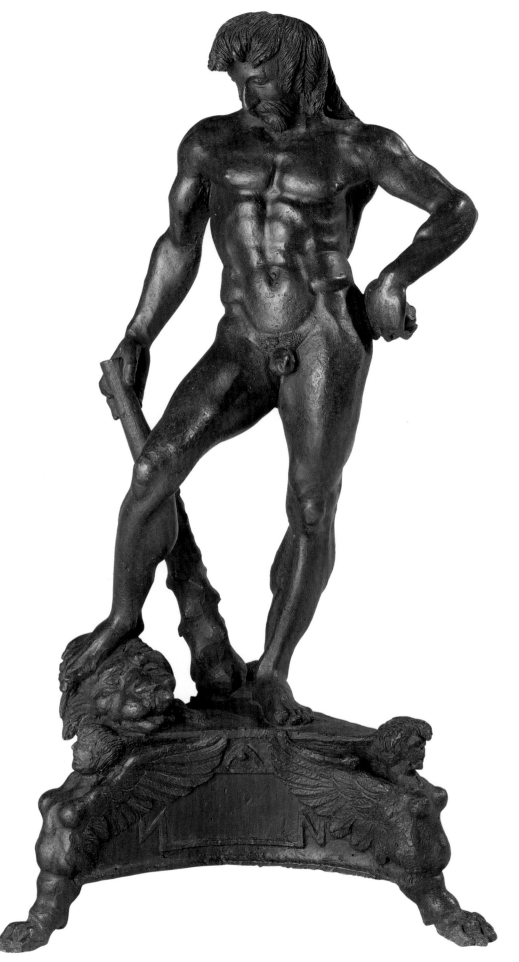

At least two antique statuettes and a relief of this type of relaxed Hercules—with the right leg crossed over the left—were known in the Renaissance (Joannides 1977, 1981), and Pollaiuolo had himself adapted this model in his drawing of *Adam* in the Uffizi (Ettlinger 1978, no. 27). The Berlin bronze appears to combine the general air of this model with a reworking of the pose of Donatello's famous bronze *David* (Bargello, Florence). The placing of the lion's head under the foot of Hercules, a motif which is not found in the antique prototypes, appears to make deliberate allusion to the subject of David with the head of Goliath and underlines the characterization of Hercules as a kind of "pagan saint." In his left hand Hercules holds the three golden apples of the Hesperides, the fruits of immortality obtained from the last of his twelve labors.

The three-sided base, with the motif of a monopodial sphinx at each corner, is consciously antique in style (Bober and Rubenstein 1986, no. 89), and serves to underscore the archaizing spirit of the piece. The judicious polishing and chasing of this splendid, patinated cast are also intended to convey an antique air. However, the wiry strength of the figure's anatomy, with knobby muscles and angular joints, the spatial complexity of the apertures between the limbs and the club, and the "saint-like" head are ultimately unlike any classical exemplar, and proclaim Pollaiuolo's own distinctive gifts in the characterization of male figures. M. K.

163 � not in exhibition

164 ✐

Bertoldo di Giovanni
Florentine, c. 1420–1491

Equestrian Battle in the Ancient Manner

c. 1485–1490
bronze
43 x 99 (16 x 39)
references: Wickhoff 1882; Müntz 1888; Pope-Hennessy 1971, 302–304; Bober and Rubenstein 1986, no. 157

Museo Nazionale del Bargello, Florence

This relief is unquestionably identifiable in the Medici inventory of 1492, when it was located above a chimneypiece in the "room opposite the great hall" (Müntz 1888). Bertoldo, a pupil and assistant to the aged Donatello, occupied a special position in the Medici household. He appears to have been in charge of the collection of antiquities and was on unusually intimate terms with Lorenzo il Magnifico. He seems to have been largely occupied in making private works for the Medici family rather than executing public commissions with the assistance of a workshop in the traditional manner.

The battle relief reflects the new kind of patronage practiced by Lorenzo. A connoisseur's piece, it is a showily impressive reworking of an actual Roman battle sarcophagus that is still in the Camposanto in Pisa (Bober and Rubenstein 1986, no. 157). There are numerous significant differences between the ancient prototype and the

adaptation. Bertoldo's version is in bronze rather than marble and is less than half the size of the original. Since none of the figures and horses in the Roman relief are intact, and the center of the scene is completely missing, Bertoldo was compelled to reinvent parts of the composition. He seems to have based the lateral figures largely on another Roman prototype, and he substantially revised even the figures that are relatively intact on the Pisa sarcophagus. He also removed many of their draperies in order to display the anatomies more fully. Bertoldo allowed the feet of some of the figures to extend over the front of the shallow foreground ledge. Moreover, the tangle of warring figures in the bronze version is radically more complex in both rhythm and depth than in the marble original.

The relative depths of relief of Bertoldo's figures, the more prominent of which appear to lean out from the back plane, suggest that the bronze was always intended to be seen from a relatively low viewpoint, and it may have been conceived specifically for the space it occupied in 1492. The iconography of Bertoldo's composition is considerably more developed than that of the Roman original, particularly by the introduction of figures of winged victories standing on vanquished male foes at either end of the relief. The carefully counterposed lateral figures, a Venus-like woman and a gruffly pensive man, have been identified as Helen and Menelaus, which would suggest that the battle is between the Trojans and Romans, with Hector at the center of the action (Wickhoff 1882). However, the central horseman with a club possesses the lion's-skin that identifies Hercules, and the battle may therefore illustrate one of his

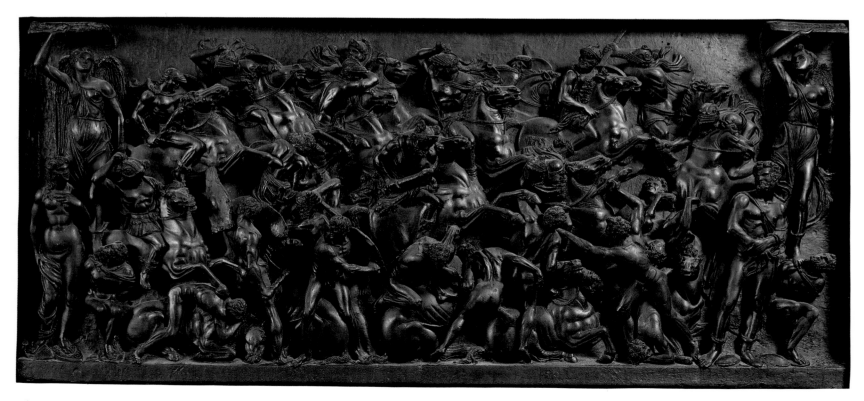

battles, such as that against Laomedon, king of Troy, or simply evoke his valor. The fondness of the Medici, particularly Lorenzo, for images of "Hercules florentinus" favors the suggestion that Hercules is the central protagonist.

The prime function of the relief was to demonstrate the artist's virtuosity in the depiction of the human figure, an effort to rival and indeed to surpass the ancients. The action is described with a fierce energy, and the figures are sculpted with a robust vigor that is difficult to appreciate from photographs. Bertoldo's inventiveness in characterizing the motions of man and animal far exceeds that of the prototype. The complex twisting poses and virtuoso passages of falling warriors display a positive relish for overcoming difficulties, and look forward to the obsession with technical challenges of Michelangelo and the Mannerists. In view of Bertoldo's likely role as a tutor to younger sculptors in the Medicean orbit, most notably Michelangelo, the great variety of poses of single figures and groups may be seen as his conscious effort to set a far-reaching agenda for the rising generation of artists in Florence.

M.K.

165

Luca Signorelli
Umbrian, probably 1441–1523

NUDE MAN CARRYING ANOTHER MAN ON HIS BACK

before 1503
watercolor heightened with white
35 x 25 (14 x 10)
references: Fumi 1891; Kurz 1937, 15; Berenson 1938, 2059 H-2; Martindale 1961; Scarpellini 1964; Carli 1965; Meltzoff 1988; Kemp 1991, 37

Musée du Louvre, Paris, département des Arts Graphiques

The crowning achievement of Signorelli's career was the fresco cycle in the San Brizio Chapel in the Cathedral at Orvieto, the vault of which Fra Angelico had begun in 1447 (Fumi 1891). Signorelli's commission dates from 5 April 1499, following Perugino's failure to undertake the work, and the cycle was largely complete by late 1503. The elaborate scheme encompasses a complex iconographic program centering upon judgment, resurrection, and damnation, which draws upon a variety of theological and poetic sources, including the writings of Dante (Meltzoff 1988). The scenes involving complex friezes of nude figures, particularly the *Damned Taken by Devils*, are the most ambitious such compositions undertaken by any artist prior to Michelangelo's *Battle*

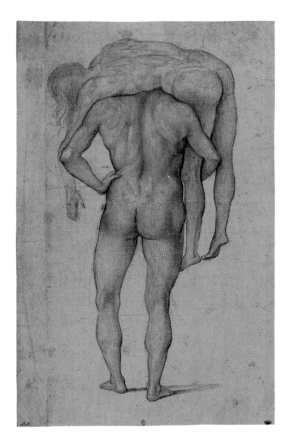

of Cascina, and there can be little doubt that Michelangelo studied the frescoes on one of his journeys between Florence and Rome.

The few surviving drawings that are definitely preparatory works for the frescoes reveal Signorelli's vigorous working procedures and free graphic style (Martindale 1961). The relationship of the more highly finished figure studies to the paintings is problematic. At first sight the present drawing bears a strong relationship to the motif of a figure being carried on another's back in the right middle ground of the tangle of terrified men and women in the *Damned Taken by Devils*. However, the motif in the fresco is in reverse, with the head of a limp figure disposed to the right, and the arms of the supporting figure are arranged differently.

The drawing is a virtuoso demonstration of the brush-drawing technique, closely related to the hatched modeling in the fresco. It has the air of an "academic" drawing made in the studio as a self-conscious exercise. Such a work could have provided the basis for the motif in the fresco, but it would not have been in the literal sense a study *for* the figures. It could also have served as an exemplary study in the context of the workshop for the apprentices. Although the anatomy of Signorelli's figures includes some schematization that is not based on direct observation, he rivals Pollaiuolo in revealing the potential of nude figures as vehicles of expression. The pendulous limbs of the unconscious figure perfectly satisfy

Alberti's requirement that in portraying a dead man there should be "no member that does not seem completely lifeless; they all hang loose; hands, fingers, neck, all droop inertly down, all combine together to represent death" (Kemp 1991, 37). The work that Alberti held out as an exemplar to modern artists was a Roman sarcophagus relief of the dead Meleager, which Signorelli adapted as a tomb relief in the background of his fresco of the *Pietà* at Orvieto.

M.K.

166

Michelangelo
Florentine, 1475–1564

STUDIES OF A NUDE MAN (RECTO) AND COMPOSITIONAL STUDY FOR 'JUDITH AND HOLOFERNES' (VERSO)

c. 1505 recto; 1508–1509 verso
Black chalk, with touches of white on recto, on paper inscribed: di Bona...
40.4 x 26 (15⅞ x 10¼)
references: Frey 1909; Berenson 1938; Hartt 1971, 42 (recto), 66 (verso); De Tolnay 1975–1980, 50; Hirst 1988; Washington 1988

Teylers Museum, Haarlem

Together with its companion drawing in the Teylers Museum (A 19r), the principal drawing on the *recto* of this sheet is a study for one of the soldiers in Michelangelo's *Battle of Cascina*, the unrealized project for a mural on which he was working for the council hall of the Florentine republic. The painting was to depict Florentine soldiers scrambling out of the water, dressing, and arming themselves to resist what was thought to be an imminent attack from the Pisans in an episode that preceded a battle which took place in 1364. Michelangelo was engaged on the cartoon (the appearance of which is best recorded in a grisaille painting by Aristotele da Sangallo, cat. 167) in 1504 (Frey 1909). The figure on this drawing corresponds closely to a soldier on the right of the Sangallo copy. Soldiers placed in front of him in the finished cartoon concealed his right arm, the lower portion of his left leg, and his right foot and ankle, while the position of his left arm is unclear in the copy. The slight sketch to the right of the figure's right arm appears to depict the contours of his belly. The sketch of shoulders below it does not appear to have been used in the cartoon.

Michelangelo's use of black chalk for such vigorous, large scale, and close-range studies of figures from the live model appears to be new in his art of this period (Hirst 1988, no. 7) and may represent his response to the challenge of the red chalk figure drawings of Leonardo, who was already working on his *Battle of Anghiari* for the

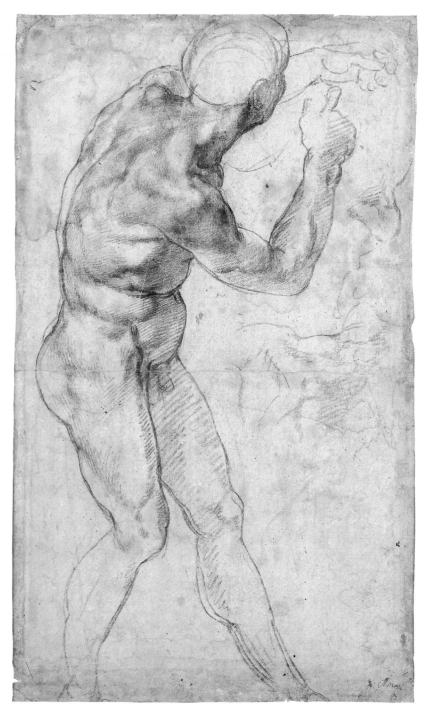

recto

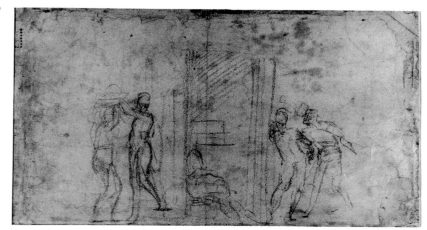

verso

council hall. The choice of black chalk gives expression to the boldness of attack adopted by Michelangelo in the Teylers sketches. The changes in the density of Michelangelo's touch (he may have moistened the chalk for the deepest shadows), together with discriminating touches of white heightening, create an extraordinary sense of plasticity. The sheet has been trimmed and folded, and is stained and patched, but the damage has done little to diminish the power of the figure study on the *recto*. The *verso* contains life studies for the group of *Judith and Holofernes* in one of the spandrels of the ceiling of the Sistine Chapel in Rome, which dates from three or four years later. Here Michelangelo has roughly blocked out the main elements of the composition: Judith and her companion bearing away the severed head on the left, a chamber with the decapitated corpse of Holofernes in front of stairs in the center, two guards who are shortly to discover the body on the right. There is a slight indication of the curved shape of the actual pictorial field at the top of the shaded portion in the center. In the scene as painted on the ceiling, however, Michelangelo eliminated the right portion of the composition and placed a sleeping guard at the left, giving Judith a more central position and filling the awkward shape more satisfactorily.

M.K.

167 ᢒ

Aristotele da Sangallo (after Michelangelo)
Florentine, 1481–1551

STUDY OF MICHELANGELO'S CARTOON FOR THE "BATTLE OF CASCINA"

1542 (based on the lost original of 1504–1505)
oil on panel
78.7 x 129 (31 x 50¾)
references: Milanesi 1878; Clausse 1900–1902;
Frey 1909; De Tolnay 1943–1960, 1:209–236; Wilde
1944; Isermeyer 1964; Gould 1966; Hirst 1986;
Bambach Cappel 1987; Bambach Cappel 1990

Viscount Coke and the Trustees of the Holkham Estate, Norfolk

To decorate the great Council Hall, built during the 1490s in the Palazzo Vecchio, the government of Florence commissioned two huge murals from its leading artists, Leonardo da Vinci and Michelangelo, each to depict an incident from a famous Florentine victory (Wilde 1944, Isermeyer 1964). Leonardo was to illustrate a battle fought against the Milanese in 1440, and Michelangelo was to portray the prelude to a battle against the Pisans in 1364. The involvement of Leonardo, who was to paint the *Battle of Anghiari*, is documented from

24 October 1503; he signed a revised agreement for the commission on 4 May 1504. Our first notice of Michelangelo's involvement dates from 31 October 1504, when payments were made for paper for his cartoon. On 28 February 1505 he was paid 280 lire for his work "in painting the cartoon" (Frey 1909). Work lapsed after he was summoned to Rome by Julius II, but after his famous dispute with the Pope's officials he returned to Florence. On 27 November 1506 the Gonfaloniere, Pietro Soderini, recorded that "he has started a history [painting] for the public hall, which will be an admirable thing". This reference is sometimes taken to indicate that Michelangelo had begun to paint on the wall, but it is more likely that Soderini was referring to the cartoon. Michelangelo's humbling reconciliation with Julius in Bologna in November 1506 marked the end of his work on the *Battle*. His rival, Leonardo, had actually begun to paint the mural in 1505, but his journey to Milan in 1506 effectively ended his involvement with the project.

The terms of Leonardo's revised contract of May 1504 indicated that he could choose either to complete the whole cartoon as his first obligation, or to begin painting from that part of the cartoon he had already completed. It seems likely that he followed the second option, making a cartoon for the central section of his battle, which depicted the equestrian skirmish around the Milanese standard, and starting to paint this section on the wall in what appears to have been an experimental and troublesome oil technique. The surviving records of Michelangelo's lost cartoon suggest that he too completed only the central section of his cartoon and may have intended to begin painting this portion on the wall.

Vasari indicates that Michelangelo worked on his cartoon in the Ospedale de' Tintori in the district of S. Onofrio and that when it was finished it was taken to the Sala del Papa in S. Maria Novella, where Leonardo had previously worked on his cartoon. It is likely that Michelangelo's cartoon was moved from the Sala del Papa in 1515 on the occasion of the visit of Pope Leo X and placed in the great hall of the Medici Palace. The cartoons by Leonardo and Michelangelo were probably not themselves intended to be used directly for the transfer of the compositions to the wall. Rather "sub-cartoons" were to be made from them and cut up for the process of transfer (Bambach Cappel 1987 and 1990). Michelangelo's cartoon became the "school" of figure drawing for the younger Florentine draftsmen. At some point, probably during the second decade of the century, it was dismembered and the parts dispersed. The last documented fragment was recorded in Turin in 1635, when the "nudes" were described as "larger than life size" (De Tolnay 1943–60, I, 209–36). The young Bastiano Sangallo, a member of the famous family of architects and artists, who came to be known by his nickname, Aristotele, was one of the young draftsmen who avidly copied the figures in the cartoon (Clausse 1900–1902). Originally a pupil of Perugino, he found that Michelangelo's complex figure style opened his eyes to new possibilities for his art. Vasari, who was closely acquainted with Aristotele, provides a well informed account of the genesis of the grisaille painting shown here. He indicates that Aristotele alone of the students drew a copy of the complete group, rather than individual figures. In 1542 Vasari himself persuaded Aristotele to make a monochrome oil painting from his prized drawing, and the painting was subsequently sent by Paolo Giovio to the King of France, "who valued it greatly and richly rewarded Sangallo." Since the original drawing by Sangallo is lost, the painting has a unique authority as a record of Michelangelo's cartoon. It is an accomplished painting in its own right, although Aristotele himself later decided to specialize in stage design and architecture rather than in figure painting. Michelangelo's own drawings, together with drawn and

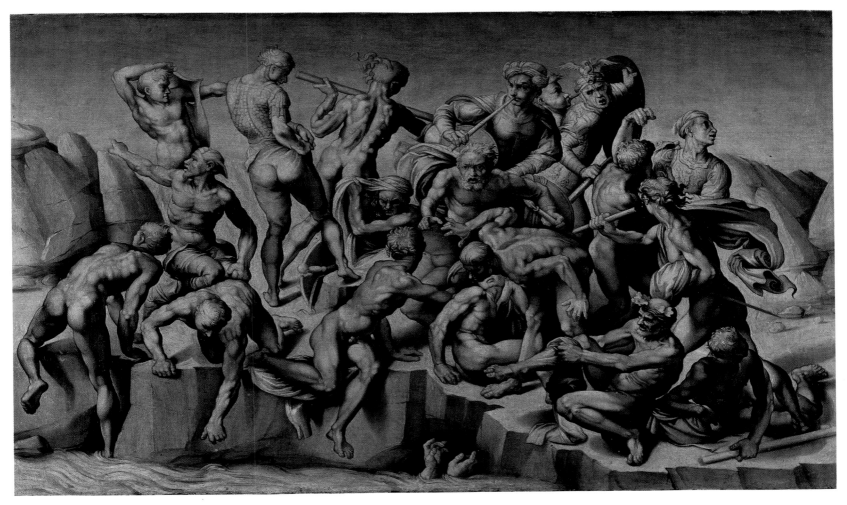

printed copies of other figures, confirm the essential accuracy of the grisaille version.

Although there is little reason to think that the Florentine government would have given Michelangelo the license to choose a battle or an incident to suit his personal tastes, the subject of the soldiers scrambling to arm themselves after bathing was ideally suited to his mastery of the human figure. The incident occurred on the day before the actual battle, when the Florentines were off guard. Realizing their vulnerability, one of the Florentine leaders, Manno Donati, shouted that the Pisans were attacking. Although Donati's cry was an intentional false alarm, he achieved his aim of making the Florentines ready for what was to be a successful fight. Donati may be the figure just to the right of center, who lunges forward. The figure in the center may be the commander, Galeotto Malatesta, whose act of winding (or unwinding) a length of cloth from his head may be a punning allusion to his surname.

The subject gave Michelangelo an ideal opportunity to take up the theme of nudes in various postures, pioneered by Pollaiuolo (cat. 160), developed by Bertoldo (cat. 164), and already explored by Michelangelo himself in his *Battle of the Centaurs* (Casa Buonarroti, Florence). Compared to the earlier examples, Michelangelo has attained new levels of complexity in his orchestration of variously posed figures on a shallow stage. In so doing he has managed to sustain a balance between expressive if rhetorical function and self-conscious artistry, though it was to be the latter characteristic that most impressed the younger generation of artists, who strove in an academic manner to emulate the celebrated "difficulty" of the "master's" figure style. Sangallo's painting, even if it misses something of the monumentality that must have characterized Michelangelo's huge drawing, is a fitting homage to Michelangelo's achievement and provides vivid testimony to the exemplary status achieved by the cartoon for what for us remains a tragically incomplete project.

The paint on Sangallo's panel is presently covered by layers of discolored varnish, and there is a good deal of dirt in the interstices of the impasto. There are also some surface scratches, a few scattered paint losses, and limited areas of percussive damage. However, the panel as a whole is in good condition, in spite of the loss of two vertical battens from the rear, and the paint surface is generally well preserved. Sangallo's rhythmic and impasted application of oil paint is fundamentally unlike Michelangelo's, but his emphasis upon the outlining of the contours of the figures—often ensuring that a dark contour appears on a light background and *vice versa,* clearly reflects the incisive draftsmanship of the original cartoon. M.K.

168 𝔞

Michelangelo

Florentine, 1475–1564

MADONNA OF THE STAIRS

c. 1495
marble
55.5 x 40 x 3.4–2.5 (21⅞ x 15¾ x 1⅜–1)
references: De Tolnay 1943–1960, 1:125–132;
Barocchi 1962; Calì 1967; Hartt 1969, no. 1;
Weil-Garris Posner 1970; Hartt 1971, no. 232;
Hibbard 1985

Ente Casa Buonarroti, Florence

Neither Giorgio Vasari in his first *Life* of the artist in 1550 nor Condivi, the writer of the "authorized" biography of Michelangelo in 1553, mentioned this relief, but it was briefly discussed in Vasari's second edition in 1568, and its authorship is not in any serious doubt. Vasari's account immediately follows his discussion of the *Battle of the Centaurs.*

> It [the *Battle*] is held in memory of Michelangelo in his house, as the rare thing it indeed is, by Lionardo, his nephew, who not many years ago also had in his house in memory of his uncle a Madonna in low relief in marble, a little more than a *braccio* high, from the hand of Michelangelo, who, still being a young man at this time, wished to replicate the style of Donatello, which he did to such effect that it appears to be by Donatello's hand, except that more grace and draftsmanship can be discerned in it. This relief was then given to Duke Cosimo [II] Medici who maintains that it is a most singular object, in that there is no low relief from his hand other than this sculpture (Vasari 1568).

The dating of the relief is more problematic than the modern consensus might suggest. It is widely assumed, following Vasari's association of it with the *Battle of the Centaurs* (Casa Buonarroti, Florence), to be one of his earliest works, undertaken while he was in the household of Lorenzo de' Medici, that is to say in or before 1492, when he was sixteen or seventeen. However, since as a very low relief—a *relievo schiacciato*—it is unique in Michelangelo's *oeuvre* as Vasari recognized, direct comparisons with other kinds of work should be handled with caution. The motif of the sibylline woman seated on a block recalls the Sistine Ceiling of 1508–1512—both the Sibyls themselves and the female ancestors of Christ. The bluntly defined boys in the background also resemble those in the ancestor lunettes of the Sistine Chapel. The motif of Christ's arm tucked behind his back may even be compared to the study from the early 1520s for the back of *Night* in the Medici Chapel (Teylers Museum, Haarlem;

Hartt 1971, no. 232). Moreover, the complex iconography and restrained sense of tragedy seem difficult to recognize as the product of an artist in his mid teens. On the other hand, the sense of experimental awkwardness in some aspects of the poses, particularly in the arrangement of the Virgin's feet, and the rather fussy carving of the drapery, support an early date. The *Battle of the Centaurs,* though very different in its high relief and tempestuous subject, testifies to the remarkable sophistication of Michelangelo's grasp of both form and content in even his earliest works. The best solution is probably to date the *Madonna* early in his career, but a few years later than 1491. It may well be contemporary with his *Angel Bearing a Candelabrum* for the tomb of Saint Dominic in San Domenico, Bologna, which shares the rather waxy texture of its draperies and which was carved in 1495. This date also works well with its possible literary source in Benivieni's *Scala della vita spirituale sopra il nome di Maria* of 1495.

Low reliefs of Madonnas were popular devotional items for domestic settings in the mid and late *quattrocento*. However, Michelangelo has looked past his immediate predecessors and back to the revered example of Donatello, who provides precedents for the somber emotion, abrupt carving of the background children, and suggestively variable degree of finish. The marks of the claw chisel are not only apparent in the figures of children but also in various aspects of the Virgin's flesh and drapery. The warm, honey-colored patina acquired by the marble nicely enhances Michelangelo's own feel for the "living" quality of the material, which, in other hands, often possesses an unyieldingly stony quality. Although he has achieved strong effects of monumental plasticity, the most prominent parts of the relief protrude little more than a quarter of an inch from the background plane. The flattened area at the back of Christ's head is probably the result of abrasion rather than miscalculation on the sculptor's part. Other minor abrasions are visible elsewhere, particularly in the fingers of Christ's right hand. The top corners of the shallow frame have also been damaged, more conspicuously on the right, but the greater part of the surface gives a wonderfully intact sense of Michelangelo's hand at work.

The iconography is of unprecedented complexity for a low relief Madonna and Child. The motif of the Child suckling, the *Virgo lactans,* has been combined with a prefiguration of the death of Christ as conveyed by the sleeping Child's sagging head and limp arm, which allude to the Pietà. The stone block may be an allusion to Christ as the rock on which the Church is to be founded. The five stairs of the background make reference to the five letters of Maria's name, which Domenico Benivieni, a theologian in Lorenzo de' Medici's Florence, interpreted in his *Scala* as meaning that the Virgin is our stairway between earth and

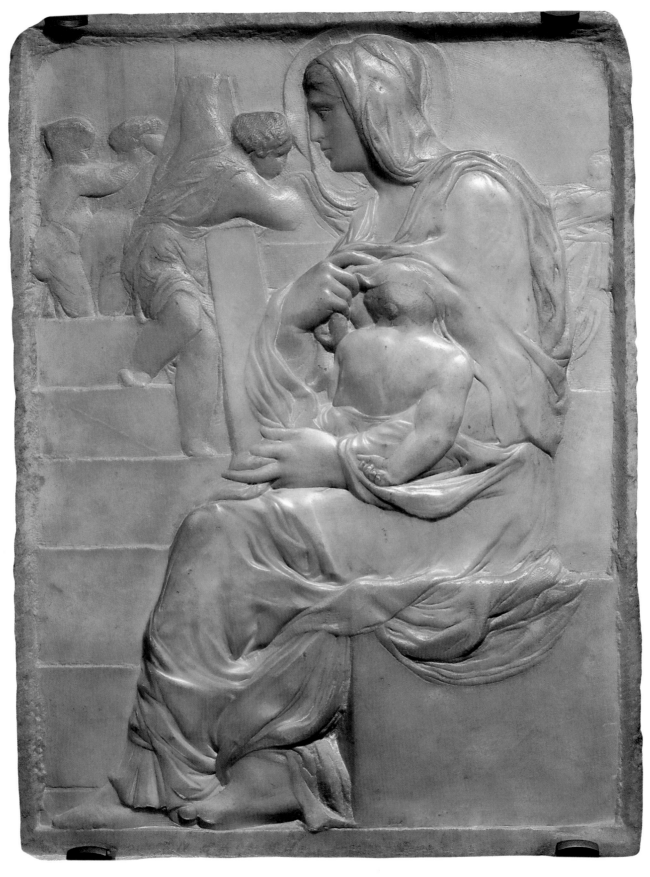

heaven. The long swathe of drapery held by the boy on the stairs and the barely defined child behind the Virgin seem to prefigure the funeral shroud of Christ, while one of the pair of *putti* at the top of the stairs appears to be consoling the other. In such a context, the impassive solemnity of the Virgin's classicizing profile assumes an air of stoic foreboding.

Although the genre of low relief sculpture of the Virgin and Child might seem to offer little scope for the exercise of originality in figure style, Michelangelo conveys the essence of the subject's meaning through the physical impact of figures of unprecedented grandeur. Particularly striking is the Herculean potential of Christ's back and arm, modeled with a far from infantile muscularity which may be intended to emphasize the corporeal reality of God's son on earth. J.M.M.

LEONARDO AND DÜRER

Leonardo da Vinci (1452–1519) and Albrecht Dürer (1471–1528) were the quintessential artist-scientists of the European Renaissance, whose wide-ranging explorations of the natural world epitomize the period's quest for knowledge. There is no record that these men ever met. Dürer's notebooks reveal, however, that he was acquainted with Leonardo's studies of human anatomy and physiognomy and of the horse, probably from reproductions of Leonardo's drawings.

The two masters shared a remarkable variety of interests, from the science of perspective, to the study of human and equine proportions and anatomy, to landscape and the details of plant and animal life. Each counted prominent scientists and mathematicians among his friends. Each believed that painting must be raised to the level of a liberal art rather than remain a mere craft; each consequently required the artist to acquire broad knowledge of the theoretical foundations of his discipline. Both Leonardo and Dürer worked on written treatises addressed to the needs of the artist, though only Dürer's were actually published.

Despite the many similar subjects that appear in their art and writings, however, Leonardo and Dürer had fundamentally different outlooks on the world. Dürer's focus was always on the individual and the specific. He was fascinated by the incredible diversity of God's creation, and his studies of landscapes, plants, and animals are as much portraits as are his paintings and drawings of people. He saw the artist's role as interpreting for man God's presence in the endlessly varied phenomena of nature. Leonardo's glacial intellect always concentrated on the unity underlying nature's diversity. Probing beneath surface appearances, he aimed at uncovering the fundamental laws governing the physical world. By mastering nature's first causes, he believed, man could use them to remake the world.

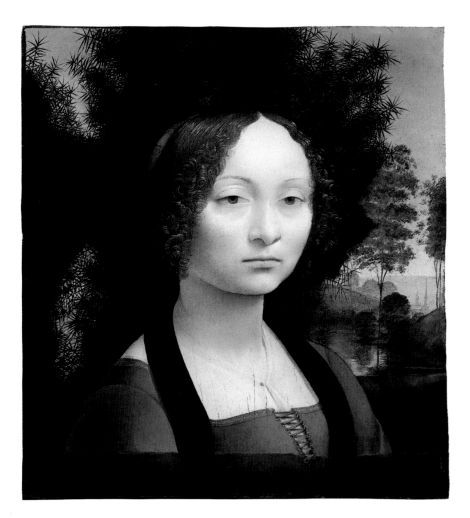

169 ❧

Leonardo da Vinci
Florentine, 1452–1519
PORTRAIT OF GINEVRA DE' BENCI

(on reverse) Emblematic Motif
c. 1475–1476
oil on poplar panel
38.8 x 36.7 (15¼ x 14½) (cut down at base)
inscribed on the reverse: VIRTUTEM FOR/MA DECORAT
references: Walker 1967; Richter 1970/1977, 416; Shapley 1979, 251–255; Brown 1985; Fletcher 1989

National Gallery of Art, Washington, Ailsa Mellon Bruce Fund

The identification of this portrait (Washington 1967.6.1.a-b) with the picture of Ginevra de' Benci described in the early sources (Antonio Billi, the Anonimo Gaddiano, and Vasari; see Shapley 1979) has been widely accepted since the nineteenth century and seems entirely secure. The juniper bush (*ginepro*) is an emblematic play on her name. The Benci were wealthy and prominent members of Florentine society. Giovanni d'Amerigo de' Benci, Ginevra's brother, is mentioned four times in Leonardo's memoranda as possessing items of interest, including Leonardo's own "map of the world" (Richter 1970/1977, 1416, 1444, 1454, and p. 416). Vasari indicates that Leonardo's unfinished *Adoration of the Kings*

(Uffizi, Florence) was in the house of Amerigo, the son of Giovanni. Ginevra was born in 1457 and married Luigi di Bernardo di Lapo Nicolini in 1474. She was the subject of ten Petrarchan poems by Cristoforo Landino and Alessandro Braccesi, extolling her virtues and recounting the devotion of Bernardo Bembo, who was Venetian ambassador to Florence in 1475–1476 and 1478–1480. Lorenzo de' Medici also dedicated two sonnets to her (Walker 1967). The motto on the reverse of the painting, "she adorns her virtue with beauty," is in the form of the opening of a hexameter verse and is entirely consistent with the tone of the poetic devotions. The porphyry background of the heraldic motif is probably meant to signify the enduring nature of her virtues. The motif of the wreath of bay and palm on the reverse has recently been identified as the personal device of Bernardo Bembo, and Bembo himself has been proposed as the patron of the portrait (Fletcher 1989). However, the "license" for the use of a personal device could be given to someone else as a special favor, and the replacement of Bembo's motto—*virtus et honor*—by Ginevra's suggests just such a transfer of the emblem to her. There is no evidence that Bembo ever possessed the portrait, and it does not appear to have been known in Venice. Although Bembo's devotion to Ginevra cannot be doubted, given the evidence of the

poems, it should be remembered that expressions of Platonic love were entirely conventional features in the Petrarchan tradition and should not be taken as indications of an illicit affair. Indeed, the chaste and ultimately unattainable character of the beloved lady is a central feature of such poetry. The portrait is in fact a key document in understanding the position of women in the art and society of Lorenzo's court.

The newly demonstrated link with Bembo suggests that the portrait was not commissioned for Ginevra's marriage in 1474, as is often hypothesized (Brown 1985) and that it dates instead from after 1475. The chronology of Leonardo's paintings in the 1470s is very uncertain, and it is always difficult to date portraits by comparison to religious subjects, but the stiff pose and polished foreground detail favor a date during Bembo's first embassy to Florence (1475–1476) rather than as late as 1478–1480, which would bring it closer to the period of the *Adoration of the Magi.*

The incompleteness of the heraldic motif indicates that as much as a third of the panel has been cut from the bottom; this must have occurred before 1780. It is likely that Ginevra's hands were originally included in the picture, as in the marble bust of a *Lady Holding Flowers* by Verrocchio (Bargello, Florence) and the closely related portrait of a *Lady Holding a Ring* attributed to Lorenzo di Credi (Metropolitan Museum of Art, New York). It is possible that Verrocchio's bust also represents Ginevra (Fletcher 1989). The slender hands drawn by Leonardo from life in a highly finished study at Windsor (12558) have often been identified as belonging to Ginevra and do indeed justify the praise accorded to her hands in the poems: "hands with the skill of Pallas," and "fingers as white as ivory." The lower margin of the picture has suffered substantial paint loss, and a painted strip has been added where the tips of her fingers might be expected to appear. Otherwise, much of Leonardo's paint surface has survived in remarkably good condition.

The appearance of the painting combines the hieratic quality of a sculpted bust with passages of intense and highly innovative paint handling. The extremely delicate linearity of her hair (in vortex curls, prophetic of his later water studies) is set against the nuanced modeling of the flesh (which has been softened by Leonardo's pressing his hand into the paint surfaces while wet) and against the spiky light on the juniper leaves. In the glimpse of lakeland in the background, Leonardo has striven for especially novel effects. There the forms are depicted with blurred brushstrokes, to convey a sense of atmosphere, but the oil-rich pigment layers have since puckered and wrinkled, much as in the experimental background of his *Madonna with the Vase of Flowers* (Alte Pinakothek, Munich). Even at this early stage of his career, Leonardo was pushing the medium of oil painting to new limits in his ambition to evoke visual effects with unremitting fidelity. M.K.

170 ❧

Leonardo da Vinci
Florentine, 1452–1519

PORTRAIT OF A LADY WITH AN ERMINE (CECILIA GALLERANI)

c. 1490
oil on walnut panel
54.8 x 40.3 (21⅜ x 15⅞)
later inscribed: LA BELLE FERRONIERE/
LENONARD DA WINCI
references: Popham 1946, 109; Zygulski 1969; Kwiatowski 1955; Richter 1970/1977, 1234, 1263; Kemp 1985; Rzepinska 1985, 66–70; Clark 1989; London 1989, 37; Brown 1990; Campbell 1990; Bull 1991

Czartoryski Museum, Cracow

Notwithstanding the crudely painted inscription, which was probably added when the background of the portrait was overpainted, the identification of the sitter in this painting as Cecilia Gallerani is reasonably secure. The animal she holds is recognizably an ermine, the Greek name of which, *galée,* makes a characteristically humanist pun on her name, and may also allude to Ludovico Sforza, the ruler of Milan. The unnaturally large scale of the ermine should not cast doubt on its identification (Campbell 1990) and may be compared to the exaggerated size of the babies in Leonardo's Madonna and Child compositions. Cecilia was a significant figure in Milan during Ludovico Sforza's reign (1481–1499). She was an educated and accomplished student of Latin and Italian literature and a devotee of the arts and philosophy. Before her marriage in 1491 to Conte Camierati

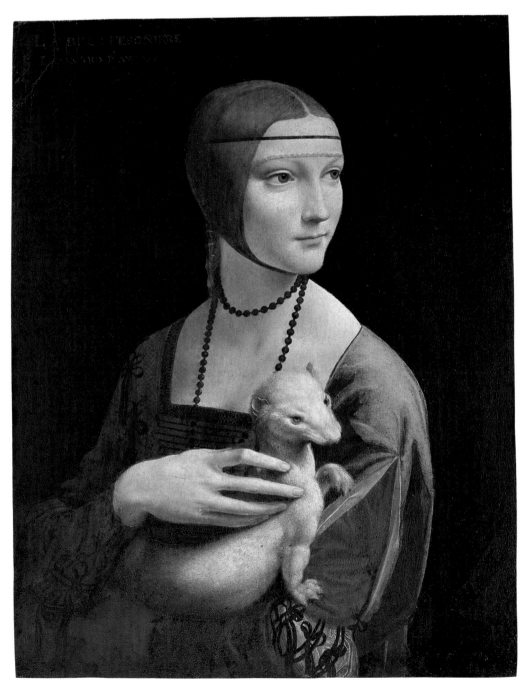

Bergamini, she had briefly been Ludovico's mistress while she was still in her teens. Leonardo's portrait was the subject of a sonnet by Ludovico's court poet, Bernardo Bellincioni, who died in 1492. In the poem, Nature declares that she has been put into the shade by the victorious "Vinci" (another pun), since the artist has captured Cecilia's "splendid eyes, beside which the sun appears as a dark shadow." The poet assuages Nature's envy by pointing out that the glory of her creation will be transmitted to posterity by the "talent and hand of Leonardo"—with due thanks to Ludovico. Some measure of the esteem in which both the sitter and the artist were held can be gained from a letter that Isabella d'Este, the notable marchioness of Mantua, wrote to Cecilia in 1498. Isabella asked to borrow the portrait to compare with "certain beautiful portraits from the hand of Giovanni Bellini." In her reply Cecilia explained that the portrait was no longer a good likeness. This problem did not arise from any "defect of the master, of whom I do not in truth believe anyone comparable can be found, but only from the fact that this portrait was made at such an immature age that I have since totally changed in appearance."

The dating of the portrait on stylistic grounds is problematic, and it has generally been related to Leonardo's work on the first version of the *Virgin of the Rocks* (Louvre, Paris) around 1483–1485. The modeling of the head is comparable to that in the study in Turin for the Angel Uriel's head (cat. 171). However, on the basis of new evidence about Cecilia's age discovered by Grazioso Sironi and Janice Shell (forthcoming), a date earlier than 1489–1490 should be excluded. The way in which the bony structure of the ermine's head has been understood by the artist is comparable to Leonardo's studies of the human skull of 1489. It is even possible that Ludovico commissioned the portrait in 1491 as a betrothal or wedding gift. The ermine was a well-known symbol of moderation and chastity. As Leonardo wrote, "because of its moderation it only eats once a day" (Richter 1970/1977, 1234), and "the ermine would die rather than soil itself" (Richter 1970/1977, 1263). A drawing by Leonardo in a private collection (Popham 1946, 109) shows an ermine subjecting itself to a beating by a cruel hunter rather than besmirch itself in a "muddy lair." The attribution of chastity to an admired lady was entirely conventional in courtly poetry, and many other features of the portrait, "the bewitching eyes, smooth brows, sweet lips, graceful neck, gentle breast and ivory hands—speak, in visual terms, the language of Petrarchan sonnets" (Kemp 1985).

The original appearance of the painting has given rise to a good deal of debate. The major change has occurred in the background, which has been repainted with black pigment (Brown 1990). Traces of the originally gray-blue background are visible under high magnification around the outlines of the figure (Bull 1991). The available technical evidence (Kwiatowski 1955) for the original presence of a window or other opening on the right is inconclusive, and it is likely that the whole of the background was more or less uniform in hue.[1] There seems no reason to accept the commonly voiced view that the motif of the hair gathered in a veil around and under her chin is not original. Indeed, it plays a significant role in the symphony of curves around her face.

Overall, the picture is in much better condition than the standard accounts suggest, and gives the clearest indication of the freshly brilliant quality of Leonardo's painting during his period at the Sforza court in Milan. As in the *Ginevra de' Benci*, Leonardo has pressed his hand into the wet paint to soften some of the tonal transitions. The motif of the sitter's glance, turned apparently in response to someone beyond the confines of the picture, is entirely novel, conveying a remarkable effect of what Leonardo called "il concetto dell'anima" (the intentions of the subject's mind). The highly charged sensibility of the "fastidious" ermine transforms it from a conventional emblem into a living metaphor for the lady's own character. The nearest parallel for the animal is the beautiful silverpoint drawing of a bear's head in a private collection (Popham 1946, 78a; London 1989, 37), which also probably dates from c. 1490. The subtle yet structurally firm modeling of Cecilia's head and hand, and of the ermine's head, achieves the sense of relief Leonardo emphasized in the 1490s as the ultimate illusionistic achievement of the painter. M.K.

1. *A detailed study of the painting's condition is being undertaken in conjunction with this exhibition. The results will appear in a forthcoming publication.*

171 ❦

Leonardo da Vinci
Florentine, 1452–1519

HEAD AND SHOULDERS OF A YOUNG WOMAN

c. 1483–1485
silverpoint with white heightening
on prepared paper
18.1 x 15.9 (7⅛ x 6¼)
references: Popham 1946, 157; Pedretti 1975, 2

Biblioteca Reale, Turin

It has been widely recognized that this study (Turin 15572), apparently drawn from life, was used as the basis of the Angel Uriel's head in the first version of the *Virgin of the Rocks* (Louvre, Paris; second version in National Gallery, London), which was commissioned in 1483 by the Confraternity of the Immaculate Conception for the large carved altarpiece in its chapel in S. Francesco Grande in Milan. Although the subsequent history of the commission is very tangled, and we cannot be certain when the first version was finished, this preparatory drawing can be dated with some confidence to the earliest phase of Leonardo's work on the project. In the painting, the angel turns his head and eyes to look out at the spectator and points to the infant St. John the Baptist, thus acting as interlocutor for the spectator. The compellingly direct gaze of the posed model shows that the angel was conceived as performing this role at an early stage in the planning of the picture. In the second version of the painting, the literally demonstrative motifs of the angel's glance and gesture were to be abandoned.

The delicacy and descriptive power of the parallel hatching Leonardo used in his silverpoint drawings during the earlier part of his career are nowhere more perfectly exemplified than in this study. Among his contemporaries, perhaps only Domenico Ghirlandaio came close to this level of refinement in the handling of this very demanding medium.

On the verso of this sheet is a pen drawing of a knot motif in an oval surround, made for an unknown decorative purpose. M.K.

171A ❦

Leonardo da Vinci
Florentine, 1452–1519

PORTRAIT OF A LADY IN PROFILE

c. 1481
silverpoint on pinkish paper
30 x 20 (11¾ x 7⅞)
references: Clark and Pedretti 1968–1969, 12505; Popham 1946, no. 73
Her Majesty Queen Elizabeth II, Royal Library, Windsor Castle

Although a significant proportion of Leonardo's production of paintings was concerned with portraiture, direct portrait drawings (rather than "studies from life" for religious paintings or other narratives) have rarely survived. The closest comparison to this sheet is the sharply characterized *Young Man in Profile* at Windsor (Popham 1946, no. 12498), probably datable to c. 1480. The drawn *Portrait of Isabella d'Este* in the Louvre (Popham 1946, no. 172) and the painted portraits all display a level of generalization at least one step removed from such uncomplicated life studies.

The amplitude and coherence of form, created by a masterly combination of descriptive contour and parallel hatching, have led scholars to suggest a dating in Leonardo's Milanese period. Yet, the simple headdress of this unidentified sitter is more comparable to his earlier Florentine drawings (for example, Windsor 12276v). Other silverpoint drawings that can be assigned to 1481 or earlier—especially the Louvre study for the *Madonna Litta* (Popham 1946, no. 19) and the

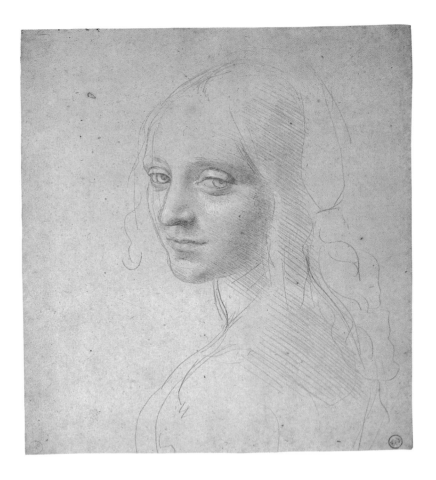

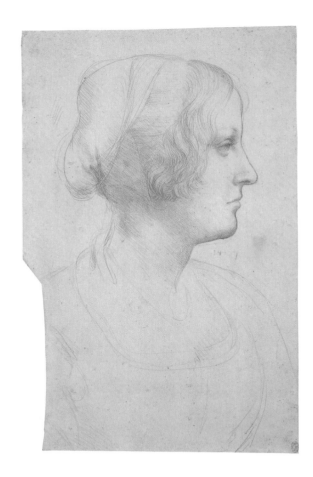

Warrior in the British Museum (Popham 1946, no. 129) — show the maturity and sophistication of the handling of this medium that he had achieved by his late twenties.

The unaffected directness and sensitivity of Leonardo's characterization serve to counter-balance his more familiar depiction of women as ideal, remote, mysterious and unfathomable beings — in keeping with the image of woman in Renaissance love poetry. It is therefore tempting to think that this sitter was a member of Leonardo's immediate circle or household. M.K.

172 &

Leonardo da Vinci
Florentine, 1452–1519

STUDY FOR THE HEAD OF LEDA

c. 1505–1507
pen and brown ink over black chalk on paper
19.8 x 16.6 (7¾ x 6½) (irregular)
references: Clark and Pedretti 1968–1969, 12516;
London 1989, 58; Shell 1991

Her Majesty Queen Elizabeth II, Royal Library,
Windsor Castle

Leonardo's project for a painting on the theme of Leda and the Swan first appears in drawings associated with the *Battle of Anghiari* around 1505, when he was planning to show Leda in a kneeling posture. The painting he eventually undertook portrayed her standing in a sinuous pose. The motif of the standing Leda was copied by Raphael in or before 1507, either from a design or from Leonardo's painting, whether finished or unfinished. The present drawing (Windsor 12516), with its almost obsessively rounded shading, can be dated on stylistic grounds to circa 1505–1507.

The completed painting is the first and most highly valued item on the list made in 1525 of the possessions of the deceased Salai, who had been a member of the master's household (Shell 1991). It appears subsequently to have entered the collection of Francis I and was housed in his Appartements des Bains at Fontainebleau. There is no definite record of the original painting during the last two centuries, though numerous copies and variants are known (such as those of Wilton House and the Palazzo Vecchio, Florence [ex-Spiridon]).

The main sketch on this sheet is very close to the head of Leda in the copies of the lost painting. The elaborately plaited hair — an extreme development of the knotted styles favored by Leonardo's master, Verrocchio — is in fact a wig. A note on Windsor 12517 records that "this kind can be taken off and put on again without damaging it." Leda's own hair is visible at the forward margins of the wig and spouting through the center of the lateral whorls. As in the study of plants associated with this painting (cat. 184), the intertwined elements become the subject of interest in their own right, and Leonardo experiments with various arrangements for the back of the wig. The visual counterpoint between the free cascades of Leda's own hair and the compact spirals of her wig recalls his famous parallel between the motions of water and the curling of hair: "Observe the motion of the surface of water, which resembles the behavior of hair, which has two motions, of which one depends on the weight of the strands, the other on the line of its revolving; thus water makes revolving eddies, one part of which depends upon the

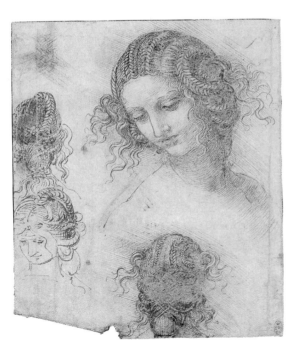

impetus of the principal current, and the other depends on the incident and reflected motions" (Windsor 12579). The artificial design, in effect, takes its cue from the natural pattern, elaborating the inherent behavior of the physical world. The parallels go beyond water and hair, extending to such phenomena as deluges, plant growth, and configurations of drapery.

M.K.

173 ❧

Leonardo da Vinci
Florentine, 1452–1519

Principal Organs and Vascular and Urinogenital Systems of a Woman

c. 1507–1508
pen and brown ink and wash over black chalk on washed paper, main outlines pricked for transfer
47.8 x 33.3 (18¾ x 13⅛)
inscribed with notes on anatomical and physiological matters
references: Popham 1946, 247; Clark and Pedretti 1968–1969, 12281; Keele and Pedretti 1979–1980, 122r; London 1989, 52

Her Majesty Queen Elizabeth II, Royal Library, Windsor Castle

This extraordinarily large and complex demonstration (Windsor 12281) represents the climax of Leonardo's attempt, in a phase of his anatomical studies in 1507–1508, to create composite demonstrations of what may be called the "irrigation" of the human body, synthesized from his dissections and readings. The left side of the sheet was drawn first, and the major outlines were pricked for transfer. The sheet was then folded vertically along the center line, and the design was duplicated on the right half. Further pricking was undertaken, presumably for the transfer of the whole scheme to another sheet. On the verso some of the outlines have been traced in a graceless and inaccurate manner, probably by another hand. Leonardo reminds himself in a note to "make this demonstration also viewed from the side, so that knowledge may be given of how much one part is behind another, and then make a demonstration from behind." We may doubt whether the desired clarity could ever have been achieved, because he endeavors to make such drawings carry more information than is really possible, using a bewildering variety of diagrammatic conventions. Some forms are shown in three dimensions, others in schematic outline, some in transparency, and a few in cross section. Even the parallel hatching, designed to provide a background for the organs, can ultimately do little

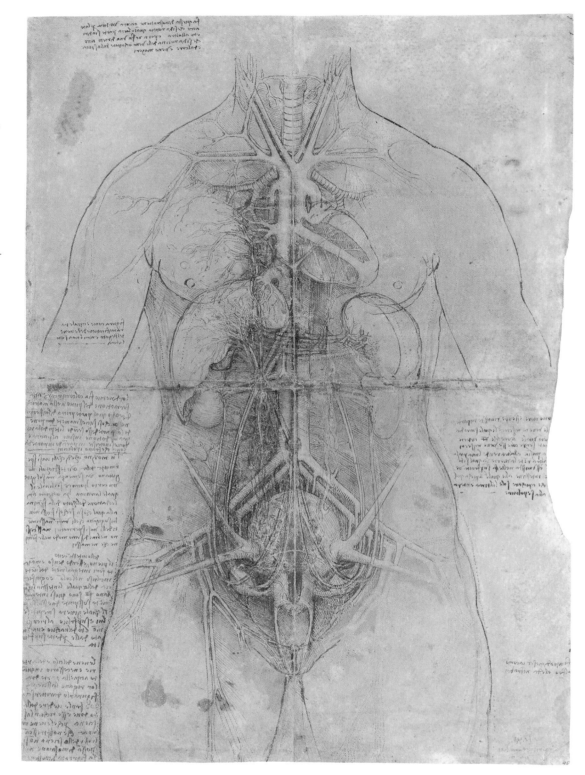

to resolve the problem of definition. In spite of these problems, however, the final effect exudes a remarkable sense of heroic grandeur and provides vivid testimony to the awe with which Leonardo regarded the complex machinery of the human body.

Several traditional notions, gleaned from his reading of anatomical texts, are apparent in this drawing, including the two-chambered heart and the spherical uterus, with its inner "cells" and tendinous "horns." His chief source is a textbook by Mundinus (Mondino de' Luzzi), probably in the version printed in Johannes Ketham's *Fasciculus medicinae* (1494), but Leonardo is not afraid to challenge his predecessor's ideas: "You, Mondino, say that the spermatic vesicles or testicles [the ovaries in women] do not cast out true semen, but only a certain salivary humor, which nature has ordained for the delectation of women in coitus, in which case it would not be necessary that the origins of the spermatic vesicles should arise in the same way in women as in men." In contrast to

long established opinion, Leonardo believed that men and women contributed "seed" in equal measure to the creation of the fetus.

One of the notes indicates his intention to make a series of studies of human generation, starting with "the formation of the infant in the womb, saying which part is composed first," while another contains speculations on the cyclical nature of life and death in the human body. The aim of such studies was to show the totality of the microcosm (the "lesser world") through the complex mapping of physiological functions, just as Leonardo also aimed to map the "body of the earth."

<div align="right">M.K.</div>

174 ❧

Leonardo da Vinci
Florentine, 1452–1519

THE FETUS IN THE WOMB WITH STUDIES OF DYNAMICS AND OPTICS

c. 1512
pen and ink with wash over traces of red and black chalk on paper
30.5 x 22 (12 x 8⅝)
inscribed with notes on embryology, dynamics, and optics
references: Popham 1946, 248; Clark and Pedretti 1968–1969, 19012; Keele and Pedretti 1979–1980, 198r; London 1989, 26

Her Majesty Queen Elizabeth II, Royal Library, Windsor Castle

The anatomical investigations undertaken by Leonardo in the last decade of his life were directed in particular toward understanding the central mysteries of life. Major focuses of his interest were the functioning of the heart, which he studied in a series of drawings undertaken around 1513 (see Windsor 19073–19074v, dated January 9, 1513), and the life of the fetus in the womb. This sheet (Windsor 19012r) is datable to circa 1512 on grounds of style and content. Further studies of the same fetus appear on Windsor 19101, though there Leonardo has reversed the crossing of the feet. He recorded that "the child was less than half a *braccio* long [about 25.5 cm, or 10 in], and nearly four months old" (Windsor 19101v), though the fetus actually appears to be somewhat more developed. The compellingly direct drawing of the infant in the breech position indicates that Leonardo had gained access to a human fetus of about twelve weeks, but the powerfully rendered womb, with its multiple or cotyledonous placenta, is based upon animal material, probably from a cow, which has been rearranged in what was then thought to be the spherical form of the human uterus.

The notes on the two sheets reveal Leonardo's typically wide range of concerns, including the role and proportional length of the umbilical cord, the interdigitations of the placenta and the uterine wall, the impossibility that the fetus should be able to breathe or speak in its watery envelope, the "great mystery" of the relationship between the souls of the mother and the fetus, the motion of an eccentrically weighted spherical object on a slope, and binocular vision in relation to artistic representation. Leonardo adopts the traditional idea that the experiences of the mother will be mirrored in the child: "The same soul governs these two bodies, and the desires and fears and sorrows are common to this creature as to all the other animal parts, and from this it arises that something desired by the mother is often found imprinted on the limbs of the infant." The integrated nature of the mother and the fetus before birth is emphasized in the drawing not only by the snug compactness of the fetus within its opened container but also by the intimate interweaving of the fingers of the placenta and the uterine wall. One of the most impressive features of this magnificent sheet of studies is the novel diagrammatic means Leonardo used to describe the relationships between inner, outer, and interpenetrating forms. It is not surprising that the companion page contains one of his insistent challenges to writers to match the painter's detailed and harmonious account of the visible world, though on this sheet he reminds us that a depiction cannot "demonstrate such relief as the relief seen with both eyes." Insofar as the limitation imposed by the representation of three-dimensional forms on a two-dimensional surface can be transcended, Leonardo has succeeded in doing so through a complex system of shading. No drawing from any area of his activity better shows the power of the type of curved hatching he adopted increasingly after 1500.

<div align="right">M.K.</div>

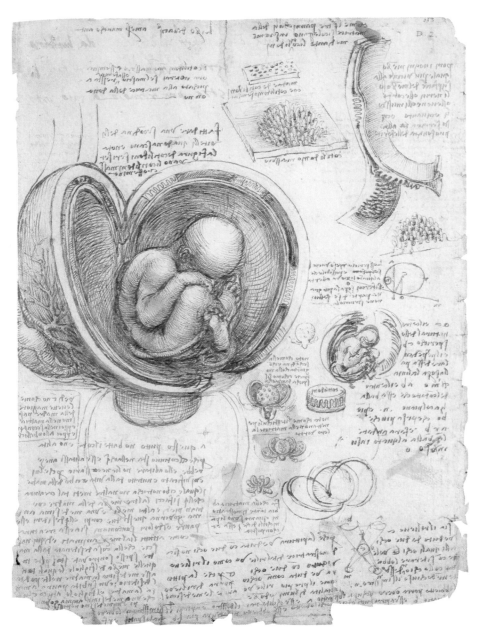

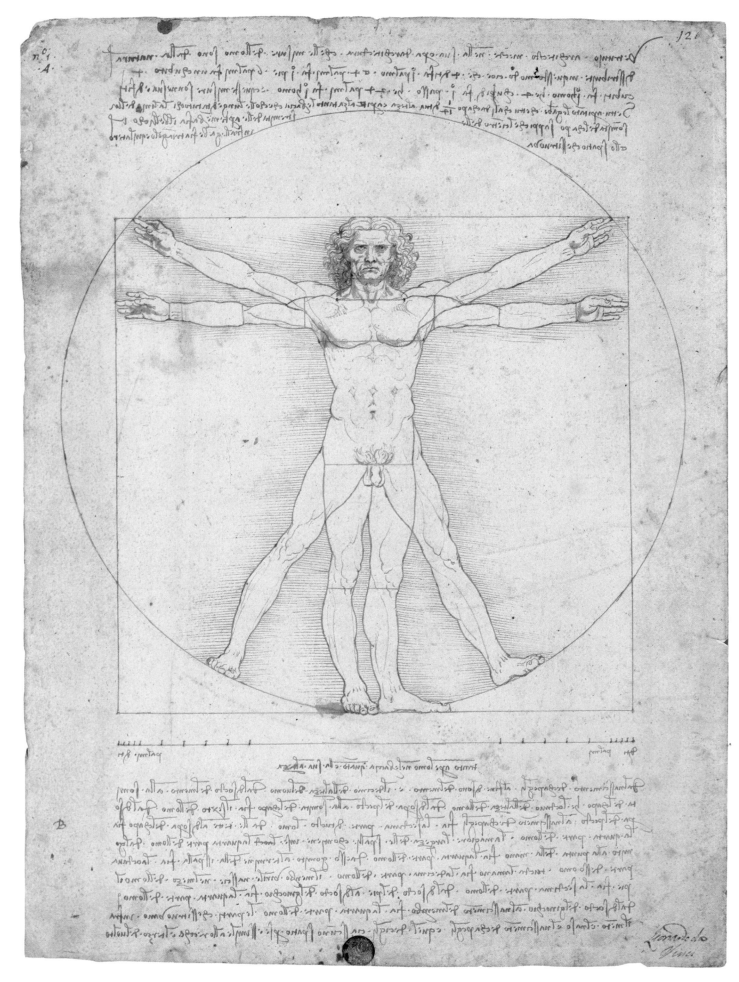

Leonardo da Vinci
Florentine, 1452–1519

STUDY OF HUMAN PROPORTION IN THE MANNER OF VITRUVIUS

c. 1490
pen, brown ink, wash, and red chalk on paper
34.3 x 24.5 (13½ x 9⅝)
inscribed with notes on proportions
references: Popham 1946, 215; Morgan 1960;
Cogliati Arano 1966/1980; Richter 1970/1977, 343;
Zöllner 1987; Kemp 1989, 309

Gallerie dell'Accademia, Venice

This large and spectacular sheet (Venice 228) was clearly drawn by Leonardo as a definitive demonstration of the overall proportional system in the human body. It belongs with the research he was conducting around 1490. The organizing principle of the drawing, the inscription of the figure within a circle and a square, is based upon the prescription of the ancient Roman architect, Vitruvius: "In the human body the central point is naturally the navel. For if a man be placed flat on his back with his hands and feet extended, and a pair of compasses centered on his navel, the fingers and toes of his two hands and feet will touch the circumference of a circle described therefrom. And just as the human body yields a circular outline, so too a square figure may be found from it. For if we measure the distance from the soles of the feet to the top of the head, and then apply that measure to the outstretched arms, the breadth will be found to be the same as the height, as in the case of plane surfaces which are perfectly square" (Morgan 1960, 73). Vitruvius then proceeds to discuss the proportions of the parts of the figure in terms of fractions of the whole. Leonardo acknowledges his Vitruvian source of inspiration but incorporates his own detailed observations and improves the formula by incorporating alternative positions for the arms and legs. "Vitruvius the architect has it in his work on architecture that the measurements of man are arranged by nature in the following manner: four fingers make one palm and four palms make one foot; six palms make a cubit; four cubits make a man, and four cubits make one pace; and twenty-four palms make a man; and these measures are those of his buildings. If you open your legs so that you lower your head by one fourteenth of your height, and open and raise your arms so that with your longest fingers you touch the level of the top of your head, you should know that the central point between the extremities of the outstretched limbs will be the navel, and the space that is described by the legs is an equilateral triangle." He adds, below the figure, "The span to which the man opens his arms is equivalent to his height. From the start of the hair to the margin of the bottom of the chin is a tenth of the height of the man; from the bottom of the chin to the top of the head is an eighth of the height of the man; from the top of the breast to the top of the head is a sixth of the man; from the top of the breast to the start of the hair is a seventh part of the whole man; from the nipples to the top of the head is a quarter part of the man; the widest distance across the shoulders contains in itself a quarter part of the man; from the elbow to the tip of the hand will be a fifth part of the man; from this elbow to the edge of the shoulder is an eighth part of this man; the whole hand is a tenth part of the man; the penis arises at the middle of the man; the foot is a seventh part of the man; from the sole of the foot to below the knee is a quarter part of the man; from below the knee to the start of the penis is a quarter part of the man; the portions that are to be found between the chin and the nose and between the start of the hair and to the eyebrows are both spaces similar in themselves to the ear and are a third of the face" (Richter 1970/1977, 343; Kemp 1989, 309).

In addition to the compass marks needed for drawing the circle and mapping out the main divisions of the figure, numerous other small indentations caused by the points of dividers pockmark the drawing. The vertical axis of the head exhibits particularly dense clusters of indentations. These marks appear to reflect detailed measurements that were taken *from* the drawing rather than used to lay out the forms. The results are recorded in Leonardo's notes below the drawing, quoted above. It appears that the drawing was the first element to be set out on the page, followed by the scale and caption below the illustration. The upper and lower notes were then written into the remaining spaces with a neatness unusual for Leonardo.

Subsequent illustrations of "Vitruvian men" by theorists and editors of Vitruvius in Italy and northern Europe suggest that Leonardo's particular interpretation of the Roman author's formula was widely influential (Zöllner 1987). Perhaps the most remarkable development of Leonardo's vision occurs in the Codex Huygens by Carlo Urbino da Crema (Pierpont Morgan Library, New York), in which Leonardo's alternative positions for the arms and legs are translated into a series of sequential or "cinematographic" poses, in keeping with Leonardo's own notions of movement across "continuous quantity" in space. M.K.

Leonardo da Vinci
Florentine, 1452–1519

NUDE MAN FROM THE REAR

c. 1503–1506
red chalk on paper
27 x 16 (10⅝ x 6¼)
inscribed: franc sinsstre sonat[ore] . . .
references: Popham 1946, 233; Clark and Pedretti
1968–1969, 12596; Keele and Pedretti 1979–1980,
84r; Kemp 1989, 302, 338; London 1989, 32

Her Majesty Queen Elizabeth II, Royal Library,
Windsor Castle

This magnificent study (Windsor 12596) of a thick-set, muscular man is related in general terms to Leonardo's work on the *Battle of Anghiari*, the huge mural he was planning in the period 1503–1506 for the Council Hall of the Florentine republic in competition with Michelangelo's *Battle of Cascina*. The two artists' rendering of heroic figures at this time set the norm for contemporary and subsequent generations of artists. The static and symmetrical pose of this figure, however, was not suitable for the *Battle* but corresponds to the formula Leonardo was adopting at this time for his demonstrations of human musculature (Windsor 12593–12594r, 12629r–12631r). The lightly drawn central vertical and the triangular disposition of the legs

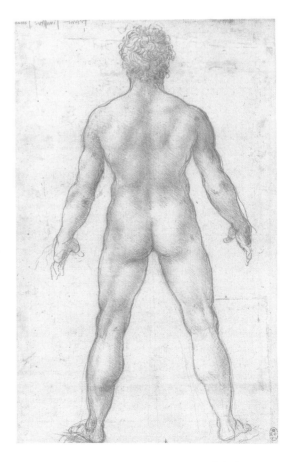

emphasize the structural solidity of the pose.

Leonardo's notes on the human figure, intended for his treatise on painting, emphasize that every part of a figure should be in keeping with every other part and with the total character of the person represented: "Thus if a man has a thick and short figure he will be the same in all his limbs, that is to say with short and thick arms, wide and thick hands, and short fingers with joints in the prescribed manner, and so on with all the rest of the parts. I intend to say the same about plants and animals universally, reducing or increasing them proportionately according to their diminution or increase in size" (Kemp 1989, 302). "Muscular men have thick bones and are short and thick and have a dearth of fat, because the muscles, through their growth, are compressed together, and the fat that would otherwise be interposed between them cannot find any room" (Kemp 1989, 338).

The note on this drawing, which has been translated as "Francesco sounds sinister (?)," may have no connection with the drawing. However, it might be interpreted as "Francesco sinistre musician" and refer to the model. M.K.

177 🐦

Leonardo da Vinci
Florentine, 1452–1519

STUDIES IN HUMAN PROPORTION

c. 1492
pen and brown ink on paper
15.9 x 21.6 (6¼ x 8½)
inscribed with notes on human proportion
references: Panofsky 1940; Popham 1946, 224; Panofsky 1957; Clark and Pedretti 1968–1969, 19132r; Richter 1970/1977, 332; Lomazzo 1974; Keele and Pedretti 1979–1980, 27r; Kemp 1989, 328; London 1989, 91

Her Majesty Queen Elizabeth II, Royal Library, Windsor Castle

Leonardo's most sustained attempts to work out a comprehensive system of proportions for large and small features of the human body appear to have been made around 1488–1494. The present drawing (Windsor 19132r) belongs to a series at Windsor, which includes nos. 12304r, 19129r, 19130r-v, 19131r-v, 19133r-v, 19134–19135r, 19136–19139r, and 19140r, of which at least four (this drawing and 12304, 19130, and 19131) originated from the same notebook. The series is closely related to studies in Manuscripts A (particularly 63r) and B (2v), which were compiled in and before 1492. The verso of 12304 contains related studies of the proportions of a horse, made during the early 1490s in connection with

Leonardo's project for an equestrian monument to Francesco Sforza. The drawings are generally characterized by thin, broken contours and proportional divisions that have been laid out freehand rather than with ruler or compasses. The three notes on the present drawing, like many others on the Windsor proportion studies, are marked with the marginal symbol of a slashed circle, which indicates that they have been transcribed elsewhere, probably by Leonardo's pupil, Francesco Melzi, although they do not appear in Melzi's surviving compilation, the Codex Urbinas (the *Trattato della pittura*). Nor is this drawing among those copied (either directly from the originals or from Melzi's transcriptions) by Carlo Urbino da Crema into the Codex Huygens (Panofsky 1940). It may have been Leonardo's original notebook or a transcribed version of it that was recorded in Lomazzo's *Idea del tempio della pittura* in 1590 (Lomazzo 1974).

The primary source for Leonardo's ideas was the section on human proportions in the treatise on architecture by the ancient Roman author, Vitruvius, whose image of a man inscribed within a square and a circle Leonardo adapted in the famous drawing in Venice (cat. 175). He may also have drawn inspiration from Alberti's treatises and the writings of Francesco di Giorgio, whom he met in 1490 if not earlier. The standing figure with arms outstretched in the present study is in the "Vitruvian" pose, which is also illustrated by Francesco di Giorgio, while one of Leonardo's basic modules, based on head height as one eighth of the body, corresponds to Alberti's recommendation in *De pictura* (para. 36).

Leonardo considerably extends Vitruvius' general prescriptions by taking detailed measurements of even such small features as the space between the bottom of the nose and the mouth, which he then relates to adjacent and remote parts of the body (Panofsky 1957). He also extends Vitruvius' program—perhaps following Alberti in *De statua*—beyond the straightforward measurement of the static body. He explores what happens to the proportions of the whole and of the parts when the body is in different positions, exhibiting his characteristic concern with the nature and consequences of motion. Accordingly he demonstrates that the extrusion of the elbow when the arm is bent occasions different proportional ratios than those related to the straight arm. In the present drawing Leonardo is concerned to define the changed proportional relationships when a man kneels or sits: "If a man kneels down he will lose a quarter of his height.

"When a man kneels down with his hands in front of his breasts, the navel will be at the midpoint of his height and likewise the points of his elbows.

"The midpoint of the seated man, that is to say from the seat to the top of the head, will be just below the breasts and below the shoulders. This seated part, that is to say, from the seat to above the head, will be more than half the height of the man by the amount of the length and breadth of the testicles" (Kemp 1989, 328). M.K.

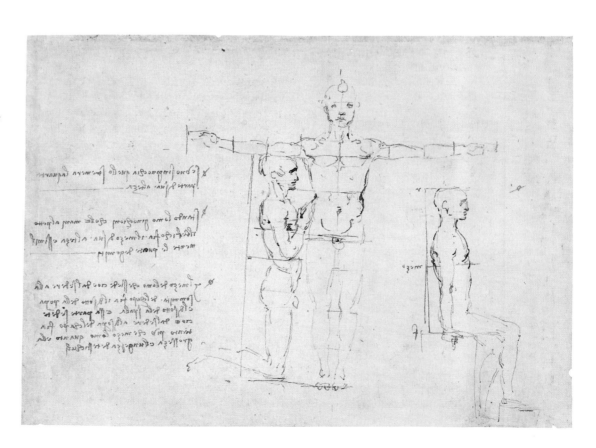

Leonardo da Vinci
Florentine, 1452–1519

STUDIES OF THE PROPORTIONS OF THE HUMAN HEAD AND EYE

c. 1490
pen and brown ink on paper
19.7 x 16 and 14 x 11 (7¾ x 6¼ and 5½ x 4⅜)
inscribed with notes on proportions
references: Richter 1970/1977, 319–320;
Pedretti 1975, 4–5

Biblioteca Reale, Turin

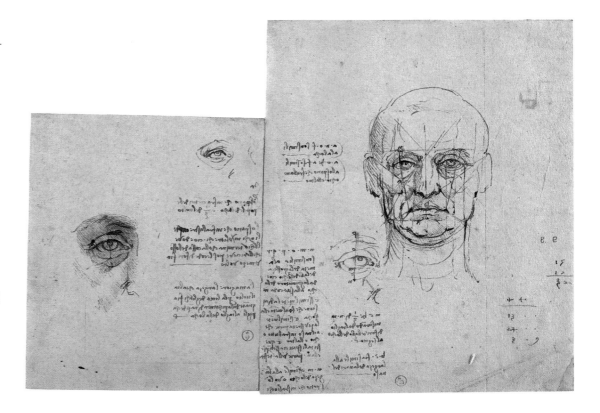

Following Carlo Pedretti's (1975) recognition that these two sheets (Turin 15574, 15576) were once part of a single page, they have been reconstituted in their original relationship. These studies of human proportion belong to a series of researches exclusively concerned with male figures, conducted around 1490. This particular facial type—that of a mature or even elderly "warrior"—is shared by Leonardo's famous "Vitruvian Man" (cat. 175) and became his standard physiognomy for a virile male. The study of the eye on the left portion of the page is shaded with a degree of care that is unusual in his studies of proportion and may indicate that it was drawn from life, to confirm the measurements.

Leonardo extended the traditional system of proportions, derived from the writings of Vitruvius, by undertaking a minutely detailed analysis of the relationships between all the components of the body, however small and however distant from one another. On this page he is chiefly concerned with understanding how the small intervals between the parts of the eye, eyelid, and eyebrow can be related to other intervals in the head, particularly the dimensions of the mouth and nose. The notes in the lower left quarter of the right portion exemplify his approach, stating that "n, m, o, p, q are equivalent to half the width of the lids of the eyes, that is to say from the lacrimator [inner corner] of the eye to its outer edge. And similarly the division that there is between the chin and the mouth, and similarly the narrowest part of the nose between one and the other eye. And each of these distances in itself is a 9th part of the head. nm is equivalent to the length of the eye or the distance between the eyes. mc is one third of nm, measuring from the outer margin of the eyelids to the letter c. bs will be equivalent to the width of the nostrils of the nose."

The verso of the reconstituted page contains some relatively slight mechanical drawings, probably representing devices for the making of screw threads. M.K.

Leonardo da Vinci
Florentine, 1452–1519

VERTICAL AND HORIZONTAL SECTIONS OF THE HUMAN HEAD, WITH THE COVERING LAYERS COMPARED TO AN ONION

c. 1489
pen, brown ink, and red chalk on paper
20.6 x 14.8 (8⅛ x 5⅞)
inscribed with notes on the layers of the scalp, skull, and brain
references: Popham 1946, 227; Clark and Pedretti 1968–1969, 12603; Keele and Pedretti 1979–1980, 32r; London 1989, 94

Her Majesty Queen Elizabeth II, Royal Library, Windsor Castle

Leonardo's earliest surviving studies of internal anatomy are the series of skull drawings, one of which (Windsor 19059) is dated 1489. Although the present sheet (Windsor 12603), which illustrates traditional concepts of the brain and the senses, seems to differ sharply in approach from the very direct observation of firsthand material in the skull drawings, it belongs to the same campaign of investigating the design and function of the human head. It shares with the demonstrations of the skull the innovative use of sections, although the combination of a vertical section with externally viewed nose, mouth, and chin in the main drawing appears rather uncomfortable.

Not the least of Leonardo's concerns in the 1489 investigations was to demonstrate the superiority of sight over the other senses, and his depiction of the eye as an extrusion of the coverings of the brain illustrates his concept of the eye as "the window of the soul." The eye itself is depicted as a geometrically designed organ with a spherical lens, as was traditional. Within the brain is a set of three linked flasks or "ventricles," within which the various mental faculties, or "inner senses," were thought to be located. Leonardo works his own variation on this conventional concept. He

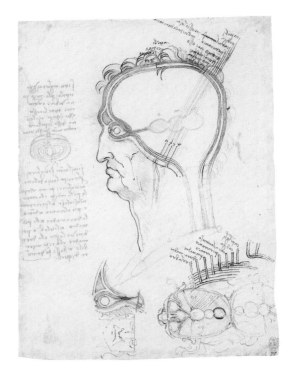

assigns the *imprensiva* (receptor of impressions) to the first ventricle and identifies the second as the *senso comune* (common sense), in which the sensory impressions are compared and the faculties of intellect, voluntary action, and imagination are exercised. The final ventricle is deemed to be the house of memory. It is through this system of outer and inner senses that the soul, which resides in the central ventricle, gains access to the knowledge of the world and can find true satisfaction, so that its "bodily prison" becomes bearable.

The analysis of the coats of the brain by analogy to the skins of an onion is typical of Leonardo's sense of the analogous natures of all the products of creation. The layers are recorded correctly in the upper diagram as "hair, scalp, lacterous flesh, pericranium, dura mater, pia mater, brain" — although in the lower diagram he inadvertently reverses the pia and dura maters. M.K.

180 🐌

Leonardo da Vinci
Florentine, 1452–1519

STUDIES OF THE GRADATIONS OF LIGHT
AND SHADOW ON AND BEHIND SPHERES

c. 1492
pen and brown ink and wash, with traces of stylus, on paper
each folio 24 x 38 (9½ x 15)
inscribed with notes on light and shade
references: Richter 1970/1977, 148–149, 275; Kemp 1989, 296–297; London 1989, 91

Bibliothèque de l'Institut de France, Paris

This manuscript originally comprised folios 81–114 of MS A in the Institut de France, but was illegally removed and sold by Count Guglielmo Libri in the 1830s and later returned. MS A can be dated with reasonable certainty to circa 1492, and the reproduced folios are of this date. The diagrams and notes were transcribed in folios 213 and 214 of the Codex Urbinas (the so-called 'Treatise on Painting'), which was compiled after Leonardo's death by his pupil, Francesco Melzi. The circles visible in the margins are marks made by the transcriber.

The meticulous study of the geometrical rules governing the gradations of light and shade on surfaces and of cast shadows and reflections occupied a good deal of Leonardo's time in the early 1490s. Comparable sets of analyses occur in MS C (Institut de France), two folios of which are dated 1490 and 1493. Leonardo designed such studies to give the painter access to precise rules for the depiction of light and shade (not unlike the

techniques of ray-tracing in modern computer graphics) and also regarded them as revealing integral parts of the mathematical laws of nature as whole. The laws decree that all effects decrease in a precisely proportional (that is, pyramidal) manner. The notes on the left-hand folio (13v) explain that:

> Every shadow made by an opaque body smaller than the source of light casts derivative shadows tinged by the color of the original shadows. The origin of the shadow *ef* is *n*, and it will be tinged with its color. The origin of *he* is *o*, and it will be similarly tinged with its color... *Fg* is the first degree of light, because there it is illuminated by all the window *ad*, and thus the opaque body at *m* is of similar brightness. *Zky* is a triangle which contains in itself the first degree of shadow, because the light *ad* does not arrive within this triangle. *Xh* is the second degree of shadow, because it is illuminated by only a third of the window, that is to say *cd*....

On the right hand folio (14r), Leonardo informs us that:

> Every light which falls on opaque bodies between equal angles produces the first degree of brightness and that will be darker which receives it by less equal angles, and the light and shade both function by pyramids. The angle *c* produces the first degree of brightness because it is exposed to the window *ab* and to

all the diameter of the sky at *mx*. The angle *d* makes little difference compared to *c*, because the angles they subtend are not of such distorted proportions as the others that are lower down, and *d* is deprived only of that part of the diameter that is between *x* and *y*. Although it acquires as much from the opposite side, nevertheless its line is of little strength because its angle is smaller than the corresponding one. The angles *e* and *i* will be of diminished light, because they are not fully exposed, lacking the light *ms* and the light *vx*, and their angles will be somewhat distorted.... *Og* will be the minimum degree of light because it is not exposed to any part of the diameter of the light, and these are the lines that on the other side reconstitute a pyramid comparable to the pyramid *c*.... The apexes of these pyramids are aligned and oriented toward each other along a straight line, which passes through the center of the opaque body....

The way that light strikes a surface, making the surface appear lightest where it strikes perpendicularly and least light where it strikes a glancing blow, obeys the laws of 'percussion' in the same way as a bouncing ball or current of water hitting a river bank. Leonardo did not intend these analyses to suggest that geometrical bands of light and shade can actually be discerned, since the gradations on a curved body are infinitely smooth, but rather to illustrate the fundamental laws at work. M.K.

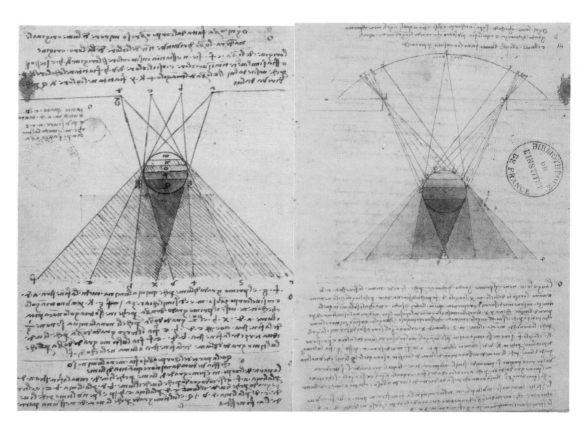

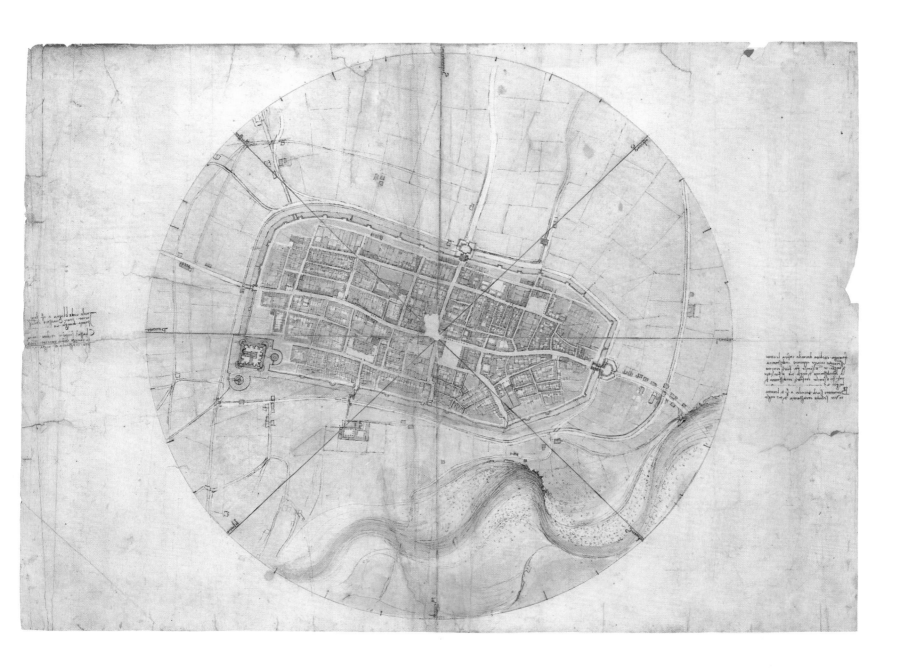

181 &

Leonardo da Vinci

Florentine, 1452–1519

MAP OF IMOLA

c. 1502–1503
pen and ink with watercolor on paper
44 x 60.2 (17³⁄₈ x 23³⁄₄)
inscribed with notes on distances and the names
of the winds
references: Popham 1946, 263; Clark and Pedretti
1968–1969, 12284; Mancini 1979; London 1989, 98

Her Majesty Queen Elizabeth II, Royal Library,
Windsor Castle

This map (Windsor 12284), one of the most mag-
nificent surviving creations of the cartographic
revolution of the fifteenth and sixteenth cen-
turies, probably dates from around 1502–1503,
when Leonardo was in the employ of Cesare
Borgia as architect and engineer with a special
dispensation to visit all the fortifications in
central Italy that Borgia, the son of Pope Alexan-
der VI, was holding as part of his effort to secure
and extend the Papal States. The technique is
closely related to that employed earlier by Leon
Battista Alberti in his map of Rome (now lost), as
recounted in his *Descriptio urbis Romae*, and later
used by Raphael in his map of Rome (also lost). It
results from the coordination of two sets of mea-
sures: one recording the length of features on the
ground, obtained either by pacing out distances or
by using a wheeled measuring device (see Codex
Atlanticus, 1r); and the other consisting of a
series of records of the angular positions of fea-
tures within a "wind rose" centered on a fixed
point, made by using a horizontally mounted sur-
veying device, such as an astrolabe or circum-
ferentor. Some of the linear measurements along
roads are recorded on sketch-maps on another
drawing at Windsor (12686). The circle within
which the map of Imola is inscribed is divided into
sixty-four parts, and the eight more heavily drawn
lines are conventionally labeled with the names of
the winds: *septantrione* (north), *grecho* (north-
east), *levante* (east), *sirocho* (southeast), *mezzodi*
(south), *libecco* (southwest), *ponente* (west), and
maesto (northwest). The notes, which record
the distances of other strategic towns at various
bearings, are written in Leonardo's characteristic
"mirror" script (written from right to left with
reversed letters), but they are unusually neat and
legible, which suggests that they were intended
to be legible to others.

It has been argued (Mancini 1979) that the domestic buildings the map records in the town do not include most of those erected during the preceding quarter-century and that the map was actually made in 1472 by the Milanese architect and military engineer, Domenico Maineri, with, at most, retouchings by Leonardo. The existence of preparatory studies by Leonardo and the entirely characteristic handling of the graphic media throughout the sheet — in particular the "living" quality with which the flat features are imbued — indicate almost beyond doubt that Leonardo was the sole author of the map of Imola. The main function of his representation was most likely to record the present disposition of the defensive structures for his warlike patron, and it may be that he took advantage of a previous record of the domestic buildings to simplify his task in delineating the less important structures.

M.K.

182 ✢

Leonardo da Vinci
Florentine, 1452–1519

STUDIES OF WATER PASSING OBSTACLES AND FALLING INTO A POOL

c. 1508
pen and brown ink over traces of black chalk on paper
29.8 x 20.7 (11¾ x 8⅛)
inscribed with notes on hydrodynamics
references: Popham 1946, 281; Clark and Pedretti 1968–1969, 12660v; Pedretti 1982, 42r; London 1989, 61

Her Majesty Queen Elizabeth II, Royal Library, Windsor Castle

This most elaborate of Leonardo's water studies (Windsor 12660v) is part of a set of investigations undertaken in MS F (Institut de France, dated 1508) and other sheets at Windsor (for example, 12659 and 12661–12663). The main drawing is synthesized from separate studies of the vortices of water and the behavior of air bubbles. The note acknowledges the composite nature of this demonstration: "The motions of water that has fallen into a pool are of three kinds, and to these a fourth is added, which is that of the air in becoming submerged in the water, and this is the first in action and it will be the first to be defined. The second is that of the air after it has been submerged, and the third is that of the reflected water as it returns the compressed air to the other air. Such water then emerges in the shape of large bubbles, acquiring weight in the air and on this account falls back through the surface of the water, penetrating as far as the bottom, and it percusses and consumes the bottom. The fourth is the eddying motion made on the surface of the pool of water, which returns directly to the location of its fall, as the lowest place interposed between the reflected water and the incident air. A fifth motion will be added, called the swelling motion, which is the motion made by the reflected water when it brings the air that is submerged within it to the surface of the water." The drawing represents a complex synthesis of three main factors: Leonardo's intense scrutiny of water in action during patient hours of observation; his knowledge of dynamic theory in the Aristotelian tradition of the late Middle Ages; and his own rational classification of the variables. The result should in no sense be taken as a direct study of a

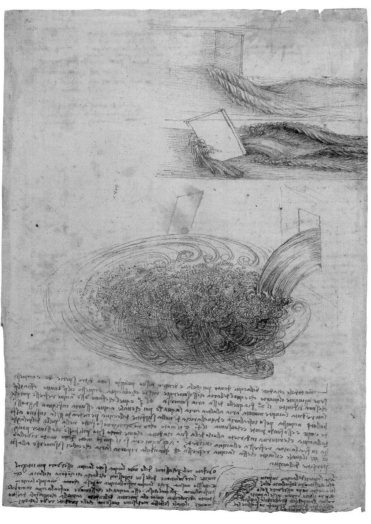

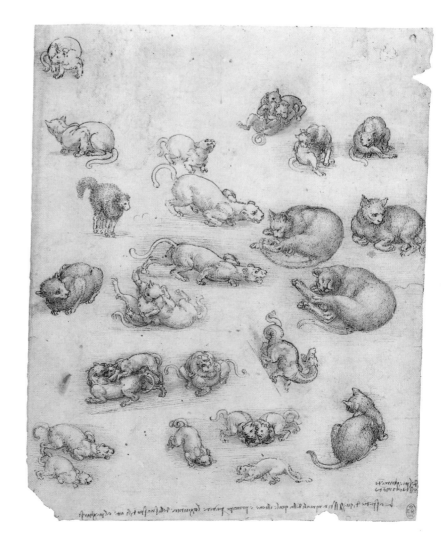

single observation, although with a receptacle of the right shape it is possible to contrive a pattern of vortices similar to that depicted in the main study. The note at the lower left records a related observation he made from a boat. In the light of recent chaos theory, it is not surprising that Leonardo experienced trouble in defining the number and result of the variables in turbulent flow.

The turbulence produced by the boards that interrupt the flow of the streams in the upper diagrams assumes the kind of hairlike configurations that led Leonardo to draw parallels between the motion of water and the curling of hair (cat. 172), and the motions of wind and other phenomena of curvilinear motion and growth in the natural world. M. K.

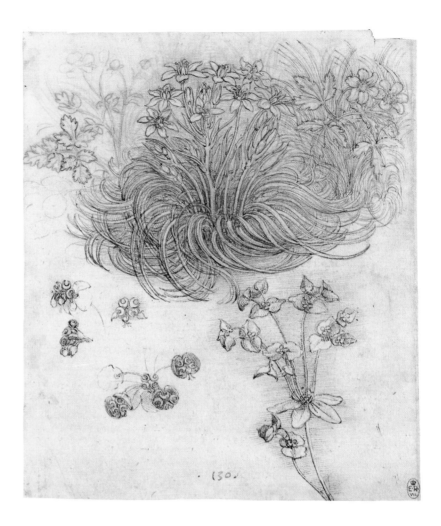

183 🐦

Leonardo da Vinci
Florentine, 1452–1519

CATS AND A DRAGON

c. 1513–1515
pen and brown ink and wash over black chalk with
red chalk offset on paper
27.1 x 20.4 (10⅝ x 8) (irregular)
inscribed with notes on the motions of animals
and human beings
references: Popham 1946, 87; Clark and
Pedretti 1968–1969, 12363; Pedretti 1987, 157;
London 1989, 38

Her Majesty Queen Elizabeth II, Royal Library,
Windsor Castle

Leonardo indicated that he intended to "write a separate treatise describing the movement of animals with four feet, among which is man, who crawls similarly in his infancy on all fours." The note at the bottom of this sheet — "on bending and extension; this animal species, of which the lion is prince, because the joints of its spinal cord are bendable" — suggests that these vivacious studies were part of a campaign he seems to have undertaken around 1513–1515 to compare human and animal motion. The sheet of studies of horses at Windsor (12331, also containing a cat and studies of Saint George and the dragon) appears to belong to the same campaign. The aim was to show how the compound jointing of animal and human bodies enables them to perform an almost infinite variety of movements in space — across what Leonardo calls a "continuous quantity."

There can be little doubt that some of the poses are based directly upon life studies, particularly the sleeping cats at the center right, which are beautifully observed. Others, most notably the "wrestlers," seem to be Leonardo's own free extrapolations, based on his understanding of

the qualities of feline motion. It is typical of the fertility of his imagination that the cats appear to have been metamorphosed into a curvaceous dragon. Such creativity characteristically leads Leonardo away from his immediate purpose and ultimately interferes with his ability to complete the circumscribed task in hand. M. K.

184 🐦

Leonardo da Vinci
Florentine, 1452–1519

STAR-OF-BETHLEHEM

(Ornithogalum umbellatum), *Crowsfoot*
(Anemone bulbosa L.), *Wood Anemone*
(Anemone ranunculoides), *and Grasses*

c. 1506–1508
pen and brown ink and red chalk on paper
19.8 x 16 (7¾ x 6¼)
references: Popham 1946, 273; Clark and
Pedretti 1968–1969, 12424; Pedretti 1982, 16r;
London 1989, 57

Her Majesty Queen Elizabeth II, Royal Library,
Windsor Castle

There can be little doubt that this drawing (Windsor 12424), like other of Leonardo's botanical studies from the period 1506–1508 (such as Windsor 12421), was occasioned by his work on the painting *Leda and the Swan* (now lost) and that the sense of flowering and fructifying vitality in the growth of the plants is designed to underscore the painting's theme of the generative powers of nature. However, as is so often the case with his apparently functional studies of components for pictures, the subsidiary items come to assume a primary interest in their own right. Leonardo subsequently appears to have considered writing a treatise on plants.

Although the present study breathes an undeniable air of having been made "from life," Leonardo's processes of observation and representation are always infused with analysis, as he searches for the principles of growth and for the structural rationale behind the configurations of natural forms. The emphatic "vortex" arrangement of the leaves of the main plant makes deliberate allusion to forms of growth and motion in other natural phenomena, such as the turbulence of water and the curling of hair. M. K.

Leonardo da Vinci
Florentine, 1452–1519

An Artillery Yard with Men Struggling to Lift the Barrel of a Huge Gun or Mortar

c. 1488
pen and brown ink on paper
25 x 18.3 (9⅞ x 7⅛)
references: Clark and Pedretti 1968–1969, 12647; Richter 1970/1977, 1309; London 1989, 113

Her Majesty Queen Elizabeth II, Royal Library, Windsor Castle

There is nothing quite comparable in Leonardo's other work to this scene of frenetic activity in a defined military setting (Windsor 12647), but the representation of the weapons recalls those in MS B (Institut de France) and suggests a date of about 1488, when he was in Milan in the employ of Duke Ludovico Sforza, whom he was trying to impress with his military inventions. It is difficult to suggest a function for the drawing. It could hardly have been designed to demonstrate his inventions to his patron, and instead exudes an almost satirical air, as the desperate gangs of naked men struggle with the monster to which they have given birth. The scene can best be related to the visions of the malignity of men's creations in Leonardo's mock-serious "prophecies": "(Of great guns that emerge from the pit and the mould) It will emerge from under the ground, and with terrific noise will stun those in the surroundings nearby, and with its breath it will kill men and destroy the city and the castle" (Richter 1970/1977, 1309). As in the later *Deluge* drawings (cat. 188), there is a tense and ironic blending of analytical observation—in the systems of windlasses, pulley, stays, and rollers—with an expressive feeling for the human condition in the face of immense power. The uneasy combination in Leonardo's mind of fascination with the technology of war and revulsion in the face of its inhuman destructiveness is one of the earliest expressions of what has become a central dilemma for scientists involved in the design of weaponry. The technology of casting involved in the making of cannons and mortars was to be adapted for his scheme to cast the huge equestrian monument to Francesco Sforza. M.K.

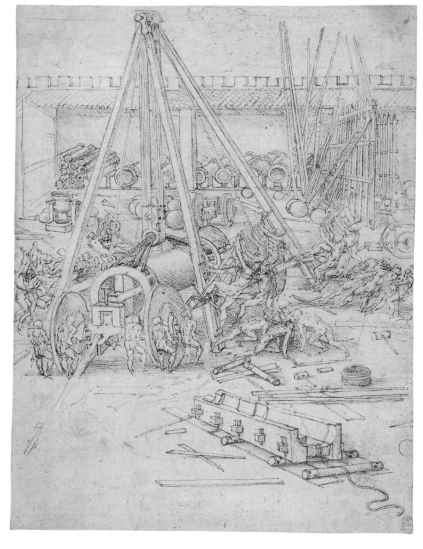

Leonardo da Vinci
Florentine, 1452–1519

Scythed Chariots

c. 1487–1488
pen, brown ink, and wash on paper
20 x 28 (7⅞ x 11)
inscribed with notes on military engineering
references: Popham 1946, 310; Pedretti 1975, 14; Kemp 1989, 612; London 1989, 68

Biblioteca Reale, Turin

This study (Turin 15583) belongs to a series that includes Windsor 12653; British Museum 1860-6-16-99 (London 1989, 68); Codex Atlanticus 113v; Ecole des Beaux Arts, Paris; and MS B 10r (Institut de France). By reference to MS B, they may be dated to around 1487–1488, although in terms of content they might almost be illustrations to the well-known letter about his military inventions that Leonardo wrote to Ludovico Sforza in or shortly after 1482 (Kemp 1989, 612).

The chariots are characteristic of a certain type of design popular among the military *virtuosi* of the Renaissance, in which they demonstrated their inventiveness and their knowledge of the principles of ancient weaponry. The scythed chariots draw their main inspiration from written accounts of systems used in classical antiquity, particularly as transmitted in the compendium *De l'arte militare* published by Roberto Valturio in 1483. In MS B Leonardo notes that "these scythed chariots were of various kinds, and often did no less injury to friends than they did to the enemies, and the captains of the armies, thinking by use of these to throw confusion into the ranks of the enemy, created fear and destruction among their own men." On the British Museum drawing he accordingly cautions that "when this travels through your men, you will wish to raise the shafts of the scythes, so that you will not injure anyone on your side." The Turin drawing contains the most vivid if improbable illustrations of the efficacy of the whirling scythes, and we may presume that the chopped-up limbs are intended to belong to "the enemy" rather than to "friends." On this sheet Leonardo notes that "this chariot will be drawn by six chargers with three horsemen. And one of the two wheels of the chariot is to turn the gear, which possesses 25 spindles, and the said wheel will have 100 teeth, and each point at the tip the scythes will extend by 12 *braccia*." Below, he notes, "This chariot will be drawn by 4 chargers, and the distance that each point extends at the tips of the scythes will be 8 *braccia*, and 2 horsemen who are placed in the middle do not have personal weapons of assault so that they are better able to support the scythes between them."

It is likely that such images were conceived more to convince patrons of the engineer's stylish

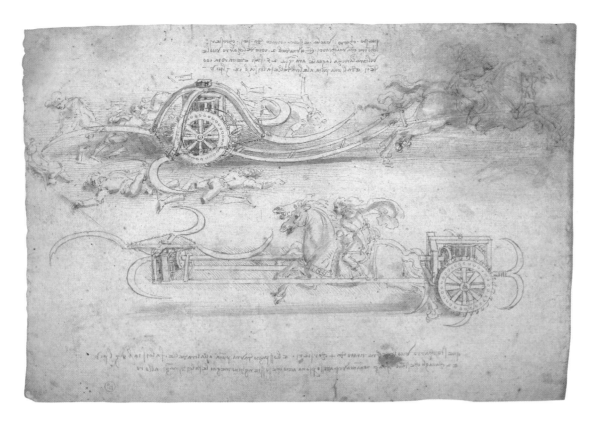

The almost ornamental grace of the arcs described by the missiles reflects Leonardo's studies of ballistics during the late 1490s and, in more general terms, his belief that every activity could be reduced to the rule of mathematical law—even the chaos of war. M.K.

188 🐚

Leonardo da Vinci
Florentine, 1452–1519

TOWN AT THE CENTER OF A DELUGE

c. 1515
pen and brown ink and wash over black chalk
on paper
16.2 x 20.3 (6⅜ x 8)
inscribed with instructions on the depiction of rain
references: Clark and Pedretti 1968–1969, 12380;
Pedretti 1982, 59r; Kemp 1989, 583, 585; London
1989, 63

Her Majesty Queen Elizabeth II, Royal Library,
Windsor Castle

This drawing (Windsor 12380) is one of ten studies of a "deluge" or "tempest" (Windsor 12377–12386) that are so close in style and size as to indicate that they were conceived as a set. The drawings are normally placed late in Leonardo's career (c. 1515), and the atmospheric use of black chalk in most of them supports such a dating. This particular image is exceptional in that the black chalk provides no more than an underdrawing for the elaborate pen lines and shading in wash. The pen work gives a more formalized definition to the

brilliance than to serve as designs for constructing actual machines. They would also have made suitable illustrations for a lively treatise. There is no indication that such "patent" devices had any significant effect upon warfare at this time. M.K.

187 🐚

Leonardo da Vinci
Florentine, 1452–1519

FOUR MORTARS FIRING STONES INTO THE COURTYARD OF A FORT

c. 1504
pen and brown ink and wash on paper
32.9 x 48 (13 x 18⅞)
inscribed: 157
references: Clark and Pedretti 1968–1969, 12275;
Marani 1984, 126; London 1989, 70

Her Majesty Queen Elizabeth II, Royal Library,
Windsor Castle

Leonardo worked on military architecture and weapons for several of his patrons during the course of his career, and his finished, formal studies are difficult to date on stylistic grounds alone. There are, however, related studies on a series of sheets that can be associated with his mural, the *Battle of Anghiari* (Windsor 12337v and Codex Atlanticus 72r, 1002v), and can therefore be dated to 1503–1505. In autumn 1504, during his work on the mural, Leonardo was sent by the Florentine authorities to provide advice on fortifications to the lord of Piombino, Jacopo IV Appiani. The

present drawing (Windsor 12275) is distinguished by a neatness and resolution that might have been intended to impress such a patron, though the applicability of the representation to actual warfare may be doubted. Like other military theorists of the Renaissance, Leonardo responded to the advent of guns by designing compound weapons that were intended to provide decisive results, although they would have required a level of technological efficiency beyond what was then available.

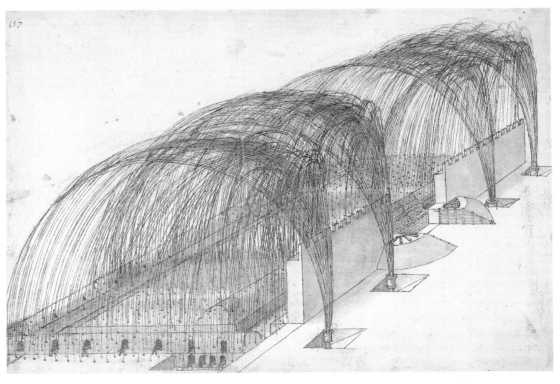

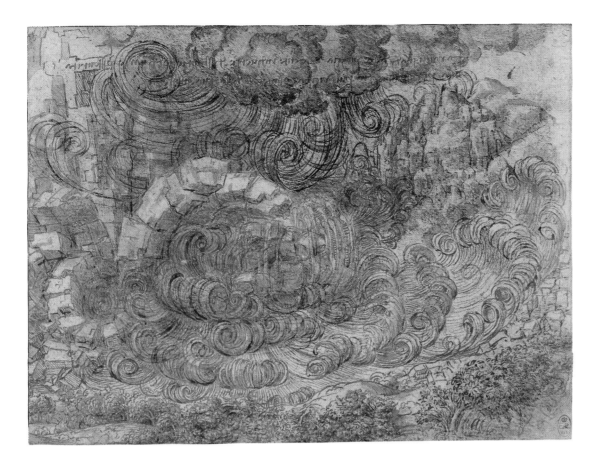

regardless of the number of percussions to which it is subject. In the motions of water and air, this inevitability is manifested in the violent configuration of vortices. Although the means are analytical, we sense that the end is expressive, and, indeed, other of Leonardo's notes make it clear that this expressive power was a conscious part of his intention: "Oh what fearful noises were heard throughout the air as it was pounded by the fury of the discharged bolts of thunder and lightning that violently shot through it to strike whatever opposed their course. Oh, how many might you have seen covering their ears with their hands in abhorrence of the uproar caused by the raging, rain-soaked winds, the thunder of the heavens and the fury of the fiery bolts" (Kemp 1989, 585). This union of a deep, analytical understanding of natural phenomena and the artist's ability to depict significant events with full communicative potency provided the foundation for Leonardo's theory of art. M.K.

vortex motion here than in the other drawings from the series.

It is tempting to read these drawings romantically as the private expression of an old man's deep pessimism, but they may more properly be regarded as powerful illustrations for the sections in Leonardo's projected treatise on painting. The note at the top of the sheet confirms its "instructional" character: "On rain. Show the degrees of rain falling at various distances and of varied darkness; and the darker part will be closer to the middle of its thickness."

Leonardo's written descriptions of "the deluge and its display in painting" contain passages that are very close to the phenomena depicted in this drawing: "Let some mountains collapse headlong into the depth of a valley.... The river bursts the dam and rushes out in high waves. Let the biggest of these strike and demolish the cities and country residences of that valley. And let the disintegration of the high buildings of the said cities raise much dust which will rise up like smoke or wreathed clouds through the descending rain.... The waves that in concentric circles flee the point of impact are carried by their impetus across the path of other circular waves moving out of step with them, and after the moment of percussion leap up into the air without breaking formation.... But if the waves strike against any object, then they rebound on top of the advent of the other waves, following the same increase in curvature they would have possessed in their former primary motion" (Kemp 1989, 583).

In this passage, Leonardo describes the furious destructive power of the deluge in the objective terms of his dynamic theory—impact, percussion, rebound, curvature, and primary motion. In the same way, the representation of the vortices in the drawings is founded upon his vivid depiction of the motions of turbulent water in his hydrodynamic research. At the heart of his theory was the concept of impetus, which decreed that any moving object must complete its assigned motion

189 &

Leonardo da Vinci
Florentine, 1452–1519

ALLEGORY WITH A WOLF AND EAGLE

c. 1515–1516
red chalk on gray-brown paper
17 x 28 (6⅝ x 11)
references: Popham 1946, 125; Clark and Pedretti 1968–1969, 12496; Pedretti 1982, 54r; London 1989, 82

Her Majesty Queen Elizabeth II, Royal Library, Windsor Castle

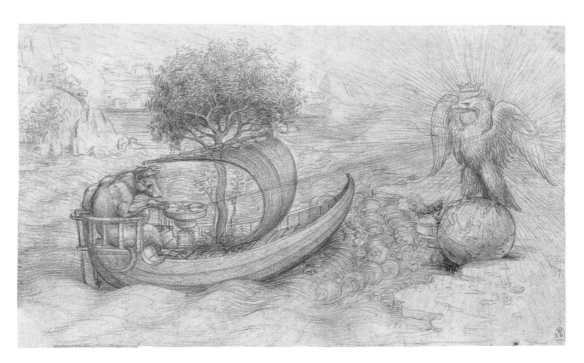

We know that Leonardo executed a "presentation" drawing (now lost) of Neptune for the Florentine Antonio Segni, a patron of Botticelli. The purpose of the present image (Windsor 12496) is not documented, but its high degree of resolution and the virtuoso handling of the red chalk suggest that it was also intended to be "presented" to a patron. As a unique survival of such a sheet in Leonardo's oeuvre, it is not easy to place in the chronology of his drawings, but the characterization of the turbulent water suggests a late date, perhaps about 1515–1516. A similar compass had earlier been illustrated by Leonardo on a sheet of emblems (Windsor 12701, c. 1508), where it signifies unswerving purpose: "He does not deviate who is attached to such a star." The star in the earlier emblem contains the fleur-de-lys of the French monarchs. It is not difficult to recognize the kind of meaning the strange narrative of the wolf and eagle was intended to convey. It can be related to printed and literary images in which animals and objects are used as symbols of prominent persons or entities, set within allegorical compositions that convey political messages. However, the specific allusions in this drawing remain elusive, and numerous interpretations have been suggested. The most straightforward reading is to identify the wolf with the pope (Leo x), the eagle with the French king (Francis I), the boat with the *navis ecclesiae* (ship of the church), and the tree-mast (*albero* means both 'tree' and 'mast' in Italian) with the olive of peace. The narrative would then allude to Francis' ambitions to become Holy Roman Emperor and to Leo's policy of steering the "ship of the church" by the light of the king. Their shared aspirations were expressed in their famous concordat of 1515, and were represented in the visual arts in Raphael's *Coronation of Charlemagne* in the Vatican, in which the key roles of emperor and pope are played by Francis and Leo respectively. In 1515 Leonardo was resident in the Vatican, and he was shortly to enter the service of Francis.

Even in a composition that depends so much upon the artist's *fantasia*, the characterization of the components is full of his searching observations of natural forms and phenomena. Not the least remarkable of these is the impressionistic rendering of the tree leaves, which is related to some of Leonardo's later notes intended for his treatise on painting in which he discusses the appearance of trees at various distances and under various lighting conditions. The marine compass in this and the related drawing (Windsor 12701) appear to be the earliest representations of this navigational instrument (Francis Maddison, personal communication, December 20, 1990).

M.K.

Albrecht Dürer
Nuremberg, 1471–1528

PORTRAIT OF A YOUNG VENETIAN LADY

1505
oil on panel
32.5 x 24.5 (12¾ x 9⅝)
references: Panofsky 1943, 116, fig. 159; Levey 1961, 512, fig. 29 (also 27–28); Anzelewsky 1971, 187, no. 92, pl. 94; Nuremberg 1971, 286, no. 531, color pl.; Strieder 1982, 116, fig. 131

Kunsthistoriches Museum, Vienna, Gemäldegalerie

Dürer first travelled to Venice in 1494–1495 to familiarize himself with the achievements of the Italian Renaissance. There he became interested in the works of Andrea Mantegna and Antonio Pollaiuolo, and especially in their reintegration of classical forms and classical subject matter. On this trip Dürer also sketched Alpine valleys and North Italian towns, Venetian ladies and orientals, exotic animals, and details from Italian paintings. He was particularly interested, it seems, in the costumes of the people he encountered, such as those of a Circassian slave girl or a Venetian courtesan.

The *Portrait of a Young Venetian Lady* in Vienna was painted during Dürer's second Italian trip, which he started in the summer of 1505, returning to Nuremberg in January 1507. The young woman is portrayed against a black background, her golden hair bound with a fillet made of fine metal thread. Her necklace is of white pearls and biconal metal beads. She is dressed in a low-necked gown of velvet or silk embellished with gold braid in a lattice pattern. Two bows tie the sleeve to the bodice. One of them appears to be of black silk; the other was not finished by the artist. The compositional formula that Dürer used here has many affinities with that of two Venetian portraits, now lost, which were attributed to Giovanni Bellini in 1627 when they were in the Vendramin Collection in Venice. The similarity of the costumes in these pictures to that worn by Dürer's sitter negates the old but still prevalent hypothesis that the lady in Dürer's portrait is dressed in the Milanese fashion. It is hardly surprising that Dürer was influenced by Bellini, as he always planned his travels with the aim of making contact with the most stimulating personalities

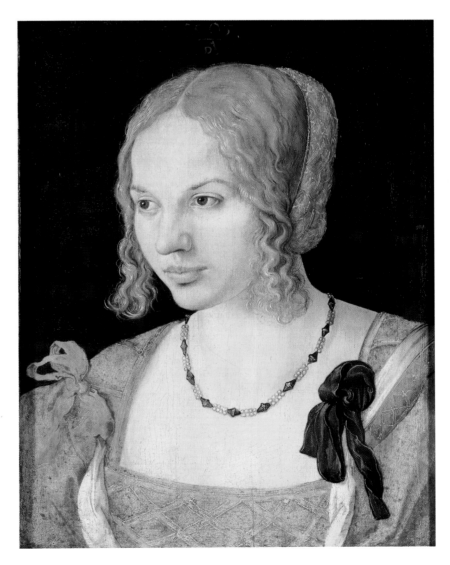

and experiences. This explains the adjustments he made to Venetian art during his Italian travels and to artistic developments in the Netherlands when he stayed in Antwerp in 1520–1521. For example, the musical angel at the feet of the Virgin in the *Brotherhood of the Rose Garland* of 1506 (Národní Galerie, Prague), is essentially Venetian in style. As the most important painting he produced during the second Italian journey, this altarpiece combines the German formula of the *Rosenkranzbilder* with the traditional characteristics of Venetian paintings such as, for example, Giovanni Bellini's *Doge Agostino Barbarigo Presented to the Virgin* of 1488 (San Pietro Martire, Murano). Dürer's friendship with Bellini, in fact, is attested to by a passage of a letter he sent to Willibald Pirckheimer from Venice on 7 February 1506: "...Giovanni Bellini, has highly praised me before many nobles. He wanted to have something of mine, and himself came to me and asked me to paint him something and he would pay well for it. And all men tell me what an upright man he is, so that I am really friendly with him. He is very old, but is still the best painter of them all" (Conway 1889, 48). The letters Dürer wrote to Pirckheimer from Venice, incidentally, also describe in great detail his purchase of jewels, pearls and precious stones. While staying in Venice Dürer became increasingly interested in Giorgione's art. Dürer's *Portrait of a Venetian Lady* in Berlin (Staatliche Museen Preussischer Kulturbesitz) and his *Portrait of a Young Man* of 1506 (Galleria di Palazzo Rosso, Genoa) show clearly the influence of that young Venetian master, as does the *Old Woman with a Bag of Coins* which Dürer painted on the reverse of the *Portrait of a Young Man* (Kunsthistorisches Museum, Vienna), a work dating from after his return to Nuremberg (1507). This striking image recalls Giorgione's famous *La Vecchia*, a portrait of an old woman (Gallerie dell'Accademia, Venice).

J.M.M.

191 ࢍ

Albrecht Dürer

Nuremberg, 1471–1528

YOUNG WOMAN WITH BRAIDED HAIR

1515
charcoal on paper
42 x 29 (16½ x 11⅜)
references: Winkler 1936–1939, 3:30–31, no. and fig. 562; Strauss 1974, 3:1578–1581, no. 1515/53; Anzelewsky and Mielke 1984, 81–82, no. and fig. 78

Kupferstichkabinett, Staatliche Museen Preussischer Kulturbesitz, Berlin

This large portrait is the same size and in the same medium as another study of the same sitter in the Nationalmuseum in Stockholm (Strauss 1974, 3:1578–1579, no. 1515/52); both are signed

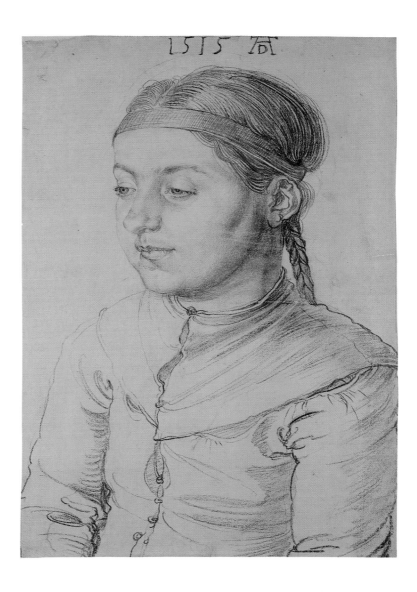

with the artist's monogram and dated 1515. The two charcoal portraits render with great subtlety the features and personality of the sitter. The likeness is so close that the drawings must depict the same sitter and not two sisters, as is commonly supposed. Nor is there any evidence for an identification of the subject with Dürer's niece, his sister-in-law, or his maid Susanna. Why Dürer executed the drawing is not known, but the artist seems to have used another study of the same model for his *Virgin and Child with Saint Anne* of 1519 (Metropolitan Museum of Art, New York), a painting in which he used a study of his wife Agnes for the face of Saint Anne. Dürer's first known portraits in charcoal date from 1503; his best known work in this medium is the portrait of his mother drawn in 1514, less than two months before her death. Later, during his travels to the Netherlands, Dürer developed a new type of highly finished drawing rendering the subject in tonal terms against a dark background. Employing this technique, Dürer could produce an elaborate portrait in an hour or two. Such studies provided him with a steady income during his trip, although most were probably done primarily to satisfy his numerous admirers.

J.M.M.

192 ࢍ

Albrecht Dürer

Nuremberg, 1471–1528

PORTRAIT OF A BLACK MAN

1505–1506 ?
charcoal on paper
32 x 21.8 (12½ x 8½)
references: Nuremberg 1971, 286–288, no. 534; Devisse and Mollat 1979, 252–253, fig. 264; Strauss 1974, 2:1062–1063, no. 1508/24

Graphische Sammlung Albertina, Vienna

This drawing is difficult to date, since the monogram and the date 1508 seem to have been added later. Dürer was already drawing with charcoal in 1503 — an example is his splendid portrait of his friend Pirckheimer (Kupferstichkabinett, Berlin). The present portrait may have been executed during the second trip to Venice in 1505–1506, as has been suggested, for example, by Strieder (Nuremberg 1971, 286). A later date, however, c. 1515, as is often proposed, cannot be excluded, as Dürer could easily have seen a black man in

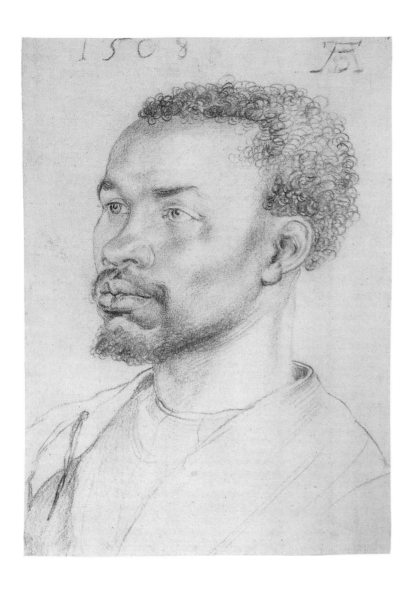
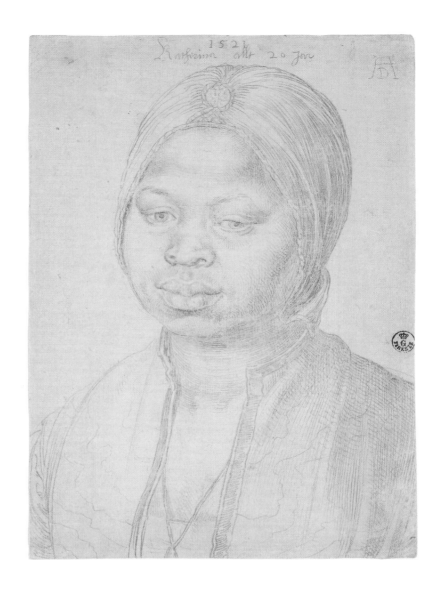

Nuremberg, which was a major cosmopolitan trade center.

During his first visit to Italy, Dürer drew two orientals in Ottoman costume who are followed by a black servant (cat. 110), but he did not sketch these from life, probably copying a drawing, now lost, by Gentile Bellini preparatory to his *Procession in Saint Mark's Square*. Later, in his altarpiece, the *Adoration of the Magi* of 1504 in the Uffizi, Dürer included a black Magus holding a gold cup. By 1500 it was quite traditional to show one of the three wise men as black. But in that work as in the present drawing, Dürer goes beyond cultural and artistic stereotypes and shows himself sensitive to the personality as well as the exotic potential of his sitter. J.M.M.

193 🐚

Albrecht Dürer
Nuremberg, 1471–1528

PORTRAIT OF KATHERINA

1521
silverpoint on prepared paper
20 x 14 (7⅞ x 5½)
references: Goris 1925, 31–32; Goris and Marlier 1971, 185, no. 66, fig. 66; Nuremberg 1971, 294, no. 543; Strauss 1974, 4:2012–2013, no. 1521/8; Kaplan 1985, 105

Gabinetto Disegni e Stampe degli Uffizi, Florence

During his visit to the Netherlands Dürer drew Katherina, the Moorish servant of the Portuguese factor João Brandão. Between 16 March and 5 April 1521, not long before he returned to Nuremberg, the artist wrote in his diary: "I have drawn the portrait in charcoal of Faktor Brandao's Secretary. I drew a portrait of his Negress with metalpoint." He inscribed that drawing *Katherina alt 20 Jahr* and dated it 1521.

From 1441, the year of the first Portuguese slave raid, to 1505 between 140,000 and 170,000 African slaves were brought to Europe (Kaplan 1985, 105). Blacks are first mentioned in Antwerp documents in the early sixteenth century; they were mostly seamen and servants owned by their masters, sold and even given away by them. Some, however, were baptized and then freed amid great pomp (Goris 1925, 31–32).

Dürer's drawing captures Katherina's features with precision. Dürer noted, as he often did, both the name and age of his sitter, leaving us with a thoughtful and sensitive portrait of the young woman, whose hair has been confined within a European headdress (see also the portrait of Paulus Topler: Strauss 1974, 4:1940–1941, no. 1520/19). J.M.M.

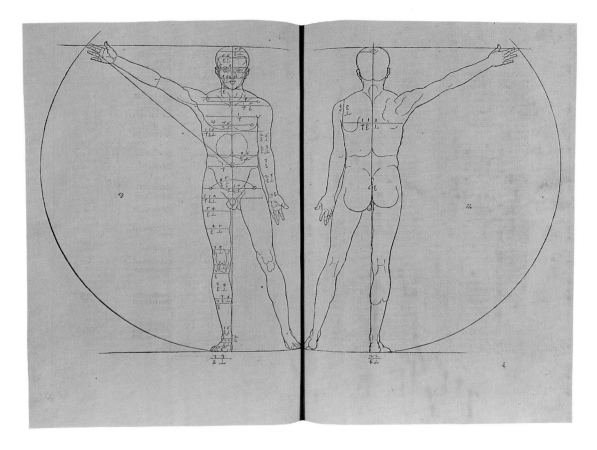

ther through the use of mathematical projections and a section on grotesque physiognomies, while in the final book Dürer attempts to analyze human movement by means of geometrical constructions.

The figure reproduced here, from the second book, follows Vitruvius' dictum that a circle whose center is the navel will touch the tips of the outstretched fingers and the toes, although Dürer in this case does not show his figure with feet extended as did Leonardo in his Vitruvian proportion study (cat. 175). J.A.L.

195 🖎

Albrecht Dürer
Nuremberg, 1471–1528

Adam and Eve

1504
engraving
24.9 x 19.3 (9⅞ x 7⅝)
references: Panofsky 1948, 1:84–85, 204; Rupprich 1956–1969, 1:102; Washington 1971,131–132, no. 30; National Gallery of Art 1973, 342; Strauss 1974, 2:760; Keil 1985, 54–61

National Gallery of Art, Washington, Gift of R. Horace Gallatin

194 🖎

Albrecht Dürer
Nuremberg, 1471–1528

Study in Human Proportion

from Hierin sind begriffen vier bücher von menschlicher Proportion, *Nuremberg, 1528*
(fols. κ6v–κ7r)
woodcut
22 x 16.2 (8⅝ x 6⅜)
references: Panofsky 1948, 1:263–270; Washington 1971, 355, no. 217

New York Public Library, Astor, Lenox and Tilden Foundations, Rare Books and Manuscripts

Although Dürer's interest in theoretical subjects began fairly early in his career, his completed books did not appear until near the end of his life. His treatise on geometry and perspective, *Underweysung der Messung mit dem Zirckel und Richtscheyt* ("A Course in the Art of Measurement with Compass and Ruler") was published in 1525, followed in 1527 by his work on fortifications, *Etliche underricht zu befestigung der Stett, Schlosz und flecken*. The treatise exhibited here, *Hierin sind begriffen vier bücher von menschlicher Proportion*, the "Four Books of Human Proportion," was published posthumously in 1528, edited by his friend Willibald Pirckheimer.

The study of human proportions occupied Dürer for nearly thirty years. Around 1500, he was primarily interested in creating figures that could be used directly in works of art. He devised a geometrical schema to determine not only their proportions but also their poses and even, in some cases, the contours delineating their forms. On his second trip to Italy, however, he encountered the proportion studies of Leonardo da Vinci, probably in the form of copies. As a consequence his own approach underwent a fundamental change of direction. He lost interest in the somewhat naive notion of finding mathematical constructions to describe human beauty and sought instead, by actually taking the measurements of individuals, to determine the objective proportions of the ideal human figure. Moreover, he became convinced that no single canon of beauty could do justice to the wealth of human types, and so he began to assemble alternate sets of proportions and to devise mathematical procedures for varying these, in turn, even further. In these later studies, following Italian practice, Dürer began to show his figures rigidly erect and in two or three different views. These new studies were intended solely as illustrations, in the scientific sense, of his research; as he admitted himself, they were of no direct practical use to the artist.

In the first book of this treatise Dürer illustrates the five different types of figures and provides detailed measurements of male and female heads, the hand and foot, and a baby. In the second book he adds an additional eight types, indexing them according to the system of measurement developed by Leon Battista Alberti in his treatise on sculpture. The third book contains methods for varying these basic figures even fur-

Dürer's woodcut series of the *Apocalypse* of 1498 established him as a great narrative artist, and it is at first glance surprising to find so little drama in his conception of the Fall of Man. The explanation is that this engraving was inspired principally by his theoretical studies in the field of human proportions. He intended the print to introduce his German public to the perfectly constructed, classical forms of man and woman.

Dürer later wrote that his lifelong interest in the study of human proportions began when he met the Venetian painter and printmaker Jacopo de' Barbari, the author of the woodcut *View of Venice* (cat. 151), "...a charming painter. He showed me a man and a woman which he had made according to measure, so that I would now rather see what he meant than behold a new kingdom." Barbari would not reveal his working method to the young Dürer, who consequently "set to work on [his] own and read Vitruvius, who writes a bit about the human figure" (Rupprich 1956–1969, 1, 102). This meeting must have taken place either in Venice in 1494–1495 or in Nuremberg in 1500, when Barbari accepted an appointment to the court of Emperor Maximilian I.

For his early series of constructed nudes, Dürer utilized a system of proportions that is based at least in part upon the canon described by Vitruvius in his first-century B.C. treatise on architecture (see cat. 175), while the method of construction is uniquely Dürer's own. The measurements of the head, face, chest, hips, and legs

are predetermined as simple fractions of the total body length. The chest and pelvis of the figure are schematized as a square and a trapezoid and are set at opposed angles to the central axis of the figure. Dürer's intention was to use this geometrical construction to create, in almost mechanical fashion, the classical *contrapposto* pose, which differentiates the figure's weight-bearing leg from its free leg, raising the shoulder above the free leg and the hip above the standing leg. Dürer even attempted to construct a number of the figures' contours, which follow arcs drawn with the compass.

While Dürer's earliest constructed female nudes have a Gothic lilt, he seems soon to have realized that a genuinely classical figure required a classical model as well as a Vitruvian scheme of proportions. By 1503, he seems to have had access to a drawing after a classical statue, perhaps a figure resembling the *Medici Venus* (Uffizi, Florence), to judge from the fact the close predecessors of the Eve have an equilibrium and a genuinely statuesque quality. Adam is the direct descendant

of a series of figure studies by Dürer, depicting Apollo and other classical gods, based on the *Apollo Belvedere* (Vatican Museums), which had been discovered in Rome in the late fifteenth century.

When Dürer decided he was ready to embody his studies in a published image, however, he changed the subject from the secular to the religious, choosing a Biblical story in which nudity was justified by the subject matter. He was apparently concerned that his audience might not be ready to accept classical nudity presented for its own sake. He combined the two separately conceived male and female images into one composition, a circumstance that accounts for the self-contained character of each figure. Dürer did alter Adam's pose in an attempt to bring the figures into an active relationship with each other, changing the balanced classical stance of his earlier studies into an energetic forward stride. He also enriched the scene with numerous symbolic details that, taken together, constitute a learned

gloss on the narrative. The parrot, for example, symbolizing the virgin birth of Christ, is the antidote to the diabolical serpent, whose guile precipitates the Fall. Adam and Eve's relationship at this critical moment is paralleled by that of the cat and mouse in the foreground, while the ibex perched on the cliff at the upper right is a traditional symbol for the unbelieving.

The presence of the other animals reflects a twelfth-century scholastic doctrine that related the Fall of Man to the theory of the four humors or temperaments. Before the Fall man had a perfectly balanced constitution, rendering him immortal and sinless. As a consequence of Original Sin this equilibrium was shattered; his body became susceptible to illness and death and his soul to vices, caused by the preponderance of one or another of the humors. Animals, however, were mortal and "vicious" even before the Fall, and in the engraving the elk denotes melancholic gloom, the rabbit sanguine sensuality, the cat choleric cruelty, and the ox phlegmatic sluggishness.

J.A.L.

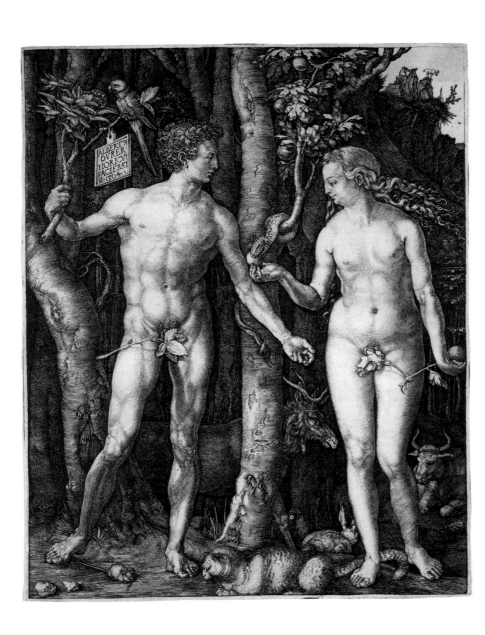

196 ʒ⹀

Albrecht Dürer
Nuremberg, 1471–1528

KNIGHT, DEATH, AND DEVIL

1513
engraving
24.6 x 19 (9⅝ x 7½)
references: Sandrart 1925, 64; Panofsky 1948, 1, 151–154; Karling 1970, 1–13; Washington 1971, 143–145, no. 58; Meyer 1978, 35–39; Scalini 1984, 15–18

National Gallery of Art, Washington, Gift of W. G. Russell Allen

Bearing the date 1513 on the tablet at the lower left (the "S" preceding the year probably stands for *Salus*, as in *Anno salutis* [in the year of grace]), this is the earliest of the three prints traditionally known as Dürer's "master engravings." The other two, *Saint Jerome in his Study* and *Melencolia 1* (cats. 198 and 199), are dated 1514. Although Dürer did not refer to them as a set, their similarities of date, style, and complexity have led scholars to interpret them as complementary subjects.

From a formal point of view, the *Knight, Death, and Devil* represents Dürer's definitive statement on the ideal proportions of the horse. The motif of the mounted knight in armor can be traced back to his watercolor study of 1498 (Graphische Sammlung Albertina, Vienna), but the idealized horse in full profile shows the further development of Dürer's studies reflected in the engravings of *Saint Eustace* and the *Small Horse* of 1505. The type of horse looks directly to Italian art, to famous mounted warriors like Verrocchio's *Col-*

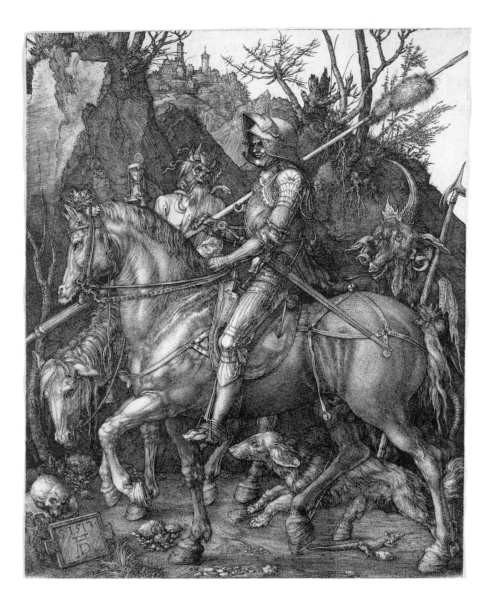

Albrecht Dürer
Nuremberg, 1471–1528

ARTIST DRAWING A LUTE

c. 1520–1525
pen and ink on paper
13.2 x 18.2 (5⅛ x 7⅛)
references: Bock 1921, 34; Anzelewsky and Mielke 1984, 122–123, no. and fig. 119a

Kupferstichkabinett, Staatliche Museen Preussischer Kulturbesitz, Berlin

This drawing illustrates an apparatus that Dürer designed in his treatise on perspective, the *Unterweysung der Messung*, published in 1525, to aid the artist in depicting objects in correct perspective. Dismissed as a copy after Dürer's woodcut (Bock 1921, 34), the drawing has only recently been reinstated as an original (Anzelewsky and Mielke 1984, 122–123). The composition is essentially that of the woodcut in Dürer's treatise, but here the figures are sketched over construction lines drawn with a ruler. That this drawing is not a copy is indicated by various *pentimenti*, especially evident in the hands of the man who is using two movable strings to fix the exact point of their intersection with the frame. The modifications in the position of his hands clearly reflect a decision to show the strings being held in a different way. The shortcomings of the drawing (for example, in the position of the right leg of the seated man), which were thought to cast doubt on its authenticity, are equally evident in the woodcut. Moreover, a copyist who bothered to change the position of the hands would probably also have added the lute represented in perspective on the piece of paper attached by hinges to the frame. Dürer was obviously more interested in making the action clear and comprehensible than in adjusting the leg under the table. He may even have thought that this clumsiness would be corrected by the artist who transferred the composition to the woodblock.

Dürer's *Unterweysung der Messung* was extremely popular, for it was one of the very few treatises on linear perspective actually published in the Renaissance. Earlier and probably more significant works, such as Leon Battista Alberti's *De pictura* or Piero della Francesca's *De prospectiva pingendi*, circulated only in manuscript. Dürer's *Unterweysung* was republished repeatedly, in German and in a Latin translation by Joachim Camerarius. Dürer hoped that his treatise would "benefit not only the painters but also goldsmiths, sculptors, stonemasons, carpenters and all those who have to rely on measurement." To ensure its usefulness he provided in his book both a theoretical framework on perspective and the kind of practical information previously found only in pattern books. The treatise is divided into four chapters. The first, which

leoni Monument in Venice and more specifically to Leonardo da Vinci's studies for the Sforza equestrian monument in Milan. Leonardo's sculpture never progressed beyond the stage of the clay model of the horse, but Dürer would have known some of the drawings through early engraved copies. In a two-sided preparatory drawing for the *Knight, Death, and Devil* (Biblioteca Ambrosiana, Milan), Dürer constructed the horse geometrically on one side of the sheet and then traced the image through to the other side of the page to complete it.

Dürer called this print simply *Reuter* (Rider) in the diary of his Netherlandish trip of 1520–1521. Joachim von Sandrart, the seventeenth-century biographer of the Northern artists, referred to it as "the Christian Knight," a description that led nineteenth-century scholars to connect the print with Erasmus of Rotterdam's *Enchiridion militis Christiani* (*Handbook of the Christian Soldier*) of 1504 in what has become the canonical interpretation of its subject. Erasmus' treatise described the virtuous Christian soldier, metaphorically enrolled in God's service, who is exhorted in one evocative passage: "All those spooks and phan-

toms which come upon you as in the very gorges of Hades must be deemed for naught after the example of Virgil's Aeneas." Erwin Panofsky believed that the *Knight, Death, and Devil* represented the obverse of *Saint Jerome in his Study*, the active as opposed to the contemplative life in the service of Christ, with *Melencolia 1* representing a contrast to both, "the tragic unrest of human creation."

Other scholars have pointed out that in the twilight of feudalism, the image of an armored warrior was more likely to suggest to a citizen of Nuremberg the robber-knights who terrorized the countryside, supporting themselves as highwaymen. They have proposed that the print should be seen as a warning against lawlessness or in the spirit of the *memento mori*. While this controversy is unlikely ever to be resolved definitively, the visual evidence seems clear. The soldier, riding an idealized mount that embodies Dürer's own belief in the perfection inherent in mathematical proportions, passes the cadaverous figure of Death and the bestial Devil with an indifference that surely reflects his concentration on eternal goals. J.A.L.

borrows its introduction from Euclid's *Elements*, gives an account of linear geometry while the second covers two-dimensional figures. The third is more practical, illustrating the application of geometrical principles to architecture and various crafts, including typography, mapmaking and the manufacture of scientific instruments. The final Book deals with the construction of three-dimensional bodies, emphasizing the stereometric approach which underlines his own so-called late style evident in works dating from 1519 onwards. It has often been pointed out that Dürer's apparatuses for drawing objects in perspective, which are described and illustrated at the end of his book, constitute his main contribution to perspective theory as developed by Italian writers; they also best reflect his practical mind.

The apparatus depicted in this drawing seems to have been invented by Dürer. The visual rays intersecting the "window," the plane between the eye and the object, are represented by a piece of string, with a weight at one end and a pin at the other, which passes through the eye of a needle driven into the wall. This needle stands for the eye of the notional viewer. The pin held by an assistant is put at different places on the object while his companion measures, for each position, the exact point at which the piece of string intersects the frame. These points are then recorded by two movable threads, and their positions are entered on the piece of paper hinged to the frame, yielding a foreshortened image on the paper.

J.M.M.

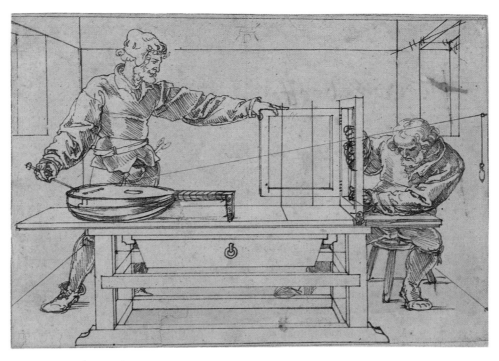

(1520–1521) — more, in fact, than for any other of his prints. The print is remarkable for its perspectival construction based on a central vanishing point and two lateral points for convergence of the diagonals. Dürer defined this method later in his treatise on measurement (*Unterweysung der Messung*) of 1525.

The theme of Saint Jerome in his study was developed in northern Europe in the fifteenth century in works such as the *Belles heures* of Jean, duke of Berry, painted by the Limbourg Brothers or the little Eyckian panel now in Detroit. There, as in Dürer's engraving, we find the saint portrayed as a patron of humanism. Dürer strikes a

198

Albrecht Dürer
Nuremberg, 1471–1528

SAINT JEROME IN HIS STUDY

1514
engraving
24.7 x 18.8 (9⅝ x 7⅜)
references: Parshall 1971; Washington 1971, 146–147, no. 60, fig. 60; Behling 1975; Strauss 1976, 212–215, no. 77; New York and Nuremberg 1986, 314–315, no. 133; Kemp 1990, 60–61, figs. 105–107

The Nelson-Atkins Museum of Art, Kansas City, Missouri, Gift of Robert B. Fizzell

In Dürer's time Saint Jerome was generally represented as a penitent or as a scholar, his main achievement being his translation of the Bible into Latin (the so-called Vulgate version) which was commissioned by Pope Damasus.

The 1514 engraving shown here is often considered Dürer's most technically perfect effort in this medium; Dürer's own satisfaction with it may explain why he sold or gave away so many examples during his trip to the Netherlands

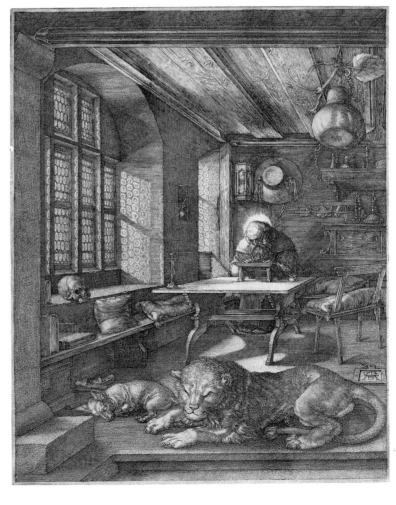

scholarly note with the gourd (*Cucurbita lagenaria* L.) hanging from the ceiling. This plant was well known during the Middle Ages and celebrated by many writers, including Walafrid Strabo, who stressed its utility as a container for water or wine. Dürer's gourd, however, recalls a famous controversy between Jerome and Saint Augustine about the meaning of the Hebrew word *ciceion* or *kikayon* in Jonah 4:6. It was usually translated as "gourd," but Jerome identified it instead with the castor oil plant, for which he knew no Greek or Latin equivalent; instead of calling it a gourd (*cucurbita*), the saint used the word *hedera* (a type of ivy). When faced with the peculiar ivy-gourd in this Saint Jerome engraving, Dürer's learned friends likely grasped the philological point.

Problems like the debate over the gourd were of great interest to Renaissance scholars; humanism was primarily concerned with establishing the accurate text of ancient works, both biblical and classical. Much of Reformation theology depended on reading the word *ipsa* as *ipse* in a crucial biblical passage. Contemporary viewers may also have seen the gourd, like the skull, hourglass, and extinguished candle, as symbols of transience. This concept too is found in Jonah (6:10), where we read that the gourd came up in a night and perished in a night. J.M.M.

199 ✍

Albrecht Dürer
Nuremberg, 1471–1528

MELENCOLIA 1

1514
engraving
24 x 18.7 (9⅜ x 7⅜)
references: Klibansky, Panofsky, and Saxl 1964, 284–373; Washington 1971, 145–146, no. 59, fig. 59; Strauss 1972, 166–169, no. 79; Strauss 1976, 218–224; Smith 1983, 111, no. 19; Białostocki 1986, 356–369, pl. XIX; New York and Nuremberg 1986, 312–313, no. 132

National Gallery of Art, Washington, Rosenwald Collection

Dürer's Melancholy is a winged personification surrounded by various more or less symbolic features. The artist took as his formal model a woodcut from Gregor Reisch's *Margarita philosophica* (Strasbourg, 1504) representing Geometry (*Typus Geometriae*), one of the liberal arts; that personification is surrounded by various people recording the position of the heavens, measuring, and drawing plans. Dürer's familiarity with the 1504 woodcut is confirmed by his use of another illustration from the same book—a rainbow and a comet,

two heavenly phenomena studied by Reisch in different chapters. By adding various attributes, Dürer effectively conveyed a mood, a state of mind, which is that of Melancholy lost in her thoughts. The many curious details with which *Melencolia 1* is filled have inspired complex interpretations. Some scholars have sought meaning in all the details of the engraving, citing as supporting evidence a preparatory sketch in the British Museum, London, for the "putto" at Melancholy's side, which bears an autograph inscription stating that "the key signifies power, the purse riches." This statement has traditionally been taken to allude to *Melencolia 1* and to the purse and the key hanging at Melancholy's side. The possibility cannot be excluded, however, that it refers to another engraving altogether, that of a peasant couple dancing, which Dürer executed the same year.

Melencolia 1 is without doubt Dürer's most perplexing work, especially if, as is often claimed, it reflects Dürer's own feelings of personal disarray. Melancholy was one of the four humors that were believed to rule over human beings; the other three were choler, phlegm, and the sanguine humor. According to the theory developed in classical antiquity, which was widespread in the Middle Ages and Renaissance, the melancholic humor was dry and cold, related to the element earth, to autumn, and particularly to an age of about sixty. It was generated by an excess of black bile and produced various effects, including depression.

The title given by Dürer to his engraving seems to indicate that he meant it to form part of a series, either of the Four Temperaments or of a number of different forms of Melancholy. Various authors have connected the print with one of three types of Melancholy discussed by Cornelius Agrippa von Nettesheim in his *De occulta philosophia*, written in 1509–1510 but published, in a revised form, only in 1531. Dürer could easily have known the text through his friend Pirckheimer, who was a friend of Abbot Trithemius to whom the book was dedicated. According to Agrippa, Aristotle knew "that all men who have distinguished themselves in any brand of knowledge have generally been melancholics." This "humor melancholicus," Agrippa relates, "occurs in three different forms, corresponding to the threefold capacity of our soul, namely the imaginative, the rational, and the mental." When "the soul is fully concentrated in the imagination…it immediately becomes an habitation for the lower spirits, from which it often receives wonderful instruction in the manual arts; thus we see a quite unskilled man suddenly become a painter or an architect, or a quite outstanding master in another art of the same kind."

Erwin Panofsky concluded that Dürer represented the melancholy of the artist who is in control of geometrical principles but has no access

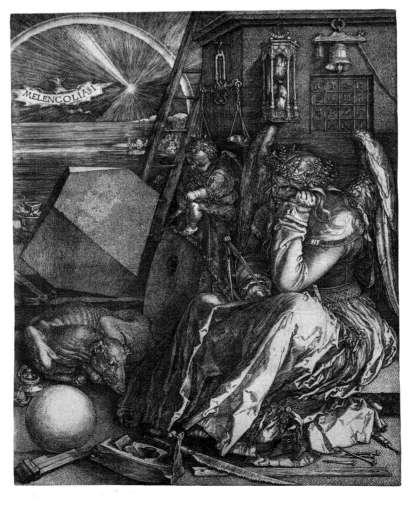

to the metaphysical dimension. If so, the engraving could have had personal connotations and might reflect Dürer's discomfiture when he abandoned his search for absolute beauty and admitted that "what absolute beauty is, I know not." J.M.M

200 🙟

Albrecht Dürer
Nuremberg, 1471–1528

WATERWHEEL IN THE ALPS

1494–1495
watercolor and gouache on paper
13.4 x 13.1 (5¼ x 5⅛)
references: Koschatzky 1973, no. 14; Strauss 1974, 1:338–339, no. 1495/39; Anzelewsky and Mielke 1984, 18–19, no. and fig. 14

Kupferstichkabinett, Staatliche Museen Preussischer Kulturbesitz, Berlin

Dürer's contribution to the development of landscape cannot be overestimated. His early watercolors record the landscape around Nuremberg with considerable topographical accuracy. Those executed during his first trip to Venice in 1494–1495, like the present sheet, reveal new concerns for landscape, even a new attitude toward the subject. Some are careful renderings, such as the highly finished *View of Arco* (Louvre, Paris), while others are simply sketched in and left incomplete.

The *Waterwheel in the Alps*—one of the first examples of *plein-airisme*—shows an artist sitting on a millstone and sketching a waterwheel. It illustrates a number of characteristic features of Dürer's art, especially in the degree of finish applied to specific areas. Certain sections are defined with great precision, while others, such as the top of the treetrunk behind the sketching

artist, are barely begun. Especially attractive are the bluish bushes, executed with the same technique and showing the same tonality as the olive trees in the *View of Arco.*

In some of these early watercolors, Dürer mixes form with light, giving an overall impression of the open air and a great sense of recession, bringing to landscape the atmospheric qualities that are usually thought of as an innovation of artists of the eighteenth and nineteenth centuries. It is difficult to determine the function of Dürer's watercolors. They clearly could be used for finished compositions, since the background of his *Nemesis* engraving, of about 1502, is a bird's eye view of Klausen, in the Tyrol, which he must have drawn in 1494–1495. Some of the watercolors are thought to be the first known autonomous landscapes, although that is difficult to determine, precisely because Dürer's landscape watercolors are unique for their time. Curiously, the *Waterwheel* was copied by Hans Bol (1534–1593) and incorporated into a much enlarged composition which is known through a drawing in Vienna and a watercolor in Weimar. J.M.M.

Albrecht Dürer
Nuremberg, 1471–1528

VALLEY NEAR KALCHREUTH

c. 1500
watercolor and gouache on paper
10.6 x 31.6 (4¼ x 12⅜)
references: Fiore-Herrmann 1972, 135–136, fig. 11; Koschatzky 1973, no. 32; Strauss 1974, 2:520–521, no. 1500/9; Anzelewsky and Mielke 1984, 21–23, no. and fig. 17; Leber 1988, 128–146, figs. 72–81

Kupferstichkabinett, Staatliche Museen Preussischer Kulturbesitz, Berlin

Dürer's view of the valley near Kalchreuth and his *Village of Kalchreuth* (formerly Kunsthalle, Bremen) are probably his most innovative landscape watercolors. He sketched the valley from the Schöllenbacher Wald, towards the hills of the Franconian Jura beyond Kalchreuth; the villages of Neunkirchen a Brand and Hetzles can be discerned at the foot of the Hetzleser Berg. Dürer presents a panorama, sketching it from a wooded hill and indicating the tops of the trees on the slope with a few brushstrokes. The valley is painted with earth colors, the trees indicated with a few wet brushstrokes. Dürer relied on color effects to suggest the receding hills: the most distant ones are appropriately depicted in bluish hues, while for those in the foreground fluid washes are combined with pure brush drawing—for example, where the hatchings define the shape of the mountains.

Dürer's two watercolors of Kalchreuth are exceptional as regards both his own development and that of the art of the time. It has thus proven difficult for scholars to place them within the chronology of Dürer's oeuvre. Most consider them to be his last watercolor landscapes, while some place them as early as his return from his first trip to Italy, and others propose a date as late

as c. 1518–1519, relating them to the etching, *Landscape with a Cannon.* Around 1500, however, seems most probable. At that time Dürer drew his famous *Large Piece of Turf,* representing nature in almost microscopic detail and subjecting it to a penetrating analysis in his quest for a basic understanding of the underlying structures of the physical world. J.M.M.

202 ᨏ

Martin Schongauer
c. 1450–1491

STUDY OF PEONIES

c. 1472
paper, watercolor and body color, heightened
with white
25.4 x 33.4 (10 x 13⅛)
references: Koreny 1985, 191, n. 66, 210, 211;
Koreny 1991, n. 30
private collection

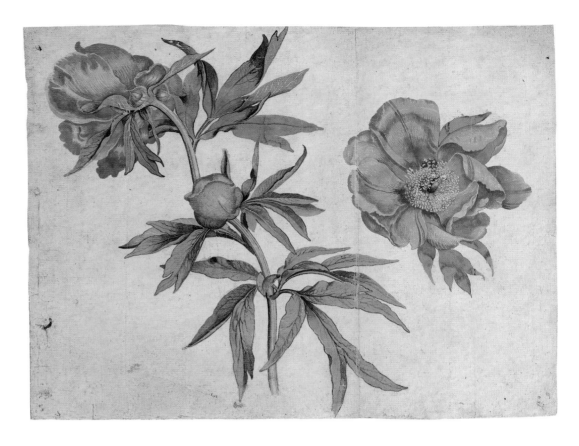

This watercolor, discovered only in 1988, is here attributed to Martin Schongauer. The sheet of paper has been restored in the upper right and left corners; the lower left corner was cut off diagonally and later replaced, as a result of which an inscription was lost. Remnants of possibly the last three letters are still recognizable. There are losses of color in the foliage around the bud and also along the vertical fold, which runs partially through the petals of the blossom at the right. There is minor flaking color in the foliage around the blossom at the upper left.

Two fully opened peony blossoms (*paeonia officinalis L.*) and one bud with surrounding foliage are represented. Copied from nature, the study served as a preparatory drawing for the peony bush in Martin Schongauer's painting of the *Madonna in the Rosegarden* (St. Martin, Colmar). There the two blossoms reappear, true to detail but, in comparison to the study, in a slightly changed overall relationship (Koreny 1991, n. 30). The painting in Colmar has been trimmed on all sides and today shows only the blossom to the right. A sixteenth-century copy in Boston reproduces the panel before its reduction in size and indicates not only the original size of the peony bush and the arrangement of the flowers, but also the characteristic features of the blossom at left, which is viewed from the side. A comparison with the Boston copy reveals that Schongauer's painting was cropped 25 cm at the left and right, losing about half of the peony bush and one stem of white lilies; 35 cm at the top, losing the bust of God the Father with the Holy Ghost that originally appeared above the angels; and about 20 cm at the bottom, losing part of the grassy foreground.

The essential features of the peony petals in the study are delineated by wide brushstrokes in pink and dark red. Over this foundation Schongauer then modeled the forms in dark red to madder, in thin, parallel lines with a fine brush to elaborate the indentations and elevations, the light and shadow. To achieve greater contrast in the details, he outlined the contours of several petals with opaque white and applied the highlights with a few broad strokes of the brush. The technique of modeling with thin lines to articulate form corresponds to Schongauer's style of drawing and may be compared to the modeling in his pen drawing of *Saint Dorothy* in Berlin.

Schongauer transferred this drawing technique to the painting when, as a final touch, in just this manner with a fine brush and white pigment, he placed accents of light in parallel strokes on the petals in the painting. This process can still be seen at the left edge of the painting, where the original peony blossom in the center was cut through when the painting was made smaller. The left edge of the picture was better protected by its frame from the abrasion that occurred over the course of centuries, when the painting was cleaned. In the same fashion, for example, the Madonna's lips have been heightened with this type of white brush hatching, thereby achieving the most sublime effects of light. In addition, the same artistic conception in the study as in the painting characterizes the application of color, the manner of painting, the dispersion of color in the stem, the drawing of the leaves, their colored outlines, and the effect of light and shadow contrasted against each other.

The study is executed on paper of Basel provenance, which contains a watermark, a gothic "p" with flower (Piccard 1019). One can pinpoint relatively well the manufacture of this coarsely ribbed paper, with the specific features of the shape of the "p" and the peculiarities of the flower, as well as the number of and distance between chainlines and laidlines: paper of precisely this origin was used by Bishop Johann of Basel in a note of 15 April 1474 to Emperor Frederick II; pages 53–60 of the Basel court judgments of March 1471 to August 1472 are also written on the same paper. The watermark not only confirms that this study originated in the early 1470s, but also indirectly substantiates, to a degree, the date of 1473 on the reverse of Schongauer's *Madonna in the Rosegarden,* which was apparently added later.

Martin Schongauer's drawing precedes Albrecht Dürer's animal and plant studies by more than a quarter of a century. It is therefore contemporaneous with Leonardo da Vinci's scientific nature studies, also to be placed in the 1470s, to which it forms, so to speak, the Northern—and artistically commensurate—counterpart. It is interesting to observe Schongauer's clarity of vision, which, by reducing diversity in favor of the essential, achieves a calm, balanced overall effect, whereas the much younger Dürer, as in the Bremen *Iris* (cat. 203), despite his brilliant rendering of details, succeeds only with difficulty in reining in his Gothic overabundance of information (compare to Koreny 1985, 191, n. 66).

Albrecht Dürer most likely knew this study by Martin Schongauer and, if the remnants of the letters at the lower left may be interpreted correctly, probably also owned it (Koreny 1991). This assumption is based on, in addition to the com-

parison of handwriting, the depiction of the peonies in Dürer's drawing of the *Madonna with a Multitude of Animals* (Graphische Sammlung Albertina, Vienna): the specific arrangement of the blossoms next to one another in Dürer's drawing is not to be found in Schongauer's *Madonna in a Rosegarden* but is nearly identical to that in the study discussed here. The corresponding ensemble of a single bud with a short stem and the two blossoms—including such astonishing details as the top leaf, curled upward, of the blossom at the left—certainly presupposes knowledge of Schongauer's study (see Koreny 1985, 210, 211 where Dürer's borrowing of this detail from Schongauer's painting was first pointed out).

As is demonstrated by Schongauer's use of the same study of lilies in the *Annunciation* from the Orliac altarpiece (Musée d'Unterlinden, Colmar), the *Madonna in the Rosegarden*, and the engravings of the *Annunciation* (B.2 and B.3), Martin Schongauer, evidently under Netherlandish influence, learned to work economically in running his studio on the basis of detailed studies after nature of this type. This is a manner of working that evidently originated with the masters of Early Netherlandish painting. There are good grounds for presuming its use by Jan van Eyck and the Master of Flémalle, and indirect evidence for its employment by Rogier van der Weyden (see Koreny 1991 for a more detailed discussion).

The discovery of this study places in a new light all that was previously believed regarding the observation of nature and the changed attitude of man towards nature, the environment, and the universe at the beginning of the Renaissance. Albrecht Dürer's representations of animals and plants no longer mark the beginning of artistic study of such details in western art, but turn out to be documents of the third generation; they are clearly based on Schongauer's observation of nature, which itself can be shown to be indebted to Netherlandish prototypes.

More than a generation before Dürer, Martin Schongauer's study of peonies anticipates the beginnings of modern scientific representations of nature, which until now had been dated around 1500. It compels us to change our ideas fundamentally. Though derived from late medieval practice, it must be considered by far the earliest nature study of the German Renaissance. F.K.

203 ࣸ

Albrecht Dürer
Nuremberg, 1471–1528

Iris

c. 1503
pen, watercolor, and gouache on paper
77.5 x 31.3 (30½ x 12⅜)
references: Winkler 1936–1939, 2:68–69, no. and

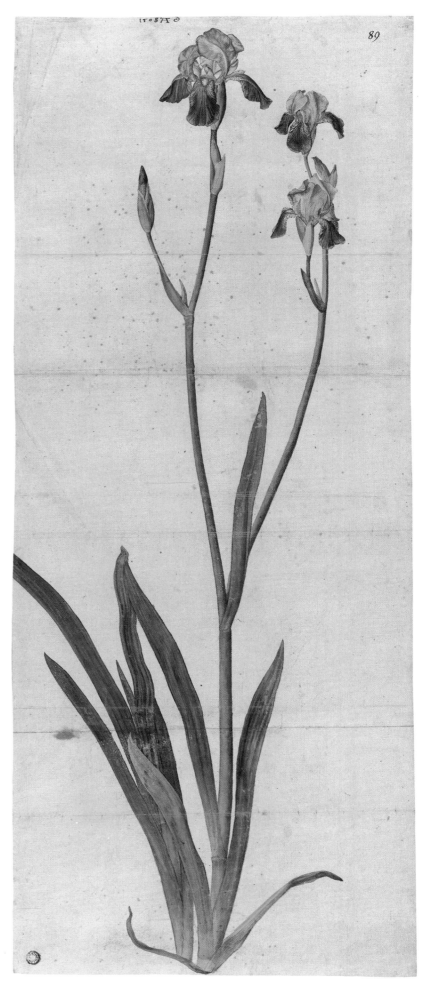

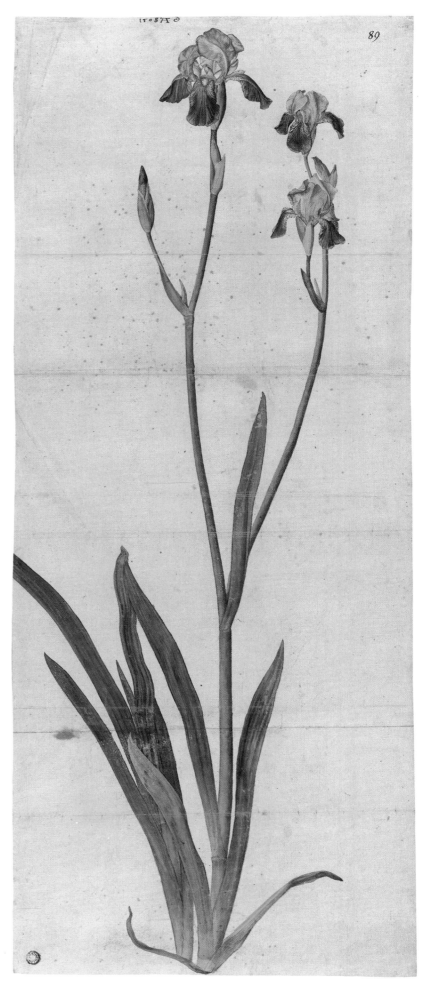

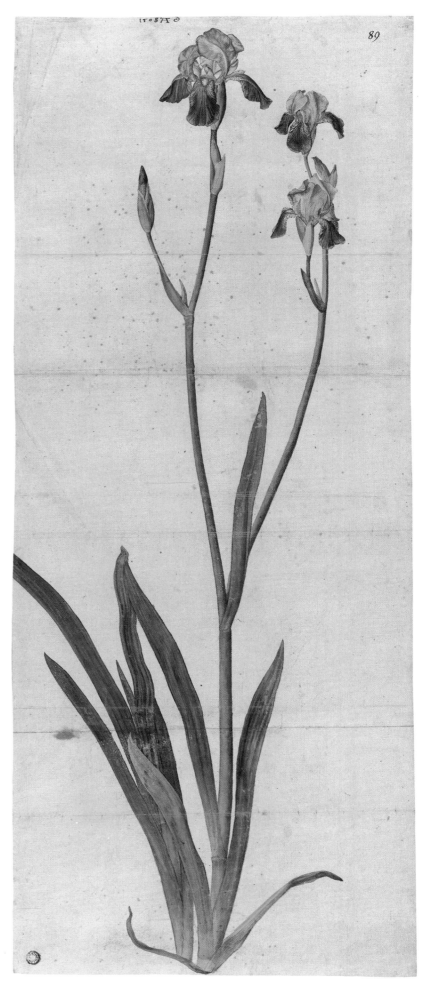89

fig. 347; Strauss 1974, 1:312–313, no. 1495/26; Horn and Born 1979, 2:181–182; Koreny 1988, 188–191, no. 66; Behling 1989, 46–53, fig. 38

Kupferstichkabinett, Kunsthalle, Bremen

In the diary of his journey to the Netherlands (1520–1521) Dürer wrote that his host in Arnemuiden gave him a sprouting bulb (not a tulip, since this flower was introduced to Europe only much later). The iris, a bulbous plant, was known in northern Europe as early as the Carolingian period, as it is indicated (as *gladiola*) on one of the beds in the medical herb garden (*herbularius*) on the plan of the monastery of Saint Gall (see Horn and Born 1979, 2:181–182). Dürer's drawing of the iris was made before his trip to the Netherlands, probably at the same time as the *Large Piece of Turf* and his *Madonna with a Multitude of Animals* (both Albertina, Vienna), that is, around 1503. The *Iris*, which was drawn on two sheets of paper glued together, is a life-size study in which the flower is rendered with botanical accuracy. The leaves and the branching stem are

shown in great detail, with special care given to color and texture. The buds are shown at different stages of development, the blooms having all the characteristics of a hybridized variety of the *Iris germanica*. The Bremen watercolor was carefully copied, probably around 1600, in the *Madonna with the Iris* in the National Gallery in London, an anonymous painting formerly attributed to Dürer. In the case of the Bremen watercolor, Dürer's principal interest seems to have been the plant itself and its botanical features.

The Latin name for the iris (*gladiolus* or *gladiolum*) simply means "little sword"; its German name, *Schwertlilie*, literally means "sword lily." The flower was therefore an appropriate symbol of the Virgin, and specifically of her sufferings. The iris is found in a Marian context in Dürer's own *Madonna with a Multitude of Animals*. Earlier artists had used the iris in a symbolic context. For example, Gentile da Fabriano included it on a small panel of the frame of his famous *Adoration of the Magi* (1423) in the Uffizi, Florence; and Hugo van der Goes painted it, along with lilies, in

the foreground of the Portinari altarpiece (Uffizi, Florence). There is also a watercolor of an iris by Jacopo Bellini, probably created as a preliminary study for a painting.

Dürer drew the *Iris* at an interesting period in his artistic development. Around 1500 he seems to have decided that ideal beauty could be attained only through an understanding of linear perspective and the study of proportion. At the same time, however, he became more and more interested in making carefully detailed, almost microscopic renderings of specific features of the natural world, thus combining in his art Italianate principles and northern realism. J.M.M.

204 🐌

Albrecht Dürer
Nuremberg, 1471–1528

BLUE ROLLER

1512
watercolor and body color in brush and pen, heightened with white and gold, on parchment
27.4 x 19.8 (10¾ x 7⅞)
references: Koreny 1985, 40–41, 54

Graphische Sammlung Albertina, Vienna

The unusual subject, the almost microscopic sharpness of observation and exemplary delicacy of execution, and the timeless validity of its statements combine to make Dürer's *Blue Roller* one of the outstanding animal studies of the Renaissance. Here Dürer captures the brilliantly colored plumage of a young blue roller (*Coracias garrulus L.*) with swift, sure brush strokes and precise pen work. The watercolor and body color are used to draw rather than to fill in colors. The way the neck stretches upwards and the wings hang down suggests that Dürer hung the dead bird by its beak to draw it, although he omits the cast shadows and thereby leaves the image without a spatial context.

This drawing has often been discussed in the literature on Dürer and has long been admired as one of the artist's undisputed masterpieces. Only a few scholars have ever cast doubts on its authorship. These arguments are refuted not only by the sheer quality of the sheet but also by the fact that the late sixteenth-century artist Hans Hoffmann, famous for his copies of Dürer's drawings, produced no fewer than four copies of the *Blue Roller* and one variation on it. These copies, two of them dating from 1583, were made at a time when the sources for Dürer's work were still reliable. Hoffmann would hardly have copied an imitation or a forgery of Dürer's style (Koreny 1985, 54).

Although the authenticity of the sheet is generally acknowledged, several scholars have recently questioned the date and monogram and tried to connect the drawing with works by Dürer

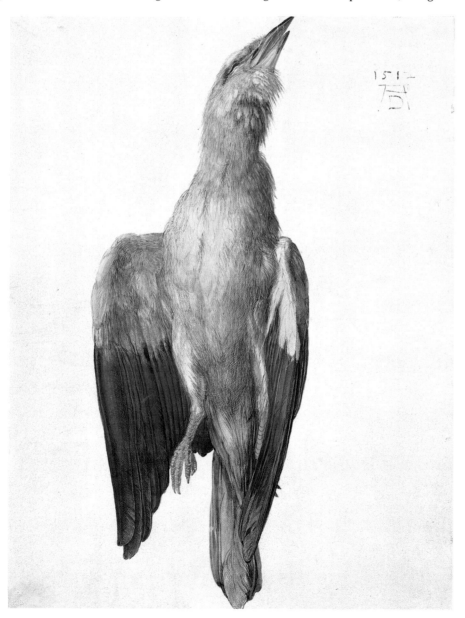

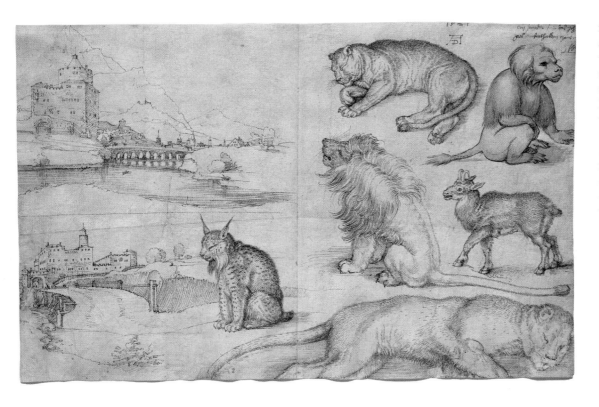

from the period 1502–1503, such as the *Hare*, the *Madonna with a Multitude of Animals*, and the *Large Piece of Turf* (all Albertina, Vienna). In fact, there are great technical and stylistic differences between these drawings and the *Blue Roller*. The *Hare* and the *Large Piece of Turf* use warm colors applied with comparatively broad brush strokes over a dominant base of watercolor. The *Blue Roller*, on the other hand, together with a companion drawing of the *Wing of a Blue Roller* (Albertina, Vienna), also dated 1512, is characterized by body color technique with strong use of the pen and virtuoso technical refinements, the whole effect being coolly colorful. The graphic detail may be compared with the so-called "Master Engravings" of 1513–1514 (cats. 196, 198). Moreover, both the *Blue Roller* and the *Wing of a Blue Roller* carry monograms and dates in very different kinds of writing, although both are actually quite in keeping with the signatures on other authentic works by Dürer from the same year. The signature on the *Wing of a Blue Roller* is typical of those on Dürer's contemporary paintings, while that on the *Blue Roller* may be compared with those on two drawings of 1512. Since the two *Roller* drawings carry such different types of signatures, both being typical of the time, the case for dating them to 1512 seems even stronger (Koreny 1985, 54).

The theme of Dürer's drawing was exceptional for the time. As a rule, earlier fifteenth-century bird pictures feature living creatures. The motif of the dead bird hanging on a wall is known from Pompeiian frescoes and may have been brought to Germany by Jacopo de' Barbari, the peripatetic Venetian master who created the *View of Venice* (cat. 151) and who departed his native city in 1500

to follow his career in the North (Koreny 1985, 40–41). He has left us both a watercolor study of a *Dead Partridge* (British Museum, London) and a painting of 1504 portraying a *Still Life with Partridge, Mailed Gloves, and Cross-bow Bolt* (Alte Pinakothek, Munich). We do not know precisely how Barbari came to know of the motif, since Pompeii had not yet been discovered, and there is no proof that examples of such paintings from classical antiquity survived in Rome. Interestingly, Lucas Cranach the Elder, who succeeded Barbari as painter to the Saxon court in Wittenberg, has left us related representations of dead birds. F.K.

(Adapted with permission from Little, Brown and Company, Boston)

205

Albrecht Dürer
Nuremberg, 1471–1528

SIX ANIMALS AND TWO LANDSCAPES

1521
pen and ink with colored washes on paper
26.4 x 39.7 (10³⁄₈ x 15⁵⁄₈)
references: Washington 1971, 89–91, no. XXVIII; Strauss 1974, 4:1932, 1933, 4:2024, 2025, 4:2072–2073, no. 1520/40; Koreny 1985, 166–169, no. and pl. 57a

Sterling and Francine Clark Art Institute, Williamstown

During his visit to the Netherlands, Dürer visited the Coudenberg Palace in Brussels and sketched

its famous park, the Warande. Probably between 3 and 11 July 1521, he drew on this sheet images of the wild animals kept at the Nederhof. Dürer had seen the park before, during his first visit to Brussels from 27 August to 12 September 1520, when he came to see the Aztec treasures exhibited in the palace. On that occasion he noted in his diary, "I saw out behind the King's house at Brussels the fountains, labyrinths, and beast-garden; anything more beautiful and pleasing to me and more like a paradise I have never seen." Quite probably the comparison to Paradise was suggested by all the wild animals that were kept there, including some from far-off countries. At this time Dürer made a topographical sketch of the Warande, which he inscribed, "This is the animal park and the pleasure grounds at Brussels seen from the Palace" (Strauss 1974, 4:1932–1933, no. 1520/15).

On the right half of the Williamstown sheet, Dürer drew, from top to bottom, a sleeping lioness (*Panthera leo leo L.*), and a baboon (*Papio hamadryas L.*), a seated lion (*Panthera leo leo L.*) and a young chamois (*Rupicapra rupicapra L.*), and a second young sleeping lioness—possibly the same animal as the one at the top of the sheet. To the left he drew a lynx (*Felix lynx L.*) which he incorporated into a landscape. Above he drew another topographical view, probably, like the lower one, from memory, as it does not seem to represent a Netherlandish scene or a view on the Rhine, the landscapes of his 1520–1521 trip. That the landscapes are not simply imaginary can be deduced from the fact that the fortress and the curiously arched bridge leading to the mill and to another fort are found reversed and seen from another angle in an etching by Augustin Hirschvogel, dated 1545, of a mountainous landscape (Washington 1971, 89–90). Unfortunately the exact location of the view has not yet been identified.

The drawing is remarkable for its depiction of exotic animals, especially the lions and the baboon, animals Dürer seems never to have recorded or even seen before his visit to the Netherlands. The baboon is carefully highlighted with blue, gray, and pink washes that define the texture of its body, the pen being used mainly for outlines. In an inscription, now partly trimmed, Dürer notes that he found it "an extraordinary animal . . . big, one and a half hundredweight." Each animal is drawn individually, as in a medieval sketchbook, with a few lines used to suggest the surroundings, rather in the manner Dürer employed for another drawing from 1521 with nine studies of Saint Christopher (Strauss 1974, 4:2024–2025, no. 1521/14).

The sleeping lioness on the bottom of the sheet is copied in a drawing from Dürer's workshop now in Warsaw (Koreny 1985, 167, no. and fig. 57a), which has none of the tension of the original. Dürer characterized the form and texture of the cat with minute strokes and with greater subtlety. J.M.M.

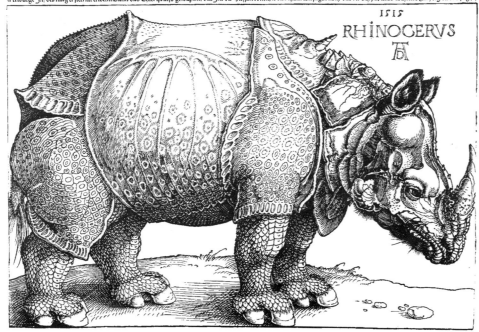

1515
RHINOCERVS

206 🐌

Albrecht Dürer
Nuremberg, 1471–1528

RHINOCEROS

1515
woodcut
21.4 x 29.8 (8³⁄₈ x 11³⁄₄)
references: Meder 1932, 254–255, no. 273; Lutz 1958, 55–56; Gombrich 1960, 70–72, fig. 59; Lach 1970–1977, 1:158–172; Nuremberg 1971, 310, no. 581; Strauss 1980, 508–510, no. 176; Clarke 1986, 16–23, pl. 1; Pass 1989, 59–64

The Metropolitan Museum of Art, Fletcher Fund, 1919, New York

The *rhinoceron* (*Rhinoceros unicornis* L.), as Dürer calls the animal he drew in 1515, is native only to Africa and Asia and had not been seen in Europe since antiquity. Valentin Ferdinand, a German printer living in Portugal, informed the humanist Konrad Peutinger (Lutz 1958, 55–56) as well as the merchants in Nuremberg, of the arrival of a rhinoceros in Lisbon on 20 May 1515; with his letter he sent a drawing and a description of the animal. This Dürer copied in a drawing now in the British Museum, London, and reused for his woodcut, which bears the following inscription: "After Christ's Birth, in the year 1513 [in fact 1515], on May 1 [in fact May 20], this animal was brought alive to the great and mighty King Emmanuel at Lisbon in Portugal from India. They call it Rhinoceros. It is here shown in full stature. Its color is that of a freckled tortoise, and it is covered by a thick shell. It is the same size as an elephant but has shorter legs and is well capable of defending itself. On the tip of its nose is a sharp, strong horn which it hones whenever it

finds a stone. This animal is the deadly enemy of the elephant. The elephant is afraid of it because upon meeting it charges with its head between the elephant's legs, tears apart his belly and chokes him while he cannot defend himself. It is also so well armored that the elephant cannot harm it. They say that the Rhinoceros is fast, cunning, and daring."

The *ganda*, as the single-horned Indian rhinoceros was known, was given by the sultan of Gujarat, Muzafar II, to Afonso de Albuquerque, governor of Portuguese India, as a gift for the king. From Goa, the governor sent it to Lisbon with the fleet that left Cochin in early January 1515 and arrived in Portugal in May of that year. Manuel dispatched the rhinoceros to Pope Leo X in December 1515; on its way to Italy it was seen near Marseilles by Francis I of France. But the ship that took the beast to Italy sank off Porto Venere, and the rhinoceros drowned, although its body seems to have been recovered, stuffed, and finally sent to Rome.

Dürer never saw the animal; he designed his woodcut solely on the basis of the drawing he had seen. His print was so popular that it ran to eight editions, and many copies were produced. Dürer's woodcut was so influential that it perpetuated a number of misconceptions about the rhinoceros — for example, the presence of a dorsal spinal horn, and the armored plating that forms the animal's skin. The latter imaginary feature persisted in representations of the rhinoceros for more than 250 years, sometimes even after the artist producing the image had seen a real specimen. Dürer himself included an image of the animal in the coat of arms of Asia in one of the woodcuts for the *Triumphal Arch of Maximilian* (1515). That same

year, Hans Burgkmair designed a woodcut of the rhinoceros, which is preserved today in only one impression, while an anonymous artist from Altdorfer's circle (known by his initials, A.A.) drew the animal on fol. 102r of the *Book of Hours of Emperor Maximilian*. These artists, like Dürer, had never seen the *ganda* but used secondary sources for their renderings. J.M.M.

207 🐌

Albrecht Dürer
Nuremberg, 1471–1528

HEAD OF A WALRUS

1521
pen and ink, with washes on paper
21.1 x 31.2 (8¼ x 12¼)
references: Veth and Muller 1918, 1:37, no. XXXVII; Tietze and Tietze-Conrat, 1928–1938, II.1:32–33, no. 850; Kiparsky 1952, 29, 46–47; Goris and Marlier 1971, 186, no. 73; Strauss 1974, 4:2048–2049, 4:2180–2181, nos. 1521/27, 1522/1; Rowlands 1988, 102–103, no. 74

The Trustees of the British Museum, London

This splendid drawing shows a walrus sketched by Dürer during his visit to the Netherlands. The artist dated it 1521, placed a description of the animal in the left corner, and signed the sheet with his monogram. The walrus, we are told, was caught in the North Sea, was twelve Brabant ells long, and had four feet ("Das dosig thÿr van dem jch do das hawbt/contrefett hab ist gefangen worden/jn die niderlendischen see und/was XII ellen lang/brawendisch mit für fussen"). In Dürer's time walruses were found in Europe mainly on the north coast of Norway; as late as the nineteenth century they could be encountered occasionally in the seas around Scotland and near the Shetland Islands. Even in the twentieth century stray walruses have been sighted from time to time near the Netherlandish coast (for the walrus, see Kiparsky 1952). The chronicles of England printed by Caxton in 1480 note that in 1456 a walrus (*mors marine*, as he calls it) was found in the Thames near London: "This yere were taken IIII grete Fisshes bitwene Eerethe and London, that one was called mors marine, the second a swerd fisshe, and the othir tweyne were wales." Already in Dürer's time walruses were hunted for their ivory tusks and their skins. It is difficult to determine whether Dürer saw a living animal, such as the one that was brought to Holland in 1612, or a dead specimen, perhaps stuffed or possibly preserved in salt, like the walrus head sent by the Norwegian archbishop Erik Walkendorf to Pope Leo X in 1520 (Kiparsky 1952, 29, 46–47). In any case, Dürer found this animal so extraordinary that he used his illustration of it a few

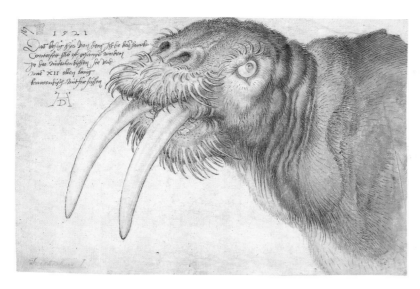

months later to characterize the dragon of Saint Margaret in a preparatory drawing (1522) for a *sacra conversazione*, a painting that was probably never executed (Strauss 1974, 4:2180–2181, no. 1522/1). J.M.M.

208 🦢

Albrecht Dürer
Nuremberg, 1471–1528

IRISH WARRIORS AND PEASANTS

1521
pen and ink with watercolor on paper
21 x 28.2 (8¼ x 11⅛)
references: McClintock 1950, 30–31, fig. 17; McClintock 1958, 1–2; Goris and Marlier 1971, 77, 94, 185, no. and fig. 69; Strauss 1974, 4:2064–2065, no. 1521/36; Anzelewsky and Mielke 1984, 111–112, no. and fig. 108

Kupferstichkabinett, Staatliche Museen Preussischer Kulturbesitz, Berlin

Dürer's fascination with exotic costumes is evident as early as his first trip to Italy (1494–1495), when he recorded the costumes of Venetians as well as those of orientals (cat. 110); it continued throughout his career. In the diary of his journey to the Netherlands (1520–1521), Dürer noted that he "drew a girl in her costume at Goes"; a few months later in Antwerp he "sketched, in black and white on grey paper, two Netherlandish costumes" (Goris and Marlier 1971, 77, 94). His most splendid costume studies from the Netherlandish trip are the present sheet and three drawings of Livonian women. He may have seen the latter in Antwerp during the great annual Assumption Day procession of 1520, which he recorded at length. In it were, in his words, "boys and maidens most finely and splendidly dressed in the costumes of many lands representing various Saints."

The costume studies cannot have been executed on that occasion, however, for they are clearly dated 1521. The only information provided by Dürer is in the inscription on the present drawing: "This is the attire of soldiers in Ireland, beyond England," and "This is the attire of peasants in Ireland." That the costumes are indeed Irish cannot be doubted (for a study of early Irish costume see McClintock 1950, 30–31; McClintock 1958, 1–2: this entry employs his terminology and descriptions of early Irish costumes from this source, often verbatim). The first soldier from the left has a helmet and wears a long quilted garment called *cotún* in Gaelic; he holds a lance and wears a dirk at his side. His companion has a coat of arms over a long tunic (perhaps the Gaelic *Léine*?); he holds a large sword in his right hand, a bow in the left, a dirk at his side, and arrows under his arm, a rather heavy load for one person. More traditionally dressed is his neighbor, who wears over his tunic an Irish *Brat*, a large woollen sleeveless cloak or cape with a shaggy lining, which was wrapped around the body and, if necessary, covered the head of the wearer; in Dürer's drawing, he holds a large sword or claymore, without scabbard. The two peasants armed with axes have long tunics; one of them wears a short tunic over the long one and has a bag hanging on his belt, while the other holds a horn. Dürer clearly based his drawing on Hibernian costumes; that the clothes were actually worn by Irish people, however, is less probable, as the figures have no trews (Gaelic *Trius*), the close-fitting trousers reaching to the ankles.

Dürer's inscription states only that this is the way soldiers and peasants dress in Ireland. His wording—especially in the original German—does not imply that he saw real Irishmen in this garb. It has been suggested that he copied someone else's drawings—the fact that when in Antwerp he lodged at Jobst Plankvelt's inn, in the Engelsche Straat, the street where the English merchants lived, would support this hypothesis—but the almost archaeological exactitude of the drawing suggests that his discerning eye was at work. Dürer may simply have dressed local models in examples of Livonian and Irish costume, which may have been used in processions to illustrate the antiquity of Irish Christianity and the universality of Christian belief. Alternatively, the costumes could have been curiosities acquired by a collector whom the artist knew. J.M.M.

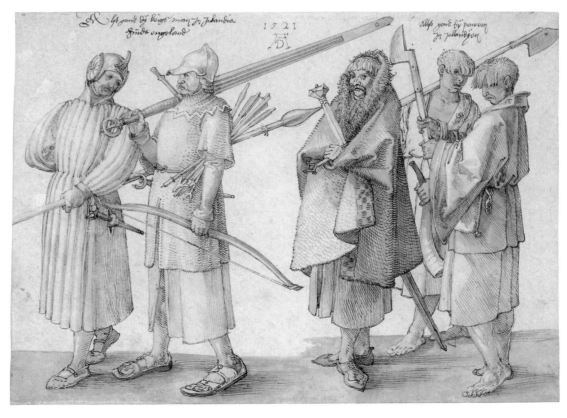

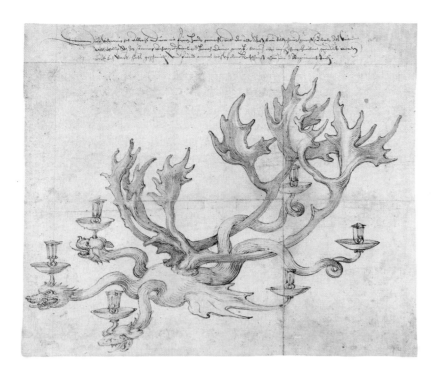

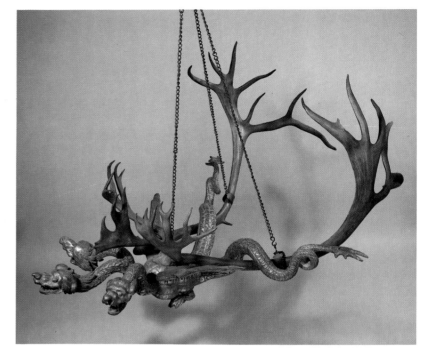

209 ᣆ

Albrecht Dürer
Nuremberg, 1471–1528

DESIGN FOR A CHANDELIER

c. 1521–1522
pen and watercolor on paper
16.8 x 21.3 (6⅝ x 8⅜)
references: Kohlhaussen 1939; Heikamp 1960,
44–46, 48–51, fig. 3; Strauss 1974, 3:1378–1379,
3:1380–1381, no. 1513/29; New York and
Nuremberg 1986, 332, no. and fig. 149

Städtische Museen Konstanz, Wessenberg-
Gemäldegalerie, Constance

The chandelier depicted in the present drawing was executed by the sculptor Willibald Stoss (cat. 210). An inscription on the sheet by either Anton or Johann Neudörfer, grandsons of Johann Neudörfer (1497–1563), the famous calligrapher who wrote biographies of Nuremberg artists, provides some details on the commission: "This design was made by Albrecht Dürer himself, and old Stoss, who was a carver, the father of Veit and Phillip Stoss (who were my grandfather's pupils and later assistants and were subsequently ennobled on account of their writings), actually carved it, and you can still see it at the Rathaus here, in the governing chamber." From another document we know that the chandelier made by Stoss after Dürer's design was commissioned by Anton Tucher for the governing chamber of the Nuremberg Town Hall.

One of the many objects recorded with interest in Dürer's Netherlandish diary is the buffalo horn. He bought a number of them, perhaps for their sheer rarity, possibly to have them mounted

as drinking horns, or simply to keep as raw material. By the time of his death, Dürer also owned a collection of antlers. In a letter to Johann Tschertte written in November 1530, Willibald Pirckheimer observed that he would have liked to have obtained these, especially one that was quite beautiful, but that Dürer's widow Agnes had secretly sold them for a pittance, along with other choice items. Pirckheimer, too, had a large collection of antlers, which were displayed around his house (for the inventory of this collection at Pirckheimer's death, see Heikamp 1960, 48–51). Another design for a chandelier by Dürer, probably executed in 1513, shows a chandelier made of antlers along with a siren that holds Pirckheimer's coat of arms; the siren may have been a tribute to Crescentia Rieter, Pirckheimer's wife, who had died in 1504 and whose coat of arms included a mermaid (Strauss 1974 3:1378–1379, no. 1513/28). J.M.M.

210 ᣆ

Willibald Stoss, after Albrecht Dürer
Nuremberg, c. 1500–1573

CHANDELIER IN THE FORM
OF A DRAGON

1522
gilded limewood and reindeer antlers
48 x 125 x 153 (18⅞ x 49¼ x 60¼)
references: Kohlhaussen 1939, 135–141, figs. 1–3;
Heikamp 1960, 42–55, fig. 4; Grote 1961, 76–77,
fig. 36; Nuremberg 1983, 172–175, no. 13,
figs. 112–113; Kahsnitz 1984, 48–49; New York and
Nuremberg 1986, 332–333, no. and fig. 150

Germanisches Nationalmuseum, Nuremberg

The inscription on the preparatory drawing (cat. 209) states that Dürer designed this chandelier, which was made by "Old Stoss," who has been correctly identified as Willibald Stoss, son of the famous Veit Stoss. Willibald carefully followed Dürer's design: his three-headed dragon has long, twisted necks and two tails curled around the antlers. The chandelier was in fact commissioned by Anton Tucher II (1457–1524), chief treasurer of Nuremberg. From his account book we learn that it was intended to be hung in the Town Hall: "Item, on March 1 [1522] I presented the city fathers with an elk horn of thirty-four points with a carved, gilded dragon holding seven lights and costing twenty-four guilders, for their newly built upstairs chamber." This room, the governing chamber, was the meeting place of the *septemviri*, the executive committee of the council.

The great antlers, with a total of thirty-four points, are not those of the elk (*elch*) mentioned in Tucher's account book, but rather of a reindeer (*Rangifer tarandus* L.), an animal that is found in Europe only in Scandinavia. Dürer's fascination with antlers and horns is well known: in 1520 he asked Georg Spalatin to remind his master, Frederick the Wise, Elector of Saxony, to send Dürer the antlers he had promised him, "as he wanted to make two chandeliers with them." Frederick the Wise was one of the most powerful of German princes, and it may have been from him that Dürer obtained the exceptionally large antlers used for the Nuremberg chandelier. The governing chamber of the Nuremberg Town Hall was, after all, the private meeting room for the seven electors—of whom Frederick the Wise was one—when the imperial Diet was in session in the city. J.M.M.

II

Toward Cathay

CIRCA 1492 IN JAPAN: COLUMBUS AND THE LEGEND OF GOLDEN CIPANGU

Martin Collcutt

Marco Polo, Columbus, and the Dream of Golden Cipangu

The Japanese have for centuries called their country Nippon or Nihon, "Source of the Sun." As early as the seventh century the characters for *Nippon* appear in a letter from the Japanese prince Shotoku to the Chinese emperor. The English word *Japan* is derived from *Cipangu*, the name by which Marco Polo (1254–1324) designated a land of great wealth he had heard about during his travels in Cathay (China) in the service of the Mongol khan Khubilai during the late thirteenth century. Probably *Cipangu* was derived from *Riben Guo*, the Chinese pronunciation of the characters for "Kingdom of Japan." Marco Polo never visited Japan, and no doubt based his description on not very reliable tales heard from the Chinese and Mongols he met on his travels. Although there were nonofficial contacts between Japan and China in the thirteenth century—Japanese monks visiting China in search of Chan (J:Zen) and other Buddhist teachings, Chinese Chan monks traveling to Japan, and Japanese freebooters engaging in illicit trade along the Chinese coast—such contacts were at best sporadic and were interrupted first by the Mongol conquest of China and Korea and then by the Mongol attempts to invade Japan in 1274 and 1281.[1]

In the account of his travels, written after his return to Italy, Marco Polo described Cipangu as a large island, one of more than seven thousand in the seas far to the east of Cathay, richly endowed with gold, spices, and pearls:

Japan [Cipangu] is an island far out at sea to the eastward, some 1,500 miles from the mainland [of China]. It is a very big island. The people are fair complexioned, good looking, and well mannered. They are idolaters, wholly independent and exercising no authority over any nation but themselves.

They have gold in great abundance, because it is found there in measureless quantities. And I assure you that no one exports it from the island, because no trader, nor indeed anyone else, goes there from the mainland. That is how they come to possess so much of it—so much indeed that I can report to you in sober truth a veritable marvel concerning a certain

palace of the ruler of the island. You may take it for granted that he has a very large palace entirely roofed with fine gold. Just as we roof our houses or churches with lead, so this palace is roofed with fine gold. And the value of it is almost beyond computation. Moreover, all the chambers, of which there are many, are likewise paved with fine gold to a depth of more than two fingers' breadth. And the halls and the windows and every other part of the palace are likewise adorned with gold. . . .

They have pearls in abundance, red in color, very beautiful, large and round. They are worth as much as the white ones, and indeed more. In this island the dead are sometimes buried, sometimes cremated; but everyone who is buried has one of these put in his mouth.[2]

As Marco Polo's fabulous accounts of the wealth and wonders of East and Southeast Asia filtered into the Western view of the world, they added to the lure of the Indies and the Spice Islands in the Western imagination. Cipangu joined the Kingdom of Prester John, St. Brendan's Isles, and Antillia as yet another fabulous kingdom to be reached and exploited. Polo's travels—by pushing the boundary of China much farther to the east than Ptolemy's Catigara in Asia and locating Cipangu 1500 miles farther east than the coast of Cathay—extended the boundaries of the known world and reshaped contemporary understanding of the size of the world, which knowledgeable people were coming to think of as a globe.[3] By the fifteenth century Cipangu was marked on maps of the world. On a Genoese map of 1457 it is shown off the coast of China. On the Behaim Globe of 1492 Cipangu, depicted on the same meridian as the Canary Islands, is the largest of a cluster of islands off the coast of Cathay.

Columbus owned a copy of Marco Polo's travels, to which he added his own marginal comments. He must also have been familiar with world maps showing Cathay and the golden kingdom of Cipangu. Cipangu (or Cipango, as he called it) played a crucial, and controversial, role in the voyages of Columbus,

and in their subsequent historical assessment. In the traditional view, one that went largely unchallenged until this century and is still generally accepted, when Columbus sailed from Palos in 1492 he did so with the intention of finding a shortcut to the gold and spices of the east by sailing west into the Atlantic, which he called the Ocean Sea. This view is enshrined in Columbus' own *Diario* (Journal of the First Voyage) and its prologue,[4] in the *Letter* of Columbus describing the first voyage,[5] in the biography by his son Fernando,[6] in the accounts of the discovery of the Indies by las Casas,[7] Peter Martyr,[8] and Oviedo,[9] and was expressed most vigorously in this century in the Pulitzer Prize-winning study by Samuel Eliot Morison, *Admiral of the Ocean Sea.*[10] All agree that Columbus set out with the intention of sailing west to Asia and hit America (although he failed to realize it) by chance or divine providence. In this great "enterprise of the Indies," he would naturally have expected to find and explore the island of Cipangu before reaching the coast of Cathay and the territories of the Grand Khan.[11]

In this century the above view of Columbus' grand Asian design was sharply challenged by Henry Vignaud and others,[12] who argue that Columbus had no grand enterprise in mind from the outset, that he was simply searching for undiscovered islands in the Atlantic in the hope of winning a valuable estate for himself and his family. Then, having found islands much farther west than he had anticipated, Columbus concluded that he had reached Asia and changed his *Journal* to suggest that Asia had always been his goal. It is true that no reference to the Indies as his hoped-for destination occurs in his *Journal* entries for the voyage across the Ocean Sea to his landfall on the island that he would call San Salvador. And the prologue, in which he does refer to an Indies enterprise, may have been added at a later date. On the other hand, within a day of the landfall Columbus records that he is enthusiastically seeking the golden island of Cipangu. And, given the many references in Columbus' *Journal* to Cipangu, the Great Khan, Cathay, and the Indies, some of them self-contradictory or left obviously uncorrected as Columbus sailed farther and learned

more, one would have to assume that if the *Journal* was consciously falsified by Columbus and those who had access to his manuscript, it was rewritten almost completely. In short, if credence can be given to the *Journal* of the first voyage, it is hard to escape the conclusion that from the moment he reached the islands of the Caribbean, if not before, Columbus was fired with dreams of gold, spices, and Christian converts. He believed he was in the "Indies." He seems to have had a fixed idea that the source of gold, if he could only find it, must be Marco Polo's Cipangu, and that he was getting closer by the day. When he left his men at La Navidad, he and they believed that the nearby region of Cybao was in fact Cipangu and that their dreams were on the point of realization. Not far away, he believed, lay a land mass that could only be the realm of the Great Khan.

Before he reached Spain on the return voyage he was driven to shelter in Portugal, where he told the doubting king that he was returning from the Indies. The Spanish monarchs accepted his word that he had been there. He received a letter from Ferdinand and Isabella addressed to "Don Cristobál Colón, their Admiral of the Ocean Sea, Viceroy and Governor of the Islands that he hath discovered in the Indies."[13] Apart from the Portuguese, most contemporaries believed Columbus' assertions that he had reached the Indies, though a few doubted that the globe was so small that he could have got there in only thirty-three days' sailing from the Canaries. Even on his second, third, and fourth voyages neither he nor the vast majority of his contemporaries seem to have seriously questioned the conviction that he had discovered a western route to Asia. This conviction blinded him to his discovery of a vast new continent.

Columbus was the first Renaissance-era European to encounter the "New World" of the Americas, but after three more expeditions to it he still went to his grave believing he had simply discovered a route to the islands of the East. Despite his four unsuccessful attempts to find and exploit the realms of the Great Khan, Cipangu, and Prester John, Columbus never abandoned his belief that he had connected Europe and Asia with a month-long voyage. When others suggested that he had discovered a new continent, he rejected the notion, only acknowledging that the Asian islands were more extensive than he had imagined. Throughout 1493, having found Cuba and Hispaniola, he insisted that each in turn was Cipangu. In 1498 he believed that he was sailing south of Cipangu and Cathay, that the mainland of South America was part of a peninsula protruding from Malaysia, and finally believed that the

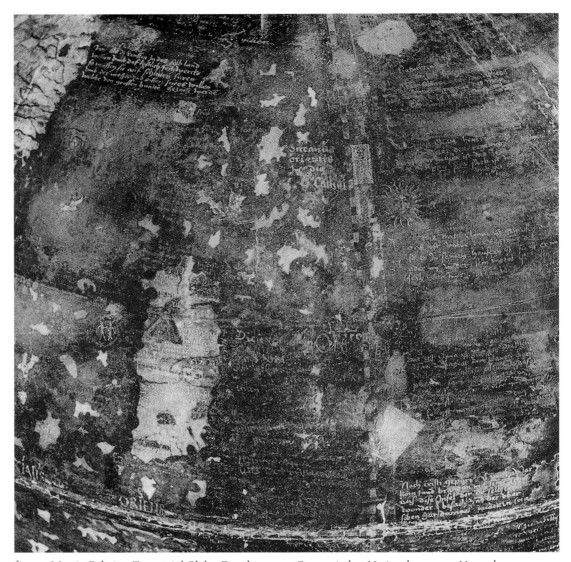

fig. 1. Martin Behaim, *Terrestrial Globe*. Dated to 1492. Germanisches Nationalmuseum, Nuremberg

coast he sailed along in his last voyage of 1502–1503 was not a new mainland, but the Malay Peninsula itself. To the end he was unable to acknowledge his discovery of a new world because he clung to the belief that he had indeed found his way westward to the old world of Cipangu, Cathay, and the Indies.

Japan in the age of Columbus
If Columbus had actually found his way to Cipangu on one of his voyages, what kind of reception might he have received and what kind of land and society would he have described in his journal and letters? The question is not far-fetched. Columbus himself hoped to circumnavigate the world. Had he recognized that South America was not an Asian island but a continent that blocked his way to Asia, he might have sailed southward looking for a passage eastward to the gold and spices he was seeking. His Florentine contemporary Amerigo

Vespucci, who did recognize America as a "New World," sailed down the coast of Argentina on one of his voyages, searching for such a passage. Magellan, sailing much farther south, found that passage in 1520 and then sailed west-north-west across the Pacific to the Philippines. Had Columbus reached the Philippines, he might have learned that Cathay was close at hand and that there were many islands to the north, including Cipangu.

If, as the Portuguese were to do in the 1540s, he had approached Japan from Southeast Asia and the China coast, he would already have heard stories of Japan and perhaps have encountered some of the freebooters (*wakō*) who in the 1490s sailed Asian waters and alternately traded with and ravaged the coastal settlements of Korea and China. Although known as "Japanese pirates," the marauders comprised Koreans and Chinese as well. Columbus might even have made a landfall at one of the small Japanese trading communities which, in the late fif-

teenth and sixteenth centuries, were beginning to mushroom in the Philippines and other Southeast Asian countries. There he would have learned something of Japan and, as he did in the Caribbean, he would undoubtedly have taken native people aboard as possible guides and interpreters. If, on the other hand, he had found his way across the Pacific on a course to the north of Magellan's, he would have had little warning or access to reliable information before making land on one of the Japanese islands.

In either case he would quickly have found that the inhabitants of Japan in 1492 were not poorly armed, naked islanders with a culture that he and his fellow Europeans could easily dismiss or exploit. Like later Iberian visitors, he would have realized that the Cipangu of his dreams was both less and more than the fabulous realm of Marco Polo's hearsay. Gold in the quantities he dreamed of Columbus would not have found, but instead a civilization to rival that of the Europe he knew and a people as proud, productive, well organized, cultured, and combative as contemporary Europeans.

Columbus' first encounter with Japan might well have resembled that of the first Portuguese, blown ashore on the small island of Tanegashima fifty years later (1543). He would have been greeted not by naked, unarmed islanders but by fishermen or local samurai armed with swords and spears. As he did in the Caribbean, Columbus would no doubt have gone ashore with a small band of armed men in one of the longboats. The Japanese, long accustomed to contacts with their Asian neighbors the Chinese, Koreans, and Ryukyuans, would have greeted these red-faced, hairy "Southern Barbarians" with great curiosity tinged with hostility. Columbus would no doubt have presented some trinkets (on his voyages he carried only very cheap trade goods, hardly gifts fit for the Great Khan or the ruler of golden Cipangu). Although the Japanese produced the finest sword blades in the world and exported them to China in great quantities, they did not yet have firearms. They would have shown great interest in the swords Columbus and his men wore, perhaps even tested their edges, but they would have been more interested in the strange-looking guns. As the Portuguese were to do, Columbus might have been persuaded to demonstrate the weapons he had on the ships, perhaps impressing the Japanese samurai he met with the military effectiveness of the cannon and arquebus. The Japanese would certainly have been intrigued by the new technology, as they were by the later Portuguese demonstration of firepower. Warrior leaders (*daimyō*) quickly adopted the new technology after 1543. The effective use of guns by warriors like Oda

Nobunaga (1534–1582) became a decisive factor in the military reunification of the country in the second half of the sixteenth century.

If the encounter had gone well, Columbus and his crew might have been allowed to sail away from this first landfall in Japan unharmed. But if he had mishandled the encounter, he might have been attacked, in which case he would have found the Japanese far more formidable opponents than even the hostile Caribs of the West Indies. Japanese samurai officials would have resisted his practice of laying claim to any land he found by planting the flags of Castile and León. They might also have been angered at any attempt to erect a cross in the name of an alien religion. He would quickly have realized that Cipangu, or Nippon, unlike many of the islands to which he laid claim in the Caribbean, had a complex political and religious structure, and a well-developed national self-consciousness, and that claiming territory in the name of Ferdinand and Isabella would be risking his life. He and those who had landed with him might have lost their heads on the spot or, more likely, been taken for interrogation to the local *daimyō*'s castle. If his arrival had sparked Japanese alarm, later comers would have met a more hostile reception than they did. Instead of initially welcoming Christianity and commerce, Japanese *daimyō* might well have rejected Western contacts from the outset, though this would probably not have prevented the eventual push by Portuguese, Spanish, Dutch, and English

into Japanese waters—Europe was too expansive to be easily halted.

If he had been able to establish good relations with the first Japanese villagers he met, Columbus would quickly have asked them about his overriding concerns: gold, the prospects for commerce and Christian conversion, and the location of the ruler's palace. If they had been candid with him, they would have told him that there was little gold or silver to be had in the villages. Iron was abundant, and copper coins imported from China circulated in some markets, but gold was rare and used only by powerful *daimyō* or the rulers in the capital. They would have told him that merchants and freebooters from Japanese ports plied Asian waters and were active in commerce, that Japan had wealthy cities, including Miyako (Kyoto), Sakai, Hakata, and many smaller towns, and that local trade and commerce was spreading and flourishing, especially in the provinces around the capital. Regarding religion, Columbus would have heard that the Japanese were devoted to the teachings of the Buddha, the native gods (*kami*), and Confucius. In general, these beliefs were not only mutually tolerant but considerably intermingled. Some Japanese might have been curious about the teachings of "Deus," but Columbus would probably have concluded that he would make more converts if he could gain the support of some *daimyō*.

In 1492 there was no single political authority ruling Japan. The country was at its most

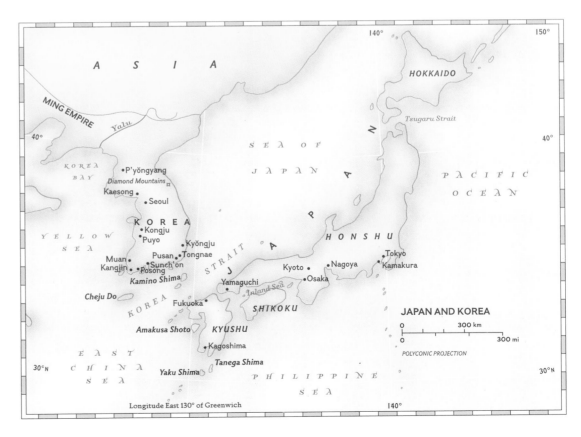

JAPAN AND KOREA

divided. Instead of the one king described by Marco Polo, Columbus would have learned that he had two shadowy rulers to contend with, the emperor and the shogun, both of whom had palaces in the capital, Miyako, but neither of whom held much political or military power. Real power was wielded by some 250 daimyō, who fought each other to defend and enlarge local territories.

Since most visitors to Japan came from the south and west, Columbus might well have entered one of the steeply wooded natural harbors of Kyushu, controlled by a powerful daimyō family like the Shimazu of Satsuma or the Ōtomo of Bungo (present-day Kagoshima and Ōita prefectures, respectively). It was the daimyō of western Japan who, a few decades later, would prove most hospitable to the Iberian traders and missionaries in their black ships. In western Japan Columbus would have gained some inkling of the power and wealth of provincial feudal lords. He would have been impressed at first sight of the Shimazu garrison town of Kagoshima, with the volcano of Sakurajima fuming above it, one of the castle towns that were to play such an important role in Japan's subsequent urban development. He would soon have realized that in southern Kyushu the writ of the Shimazu family, who had been entrenched there for centuries, ran larger than that of any central authority. He would have seen evidence of the daimyō's power and wealth in the massive stone ramparts of the castle and its tall wooden superstructure, in the awed deference accorded the daimyō and his samurai officials by merchants and farmers. He would not, however, have found much gold, other than in paintings and inlaid metal and lacquerwork, nor any gold mines. He and his crew members might have been showered with gifts, and eventually sent on their way home knowing something of the reality of Marco Polo's Cipangu. Had that happened, no doubt Portuguese and Spanish traders and missionaries would have headed for Japan sooner than they did, and the curtain would have opened a little earlier on what has come to be known as Japan's "Christian century." Or Columbus might have been permitted to stay, perhaps encouraged to make his way through the Inland Sea to the port of Sakai, whence he could easily have visited the capital, Kyoto. En route he might have called at the castle town of Yamaguchi, where the Ōuchi daimyō family ruled over one of the liveliest, richest, and most cultured provincial courts in Japan. He would have seen evidence of a thriving local commerce in the Inland Sea and perhaps of the Ōuchi trade with China.[14] He might even have been shown some of the paintings of Sesshū, greatest of Japanese painters of the age

(cat. 230–233), who enjoyed the patronage of the Ōuchi.

Politics and society

In order to find a source of central authority with whom to negotiate, appeal for gold, and perhaps claim territory or discuss Christianity and the conversion of the country, Columbus would naturally have been eager to learn more about the ruler of Japan, the owner of the golden palace described by Marco Polo, and about the political structure of the country.

Any knowledgeable and candid informant would have told Columbus that he had reached Japan at a time when central authority was at its lowest ebb and the country seemed in danger of total fragmentation through feudal rivalries and provincial wars. A sovereign, the emperor (tennō, referred to later by the Portuguese as mikado), and a military overlord, the shogun, both lived in palaces in the capital of Miyako. Though they could be described as wealthy, both had far less wealth and political power than their predecessors, and neither exerted much influence beyond the capital.

In 1492 the emperor was Go-Tsuchimikado (1442–1500, r. 1465–1500), eldest son of Emperor Go-Hanazono. He was succeeded by his son Go-Kashiwabara (1464–1526, r. 1500–1526). The court was weakened and financially distressed, both by the Ōnin War (1467–1477), which had devastated the capital and interrupted revenues from the court's provincial estates, and by the encroachments of provincial warrior clans on these same estates. Nevertheless, the sovereignty of the emperors, who claimed descent from the Sun Goddess, went unchallenged. Though politically enfeebled, the emperor continued to serve an important political legitimating function; though financially straitened, and with many of the nobility and high clergy fled to the countryside for safety, the court continued to serve as a center of cultural leadership.[15] Like his father and his son, Go-Tsuchimikado was a student of classical literature and a talented poet and calligrapher (see cat. 237, 238).

The emperors had headed a strong centralized government and ruled in their own right in the Nara (710–794) and Early Heian (794–898) periods. Over the centuries their power had been whittled away: first by Fujiwara nobles who ruled as regents for child emperors; then by members of the imperial line itself who abdicated but continued to wield power, making puppets of the sons they installed in their place;[16] then by the Taira warrior clan who dominated the court in the twelfth century till

they were annihilated and replaced by warrior shoguns of the Minamoto clan who established a military government at Kamakura in eastern Japan; then by regents from the Hōjō warrior clan who asserted control over the Minamoto shogunate in eastern Japan and brought child nobles and imperial princes from Kyoto to serve as puppet shoguns. The imperial court made several attempts to stem the erosion of its political authority. One such attempt, led by abdicated Emperor Go-Toba in 1221, failed miserably. In 1333 Emperor Go-Daigo, leading a coalition of imperial princes, eastern warriors, and Buddhist monastic armies, toppled the Kamakura shogunate and restored centralized imperial government in Kyoto. This restoration ended after barely three years with Go-Daigo ousted from the capital by his former ally, the warrior Ashikaga Takauji (1305–1358), who set up a puppet rival emperor and then took the title of shogun.[17] The court and much of the country was divided by a sporadic but bitter civil war, known as the war between the Northern and Southern courts. It was only reunited in 1392 by the powerful third Ashikaga shogun, Yoshimitsu, who while dominating the court also patronized it and restored its material fortunes somewhat.[18] Any recovery, however, was fleeting. In the fifteenth century the waning power of the Ashikaga shogunate grew ever less adequate to support the court and control the country.

By 1492 the capital was beginning to recover, but the country was still embroiled in local wars and the emperors were too poor and weak to affect political life. Politically and economically the imperial court was at a nadir. For want of funds, Emperor Go-Kashiwabara was unable to hold either his father's prescribed funeral services or his own accession ceremony until many years after he had ascended the throne. Emperor Go-Nara (1496–1557, r. 1526–1557) had to wait ten years for his accession ceremonies, which finally came about only through the support of contributions in gold from various daimyō, including the Hōjō of eastern Japan and the Ōuchi in the west.

In 1492 the political authority of the Ashikaga shoguns was not much stronger than that of the emperors. From its inception the Ashikaga shogunate had been a fragile coalition of the shogun and his most powerful vassals, whom the shogun appointed as shugo or provincial military governors. The third and sixth shoguns, Yoshimitsu and Yoshinori, had exerted considerable power in the late fourteenth and early fifteenth centuries and had generally been able to impose their wills on this coalition and use loyal shugo to isolate and crush opposition by recalcitrant shugo. After Yoshinori's assassi-

nation at the hands of a rebellious *shugo* in 1441, shogunal authority faltered and continued at a low ebb until the mid-sixteenth century. The *daimyō* Oda Nobunaga in his drive for hegemony briefly restored Ashikaga authority, then ended it completely.

During the turbulent fourteenth and fifteenth centuries some *shugo* extended their influence over several provinces, and some, like the Hosokawa, Ōuchi, and Yamana, controlled large areas of western Japan. Eastern Japan (called Kantō), whose warriors were a constant source of challenge to the government in Kyoto, had been placed by the Ashikaga under the control of a deputy entitled *Kantō Kubō*, but was by 1492 effectively out of shogunal control, riven by power struggles between rivals for the office of *kubō* and between rival *shugo* such as Uesugi and Hōjō. By the mid-fifteenth century some of the most powerful *shugo*, known to modern historians as *shugo-daimyō*, were stronger than the shogun and struggled for power among themselves. Lacking a strong army of their own, the Ashikaga shoguns were forced to look on helplessly as *shugo* contended throughout the provinces. The Ōnin War, erupting during the shogunate of Ashikaga Yoshimasa (r. 1469–1473; cat. 214), was a conflagration of *shugo* rivalries.

At first Yoshimasa attempted to govern, but his authority as shogun was steadily undermined by his wife, her family, and other corrupt power-brokers and power-seekers of the shogunal court. The Ōnin War was precipitated by a rash of succession disputes—within various *daimyō* clans and, most importantly, within the Ashikaga clan—which served as pretexts for two rival *shugo-daimyō*, Hosokawa Katsumoto (1430–1473) and Yamana Sōzen (1404–1473), to square off against each other in Kyoto in 1467. *Shugo* and warriors from across the country joined the conflict on either side. The war destroyed much of Kyoto but decided nothing, and even after the fighting ended in the ravaged capital, outbreaks continued in the provinces. Yoshimasa, unable to control political events, abdicated early in 1474. From his retreat at the foot of the Eastern Hills in Kyoto (a villa referred to as Higashiyama, "Eastern Hills," or Ginkaku-ji, "Silver Pavilion") he exerted through his patronage a profound and creative influence on Japanese culture.

After the Ōnin War shogunal authority was increasingly usurped by shogunal deputies (*kanrei*) from the Hosokawa and other warrior families. Ashikaga Yoshitane (1466–1523), installed as the tenth Ashikaga shogun in 1490, was by 1494 displaced from the shogunal office by the warrior Hosokawa Masamoto, who set up the child Ashikaga Yoshizumi as shogun. Yoshi-

tane then turned for support to Ōuchi Yoshioki and Hosokawa Takakuni in driving out Yoshizumi. In 1508 Yoshitane regained the title of shogun but eventually fell out with *kanrei* Hosokawa Takakuni, was again displaced as shogun, and died at Awa.

The Japanese use the term *sengoku jidai* (Age of the Country at War) to describe their turbulent history in the fifteenth and sixteenth centuries, and the word *gekokujō* (inferiors toppling superiors) to describe the volatile process apparent at every level of society. In 1441 the *shugo* Akamatsu Mitsusuke assassinated the shogun Yoshinori and was killed by the *shugo* Yamana Sōzen, to the great benefit of the Yamana fortunes. The *kanrei* Hosokawa Takakuni expelled Shogun Yoshizumi. The Hosokawa were in turn toppled by their vassals the Miyoshi, and the Miyoshi then overthrown by their vassals the Matsunaga. Many *shugo* claimed large territories but lost them to their deputies or other local warriors (*kokujin*) with more tightly knit domains.

In 1492 this social upheaval was still in process. Had Columbus been in Japan, he could have observed the emergent *sengoku daimyō* carving their more compact and better controlled domains out of the larger but more loosely held domains of the *shugo*. From among these *sengoku daimyō* the unifiers of the late sixteenth century, who would reforge the country through war, would emerge. Nor did *gekokujō* stop at the elite level. Peasant uprisings (*tsuchi ikki*), which first broke out in the fifteenth century, also challenged established authority. Serious uprisings occurred in 1426, 1428, 1429, 1441, 1447, 1454, 1457, 1474, 1480, 1485, 1488, and 1532. Some of the peasant leagues were associated with the True Pure Land school of Buddhism and known as *ikkō ikki* (Confederations of the Single-minded), and their outbreaks had religious overtones. In 1488 an *ikkō ikki* took over the province of Kaga in northern Japan and governed it, in defiance of all secular authority, for nearly a century.

Despite warfare and social upheaval, perhaps partly because of it, Japanese society in the late fifteenth century was vibrant and active. Responding to the needs of war and the domain-strengthening policies of the more successful *daimyō*, urban and commercial life was vigorous and expansive. In 1492 Kyoto, recovering from the ravages of the Ōnin War, was rebuilding some of its temples and palaces. Its merchant community (*machishū*) was vigorous, famous for saké brewers, money lenders, and fine craftsmen. Sakai, Nara, Hakata, and other towns enjoyed renewed prosperity. As *sengoku daimyō* established their vassals around their castles, they encouraged local merchants and

tradespeople to come, leading to the formation of castle towns. Early examples include the Ōuchi's Yamaguchi, the Imagawa's Fuchū, the Hōjō's Odawara, the Ōtomo's Funai (Ōita Prefecture), and Shimazu's Kagoshima.

Coastal and river ports were springing up. Yodo served Sakai, Kyoto, and the Yodo River area; Sakamoto and Ōtsu on Lake Biwa were transshipment points to Kyoto from the north; Obama, Tsuruga, and Mikuni were small but active centers on the Japan Sea coast; Hyōgo, Sakai, Ōdou served the Inland Sea area; Kuwana, Yokkaichi, and Ōminato gathered the commerce of the Ise Bay area; and Hirata, Bōnotsu, and Hirado were developing in Kyushu. The Inland Sea was a vital channel for increasingly lively interregional coastal trade. As in European and other societies, religious centers became commercial nuclei. These temple gate towns (*monzen machi*) included Zenkō-ji in the mountains of Nagano, Ujiyamada serving the Ise Shrines, Sakamoto for the great Buddhist monastic complex of Enryaku-ji. True Pure Land temples in Osaka (Ishiyama Hongan-ji) and Kyoto (Yoshizaki Dōjō) had commercial centers within their confines.

Guilds (*za*) under the sponsorship of temples in Nara and Kyoto were active in the production and distribution of such commodities as oil, paper, and saké. These guilds, enjoying monopolies and exemptions from market taxes and toll barrier fees, extended commerce but also controlled and restricted it. Commerce was hampered as well by poor roads and by private toll barriers (*sekisho*) on roads and rivers, mostly controlled by powerful temples but also by Shinto shrines and perhaps by some *shugo*. The *daimyō* domains likewise impeded nationwide trade, as each *daimyō* sought to promote local merchants, guilds, and markets in an effort to strengthen his own domain.

Hakata, Yamaguchi, Sakai and other coastal cities of Kyushu and the Inland Sea area benefited from trade with China and Korea. A carefully restricted official "tally" trade was recognized by the Chinese authorities, who issued tallies to a limited number of Japanese vessels, authorizing them to trade in Chinese ports. The trade was initiated by Ashikaga Yoshimitsu, cut off by his successor, revived again by the sixth shogun, Yoshinori. *Shugo*, merchants, and Zen monks of Kyoto temples such as Tenryū-ji and Shōkoku-ji handled this trade, with part of their profits going to the shogunate in taxes. After the Ōnin War the Ōuchi and Hosokawa families fought over the trade, the Ōuchi eventually gaining a dominant position. Both clans remained involved until the official tally trade withered in the mid-sixteenth century. Major exports were sulfur,

swords, and fans. Imports included copper cash, raw cotton and cotton textiles, Chinese ceramics, books, and religious texts.

From the Kamakura period (1185–1333) a coinage-based economy had been developing in Japan, with copper coins imported in great quantities from China in the fifteenth century. The Ashikaga shoguns did not attempt to mint their own coins, preferring, or finding it easier, to control the flow of Chinese coins. During the Muromachi period a variety of Chinese copper coins of the Song (960–1279), Yuan (1279–1368), and Ming (1368–1644) dynasties were in use. Because the coinage was not standardized and the quality of coins fluctuated wildly, traders hoarded good coins, despite frequent shogunal and *daimyō* edicts to the contrary.

As Columbus' *Journal* attests, greed for gold was the spur that pricked his expeditions along. Though the gold-roofed palace of Marco Polo's account never existed, a more modestly golden palace had been built in 1397 by the third Ashikaga shogun, Yoshimitsu (r. 1368–1405) as a shogunal retreat in the Northwestern Hills (Kitayama) of Kyoto, overlooking a lake. The three-story building, covered with gold leaf, came to be known as the Golden Pavilion (Kinkaku-ji). It symbolized Yoshimitsu's political and cultural leadership and his interest in Zen and Pure Land Buddhism, and became a center of the cultural spirit of Yoshimitsu's age, known as Kitayama culture. The ground floor was an Amida worship hall, formal and symmetrical in its architecture (a style known as *shinden*); the second story was a Kannon worship hall in the more informal warrior style (*buke-zukuri*); and the upper story was a Chinese style meditation chamber.

Yoshimasa's Ginkaku-ji, completed two years before Columbus sailed, reflected the straitened circumstances of the shogunate in Yoshimasa's day. Built as a Kannon worship hall, the two-story building was to have been faced with silver leaf; although this was never done, the building came to be known as the Silver Pavilion and became a center of the culture of the Higashiyama era.

In Japan as in Europe, gold was prized. It was found in rivers and streams in several provinces, although the supply was not abundant before the sixteenth century, and some was imported from the continent. In the Nara (710–794), Heian, and Kamakura periods it had been used for personal accessories, coins, Buddhist sculpture, and works of art and craft. Gold was effectively combined with lacquer, paper, and metal to produce some of the finest works of Japanese art. Gold mines began to be exploited by the *sengoku daimyō* and gold was mined in increasing quantities in the sixteenth century, which

fig. 2. View of the Silver Pavilion (Ginkaku-ji), Kyoto

has been described as a "golden age" in Japan for the lavish use of gold in paintings and decorative arts. The most bountiful gold mines were in Kai and Hitachi provinces and on Sado Island.

Like gold, silver was used from early times for art objects, ornaments, and exchange. Its use was restricted only by the limited supply prior to the sixteenth century. From the sixteenth century silver mines were opened up by many *sengoku daimyō* seeking financial resources for armaments, warriors, and castle construction. Two of the largest and most famous were the Ōmori and Ikuno mines in the provinces of Iwami and Tamba.

Shortage of gold and silver throughout the medieval period prevented their use in a reliable coinage. The commercial economy that developed vigorously in the Kamakura and Muromachi periods relied on imported Chinese copper cash, with occasional reversions to barter caused by the inadequate or erratic supply and quality of the coins. In the late fifteenth and sixteenth centuries gold and silver began to inundate the Japanese economy. The warrior-unifiers, Nobunaga and Hideyoshi, coveted precious metals and used them in large quantities to finance their military campaigns. Hideyoshi, in particular, sought to monopolize the mineral

wealth of the nation. He instituted the minting of gold coins, used gold prolifically in his personal effects and buildings, and built himself a golden tea room with pure gold tea utensils. Still, although shoguns and emperors and many of the *daimyō* lived in palaces and castles with gilded screens and wall paintings and ate off gold-inlaid lacquered dishes, none commanded the immense treasure alleged by Marco Polo. The closest to Marco Polo's legend were the shogun Yoshimitsu, whose three-story Golden Pavilion was completely covered with gold leaf, and the warrior-hegemon Toyotomi Hideyoshi (1537–1598), who minted great golden coins and flaunted his wealth and power in a golden tea house.

Religion

In describing religious life in China, Marco Polo lumped all schools of Buddhism under the heading of idolatry. Any observant visitor to Japan in 1492 would have noted that there was considerable diversity to Japanese religious life and also that the various religious traditions generally, though not always, coexisted harmoniously. Buddhism, in a variety of different schools, was the dominant religious and intellectual force in medieval Japanese society, but the Japanese also revered the native Shinto gods (*kami*), observed Confucian teachings, and were interested in Daoism and in the Chinese cosmology of *yin* and *yang* and the five elements.

Buddhist temples and Shinto shrines were everywhere, and coexisted easily. Most Buddhist temples had a protective Shinto shrine within their precincts, and Buddhist monks served as priests in many Shinto shrines. In cultic centers like Kumano and Kasuga the *kami* and the Buddhas reinforced each other according to a syncretic construct called *honji-suijaku* (Original Ground–Manifest Trace), in which the Shinto *kami* were considered to be local manifestations (*suijaku*) of the original and universal Buddhist deities (*honji*; see cat. 211, 241). Buddhism and Shinto also intermingled in the growing cult of mountain asceticism and mountain pilgrimage (*Shugendō*; see cat. 252). Already, however, some Shinto advocates objected to such syncretism and to the dominance it accorded Buddhism, advocating a doctrine of Shinto primacy (*yūitsu* Shinto) which encouraged veneration for, and pilgrimage to, the Ise shrines.

A Western visitor to Japan in 1492 would have been struck by the institutional authority, landed wealth, and armed might of such older Buddhist centers as Enryaku-ji, Kōyasan, Negoro-ji, and the monasteries of Nara, the old capital. Among the various schools of Japanese Buddhism he might have found most in common with one of the branches of the devotional Pure Land (Jōdo, or Amidist) movement, which had been offering the promise of easy salvation to all—specifically including the commoners—since the late twelfth century. Pure Land practice called only for faith—faith in the compassionate vow of Amida Buddha that all sentient beings could attain salvation in his Pure Land, or Western Paradise. Salvation (*ōjō*) did not require a heroic religious life; simple devotion to Amida, expressed in the formula "Homage to Amida Buddha" (*Namu Amida Butsu*, known as the *nembutsu*), sufficed. This teaching held powerful appeal in an age of war, when it was believed that Japan had entered the last stage of moral dereliction (*mappō*), predicted in Buddhist teaching. The three major currents of Amidist belief in the medieval period were the Pure Land school (Jōdo), the True Pure Land school (Jōdo Shin), and the Timely school (Ji). All three branches were flourishing in the late fifteenth century. The True Pure Land school, revitalized and reorganized by Rennyo (1415–1499), who established the Ishiyama Hongan-ji of Osaka as its principal temple, was emerging as the largest and most powerful popular Buddhist movement in Japanese history. Pure Land Buddhism contained strong resonances with Christian concepts of personal sinfulness and repentance, a saving power greater than oneself, rebirth in Paradise for repentant sinners as well as for the righteous, and punishment in purgatory or hell for the unrepentant (see cat. 213).

Pure Land was not the only popular Buddhist movement. Among the townspeople of Kyoto and the samurai of eastern Japan belief in the efficacy of the Lotus Sutra, popularized by Nichiren (1222–1282), was deep-rooted. And Zen, which had gained a foothold in Kyoto and Kamakura under elite patronage in the thirteenth century, was by this time a nationwide movement with both elite appeal and a strong popular character. By the 1490s its two major schools, Rinzai and Sōtō, spread throughout Japan, and distinguished Zen prelates moved easily and expertly among the courtly and warrior aristocracies—as advisers in government and diplomacy, as poets, essayists, scholars, painters, and connoisseurs, and of course as spiritual mentors.

In the 1490s the various Rinzai Zen lineages could be divided into establishment and antiestablishment camps. The Rinzai establishment, officially sponsored, comprised the "Five Mountains" (*Gozan*)—five leading metropolitan monasteries in Kamakura and five in Kyoto—and their many provincial satellite temples, forming a network of several hundred monasteries across the country. From the fourteenth century the most influential *Gozan* lineage was that of Musō Soseki (1275–1351). Monks of his lineage frequently headed the great Kyoto monasteries of Tenryū-ji, Shōkoku-ji, and Nanzen-ji, as well as Engaku-ji in Kamakura and many leading provincial monasteries. The antiestablishment Rinzai lineages were those of the Kyoto monasteries of Daitoku-ji and Myōshin-ji and their subtemples. Whereas the *Gozan* lineages had been sponsored in the thirteenth century by the Hōjō regents who headed the Kamakura shogunate, and in the fourteenth and fifteenth centuries by the Ashikaga shoguns, Daitoku-ji and Myōshin-ji, because of their close ties with Emperor Go-Daigo and their distinctive Zen traditions, had been excluded from shogunal patronage and official sponsorship. A perceptive observer of Rinzai Zen in 1492 might have noticed that the *Gozan* monasteries, weakened by the destruction of the Ōnin War, the erosion of shogunal sponsorship, and institutional lethargy, were declining in influence, while Daitoku-ji and Myōshin-ji were coming into their own under the patronage of the emerging *sengoku daimyō*.

Sōtō Zen, centered on Eihei-ji in Echizen and Sōji-ji on the Japan Sea coast, was strong among samurai and farmers. Both branches of Zen emphasized the importance of seated meditation (*zazen*). But whereas Rinzai Zen maintained a strong Chinese monastic tradition and stressed *kōan* practice and monastic life, Sōtō Zen after the mid-thirteenth century combined *zazen* with prayers for worldly purposes and with funeral rituals.

A Western visitor would have found the monasteries, monks, and teachings of the two major Zen schools in Japan both impressive and perplexing. Several sixteenth-century Portuguese and Spanish Jesuit visitors, who generally expressed little but contempt for most Buddhist religious, admired the simplicity, directness, and frugal, contemplative lives of the Zen priests they met, and found them formidable intellectual opponents:

There are two sects called *Zenshū* [the *Gozan* schools] and Murasakino [Daitoku-ji], which are much given to meditation and comparisons, such as: If you spoke to a man just after they had cut off his head, what would he reply? After a lovely flower withers, what does it become? etc. Most of the nobles belong to this sect. Some people hit the mark in one meditation, others in many, and thus they strive mightily until they succeed.[19]

Certainly the most famous and possibly the most brilliant monk in the medieval Daitoku-ji lineage was Ikkyū Sōjun (1394–1481), a bitter critic of the hypocrisy, worldliness, and self-satisfaction of *Gozan* monks. By the middle of the Muromachi period the Zen institution as a whole, and especially its *Gozan* branches sponsored by the military government and patronized by people in high places, was showing signs of religious complacency. Ikkyū (see cat. 221, 238) spent the greater part of his long life criticizing, often with vitriolic intensity, the corruption, stupidity, and pretensions of the Zen clergy. For much of his life Ikkyū avoided monastic office, preferring to spend his time wandering the streets and pleasure quarters of Kyoto and Sakai, writing satirical verses and making Zen accessible to the common people through straightforward and humorous sermons in the vernacular. He was at the same time a poet of passionate intensity and moral seriousness, and a brilliant calligrapher, whose brusque, slashing style reflects his character. Toward the end of his life he reluctantly accepted the headship of Daitoku-ji, working hard to restore it and its subtemples after the ravages of the Ōnin War. He forged ties between Sakai merchants and the monks of Daitoku-ji, many of whom were experts in the monastic style of Tea Ceremony, which the merchants were eager to learn. Irreverent, fearlessly eccentric, sometimes harsh and histrionic, the antithesis of a Zen dignitary, Ikkyū exerted great and lasting influence on the Zen tradition.

Zen monks played a major role in the introduction of Neo-Confucianism to Japan. Keian Genju (1427–1508), a Rinzai monk and Neo-Confucian scholar who had studied Chan in Ming China, was one of the most distinguished of these, patronized by the Kikuchi *daimyō* family of Higo Province, then by the Shimazu of Satsuma. In Satsuma, in addition to teaching Zen, he published a commentary on the Confucian classic *The Great Learning* and established a tradition of Neo-Confucian studies.

In his *Journal* Columbus spoke frequently of converting the island people he encountered to Christianity. Had he visited Japan he would quickly have inquired about its religious life and weighed the prospects for Christian conversions. Like the later Portuguese and Spaniards, spearheaded by the Jesuit missionary Francisco Xavier, who arrived in Kagoshima in 1549, he might have found some Japanese *daimyō*, perhaps even some lower-ranking samurai and their wives, who were genuinely curious about the teachings of Christianity. He would no doubt have found more who were prepared to tolerate and even promote Christianity if that brought the "Southern Barbarians'" black ships,

with guns and other trade goods from the West. He would probably have concluded that, although competition existed, Japan was a promising field and that Christianity could be most rapidly implanted by seeking the conversion of sympathetic *daimyō* and their wives, in the hope that their domains would then be converted en masse. This policy might well have worked successfully in 1492, as it was to work in the 1550s, 1560s, and 1570s. In 1492, however, efforts to promote Christianity would not have had the fortuitous tacit support they would later receive from a unifier like Nobunaga who, bent on curbing the power of militant Buddhism, was uncommonly willing to tolerate Christian missionary activity, to entertain missionaries at his castles, and to permit the building of churches and seminaries in the capital and the territories he was bringing under his control.

Cultural life

A perceptive and open-minded European finding his way to Japan in 1492 would have been intrigued by its cultural vitality and would quickly have identified several overlapping centers and modes of cultural activity. Kyoto, recovering from the Ōnin War, was a major cultural center. Although the imperial court had lost its political leadership and some of the cultural hegemony it had enjoyed in earlier centuries, it was still a cultural arbiter. The age did not see the compilation of great imperial poetry anthologies to rival those of the Heian and Kamakura periods, but emperors and courtiers still wrote poetry and prized fine calligraphy. There was a vogue for linked verse (*renga*), among courtiers and at all levels of literate society. When it could afford to restore or rebuild damaged palace buildings, the court commissioned screens and hanging scrolls from early masters of both the Tosa school of Japanese style painting and the Kanō school, which was greatly influenced by Chinese painting styles of Southern Song (1127–1279).

Several of the Ashikaga shoguns were cultural pace-setters, connoisseurs and collectors of Chinese and Japanese art. Yoshimitsu set his stamp on the style of the late fourteenth century. In the creation of what came to be known as the "culture of the Northern Hills" (*Kitayama bunka*), after his Golden Pavilion in the northern hills of Kyoto, Yoshimitsu brought together emperors, courtiers, warriors, Zen monks, actors of the emerging *Nō* drama, and the arbiters of shogunal taste known as *dōbō-shū*. The eighth shogun, Yoshimasa, played a similar, though less resplendent, role in the

post-Ōnin cultural salon centered about his Silver Pavilion. This phase of Japanese culture is commonly referred to as the "Culture of the Eastern Hills" (*Higashiyama bunka*), from the location of Yoshimasa's villa.

Late fifteenth-century elite culture blended courtier, warrior, and Zen elements. The prevailing tone was monochromatic, reflected in the vogue for ink painting, and the dominant aesthetic was expressed in such terms as "mystery and depth" (*yūgen*), "the beauty of worn and rustic things" (*sabi*), and "cultivated poverty" (*wabi*). These cultural preferences, imbibed by *daimyō* in Kyoto, were transplanted by them to their castles and garrison towns. Some *daimyō*, like the Hosokawa, Ōuchi, and Hōjō, became major and generous patrons of the arts in their own right. The walls and screens of the great castles would become grounds for the powerful decorative painting of the sixteenth-century Kanō masters.

Buddhist monasteries, especially Rinzai Zen monasteries, remained centers of cultural leadership. The abbot's quarters (*hōjō*) of Zen monasteries set the style for domestic architecture. Zen dry-landscape gardens (*kare sansui*), like those of Daitoku-ji, Ryōan-ji, or Saihō-ji (the Moss Temple), brought Japanese garden design to an unparalleled level of subtlety and sophistication, combining directness and simplicity with abstraction. Many Zen monks were also masters of calligraphy, Chinese poetry, ink painting or portraiture. The Zen monastic custom of formally serving tea to monks and monastery guests was carried into secular society, there to be transformed into a passion among warriors, merchants, and villagers. Zen ideas of the "dropping of self," "original emptiness," "no-mind," "spontaneous self-perception of Buddha-nature," and "direct experience of reality" all influenced painting, calligraphy, *Nō* drama, Tea, and the martial arts.

Culture was also vigorous at the popular level. Mendicant monks and balladiers traveled the country, teaching the lessons of Buddhism from paintings depicting the life of the Buddha or the various realms of paradise and hell. Blind lute players wandered from town to village, bringing to imaginative life the clash of arms that ended the twelfth century with their tales of the rise and fall of the Heike clan or the exploits of the young tragic hero Yoshitsune. Wandering poets like Iio Sōgi (1421–1502) attended village gatherings for the composition of linked verse (*renga*). Troupes of *Sarugaku* and *Nō* performers entertained crowds in shrines and temple compounds across the country.

Nō theater matured in the fifteenth century: the creative genius of Zeami (c. 1364–c. 1443),

fig. 3. View of the garden of the Daisen-in, Daitoku-ji, Kyoto

About 1492 the Kanō school, official painters to the shoguns, was being established by Kanō Masanobu (1434–1530) and his son Motonobu (1476–1559). The distinctive Kanō style and repertoire mingled Zen themes and Chinese ink monochrome techniques with decorative *yamato-e* styles in works that appealed strongly to warriors as well as courtiers (cat. 222, 223, 236). At the same time painters of the Tosa school, especially Mitsunobu (act. 1469–1521) and Hirochika (15th century), were reviving Japanese style painting (*yamato-e*) and finding patrons in the imperial and shogunal courts and the upper ranks of warrior society.[20]

For any visitor to Japan in 1492 one of the most striking cultural phenomena would surely have been the passion for Tea Ceremony (*Cha no yu*) and the aesthetic refinement surrounding it. This was a critical period in the development of *Cha no yu*. Merchants from Kyoto, Sakai, and Nara were replacing Zen monks as the arbiters of Tea taste, the tea room was changing from a large audience chamber (*kaisho*) to a small hut, Japanese ceramics from kilns like Bizen and Shigaraki were becoming at least as popular as Chinese utensils, and the aesthetic of refined austerity known as *wabi*, which would be fully articulated by Sen no Rikyū in the late sixteenth century, was already being formulated. The great Tea master of the age was Murata Shukō (or Jukō, d. 1502), a Nara merchant who is reputed to have studied with Ikkyū. Shukō was a transitional figure in the development of *Cha no yu*. He is believed to have favored the use of the small four-and-a-half mat tea room as the proper setting for Tea and to have deepened the aesthetic by drawing more heavily on Zen ideas of emptiness, restraint, and austerity (*wabi*).

A receptive Western visitor to Japan in 1492, then, would have found much to interest him, and much to compare with the Europe he knew. Though disappointed of the royal palace roofed and floored with gold, as promised by Marco Polo, he would have seen other wonders. Even without gold the castles and palaces of the shogun, emperor, and powerful feudal lords were impressively grand, and held works of art in which gold was used as elegantly as anywhere in Europe. The visitor could have told of earthquakes and volcanoes, of verdant, heavily wooded islands producing an abundance of rice, silk, and other crops. Europeans would have been impressed by reports of the markets and of vigorous domestic and foreign trade, and by the diligence of farmers who made the most of their small fields.

A truthful observer would surely have reported that although Japan was politically fragmented, it would not be an easy country to

following the lead of his father Kan'ami, transformed *Nō* from a strolling entertainment into a refined dramatic art whose beauty consisted in "depth and mystery" (*yūgen*) coupled with "rusticity" (*sabi*, implying a solitude tinged with desolation or deprivation).

Zeami enjoyed the patronage of Ashikaga Yoshimitsu but fell from favor under the shogun Yoshinori. His work was continued and enlarged on by his son-in-law Komparu Zenchiku (b. c. 1405), who knew Ikkyū and Ikkyū's successor Sōgen and added new depths to *Nō* drama by a further infusion of Buddhist ideas of emptiness and the Buddha-nature of all things. *Kyōgen* (mad words), which developed along with *Nō*, was an earthier dramatic form, parodying human foibles all up and down the social

scale. *Kyōgen* pieces, farcical or satirical, served as foils to the elevated, lyrical *Nō*, and were often presented as interludes in a sequence of *Nō* plays.

Fifteenth-century painting saw several important developments. Ink monochrome painting (*suibokuga*), stimulated by acquaintance with Chinese monochrome landscape painting, was carried to a high level of strength and subtlety.

Although admitting a debt to the Chinese masters, Sesshū (1420–1506) developed his own powerful individual styles and a wide range of subject matter. He was a master of "splashed ink" (*hatsuboku*), monochrome landscape, bird-and-flower painting, and Zen style portraiture and thematic painting.

conquer or to claim. The Japanese *daimyō* and their samurai would resist such claims with armed force. They did not yet have access to the technology of the gun, but their martial tradition and fine blades made them formidable antagonists. Like Francisco Xavier a few decades later, a Columbus in Japan might have concluded that Japan, although ripe for conversion, was unlikely to become Christian without the backing of at least some of the *daimyō*. Advocates of Buddhism and Shinto could be expected to protest any Western missionary effort. Without the encouragement of their feudal lords few samurai or farmers would have dared to espouse an alien faith.

Like the actual European visitors of the following century, our hypothetical visitor of 1492 would no doubt have reported that the Japanese language seemed a veritable "devil's tongue." At the same time he could hardly have failed to notice the widespread respect for literacy, for the written word, and for fine calligraphy as an expression of the writer's personality. Intertwined with the powerful martial tradition was an equally strong tradition of civilian arts of government and literary culture. He would have seen this expressed in the poetry meetings of courtiers, warriors, and Zen monks, in *Nō* and *Kyōgen* performances, and in the linked-verse meetings in which commoners participated. He would have compared the early Japanese castles, with their great stone foundations and wooden superstructures, with the stone ramparts of Europe. He might have found wooden Japanese residences flimsy in comparison with European houses, but he would also have noted their airy suitability to the climate and their simple, uncluttered interiors. The passion for Tea, and the ritual care with which it was served, might

have bemused him, but an insightful visitor would perhaps have perceived that an aesthetic of austere simplicity, of *wabi* and *sabi*, could be as satisfying as an emphasis on gilded, florid beauty.

NOTES

1. On Marco Polo's travels, see Leonardo Olschki, *Marco Polo's Asia, An Introduction to his 'Description of the World' called 'Il Milione,'* trans. John A. Scott (Berkeley and Los Angeles, 1960).
2. Marco Polo, *The Travels*, trans. Ronald Latham (London, 1958), 243–248. For a close comparison of variant texts, see A.C. Moule and Paul Pelliot, eds., *Marco Polo, The Description of the World*, 2 vols. (London, 1938), vol. 1, 357–363.
3. The implications of Marco Polo's travels for contemporary estimates of the size of the globe and the balance between land and sea are discussed by Samual Eliot Morison, *Admiral of the Ocean Sea* (reprint, Boston, 1983), 65.
4. The original *Journal of the First Voyage*, known in Spanish as the *Diario de Colon*, does not survive. What we have today is a paraphrase, with some direct quotations, made from a copy of the original prepared by a scribe. It was compiled by Friar Bartolomé de Las Casas about 1530. In writing his journal Columbus had Ferdinand and Isabella in mind. Columbus was not above exaggeration, even outright falsification. Other misrepresentations may have crept in before Las Casas' version was completed. There are several English translations of the *Journal*. Citations in this essay are from *The 'Diario' of Christopher Columbus's First Voyage to America 1492–1493*, transcribed and translated into English by Oliver Dunn and James E. Kelley, Jr. (Norman, Okla. and London, 1989). This edition has the Spanish transcription and English translation on facing pages.
5. Discussed in Cecil Jane, ed., *The Four Voyages of Columbus* (paper, New York, 1988), cxxiii-cxliii.
6. Ferdinand Columbus, *The Life of Admiral Christopher Columbus*, trans. Benjamin Keen (New Brunswick, N.J., 1959). Fernando was only an infant at the time of the first voyage.
7. Bartolomé de Las Casas, *Historia de las indias*, 3 vols. (Mexico, 1951).
8. Peter Martyr, "The Firste Booke of the Decades of the Ocean," in Richard Eden, *The First Three Books on America (?1511)–1555 A.D.* (Birmingham, England, 1885).
9. Gonzalo Fernández de Oviedo y Valdés, *Historia general y natural de las indias*, 14 vols. (Asunción, 1944).
10. Cited above, n. 3.
11. Some of the books known to have been read by Columbus, most of them with marginalia in his hand, have survived. Among them are a copy of Marco Polo's *Orientalum regionum* and an Italian resumé of it dated to 1485.
12. Henry Vignaud, *Toscanelli and Columbus* (New York, 1902). For brief discussions of the controversy over Columbus' objectives, see Cecil Jane, *The Four Voyages of Columbus*, xiii-cxii, and Kirkpatrick Sale, *The Conquest of Paradise: Columbus and the Columbian Legacy* (New York, 1990).
13. Cited in Morison, *Admiral of the Ocean Sea*, 354.
14. On the Ōuchi in the fifteenth century, see Peter J. Arnesen, *Medieval Japanese Daimyo* (New Haven, Conn., 1979).
15. John W. Hall and Takeshi Toyoda, eds., *Japan in the Muromachi Age* (Berkeley, Cal., 1977).
16. G. Cameron Hurst, *Insei: Abdicated Sovereigns in the Politics of Late Heian Japan, 1086–1185* (New York, 1976).
 John W. Hall and Jeffrey P. Mass, eds., *Medieval Japan, Essays in Institutional History* (New Haven, Conn., 1974).
17. For the political events of the thirteenth and early fourteenth centuries, hinted at only cryptically here, see Hall and Mass 1974 and Mass, *Court and Bakufu in Japan: Essays in Kamakura History* (New Haven, Conn., 1982).
18. H. Paul Varley, *Imperial Restoration in Medieval Japan* (New York, 1971).
19. Balthasar Gago, S.J. Cited in Michael Cooper, *They Came to Japan, An Anthology of European Reports on Japan, 1543–1640* (Berkeley, Cal., 1965), 316.
20. See "Art in Japan," by Sherman E. Lee, below.

ART IN JAPAN 1450–1550

Sherman E. Lee

TRADITIONAL PAINTING

Certainly the most traditional paintings circa 1492 were Buddhist icons associated with sects other than Zen. Zen, born of close contacts with Chinese émigrés and then with China itself, also adopted from China the ink monochrome painting style—the "New Manner." But the older sects possessed a repertory of thousands of icons whose efficacy was proven and whose forms were therefore repeated over almost a thousand years. Some of these were modified very slowly over time, others were changed more abruptly—whether little or much—in answer to shifts in the climate of faith. The most remarkable example of the latter is the *Amida Raigō*, a particularly compassionate vision of deity in which Amida Buddha descends amid a heavenly host to escort the soul of a dying devotee to Amida's Western Paradise. These paintings, in which the deity approaches the viewer directly (*raigō*), became popular with the rise of Pure Land Buddhism (Amidism, or Jōdo) in the Late Heian period (897–1185).

The *Amida* from Shonen-ji (cat. 211) is virtually identical to an image dated to 1329 at Dan Ō Hōrin-ji, Kyoto, and thus exemplifies the practice of repeating efficacious images. It differs notably in the decorative patterning of the clouds covering the lower part of Amida's body in the Shonen-ji painting, and in the forcing of the snow at the bottom to the outer edges of the overlapping hills. This is a "folk art" note, also found, for example, in the famous *Sun and Moon* screens at Kongō-ji in Osaka Prefecture. By combining Buddhism (Amida) and Shinto (the sacred Nachi mountain and waterfall), the Shonen-ji *Manifestation of Amida Buddha at Nachi* exemplified the syncretic system called *honji-suijaku* (Original Ground–Manifest Trace), a reconciliation of imported faith with native cults whereby each Buddhist deity was paired with a local Shinto counterpart. *Honji-suijaku* belief became popular after the eleventh century, particularly in rural and mountain areas. In *Amida at Nachi* the worshipers at the lower left include a Buddhist monk, but all are making Shinto offerings or devotions, while on the right a mountain priest of the ascetic Shugendō sect adores the manifestation. Thus the Buddha has been joined with one of the three most sacred shrines of the Kii Peninsula.

In more sophisticated centers theological reconciliation of Buddhism and Shinto followed social and political accommodations between major temples and shrines. In the eighth century, when the court was at Nara, the powerful Fujiwara clan established there one Buddhist and one Shinto tutelary sanctum, Kōfuku-ji and the Kasuga Shrine, which cooperated closely on matters religious and political. Fukūkenjaku Kannon, a form of the Bodhisattva of Compassion particularly efficacious for the spiritually lost, was venerated as early as the eighth century. At Kōfuku-ji, from the thirteenth century, this Buddhist deity was identified with the sacred deer of the Kasuga Shrine; either image might serve to evoke the other, or the two images might be depicted together. The syncretic Kannon-deer image continued into the fifteenth century, when it was at least once depicted in an eclectic and visually realistic way. The Kannon, three-eyed and six-armed, was rendered with extreme conservatism, but the deer of Kasuga shrine who bears the enthroned deity was shown sitting on its haunches, in three-quarter view. The immediate effect is that of a pictorial rendering of a *sculptural* image, seen slightly askew. Previously, figural icons had always been shown full front, while in Kasuga *mandala* images the deer were shown in strict profile. This image combines frontality with a three-quarter view. How much of this combination—almost bizarre by traditional image-making standards—was inadvertent and how much a deliberate attempt at change and realism is undeterminable. The tension between the two parts of the icon reflects the inherent stress in these syncretic images.

The inherently traditional reproducing of efficacious icons is nowhere clearer than in the paintings graphically depicting the punishment of evil. Depictions of judgment, condemnation, and punishment may have originated in Chinese Daoist lore but were soon adopted by the Buddhists. In Southern Song China, that great source of Japanese pictorial styles as well as Buddhist iconography, representations of the Ten Kings of Hell became common. They were exported from the southern port of Ningbo to Japan in considerable numbers, and many of the sets still are extant in temple collections. These

were widely copied in Japan—and those copies copied in turn—by professional painters attached to the temples. Two hanging scrolls (cat. 212) painted by Tosa Mitsunobu in 1489 are copies of extant paintings by a fourteenth-century forebear, Tosa Yukimitsu, who in turn copied, or was much influenced by, Song Chinese originals. At least six Chinese sets of the thirteenth and fourteenth centuries are still extant in Japan—at Eigen-ji, Zendō-ji, Hōnen-ji, Nison-in, Jōdo-ji, and Kōtō-in. The Chinese *Emma-Ō* at Nison-in in Kyoto is the closest to the Japanese version displayed here.

Mitsunobu's representation is totally Chinese, a recreation of Chinese magisterial trials with one of the Ten Kings of Hell as magistrate and demons as officers of the court. The landscape screen behind Emma-Ō, the table, and the view of balustrade and garden beyond combine to evoke the typical Chinese scholar-officials' environment. Bright colors and firm brushwork, with "nail-head" strokes in the demons and "iron-wire" lines depicting officials and deities, characterize the professional style of Buddhist icon painters. Above the infernal courtroom is a traditional representation of the deity who most particularly provides solace, rescue, and salvation for the sufferers in Hell: the seated Jizō within his flaming *mandorla*. In itself, it is a good late rendition of the fine-line, color-rich method of icon painting adopted from Southern Song China. Particular styles had become mandatory for particular subjects.

The painter, however, was a master of the Tosa school, adept at the old courtly Japanese style (cat. 215, 216). His proficiency at both these traditional professional modes is characteristic of the period's growing eclecticism, a mind-set increasingly common from this time on.

The *Ten Realms of Reincarnation* (*Jikkai Zu*, cat. 213), a pair of six-fold screens, is a striking and complex example of those combinations of manners. In itself, the folding screen was fundamentally a decorative format. A few screens were used in religious ceremonies—the twelfth-century "ordination" screen at Tō-ji in Kyoto is the most famous—but these were not necessarily religious or even apropos in subject

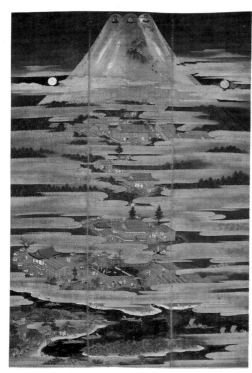

fig. 1. Attributed to Kenkō Shōkei (act. c. 1478–1506). *Fuji Pilgrimage Mandala*. 16th century. Japanese. Hanging scroll; color on silk. 180.6 x 118.2. Fuji-san Hongu Hengen Sengen Jingu, Shizuoka Prefecture.

matter. The Tō-ji screen shows a charming green landscape with figures that were deemed appropriate for imperial ceremonies. But most screens were used to decorate and divide rooms, and their subject matter was landscapes, flowers-and-birds (*kachō*), martial themes and, later, classic narratives such as the *Tale of Genji*. The *Jikkai* screens, however, are certainly religious in subject matter, and the realms of reincarnation include visions of hell, cruelty, and suffering customarily confined to hand- or hanging scrolls. Most surprisingly, the screens end with a copy of the most precious and famous of all *mandalas* (J: *mandara*, schematic representations of cosmic beings or forces, used in religious meditation or ritual), the *Taima Mandala*, belonging also to the temple that commissioned the screens, Taima-dera in Nara Prefecture.

Compositionally the screens combined the vertical orientation of the hanging scroll (cat. 212) with the horizontal linkage provided by cloud-bands (a common feature in narrative handscrolls; see cat. 216). From right to left on the screens the realms of reincarnation unfold in order of amelioration: realms of Hell, Hungry Ghosts, Demons, Beasts, Humans, and five stages of Heaven—as prescribed by the monk Genshin (942–1017) in his *Ōjō Yōshū* (*Essentials of Salvation*). The scenes of horror on the right screen are incongruously set in a

green landscape of rolling hills with a few rocky cliffs, but only on the second screen, as we approach human courtly life and the divine realms, do we find flowering trees. Both screens are in the *yamato-e* style inherited by the Tosa school: a harmonious palette of bright mineral colors, softly undulating terrain and trees, loving attention to details, an interest in secular life obvious even in the depiction of religious themes. Framing the panorama is a golden sun at the far right and a silver moon on the far left. Scattered along the upper register of both screens are pages of text, purposefully and decoratively superimposed on the landscape. These were written both in Chinese script (*kanji*) and in the abbreviated and flowing Japanese cursive (*kana*). In the final two panels of the left-hand screen an imaginative and literal rendition of a Buddhist paradise (*hensō*, apparitional vision) has been set into the landscape. Perhaps the monk-artist(?) was prompted by Amida *raigō* paintings (cat. 211) to reproduce the sacred *Taima Mandala*—a detailed depiction of Amida Buddha's Western Paradise—as a vision set in a landscape. But the superimposition of texts *over* the *hensō* and, even stranger, the omission of the upper left corner of the *hensō* so that one sees the landscape topped by the moon beyond, suggest either confusion in execution or an arbitrary decision to include the moon for symmetry with the sun at the beginning of the right-hand screen. In any case, the result is daring and effective, an apotheosis of Taimadera's most precious possession, the Chinese Tang dynasty (618–907) tapestry showing the Western Paradise of Amida bordered by illustrations of Buddhist legend and of prescribed contemplative exercises.

Provincial cults motivated other variations on traditional themes. We have seen syncretic Buddhist-Shinto iconography associated with ancient shrines and sites. Mt. Fuji, dominating the Pacific side of central Honshu, has always been a sacred mountain, usually associated with the Shinto goddess Konohana no Sakuya Hime. It was one of the centers for the Shugendō sect, a uniquely Japanese synthesis of Esoteric Buddhism and Shinto, partial to ascetic practices in remote mountain locales. Fuji was also considered a manifestation of Dainichi Nyorai (the Supreme Buddha, the Center). By the second half of the sixteenth century making the ascent of Fuji had become a popular way of achieving grace by the practice of austerity, and it is this aspect of the mountain that is presented in a *Fuji Pilgrimage Mandala*. Only the three tiny Buddhist deities on Fuji's tripartite crest witness the Buddhist element in this now dominantly Shinto icon. The Sengen shrine, still the owner of this "pilgrimage *mandala*" which it commis-

sioned, dominates the lower part of the picture. Cloud bands supply a major part of the visual impact of the image and serve also to divide this depiction of the ascent into clear stages. Pilgrims clad in purifying white, though tiny in scale, are clearly seen. At the very bottom of the picture is the Pine Beach at Miho (Miho no Matsubara), about fifteen kilometers southwest of Fuji along Suruga Bay, one of Japan's "scenic wonders" (and one of the few *native* sites painted by at least one of the ink painters in the "new manner").

Portraiture in the traditional idiom continued, especially of subjects associated with the imperial court or the shogunate. The portrait of Ashikaga Yoshimasa, shogun and aesthete (cat. 214), is a smaller-scale, more retiring version of the large, assertive *yamato-e* portraits done at the beginning of the Kamakura period (1185–1333). Only the setting of monochrome ink-painted sliding panels suggests changes in taste. The portrait of his successor, attributed to Kanō Motonobu, is from a different tradition, but equally formal. Its antecedents are *yamato-e* representations of mounted warriors as often seen in the narrative handscrolls of military subjects. The horse, sharply and stiffly delineated, is a formal counterpart to two votive tablets painted by Motonobu as offerings to Kamo Shrine in Kyoto. The stabled horse, whether a battle charger or one of many "divine steeds" quartered at Shinto shrines, was already particularly favored by the warrior class as a subject for six-fold screens.

Beach of Pine Trees (Hamamatsu) is one of the most striking demonstrations of a traditional style rising to a new occasion. The subject occurs in various narrative handscrolls of the thirteenth and fourteenth centuries as landscape accompaniment to human activity. The *yamato-e* manner emphasized the decorative, rhythmical repetition of the boughs and trunks and the rolling, sinuous curves of the beach, and made the waves conform to a kind of patterning used not only in painting but on decorated lacquer writing boxes. Beginning in the later fifteenth century the demand for pairs of six-fold screens and for sliding screens led painters to experiment with enlarging the traditional subject in the traditional manner—an experiment crowned with total success.

Other enlargements of traditional subjects, such as Sesshū's *Flowers and Birds* screens (cat. 233), were also tried by the Tosa masters in their refined *yamato-e* style (cat. 215). This *Flowers and Birds of the Four Seasons*, probably by a Tosa master circa 1500, combines the native vocabulary of decorative water patterns, rolling green hummocks, writhing pine trees and rich, opaque color with a Chinese style of

flower-and-bird painting exemplified by works of the Piling school of Zhejiang Province and of Chinese court masters such as Yin Hong (cat. 292). The native and imported styles are employed for separate subjects on these screens, except in the description of the rocks, where a not altogether successful attempt was made to blend the two: sharp, calligraphic brush strokes in the Kanō manner, repeated rhythmically inward from the edges of the rock in a more *yamato-e* fashion. This pair of screens appears to derive from a time when the confluence of the Tosa and Kanō schools was socially affirmed by Kanō Motonobu's marriage to a daughter of Tosa Mitsunobu.

The name of this latter painter is closely associated with the narrative handscroll (*emaki*) *Seikō-ji Engi* (*History of Seikō Temple*), almost certainly painted by Mitsunobu for the courtier Sanjōnishi Sanetaka in 1487 (cat. 216). Miracles worked by the bodhisattva Jizō on behalf of his devotees are the subject of the scroll, which celebrates the founding and subsequent history of Seikō-ji. Mitsunobu was an accomplished artist, adept in various idioms of his day: the court style of the Tosa school, the realism found in earlier narrative handscrolls of battle and genre subjects, and the "new manner" of ink painting practiced by his new son-in-law Motonobu, founder of the Kanō school. The *Seikō-ji Engi* displays this threefold mastery, with emphasis on the first two idioms. Courtiers and palace scenes are done in the decorative, formal, and unrealistic way associated with "woman's painting" (*onna-e*): roofs are absent, to allow interior scenes to be seen from above; isometric perspective renditions of architectural elements, *tatami*, and screens serve to mark and measure

the movement of the scroll from right to left; textile patterns are carefully depicted, and the starched, decorative quality of court garments is carefully shown. The old narrative realism reserved for depictions of warriors and commoners in untidy environments is exploited to good effect. A single detail presents a muddy well, a bamboo fence decorated with morning glories, and nearby a scratching dog. The "new manner" is found only on the folding and sliding screens we see furnishing the interiors. There monochrome ink depictions of the new subjects—cranes landing on a reedy shore, a bamboo grove, gibbons, rocks and grasses— indicate that the household is a fashionable one. In this handscroll Tosa, Kanō, and narrative-realist modes coexist in eclectic harmony.

The subject of the scroll—the miracles of Jizō—directs us to major changes occurring in the style of Muromachi *emaki* executed outside the courtly perimeters of the Tosa school. Jizō was above all a compassionate divinity, accessible to the poor, to the underclass, even to sinners in hell (see cat. 212). Jizō's increasing popularity from the Kamakura period on signaled also a recognition on the part of the priesthood of growing social mobility not only in the warrior and merchant classes but also among farmers and artisans, including professional artists and performers. The "three Ami" (Nōami, Geiami, Sōami), cultural advisers to the shogun Yoshimasa (1436–1490) and his successors (cat. 224, 234), had risen from lowly origins; the great *Nō* dramatist Zeami and his father Kan'ami, who enjoyed the patronage of the shogun Yoshimitsu (1358–1408), had begun as strolling players.

The change can be seen in certain scrolls

satirizing poetry competitions. The passion for poetry and poetry competitions or performances may have been learned by the Japanese early on from China, but the pupils surpassed their mentors in enthusiasm and ingenuity. One of the principal subjects of early courtly painting was the serial depiction in handscroll format of the Thirty-Six Immortal Poets (*Sanjūrokkasen*)—aristocrats all—accompanied by stylishly written transcriptions of their poetry. By late Kamakura a scroll had been painted recording a poetry competition, held in 1217, whose participants were not courtiers or aristocratic prelates but artisans (*shokunin*). The laughter among courtly viewers of the scroll must have been matched by the satisfaction of the *shokunin*; the painter, quite obviously, was amused by both.

Such leavening of the high art tradition from below can be seen in the *Artisans' Poetry Competition*. The term "artisans" is rather widely construed to mean "nonaristocrat"; here we are shown a blind *biwa* player (a public entertainer) walking and a seated priestly bow maker. The rendering of this scene anticipates the brusque no-nonsense depiction of village and rural life that became the staple achievement of later Japanese genre painting in the Momoyama (1573–1615) and Edo (1615–1868) periods.

By the late fifteenth century even the clergy were using commoners' vernacular in their pastoral letters. Rennyo (1414–1499), monk of the Amidist (Pure Land, or Jōdo) school founded by Hōnen (1133–1212), pushed the populist tendencies of that school to the extremes necessary for successful proselytization in a changing social world. He wrote of his pastoral letters, "You should regard [a pastoral letter] as the

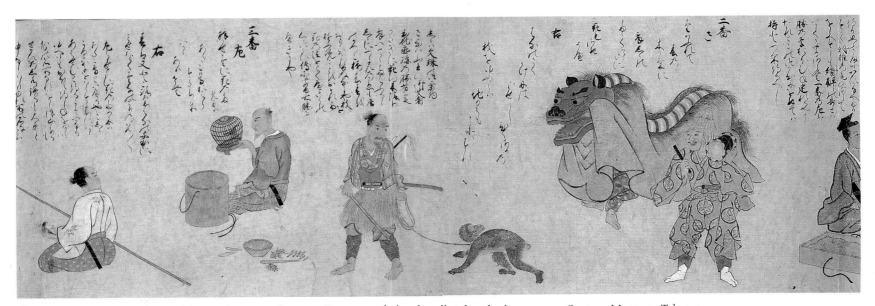

fig. 2. *Artisans' Poetry Competition.* 14th century. Japanese. Fragment of a handscroll; ink and color on paper. Suntory Museum, Tokyo

utterance of the Buddha—when you see [it], you are looking at Hōnen; when you hear its words, you are listening to the discourse of Amida" (Hall and Toyoda 1977, 347).

Still another and more direct example of this folk leavening of traditional bread are the pictorial scrolls used by *etoki hoshi* (male or female "picture explainers") to illustrate their oral (spoken or sung) recitations. These might be presented in temples, elucidating doctrine or temple history. *Legends of Kiyomizu Temple* (cat. 217) may well have been painted for that purpose. It is datable to 1517, and attributed to Tosa Mitsunobu. It stands, however, stylistically between his authentic work (cat. 216) and the folk style *emaki* we shall consider next. Its wild composition and frenetic movement are amazing—and totally removed from the fully professional control of Mitsunobu. "Picture explainers" plied their trade also at fairs or markets, reciting true history, fantastic legends (cat. 219), or vulgar tales that lampooned well-known local figures. The *etoki hoshi* were almost certainly responsible for the practice of writing texts—some of them spoken by the painted characters in the scrolls—directly onto the pictures, in contrast to the usual practice whereby sections of text preceded, followed, or alternated with the pictorial sections. These devices, strikingly similar to our comic-strip "balloons," made both text and pictures more accessible to popular audiences.

Thus the artist of *Legends of the Founding of Dōjō-ji* (cat. 219) sprinkles the text of his wildly imaginative and lurid tale among the sharply simplified and "primitive" settings and characterizations of the pictorial matter. The resulting "folkish" style, certainly persuasive on a fundamental and popular level, is a polar opposite to the old courtly style and shows less skill than the narrative scrolls of the Kamakura period *emaki* artists.

The fashionable revival of folk art in Japan before World War II recognized and used an aesthetic code deeply rooted in medieval Japan. The fullest expression of this folk substratum in the time around 1492 occurred in the modifications of more traditional art—icons, *yamato-e*, and narrative painting. Perhaps the hold of the "new manner" on the court and the military made it easier for the now more mobile underclass—merchants, artisans, farmers—to exert their preferences on some forms of art. But certainly the rich variety of Momoyama and Edo art had its beginnings in Muromachi period.

CHANGING THE SUBJECT: ZEN ICONOGRAPHY

To those Westerners who became interested in East Asian art from the end of the nineteenth century, traditional Buddhist painting in both China and Japan offered few serious barriers to appreciation. The collectors and curators of Buddhist painting—Ernest Fenollosa and Denman Ross in Boston, Charles Freer in Detroit, S. C. Bosch-Reitz at the Metropolitan Museum in New York, Bernhard Berenson in Florence, Laurence Binyon in London, to name a few—moved to an appreciation of Buddhist icons from a familiarity with Christian icons, especially those of the late Middle Ages. Some of the enthusiasts readily transferred their growing enthusiasm for gold-ground Italian paintings of the trecento to richly colored and often gold-embellished Buddhist icons of the ninth to the fourteenth centuries.

These icons were duplicated and reduplicated by successive generations—copies of copies of copies—for good reason: to be effective, salvation magic, like any other magic, must adhere precisely to formula. Sedulous imitation, however, enfeebled their aesthetic effectiveness, which was revitalized only with infusions from popular culture. The old icons could be realized in new manners, but no new energy informed latter-day productions of the traditional icons, *mandalas*, or founders' portraits. By the fourteenth and fifteenth centuries the old careful and expensive use of cut gold-leaf (*kirikane*) patterns on deities' garments had largely given way to painted gold-dust ornament. Literally and figuratively, the traditional icons were impoverished.

With the importation of Zen Buddhism in the thirteenth century, and its development and dominance in the fourteenth and fifteenth centuries, came a new vocabulary and grammar. Perhaps the most iconic of images in the new iconography were those least expected to be so—the portraits of the founders and transmitters of Zen tradition (cat. 218), a genre developed out of the Chinese Chan portraits brought to Japan in the Kamakura period (1185–1333). Despite their contemporary subjects, realistically rendered as to physical appearance, settings, furniture, and disposition, overall these portraits (*chinsō*) show a uniformity previously found in the icons of Esoteric Buddhism. The abbot's chair and robes, the three-quarters position, the sober coloration, and the fine-line delineation of the subject are omnipresent. And this is understandable, for one of the key elements in Zen Buddhism was the transmission of teachings through adept to pupil, establishing long and complex lineages.

The master's portrait was given to a pupil as indispensable evidence that the transmission had occurred, and the evidence then became, for Zen adepts, an icon.

The traditional Zen transmission *chinsō* seem even more icon-like when compared with occasional experiments by innovative artists dealing with unusual subjects. Bunsei's *Yuima* (S: Vimalakīrti; cat. 220) is based on a traditional Chinese representation of that legendary savant and pattern of virtue who, though a layman and sick at the time, could expound Buddha's teachings even to Monju (S: Mañjuśrī), Bodhisattva of Wisdom. Their meeting and Yuima's exposition were the subject of an early sutra, called in Japanese *Yuima Kyō* (S: *Vimalakīrti Nirdeśa Sūtra*). In Chinese painting of the Song dynasty (960–1279) Yuima was customarily represented as bearded, benign, and elderly, reclining on an arm rest and usually attended by a heavenly acolyte. Bunsei's depiction owes much to the circumstances of the commission: the painting was requested by a Zen monk named Zensai as a memorial image of his warrior-father, Suruga no Kami Arakawa Akiuji. The close-up view of head and torso alone, combined with the piercing, even combative expression of the face, transmutes the benign sage into an ideal warrior.

Only four years earlier an even more formidable figure, the brilliant and eccentric Ikkyū Sōjun, poet, calligrapher, Zen monk, and debauchee, later to become abbot of Daitoku-ji, was directly portrayed, probably by Bokusai. The arresting, aggrieved countenance looks directly at the beholder, a most unusual, even unique, depiction in Japanese painting (as noted by Donald Keene). A lifetime spent equally in bodily dissipation and in defense of Zen morality and integrity can be read—correctly—into the unkempt head. Paradoxically, such a portrait violated accepted canons, both contemporaneous and historical, of Zen portraiture, and at the same time was only possible within the Zen culture and aesthetic. The Zen emphasis on direct experience, intuitive recognition of truth, and transmission "from mind to mind" called for such portraiture, but, to judge from extant works, only Bunsei, Ikkyū, and Bokusai heard the call.

Along with Zen teachings came new artistic subjects, radically informal compared with the icons of the older sects but quickly and vastly popular. One of the appropriate new subjects was Daruma (S: Bodhidharma), the legendary Indian prince who founded Zen (S: Dhyāna; C: Chan) Buddhism. Whether a close-up image depicting only the head and upper torso (cat. 221), or a full-length figure in a landscape (often crossing the Yangzi River standing on a

single reed), or in a narrative context, the Daruma type was distinctive. His robe was usually draped so as to cover the head, revealing only the rotund, masklike face. The eyes, large and intent in early images from China, became huge and glaring in Japanese versions. In the bushy-bearded face, the mouth was usually stern, even grimacing, and the hairy chest was usually exposed. This is no exquisite heavenly being; one's initial impression is of piercing intensity coupled with great size and almost animal power. The insistent earthiness of the image is a pure Zen conception, but something of Daruma's exotic appearance is due to his legendary Indian origin.

Daruma left India for a politically divided China, arriving first at present-day Nanjing, capital of the Liang kingdom, whose ruler—a conventional "good" Buddhist—failed utterly to understand his curt and cryptic guest. Thereupon Daruma journeyed north to the Wei kingdom, his miraculous crossing of the Yangzi balanced on a single reed furnishing Zen painting with one of its most popular subjects. In Wei he performed the nine-years meditation before the cave wall, during which he was sought out by his successor, the Chinese Hui-Ke (J: Eka), who cut off his own arm to prove to Daruma his steadfast resolve to seek Enlightenment. These two awesome acts of single-minded determination—Daruma's nine-year meditation and Hui-Ke's self-amputation—are shown together in Sesshū's great painting. The subject is certainly Chinese in origin, and probably Sesshū found his starting point in an anonymous Southern Song (1127–1279) work. Daruma's burly form and fierce expression may remind some of the extroverted "terrible aspect" deities and divine guardians of earlier Esoteric Buddhism, but the resemblance is largely coincidental. The expansive, even vulgar humanity of Daruma is a new creation of Chan and Zen Buddhism.

An equal favorite with Zen painters, related to Daruma in appearance and sometimes displayed with him as part of a triptych, is Hotei (C: Budai). He was more often shown alone on a single hanging scroll, short, obese, and jolly, always with a big sack containing his belongings, a satirical and vulgar figure. By the more serious-minded he was considered a manifestation of the bodhisattva Maitreya, but his popular appeal is summed up in his Chinese name: Budai is a homonym for "Round Belly" or "Cloth Bag." The audience for *kyōgen* satirical performances and *otogi-zōshi* (cat. 219) narrative scrolls must have understood Hotei well. Numerous other eccentrics, mostly of Chinese origin, were included in the Zen painters' repertory, though they hardly qualify as icons.

Besides these "deities," Zen imagery included disciples of the Buddha, whether his contemporaries or later devotees. These *rakan* (S: *arhat*; C: *luohan*) were especially popular in China, where they were seen as Chan Buddhist counterparts to the venerable and traditional Daoist and Confucian sages. The Chinese practice of representing *luohan* as gnarled ancients, closely related to the old trees (cat. 312) and convoluted rocks beloved of the literati, dates at least from the tenth century, as attested by the sixteen *luohan* panels now in the Imperial collection in Tokyo. These fascinating grotesques were balanced by somewhat more average monkish types—thin, fat, young, old, light, or dark. But all *luohan* paintings, whether they depicted a single disciple (rarely), the classic complement of sixteen (often), or a monastery-full of five hundred (sometimes), required considerable imagination and technical skill and a nice balance of realism and caricature to keep the *luohan* theme and its variations from being boring.

Professional paintings of the Ten Courts of Hell scenes (cat. 212) demonstrated a full repertory of distortions and creative ugliness. Their prototypes were the Chinese versions produced by the workshops of Ningbo and directly exported in large numbers to supply the rising Japanese demand from Zen monasteries in Kyoto and Kamakura. Many sets of Chinese origin are listed as still extant in Japanese temple collections. These in turn were copied by Japanese professional Buddhist painters (*e-busshi*), and occasionally by the Tosa masters patronized by the court. But as monochrome ink painting became increasingly the medium of Zen art, the *rakan* became far less popular subjects than Daruma, Hotei, the Zen patriarchs, Kanzan and Jittoku (C: Hanshan and Shide, archetypes of Enlightened laymen) and other, more specifically Zen, figures.

Exemplary Zen tales or historically significant Zen events were also staple subjects of the new monochrome ink painting (*zenki zu*, literally, "pictures of Zen activities," in fact referring to Zen didactic paintings). The great Daruma painting by Sesshū mentioned above, though dominated by the First Patriarch, is technically a *zenki zu*, the story of the perseverance of Eka. Still other narrative subjects became increasingly popular in the fifteenth and sixteenth centuries: *The Three Laughers of Tiger Valley*; *Śākyamuni Descending the Mountain After Austerities*; *The Ten Ox-Herding Songs*, a Zen parable of the quest for Enlightenment in ten scenes of an ox-herd searching for and finding his strayed ox; and incidents from biographies of the Zen patriarchs as compiled in *Record of the Transmission of*

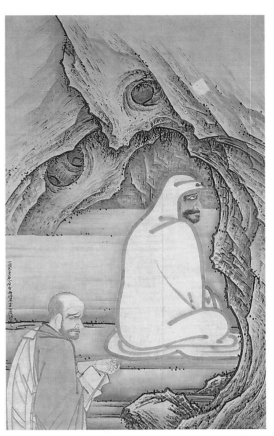

fig. 3. Sesshū Tōyō (1420–1506). *Daruma and Eka*. Dated to 1496. Japanese. Hanging scroll; ink and color on paper. Sainen-ji, Aichi Prefecture, Japan

the Lamp (J: *Keitoku Dentōroku*, a Chinese Chan text of 1004). The Three Laughers also appeared in two other guises, as *The Men of Three Creeds Tasting Vinegar*, and as *Patriarchs of the Three Creeds*; their common theme is the essential unity or complementarity of Buddhism, Confucianism, and Daoism. Philosophically, this "Unity of the Three Creeds" could be more thoroughly expounded in literary texts, but the pictorial versions, especially of Tiger Valley, allowed artists to explore the permutations of figures in a landscape.

Two works (cat. 222–223) from six sliding screens painted by Kanō Motonobu for the abbot's residence (*hōjō*) at the Daisen-in of Daitoku-ji are among the earliest *zenki zu* illustrating episodes from *The Record of the Transmission of the Lamp*. *The Flight of the Sixth Patriarch* (cat. 222), a bold, split composition, concentrates one's attention on the narrative rather than the landscape. Below, E'nō (C: Hui-Neng, 638–713) is shown in the prow of the boat propelled by a standing boatman; above, disciples of the Fifth Patriarch, Gunin (C: Hong-Ren, 601–674), search for E'nō on learning that he has just received the patriarch's robe, i.e., has been made Sixth Patriarch. The second painting (cat. 223) is even more concentrated, offering a single action in a near landscape view

framed by curling clouds. The disciple Kyōgen Chikan (C: Xiangyan Zhixian) sweeps the ground outside his hut and dislodges a pebble which strikes a bamboo with a resonant sound. At the sound he laughed, and in that instant attained Enlightenment.

Of all Zen figure subjects, certainly the most popular was the White-Robed Kannon (J: Byaku-e Kannon) and its numerous variations: Willow Branch Kannon (J: Yōryū Kannon), Kannon of the Sacred Jewel and Wheel of the Law (Nyoirin Kannon), and Kannon Contemplating a Waterfall (Takimi Kannon), among others. The Chinese *Record of Famous Paintings of Successive Ages (Li Dai Ming Hua Ji,* compiled 847 by Zhang Yanyuan, in Acker 1954, p. 293) notes a Tang dynasty painting of Kannon seated in a landscape, but this was a work in color by the famous eighth-century painter of court ladies, Zhou Fang. Almost all Japanese painters of the subject were indebted, directly or indirectly, to the great image at Daitoku-ji by the Chinese Chan painter-abbot of Hangzhou, Mu Qi (Fa-Chang, early 13th century–after 1279). The basic type as it developed over more than a century in Japan is represented by Nōami's *Byaku-e Kannon* of 1468 (cat. 224). The totally uniconic nature of the representation, informal in pose, costume, and landscape setting, complemented the Zen ideal of sudden, intuitive Enlightenment independent of ratiocination or rituals. The usual utter simplicity of the subject also made it accessible to the amateur monk-painter, and we owe many of the early surviving representations of Byaku-e Kannon to such amateurs.

But even these informal images could be made more informal within Zen iconography and monochrome ink practice. Among the thirty-two Kannon paintings attributed to Kenkō Shōkei (act. c. 1478–1506) at Kenchō-ji in Kamakura, the most informal shows the deity washing his bare feet in a waterfall. Gakuō's version of the White-Robed Kannon, a variation called Water-and-Moon Kannon (Suigetsu Kannon; cat. 225), depicts a standing, swaying figure contemplating the moon's reflection in the water.

Muromachi ink painting includes few non-Zen figural subjects. Some subjects, such as Sugawara no Michizane (845–903), an imperial minister who died in exile and was later absorbed into Shinto as patron deity of scholarship and literature, were represented as single figures, mostly for Zen patrons. Michizane's position as god of poetry, his (extant) poem written on the eve of exile to the plum tree in his garden, and the legend current by the end of the fourteenth century that he had sought and received instruction in Zen from a famous

Chinese master, made him an appealing subject for the Chinese-oriented Zen monks with their penchant for poetry and nature.

By far the largest number of monochrome Japanese ink paintings of this period are landscapes. Though the ink monochrome style was not limited to Zen painters in Muromachi Japan virtually all landscape paintings were either painted by Zen monk-painters, commissioned by Zen patrons from professional painters working in a Zen environment, or "adopted" and inscribed with numerous texts or poems composed or written by Zen monks. Landscape evoked nostalgia for the mountains near the great founding Chan temples of China and inspired recognition of the truth to be found in nature. Such emotions were also clearly and directly expressed through the garden art embraced by all Zen monasteries and subtemples, gardens quite different from those cultivated by the Chinese literary-official class.

Some landscapes of Chinese subjects were derived from the Chinese paintings in temple, shogunal, or *daimyō* collections. Thus the *Eight Views of Xiao and Xiang* by Mu Qi and by Yu-Jian were influential both as subject and as examples of *hatsuboku* technique (see cat. 231). Sometimes a specific Chinese scene is designated, as in *Landscape in Sichuan*, a work of the Shūbun school in the Seikadō Foundation, Tokyo. Sesshū's *Four Seasons* of circa 1469 (cat. 230) and his masterpiece, *The Long Landscape Scroll* in the Mōri Museum, are clearly Chinese in subject, even to the architecture of temples and the representation of a Chinese city wall. Sesshū, however, was painting from life, or at least from memory, having traveled extensively in China. Shūgetsu (see cat. 227), Sesshū's disciple, who may have gone to China in 1493, painted a view of Hangzhou's West Lake with the bridge of the famous Tang dynasty poet Li Bo, and Gakuō executed a pair of scrolls showing *The Peach Blossom Field of Wu Ling* and *Li Bo Viewing a Waterfall*.

Contrariwise, in Muromachi ink painting Japanese landscape subjects are conspicuous by their rarity. The most famous of these landscapes is *Ama no Hashidate*, by Sesshū (cat. 232), who also painted a *Chinda Waterfall*, destroyed in the great earthquake of 1923. Mt. Fuji would seem to have been an obvious subject, but only a handful of Fuji scrolls exist, notably ones by Kenkō Shōkei and Chūan Shinkō, a Kenchō-ji monk-painter active in the mid-fifteenth century, said to have been Kenkō Shōkei's teacher. *The Pine Beach at Miho*, originally painted as a set of sliding screens by an anonymous fifteenth-century artist, is extant, now mounted in scroll form. But by and large most of the landscapes from the Muro-

machi period are generalized mountain landscapes. Small wonder that earlier writers referred to the "Ashikaga Idealist school."

In a typical monochrome ink landscape of the period (cat. 229) verticality dominates both the composition and the mountains it contains. Compared with the usual Southern Song Chinese landscape, composition is notably centralized, a trait certainly due to the Japanese inheritance from Korea, which in turn learned much from an earlier North Chinese tradition. The verticality of format may serve two practical functions: to provide space above the picture for inscriptions, and to permit hanging within the relatively high and narrow tokonoma, or niche for picture and object display. But the vertical mountains are a far cry from the typical Japanese mountains of a *Fuji Pilgrimage Mandala* or of Sesshū's *Ama no Hashidate* (cat. 232), the gentler, rolling hills of the "lovely" land of Yamato. Further, an exhibition devoted to Muromachi ink painting would reveal that the collective "staffage" of these landscape scrolls—wine shops, huts, temples, palaces, boats, fishermen, travelers, resting scholars or reflective monks—is not that of a specific place or time but is "typical," "generic," or "idealized." The figures and architecture are elements combined with nature in an ink meditation on nature, man, and Enlightenment. In a very real sense they are as abstracted as twentieth-century Western work. The tones of ink, the rhythm of the brush strokes, the relationship of stroke to wash, are all part of this meditative-aesthetic process. And, especially in comparison with other East Asian paintings, these landscapes seem more indebted to intuition than to rationality.

The last of the subject categories in Muromachi ink painting is subsumed under the Japanese term *kachō-ga* (flower-and-bird painting), which is not entirely appropriate since it also includes actual animals, legendary animals, and vegetables and fruits. Even the old Chinese term, "fur and feathers" (cat. 305), is not wholly inclusive. Within this category Zen painters worked with a broad range of subjects. Spectacular birds (cat. 226, 227, 233, 236), often in landscape settings depicting the four seasons, were particularly favored, followed by the humble sparrow, mynah, wagtail, swallow, goose, duck, quail, eagle, and hawk. The laboring bullock and the free monkey, more rarely the powerful tiger, make up most of the animals used. Bamboo and orchid, previously much used by the Chinese and also elegantly symbolic, were particularly popular, especially for the early amateur monk-painters such as Gyokuen Bompō (c. 1347–c. 1420) and Tesshū Tokusai (d. 1366). Vegetables and fruits in the repertory

were particularly those used often in Zen vegetarian meals—large radish (*daikon*), eggplant, melons, grapes, and chestnuts. Fish or crustaceans rarely appear, and then only as adjuncts to a Zen parable such as Josetsu's famous *Catfish and Gourd*, or as staffage in close-up waterscapes. Rarely, hanging-scroll triptychs whose central image was a figure employed *kachōga* for the flanking scrolls; examples are the very early *Śākyamuni and Plum Blossoms* with inscription by the Zen abbot Hakuun Egyō in the Rikkyoku-an of Tōfuku-ji in Kyoto, and the *Byaku-e Kannon, Bamboo, and Plum* in the Ackland Museum, Chapel Hill, North Carolina.

THE "NEW MANNER" IN PAINTING

Few monochrome ink landscapes are known before the fifteenth century. Ink alone had been used with increasing frequency from the late twelfth century for "sketched" iconographic models, including whole manuals of such sketches in handscroll format. As the tidal wave of Chan (J: Zen) Buddhist influence began to reach Japan from China in the thirteenth century, some ink copies or variations of the principal Zen subjects were produced, notably at Kōzan-ji in northern Kyoto. By the fourteenth century such ink monochrome subjects were more common, and for the first time Chinese landscape subjects, such as the *Eight Views of the Xiao and Xiang Rivers*, a subject that had been taken up by Chan painters, were being painted in Japan by Japanese artists. The earliest extant Japanese rendition of the *Xiao and Xiang* theme was painted by Shitan (d. 1317). Landscapes by Gukei Yūe (act. c. 1360–1375) and Ka'ō (act. before 1345) followed; nevertheless 1413 (approximately) was a watershed year, quantitatively and qualitatively, in the production of Japanese ink monochrome landscape.

Zen monk-painters

The key monument at the base of the grand structure of Muromachi period (1333–1573) ink painting (*suiboku-ga*) is the famous *Catfish and Gourd* (c. 1413) by Josetsu, an illustration, in a landscape setting, of a Zen *kōan*, or parable:

> Poised! With the gourd
> He tries to pin that slippery fish.
> Some oil on the gourd
> Would add zest to the chase.
> (Shusu [d. 1423], trans. Matsushita 1974)

The picture, now a hanging scroll with texts of thirty-one poems and comments above, was originally a small dais screen with the picture

fig. 4. Josetsu (act. c. 1400). *Catching a Catfish with a Gourd*. Japanese. Hanging scroll; ink and slight color on paper. Taizō-in, Myōshin-ji, Kyoto

on the front and poems on the back. It was commissioned, according to attached texts, by the shogun, almost certainly Yoshimochi (r. 1394–1423), from the monk-painter Josetsu of Shōkoku-ji, one of the five major Zen temples of Kyoto (the *Gozan*, or Five Mountains) and a favorite establishment of Yoshimochi. The picture is most unusual. It is much wider than high, basically a horizontal expanse with the principal, darkest, and sharpest motifs in the foreground—a near-caricature of a man holding a gourd, a realistic catfish in the stream, a clump of bamboo, and around the bend in the stream at the left, some small but heavily inked

rocks around which the water eddies into the calm foreground stream. There is no middle ground, but a moderate to faint wash suggests mountains dotted with vegetation in the far distance. To delineate the figure Josetsu used sharp, angular, crackling brush strokes, clearly influenced by the art of the Chinese master Liang Kai (act. early 12th c.), whose works were already to be found in the shogunal collection begun by Yoshimitsu (r. 1368–1394). The asymmetric "one-corner" composition recalls the late Southern Song landscapes of Ma Yuan (act. before 1190–c. 1230) and Xia Gui (c. 1180–c. 1220), also represented among the shogun's holdings. The bamboo quite resembles Ma Yuan's painting of bamboo, notably in two seasonal landscapes, *Spring* and *Summer*, respectively in the Cleveland Museum of Art and the Yamato Bunkakan, Nara.

Shusu's first poem is preceded by his preface: "...the *Taisōkō* [shogun] had the monk Josetsu paint this theme in *the new style* [ital. added] on the small single-leaf screen which stands beside him and has asked various monks to add some spontaneous comments...."

The key phrase "the new style" has been variously interpreted: most specifically by Matsushita as "the Liang Kai manner"; by Fontein and Hickman as "a landscape setting [incorporated] into a *zenkiga* [painting of Zen activities]"; more obviously, and for once more plausibly, as the monochrome ink style freshly known to the Japanese from China and Korea. Almost certainly Josetsu knew Liang Kai's two paintings in Yoshimitsu's Kitayama collection representing Chan monks attaining Enlightenment, one chopping bamboo, the other tearing up a holy text (*sūtra*). But he also knew other works in that collection and many more imported from China and Korea and available at temples and sub-imperial collections.

Travel and commerce between these two mainland countries and the island empire had increased steadily after a hiatus from the tenth to the twelfth century and by 1400 had reached a critical level for the transmission of Zen Buddhism, the importation of works of art (especially painting and ceramics), and the travel of Japanese monk-artists. Yoshimitsu in particular had expanded contacts with the Chinese Ming court; as for Korea, the cooperation of the new Chosŏn (Yi) dynasty (1392–1910) with the Japanese Sō clan, lords of Tsushima, in suppressing the activities of pirates (*wakō*) and fostering legitimate trade had greatly increased monastic travel in both directions as well as the exchange of religious texts and appurtenances, thereby also increasing artistic interaction.

At the beginning of the fifteenth century

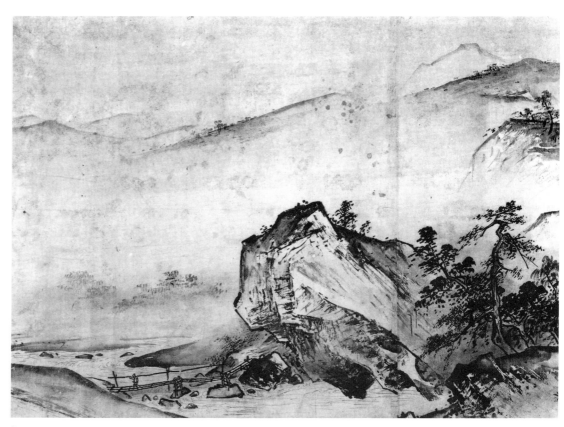

fig. 5. Xia Gui (c. 1180–c. 1220). *Clear and Distant Views of Streams and Hills.* Chinese. Handscroll; ink on silk. Collection of the National Palace Museum, Taipei

Josetsu of Shōkoku-ji, who enjoyed shogunal patronage, dominated Japanese painting. Although his following has been called an "academy," it was far less formally organized, but the prestige of the temple and of the shogun assured the dominance of the Shōkoku-ji lineage in the fifteenth century over the more traditional professionals following the artist-monk Minchō (1352–1431) of the older temple Tōfuku-ji. These latter masters worked in both the figural iconic modes inherited from the Chinese professional religious painters of Ningbo in Zhejiang Province and in the "new manner," including some ink monochrome landscapes.

Tenshō Shūbun (act. first half of 15th century) succeeded Josetsu as painter to the shogun. He was also the business manager of Shōkoku-ji, and is recorded to have done paintings on sliding screens (*fusuma-e*) and to have collaborated in the making of some religious sculptures. No landscape — or, indeed, painting of any kind — is firmly assigned to Shūbun by either signature or unassailable seal; but some two to six scrolls and screens are considered likely to be his. One of the two most likely is *Suishoku Rankō* (*Color of Stream and Hue of Mountain*), painted circa 1445 by the evidence of an inscription — one of three written by other monks on the scroll. This beautiful image, the

personification of what earlier scholars described as "Ashikaga Idealism," is a creative synthesis of Southern Song (1127–1279) landscape style and a North Chinese continuation of earlier landscape style transmitted through an active school of ink monochrome artists in Korea.

Shūbun visited Korea in 1423–1424 as a member of a diplomatic mission whose roster included merchants and Zen monks. A Korean painter named Yi Sumun (J: Ri Shūbun, act. in Japan after 1424) arrived in Japan at the same time, perhaps sailing with Shūbun on his return. His work in the pair of landscape screens in the Cleveland Museum of Art (cat. 267) reveals elements of the Korean adaptation of Chinese styles. The rather bare, dry landscape grounds are characteristic of works painted in North China under the Jin dynasty (1115–1234), as is the nervous, searching, "pictorial" brushwork used to represent foliage and shrubbery. The reaching, preternaturally extended trees and the use of plateaus or "platforms" to suggest recession from fore- to middle ground are common devices of the Ma-Xia school of Southern Song China. The nervous "sketching" brushwork was particularly used by the Koreans in landscapes of the early Chosŏn dynasty, from the fourteenth well into the sixteenth century, and this is the brush-

work adopted by the Japanese Tenshō Shūbun in *Suishoku Rankō* and in the other late work, *Reading in a Thatched Hut,* now in the Tokyo National Museum. The Korean contribution to the early Japanese ink landscape tradition has been underestimated and will repay further study. But Tenshō Shūbun was the master who transmuted these elements into a Japanese style, in which his most famous pupil, Sesshū, was undoubtedly trained (though he later abandoned it), and in which other artists following Shūbun, such as Gakuō Zōkyū (cat. 229), produced major pictorial accomplishments.

Sesshū

Sesshū Tōyō (1420–1506), pupil of Shūbun and monk of Shōkoku-ji, would seem the logical successor to the position of painter to the shogun, but this remarkable individualist left the temple in 1464 (just one year after Sōtan of Daitoku-ji assumed Shūbun's stipend), perhaps out of pique but more likely to pursue his own way, avoiding the Ōnin War and the artistic postulates of the Shōkoku-ji "academy" at one stroke. The Ōuchi *daimyō* clan provided him with a studio and patronage in western Honshu, relatively far from the tensions (leading to the outbreak of open warfare in 1467) of the capital, and also with access to their diplomatic-cum-trading missions to China. Sesshū's trip to China in 1468–1469, as a member of one such mission, was a crucial event in his artistic career. It was by no means unusual for Zen monks, acting as highly placed servants of the shogunate and the *daimyō* clans as well as the major temples, to accompany these missions, but Sesshū was apparently received in China as a major figure, both as priest and painter. He certainly encountered the paintings, and probably some of the painters, of the imperial court—he mentioned Li Zai, and he painted a decoration for a pavilion in the Imperial Palace in Beijing. But in the judgment of this author, China's most important contribution to Sesshū's art was the native artist-scholar-professional emphasis on the supreme importance of brush-work in the production of paintings. Scholars have been justifiably puzzled by the lack of any works by Sesshū antedating 1467, the year of his departure for China. Tōyō, the name he used before adopting the name Sesshū (*Snow Boat*) about 1463, has led to several hypothetical attributions, not widely credited. What is certain is that the paintings he produced immediately after his return from China (cat. 230) do not look like any Japanese or Korean landscapes of the period. Further, the only two paintings dated in the seventies—the "short" landscape handscroll of 1474 and the (destroyed

in 1923) *Chinda Waterfall* of 1476—already showed the master's characteristic mature style. In the 1474 work we find the styles of Dai Jin (cat. 288) and Shen Chou (cat. 313–315) refracted through the artistic personality of Sesshū. The 1476 work is pure Sesshū. Still later works (cat. 232, 233) clearly demonstrate the artist's unique position within Muromachi ink painting. In contrast to the "pictorial" and nervous brush of the Shūbun school and the formal decorative qualities of the Kanō school (cat. 236) in the sixteenth century, Sesshū, and to a limited extent his companion and follower Shūgetsu (cat. 227), emphasized the single brush stroke, following the Chinese concepts of brush handling. Theirs was not a Chinese stroke, however; it was more uniform in width, more firmly defined in silhouette, and more geometric, angular in application and grouping. Japanese painting had been, was, and is continually denigrated by Chinese critics; but Sesshū's painting for the Board of Rites in Beijing had elicited his hosts' praise. Perhaps it was because he had already modified an unknown early manner in the direction of "bone structure," the prime desideratum of Chinese painting, even if Sesshū's "bones" were differently shaped than those created by Chinese painters.

In any case, as has been indicated in our comparison of Sesshū with Shen Zhou, the Japanese artist was a singular individual within the mainstream of fifteenth-century ink painting, able to do what other painters could or would not—produce major landscapes of Chinese and Japanese subjects and figure paintings as well. *Daruma and Eka* is undoubtedly the greatest icon of Zen ink painting; *Ama no Hashidate* (cat. 232) is *the* great Japanese ink landscape of the Muromachi period; and the *Hatsuboku Landscape* of 1495 is the finest of all Japanese essays in that extreme mode.

The painters remaining at Kyoto after the Ōnin War (1467–1477) were either hereditary Tosa masters working for the court aristocracy (see "Traditional Painting") or "new manner" artists patronized by the shoguns who followed Yoshimitsu and Yoshimochi, especially Yoshimasa (1436–1490, r. 1443–1474). The years of Yoshimasa's retirement, fruitfully devoted to patronage and connoisseurship, were spent almost entirely at his villa in the eastern part of Kyoto known as Higashiyama, the name that has come to designate Yoshimasa's cultural achievement. For his inability to control political events or even to mitigate the catastrophic effects of civil war, Yoshimasa compensated by building and perfecting his personal environment—residence, collection, literature, drama and, not least, the *dōbōshū* (companions), whose aesthetic discernment and knowl-

fig. 6. Sesshū Tōyō (1420–1506). *Splashed-Ink (Hatsuboku) Landscape.* Dated to 1495. Japanese. Hanging scroll; ink on paper. Tokyo National Museum

edge of traditions merged all these into "Higashiyama culture."

The "Three Ami"

Dōbōshū were cultured companions to the retired shogun, but of lowly antecedents. The most famous were the "three Ami": Nōami (1397–1471), Geiami (1431–1485), and Sōami (d. 1525). Originally named (respectively) Shinnō, Shingei, and Shinsō, the three adopted the *ami* ending to denote that they were Amidist lay priests of the Ji (Timely) subsect, dedicated to the worship of Amida (Buddha of the Western Paradise), to belief in the saving efficacy of the *nembutsu* ("Homage to Amida Buddha"), and to the teachings of the Lotus Sutra. Due principally to their able services to the warrior class, the *dōbōshū* came to be indispensable to their masters, experts in the non-military arts. Their backgrounds made them familiar with "lowly" arts, notably popular narrative and poetry and satirical drama. In a broad sense they began as entertainers and ended as arbiters of taste in various aspects of culture.

Nōami, poet, designer, painter, and painting mounter, was commissioned by Yoshimasa to compile a catalogue, the *Gyomotsu On'e Mokuroku*, listing the Chinese works in the collection inherited from Yoshimitsu. Naturally this listing included paintings important in establishing the direction of the "new manner." Sōami wrote the *Kundaikan Sōchōki*, a catalogue-commentary on things Chinese, including the environment for and manner of displaying treasures from the mainland. The influence of these and other *dōbōshū* on architecture and garden design, on the emerging *Nō* and *Kyōgen* drama, and on the still unstructured Tea Ceremony (*cha no yu*), was enormous. Yoshimasa's personal gifts and temperament permitted, in his time of retirement (1474–1490), the flourishing of a highly sophisticated and subtle culture, whose most characteristic manifestations were the Tea Ceremony, *Nō* drama, and *shoin* architecture. The latter was residential architecture in a new, "Japanized" Chinese manner, characterized by informality and simplicity, with the tokonoma (alcove for the display of paintings and objects) as the principal innovation. The Silver Pavilion (Ginkaku), the Tōgu-dō residence hall, and the garden of Yoshimasa's compound at Higashiyama, all within the precincts of what is now Jishō-ji in eastern Kyoto, still remain as the finest expression of the early creative accomplishments in the "new manner" in architecture, landscape design, and related arts. Modest in scale, the buildings reflect the ideals in process of creation as corollary to the developing "Way of Tea": beauty, *wabi* (refined austerity), and *sabi* (cultivated poverty or the beauty of worn and rustic things). The "Way of Tea" was to become a cult by the early seventeenth century.

Although the "three Ami" are usually grouped together in any analysis of Muromachi ink painting, their extant works are not neatly similar in style. Nōami's signed and dated *White-Robed Kannon* of 1468 (cat. 224) offers a quiet and subtle version of Sesshū's sharp, linear brushwork in the representation of a standard and oft-repeated Zen icon. Although the handling of the setting is recognizably Japanese, the soft face and expression owe much to the Mu Qi image in the triptych at Daitoku-ji, the font for all White-Robed Kannon images from the Kamakura period on. The screens attributed to Nōami (cat. 226) are freely washed, suggestive rather than explicit, and owe much to the late Song Chinese "boneless" manner of "fur and feathers" painting. Still more different is *The Pine Beach at Miho* in the Egawa Museum, Hyōgo Prefecture. This simple six-fold screen, sometimes — rather shakily — attributed to Nōami, combines landscape in the "boneless" style of the Chinese Song dynasty painter Mi Fu (1051–1107) with pine trees and low, rolling hills done in monochrome ink in the native *yamato-e* manner.

Geiami's masterpiece is *Viewing a Waterfall* (cat. 234), executed in 1480 in the sharp angular style of Nōami's *Kannon*, but far bolder and more dramatic — recalling the manner of Sesshū equally with that of the Southern Song painter Ma Yuan, who was well represented in the shogun's collection. Geiami's work seems thoroughly professional, reflecting nothing of the Chinese amateur's "boneless" manner that Nōami sometimes adopted — if indeed *The Pine Beach at Miho* even dimly reflects any of his artistic habits. The art of the Amis seems eclectic, reflecting something of the stylistic variety in the shogunal collection of the Chinese painting curated and catalogued by them.

The Ami corpus even includes a touch of the "amateur" qualities so highly valued by the Chinese literati (*wen ren*) in painting, though it was not derived from the contemporaneous *wen ren* of Ming China. Rather it was apprehended of certain aspects of Song dynasty painting known to the Japanese from the poetic and literary texts associated with the circle of Mi Fu in eleventh-century China. Sōami's paintings in particular, with their abundant use of "boneless" broad washes and simple, dabbing brushwork of the "Mi" style, display an effective, even poetic, combination of pictorial devices, including measured and subtle atmospheric effects and bold, simple designs. He could also improvise on the sharper and more angular brush effects of Ma Yuan, as transmitted by Geiami from Nōami. The difficulties of discovering the Ami style (or styles) are compounded since they had no real following, hence no later lineage whose works might reveal their forerunners. Among the professional monk-painters who dominated Japanese art in the fifteenth century the Ami seem to have exerted little influence; perhaps their occasional use of a Chinese amateur manner was found antipathetic.

Shōkoku-ji, which dominated the art scene in Kyoto for the first three-quarters of the fifteenth century, declined with the decline of shogunal power. By the end of the century a newer Zen temple, Daitoku-ji, and its subtemples had become a dominant force. Under Ikkyū's (cat. 238) abbacy Daitoku-ji flourished, a scourge to the slack morals and discipline of the old *Gozan* temples, increasingly supported by the tea masters and especially by the prospering merchants of Sakai, the chief port (near present-day Osaka), whose pragmatic ambience was well known and understood by Ikkyū. Beginning with the shadowy painter Sōtan (1413–1481), followed by the still unclear figure of Soga Jasoku (or Dasoku, act. c. 1491), a tradition developed that became the Soga school. Bokusai Shōtō (d. 1492), friend of Ikkyū and presumably the painter of his remarkable portrait-study, was nominally of that line. Its later accomplishments, in the late sixteenth and early seventeenth century, are outside the limits of this exhibition.

Zen Painting in Kamakura

Still another significant constellation of Zen temples, in Kamakura, just southwest of present-day Tokyo, was also important within the Muromachi ink painting tradition. As early as the fourteenth century, when the Hōjō regents exercised the remains of shogunal authority at Kamakura, Zen art, including "monk-amateur" ink painting, flourished. The most important of the "Five Mountains" (*Gozan*) temples in Kamakura, in particular Enkaku-ji, possessed numerous Chinese paintings: thirty-nine portraits of Chinese monks and thirty-six paintings of landscape, flower-and-bird, and figural subjects. A 1320 inventory of the Hōjō art collection, the *Butsunichi-an Kōmotsu Mokuroku*, records these works. Most of them came from south China, especially the region around Ningbo, a center of professional painting workshops producing Buddhist icons and sets of *luohan* paintings with landscape backgrounds. Significantly, the great Chan temple Jingde Si, where the visiting monk-painter

Sesshū had been signally honored, was near Ningbo (then called Siming). When the Ashikaga clan established its shogunate in 1336, Kyoto became shogunal as well as imperial capital, and what power remained with the five official Zen temples at Kamakura was dissipated, with a corresponding rise to great power of the *Gozan* temples of Kyoto, especially Shōkoku-ji. As the Kyoto *Gozan* declined with the decline of the Ashikaga shogunate, ink painting in Kamakura experienced a modest revival.

Kenkō Shōkei (act. c. 1478–1506), better known as Kei Shoki (Secretary Kei, of Kenchō-ji in Kamakura) was the most gifted and significant painter of this region at this time. His early training drew upon the Chinese painting collections in Kamakura. In 1478 he went to Kyoto, where he studied under Geiami; he returned to Kamakura in 1480, made a second trip to Kyoto in 1493, and is known to have been again in Kamakura in 1499. Geiami's masterpiece of 1480, *Viewing a Waterfall* (cat. 234), was the master's parting gift to Kei Shoki. Three highly prestigious Zen monks inscribed the painting, Ōsen Keisan noting the pupil's technical progress, one of the others mentioning that Geiami had helped his pupil gain entrance to the shogunal collections. It should not surprise, then, that Kei Shoki's *Eight Views of Xiao and Xiang* (cat. 235), is heavily indebted to Geiami, though with three distinctive differences. Kei Shoki's ink tonality is lighter. The profiles of rocks, cliffs and cavelike formations were deliberately and somewhat geometrically contorted and outlined with dark ink in the manner of Sesshū. Finally and most individually, the dots representing lichen or moss were made sharper and darker and more widely separated than usual. The resulting almost musical pizzicato creates a lively and distinctive mood. Only one later master, perhaps following the Kei Shoki manner in part, achieved high fame: Sesson Shūkei (c. 1504–1589), from northern Honshu, is reputed to have lived in both Kamakura and Odawara (cultural centers of the Kantō area in his time), and to have served the increasingly independent local *daimyō* of northeastern Honshu. His style was personal, even willful, but he was active as a painter largely after 1550.

The Kanō Lineage

The dominant tradition after 1500 was Kyoto-based, embodied in one of the longest-lived "family practices" in the history of art, the Kanō school, which maintained its leading position until Japan entered modern times with the Meiji Restoration (1868). The family lineage began to be recorded only in the seventeenth century but claimed ultimate descent from one Muneshige from the Izu Peninsula, identified as a retainer to no less a personage than Minamoto no Yoritomo (1147–1199), founder of the Kamakura shogunate. The father of the "founder" of the Kanō school is listed as Kagenobu, a retainer to the Imagawa *daimyō* family of Izu and reputedly a painter. The first contemporary or near contemporary references contain no mention of these forebears, but begin with Kanō Masanobu (1434–1530), crediting him with at least six portraits and three sets of Buddhist icons, but only one possible ink painting, an *Eight Views of Xiao and Xiang*. The only surviving example with a reasonably firm attribution is a representation of Hotei, in ink and color on paper, with an inscription by Keijo Shūrin, the Zen monk who inscribed Sesshū's *hatsuboku* landscape of 1495. *Hotei* is a sound, professional work, but the minimal cliff and rock elements reveal no great ink technique. The famous *Zhou Maoshu Admiring Lotus* is a delicate and atmospheric landscape, but the seal is uncertain and the work is closer in style to Geiami and Kei Shoki. In short, we have little way of knowing what Masanobu's style was, and certainly insufficient evidence to establish him as the innovative founder of the Kanō style.

That title belongs to Kanō Motonobu (1476–1559), whose managerial and diplomatic skills and eclectic painting talent combined to establish a Kanō school on a remarkably broad foundation. Like his father, Masanobu, he was a professional and was also appointed painter to the shogun. Marriage to a daughter of the Tosa family, hereditary masters of the traditional *yamato-e* style favored by the imperial court, made Motonobu heir to that lineage. Temples, shrines, *daimyō*, the shogun, and the court commissioned numerous works to be supplied by his flourishing workshop. His Tosa manner can be seen in two signed painted wood panels (*ema*, votive offering) of horses and grooms, probably dating from about 1525, as well as in narrative handscrolls of temple histories.

Motonobu's renditions of standard Zen figural subjects, such as *The Flight of the Sixth Patriarch* and *Xiangyan Attaining Enlightenment* (cat. 222, 223), painted about 1513 for the *hōjō* (abbot's quarters) of the Daisen-in of Daitoku-ji, were dominated by the decorative requirements of wall painting. Clouds, heretofore painted as part of the background, were brought into the foreground to provide blank space as a contrast with the complexities of the Chinese style rocks and small-scale figures. The latter were rendered in sharp, angular strokes, reflecting the heavy influence of the Southern Song master Liang Kai, who was well represented in the collections available to the artist.

Motonobu's important innovations can best be seen in the *fusuma* panels now mounted as hanging scrolls, also painted for Daisen-in of Daitoku-ji, circa 1510, and representing birds and flowers in a landscape (cat. 236). Although they may be descended from Sesshū's folding screens of the same subject (cat. 233), the screens show the systematic use of all means available to produce a highly decorative and dramatic result. Many writers have emphasized the Chinese sources of Motonobu's art, but he was equally adept at opaque color in the Tosa style, and artful in the placement of fragments of landscape—all the while emphasizing a firm, even "center-line" brush stroke in dark ink to clearly define the profiles of trees, rocks, and mountains. Even the pine needles are organized coolly, in a regular decorative pattern. This consistency of practice was most suitable for workshop production, and it is no wonder that the Kanō school swept the field of decorative painting and provided a well-developed starting point for the flowering of decorative painting in the reunified Japan of the Momoyama and Edo periods.

CERAMICS

Rough rather than smooth. Asymmetrical rather than symmetrical. Monochromatic and earthy rather than polychrome and finished. The contrast between standard Japanese and Chinese ceramics of the late fifteenth century could not be greater. Some of the difference can be attributed to the desperately depressed character of the Japanese economy and society during and following the Ōnin War (1467–1477), centered at first in and around the capital, Kyoto, and then spreading into the provinces as former vassals overthrew their appointed lords and fought each other. Notwithstanding the munificent expenditures of Yoshimasa (1436–1490, shogun 1443–1473) on his unrivaled collection of Chinese art and his disarmingly simple but elegant Silver Pavilion (Ginkaku-ji, begun 1483) in the Higashiyama suburb of Kyoto, the real state of the country is more realistically depicted in the "samurai Westerns" of modern cinema, directed with knowing accuracy by Kurosawa and Mizoguchi. The taste for Chinese ceramics, especially celadons and *temmoku* (C: *jian* ware) tea bowls, as well as for elegant bronze and brass containers, was common among the newly powerful military chiefs and the always powerful high Bud-

dhist clergy. This left patronage of native ceramics to the townsfolk and, even more, to the farmers.

Japan's ceramic tradition was perhaps even older than that of China. The earliest vessels, earthenware jars of the Jōmon culture, are now convincingly dated as early as 10,500 B.C. By about 2500 B.C. we find the complex and fantastically modeled vessels of Middle Jōmon—among the greatest of all Neolithic ceramics. This low-fired earthenware tradition continued through various permutations until the seventh and eighth centuries A.D. With the rapid wholesale importation and adoption of Chinese Buddhism and Chinese culture in the Asuka, Hakuhō, and Nara periods (mid-6th–late 8th centuries), the first glazed ceramics, some relatively high fired, make their appearance. In this transformation of Japanese religion, culture, and art Korea was a major intermediary. Korean influence was most important in the development of sueki, the first Japanese ceramic to be made on the potter's wheel. This was a gray ware, often glazed (sometimes as a result of kiln accident), and fired in elementary tunnel, or "dragon," kilns. Called anagama, these kilns were tunnels, dug along the slope of a hill and then roofed over, and they were capable of temperatures well over 1000° C.

Beginning in the ninth century the decline of imperial power both in China and Japan had a dampening effect on overseas cultural and trade relations, except for continuous contacts among Buddhist clergy and institutions. The development of native traditions in secular painting (yamato-e, Japanese painting), in lacquer decoration (maki-e, powdered-metal picture), and in stonewares was a major achievement of the Heian period (794–1185). Kilns expanded and proliferated mainly in the Sanage mountain area, just east of Nagoya, a region that was to be the major ceramic production center in Japan to the present day.

The Kamakura period (1185–1333) marked the renewal of substantial contacts with China through the religious and commercial activities of the newly powerful Zen (C: Chan) monasteries in Kamakura and (somewhat later), Kyoto. Chinese celadons and qingbai wares as well as jian ware (J: temmoku) tea bowls were imported in large numbers. Especially celadons—the beach at Kamakura is still littered at low tide with shards of Song celadons from the cargo ships that unloaded there in the thirteenth century. At Seto, just north of Sanage, new kilns were built, and green- to brown-glazed stonewares in Chinese shapes with Chinese and some Japanese decorative schemes were made in quantity. That this early Seto production proved uncongenial to Japanese taste is evi-

dent from its inability to survive the competition of the various provincial kilns loosely called the Six Old Kilns—Shigaraki (Shiga Prefecture) and nearby Iga (Mie Prefecture); Tokoname, just south of Nagoya on Chita Peninsula; Tamba, just north of Osaka (Hyōgo Prefecture); Bizen, east of Okayama, and Echizen, on the Japan Sea coast (Fukui Prefecture).

By the fifteenth century there were other, smaller, ceramic centers, but the Six Old Kilns, along with Seto (no longer making Chinese style vessels), were the dominant ones. All made rather similar simple wares for similar purposes: burial jars; storage jars for grain, tea, pickled vegetables, and liquids; graters; platters; bottle-vases. The manufacture entailed local clays, often with impurities; the use of ash-induced or ash glazes; tunnel, or climbing, kilns; and firing over many days in an oxidizing atmosphere at about 1100° C. The key word in any description of the products of all these kilns is local. Their wares—especially Seto—were exported to other parts of Japan, but their profiles, colors, and textures were determined by local potters, often from farm families; local materials; local techniques; and peculiarities of local usage. The differences among these agricultural communities were minor, and often it is difficult to tell their ceramics apart. Tamba clays seem more refined, and the shapes more regular. Echizen jars differ from Tokoname in the shape of shoulders and neck. Bizen often dispenses with the green to brown ash glaze in favor of a matte biscuit surface streaked with red fire burns. But all these wares reflect the rough-hewn provincial circumstances of their manufacture and use: the autonomy of local warrior-chiefs, a need for food storage and preparation vessels, and a "fine disregard" for refinement and perfection. These rugged, monumental vessels show clearly both the methods and the accidents of their making—whether they were coiled or thrown, whether the kiln supports or adjacent pots stuck to their skins, whether their walls blistered or fissured or partly collapsed during firing. All were put into use, at first because their makers could not afford to discard them and later, as the sixteenth century progressed, because the growing number of priestly and samurai devotees of the Tea Ceremony (Cha no yu) bestowed aesthetic cachet on what the local potters had produced of necessity.

The Tea words wabi and sabi subtly denote qualities of naturalness, of noble and antique yet unassuming poverty, of a certain nostalgic sadness. Shibui means roughness, "astringency." These qualities, which are as one with the products of the Six Old Kilns, emerged as ideals in the world of the Ōnin War and the century that

followed, aptly known as "The Age of the Country at War." Seto ware imitations of Chinese and Korean mei-ping vases, temmoku tea bowls brought from China's Fujian Province or copied after these, transcriptions of Chinese guan jars and four-handled tea storage jars from south China, these were the formal school in which the Japanese developed an early, Sinicized taste in tea and its utensils. But the ultimate appearance, not only of Tea Ceremony wares but of the tea house and its garden as well, corresponded subconsciously and intuitively to the rough, unassuming, provincial wares of Japan. Yoshimasa's Silver Pavilion and its garden embody the same aesthetic character and mode as wares from the Six Old Kilns. By the mid-sixteenth century tea masters (chajin) were designing and commissioning wares specifically for their very special purposes. Murata Shukō (1423–1502), the master of "informal" tea and the revered "father" of Cha no yu is reported to have said, "I think that Japanese utensils like those of Ise Province (Mie Prefecture) and Bizen Province (Okayama Prefecture), if they are attractive and skillfully made, are superior to Chinese ones" (Hayashiya, Nakamura, and Hayashiya, 1974, 27–28).

The early tea masters, then, were the inheritors of a Chinese custom, informally organized at first to accompany social gatherings and later to be compatible with Chan Buddhist ritual, especially meditation. The Tea Ceremony as practiced by Shukō and his patron Yoshimasa tended toward informality and the use of Chinese implements—ceramic tea bowls and metal and ceramic flower holders. The shogun's famous collection of Chinese objects and paintings, of which Nōami (considered by some to have been Shukō's tutor in Tea) was curator, followed the Chinese taste in tea utensils. In declaring that Japanese ceramics also were appropriate for Tea, Shukō determined the direction of their future change and development. This was manifested earliest at Seto: there, beginning in the early fifteenth century, to the repertory of vessels in the style of Chinese qingbai, longquan celadon, and cizhou wares were added tea bowls imitating Chinese jian ware. These were clearly inexpensive substitutes for the highly prized Chinese temmoku, the most efficient drinking bowl ever designed, of which the shogun's collection included a few very special examples. By the early sixteenth century the Mino kilns near Seto were producing a few light-colored bowls in temmoku shape (cat. 259) that appear to anticipate the kind of glaze later characteristic of Shino wares made at Mino specifically for the Tea Ceremony. Some of these were designed by tea masters, thus anticipating the "artist-potter" production of

the seventeenth and eighteenth centuries.

Ceramic production from 1450 to 1550 was basically conservative and subject to the serious economic, social, and agricultural disturbances of the time. But the fortunate link between emerging Tea taste and the continued rural character of native ceramics reinforced the peculiar rough informality of Japanese ceramics and laid the foundation for the extraordinary developments of the Momoyama period (1573–1615), when the country was reunified and prospering under the powerful dictator-shogun Hideyoshi. While the ensuing gradual codification and complex refinement of the Tea Ceremony produced results far from the original intentions and practices of Shukō and his disciples, the strength and persistence of the Tea Ceremony, with its ancillary art of flower arrangement, provided the Japanese with an instrument for aesthetic education unmatched by any comparable social device in world history.

BIBLIOGRAPHIC NOTE

Harada 1937; Okudaira 1962; Ienaga 1973; Hall and Toyoda 1977; Okazaki 1977; Cleveland 1983; New York 1983.

Acker 1954; Boston 1970; Tanaka 1972; Matsushita 1974; Princeton 1976; Rosenfield, in Hall and Toyoda 1977; Kanazawa 1979.

Covell 1941; Boston 1970; Tanaka 1972; Covell and Yamada 1974; Matsushita 1974; Princeton 1976; Hall and Toyoda 1977, esp. chaps. 2, 12–17; New York 1981; Los Angeles 1985; Speiser, n.d.

Sadler 1962; Lee 1963; Castile 1971; Jenyns 1971; Hayashiya, Nakamura, and Hayashiya 1974; Cort 1979, 1981; Mikami 1983; Tokyo 1985.

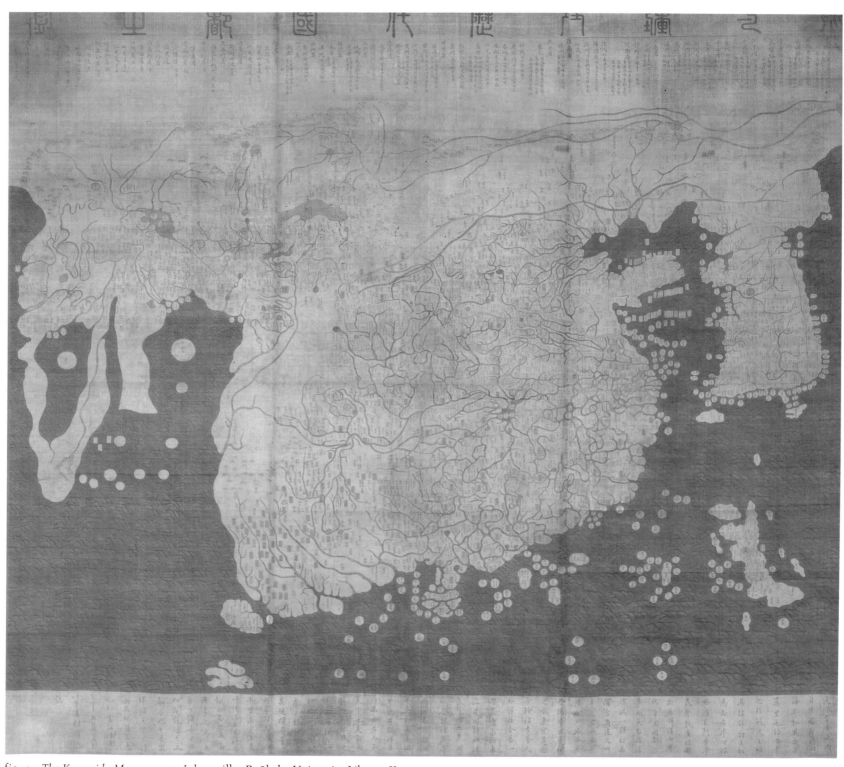

fig. 1. *The Kangnido Map*, c. 1470. Ink on silk. Ryūkoku University Library, Kyoto

THE KANGNIDO: A KOREAN WORLD MAP, 1402

Gari Ledyard

Unless Columbus understood a few obscure references in Marco Polo that the Venetian traveler himself had probably misunderstood, he knew nothing of Korea when he set out on his first voyage. He knew about China and Japan. But if he had wanted to find the most complete map of the world that any East Asian country had to offer, he would have had to go to Korea, then known as the Kingdom of Chosŏn, to see it. For in Chosŏn's royal palace was a map that not only included all of China and Japan, but showed India, the countries of the Islamic world, the African continent, and — most astonishing of all — Europe itself. Spain was easy to recognize on this map, and Columbus might even have found Genoa along the strangely bending shores of its Mediterranean. Admittedly, the image of Europe needed some improvement, and Korea itself, we have to acknowledge, was much bigger than it ought to have been. But what map made in Europe had as good an image of Asia as this map had of its own world?

This essay is an attempt to understand how such a rare cartographic gem was put together. Like most gems, this one needs a setting, and that is where we will begin.

The founder of the Chosŏn dynasty (1392–1910) was Yi Sŏng-gye–1335–1408; r. 1392–1398, a military man and native of the northeast frontier, who had risen to fame for his resistance to the Japanese marauders who had plagued Korea throughout the fourteenth century. These were veritable armies, sometimes two or three thousand strong, whose coastal raids often penetrated far into the interior; no town anywhere in the southern provinces was safe from them. Yi's successive victories over this menace throughout the 1380s had brought him a national following. He came to power in 1389 in a spectacular military coup. In 1388, the Ming dynasty, which had just ousted the Mongols from the Liaodong area, demanded that Korea turn over the lands northeast of the "Iron Pass" (*Chŏllyŏng*) that had been administered directly by the vanquished Yuan dynasty. Koryŏ refused, and ordered Yi Sŏng-gye to attack Ming forces in Liaodong, but Yi, thinking this policy ill-advised, took over the government instead. Ming, given the change, did not push its demands, and the northeast territories stayed with Koryŏ. Three years later, Yi took the throne himself, bringing the Koryŏ dynasty to an end after almost five centuries of rule.

This was no mere dynastic change. Into power with Yi Sŏng-gye came a movement of Neo-Confucian reform that within a generation remade Korea into a completely different kind of kingdom. With the dispossession of the old Koryŏ aristocracy, and the disestablishment of Buddhism as a state-protected religion, the reformers launched a political program that proclaimed Confucian priorities in social policy, educational reconstruction, and cultural development. Thousands of monks were laicized and a multitude of slaves manumitted, all to reinvigorate the revenue-producing peasantry, on lands often confiscated from monasteries. A small but dynamic corps of Confucian ideologists rewrote the legal codes, redesigned governmental institutions and the civil service, and in countless other ways turned the Neo-Confucian intellectual revolution of the Chinese philosopher Zhu Xi (1130–1200) into state orthodoxy. These men, who saw their regime as having the classical "Mandate of Heaven," had a keen awareness that they were effecting millennial change, and their vision became concrete in a 518-year rule, which apart from China's chronologically problematical Zhou dynasty, and Japan's very different monarchical institution, is the longest dynastic duration in East Asian history.

It is no accident that among the early cultural projects of this new regime we should find a map of the world and a map of the skies — heaven and earth themselves redefined and proclaimed within the cadre of Korea's cultural revolution to demonstrate the new dynasty's cosmic legitimacy. Nor is it mere coincidence that the official guiding both of these projects, Kwŏn Kŭn, was one of the key Confucian scholars among the reformers.[1] The star map, which purports to be a revision of an ancient Koguryŏ map, was engraved on stone in 1395. It has been the object of several studies.[2] Here we limit ourselves to consideration of the world map.

The *Honil kangni yŏktae kukto chi to* ("Map of integrated regions and terrains and of historical countries and capitals"), hereafter referred to as the Kangnido),[3] was completed in 1402. It easily predates any world map known from either China or Japan and is therefore the oldest such work surviving in the East Asian cartographical tradition, and the only one prior to the Ricci world maps of the late fifteenth and early sixteenth centuries. Although it is no longer preserved in Korea itself, there are three versions in Japan; of these the copy in the Ryūkoku University Library (Kyoto), which is displayed in this exhibition, is acknowledged to be the earliest, and in the best condition. The principal distinguishing characteristics of the Ryūkoku copy are its generally excellent condition and its preservation of the original Kwŏn Kŭn preface. Painted on silk and still preserving its colors well, it is a very large map, nearly square at 171 × 164 cm (67¼ × 64½ in). It was first brought to scholarly notice by the Japanese historical geographer Ogawa Takuji, in 1928.[4]

The place to begin discussion of this very unusual map is with its preface, the crucial part of which is translated here from the text on the Ryūkoku copy, with reference to the closely similar version in Kwŏn Kŭn's collected works, the *Yangch'ŏn chip.*[5]

The world is very wide. We do not know how many tens of millions of *li* there are from China in the center to the four seas at the outer limits, but in compressing and mapping it on a folio sheet several feet in size, it is indeed difficult to achieve precision; that is why [the results of] the mapmakers have generally been either too diffuse or too abbreviated. But the *Shengjiao guangbei tu* (Map of the Vast Reach of [Civilization's] Resounding Teaching), of Li Zemin of Wumen, is both detailed and comprehensive; while for the succession of emperors and kings and of countries and capitals across time, the *Hunyi jiangli tu* (Map of Integrated Regions and Terrains), by the Tiantai monk Qingjun, is thorough and complete. In the 4th year of the Jianwen era (1402), Left Minister Kim [Sahyŏng] of Sangju, and Right Minister Yi [Mu] of Tanyang, during moments of rest from their governing duties, made a comparative study of these maps and ordered Yi Hoe, an orderly, to collate them carefully and

then combine them into a single map. Insofar as the area east of the Liao River and our own country's territory were concerned, Zemin's map had many gaps and omissions, so Yi Hoe supplemented and expanded the map of our country, and added a map of Japan, making it a new map entirely, nicely organized and well worth admiration. One can indeed know the world without going out of his door! By looking at maps one can know terrestial distances and get help in the work of government. The care and concern expended on this map by our two gentlemen can be grasped just by the size of its scale and dimension. . . .

Both Kim Sahyŏng (1341–1407) and Yi Mu (d. 1409) held high offices during the formative years of the Chosŏn dynasty, although Yi Mu fell afoul of King T'aejong and was later executed for his alleged role in a political plot. Both went to China on diplomatic business during their careers, and it is believed that Kim's trip, completed in the summer of 1399, was the occasion for obtaining the Chinese maps mentioned by Kwŏn Kŭn.[6] Both Kim and Yi probably had administrative experience with maps, as they had reported to King T'aejong on the progress of the land surveys of the northern frontier area in the spring of 1402, just a few months before the world map was made.[7] But as high ministers they probably had little time for actual cartographical work. Kwŏn's own role was probably important, even though he insists that he only stood in the background and "enjoyably watched the making of the map." But he was being modest and tactful, since he was younger in age and junior in rank to the two ministers. But the real cartographer, even though Kwŏn minimizes his role, was Yi Hoe, whose entire career was in rather low-ranking but often special positions. His map of Korea, which was separately known, was almost certainly the basis for the Korean part of the world map.

Judging by Kwŏn's description of the monk Qingjun's *Hunyi jiangli tu*, it was probably an ordinary historical map of China, compiled in the late fourteenth century. Qingjun (1328–1392) was a close advisor to the Hongwu emperor (r. 1368–1398), who was the founder of the Ming dynasty and himself an erstwhile monk.[8] Apart from its use as a source for the Kangnido, nothing is known of Qingjun's map. Its chief contribution to the latter is believed to have been the Chinese historical dimension — the indication of the areas and capitals of the earlier dynasties, which was accomplished by a combination of textual notes and cartographic devices. Other than that, the main feature that stuck on the Korean map was probably its name: it reads *Honil kangnido* in Sino-Korean.

The international dimension of the Kangnido

unquestionably came from Li Zemin's *Shengjiao guangbei tu*. Li is mentioned by the Ming cartographer Luo Hongxian (1504–64) as a contemporary and possibly as an associate of Zhu Siben.[9] Aoyama's careful study of the Chinese place-names on the Kangnido shows them in general accord with those on Zhu's map, as preserved in Luo's *Guang yu tu*, but with variants that would indicate place-name changes made in 1328–1329; this suggests that the Kangnido's source map was made around 1330. Since Zhu explicitly excluded most non-Chinese areas from his map,[10] Aoyama and others have reasoned that Li Zemin must have found his cartographic sources for these areas elsewhere, the only plausible source being Islamic maps, which made their appearance in China under Mongol rule.[11] Luo Hongxian's probable use of the *Guangbei tu* is deduced from his maps of the southeast and southwest maritime regions; and it could well be from the *Guangbei tu* that the *Da Ming hunyi tu* (Integrated map of Great Ming), in the Palace Museum in Beijing, derives. But for the missing or incomplete detail in the eastern areas of Manchuria, Korea, and Japan, that map bears a very close resemblance to the Kangnido.[12]

Takahashi Tadashi has shown that the Kangnido's Chinese transcriptions of place names in southwest Asia, Africa, and Europe come from Persianized Arabic originals. While some of Takahashi's matches do not command credence in early-modern Chinese phonological terms, he generally makes a convincing case. One of the more interesting correspondences is the name placed by the mountains near the Ptolemaic twin lakes that are the source of the Nile. Though not on the Ryūkoku copy of the Kangnido, the Tenri University copy shows the Chinese transcription *Zhebulu hama*, which Takahashi identifies with Persianized Arabic *Djebel al-qamar*, "Mountains of the Moon."[13] All in all there are about thirty-five names indicated on or near the African continent, most of them in the Mediterranean area.

The European part of the map, which is said to contain some 100 names, has not yet been the object of an individual study, and no details of this section of the Kangnido seem to have been published. The Mediterranean is clearly recognizable, as are the Iberian and Italian peninsulas and the Adriatic, but until the place-names can be read and interpreted it will be impossible to come to any firm understanding of it.[14]

Kwŏn Kŭn observed in his preface that the *Guangbei tu* had only sketchy treatment of the area east of the Liao River and of Korea. His language suggests that some image of Korea, however deficient, was on the original *Guangbei*

tu, and that this was supplemented or replaced by Yi Hoe. Yi is known to have produced a map of Korea, called the *P'altodo*, or "Map of the Eight Provinces,"[15] and it was probably a version of this that appears today on the Kangnido. It is only through the Kangnido that that map is known today.

The last major element of the map to be supplied, as far as the Koreans were concerned, was Japan. At this particular moment in time, Korea's relations with the Japanese were very difficult owing to the continuing problem of Japanese marauders, who were beyond the ability of the Ashikaga shogunate to control. Diplomatic initiatives were in progress, and coastal defenses and strategies were undergoing constant development. All this was backed by a general Korean effort to improve the government's knowledge of Japan, and this involved maps in particular. Pak Tonji, a military man and diplomatic specialist in Japanese affairs, made at least two trips to Japan, one in 1398–99, the other in 1401, and the second visit resulted in a map. A later report quoted his statement that in 1402 he had been given a map by the "*Bishū no kami*, Minamoto Mitsusuke." He says: "It was very detailed and complete. The entire land area was on it, all but the islands of Iki and Tsushima, so I added them and doubled the scale." In 1420, this report states, he formally presented this map to the Board of Rites, which was the branch of the Chosŏn government that handled foreign affairs.[16]

It is generally assumed by Korean cartographical specialists that this map, brought back in 1401, was the basis for the representation of Japan on the Kangnido. As maps of Japan go in this period, the outline on this one is unusually good: the positioning of Kyūshū with respect to Honshū is quite accurate, and the bend north of the Kantō area is indicated better than on many of the Gyōki-style maps then current. But for the joining of Shikoku to Honshū, the three main islands (adding Kyūshū; Hokkaidō, of course, not included at that time) make a very decent appearance. But this splendid effort seems to be vitiated by orienting the Japanese portion so that west is at the top. Worse, the whole ensemble is positioned far to the south, so that the first impression of a modern observer is that the Philippines, not Japan, is under view. A possible explanation for this is that the cartographers had run out of space on the right (east) edge of the Kangnido, and so had to place Japan in the open sea to the south. But since Japan had always appeared east of southern China on Chinese maps, there was some earlier cartographic basis for its placement there. As for the west-at-the-top orientation, it is possible that this was the original orientation of the map Pak

Tonji received from Minamoto Mitsusuke; indeed the earliest known map of Japan (805) has this orientation.[17] Interestingly, the Korean makers of the Tenri and Honmyō-ji copies corrected the orientation to the north, even while substituting more conventional Gyōki-style outlines.

The overall disposition and bulk of the different components of the Kangnido at first make an odd appearance. On the one hand, there is nothing formulaic or mandated about its structure, such as the traditional European T-in-O scheme, or the wheel arrangement of the quasi-cosmographic ch'ŏnhado of later Korean popularity. The attempt here was to study the best maps available in China, Korea, and Japan, and put together a comprehensive, indeed "integrated" (honil), map that included every known part of the world, truly a breathtaking objective by the cartographic standards of any nation at that time.

The result is inevitably strange to our eyes. China and India, like a monstrous cell that had not yet divided, make up a dominating mass that overfills the entire center of the map. India has its west coast, but is not drawn as a peninsula and so has no east coast. To the west, the Arabian peninsula, with a clearly delineated Persian Gulf, and the African continent, with its tip correctly pointing south (and not east, as on many early European maps), hang thinly but with assurance, as if they belonged exactly where they are. At the top of Africa the Mediterranean supports a less securely grasped Europe, and the entire north fades into mountains and clouds. On the eastern side of the map, a relatively massive Korea, easily occupying as much space as the whole African continent (which, to be sure, is unduly small) identifies itself as a very important place, while Japan, as if randomly flipped off the fingers into the ocean, floats uncertainly in the South China Sea. The relative size and disposition of the three major East Asian countries reflects a plausible Korean view of the world in the early fifteenth century: Korea projecting itself as a major East Asian state, refurbishing its traditional view of China as the major center of civilization, and playing its eternal game of keeping Japan as far away as possible. On the other hand, Koreans were telling themselves that theirs was not just an East Asian country, but part of the larger world. Their ambition and ability to map that world would validate their position in it.

To say this is to begin to answer the question, what was this map for? A map whose composition was guided by the nation's top educator and Confucian ideologist, and presided over by two ministers of state, was surely destined for display in a prominent, central place in the capital. It was probably on a screen or a wall in some important palace building frequented by the king and senior officials. But a good understanding of its function is hampered by the fact that we know nothing of its history after its completion. The Ryūkoku Kangnido, judging by Korean place-name indications, is a copy reflecting place-name changes made around 1460.[18] If its source map was the original Kangnido, then this is the last that is heard of it.

We know little about how the Kangnido came to Japan, but it probably arrived there independently on three separate occasions. Both the Ryūkoku and Honmyō-ji copies were evidently part of the loot from Hideyoshi's invasion of Korea (1592–1598). The Ryūkoku map was reportedly given by Hideyoshi to the Hongan-ji, an important Buddhist temple in Kyoto. This institution ultimately was divided into two branches, east and west, of which the latter (Nishi Hongan-ji) is today associated with Ryūkoku University, which explains the map's present location.[19] The Honmyō-ji copy (paper scroll), which is entitled Dai Minkoku chizu (Map of Great Ming), was given to that institution by Katō Kiyomasa, its major patron and one of the senior Japanese commanders on the Korean expedition.[20] Nothing is reported concerning the provenance of the Tenri University copy (silk scroll, no title), but according to a study by Unno Kazutaka, it is a "sister map" to the Honmyō-ji scroll; his persuasive analysis of the place names indicates that both maps were copied in Korea about 1568, from a version already cartographically distant from the Ryūkoku copy.[21]

This information permits the conclusion that the Kangnido was probably often copied in Korea during the fifteenth and sixteenth centuries. There is an arguable possibility that its fortunes intersected with those of the ch'ŏnhado ("map of all under heaven"), which came to have a special place in Korean affections and invariably was the first map in the map albums which were especially popular in the eighteenth and nineteenth centuries. It also seems conceivable that it is reflected in an interesting map entitled Yŏji chŏndo (Complete terrestrial map), dated about 1775. This map, while clearly influenced by some Sino-Jesuit world map, also shows a strong structural similarity to the Kangnido, as its owner, Yi Ch'an, has pointed out.[22] Thus Japan is righted and put in its proper place, the respective masses of Korea, China, and Africa are brought into more accurate relation, and England and Scandinavia emerge from Europe. But the map as a whole, and particularly its treatment of India and Africa, strongly evokes the Kangnido. This is

good evidence that the Kangnido tradition was not broken by the Hideyoshi wars, but stayed alive in Korea for two more centuries. Somewhere in Korea a copy may be hiding still.

The Kangnido was only the first of many distinguished scientific and cultural projects carried out in Korea during the fifteenth century. King Sejong (r. 1419–1450) and his son King Sejo (r. 1455–1468) extended Korean cartographical foundations by standardizing linear measurement and assembling detailed distance data between Seoul and the approximately 335 districts of the country. As a result of these efforts, an excellent national map was produced in 1463, and a complete geographical survey of the nation, the Tongguk yŏji sŭngam, was compiled in 1481. During the 1430s, Sejong built an astronomical observatory and a variety of astronomical instruments and clocks. This provided a foundation for continued research and observation in the reigns of his successors. Many projects were also carried out in meteorology and agronomy which not only led to new scientific understanding in Korea but which provided for rationalized administration and taxation. Movable type printing with cast metal movable type, which Korea had pioneered among the East Asian nations in 1242, underwent considerable development and refinement under the fifteenth-century kings; by the time Gutenberg perfected his press in 1454, hundreds of editions of books in Chinese and several in Korean had been printed in Korea with movable type. Finally, King Sejong in 1443 invented the Korean alphabet, an amazingly original and scientific system which still serves as the writing system of Korea and which is the only indigenous alphabetic system in use among the East Asian countries.

The spirit that animated all of these projects, and that marks the fifteenth century as perhaps Korea's greatest, was both national and international in character, and showed a high degree of independent thinking. Koreans did not merely copy the Chinese culture they imported, but recast and it into forms and institutions which were distinctively different from China's. The Kangnido is a perfect example of this process: China, either as originator or transmitter, provided Korea with most of the materials for the map, but the transformation and processing of those materials into a genuine world map was conceived and executed in Korea.

NOTES

1. Even though the two projects were seven years apart, the prefaces for both appear next to each other in Kwŏn's collected works, Yangch'ŏn chip (Collected writings of Kwŏn Kŭn) (xylograph, Chinju, 1674; reprint, Chōsen shiryō sōkan, No. 13, Keijō, Chōsen sōtokufu, 1937), 22/1a-2b.

2. See W. Carl Rufus, "The celestial planisphere of King Yi Tai-jo [T'aejo]," *Transactions of the Korea Branch of the Royal Asiatic Society*, 4 (1913), 23-72, and "Astronomy in Korea," ibid., 26 (1936), 1-52; also Rufus and Celia Chao, "A Korean Star Map," *Isis*, 35 (1944), 316-326, and, more recently, Joseph Needham, Lu Gwei-djen, John H. Combridge, and John S. Major, *The Hall of Heavenly Records, Korean astronomical instruments and clocks, 1380–1780* (Cambridge, 1986), 154-59.

3. This is the title on the Ryūkoku University copy of the map and the one standard in the literature. The title indicated in Kwŏn Kŭn's preface, *Yangch'ŏn chip*, 22/2a, is: *Yŏktae chewang honil kangnido*, "Map of historical emperors and kings and of integrated borders and terrains."

4. Ogawa Takuji, *Shina rekishi chiri kenkyū* (Studies in Chinese historical geography) (Tokyo, Kobundō shobō, 1928), 59-62.

5. The translation is from the text transcribed from the map by Ogawa Takuji, *Shina rekishi chiri kenkyū*, 60; see also Aoyama Sadao, "Gendai no chizu ni tsuite" (On maps of the Yuan dynasty), *Tōhō gakuhō* (Tokyo), 7 (1937): 110-11. These texts differ very little from that in the Yangch'ŏn chip, 22/2a-b.

6. *Chŏngjong sillok*, 1/17a. Yi Mu's trip took place in 1407, after the map was finished. The Chosŏn dynasty's royal annals, generally called the sillok of a given king, are cited from the edition *Chosŏn wangjo sillok*, 48 vols., plus index volume (Seoul: National History Compilation Committee, 1955–1963).

7. *T'aejong sillok*, 4/10b-11a.

8. Aoyama Sadao, "Gendai no chizu . . . ," *Tōhō gakuhō* 8 (1938), 122-123.

9. Luo Hongxian's preface to the *Jiubian tu*, partly quoted in Aoyama, "Gendai no chizu . . . ," *Tōhō gakuhō* 8 (1938), 123.

10. Zhu's preface to his lost *Yu(di) tu*, preserved in Luo Hongxian's *Guang yu tu*, quoted in Aoyama Sadao, "Gendai no chizu . . . , *Tōhō gakuhō* 8 (1938), 105.

The exclusion, in Zhu's own words, was: "the areas southeast of the overflowing seas and northwest of the sandy wastes, and all the bordering tribes and strange territories."

11. See Joseph Needham, *Science and Civilization in China*, 3 (Cambridge, 1959), 551-556.

12. On this map see the description of Walter Fuchs, "Pekin no Mindai sekaizu ni tsuite" (On the Ming-period world map in Peking," *Chirigakushi kenkyū* 2 (1979), 3-4, with 2 plates.

13. Takahashi Tadashi, "Tōzen seru chūsei isuramu seikaizu," *Ryūkoku daigaku ronshū* 374 (1963), 86-94. Takahashi cites a number of features that are on the Tenri but not the Ryūkoku map, mainly in the African part.

14. Takahashi, 1963, 89, note 9, cites four Chinese transcriptions from the European part of the map, and matches them with names from al-Idrîsî's map of 1154. Without however knowing where on the map these names are, it is hard to evaluate them. The 100 names from the European part still await a thorough study by the appropriate specialists.

15. This may have been the same map as the "map of this country" presented by the State Council to King T'aejong on 6 June 1402 (*Taejong sillok*, 3/27a). This date coincides with the period in which Yi Hoe would have been working on the Kangnido, which must have been completed by the 8th lunar month of 1402 — solar 19 August to 16 September — the date of Kwŏn's preface. Yi Hoe's death date is unknown; the latest mention of him I have seen is during May–June 1409 (*T'aejong sillok*, 17/35a), when he was appointed to a supernumerary post in the censorate. It is only many years later, in 1482, that his authorship of the P'altodo finds documentary confirmation, in a list of maps which the official Yang Sŏngji was seeking to have restricted to official use (*Sŏngjong sillok*, 138/10b).

16. These events of 1401 and 1420 are reported retrospectively, in 1438; see *Sejong sillok*, 80/21a-b. For his 1398–1399 mission to Japan, which lasted more than 17 months, see *Chŏngjong sillok*, 1/13a-b. The

Bishŭ no Kami ("Governor of Bishŭ") Minamoto Mitsusuke is not otherwise identified. Tsushima and Iki were well-known pirate bases, of special interest to the Koreans.

17. The original of this map is lost; only a mid-seventeenth century copy survives. This circumstance proves the possibility of such a map being available for Pak Tonji in the early fifteenth century. See the illustration in Akioka Takejirō, *Nihon chizushi* (Cartographic history of Japan) (Tokyo, Kawade shobō, 1955), plate 1.

18. Aoyama, "Gendai no chizu ni tsuite," 143-145.

19. See Aoyama, "Gendai no chizu ni tsuite," 110; and Takahashi, 1963, 85 and 89, n. 1. Takahashi examined an unpublished catalogue of the Hongan-ji's books and manuscripts compiled during the 1840s and 1850s and found an item entitled *Rekidai teikyō narabi sengizu* (The capitals of historical emperors, together with a usurpatious map). The *rekidai* (Korean *yŏktae*) evokes the Korean title of the map. The "usurpatious" probably reflects Japanese umbrage either at Japan being part of a world map which listed only foreign "emperors and kings," or at Japan's incorrect orientation and position on the map, both of which could have been seen as detracting from the dignity of the Japanese imperial institution. Such nationalist attitudes were very strong in some Japanese scholarly circles in the mid-19th century, when the Hongan-ji's catalogue was being compiled.

20. See Akioka Takejirō, *Nihon chizushi* (Cartographic history of Japan) (Tokyo, Kawade shobō, 1955), 80-81 (illustration).

21. Unno Kazutaka, "Tenri toshokan shozō Dai Min kokuzu ni tsuite" (On the 'Map of Ming' held by the Tenri University Library), *Osaka gakugei daigaku kiyō* 6 (1958), 60-67, with 2 plates.

22. Yi Chan, *Han-guk ko chido*, 41. There is another copy of this map in the Sungjŏn University Museum (Taejŏn).

This essay has been abridged from the author's discussion of Korean geography in J.B. Harley and David Woodward, eds., *The History of Cartography*, 2, *Cartography in the Traditional Asian Societies* (Chicago and London, forthcoming).

KOREAN PAINTING OF THE EARLY CHOSŎN PERIOD

Sherman E. Lee

Korean art, especially that between 1450 and 1550, is important in its own right as a transformation of Chinese styles and subjects and as an influence upon the art of Japan. But our knowledge of Korean art, especially painting, is so limited and fragmentary that our approach to the subject should be cautious and our conclusions most tentative. The invasions of Toyotomi Hideyoshi (1537–1598) in 1592 and 1597, the sack of Korea by Manchu armies in 1627 and 1636, and the annexation of the hard-pressed country by Japan from 1910 to 1945, caused both destruction and displacement of works of art on a large scale. Even identifying Korean works became problematic; because all styles of Korean painting reflect in some degree its influence *from* Chinese and Japanese art, and because Korean art, with its Chinese components, was so strong an influence on Japanese art, numerous Korean paintings, once removed to foreign locations, came to be considered Chinese or Japanese. Only since the Korean War (1950–1953), and the subsequent recovery of the Korean political, economic, and social order, has the study of Korean painting begun slowly to develop, producing evidence and permitting distinctions that are clearing away the errors and prejudices of the past. The first formal effort in this direction was the 1973 exhibition at the Yamato Bunkakan (Nara, Japan), *Korean Painting of Koryŏ and Yi Dynasties*, with one hundred works from Japanese temples and secular collections. Since then research and publication has proceeded with "all deliberate speed," but only a beginning has been made, and this brief essay must be circumspect in its assumptions and provisional in its conclusions.

The massive cultural and aesthetic presence of China, Korea's nearest neighbor, naturally influenced the development of later Korean painting. Chinese paintings and painters could reach Korea easily—from north China by land through Shenyang (formerly Mukden, capital of Manchuria), from south China by the Yellow Sea (Huang Hai) from such ports as Ningbo on the Bay of Hangzhou. From the north, under both the Northern Song dynasty (960–1127) and its conqueror, the proto-Manchu Jin empire (1115–1234) came the early monumental landscape style. From the south came the more intimate and "romantic" landscape mode of the Southern Song dynasty (1127–1279) and the

highly colored style of Buddhist icon painting, dating from the Tang dynasty (618–907). The *wen ren* style, fully launched in China by 1350, did not affect Korean painting until the late sixteenth and seventeenth centuries, except for the distinctive massed-dot manner begun by Mi Fu (1051–1107) and continued by the Yuan master Gao Kegong (1248–1310). Gao's influence resulted from the close connections between the Korean King Ch'ungnyŏl (r. 1274–1308) and the Mongol Yuan dynasty, which Gao served as a high official in its capital at Dadu (present-day Beijing). In Dadu Ch'ungnyŏl built a well-known library called Hall of Ten Thousand Volumes (Mangwan Dang; Kim 1991, 186–187), and it is recorded that numerous celebrated Chinese scholar-official painters such as Zhao Mengfu visited the king and his library in Dadu.

Korean artists who had no direct access to Chinese painters might draw inspiration from Chinese paintings. Scroll paintings, being eminently portable, lend themselves to collecting, and a remarkable group of Chinese scrolls was amassed by Prince Anp'yŏng (1418–1453), third son of King Sejong (r. 1418–1450). Though the collection is long dispersed, a list of its contents survives, but one cannot judge the worth of the paintings by the names of the artists. Gu Kaizhi (c. 345–c. 406) and Wu Daozi (active c. 710–760), for example, were almost certainly not represented by genuine works, or even by works in their styles. But the presence of fifteen scrolls credited to Guo Xi (c. 1001–c. 1090) and two attributed to Ma Yuan (act. before 1190–c. 1230) is significant even if the works were not genuine, for their manners were so distinctive as to be readily paraphrased. Guo's grand and astringent style, expressed through the barren plateaus and mountains of north China, and Ma's romantic "one-cornered" compositions of fragments of nature are both very much represented among the works produced by Korean painters of the fifteenth and sixteenth centuries.

Japanese artists at least occasionally visited Korea. The visit by Tenshō Shūbun in 1423–1424 is well documented, and others are mentioned. From these contacts, influences proceeded in both directions. Chinese Ma-Xia school works in the shogunal collections colored Japanese painters' attitudes to composition and subject matter. Since both Korean and Japanese

painting were directly influenced by the Chinese monochromatic ink painting tradition, and since the two were also mutually influential, it is not surprising that we cannot tell which of numerous fifteenth-century paintings are Korean and which were executed by Japanese artists. The discovery of paintings bearing convincing inscriptions or seals that offer evidence of authorship or provenance helps to resolve this confusion. Thus the discovery, about 1968, of the ten-leaved album of bamboo paintings by Yi Sumun (cat. 266) with its signature, seal, and inscription effectively separated the Korean Yi Sumun (J: Ri Shūbun) from the Japanese Tenshō Shūbun (cat. 228). It also established that the album was painted in Japan in 1424. Since Tenshō Shūbun returned to

fig. 1. *Sākyamuni and Two Attendants*. Late Koryŏ period. Korean. Hanging scroll; ink, color, and gold on silk. The Cleveland Museum of Art, John L. Severance Fund

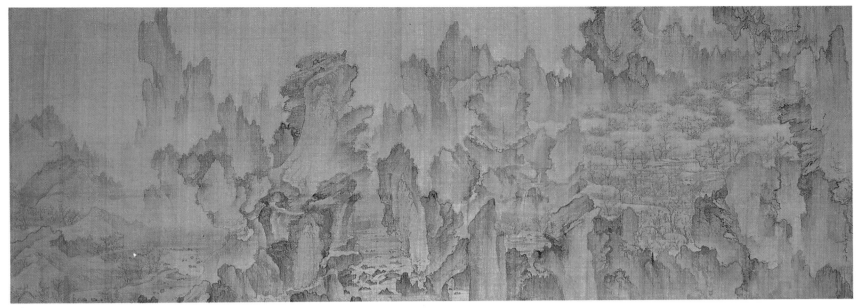

fig. 2. An Kyŏn (1418–after 1464). *Dream Journey to the Peach-Blossom Land*. Dated to 1447. Korean. Handscroll; ink and light color on silk. Central Library, Tenri University, Nara

Japan from his mission to Korea in 1424, it is at least possible that the two artists were in contact with each other just before, during, or after the voyage.

The album itself is not clearly related to any Chinese or Japanese representations of bamboo. Certain leaves are related to the handling of the bamboo in Josetsu's *Catfish and Gourd*, painted as a screen for the shogun about 1413. Other leaves recall Chinese Song and Yuan bamboo renditions, but not by mainstream *wen ren* bamboo specialists such as Li Kan or even traditionalists like Pu-Ming (Xue Chuang). Rather, Yi Sumun's album recalls the paintings usually assigned by the Japanese to "Tan Zhirui," pictorial treatments that emphasize bamboo in wind, rain, moonlight, or a minimal landscape setting. Yi's markedly personal variations on this type of bamboo painting include an almost geometric and planar patterning of leaves and even rain, for which this writer knows no precedents. Massed rocks and hills are angled to the viewer's right, a habit also discernible in the screens to be considered next.

Clearly Korean and Japanese monochrome ink styles are closely related, and future studies must take their relationships into account. Literary ties also exist, notably embodied in the famous, if anonymous, *Banana Trees in Night Rain* in the Hinohara collection (Matsushita 1974, 51–53). This work, which we still take to be stylistically typical of early Muromachi ink painting, was painted to accompany the composition of Chinese poetry by like-minded souls gathered at Nanzen-ji in Kyoto to celebrate the investiture of Yoshimochi as the fourth Ashikaga shogun. The gathering included part of a

visiting Korean delegation, one of whom added an inscription to the painting.

The Cleveland Museum's screens bearing seals of Yi Sumun (cat. 267) only exacerbate the problem of identifying Korean works and Korean influences. The screens appear to have been painted in Japan, for their particular six-fold format conforms to the developing Japanese norm. Also, the cedar and hemlock trees owe something to the Japanese Shūbun and resemble works usually clustered under the shadowy name of Soga Jasoku (act. c. 1491). Later sources identify Jasoku as a painter, perhaps even the son of Yi Sumun, working in Echizen Province (present day Fukui Prefecture), where Yi came to rest after his arrival in Japan. The Cleveland screens are unusual in their warm ink tones, their pictorial shading of rock and hill forms, the horizontal emphasis of the overall compositions, the rock projections to the right, and the major use of foreground *repoussoirs*, flat in the left screen and rising in the right one. The rough brushwork and the forced contrasts of ink tones are also unlike Japanese ink habits of the fifteenth century but similar to most Korean works of this time. All of this, with the evidence of old seals, strongly suggests this pair of screens to be significant works by or closely associated with Yi Sumun and major evidence for the mutual dependence of Korean and Japanese monochrome ink painting in the first half or three quarters of the fifteenth century.

The dominant Chosŏn landscape style is represented by the works of An Kyŏn (1418– after 1464) or those of his school. His masterpiece, *Dream Journey to the Peach Blossom Land*,

dated to 1447, is an original and creative pictorial commentary on the north Chinese tradition of landscape begun by Li Cheng and Guo Xi, maintained in the north by the conquering Jin dynasty, and transmitted to Korea at least in part through the collection of paintings formed by Prince Anp'yŏng. Although the inscriptions on the handscroll describe the work as a depiction of Anp'yŏng's dream, the representation is derived from the famous tale by Tao Yuanming (365–427), *The Haven of the Peach-Blossom Spring*, obviously well known to both the dreamer and the artist. A classic expression of the Confucian ideal of an earlier Golden Age, *Peach-Blossom Spring* tells of a Shangri-la discovered by a poor fisherman who follows a stream lined with magically blossoming peach trees into a mysterious cave. The cave debouches onto a fertile plain where lies a pretty and prosperous village, whose inhabitants live in perfect harmony and contentment according to Confucian precepts. They shower the stranger with hospitality but implore him to keep their existence a secret from the outside world—a request the fisherman promptly betrays on returning home. Fortunately, neither he nor anyone else finds it possible to retrace his steps, and so the fabled land is safe forever (Cyril Birch, ed., *Anthology of Chinese Literature* [New York, 1965; reprint 1967], pp. 167–168).

An Kyŏn painted the bare, steep mountains common in the Guo Xi style, using nervous, interlaced linear strokes to bound the rocks and mountains. Flat valleys with dry, barren shores penetrate the mountains, creating depth. The rational emphasis in this Chinese tradition was

transformed by An Kyŏn's imagination into a fantastic and irrational organization—ordinary nature to the left, the fantasy world of the Peach Blossom Land to the right, hemmed in all around by craggy peaks and rocks. Notwithstanding Tao Yuanming's emphasis on happy and hospitable farmers, in the painting no figures are visible. An Kyŏn depicted the magic land utterly desolate of people; only in the middle of the peach grove, beside a reach of water, can one see a small boat with an abandoned oar, signifying the fisherman.

This knotty and expressive style was imitated by various still unknown masters (cat. 264) for at least a century or more, and created a manner for the later depiction of Korea's dramatic Diamond Mountains. But it had almost no impact in Japan after the fifteenth century.

The third style reflected in Korean ink painting was that associated with the professional painters of Ming China, including the landscape masters of the Zhe school (cat. 288, 290, 291). Kang Hŭi-an (1419–1464) and his younger brother Kang Hŭi-maeng (1424–1483) are the best-known practitioners of this conservative Chinese style. The older painter had acted as an envoy to the Ming court in 1455 and, just as his colleagues knew artists in Kyoto, Kang surely became aware of the style practiced by the professionals at the Chinese court. His *Sage in Contemplation* (cat. 265), despite its small size, has much in common with the work of Zhang Lu, for example (cat. 305). The younger brother's *Sage Fishing* (Tokyo National Museum) practices the same simplifications of tone and composition, adding an unusual and personal way of modeling in light and shade in the tree trunk, which lends a touch of Western solidity to the image.

Although a very few Korean Buddhist paintings from the period 1450–1550 are known, the social climate of the Chosŏn state at this time was hardly conducive to a flourishing art or craft of icon painting. Beginning with the suppression of Buddhism in 1406, the faith was dealt a series of severe blows, culminating in the abandonment of a state-supported examination system for the Buddhist clergy in 1501. From this time until the de facto reign of Queen Munjŏng (r. 1546–1565) Buddhist worship and Buddhist art were hardly a factor in Korean culture. From 1549 onward the situation changed; numerous Buddhist icons of varying degrees of artistic interest were thenceforth produced and are extant in Korean, Japanese, and Western collections (Kim, New York 1991, 22–23).

Two of the paintings included here are without any contemporary parallels, indicating either that others like them have been lost or that Chosŏn Confucianism encouraged heterodox individualism. The *Dog and Puppies* by Yi Am (cat. 268) is a rather rough work, evidently by an amateur princely painter. The huge discrepancies in scale among tree, puppies, and the dog's head and tail are both naive and effective. Its "folkish" character reflects a recurring strain in Korean art.

Seeking Plum Flowers, attributed to Sin Cham (cat. 269), is quite another matter, suggesting a ninth- or tenth-century Chinese master reborn. The slow, grave rhythms of the landscape and the lonely separations of figures and trees all recall such Chinese masters as Zhao Gan in his famous *First Snow on the River* in Taibei. The dignity and decorum of the mood is most appropriate for the subject. Meng Haoran (689–740) was a noted poet of the Tang dynasty (618–907), and like many Confucian heroes moved from engagement at court to solitude in nature. His love for the flowering plum tree was legendary, and the scroll, which begins and ends with a flowering plum tree, shows him seeking out the first blossoms of the new year. Here one can be reasonably sure that the painting style is informed by a conscious archaism—that the artist, a Korean court official who experienced the great factional struggles which began in the later fifteenth century, was alluding to the similar tensions and uncertainties besetting government service in eighth-century China. Meng Haoran put it well:

> Slow and reluctant, I have waited
> Day after day, till now I must go.
> How sweet the roadside flowers might be
> If they did not mean good-bye, old friend.
> The Lords of the Realm are harsh to us
> And men of affairs are not our kind.
> I will turn back home, I will say no more,
> I will close the gate of my old garden.
> (Witter Bynner, *The Chinese Translations* [New York, 1978], p. 153)

BIBLIOGRAPHIC NOTE

McCune 1962; Rhodes 1970; Seoul 1972; Nara 1973; Kim and Lee 1974; San Francisco 1979; London 1984; Kim 1990–1991; New York 1991, esp. pp. 22–23.

CHINA IN THE AGE OF COLUMBUS

F. W. Mote

A . . . more important failure occurred in chapter 10, which treats world affairs between A.D. 1000 and 1500. In this case, new scholarship since 1963 has pointed the way to a firmer and better understanding of what was going on in the Eurasian world, and it is therefore obvious why I missed the centrality of China and Chinese civilization in these centuries. . . . In retrospect it is fascinating to see how some of the material for a proper appreciation of Chinese primacy between A.D. 1000 and 1500 was available to me before 1963 My excuse is that the historiography available a generation ago still reflected the traditional valuations of China's past my ignorance (and residual Eurocentrism) hid this from me in 1963. This indeed is the central failure of the book.

So writes the eminent historian William H. McNeill in a recent essay reflecting on his powerful work of world history, *The Rise of the West*, first published in 1963; twenty-five years later he finds it in serious need of revision in only one or two respects. In particular he notes that he had underestimated China's social organization, political sophistication, high development of craft industry and commerce, and application of technology in many aspects of life. He now presents convincing evidence that China was the most advanced civilization in the world throughout the half-millennium that ended in A.D. 1500. "The rise of the west to world hegemony," the dominant process in world history from that time onward into the twentieth century, got quickly underway only after 1500.[1]

William McNeill has been one of the most influential historians of our time. In his view —now widely held among historians—the voyages of the European navigators and empire builders in the late fifteenth and early sixteenth centuries marked the beginnings of Europe's rise to dominance in world history. Thereafter, by many measures of their relative strengths, China was overtaken by the West. Yet it would be incorrect to speak of an absolute decline in the quality of China's civilization, and even its "decline" relative to a newly invigorated Europe was within the technical means of China to have contested, had it chosen to do so. Why it did not contest with the European powers for control, at least of East Asia, in the centuries following 1492 is a question that proceeds from European assumptions about what civilizations *should* do; to understand China's relationship to the rest of the world in the time of Columbus we must set those assumptions aside and look at the civilizations of the fifteenth and sixteenth centuries from the ground of their own histories.

It is not well known that Ming dynasty China (1368–1644) had been the world's greatest maritime power in the first half of the fifteenth century. That the Chinese state did not pursue the possibilities in maritime expansion, but instead turned away from that kind of engagement with the rest of the world, has come in recent times to intrigue many historians in China and elsewhere. McNeill observes:

> Scholarly investigation of what happened in China and why the Ming dynasty chose to abandon overseas ventures after the 1430s remain very slender by comparison with the abundant literature on European exploration of the new worlds their navigation opened to them. Comparative study of the dynamics of Chinese and European expansion before and after the tip point that came about 1450 to 1500 offers an especially intriguing topic for historical inquiry today, poised as we are on the horizon of the twenty-first century, when, for all we know, the displacement of the far east by the far west, that took place in the sixteenth century, may be reversed.

> It is, nonetheless, worth noting that just as China's rise after A.D. 1000 had depended on prior borrowings from the Middle East, so Europe's world success after 1500 also depended on prior borrowings from China. . . . any geographical displacement of world leadership must be prefaced by successful borrowing from previously established centers of the highest prevailing skills.[2]

McNeill's reassessment of China's place in world history helps us to focus on several issues: (1) the development and diffusion of those kinds of science and technology that supported the fifteenth century's great maritime adventures, and China's contributions to the ebb and flow of such international cultural borrowings; (2) China's record as a maritime power and the role of the state both in supporting and, by the mid-fifteenth century, in curtailing that; (3) some special characteristics of China's ruling institutions—emperor, court, and scholar-officialdom; (4) the qualities of Chinese life that might have impressed Columbus had he succeeded in reaching "Cathay"; (5) art and Chinese civilization.

Science and Technology

Throughout the histories of all civilizations, advances to positions of preeminence have always been built upon the command of knowledge. The capacities to generate new knowledge (often stimulated in some measure by borrowing), to preserve essential knowledge so that it accumulates and is not dissipated, and to transmit knowledge effectively to succeeding generations in circumstances that reward its application and refinement—these capacities have always been crucial to the advance of civilization. Special features of Chinese life early established the necessary conditions for the effective command of important fields of knowledge.[3] More than three thousand years ago China independently produced one of the world's two or three fully developed writing systems. Westerners in recent centuries, having found Chinese writing difficult to learn, have invented groundless deprecations of the Chinese writing system—that the complicated-looking characters functioned to deny literacy, and thereby knowledge, to the common people, or that the nature of the writing system limited the ability of the Chinese to think in general or in abstract terms. But young Chinese lucky enough to receive education learn their logographic script as easily and quickly as young students elsewhere learn their alphabetic ones; having learned it, they have acquired a powerful tool better suited to China's linguistic conditions than a strictly phonetic script. The complex but culturally rich Chinese writing system has in fact been an effective instrument of unity and of continuity, both in transmitting knowledge and in serving the needs of governing. China's rate of literacy in the fifteenth century, and for many centuries before and after, appears to have been higher than that of any other society of the premodern world. Finally, any language can adapt to any needs, can express whatever its speakers wish to express; the quaint notion that either the Chinese language

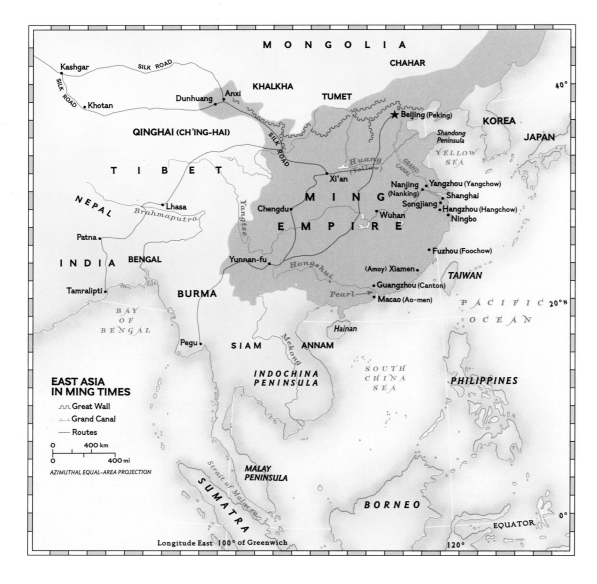

**EAST ASIA
IN MING TIMES**

ᴨ Great Wall
ᴨ Grand Canal
— Routes

| 0 | 400 km |
| 0 | 400 mi |

AZIMUTHAL EQUAL-AREA PROJECTION

Longitude East 100° of Greenwich

families and communities to provide education and young men to study. The *Village School Scene* (dated to 1649), a leaf from an album of *Figures in Settings* by Zhang Hong, is a humorous rendering of a stock subject known since the eleventh century. For all the deficiencies of this very poor village school, it was a setting in which the "poor but bright boy" (even if surrounded by mischievous or dull children and taught by a barely competent teacher) could begin the life of learning through which he might rise in society. This represents the Confucian social dynamic in its most humble and most broadly dispersed aspect. Since official position gained through the state civil service examinations was *not* hereditary (though the social standing conferred by office tended to endure for a time), the motive to achieve individual success through education remained operative from generation to generation. It was a strongly achievement-oriented, open society.

The painting *Literary Gathering in the Apricot Garden*, by Xie Huan, depicts an actual social gathering of the highest officials of the realm in the suburbs of Beijing in 1437. In the first of two details shown here, we see the host, Yang Rong (1371–1440), who had been a Hanlin Academician since 1402 and Grand Secretary since 1419, in the red gown, at the left of the group of three central figures. The central figure, in the blue gown, is Grand Secretary Yang Shiqi (1365–1444), who had come into the Hanlin Academy with Yang Rong in 1402, and had been named Grand Secretary in 1421. His central position and dignified posture indicate that he is honored as the oldest person present. In detail number two the central figure in the red gown, shown admiring a painting held up by a servant, is Yang Pu (1372–1446); although long in high office, he had been named Grand Secretary only in the previous year. Although the "Three Yangs" shared a surname, they were not related.

They and like-minded colleagues, however, dominated the government under the reigns of three emperors, beginning in the Yongle reign (1402–1424). Zheng He's vast maritime expeditions (discussed below) had the personal support of those three emperors, but when the Xuande emperor, Yongle's grandson, died in 1435, it was these great court officials who guided the decision to abandon all further state-sponsored voyages, as well as other expansive and expensive involvements beyond China's borders, just as they had influenced the decision to withdraw from the occupation of Vietnam after the death of the Yongle emperor in 1424. In this group portrait we see realistically depicted the highest level of fulfillment of the life of Confucian learning, at the opposite end of

or its script imposes limitations on its users' mental activity is passé.

The philosophy of government and the outlook of the governing class were also conducive to the systematic development of knowledge. In addition to their long and unbroken tradition of literacy and learning, the Chinese very early on developed a tradition of employing learned men in leading positions in society. Early on they created many schools of philosophy, out of which came the dominant Confucian school. Confucianism, like all early schools of Chinese thought, avoided the idea of revealed truth, teaching in its place that men must study the past, observe the world about them—especially the human world—and apply the lessons derived from human experience to solving present problems. The Confucians' competitors urged that the patterns of nature offered a better guide to human conduct, but since no one school claimed divine or suprarational authority, all schools coexisted and competed for adherents. All early Chinese trends of thought posited similar sources of authority in human

affairs: these were derived from accumulated knowledge accessible to all through observation, learning, and study. That environment was very conducive to the systematic development of knowledge.[4]

A further element encouraging scholarly pursuits is found in the social patterns of China, beginning well before the Western Common Era. China began to depart from its feudal system of closed social classes and a perpetuating aristocratic elite by the third century B.C.,[5] gradually substituting a more or less open elite recruited on the basis of demonstrated ability founded on education. The ideal image of the poor but bright boy, enabled by some good fortune to acquire education, advancing up the ladder of success to become a chief minister of the throne, was very actively present in Chinese minds. Such success brought material reward to the man's family and descendants and glory to his ancestors. However few the poor boys who actually achieved this scenario in any generation, the strong belief that education and individual excellence brought success motivated

fig. 1. Zhang Hong (1577–after 1660). *Village School Scene*. Leaf *i* from the album *Figures in Settings*; ink and color on silk. Chinese. George G. Schlenker collection: on extended loan to the University Art Museum, University of California at Berkeley. Used by permission of the University Art Museum and Professor James Cahill.

the spectrum from the rustic village schoolroom. The Three Yangs, the most powerful officials of the realm, are shown along with other high officials engaging in cultivated conversation, writing poetry, admiring paintings and calligraphy, enjoying the elegant leisure of a garden gathering in April when the apricots were in bloom. The other six officials (and in the other known version of the painting, the painter Xie Huan himself) include ministers of state, the Chancellor of the National Academy, and Hanlin academicians, some of whom had

risen to this pinnacle of prestige and power from quite humble beginnings.

China's social characteristics, graphically illustrated by these two paintings, emphasized learning of broadly humanistic character, but that included several specialized fields of scholarly endeavor that had contributed to sciences of high practical utility.

Because the true nature of the world about them was not revealed to the early Chinese by a creating god, they had to observe and explain it as best they could on their own. Prodigies of nature seemed to demand special explanations, and wise men systematically recorded prodigies in order to explain them by connection with human behavior. For that reason the systematic, continuous observation and recording of eclipses in China goes back to the second millennium B.C., and records of meteors and meteorites, and even of sun spots, go back at least to the first century B.C. This systematic and thorough accumulation of astronomical knowledge was elsewhere unparalleled until the Renaissance in Europe. Instruments such as the gnomon and the armillary sphere have been in use in China for two to three millennia. The methods of defining star positions in degrees also evolved quite early, implying a knowledge of the celestial sphere and of the orbital movements of heavenly bodies. We may suspect some sharing of these kinds of astronomical knowledge with ancient Babylonia and Greece, but there is no clear evidence for the exchange of such ideas between eastern and western Asia until many centuries later. In general, the conceptual and the technical differences between the astronomies of East and West are more striking than their similarities. To take one example, for considerably more than two thousand years the Chinese have mapped the star patterns, or constellations, in the night sky and have related their positions to lines drawn from

the true celestial pole to the equator; this served the practical need of determining one's position on the surface of the earth, thereby aiding navigation. It also served theoretical needs: to understand the rotations of celestial bodies in order to explain the abnormalities as well as the regularities of the observable universe. In mapping the heavens the Chinese grouped the stars in constellations often quite different from ours, and gave them names reflecting quite different cultural allusions. This reinforces the view that early Chinese astronomy was in its origins independent of the West.[6]

We see here a star-map, one of a set of five printed in 1094, worked out by the high statesman and scientist Su Song. Joseph Needham (*Science and Civilization in China*, vol. 3 [Cambridge, 1959], p. 277) has remarked that "these are the oldest printed star-charts which we possess," although we also have several other examples almost as early. We know from literary sources that star-charts were plentiful in the eleventh century and thereafter. The astronomical knowledge they recorded and transmitted was applied in navigation and other sciences and in technology, as well as in legend and folklore. Su Song's five star-maps of 1094 show, respectively, the northern and southern polar projections, the north polar region, and (divided equally between two maps, one of which we see here) the twenty-eight *xiu* (lunar mansions), including within them many of the familiar constellations as the Chinese identified those. The caption reads: "Map of asterisms on either side of the equator in the southwest sky; 615 stars in 117 constellations." The horizontal line running through the middle is the equator.

During the period of Mongol conquest and rule over China, proclaimed as the Yuan dynasty (1272–1368), the Mongol rulers of Persia frequently exchanged delegations of astronomers, mathematicians, calendrical spe-

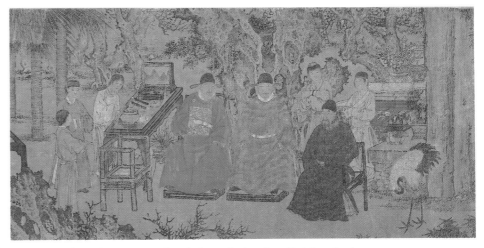

fig. 2. Xie Huan (act. 1426–1436, d. after 1452). *Elegant Gathering in the Apricot Garden*. Chinese. Two details from the handscroll; ink and color on silk. The Metropolitan Museum of Art, Purchase, The Dillon Fund Gift, 1989.

fig. 3. Su Song (1020–1101). *Star Map Showing Fourteen of the Lunar Mansions*. Printed in 1094. One of five star maps from Su's *Xin Yi-xiang Fa-yao* (*New Description of an Armillary Clock*); facsimile reprint from *Congshu Jicheng*, vol. 1302 (Shanghai, 1937).

cialists, and other scientists with their cousins' court at Dadu (present-day Beijing). When Marco Polo was in China, during the reign of Khubilai Khan (r. 1260–1294), the court astronomer was Guo Shoujing (1231–1316), one of the outstanding scientists in all Chinese history. He participated in the intellectual exchanges. Guo took a new and quite advanced Persian armillary sphere, a version that had undergone technical refinements in Muslim Spain in the twelfth century and was brought to China by a Persian delegation about 1276, and adapted it to his needs at the Astronomy Bureau. His adaptation, the equatorial armillary sphere, was a vast con-

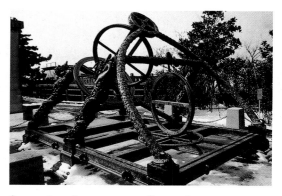

fig. 4. Guo Shoujing's Armillary Sphere (*jian-yi*, "simplified instrument") of 1276, in an exact copy made for the Ming Astronomical Bureau in 1437. Cast in bronze, it measures roughly 12' x 18'; the largest of the rings is 6' in diameter. Photograph courtesy Thatcher Dean, Seattle.

ceptual and technical break-through, what Joseph Needham has called "the cardinal invention which marked the transition from medieval to modern instruments," anticipating by several centuries the parallel conceptual advances in instrument design later achieved in post-Newtonian Europe.[7] What Needham calls "an exact fifteenth-century recasting" of Guo Shoujing's instrument, made about 1437 for use in the Ming astronomical bureau, still exists,[8] as do also some of the original thirteenth-century instruments.

In short, China's practical needs for reliable astronomy, going back to earliest historical times, led the court to emphasize astronomical study and to realize that new knowledge might be gained through borrowing as well as through independent investigation. During the half millennium from 1000 to 1500, science in China was at a high point of creativity and inventive applications that extended from basic sciences such as mathematics to supporting technologies such as precision bronze casting for making instruments, and to such practical applications as the refinement of the calendar, the production of maps and charts, navigation techniques utilizing astronomy, design and use of the compass based on the science of magnetism, and many other related branches of knowledge. Astronomy offers but one example of that overall flowering of China's scientific knowledge. One could easily cite parallel examples in fields

such as nautics; in the interrelated fields of botany, pharmacology, and medicine; in mathematical fields such as algebra, decimal metrics, and calendrics; in mechanics; in physics; in alchemy and early chemistry; and even in seismology. Although Western advances in these fields were rapid after about 1500, before that date China was more often than not in the vanguard, as Needham has pointed out: "One has to remember of course the earlier situation, pertaining in the [European] Middle Ages, when nearly every science and every technique, from cartography to chemical explosives, was much more developed in China than in the West."[9]

The Voyages of Admiral Zheng He between 1405 and 1433

The voyages of the early Ming fleet under Admiral Zheng He (1371–1433) are so spectacular that they tend to deflect attention from the larger contours of earlier Chinese maritime activity. We are not sure why Zheng's government-sponsored expeditions were undertaken in the first place, and their abrupt termination despite brilliant successes is even more puzzling, especially when viewed from a European perspective. These enigmas, added to the scale of Zheng He's seven voyages, have in recent years attracted considerable attention, but they cannot begin to be solved without knowledge of their Chinese historical context.

Chinese seafaring did not emerge full-blown with Admiral Zheng He in the early fifteenth century. It had a long prior history. A few Chinese traders traveling in Chinese ships had gone as far as the Straits of Malacca by the fourth century, and others reached India and beyond by the fifth. Chinese goods, however, were mostly transshipped from the ports of Southeast Asia and India, and that traffic was for many centuries largely in the hands of Arab seamen. It was Arabs who linked the Middle Eastern and Mediterranean worlds with the Chinese source of luxury craft products. Silks and porcelains in particular drew their merchants to China. From the eighth century Arab and Persian merchant communities in the ports of southeast China grew large and wealthy. But some Chinese merchants, at the same time, gradually extended their regular voyages westward to the Persian Gulf and the coast of Africa. Important elements of ship construction, navigational techniques, and detailed information about ports and trade items were shared within both the Arab/Persian and the Chinese seafaring populations. Maritime technology made its greatest strides from about the year 1000 onward, contributing significantly to Chinese seafarers' competitive edge in the world of the

private trader. Official China did not know or care much about that world of commercial activity. Despite heavy reliance on income from tariffs during the Song dynasty (960–1279), foreign trade, especially by sea, though encouraged at the ports where customs tariffs were collected, was neither sponsored nor protected by China's government, as it was in Europe. Nor did the Chinese scholar-officials investigate it or write much about it. Nonetheless scholars have in recent decades reconstructed much of the history of Chinese participation in private maritime commerce, the flourishing arena in which Chinese shipbuilders and navigators made important contributions to the fund of nautical technology shared by the Asian world.[10]

The constant interchange among seafaring people in Asia did not, however, lead to entirely uniform technologies and operating modes. Some things the Chinese did differently at sea, mostly innovative practices that others did not quickly copy. From the point of view of a developing worldwide nautical science, their contributions to marine navigation, to naval architecture, and to sailing ship propulsion interest us most directly.

NAVIGATION. The discovery in China of magnetism goes back to the first millennium B.C., and long before Columbus the Chinese had used a magnetic compass, which they called a "south-pointing needle" because Chinese geomancy ascribed salubriousness to the southern direction. This took the form of a magnetized piece of iron mounted on a strip of wood, floated in a small basin so that it could freely revolve, or of a magnetized needle suspended by a thread. Simple forms of the magnetic compass are two thousand years old, but its early uses were mostly for magic and geomancy. Not until some time between the ninth and eleventh centuries A.D., though still a century or two before the Arabs or Europeans, did the Chinese take their magnetic compass aboard ships and use it for navigating. Refinements soon followed. A text of 1088 notes that there is a measurable and constant declination of a few degrees to the east.[11] The earth's magnetic variation was not yet known in the West; by some accounts Columbus may have discovered it, as noted in his log for September 13, during his voyage of 1492.[12] The compass enabled the sea captain to steer his ship when fog and clouds interfered with visual navigation. But when skies were clear, the Chinese also had recourse to star charts, to sea charts identifying coasts and islands, and to methods for measuring the speed of sea currents. Printed manuals with charts and compass bearings began to become available by the thirteenth century.

It should be noted that printing, using woodblock technology, arose in China in the seventh and eighth centuries, and movable-type technology was developed in the mid-eleventh century. Because of the cumbersome nature of the Chinese script, printing with movable type, or typography, did not compete strongly with woodblock printing for centuries and did not supersede it until the late nineteenth or early twentieth century. Nonetheless books were plentiful and inexpensive in China from the tenth and eleventh centuries, and contributed greatly to China's relative advantage in the accumulation and spread of knowledge.

It is difficult to separate the Chinese from the Arab and Persian contributions to some of these aspects of nautical technology. Through constant extension and refinement marine navigation in Asia was transformed from an art to something more like a science. Up to the time of Columbus Chinese navigational techniques significantly surpassed those of their Asian competitors and of the Europeans (who had not yet begun to enter Asian waters).

NAVAL ARCHITECTURE. Various aspects of Chinese ship construction were markedly distinct from European practice. Most remarkable, probably, was the Chinese method, used since the second century, of building hulls divided into water-tight compartments, a technique not adopted in the West until the eighteenth century. Such a ship was much less apt to sink if its hull was damaged; if the damage could be confined to one or two of the separate compartments, cargo could be salvaged from the affected parts of the hull and emergency repairs made while still at sea. Less dramatically, to meet the demands of a Chinese consumer market which valued freshness of foods, one compartment of a fishing boat could be filled with sea water in which the catch could be kept alive until the ship reached port.

A feature of ship design crucial for navigation is the sternpost rudder, likewise a Chinese invention. This steering device, mounted at the outside rear of the hull, could be lowered or raised according to water depth, and on large ships could be turned by pulleys and ropes from the deck. The sternpost rudder greatly assisted steering through narrow channels, crowded harbors, and river rapids. Chinese graves dating to the first century A.D., about the time the magnetic compass was invented, have yielded clay ship models showing the sternpost rudder; it also appears in many paintings and was named in literary sources of the following centuries. Neither invention was known in Europe until a

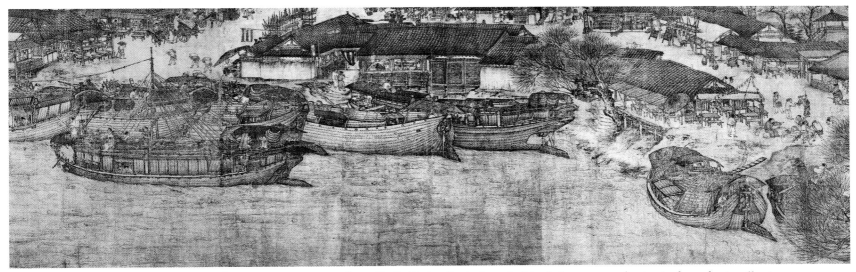

fig. 5. Zhang Zeduan (act. beginning of 12th century). *Qing-ming Shang He Tu* (*Spring Festival on the River*). From a reproduction in the author's collection.

thousand years later. In the West the invention of the sternpost rudder is usually credited to the Dutch in about 1200. It could have been an independent invention at that time, but diffusion from China via the Arabs is much more plausible.

Zhang Zeduan's famous *Qing-Ming Shang He Tu* (*Spring Festival on the River*) was painted about 1127. This detail from the long narrative scroll depicts the Bian Canal leading from the Yellow River into the Northern Song capital, modern Kaifeng, just before its fall to the Jurchen invaders in 1126. The artist was an acute observer and superb draftsman, painting at a time when realistic representation was valued, and clearly he must have made his detailed sketches from direct observation. For those reasons his painting is an important document of twelfth-century Chinese material life. In the detail shown here, the river transport boats and barges are precisely drawn, their design and structure accurately portrayed. The sternpost rudder is clearly visible at the stern of each boat.

PROPULSION. The Chinese had never used ranks of human rowers to propel their large ships. In the Mediterranean the Greco-Roman tradition of the oared galley, especially for naval warfare, persisted alongside that of sailing craft; the Battle of Lepanto in 1571 was fought largely by oared galleys, those on the Christian side supplied mostly by Philip II of Spain; though by 1588, when Philip launched his Invincible Armada, Spain's shift to rigged sailing craft for the high seas was complete. The Chinese, by contrast, had very early on developed several important features of sailing-ship design that obviated the need for rowers. From at least the seventh or eighth century they used paddle-wheel–propelled ships with human-powered treadmills, especially on inland waterways. Of greater practical significance, however, were the advances in rigging and sail design. Their three- and four-masted sailing ships of wind-efficient design appeared a thousand years before the adoption of like features in the thirteenth and fourteenth centuries in Europe, apparently in imitation of Chinese models that had become well known through Marco Polo and other European visitors to China. For instance, in the early centuries of the present era the Chinese invented forms of the lug sail to aid in sailing against or across the prevailing wind, and from about the eighth century they adopted the outstanding Arab improvement in that technology, the lateen sail; it spread not only to China but thereafter also to the Mediterranean, where it became an important element in the design of

the Portuguese caravel, the preeminent "explorer's ship" of the fifteenth century.[13]

Ships approaching 200 feet in length and capable of carrying 600 to 700 men had already existed in China in the eighth century. During the Song dynasty (960–1279), when ship-building was concentrated in the great southeastern port cities, especially Quanzhou (Arab Zayton, near modern Amoy on the Fujian coast), sea-going ships up to 200 feet in length and carrying up to 500 tons cargo were not uncommon.[14] Since Song China was encircled by powerful enemies on its northern and western inland frontiers, its international commerce was concentrated in the southeastern coastal provinces, spurring great advances in nautical technology and maritime ventures of increasing scope. Arab and Persian traders of this time considered the stout and stable Chinese vessels the ships of choice in their travels from the Persian Gulf ports around India to China. They noted with pleasure that the Chinese merchantmen provided convenient private cabins for travelers, fresh water for bathing and other hygienic amenities, and fresh foods en route — luxuries unknown in other vessels.

Curiously, it was during the Yuan dynasty, when conquering Mongols from Inner Asia ruled China, that the Chinese made great further progress in maritime activity.[15] The Mongol conquerors were themselves totally unacquainted with ships and seafaring. But Khubilai Khan's conquest of the Southern Song dynasty between 1260 and 1280 was accomplished largely with the use of navies, on China's inland waterways in the earlier phases, and ultimately by coastal armadas borrowed in significant part from Arab and Persian merchant-princes based in south China. Captured Chinese, Korean, and other non-Mongol ship builders and sailors created and manned the Mongols' marine forces. Khubilai Khan planned vastly to enlarge the Mongol realm by invading Japan, then Indonesia, making the continued buildup of naval forces a high priority. At the same time the Mongol rulers had none of the Chinese elite's disdain for commerce; they actively promoted merchant associations, granting government funds and protection to extend the spheres of their profit-seeking activities.[16] It is not surprising, then, that upon the founding of the Ming dynasty in 1368 China had shipyards of considerable scale, concentrations of skilled shipyard workers, an increasingly well-developed tradition of foreign trade, and a command of nautical technology significantly enhanced by the international contacts that the Mongols' world empire had afforded. In particular, Khubilai Khan maintained cordial relations with those cousins whose Mongol/Persian Il-

Khan dynasty controlled the Persian Gulf and had wide contacts in western Asia, even to the edges of the Mediterranean.

Zhu Yuanzhang, founder of the Ming dynasty (r. 1368–1398), also recognized the importance of naval power and continued to support its growth. At Nanjing, his new capital, he founded two large shipyards where principal elements of Zheng He's fleets were built. One of those, directly on the banks of the Yangzi, had six great slipways measuring 100 to 160 feet in width and almost 1000 feet long.[17] The largest ships could easily be accommodated there.

Comparing the various aspects of ship-building and nautical technology in the fifteenth century, East and West, makes clear how far China and much of Asia had surpassed Europe by the century that saw Christopher Columbus and Vasco da Gama carry the flags of Spain and Portugal to the New World and to Asia. Columbus' *Santa Maria* was but 125 feet long and probably of about 280 tons capacity; no ship of da Gama's exceeded 300 tons. Zheng He, by contrast, commanded great fleets whose largest class of ships, the famed Treasure Ships, were at least 300 feet in length (perhaps considerably more),[18] and appear to have averaged about 2500 tons cargo capacity, or 3100 tons displacement. In his first expedition, 1405–1407, Zheng commanded a fleet of 317 vessels, of which 62 were Treasure Ships. The Invincible Armada sent by Philip II of Spain more than a century later to invade England comprised less than half as many ships, of which only seven equaled 1000 tons burden.

Admiral Zheng He

Zheng He is one of the great personalities in maritime history. He was a Chinese Muslim, born in 1371 in Yunnan Province, in China's southwest frontier region. Yunnan had become significantly Islamicized under the Mongols, and apparently Zheng was partly non-Han Chinese; he knew some Arabic, and his father and grandfather, who may have served the Mongol period princes of Yunnan, had made the pilgrimage to Mecca and bore Arabic-sounding names. When about ten years old Zheng He was selected for the court's eunuch service by Chinese military forces then completing the conquest of Yunnan for the new Ming dynasty; that is, he was castrated and sent to the court at Nanjing to be trained. He was perhaps fortunate in being assigned to the staff of the Ming founding emperor's fourth son, Zhu Di (1360–1424), who became emperor by usurpation in 1402 and reigned as the Yongle emperor for twenty-two years thereafter. Educated at first in

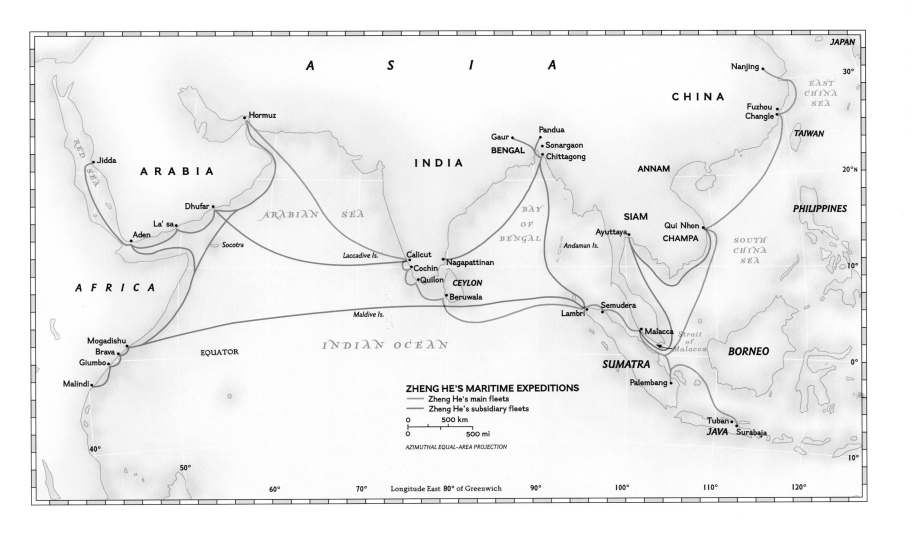

Map: ZHENG HE'S MARITIME EXPEDITIONS
— Zheng He's main fleets
— Zheng He's subsidiary fleets

0 — 500 km
0 — 500 mi

AZIMUTHAL EQUAL-AREA PROJECTION

civil learning, Zheng grew to heroic stature and found his vocation in military service, showing great ability under Zhu Di's command in campaigns against the Mongols along the northern borders of China in the 1390s. He was trusted, and assigned to ever more important posts. Having assisted Zhu Di in the civil war of 1399–1402, he was in line for leading assignments when his master ascended the throne. He was noted for his imposing appearance, courage, and sagacity.

The Yongle emperor sat uneasily on the throne he had usurped; his predecessor, a nephew, was officially said to have died in the fighting for the palaces in Nanjing, but many believed he had in fact fled. Could he have gone overseas with sympathetic Chinese seafaring merchants, from which refuge he might return to reclaim his throne? It has been said that Zheng He's sea voyages were organized in part to hunt for him. Whatever truth there may be in that tale, the new emperor must also have wished to validate his reign and elevate the prestige of his dynasty by displaying China's power among neighboring states. He was also interested in the rare products, treasures, and

exotic flora and fauna that heads of tropical states could submit in tribute or supply by trade. Probably for a combination of such reasons the Yongle emperor decided in 1404 to launch an expedition that would call on the rulers of the innumerable small states between the Indochinese peninsula and the coasts of India; the stated purpose of this expedition was to establish relations that would bring those rulers to his court as bearers of tribute, therein acknowledging a vague and politically insignificant but ritually valued form of suzerainty. Unlike Columbus and da Gama, Zheng He was not sent to make war, to claim territory, or to impose imperial rule on any people, but his awesome armada undoubtedly persuaded those who might otherwise have been inclined to reject the Chinese approach to international relations. At the same time, employing his noted diplomatic skills, he ceremoniously bestowed rich gifts in the name of the Son of Heaven, bringing the aura of China's magnificence into the daily life—and the political considerations—of dozens of petty statelets. Only thrice during his seven great expeditions did this skillful diplomat resort to military action,

and then only to restore a displaced legitimate ruler, to protect his landing party from attack, or to put down banditry. Many of the rulers whose courts he visited volunteered to return with him to China; they were received at court, lavished with gifts, and allowed to return to their countries, often carried back on Zheng He's next voyage. Much of East and South Asia as well as the Middle East and the eastern shores of Africa were made aware of China in a new and more immediate way.

The first expeditionary force (1405–1407) comprised 317 ships and carried 27,870 men. It stopped in Java and along the Straits of Malacca, then visited Indian ports before reaching its principal destination, the court of the King of Calicut on the Malabar Coast. On the return voyage Zheng He was forced to put down a pirate uprising in Śri Vijaya (present-day Palembang, in Sumatra); he captured the pirate chief, an overseas Chinese, and took him back to Nanjing, where he was tried and beheaded.[19]

The second voyage (1407–1409) was a relatively unimportant ceremonial visit to the court of Calicut, to attend the installation of a new king. This was the one voyage Zheng He orga-

fig. 6. Courtyard facing the Gate of Great Harmony (Taihe Men) within the Imperial Palace, Beijing. Courtesy of the Ministry of Cultural Affairs, People's Republic of China, Beijing.

nized and oversaw but did not lead in person.

He led the third voyage (1409–1411), whose fleet numbered 48 large ships and carried 30,000 troops. This expedition visited many of the same places as the first one but also went to Śri Lanka, where Zheng set up a stone monument inscribed in Tamil, Persian, and Chinese, to commemorate the gifts sent by the emperor to the great Buddhist temple at Kandy. When violent fighting broke out between Zheng's forces and the king of a small Sinhalese kingdom in northern Śri Lanka, Zheng put down the fighting, captured the king and his family, and brought them to China. There the Yongle emperor pardoned them and sent them home, duly impressed.

The fourth voyage (1413–1415) comprised 63 ships and 28,560 men. In addition to visiting many places along the way to Calicut and Śri Lanka, this expedition continued to Hormuz on the Persian Gulf. On his way back Zheng He, under instructions from the Chinese court, arrested a usurper and restored the rightful sultan of Semudera in northern Sumatra. On their return to Nanjing the usurper was executed.

The fifth expedition (1417–1419) was designed primarily to escort seventeen rulers of South Asian states home after their tribute-bearing missions to the Chinese throne, then to present them with imperial gifts and to ensure the future of good relations. On this voyage

Zheng He made his first calls along the coast of Africa, at Mogadishu and other points; despite the euphemistic descriptions in the official accounts, he appears to have required shows of considerable force to gain entry at some places. Many ambassadors from the countries visited accompanied the return voyage to Nanjing.

The sixth expedition (1421–1422), of 41 ships, again visited many of the same South and Southeast Asian courts, including Calicut and Śri Lanka, as well as Hormuz, Aden, and Africa. It appears that Zheng He returned after less than a year, leaving most of his fleet, divided into separate squadrons under other leadership, to complete the itinerary on their own.

The seventh expedition (1431–1433) was

despatched by the Yongle emperor's grandson, who ascended the throne in 1425 and reigned as the Xuande emperor. This expedition too, with more than a hundred large ships, visited all the important ports in the Indian Ocean as well as Aden and Hormuz.[20]

Zheng He died, probably at Nanjing, late in 1433. Many leading scholar-bureaucrats of the court had long opposed the expeditions as wasteful and improper undertakings for a Confucian, agrarian-oriented society. No attempts were made to repeat them during the remainder of the imperial era, but Chinese private shipping and trade continued to flourish, even through the century and more when overseas travel and trade were formally proscribed by the Ming government. Merchants built smaller and more economical vessels but continued to appear everywhere that Zheng He's armada had stopped, and profited from the aura of Chinese magnificence that remained.

What had Zheng He accomplished? He went to no place that Chinese had not previously visited, so one might conclude that he was not a discoverer. Yet he did assemble much new and detailed knowledge that interested Chinese elite society and served the needs of government and of the private merchant community. His voyages represented a new kind of undertaking in that they were vast and well-organized expeditions carried out by fleets of the Chinese imperial government, accomplishing essentially diplomatic objectives. It would be centuries before any other country in the world could emulate this achievement. Perhaps Commodore Perry's opening of Japan in 1853 bears comparison, but Zheng He was sent to accomplish far less specific national policy objectives, and his means were both less threatening and more grandiose. Perhaps the search for historical comparisons yields little; the grand voyages of Zheng He truly have no counterparts in other nations' histories.

What tantalizes the reader of this account is no doubt Zheng He's demonstration that China could deploy larger and better-organized naval forces than those with which Spain and Portugal and the other European powers, in the centuries after 1500, built their far-flung world empires. If Zheng He had carried Vasco da Gama's or Affonso de Albuquerque's mandate, or that of other early European empire builders, might the Chinese not have preempted them all in building the first great world empire of modern times? But history is about what happened, not about what might have been. To understand why this outcome was not even distantly possible within the context of Chinese history, we must look at the Chinese emperors, their court, and their government.

China's Ruling Institutions in the Age of Columbus

Zheng He served a ruler worthy of his own unusual abilities. The Yongle emperor was a man of vast energies and ambitions. The Xuande emperor, Yongle's grandson, who despatched Zheng He on his last expedition, also attempted a vigorous and martial rule. But after his death in 1435 the Ming dynasty continued for two hundred more years without producing another emperor in the heroic mold. Some of the later Ming rulers were tyrannical, others willful or perverse. A few were conscientious about governing, but none was notably effective or strong. Does a two-hundred-year succession of second-rate emperors not imply a weak and declining state? Not necessarily, in the case of China, where the government in the later dynasties of imperial rule was a bureaucratic machine of large scale and virtually unshakable stability. The rulers' personal characteristics of course had some impact on government, but they did not threaten the continuity of Ming statecraft. The tone of government was set more by the bureaucrats—the scholar-officials—than by the rulers. Among the scholar-officials who staffed the bureaucracy a conservative devotion to tradition and precedent guaranteed the continuity of procedures and policies and maintained the daily operations of governing.

In the 1420s the Yongle emperor had moved the Ming capital from Nanjing (which remained the "secondary capital") to Beijing. There he built the imperial palace city, the so-called Forbidden City, more or less as it is today. The inner, walled, palace city, lying within the great outer walls of Beijing, represented the other terminus of Zheng He's diplomatic ventures. It was built to overawe not only the Ming dynasty's native subjects, but also the rulers and envoys of other states. At dawn on New Year's Day the court officials and the assembled envoys made a long formal progress along the central axis of the Imperial City. After passing through the Gate of Heavenly Peace (Tian'an Men) and proceeding northward through the Meridian Gate (Wu Men), they arrived at the vast courtyard shown here. Beyond this looms the Gate of Great Harmony (Taihe Men), entrance to the "center of the very center of the world." About 600 feet on each side, this vast courtyard and its buildings appear today as rebuilt after a fire in 1627, when the five bridges in the foreground were added. Nevertheless, despite that rebuilding, and changes in all the names after the end of the Ming dynasty in 1644, this scene appears more or less as the envoys of foreign states would have seen the

Ming palaces at a New Year's reception in the 1490s. After crossing this courtyard and passing through the Gate of Great Harmony—hardly a gate in our sense, but a massive building with portals—they would have entered a second courtyard of similar size, where they would have formed ranks facing the throne hall centered at the far side. This is an immense building of perfect proportions, with gleaming yellow-glazed roof tiles and deep red walls, set high upon a three-tiered white marble terrace with carved white marble steps and balustrades. To reach that courtyard facing the throne hall was the climax of their diplomatic journeys. Here they waited, to prostrate themselves on the signal that the emperor was entering the throne hall. But they would not enter that hall, and probably would not even catch a glimpse of his august person, unless the envoys were later entertained at a formal banquet served there and on the surrounding terraces. Even then, they probably would never speak to the emperor, who was always seated high above them, surrounded by eunuchs and palace guards. Behind the immense throne hall, where outsiders never were allowed, lay a vast complex of palaces, courts, and gardens, making up the private residence quarters of the imperial family.

All relations with envoys, even those who were heads of state, were mediated by the Ministry of Rites, not by an agency functioning like a modern department of foreign relations. Ritual defined relations among states. Ritual projected, in a highly formalized manner, the Chinese view of their place in the world: China occupied the center of the world and possessed its only true culture; civilization radiated outward from that center; China's nearer neighbors shared more fully in that civilization, as evidenced by their use of the Chinese script and their acceptance of the authority of China's classics, which taught how humankind should live; the farther the distance from China to a foreign state, the more benighted it was expected to be. But this sublime arrogance did not imply an immutable we/they distinction. On the contrary, as non-Chinese peoples progressed in their assimilation to civilized—i.e., Chinese—patterns, they were to be considered increasingly "Chinese," that is, "civilized." It was assumed that in time all people would wish to make that progress. Yet even those who had advanced little or not at all toward that goal were still regarded as human beings, with the potential for becoming worthy persons. The emperor was, in principle, obligated to extend benevolence to all who appeared at his court, and his agents were expected to do the same to all fellow humans, unless they were so untamed

as to be dangerous; then defensive measures were appropriate. Such savages apart, it was assumed that all borderland peoples, and even some of those at more remote distance, would want to come to Beijing and show their respect for the Chinese throne.

That is the underlying meaning of what is called the "tribute system" of Chinese foreign relations. Notwithstanding that idealized picture of the world, the Ming Chinese could be far more pragmatic when circumstances demanded. Central Kingdom or no, they knew that China could be coerced by steppe nomads with superior military power, and they could devise realistic settlements under the camouflage of ritualized patterns. And the high officials of the court (as no doubt also the private merchants) were not unaware that tribute-bearing envoys and heads of state were motivated more by the opportunities for trade that tribute status brought than by any belief in Chinese cosmological pretensions. Yet the antique, ideal world view, revived by the Ming, was upheld to the fullest extent possible. Zheng He's management of the situations he encountered in his voyagings can be explained only by invoking the grandiose model of the tribute system. China's search for advantage in its relations with other peoples had to be measured in those ideal, nonmaterial terms. To abandon the notion that China was the center of the civilized world would have been too destabilizing. Chinese did not have to think seriously about such a possibility until the nineteenth century.

There was also a more practical, domestic, side to the equation. The statesmen who supervised China's government knew what made their society function. China was a highly developed agrarian society, and a generally prosperous one. The ordinary Chinese of Ming times probably were the best-clothed and housed and best-nourished people in the world.[21] Their family-based village society worked rather well, held together, as they all knew, by Confucian ethical norms. The state flourished when village society was stable and the agricultural population prospered. China had no hereditary aristocracy. Its elite stratum was dominated by the scholar-officials, recruited by civil-service examinations, and these hailed predominantly from the villages, whether or not from farming households. The scholar-officials thus understood the needs of the farming people; they came from the same social base. China, moreover, had a self-sufficient economy. With very few exceptions (cavalry horses, copper, etc.) it had no need to import any essentials, and exports of China's famed luxury goods and craft products were considered a boon to the outside world rather than

an economic necessity to China. From a twentieth-century point of view we can argue that an expanded foreign trade could have greatly enriched the producers of its goods and the ports through which they passed, and might also have stimulated significant growth throughout the entire economy. Yet it is not difficult to see why China's scholar-bureaucrats could overlook the potential benefits of trade; they were concerned with social needs for which appropriate solutions lay elsewhere. Guarding the northern land frontiers along which the steppe peoples could invade, limiting the burdens of government that fell on the hard-working farmer-taxpayers, and upholding the time-honored conservative social ideals—these tasks had prior claim on their political energies. Overseas adventurism was to be avoided. When the two early emperors who for personal reasons had sponsored the expeditions of Zheng He had passed from the scene, it is not surprising that the high officials of the court would urge discontinuing the voyages on the grounds of waste and frivolity. After 1434 China totally abandoned all state interest in such expeditions. A powerful sense of competition among the European powers drove their empire-building efforts. China was not in competition with any other state; the very idea was inconceivable.

Europe's Awareness of the East in the Age of Columbus

In the "Prologue" to his *Diary* of the First Voyage in 1492–1493, Christopher Columbus addressed the king and queen of Spain:

> Your Highnesses, as Catholic Christians and Princes, and enemies of all idolatries and heresies, you thought of sending me, Cristobal Colon, to the said regions of India to see the said princes and the peoples and the lands And you commanded that I should not go to the East by land, by which way it is customary to go, but by the route to the West, by which route we do not know for certain that anyone previously has passed.[22]

Columbus describes "the said regions of India" in terms drawn from Marco Polo's description of China and Inner Asia, as Polo observed them in the late thirteenth century. That was a time when Europeans traveled to the East via the Central Asian caravan routes in unusually large numbers. Yet Columbus' comments in the "Prologue" suggest that India and China had merged in his consciousness, for clearly he was referring to China. Columbus suggested to Ferdinand and Isabella that their sending him to the East was the next logical step in pursuing

Christendom's triumph over "idolatries and heresies." He wrote:

> Later in that same month [following the January surrender of Granada], because of the report that I had given to Your Highnesses about the lands of India and about a prince who is called "Grand Khan," which means in our Spanish language "King of Kings"; how, many times, he and his predecessors had sent to Rome to ask for men learned in our Holy Faith in order that they might instruct him in it and how the Holy Father had never provided them

That clearly refers to the exchanges between the popes and the Mongol emperors Chinggis (Genghis) Khan and his successors.[23] Chinggis Khan's grandson Khubilai Khan ruled China at the time of Marco Polo's sojourn there, 1275–1292, and figured prominently in Polo's account. It seems certain that Columbus had long known about the Venetian's great travel book, but his careful study of it and the marginal notes he made on his copy of the book may date from a time following his return from the First Voyage in 1493.[24]

Polo's account mentioned earlier contacts between Christendom and the Mongol world empire, but his references to Christian groups encountered in China concerned Inner Asian Nestorian Christians, not missionaries and travelers from Catholic Europe. It was not until two or three years after he left China for Venice in 1292 that the first Franciscan fathers sent from Rome arrived in Khanbaliq (as the Mongols called their capital, present-day Beijing). They began a new chapter in relations between Europe and China, but one which appears to have slipped from European memory by the late fifteenth century. The Franciscan friar John of Montecorvino (c. 1246–1328) left Europe for China by the overland route in 1289, probably arriving in 1293 or 1294. On the basis of his hopeful letters the Pope elevated him in 1307 to Archbishop of Khanbaliq and sent him seven suffragan bishops, followed by three more in 1310. Some of his letters sent back to Rome have survived. We also have letters from the Franciscan Andrew of Perugia, Bishop of Zayton (present-day Quanzhou, the great port city in Fujian), whose last known letter to Rome is dated 1326.[25] A number of letters to Europe from these missionaries and envoys in China are preserved in European collections, as are documents referring to the dispatch of Europeans to the empire of the Great Khans. These and other travelers from Rome to China created an interesting though not enduring chapter in Christian mission history, but one that was

quite forgotten until modern researches brought it again to light.

Western Asians, particularly Persians and Arabs, continued to travel to China by the caravan routes and by sea, right up to the time of Columbus, Magellan, and Vasco da Gama. The extensive knowledge about the East that they had garnered also was unknown to the Europeans of Columbus' time, who might have learned much from it. Columbus, for example, would have learned that the Mongol conquerors had been driven out of China and supplanted by the native Ming dynasty in 1368, and that the Chinese emperor was no longer to be addressed as "Grand Khan," as in Marco Polo's day.

Had Christopher Columbus sailed around the Americas (as Magellan did about thirty years later) and reached China, what might have happened? He is unlikely to have dealt with China as an equal of Spain, and the Chinese court surely would have regarded as preposterous his claim to represent a superior (or even an equal) power. He might have gained admission to the New Year's reception for foreign envoys in 1493—if he had remained obsequiously respectful, and if his captains and crews had not committed too flagrant atrocities on shore, and if he had, with Chinese assistance, worked out ritually appropriate forms of petitioning the court for the privilege of offering abject obeisance in the name of his uncultured, hence pitiable, sovereigns. But to judge from the experience of the first Portuguese envoy, Tomé Pires, twenty-five years later, little would have followed from that. In 1517 a few Portuguese ships from fleets based at Goa, where in the years 1507–1515 de Albuquerque had created the colonial base of Portugal's Asian commercial empire, sailed from a newly won Portuguese base at Malacca, up the China coast to the Pearl River estuary below Canton, very near modern Hong Kong. Attempting to intimidate the natives before pressing for commercial advantages, the Portuguese opened fire from their ships, then went ashore and behaved outrageously in the standard manner of Iberian empire builders. Pires, a reasonable man, was put ashore, and after three years' delay at Canton was finally allowed to proceed to Beijing, in 1520, to present his credentials from King Manuel I. There he waited, a guest of the state in a locked and guarded compound, until May 1521. Then, because the reigning emperor had died on April 20, he was told that no court reception would be feasible and was sent back to Canton. In Canton he and his entourage were imprisoned by local authorities still smarting over the destructive bellicosity of the fleet that had brought Pires to Canton four years earlier. Eventually he and most of his party died in prison, but one of the Portuguese, Cristavao Vieira, had letters smuggled from jail which eventually reached the Portuguese court, giving lengthy and perceptive information about conditions that might affect future trade and diplomacy with China. As the historian Donald Lach has noted, despite his many frustrations and sufferings "... Vieira is fair enough to point out that the [Zhengde, r. 1506–1521] emperor responded with characteristic, condescending grace to the complaints of his officials against the Portuguese by reminding them: 'These people do not know our customs; gradually they will get to known [sic] them.' Such sentiments were in harmony with the compassion traditionally expected in China from the emperor in his dealings with 'barbarians'."[26] Compassion, to be sure, was forthcoming, but not trade on Western terms.

Columbus in China

Had Columbus actually met the emperor of China at the end of the fifteenth century, he would have encountered a singularly mild-appearing, mediocre little man. The Hongzhi emperor, whose personal name was Zhu You-tang, was born in 1470 and ascended the throne in 1487. On his death in 1505 he left China to his erratic and impulsive son the Zhengde emperor (r. 1506–1521), who died just after Tomé Pires arrived in Beijing. One eminent biographer called Zhu Youtang "the most humane" of the Ming rulers and observed that this emperor apparently was the only monogamous ruler in all of China's long imperial history.[27] Within traditional Chinese historiography the Hongzhi emperor was adjudged the best Ming emperor, not for any remarkable accomplishments of his reign, but because in his relations with his scholar-officials he was so different from the other rulers of the dynasty. He was temperate and self-restrained, sincerely committed to being a good ruler according to Confucian prescriptions. He was particularly respectful toward his advisors and officials, usually accepting their advice and striving to meet the high standards of performance they demanded of him. They and their kind wrote the histories that judged him; posthumously they praised him lavishly, trying to make of him a model they could use to curb the rash behavior of later rulers. But although he was generally compliant and hard-working, careful reading of the historical record reveals that he was in fact no paragon: he was subject to petty jealousies, somewhat avaricious, subservient to his constantly complaining wife and protective of her relatives, who in time-honored fashion abused their relationship to the throne for their own advantage.

Columbus would have seen none of that. He might have observed the emperor from afar at a few audiences, for this emperor attended all such ceremonies, exerting all his feeble strength to observe the weighty proprieties of his office. But in any relations with the king of Spain or in the treatment of his envoy Zhu Youtang would have unquestioningly accepted the traditionally reasoned counsel of his ministers. Though he enjoyed the position of an oriental despot, the Hongzhi emperor was a mouse who never roared.

Columbus' arrival in the West Indies had an immediate and almost cataclysmic effect on the native population. In China his presence would have made scarcely a ripple. Tact and patience might have produced opportunities to discuss Sino-Spanish relations with a few officials of middling rank. Most Chinese scholars and officials of the time would have treated him courteously, and some would no doubt have been curious to learn about far-off Europe, and might have recorded their conversations with him. But it would have been very difficult for him to break through attitudes formed in the days of Zheng He's voyages, when dozens of heads of state and hundreds of envoys were brought to the Chinese court. Columbus would not have been seen as important in any way to the interests of China, only as another petty barbarian who was to be overwhelmingly impressed and sent on his way.

Knowing that he was an impressionable observer, we can speculate on the kinds of descriptions he might have left had he traveled down the Grand Canal from Beijing, stopping in the great cities, wandering through the markets seeking luxuries to take back to Ferdinand and Isabella, watching skilled craftsmen make their fine products, or observing the industrious farmers at work in their terraced rice fields, orchards, and fish ponds. The wealth of China would have struck him keenly, as it had Marco Polo two hundred years earlier. Doubtless he would not have understood most of the refinements of elite life, the gardens and libraries, the elegant restraint in furnishings, or the intricate conventions of social behavior. Innumerable aspects of Chinese decorative arts, those gaudier things that later Europeans avidly imitated in the pursuit of what they called "chinoiserie," might well have taken his fancy, but the higher arts, especially Chinese poetry and painting, may well have remained quite beyond his ken. It is also unlikely that the scholarly traditions of China, and their manifestations in all aspects of public and private life, would have been in any degree intelligible to him. A century later the Italian Jesuit Matteo Ricci (1552–1610), employing superb qualities of intellect and spirit

through almost thirty years of profound study in China (1583–1610), was able to penetrate these dimensions of Ming life; no foreign envoy passing through could have done so.

If Columbus had brought along missionaries, they are not likely to have possessed the qualities of Ricci and his colleagues a century later. And even the remarkable Jesuits, imbued with powerful new currents of learning that marked the age of Galileo in Europe, and for their time radical in accommodating to the cultures of Asia in order to convey their Christian doctrines, had scant success as evangelists in the two or more centuries following Ricci's arrival in China in 1583. But the streets full of well-dressed people of all classes, the shops full of foods and craft products in a variety unknown to Europe, and the bustling, stable life of the entire society surely would have impressed Columbus deeply. He might have thought China poorly defended, open to invasion and conquest, and he might, however incorrectly, have seen the Chinese people as pacific, unprepared to defend their coastal regions and incapable of soldiery. Within the century that followed, several Iberian observers would urge their rulers to invade and conquer these affluent heathens who did not accept the superiority of European faith and morals. But Columbus would more likely have seen opportunities for profitable trade and would have urged a Spanish foothold near China from which to exploit this font of riches. Precisely such an end was accomplished by the Manila Galleon, connecting Spanish Mexico with the Spanish colony in the Philippines from the 1570s, and by the base at Macao which China granted to the Portuguese in the 1550s. Columbus might well have anticipated such developments.

Art and Chinese Civilization

We can assume that Columbus himself, along with the entire late fifteenth-century European world from which he came, would have been quite unable to understand the high arts of China. Five hundred years later, however, we can confidently say the West has achieved considerable appreciation and understanding of non-Western art on its own terms. There are, to be sure, difficulties in penetrating the cultural mode that united calligraphy, poetry, and painting in mutually reinforcing forms of expression. To see the calligraphy in the context of its artistic traditions, to comprehend the richness and subtlety of the poems' allusions, to view the paintings with a cultivated connoisseur's eye—especially in those examples where the three are united in one creative act—places very high demands on the viewer. Even modern Chinese reach full understanding of these supreme elements of Chinese art only with long study and cultivation. Even without such expertise, however, we can grasp the elements—the evocative power of the poem or the inscription, the line and movement of the calligraphy, the way in which the inscription and its calligraphy complete the painting. The inspired union of those "three perfections" (san jue) represents the highest level of Chinese aestheticism.

One of the most interesting differences between the place of the arts in European and Chinese societies is embodied in their respective definitions of the high arts, as differentiated from the artistic crafts. Another is revealed in the composition of the two artistic communities, East and West, and the relationship of those to their societies at large.

The Chinese held calligraphy, poetry, and painting to be the most important of the high arts. Other forms of belles lettres, especially the prose essay and prose-poem, also had venerable ranking among the high arts. Literary drama was a late-comer (eleventh or twelfth century at the earliest) and held marginal status. A few "minor arts," like the design and cutting of seals, rather peculiar to East Asian civilizations, also were respected adjuncts of the high arts. A remarkably short list compared with its Western counterpart. Most notably lacking is sculpture. The Chinese did not idealize the human form as such, nor did they focus on it in painting or in sculpture. There was virtually no secular sculpture of the human form. Whether in sculpture or in painting, the Chinese rarely depicted the nude or seminude human body. The occasional exceptions were Buddhist figures, and later other religious figures, often depicted for votive purposes; they might for iconographic reasons display a bare upper torso. Beggars' emaciated bodies might be depicted barely concealed by rags (cat. 296), but such works are few and hardly exalt the perfection of the human body. Chinese religious art, to be sure, drew on and perpetuated something of Buddhism's Indian backgrounds, and Indian Buddhist art was strongly influenced by classic Grecian models. In China something of that influence informs early wall paintings and the earlier Buddhist sculpture. But although we now regard much of that output, along with later Buddhist sculpture and painting, as superb art, the Chinese in the main regarded it as religious paraphernalia and temple decoration. The sculptor-craftsmen were almost all anonymous. Many more Buddhist sculptures are found in museums outside of China than in China, where they have been granted the status of art objects only in the present century.

Human portraiture in both painting and sculpture was a minor tradition; again, the portraitists were mostly unknown figures who practiced a craft, not held to be artists of significance. The contrast with Renaissance Europe could scarcely be greater. To be sure, we have portraits of the Ming rulers and their consorts (cat. 283), but only because those were needed for the rituals of the imperial ancestral shrines. They were not painted to be viewed and admired by any sector of society. Stylized portraits of other members of the Ming elite exist for analogous reasons. A few real and remarkable portraits of Ming personages (cat. 310), some by eminent painters, show that the skills of portraiture were present. Yet such portraits are rare. Human figures in Ming paintings are mostly adjuncts of landscape scenes. Paintings in which human figures are the central subjects—city street scenes, genre paintings, depictions of Buddhas and demons, hermits and heroes—were mostly the work of professional artists rather than cultivated literati amateurs. And paintings done for a living rather than for self-expression came, not long after Columbus' time, to be viewed with disdain by the Chinese elite. In any event, the depiction of human figures in Chinese painting was far less important than in Western painting of that time.[28]

The artistic crafts, on the other hand, included a great many kinds of things that Chinese connoisseurs valued most highly. Antiquity itself conferred worth. Antique bronze vessels and mirrors and antique carved jades were held in reverence, less as art objects than as links to the historic origins of the civilization. Also prized were rubbings of famous early calligraphies that had been incised in stone; rare printed works too were esteemed, especially the finest of Song dynasty printings. Song dynasty ceramics, which generally combined beauty with antiquity, were collected with passion. Ming scholar-officials were avid collectors, and were served by dealer-experts of high erudition (cat. 293).

At the same time contemporary crafts—metalwares, porcelains, lacquers, and carvings in stone, ivory, horn, bamboo, and wood—were also treasured by Ming collectors. The accouterments of the scholar's study enjoyed particular cachet: brush pots, brush washers, and brush rests, inkstones and inkstone boxes, water droppers (for making ink), wrist rests, seals, boxes of all sizes and shapes, vases and small decorative screens for the writing table. In the informal writings of the age we find many stories of superb objects, of their craftsmen-makers (emerging from millennia of anonymity), and of the competition among collectors to acquire their creations.

On another level, the commoner crafts added

much to the color and richness of ordinary Chinese daily life; the markets were filled with carvings and embroideries, basketry and lacquerwares, the coarser ceramics, woodblock prints for use as icons and as holiday decorations, metalwares and leather goods, an unending list. The skills to produce most of these, alas, have nearly vanished within the present century, and we now elevate surviving examples to the level of art.

A second point has to do with the composition of the artistic community in China as compared with the West. The artist community in traditional China (if we exclude that portion which produced what the Chinese held to be crafts) was virtually identical with the entire elite stratum, the literati (*wen ren*), men who, whether in or out of office, had been educated in the classical tradition for government service. This phenomenon, for which there are peculiarly Chinese reasons, seems to have few parallels in other societies. Let us look at the social dimensions of the three most valued of the arts: poetry, calligraphy, and painting.

All males sufficiently learned to sit for the civil service examinations through which one entered the official elite (perhaps, in 1500, close to one million, including qualified men who never in fact sat for the examinations) were expected to be able to compose technically correct poetry. Poets of true genius may not have been more numerous in China than elsewhere, but people who wrote competent poetry were. Moreover the best poets were within the mainstream of elite society: scholar-officials, or qualified to be so. Their poetry addressed the entire elite sector of their society as fellow poets; both the creation of poetry and its critical appraisal were acts in which all participated. Of course, the great poets were recognized as such, but their achievement differed only in degree from the rest.

This description of the composition of the artist community applies as well to calligraphers and painters. Because ink, paper, and brush were the basic tools of literacy as well as high art, everyone who could write commanded the same techniques as the great calligraphers and understood from their own practice what made calligraphy the greatest of the arts. In the West calligraphy was an applied craft of limited scope for artistic expression; although there too every literate person shared the calligrapher's material means, that did not give either of them access to a supreme form of high art.[29]

As for painting, in the West it was a technologically specialized skill employing brushes, pigments, oils, and canvas or other painting grounds—tools with which the average person never dealt. In the West, too, great painters might be recognized as persons of rare genius, might even be granted elite rank and titles, but they still were considered to be highly specialized craftsmen. In China painting and calligraphy were less exotic, precisely because the tools employed were ubiquitous. To be sure, the great artists felt themselves to be extraordinary, apart from others, and may have scorned the aesthetic capacities of more ordinary persons; nonetheless the fact that their technical means were employed by millions of persons in the uses of everyday life, kept the spheres of high art within the psychic access of all who put brush to paper.

Out of those circumstances emerged an artistic community of strikingly different composition from its counterpart in the West. The broad elite social base of its arts set China apart; Chinese artists were expected to be persons of cultivation and of social responsibility, who shared the roles and aspirations of all the elite. If they were not actually in government service, they were eligible for it or qualified by their education to seek such eligibility. Their art was an expected accompaniment of their public roles as social leaders and government officials; when despite their qualifications they pointedly chose to forgo those roles, the Chinese considered them to be "recluses," which did not signify anchorites withdrawn from society but simply persons of learning who did not strive for office.

Shen Zhou (1427–1509), the most noted painter of the period, is an example (see cat. 310–315); he came of a landed family near Suzhou that for four generations had produced noted artists and poets. None of those forebears had held office, and Shen himself steadfastly refused to do so, although he was in intimate contact with many high officials of his region. Shen collected books, art objects, antiquities, and craft products, and he dabbled in a number of minor arts and curious pursuits. One may almost conclude that the high arts, as defined in China, were those that the entire elite stratum could be expected to practice at some level of competence. The artistic crafts, on the other hand, were so specialized in technique, or so removed from the concerns of the literati, that those "persons of literary cultivation" (*wen ren*) seldom tried their hands at them, though they might admire and avidly collect the best of the craft objects to enhance their living environments. Thus their cultivated taste affected trends in both the arts and the artistic crafts.

Finally, a note on a different social dimension of Chinese painting is in order. From the Song dynasty onward a development occurred that in some measure bifurcated the history of Chinese painting. Song emperors—of whom several were gifted painters and/or calligraphers, and a larger number were discerning connoisseurs—established and maintained a court academy, an assemblage of painters and calligraphers of outstanding technical skills, who received official titles and salaries. Most of them possessed the same general educational backgrounds as the scholar-officials but did not have to follow the official career patterns of examination and administrative appointment. They were the "kept artists" of the court, and their surviving works are in the main descriptive and decorative, reflecting the tastes of their imperial patrons. Chinese literati, however, considered themselves, not their rulers, to be the true guardians of China's cultural values, and the literati of Song (and even more so of Yuan) increasingly adopted the philosophical position that the true function of painting was neither to describe nor to decorate but to express the emotional responses and the enduring character of the painter. The corollary of this position was that only a truly estimable man could be a true painter. Some outstanding poet-painters and calligraphers among the Song literati began to make a point of painting and writing in a deliberately artless, markedly non-professional (but often no less skillful) style to display the artistic independence and integrity comprised in this expressive ideal. This philosophical division introduced competition and intellectual stimulus, and led to some of the highest achievements in Song and Yuan dynasty arts.

By Ming times this *wen ren* stance had become a somewhat precious affectation, but one nonetheless widely and firmly held. In their roles as historians or critics of art the literati could not ignore the Ming period professional painters (often associated loosely with something approaching a court academy), and they genuinely admired some of them. Yet they unfailingly upheld the "amateur" *wen ren* painters as the bearers of a nobler tradition. The distinction between the amateur *wen ren* (and often semi-recluse) painters and the professional painters was exaggerated by tradition-minded—that is by almost all—Chinese art historians. Until recent years Western students of Chinese art have tended to follow their lead. It is now clear that the distinction is somewhat artificial and that a few important painters of the mid-Ming period moved in both milieus. Even so, most art historians from that time to this have clung to the distinction and exalted *wen ren* art over that of the professionals.

The present exhibition boldly departs from that tradition in giving equal weight to painters of both categories. Here we can see masterpieces of both, note their obviously distinctive qualities, and perhaps discover our own preferences. Probably the often bolder, more colorful,

and technically more skillful court and professional paintings will be more readily appreciated by modern audiences. *Wen ren* paintings are apt to be more reticent and allusive, to stress the subtlety of brushwork and the unity of poetry, calligraphy, and painting—in a word, they are apt to be "more Chinese." The historian must see the importance of each in the context of Chinese civilization. The exhibition-goer may respond directly and freely to the paintings, without regard to the accumulation of Chinese traditional attitudes. In this as in so many other ways, the present exhibition provides rare opportunities for discovery.

NOTES

1. William H. McNeill, "THE RISE OF THE WEST After Twenty-five Years," *Journal of World History* 1 (No. 1, Spring 1990): 1–21. The passages quoted are found on pp. 5, 6, 18. McNeill's article is quoted with the kind permission of the copyright holders. I am grateful to my colleague Professor Frank A. Kierman, Jr., for calling my attention to McNeill's article when it was first published, and for invaluable advice on other aspects of the present essay.

2. McNeill, 1990, 18–19.

3. There were, nonetheless, limitations in pre-Newtonian science and proto-science, East and West, that had to be overcome before any civilization could move onward into the transforming process of modernization that characterizes the modern world. That Europe *did* overcome those limitations, not that China did not, prior to its fuller interactions with the West from the nineteenth century onward, is the remarkable feature of the world's modern history. For an analytical discussion of this with special reference to China, see Marion J. Levy, Jr., *Modernization and the Structure of Societies*, 2 vols. (Princeton, N.J., 1966), 2:716–722, especially 720–721. I am indebted to Levy for much of the conceptual framework which informs my study of China.

4. See the discussion of the world of early Chinese thought in F. W. Mote, *Intellectual Foundations of China*, 2d ed. (New York, 1989).

5. In the present century it has become commonplace to refer to the Chinese past up to 1949 as "feudal" or "semi-feudal," but that is a misnomer dictated by Marxian historical fancies. Here we shall use "feudal" as the name of a particular type of political organization (the model for that being post-Roman Empire European feudalism). It should not be used as a catchall pejorative for a precapitalist or presocialist stage of any national history.

6. Except where otherwise stated, the information about early Chinese science in this and following discussions is drawn largely from the writings of Joseph Needham and his associates; see in particular *Science and Civilization in China*, vol. 3 (Cambridge, 1959), and vol. 4:3 (1971); *Clerks and Craftsmen in China and the West* (Cambridge, 1970); and *The Grand Titration* (London, 1969).

7. Needham 1970, 9.

8. See illustration in Needham 1970 facing p. 440, and a fuller discussion of Yuan and Ming astronomical instruments in Needham 1959, 3:367.

9. Needham 1970, 405. The quoted passage comes from an important essay entitled "The Evolution of Oecumenical Science" (1966), offering a full range of comparisons in all branches of science and technology, and showing how "... from the time of Galileo (+1600) onwards, the 'new, or experimental philosophy' of the West ineluctably overtook the levels reached by the natural philosophy of China..." (p. 397).

10. For a brief review of the interaction of Chinese with other Asian seafarers, see "China, Europe, and the Seas Between" (1966), in Needham 1970, 40–70.

11. See Needham 1971, 4:249–251, 293. The Chinese text on which Needham bases much of his argument is Shen Gua (1029–1093), *Meng Xi Bi-Tan*, written 1086–1091. For a recent study (in Chinese) of the natural science content of this famed miscellany, see Anhui Provincial University of Science and Technology, *Meng Xi Bi-Tan Yizhu* (Translation and annotation of the Meng Xi Bi-Tan, Natural Science Portions) (Hefei, Anhui, 1979), especially pp. 140–143, on the compass and magnetic declination.

12. *The Journal of Christopher Columbus (Diario)*, trans. Cecil Jane, ed. L. A. Vigneras, reprint (New York, 1989), 9, 11, entries for 13 September and 17 September; also 204, n. 10. A number of scholars have doubted that this comment on the diurnal rotation of the polestar, first noted on these dates, indicate that Columbus or his contemporaries had an understanding either of polarity or of magnetic declination. See Needham 1971, 308. Recent scholarship appears to confirm the view that magnetic declination was discovered only much later in the West.

13. Needham 1971, 4:3, provides a useful summary at the end of the section on "Nautics" (pp. 695–699) of the distinctive features of Chinese marine technology and their possible influence on the rest of the world.

14. Needham 1971, 4:3, 588–617, (summary) 696–697.

15. Mongol period contributions to the growth of Chinese maritime strength are stressed in a recent survey by Chen Dezhi, "Yuan-dai hai-wai jiao-tong yu Ming-chu Zheng He Xia Xi-yang," (Yuan Period Overseas Traffic in Relation to the Early Ming Voyages of Zheng He to the Western Oceans), in *Zheng He Xia Xi-yang Lun-wen Ji* (Collection of Essays Relating to Zheng He's Voyages), ed. Committee for the Observance of the 580th Anniversary of Zheng He's Voyages, Nanjing University, vol. 2 (Nanjing, 1985), pp. 190–202. For the Mongol rulers' attitudes toward commerce in Yuan China, see Elizabeth Endicott-West, "Merchant Associations in Yuan China: The *Ortoγ*," *Asia Major* 3:2 (1989), 127–154.

16. Chen Xinxiong, "Song Yuan de Yuan-yang mao-yi chuan" (The Long-range Merchant Vessels of the Song and Yuan Dynasties), in *Zhongguo Haiyang fa-zhan shi lun-wen ji* (Collected Essays on Chinese Maritime Development), ed. Academia Sinica, Committee for the Study of Chinese Maritime Development, vol. 2 (Taibei, 1986). This very important article, utilizing recent archaeological and documentary research, is able to correct and supplement at many points the section on "Nautics" in Needham 1959, 4:3.

17. Hong Changzhuo, "Bao chuan chang yi-zhi ji bao-chuan chi-du wen-ti" (The Site of the Treasure Ship Shipyard and the Question of the Size of the Treasure Ships), in Nanjing 1985, especially the archaeological drawing on p. 41.

18. Needham (and many others) has said that wooden ships could not get much longer than 300 feet, and thus he discounts the reports in Ming period sources describing the Treasure Ships as over 400 feet long. Recent Chinese scholarship tends to credit the possibility of the larger figure; see, for example, Hong Changzhuo in Nanjing 1985, 37–50.

19. From literary evidence we know that Chinese settlement at Palembang goes back to the eleventh century; see the brief historical background note in Wolfgang Franke, *Chinese Epigraphical Materials in Indonesia, Volume One, Sumatra* (Singapore, 1988), 445. No epigraphical evidence earlier than the fifteenth century has yet been found, however, for Chinese settlement in Sumatra.

20. Much of the foregoing is based on the splendid study by J. V. G. Mills accompanying his translation of a descriptive account, the book by Ma Huan, *Ying-yai sheng-lan: The Overall Survey of the Ocean's Shores [1433]* (Cambridge, 1970).

21. See F. W. Mote, "Yuan and Ming," in *Food in Chinese Culture: Anthropological and Historical Perspectives*, ed. K. C. Chang (New Haven and London 1977), 193–258.

22. The quotations from Columbus' *Diario* here are drawn from Oliver Dunn and James E. Kelley, Jr., *The DIARIO of Christopher Columbus's First Voyage to America, 1492–93* (Norman, Okla., 1989), 17, 19.

23. See Igor de Rachewiltz, *Papal Envoys to the Great Khans* (London, 1971).

24. Juan Gil, ed., *El Libro de Marco Polo anotado por Cristobal Colon* (Madrid, 1987).

25. See A.C. Moule, *Christians in China before 1550* (London and New York, 1930), especially chapter 7, "The Mission of the Franciscan Brothers," 166–215.

26. Cited from Donald F. Lach, *Asia in the Making of Europe*, vol. 1, *The Century of Discovery*, book 2 (Chicago, 1965), 735.

27. Chaoying Fang, "Chu Yu-t'ang [Zhu Youtang]" in *Dictionary of Ming Biography, 1368–1644*, ed. L. Carrington Goodrich and Chaoying Fang (New York, 1976), 1:375–380. A more extensive account of this emperor's reign is found in *Cambridge History of China*, ed. F. W. Mote and Denis C. Twitchett, vol. 7, *The Ming Dynasty, 1368–1644, Part One* (Cambridge, 1988), pp. 343–402.

28. The best treatment of the subject is in Thomas Lawton, *Chinese Figure Painting* [exh. cat., Freer Gallery of Art] (Washington, 1973).

29. For a discussion of the differences between calligraphy in the West and in China (including East Asia where the Chinese script is used), see F. W. Mote, Preface to *Calligraphy and the East Asian Book*, special catalogue issue of *The Gest Library Journal*, vol. 2, no. 2 (Spring 1988): 3–17. This volume also has been published as a book by Shambhala Press, Boston, 1989.

ART IN CHINA 1450–1550

Sherman E. Lee

CALLIGRAPHY

Ode to the Pomegranate and Melon (cat. 284), with calligraphy by Wang Ao and painting by Shen Zhou, poses the basic problem in Western understanding of Chinese painting. The calligraphy of the poem occupies most of the space and is signed by the famous scholar-official. Notwithstanding the justified fame of the painter, Shen Zhou, his painting is not signed but only sealed, and it occupies less than a third of the paper surface. Clearly the calligraphy and the poem it expresses are more "important" than the painting. How did this come about in China?

Intentions and circumstance combined to make this the case. Just as thoughts—moral, historical, practical, and aesthetic—were expressed through letters and words in the West, in China they were expressed through *characters* ultimately derived from pictograms. These characters, throughout their many permutations over time and mediums, retained a certain pictorial nature, whether in the form of oracle-bone inscriptions (*jia gu wen*, first engraved c. 1500 B.C. on bovine or cervid scapulae or on tortoise plastrons), or cast bronze vessels with inscriptions in seal script (*zhuan shu*, so called from its much later use in carved seals, but first appearing on bronzes of c. 1300 B.C.), or in the form of characters fluently brushed in ink, which we know to have been common from the second century B.C. Over time they may have lost their directly pictographic appearance, but they acquired an abstract pictorial character.

Every Chinese character is a composition within itself, made up of as many as twenty-four brush strokes. It is also a single unit, to be arranged with other comparable units in meaningful sequence, usually in vertical order, top to bottom, then right to left. The form of the earliest extant *brushed* characters, in use by early Eastern Han (A.D. 25–220), is called *li shu*, "clerical script," the direct ancestor of later forms, to which it is clearly comparable. Commerce, and the civil administration and military defense of a large empire, led in Eastern Han to the development of an abbreviated script, quickly written and easily read, called *cao shu* (cursive script); and a compromise between the angularity and horizontal emphasis of *li shu* and the elongated, curving *cao shu* produced *kai shu*, regular (or standard) script, which has

remained the basic form of Chinese writing until the present day. In later centuries *cao shu* became an art form, subject to infinite variations even to the point of illegibility (*kuang cao shu*, crazy cursive), and the province not of prosaic administrators and merchants but of inspired and/or drunken literati or ecstatic Chan priests. Semicursive (*xing shu*), a looser and less formal version of regular script, with some linking of strokes within a character, came into general use during Northern Song (960–1127), and the Northern Song style of *xing shu* saw a considerable revival during the Ming.

Merely memorizing thousands of characters and their meanings required years of study; skillfully writing them required lifelong dedication and practice with tutors or esteemed models—whether originals, copies, or rubbings of stone engravings after brushed originals. To read easily was obviously a prerequisite for education and for advancement as scholar and official. To write well was equally, though less obviously, a prerequisite to one's standing as a gentleman-scholar (*wen ren*). According to Confucian teachings writing was the moral act of a man fulfilling his responsibility to society at large as embodied in the emperor and to his particular family and clan, past, present, and future. Writing revealed one's character and individuality.

The materials of writing, no less than its philosophical and moral significance, were of serious importance to the influential minority that studied writing. The standard ground for calligraphy was paper of many kinds and textures, made from mulberry bark, bamboo fiber, or hemp, plus some rarer, more exotic mixes. Paper, like silk, could be sized or unsized, hard and smooth or soft and absorbent, and became the preferred ground for the calligrapher. From the Yuan dynasty (1279–1368) the gentlemen-scholars also preferred paper as the ground for their new style of "written" painting, whose true subject was brushwork and whose true theme was the nature of the artist. Silk, which had earlier been the preferred medium, continued to be used mostly by the court and "professional" painters.

Ink, too, was a subtle and complex matter, a substance capable of embellishing the messages of the writer. The characteristics of the basic

cake or stick of soot were affected by its binding adhesive and by the addition of substances that modified its "color"—from cool to warm, from blue to red-brown tones of black and gray.

The brush was the most amazing of the tools for writing, variously flexible, huge to tiny in size, able to hold a a considerable reservoir of ink, able to discharge it in the finest hairline. The hair, fur, and bristle used for brush tips came from rabbits, deer, horses, goats, and pigs. The skillful selection and use of ground, ink, and brush made possible a flexible, subtle, and powerful technique capable of producing the widest possible range of calligraphy, expressively suited to the mood of a text or the feelings of the writer. Significantly, these tools of the calligrapher's trade were the same tools used by the painter, with the addition, often, of color. And the discipline of writing characters complex in themselves and visually related to the other characters in the text was comparable to, and often identical with, the discipline of providing the structure of pictures.

It is not surprising, then that the critical literature on calligraphy, beginning as early as the second century A.D., should anticipate the slightly later criticism of painting. Striking poetic and metaphoric descriptions of the appearances and qualities of writing provide the two most important of the Six Canons of Painting of Xie He (c. A.D. 500):

1. Sympathetic responsiveness of the vital spirit
2. Structural [bone] method in the use of the brush
(Translation by Alexander C. Soper)

Both of these canons derived from concepts about calligraphy and music involving resonance and vibration and the induction of these from the movement of creation into the object of creation and from object to beholder. All commentators on calligraphy recognized the moral and instinctive nature of creativity but also the need for models from history and for rational organization. The earliest of these commentaries on calligraphy sets the tone for subsequent criticism:

In writing first release your thoughts and give yourself up to feeling; let your nature do

whatever it pleases. Then start to write. If pressed in any way, even if one had [a brush of] hair from hares of [Zhongshan], one would not do well.

In writing first sit silently, quiet your mind and let yourself be free. Do not speak, do not breathe fully; rest reverently, feeling as if you were before a most respected person. Then all will be well.

In its forms writing should have images like sitting, walking, flying, moving, going, coming; lying down, rising; sorrowful, joyous; like worms eating leaves, like sharp swords and spears, strong bow and hard arrow; like water and fire, mist and cloud, sun and moon, all freely shown—*this* can be called calligraphy.
(Cai Yong (A.D. 133–192), quoted by Chen Si (13th c.) in *Shu Yuan Ying Hua*, translated in Driscoll and Toda, 1935, 1964.)

The dynamism of Chinese calligraphy is implicit in the numerous critical writings on the subject. From the initial intention and conception, through the physical activity of fingers, hand, arm, and body in making the conception visible through brush, ink, and paper, to the "sympathetic responsiveness" of the beholder to the implications of the appearance of the result, the relationships are complex and shifting, hardly amenable to "laws" of doing and appreciating. Yet from Cai Yong on a continual sequence of writers about calligraphy have attempted to lend objectivity and precision to standards expressed largely in metaphor.

These efforts increased markedly during the Southern Song dynasty (1127–1279), accompanying the pragmatic Neo-Confucianism of Zhu Xi (1130–1200). The rise of *wen ren* pictorial art in the fourteenth century imposed on brushwork an explicitly historical approach and more stringent standards. While this may have inhibited the majority of practitioners after 1400, it also provided a firm base line and frame of reference for the determined individualism of the outstanding masters of Ming (1368–1644) and Qing (1644–1911).

COURT, PROFESSIONAL, AND "HETERODOX" PAINTING

The death of Shen Zhou in 1509 marks almost exactly the midpoint of the Ming dynasty, both chronologically and artistically. By the end of the sixteenth century critical opinion had been preempted by the literati (*wen ren*), at whose hands conservative painters and painting received a widespread and lasting bad press. A

retroactive reordering of the history of Chinese painting was accomplished, making the so-called Southern school the sole transmitter of a tradition that the literati designated true and orthodox. The "others" were piled into a so-called Northern school, henceforth decried as false and unorthodox. We have seen such dramatic revisionism in other times and other places—in French neoclassicism of the late eighteenth and early nineteenth centuries, or within the numerous "isms" of the twentieth century. The Yuan dynasty (1279–1368) *wen ren* masters were instrumental in this rewriting of history, but the murderous hostility of the first Ming emperor toward their immediate successors virtually wiped out the *wen ren* tradition in the first half of Ming. Indeed, from the removal of the capital from Nanjing to Beijing in 1421 until the early sixteenth century Ming art was dominated by traditional painters building creatively on the past—by the artists called to court and by professional painters elsewhere, especially in the regions of Suzhou and Nanjing. If a narrow trail of literati connects the late Yuan and early Ming painters of that persuasion with Shen Zhou (only four artists make up this trail—Wang Fu [1362–1416], Liu Jue [1410–1472], Du Qiong [1396–1474], and Yao Shou [1423–1495]—and of these only Wang Fu can claim major importance), a broad road runs from earlier dynasties to the professional masters.

Court Painters and the Embroidered Uniform Guard
One of the major concerns of all Ming emperors, beginning with the Xuande emperor (r. 1425–1435), was the maintenance of a kind of legitimacy based on a connection with earlier, more glorious reigns. The Xuande emperor had good reason to support painters, for he was a good, if not great, painter in his own right. In this he was a minor echo of Emperor Hui Zong (r. 1101–1126), a marvelous artist and discerning patron under whom the Northern Song court painting academy (Hua Yuan) achieved heights of artistic accomplishment. Since a true academy like Hui Zong's, complete with designated academicians, competitions, hierarchies of masters and students, was not considered appropriate for a Ming court, the Xuande emperor made the imperial bodyguard, the Embroidered Uniform Guard (Jin Yi Wei), function as a substitute. Founded in 1382, soon after the beginning of the dynasty, the guard was a military organization, personally responsible to the emperor and with often-abused powers of imprisonment and torture. Its reputation varied from fearsome to disreputable, and it was often a hotbed of intrigue and competition among

individuals and factions. Obviously the Jin Yi Wei was not an apt instrument for the support of artists, but supported they were through appointments to and ranks in the guard. Perhaps the Xuande and succeeding emperors used the guard not only as a means of paying painters and assuring their presence for service at court but also, and more importantly, as a means of restraining any subversive intent or inclinations to what could be considered license. One can readily understand the painters' lack of enthusiasm for such service, and the reasons why many of the very best professionals preferred to breathe the freer air of southern Jiangsu Province, especially in the prosperous Suzhou-Nanjing area. North China, including the capital, became additionally unattractive in 1449, after the disastrous defeat of the imperial army and the capture of the emperor by the Mongols. It was many years before the military threat abated, even in the capital.

The perilous vagaries of service in the Embroidered Uniform Guard may also explain the curious history of Dai Jin (1388–1462), by general opinion the painter of the greatest ability and breadth of the mid-fifteenth century. Called to court to paint for the Xuande emperor, he was forced to flee for his very life by the intrigues of his painter-rival Xie Huan (act. 1426–1436), who had the emperor's ear. Dai fled first to Hangzhou; finding that not far enough for safety, he moved on to Yunnan Province in the far southwest, where he was fortunate to be befriended by the local prince, Mu Sheng (1368–1439), a collector and connoisseur. Later Dai returned to Beijing and pursued his painting career there, though not under court patronage. The Xuande emperor, however, was safely dead by the time of Dai's return.

Notwithstanding the capricious and constraining nature of Ming imperial patronage, in the second half of the fifteenth century the court attracted many fine painters, particularly in the reigns of the Chenghua emperor (r. 1464–1487), the Hongzhi emperor (r. 1487–1505), and the Zhengde emperor (r. 1505–1521). It is no coincidence that these reigns also produced splendid ceramics and lacquers (see cat. 321–329, 334–336). The professional-conservative painters were quite evenly divided between northerners and southerners, and the conservative painters represented in this exhibition reflect this balance between the capital in the north and the Suzhou-Nanjing area.

Subjects and Materials
The production of the court painters was even more varied than that of the southerners, and the imperial patronage may account for this.

Large-scale historical works (cat. 287, 302), as well as almost as large "fur and feathers" scrolls (cat. 303, 305), were needed to decorate the enormous palace buildings. Such grandiose works were not much required by the predominantly private patrons of the south. Landscapes were the dominant subject of the professional artists in Suzhou, usually on a smaller, domestic scale (cat. 298). "Fur and feathers" was not a major category for any of the southern painters, perhaps because no court-academic tradition required them to use the subject. Among the three major professionals of Suzhou—Zhou Chen, Tang Yin, Qiu Ying—Tang Yin's *Mynah Bird* (cat. 299) is exceptional for its subject matter. Shen Zhou's relatively numerous bird and plant paintings (cat. 314) place him closer to the court tradition, albeit in subject matter only. In brief, a variety of subject matter was shared by most of the court-professional painters from the Xuande reign until the early sixteenth century.

All the painters of the period, professional or literati, used the same materials save for the ground. The vast majority of the literati paintings are on paper; the majority of the court artists and the professionals most often used silk. Aside from tradition, a major factor, it is hard to know why this was so. Perhaps tradition was the main reason. But since paper was customarily used for calligraphy practice, it must have seemed the appropriate ground for the literati's new "written paintings."

Range of Styles

The nature of painting in the time we are considering is quite clear. All of the schools of the past were honored by imitation as well as in critical or art-historical writings. The court and professional artists, reasonably designated as conservative in the best sense of that often misused word, tended to the common Chinese practice of choosing from the past the stylistic model that best suited a given subject. As early as the decade of the 1070s Guo Ruoxu (11th century) had written in his *Experiences in Painting* (*Tu Hua Jian Wen Zhi*, trans. Alexander C. Soper, American Council of Learned Societies, 1951), that religious and secular painting of the past (especially the Tang dynasty) was superior to and a model for his present, but for landscape and other subjects drawn from nature "then the ancient does not come up to the modern," i.e., the Northern Song dynasty, (960–1127). The creative eclecticism engendered by this attitude was found particularly sympathetic by the painters of 1420–1520. Thus Tang Yin's landscapes (cat. 298) were often indebted to Northern Song

prototypes, while his figure painting (cat. 297) derived—though not slavishly, particularly in physical proportions—from late Tang paintings of court ladies, such as those by Zhou Fang. Qiu Ying's command of whatever past style suited his purpose was always remarked upon with wonder, though the works easily recognizable as his are so recognized by virtue of the variations he worked on the style he appropriated. The forgeries he painted for various distinguished patrons, including one of the great collector-dealers in Chinese history, Xiang Yuanbian (1525–1590), present a different and most difficult problem.

The view of middle Ming Chinese painting outlined here is confirmed by the literary criticism of the same period. As Wai-kam Ho has demonstrated, the art criticism owes much to the propositions of literary criticism, embodied in writings more numerous and more sympathetic to the Chinese scholar of the period than the writings on art. Until late in the sixteenth century conservative and eclectic standards of judgment represented the majority opinion in literature *and* in art. Song dynasty traditions, including those of Southern Song (1127–1279), were admired and followed. So were the Yuan masters, but those fourteenth-century masters were not elevated above the Song painters, nor were the Southern Song masters denigrated—a reversal that would shortly come to pass at the hands of the overwhelmingly authoritative painter-theorist Dong Qichang (1555–1636). The formulations of the major critic Wang Shizhen (1526–1590), for example, recognized the "changes" (read "innovations") effected by all the major schools of Chinese painting, from earliest times to middle Ming. In his reasonable, pragmatic, Neo-Confucian interpretation the history of Chinese painting was seen as continuous and creative. This approach was reversed by Dong, whose newly formulated principles, retroactively applied, simply bypassed Southern Song and relegated the Ming dynasty Zhe school and most court and professional painters to the "dustbin of history." These biases, lasting to the present day, distorted subsequent readings of the history and achievements of Chinese painting.

Distinguishing Traits

What were the shared characteristics that distinguished the works of the court and professional painters? Not all of the traits discussed below will be found in any one work or even in the oeuvre of one master, but most can be found in a majority of the works of these schools. Much of Richard Barnhart's excellent discussion

of the "heterodox" school of painters applies as well to the court-professional group.

1. The size of paintings was limited only by the size of the ground. The few existing very large works on paper (cat. 301) are large only in the vertical dimension. Vertical and horizontal extension seems to have been possible only on silk, or in dry fresco on temple walls, which was the province of professional muralists specializing in Buddhist and Daoist painting.

2. Subject matter ranged widely. A majority of the paintings may have been landscapes, but not an overwhelming majority, as was the case in literati painting. Figure paintings, or large figures in natural or architectural settings, were substantially represented, and knowledge of the great prototypes and the ability to produce believable and expressive representations were the province of the professional and court painters.

3. Techniques used to represent nature and humanity were also widely varied. The continuous, fine "iron-wire" line of even width was necessary for delineating figures or architecture in the archaic styles of Six Dynasties and Tang (cat. 294) and for representing figures in an elite domestic setting (cat. 293). But representations of fishermen, unfortunates (cat. 296), or Daoist sages permitted rapidly executed, varied brushwork, expressive sometimes to the point of wildness. In the works of the

fig. 1. Ma Yuan (act. before 1190–c. 1230). *Winter: Egrets in Snow*. Chinese. Collection of the National Palace Museum, Taipei.

"Wild and Heterodox" school this expressiveness could become a total personal license to crazy or drunken expressionism (cat. 304).

4. Compositions tended to be dramatic, with tensions produced by asymmetry (cat. 291, 292) or by powerful contrasts of ink tone (cat. 290, 304), producing a "push and pull" of the parts of the composition. The asymmetry can be attributed to the influence of the Ma-Xia school of late Southern Song, the emphatic contrast of monochrome ink tones with bare silk was a creation of these middle Ming masters.

5. Compositions were unitary, usually requiring to be read as a whole. Like a *gestalt* ink blot, the typical court-professional scroll reads better from a distance. Close viewing can reveal exciting brush movement and material, but the extrinsic aesthetic meaning of the picture is to be grasped from afar—again in contrast to the majority of *wen ren* works, which were intended to be read up close, as if they were books, literary works of visual art.

6. There was considerable experimentation with ink techniques to create unusual pictorial effects (cat. 303). The daring use of the "boneless" ink wash method to render flora and fauna without outline went hand in hand with experiments in reserve painting, in which the raw silk ground became a silhouette against a background of ink wash. Both of these techniques were used sparingly by Southern Song masters such as Li Di and Luo-Chuang, but in the two Ming works cited above the scale of the technique is daunting.

7. All, or at least most, of these traits tended to produce paintings that can be described, not pejoratively, as decorative. They make immediate and lasting impressions on the beholder. Their virtues, including subtlety, are not to be found in fine nuances. By contrast, even the earliest works of Wen Zhengming (1470–1559; cat. 316, 317), leading literatus of his time, reveal just such nuance and miniaturization, *wen ren* tendencies which were fully displayed by his mid-sixteenth-century followers.

8. Finally, only among the professionals—and even there only rarely—does one find explicit and believable representation of social subjects or classes. As represented by the *wen ren*, fishermen, peasants, or gardeners (cat. 315) are staffage, a few schematic brush strokes signifying but not representing persons. On the other hand, Zhang Lu painted a real fisherman laboring with the weight of his net, Huang Ji's figure (cat. 289) is a believable "tough," and above all Zhou Chen's *Unfortunates* (cat. 296) are a moving record of actual hunger and misery.

Zhou Chen, Tang Yin, and Qiu Ying

The dichotomy between *wen ren* and professionals lies basically in attitudes assumed after the mid-sixteenth century. Close connections between the two groups were common in the fifteenth and early sixteenth centuries. Indeed, it is most likely that the few literati painters active in that time were largely unaware of the gulf between them and their colleagues proposed by later critics and scholars. The most famous painters of the day, professional and literati, formed a reasonably close artistic family in Suzhou in the early sixteenth century. Later acclaimed as the Four Great Masters of Wu, they were the *wen ren* Shen Zhou and his disciple Wen Zhengming, and the professionals Tang Yin and Qiu Ying, whose varied brush disciplines were available for the patrons of all four masters.

Zhou Chen (cat. 295, 296) must have been pleased, if a little envious, at the success and recognition achieved by his two pupils Tang Yin and Qiu Ying. He had been the ideal teacher for the two disciples, his complete command of late Northern Song and early Southern Song landscape techniques giving him a solid and rational foundation to transmit. He had used it well, with some innovations in scale and in subtlety of middle ink tones; he had also achieved a figure style brilliantly suited to depict lower-class types, for whom numerous models existed in the Hell scenes painted by the Southern Song professionals at Ningbo. Zhou's paucity of social connections, compared to those available to his young pupils, may have diminished his chance for lasting fame, but his achievements were solid and are now increasingly respected.

Tang Yin (1470–1523) was forced into professionalism by misfortune. He was still in his early twenties when most of his immediate family, including his wife, died in the space of a year. His subsequent hard-earned recognition as a brilliant scholar was aborted by accusations, probably false, of cheating before the highest-level examination at Beijing. Disgraced and unemployed, he avoided penury by his pictorial talents, becoming an acknowledged master of landscape and figural painting, especially of "court lady" subjects. At the same time he became known as a master of stews and wine shops. Perhaps this unwelcome notoriety was exaggerated by later writers who could not resist moralizing on the fall from grace of a potential scholar-official.

Qiu Ying (d. 1552) was simply a child prodigy of lowly origins, acquiring an admiring audience of buyers and patrons by his early teens. Judging by reputation and by the incontrovertible evidence of his remaining paintings,

there was nothing within the highest reaches of past or present Chinese painting that he could not equal or surpass. Because of his huge success and the variety of his patronage, the range of his subject matter was immense. Imitators debased his excellence by overusing and coarsening his blue-green-gold landscape style. But some of his paintings, if not the most characteristic ones, rival in clarity, subtlety, and elegant brush manner those of the literati followers of Wen Zhengming.

Lamaist Painting

We still know little about the relationship of professional Buddhist icon painters to the production of the numerous Lamaist *thangkas*, paintings representing deities and disciples of that form of Esoteric Buddhism. Many of these scrolls look quintessentially Chinese (cat. 308), despite their being painted on cotton, as is done in Tibet, instead of on silk as is done in China. We do know that Chinese professional painters were employed on wall paintings in Tibetan monasteries. Gilt bronze images in Tibetan style with Lamaist iconography, bearing Yongle (1403–1425) and Xuande (1426–1435) reign-marks, are particularly well known, and it seems reasonable to assume that the Chinese icon painters were as skillful as their sculptor colleagues in the production of works under Lamaist patronage, whether in Tibet or in China. There were numerous Lamaist temples in the Beijing area, and these required the full panoply of altar furniture, banners and paintings for celebratory occasions.

For Chinese participation in Lamaist painting during the Ming dynasty, the clearest and most convincing evidence is the almost universal adoption, even by Tibetan icon painters, of the traditional blue-green-gold landscape manner for the background in paintings of arhats and of bodhisattvas depicted in a natural setting. This ancient manner was hallowed by its origins in the great Sui (581–618) and Tang (618–907) dynasties and, being itself redolent of antiquity, made a suitable backdrop for venerable figures, much as gnarled old trees (cat. 308, 309) provided such figures with both shade and an allusion to age and wisdom. Pratapaditya Pal has written, aptly, that the blue-green-gold manner developed, in the Lamaist context, into a visionary landscape (cat. 309), quite different from the more expansive and rhythmical use of the manner in archaic and archaizing works by recognized Chinese practitioners. In this representation of Cūdapanthaka the tightly packed mixture of rocks, hills, and trees in blue-green-gold seems almost a personal and idiosyncratic vision, very effective in conveying the intensity

of the meditating arhat. By contrast, Qiu Ying's landscapes in the same manner reveal their basically Chinese origins.

The "Wild and Heterodox"

Richard Barnhart's analysis of the "Wild and Heterodox" school cannot be improved upon. These painters' deliberate rejection of social amenities and wholehearted adoption of wild ways and crazy soubriquets may have seemed both anti-literati and antitraditional, but there were precedents for both their manners and their artistic styles. The art of Wu Daozi (act. c. 710–c. 760), greatest of all Tang masters, was described as unrestrained, free, and imbued with "untrammeled feelings," a term beloved in *wen ren* criticism. The earliest Chan painters of the tenth century, such as Shih-Ke, used stalks, rags, or other exotic tools to manipulate ink in extraordinary and unpredictable ways. The late Song dynasty Chan or Daoist painters did the same—terms such as "splashed ink" or "flung ink" are often used in describing the more extreme works by Yu-Jian or attributed to Mu Qi. The stylistic precedents for "Wild and Heterodox" were all in place. So also were behavioral precedents. "[Wu Daozi] loved wine.... to flourish his brush, he had to become intoxicated"; Wang Mo (d. c. 800) "...excelled in splattering ink to paint landscapes....there was a good deal of wildness in him...he would first drink, then after he was drunk, he would splatter ink. Laughing or singing, he would kick at it with his feet or rub it with his hands, sweep [with his brush] or scrub...." (trans. Alexander Soper, *Artibus Asiae* 31 [1958]: 204–230). Liang Kai, the southern Song academician, turned to Daoist and Chan subject matter executed in a wild and abbreviated manner and took the soubriquet Crazy Liang. More examples could be cited. Though unusual, it was nevertheless sanctioned practice to opt out of a deteriorating or immoral society or situation by embracing eremitism, as many scholar-painters did; it was likewise acceptable to "become mad," to adopt extreme social behavior as a form of protest or escape. So Shi Zhong (cat. 304) adopted the name "Crazy Old Man," Sun Long (cat. 303) chose "Stupid in Everything," and Zhang Lu (cat. 305), who came from a good family and began a propitious career, was reputed to have turned away from his success and acted like a leopard hiding in the wilderness, wearing straw sandals and coarse cotton. Many of these nicknames bear Daoist connotations. The traditional intuitive, magical, and animistic aspects of Daoism were particularly congenial to those choosing a way outside social conventions. Untrammeled nature was an old

ideal still very much alive to many artists of later periods.

The connections of these "Wild and Heterodox" painters were clearly with the professional and conservative painters of middle Ming, however extreme their position within this group. But the virulence of the attacks on them by the *wen ren* critics of late Ming surpasses the artists' own extremism. He Liangjun wrote (c. 1550), "As for the likes of [Jiang Song]...and [Zhang Lu; cat. 305] of the North, I would be ashamed to wipe my table with their paintings" (Barnhart 1983, 44).

If the "Wild and Heterodox" were anathema to the late Ming literati, their descendants, however tainted and removed, were the individualists of the early Qing dynasty, the most progressive and aesthetically curious of all the artists of the seventeenth century. And, with poetic justice, their conservative opposites were the orthodox followers of the radical *wen ren* formulations of Dong Qichang in the early part of that century.

SHEN ZHOU AND THE LITERATI (WEN REN) STYLE IN CHINA; SESSHŪ AND HIS CHINESE STYLE IN JAPAN

...the trees that formed a grove looked fresh in spirit and were flourishing in their mutual sustenance. Those which could not form a group crouched by themselves as if to keep their own creeds within themselves. Some trees exposed their winding roots out of the ground; others lay directly across a wide stream; others were suspended over the cliffs and still others crouched in the middle of the ravine. Some grew tearing mosses and cracking rocks. I marveled at this curious sight and walked around admiring the scenery.

From the next day onwards I brought my brush to this place and sketched the trees. After sketching some ten thousand trees my drawings came to look like the real trees. (Kiyohiko Munakata, *Ching Hao's Pi-fa-chi: A Note on the Art of the Brush* [Ascona, 1974], p. 11.)

[Zhang Yizhong ?] always likes my bamboo paintings. I do bamboo simply to express the untrammeled spirit [*yi ji*] in my breast. Then how can I judge whether it is like something or not; whether its leaves are luxuriant or sparse, its branches slanting or straight? Often when I have daubed and rubbed awhile, others seeing this take it to be hemp or

rushes. Since I cannot bring myself to argue that it is truly bamboo, then what of the onlookers? I simply do not know what sort of thing [Yizhong] is seeing.
Ni Zan (1301–1374), in colophon dated to 1368
(Bush and Shih, 1985, 280.)

These two quotations and their visual counterparts clearly and neatly confirm the sharp contrast that generally obtains between Chinese paintings done before and after 1350. Although later Ming art critics and theorists purported to find numerous literati precursors among artists as early as late Tang (ninth century), visual evidence overwhelmingly attests that Jing Hao's rational realism was the norm of pre-Yuan dynasty painting, whereas the literati (*wen ren*) style and aesthetic (expressed by Ni Zan) has been the dominant mode from Yuan even to the present day.

Perhaps the major components of earlier Chinese painting, its complex and patient techniques, its painterly observation and recording, its rationality in organization and appearance, corresponds to the rise of "science and technology" in China, so thoroughly documented by Joseph Needham in his monumental survey of the subject. It is probably equally significant that the triumph of *wen ren* painting in the middle Ming dynasty accompanied a reversal of interest in technology and exploration (see Frederick Mote's essay in this catalogue), a turning inward of national interest, and a growing stasis in government and bureaucracy in the period from 1450 to the end of the Empire.

Wen ren ideals utterly changed the appearance of Chinese art. Paper, not silk, became the preferred ground—as it had been from the beginning for calligraphy. Ink, usually without color other than some pale washes, was de rigueur. To express the artist's own spirit, rather than the subject's outward form or inward nature, was the aim and theme of painting. The demands of realism were set aside in favor of self-expression through brushwork; for *wen ren*, painting no less than writing "revealed the character of the man." Careful technique, built-up washes, massed strokes were replaced by "single stroke" calligraphic expression whose ideal qualities were informality and "blandness" (*ping dan*), a quality of understatement, or seeming artlessness, carried to the point of seeming awkwardness. Pictures as windows on the world and also as grand decoration for large halls and offices gave way to "written pictures" intended for close examination in the study or at in-group gatherings. Earlier painters looked often to China's political and social history for incidents and exemplars of high moral serious-

ness to serve as their subjects. *Wen ren* painters looked to the history of art; their subject was to a great extent their own aesthetic lineage and traditions. In other words, the new style was a kind of "art historical" painting, informed by references to the great ancestors of *wen ren* art—the Tang poet-painter Wang Wei, the tenth-century master from the south Dong Yuan, the Northern Song eccentric critic and painter Mi Fu, and above all the true inventors of the new tradition, Zhao Mengfu, Qian Xuan, Gao Kegong, Huang Gongwang, Wu Zhen, Wang Meng, and Ni Zan of the Yuan dynasty.

This lineage, largely formalized and made dogma about 1600, was the source for most of the styles so faithfully and so inventively exploited by the self-designated inheritors of the *wen ren* tradition. To be a *wen ren* artist, one must have studied the precursors' paintings, and know the nuances of their brush techniques, compositions, and flavors. It was commonplace, beginning with Shen Zhou in the second half of the fifteenth century, to paint works in homage to an earlier master and in his style. Later, whole albums were made, with eight or twelve pictures in sequence, each alluding to the manner of a different earlier master. Even handscrolls were often painted in such stylistic segments; at the hands of a skillful artist one section blended into the next with hardly a whisper of tension or incongruity. This is not to say that later artists did not have their own styles; they did, and highly individual at that, but even their most idiosyncratic passages might include an inscription or poem that evoked the spirit of one of the great ancients of the true tradition.

Just as Ming *wen ren* painters selected a lineage of approved precursors, so they also selected an approved subject for representation: landscape. To the representation of this chosen subject the *wen ren* brought concepts derived from Confucian, Daoist, and Chan Buddhist thought: *li* (the essential reality of things), *tian ji* (artistic instinct or inspiration), and *shen hui* (insight into the subject to the point of fusion between artist and subject). Such an approach was particularly productive of those visual qualities most prized by the *wen ren*: spontaneity (*zi ran*), "blandness" (*ping dan*), expressiveness (untrammeled feeling, *yi*), and the spirit of antiquity (*gu yi*).

With landscape, as any aspiring or practicing painter knows, the successful representation is both easily accessible and terribly remote. The semblance of reality, however much it may be declared unwanted, is easily attained; essential reality, transcending formal resemblance, is remote to all but a few. Nevertheless landscape became the only subject, aside from calligraphic

exercises (later codified in woodblock-printed handbooks on bamboo, orchids and the elements of landscape). *Wen ren* painters shunned non-landscape—figure compositions (notoriously difficult); "fur and feathers"; the whole genre of "still life" so popular with the professional and academic painters of the past; and the large-scale decorative works favored by the court, past and present.

The location of the court was crucially important to the development of *wen ren* painting, both in particular and in general. Particularly, the immediate successors of the Four Great Masters of Yuan, asserting the independence of patronage and authority that they considered appropriate to gentlemen-amateurs, received short shrift at the court of the first Ming emperor. This pockmarked peasant-soldier, Zhu Yuanzhang (often known by his reign-name Hongwu) restored the prominence of the south by locating the capital at Nanjing, and reinstituted many of the imperial institutions and practices of the last native dynasty, the Song. But the tenor of his reign was determined by his suspicious, brutal, and violently anti-intellectual character, nowhere clearer than in his treatment of the second wave of *wen ren* masters: of six major artists who lived from late Yuan into early Ming, only Wang Fu survived the reign of the Hongwu emperor; two of the others died in prison and three were executed for treason. When the Yongle emperor moved the capital north to Beijing in 1421, he also ratified a division in the artistic community. At the new capital on the dry northern plains a revived imperial patronage benefitted and stimulated painters of professional-academic orientation; far to the south, in the fertile and affluent "eye area" of Suzhou, Nanjing, Yangzhou, and environs, the gentry pursued their own *wen ren* ideas, without benefit of the patronage they would in any case have scorned and at a relatively safe distance from the lethal intrigues of the Ming court. From the 1420s through the end of the century, the attraction of imperial patronage assured the dominance of the "conservatives" over the *wen ren* of the south.

Shen Zhou

This dominance delayed the development of *wen ren* painting. The new *wen ren* movement, centered around Suzhou, was called the Wu school, as Suzhou itself was called Wu after an ancient kingdom lying largely in southern Jiangsu Province. But the Wu school sputtered almost to a halt in the first half of the fifteenth century. Several painters are known, but two of them, Liu Jue (1410–1472) and Du Qiong (1396–1474), only because they played a part in

the early development of Shen Zhou (1427–1509), the most famous *wen ren* of early and middle Ming. Founder of the Wu school and epitome of *wen ren* ideals and practice, Shen stands alone as an ideal model of his age.

He was alone as well in artistic style until Wen Zhengming (1470–1559), also of Suzhou, became his pupil and follower (cat. 316, 317). This is not to say there were no other contemporary painters of merit in the area, nor that Shen Zhou was without friends among painters, scholars, and officials. It does mean that there was no circle of like-minded painters influencing each other's work; only the landscape masters of the past, especially the Four Great Masters of the Yuan dynasty (Huang Gongwang, Ni Zan, Wang Meng, Wu Zhen) contributed to the style Shen Zhou created almost in isolation.

Born into a wealthy land-owning family living at Xiangcheng, ten miles north of Suzhou, Shen could easily afford the expensive and creative self-indulgence of collecting fine paintings and bronzes. One painting alone in his collection provided lessons enough for a lifetime—the most famous of all works of the fourteenth century, Huang Gongwang's (1269–1354) *Dwelling in the Fuchun Mountains*, a handscroll painted between 1347 and 1350 that was *the* most significant fountainhead of *wen ren* style and aesthetic. But Shen also collected works by near-contemporary professional painters such as Dai Jin (cat. 288) and Dai's rival Xie Huan, a professional and conservative master attached to the court.

As Shen Zhou's painting tutor, his father Shen Heng (c. 1376–after 1470) selected Chen Kuan, grandson of the late Yuan–early Ming painter Chen Ruyan. This choice may well have contributed to Shen Zhou's famous reluctance in later life to travel beyond Wu, especially to the capital, Beijing. Shen's great-great-grandfather Shen Liangchen had been a collector and friend of Wang Meng (1309–1385), one of the Four Great Masters of Yuan, and Wang had died in prison, a victim of the purges set in motion by the anti-intellectual paranoia of the first Ming emperor. Shen Zhou's great-grandfather Shen Cheng had set a family precedent by declining a government appointment; and the tutor Chen Kuan's painter-ancestor Chen Ruyan had been executed by the Hongwu emperor before 1371. It is no wonder that the *Ming History (Ming Shi Lu)* lists Shen Zhou in the "recluse-scholar" category, meaning simply that he refused to enter the government bureaucracy.

By no means a recluse in Western terms, Shen was a close friend of Wu Kuan (see cat. 312, 315) and Wang Ao (cat. 284), Du Mu, and Wen Lin (father of Wen Zhengming)—all in

fig. 2. Huang Gongwang (1269–1354). *Dwelling in the Fuchun Mountains*. Dated to 1347–1350. Chinese. Section of the handscroll; ink on paper. Collection of the National Palace Museum, Taipei.

government service—and he took the trouble to build a studio on the edge of Suzhou, referred to as a *hsing wo* (travel nest?), probably to provide a pied-à-terre from which to sell paintings. In later life, after 1480, he sold many of the important works in his collection, including the famous *Dwelling in the Fuchun Mountains* and a tenth-century landscape by the great early master Guo Zhongshu. This suggests that he likely sold his own works as well; after all, during Shen's lifetime "professionalism" was not the term of opprobrium that it became for later generations of literati. Zhou Chen, the fine professional master and teacher of Tang Yin and Qiu Ying, was almost surely one of Shen's Suzhou circle. Furthermore, by refusing government office his whole life long (citing as an unimpeachable Confucian excuse his long-widowed mother's need of him), Shen also relinquished the income that came with government service. And money was needed, if only to pay the taxes on his and his mother's estates.

Shen's mature style influenced several minor masters of the next generation: Xie Shichen (1487–c. 1561), Qian Gu (1508–1578), Wang Chong (1494–1533), Chen Shun (1483–1544), and Sun Ai, who in 1490 painted Shen's portrait. But his only direct pupil of consequence was the well-to-do son of his friend Wen Lin (1445–1499), Wen Zhengming. Wen's beginnings as an epigone of Shen Zhou can be seen in Wen's early (pre-1504) addition to Shen's album (now mounted as a handscroll; cat. 316), and in the upper part of his own *Spring Trees After Rain* of 1507 (cat. 317). In his maturity he became recognized as the second great master of the Wu school, enormously influencing the development of *wen ren* ideals; his own mature style, expressive if constricted, set the pattern along which his family continued the Wu tradition.

The achievement of Shen Zhou was to form, or rather to transform, the idioms of his favorite Yuan masters, first Huang Gongwang and later Wu Zhen, into a new and original style. His earliest works were either modest essays in local landscape (*Living in Retirement*, 1464, Osaka Municipal Museum), or complex and difficult "homages" to Yuan masters, such as *Lofty Mount Lu* of 1467 (cat. 311). The latter painting, which Shen dedicated to his tutor Chen Kuan, was a major work, a "variation on a theme" of Wang Meng, friend of Shen's great-great-grandfather and one of the Four Great Masters of Yuan. The mountain was famous, revered, associated with celebrated figures from the past, and a fitting metaphor for the lofty character of the artist's tutor. Evidently, then, the painting was seriously undertaken, a major effort, perhaps even a "master-piece," a demonstration of his maturity in relation to the artistic tradition. The writhing forms and hairy textures are Wang's, but the bold drama of the dancing pines in the foreground, the arbitrary lightening of the central rising plateau, almost ghostly in effect, and the metamorphic distant peaks above are all new, and express the powerful individuality of Shen Zhou.

In addition to Shen's study of Huang Gongwang, and his mastery—apparent in this painting—of the style of Wang Meng, in other works of this same period he at least dealt with the spare and austere elegance of Ni Zan (1301–1374). Clearly, Shen looked to the Yuan masters for his antecedents, and among the Yuan masters the most significant influence in the formation of Shen's mature and consistent way proved to be Wu Zhen (1280–1354). The sixteenth-century painter-critic Li Rihua (1565–1635) wrote of Shen Zhou: "In his middle age he chose Huang Gongwang as his master, but in later years he was completely carried away by Mei Daoren (Wu Zhen). He became quite intoxicated by Wu Zhen's art and blended so closely with it that some of his works could not be distinguished from Wu Zhen's if they were mixed up" (*Wei Shui Xuan Ri Ji*, c. 1619). Although the last phrase is simply a cliché, the first

phrase of the last sentence is partially correct. Wu's characteristic style was a combination of vertical and horizontal "single strokes" with pale washes of ink, producing a deceptively simple and plain (bland, *ping dan*) landscape that was highly approved among the *wen ren*. Shen took the single-stroke idea and the broad use of wash and joined it to his forceful, even dramatic energy. In this (the author believes) Shen Zhou was recalling something of the drama to be found in Zhe school and "Heterodox" pictures, something really different from such *wen ren* ideals as "blandness" or the cloaking of skill. The album-scroll of *Five Landscapes* (cat. 315) and the handscroll of *The Three Junipers* (cat. 312) are hardly to be explained in traditional *wen ren* terms. *The Three Junipers* has other claims to fame, for it is a major innovation in the treatment of a traditional Chinese "landscape" theme, one especially associated with the great monumental landscape artists of the tenth and eleventh centuries and treated sporadically during the Yuan dynasty, once (to fine effect) by Wu Zhen. For the cutoff, near view that Shen Zhou gives us of segments of the grand old trees, Cahill's description and comment cannot be improved:

> Metamorphic and metaphorical effects are present in Shen Chou's painting, but they depend on real aspects of the trees and are not mere products of the artist's imagination. The grandeur of Shen [Zhou's] presentation admits nothing of the fanciful; with brush drawing of a rugged integrity that is worthy of its subject, he describes movingly the outcome of a millennium of slow growth, of survival through a thousand winters. (Cahill, 1978, 95.)

Wen Zhengming also painted old trees, especially in his later years, and they owe much to Shen's innovation, but the balance between innovation and tradition, personal expression and respect for nature, brushwork and delinea-

tion, reached its splendid zenith in the man of the fifteenth century, before the triumph of the *wen ren* painters of Suzhou.

Shen Zhou and Sesshū

Shen Zhou's life span (1427–1509) almost exactly matches that of the Japanese master Sesshū Tōyō (1420–1506). Each in his own country was the acknowledged great master of the century. Both possessed innate strength of character, expressed in their pictures; but their lives and works are quite different and reveal much about the possibilities open to the painters of East Asia in the fifteenth century. In vast China Shen Zhou confined his travels to the "eye area" around Suzhou and Lake Tai, famous for its scenery and its remarkable weathered rocks beloved by the Chinese literati. His albums and scrolls depicted only this area, with a few early exceptions such as *Lofty Mt. Lu*. In the album format Shen was most innovative, producing for the first time in Chinese painting sequential album leaves showing the styles of different masters, or markedly different views of a single site such as the *Twelve Views of Tiger Hill* (Cleveland Museum of Art). His 1494 album *Drawings from Life* (cat. 314) was the first instance of what became a standard use of the format—the depiction of numerous animals, birds, vegetables, flowers, etc. The album is an innovative use of "boneless" (*mo gu*) wash technique on an innovative subject sequence, despite the modest caveat in Shen's inscription:

> I did this album capriciously, following the shapes of things, laying them out on paper only to suit my mood of leisurely, well-fed living. If you search for me through my paintings, you will find that I am somewhere outside them.
> (Translation from Cahill, 1978, 95.)

"Leisurely, well-fed living," circumscribed travel, filial piety toward his mother—Shen was indeed a "recluse-scholar," revealing the inner strength of his character through the uncompromising boldness of his later landscapes.

Sesshū was a "priest-painter." A Zen monk of middling provincial warrior-class origins, in his twenties he entered Shōkoku-ji, one of the major Zen temples of Kyoto. His monastic duties were to screen and receive visitors to the abbot, but another of the Shōkoku-ji monks at this time was the great Shūbun (cat. 228), the most important ink painter of the first half of the fifteenth century. It is entirely likely that Sesshū studied painting with Shūbun, whom he named, later, as his artistic mentor. By leaving the temple to enter the service of the Ōuchi

clan, rulers of the Yamaguchi area in Western Japan, he shifted his emphasis from religious to artistic activities, identifying himself as a painter-monk. Having already traveled farther than Shen Zhou ever had, he left Japan for China in 1468, as part of an Ōuchi trade mission. For nearly two years he traveled eastern China from south to north, meeting leading painters and government officials as well as Chan priests, and being honored by all. During his stay at Jingde Si, a Chan temple near Ningbo in Zhejiang Province, he was given the seat of honor in the meditation hall; that he inscribed this on paintings done after his return to Japan reveals a proud nature that delighted in (and perhaps needed) public ratification, in sharp contrast to Shen Zhou's practiced diffidence. From 1476 until his death he traveled almost incessantly, between northeastern Kyushu (where he had settled on his return from (China), the Ōuchi domain in western Honshu, where he again opened a studio, and central Honshu. His travels not only spread his fame but also revealed to him the extraordinary variety of the Japanese landscape. Yet, save for the remarkable exception of *Ama no Hashidate* (cat. 232), and a lost picture of a Japanese waterfall, his landscapes were basically of Chinese subjects and were tightly linked stylistically to the monochrome ink techniques and manners imported from China and Korea just before and after 1400. Unlike Shen, he had several pupils and many followers who emulated him closely, if not slavishly, and his influence on later Japanese ink painting was extensive and profound.

Whereas Shen's departures from landscape subject matter were few and usually not of major importance, Sesshū was master of landscape, figure painting, and, on screens especially, of bird, flower, and decorative painting. Further, he was master of a late thirteenth–early fourteenth-century Chinese achievement, later largely abandoned in its country of region, the "splashed ink" (C: *po mo*; J: *hatsuboku*) landscape. The Japanese master's varied repertory would have somewhat discomfited the *wen ren* constituency, and his decorative screens they would certainly have considered artisan's work, unworthy of attention. It should be remembered that Sesshū was reported to have painted a wall painting (screen?) for a government building in Beijing; this, if true, suggests that in China his contacts with Chinese painters and his study of Chinese painting extended mostly to the court painters and to their highly professional and decorative techniques. It is doubtful that he saw much, if any, *wen ren* painting, especially since Shen was the only major practitioner at that time and he confined

his activities to Suzhou. The Japanese who turned their eyes and thoughts to China in the fifteenth century took up and celebrated the artistic achievements of Southern Song. Not until the eighteenth century did they begin to investigate *wen ren* style.

And yet when we compare mature works by each master—say, Shen Zhou's *Five Landscapes* (cat. 315) and Sesshū's *Ama no Hashidate* (cat. 232)—despite differences owing to individual nature and national origin, they share a breadth of vision and character, a strength in brush and organization, and above all a freshness of outlook, a very real expression of a personal style achieved through long practice and grown accustomed as breathing. Shen Zhou painted no such figural masterwork as Sesshū's *Daruma and Eka*, 1496, but figure painting was not a Ming gentleman-scholar's genre. One is left to imagine what Shen Zhou might have painted, if Shen Zhou had painted figures, through the powerful image of Zhong Kui by the traditionalist painter Dai Jin (cat. 288).

Two portraits, one of Shen (cat. 310), the other of Sesshū, both either pedestrian works by professional figure painters or good copies of such works, are of some interest here. Neither rises much above the conventional image required by the culture in which the artist lived. Shen is in the costume of a scholar, Sesshū in priest's robes; both wear hats of stiffened gauze, the prerogative of the learned classes. The two works are enough alike in costume to point up the differences between the faces. Shen, with his white beard, crow's-feet (he was then eighty), and benign expression is an epitome of his social role—the recluse-scholar. The individualism and strength visible in his works are not apparent in the portrait. Sesshū, on the other hand, is stubble-bearded, his face seems creased rather than merely wrinkled, and the slightly lumpy conformation of the cheekbones, jaws, and neck suggests a manual laborer, even a peasant. The implication of rough strength matches the brusque, staccato effects of his work.

Both portraits are "conventional," but the monk's image derives from a Zen tradition whereby a master gave his portrait to a student in token of the transmission of spiritual enlightenment and priestly authority. To the "reflection of reality" required in such portraits (*juzō*), Japanese Zen monk-painters added a sometimes brutal realism, bordering on caricature. Sesshū's portrait, following in this tradition, may suggest the physical presence of a singular man. Shen's does not: the artist remains as unrevealed here as he claims to be in the inscription on *Drawings from Life* (cat. 314). Contemplating the blandness of Shen's portrait, we must

not forget that "blandness" (*ping dan*) was an ideal quality in *wen ren* art, as a special kind of decorum was in *wen ren* life; Shen Zhou has ratified this portrait by inscribing it. One should not let him deceive; one should go behind both inscriptions to the work of his last twenty-five years.

APPLIED ARTS

To most Westerners "art" now means painting, sculpture, perhaps architecture. All other endeavors, however skilled the maker, however beautiful the result, are only qualifiedly art, and the qualification implies a derogation—thus "minor arts," "decorative arts," "crafts." Perhaps "applied art" is the least objectionable term, connoting objects applied to a purpose that includes contemplation as well as use. Thus a carved chair (cat. 346) is meant to be sat on but also to evoke aesthetic appreciation. To mend a hole in the roof with an oil painting, however, seems clearly perverse, at least for certain oil paintings.

Applied art is particularly subject to technology and to the development of effective means to achieve practical ends—to pour tea, hold wine, protect sweets. And technology affords a credibly objective criterion by which to evaluate the accomplishments of the artist: the effectiveness with which a seemingly unpromising and certainly recalcitrant material—clay, quartz, metal, enamel, jade, the sap of the lac tree, the filament of the silkworm—is put to the artist's purpose. Most of these substances were conquered by the Chinese with patient skill and imaginative science and technology long before they succumbed to late-developing science in the West. Western consumers could only wonder at the seemingly magical knowledge and technique that permitted the Chinese to produce such exportable superfluities of porcelain, silk, and lacquer.

Jade

The Chinese priority in the working of jade, the firing of porcelain, the cultivation of silk, and the making of lacquer has been well documented. Excavations of the last two decades, from Manchuria in the north to Shanghai in the south, have not only moved the known beginnings of Neolithic jade working back to the fourth millennium but have totally changed our estimates of the technical accomplishments possible within a Neolithic culture. The complexity of design and minuteness of detail achieved within the constraints of the most obdurate of stones (nephrite, or *yu*, the original and quintessential Chinese jade, is 6.5 on the Mohs scale)—impervious to the aggressions of normal steel cutting tools—have amazed even the most skeptical of critics. We are confronted, by the third millennium, with an accomplished technology of hardstone working within a limited vocabulary of difficult and convoluted designs, forming a tradition that continues for thousands of years with improved but not different means.

The material itself—*yu*—comprised not one but a number of different hardstones that are similar only in being appealing to sight and touch, capable of taking a high polish, and valuable because rare; of these stones nephrite was the most highly regarded. *Yu* commanded veneration in Chinese society, its visual and tactile qualities having been associated by none other than Confucius with the preeminent virtues of kindness, righteousness, courage, compassion, eloquence, and restraint. *Yu* also became the supreme metaphor for beauty and for a mystical purity that could hold at bay even the forces of decomposition—hence its immemorial association with longevity and its long and abundant use in aristocratic burials. This paragon of stones, from earliest times into and beyond the world of 1492, was reserved for objects of ritual and ceremony and for secular luxuries, including personal adornment.

By 1492 the Chinese appetite for jade was such that nephrite was being imported from Central Asian riverbeds and mountain mines; the more brightly colored Burmese "jewel jade" (also called *yu* but a different mineral, jadeite) was still in the future. The materials available to carvers of the Ming dynasty (1368–1644) were the same white, pale green, brown, and black jades known from earliest times. None of the "boulders" or pebbles and few of the mined blocks were of such size as to permit huge pieces like the mountains, stupas, landscapes with figures, or Buddhist figures so common among Qing dynasty (1644–1911) jade carvings. Early and middle Ming dynasty works were most often relatively small, especially those executed in the rare and small stones of white "camphor" jade, the favorite material for the best works of Song through Ming.

Though the terms are often used, jade (nephrite) cannot be "carved" or "incised." From the earliest Neolithic to the present, jade can only be worked by abrasion; new abrasives and improved means of applying them have been developed, but the method has not changed. The Ming repertory of techniques for abrasion still required quartz in the form of sand as abrasive, water as medium, various drills and wheels as implements, and infinite care and stubborn patience as ultimate ingredients.

Ceramics

Though recent by comparison with the five-thousand-year-old jade tradition, porcelaneous ceramics had by 1492 been made for more than two thousand five hundred years, and white, "pure," porcelain for some seven hundred. Until excavations at Zhengzhou, Henan Province, in the last twenty-five years, porcelaneous celadon wares (protoporcelains) were believed to have originated only in the fourth century B.C. Now we know that protoporcelain was made at Zhengzhou (a Shang city that may well have been the next-to-last Shang capital, Ao) about 1600 B.C. The necessary technology seems to have been developed as a by-product of bronze casting, for which the Chinese used piece-molds made of clay rather than the lost wax process common to Near East and Mediterranean production. Kiln temperatures of about 1200° C were necessary to produce these early Shang glazed wares, whose discovery increases our admiration for early Chinese technology and artistry.

The celadon tradition struck deep roots in China, and over two and one half millennia potters at many kilns throughout the country continued to refine this gray-bodied, greenish-glazed, relatively impermeable ware, much (if not all) of which came by the Tang dynasty (618–907) to be called Yue ware. The tradition climaxed in the splendid and exquisite celadons of Northern (960–1127) and Southern (1127–1279) Song. In beauty and utility (nonporosity) Yue ware and other porcelaneous celadons far surpassed the best that local potters outside China had achieved. They were everywhere prized: excavations show that from the Tang dynasty they were exported eastward to Indonesia and the Philippines and westward to India, Iraq (Samarra, 836–883), Iran (Nishapur and Siraf), and Egypt (Fostat, before 1169).

Ultimately even the porcelaneous celadons were displaced in esteem by white porcelain, which had its beginnings during Tang but did not become the standard of excellence until the Yuan (1279–1368) and early Ming dynasties. By this time the hillside tunnel, or "dragon," kiln—a series of connected chambers dug along the slope of a hill—had been developed and refined so that the draft induced by the sharp slope could bring the wood fire to very high temperatures. The clear-glazed white porcelain fired in these kilns at 1300° C or higher provided a remarkable ground for decoration in two different techniques: the design might be painted in copper oxide red or cobalt oxide blue directly on the unglazed vessel, which would then be clear-glazed and fired to porcelain hardness; or the undecorated vessel might be clear-glazed and fired to porcelain hardness, then

decorated with low-firing, lead-fluxed glazes (usually called "enamels") in yellow, red, green, turquoise, purple, or black, and refired at about 850° C to fuse these glazes. The former are referred to as "underglaze-decorated," the latter as "overglaze enamels." In Chinese critical literature and in most Western literature pure white ware is considered to have reached its apogee in the Yongle reign (1403–1424), underglaze blue-and-white in the Xuande reign (1425–1435); potters of the Chenghua reign (1464–1487) produced masterful blue-and-white (cat. 321, 322) as well as enameled wares, especially the exquisite *dou cai* ("fighting yet fitted colors") wares, whose decoration combined underglaze blue with overglaze enamels in soft tones (cat. 323–325). The Hongzhi reign (1487–1505) witnessed a decline in variety and quality (cat. 327); and the following Zhengde reign (1505–1521) is remarkable for its so-called Muhammadan wares (cat. 328)—blue-and-white porcelains rather stiffly and symmetrically decorated and often bearing inscriptions in Arabic or Persian, presumably made for the predominantly Muslim officials and attendants surrounding the Zhengde emperor.

In the Jingdezhen area of Jiangxi Province, which supplied the vast demands of the Imperial Household, non-Imperial wares were also produced, as they were at various old kiln sites in north and south China. For ordinary use slip-decorated stonewares were dominant in the north, celadons in the south. Some complex porcelains made in imitation of cloisonné-enameled brass vessels—often massive pieces dominated by large areas of aubergine, yellow, and turquoise overglaze enamels—display astonishing technical mastery (cat. 330).

In their time, white and decorated porcelains were as eagerly coveted by the outside world as porcelaneous celadons had been. The Topkapi Saray in Istanbul lists increasing quantities of white porcelain in inventories of 1495, 1501, 1505, and after, and white wares have been found at Samarra, Iraq, and at Nishapur and the Ardebil Shrine in Iran. Blue-and-white decorated wares reached India, the Middle East, and Egypt beginning in the fourteenth century and resumed in even greater quantity at the end of the fifteenth century, following the interruption in commerce caused by the Timurid invasions. Not till the early sixteenth century (when the Portuguese sent a royal embassy to Beijing) did Chinese porcelain begin to reach Europe; the silver or gilded mounts with which it was often fitted there are a measure of its value in European eyes.

The organization of the kilns, especially the imperial ones, at Jingdezhen was necessarily complex and bureaucratic in order to deal with the sheer quantity of material ordered by the court each year. Production was under the control of the Gong Bu, the Board of Public Works, and wares were made for the Imperial Palace and for the Grand Secretariat of the government. Though figures for the first two reigns of active production, Yongle and Xuande, are unavailable, the figures for 1554, in the reign of Jiajing, show 26,350 bowls with dragons in underglaze blue, 50,500 plates with dragons, 6,900 cups with floral designs, 680 large fish bowls, 9,000 white tea bowls, 10,200 bowls with designs inside and out of fish, dragons, phoenix, and water plants, 19,800 tea bowls with the same decoration, 600 libation cups with design of dragons and waves in underglaze blue, and 600 white wine ewers. That earlier Ming courts also required such staggering production is confirmed by a general order of 1433 (Xuande reign-era) for 443,500 pieces based on designs submitted by the Board of Public Works.

Shapes were standardized within the necessarily flexible specifications for vessels hand-thrown and/or molded and then wood-fired. According to Brankston, eleven shapes were most common during the Yongle period: (a) lotus-form bowl (*lian zi*) in two sizes, (b) "press hand cup" (*ya shou bei*) in two sizes, (c) plain bowl, (d) teapot, (e) three types of stem cup (*ba bei*), (f) monk's-cap jug (*seng mao hu*), (g) vase (*mei-ping*), (h) small wine pot, (i) gourd bottle (*hu lu ping*), (j) medium dish, (k) small saucer. In the Xuande reign (a), (b), (c), (e), (g), (h), and (i) were continued with variations, and the following were added: steep-sided bowl with ribs on the lower part of the exterior, clear-water bowl (*jing shui wan*), beaker, jar with foliate cover, large ewer, leys jar (*zha dou*), bottle vase, flask with cusped handles. Chenghua afforded less variety: *zha dou*, truncated jar (cat. 323), bowl, deep dish, three types of small wine cup (cat. 324, 325), varied stem cups. The Hongzhi reign continued the *zha dou*, bowl, deep dish, and a few larger stem cups. Repeating shapes was economical and helped maintain quality control. But modest variations in shape and in treatment of the foot rim are recognized means of distinguishing the wares of different reigns, perhaps even of different kiln supervisors, and help in constructing development sequences.

These records and the substantial number of remaining examples of Ming porcelain (no census has been taken, but the catalogues of museums, Eastern and Western, exhibit considerable quantities) indicate that the methods of porcelain production approximated what the West, much later, came to call "division of labor." The process required close coordination and supervision of a variety of tasks—transporting kaolin; crushing, levigating, and refining granitic rock (*petuntse*); potting; molding; making saggars; glazing; providing designs; producing decoration; stacking; firing; and examining. Their whole end product had to please a clientele even more demanding than a modern market. Ming porcelains not only succeeded in pleasing native patrons, they also achieved aesthetic and technological standards far beyond those of any ceramics in the world to date.

It should be noted that the late fifteenth and early sixteenth centuries, encompassing the Chenghua, Hongzhi, and Zhengde reigns, represent a revival, a renaissance of the qualities embodied in the Yongle and Xuande wares of the early part of the century. The thirty years between the two is designated a "ceramic interregnum," a time to which many dubious, uncertain, heterodox, or just plain troubling porcelains are attributed. Questions of date are further complicated by the fact that the Jingdezhen industry, even the imperial potters, designers, and decorators, also produced porcelain for non-Imperial clients. Such works must have differed from the wares produced for the court and its epigones, and would consequently not fit easily into the neat categories set up by later scholars and connoisseurs. Still, there was a lull, followed by a half-century's glorious revival, whose products equaled and sometimes surpassed their predecessors.

Lacquer

Lacquer fragments have been found in late Shang tombs at Anyang, and large-scale and technically advanced production is known from late Zhou (4th–3rd centuries B.C.) on. Quality and quantity first peaked in the Han dynasty. Even for this early date historical texts and inscriptions on lacquer objects permit reasonably certain conclusions about the nature of the lacquer industry, conclusions that can be applied to even later production. Although the lacquer industry resembled the ceramic industry in its well-calculated division of labor, the last stages of the manufacturing processes were dissimilar, with lacquer requiring a highly specialized artist-craftsman. From Han times on we find many lacquers signed by their makers; even more significant, there are texts criticizing the "luxuriousness" of lacquer wares and the vast wealth expended on production.

The basic process begins with the extraction of sap from the lac tree (*Rhus vernicifera; qi shu*), largely grown throughout China south of the Yangzi River. The juice is mildly toxic, and the work would today be called hazardous. Wood, cloth, metal, and ceramic could be used as grounds for the application of lacquer, which is not remarkable for its tensile strength but

extraordinary in its lightness and its ability to resist damage or deterioration from liquids. The stages of manufacture can be summarized through the titles of the various expert craftsmen involved in the process: the primer; the lacquerer who applied the initial (many) layers of lacquer over the priming; the lacquerer who applied the final coat that was to receive the decoration; the decorator. This last individual might be a painter (for painted lacquer), or a carver (carved pieces were called *ti hong* if executed entirely in cinnabar red, *ti cai* if the carving revealed layers of different colors), or an engraver, who rendered a design in incised lines which were then filled with gold or silver dust over wet lacquer as the adhesive. Engraved-and-inlaid lacquers were called *qiangjin* if gold dust was used, *qiangyin* if silver. After being decorated, the piece was turned over to the polisher, then finally to the "responsible person," or supervisor. To this list should be added the designer, for many of the later lacquers, especially those of the Ming dynasty, received elaborate pictorial decoration requiring knowledge of history and the use of long inscriptions (cat. 335).

From the late seventeenth to the mid-eighteenth century, Chinese and Japanese lacquerwork was fashionable in the West, particularly screens of lacquer on wood, which were sometimes used intact but more often cut up and made into cabinets and paneling by French, German, English, and Dutch *ébénistes*. The material itself was accurately described by Engelbert Kaempfer in the late seventeenth century, and in 1738 by J.B. du Halde, who tried, not altogether successfully, to banish the misconception that lacquer was a man-made substance.

> This varnish which gives so fine a lustre to their works, and makes them so esteem'd in Europe, is neither a composition, nor so great a secret as some have imagin'd; to undeceive whom, it will be sufficient to give an account of where the *Chinese* get it, and afterwards how they use it.
>
> The varnish, called *Tsi*, is a reddish gum, distilled from certain trees, by means of incisions made in the bark... these trees are found in the Provinces of *Kyang-si* and *Si-chwen*.
> (Feddersen 1961, 184)

The "Mysterious East" of Western imaginings was too strong, and the fiction of a man-made coating persisted into the nineteenth century. Even today the remarkable applied arts of China continue to arouse popular awe at Chinese "workmanship."

Cloisonné

With *cloisonné* enamel we are on different ground. Columbus would have recognized its European character at once, as did his Chinese near contemporaries. The earliest Chinese textual reference to cloisonné occurred in 1387, in the *Ge Gu Yao Lun (Essential Criteria for Judging Antiques)* of Cao Zhao. In the third volume (*quan*), section fifteen, "On Ancient Porcelain," we find this reference to Muslim ware (*Da shi*):

> The base of this ware is copper, and the designs on it are in five colors, made with chemicals and fired. It is similar to the Fo-lang-k'an ([Frankish] enamel ware). I have seen pieces such as incense burners, flower vases, boxes and cups, which are appropriate for use [only] in a woman's apartment, and would be quite out of place in a scholar's studio.
>
> It is also known as Ware from the Devil's country. [*Gui Guo Yao*].
> (David 1971, 143.)

Aside from the Chinese scholar's disdain for women, Westerners, and all things gaudy or brightly colored, this passage reveals the Chinese awareness of cloisonné and its Western origins as early as the late fourteenth century. The technique of enameling was known in both China and Japan even earlier, at least by the eighth century, but it was little used, perhaps because it was too colorful not to seem "vulgar." But the Mongol Yuan dynasty brought Mongol taste to imperial patronage and numerous Tibetan artists to the imperial workshops, leaving a strong influence on succeeding Ming tastes in porcelain and its related art, enameling on metal.

Cloisonné technique and style apparently originated in the preclassical and classical Mediterranean world, and was well known in Europe from the fifth or sixth century through the whole of the Middle Ages. Byzantium had a strong enameling tradition in the tenth and eleventh centuries, which passed into the Islamic world. Seljuk Muslim rulers of northern Mesopotamia and Persia enjoyed fine enamelwares, both champlevé and cloisonné, as early as the first half of the twelfth century. The Mongols conquered Yunnan, in far southwest China, in 1253, appointing a Muslim governor there from 1274, and Yunnan supplied enamel craftsmen to the Mongol court in Beijing. Unlike so many of the applied arts, the technique of enameling moved from West to East.

Tibetan (Lamaist) Buddhism and its distinctive art styles continued, after the expulsion of the Mongols, to receive strong imperial support from the native Ming and conquering Qing dynasties. Cloisonné-enameled brass altar vessels were much used in Lamaist temples throughout China, and smaller versions must have equipped household shrines.

A painting by Du Jin (act. c. 1465–c. 1500), *Enjoying Antiquities* (cat. 293), displays a low stool with a cloisonné top, and we must assume from extant cloisonnés believably dated to the fifteenth–early sixteenth century that they were used by both the scholar-official and merchant classes, though the former certainly said little about enameled vessels in their writings. In their fluidity of design, brightness of color, and baroque energy of shape and design cloisonné vessels were at odds with the literati aesthetics of "blandness," simplicity, and restraint. It is hard to imagine the opulence of cloisonné in juxtaposition with Shen Zhou's *Night Vigil* (cat. 313). It is certainly no coincidence that many, perhaps even a majority of extant Chinese cloisonnés of Ming date had European or Tibetan owners. Only during the Qing dynasty, with its "foreign" Manchu dynasty and ruling class, were many enameled brass and bronze vessels made for use within China. Any visitor to Beijing will remember the many large and elaborate enamels, answering to the Manchu's Mongol and Tibetan tastes, in the Forbidden City, the Summer Palace, and the various halls and temples.

Furniture

Chinese furniture ranges from rustically simple pieces in bamboo and softwoods, made for farmers and townspeople, to the sophisticatedly simple works in exotic hardwoods made for scholars, officials, and other gentry, as well as the often rich and complex ceremonial furniture characteristic of the Imperial court and the numerous governmental agencies.

Before the Sui and Tang dynasties the Chinese, as the Japanese have continued to do, lived on the floor or on low raised platforms (*kang*) with some heating built in. Early pictorial reliefs and paintings of the Han (206 B.C.– A.D. 220) and Six Dynasties (221–589) periods show mats, sometimes elaborate ones; low tables for writing, eating, or toilet articles; framed screens; and, rarely, a stool. Although the chair (*hu chuang*, "barbarian couch," according to Berthold Laufer) may have been introduced as early as the second century A.D., it was not at all common until the tenth century, when Gu Hongzhong painted his famous handscroll, *The Night Revels of Han Xizai*, known to us today through an excellent version executed in the Song dynasty and now in the Palace Museum, Beijing. The scroll shows a full

panoply of beds, screens, tables, chairs, and stools, apparently executed in dark woods, in designs of great simplicity and elegance that emphasize straight verticals and horizontals with rounded corners. The forms and types basically characterize Chinese furniture from the tenth century until modern times.

As in the West, indoor furniture differed from outdoor. Many Ming paintings show gentlemen-scholars gathered in a garden to examine paintings and antiques; they sit on mats, stone benches, or platforms, with a few low stools. As these gatherings move closer to the house — onto a terrace, for example (cat. 293) — one may find table, chairs, and a screen, moved out from indoors to accommodate the scholar-official. The "outdoor" parties were consciously modeled on such historic early gatherings as those of the Seven Sages of the Bamboo Grove of the late third century or Wang Xizhi's "Lan Ting poetry party" of 353, and archaistic intent or nostalgic feeling led the participants willingly to accept an archaistic, even if less than comfortable, setting.

Genre interiors, with all furniture in place, were less often painted in early or middle Ming. Fortunately three works survive: the first showing furniture moved from a hall to a nearby garden (*Elegant Gathering in the Apricot Garden*, by Xie Huan, in the Palace Museum, Beijing); the second, showing both garden and pavilion or hall (*The Nine Elders of the Mountain of Fragrance*, attributed to Xie Huan, Mrs. A. Dean Perry collection, Cleveland, Ohio); and the third, revealing a scholar's study (*Scholar Picking His Ear*, anonymous, Freer Gallery, Washington, D. C.). All these fifteenth-century scrolls depict furniture differing little from that shown in the tenth century,

apart from a few more curvilinear elements among the verticals and horizontals. The *Scholar Picking His Ear* shows one trait endearingly at variance with the characteristically elegant and simple furniture: an all-too-human disorder of books, lute, scrolls, sweetmeats, tripods, and peaches on the table tops. The table at which the scholar sits, presumably interrupted while writing on the sheet of paper before him, is unusual in its top surface of black and white *da li* marble, a scholarly favorite because its veining suggests landscapes and because it is easily cleaned and therefore an ideal work surface for painting and calligraphy.

All this suggests how difficult and problematical it is to accurately date the numerous surviving pieces of this elegant furniture. Currently the quality of the wood, the nicety of the complicated nailless and screwless joints, and the clarity and elegance of the design are the only real criteria available for approximate dating. The reasonable assumption has been that the best furniture corresponds with the most prosperous and aesthetically creative reigns, which means, in effect, that it dates from the periods of finest porcelain production — 1400–1440, 1465–1620, and the Qing dynasty to the end of the eighteenth century.

The woods selected and their treatment form a large part of the connoisseurship of Chinese furniture. Like Chinese connoisseurship of old rocks and twisted trees such as juniper (cat. 312), the natural grain of the finest south Chinese and Southeast Asian hardwoods was studied, judged, and appreciated. A high polish on a meticulously finished surface — child's play for a people working jade for six thousand years — was necessary to bring out color and grain. The fine woods considered most desirable

were, in order of preference: *zitan*, purple wood, perhaps of the *Pterocarpus* (rosewood) family; *ji chi mu*, chicken-wing wood, a kind of striated satinwood; *huali* or *huanghuali*, another rosewood, ranging from pale tan to light brown; and *hongmu*, blackwood, the least desirable and still common today.

Ornate court furniture and its debased nineteenth-century descendants were much appreciated in the West until the rise of the modern movement. The aesthetic of the Bauhaus, though deliberately sympathetic to the machine world, awakened many to a reappraisal of traditional Chinese furniture and, together with the growing interest in *wen ren* painting after World War II, sealed its adoption as a classic achievement in the world history of furniture.

BIBLIOGRAPHIC NOTE:

Driscoll and Toda 1935, 1964; Willetts 1958; Chiang 1954; Ch'en 1966; Philadelphia 1971; DeWoskin, in Bush and Murck 1983; Lin, in Bush and Murck 1983

Yonezawa 1956; Vanderstappen 1957; Soper 1958; Sirén 1963; Taipei 1974; Taipei 1975; Murck 1976, esp. pp. 113–129; Cahill 1978; Cleveland 1980, esp. pp. xxxv–xlv, 157–209; Loehr 1980; Barnhart, in Bush and Murck 1983; Little 1985; Hong Kong 1988; Rogers 1988; Beijing and Hong Kong 1990..

Edwards 1962; Cahill 1978; Bush and Shih 1985; Edwards, in Goodrich and Fang 1986, vol. 2, pp. 1173–1177; Rogers 1988.

Brankston 1938, 1970; Kates 1948, 1962; Sayer 1951; Jenyns 1953; Willetts 1958; Feddersen 1961; Garner 1962; Medley 1963; Medley 1966, sect. 5; David 1971; Ellsworth 1971; Medley, 1976, 1982; Garner 1979; Jenyns and Watson 1980; New York 1980; Chicago 1985; New York 1989.

ENCOUNTERS WITH INDIA: LAND OF GOLD, SPICES, AND MATTERS SPIRITUAL

Stuart Cary Welch

India is rich — and vulnerable. In the western world, from ancient times into the eighteenth century, this has been the seductive and inviting legend, one more concerned with taste buds, fine raiment, and full purses than with mind or spirit. It grew over many centuries from a hotchpotch of soldiers' and sailors' yarns and travelers' and merchants' dreams, most of which must be sifted for hard facts. Herodotus, writing between 450 and 430 B.C., is our earliest source. The first of his piquant anecdotes tells of Indian hounds, of which the Great King of Babylon (Assyria) owned so many that their maintenance drained all of the taxes from four large villages. Another of his claims is as fresh as today's news: in the sixth century B.C. there were more Indians "than any other people known to us." Furthering the legend of wealth he wrote that Persia's north Indian provinces paid the empire's highest tribute, three hundred and sixty talents of gold dust. His information slithers between the humdrum and the fantastic, touching on Indians and their ways before revealing the surprising source of all that gold:

> There are many Indian nations; and they do not all speak one language, some are nomads; . . . some live in the marshes beside the river and eat raw fish . . . other Indians . . . to the east . . . are nomads and eat raw flesh. It is . . . a custom . . . that if one of their folk is sick, he is killed by his nearest kinsmen, who say that as he is wasted with sickness his flesh is . . . spoiled . . . ; but [the others] not agreeing, kill and eat him. . . . On the other hand, there are Indians who will kill no living thing, who sow no seed nor are accustomed to have houses, and they are grass eaters . . .

The gold, we are told, is found in the desert near the city of Caspatyrus, where giant ants, "somewhat smaller than dogs but bigger than foxes," in burrowing into the ground bring up sand mixed with gold:

> It is in search of this sand that the Indians make journeys into the desert. Each man has a team of three camels . . . [with which he goes] to fetch the gold . . . at the hottest time, for then . . . the ants disappear into the ground . . . When the Indians reach the place where

the sand is, they fill sacks with it and ride away homeward with all speed. For the ants no sooner become aware of them . . . by smell . . . than they give chase.

During the fourth century B.C., Alexander the Great, inspired by legends of India's wealth and curious about its anomalous culture, led his armies across the known world as far as the Beas River. But the heat and distance were so great that his armies refused to go farther. He withdrew, leaving behind governors who established long-lasting, eventually independent provinces, well known to today's museum visitors from their sculptures in which classical naturalism blends with indigenous inner vision. Although Alexander's "conquest," which fostered international trade, was celebrated by western historians, Indian sources scarcely mention it.

In 115 B.C., King Ptolemy III Euergetes sent Eudoxus of Cyzicus to India. Guided by an Indian whose life he had saved during a shipwreck, he sailed as far as the Malabar coast, where he acquired a wealth of precious stones and spices before returning home. Word spread; trade burgeoned; and greed fanned investigations of the east and how to go there. Alexandrian geographers such as Eratosthenes in the third century B.C. separated truth from fiction and drew charts that included India. Although mere fragments of these are known, they seem to have been more accurate than those prepared a century later by Claudius Ptolemy, whose maps, preserved in Byzantium, reached western Europe in the fifteenth century and profoundly influenced cartography there (see cats. 126, 127).

Indian trade flourished under the Romans, who established stations along the west coast for buying spices and textiles. Western goods, however, were of little interest to Indians, who demanded gold and silver coin. A worryingly uneven balance of trade brought complaints from Pliny in the Senate. Increasing commerce led to first-hand knowledge of India, such as that compiled by the anonymous Greek or Greek-speaking Egyptian trader or ship-master who, between 95 and 130 A.D., wrote *The Periplus of the Erythraean Sea*, an invaluable source of information on sea routes and trade goods.

Christianity came to India when the Apostle Saint Thomas journeyed overland to the Persian Gulf, sailing the rest of the way to Malabar in south India on a Moorish ship. He established churches there and in Sind, always maintaining contact with the Syrian Church in Aleppo. Even King Alfred of England (843–899) supported Indian missions, to fulfill a vow made before one of his battles. After winning, true to his word he sent Bishop Sigelm of Shireburn to south India, whence — according to William of Malmesbury (d. 1143) — he brought back "many brilliant and exotic gems, and aromatic juices, in which the country abounds." Many Franciscans were sent to India during the first half of the fourteenth century. John of Monte Corvino served in southern India before becoming archbishop of Peking. Odoric of Pordenone traveled by land from Ormuz to Tana in Salsette, after which he sailed to Polumbum (Quilon), Ceylon, and to the Coromandel coast. A French monk, Jordanus, urged the establishment of missions at Poroco (Broach) and Supra (Surat), although he was stationed as Bishop at Polumbum (Quilon), the largest trading center near the tip of the peninsula.

Compilers of the *Catalan Atlas* of 1375 (cat. 1) gathered and summarized information from ecclesiastical travelers as well as from Marco Polo and others. It is the earliest extant map to show India as a peninsula. Most of Asia, however, was still lumped together as "the Indies," subdivided into India within and India beyond the Ganges, India Extrema or Superior, Greater India, Middle India, and Lesser India. According to Marco Polo, Abyssinia was in Middle India, while Greater India reached from Malabar to Kech-Makran (on the coast of Iran), and the eight major kingdoms of Lesser India extended from Chamba (in South Vietnam) to Motupalli.

Knowledge of India proliferated, especially after Byzantine Constantinople fell to the Ottoman Turks in 1453. During this era of travel, Hindu yogis were also on the road, following quite different quests. A painting from Turcoman Tabriz, now in Istanbul, depicts them accurately, apparently from life, in the company of Muslim holy men at a startlingly ecumenical shrine the walls of which are adorned with Christian imagery. A few decades after this miniature was

painted in western Iran, men of learning in the west were busy digesting the newly available information from Constantinople, important work by Arab travelers and geographers and Ptolemy's long hidden maps.

The Ottoman victory of 1453 also disrupted trade. This was a serious matter at a time when refrigeration was either primitive or non-existent, and not only royalty but wealthy nobles and rich merchants craved spices to improve the flavor of food and to help preserve it. *Merces subtiles* (cinnamon, pepper, nutmeg, vanilla, cloves, ginger, *et al.*), as well as indigo for dyeing and gold, previously had reached Europe from the Black Sea and Constantinople via Genoese and Venetian middlemen. Virtually overnight, the Ottoman triumph cut off supplies of these luxuries that had become necessities, valued as highly as gold or precious stones. And when fresh inventories were again available, delivered via circuitous routes by greedy Italians who had to pay fierce tolls, prices were exorbitant. In Europe, only the Genoese and Venetian traders with their small but seaworthy xebecs and carracks profited, repacking and transporting cargoes brought from India by Arab dhows to Syrian ports. Finding a new route to the East became a matter of some concern for the rest of Europe.

Following Christopher Columbus' "Enterprise of the Indies," an auspicious failure on behalf of Spain, Portugal's program of voyages down the African coast reached its successful climax. On 9 July 1497, Vasco da Gama set forth with three vessels destined for India via the Cape of Good Hope by a direct sea route. More than eight months later, on 20 May 1498, he reached Capucad, a small village eight miles north of Calicut. Landing there was a stroke of good fortune. His pilot was an Arab unaware of the long-term results of this minor task, for he had spared the Portuguese from landing in the territories of the Muslim sultan of Gujarat, who probably would have disrupted — if not ended — Vasco da Gama's ambitions. By chance, Da Gama had been brought to the lands of the friendly Hindu Zamorin of Calicut, who welcomed him and offered every facility of this major center of the spice trade.

This initial encounter between Portugal and India brought with it some tense moments. The meager trade goods of the Portuguese were scoffed at by the Indians, whom the Portuguese amazingly took to be Christians, reasoning that they could not be Muslims because the Hindu temples contained images of gods in human form. After his welcome, the Zamorin, advised by knowledgeable Moorish traders that these new visitors were not trustworthy, pursued a rather ambiguous policy toward the Portuguese,

at one point taking some of them prisoner and, when Da Gama sailed, fighting a brief naval battle with his ships.

This initial success invited further Portuguese royal ventures. On 9 March 1500, thirteen vessels led by Pedro Alvarez Cabral set sail. Carried by winds and current to Brazil, which he called *Vera Cruz* (Land of the True Cross), he profited from his mistake by claiming it in Portugal's name. But India was his goal, and after losing four ships off the Cape of Good Hope, he finally dropped anchor off Calicut on 13 September. Cabral was well received by the benevolent Zamorin, who overlooked further protests by Arab merchants and permitted the establishment of a trading station. Friction between the Portuguese and the Muslim traders, who saw the new arrivals as trespassers on their own trading grounds, led to a riot against the Portuguese and the destruction of their outpost, and to Cabral's rash decision to bombard the city in revenge.

Cabral then sailed to Cochin, a lesser Hindu kingdom to which he promised aid against his former ally the Zamorin. Cabral's alliance with spice-rich Cochin was followed by one with Cannanore. This so pleased the king of Portugal that in 1502 he commissioned Vasco da Gama to return to south India with twenty vessels, not only to augment trade but to establish a Christian mission. Despite these pious — as well as mercenary — intentions, while *en route* da Gama intercepted a rich Muslim pilgrimage vessel homeward bound from Arabia laden with men, women, and children. The ship was attacked, plundered and scuttled.

Worse followed. Vasco da Gama arrived in Calicut where he demanded "as a preliminary condition of peace" that the Zamorin expel every Muslim from the land. When this was refused, he blasted the town with cannon, killing many people, and sailed away, still smarting. He also butchered or burned alive several hundred fishermen who had sailed out that day unaware that hostilities were about to resume, evincing a brutality that was lamentably typical of these early campaigns. Cabral's and Da Gama's expeditions were the spearhead of an expansionist Portuguese policy that soon led to the establishment of a string of bases and fortresses in western India and to Afonso de Albuquerque's capture of Goa in 1510.

When European sailor-adventurers first landed on the shores of south India and met their inhabitants, what must these so dissimilar beings have thought of one another? Although neither the Indians nor the Portuguese have left us specific reports of this encounter, it is not difficult to picture the scene. Documents from the age of these European mariners bring them

so fully to life that we can envision, hear, and indeed smell them. Except perhaps for a few astutely professional senior officers and the ships' doctor, they must have been — like most mariners of their period — a raucously tatterdemalion lot, at best hardy and brave — men who quite literally "knew the ropes."

However much one empathizes with the afflictions withstood by these rugged officers and crews on what must have seemed like endless voyages from Europe, one also sympathizes with the Indians whose culture they misunderstood, often affronted, and weakened. Is it poetic justice that this first contingent of Portuguese, bent so exclusively on trade, saw and experienced so little of India? On the hot, sunny day on which Vasco da Gama arrived at Calicut on the Malabar coast, he and his men had landed near the lower extremity of the Indian subcontinent, a triangular peninsula 2,000 miles long suspended beneath the vast land mass of Central Asia. Closed off at the top by 1,600 miles of almost impenetrable mountain ranges — the Hindu Kush, Karakorum, and Himalaya — it was bordered by the Bay of Bengal to the east and by the Indian Ocean to the west. It could be seen as an enclosed garden, in which varied but interconnected cultures, isolated as though in a test tube, ever gained in intensity and savor. The land is naturally divided by mountain ranges (*ghats*) into high plateaus and plains, some of them desert, others watered and provided with rich loam by rivers fed by melting mountain snow. Northern and southern India are noticeably distinct. Sealed off by geography, the south has been harder to reach than the north; and before the arrival of sizeable vessels its people were less open to foreign influences.

Three and a half millennia ago, the "original Indians" — probably Australoids — were driven away to less desirable lands by Aryan tribes who had worked their way from Central Asia through the always vulnerable mountain passes of the northwest. These so-called Dravidians (descended from the land's prehistoric inhabitants) can be found in remote tracts of the subcontinent among India's tribal people. Of similar ancient lineage are the Dravidians of south India, people encountered by the Portuguese. The ancient Aryans were probably the last of many waves of invaders and immigrants of the early period whose ways were not gradually absorbed or Indianized entirely beyond recognition. They not only contributed to Indian culture the earlier Vedas (knowledge), written in Sanskrit probably between 1500 and 1000 B.C., but they should be credited with codifying (if not initiating) the caste system, a specifically Indian concept which was still rigorously followed in 1498.

Although the word caste was derived from the Portuguese word for color, this system must have baffled and occasionally embarrassed Vasco da Gama and his men. They could not have understood its subtle distinctions according to which Aryan society was led by priests whose complex rituals had become accepted as indispensable to tribal prosperity. They divided humankind into four still familiar social classes, each further divided into many castes and subcastes. The scholars and priests who devised and perpetuated the system constituted themselves as the highest class, the Brahmins. The Kshatriyas, warriors and rulers intended to protect and maintain the Brahmins, came second. The third class, the Vaishyas, was composed of farmers and merchants, and the laborers and serfs who worked the land were the fourth class, the Shudras. The darker, "uncivilized" aboriginals whom the fair-skinned Aryans had defeated were relegated to a fifth group, the Panchama, who, along with the Portuguese and other foreigners, were outside the caste system.

However oblivious Vasco da Gama and his followers were to the land and people before them, they were fortunate in having been guided to Malabar's most powerful kingdom and its chief center of trade. The Zamorin was mightier than the Raja of Cochin, who traditionally paid him annual offerings of elephants and who was neither permitted by him to strike coins nor even to roof his palace with tiles. Astute in trade as well as royal, this cosmopolitan ruler received merchants from places distant as China, Sumatra (Jawa), Ceylon (Saylan), the Maldive Islands, Yemen, and Fars (Persia). We must realize, however, that except for these foreign ships and men, everything that the Portuguese saw stretched out before them — each picturesque date or coconut palm, low-slung whitewashed mud-brick building, all the lean boats with graceful prows reminiscent of gondolas, every elephant, temple, and all the people — represented but a tiny sampling of India's overwhelming variety.

The Portuguese must have been struck by Malabar's crisp freshness. Roadways, animals, buildings, and people alike would have been immaculately clean. Very dark skinned, the Zamorin and his people were finely featured. They dressed lightly, the women naked above the waist and wrapped below in unstitched white cotton, relieved by occasional stripes and block-printed floral patterns. Like the men, who also wore white cotton, they were small-boned and most of them were thin, with lustrously oiled hair. They moved gracefully, with elegance and dignity. To the comparatively rough-hewn Portuguese, Indian women must have been greatly attractive and voluptuous, but

except for the lowliest prostitutes they were completely unapproachable. Men probably seemed refined to the point of effeminacy. Both must have smelled oddly to these sweaty visitors, for they would have worn — or been massaged with — oil-based scents concocted from musk, sweetly smelling earths, and unfamiliar flowers.

Meeting and communicating with these incomprehensibly exotic people would have been difficult. Immediately troublesome was the language barrier; for surely no Portuguese at that time spoke Malayalam, the language of Calicut, one of India's 845 languages and dialects. But India's sights and sounds must have attracted, even delighted the strangers, especially if they came upon a religious procession, glorious with glitteringly caparisoned elephants, huge wooden chariots teeming with carved and polychromed Hindu deities. It would have been accompanied by musicians sounding horns and shrill pipes, twanging stringed instruments, tinkling bells, and pounding several kinds of drums which must have astonished Portuguese ears. The intense — sometimes extreme — religious faith of many Hindus would have been apparent in such processions, during which people normally decorous suddenly lost themselves in divine adoration, perhaps reminding the Portuguese of similar ecstacies at home.

Although the Zamorin and most of his people were Hindus, whose religion had developed over millennia and encompassed every level of thought and religious feeling, from animism to Brahminism and to highly evolved philosophical systems, Muslims were powerful at court and in trade, as Vasco da Gama learned. Unlike the Hindus they had come to India in 712 A.D., less than one hundred years after the death of the Prophet, when Arab traders reached Sind in what is now Pakistan. Over the next three centuries, the teachings of Muhammad spread throughout Central Asia, and the armies of Islam gathered strength. In the eleventh and twelfth centuries, far greater forces led by rugged Turks and Afghans raided India through the same northwestern mountain passes entered by the Aryans. These invaders not only destroyed many Hindu temples but also dealt the final blow to Buddhist culture in north India. As the conquerors adjusted to their new surroundings, Islam's cultural heritage enriched and blended with India's, and by 1300 truly Indo-Muslim idioms were emerging in the art and architecture of the sultanates of northern India and the Deccan. Many of the Muslims encountered by Vasco da Gama would have been affiliated with the Deccani sultanate of Bijapur, which yielded Goa, its major port, to Afonso de Albuquerque in 1510.

Vasco da Gama and his men in all likelihood encountered more Hindus than Muslims. Especially eye and ear-engaging would have been Hindu dancers. With luck, they might have seen early forms of Kathakali, the Hindu dance epics of a kind associated with Kerala, in which heroes, heroines, and monsters dressed in bell-shaped skirts wear god-size "masks" built up to deeply sculptural forms in layers of polychromed rice-flour paste. Although it is claimed that this tradition was codified during the nineteenth century, early sixteenth-century Calicut must have taken pleasure in comparable religious dancing. At once instructive to the public, with its characterizations drawn from the Hindu pantheon and religious epics, it also provided ecstatic release by stimulating trance states in its dancers. Unless its dynamically "heathen" characters, including droll demons, offended Portuguese religious sensibilities, it should have thrilled them.

Observing non-Christian religious activities, alas, might not have gratified the Portuguese, to whom revering images of Christ or the Virgin Mary was admirable but doing so to images of Hindu Gods shaped like elephants or monkeys was not. Once the Portuguese were established in India, instead of acquiring such items, they commissioned Indian craftsmen to carve ivories of Christian subjects and to manufacture richly carved and inlaid chests, tables, cupboards, and other furniture based upon European forms. We are unaware of any significant Hindu or Muslim object or painting brought back from India by the scrupulously Christian Portuguese during their colonial period.

Had Vasco da Gama and his followers been observant, interested, and open-minded they could have learned remarkable things about Indian life and customs. As Christians, they might have noted that in Hinduism there are many priests but no religious hierarchy, no equivalent to their bishops, cardinals, or pope. Holy men, however, abounded; and many would have seemed wildly picturesque, with long hair, sometimes wrapped as turbans, and curling, untrimmed fingernails. Some of them spent their days staring into the sun; others proudly suffered fiercer discomforts, such as holding their arms above their heads for years on end or stretching out on beds of sharply pointed nails. Perhaps the Portuguese sensed similarities between these self-imposed austerities and those of Christian *Penitentes*.

After shipboard fare the Portuguese must have enjoyed south Indian food, with its succulent fruits, rice, crunchy rice-flour breads, and vegetables cooked in clarified butter. Inasmuch as the chili peppers for which Indian cuisine is now famous were brought there from America

by the Portuguese themselves — along with maize, potato, and tomatoes — Vasco da Gama and his men could not have complained that the food was too hot. Food was eaten simply but appealingly from nature's own dinner plates, brilliantly green, neatly trimmed plantain leaves. Cups were folded from dried leaves held together with twigs. Hindus ate only with their right hands, reserving the left for "hygienic purposes." Although most south Indians were vegetarians, Hindus of the princely caste, those outside the caste system, and Muslims ate fish and even meat, cooked in sauces or grilled as kebabs.

Most Indian people live in villages; and most works of art belong to the folk level. We assume that the earliest Portuguese in India saw such works: small images of bronze, wood, or ceramic, made for family or village shrines; embroidered, block-printed, painted, or woven textiles; silver or bronze jewelry, sometimes set with stones; arms and armor, in shapes that would have seemed eccentric to Europeans, often adorned with reliefs of divinities, animals, and birds; gilt-bronze or silver-gilt horse and elephant trappings; and religious images painted on paper or on walls. Inasmuch as art of this sort was made for immediate use and much of it was ephemeral, it has not survived. Probably because broken images are believed to have lost their power, there is little respect in India for anything that is soiled or damaged, and such things are discarded, unless their materials are valuable, in which case they are refashioned. Although the styles of court art changed swiftly, folk traditions were more conservative. Its artifacts are "timeless" in design, hence very hard to date. For all of these reasons, this important category of art is represented in this exhibition only by its influence upon "higher" forms, as in the Orissan relief of Lord Shiva and his family, to which it lent earthy and spiritual power (cat. 350).

Vasco da Gama and his officers might also on occasion have seen grander works of art made for the court. If so, they must have admired the Zamorin's rich but starkly shaped gold jewelry and splendid sword hilts, as well as boats with carved and polychromed prows, and palanquins enriched with panels of ivory, engraved and polychromed with garlands, birds, animals, and deities.

Inasmuch as the Portuguese at this time scarcely roamed beyond the coastal trading centers, they cannot have discovered the varieties and qualities of India's arts. Nor, alas, can we provide in this exhibition more than a small sampling. It is difficult to represent the period around 1492 in works of art that may be exhibited. Once-magnificent textiles have survived in tattered bits; few ivories or wood carvings are available to us; and the dazzling jewels, richly set in gold, that have escaped the melting pot are inaccessible. Greatly impressive architectural complexes that still delight travelers are not easy to envision from transportable fragments.

We are nevertheless fortunate in being able to show India's brilliant artistic heritage through a small number of superb bronze and stone sculptures, manuscripts, and pictures. Whether Hindu, Muslim, or Jain, whether from north, south, east, or west, each proclaims the range, depth, and skill of India's artists and craftsmen. During the later fifteenth century, India's always fertile cultural traditions were in flux. If by this time much of India was in Muslim hands, these were no longer "foreign" hands. Works of art — whether made from Muslim, Hindu, or other patrons — were instilled with indigenous character. The stately, lively script of the Muslim dedicatory inscription from West Bengal (cat. 354) is as "Indian" as the Deccani *Qur'an* (cat. 353). Both, indeed, draw upon the earthly dynamic rhythms we associate with Indian art through the millennia. Vital as drum beats, these can be sensed in the ground-quaking dance of Ganesh, the auspicious Hindu God of wisdom, jovially represented by a south Indian bronze (cat. 349). Comparable energy and verge appear again in another south Indian bronze, a particularly lithe and voluptuous image of Parvati in which earthly beauty and divine wisdom unite (cat. 347).

Although it might be argued that south India's sculptural traditions reached their peak far earlier, under the Chalukyas, Pallavas, or Cholas, the image of Yashoda and Krishna in honey-toned bronze (cat. 348) is as moving as virtually any south Indian metal image. Its fresh human intensity, taut amplitude of form, and the engaging interaction between the godly infant and his lovely foster parent emerge not from humdrum repetition of learned aesthetic formulae but from the ripening of an emergent new phase in the cycle of art. Here, as in other major examples of traditional Indian art, the creator's spiritual achievement was inspired as much by observing life as by studying older works of art. But Indian artist-craftsmen, like Indian musicians, were encouraged to improvise upon prescribed themes. In western India, the artist of the Jain *mandala* (cat. 351), while adhering painstakingly to tradition, took pleasure in lending a particular wiggle to his wiry outlines and filling them in with vibrantly bright color. Similarly, the illustrators of a *Shahnama* (Book of Kings) (cat. 352) so contagiously express their enjoyment in painting tents, heroes, and demons that more than five centuries later we share not only the joy but the underlying seriousness.

One of the objects exhibited, an elephant beguilingly worked in rock crystal (cat. 14), is known to have been admired in the West, where it was richly mounted in gold. Smallness belies artistic stature. For this tactile pachyderm, a paradoxical handful for a Muslim patron in the Deccan, is truly monumental. Drilled, ground, and polished, it expresses India's genius for stone sculpture. Sensitively observed, impressively abstracted into sensuously rounded curves, it defines the gentle might and spirit of India's most picturesque and fascinating animal. One wishes that Vasco da Gama and his comrades could have known — and understood — this enlightening object, a perfect souvenir from a glorious culture.

Bibliographical Note:
Diffie, Bailey W., and George D. Winius. *Foundations of the Portuguese Empire, 1415–1580 (Europe and the World in the Age of Expansion, ed. Boyd C. Shafer, 1)*. Minneapolis and Oxford, 1977.

Heras, H. *South India Under the Vijayanagar Empire*. reprint, New Delhi, 1980.

Herodotus. *Works*. trans. A. D. Godley. Cambridge, Mass. and London, 1946.

Sastri, K. A. Milakanta. *A History of South India from Prehistoric Times to the Fall of Vijayanagar*. Madras, 1958.

Scammell, G. V. *The World Encompassed: The first European maritime empires c. 800–1650*. London, 1981.

Welch, Stuart Cary. *India: Art and Culture 1300–1900* [exh. cat., Metropolitan Museum of Art] New York, 1985.

211

MANIFESTATION OF AMIDA BUDDHA AT NACHI

15th century
Japanese
hanging scroll; ink, color, and gold on silk
84.5 x 39.5 (33¼ x 15⅗)

Shōnen-ji, Kanagawa Prefecture

Although sparse in obvious narrative detail, this painting apparently depicts a tale well known in Kumano lore. An elderly woman from the provinces had a single pious wish: to make a pilgrimage to Kumano before dying. Arriving at the Miyaōji Shrine at Hama in her seventieth year, the old woman was rewarded by a spectacular vision of Amida Buddha emerging in an elaborately conceived cloud formation from behind a mountain range.

The Kumano region, located in the southeastern portion of the Kii Peninsula, is an area of dramatic topography and natural beauty to which numinous qualities were ascribed from ancient times. Two Shinto shrines—the *shingu* (Hayatama Shrine), located near the mouth of the Kumano River as it empties into the sea, and the *hongu* (Nimasu Shrine), set farther into the mountains, nearer the source of the same river, were established during the Early Heian period (794–897). They imposed a degree of religious structure on a vicinity already recognized as sacred. In the mid-Heian period Nachi, an adjacent mountain with a magnificent waterfall, was incorporated with the other two sites to form the three-shrine system called Kumano Sanzan, or Mi-Kumano.

Kumano was an important and popular pilgrimage destination. Indeed there were centuries of imperial devotion, with the journeys of successive royal entourages from Kyoto recorded in paintings and in poetic travel diaries. This imperial patronage and interest, along with its privileged assumption into court literature and visual art, afforded the pilgrimage route to Kumano an almost prototypical status among the possible forms of Japanese religious journey. In addition, Kumano was a prominent training place for mountain ascetics (*yamabushi*) of the syncretic Shinto-Buddhist Shugendō sect. Not only a destination, Kumano was the starting point on a pilgrimage route of thirty-three temples in central Japan dedicated to Kannon, Bodhisattva of Com-

passion. The area around Nachi was interpreted to be the site of Mt. Potalaka, the paradise of Kannon, projected by Buddhist adherents of various Asian cultures upon various auspicious locales.

The Amida portrayed in this painting is understood to be the Buddhist deity corresponding to the indigenous (Shinto) spirit of the Kumano *hongu*. The assimilation of nativist religion by Buddhism was, until the eleventh century, a relatively unstructured process of mutually affecting influences. From the eleventh century, however, Buddhist theorists categorized the relationships between Buddhist and indigenous gods, establishing individual correspondences. Their goal was to present the local deities as manifestations of an overarching Buddhist pantheon. This was known as the *honji-suijaku* system: *honji* (Original Ground) referring to the Buddhist deities, and *suijaku* (Manifest Trace) referring to their localized Shinto manifestations. The image seen here greatly resembles a type of purely Buddhist icon called *yamagoshi raigō*, which depicts Amida Buddha, Kannon, and other heavenly beings coming over a range of mountains to welcome the soul of a recently deceased believer into paradise. This painting, however, in which the Buddhist deity Amida is shown emanating from a specifically Shinto holy place, and kneeling pilgrims on the left make folded-paper offerings of a kind used in Shinto ritual, is a syncretic *honji-suijaku* icon.

Such combined Buddhist-Shinto icons, commissioned by the Imperial and noble families, were relatively common from the Heian period (794–1185) on. The Japanese, blessed by a singular lack of religious zealotry, readily amalgamated their ancient and local Shinto with the newer, imported doctrine—adding to Shinto's cult of purity, simplicity, and reverence for all things in nature the complex metaphysics and compassion emphasized in Buddhism. Both were in a real sense the national religions of Japan. They also corresponded to the two strongest strains in Japanese culture, the Chinese tradition of rationality and formal symmetry and the native tradition of intuition, naturalness, and simplicity. The Imperial family, practicing Buddhists since at least the seventh century, were also descendants of Amaterasu, Shinto Sun Goddess and chief deity, and ministers of her Grand Shrine at Ise, which was Shinto's holy of holies. Neither the emperors nor the nobles found any contradiction in simultaneous patronage of both doctrines.

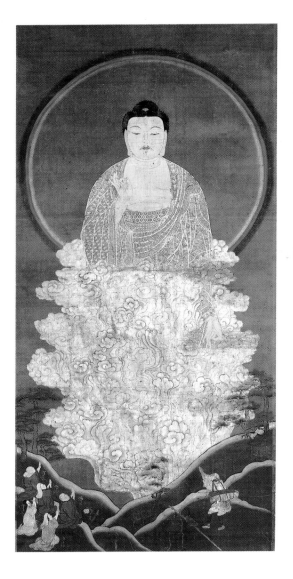

An understanding of the geography of the Kumano shrines and the narrative mentioned above suggests that the perspective presented in this painting is a view from the southeast to the northwest. In other words, from the coastal area to the mountains. A painting in the collection of Dan Ō Hōrin-ji in Kyoto offers an earlier (1329) version of such a composition but with informative variations. The earlier painting depicts a similar valley or vortex of inward-sloping mountains and the ascending Amida. The astounded pilgrims, however, appear only on the right of the painting, together with the architectural elements of a small Shinto shrine. By comparison, the Shōnen-ji painting seen here has supplicant fig-

ures on both sides and rendered in larger scale, but no indication of shrine setting. Five devotees are at the left, and a *yamabushi* (not seen in the earlier painting) is at the right. What appears to be a name, lettered in gold, is seen near the figure of the old woman in the group at the left. This is the only suggestion that the painting may have had a specific context or intention.

Of the two paintings compared above, the later one is the more formalized. Radiating light cast by the ascending deity is rendered as schematic bands outlining the mountain ridges. This handling is quite distinct from the earlier painting, where shading and modeling were employed in an attempt at naturalistic landscape. The Shōnen-ji painting is also the more symmetrical of the two, with the pilgrims affecting the poses of supplicant benefactors or donors at the feet of a central icon. The painting is a distinguished example of boldly rendered Buddhist iconography of the fifteenth and sixteenth centuries. Pattern and color have here overwhelmed the subtlety of an earlier style. Cut gold leaf (*kirikane*) embellishes the robe, but figural representation is less adroit. The Heian and Kamakura (1185–1333) union of palette with modulated brushwork to define form or shape has given way to shape defined primarily by pattern and color. The brush is far less apparent. This painting reflected a new, populist Buddhist faith whose iconographic needs were best expressed forcefully.

<div style="text-align: right">

J.U.
S.E.L.

</div>

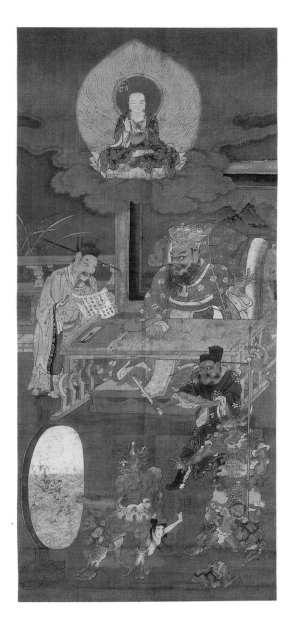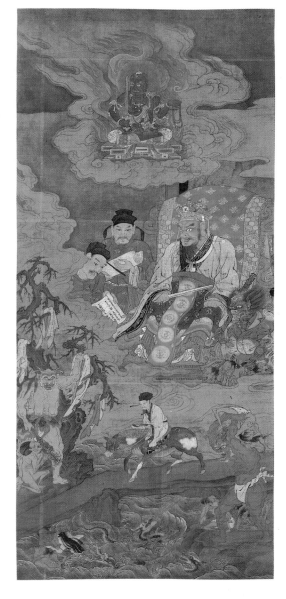

212 ✣

Tosa Mitsunobu
active 1469–1521

KINGS SHINKŌ AND EMMA, FROM THE SERIES TEN KINGS OF HELL

dated to 1489
Japanese
hanging scrolls; ink, color, and gold on silk
each 97 x 42.1 (38¼ x 16⅝)

Jōfuku-ji, Kyoto (housed at Kyoto National Museum)

Images of the courts of Shinkō-Ō and Emma-Ō are two of a series of ten paintings of the Buddhist Kings of Hell and their courts commissioned by Emperor Go-Tsuchimikado (r. 1465–1500). The series was to be produced at the rate of one painting per month, beginning in the eighth month of the third year of the Chōkyō era (1489) and continuing through the fifth month of the second year of the Entoku era (1490). These icons were to

function in a *gyakushu*, or reverse ritual, in which liturgies appropriate for a deceased person were performed on behalf of a yet living supplicant as a means to gain merit and avert suffering in the afterlife.

Inscriptions on the reverse of the paintings and a diary entry by courtier Sanjōnishi Sanetaka (1455–1537) describe the probable circumstances of the commission. Sanetaka, a Mitsunobu intimate and subject of a well-known portrait-sketch by the artist, notes that Mitsunobu made copies of a set of Kings of Hell paintings attributed to Tosa Yukimitsu (14th century) and held in the collection of the Nison-in, a temple in Kyoto. It is assumed that the copying was related to the emperor's commission.

The Yukimitsu scrolls are also extant, and their approximate date of execution suggests they are not far removed from a Song Chinese (960–1279) iconographic type which arrived in Japan in the late twelfth century. In Buddhist cosmology the actions of all sentient beings are consequential,

determining which of the Six Realms of Existence (*Rokudō*) one will inhabit in the next life. Right actions impel transmigration to higher realms and eventually to Enlightenment, which brings release from the cycle of karma. Hell is the lowest of the Six Realms. Its depiction in these paintings derives from a fourth-century Daoist concept of a netherworld ruled by a lord with ten attendants, and a Song dynasty distillation of that notion into a tribunal of ten judges (with assistants) modeled on the Chinese judiciary.

Such paintings served a precise function in Buddhist funerary practice. Following the death of a believer, a memorial service was held every seventh day for forty-nine days, then on the one hundredth day and on the first and third anniversary. Each of the Ten Kings (or Judges) presided over one of the ten days in this memorial sequence. Appearing in the paintings of each of the Ten Judges is a corresponding Buddhist deity, signifying both the protective role and the causal primacy of the Buddhist pantheon.

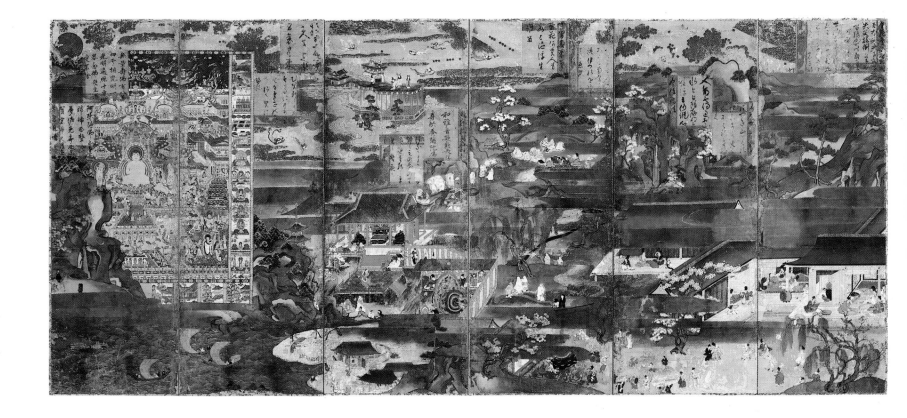

Shinkō-Ō, lord of the first memorial day, observes the forlorn figure on horseback, dressed as a Chinese scholar, crossing a bridge to the entrance of the netherworld. Awaiting him is the monstrous hag Datsueba who strips all new-comers, hanging their garments on the sinister tree to her left. Unfortunates are tossed into the churning waters to fend against demons. A passage in the *Hokke Gengi* (C: *Fahua Xuanyi*, the commentary on the Lotus Sutra by the monk Zhi-Yi [538–597]), describes such a scene. Presiding above this dismal passage is the deity Fudō Myō-ō, chief of the fierce Wisdom Kings, whose attributes of sword and rope respectively slashed through the toils of ignorance and bound evil (or, alternatively, pulled the seeker toward Enlightenment).

Emma-Ō, lord of the fifth memorial day, presides over a demonstration of evidence. Held by an implacable demon, the evil-doer sees himself, in the great bronze mirror, committing the act of murderous piracy for which he will be condemned. Other sinners await their turn before the incriminating mirror. Above, in marked contrast to this scene of terrible revelation and grim justice, is the benign image of Jizō Bosatsu (bodhisattva), suggesting the ever-present possibility of compassionate intercession.

Mitsunobu imparts energy and vitality to this series of traditional icons. Possibly the lively drama in each of the ten scenes appealed to the artist's narrative interests. By contrast, in many statically posed icons made about this time, the earlier sense of regal power had given way to mere stiffness. J.U.

213

TEN REALMS OF REINCARNATION (JIKKAI ZU)

15th century
Japanese
pair of six-fold screens; color, gold and silver foil, and metallic powder on paper
each 142.2 x 295.0 (56 x 116⅛)

Okuno-in, Taima-dera, Nara

These screens are said to depict the Ten Realms of Reincarnation of the Buddhist cosmology. The Ten Realms are equivalent to the Six Realms of Existence (*Rokudō*, comprising the realms of hell, hungry ghosts, animals, bellicose demons, humans, and divinities), with the highest, or divine realm, subdivided into five grades, the highest being the realm of Buddhas. Buddhist religious speculation and doctrine has developed from the fundamental understanding of sentient beings as bound to a cycle of birth and death by ignorance and desire. By "right understanding" and the stilling of "attachment" (craving), upward transmigration was held possible, its ultimate goal being Enlightenment and liberation from the karmic cycle, or Nirvana. The various schools, or sects, of Buddhism offered soteriologies ranging from complex gnosticism to release attained by sudden insight or through the repetition of a simple prayer formula. Their iconography was correspondingly varied.

The Pure Land (Amidist, or Jōdo) sect offered rebirth in Amida's Western Paradise (the Pure Land) in return for fervent repetitions of the *nembutsu* ("Homage to Amida Buddha," *Namu Amidabutsu*). Its doctrinal and structural antecedents were Chinese, but it was in twelfth-century Japan, impelled and guided by the monk Hōnen (1133–1212), that Pure Land Buddhism entered its period of greatest growth, becoming foremost among the rapidly proliferating populist sects. Its iconography was pragmatic and forceful, contrasting splendid visions of the Western Paradise and the mediational activities of compassionate bodhisattvas with gruesome descriptions of retributive sufferings.

These screens suggest an amalgamation of imagery from two particularly expressive periods of Pure Land iconography. The *mandala* painting at the extreme left of the left-hand screen is a depiction of the *Taima Mandara* (*mandala*), perhaps the most famous and influential of the Western Paradise icons. The original eighth-century work presented a geometrically composed and splendidly ordered paradise — Buddhism translating Tang Chinese social ideals into an iconography of heaven. In contrast to this beatific and stately image, the right-hand screen depicts the courts of hell and the vicissitudes of existence in the *Rokudō* (Six Realms). This type of image owes much to the writings of the reformer-monk Genshin (942–1017). Genshin's singularly influential treatise *Ōjō Yōshū* (985) contained vivid descriptions of hell and of the sufferings in the various realms. The iconography, which was inspired by Genshin's vision, also expressed the social and political turbulence of the Kamakura (1185–1333) and early Muromachi (1333–1573) periods. Suf-

fering was widespread; attempts to locate its meaning within a larger cosmological explanation, and fascination with its accurate and imaginative visual rendering led to the production of a wide range of *Rokudō* images.

Although hell and heaven begin and end these horizontally read screens, the fulcrum, the dominant and linking space of the total screen composition, is reserved for depiction of the human realm. Human suffering is acknowledged in the form of a graphically represented battle scene in the fourth and fifth panels of the right-hand screen, but far more space is given to the productive, pleasurable, and optimistic activities of humankind. Vignettes of commerce, planting and harvest, and a variety of recreational pursuits present a world rather at ease with itself. The religious visions of ultimate suffering and paradisiacal reward are rendered in markedly archaistic fashion, which vitiates their intensity.

Discrete episodes within the overall work are generally enclosed by hillocks and mountains or by cloud bands rendered in the "spearhead" (*suyari*) style. Gold and silver cut foil and sprinkled metallic powder elaborately embellish the painting. Pairs of poetry sheets (*shikishi*) in each of the screen panels are also an archaizing gesture. These bear quotations from Genshin's *Ōjō Yōshū* and from several of the prominent imperial poetry anthologies compiled in the twelfth and thirteenth centuries. All of these devices create a decorative effect quite at odds with the implacable concept of the Ten Realms of Reincarnation, which is the ostensible theme of the screens.

The screens are housed within Taima-dera, the Nara temple that gave its name to the icon depicted in the left-hand screen. The original tapestry *Taima Mandara* was likely a product of eighth-century China, imported to Japan; a twelfth-century Japanese text offers 763 as its date of arrival. By the Kamakura period the image was in grave disrepair, and remnants of the textile were appended to a newly painted version. It was from this period that numerous copies were commissioned.

In addition to the vision of paradise occupying the *mandala*'s center, border registers depict the legend of the Indian queen Vaidehī, who was instructed by the compassionate Śākyamuni in the sixteen stages of contemplation leading to rebirth. The final three stages of contemplation, each subdivided into three grades, represent the nine grades of Amida's Paradise, in which (according to one's virtue) one might be reborn. Prominent copies of the *Taima Mandara* include the version housed at Zenrin-ji, Kyoto, dated to the fifth year of Kempō (1217), popularly designated the *Kempō-bon*, and a much later version, the *Bunki-bon*, named for its presumed creation in the Bunki reign-era (1501–1504). This latter version was commissioned by the emperor Go-Kashiwa-bara and was kept at Taima-dera. Stylistic similarities between the Bunki version and the rendering of the *mandala* in these screen paintings lend some support to an early fifteenth-century dating for the screens.

Several diverse intentions and styles seem to meet in these screens. The figure painting is skilled. The celebratory qualities of genre painting are joined with didactic and talismanic features of religious iconography in a slightly awkward but pleasing manner. The religious mode is a subordinate element in the overall depiction.

J.U.

214

PORTRAIT OF ASHIKAGA YOSHIMASA (1436–1490)

late 15th century
Japanese
hanging scroll; ink, color, and gold leaf on silk
44.2 x 56 (17⅜ x 22)
reference: Washington 1988–1989, 60, 61

Tokyo National Museum

This modest portrait catches something of the shogun's predominating aestheticism, and seems to hint at his attenuated authority, but it is almost more engrossing for what it does not show.

An intelligent and versatile man, Yoshimasa as shogun was nevertheless helpless against accelerating economic, social, and political disintegration. In 1473, while his capital city of Kyoto was being devastated by the Ōnin War (1467–1477), he resigned his office and retired to his estate below the Eastern Hills (Higashiyama) in northeastern Kyoto. Thenceforth he exercised only enough authority to control his estate and to finance his aesthetic pursuits: forming a distinguished collection of Chinese paintings, lacquers,

and ceramics; practicing the Tea Ceremony; patronizing the Nō drama and poetry; and building several residences and worship halls in a new and enduring style.

Here he is shown in court robes and headdress, barefooted, holding a closed fan in his right hand while his left rests on his leg. Compared with portraits of earlier shoguns, this painting is small, and within it Yoshimasa seems dwarfed by the sliding screens (*fusuma*) behind him and the expanse of green matting (*tatami*) on which he sits. Both his posture and his expression seem apprehensive (cf. the portrait at Jingo-ji, Kyoto, in which the commanding figure of the shogun Yoritomo occupies almost the whole ground). The sympathetic rendition of the sensitive but not forceful visage accords with what we know of

Yoshimasa, and the whole composition conduces to an impression of diminished power.

Two art works share the picture with the shogun: the painted sliding screen behind him, with its lacquered black frame dividing the picture in half, and a silvered bronze mirror in the right foreground, its reflecting face toward the spectator, supported on a black-and-gold lacquered stand with a small drawer in the base. The presence of the mirror and its relationship to Yoshimasa is enigmatic. Does it witness the hyperaesthetic nature of the man? Is it a rather pathetic sun-symbol (as mirrors had always been in East Asian cosmology), recalling the power of the now retired shogun? Certainly it does not attest to his superb collection of Chinese paintings, lacquers, and ceramics.

The painted panels can be seen as evidence of his interest in Chinese style monochrome ink painting (the "New Style" in Muromachi Japan). The landscape depicted is sparely dominated by tall pines, accompanied by some unidentifiable pavilions, with the human presence supplied on the right by a scholar and servant on a bridge and on the left by a lone fisherman in a boat. While the painting style is generally Southern Song Chinese, it is also related to fourteenth- and fifteenth-century Korean painting, as well as to the Japanese inheritors of both Chinese and Korean traditions, the Zen monk-painters of Kyoto—Shūbun, Gakuō, and others. Since the sliding-screen format was not used in China or Korea, this landscape must be a Japanese creation in the "New Style." So nothing of the shogun's Chinese collection is visible here. All the accouterments, from costume to mirror stand to *fusuma*, are Japanese.

His major accomplishment was to afford to all the arts, in a chaotic and bloody time, patronage that gave them scope, shape, and direction. Among his achievements, tragic and pathetic in view of the ruin inflicted on his capital during and after his shogunate, was the building of the Silver Pavilion (Ginkaku-ji) and of the adjoining modest Zen temple and tea house (called Tōgu-dō) in 1483. These embodied his devotion to both Zen and Pure Land Buddhism and to the emerging Tea Ceremony (*cha no yu*) in a convincing blend of simplicity, modesty of materials, and naturalness—an arresting contrast to the magnificent and luxurious edifices of Chinese and European rulers. Yoshimasa's character, circumstances, tastes, and interests may not be explicit *in* the portrait, but they certainly inform it.

Between this portrait of the de facto ruler of Japan and that of the Hongzhi emperor of China

(cat. 283) the visual contrast could hardly be more striking. Though ruling at the same time and in the same cultural ethos, their portraits reveal them to be worlds apart. The Chinese professional portrait celebrates magnificence and power; the Japanese Tosa school likeness offers a studied modesty. s.e.l.

215 ⌇

attributed to Tosa Hirochika
15th century

FLOWERS AND BIRDS OF THE FOUR SEASONS (SHIKI KACHŌ ZU)

Japanese
pair of six-fold screens; ink and color on paper
each 150 x 361.8 (59 x 142½)

Suntory Museum of Art, Tokyo

These screens present an idyllic vision of nature, at once stately and vigorous. Unlike Sesshū's screens (see cat. 233), they do not offer a structured presentation of "untrammeled" nature, but rather an intimate study of an aristocrat's carefully cultivated garden.

Understanding of this work has been prejudiced by the painter Tosa Mitsuoki (1617–1691), whose inscriptions (with seals) on the extreme right and left panels assert that the screens are the work of Tosa Hirochika. Mitsuoki's reasons for this attribution—documentation, oral tradition, or stylistic analysis—are unknown. The very few extant works attributed to Hirochika (a Buddhist icon, several portraits and handscrolls), however, suggest that these screens issued from a different

hand, perhaps a *yamato-e* painter experimenting with Chinese styles, perhaps the reverse. Other scholars have suggested a relationship to the Sesshū lineage, or to the Kanō painters, who by the late sixteenth century would emerge as the masters of such Sino-Japanese eclecticism.

The work itself is a carefully composed selection of flowers and birds, some recognizable, others fabulous, produced by an artist clearly adept at integrating polychromy with the modulated brushwork of monochrome ink painting. Thus the screens constitute an excellent example of the late fifteenth- and early sixteenth-century Japanese interest in wedding continental ink monochrome painting to indigenous traditions. At the same time they demonstrate considerable knowledge of approximately contemporaneous Chinese professional painting, wherein color and ink were lavishly employed. The "oyster shell" style of scalloped rock formations, seen throughout, is distinctively Chinese.

Each season is represented by appropriate birds and flowers; red camelias, emblematic of late winter and early spring, begin and end—and thereby frame—the composition. The effect of movement, however, is achieved less by the changing subjects than by meticulous composition, effective use of ink modeling, and compression of the image into the foreground of the picture, with the middle and far views mostly obscured by bands of gold mist or cloud. Within the foreground space, tension, temporary balance, and movement are skillfully effected by purposeful twists and bends in branches, and by the accents afforded by particular blossoms, birds, and rocks. At the same time the roughly elliptical composition within each successive unit of four panels invites the eye to linger in that unit before moving on.

Skillful oval-shaped repairs where finger-grasps (*hikite*) were once placed clearly indicate that the panels of these screens were at some point employed as *fusuma-e* (painted interior sliding screens). Their size, relative to examples of medieval *fusuma*, suggests that they were originally produced as freestanding screens, later adapted as sliding panels, and in fairly recent times restored to their original form. j.u.

216 ⌇

attributed to Tosa Mitsunobu
active 1469–c. 1521

LEGENDS OF THE FOUNDING OF SEIKŌ TEMPLE (SEIKŌ-JI ENGI)

c. 1500
Japanese
two handscrolls; ink and color on paper
33.1 x 1063.9 (13 x 418⅞)

Tokyo National Museum
Important Cultural Property

From late in the Heian period (794–1185) the phenomenal rise of the Pure Land (Amidist) school of Buddhism brought increasing popularity to the cult of the bodhisattva Jizō—the compassionate and gentle manifestation of deity in the guise of a young monk who figured in Amida Buddha's retinue.

This narrative scroll recounts the events leading to the founding of Seikō-ji in the final quarter of the thirteenth century, the temple's special relationship to Jizō Bosatsu (Bodhisattva), and various miraculous occurences in the temple's subsequent history. A work of this type was usually created when a temple or its sect became sufficiently

prosperous to commission a commemorative work in this charmingly revisionist vein, or when a sect was inaugurating a period of concentrated proselytizing.

Each scroll contains two miracle tales, each presented in four units of text and four painted scenes. In the first tale Taira no Sukechika, a prosperous resident of the Rokkaku Inokuma district of Kyoto, is visited by a monk who urges him to reclaim a Jizō Bosatsu sculpture abandoned in the hills to the east of the city. Sukechika investigates, and finding the sculpture battered and undistinguished, returns to his residence without it. That night in his dreams he sees Jizō washing his feet at the well within his compound. In the morning Sukechika finds footprints on the stone beside the well, whereupon he fetches the statue from the mountain and installs it in his chapel.

The second story in this first scroll concerns an elderly woman, a fervent devotee of Jizō who makes her living selling writing brushes. When a high wind destroys the roof of her home, she thinks her prayers ill rewarded and is angry with Jizō. But the next day several young monks appear unannounced, repair her roof, and depart. That night in a dream Jizō gently reproves the woman for her lack of faith. Her remaining days are spent in unceasing devotion, which Jizō rewards by attending her passage into paradise.

Further tales of Jizō's miraculous intervention occupy the second scroll.

The paintings in the scroll have long been attributed to Tosa Mitsunobu and the calligraphy to Sanjōnishi Sanetaka (1455–1537), the famous courtier, aesthete, patron, and calligrapher. Sanetaka's diary mentions work on such a scroll in collaboration with Mitsunobu in 1487. These attributions have recently been contested by scholars who identify the work as an early copy, painted within the latter half of the fifteenth century. Indeed the naive, almost primitive quality of this scroll is oddly at variance with Mitsu-

nobu's exceedingly sophisticated painting of the Kings of Hell (cat. 212), dated to 1489. Along with its comparatively garish palette and brusquely rendered cloud or mist patterns, however, the *Seikō-ji Engi* reveals careful composition, well-rendered *kachūga* (literally, "paintings within paintings") on the sliding screens, and a vigorous style of figure painting. Mitsunobu was certainly capable of employing a somewhat unpolished style if it suited the overall mood of the work. J.U.

217 ༄

Tosa Mitsunobu
active 1469–c. 1521

LEGENDS OF THE FOUNDING OF KIYOMIZU TEMPLE (KIYOMIZU-DERA ENGI)

dated to 1517
Japanese
scroll two of three handscrolls; ink and color on paper
33.8 x 1786.7 (13¼ x 703⅜)

Tokyo National Museum
Important Cultural Property

The *Kiyomizu-dera Engi* describes the founding of this temple in the eastern hills of Kyoto, the military action against the Ezo people in northern Japan, and the miraculous manifestations of Thousand-Armed Kannon (Senju Kannon), principal deity of the temple. The three illustrated scrolls are divided into thirty-three chapters or units, a symbolic reference to the thirty-three manifestations of Kannon as described in the Lotus Sutra.

The temple traces its founding in the late eighth century to the Nara monk Enchin (814–891). A sacred messenger appeared in a dream,

directing him to a "stream the color of running gold" in the hills east of Kyoto. There Enchin established a hermitage and conducted fervent devotions to Kannon. Chancing to meet the warrior Sakanoue no Tamuramaro (758–811) hunting in the foothills, Enchin converted him and obtained his sponsorship for the construction of Kiyomizu Temple at the site of his hermitage. The precipitous slopes offered no level site for the construction until a herd of sacred deer miraculously appeared, causing a landslide which provided a table of land for the structure.

In 794 Sakanoue no Tamuramaro led an expedition against the Ezo, a non-Japanese people living in northeastern Japan. From the fifth century through the Early Heian period (794–897) the court powers of central Japan sponsored military actions that eventually subdued and assimilated these people. As a prelude to his campaign, Tamuramaro petitioned the protection of the bodhisattva Jizō and the Guardian King of the North, Bishamonten, commissioning sculpted images of these divinities to serve as attendants to Senju Kannon, the principal icon of Kiyomizu-dera. He then went on to wage a successful campaign.

In the illustrated scrolls depicting these events the military campaign and the divine forces assisting the warriors in battle receive conspicuous emphasis, with the stories of the temple's founding and the latter-day miracles of Senju Kannon serving to frame the turbulent battle scenes.

Important courtier diaries of the early sixteenth century indicate completion of the scroll in 1517. The hands of Sanjōnishi Sanetaka (1455–1537), Nakamikado Nobutane (1442–1525), and Kanroji Motonaga (1457–1527), three outstanding calligraphers of the period, are seen in the scroll. A diary entry by Nobutane makes clear that Tosa Mitsunobu was the artist. It can be inferred from records that Mitsunobu died in or about 1522, making this narrative scroll one of his last known works. J.U.

218

painting attributed to Kenkō Shōkei
active c. 1478–1506

calligraphy by Gyokuin Eiyo
1431–1524

PORTRAIT OF ZEN MASTER KIKŌ ZENSHI

c. 1500
Japanese
hanging scroll; ink on paper
84.9 x 35.5 (33⅜ x 14)

Kenchō-ji, Kamakura

Implicit in this inscribed portrait of the monk Kikō Zenshi is the central role of Kenchō-ji in the establishment of Japanese Zen and in the continuing Zen tradition of innovative portraiture. Kenchō-ji was founded in 1253 under the patronage of the powerful regent Hōjō Tokiyori (1227–1263), who invited the emigré Chinese monk Lanqi Daolong (J: Rankei Dōryū, posth. title Daikaku Zenji, 1213–1278) to become its first abbot. Lanqi Daolong with several disciples had come to Japan in 1246, to escape the invading Mongols or to spread Chan (J: Zen) teachings (or both), bringing with him the unmixed and rigorous form of Chan then current in Song dynasty China. He quickly attracted strong support from both the military regency in Kamakura and the imperial court in Kyoto, and was instrumental in the flourishing of Japanese Zen.

In 1271 a formal Zen portrait (chinsō) was painted of Lanqi Daolong, posed in the orthodox fashion for such portraits: seated with legs pendent and feet resting on a footstool, in a high-backed Chinese style chair draped with fabric so that only the legs of the chair are visible. Such portraits functioned as a kind of certificate of spiritual inheritance, and were passed on from master to disciple to certify authenticity of teaching. In this portrait of Lanqi Daolong Japanese innovations on the Song Chinese prototypes are already apparent: delicate rather than vivid color, pale ink wash, and thin ink lines.

On the upper third of Kikō's portrait is an inscription signed by the eminent Zen monk Gyokuin Eiyo, whose dated inscriptions occur also on two landscape paintings by Kenkō Shōkei, the Sōsetsusai Zu (1499, in the Seikadō Foundation, Tokyo) and the Shōshusai Zu (1506, in the Ueno collection, Hyōgo Pref.). Other sources record Eiyo's death at the age of ninety-three in 1524, making him sixty-nine in 1500. Much of the available biographical information about Kikō Zenshi is gleaned from Eiyo's inscription, which states that Kikō was abbot of Kenchō-ji, residing at Kotoku-an within that complex. He traced his lineage to the early Yuan dynasty Chinese monk Zhongfeng Mingben (J: Chūpo Minpon), his most immediate predecessor being Chūwa Toboku. From somewhat fragmentary documents Kikō was calculated to be about eighty years old at the time of this portrait. He and Eiyo were both originally from Shinano Province (present-day Nagano Pref.), where Kikō returned toward the end of his life to live in seclusion.

Although this portrait bears no artist's seal or signature, it has long been attributed to Kenkō Shōkei, based not only on the superior quality of the dense and skillfully modulated monochrome ink painting but also on circumstantial evidence. The tradition of ink monochrome chinsō seems to be distinctive to the Kamakura painters, the more orthodox polychrome portraits having by the sixteenth century lapsed into a rigid formalism. It is altogether likely that the portrait of an abbot of Kenchō-ji, inscribed by a distinguished chronicler, would have been executed by the best of the Kamakura Zen painters.

This portrait and others like it in ink monochrome seem a logical infusion of particular artis-

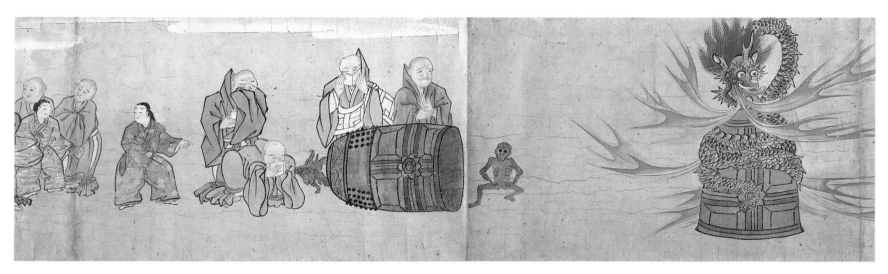

tic strengths into a somewhat moribund format. Other portraits perhaps forming a stylistic lineage with the Kikō portrait are found in Kamakura: one of the monk Zaichū Kōen, dated to 1388, at Hōkoku-ji, another of Donhō Shūō, dated to 1401, at the Butsunichi-an retreat of Enkaku-ji. J.U.

219 ❧

LEGENDS OF THE FOUNDING OF DŌJŌ TEMPLE (DŌJŌ-JI ENGI)

early 16th century
Japanese
two handscrolls; ink and color on paper
31.52 x 1038.5 (12²⁄₅ x 409)
references: Okudaira 1962, 108, 109, 135, 202, 203; New York 1983, 162–164

Dōjō-ji, Wakayama Prefecture
Important Cultural Property

Viewed as usual from right to left, the moral tale associated with Dōjō Temple unfolds in a lively, graphic, and easily understood fashion. A young priest rejected the advances of a woman at an inn

during his pilgrimage to Kumano in 938. When he left the inn, she continued to pursue him, the power of her obsession causing her to metamorphose into a dragon. Scroll two opens with a long inscription recounting this tale, then depicts its climax in two illustrations. In the first, the fleeing young monk appealed to the monks of Dōjō-ji for sanctuary. Skeptical at first, they agreed at last to help, and hid the fugitive under the massive bronze bell of the temple. The pursuing dragon-lady embraced the bell and engulfed it in flames, reducing the youth to a carbonized and shrunken corpse. Then both protagonists, reborn as snakes, appeared in a dream to the abbot of Dōjō-ji, pleading with him to copy the Lotus Sutra (associated with Amida Buddha, the compassionate Lord of the Western Paradise) as a pious offering to deliver them from this terrible rebirth. The abbot and priests did so over a period of days, then consecrated the text. Forthwith two angels appeared in the abbot's dream, informing him that the young monk was now in the Paradise of the Buddha of the Future (Miroku), and the lady in the lesser Paradise of Indra (Taishakuten). Finally we see three monks chanting the Lotus Sutra in unison.

A colophon at the end of the second scroll records that the shogun Ashikaga Yoshiaki (1537–1597) viewed the scroll in December 1573 and consequently made donations to Dōjō-ji. Eliciting donations was indeed the purpose of these scrolls, visual sermons designed to persuade the viewer of the virtues of Pure Land Buddhism and of the specific efficacy of benefaction to Dōjō-ji.

In style the illustrations are halfway between the skilled professionalism of early narrative handscrolls of the thirteenth and fourteenth centuries and the folk and semifolk paintings of the fifteenth and sixteenth centuries. What it lacks in polish the *Dōjō-ji Engi* makes up in full in pungency and clarity — both graphic and literary. For here the prosaic narrative is supplemented by running comments and quotations akin to those furnished by comic strip "balloons," expressed in a lively vernacular. This derives from the oral tradition of story-telling professionals (*etoki*) whose stock of tales, both saintly and ribald, influenced a whole group of Muromachi period narrative scrolls called *otogi-zōshi*. Such plebeian tang and vigor can well seem a delightful relief from the formalities and protocol inherent in the scrolls of the court tradition (cat. 217). The *otogi-zōshi*

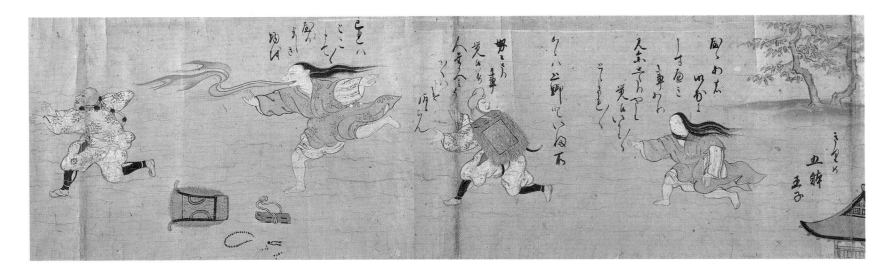

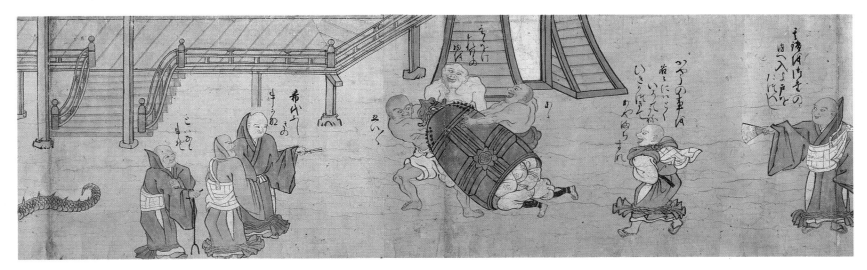

notably concentrate on the human drama, contrasting in this respect too with the elaborate settings, whether landscape or architectural, of the more sophisticated traditional modes. This concentration of effect is particularly evident in the *Dōjō-ji Engi* scrolls. S.E.L

220 ༄

Bunsei
active mid-15th century

THE LAYMAN YUIMA (YUIMA KOJI)

dated to 1457
Japanese
hanging scroll; ink on paper
92.7 x 34.4 (36½ x 13½)
inscription by Sonkō Somoku (d. 1467)
references: Yashiro 1960, 2:361; Tanaka 1972, 89,
fig. 78; Matsushita 1974, 93, 94, fig. 96

Yamato Bunkakan, Nara

In this famous and extraordinary work the Buddhist lay philosopher-scholar Yuima (S: Vimalakīrti) is represented bearded and intense, and clad in the traditional Chinese scholar's cap and robe. He leans forward eagerly, resting his right arm on a carved wooden arm rest, a fly whisk in his right hand. The inscription by Sonkō Somoku records that the painting was commissioned by Priest Zensai in offering for his deceased father's salvation. The painting therefore may date slightly earlier than the inscription, but not significantly so.

Yuima, the Japanese name for the Indian sage Vimalakīrti, became a popular subject in Chinese art as early as 642, the date of a fresco at Dunhuang, in northwest China, in which he appears. By the time of this early work the image type was already set according to the account in the *Vimalakīrti Nirdeśa Sūtra* (J: *Yuima Kyō*), reputedly of the second century A.D. In this text Yuima is ill, and the Buddha has sent Mañjuśrī (J: Monju), Bodhisattva of Wisdom, to inquire after him. Yuima explains his infirmity as the sickness common to all mankind, that is, the suffering born of ignorance and appetite. This Buddhist sentiment, added to his character as an aged scholar, endeared him to the Chinese, and his image as an elderly literatus reclining on a dais with an arm rest for support became a common pictorial expression of piety and wisdom. The subject was exported to Japan in the early seventh century, and the *Yuima Kyō* was reportedly one of the favorite texts of Shōtoku Taishi (574–622), the prince-regent who ensured the triumph of Buddhism in Japan during the Asuka period (552–645).

The ink painting image of Yuima owes much to Chinese representations of the Northern Song period, particularly to a type associated with the great master of monochrome line painting Li Gonglin (Li Longmian, c. 1049–1106). Bunsei's origins are not clear, but this work, a landscape in the Boston Museum of Fine Arts, and landscapes in the Takano collection, all bearing Bunsei's seal, seem to point either to a Korean origin for the artist or at least to Korea as a major influence on his art (as it was on the art of his more famous and equally mysterious colleague, Shūbun). Yuima's face in Bunsei's masterpiece is one of the most expressive in East Asian ink painting, reflecting to a remarkable degree pain, age, and contemplation. The washes suggesting facial hair are most subtle, as if breathed upon the paper. The folds and creases of the cloth, in both cap and gown, are less realistic observations than true

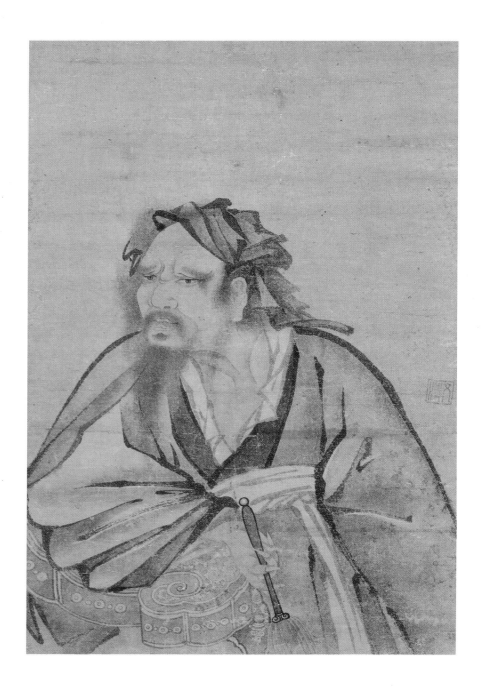

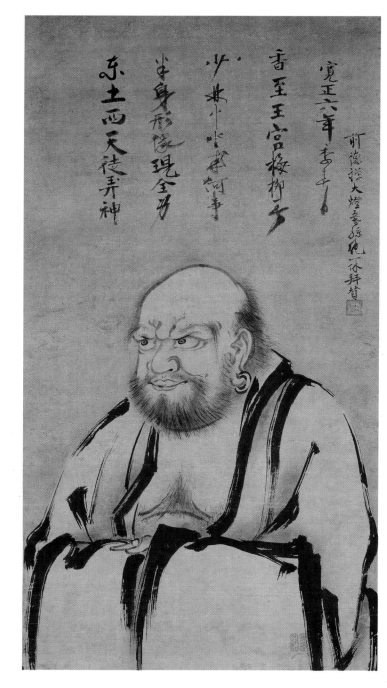

impressions brilliantly rendered in virtuoso brushwork from an inherited pattern some three hundred years old. The combination of gravity and virtuosity is unusual and recalls, not in appearance but in method, the art of the great Southern Song master Liang Kai (act. early 13th century). S.E.L.

221 ❧

Bokkei Saiyo
active 1452–1473

DARUMA

c. 1460
Japanese
hanging scroll; ink on paper
110 x 58.3 (43¼ x 23)
two seals of the artist
inscription with signature and seal by Ikkyū Sōjun
(1394–1481)
reference: Washington 1988, no. 81

Shinju-an, Daitoku-ji, Kyoto
Important Cultural Property

Images of the First Patriarch of Zen have been produced from as early as the eighth century in China. Bodhidharma (J: Daruma, trad. c. 470– c. 543) was an Indian prince, and the twenty-eighth patriarch of Indian Buddhism in the lineage beginning with Śākyamuni Buddha. His journey to China eventually brought him to the Shaolin monastery in southern China, where, as legend recounts, he remained seated in meditation before a cave wall for nine years. This archetypal image of meditation was most memorably depicted by Sesshū (see "Shen Zhou and the Literati Style." Zen (C: Chan) traces its origins to Daruma's teachings, which called upon adherents to single-mindedly seek the Buddha nature within, dispensing with religious rituals and even with study of the sutras. Transmission of this teaching was from

mind to mind—from master to disciple.

Images of Daruma, like this one, usually portray him with Indian features, including full lips and prominent nose. His princely status is signified by the ear lobe, elongated from the weight of the ring. The long fingernail of the left thumb marks him as an ascetic. Sometimes he is shown full length, standing on a reed, as he did for his miraculous crossing of the Yangzi River on his journey to Shaolin Si. Yet other paintings show him seated in meditation, either within a natural landscape setting or without any context. All three of these image types were rendered both in ink monochrome and in polychrome, the latter version showing Daruma clothed in a red robe.

At the figure's left elbow are two seals of the artist, Bokkei Saiyo. The inscription is signed and sealed by the famous monk-poet and abbot of Daitoku-ji, Ikkyū Sōjun (1394–1481), and dated to the sixth year of Kansei (1465). In the inscription Ikkyū identifies himself as "former abbot" of Tokuzen-ji, a subtemple of Daitoku-ji to which he had been appointed abbot in about 1459. While abbacies were often brief, the short tenure indicated by this inscription may also reflect Ikkyū's volatile relationship with the Daitoku-ji hierarchy (see cat. 238).

The inscription reads:

Followers in China and India conjure
 your spirit;
Half the figure, a portrait, reveals your
 entire body;
What did the grass mat at Shaolin accomplish?
At the Palace of King Xiangzhi, spring of
 plums and willows.
(Translation from Washington 1988, no. 81.)

"The Palace of King Xiangzhi" refers to Daruma's father and to a life of privilege abandoned. Regal Indian origin and its rejection suggest for Daruma, and thus for Zen, a lineage much resembling that of Śākyamuni Buddha. Ikkyū's inscription is a reflection on latter-day distortions of original teachings and on the efficacy of austerities.

Two portraits of Ikkyū by Bokkei are known (dated to 1452 and 1453). Bokkei is recorded as Ikkyū's disciple as well as portraitist. Apparently, like Ikkyū, he enjoyed the patronage of the Asakura warrior clan of Echizen, the first of a group of painters serving the Asakura and using the family name Soga. Bold and highly individual brushwork is characteristic of this lineage of painters through the sixteenth century. The Soga style is one of several significant artistic developments of the fifteenth century, when political instability at the capital and sophisticated provincial patronage combined to stimulate innovation and stylistic variation in the arts. J.U.

attributed to Kanō Motonobu
1476–1559

FLIGHT OF THE SIXTH PATRIARCH
XIANGYAN ATTAINING ENLIGHTENMENT

c. 1513
originally sliding screens (fusuma-e), now mounted as hanging scrolls; ink and color on paper
175.2 x 137.4 (69 x 54⅛) each

Tokyo National Museum
Important Cultural Property

These two paintings, along with four others not shown here, were originally part of a *fusuma-e* composition (paintings on interior sliding screens) commissioned for the *Iho no ma*, a room in the guest quarters of Daisen-in at Daitoku-ji. Since the building program was completed in 1513, that is the date assigned to the paintings. Although they are unsigned, both temple tradition and stylistic analysis point convincingly to Kanō Motonobu as the painter. These two scenes were on the eastern wall, *Flight of the Sixth Patriarch* to the left and *Xiangyan Attaining Enlightenment* to the right. The four remaining scenes were on the southern wall.

Usually these paintings are considered to be *zenki zu* (didactic Zen painting), a strong tradition comprising imagined formal portraits of Zen masters as well as narrative paintings of such revered adepts at moments of Enlightenment or in other well-known incidents of their lives. The *Flight of the Sixth Patriarch* illustrates the traditional Zen account whereby Hui-Neng (J: E'nō, 638–713), chosen successor to the Fifth Patriarch, Hong-Ren, fled south to avoid the jealous wrath of Shen-Xiu, the learned monk who had expected to "receive the robe." Hui-Neng's flight marked (or symbolized) the division of Chan (Zen) into the so-called Northern and Southern schools—the former, stemming from Shen-Xiu, espousing gradual Enlightenment, the latter, from the nearly illiterate but profound Hui-Neng, instantaneous Enlightenment. The patriarchal succession from Bodhidharma through Hui-Neng was a retrospective construction, designed to advance the cause of the Southern school, which in fact emerged triumphant.

In the adjoining scene the Chan master Xiangyan Zhixian (J: Kyōgen Chikan, d. 898) is seen sweeping in front of his hut. Xiangyan, in contrast to Hui-Neng, was greatly learned, but having failed to achieve Enlightenment, he abandoned his books and retired to a life of rural seclusion and manual labor. One day the sound of a pebble, sent flying by his broom and striking the nearby bamboo, brought on the moment of Enlightenment.

Even outside their original context these paintings reveal an artist with a commanding ability to manipulate space and to render detail precisely. Middle-ground bands of voluminous clouds link and frame the action in each scene and serve further to divide the narrative foreground from the hills and trees that evoke deep distance. The effective balance of foreground anecdote and background vista was surely decorative as well as instructional. Some would suggest that, content notwithstanding, Motonobu's aesthetic interest in these paintings was more decorative than Zen. Within a few years of this commission Motonobu produced the *Seiryō-ji Engi* (1515), a set of six narrative scrolls depicting the miraculous founding and other legends of Seiryō-ji, which demonstrates convincing command of the narrative format previously dominated by the Tosa painters. Motonobu moved the Kanō atelier firmly in the aesthetic direction begun by his father, Masanobu (1434–1530), achieving a substantial and remarkably varied patronage and thereby a considerable and lasting prosperity. The fusion of Chinese brush style and Japanese palette was a hallmark of Kanō painting well into the Edo period (1615–1868).

It should be noted that Sōami (d. 1525), third generation of the distinguished Ami lineage, also worked on the decorations of the Daisen-in, contributing landscape painting on *fusuma* considered to be his masterpiece. J.U.

detail

224 🐚

Nōami
1397–1471

White-Robed Kannon (Byaku-e Kannon)

dated to 1468
Japanese
hanging scroll; ink and light colors on silk
77.7 x 39.3 (30⅝ x 15½)

Hasebe Yasuko

In Nōami's vision the White-Robed Kannon, composed, attentive, and attractive, is seated atop a fantastical rock beside a tranquil body of water. Bending bamboo and densely rendered background clouds evoke a tropical atmosphere. The painting, dedicated to the artist's son on the occasion of his receiving the tonsure at a Zen monastery, depicts one of the iconographic subjects most popular among Zen adherents.

The White-Robed Kannon is a form of the bodhisattva derived from the fusion of two distinct scriptural references. The "Fumon" chapter of the profoundly influential Lotus Sutra (J: *Hoke Kyō*) names the thirty-three manifestations of Kannon, the Bodhisattva of Compassion, who seeks to relieve the suffering of sentient beings and whose name means, literally, "one who hears the cries of the world." A passage in the *Avataṁsaka Sūtra* (J: *Kegon Kyō*) describes Mt. Potalaka, the imagined abode of the bodhisattva Kannon, as a bountiful locale of fruit, flowers, and flowing waters. As early as the Tang dynasty (618–907) the Chinese popular religious imagination transformed Mt. Potalaka into an island off the south China coast. Depiction of Kannon in this intimate paradisiacal setting is thought to have begun in

China during the eighth century. Unfettered by precise description in a particular religious text, the image was an amalgam of several other Kannon images, notably the Kannon with Wish-Granting Jewel and Wheel of the Law (Nyoirin Kannon) and the Willow-Branch Kannon (Yōryū Kannon). Poses ranged from the serious and contemplative, seen here, to the position of "royal ease," to playful lounging and foot-splashing in the pool or stream or waterfall that was a necessary element of the setting.

The White-Robed Kannon in Daitoku-ji, attributed to the Chan (Zen) abbot Mu Qi (13th century), is considered to be the seminal work of its type for Japanese painters. In the depiction seen here Nōami accepted the general iconography of the Mu Qi but rendered it in a painting style incorporating the angular brush strokes and washes of Ma Yuan, i.e., in what was perceived to be the academic style of Southern Song China (1127–1279). Nōami's access to and close study of the Ashikaga shoguns' Chinese painting collection is readily apparent in this painting. This is one of the few firmly attributed Nōami works; several other Byaku-e Kannon paintings, generally thought to be by his hand, reveal totally different approaches to this serviceable and popular image.

Nōami was the first of the "three Ami" (succeeded by Geiami [1431–1485] and Sōami [d. 1525]), each of whom functioned as artist, aesthetic advisor, and cultural impresario (*dōbōshū*) for the Ashikaga shogunate. The "ami" suffix to their names indicates adherence to the tenets of Pure Land (Jōdo) Buddhism, in particular the Timely (Ji) subsect established by the charismatic mendicant Ippen during the second half of the thirteenth century. Pure Land Buddhism and its offspring sects offered formulaic prayer repetition as an uncomplicated way to rebirth in Amida Buddha's Western Paradise. An iconography of gentle, compassionate deities, shown inhabiting worlds of supramundane beauty and bliss or engaged in acts of intercession within this-worldly genre settings, afforded painters the opportunity to develop a style appropriately linking religious sentiment with indigenous landscape.

As painters, the three Ami worked a sophisticated transformation of the popular polychrome genre style associated with Pure Land Buddhism and especially the Ji subsect. At the same time, though the elite circles they moved in were heavily influenced by Zen, the three Ami tended to temper the stringency and challenging ambiguity characteristic of much Zen painting. This very painting embodies the complexity of fifteenth-century Japanese high culture: a popular Zen icon offered by a Pure Land adherent on the occasion of a son taking Zen tonsure, but stylistically closer to academic or professional painting than to the direct, abbreviated, expressive manner that was thought to embody the Zen intention. J.U.

attributed to Gakuō Zōkyū
active c. 1470–c. 1514

WHITE-ROBED KANNON (BYAKU-E KANNON)

c. 1500
Japanese
hanging scroll; ink on paper
104.5 x 44 (41⅜ x 17⅜)
references: Boston 1970, 79–81; Matsushita 1974,
69; Kanazawa 1979, 69–72

The Cleveland Museum of Art, John L. Severance Fund

The White-Robed Kannon, including the types known as Water-and-Moon Kannon (Suigetsu Kannon) and Willow-and-Moon Kannon (Ryūgetsu Kannon), is one of the figural subjects most closely associated with Zen Buddhism. The earliest dated representation of the subject, now in the Musée Guimet, Paris, is from the caves of Dunhuang in western China—a painting on paper of the Kannon of the Willow Branch (Yōryū Kannon), dated to 953. A Water-and-Moon Kannon was painted by the illustrious painter Zhou Fang (c. 740–800) in the Shengguang Temple of the Tang dynasty capital, Chang'an (present-day Xi'an); the work was recorded in Zhang Yanyuan's *Li Dai Ming Hua Ji* (Record of Painters of Successive Ages) of 847, in chapter 3, section 4. Water, moon, willow branch, and bamboo are the usual attributes of the deity, who is most often shown seated.

Kannon (S: Avalokiteśvara; C: Guanyin) is the most popular and efficacious of the bodhisattvas, deities who have achieved Enlightenment but renounced their entry into Nirvana in order to aid all sentient beings along the same path. In India this compassionate ideal was popularly embodied in Avalokiteśvara, the Lord of Mercy. In China he became Guanyin, the savior and benefactor of all but especially of those most needing compassion—the sick, the poor, and women. Among painters of Buddhist subjects in late Southern Song Hangzhou, Guanyin achieved a somewhat androgynous form, soft in flesh and robed in white from head to toe. Southern Song images of Guanyin are usually depicted in a nocturnal setting that includes several or all of the following—waterfall, moon, bamboo, miraculous vase, willow branch, and cave. The supreme image of this Byaku-e Kannon type is the centerpiece of a triptych painted by Mu Qi (Fa-Chang, early 13th century–after 1279) in Hangzhou in the late thirteenth century and soon afterward exported to Daitoku-ji in Kyoto, where it still remains. Mu Qi's image is shown seated on rocks before a cave, bamboo at the left, a vase of willow at the right. The physical type is vaguely feminine, and the white cowl is drawn over the bodhisattva's crown.

This image became the source and standard of Japanese representations of the deity. It also

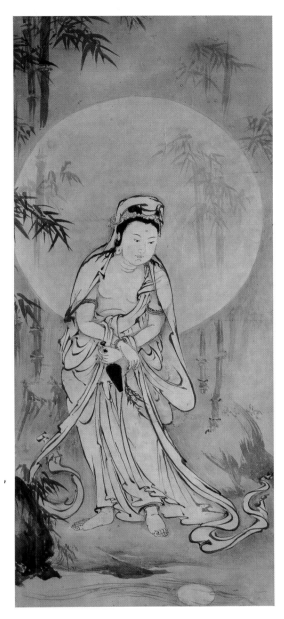

became particularly associated with Zen, for Mu Qi was a Chan abbot and Daitoku-ji was one of the five preeminent Zen temples (*Gozan*, "the Five Mountains") of Kyoto. Although iconic traditions are in general intensely conservative, fourteenth- and fifteenth-century Japanese painters experimented with variations in the presentation of the Byaku-e Kannon. The deity was shown washing its feet, reaching for a bamboo sprig, or, as in the present scroll, standing gracefully near the water. In this scroll the bamboo grove behind Kannon is visible through the translucent halo, and its recession in space is suggested by graded tones of ink. The moon's reflection, seen in the water at the lowest, nearest point of the foreground, substitutes for the waterfall that usually is the object of the bodhisattva's contemplation (a type called Takimi Kannon, literally, Kannon Contemplating a Waterfall).

The only clear evidence of Gakuō's style is to be found in the somewhat triangular wash planes of the rocks and earth in the foreground. S.E.L.

Nōami
Shinnō, 1397–1471

FLOWERS AND BIRDS (KACHŌ ZU)

dated to 1469
Japanese
pair of four-panel screens; ink on paper
132.5 x 236 (52⅛ x 92⅞)
two inscriptions and two identical seals

London Gallery, Ltd., Tokyo

These screens, by admission to the Nōami corpus, comprise the oldest known pair of signed, sealed, and dated Japanese screens. Each bears a seal of Nōami and a signed inscription: the inscription on the extreme right-hand panel includes the dedication, with its self-deprecatory reference to the artist as an "old man in his seventy-third year" (i.e., one year after his *White-Robed Kannon* of 1468 [cat. 136]); the inscription on the extreme left-hand panel includes the date. Research into the provenance of the screens indicates that they were held by the Mitsui family perhaps from the early seventeenth century, entered an American collection after World War II, and recently returned to a Japanese collection.

Nōami's dedicatory inscription suggests that the painting was offered in celebration of the transfer of temple responsibilities in the spring of 1469 at the Kyoto temple Keon-in. Records indicate that the monk Kyōgō did succeed Kōkyō at that time. Records trace the screens to the possession of Kyōgō's son Renshū at the time of his death in the second quarter of the sixteenth century.

Beginning in the fifteenth century, records or catalogues assembled by Japanese collectors and connoisseurs referred to paintings done in the style of, or "after," admired Chinese masters such as Ma Yuan, Xia Gui, and Mu Qi. This pair of screens, recently rediscovered, presents the most impressive substantiation now known of those tantalizing fifteenth-century records. The screens present a series of quotations from several of Mu Qi's known works, attesting Nōami's intimacy with Mu Qi's paintings and his highly original assimilation of the Chinese master.

Opening the composition at the right is a pine tree overhanging a stream, which cascades among cliff and rock formations into a central expanse of water. A gaggle of Chinese mynah birds occupies the boulder overhanging the cascade, with a single wagtail on a smaller rock below them. The composition's central and linking feature is a small island or spit of land emerging from a point in the unseen foreground, on which lotuses in full bloom are clustered at the water's edge and a trio of egrets stand in varied postures at the center. Overhead, a single egret, swallows, and grebes occupy the sky in consecutive panels.

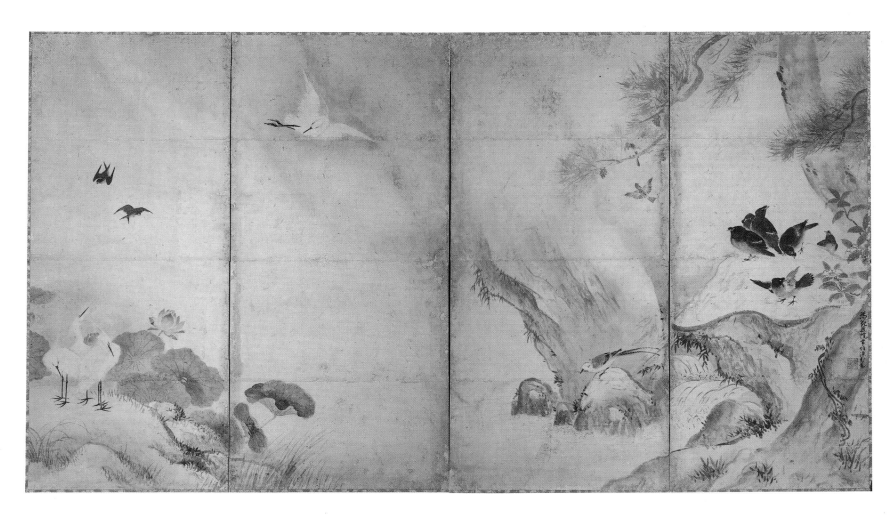

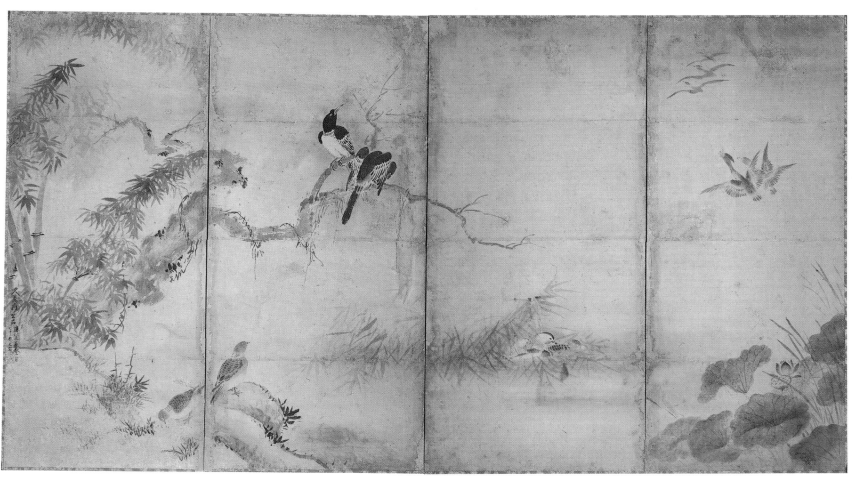

Less dramatic than the opening topography is that which closes the composition at the far left: bamboo and a bare tree projecting from a gently sloping bank. A pair of doves on the bank and a pair of magpies above them on a branch of the bare tree offer striking contrast between soft shading and sharp black-and-white. To the right of the magpies and below them, partly obscured in water weeds, is a pair of mandarin ducks. The stream carries one's eye gently from right to left, perhaps suggesting a sequence of seasons along its banks; the birds, in vivid counterpoint, form a sharp zigzag across the two screens.

The centrality of the lotuses in the composition made this painting thoroughly appropriate for a celebration within a Pure Land Buddhist establishment. Viewers accustomed to paintings of the White-Robed Kannon seated on a rock dais beside a pool or stream would not fail to discern the humorous intent in a gaggle of Chinese mynah birds at the extreme right of the right-hand screen—just where one would expect a depiction of the sacred figure. J.U.

227 🐌

Shūgetsu Tōkan
1440(?)–1529

HERONS, WILLOWS, AND
PRUNUS IN SNOW

c. 1500
Japanese
pair of hanging scrolls; ink on paper
96.3 x 32.3 (38 x 12¾)
two signatures and two seals of the artist

The Okayama Prefectural Museum of Art

The righthand scroll shows a plumed white heron preening its feathers on a willow branch; in the lefthand scroll another white heron rests on one leg on a snow-covered outcropping beneath a prunus branch mantled in snow and enlivened by a few tentative blossoms. Both paintings are signed and sealed by the artist.

Birds and snow are shown in reserve, as silhouettes of white paper against the surrounding ink wash, with the birds' legs and bills, and the branches beneath the snow, in dramatically dark strokes of ink. Particularly in the lefthand scroll this technique was used to perfection, resulting in an image at once clearly depicted and suggestive. This reverse technique was practiced in thirteenth-century China by painters associated with the Chan (Zen) Buddhist sect; its use there is exemplified in a hanging scroll by Luo-Chuang of a rooster, now in the Tokyo National Museum. Surprisingly, the method seems to have been scarcely known in Japan by 1500, the approximate date of Shūgetsu's painting.

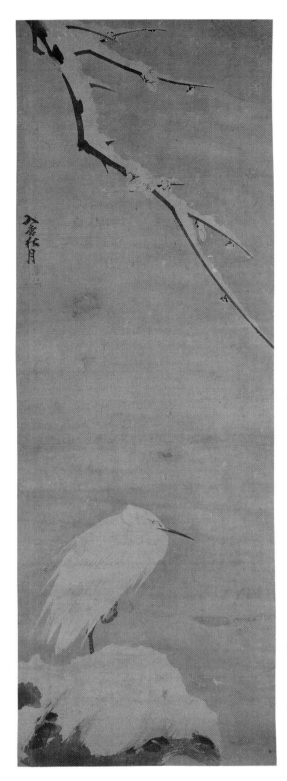

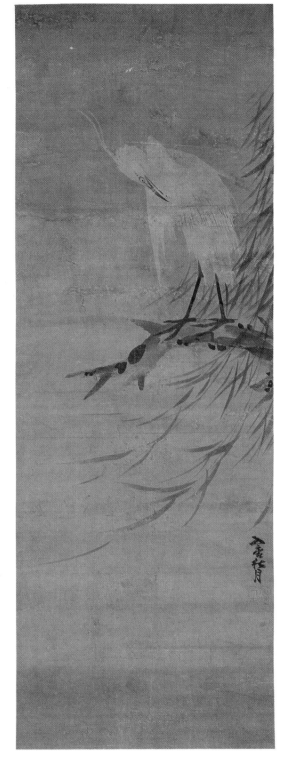

Shūgetsu was a monk-painter from the Satsuma domain in Kyushu, a subject of the Shimazu *daimyō* clan. He became a friend and follower of Sesshū (1420–1506) at that famous artist's studio in present-day Yamaguchi Prefecture, the Unkoku-an. In 1490 Sesshū's gift of a self-portrait attested Shūgetsu's position as his pupil and honored successor. The supposition that he accompanied Sesshū on his famous visit to China in 1468–1469 is probably false; a visit in the early 1490s, though also suppositional, is more likely.

Shūgetsu's relationship to Sesshū as pupil and successor is confirmed by most of his few extant works: the "splashed-ink" *(hatsuboku)* landscape in the Cleveland Museum; the *Reeds and Wild Geese* formerly in the Otsuka collection, Tokyo; and a few landscapes in Sesshū's sharply defined *(shin)* style.

The present work, however, is only superficially related in style to Sesshū's screens (see cat. 233). Sesshū never used reverse wash technique in its purest form but always supplemented it

with additional outlines or strengthening touches. Shūgetsu recognized that such additions in fact vitiated rather than enhanced the strength of this form. The results indicate that there may well be more to Shūgetsu than is currently accepted.

<div align="right">S.E.L.</div>

228 🐦

Shūbun school
active second quarter of 15th century

PINE-LISTENING COTTAGE (CHŌSHŌKEN)

Japanese
hanging scroll; ink and color on paper
100 x 31.7 (39⅜ x 12½)
5 inscriptions dated between 1433 and c. 1458
references: Yashiro 1960, 360; Tanaka 1972, 67–94;
Matsushita 1974, 61, 64–69; Princeton 1976, 28–30,
118–120

Seikadō Foundation, Tokyo
Important Cultural Property

Of the five poetic inscriptions on the theme of the title, the earliest was written by the Zen scholar-monk Ishō Tokugan (1365–1437), and is dated to 1433:

> A priest reads in the night by candlelight in his study sheltered by the green umbrella of pine trees. The wind blowing through the pine branches is an accompaniment to his voice all through the night.

The brushwork of the foliage on both pine and small bushes owes much to the productive studio of Minchō (1352–1431), artist-monk of Tōfuku-ji, but the rocks and distant mountains are constructed of vertical and horizontal strokes, very much in the loose Korean brush manner originated among northern Chinese painters of the Tartar Jin dynasty (1115–1234). This Korean manner can also be seen in an anonymous landscape in the Jishō-in of Shōkoku-ji, also with an inscription by Tokugan, as well as in the famous *Suishoku Rankō*, probably painted about 1445 by Shūbun or a very close follower.

Tenshō (or Ekkei) Shūbun is a key but shadowy figure of the first half of the fifteenth century, the crucial period in which Japanese ink painting reached maturity and turned to landscape for its primary subject. His birth and death dates are unknown. Documentary sources are few and not wholly germane to his career as a painter. A Zen monk as well as an artist, he was the general administrator of the great Zen temple Shōkoku-ji, one of the *Gozan* (Five Mountains, i.e., five chief Zen temples) in Kyoto. He was both painter and sculptor, and is recorded as painting sliding

screens with prunus in 1438, and assisting (?) with sculptures for Shōkoku-ji and Ungo-ji in Kyoto and for Daruma-dera in Nara Prefecture, as well as a statue of Prince Shōtoku for Shitennō-ji in Osaka, to replace one destroyed by fire in 1443. Most significant for his artistic career is his participation in a diplomatic and trade embassy to Korea in 1423–1424—the embassy that on its return to Japan almost certainly brought the Korean painter Yi Sumun (J: Ri Shūbun). No extant paintings can be surely documented as the work of Tenshō Shūbun.

This visit to Korea, which must have been crucial in Shūbun's artistic development, most likely took place well before he reached the age of thirty. As a mere youth (in terms of East Asian artistic seniority) he was exposed to the Korean ink painting of that time (cat. 264). Its heritage was mixed: Korea shared a common boundary with north China but also enjoyed sea connections with south China, especially the port of Ningbo. Close to Ningbo was Hangzhou, the seat of Southern Song painting style and its continuation in the Yuan and early Ming dynasties. Korean ink painters used both the northern and southern modes. Thus the famous An Kyŏn handscroll of 1447 and the paintings of his school (cat. 264) reflect the complex and monumental art of north China during the Tartar Jin dynasty (1115–1234) and the Mongol Yuan dynasty (1279–1368). On the other hand, an album leaf by Kang Hŭi-an (cat. 265) shows clearly the Southern Song penchant for asymmetry and abbreviation.

In the artistic environment of his native land, Shūbun could make use of both modes. Japanese ink painting of the Muromachi period was in large part a creation of Zen monk-painters, who adopted the subjects developed by Chinese Chan monk-painters and their literati colleagues of the Hangzhou region: first, imaginary portraits of the Chan patriarchs and other figures central to Zen teaching, and second, the landscape of China. Since many Japanese painters never visited China, their landscapes were aesthetic meditations on Chinese scenery—particularly hermitages in mountain fastnesses—as mediated through Chinese poetry and paintings. The primary element in this pictorial environment was the manipulation of ink by brush. What Shūbun, his even more famous pupil Sesshū, and their epigones achieved was no mean feat—the creation of poetic pictures expressing both nostalgia and retreat, valued qualities in the extreme social and political unrest of Japan during the second half of the fifteenth century.

Chōshōken is a hanging scroll (*kakemono*), tall in proportion to its width to a degree unusual in China and Korea but common in Muromachi Japan. Monks' quarters for private gatherings—proto-Tea Ceremony rooms or huts—did not afford large spaces for paintings; furthermore the paintings themselves had to leave room for inscriptions, which were as important as the

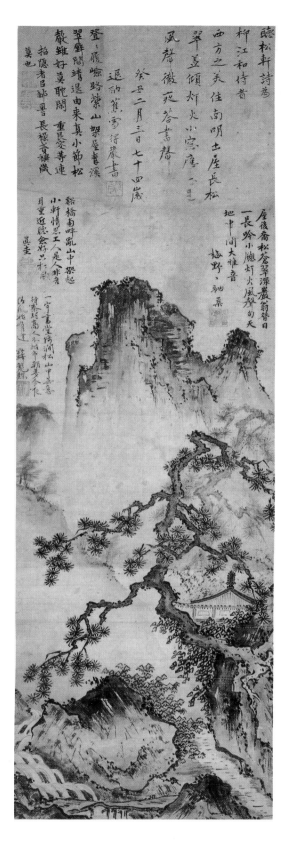

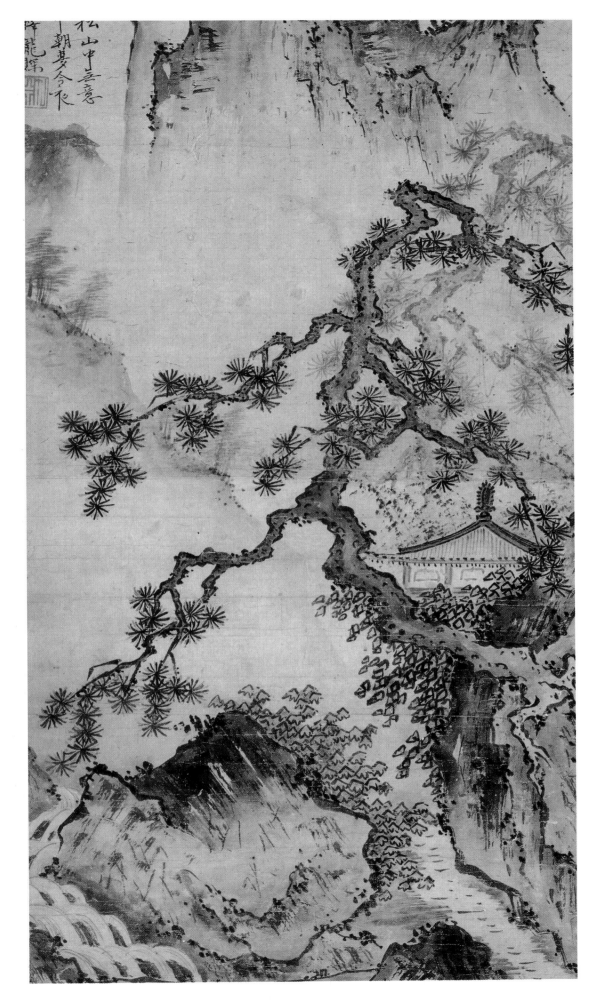

image below them. The composition here is simple and centralized. A tripartite mountain towers vertically above two implausibly tall pines. The foliage on the mountaintops recalls north Chinese Jin conventions. But the rocks at the bases of the pines are denoted by brush strokes derived from the "ax-cut" brush strokes of the Ma-Xia school of Hangzhou. The pictorial effect is lyrical and sprightly. The more linear brush strokes create an overall spidery effect, which the author takes to be an identifying characteristic of the style associated with Shūbun and his immediate circle. S.E.L.

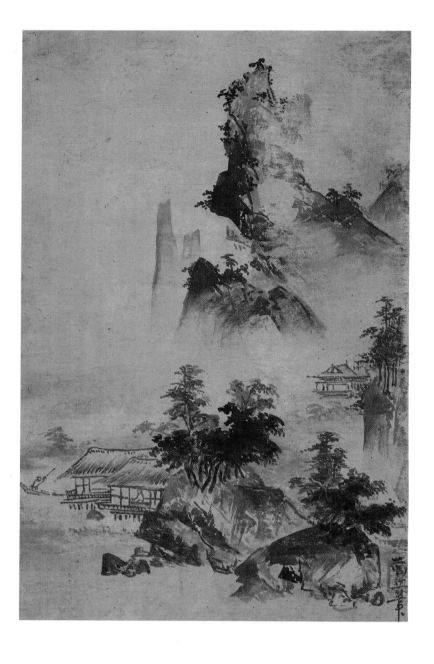

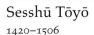
230

Sesshū Tōyō

1420–1506

LANDSCAPE OF THE FOUR SEASONS (SHIKI SANZUI ZU)

c. 1470
Japanese
four hanging scrolls; ink and slight color on silk
149.2 x 75.8 (58¾ x 29⅞)
signed: Nihon Zenjin Tōyō (Japanese
Zen-Man Tōyō)
references: Covell 1941, 1974; Tanaka 1972, 105–
129; Matsushita 1974, 70–85

Tokyo National Museum
Important Cultural Property

Born into the Oda family, minor samurai of limited means living in present-day Okayama Prefecture, Sesshū was entered at the age of twelve as a novice at a local Zen temple. By his twenties Tōyō, as he was then called, was at Shōkoku-ji in Kyoto, where he evidently served as a receptionist for visitors to the abbot. Tenshō Shūbun (act. first half of 15th century) was a monk at the same temple, and it is likely that Sesshū studied painting under Shūbun; later, in a famous inscription, Sesshū named Shūbun and Shūbun's predecessor Josetsu as his artistic mentors. Although he was certainly painting at this time, and had access to the considerable collections of Shōkoku-ji and perhaps to the shogun's collection as well, no extant work antedating the 1460s can be definitely attributed to Sesshū. About 1464 he was summoned to what is now Yamaguchi Prefecture by the Ōuchi, lords of the region, to be abbot of the clan temple, Unkoku-ji. His willingness to accept argues a relatively low position at Shōkoku-ji and a need for greater independence and breathing room. He was in his art clearly a strong and unusual personality. Further, his life shows the readiness to travel that seems to have characterized the freer spirits in Japanese history.

At Unkoku-ji he was joined by a faithful disciple-friend-pupil, Shūgetsu Tōkan (d. 1529), and there, sometime in the early 1460s, he took the familiar name (*azana*) Sesshū. The two characters making up the *azana*, *setsu* (snow) and *shū* (boat), also allude in their pronunciation to both Josetsu and Shūbun. Sesshū's ancient priest-mentor Ryūkō Shinkei, elaborating on the deep significance of "snow-boat," stresses the purity and coldness of snow and the quiet movement of boats. Indeed "ice" is mentioned in this inscription and in another by Genryū—and "icy" is a not inappropriate description of one element in Sesshū's mature painting style.

The Ōuchi *daimyō* controlled far western Honshu, including the port and strait of Shimonoseki between Honshu and Kyushu, and main-

229

Gakuō Zōkyū

active c. 1470–c. 1514

LANDSCAPE

late 15th century
Japanese
hanging scroll; ink on paper
69.1 x 32.7 (27¼ x 12⅞)
signed at lower right: Zōkyū hitsu (painted by
Zōkyū); seal: Gakuō
references: Tanaka 1972, fig. 74,
164–165; Matsushita 1974, 68–69

Tokyo National Museum
Important Cultural Property

A contemporaneous record of 1486—*Shaken Nichosoku* by Kikō Daishuku—calls Gakuō a disciple of Tenshō Shūbun. Inscriptions by Ryōan Keigo (1425–1514) on paintings attributed to Gakuō suggest that the painter was a friend or associate of this eminent Zen monk of Tōfuku-ji in Kyoto. Inscriptions also suggest that Gakuō was with Ryōan at An'yō-ji, south of Nara in Ise Province, from about 1469 to 1477. Ryōan later (1511) served as envoy to China and was a familiar of Sesshū, but there seems to be no trace of Sesshū's influence in the works attributed to Gakuō.

The Tokyo National Museum *Landscape* is usually regarded as Gakuō's classic work; it is signed "painted by Zōkyū" and includes his seal: *Gakuō*. In composition it is a variation on Shūbun's but rendered with more dramatic contrasts in tone, heavier ink, broader washes, and with a distinctive use of triangular planes to produce an often crystalline effect. The modeling of foliage with dark washes recalls the Chinese Southern Song artist Xia Gui (c. 1180–1220). Compared with the even and delicate mists of his master, Shūbun, Gakuō's rendering of mist, as in this scroll, is more palpable, less mysterious and transparent. S.E.L.

tained active trade and diplomatic relations with China. In 1467, under the nominal patronage of the politically enfeebled shogun Yoshimasa, the rival Ōuchi and Hosokawa clans organized a trade mission to China, and after delays the ships left the port of Hakata for Ningbo in early 1468. Sesshū and Shūgetsu accompanied the mission for the Ōuchi, the former being described as "purchaser-priest." The two-year sojourn in China, taking Sesshū from Ningbo north to Beijing by way of Hangzhou, Suzhou, and Nanjing, was a crucial event in the artist's career, both personally and artistically.

Ningbo was the center of the painting workshops continuing Southern Song landscape, figure, and Buddhist traditions, and there Sesshū certainly saw plentiful examples of the Ma-Xia (Ma Yuan and Xia Gui) landscape style. Suzhou must have afforded some exposure to the emerging *wen ren* (literati) school of painting, led by Shen Zhou (1427–1509). And in Beijing the court painters received the Japanese artist as an equal. Only eight years after Sesshū's return from Japan Priest Ryōshin documented Sesshū's commission from the Ming court for a wall painting (screen? or mural?). On his 1495 "splashed-ink" landscape Sesshū himself recorded that he had learned from Zhang Yousheng (now unknown) and Li Zai (act. c. 1425–1470); it is not clear whether he knew the painters personally, or only their works. The breadth and depth of Sesshū's exposure to Chinese art in China was almost certainly greater than that of any other Japanese artist of his time. By the time he returned to Japan, the monumental tradition of Northern Song landscape as preserved by Li Zai, the Southern Song Ma-Xia tradition, the Buddhist painting and flower painting traditions of the Ningbo area, the new court painting of early Ming, and the new *wen ren* style were all familiar to him.

His social position and self-esteem were also bolstered by his trip. Touches of precedence, such as being chief guest at the great Chan (Zen) temple Jingde Si on Mt. Tiantong near Ningbo, were treasured by Sesshū and flaunted in his signatures on later major paintings: "Occupant of the First Seat at Tiantong in Siming [Ningbo]." Especially after his relative obscurity in Japan's artistic capital, Kyoto, to be acclaimed in China as a major master was probably most heartening.

For Sesshū's mastery of Chinese styles our major pictorial evidence is the set of *Landscapes of the Four Seasons*, exhibited here. The overall effect of the four hanging scrolls—in tone, composition, and allusions to tradition—is almost totally Chinese. Only in certain brush details and in a few idiosyncratic descriptions of motifs such as rocks and bamboo can one clearly distinguish the mature and classic Sesshū. In the lower half of "Spring" the abbreviated indications of architecture, crackling prunus branches, and axlike brush strokes defining rocks are pure Ma Yuan, while

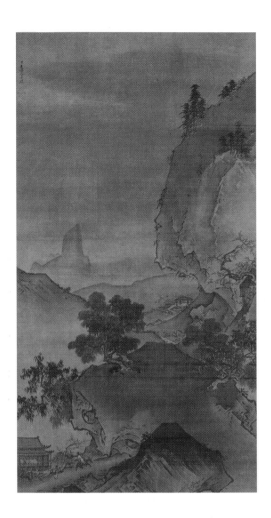
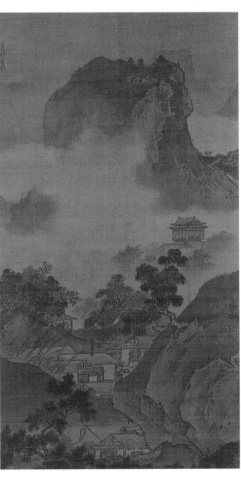
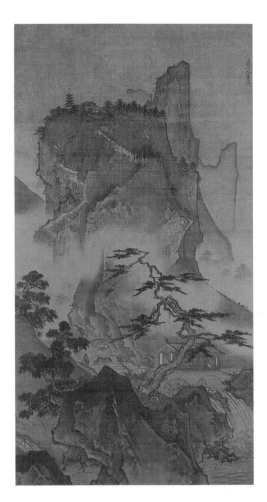

the tree foliage and broad ink wash plane of the slanting plateau are equally pure Xia Gui. The strongly one-cornered composition is a Ma-Xia characteristic, as are the forced-edge washes of the distant mountains. "Summer" is a well-understood essay in the style of the fourteenth-century Ma-Xia follower Sun Junze except in its composition: the centrally placed mountain mass echoes earlier traditions of monumental landscape. The skillful use of "palpable" mist and broad ink washes paling into exposed silk has much in common with such conservative Chinese masters as Zhou Chen (d. c. 1536) and Tang Yin (1470–1523). The resonant summer calm evoked with bare silk or light washes of ink provides a startling counterpoint to the angular and energetic thrusts of rocks, pine branches, and mountain ridges and paths. "Autumn" is thoroughly dominated by the ways of Xia Gui, save again for the dominant centrality and symmetry of the landscape elements. "Winter" rivals "Summer" in its successful evocation of a snowy landscape by means of large areas of untreated or only lightly washed silk defined by sharp, crystalline, "icy" brush strokes. The curious clovelike representation of mountain tree and bush foliage ultimately derives from the tenth-century monumental master Fan Kuan. But Sesshū assumed the convention to come from Xia Gui, as he indicates in an inscription on one of his many free copies after Southern Song landscapes on fans. By Southern Song Fan Kuan's style had been adopted as a norm for rendering winter landscape.

It is assumed, probably rightly, that the *Four Seasons* scrolls were painted during or just after Sesshū's China trip. The mastery of Chinese painting traditions is patent; the identification "Japanese Zen-Man" in his signature would hardly seem necessary if he had remained at home; the name "Tōyō" implies an early date, since in later years he more commonly used Sesshū. S.E.L.

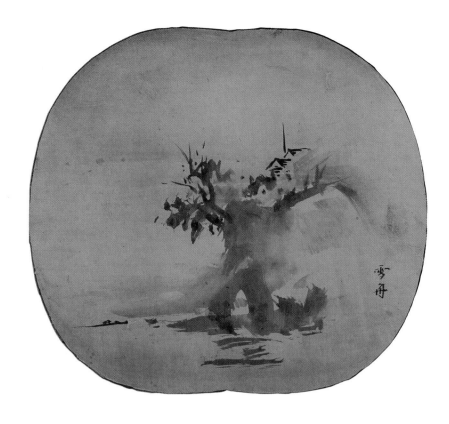

231

Sesshū Tōyō
1420–1506

Splashed-Ink (Hatsuboku) Landscape

c. 1490
Japanese
fan painting mounted as a hanging scroll;
ink on paper
30 x 30.6 (11¾ x 12)
inscribed (by the artist): Yu-Jian; signed: Sesshū
references: Covell 1941, 1974, 94–96; Tanaka 1972, 125–129

Okayama Prefectural Museum of Art

This work is one of some nine fan-shaped pictures after Southern Song fan paintings by such classic Chinese masters as Xia Gui, Liang Kai, Li Tang, and Yu-Jian. Though often called "copies," none of these paintings can be closely related to any extant works by those Chinese artists in Japanese temples and collections. Their manner is that of Sesshū in his later works, well after his return from China. It seems more likely that these fan-shaped pictures are small essays in the style of the masters whose names are inscribed outside the "frame." The real originator is surely Sesshū, whose name is proudly placed within the frame. These fans lie within the mainstream of Ming and Qing aesthetics, in which the theme-and-variation mode was commonplace: a style or manner handed down from the past was used as a starting point to display the knowledge and virtuosity of the executant.

In this present work the manner, called by the Japanese "splashed ink" (J: *hatsuboku*; C: *po mo*), was associated with two late Southern Song painters represented in the shoguns' collections: Mu Qi (or Fa-Chang) and Yu-Jian (or Ruo-Fen). Mu was a Chan (Zen) abbot-painter of Hangzhou; Yu-Jian was perhaps a priest of the Buddhist Tiantai (J: Tendai) sect. The *hatsuboku* works attributed to Mu Qi are not signed or reliably sealed, but those by Yu-Jian are. Splashed-ink painting has been considered the exclusive province of Chan Buddhists, but there seem to be exceptions,

witness Yu-Jian. But the paintings are closely associated with late Southern Song Buddhism, and their appearance, manner of making, and association by inscription with well-known priests, principally Chan, make it possible to describe them generically as congruent with Chan methods of meditation and elucidation—silence often interrupted by terse, sometimes rude, and always enigmatic and problematic explanation. Further, in Japan *hatsuboku* is almost exclusively associated with Zen priest-painters like Sesshū, or with lay priest–warrior painters like Kaihō Yūshō (1533–1615).

This *hatsuboku* essay by Sesshū is a relatively quiet and understated "meditation" in ink as compared with the same artist's dramatic masterpiece of 1495. Here the darkest and sharpest strokes define a distant two-storied structure, probably an inn, on a high bluff with trees overhanging its edge. The foregound is half-toned, and the rock (?) in the center of this spit of land seems overly large in relation to the hill and building. At the left, balancing the signature *Sesshū* on the right, a fisherman or ferryman huddles in his boat. The overlapping of the large rock and the equal-toned wash of the central point of land is a little heavy and uncertain. But what counts is the overall gestalt, the total image, soft, wet, suggesting patchy mist and rain covering parts of a relatively near view. S.E.L.

Sesshū Tōyō

1420–1506

AMA NO HASHIDATE

c. 1503
Japanese
hanging scroll; ink and notes of color on paper
89.5 x 169.5 (35¼ x 66¾)
references: Tanaka 1972, 108, 109, 128; Tanaka and
Nakamura 1973, 7: pls. 20, 54; Matsushita 1974, 82

Kyoto National Museum
National Treasure

The lack of signature and seal does not diminish the firmness of the attribution; it furthermore attests the character of this work as a large sketch based on smaller on-the-spot sketches. As a direct rendering of a Japanese scene, the famous "Bridge of Heaven" near Miyazu on the Japan Sea side of northern Kyoto Prefecture, this vigorous work is unique in early Japanese ink painting. It belies Sesshū's self-deprecating references to his misty eyes and exhausted spirit in the inscription on the *Hatsuboku Landscape for Sōen* of 1495. For *Ama no Hashidate* was painted about 1503, when the artist was at least eighty-two. The small one-story pagoda *(tahōtō)* of Chion-ji in the temple depicted at the lower left was not completed until 1501, so the painting must have been made thereafter.

Although Sesshū maintained two more or less permanent studios after his return from China, he was, like many Chinese and Japanese scholars, painters, and monks, an inveterate traveler. Since travel was almost unimaginably slow and arduous by present-day standards, these trips took a very long time, and were lengthened even further by the painting demonstrations which it was customary for a famous artist to give, at least at the more important of the temples and domain castles that offered him extended hospitality en route.

Ama no Hashidate is the result of one of these trips. The legendary sand spit, covered with pines and surrounded by marvelous views, is still one of the top tourist attractions in Japan. In the painting we view it from a hill looking northwest across part of Miyazu Bay. Mount Nariai is on the right, with the temple complex of Nariai-ji, including a Shinto shrine, below it. At the lower left, opposite the end of the Bridge of Heaven, we can see Chion-ji with its red Image Hall and just beyond on the left the one-storied pagoda. The numerous houses of the five small villages on the far side of the bay are boldly indicated in an abbreviated, staccato shorthand. These quasi-geometric forms contrast with the rolling washes and running

brush strokes defining the hills and mountains. Nothing in ink painting could be further from the nostalgically imagined Chinese scenery of most Muromachi painted landscapes. Even Sesshū may have been surprised by what he had created.

Nor does *Ama no Hashidate* reveal much in common with the strong verticality and the angular and energetic thrusts of Sesshū's earlier, purportedly Chinese, landscapes (cf. cat. 230). Although some may attribute the gentler, more horizontal expanse of this landscape to a resurgence of the native style of painting found in the narrative handscrolls and the landscape *mandalas* of the earlier Fujiwara (897–1185) and Kamakura (1185–1333) periods, the differences in *Ama no Hashidate* would seem to be mainly attributable to the artist's individuality and strength as well as to nature herself—this is the way the scenery of the Bridge of Heaven looks. The presence of eight place and temple names in the distinctive calligraphy of the artist attests his keen interest in the local topography.

As many as twenty-eight sheets of paper were joined to create the painting surface for *Ama no Hashidate*; since old fold marks look like joins, the exact number is not determinable. S.E.L.

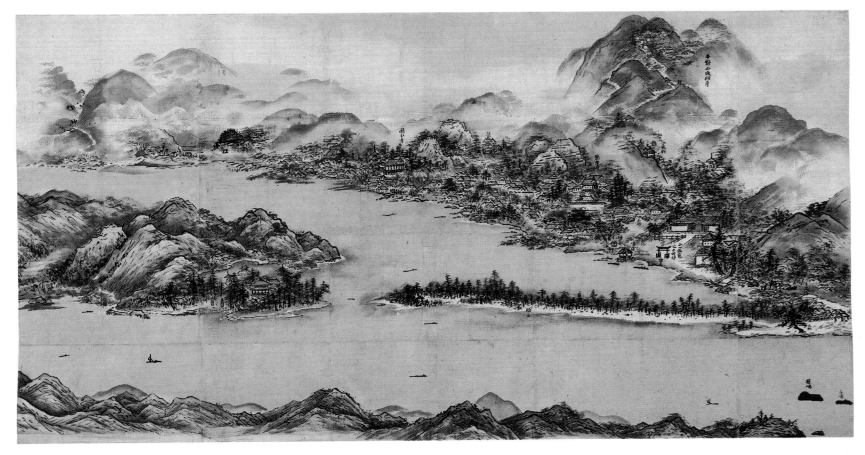

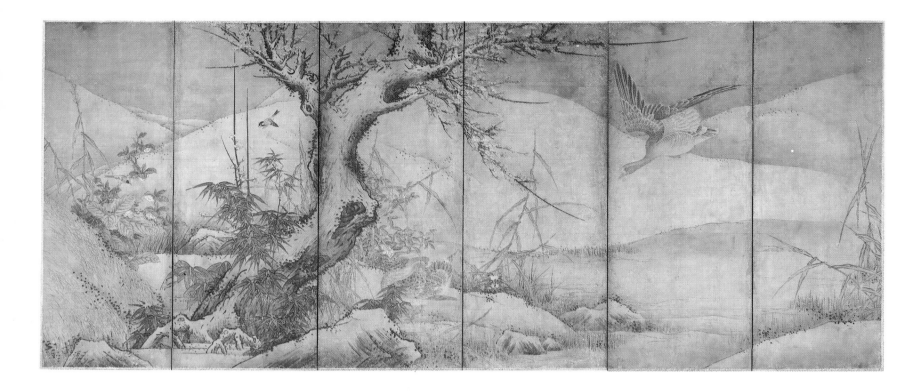

233

attributed to Sesshū Tōyō
1420–1506

FLOWERS AND BIRDS OF THE FOUR SEASONS (SHIKI KACHŌ ZU)

Japanese
pair of six-fold screens; ink and color on paper
each 151.6 x 366 (59⅝ x 144)
references: Covell 1941, 1974, 111–114; Tanaka
1972, 170–172; Tanaka and Nakamura 1973,
7:20–23; 7:61–62, 7:63

Shinagawa Yoichiro

The paper-ground folding screen appears to be a Japanese invention, and was the base for one of their most important contributions to art — a Japanese decorative style as distinctive as the European rococo. The Imperial gift placed in the Shōsō-in repository of Tōdai-ji, the Great Eastern Temple of Nara, in the year 756, included folding screens of court ladies and decorative screens with calligraphies. Narrative handscrolls of the Fujiwara period (897–1185) depict single-panel and folding screens with flower-and-bird motifs *(kachō)*, and the portrait of Retired Emperor Go-Shirakawa (1127–1192) shows a screen with *kachō* in a vaguely Song Chinese style. By the fifteenth century the pair of six-fold screens (later to become the canonical format) was relatively common, painted both by Tosa traditional artists and by "new wave" masters such as Shūbun, Sōami and Sesshū.

The subjects of these screens — clouds-water-flowers-birds from the Tosa traditionalists, land-scape from the innovating ink painters — were extensions of the traditional vocabulary used for hanging scrolls, handscrolls, and panels. Sesshū seems to have popularized a new category — daring compositions with dramatic, large-scale *kachō* motifs. These were based not on the Japanese courtly artistic tradition (Tosa and *yamato-e*) but on a Chinese repertory dating from the Song dynasty (960–1279) as well as from contemporary fifteenth-century Ming China. The Song paintings — small works by such artists as Li Anzhong and Ma Lin — could be seen in Japanese temple and *daimyō* collections; Sesshū had seen large-scale Ming works by the likes of Lü Ji, Yin Hong, and Lin Liang on their native ground, and they were also to be found in Japan in some of the larger Zen establishments.

An early pair of small paintings on silk of birds and flowers (now in the Perry collection, Cleveland, Ohio) reveals Sesshū experimenting with a richer and more strongly outlined approach to *kachō* subject matter. (The copy made by Kanō Tanyū in 1666 attests that this work was even then considered to be by Sesshū.) Expanding this to the large scale of the folding screen was an easy and logical development. Some five or six such pairs of screens attributed to Sesshū are known. None of them have reliable inscriptions or seals, and most have no inscriptions at all. But they share a style congruent with the pair of small paintings, and their brushwork is very close to Sesshū's. For example (as indicated by Shimizu in Washington 1988, cat. 88), *The Deified Michizane as Tenjin* of 1501 by Sesshū, now in the Okayama Prefectural Museum, has pine and plum elements markedly like the motifs in the flower-and-bird screens attributed to Sesshū. The attributions to Sesshū's hand are plausible, and at the very least it is certain that these screens came out of his studio-workshop. They are not only great decorative productions in their own right, they completely anticipate the remarkable achievement of Kanō Motonobu in the sixteenth century as well as much of the work of the great Momoyama period (1573–1615) decorators Kanō Eitoku and Kanō Sanraku.

The screens exhibited here display free and vigorous brushwork and deliberate roughness in the rendering of rocks and trees; they seem to this author more characteristic of Sesshū's later efforts than the more careful and overtly decorative effects of the other claimants to Sesshū's hand (the so-called Maeda and Masuda, or Ōhashi, screens). Summer begins at the right of screen one with full-blown tree peonies, followed to the left by the reeds and lotus leaves of early fall. Those dry reeds on the first screen herald the passage of fall into winter on the second screen, with the dormant plum tree and the camelia as harbingers of spring at the far left. Pine, bamboo, rock, and two cranes dominate screen one, prunus, geese, and bamboo the second screen; small birds serve as grace notes throughout. The startling juxtapositions of near, middle, and far distance resemble similarly sudden shifts in the master's most famous work, the *Long Scroll* of 1486. Our eyes are led along an abruptly zigzagging path from the close-up pine trunk and rock to the distant first crane and bamboo, then partway back to the second crane in middle distance and out again

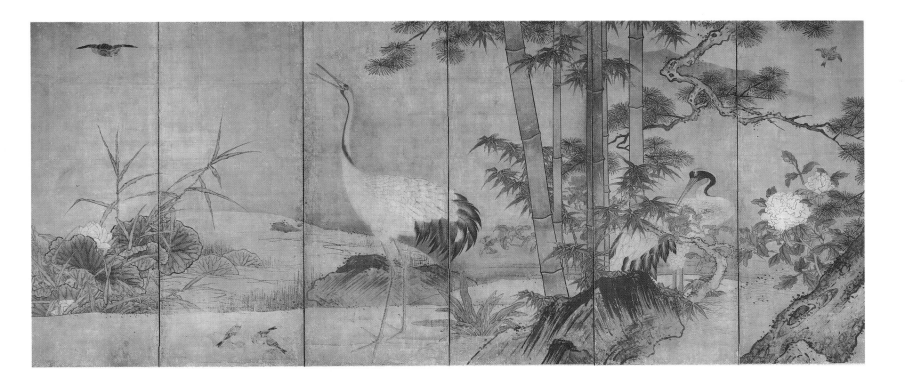

to the far-off reeds and lotus. In the second screen the foreground reeds, prunus, and grass hummock establish the distance of the far-away geese and the even farther snowy mountains. The design consequently does not appear flat and solely decorative, but maintains contact with reality through suggested space.

Patronage, particularly from the *daimyō* of the more powerful and remote provinces, helped greatly in establishing the popularity of large-scale *kachō* subjects. Such works afforded all the connotations desired by these rulers: references to China in the subject and the ink-painting medium; associations with Zen through the painter and the vibrant brushwork; manifestations of power in the large format with its potential for dramatic imagery. The present screens do begin to project visual manifestations of power. S.E.L.

234 ✌

Geiami
1431–1485

Viewing a Waterfall (Kambaku Zu)

dated to 1480
Japanese
hanging scroll; ink and color on paper
106 x 30.3 (41¾ x 13⅛)
inscriptions by Getsuō Shūkyō (d. 1500), Rampa Keishi (d. 1501), and Ōsen Keisan (1429–1493)

Nezu Art Museum, Tokyo

Viewing a Waterfall is the only painting that can be reliably attributed to Nōami's son Geiami, who was aesthetic adviser (*dōbōshū*) to the shogun and curator of the shogunal art collections. The work is valued as much for its documentary importance as for its aesthetic appeal. Three inscriptions, respectively by Getsuō Shūkyō, Rampa Keishi, and Ōsen Keisan, offer description and poetic observation and identify the figure as Li Bo, the celebrated Chinese poet of the Tang dynasty (618–907). Ōsen's inscription includes a brief account of the circumstances of the painting's creation. It was painted by Geiami and presented to his pupil Kenkō Shōkei (see cat. 235) on the occasion of Shōkei's departure for his home temple of Kenchō-ji in Kamakura after completing his period of tutelage in Kyoto. Ōsen was a renowned scholar of Chinese literature and one of the most prominent figures in the Sinophile literary culture centered around the major Zen monasteries (a cultural movement referred to as *Gozan bungaku*). Between 1472 and 1475 he accompanied

official Japanese embassies to Korea and to China. A "dedicatory" painting by the principal aesthetic advisor to the shogun, bearing an inscription by Ōsen, would have constituted a particularly prestigious "diploma with honors" for Shōkei.

Sōami succeeded Geiami as the last of the "three Ami" line of painters. Nōami (Shinnō, 1397–1471; see cat. 226) had adopted a byname incorporating the Ami suffix as a sign of devotion to *Ami*da, Buddha of the Western Paradise. This was relatively common practice among members of the Ji (Timely) sect founded by the charismatic monk Ippen Shōnin (1239–1289). Ippen had stressed the merit to be accrued toward salvation by simply repeating the name of Amida (the practice of *nembutsu*). This easy and useful routine appealed immensely to all classes, especially to workmen and artisans, among whom were included painters and sculptors. Nōami, his son Geiami (Shingei), and Sōami (also known as Shinsō, d. 1525) were major artistic figures, close to the shogunate and especially to the shogun Yoshimasa (1436–1490), whom they served as advisers in the arts of Nō drama, music, Chinese and Japanese poetry, garden design, and the emerging Tea Ceremony, and as connoisseurs of Chinese works of art, especially painting. Nōami's catalogue of the shogun's collection, *Gyomotsu On'e Mokuroku*, was a systematic inventory of more than ninety Chinese paintings of the Song and Yuan dynasties; while Sōami's *Kundaikan Sōchōki* added biographies of the artists and a complex ranking system, with ranks named for the levels of spiritual attainment in Amida's Western Paradise.

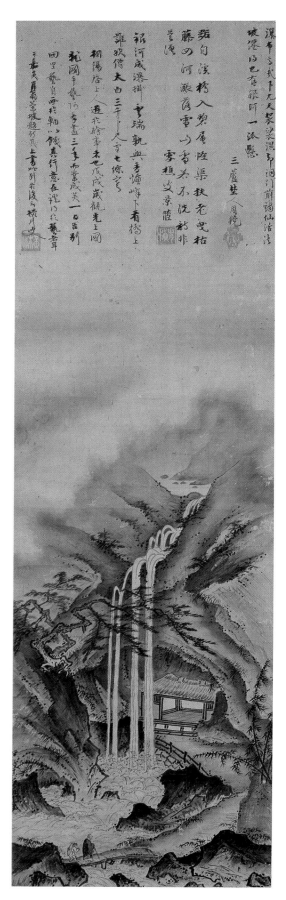

As painters, the Ami appear to have adopted a softer and less calligraphic linear mode of brushwork combined with ink wash, producing works quite different from their contemporaries Shūbun, Sesshū, and Kei Shoki. One of Nōami's few surviving works is a pair of screens with flower-and-bird subjects (cat. 226). It not only displays the softer Ami touch but shows a virtuosity unexpected in a convert. The effect is suggestive, evanescent, with an ink method well termed "boneless" (mo gu) by the Chinese. The derivation of the style can be easily demonstrated, especially if one consults the inventory of Sōami's *Kundaikan Sōchōki*. This includes paintings of the Eight Views of Xiao and Xiang by the great Chan abbot Mu Qi (Fa-Chang) of Hangzhou. Many of these are extant, and they are rendered in Mu Qi's characteristic broadly and swiftly brushed boneless ink washes — the ultimate in intuitive, almost abstract landscapes. Three paintings by Yu-Jian (act. 13th century), however, embody the most extreme and specialized forms of this suggestive boneless style; these are three landscapes from the Eight Views, *Mountain Village, Harvest Moon,* and *Returning Sails.*

The *Kambaku Zu* represents a theme of particular appeal to Chinese and Japanese Zen literati. Representations of a single figure, frequently with an attendant, approaching or contemplating a waterfall, were assumed to depict the renowned Tang poet Li Bo, and thereby to recall the poetry he composed on viewing the monumental waterfall at Mt. Lu in Jiangxi Province. Li Bo's poetry (along with that of his equal and contemporary Du Fu) exerted pervasive influence on the development of Japanese verse. A poetic spirit engaged by natural splendor and the purifying power of rushing water was an image of understandable appeal to Zen literati.

Geiami's waterfall emerges from a mist-shrouded upland lake, forms a series of arching cascades, and then plunges straight down to a foaming pool at the center of a grotto-like formation. Sheltered by overhanging rock is an empty viewing pavilion, which the two figures are approaching. The artist's sophisticated use of intersecting diagonal and circular constructions emphasizes the swirling pool at the base of the waterfall and allows the water — in all its protean manifestations — to be the "light-bearing" feature of the painting. Geiami's stylistic and compositional references are to the Chinese professional painters Ma Yuan and Xia Gui of Southern Song (1127–1279), but the characteristic Ma-Xia use of unarticulated but highly suggestive open space is here modified by the softly contoured clouds that were to become a trademark of the Ami painters.

For a work created as an encomium of Shōkei's artistic ability and a "certificate" of aesthetic transmission — as the occasion of its execution suggests — a mannered landscape in Ma-Xia style would have been the orthodox choice. J.U.

S.E.L.

235 🐍

Kenkō Shōkei
active c. 1478–1506

EIGHT VIEWS OF XIAO AND XIANG RIVERS

Japanese
album leaves; ink and slight color on paper
36.7 x 23.7 (14½ x 9⅜)
seal of the artist on each leaf
references: Matsushita 1974, 117–120; Princeton 1976, 186–193

Hakutsuru Art Museum, Kobe Prefecture

Shōkei's period of study with Geiami (cat. 234), from 1478 to 1480, gave him both a basic style and a broad knowledge of Chinese paintings in the shogunal collection curated by his mentor. A painting of the *Eight Views* listed in the shogunal catalogue (*Gyomotsu On'e Mokuroku*), was attributed to the Chinese Southern Song artist Xia Gui (c. 1180–c. 1220). Although that work may well have been Shōkei's direct inspiration, the brush language of this famous album is derived as much from Geiami as from Xia Gui, and reveals Shōkei's personal accent — sharp and abbreviated depiction, a strongly staccato pattern of dark dots representing moss or lichen, and a clear division between complex foreground and simple, overlapped mountain background. The artist's most characteristic trait is his twisting calligraphic rendering of the rock contours.

As early as the third century B.C. a Chinese poet had celebrated the beauty of the Xiao and Xiang rivers where they empty into Lake Dongting in Hunan Province. During the Northern Song dynasty (960–1127) the scenery of Xiao and Xiang emerged as a pictorial theme, attributed in the writings of the famous scholar-official Shen Gua (1029–1093) to the contemporary painter Song Di. In the Sinophile culture of Muromachi Japan the *Eight Views* became a favored theme, the Japanese renditions partly imagined, partly based on imported Chinese prototypes.

The Eight Views of Xiao and Xiang comprise the following individual scenes: *Night Rain on the Xiao and Xiang, Harvest Moon Over Dongting Lake, Evening Bell from a Temple in the Mist, Twilight over the Fishing Village, Returning Sails off a Distant Shore, Wild Geese Alighting on the Strand, Mountain Village in Clearing Mist,* and *Evening Snow on a Distant Mountain Horizon.* (During the Edo period [1615–1868] various scenic places of Japan, particularly Lake Biwa in Ōmi Province, were substituted for the unknown Lake Dongting, but the subjects of the Eight Views remained the same: *Night Rain, Harvest Moon,* etc.)

Shōkei was certainly the most important of the monochrome ink painters in the Kamakura region. If his style was formed in his first of two

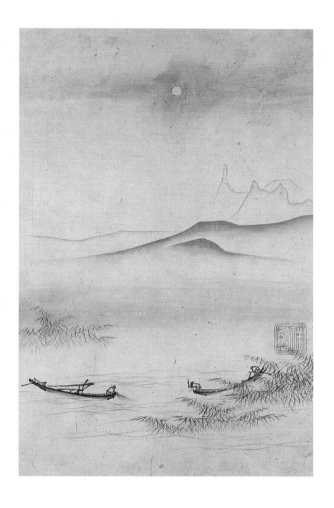

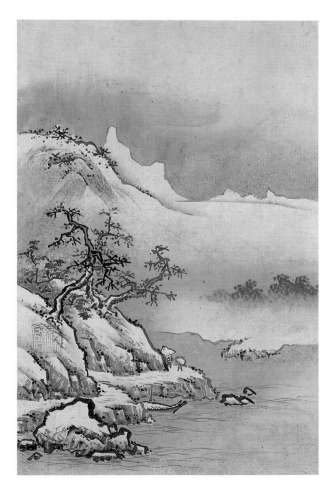

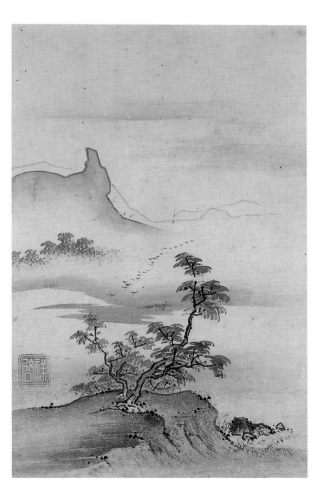

sojourns in Kyoto (the second being in 1493), it certainly was remarkably consistent through the time of his last dated painting, the *Shōshūsai Study* of 1506 (Ueno collection, Hyōgo Pref.). Efforts to define a "late" style influenced by the Shūbun school (cat. 228) have not been convincing, and the date of the Hakutsuru album is consequently not clear. It may well have been painted at the end of his first stay in Kyoto (1478–1480), but the independence of style clearly emerging in these eight leaves seems to point to a somewhat later date, perhaps closer to 1493, when he had returned to Kyoto better able to assimilate Xia Gui's *Eight Views* without falling into mere emulation. S.E.L.

236 ⅌

Kanō Motonobu
1476–1559

FLOWERS AND BIRDS OF THE FOUR SEASONS (SHIKI KACHŌ ZU)

c. 1510
Japanese
originally four (of a total composition of eight) sliding screens, now mounted as hanging scrolls; ink and color on paper
178 x 142 (70⅛ x 56)
references: Covell and Yamada 1974, 135–136; Matsushita 1974, 123–125; Princeton 1976, 212–217

Daisen-in, Daitoku-ji, Kyoto

If Sōami appeared as a low-key stylist and a knowledgeable connoisseur of Chinese painting, Kanō Motonobu burst on the Kyoto artistic scene as a bold decorator with a dazzling brush technique. Though his father, Kanō Masanobu (1434–1530), is traditionally credited with founding the Kanō school, which endured for some four hundred years, it was certainly Motonobu who established this most famous of all Japanese schools (or traditions) of painting. Motonobu was only about thirty-three when he was commissioned, along with his much younger brother Yukinobu, to paint sliding screens (*fusuma*) for the abbot's apartment at the Daisen-in. This established Motonobu's preeminence and his firm connection with the sources of patronage: the Imperial Household, the shogunal government (*bakufu*) and samurai aristocracy (*daimyō*), and the abbots of the major Zen temples. His marriage to a daughter of the painter Tosa Mitsunobu (cat. 212, 216) ensured his access both to the traditional Japanese *yamato-e* style and to the supporters of that style, the Imperial court. He was also a born executive, and the painting workshop that he organized provided a model for ambitious and busy artists of the future.

Motonobu's two sets of decorations for the Daisen-in comprise both the decorative *kachō* (flower-and-bird) genre and Zen figure-in-landscape subjects. The former were suitable for striking effects; the latter drew shrewdly on Chinese academic and court painting of Southern Song and Ming (cat. 291) along with the "New Style" of monochrome ink painting as practiced by Japanese predecessors of Motonobu.

The four panels shown here represent spring and summer. Originally on four sliding screens, now mounted as hanging scrolls, they are early statements of a compositional schema that became standard for Motonobu's Kanō successors. Reading from right to left, we find a near and understated theme of rock, flowering tree, bamboo, and birds, touching the top, right, and bottom frames. Then open space and the faint beginnings of distant hills and trees, with relatively near motifs of ducks and swallows. In the third panel the artist begins to build a wealth of foreground detail—rocks, peonies, pheasants, bamboo, and overhead a sparse pine branch. This latter, we finally see, comes from the large pine in the fourth panel, a heavily corrugated trunk running in a twisting reverse curve from lower right to upper left. On this major and dominant motif, strongly played against the vertical geometry of a decorative waterfall close behind the trunk, a noisy but minor note of three magpies and a single woodpecker closes the summer's carnival of birds. The individual elements may recall almost contemporary Chinese decorative specialists such as Yin Hong (cat. 292), but the heavy asymmetry and sharp, dark, and domineering brushwork are far more extreme than anything the Chinese would have permitted themselves.

Unquestionably these panels show the direct influence of *kachō* folding screens *(byōbu)* by Sesshū (such as cat. 233). A close relationship between Sesshū and Motonobu's father, Masanobu, is strongly supported by the persistent tradition that Sesshū was instrumental in having Masanobu substitute for himself in the decoration of Shogun Yoshimasa's Silver Pavilion (Ginkaku-ji). The knowing and exaggerated manipulation of a decorative style on large-scale panels was to be the foundation of Japanese painting design in the following Momoyama period. Motonobu's use of color is also daring and decorative, relying on rather solid flat areas of relatively pure azurite, malachite, and cinnabar. This he had almost certainly appropriated from the native *yamato-e* tradition of the Tosa school; the mixture of Tosa and Kanō style is clearly seen in his narrative handscroll *Legends of the Founding of Seiryō-ji (Seiryō-ji Engi)*. S.E.L.

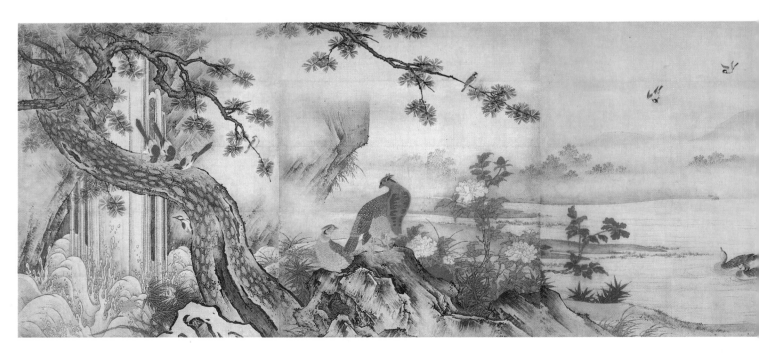

237

Emperor Go-Hanazono
1419–1470

SELECTIONS FROM THE TALE OF GENJI

c. 1460
Japanese
handscroll; ink on decorated "cloud" paper
(kumogami)
33.4 x 105.8 (13⅛ x 41⅝)

Daiō-ji, Kyoto (housed at Kyoto National Museum)

Fine calligraphy is the true topic of this fragment from what must have been a much longer handscroll or set of scrolls. The subject on which the writer exercised his skill was selected passages from the classic novel of Heian (794–1185) court life, the *Tale of Genji*.

The work is reasonably attributed to Emperor Go-Hanazono, the astute and learned but powerless sovereign who at the age of ten succeeded the childless Emperor Shōkō and reigned until 1465, when he abdicated in favor of his son Go-Tsuchimikado (see cat. 212). During his reign, central government virtually disintegrated, as the uneasy hegemony of the Ashikaga shoguns declined and real power devolved on the landed provincial barons at the head of their private armies. The Ōnin War (1467–1477)—a ferocious and ultimately pointless conflict between two such warlords—ravaged Kyoto in the last years of Go-Hanazono's life.

Deprived of all political power, Go-Hanazono, like many other court aristocrats of the period, pursued scholarly and artistic interests. These cultural pursuits might be considered "reactionary" in that they espoused Japanese classical literature and nativist painting and calligraphy styles, in contradistinction to the Sinophile leanings of the Ashikaga shogunal circle.

The passages here transcribed from Lady Murasaki's eleventh-century romance have as a common thread impossible or unrequited love. The first concerns Yūgiri, Prince Genji's son, who, rebuffed in his wooing of his best friend's widow, is brought close to tears by the combination of moonlight, the sound of rushing water, and the cry of a stag (Murasaki 1976, chap. 39, p. 681). In the second Prince Niou, Genji's womanizing grandson, speaks of braving snowy peaks in pursuit of his heart's desire (Murasaki 1976, chap. 51, p. 993).

The calligraphy is in the Chokuhitsu style, a rather affected hybrid derived in the fourteenth century from earlier Japanese aristocratic calligraphy styles. *Kumogami* (also called *uchigumori*, "pounded cloudiness") is a paper in which long fibers, dyed blue (and sometimes purple), are mixed into the pulp to create cloudlike patterns. On this ground a landscape with prominent willow, marsh plants, and bush clover was painted before the calligrapher set to work. In deliberately rustic fashion this paper evokes the elegantly decorated papers of the Heian and Kamakura (1185–1333) periods, and is a striking foil for the self-consciously refined calligraphy. J.U.

238

Ikkyū Sōjun
1394–1481

PRECEPTS OF THE SEVEN BUDDHAS

c. 1460–1465
Japanese
hanging scroll; ink on paper
133.8 x 41.6 (52⅝ x 16⅜)

Shinju-an, Daitoku-ji, Kyoto

"Do not commit evil deeds; strive to do good." These two precepts, each composed of four vertically written characters, are the first two of four similarly constructed verses. The latter two verses read: "Purify your thoughts—this is what the Buddhas teach." Together, the four verses constitute precept 183 of the *Dhammapāda*, an ancient and enormously popular compendium of basic Buddhist teachings which was translated from Pali into Chinese at least four times between the third and tenth century. Once translated into Japanese from Chinese, these verses were desig-

The calligraphy reads:
"Strive to do good."

nated the "Precepts of the Seven Buddhas" (J: *Shichibutsu tsūkaige*). They are frequently employed as an aphoristic distillation of Buddhist teaching not likely to be contradicted by any Buddhist sect.

A brusquely confident manner, suitable to the imperative or preceptive mode, is the essence of Ikkyū's style, and this work is widely regarded as his calligraphic masterpiece, although these aphorisms were cherished by Ikkyū and were brushed by him in other formats as well.

Widely regarded (though never formally acknowledged) as a son of the emperor Go-Komatsu (1377–1433), Ikkyū from the age of six was placed in various Zen temples under the tute-lage of distinguished teachers. Trained in the Rinzai Zen tradition, Ikkyū was throughout his life an acerbic critic of the Zen establishment, as well as wildly unconventional in his behavior. One may reasonably infer that his more insightful colleagues acknowledged the morals pointed by his eccentricities; the others were doubtless moved to tolerance by Ikkyū's connection with the imperial line. His links were always with Dai-toku-ji, where he held responsible positions as abbot of various subtemples, at the same time remaining the castigating outsider. Only in 1474, at the request of emperor Go-Tsuchimikado (r. 1465–1500), did Ikkyū—then eighty-one—assume the abbacy of Daitoku-ji, which had been destroyed during the Ōnin War (1467–1477). It was a sublimely ironic appointment: the inveter-ate critic of the religious establishment's worldly excesses was now head of a temple reduced to ashes. His investiture took place at a small retreat called Ummon-an in the port city of Sakai. Ikkyū's strong relationships with wealthy mer-chants in Sakai eventually elicited funding for the rebuilding of Daitoku-ji, and the work was in process when Ikkyū died, seated in meditation, in 1481.

Ikkyū bridled against any attempts to institu-tionalize Zen. In a climate which encouraged legitimization of spiritual insight and lineage through the presentation of certificates (*inka*) or portraits (*chinsō*) from master to disciple, Ikkyū noted in one of his final directives that he had never given an *inka* to any disciple. In pure Zen style he confounded the usual interpretation of the straightforward dictum shown here in his own hand: his true followers, Ikkyū said, would roam the forests, drinking and indulging the flesh, while false monks would teach pieties for their own profit.

Ikkyū's own writings are primarily verse, passionate, blunt, and often ironic—the irony expressing both deprecation and affection for human foibles and a quizzical mistrust for all human pretention. In spirit, tone, and intention his verses contravene the elegant ambiguities of court poetry. The very style of Ikkyū's calligraphy bespeaks his character and purpose. J.U.

Kōei
active 15th century

AMIDA

dated to 1472
wood with traces of polychromy
height 53.5 (21⅛)
references: Saunders 1960, 66–74, 85–93;
Fukuyama 1976, 151, chart opp. p. 153; Los Angeles
1984, 304–305

Robert H. Ellsworth collection, New York

In Japan from the eleventh century the most popular of the Buddhas was Amida, Buddha of the Western Paradise, to whom worshipers ascribed a signal and predominating mercy. Appearing alone or accompanied by his compassionate attendant bodhisattvas, Kannon and Seishi, Amida alone of all the Buddhas is often shown descending to wel-come the liberated soul, whom he escorts to his Western Paradise, or Pure Land (*Jōdo*). When seated, he was often shown with both hands in the gesture of meditation (J: *jō-in*; S: *dhyāna mudrā*), resting palms up in his lap. Here the hands are now missing, but from the position of the arms it seems certain he was making the ges-tures of consolation or appeasement (J: *an-i-in*; the same hand positions, called *vitarka mudra* in Sanskrit, signify in Indian Buddhist icons discus-sion or teaching).

When the image was recently dismantled for inspection and cleaning, an ink inscription was found inside the head at the back (a commonplace location, since the head was made in two pieces, the mask and the balance, leaving a reasonably large and flat surface for writing). The inscription reads as follows:

Carved by Unkei 9th on the 8th day of the 8th month, 4th year of Bummei [1472] at Daisan-ji of Yoshu, at Matsuyama, Shikoku. Carved by Kōei, *daiyū hōgen* [the second of three honor-ary ranks] of the Shichijō Bussho workshop. (Translation by Itoh Keita.)

This places the sculpture in a notable line of descent. The Shichijō (literally, "Seventh Ave-nue," in Kyoto) school originated with Jōchō (d. 1057), the most significant sculptor of the Late Heian period (897–1185). Jōchō's icons—graceful, serene, and mild, as exemplified in the *Amida* in the Phoenix Hall of the Byōdō-in—expressed a truly Japanese sculptural style. Jōchō is credited as well with perfecting the technique of joined woodblock construction (*yosegi zukuri*). In this method, which economized on wood and prevented checking, images were carved of many separate blocks of wood, split, hollowed out, and then joined. From Jōchō and his disciple Kakujo (d. 1077), reputed to be Jōchō's son, the famous Kei school is said to have descended, by filiation

perhaps personal as well as artistic. Of the Kei school sculptors, the greatest are considered to be Kaikei (active c. 1185–1223) and Unkei (active 1163–1223). The sculptor of this *Amida* claimed to be the ninth of Unkei's line.

The image was made for a temple no longer in existence, Daisan-ji, near Matsuyama on Shikoku. Until the fifteenth century this was an isolated locale, which would account for the conservative fashion of the image, whose conformation recalls the often massive proportions of Unkei's images. The inlaid crystal eyes are characteristic for images in this tradition from the early Kamakura period (1185–1333).

Observing the contrast in effect between this powerful yet benign image and the horrific *Datsueba* (cat. 240) is an effective lesson in the relation between iconographic purpose and the appearance of images. Both icons pertain to the Jōdo, or Pure Land, school of Buddhism, but one presides over the Western Paradise, a world of salvation and compassion, while the other prowls the River of the Three Currents (*Sanzu no Kawa*) at the gates of hell. S.E.L.

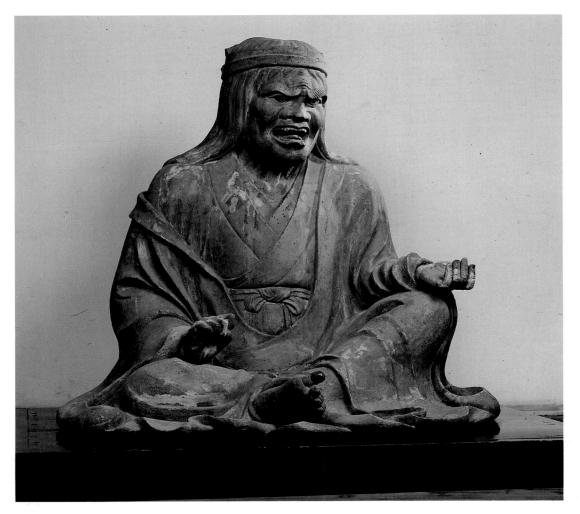

240 ᘐᕽ

Kōen
active 1480s–early 16th century
DATSUEBA

dated to 1514
Japanese
wood with traces of polychromy
height 91 (35⅞)

En'ō-ji, Kamakura

Datsueba is the demon-hag who acts as greeter to souls of the damned on the far side of the Sanzu River at the entrance to hell. This monstrous figure, clad only in loincloth, strips the newcomers, hanging their garments on a barren tree before they proceed to alloted punishments. The iconography of the Kings (or Judges) of Hell places Datsueba in the precinct of Shinkō-Ō, the judge of the first memorial day (the seventh day after death). Usually she is depicted as horned, claw-toed, and brandishing a club, her pendulous, sagging breasts providing the only hint of gender (see cat. 212).

It is all the more startling, therefore, to find this fiend now robed and seated apparently in the posture of meditation or prayer. The image succeeds in suggesting the power of Buddhism over all creatures—even demons—and in jarring the viewer from complacent stereotypes. Dated to the year 1514 (Eishō 11) and signed by the sculptor Kōen, this work displays the mannered and some-

what gothic interests of religious sculpture in the sixteenth century. There are other examples of Datsueba sculptures from the same period, showing her seated, as here, in prayer or meditation, but attired only in a loincloth.

Kōen's name is prominent from the 1480s, appearing in connection with a variety of restoration projects taking place in the Kantō region (the area around present-day Tokyo). He was probably the preeminent Buddhist sculptor of the period in eastern Japan.

From the seventh century the primary patronage of Buddhist sculpture had come from western Japan, particularly from temples in Nara and, later, Kyoto. These temples also commissioned the major restorations required after the ravages of civil war in the second half of the twelfth century. The force of the new "realism" developed at that time in western Japan by such influential artists as Unkei (act. c. 1163–1223) and Kaikei (act. c. 1185–1223) was also felt in eastern Japan. It proved well suited to the portrait sculpture emphasized in the Zen tradition brought in the thirteenth century by Chinese refugees from the Mongol invasion. These Chinese immigrants, moreover, brought with them the trends and styles of late Song (960–1279) and Yuan dynasty (1279–1368) painting, and it has been suggested that painting also played a part in the development of a distinctive Kamakura, or eastern Japanese, sculptural style. Surely the bizarre subject matter of the Datsueba sculpture emerged from painted sources, and in style it clearly parodies the Zen portrait-sculpture tradition.　　J.U.

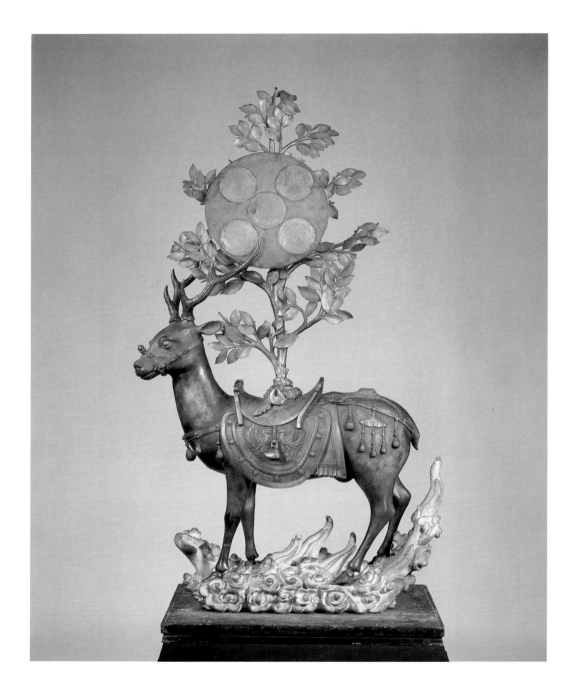

241 ⧼

Deer Bearing Sacred Mirror with Symbols of the Five Kasuga Honji-Butsu

15th century
Japanese
gilt bronze
height 105.3 (41½); diameter of mirror 23.5 (9¼)

Hosomi Minoru, Osaka
Important Cultural Property

In 710, when the imperial court moved to Nara, the Fujiwara family was already firmly established in power as advisors and ministers to the royal line. In the preceding century Nakatomi no Kamatari (614–669) had skillfully served a series of emperors and in 669 was awarded the family name of Fujiwara.

The Nakatomi clan, originally from Kawachi Province to the east of present-day Osaka, reverenced as tutelary deities Ame no Koyane no Mikoto and his female consort Himegami. When the court—including the Fujiwara—settled at Nara in 710, these divine protectors were moved to a Nara site; Mt. Mikasa, to the east of the city and long regarded locally as a sacred place, was chosen. In addition, two more guardian deities, Futsunushi no Mikoto of Katori (present-day Ibaraki Pref.) and Takemikazuchi no Mikoto of Kashima (present-day Chiba Pref.), were adopted. These latter two are understood originally to have been guardian or warrior spirits instrumental in the pacification of clans in the eastern provinces.

During the Jingo-keiun era (767–770) the Kasuga Shrine of the Fujiwara family was erected at the foot of Mt. Mikasa and the four deities were installed there. Later a fifth deity, known as Kasuga Wakamiya and depicted as a youth, was added to the group. The *wakamiya* figure occurs among the Shinto deities of many locales, and may be understood as an offspring of the senior deities of a particular sacred place. Unlike the *wakamiya* of other cults, the Kasuga Wakamiya is thought to spring from local mountain deities who antedated the establishment of the shrine. Deer too are prominent in the wide range of Kasuga-related iconography, in general because they were conceived to be auspicious divine messengers, in particular because a white deer bore Takemikazuchi no Mikoto to Mt. Mikasa from the eastern provinces.

The gilt bronze figure seen here was likely created for a family shrine. Its iconography is fraught with symbols of the linked Buddhist and Shinto cosmologies (*honji-suijaku*) specific to the cult of the Kasuga Shrine. On the deer's saddle stands a *sakaki* (*Cleyera japonica*) branch, and centered in the branch a sacred mirror to which are affixed five smaller circular plaques, each with an incised image of a Buddhist deity. The *sakaki* and mirror figure centrally in the Japanese creation narrative. Amaterasu Ōmikami, the Sun Goddess, retreated to a cave in anger over the misbehavior of her brother Susano-o, thus depriving the world of light. She was eventually lured out again by the sight of a mirror, jewel, and sword suspended from a *sakaki* branch and dangled at the cave's entrance. The *sakaki* is used in ceremonial invocation of indigenous gods, and the deer is here intended to bespeak the presence of Takemikazuchi no Mikoto. The mirror refers to Amaterasu and to her infliction of darkness and restoration of light; additionally, it is also a *mishōtai*, a mirror incised with Buddhist imagery, in this case images of the five Buddhist deities (*honji-butsu*) correspondent to the five tutelary Shinto deities of Kasuga Shrine. Use of the sacred mirror in this fashion became prominent from the eleventh century, when the syncretic *honji-suijaku* theory established systematic iconographic relationships between Buddhist and Shinto deities, with the latter identified as native Japanese manifestations (*suijaku*) of the former (*honji*). In the Kasuga cult the bodhisattva Jizō corresponds to Ame no Koyane no Mikoto, Jūichimen Kannon to Himegami, Fukūkenjaku Kannon or Shaka Nyorai (Śākyamuni Buddha) to Takemikazuchi no Mikoto, Yakushi Nyorai (Buddha of Healing) to Futsunishi no Mikoto, and the bodhisattva Monju to Kasuga Wakamiya.

For this unusually large image the mirror, branch, antlers, and body were all separately cast. The deer stands on a stylized cloud formation constructed of wood covered by gesso and paint. The cloud evokes Buddhist *raigō* imagery (in which the compassionate Amida descends on a cloud to receive the soul of the deceased); its allusion to a deity in transit was most likely borrowed to refer also to Takemikazuchi no Mikoto's passage from Kashima to Nara. Paintings of mirror-bearing deer are numerous, but this masterfully crafted sculpture is unique in scale and precision.

J.U.

242 &

GUARDIAN LION-DOG (KOMA INU)

c. 1500
Japanese
Seto ware
height 19.7 (7¾)

Aichi Prefectural Ceramic Museum, Seto city

Paired male and female lion-dog guardians (also known as *kara-shishi*, Chinese lions) became common at the entrances to Shinto shrines from the thirteenth century. Two stone lions almost seven feet high, made by Chinese artisans and installed at Tōdai-ji, the Great Eastern Temple of Nara, in 1196, gave impetus to this practice. In China the use of such guardian animals dates from the Eastern Han dynasty (A.D. 25–220), and the type can be traced back to Mesopotamia, whence it was assimilated into Buddhist iconography, appearing on the bases of Buddhist sculptures from Gandhara.

In Japan, which lacked suitable stone, wood was the preferred sculptural medium, and the understanding and mastery of wood carving became second nature to the Japanese sculptor. Since *koma inu*, as gate guardians, were placed outdoors, and wood tended to deteriorate rapidly when exposed to the elements, the sculptures needed frequent replacement. At smaller wayside shrines wooden *koma inu* gave way to glazed stoneware. In its ceramic form the *koma inu* occurs only in Japan, where it has come to be associated with petition and thanksgiving.

Such ceramic sculptures were an early specialty of the Seto kilns, near Nagoya, and numerous examples exist, the earlier ones generally quite lionlike, the later ones tending to a more doggy appearance. Often, as with temple guardian figures in human form, one of the pair has its mouth open, the other closed—referring to *a* and *un*, the first and last letters of the Sanskrit alphabet. The earliest dated sherd of such a figure was made in 1324, but it is assumed that ceramic *koma inu* were produced from the thirteenth century through the sixteenth.

The present *koma inu* is a sly, compact rendition of the subject, with an even, straw-colored glaze often found on Seto ware of the Muromachi period (1333–1573). Its mouth is firmly closed.

S.E.L.

243 not in exhibition

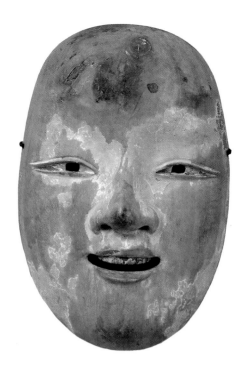
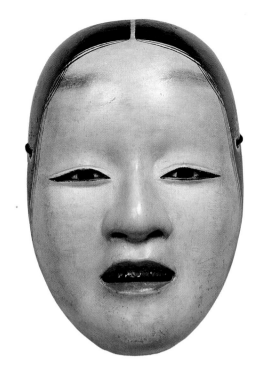
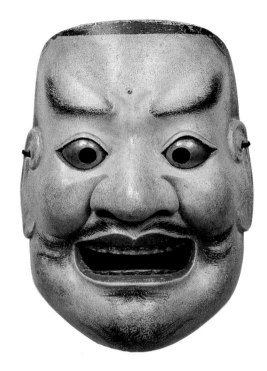

244 ✍

Nō Mask: Waka Onna

Muromachi period (1333–1573)
Japanese
polychromed wood
21.3 x 13.6 (8½ x 5⅜)

Suwasuzuki Shrine, Fukui Prefecture

Variously identified as a young woman, a middle-aged woman, or a madwoman, this mask reveals the youthful contours and vitality of typical young woman masks. Older woman (*shakumi*) masks are often lean and wan, with bone structure prominent and youthful plumpness nowhere apparent. The hair was parted in the middle, probably with three strands framing the face. Catlike eyes, partly closed, seem at once dreamy and intense. In the *waka onna* masks, the lips are parted, and their expression is firm. Overall, the image suggests a confident youth and beauty. The loss of pigment on this particular mask further contributes to an impression of ambivalence.

On the inside of the mask is an inscription reading *Inari Miya*, an alternate name for the Suwasuzuki Shrine.

245 ✍

Nō Mask: Zō Onna

Muromachi period (1333–1573)
Japanese
polychromed wood
21 x 13 (8¼ x 5⅛)

Mitsui Bunko, Tokyo

Like the *waka onna* mask (see cat. 244), the *zō onna* represents a woman, but one of "a certain age." The points of resemblance and contrast between the two are instructive. Here the corners of the mouth are horizontal, not upturned as in young woman masks; the eyes are placed two-thirds the distance from the bottom to the top of the mask, whereas in the masks of younger women they tend to be slightly lower and might be described as downcast; the curve of the carved eyes is gentler than in the masks of young women. But in place of the *shakumi* mask's suggestion of melancholy, even distraction, the countenance of this *zō onna* is reserved, dignified, elegant, and suffused with a calm, passionless, eerie beauty, ideally suited to the goddess roles for which it is most often worn.

It is not, however, exclusive to divinities. The *zō onna* character is prominent, for example, in the *Nō* play *Teika*, an elaborately fictionalized romance between the renowned courtier-poet Fujiwara Teika (1162–1241) and Princess Shokushi (d. 1201), whose superb and passionate poems of love lent themselves to autobiographical interpretation.

The term *zō onna* is said to derive from the name of Zōami (c. 1400), a master *dengaku* performer and respected contemporary of the great *Nō* actor-playwright Zeami, but the nature of the connection between Zōami and the *zō onna* type is unclear. J.U.

246 ✍

Nō Mask: Tenjin

Muromachi period (1333–1573)
Japanese
polychromed wood
23 x 15 (9 x 6)

Mitsui Bunko, Tokyo

Buddhist iconography offers a variety of guardian figures, stern and frightening in appearance, who might easily be misconstrued by the uninitiated as demonic. This mask, too, is one of a class of fierce-featured supernatural beings sometimes misleadingly referred to as demons (*oni*). Contemporaneous documentation notes that the master carver Shakuzuru of Ōmi Province (present-day Shiga Pref.), who specialized in demon masks, was also commissioned to create *tenjin* visages. The rendering of both benevolent and harmful spirits required similar skills.

The emergence of the *tenjin* (heavenly being) role or character within the *Nō* drama repertoire has been associated with the innovations of

Kan'ami (1333–1384), Zeami's father. The *tenjin* appears as a benevolent spirit in the play *Kinsatsu*, and in *Tamura* as a manifestation of Sakanoue no Tamuramaro (758–811), a military hero associated with the founding of Kiyomizu Temple in Kyoto (see cat. 217). In yet other plays the mask represents the justly vengeful spirit of Sugawara no Michizane (845–903), the slandered scholar-statesman who died in exile from the court, a victim of political intrigue.

The highly stylized features and coloration of this mask, including the gilding of the bulging eyes, convey an otherworldly aspect, but the image was surely based on a nobleman of middle years. J.U.

247 �

Lion Mask

dated to 1485
Japanese
polychromed wood
approx. 40 x 60 (15³⁄₄ x 23⁵⁄₈)

Kuromori Shrine, Iwate Prefecture

In Japan lions were unknown outside Buddhist iconography, and depictions of them were flights of fancy based on images from China and Korea, where lions were likewise unknown. Among several dozen dated lion masks produced from the mid-fourteenth through the early seventeenth century is this one from Kuromori Shrine. The mask is constructed according to a stylistic formula characteristic of fifteenth-century interpretations of the beast. Articulated from a series of fleshy, rounded components, the features are designed to emphasize the wide and fiercely focused eyes. The prowlike upper mouth and bulbous snout jut menacingly, the nose slopes into the face. An overhanging continuous eyebrow line completes the cavernous frame for the eyes. The lower jaw is a separate unit attached at either side near the rear of the head; this lower element also serves as a rectangular base for the mask. The teeth somewhat resemble round-cornered stone tablets. A curling upper lip reveals stylized incisors, of architectonic rather than carnivorous function.

The lion dance (J: *shishi mai*) was probably first introduced to Japan by Koreans in the early seventh century as one element in the repertory of *Gigaku*, a kind of religious mime originated in China and enacted by masked performers. The masks generally depicted grotesquely or comically exaggerated human faces, perhaps caricatures of Indian or Central Asian facial types. The *Gigaku* lion form required two performers, concealed under a large drape: one wore the mask and

served as the forelegs, the other comprised the hindquarters and rear legs. The *shishi* was also prominent in other imported dance forms.

The *Gigaku shishi* was quickly adapted to a variety of masked dance forms performed from early times at Shinto shrines and grouped under the general heading *Kagura* (gods' music). Pre-Buddhist forms of religious dance were intended primarily to ensure fertility and exorcise evil. Shamanistic dancing seems to have included the exorcistic features as well as rhythmic repetition to induce trance or ecstasy. The earliest of recorded Japanese myths refers to dance as a form of seducing or pleasing the gods (see cat. 241).

The dedication in 752 of the Great Buddha sculpture (*Daibutsu*) at Tōdai-ji in Nara marked the high point of early Japanese assimilation of continental culture and of early Japanese admiration for Tang Chinese aesthetics and political principles. Religious dances and processions attendant to that watershed celebration displayed the wide variety of Asian dances imported to Japan. Virtually all of the imported dances contained the *shishi mai*, or lion dance. *Gigaku* masks from that time preserved in the Shōsō-in repository of Tōdai-ji include lion masks. The Tōdai-ji lion mask type, from the eighth century, has some of the blockish features seen in fifteenth-century types, but the earlier style and construction were directed more toward ingenious mechanical effects, such as a movable tongue and metal sheaths on the teeth to produce a distinctive sound when the mouth was snapped shut. Ears were separate pointed elements attached to the

head. A Hōryū-ji type has been distinguished from the Tōdai-ji masks by its greater linearity, more reminiscent of dog or wolf features. These two early types emphasize animation achieved through fierce features and movable parts. The later lion masks, as typified by this one from Kuromori Shrine, have fewer moving parts; they were intended more as awesome sculptures than as "dramatis personae."

The use of these masks, and the lion dance, are recorded in various narrative scroll-paintings, most notably the twelfth-century *Shinzei Kokaku Zu* (Shinzei's Illustrations of Ancient Music). Other works depict the *shishi mai* as part of larger processions and also, in later times, as an independent street entertainment.

So popular was the *shishi mai* that it was incorporated into many forms of dance and theater: some *Nō* performances incorporated it as an interlude. One reason for its wide adoption may be its exorcistic nature: its rhythmic and incantational aspects clearly complemented both indigenous cult practices and certain Buddhist rituals. The advent of populist strains of Buddhism in the Kamakura period (1185–1333) familiarized the Japanese with *odori nembutsu*, a rhythmic dance of repetitive foot movements and sung or chanted prayer formulas. It has been suggested that a growing popular use of incantational dance in Buddhism made the rhythms of the *shishi mai* all the more appreciated.

Another type of dance, called *shishi odori*, involved a dancer costumed with a deer headdress. It was performed in late summer and autumn as

a rite of protection against evil spirits, and seems to have been most strongly rooted in northeastern Honshu. Many lion masks—like this one from Kuromori Shrine—have been found in this region, suggesting that this imported continental form found particularly sympathetic acceptance where certain native animistic practices were most prevalent. J.U.

248 ஃ

COSMETIC BOX (TEBAKO)

16th century
Japanese
lacquer on wood (?) with engraved and
gilt decoration
length 38.4 (15⅛), width 24.6 (9¾), height 25.5 (10)

Shirayamahime Shrine, Ishikawa Prefecture

Although made in Japan, this stately rectangular container with gilt inlay design is faithful to its Chinese stylistic origins. The decorative technique of incising hairline designs in lacquer, then filling the incised lines with gold dust over wet lacquer as adhesive, was called "inlaid gold" (C: *qiangjin;* J: *chinkin*). It was perfected in China during the Southern Song period (1127–1279) and known in Japan from the latter part of the Muromachi period (1333–1573). In general, the Japanese adopted the technique quite faithfully but employed it on distinctively Japanese designs. In this box, however, rather typical Chinese design

elements of phoenix, peony, and chrysanthemum—auspicious symbols all—are seen.

On each side of the box is an applied panel, adding a slight dimensionality to each surface. The top is a gently domed rectangle with a narrow flat border around all four sides. The side panels likewise allow for indented borders, which frame the decoration. This architectonic style contrasts with the soft and curving shapes so prominent in Japanese containers dating from the Heian period (794–1185). The decorative program is not unlike the roughly contemporaneous *kinrande* ceramic style, created in China for the export market and particularly cherished by the Japanese. *Kinrande* wares employed typically Chinese motifs on rather elaborate shapes such as ewers, and the decoration was often organized into medallions or panels.

Although this box is described as a cosmetic box (*tebako*), other containers of this general style have been used to hold sutras. J.U.

249 ஃ

LACQUERWARE INKSTONE CASE (SUZURIBAKO)

16th century
Japanese
lacquer on wood (?) with design in sprinkled gold
and inlaid metals
22.2 x 20.7 x 4.1 (8¾ x 8⅛ x 1⅝)

Kyoto National Museum

The shrine at Sumiyoshi, its precincts now enclosed in a public park within present-day Osaka city, was long held to be the abode of the God of Poetry. Sumiyoshi (also called Suminoe) was distinguished by its beautiful beach, pine trees, and a view of Awaji Island offshore in the Inland Sea. Countless Japanese poems invoke as muse the Sumiyoshi deity, whose physical manifestation is a particular pine tree within the precinct of the shrine. Poets also went on pilgrimage to Sumiyoshi, as numerous poems relate.

To decorate an inkstone case (*suzuribako*), therefore, Sumiyoshi is an appropriate subject, calling attention to the high purpose of the implements contained within. The complex landscape also allows for use of several lacquer decorative techniques. As with most *suzuribako*, the lid is decorated inside and out, and the two surfaces are closely related in theme. On this *suzuribako* the lid exterior and interior depict the same subject as well: an elaborately conceived and specific landscape. A rocky shore line with pine trees, a portion of a large building, and the moon are the central features of the lid exterior. The interior of the lid continues the landscape, providing further recognizable features of Sumiyoshi environs. In the foreground are wind-battered pines and, more prosaically, an oven for extracting salt from brine (*shiogama*). In the middle ground is the distinctive barrel-vault bridge connecting the shore with a small island containing the shrine proper and the sacred pine. The mountain silhouette of Awaji, seen in the distant mists, is rendered in a burnished red-gold color. Like the famous inkstone case "Hana no Shirakawa," this one bears characters referring to a poem, but here they are on the inside of the lid and written in *kana*, the cursive form of phonetic syllabary that the Japanese developed from Chinese characters. Here, in *kana*, are the words *Sumiyoshi, pine tree, year,* and *cry,* conjuring a poem by the Late Heian poet Minamoto no Yorimasa (1104–1180).

For the background of the designs, tiny irregularly shaped gold particles were suspended in translucent lacquer, an effect called *nashi-ji* after the speckled skin of the *nashi* pear. The lacquer used on this piece is amber toned. Certain design

elements were executed in slight relief, built up with layers of lacquer, possibly mixed with other materials, before being sprinkled with metallic powder. This technique, called *takamaki-e* (relief sprinkled picture) makes the design subtly three-dimensional. J.U.

250 🐎

LACQUERWARE FOOTED TRAY (RINKA BON)

dated to 1455
Japanese
*red over black lacquer on wood (*negoro-nuri*)*
height 11 (4⅜); diameter 49.5 (19½)

Saidai-ji, Nara

This generously proportioned tray (*bon*) is of a type popularly named *rinka* (ring of flowers) for the petal-like fluting of its rim and foot. An inscription on the underside, dated to lunar New Year's Day of 1455, indicates that it was made for use at Saidai-ji. A very similar tray, differing only fractionally in size from the Saidai-ji tray and almost identically inscribed, is now in the collection of the Tokiwayama Bunko (Kanagawa). On the latter is an additional phrase indicating that the tray is one of a pair; the Saidai-ji tray lacks this phrase but bears an erasure that may have deleted those words from the inscription.

A red lacquer surface worn through in places to reveal an undercoating of black lacquer is characteristic of *negoro* ware, although solid black and solid red pieces, as well as some transparent-lacquered ones, are also known. The name derives from Negoro-ji (Wakayama Pref.), where this type of lacquerware is said to have appeared first, some time in the thirteenth century. The softly shaded red-to-black surface created by long use was highly prized, and in later years artificially rendered. In shape the *negoro* wares emulated contemporaneous Chinese lacquers, which were greatly prized in the late Kamakura (1185–1333) and Muromachi (1333–1573) periods by the military aristocracy and the Zen establishment.

The function of such a large, sturdy tray is revealed by genre details in several well-known narrative scroll-paintings. In the *Boki Ekotoba* (mid-14th century) such a tray is in use in a large monastery; in the pungently satirical *Fukutomi-zoshi* (early 15th century) it is one of the appointments in the home of a nouveau riche commoner. In both instances the large tray holds the smaller lacquerware cup stands into which conical ceramic tea bowls were set. These were usually imported Chinese *jian* ware (J: *temmoku*), black or black-brown glazed, sometimes with the prized streaked or spotted effect in the glaze and often bound

with silver at the lip. A bamboo tea whisk is also seen on the trays. These paintings amply attest the rage for the "Chinese style" among Japanese of the Muromachi period. Chinese ceramics were treasured, and their import was an important source of income for some Buddhist monasteries.

Saidai-ji, founded in the mid-eighth century, has had a long association with tea. Moribund by the thirteenth century, it was revived by the noted monk Eizon (or Eison, 1201–1290), who arrived at the temple in 1238. Among his many pragmatic reforms Eizon encouraged the cultivation of tea and preached its restorative spiritual and physical powers. He was not the first to have proclaimed the virtues of tea: in the preceding century the Japanese monk Eisai (1141–1215) returned from China, bringing with him the teachings of Rinzai Zen and tea seeds of a variety judged to be superior to the indigenous type. The ritualized preparation and drinking of tea had long been a part of Chinese Chan (Zen) monastic life. Proselytizers such as Eisai and Eizon incorporated the element of tea into a populist Buddhism which extended beyond the monastic communities.

The Saidai-ji *rinka bon* is one of the preeminent pieces of medieval Japanese lacquer. Like many other extant works of that period, it was created as an implement for the serving of tea. The underside inscription, the commanding physical presence of the tray, and its state of preservation suggest that it was highly regarded, even from the time of its manufacture. By the close of the sixteenth century practitioners of the Tea Ceremony had formulated an aesthetic that further singled out for admiration the qualities of unassuming elegance and gentle aging which characterize this tray. J.U.

251 🐎

LACQUERWARE EWER (YUTŌ)

c. 1480
Japanese
red over black lacquer on wood
36 x 35 (14⅛ x 13¾)

Suntory Museum of Art, Tokyo

This vessel served as a container for hot water used in the preparation of tea. Modeled after Chinese prototypes brought to Japan by immigrant Chinese Chan (Zen) monks or by Japanese Zen monks returning from study in China, this ewer and others like it show a strong yet unpretentious design, suitable for use in a Zen environment. The coloring of cinnabar red lacquer

applied over a base of black lacquer is called *negoro-nuri*, after Negori-ji, the temple in present-day Wakayama Prefecture, which was thought to have been the center of production for this ware from the thirteenth century (see cat. 250). A variety of vessels, trays, and tables were produced using this technique.

While maintaining a consistently recognizable profile, Negoro ewers exhibit a variety of styles, ranging from attenuated shapes with fairly complex design schemes to the simple and robust example seen here. The bail handle is typical of Negoro ware vessels: it rises in two curved segments from the shoulder of the vessel to a strongly horizontal uppermost transverse which effectively echoes the predominant horizontality of body and lid. Thin circumference bands on the lid and body are reserved in black, as are the lid knob and the foot. Variations in the basic *negoro* ewer style typically consist of decorative flourishes where the handle joins the body and on the spout, both at the lip and at the point of join with the body. Bodies are also seen with multiple horizontal ribbing lines or with a wide circumference band of visible wood grain covered by translucent lacquer. The triangular foot is also common. This ewer has a slightly raised circular base.　　　　　　　　　　J.U.

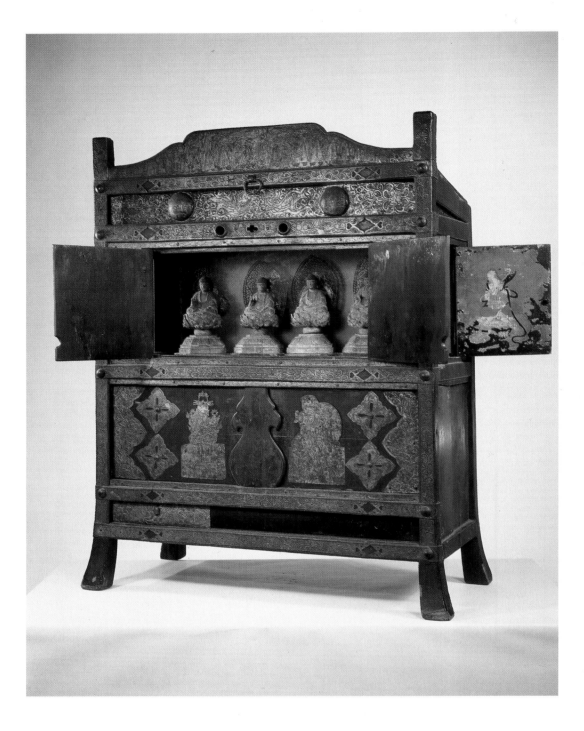

252 ༄

Portable Shrine (*Oi*)

15th century
Japanese
wood with gilt bronze and painted decoration
height 79.2 (31¼)

Matsuo-dera, Nara

Shugendō refers to a regime of asceticism practiced in Japan from at least Early Heian (794–897) times. Its followers were called *yamabushi* (literally, "one who lies in the mountains"). Their disciplined journeys into designated "sacred" mountains were intended to facilitate spiritual rebirth as well as confer the gifts of healing, exorcism, and other thaumaturgic powers. Various forms of mountain faith (*sangaku shinkō*) surely were manifested in pre-Buddhist Japan. Mountains, or certain mountains, were numinous sites. Their rugged profiles asserted physical realities and symbolized spiritual realities. Notions of arduous training, ascent, and descent, as well as more complex understandings of the mountain as womb, all figured into the metaphor of the mountain as the site of spiritual transformation of the seeker. It has been suggested that the early Japanese forms of this spiritual phenomenon

reflected elements of Siberian shamanistic practice. When Buddhism arrived in Japan from the continent, particularly the Esoteric teachings of the Tendai and Shingon sects proved sympathetic to the "mountain faith" and eventually assimilated its practices. Imagery and iconography of Buddhism as well as specific ritual implements were incorporated into the *yamabushi*'s accouterments. Many of these implements, including small Buddhist statues and sutras, were transported in a portable altar or carrying case called an *oi*. *Ita oi* and *hako oi* are the two principal categories or types of these carrying cases.

Early sources define the *oi* by their users rather than by their forms, and employ a somewhat dif-

ferent terminology: the *fuchi oi* was used by advanced practitioners or teachers, the *yoko oi* by novices. It has been suggested that perhaps the *fuchi oi* was comparable to the *ita oi*, and the *yoko oi* to the *hako oi*, but this remains a speculation. The *ita oi* somewhat resembles a modern backpack, with a decorated textile bag attached to or suspended within a frame formed of an unpainted tree branch curved into horseshoe shape. The bag is secured to the curve of the branch, whose two ends form the legs of the *oi*. *Ita oi* are depicted in charming detail in such early narrative handscrolls as *Ippen Shōnin Eden* (*Illustrated Biography of the Monk Ippen*, 1299) and *Saigyō Monogatari Ekotoba* (*Illustrated Biography of*

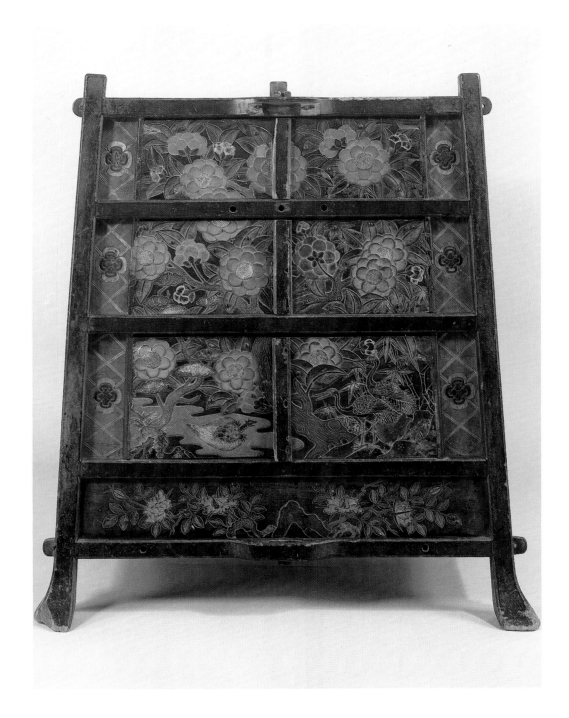

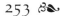 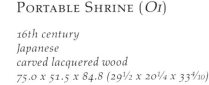
PORTABLE SHRINE (*Oi*)

16th century
Japanese
carved lacquered wood
75.0 x 51.5 x 84.8 (29½ x 20¼ x 33⁴/₁₀)

Chūson-ji, Iwate Prefecture

Shugendō monks used this three-legged type of carrying case as a kind of backpack for the transport of Buddhist sutras and ritual implements. Its face—the outward, visible surface when carried on the back—was usually elaborately decorated. Here a comprehensive and fantastic landscape is dominated by a camelia bush. At the base of the camelia, literally and figuratively overshadowed by it, are symbols of pine, cranes, and a turtle, all alluding to long life or immortality. These emblems of longevity are mutually consistent in scale, but all are dwarfed by the camelia. Other design elements include a quince pattern and a rose-like flower pattern. The doors are vertically hinged.

These raised decorative elements were rendered by the *Kamakura bori* technique, a simpler, less time-consuming, and hence less costly version of the Chinese carved lacquer process, devised to meet the Japanese demand for objects in the "Chinese taste." Chinese carved lacquers were created by the infinitely painstaking process of coating a wooden form with multiple thin layers of lacquer, sometimes in several colors, then carving through the layers to precise depths to produce the design. In the *Kamakura bori* technique, known from about the fifteenth century, the carving was done in the wood itself and lacquer was then applied over the carved decoration. Here the tinted lacquers make up a color scheme called *kōka-ryokuyō* (red flower–green leaves). The inside of the *Oi* also is decorated. *Oi* with *Kamakura bori* decoration were particularly popular in northeastern Japan, in areas such as Iwate, the source of the work seen here. J.U.

the Monk Saigyō, 13th century).

The *hako oi*—*hako* meaning "box," or "chest" —is of two types: a four-legged wooden case, or box, with decorative metal fittings, and a three-legged version decorated with lacquer (see cat. 253). The *oi* from Matsuo-dera, shown here, is four-legged; some of its gilt bronze fittings are purely decorative, others, such as the pagoda or the Wheel of the Law, symbolic of Buddhism. Upper doors open to reveal a shelf holding five seated Buddhist statues. Side panels at the same level open outward to reveal paintings. Decorating the lower shelf, which contains other religious implements, are gilt bronze appliqués of Monju, Bodhisattva of Wisdom, on the left and

Daikoku-ten, God of Plenty, on the right.

On early bronze-decorated *oi* the metal is thick and the designs are comparatively simple. Later examples exhibit more thinly cut and elaborately detailed metal work. J.U.

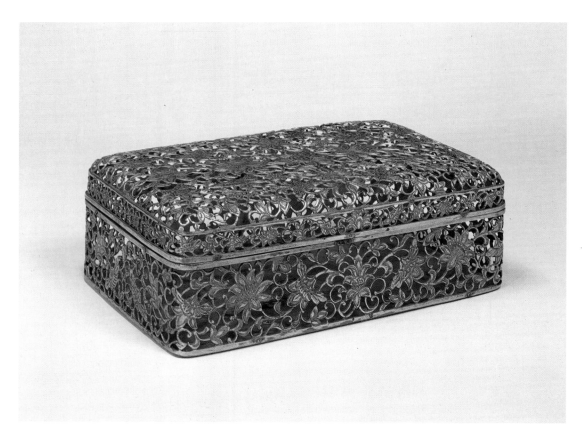

faithful copy of earlier, lost, *kyōbako*. A running arabesque of lotus and tendrils ornaments the sides of the box. On the lid a central, formal lotus design, seen from above, is flanked by two lotuses in side view, and then two more fanciful and simplified lotus motifs. The technique is excellent, but the motifs are rendered with less relief than is found in the thirteenth-century flower trays from Jinshō-ji. The lotus refers, of course, to the Lotus Sutra that was originally contained within the luxurious box. S.E.L.

254 ❧

SUTRA CONTAINER (KYŌBAKO)

dated to 1555
Japanese
ajouré gilt bronze
length 30.6 (12), width 19.1 (7½), height 10.9 (4¼)
references: Nara 1979, 155

Yōhō-ji, Kyoto

According to the inscription on a copper sheet on the bottom of this sutra box, Lord Narita Naga-hiro presented Yōhō-ji in 1555 with an eight-roll set of the Lotus Sutra (*Hoke-kyō*), which was placed in this gilt bronze container. The sutra is the principal text for the Tendai sect and also important for Jōdo (Pure Land Buddhism), the cult of Amida and the Western Paradise, which became especially popular beginning in the early eleventh century. It was an act of piety to copy the text, or to commission a copy, preferably in gold and/or silver calligraphy on deep blue or purple paper.

Earlier sutra containers exist: one, made to hold a single roll and dated to the thirteenth century, is at Mantoku-ji in Aichi Prefecture. Even more famous prototypes for the *ajouré* (pierced) technique in gilt bronze are the flower trays of Jinshō-ji in Shiga Prefecture; one of these is now in the Honolulu Academy of Art.

The pierced gilt bronze of the "Nagahiro" *kyō-bako* is worked into scrolling designs of lotuses and *hōsōge* (an imaginary flower peculiar to

Buddhist contexts) arabesques. This is the earliest such well-preserved container for the Lotus Sutra. Because it contained a sacred text presented as an offering to deity, because religious ritual depends for its efficacy on precise adherence to a prescribed model, and because the Tendai sect laid particular emphasis on rituals and ritual furnishings, we can be sure that this sutra container is a

255 ❧

HOT-WATER KETTLE FOR THE TEA CEREMONY, *SHINNARI* TYPE

c. 1500
Japanese, from Ashiya (present-day Fukuoka), Kyushu
sand-cast iron
height 17 (6¾); diameter 24.5 (9⅝)
references: Yamada 1964; Castile 1971

Tokyo National Museum

Like all utensils for the Tea Ceremony (*Cha no yu*), the kettle (*kama*) in which the water was boiled was chosen with exhaustive care for its appearance and history. Of all the orthodox shapes, this one, called *shinnari* (truth-shaped), was probably the most used. Ornamenting the two lug handles are *kimen* (C: *taotie*; ogre mask); ogre masks decorating vessel handles descend from Zhou dynasty China (1045–256 B.C.). About two-thirds of the way down the body, where the kettle is damaged, was originally an encircling

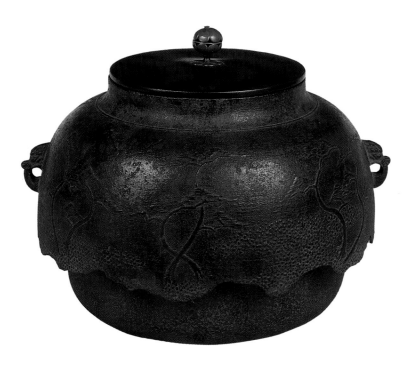

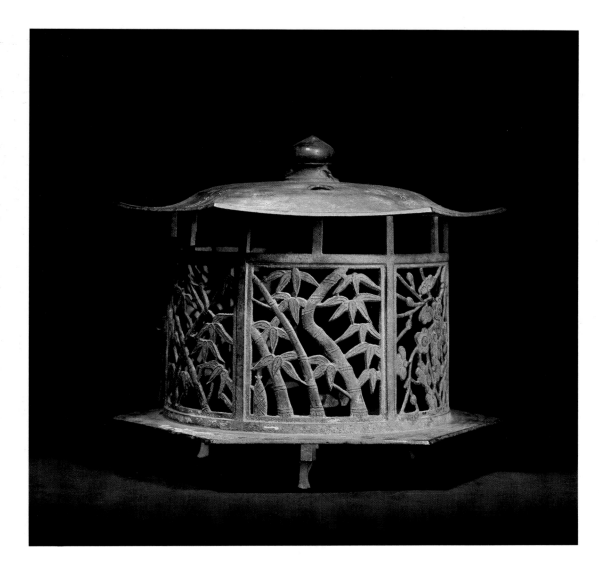

boar's eye openings in the top serve to release smoke. Six openwork panels with alternating plum and bamboo patterns form the central body cylinder. Above each such panel are smaller, double-panel rectangular openings. One of the bamboo-patterned panels serves as a door opening into the lantern. With the exception of that door, the lamp was cast as a single piece. The base plate is a flat hexagon, supported by three feet.

The earliest dated metal hanging lantern bears a 1319 inscription. Stylistic development moved from comparatively simple and understated form to a preference for the complex *ajouré* panels seen here. The boldly executed floral designs suggest certain painting trends during the same period.

J.U.

257 ᷧ

DŌMARU ARMOR

late 15th–early 16th century
Japanese
height of cuirass 56.0 (22)
height of helmet (without the horns) 11.8 (4⅝)
length of shoulder-and-arm guard 43.7 (17¼)

Sata Shrine, Shimane Prefecture

Dōmaru originated in the Heian period (794–1185) as a cuirass for foot soldiers. In the Muromachi period (1333–1573), as mounted archers were superseded by infantry pikemen and swordsmen, high-ranking warriors replaced their earlier, more cumbersome armor with the *dōmaru*, supplementing the cuirass with one-piece shoulder-and-arm guards of similar construction, and a helmet. The whole was called a "three-piece set" (*mitsumono*).

The standard *dōmaru* cuirass was a lamellar sheath around the chest and belly, fastened at the wearer's front right, with an attached lamellar skirt of eight panels (for ease of movement) protecting the thighs. Most of the lames were lacquered leather, interspersed with iron at critical points; the individual lames were tied into horizontal bands, which in turn were laced together vertically. Braided cords, often (as here) of silk, were used for the lacing. An iron border, usually ornamented, sometimes leather-clad, edged the top of the cuirass, and similarly decorated iron plates hung from the shoulder guards to protect the shoulder straps of the cuirass.

This *dōmaru* is a representative three-piece set. Red is the main color of the leather lames; the shoulder and chest areas are corded with light blue and white, the skirt with white only. Different-colored cording for the sleeves and skirt was particularly popular in the Muromachi period. Braided silk cords were expensive, as were the gilt bronze openwork arabesque and paulownia-shaped studs ornamenting the solid iron edges of the cuirass and shoulder guards.

skirt or mantle; this sloped downward and acted as a flange to hold the kettle on its support within the *ro* (fire pit) during winter or on the *furo* (brazier) during midyear. The cover is a bronze replacement for the lost original iron lid.

Between the skirt and the lip of the kettle is a relief decoration of pine trees against an allover pattern of relief dots (J: *arare*; hailstones), the whole hand-carved into the interior of the mold in which the kettle was cast. The result is a graceful, native style image (*yamato-e*) of bending pines growing along an undulating sand beach. The pine beach (*hamamatsu*) was a common motif in the arts of the Muromachi period. The dark purplish color of the iron surface, often found on Chikuzen-Ashiya kettles, is highly prized.

S.E.L.

256 ᷧ

HANGING LANTERN

dated to 1550
Japanese
ajouré cast bronze
height 29.7 (11¾)

Tokyo National Museum

In 1910 this cast bronze lantern was excavated on the grounds of Chiba Temple in Chiba city to the east of Tokyo. An inscription on the top surface of the headpiece of the lantern indicates that it was cast in 1550 for use in the Aizen-dō of the temple. Extant examples of lanterns of this excellent quality and style were produced by the Temmyō metalworkers of Sano in Tochigi Prefecture during the mid-sixteenth century. It has been suggested that this lantern may also have originated in the same workshop.

Headpiece, body, and base are all hexagonal, though not identical in conformation. A "flaming jewel" finial, pierced for hanging, tops the headpiece. From the center the headpiece slopes in a regular, gentle curve to a hexagonal edge, with the six angles slightly upturned. Three so-called

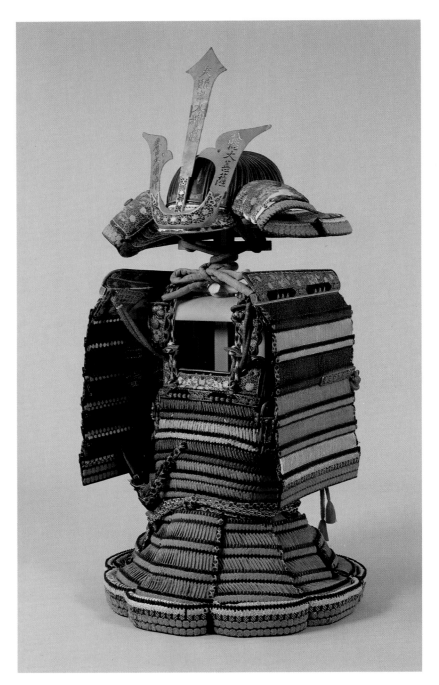 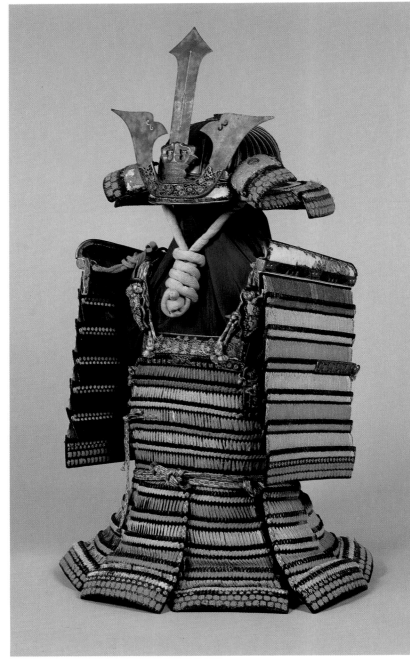

A pair of horns flanking an upright three-pronged sword's point ornament the front of the helmet. On this ornament are names of deities in openwork: *Amaterasu Kōtaijingū* (Sun Goddess Amaterasu) on the sword tip, *Hachiman Daibosatsu* (Great Boddhisattva Hachiman, god of warriors) on the (viewer's) right horn, and *Kasuga Daimyōjin* (Great Bright Wisdom Deity of the Kasuga Shrine) on the left, suggesting that these Shinto deities figured prominently as protector-divinities for warriors.

An inscription inside the lid of the chest containing this helmet states that the helmet was consecrated to Sata Shrine by Amako Tsunehisa (1458–1541), *daimyō* of a domain in southwestern Honshu. H.Y.

258 🐌

DŌMARU ARMOR

16th century
Japanese
height of cuirass 55.5 (21⅞)
height of helmet (without the horns) 11.6 (4½)
length of shoulder-and-arm guard 42.4 (16⅝)

Kagoshima Shrine, Kagoshima Prefecture

The small leather or iron lames of which Muromachi period (1333–1573) *dōmaru* armor was made are pointed on top and measure 5–6 centimeters long by 1.5 centimeters wide. These lames, called *sane*, were strung together, slightly overlapping, into bands, and fixed in place with

lacquer. The bands were joined vertically with tanned deerskin or braided silk cords. The colors of the cords were carefully chosen for decorative effect against the black-lacquered lames, as was the ornament on the solid metal portions of the cuirass.

On this cuirass purple cording was used for the topmost band of the chest and shoulder areas, with white and red cording alternating below. White alternating with color was a favorite scheme in the Kamakura (1185–1333) and Muromachi periods.

Over the chest lames is pasted tanned leather, dyed with a design of lions against an overall background of peony flowers and leaves. The ornamental metalwork on the solid iron parts of

the cuirass consists of floral arabesque rendered in gilt bronze openwork, and studs in the shape of double-petaled chrysanthemums.

The horns of the helmet flank a three-pronged sword tip—an ornament with Buddhist significance.

A set of similar *dōmaru* armor but with different-colored cording is extant at the same shrine. Both sets are said to have been an offering by Shimazu Takahisa (1514–1571), a *daimyō* of southern Kyushu, and his clansmen. H.Y.

259

TEA BOWL, *TEMMOKU* TYPE

first half of 16th century
Mino ware (?): stoneware with off-white crackled glaze and silver rim mounting
height 6.7 (2²/₃), diameter 12.3 (4⁴/₅)
references: Jenyns 1971, pl. 46a; Seattle 1972, no. 25

Hinohara Setsuzo

Uncertainty still surrounds this tea bowl and another of the same type, equally rare and famous, in the Tokugawa Art Museum in Nagoya. The date given above is approximate. Current writers favor Mino, north of Nagoya (in present-day Gifu Pref.), as its kiln site, but it may equally well have been made at one of the older and more southerly kilns at Seto (closer to Nagoya, in present-day Aichi Pref.). The historical importance of the two bowls, however, is unambiguous.

Their simple, natural, and roughly symmetrical shape was certainly copied after Chinese Song dynasty (960–1279) tea bowls from Fujian Province. These were called *jian* ware (after Fujian) by

the Chinese but *temmoku* by the Japanese, presumably from the Japanese pronunciation of Mt. Tianmu, site of the Buddhist establishment in Zhejiang Province, where many Japanese student-monks acquired the bowls and brought them back to Japan.

Jian ware was made exclusively for drinking tea; tea bowls were the only shape produced. The body was a purple-brown stoneware with a thick "treacly" brown-to-black glaze, often marked with streaks (and then called "hare's fur") or, more rarely, with silvery "oil spots." Tea, long credited in East Asia with health-giving properties, was additionally prized by Chan Buddhists as a stimulant conducing to the alertness necessary for meditation. When in the twelfth-thirteenth century Chan reached Japan, there to flourish mightily as Zen, tea and its appurtenances became almost mandatory for the Japanese monasteries and, by extension, the powerful ruling warrior class. Direct imitations of *temmoku* bowls were made at Seto from the late thirteenth through the fifteenth century. These are easily identified by their gray body, radically different from the dark body of the Chinese wares.

This bowl retains the regularity of the Chinese ware but is covered, save for its lower quarter and the foot, by a thick, opaque, crackled, warm white glaze. The unglazed body, now dark from use and accumulated grime, was originally gray, like Seto ware. The silver rim, a later addition with precedents among the *jian* wares of China, suggests how greatly the bowl was valued. The glaze anticipates one of the classic Tea Ceremony wares of the Momoyama period (1573–1615)—Shino ware made at Mino—hence the importance of these two bowls. They stand at the transition from the derivative Seto wares of the fourteenth century to the innovative and unique "tea taste" wares of the late sixteenth century.

260

TEA CADDY, CALLED "ROKUSHAKU" (PALANQUIN BEARER) OR "MASANOBU SHUNKEI KATATSUKI CHA-IRE"

late 15th century
Japanese
black-glazed Seto ware
height 7.7 (3), diameter 6.4 (2¹/₂)

Fujita Art Museum, Osaka

Undocumented tradition tells of the founding of the pottery kilns at Seto, to the east of present-day Nagoya, by one Katō Shirōzaemon Kagemasa (also known as Tōshirō) in the first half of the thirteenth century. Kagemasa purportedly traveled in China during the 1220s studying ceramic technique, particularly the manufacture of tea caddies. On returning to Japan, he declared the clays at Seto to be most suitable for the production of ceramics. Archaeological investigation does confirm the production of glazed Chinese style ceramics at Seto during the period of Kagemasa's ostensible activity. Vessels related to Tea Ceremony that were produced in China and eagerly collected by successive Ashikaga shoguns clearly served as the prototypes for the tea caddy seen here.

The formal Japanese title for this vessel, "Masanobu Shunkei katatsuki cha-ire," describes a square-shouldered tea caddy that was a joint creation of Yamana Zensho Masanobu and Katō Shirōzaemon Shunkei. Not much is known about Masanobu (act. 1469–1486), except that he was a retainer to Yamana Sōzen (1403–1473) and practiced the Tea Ceremony and the manufacture of related vessels—a bent thoroughly consistent with the cultural interests of the warrior class. Shunkei, a descendant of the semilegendary Kagemasa, instructed Masanobu in making ceramics.

The Yamana had been the dominant clan in western Honshu from the early fourteenth century, when eleven of Japan's then sixty-six provinces were in their hands and the clan head was referred to as "Lord of One-Sixth [of the Country]" (*Rokubun no Ichi Dono*). By Sōzen's day their domain had shrunk, though they were still powerful enough to be one party to the prolonged and disastrous Ōnin War (1467–1477).

More than a century after its creation this tea caddy was a favorite of Kobori Enshū (1579–1647), the renowned tea master and garden designer. It was Enshū who named this piece "Rokushaku," meaning "Palanquin Bearer," and inscribed the name on the box containing the caddy. Only the neck and shoulder portions of the vessel are glazed; the remainder is bare clay, which apparently reminded Enshū of the minimally attired bearers.

An amber glaze infused with black created the smoky yellow color which covers the caddy from

mouth to a line just below the shoulder, where a run breaks its otherwise even edge. A horizontal groove circumscribes the unglazed body approximately at midpoint, intersected by several evenly spaced incised vertical lines. The red-black surface of the clay blends attractively with the dark glaze. From the shoulder to the cantilever, where the torso is supported by a trim, narrow foot, the vessel shows a slightly bulging cylindrical silhouette.

The cultivation of a heightened sensibility for *cha-ire* by Japanese warriors constitutes one of the more curious features of medieval aesthetic history. *Cha-ire* became a currency powerful all out of proportion to their unassuming size. They were cherished rewards for loyalty or battlefield valor. Perhaps their intimate scale and subtle, unobtrusive beauty functioned as the ultimate corrective in a world of extreme danger and uncertainty. In the calmer times of early Edo (1615–1868) these diminutive vessels were appreciated as elements in the Tea Ceremony in part for the level of nuance added by their incongruous heritage of violence. J.U.

261 ✑

Tsubo Storage Jar

late 15th century
Japanese
Shigaraki ware: stoneware with ash glaze
height 42 (16½)
reference: Cort 1979, 1981, 19–103, fig. 96

The Cleveland Museum of Art, John L. Severance Fund

Large size and globular profile are the most immediately striking characteristics of this storage jar. From a flat base it swells to its widest diame-

ter at about mid-height, then rounds inward to a brief, constricted neck and slightly flared (damaged) mouth. It was made by adding coils of clay to the flat clay disk that formed the base, and smoothing the surface inside and out with a paddle of wood or bamboo. The clay is typical of the Shigaraki area, dark and rough and heavily sprinkled with white feldspar inclusions ranging in size from granules to an occasional pebble. High-temperature (approx. 1300° C) firing produced a skin ranging in color from orange to cinnamon to a dark purplish hue. Areas of greenish glaze formed on the upper part, where the wood ash used as a flux fell on the vessel and interacted with iron oxides in the clay during its reduction firing in the high, wood-fired, double-tunnel kilns typical of Shigaraki manufacture. The cross-hatched pattern incised between parallel lines around the shoulder is typical of Shigaraki jars, although the parallel lines are not always three in number.

The high Shigaraki valley lies near the border between Shiga and Mie prefectures, about thirty kilometers northeast of Nara and some twenty to twenty-five kilometers south of Lake Biwa. Always famous for timber, the region became a ceramic center at the end of the thirteenth century, stimulated principally by influence from the older kilns at Tokoname, south of Nagoya. A brief period of political fame came to the town from 744 to 745, when the emperor Shōmu chose it as his new capital and built the Koga Palace there. This palace, barely completed, was abandoned because of ill omens and changing court politics.

Shigaraki, like others of the traditional "Six Old Kilns" of medieval times (c. 1050–c. 1600), limited its production almost wholly to jars (*tsubo*), wide-mouthed containers (*kame*), and grater bowls (*suribachi*). Postwar studies and excavations have revealed many more than six old kilns, but the term remains. Aside from domestic use as storage, fermentation, and grinding implements, the medieval ceramics were used as funerary jars for cremated remains and as offering containers for Buddhist and Shinto rituals. The decorative motif at the shoulder has been, perhaps fancifully, called both cypress-fence weave (*higaki*) and lotus petal, but is most widely known as rope pattern (*nawame*). S.E.L.

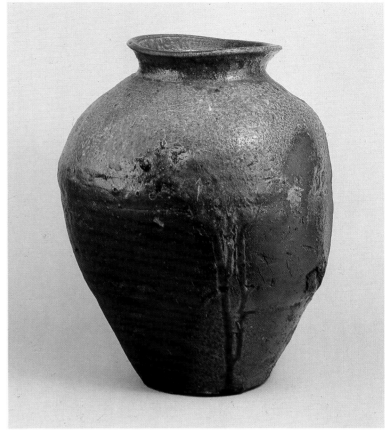

262 ❧

COVERED JAR CALLED "IMOGASHIRA" (POTATO HEAD)

c. 1500
Japanese
stoneware with ash glaze
height 20.3 (8)
references: Faulkner and Impey 1981, 23–26, 45–51;
Tokyo 1985

Eisei Bunko, Tokyo

Although its precise place of origin is not known, this jar seems likely to have been made in the Seto-Mino area, respectively east and north of Nagoya. Certainly the dark-glazed Seto wares of the fourteenth and fifteenth centuries influenced Mino production in the earlier stages of its development. In shape this jar somewhat resembles Seto ware jars made in the Kamakura period (1185–1333) under the influence of the Chinese *guan* shape.

The date of manufacture is likewise approximate, but Imogashira is a transitional vessel, coming somewhere between the rough farm utensils originally produced by the Six Old Kilns (including Seto) and the wares made by these same kilns for the Tea Ceremony in the late sixteenth and early seventeenth centuries. It was apparently not made as a cold-water jar (*mizusashi*) for the emerging Tea Ceremony (*Cha no yu*), its mouth being awkwardly small to accommodate the bamboo ladle used to dip the cold water. Imogashira was originally made as a small covered storage jar. Like the Korean peasant bowls imported to Japan, it was adopted, or rather "found" to be a useful part of the Tea Ceremony some fifty to a hundred years after its manufacture.

The roughly incised markings in the glaze are asymmetrical enough to satisfy the new "Tea taste," and the glaze is rough-textured enough to suggest rocks and to subtly complement the environment and other utensils of *Cha no yu*. The mere fact of being named attests the high regard in which a Tea vessel was held by its owner, and the deliberately colloquial and astringent name Imogashira was part of the ambience bestowed on this well-known Tea treasure by the Hosokawa *daimyō* family in which it descended. S.E.L.

263 ❧

TSUBO STORAGE JAR

15th century
Japanese
Tamba ware: stoneware with ash glaze
height 31.7 (12½)

The Metropolitan Museum of Art, New York

Near Osaka, just over the first range of mountains to the north, lies Tamba, site of one group of the so-called Six Old Kilns. Like the other kilns of this category, Tamba began production with Late Heian (897–1185) and Kamakura (1185–1333) renditions of Sue and Sanage type stonewares, reaching peak production during the Muromachi period (1333–1573). Excellent wares of the old types are still produced there today.

The Tamba body is more homogeneous and less contaminated with flecks of quartz than Shigaraki ware (cat. 261), and the accidental ash glaze, often runny, seems greener-tinged and slightly more viscous than on wares of the other Six Kilns. Decoration is uncommon but "kiln marks" or logos occur more often, usually on the body at the shoulder. Tamba shapes are not so full-blown as either Shigaraki or Tokoname or even Bizen, and the rims of the jars are usually rather large and thin, though less prominent than those characteristic of Tokoname. In all respects Tamba ware satisfied late medieval Tea taste for unpretentious farm/folk products. S.E.L.

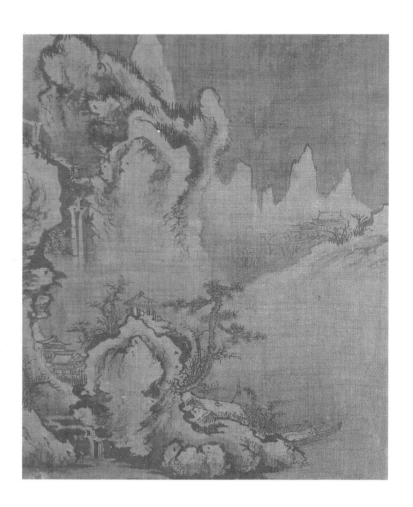

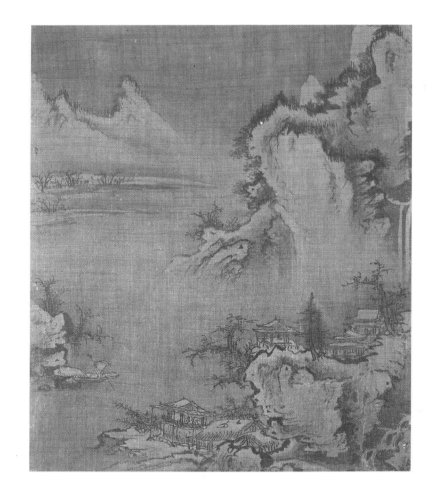

264 ❧

attributed to An Kyŏn

1418–after 1464

LANDSCAPE OF THE FOUR SEASONS

Korean
album leaves; ink on silk
35.8 x 28.5 (14⅛ x 11¼)

National Museum of Korea, Seoul

Of the ten leaves of this album, attributed to
An Kyŏn, eight represent landscapes of the four
seasons, a traditional theme popular during the
Chosŏn period. By devoting two leaves to each
season, the painter of this album was able to
depict each season toward its beginning and
its close.

An Kyŏn, a gifted court painter, enjoyed the
patronage of Prince Anp'yŏng (1418–1453). That
nobleman was famous for his collection of paint-
ings and calligraphies predominantly by Chinese
artists of the Northern Song (960–1127) and Yuan
(1279–1368) dynasties. An Kyŏn, the only Korean
painter honored by inclusion in this collection,
therefore had the unusual opportunity of studying
many Chinese paintings of the Northern Song's
Li-Guo school and of the Yuan dynasty. He was
also acquainted with contemporaneous Chinese
paintings of the Zhe school, rooted in the Ma-Xia
school of the Southern Song (1127–1279) dynasty,
which had been newly introduced to Korea. By
synthesizing many styles of ancient masters both
Korean and Chinese, An Kyŏn created his own
style, which dominated Korean painting until the
seventeenth century.

Each of the landscapes in this album has a
clearly distinguished fore-, middle-, and back-
ground. The forms of mountains, trees, and build-
ings are massed along one vertical half of each
pictorial surface, leaving the other half for the
representation of vast space. Such a composition,
combining dramatic verticality with equally dra-
matic spatial recession, was widely adapted by
Korean painters who followed An Kyŏn during the
fifteenth and sixteenth centuries. The fantastic
mountain forms, sparsely textured with wavering,
threadlike brush strokes, tend to remain separate
pictorial entities rather than suggesting organic
mountain ranges. Their extremely exaggerated
outlines are rendered in short, twisting and turn-
ing brush strokes of variable width. Despite the
pictorial excitement created by energetic brush
strokes and strong contrasts of light and dark, the
forms themselves seem weightless. These stylistic
features are also characteristic of An Kyŏn.

Each seasonal pair of album leaves is meant to
be viewed with the early phase of the season at
the right and the late phase at the left. Viewed
thus, as a single composition, each pair comprises

deep, misty space in the center, "framed" by the massed forms along either side.

The pictorial means employed in each leaf convey the mood of the season. In the early winter scene, for instance, fantastic mountains are rendered in deep black brush strokes of fluctuating width and show sharp contrasts of light and dark, thus evoking the harshness of nature in winter.

K.P.K.

265 ঌ

Kang Hŭi-an
1419–1464

A Sage in Contemplation

mid-15th century
Korean
album leaf; ink on paper
23.4 x 15.7 (9¼ x 6⅛)
seal of the artist

National Museum of Korea, Seoul

An eminent scholar-official of the early Chosŏn period, Kang Hŭi-an rose steadily in the bureaucracy after passing the Erudite Examination (*munkwa*) in 1441, and was sent to Beijing as vice-ambassador of a Korean mission in 1455. He was also a noted poet, calligrapher, and painter.

Here Kang has divided the pictorial space into two planes. In the foreground is a stream indicated by horizontal brush strokes in light ink. Small rocks and water weeds at lower left are

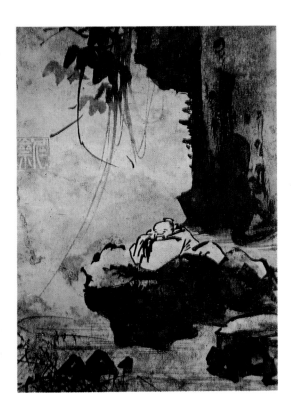

balanced by large boulders along the water's edge on the right. Slightly off center, on the largest boulder, a scholar lies prone, gazing out at the river in front of him. From a sheer cliff rising behind the solitary figure grows a canopy of overhanging vegetation.

The emphasis on verticality, the concentration of pictorial weight on one side, bold and assertive brushwork, emphatically black ink showing no effort at subtle tonal gradation, and empty space which is *not* used to imply infinite recession all suggest prior knowledge of Chan (K: Sŏn; J: Zen) Buddhist painting and of the work of leading Chinese Zhe school painters such as Dai Jin (1388–1462), Li Zai (act. c. 1425–1470), and Zhou Wenjing (act. c. 1430–c. 1460), who dominated painting at the Ming court, where Korean emmissaries were frequent visitors.

Under normal circumstances Chinese pictorial methods soon found their way to Korea. New stylistic developments introduced from China were usually taken up by innovative Korean scholar-painters, each innovation initiating a new progressive trend. *Sage in Contemplation*, which reveals Kang as the earliest Korean proponent of the Zhe school mode, represents the progressive direction in mid-fifteenth century Korean painting. By the sixteenth century painting in the Zhe style had become enormously popular in Korea.

Kang survived one of the most violent political struggles of the Chosŏn dynasty, in which Prince Anp'yŏng (1418–1453), the famous collector and patron of arts, was assassinated in 1453 by the faction of his brother, Prince Suyang. Many worthy scholar-officials perished then in their defence of the young king, Tanjong (r. 1452–1455), who was eliminated by his ambitious uncle, Prince Suyang. The ruthless Suyang, ascending the throne as King Sejo (r. 1455–1468), proved an able ruler. In this painting the touch of self-mockery in the sage's expression may not have been Kang's conscious intent, but it would not be inconsistent with the probable feelings of a scholar-official serving the usurper who had put to death of many of his friends and colleagues.

Kang's paintings are rare and usually lack inscriptions or signature. This work bears only a square intaglio seal reading *Injae*, Kang's studio name (K: *ho*).

K.P.K.

266 ঌ

Yi Sumun
active first half of 15th century

Ink Bamboo

dated to 1424
Korean
album leaves; ink on paper
30.6 x 45 (12 x 17¾)
inscription with signature and seal of the artist

Matsudaira Yasuharu

Although Yi Sumun is not mentioned in Korean sources of the Chosŏn period (1392–1910), his name occurs in Japanese sources of the Muromachi period (1333–1573). He is believed to have married a daughter of the Soga family, and his style is considered to have been the source of the Soga painting lineage in Japan. He taught painting to the famous Zen monk Ikkyū (1394–1481), of the Kyoto monastery Daitoku-ji, and was known for his monochrome ink depictions of bamboo as well as for landscapes with figures and flower-and-bird paintings.

For a long time Yi Sumun (pronounced *Ri Shūbun* in Japanese) was mistaken for the famous Japanese monk-painter Tenshō Shūbun, approximately his contemporary, although the two names employ a different character for the syllable *Shū*. To complicate matters further, Tenshō Shūbun (act. first half of 15th century), who was an important figure in early Japanese ink painting, came to Korea in 1423 with a Japanese embassy sent to obtain the printed Buddhist sutras, returning to Japan in 1424. This album, according to the inscription on the last leaf, was "painted by Sumun [J: Shūbun] in 1424 at Pukyang after coming over to Japan."

Bamboo first became an important theme among Korean scholar-painters during the twelfth century (Koryŏ dynasty). Such prominent Koryŏ scholars as Kim Pusik (1075–1151) and Yi Illo (1152–1220) painted ink bamboo. They were great admirers of the scholar-official-poet Su Shi (1037–1101), a seminal and leading figure in the literati painting movement in Northern Song China (960–1127), and of Su's friend Wen Tong (1019–1079), who is considered the first great master of ink bamboo. During the late thirteenth and early fourteenth century, when the Korean court maintained a library named the "Hall of Ten Thousand Volumes" (K: *Mangwan Dang*) in the Chinese capital (at present-day Beijing), many Korean scholar-officials made frequent visits there. Yi Che-hyŏn (1287–1367), who served the Korean King Ch'ungsŏn, became acquainted with the painters Zhao Mengfu (1254–1322) and Li Kan (1245–1320) — both known for their bamboo painting, and the latter also for his *Treatise on Bamboo* (*Zhupu*). To the Confucian scholar-officials who dominated the succeeding Chosŏn

dynasty (1392–1910), bamboo symbolized Confucian virtues of resilience and fortitude, thus enhancing the significance of bamboo painting.

Yi Sumun's album comprises ten leaves, each showing bamboo growing in a natural setting. These settings vary from a private garden to a wild grove. The most dramatic leaves show bamboo blown by wind or pelted by rain, the most lyrical leaf represents bamboo against the full moon. Unlike most bamboo paintings executed after the sixteenth century, which were explicitly conceived as vehicles to express the painter's nature or emotions, Sumun's bamboo, with their thin stalks and narrow leaves, look like the plants they represent. The windblown or rain-drenched bamboo, for instance, seem to convey the artist's direct experience of nature. Tonal gradations in the paintings imply air and light, also enhancing the illusion of a real world. On the last leaf are several tall bamboo beside a fantastically weath-

ered garden rock, together with new bamboo shoots. Compositionally, this leaf is the most unusual for its time: bamboo paintings of this period rarely depicted the new bamboo shoots or cut off the top part of the bamboo.

At the upper left of this leaf is an inscription accompanied by the artist's signature, *Sumun*, and a rectangular relief seal also reading *Sumun*.

K.P.K.

267 𐆓

Yi Sumun
active first half of 15th century

LANDSCAPES OF THE FOUR SEASONS

Korean
pair of six-fold screens; ink on paper
each 92.7 x 348.7 (36½ x 137¼)
references: Matsushita 1961, no. 21; Nara 1973, no. 24; Matsushita 1974, 64–65, figs. 53, 54; Princeton 1976, 217, n. 11; Cleveland 1977, 4–5, no. 2; Tanaka 1977, 81–82, pls. 6, 7

The Cleveland Museum of Art,
John L. Severance Fund

The four seasons are depicted as was customary, from right to left and beginning with spring. A gentleman-scholar attended by two servants opens the scene; standing before a pavilion built on a

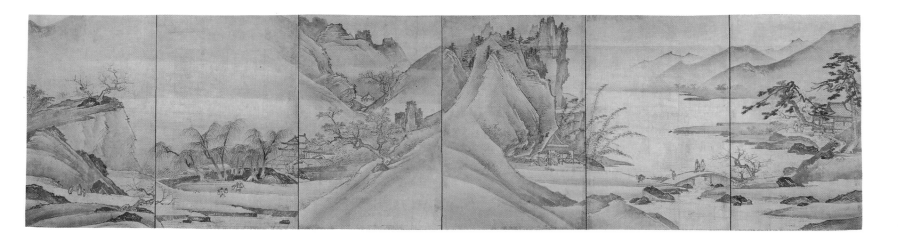

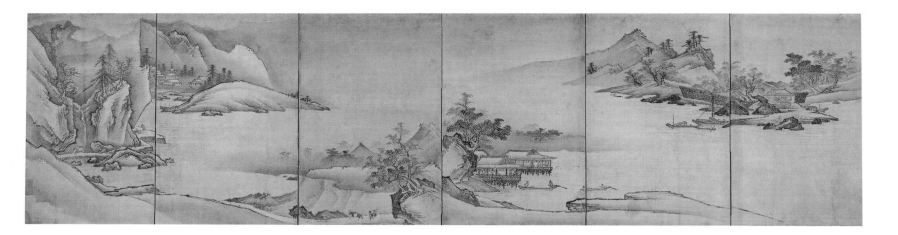

spit of level land, he gazes out over an expanse of calm water. Not far away (in the second panel) are two more gentlemen, similarly attended. They are crossing a footbridge that will take them toward the pavilion, and have stopped to admire a tree in flower. Beyond them, in the middle distance, fresh, tall bamboo are shown below towering vertical peaks. At the center of the next three panels a copse of willows in full foliage marks the summer. Autumn opens the left-hand screen. Past distant tree-clad hills sloping down to fenced-in houses and moored boats, gentlemen-scholars are being ferried to a viewing pavilion built out over the water from a peninsula stretching into the distance. The last two panels give us distant, rugged country, snowbound by winter.

The composition is simple but ingenious. Each screen is centered on a foreground *repoussoir*—one a rising mountain mass, the other a sharply receding series of plateaus. Framing these central *repoussoirs* are views set in the middle distance. The result is stable and balanced. Some of the rock forms recall the 45° angle projections in Yi Sumun's *Ink Bamboo* album (cat. 266). The solid, dark ink washes for farmland and wet ground in the right-hand screen resemble nothing like such areas in Chinese and Japanese paintings, but they do resemble ink washes in a Korean painting of *The Eight Views of Xiao and Xiang* (exhibited in Nara, 1973), though the nervous brush manner there bespeaks a different artist.

At the lower outer edge of each screen is the seal of the artist, *Sumun*, in fine-line "maze" characters within a vertical oblong. The same characters on a differently cut seal appear on Catalogue 266, accompanied by the artist's signature. Still another *Sumun* seal marks a hanging scroll depicting the Chinese poet Lin Heqing (Lin Bu, 967–1028) in a landscape; this has been accepted as genuine by Matsushita (1961, no. 21).

When the Cleveland screens were discovered (before 1950), the *Ink Bamboo* album (cat. 266), which documents Yi Sumun's arrival in Japan from Korea, was unknown; and until its publication in 1961 the painting of Lin Heqing was virtually unknown. Since at the time the Cleveland screens came to light Yi Sumun (the "Korean Shūbun") was scarcely known to exist, the seals on these screens are highly unlikely to be spurious.

Any study or discussion of early Chosŏn ink painting and the place of Yi Sumun within that tradition must take account of these *Landscapes of the Four Seasons*. S.E.L.

268 ૐ

Yi Am

16th century

DOG AND PUPPIES

Korean
hanging scroll; ink and color on paper
73 x 42.2 (28¾ x 16⅝)
two seals, one of the artist

National Museum of Korea, Seoul

Under a leafy tree sits a mother dog suckling her puppies, appearing simultaneously contented and alert. Yi Am executed this painting using primarily the "boneless" technique—as in the strong, gently curving tree trunk, the lush leaves filling the top part of the painting, and the sleek bodies of the dogs. He used outline strokes only to describe the dogs' paws, the white puppy clinging upside down to the mother dog to nurse, and, in light ink, a dozen long grass blades. Apart from this, the brush is apparent only in some dark triangular dots texturing the ground beneath the tree. The sensitive contrast between a light-colored puppy dozing on its mother's back and two other pups, one dark and the other white, eagerly suckling below testifies to Yi's keen observation of his subjects.

Yi Am (1499–after 1545) was a great-grandson of Prince Imyŏng, who was the fourth son of the illustrious King Sejong (r. 1419–1450). His paintings, of animals, birds, insects, and flowers, are imbued with a childlike innocence, and his dogs and puppies are always shown as much-loved creatures inhabiting a tranquil private garden. A red collar with a bright metal bell around the neck of the mother dog not only draws the viewer's attention to her but also conveys Yi's own feeling for her.

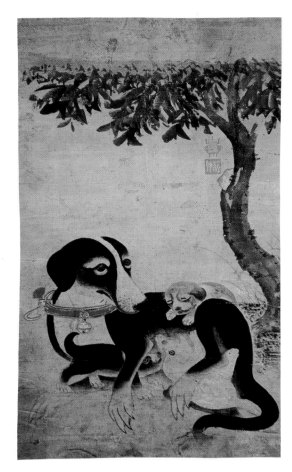

Only eight or nine paintings by Yi Am have survived. They are mostly in Japanese collections and lack signature or inscriptions. This work is likewise unsigned and uninscribed, but it bears a tripod-shaped relief seal reading *Kŭmhŏn* and a square intaglio seal reading *Chŏngjun*, which is Yi's style or courtesy name (K: *cha*; C: *zi*).

K.P.K.

269 ૐ

Sin Cham

1491–1554

SEEKING PLUM FLOWERS

mid-15th century
Korean
handscroll; ink and color on silk
43.9 x 210.5 (17¼ x 82⅞)

National Museum of Korea, Seoul

The scholar-painter Sin Cham was renowned as a master of the "three perfections" (K: *sam jŏl*; C: *san jue*)—poetry, calligraphy, and painting. He was particularly famous for his calligraphy in the Chinese cursive and clerical modes. After passing the standard literary examination (K: *chinsa*; C: *jin shi*) for government service, Sin began his official career in 1513. In 1519, however, the factionalism that plagued Chosŏn government eventuated in a great purge of high-ranking civil servants; Sin Cham was banished to the hinterlands and not reinstated until 1543. Thereafter he served as magistrate in several counties until his death.

Sin is known for his ink renditions of orchids, bamboo, and grapes, appropriate in medium and subject matter alike to the Confucian scholar-official. Here he has painted a landscape with figures inspired by a classical subject also dear to the hearts of scholar-officials, whose duties usually confined them in cities. The gentleman seeking plum flowers is Meng Haoran (689–740), a Chinese poet of the Tang dynasty, who was admired by many men of letters in Korea. Meng, a friend of the famous Tang poet Wang Wei (699–759), is said to have refused high government office, preferring to live in "reclusion" (i.e., out of office) on Mt. Lumen. Each spring he is sup-

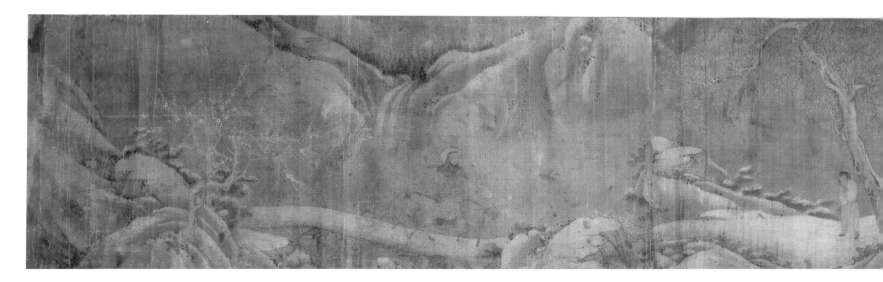

posed to have set out over the Ba Bridge in search of the first plum blossoms.

The scroll opens on the right with a large hill nearly the height of the painting surface. Trees clinging to its slope lead the viewer into the painting. Using a series of contrasts, Sin divided his composition roughly into balanced halves: the empty space forming the background on the right contrasts sharply with the mountain forms that fill the background on the left; the road paralleling the pictorial frame on the right contrasts with the bridge on the left; and a repoussoir in the form of hillocks with two large trees on the right contrasts with the absence of repoussoir on the left.

Mountains, hills, and trees show unusual solidity and monumentality, which Sin created by unobtrusive outlining with long, even strokes and by shading his forms with broad wet brush strokes. In the early sixteenth century Korean painting was dominated by the followers of An Kyŏn (1418–after 1464), whose works were characterized by vigorous brush strokes, variable "calligraphic" outlines, and a sense of vast space. Sin's departure from this style is striking, and appears as well in his abrupt cutting off of the tops of the tree branches as well as the sides of the landmasses that begin and end the scroll. At the beginning and end of the scroll blossoming branches of the old plum trees allude to Meng Haoran's romantic preoccupation with plum blossoms. K.P.K.

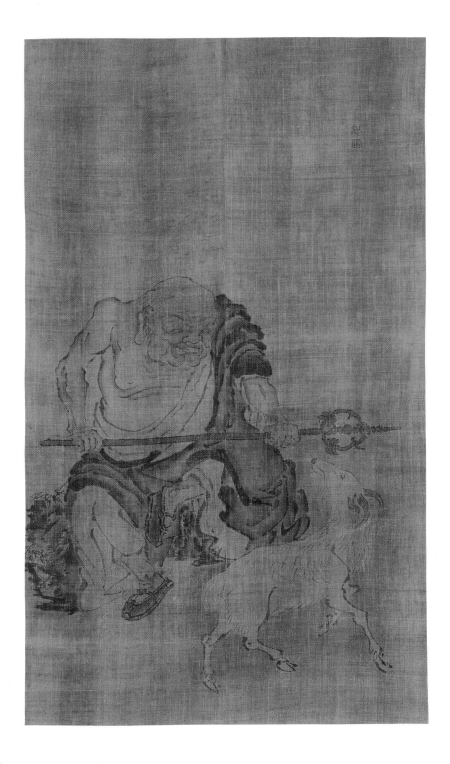

270

Yi Sangjwa
active 16th century

SEATED ARHAT WITH GOAT

hanging scroll; ink on silk
138.6 x 78.2 (54½ x 30¾)
signature and seal of the artist

Tokyo University of Fine Arts

Arhats (C: *luohan*) are the ideal figures of early Buddhism, the Theravadin tradition, which is sometimes referred to as the Southern tradition because its present-day adherents are mostly found in southern and southeastern Asia. Like bodhisattvas, arhats are fully Enlightened beings, free forever of passions and defilements and therefore capable of entering Nirvana, or extinction, at the end of their current life. Arhats differ from bodhisattvas in concentrating their efforts on their personal salvation, while bodhisattvas are dedicated to freeing all beings from the cycle of rebirth. Arhats, who were, historically, Indian, are usually represented in assemblages of sixteen, sometimes eighteen, early holy men who indeed attained Enlightenment and freedom from the cycle of rebirth. Though Zen (K: Sŏn) springs from the Northern, or Mahāyāna, tradition of Buddhism, the individualistic and focused nature

of the arhats' single-minded pursuit of Enlightenment, and their avoidance of rote devotional practices caused their images to be revered in Zen circles.

Traditions of arhat iconography emerged and were sustained in China; Korean and Japanese interpretations followed one of two fundamental Chinese painting styles. One was a polychrome tradition particularly well articulated in works attributed to two Song dynasty painters recorded only in Japan: Zhang Sigong and Lu Xinzhong, both of whom were active in the port city of Ningbo in Zhejiang Province. Their works were much exported and were widely copied in Japan during the fourteenth century. The *arhats* were sometimes painted in various groupings, sometimes individually, though the paintings of individual *arhats* might be composed as sets. Usually they were depicted in outdoor settings, which afforded the artist some creative latitude, the figural iconography being largely immutable. The other tradition for arhat representation names as its source the style of the Chinese Chan adept and poet-painter Guan-Xiu (832–912). Although nothing of Guan-Xiu's painting survives, later paintings of gnarled, quirky, and grotesquely featured holy men depicted in vigorous, expressionistic brushwork are usually associated with his name or said to be "after his style." Guan-Xiu purportedly painted such figures on temple walls. Rubbings from stone engravings have, ostensibly, transmitted his style, but our knowledge of it remains derivative and speculative.

In the present painting the arhat is seated in a casual pose on a partially visible rock, surrounded by scattered tufts of grass or bamboo grass. The figure grasps a monk's staff (J: *shakujō*) with both hands, holding it not upright in the usual fashion but across his lap, parallel to the ground. Tradition assigns to this wooden staff with its metal finial and loose metal rings two purposes, both imparted by the Buddha to his disciples and both accomplished by the jingling of the metal rings when the staff is shaken: to announce the presence of an alms-seeking monk while preserving his vow of silence, and to warn off small creatures that might otherwise be crushed by a monk's inadvertent step. Although the painting's subject is merely identified as an arhat, the twelfth arhat, Nāgasena, is often depicted with a goat, symbolizing that holy man's Enlightened ease with other orders of the sentient world. In this painting a goat stands before the figure, its head turned toward him with an expression of affectionate trust. The arhat, hunched forward, returns the gaze with intense, delighted eyes.

The present painting is rendered on roughtextured silk. Its essential elements, though sparse, are carefully composed in a series of vectors and diagonals which not only convey the communion between arhat and beast but also create a sense of space and dynamism. The skillfully rendered parallel between the arhat's posture and the goat's creates overall visual coherence and also suggests the religious hypothesis underlying the painting—that the Enlightened being is at one with the universe.

In the upper right corner of the painting is the artist's signature, *Hakp'o*, rendered in carefully blocked script, and beneath it his seal, *Yi Sangjwa*. Other of his works survive, including a tiger and an interpretation of the Daoist Immortal Xia Ma, sufficient to identify Yi Sangjwa as a representative painter of the sixteenth century. Although many features of this painting place it in the Guan-Xiu tradition, the brushwork is controlled and the modeling of the figure and his dark outer robe carefully executed. These features suggest the "professional" touch common to Chinese paintings of the Zhe school, which particularly influenced such Korean artists as Yi Kyǒngyun (1545–?) and Yi Chǒng (1541–1622), both of whom were active at the time this painting was made.

J.U.

271 ❧

Ham Yundǒk
16th century

MAN RIDING A DONKEY

Korean
album leaf; ink and light color on silk
15.5 x 19.4 (6⅛ x 7⅝)

National Museum of Korea, Seoul

Except that he was a professional painter active in the sixteenth century, not much is known of Ham Yundǒk. Here he has employed a type of composition apparently introduced into Korean painting by Kang Hŭi-an (cat. 265) in the mid-fifteenth century: a pictorial surface divided into two planes; in the foreground a central figure on which the composition is focused; the background divided vertically between the solid mass of a cliff and empty space; overhanging vegetation growing from the cliffside serving to canopy and further frame the traveler on his donkey. Across the road and parallel to it runs a narrow stream. Beyond the stream the cliff rises on the left, cutting off the traveler's view and ours, while on the right space recedes and beckons.

In this painting more than the composition is reminiscent of Kang Hŭi-an. The brisk depiction of the cliff with a minimum number of short, irregular, parallel brush strokes; the large leaves indicated by wet ink dabs; and the small triangular rocks in the creek all recall the earlier master. Between the traveler and his mount there appears a pointed contrast—the man erect and smiling, the donkey with head hanging and legs splayed, exhausted by his burden.

The road leading past the picture frame, the implied motion of the donkey, and the quickly executed, spirited brush strokes convey a sense of energy and movement and are characteristic of the Chinese Zhe school mode, which became popular with both professional and amateur painters of Korea during the sixteenth century. The light pink of the traveler's robe adds a lighthearted quality to the painting.

K.P.K.

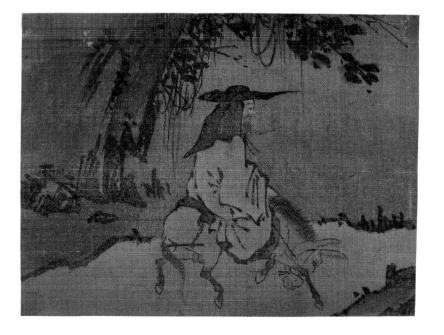

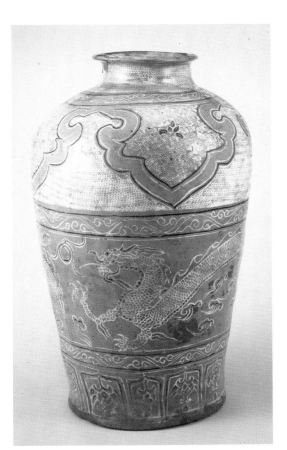

272

Tall Jar

early 15th century
Korean
punch'ŏng *ware with incised, impressed, and slip-inlaid decoration*
height 49.7 (19⁵/₈)
references: Gompertz 1968, 25–42; Rhee 1978, 3:pl. 2

National Museum of Korea, Seoul

This imposing gray-bodied stoneware vessel has an approximately cylindrical body, which narrows only slightly in its descent from high shoulders to broad base. The short neck widens to the everted mouth rim, and the surface is fully decorated from the area inside the mouth down to the base. Primary motifs in the complex design are marshalled into broad horizontal zones separated by narrower scroll-filled borders. Four pendent panels on the shoulder—an arrangement called a "cloud collar" for its resemblance to the collars of princely Mongol dress—are filled with stylized waves and floating blossoms. Two dragons stride across cloud-flecked skies in the zone below, and a fence of upright lotus-petal panels encircles the base.

The designs were produced by incising the clay with a sharply pointed instrument and filling the depressions with slip (clay diluted with water). Here both white and dark-colored slip were used. Forming the backdrop for the cloud collar on the shoulder and covering the neck and mouth interior is a dense mesh-like ground, produced by stamping the clay surface all over with a patterned die or a piece of woven material, then rubbing or brushing the stamped surface with white slip. Finally the vessel was covered with glaze and fired.

Potters active during the early Chosŏn period (1392–1910, also called the Yi dynasty for the surname of the ruling family) inherited a rich ceramic tradition from their predecessors of the Koryŏ period (918–1392) who had distinguished themselves creating exquisite, highly refined, consummately graceful celadon wares. The term celadon refers to high-fired ceramics covered with a muted green glaze—the color resulting when iron oxide in the glaze was fired in an oxygen-deprived, or reducing, atmosphere. Although the basic techniques of celadon manufacture and decoration had been learned from the Chinese, Koryŏ potters modified their ceramic models and invented and perfected the inlaid-slip technique for celadon decoration. The resulting coloristic and graphic effects contrasted with the monochromatic carved celadons of the Chinese tradition.

The carefree and somewhat slapdash technique evident in the present piece reflects the deterioration that had beset the potters' art in Korea during the last century of Koryŏ rule, a deterioration believed to have originated with the Mongol invasion of Korea in 1231 and the subsequent weakening of the Koryŏ state and spirit. Yet, for all its technical and artistic gaucherie, the approach and aesthetic here reflect a fresh vigor, robustness, and vitality which are the hallmarks of Chosŏn ceramic style. Coarse body fabric, heavy potting, emphasis on slip decoration, and a thin transparent glaze that is not a true celadon color are characteristics of Chosŏn period stoneware. *Punch'ŏng*, as this ware is called, is a shortened form of the term *punjang hoi ch'ŏng sagi*, "powder-dressed gray-green ceramics"—"powder-dressed" referring to the slip decoration and "gray-green" reflecting the celadon ancestry.

Transitional between typical Koryŏ and Chosŏn wares in technique, the present piece seems transitional in shape as well: between the popular Koryŏ type of tall, high-shouldered, small-mouthed bottle called *maebyŏng* (from the Chinese *mei-ping*, "prunus vase," a term used for wine containers) and the broader, larger-mouthed Chosŏn period jar. The decoration, both motifs and composition, was borrowed wholesale from a fourteenth century Chinese blue-and-white porcelain vessel. However, in the Korean version, the dragon has acquired a note of humor and whimsy which, along with the more casual workmanship, demonstrates a significantly independent attitude toward the model. M.A.R.

Bottle

15th century
Korean
punch'ŏng *ware with impressed and slip-inlaid decoration*
height 26.8 (10⁵/₈)
references: Kim and Gompertz 1961, pl. 82; Gompertz 1968, 25–42

National Museum of Korea, Seoul

Pear-shaped bottles like this one—with slender neck and gracefully everted lip—were quite popular during the fourteenth and fifteenth centuries in China and particularly popular during the fifteenth century in Korea, where numerous examples were produced in a variety of wares. The present piece owes its special attractiveness in large part to finely balanced and evocative proportions. Such features as its full, swelling body, its low center of gravity, and the firm and steady anchoring provided by the low ring-foot produce a strong impression of ripeness and plentitude, stability and strength. Surface adornment is present but does not compete with the beauty of the form.

The impressed and slip-inlaid mesh pattern is a perfect wrapping for the vessel, and the glaze, while providing a high gloss, is neutral in color and also visually passive. Great care, however, was exercised in the decoration; this is evident in the fastidiously reserved narrow band, free of slip, encircling the neck and in the balance between impressed floret bands at the lip and on the foot. These flowers resemble small chrysanthemum blossoms seen from above, hence the term chrysanthemum-head pattern, a pattern sometimes employed as an overall body design.

Notwithstanding the humble or plebeian character attributed to *punch'ŏng* wares, they also enjoyed official patronage. The ceramics destined for official or royal use were deposited in warehouses for safekeeping before they were distributed. Inscriptions, produced usually by incising and slip inlay, exist on a good number of extant stamped and slip-inlaid *punch'ŏng* wares. These inscriptions include the names of such government agencies as those in charge of royal household cuisine, entertaining, and ceremony. And *punch'ŏng* wares have been discovered among grave goods in princely burials.

Government supervision may in fact have been instrumental in encouraging more careful crafting of some wares; the present piece, though uninscribed, reflects meticulous manufacture. Such wares were also in aesthetic accord with the new Confucian emphasis that marked the early years of the Chosŏn period (1392–1910). The highly aristocratic and often precious taste which prevailed in ceramic patronage during the height of Koryŏ rule gave way to a mood and tenor perfectly at ease with the austere and spartan quality of the new *punch'ŏng* wares. M.A.R.

274 ৯৯

PLACENTA JAR

first half of 15th century
Korean
punch'ŏng *ware with incised, slip-inlaid, and impressed decoration*
height 37.8 (14⅞)
references: Gompertz 1968; Rhee 1978, 3:pl. 10

Ho-Am Art Museum, Kyŏnggi Province

From its flat, stable base this jar widens gently to high taut shoulders, then narrows slightly through the brief neck to a wide mouth with strongly everted lip. The generous opening at the top is a characteristic feature of the outer of two receptacles which together served as the burial vessel for a placenta. The inner jar was narrower and might be provided with loop handles on the shoulder for securing a lid. The outer jars were likewise provided with covers, presumably lost in the present example. An outermost casket of stone formed a durable protective casing for the ceramic jars and their contents. Whereas placenta receptacles of the early Chosŏn period (1392–1910) are predominantly from *punch'ŏng* kilns, in the later Chosŏn (Yi) period white porcelain was prevalent. According to Itoh Ikutarō, "Underground burial of the placenta was the custom in Korea from the Three Kingdoms [37 B.C.–668 A.D.], through the Unified Silla [668–918], Koryŏ [918–1392], and Yi [Chosŏn] dynasties. In Yi times, the royal family installed placenta jars in 'placenta chambers' on the peaks of celebrated or scenic mountains."

The expansive body zone of the present jar is entirely covered with an impressed and slip-filled mesh pattern. Above and below this uninterrupted field of design are borders of petals formed by series of roughly parallel incised lines, likely a simplified rendering of the ubiquitous lotus-petal motif. Lotus-petal bands encircling vessels, usually around the shoulder and just above the base, were originally inspired by the lotus thrones that supported images of Buddhist deities. Such was their suitability as a border design that they have continued as a stock decorative device down to the present. An abbreviated depiction of the key-fret motif (called thunder pattern in East Asia) decorates the neck.

The mesh pattern of the main body zone, called a "rope-curtain" design in Korean, is generally said to have reminded Japanese connoisseurs of the multifold columns of tiny characters in the almanacs printed at the Mishima Shrine, on Izu Peninsula, Shizuoka Prefecture. Therefore the name Mishima was applied in Japan to these slip-decorated wares from Korea, and the term was extended to *punch'ŏng* wares in general, whatever their slip-inlaid decoration. The term is likewise used in the West. An alternate explanation for the use of the name Mishima, and one that would account for its generalized use, is that Japanese pirates once operated from a group of islands called Mishima, and it was these Mishima pirates who first brought *punch'ŏng* wares to Japan.

In any case, the Japanese have always greatly treasured *punch'ŏng* wares. The impromptu approach of the Korean potter, the lack of precision and finish in his works, as well as their natural unpretentiousness, were all qualities that directly appealed to the sophisticated taste of tea masters in Japan, qualities which we still can easily admire today. M.A.R.

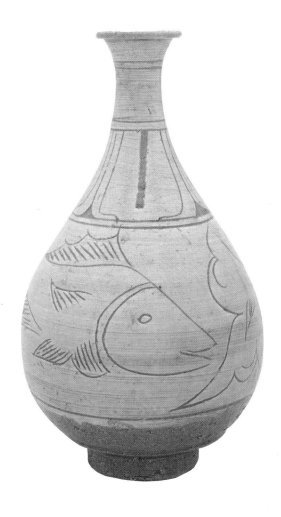

275 ৯৯

BOTTLE

late 15th century
Korean
punch'ŏng *ware with slip coating and incised decoration*
height 30.5 (12)
references: Gompertz 1968, 25–42; New York 1968

The Cleveland Museum of Art

Supported on a strongly cut foot, the gently pear-shaped body narrows to a tall, slender neck, then flares slightly to a modest mouth opening and cautiously everted lip. White slip was applied with a large brush while the piece was turned on a wheel or turntable, the coarse brush leaving horizontal striations still visible on the finished bottle. The design was produced by incising through or scraping away the hardened slip, exposing the darker body fabric. The design is organized into two horizontal bands: plump fish occupy the wider one around the belly, and sketchily drawn stylized lotus petals encircle the lower and wider part of the neck. The contrast between the dark, iron-rich clay body and the pale creamy slip makes the design stand out sharply and clearly. The glaze is no more than an unobtrusive window to the design, neutral in color and perfectly transparent.

Punch'ŏng ware with brush-marked slip is popularly known as *hakeme* (brush-marked), a term borrowed from Japanese connoisseurship. Several centuries prior to the development of *punch'ŏng* ware in Korea, Chinese potters at numerous kilns throughout northern China had perfected a slip-decorated stoneware called Cizhou ware, Cizhou in Hebei Province being the major center of production. In China the vessels were usually dipped in the white slip, whereas a sturdy brush proved to be most effective in making slip adhere to the coarse, iron-rich clays of Korea. Chinese slip-coated ceramics might be left plain, or designs might be painted in dark slip on the white ground, or incised through the white slip to the darker body beneath. All of these methods were used also by *punch'ŏng* potters. By the fifteenth century painted designs predominated in the Chinese wares, and Chinese potters had almost completely abandoned the slip-incised or carved technique, which was carried on by their Korean counterparts.

The present piece exemplifies the refreshing simplicity and straightforward technique and design that make these wares so endearing and admired. An interesting contrast obtains between the formal regularity of the lotus panels and the whimsical informality of the fish, a very popular motif within the limited repertory of representational designs on *punch'ŏng* wares. In China fish symbolized affluence and abundant progeny, and a pair of fish represented connubial bliss; given the profound and far-reaching influence of Chinese thought in Korea during the Chosŏn period, the same symbolism probably obtained. The founder of the Yi dynasty and his early successors modeled their new state of Chosŏn on Ming dynasty China, adopting enthusiastically and wholeheartedly the form and content of that highly bureaucratic state shaped by Confucian doctrine and manned by officials who acquired their positions by way of exhaustive, state-sponsored examinations in Confucian learning. In China the Confucian scholar was likened to a carp fighting its way upstream past the rapids of Longmen (Dragon Gate); perseverance and eventual triumph transformed the humble fish into a glorious dragon, as perseverance and success in the examinations transformed the struggling student into an honored official. The possibility of some relation between that Chinese metaphor and the prevalence of fish motifs on ceramics of Confucianist Chosŏn society is buttressed by fifteenth-century Korean bottles whose slip-inlaid decoration includes fish metamorphosing into dragons: their bodies are those of common fish, their heads those of dragons.

The fish motif, however, could as well have been inspired by more mundane concerns. Being good to eat, fish were a most suitable motif for this widely produced and used tableware. The Chinese characters *you yu*, meaning "I have a fish," are homophonous with different characters meaning "there is enough and to spare," making the fish an especially appropriate motif for a wine bottle. It was also believed that overimbibing could transform one into a fish. But that was held a happy fate, if the *punch'ŏng* wares are any indication, since most of the fish appearing on them have upon their faces quite unmistakable smiles.

M.A.R.

276

JAR

16th century
Korean
punch'ŏng *ware with slip coating and incised decoration*
height 43.8 (17¼)
references: Gompertz 1968, 25–42; Rhee 1978, 3:pl. 13

National Museum of Korea, Seoul

This substantial jar has an everted lip, constricted neck, low sloping shoulders, and a trunk which tapers gradually to the wide base. White slip was roughly brushed over the entire surface of the vessel, and the design was produced by incising and scraping through the hardened slip to the dark body clay below. In certain areas the glaze, irregularly applied, streaked down the sides and streamed into thickened globules. A massive lotus scroll swings and curls rhythmically around the expansive body zone, bordered near the base by a band of pointed petal shapes and at the shoulder

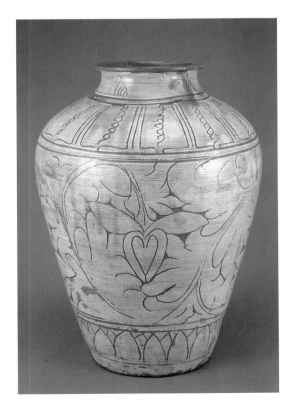

by geometricized lotus-petal panels. Several clusters of curved lines, which may represent grasses, are spaced around the neck.

Due to the paucity of dated material the exact chronological development of *punch'ŏng* wares is uncertain. It is generally and logically believed, however, that the carefully wrought incised or impressed slip-inlaid wares are earlier than the more spontaneous, uninhibited slip-brushed wares with either incised or iron-oxide brown painted decoration. Bold design and dynamic, vigorous execution are characteristics associated with the later wares, of which the present jar is a superb example. Although the workmanship may at first seem overcasual, the genial freedom and exuberance of the piece are exceedingly attractive, and one soon comes to appreciate the carefree approach of the decorator. The unconcealed creative process, in fact, becomes part of the aesthetic, and in the end quite seductive.

The great stylistic diversity among *punch'ŏng* ceramics is not a result of temporal factors alone. Produced at numerous kilns throughout central and southern Korea, the wares reflect the differences in local materials, in the skills of particular workers, and even in local tastes which influenced style. This rich, vital, and widespread indigenous tradition, which served Korean society so well during the fifteenth and sixteenth centuries, was devastated by the invasions from Japan initiated by Toyotomi Hideyoshi (1536–1598) in 1592. During the ensuing seven years of upheaval the wholesale destruction of kilns and uprooting of potters was so thorough and complete that the production of *punch'ŏng* wares, those paragons of simple grace and ruggedness, either diminished to insignificance or vanished entirely from the repertory of the Korean potter.

M.A.R.

277

COVERED BOWL

15th century
Korean
white porcelain
height 22.5 (8⅞)
reference: Gompertz 1968, 43–47

Horim Museum of Art, Seoul

Slightly above its modestly flared ring-foot the body of this bowl swells to its greatest diameter, then contracts gently to the wide mouth. The high, domed lid has a thickened ridge where it fits over the mouth of the bowl, serving, like a belt at the waistline, to emphasize the contraction. Atop the lid is a finial in the shape of the magical wish-fulfilling gem of Buddhist iconography, encircled by two incised rings. The gently balanced rotundities of bowl and lid are typically Korean. Gray

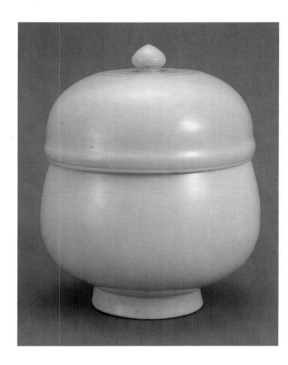

tinges the white body fabric and the clear, thick glaze, which seems suffused with soft light.

Superb white porcelains were produced during the fifteenth century in Korea as craftsmen and court patrons responded to China's lead. So attractive were these wares that even the Chinese emperor, who commanded the choicest wares of the finest Chinese potters, sought to acquire them. In 1425 an emissary from the court of the Xuande emperor, who reigned in China from 1425 to 1435, requested that porcelains from the official Chosŏn kilns near the royal capital at Seoul be provided for presentation to the Son of Heaven.

Although strongly influenced by early Ming dynasty porcelains, the Korean potters were not slavish imitators of Chinese white wares. The basic shape of the present bowl, for example, is as ancient as the potter's art itself, yet it is at the same time distinctively Korean. The distinguishing difference was produced primarily by substituting the high-domed lid for the shallower one typical of Chinese covered bowls, and the effect is at once suave and imperious. Although capacious, wide-mouthed bowls were produced in China, a closer model was to hand in eleventh–twelfth century Korean metalwork.

Contemporaneous with the white wares are *punch'ŏng* bowls of similar proportion, shape, and size, but their lids are flattened and sometimes surmounted by standing rings rather than by finials, so that when inverted, the *punch'ŏng* lids could also serve as receptacles. *Punch'ŏng* bowl-and-cover sets thus are clearly functional—one can easily imagine them being used as ordinary tablewares—whereas the more majestic and formal appearance of the porcelains seems more suitable for use at court or in religious ritual.

Slight imperfections, such as potters' finger-marks in the glaze, uneven borders where the glaze ends, or bits of sand or grit adhering to a roughly finished base, do not strike us as flaws or blemishes. Meticulous execution was simply not the Korean potter's primary aim, which might have been instrumental in preserving Korean ceramics from the stiffness, coolness, and remoteness that often accompany technical perfection. The aesthetic power of Korean wares lies in their tactile strength, directness, and sculptural beauty—qualities that came to glorious fruition in the fully independent Chosŏn porcelain style of the seventeenth and eighteenth centuries.

M.A.R.

278 🐚

EWER

15th century
Korean
white porcelain
height 33 (13)
reference: Gompertz 1968, 43–47

Horim Museum of Art, Seoul

A relatively high foot with thickened rim supports the pear-shaped body of this ewer. Its brief neck expands slightly to form the mouth opening into which a domed cover fits. Attached to one side of the ewer, where a hole was cut through the body, is a strongly curved spout, balanced by the high arc of the handle on the opposite side. Two ring-shaped loops, one affixed to the neck above the handle and the other to the lid, would have secured a cord or chain that kept the small cover attached to the ewer. Body fabric and glaze unite with the shape to produce an effect of purity, softness, and consummate grace.

White wares of great delicacy and refinement were produced during the Koryŏ period (918–1392), albeit in small numbers compared with contemporaneous celadon production. These white wares reflect the profound influence of the greatly esteemed Song dynasty (960–1278) ceramics produced in north and south China alike. Astonishing strength and gravity, however, set the early Chosŏn porcelains aesthetically apart from those earlier wares; on the whole the Chosŏn pieces were more sturdily constructed and their shapes adhered closely to fifteenth-century Chinese prototypes.

Yi Sŏng-gye (1335–1408, r. 1392–1398), a general of the Koryŏ state, overthrew the Koryŏ rulers and established a new dynasty in 1392. He looked to Ming China as the perfect model upon which to structure his own state. So important were the approval and support of China's powerful Hongwu emperor (r. 1368–1398) that Yi Sŏng-gye requested that exalted being to select from two alternatives the name by which the newly formed Korean kingdom would be known. The Chinese emperor selected Chosŏn, "Land of the Morning Calm," a name which was formally adopted by the Yi dynasts. The Chosŏn state paid respect and obeisance to the Ming rulers in the form of tribute, presenting vast quantities of gifts and goods at least annually. As was customary in the tribute relationship, the Chinese reciprocated with precious gifts, including porcelain vessels from their imperial kilns at Jingdezhen.

During the rule of the Ming dynasty's Yongle emperor (r. 1402–1424) pure white porcelain—some with the subtlest of incised or impressed decor but much of it immaculately undecorated—was unquestionably the favored ware, a direct and immediate reflection of the emperor's personal taste and preferences. The extraordinary white porcelains, masterworks of the Yongle imperial kilns, included such ewers as would have provided a model for the present piece, albeit the Korean potter altered the form slightly by reducing the flare of the mouth, shortening the neck, and modifying somewhat the curve of the handle.

During the reign of Sejong (r. 1419–1450) only white wares appear to have been used in the royal household, suggesting unstinting approval of Chinese models. And in fact, in 1466 production of white wares was restricted to those ordered by the court. The purpose, apparently, was to preserve the supply of raw materials necessary for the fabrication of fine white ware as well as to ensure the exclusivity of these marvels of the potter's art.

M.A.R.

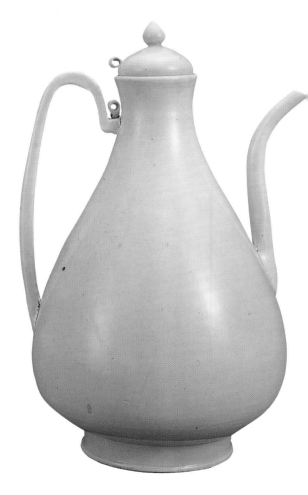

279

JAR

late 15th century
Korean
white porcelain with underglaze blue painted plum
tree and bamboo
height 41 (16⅛)
reference: Gompertz 1968, 53–68

Ho-Am Art Museum, Kyŏnggi Province

From a short, wide neck the body of this massive jar first swells outward, then curves rather sharply inward before flaring gently outward just above the thick foot. Between borders of ornate, stylized lotus petals at the shoulder and base the entire body is given over to a picture of a blossoming plum tree and stalks of bamboo. The gnarled trunk and branches of the old tree twist and recurve; only the younger twigs sprout blossoms. Leafy bamboo intersects and intermingles with the plum. Balancing this powerful primary zone of decoration, the lotus panels are strongly painted and their interiors richly embellished. The lower ring of petals in particular engages our attention, since it functions not as a mere abstract border but pictorially, as a fence blocking our view of the base of the plum tree and the bamboo stalks.

Blossoming plum and bamboo were of course prized for their natural beauty, but in addition they were endowed by the Chinese literati (and, following their lead, by the Koreans) with attributes which they themselves esteemed and identified with. The plum, which blossoms when winter still grips the land, symbolizes purity and loftiness; the bamboo, which bends under the storm but does not break and straightens when the storm has passed, was a symbol of resilience and straightness. These two, together with the pine, which stood for courage, steadfastness, and incorruptibility, were known as the "Three Friends of Winter," emblematic of scholarly perseverance and integrity. That such images should have wide appeal during the fifteenth century in Korea is easily understandable; it was a period of intense literary activity and one during which the highest value was placed on scholarly principles and pursuits.

A number of early Ming Chinese porcelain jars, splendidly painted in underglaze cobalt blue or copper red with the "Three Friends of Winter" bordered by lotus panels, serve as precedents for this one. Korean decorators however, usually depicted only two of the "Three Friends" on any one piece, as was done on the present jar. Most noteworthy here, however, is the astonishing technical proficiency and aesthetic individuality of the painter. The undulating outline of the tree moves swiftly and rhythmically, breaking here and there and resuming with great verve and strength. Much as in calligraphy, the brush line possesses independent aesthetic interest while still clearly describing the subject. The dark-on-light patches of blue forming the plum blossoms, the thin, pale outlines of the bamboo stalks with their even lighter interiors, and the treatment of the bamboo leaves all contribute to the uniqueness of this vessel's style and design.

Although the shape of the jar and the subject and composition of its decoration as well as certain elements of style relate to late fourteenth and early fifteenth century Chinese wares, other features, such as the use of fine outline with pale, even wash, compare with Chinese wares of the later fifteenth century, that is, from the reign of the Chenghua emperor (1464–1487) onward. Approximately contemporaneous with the Chenghua reign-era was the reign of King Sŏngjong in Korea (r. 1469–1494), when court painters were called upon to assist in decorating blue-and-white ceramics. On a well-known *maebyŏng* (C: *meiping*) bottle in the Dongkuk University Museum is a design of pine and bamboo, painted with stirring individuality; the vessel bears a date corresponding to 1489. Very probably this as well as the present jar with plum and bamboo are examples of the superlative work produced by the highly skilled and creative artists of the royal Chosŏn court.　M.A.R.

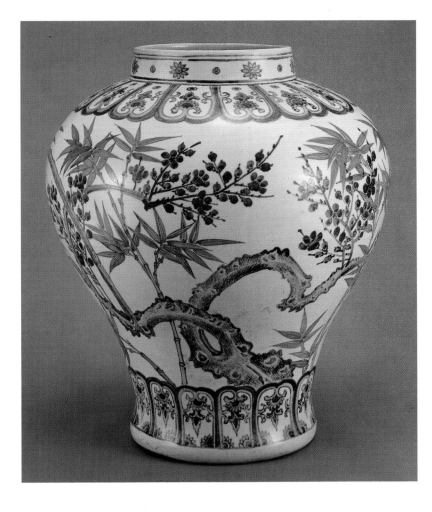

280

BOTTLE

15th century
Korean
white porcelain with underglaze blue decoration
height 25 (9⅞)
reference: Gompertz 1968, 53–68

Ho-Am Art Museum, Kyŏnggi Province

A fuller upper torso than is usual for a "pear-shaped" vessel characterizes this bottle. From a low, wide ring-foot, which imparts a feeling of steadiness and stability, the globular lower body contracts gently toward the narrow neck and gracefully everted lip. To produce the painted decoration, cobalt oxide pigment was brushed onto the clay body before glazing; firing transformed the gray-black pigment to the rich and vibrant blues visible here. Where the pigment was thickly applied, it fired to an inky blackish hue, which on this piece is particularly noticeable on the snout of the dragon charging through a cloud-filled sky. Its body and outstretched limbs are crusty with scales, and a ridge of jagged upright scales runs the length of its serpentine back. The beast is bearded and maned. Its long snout is snapped shut and its bulging eyes are intently

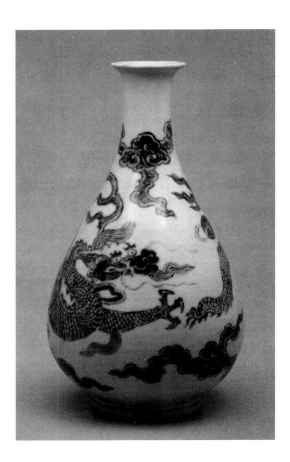

which include the present example, were done in Chinese style.

The hue and quality of the blue, the style of painting, and the form of the dragon in almost every detail are all but indistinguishable from Chinese dragons of the Xuande reign-era; were it not for the character of the clay, the casual treatment of the bottle's foot and base, and the appearance of the glaze, the piece could easily be mistaken for Chinese. Gifts of blue-and-white porcelains presented by the Xuande emperor to the Chosŏn court in 1430 included vessels with dragon-and-cloud designs, so it is not impossible that the painter of this piece had an actual Xuande period porcelain close at hand. Unfortunately the Korean potters did not adopt the Chinese practice of inscribing reign-marks on their ceramics, thus making it impossible to tell exactly when such fastidious renditions of China's classic blue-and-white style began to be made. M.A.R.

TEA BOWL, CALLED "KIZAEMON"

late 15th–16th century
Korean
stoneware, slipped and glazed
diameter 15.3 (6)
references: New York 1968, 46–47; Jenyns 1971; Covell and Yamada 1974, 60–61, pls. 20, 21; Hayashiya et al. 1974

Kōhō-an, Daitoku-ji, Kyoto

One of a small number of Korean wares adopted for the Tea Ceremony in early times (late six-teenth–seventeenth century), "Kizaemon" is a cultural document of importance because of its association with Tea and its particular character within that context. Tea bowls of this type are generically designated *Ido* ware; the origin of the term is unknown but the bowls were made in Korea, where they were used as rice bowls. There they were a country form of what is called *pun-*

focused, giving a purposeful expression to this majestic symbol of royal goodness and might.

During the fourteenth century Chinese potters had created an array of cobalt-blue decorated porcelain that marked the beginning of a new stylistic direction in Chinese ceramic art and was furthermore a staggering economic success. High quality cobalt oxide was imported from the Middle East— a major market for the ware—since local ores produced less intense and far less brilliant and attractive blues. During the early Ming, under enlightened imperial patronage, blue-and-white ware attained such aesthetic and technical excellence that connoisseurs have ever since considered that period the classic phase of Chinese blue-and-white, with wares of the Xuande reign-era (1426–1435) singled out as supreme.

When Korean potters began to make under-glaze blue decorated porcelains, they imported Middle Eastern cobalt from China along with the technique and current styles. Production was severely limited, however, by the prohibitive cost of the cobalt. In fact, in 1461 an attempt was made to limit the use of blue-and-white wares to the royal household, with military personnel per-mitted the use of blue-and-white wine bottles; awards of cloth or official rank were offered for presentation to the court of the coveted ware. Today only a small number of fifteenth-century examples survive. Some of these were decorated in a rather spare and sketchy style, anticipating the major trend in later Chosŏn period blue-and-white porcelain, but the most ambitious wares,

ch'ŏng ware, stoneware on which slip was applied in a variety of decorative ways (see cats. 272–276), but on *Ido* wares used simply to cover the rough gray stoneware body. In firing the glaze and slip often bubbled, resulting in large granular formations of nodules where the glaze was thickest, at the foot or even on the base. These rice bowls, a staple of sixteenth-century country production in Korea, were appreciated and appropriated by the Japanese warlords who devastated Korea at the time of Hideyoshi's invasion (1592–1598). The bowls were prized for their roughness and simplicity, qualities that had come to be esteemed by practitioners of Tea, who included the officers and officials of the occupying army. In a very real sense the *Ido* bowls are "found objects," like the bicycle seat and handlebars of Picasso or the urinal presented satirically as a work of art by Marcel Duchamp. Arriving in Japan, these "old Ido" wares (*ao Ido*) acquired an aura that only increased in the succeeding centuries of growing enthusiasm for the Tea Ceremony.

The bowl "Kizaemon" was reputedly once owned by a seventeenth-century Osaka merchant, Takeda Kizaemon, who died impoverished and ill, holding his tea bowl. All subsequent owners of the bowl were also afflicted, until "Kizaemon" was given to the Daitoku-ji subtemple Kōhō-an. This tale has been told of many treasures, East and West, but its significance here lies in its demonstration of the romantic and cultist nature of the later Tea Ceremony.

The spirit of Zen, directing and confirming the new masters of Japan in their appreciation of utilitarian Korean farm vessels, helped to make the Tea Ceremony an insignia of the cultural elite of the post-Momoyama (after 1615) period. In this development Korea was a passive and humble but ultimately potent agent: invaded by the Japanese (1592), despoiled by the invaders of not only its folk wares but many of the potters who made them—and thereby coming to exert strong and

lasting influence on the aesthetics of the Japanese cult of Tea.

The initial instincts of the "finder" of such a tea bowl were largely correct. The *Ido* type bowl was an almost perfect expression of the ideals of the early Tea Ceremony (*Cha no yu*): humble, rural, natural, and congenial to hold. The neutral "loquat" color, the rough surface, the granitic, stony nodules of the base, the straightforward shape and casual potting, all combine to express the not ignoble ideals of the Tea Ceremony in its early and most convincing form.

Today the world of Tea is far different: a contemporary tea bowl (J: *cha wan*) or a cold-water jar (J: *mizusashi*) may be bought for less than half price it one does not insist also on acquiring the accompanying wooden container, inscribed not by the potter but by a leading master of a contemporary Tea Ceremony organization. "Kizaemon" became a tea bowl in a far different time and context. It exists in its own right and, stripped of old and modern myth, bespeaks the humble and forthright virtues of what we condescendingly call folk art. S.E.L.

282 ଌ

ORNAMENT CASE

15th century
Korea
lacquered wood with mother-of-pearl inlay
height 15.2 (6), width 28.5 (11¼), length 19.8 (7¾)

Museum für Ostasiatische Kunst, Cologne

The design, complex and well executed, is focused on the lid, with a pair of flying phoenixes flanking a circular motif (sun?) within a cusped cartouche; the remaining decoration on the lid, and on all four sides of the box, consists of seven-petaled floral arabesques within rectangular borders of

flowers, Xs, or dots. Paired phoenixes allude to a flourishing marriage, and the box may have held valuable presents, perhaps a headdress with accompanying ornaments.

Mother-of-pearl inlay was common to the decorative arts of China, Korea, and Japan, and flourished particularly in China in the Tang (618–907) and Ming (1368–1644) dynasties and during the Heian period in Japan (794–1185). Mother-of-pearl–decorated Korean objects antedating the Chosŏn period (1392–1910) are rare, one notable example being the thirteenth-century sutra box in the British Museum. With the Chosŏn period examples become more numerous, and early ones, such as this box, retain to some extent the small scale and finely detailed execution of Chinese works. On later objects the floral arabesque is omnipresent, and the motifs tend to be much larger and rougher in execution. In their boldness and strength those designs recall the decoration of the popular (or "folkish") Cizhou ceramics produced in Northern Song (960–1127) China.

The style of decoration on the present box falls somewhere between the small scale of the thirteenth century and the bold works of the seventeenth century and later. Decorative fields bounded with twisted wire, as on this box, seem to be characteristic of Korean lacquer work. S.E.L.

MING CHINA

PORTRAIT OF THE HONGZHI EMPEROR

16th–17th century
Chinese
hanging scroll; ink and color on silk
209.8 x 115 (82⅝ x 45¼)

National Palace Museum, Taipei

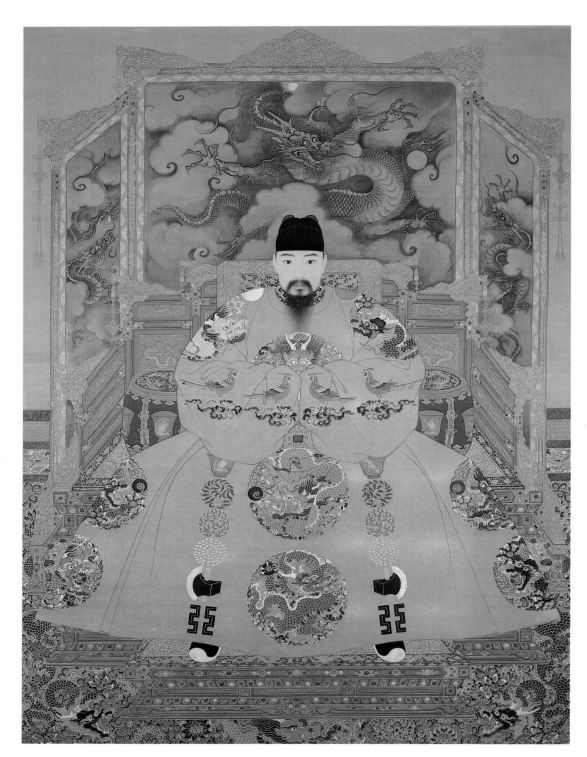

To manifest and to consecrate the glory of the emperor and his reign may be regarded as the general function of all court art, but this proposition is nowhere so clear as in formal imperial portraits. These present and magnify not so much the specific individual, although affording some verisimilitude in facial details (such as the full beard in the present example), but rather the institution itself—the eternal throne rather than its temporary occupant. Symbols and their extended connotations are thus of more than ordinary importance and carry much of the intended meaning of such paintings.

Yellow, the color of the northern loess soil of the Middle Kingdom, was the actual name of one of China's most famous legendary rulers and, from about the sixth century onward, only the emperor could wear garments of that color. The dragon, general symbol of fertility and male vigor, also signified the emperor from the Han dynasty (206 B.C.–A.D. 220) onward, especially dragons with five claws; nine dragon-filled rondels are visible on the robe here and additional dragons appear on the three-panel screen which encloses the Son of Heaven and on the rug beneath his throne. Monkeys alternate with tigers on the cushion which bolsters the ruler and appear also in vessels depicted just below the waist of his robe. The very loose and flowing sleeves bear images of pheasants, which are female symbols and here represent the empress.

A red sun and white moon embellish the shoulders, and paired insignia extend vertically from waist to hem of the robe; two sacrificial vessels (one decorated with a monkey, the other with a tiger), water plant, flames, rice, ax, and a *fu* pattern (symbolizing the distinction between right and wrong). Together with the dragons and pheasants, and with the addition of symbols for mountains and constellations (not seen on this robe), these make up a standard group of twelve imperial insignia that were incorporated into the Ming legal code by the dynastic founder. Long before that, however, since about the third century B.C., these symbols had been hallowed by

association with Emperor Shun, an early successor to the Yellow Emperor: "I wish to view the symbols of the ancients. Take those for the sun, the moon, the stars, the mountain, the dragon, and the pheasant and do paintings in color on ancestral temple vases; take those for the water plant, fire, husked grain, rice, the ax, and the symbol of distinction and embroider them in color on robes of fine linen." Relating to the emperor's powers as well as to his ritual obligations, the symbols also

assert his explicitly cosmic role as intermediary between heaven and earth.

Having learned so much about the emperor's status from the painting, it may seem ungrateful to observe that it tells us little about Zhu Youtang (1470–1505) himself. Born the third son of the Chenghua emperor (r. 1464–1487) and an aborigine maid in the palace, Zhu grew into a humane and much admired monarch (r. 1487–1505) who is also notable for his devotion to one woman, his empress and the mother of all his children. Although the court academy of painters was quite active under this ruler, the only portrait of him by a known artist was painted by a man who refused an invitation to join that body. Recommended by a provincial governor, Jiang You traveled to Beijing and successfully completed a portrait of Zhu but then declined a permanent appointment on the grounds that he was uncultivated and rustic. The present painting, however, which adheres closely to established laws and protocols for imperial portraiture, must be the work of some court specialist in the genre.

Among the twenty-seven extant large-scale imperial portraits of the Ming period, five are half-length bust images (four depicting the first emperor and one his empress), and one is an equestrian portrait of the Xuande emperor (r. 1425–1435). The remaining twenty-one portray their subjects seated; within this group there are considerable differences among the earlier eleven portraits, whereas the ten beginning with Zhu Qizhen (1427–1464) are very close in composition, detail, and even physical condition, suggesting that they may not all date from the lifetime of the person portrayed. This in fact is certain in the case of the emperor posthumously titled Xian Huangdi, for Zhu Youyuan (1476–1519) was elevated to imperial status only posthumously and never actually ruled.

According to an account of Beijing during the late Ming period, written by Sun Chengze (1593–1675):

> The Spirit-Shadow Hall is to the northeast of the imperial ancestral temple. It receives and stores portraits of emperors of the various dynasties. Each year, on the sixth day of the sixth lunar month, the temple provides them with festive coverings and they are taken to the ancestral temple. On their return to the Spirit-Shadow Hall they are hung to dry in the sun.

On the fall of the capital to the Manchus in 1644, the entire group of Ming and earlier imperial portraits became part of the Qing imperial collection. The paintings were stored by the new rulers from the north in the Southern Fragrance Hall and were recorded in palace inventories taken in 1749 and 1816. Subsequently moved to a summer palace in Manchuria, the paintings were returned to Beijing in 1913 and, in 1948, were transported to Taiwan, the easternmost portion of the domain ruled by this august Ming personage. H.R.

284 ❧

Wang Ao and Shen Zhou
1450–1524 and 1427–1509

ODE TO THE POMEGRANATE AND MELON

c. 1490
Ming China
hanging scroll; ink and color on paper
147 x 86 (57⅞ x 33⅞)
references: Edwards 1962, 75, 76, XXXII, pl. 46a; Goodrich and Fang 1976, 2:1343–1346; New Haven 1977, 195, 263–264, no. 32

Detroit Institute of Arts

The calligrapher Wang Ao signed this work and added one seal, the painter Shen Zhou appended two seals but no signature. Of the four collector's seals, the two on the left are unidentified, the two on the right are those of the noted connoisseur Liang Qingbiao (1620–1691).

Wang's long poem is executed in *xing-cao* (part way between semicursive and cursive) style, a sketchy mode which may be traced back to the Eastern Han Dynasty (A.D. 25–220). Richard

Edwards has summarized the poem as a "kind of talisman, a propitiatory offering for the birth of a son to one long denied this blessing, to be presented to a mutual friend." In many cultures the pomegranate has been a symbol of fertility and fecundity, a symbolism reinforced here by the ever-replenishing nature of the melon.

Shen's authorship of the painting, attested by his two seals and by Wang's poem, which names him as the painter, is confirmed by the high quality, freshness, and spontaneity of the image. Branches, twigs, and vine are linear and calligraphic, while the better part of the painting is executed in colored washes without ink outlines— what the Chinese call the "boneless" (*mo gu*) method. The result is a wet and apparently burgeoning depiction of leaves and fruit, visually suggesting the celebration of fertility written above.

Wang Ao rose from the peasantry to become a scholar-official and eventually Grand Secretary at the court of the Zhengde emperor (r. 1505–1521). An accomplished Confucian scholar, he followed the conservative Han dynasty Confucian tradition rather than the more fashionable Neo-Confucianism of the thirteenth and later centuries. His

relationship by marriage to the imperial family, along with his native ability and subtlety, enabled him to endure and prevail amid the swarming intrigues of court and army during the middle Ming period. He was also a learned student of his region, editing gazetteers of Suzhou and of the Lake Tai area. His calligraphy, prose, and poetry were much admired.

Shen Zhou was primarily a landscape painter; for him, flowers or "fur and feathers" were infrequent subjects. This *Pomegranate and Melon* picture is one of his very best essays in the genre — an opinion concurred in by Liang Qingbiao, one of the two or three greatest collectors in Chinese art history, who included this work among the relatively small number of Ming paintings in a vast collection devoted primarily to earlier works.

S.E.L.

285 &

Zhu Yunming
1461–1527

THOUSAND-CHARACTER ESSAY

dated to 1523
Chinese
handscroll; ink on paper
31.1 x 372.9 (12¼ x 146⅞)
reference: New Haven 1977

National Palace Museum, Taipei

. . . Although my brushwork is clumsy, it has never before come out like this. On the 16th day of the 4th intercalary month of the year [1523], I went by Yunzhuang's house. After drinking wine, he brought out some sutra paper and requested me to write the *Thousand-Character Essay*. Yunzhuang and I are close friends, so I forced myself to write this, but it will certainly be laughed at even by the generous. The old wood-gatherer of Zhi Mountain, Zhu Yunming.

The *Qian Zi Wen*, or *Thousand-Character Essay*, employs one thousand characters, each only once. At least two partly differing versions of the text are known. Authorship of the original essay is also unclear, but one tradition holds that Zhong You (151–230) was the first to write the text and that Wang Xizhi (303?–361?) followed him. During the Sui dynasty (589–618) a descendant of Wang Xizhi, the monk Zhi-Yong (act. late 6th century), over a period of about thirty years wrote some eight hundred copies of the text in his ancestor's style of calligraphy and distributed them among various monasteries, thereby ensuring that Wang's style gained ever greater acceptance and authority. The Qian Zi Wen attained great pedagogical importance, for it was often written employing a different mode of script in

detail

each of the parallel vertical columns, thus providing students with canonical models to learn from. Accomplished calligraphers also wrote the text, which became so well known that viewers could concentrate their full attention on style rather than content, on the writing performance rather than the denotative meaning of the characters themselves.

Zhu Yunming is widely hailed as the greatest calligrapher of the Ming dynasty, peer of the greatest masters of antiquity. He was trained in literature and guided in his early study of calligraphy by his father, Zhu Xian (c. 1435–c. 1483), and by his two grandfathers, the scholar-official Zhu Hao (1405–1483) and Grand Secretary Xu Youzhen (1407–1472). Zhu later married the daughter of the highly regarded calligrapher Li Yingzhen (1431–1493), who was also the teacher of Zhu's close friend Wen Zhengming (cat. 286, 317). After passing the second-level examination in 1492, Zhu held office for only about five years, as magistrate in Guangdong Province from 1515 to about 1520, and enjoyed most of the rest of his life in Suzhou with such friends as Wen and Tang Yin (cat. 297–299).

According to Zhu himself, his father forbade study of any modern calligrapher, insisting that the precocious youth learn from the great masters of the past. Wen Zhengming thus wrote of his friend: "... [Zhu Yunming] alone was able to absorb the merits of all the different scripts. The reason is that when he was young, there was no calligraphy he did not study; but having once

studied it, there was nothing in which he was not able to achieve complete mastery" (translation from New Haven 1977, p. 205). Zhu's particular interest in the cursive style was likely inspired by his grandfather Xu Youzhen, who himself followed the Tang paragons of that style, Huai-Su and Zhang Xu. Zhu Yunming's highly subjective, "wild" transformation of this mode was exceptionally innovative, therefore drawing great opprobrium from conservative critics. His nonconformist personality and his iconoclastic ideas on history and society seem entirely congruent with his cursive writing, in which he at times sacrificed coherent and balanced structure in order to achieve maximum visual impact from simple forms spontaneously written.

Zhu's *Thousand-Character Essay* of 1523 is unusual within his oeuvre, and his colophon suggests that he was aware of that fact. It is written in semicursive script (*xing shu*). The columns of the text are spaced rather closely, which tends to stress lateral connections and hence balances the verticality of the columns themselves. Most of the individual characters have broad or squat constructions, but within each column Zhu established a rhythmic progression of vertical, horizontal, and oblique strokes that creates a powerful and compelling movement from beginning to end. The strokes themselves are generally fleshy and broad, with the clear and decisive changes in width that suggest pulsating energy. Zhu's various earlier models had long since been internalized as a stylistic vocabulary that he could

manipulate freely. Although that freedom sometimes led him to flamboyant excess or to careless instability, the present work shows him at his very best, with strong, forceful, and individual brushwork creating pictorial structures that are truly classic in their disciplined balance and restraint.

H.R.

286 ঞ

Wen Zhengming
1470–1559

Ten Family Admonitions

dated to 1541
Chinese
handscroll; ink on paper
32.7 x 1,463.9 (12⅞ x 576⅜)

National Palace Museum, Taipei

This scroll is not only a superb example of Wen Zhengming's mature style of calligraphy but, considering the content of the text as well as the artist's own inscription and the colophon, it is also a document illuminating some basic cultural and social values. It is inscribed:

Prefect Ziwu [Chen Yide] brought the admonitory words he had received from his father and asked me to write them out so he could keep

detail

them always at his side. How could I then not sympathize with his desire not to neglect the documents he had received? It is unfortunate that my writing is less than exemplary and thus not a match for the ideas. On the 24th day of the 2nd lunar month of the year [1541], inscribed by Wen Zhengming.

The colophon reads:

This scroll was written by Master Hengshan (Wen Zhengming) after I paid my respects and requested it of him. During the eighth lunar month, autumn, of the year [1538] of the Jiajing reign-era, my father, the venerable minister and prefect, personally wrote out a scroll and presented it to me, entitling it *Further Words on Transgressions for the Family*. I knelt down [to receive the scroll] and then kept it as a treasure, carrying it in my hands wherever I went. It is now thirty-two years later, but each time I hold and read the scroll I truly hear my parent's teachings and am overcome by emotion. I had the scroll carefully traced and engraved in stone and also wrote it out myself, keeping that in the ancestral shrine together with the sacrificial vessels.

Now I present this scroll [by Wen Zhengming] to my second son, Compiler Siyu, hoping that it will be handed down forever and never perish. Throughout his life my father was honored for his essays on government affairs and was written up in the dynastic records for a title, but this need not be repeated here. It is now ninety-six years since my father was born and one hundred years since Hengweng (Wen Zhengming) was born. In winter of the year 1570 I, the unfilial son Yide, wipe away my tears and respectfully inscribe this with a hundred prayers at the age of seventy-four.

The text was originally composed by Chen Hongmu (1474–1555), an official who rose in rank from censor in Yunnan Province to vice-president of the Ministry of War in the capital. Chen was not the first in his family to achieve official prominence, for both his father, Chen Liang (1446–1506), and his grandfather, Chen Yong (1420–1462), had also served with distinction. Given his heritage and training, it is natural that Chen Hongmu's "family admonitions" in fact had little to do with strictly household concerns but rather dealt with the kinds of situations and problems that would be encountered by his son when he took office. The sections thus touch on law, trade, hearing litigation, etc., but concentrate mostly on human relations, as two examples will demonstrate:

If you should happen to meet a prominent official at a rest station along the road, make it your business to assist him with respectful attention. Answer when questioned, but you must not speak excessively. And even in ordinary intercourse it is good to consider [your words] carefully.

When in office, all public business will naturally be done according to law. But you will also serve senior officials sincerely and deal with colleagues harmoniously; meet your superiors with proper etiquette and your subordinates with fairness. This is most important....

By 1538, when he was in his mid-sixties, Chen Hongmu had retired and was living in seclusion at the foot of Mt. Gaowu. Perhaps feeling the pressures of advancing years, Chen, according to his own statement here, "freely wrote out these ten precepts as the spirit moved me. Although my words are not in orderly sequence, they are moral and practical. If you are able to embody them in your actions they will serve as foundation for great and far-reaching [undertakings]." Chen then presented the scroll to his son, Chen Yide, who had earned his second-level degree in 1525 and later served as a prefectural official. Yide kept his father's writing with him at all times, hence by 1541 the scroll must have shown signs of wear.

Yide then requested Wen Zhengming to write the present copy, which in 1570 was passed on to Yide's son, Chen Siyu, who five years earlier had passed the top-level examination and who served ultimately as vice-president of the Ministry of Rites. Five generations of the Chen family are thus known to have achieved some degree of success in officialdom, and both the strength and the burdens of that tradition are evident from Chen Yide's account here.

Most artists of the brush tend to become specialists in either painting or calligraphy; Wen Zhengming is one of very few who is famed nearly equally for both achievements. While still a student in the prefectural school, Wen had already demonstrated his determination to become a good calligrapher by declining to join his fellows in play during an absence of the teacher, rather spending the entire day copying and recopying the *Thousand-Character Classic*. Wen's assiduous dedication may be attributed in part to the practical need for good writing when taking the official examinations, but perhaps even more to his family circumstances. Wen's grandfather was a collector of some note, owning, for example, calligraphy masterworks by such as Wang Xianzhi (344–388). At least by 1488 Wen was studying both calligraphy and painting with Shen Zhou (cat. 316) and met and studied the Classics with Shen's close friend Wu Kuan (see cat. 312). Three years later Wen's father, the highly respected scholar-official Wen Lin (1445–1499), introduced the dedicated youth to Li Yingzhen (1431–1493), then the ranking calligrapher in Suzhou and also the father-in-law of Zhu Yunming (cat. 285). Wen and Zhu played important roles in the mid-Ming revival of earlier styles of calligraphy and established paradigms of excellence that remain standards yet today.

By 1541, the year in which he wrote the *Ten Family Admonitions* for Chen Yide, Wen Zhengming was generally recognized as the preeminent calligrapher in the country, especially in the small regular (*kai shu*) and the semicursive (or running, *xing shu*) script styles. His early style of semicursive calligraphy had been strongly influenced by that of the great Song dynasty master Huang Tingjian (1045–1105), several of whose works were owned by Shen Zhou. The present rather cursive example of large semicursive style reveals Wen's study of the works of Zhi-Yong (act. late 6th century) and Wang Xizhi (303?–361?). Wen's typical control is visible in the straight lines and ordered disposition of the individual characters, which are given equal visual weight by the forceful yet free and elegant strokes. The heritage of such Yuan dynasty masters as Kangli Naonao (1295–1345) is here transformed by a more disciplined approach in which the direction, orientation, shape, tonality, and speed of each stroke is calculated with reference to an ideal aesthetic whole. H.R.

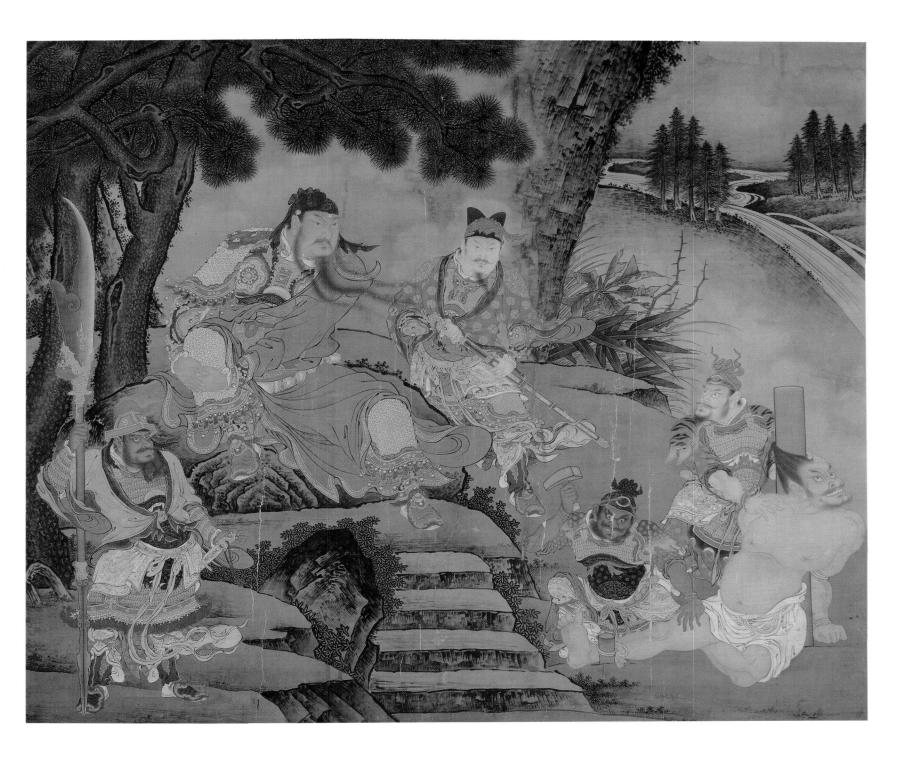

287 ॐ

Shang Xi
active c. 1425–c. 1450

GUAN YU CAPTURING PANG DE

c. 1430–1441
Chinese
hanging scroll; ink and color on silk
200 x 237 (78¾ x 93¼)
references: Brewitt-Taylor 1925, 147–156; Cahill
1978, 25–26

Palace Museum, Beijing

Little is known about Shang Xi except that he was from Puyang, now in southern Hebei Province, just over fifty miles southeast of Anyang, last capital of the Shang dynasty (trad. 1766 B.C.–1045 B.C.). By the Ming dynasty this region, the heartland of ancient China, had become artistically conservative. Shang Xi must have been recognized as a talented master to have been called to the court of the Xuande emperor (r. 1425–1435) and to have been appointed Commander in the Embroidered Uniform Guard. This, the emperor's personal bodyguard, functioned as a sinecure for the ruler's personal favorites, including professional court musicians and painters. Shang was

noted as an animal and figure painter, but only some four of his major works survive.

It is no coincidence that the huge scale, brilliant color, and theatrical figures in this painting recall the comparable world of the great Chinese novels, which were a literary innovation of the early Ming dynasty. The subject is taken from the earliest of these inventions, the *Romance of the Three Kingdoms* (*San Guo Zhi Yan Yi*) by Luo Guanzhong. Written in simple and accessible literary style, tending even to the colloquial in passages of dialogue, *Romance of the Three Kingdoms* was based on the turbulent events of the years 168–265 A.D., encompassing the breakdown

and fall of the four-hundred-year-old Han dynasty. Narrative, action, and dialogue in this work are basically pictorial, and were embroidered for dramatic, popular, and theatrical effect. The late Yuan and early Ming period also witnessed the rise of Chinese drama, and Shang Xi's painting may well owe much in its appearance to the grand poses and heroics beloved of the Chinese theater. Even though the point of view in these new literary genres was populist and anti-elitist, they were still most popular among scholar-officials. Judging from Shang's large-scale decorative painting shown here, they pleased the court as well—at least in its relaxed and "unofficial" moments.

The subject came from chapter 74 of *San Guo Zhi Yan Yi*, in which the powerful officer Pang De (d. A.D. 219) was charged by the wicked general Cao Cao (A.D. 155–220) with the capture of the virtuous general Guan Yu (d. A.D. 219). But Guan was a master strategist: taking advantage of an imminent flood, he turned the tables on Pang De, taking him prisoner after destroying most of his army in a heroic assault abetted by the rising waters. Guan Yu then held a summary court on the field of battle:

[Guan Yu] then returned to the higher ground where his tent was pitched and therein took his seat to receive his prisoners. . . . [Pang De] was sent for. He came, pride and anger flashing from his eyes; he did not kneel but stood boldly erect.

"You have a brother in [Hanzhong] and your old chief was Ma Chao (A.D. 176–222), also in high honor in Shu. Had you better not join them?"

"Rather than surrender to you I would perish beneath the sword," cried [Pang].

He reviled his captors without ceasing till, losing patience at last, [Guan Yu] sent him to his death. He was beheaded. He stretched out his neck for the headsman's sword. Out of pity he was honorably buried.
(Translation by C. H. Brewitt-Taylor.)

Obviously Shang Xi has not literally followed the text: there is no tent for Guan Yu; Pang is shown pinioned by his hair and right leg to a post and stake; the flooded battlefield is suggested only by ribbons of water gliding between cedar copses. But simplifications such as these were used, then and after, in Chinese theater. All emphasis is on the actors, especially the two protagonists, who are portrayed significantly larger than the bland attending official, the guard with his halberd, and the two soldiers binding the defeated general. The facial expressions are histrionic, and suggest theatrical makeup. Probably the overall effect is just what was intended—high drama, highly visible from a distance, not unlike the mural art of Buddhist temples during the Tang dynasty but wholly

unlike the grave and reserved figure paintings illustrating various classical episodes of Confucian decorum. Some of the drama in the painting is derived from the convincing detail of the military costumes. These are rendered with a realism and complexity quite different from the flatter, simplified symbolic fragments of nature in the setting—pine, bamboo, briar, rock, cedar, and water forming a somewhat perfunctory mise-en-scène for the fully realized figures.

In another hanging scroll in the Palace Museum, comparable in size to this one, Shang Xi depicted *The Xuande Emperor and His Hunting Party*. But how different this work from the scene of Guan Yu and Pang De! Here the eclectic-traditional mode is dominant, and a more Confucian decorum rules. Overall composition and disposition of the figures derive from traditional Tang dynasty (618–907) depictions of imperial processions. The horses clearly echo the fourteenth-century manner of the classic masters of the genre, Zhao Mengfu, Zhao Yong, and Ren Renfa, in turn beholden to Tang masters like Han Gan. But the landscape and wild-animal elements are all owed to the court painters of the Song dynasty (960–1279). Indeed a survey of the gully on the right presents almost a compendium of the achievements of twelfth- and thirteenth-century masters—the crackling branches of Ma Yuan, the birds and animals of Li Di, the pines of Liu Songnian. Mastery of these styles was required of an important court painter of early Ming, as was emulation of the realist style practiced in the famous "Academy" of the last Northern Song emperor, Hui Zong.

What truly distinguishes this scene is its inactivity. No one is hunting. No one has hunted. In place of the older, more believable huntsmen found in earlier scenes of this type, here we find boy attendants resembling those at scholars' party-gatherings. The cases that they bear could contain *qin*—a kind of zither, and the badge of the gentleman-scholar—as easily as bows. This is a hunting scene for a sybaritic and aesthetic monarch. Tradition continues, but reality escapes. The artist's talent for the dramatic, so fully expressed in *Guan Yu Capturing Pang De*, has been overcome by the requirements of archaism and protocol.

Besides Song Hui Zong (r. 1101–1126), the only really gifted and accomplished painter in the long roster of China's imperial rulers was the Ming Xuande emperor (r. 1425–1435). And like Song Hui Zong, the Ming artist-emperor was a devoted, even too-generous patron of the arts, recapturing at least in part the reputation of his Song predecessor. S.E.L.

288 🐛

Dai Jin
1388–1462

ZHONG KUI TRAVELING AT NIGHT

Chinese
hanging scroll; ink and color on silk
189.7 x 120.2 (74⅝ x 47⅜)
signature and two seals of the artist at center left
references: Sirén 1958, 4:128–133; Cahill 1978, 45–53, pls. 10, 12–14; Rogers 1988, 117–118

Palace Museum, Beijing

Traditionally the legend of Zhong Kui began in an emperor's dream. During the Kaiyuan reign-era (713–741) of the Tang dynasty Emperor Ming Huang dreamt that a small demon stole his jade flute and his concubine Yang Guifei's purple scent bag, whereupon a large and frightening demon in scholar's cap and boots grabbed the thieving demon, gouged out his eyes, tore him to pieces, and devoured him. In the dream the large demon identified himself as Zhong Kui, who some hundred years earlier had dashed out his brains in shame and chagrin at having failed the civil service examination. The then emperor had ordered an honorable burial befitting an official for the failed scholar, who in gratitude vowed to be a Demon Queller. Pictures of Zhong Kui with a retinue of obedient, subservient demons still are displayed during the twelfth lunar month just before the Chinese New Year, and on the fifth day of the fifth month, "Dragon Festival" day. Naturally Zhong Kui also became a kind of patron saint for scholars and a generally protective and auspicious deity.

The New Year was customarily celebrated at the Imperial Palace by a great exorcism of demons, carried out by attendants and servants dressed to represent various demon expellers, including Zhong Kui, Pan Guan (Daoist Judge of Hell), Zao Jun (the Stove King, or God of the Kitchen), and others. Among commoners the Twelfth Moon festivities were mostly focused on the Stove God, Zao Jun, but small groups of beggars and unfortunates impersonated Zhong Kui's demons and thus provided visual stimulation for pictorial representations.

This masterly depiction of a demanding subject situates Zhong Kui and his accompanying six demons in a chilly, wintry landscape, with twisted trees and branches competing with powerfully drawn rocky cliffs and a waterfall foaming over stepped rocks. Nevertheless figures dominate the landscape, by virtue of strongly brushed drapery and body boundaries as well as shaded ink wash modeling. This is not a landscape with figures but figures in a supporting setting. In its manner of resolving the tension between figures and landscape, Dai Jin's work resembles Sesshū's *Daruma and Eka*. The sheer size of the scroll

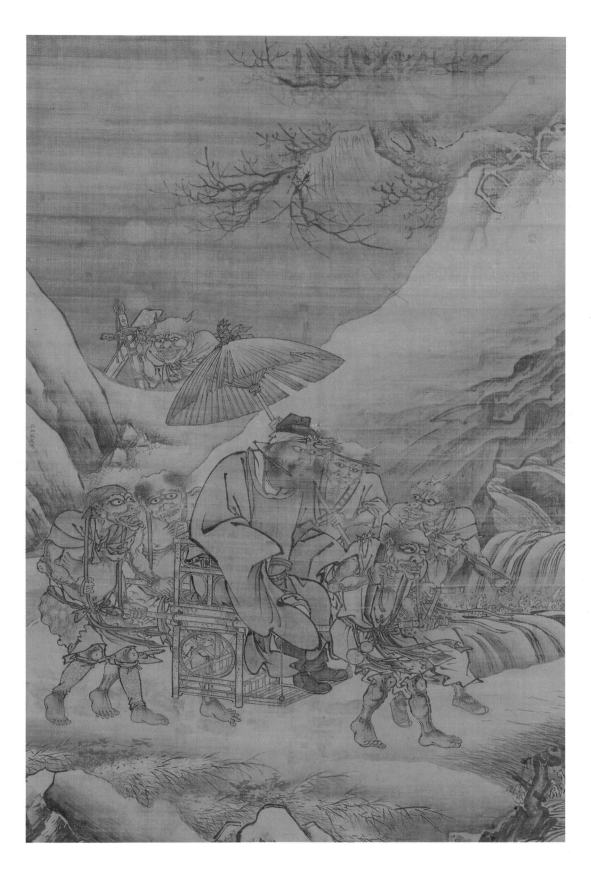

seventeenth century, offered a perceptive appreciation of Dai's accomplishment: "... his pictures of gods were most dignified and the devils were fierce. He mastered completely the coloring of the garments and the drawing of their folds (with light and dark tones) and was not inferior to the great masters of the [Tang] and [Song] periods." (Translation from *Tuhui Baojian, xuzuan*, in Sirén 1958, 131.)

One should note that the red-haired demon bringing up the rear carries Zhong's sword and zither (*qin*), attributes of the scholar-official, and that the tattered parasol and lightweight bamboo chair-litter seem more appropriate for south China than for this wintry environment. Still, the lone sprig of blossom in the demon-scholar's cap suggests the approach of spring.

Dai Jin, from Hangzhou in Zhejiang Province, is traditionally acknowledged as the founder and first master of what came to be known as the Zhe school of painting (after the first syllable of his native province, Zhejiang). He was considered a great master in his own time, and legends and anecdotes gathered about his name. His excellence at figure painting and realistic depiction found (apocryphal) expression in the tale of his locating a larcenous porter by circulating the local wine shops with a sketch of the man. Dai may have worked on the Bao'en Si, a major Buddhist temple begun under imperial auspices in 1407 at Nanjing, then the Ming capital. By 1421 the capital had been moved to Beijing, and Dai followed in hopes of appointment as a court painter. Though recommended by a high court official, Dai Jin fell afoul of the intrigues and jealousies of the Xuande emperor's court and its leading painters and fled Beijing for Hangzhou, re-embarking on a career of Daoist and Buddhist figure painting. The animosity of the imperial art advisor, Xie Huan, remained unappeased, however, and forced Dai to flee to Yunnan Province in the far southwest, to the entourage of Mu Sheng (1368–1439), a nobleman well known as a connoisseur and collector. Ultimately he returned to Beijing, probably after 1440 (when the Xuande emperor was dead), and finally achieved the measure of success his outstanding talent and accomplishments deserved. Among his prominent supporters in the capital was Wang Ao (1384–1467), a famous official and calligrapher.

Dai Jin's excellence was fully understood by his only rival of the time in fame, Shen Zhou, the leading master of literati painting (*wen ren hua*) and founder of the Wu school, centered in Suzhou. Contemporaneous and near-contemporaneous records and critical literature were highly respectful of Dai Jin's art; only in late Ming and in Qing, after Chinese art had become polarized between the "professionals" and the *wen ren*, with the *wen ren* seizing the moral and aesthetic high ground, did the Zhe school in general and Dai Jin in particular begin to lose their luster in received opinion.

S.E.L.

suggests its use in a large chamber or hall, perhaps even in a noble, princely, or imperial setting, as a decoration on Twelfth Moon day. In the strength and especially the solidity of the figures this work recalls the early fourteenth-century master Yan Hui, who pursued a relatively "realistic" light-and-shade modeling technique which rivals analogous achievements in fourteenth- and fifteenth-century European painting. Unfortunately, aside from such rare essays as this one by Dai Jin, this way of painting was abandoned by the leading masters of the Ming dynasty, thus cutting off certain possibilities for variety and complexity in later Chinese painting. Mao Dalun, writing in the

Huang Ji
active late 15th century

SHARPENING THE SWORD

Chinese
hanging scroll; ink and color on silk
170.7 x 111 (67¼ x 43¾)

Palace Museum, Beijing

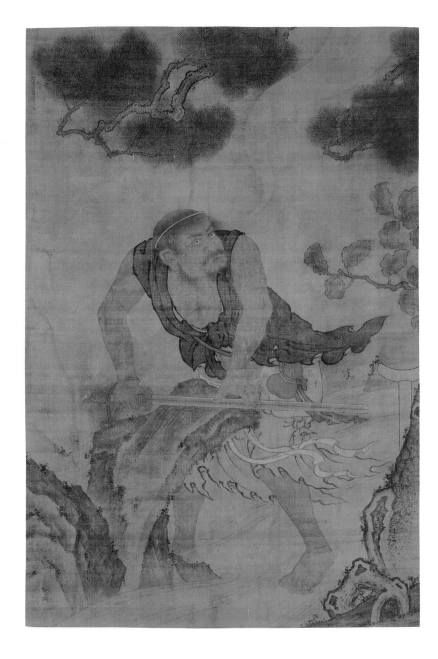

A bearded, fiery-eyed, and muscular figure, standing barefoot in a river, whets the blade of his sword. The tattered gown and the double-gourd (a medicine container) attached to his sash make him a Daoist, and the nearby crutch—incongruous for this strapping fellow—identifies him as Li Tie-guai, "Iron-Crutch Li," one of the most potent of the Eight Immortals of Daoism. As suggested by the astral emanation rising from his head, Li was able to roam the universe in spirit, leaving his mortal body behind in the care of a disciple. Once, however, the disciple was called away to the deathbed of his mother and, hastily concluding that his nearly overdue master was never return-ing, cremated Li's body before leaving. When Li did return, he found his own body in ashes, and for mortal housing his spirit was forced to enter the body of a crippled beggar who had just died not far off. Lao Zi, the progenitor of Daoism, then gave Li an iron crutch for the crippled leg and a halolike gold band to restrain his disheveled hair.

A sword, on the other hand, was the standard accouterment of the leader of the Eight Immor-tals, Lü Dongbin, who used his "Exorcising Evil Spirits" blade throughout the realm on behalf of the forces of good. The tense posture and heedful expression of the present figure suggests that the powerful Daoist is in fact on guard, ready at a moment's notice to fly with righteous sword in hand to the defense of the realm. This interpreta-tion of the iconography is supported by a label, recorded as having belonged to the painting, which read: "Single-handedly Guarding Court Principles."

The unusual combination here of the whetstone rock and a river is also to be found in the oath of allegiance sworn to the founder of the Han dynasty, Emperor Gao Zu (r. 206–195 B.C.), by subjects being ennobled. Those so honored prom-ised fealty until sacred Mt. Tai was reduced to the size of a whetstone and the mighty Yellow River narrowed to the width of a sash. Thus the present painting may also have connoted loyalty to the throne, and might have been intended for presen-tation to an official charged with overseeing court ethics.

Virtually all that is known of the painter of this arresting image comes from his inscription here: "Painted by Huang Ji of Sanshan, a Judge in the Embroidered Uniform Guard attached to the Hall of Humane Knowledge." Huang thus held rank in the personal bodyguard of the emperor and came to court from coastal Fujian Province, the birth-place of a number of artists who served the court during the fifteenth century. A local gazetteer records that Huang Ji was summoned to court with Zhou Wenjing, but Zhou's dates are as elu-sive as those of Huang. Perhaps the clearest indi-cation of Huang's period of activity comes from the legend on one of his seals appearing on this, his only known painting: *Daily Approaching the Pure Radiance*. This legend appears on the seals of a significant number of artists who served the court of the Chenghua emperor (r. 1464–1487), the presumed source of "pure radiance" during his reign. The succeeding Hongzhi emperor (r. 1487–1505) was himself a moral man and highly prin-cipled ruler who is known to have praised one of his court artists for "skill in manipulating his craft for the purpose of admonishment." The present painting, which in expressionistic style suggests acquaintance with the work of Yan Hui of the early Yuan dynasty, manifests a didactic intent that is commensurate with a dating to the late fifteenth century.

H.R.

Wang E

c. 1465–c. 1545

Gazing Afar from a Riverside Pavilion

Chinese
hanging scroll; ink and color on silk
143.2 x 229 (56⅜ x 90⅛)

Palace Museum, Beijing

A scholar, attended by no fewer than three servants, stands on the veranda of a viewing pavilion built over the shoals of a wide expanse of water; a covered walkway connects that quiet retreat with a larger building complex situated on the rocky shore. Tall pines overhang the building but are dwarfed in turn by the massive bulk of the overhanging escarpment. This cliff serves to emphasize the seclusion of the house and its degree of separation from the mundane world, which is represented by the fishing village on the far shore and the roofs of large structures visible above the distant mist.

Deep recession into pictorial space is achieved through skillful manipulation of size relationships, judicious decrease in the amount of descriptive detail, and careful grading of ink tonality. This self-contained pictorial world is organized around the diagonal axes of the picture so as to create tension between the lower right corner, filled with solid, discrete forms, and the upper left, occupied by mist and far less substantial forms. The painting is further distinguished by the use of meticulous, ruled-line drawing for the architecture and slashing "ax-cut" brush strokes to texture and model the rock and mountain forms. These stylistic features are all hallmarks of an academic style of painting associated especially with the Southern Song master Ma Yuan, whose "one-cornered" compositions were surely models for the present painting.

Its technical virtuosity, sheer size, and unusual format all mark *Gazing Afar from a Riverside Pavilion* as a painting destined for the topmost levels of contemporaneous society, for only the very rich or artistocratic could command the services of an artist so accomplished, or possessed houses sufficient to accommodate the finished work. The painting was clearly designed to function as the centerpiece of some room and was originally mounted either to be hung in a formal reception hall or as a screen similar to that seen in the painting by Du Jin (cat. 293). The precise provenance of the present work is in fact indicated by the legends of two of the seals impressed on its surface: *Hongzhi*, which was the reign-name used by Emperor Zhu Youtang (r. 1487–1505), and *Guang yun zhi bao*, a legend appearing on seals used by the Xuande emperor (r. 1426–1435) and his successors.

Wang E, the painter of this striking landscape, was born in Fenghua, Zhejiang Province, near the important port city of Ningbo. His earliest teacher, an artist named Xiao Feng, was from the same district and may have held rank in the Embroidered Uniform Guard, the imperial bodyguard. It was likely via recommendation by such as Xiao that Wang E first came to the attention of the imperial court, which he served during the Hongzhi reign while attached to the Hall of Humane Wisdom. Wang's skill in painting soon drew the praise of such notables as the philosopher Chen Xianzhang (1428–1500), but seemingly no one admired his work more than the reigning emperor, who expressed his respect for the artist in terms of comparison with the great Southern Song master: "Wang E is the Ma Yuan of today."

During the succeeding Zhengde reign (1506–1521), Wang seems to have been reassigned

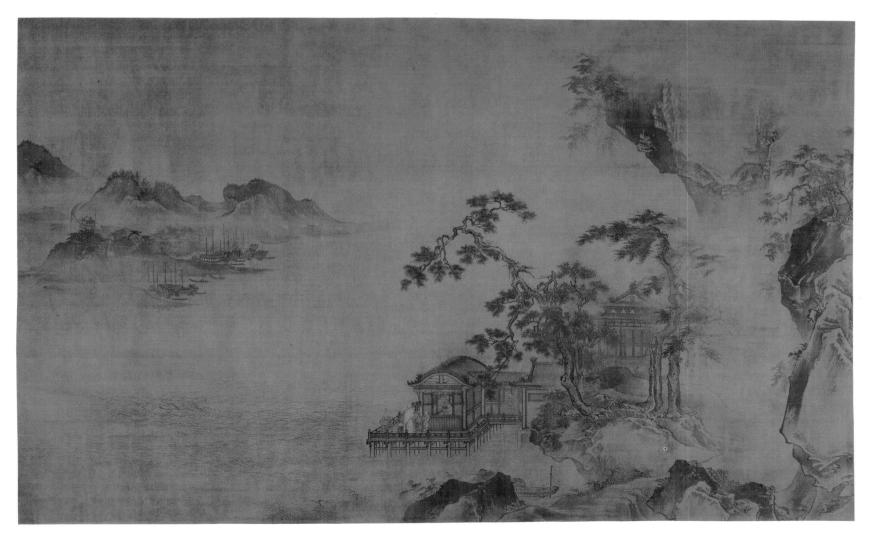

to the Hall of Military Valor and was promoted first to battalion commander and then to guard commander in the Embroidered Uniform Guard. In the year 1510 the emperor also conferred on Wang a seal which he subsequently used on his paintings, together with a patterned sash and strings of white-gold cash.

Although Wang was one of the major court artists of the mid-Ming period, only two of his extant paintings can be associated with specific dates; both were painted for Japanese envoys on their departure from the court in Beijing. The earlier work was done for Minamoto Nagaharu in 1510, the later for Sakugen Shūryō (1501–1579), who made two trips to China, first in 1539–1541 and again in 1547–1550. Wang E's painting, which most likely commemorates Sakugen's earlier trip, bears seals whose legends testify to his imperial service extending over two reigns: "Seal presented by the emperor to Wang E" and "Twice invited to face the Brightness [i.e., into the presence of the emperor]." It is said that Wang retired from court service because of illness and returned home, where he trained several students before dying past the age of eighty. This would suggest that Wang was born about 1465 and died about 1545. H.R.

291 ∾

Lü Wenying
active late fifteenth century

River Village in a Rainstorm

c. 1500
Chinese
hanging scroll; ink and slight color on silk
169.2 x 103.5 (66⅝ x 40¾)
signed (at upper right): Lü Wenying; seal of the artist: Ri Jin Qing Guang (Daily Approaching the Pure Radiance)
references: Cahill 1978, 108, 125; Cleveland 1980, no. 139

Cleveland Museum of Art

Until the appearance of this painting in 1969–1970, Lü Wenying was known only through two figure paintings of the traditional virtuoso subject *The Knickknack Peddler*, requiring technical virtuosity in the depiction of the "hundred things," but not much imagination or invention. The wild, driving quality and singleness of purpose of this painting is therefore astounding by contrast — it is one of the very best renditions of a rainstorm within the traditional mode of Chinese painting, revealing Lü the prosaic figure painter as Lü the master of dramatic landscape.

Lü became a vice-commander in the Imperial Guard of the Hongzhi (r. 1487–1505) and

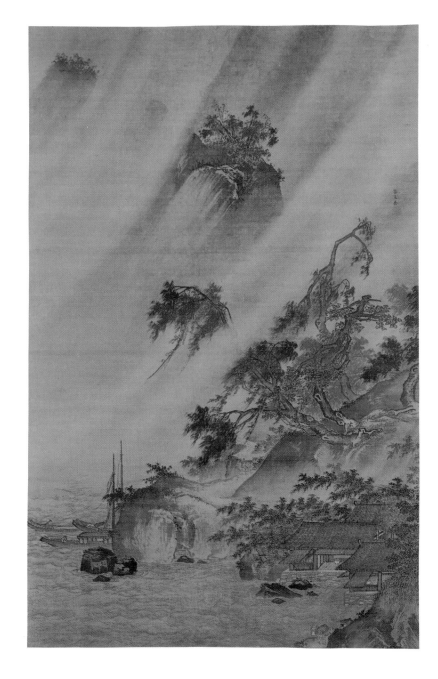

Zhengde (r. 1505–1521) emperors, and is said to have given up painting for civil administration by 1507. Contemporaneous records associated him with Lü Ji (c. 1440-c. 1505), who as the more famous of the two was "Big Lü" to Wenying's "Little Lü." Aside from this we know nothing except his capabilities as attested by this painting.

Rainstorms had become a subject for Chinese painting at least as early as Southern Song (1127–1279), in lost works by Xia Gui (c. 1180–c. 1220), and the genre was continued by such Ming stalwarts as Dai Jin (1388–1462). In this rendition Lü achieved a perfect if precarious balance between inspiration and skill. Nature in a violent aspect was presented with sweeping grandeur, at the same time that the technical virtuosity of the artist was allowed full play. Some scholars see a reliance on the traditions of the Southern Song dynasty, but a more localized reading suggests the artist's awareness of his contemporaries, especially

Zhou Chen's (d. c. 1536) landscapes (cat. 295). These in turn owe much to thirteenth-century styles, but in place of the tranquil landscapes of the Southern Song tradition offer a daring new view of nature in its most dramatic, even threatening aspects. Lü Wenying's painting, revealing a striking balance between professional control of technique and dynamic realization of the forces depicted, is a major work by a major artist. S.E.L.

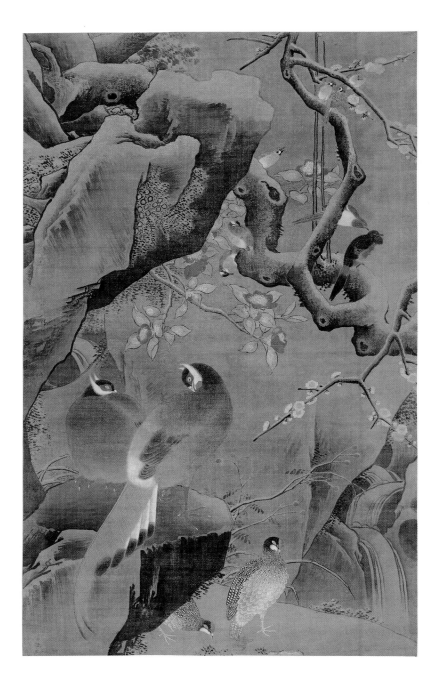

Works like Ma's hanging scroll of *Spring* in the Cleveland Museum of Art were available at court to be studied. To the smaller scale and decorous elegance of the Ningbo tradition of flower-and-bird painting, Ming court painters added elements from this currently approved Southern Song court style. They could hardly have known that their manner would soon—and for centuries to come—be roundly denigrated in China by the practitioners and theorists of the ascendant literati (*wen ren*) mode.

Japan, however, offered fertile soil for their achievements. From the port city of Ningbo, which had long been also a center of commercial decorative painting, flower-and-bird paintings were shipped in quantity to Japan, where they are still to be found in large numbers. Their conservative, decorative style, realistic in detail, obviously recommended itself to Japanese buyers. Likewise, the style of the Southern Song academy became a major force in Japanese art. This scroll and others anticipate the decorative revolution of the Kanō school in Japan (cat. 236), which began only about two decades later.　　　　S.E.L.

293 ১৯

Du Jin
active c. 1465–c. 1500

ENJOYING ANTIQUITIES

Chinese
hanging scroll; ink and color on silk
126.1 x 187 (49⅝ x 73⅝)

National Palace Museum, Taipei

Two scholars examine a variety of ancient bronze and ceramic vessels while a servant approaches with a chess board in the lower left; two women attendants unwrap a musical instrument on a marble-topped table which bears several scrolls and albums. The four canonical scholarly pleasures of lute, chess, calligraphy, and painting thus await their turn to enrich the lives of the gentlemen, who inhabit a realm separated from the outer world both physically and symbolically by works of art. The inscription makes great claims for art—the verse asserting the moralizing effect of connoisseurship, the prose claiming a transcendental theme for the painting itself:

> Enjoying antiquities is of course common
> and their scope is great;
> In paying homage to images and determining
> their names lie propriety and pleasure.
> If a man's days lack propriety and pleasure
> then to the contrary he will be ashamed;
> Doing this will rectify one,
> and that is what I wait for.
> [signed] Du Jin, called Chengju. Jianmian

292 ১৯

Yin Hong
active c. 1500

FLOWERS AND BIRDS OF EARLY SPRING

hanging scroll; ink and color on silk
168.7 x 102.7 (66⅜ x 40⅜)
signature and one seal of the artist

The Kimbell Art Museum, Fort Worth

Yin Hong is known by only two works, both in American collections—the present scroll and *The Hundred Birds Admiring the Peacock* in the Cleveland Museum of Art. Nearly contemporaneous records indicate that his specialty was "fur and feathers" and that he rivaled his famous contemporary, Lü Ji, in his depiction of bird, flower, and animal subjects. The *Hundred Birds*, which epitomizes the respect due the emperor from his subjects, suggests that Yin was working at or near the imperial court. The Kimbell painting, less traditional, anticipates fruitful future developments by later artists, especially in Japan, in the "fur and feathers" genre.

A bolder sense of design than was traditional in "fur and feathers" paintings is more than manifest in this work. Though *Early Spring* employs standard motifs—pheasants and other exotic birds, rocks and torrents, snow-covered cliffs and overhanging tree limbs—these are shown close up and dramatically organized for a daring, large-scale, highly kinetic decorative effect. The sources for this seem evident; as part of their effort to restore bygone glories, Ming emperors patronized the styles of the Song emperor Hui Zong (r. 1101–1126) and of such Southern Song court painters as Ma Yuan (act. before 1190–c. 1230)

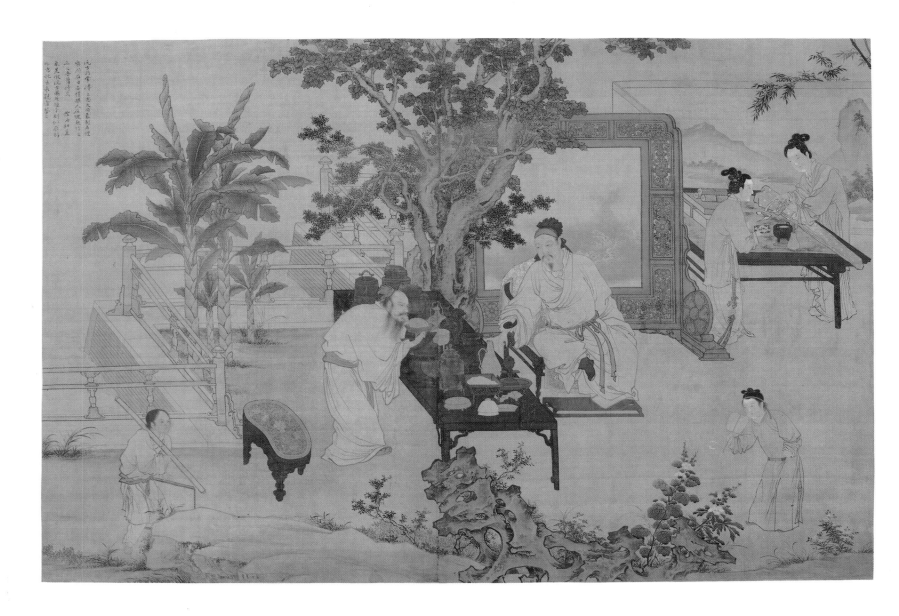

requested an *Enjoying Antiquities* picture together with an inscription. I seem to have sought for something beyond the forms, and that concept is manifested apart from my words. Viewers can judge for themselves.

Unusual in both size and shape, the original format of *Enjoying Antiquities* was undoubtedly a fixed-frame screen of the type portrayed in the painting itself at upper right. The illusionistic device of portraying another painting within a painted screen—so-called double-screen pictures—seems to have been popularized in the tenth century by such artists as Zhou Wenju. Paintings-within-paintings also appear in Gu Hongzhong's (act. 943–960) *Night Revels of Han Xizai,* a scroll known to have been copied by the present artist and one which provides clear precedent for the diagonal placement of the utensil-laden table seen here. Thus, in its original format, *Enjoying Antiquities* not only engaged the eye and protected the body from winds and drafts but also carried historical and stylistic connotations that would have served to validate the high cultural status of its owner.

Du Jin was born in Zhenjiang, Jiangsu Province, but was a registered resident of Beijing during most of his adult life. During the Chenghua reign (1464–1487), after pursuing a course of classical studies, Du sat for the highest-level examination in the capital; failing to place, he gave up the idea of an official career and turned to writing and painting. Du's prose was characterized as strange and antique, his poetry as elegant and assured, but it was as a painter that Du made a lasting mark. The painter and art collector Zhan Jingfeng (1520–1602) ranked him as the foremost figure painter of the Ming dynasty, and Du's influence can be seen in the work of both Qiu Ying (cat. 301) and Tang Yin (cat. 297). In fact, according to Zhan Jingfeng, Tang based his own copy of the *Night Revels* scroll on Du's version rather than on the original painting.

Du Jin must have been very close in age to Shen Zhou (cat. 311–315), who wrote to his friend (addressing Du by his earlier surname, Lu): "... I would like to keep you here through the winter; in a deep bamboo grove by the clear river is a rustic hut." When Tang Yin met Du in Beijing

in 1499, the master was not only old but poor, suggesting that the taste for Du's elegant and highly skilled renditions of classical subjects was being eroded, especially in the north, by the far more forceful styles of Wu Wei and Wang Zhao. The calligraphic scribbling of rock textures in one of Du's latest extant paintings suggests that Du himself perceived a limited future for the harmonious restraint exemplified so beautifully in *Enjoying Antiquities.* H.R.

294 ❧

Du Jin
active c. 1465–c. 1500

ON VIEWING A PAINTING OF THE PEACH-BLOSSOM SPRING

Chinese
section of a handscroll; ink on paper
28 x 108.2 (11 x 42⅝)

Palace Museum, Beijing

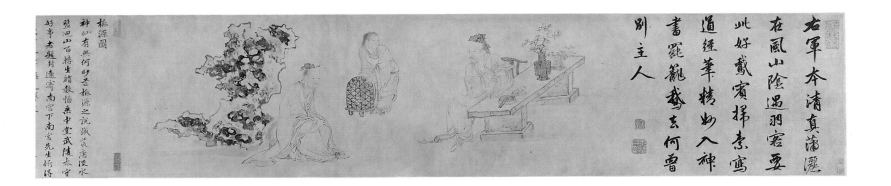

A gowned and capped scholar stands before a fixed-frame screen in the corner of a secluded garden, his only companions a large, fantastically weathered garden rock, banana palms, and a servant holding a scroll and lacquered box. As in *Enjoying Antiquities* by the same artist (cat. 293), the high and focused viewpoint is reminiscent of handscroll compositions of the tenth century; here, as in those earlier paintings, the isometric perspective creates an extremely intimate mood as we peep through a corner crack of the angular pictorial box and experience for a moment the privileged life of a Chinese literatus.

According to an inscription written for this scroll in 1500 by the well-known calligrapher,

poet, and painter Jin Zong (1449–1501), some-
one—whose name was subsequently erased,
presumably to avoid embarrassment when that
person disposed of the scroll—commissioned Jin
to write out twelve famous poems by the greatest
of Tang and Song dynasty poets. Jin continued:

I then took these and requested Du Chengju
(Du Jin) to do illustrations of them. Chengju
didn't mind that my calligraphy was presump-
tuously placed in the position of honor. When
the pure traces [of his brush] are present, and
his paintings are finished, there will certainly
be those who will say that the pearls and jade
are to the side and will regard my imitations as
corrupt. But how can I excuse myself?

Despite those polite words of Jin Zong, the ab-
sence of Du's signature and seals on his paintings
suggests that in fact he was the less important
member of the artistic partnership.

Second among the nine extant sections of the
original twelve, Du's *On Viewing a Painting of
the Peach-Blossom Spring* illustrates a poem by
Han Yu (768–824) describing his reaction to a
painting received from a friend; that painting
illustrated the *Peach-Blossom Spring*, a prose tale
composed by Tao Qian (365–427). Du's painting
thus portrays the Tang poet Han Yu as he is led
by the thoughtful gift first to muse on the orig-
inal story, in which a fisherman discovers a para-
disiacal village lost to the outer world since the
third century B.C., and then to consider the
epochal political and social changes since then.

Han's tense posture and concentrated expression
suggest that he is composing his own poem as we
watch, his upraised hand beating out the metric
rhythms of his lines.

In the screen painting at which Han Yu gazes,
the fisherman, in straw coat and hat, has moored
his boat and walks with oar on shoulder toward
the cave from which the spring emerges and
which, in Tao's original story, gave access to the
hidden valley. Quickly and spontaneously drawn
strokes structure the amorphous washes in the
painting-within-a-painting, much as they do the
strangely shaped rocks in the garden within which
both screen and poet stand. Du's landscape style
thus appears quite up-to-date and "modern" in
comparison with the more conservative style
found in *Enjoying Antiquities*. But given Du's
knowledge of earlier motifs and styles, as well as
the subtlety with which he used them, it is also
possible that the screen painting at which Han Yu
gazes embodies to some extent Du's conception of
Tang landscape styles, especially that termed *po
mo*, "splashed or broken ink," which is known to
have flourished during the ninth century and
within the lifetime of Han Yu.

Du's stylistic range in figure painting, broader
even than that in his landscapes, extends from the
tautly controlled line-and-color approach of
Enjoying Antiquities to the freer, more relaxed
rhythms found in this *bai miao* monochromatic
linear style. This too has Tang dynasty precedents,
in the work of Wu Daozi (d. 792), for example,
but Du's more direct models were such literati

masters as Li Gonglin (c. 1049–1106) of the Song
and Zhao Mengfu (1254–1322) and Zhang Wu
(act. c. 1336–c. 1366) of the Yuan dynasty. Du
came to be regarded by some critics as the finest
Ming practitioner of the *bai miao* style. Zhan
Jingfeng (1520–1602) was one such admirer, and
his comments on Du's paintings are most
perceptive:

His drawing of both large and small figures is
the best of this dynasty. The brushwork of his
trees and rocks too is exceptionally dynamic,
unusually crisp and free, but in composition he
sometimes sinks to histrionics, an everlasting
injury to the painting. Throughout his whole
life he concentrated his mind on painting the
figures, whereas for the occasional tree or rock
he didn't pay attention and was careless....

Some viewers today may well agree with Zhan,
while others, responding more to formal than to
descriptive criteria, will appreciate the sponta-
neity and expressiveness of those "careless" pas-
sages. It redounds to Du's credit and reputation
that he was able to present complex iconography
in such richly varied pictorial terms that his
paintings are as fresh and captivating now as they
were then. H.R.

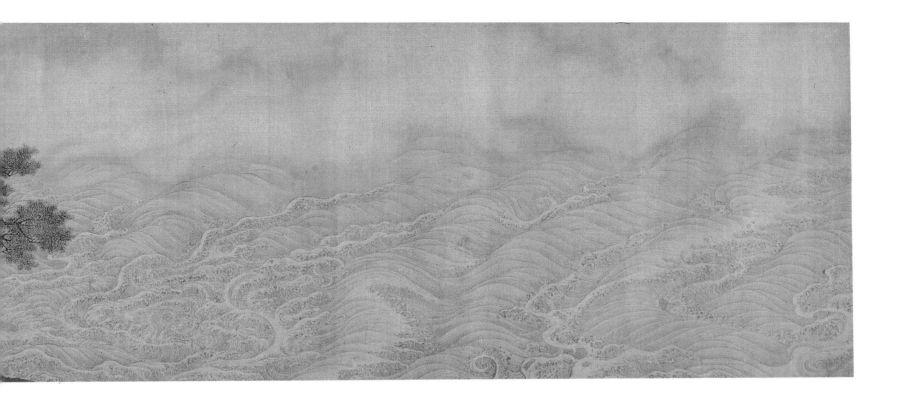

295 🐾

Zhou Chen
died c. 1536

THE NORTH SEA

Chinese
handscroll; ink and color on silk
28.4 x 136.6 (11¼ x 53¾)
signed: Dongcun Zhou Chen; seal of the artist:
Zhou Shi Shunqing; title (inscribed by the artist):
Bei Ming Tu (Picture of the North Sea)
references: Cahill 1978, 168–193; Cleveland 1980,
192–193

The Nelson-Atkins Museum of Art, Kansas City,

As one unrolls the handscroll from right to left, the first motif to appear is the one embodied in the title. An expanse of turbulent sea—all rolling waves and whitecaps—is masterfully depicted with varied linear brush strokes. A wind-lashed pine tree marks the first land, then a two-story scholar's residence appears, with the owner seated in the upper "viewing pavilion." From the left a friend approaches, via a slender bridge over a stream and falls. Deciduous trees compete in movement with the thrusting large rocks leading up to the mountain behind the house, a solid mass that closes the picture. It is a deceptively simple composition, but it powerfully expresses conflict, stress, and agitation.

Laurence Sickman has pointed out that the title, *The North Sea*, originates in the first chapter of the Daoist classic *Zhuang Zi*, where a "great fish, called [Kun], living in the North Sea . . . transforms itself into a monstrous bird called [Peng]. With a mighty effort the bird rises, and its wings obscure the sky as it flies south, mounting on a typhoon to a height of ninety thousand *li*. Through this story, the North Sea (a Dark Ocean) with its towering waves becomes a symbol of the man who has high ambitions to succeed, and so [Bei Ming] may serve as a man's *hao* [by name] or a suitable name for his studio."

Cahill has described the work as a "near-perfect replication of the Li [Tang] mode as practiced in the Southern [Song] period by Academy artists" The manner rivals the best of Southern Song (1127–1279) water pictures, such as the Ma Yuan album in Beijing or the album leaf by Li Song in Kansas City. But the look of the scroll is pure Zhou Chen, impossible to confuse with earlier works. The solid realism evident here may well derive from Song attitudes to the natural world, but Zhou's strong individuality and thorough professionalism are manifest in a manner more brusque than Li Tang's, an organization that is simpler and more direct, and tonal contrasts that are less extreme, less dramatic. Zhou was the teacher of Tang Yin (cat. 297–299) and Qiu Ying (cat. 300–302). He was not a *wen ren* and few of his works bear inscriptions by others, but he surely knew Shen Zhou, and he was recognized in his own day as one of the best masters of Suzhou, though in fame and reputation he fell short of Shen, Tang, and Qiu. Current studies are beginning to rectify that imbalance. S.E.L.

296 🐾

Zhou Chen
died c. 1536

BEGGARS AND STREET CHARACTERS

dated to 1516
Chinese
album leaves mounted as two handscrolls; ink and
light color on paper
31.9 x 244.5 (12½ x 96¼)
inscription with signature and three seals of the
artist; three colophons
references: Cahill 1978, 168–193, pl. 83; Cleveland
1980, 194–195; Sirén 1958, 4:205–207, 6:pl. 236

The Honolulu Academy of Arts (scroll 1)
Cleveland Museum of Art (scroll 2)

This album of 24 leaves has been equally divided and mounted as two handscrolls; the first is in the Honolulu Academy of Arts. The second bears the artist's inscription, signature, three seals (*Dongcun, Shunqing, Echang Sanren*), and date of 1516. The artist's inscription is a succinct account of the origin and purpose of this unusual and remarkable painting.

In the autumn of the [*bingzi*] year of Zhengde [1516], in the seventh month, I was idling under the window, and suddenly there came to my mind all the appearances and manners of the beggars and other street characters whom I often saw in the streets and markets. With brush and ink ready at hand, I put them into pictures in an impromptu way. It may not be

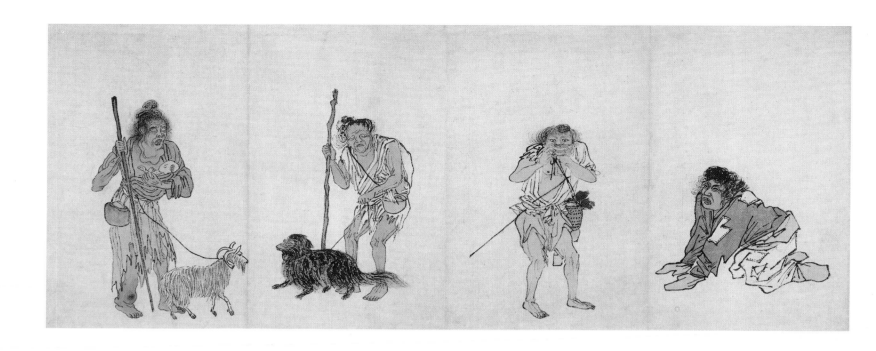

worthy of serious enjoyment, but it certainly can be considered as a warning and admonition to the world. (Translation by Wai-kam Ho in Cahill 1978, p. 191.)

"A warning and admonition to the world" might suggest that Zhou was warning viewers against wrongdoing, which (according to Buddhist teaching) would cause their rebirth into such lives of misery as he had depicted. But of three colophons added to the Cleveland section of the scroll during the second half of the sixteenth century, one construed the beggars metaphorically as unworthy office-seekers ("beggars" for position and wealth), another interpreted them as a protest against governmental harshness and misrule, and the third saw merit in both interpretations. Certainly these colophons place the work unmistakably within China's very sparse tradition of social protest.

The first colophon, by Huang Jishui (1509–1574), a literatus and collector and, interestingly, author of the *Pinshi Zhuan* (biographical sketches of poverty-stricken scholars), is dated to 1564:

> This album depicts the appearances of all the different kinds of beggars whom [Zhou Chen] observed in the streets of the city, capturing perfectly the special aspect of each. Looking at the pictures, one can't help sighing deeply. Nowadays people come around on dark nights [covertly], begging and wailing in their desires for riches and high position—if only we could bring back Mr. [Zhou] to portray them!
>
> The summoned scholar Woyun brought out this album to show me, and I wrote this impromptu inscription at the end. (Translation by James Cahill.)

Zhang Fengyi (1527–1613), a scholar, poet, and playwright from Suzhou, wrote the second colophon:

> This album presents us with the many aspects of misery—hunger and cold, homeless destitution, infirmity and emaciation, deformity and sickness. Anyone who can look at this and not be wounded to the heart by compassion is not a humane person. The [*bingzi*] year of the [Zhengde] era... was only a few years after the seditious [Liu Jin] spread his poison; this was the height of [Jiang Bin's] and [Wang, or Qian?] Ning's exercising of their brutality. I imagine also that the officials and nobles were seldom able to nurture and succor the common people.

Thus this work by [Zhou Chen] has the same intent as [Zheng Xia's] "Destitute People": it was meant as an aid to government and is not a shallow thing—one can't dismiss it as a 'play with ink'." (Translation by James Cahill.)

Zheng Xia (1041–1119)was an official-artist who in the famine of 1073–1074 depicted scenes of starvation and used them as an admonition to the emperor, following good Confucian practice.

Third colophon by Wen Jia (1501–1583), son of Wen Zhengming, dated to 1577:

> This painting by [Zhou Chen] depicts the appearance of hungry and chilly beggars, in

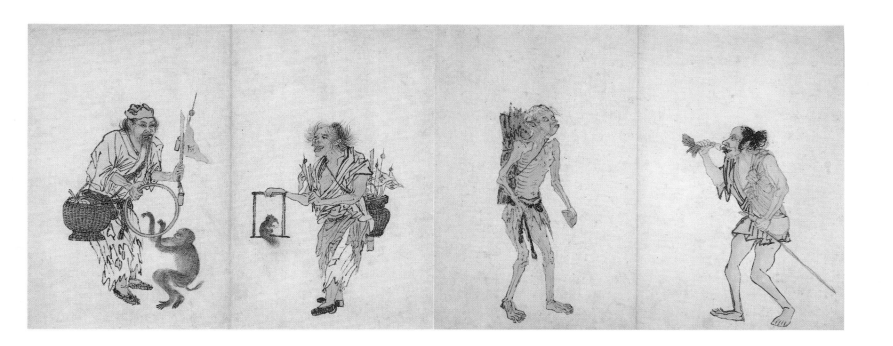

order to "warn the world." Huang [Jishui] takes it to represent those who "come around on a dark night seeking alms," while [Zhang Fengyi] compares it to [Zheng Xia's] picture of the [An-shang] Gate. These views of the two gentlemen both have their points.

In the old days [Tang] Yin, whenever he saw a painting by [Zhou], would kowtow deeply before it and cry "Master [Zhou]!"—so much was he aware of not being able to equal [Zhou's] divine wonders. This album could not, I believe, have been done by anyone else; I am in complete agreement with [Tang] Yin's heartfelt obeisance.... (Translation by James Cahill.)

The artist's self-abnegating "It may not be worthy of serious enjoyment..." is a recognition that his subject matter is nonstandard by professional as well as *wen ren* criteria, as well as emotionally disquieting. But clearly his realistic images did reach at least some of their moral targets over the next sixty years, only to be ignored thereafter until the present day (the few remaining seals on the scrolls are of recent owners).

These paintings are rapid and sketchlike, as if resulting from direct on-the-scene observation, despite the artist's explicit "there came to my mind...." Sharp memory and superb technique combine to provide immediacy. Paintings of a *Cockfight*, at the Princeton University Art

Museum, and *Bidding Farewell at a Brushwood Fence*, at the Nanjing Museum, both by Zhou Chen, demonstrate that the artist often used a rapid, sketchy manner for déclassé subjects. In that respect *Beggars and Street Characters* is not a lone gesture.

S.E.L.

Tang Yin
1470–1523

PALACE LADIES OF THE STATE OF SHU

Chinese
hanging scroll; ink and color on silk
124.7 x 63.6 (49⅛ x 25)
inscription with signature of the artist
reference: Shanghai 1922, 23: pl. 8

Palace Museum, Beijing

In lotus-blossom headdresses and Daoist robes,
They daily served their sovereign and
 entertained in private palace chambers:
These flowery willows don't realize that the
 man has already gone,
And year after year struggle over greens and
 wrangle over reds.

The last ruler of the Shu kingdom was always
in the palace with his young ladies. He ordered
the palace concubines to wear Daoist robes and
to don lotus-blossom caps, and daily sought out
"flowery willows" to serve at drinking parties.
Rumors had already spread to every ear in Shu,
but the ruler did nothing to counter them, so
in the end his frivolity brought him to ruin.
I think in retrospect of the time when people
shook their heads [in dismay] [and note that] he
then had someone to grasp his wrist [i.e., to
admonish him]. Tang Yin

Four exquisitely gowned and carefully groomed
court beauties converse in a group, their flutter-
ing hands serving as visual analogue for the music
of their high-pitched voices. Tightly unified by
their general similarity of posture and form, they
are each individually characterized by variety in
costume, position, and orientation. Distinguished
from high-born ladies of their court by their viva-
cious manner and deep decolletages, these lovely
young women were courtesans or entertainers
who served, according to the artist's inscription,
as attendants and companions at imperial drinking
parties. The inscription further identifies the
court as that of the last ruler of the Kingdom of
Shu in present-day Sichuan Province. It is telling
of the great and continuous length of Chinese
political history in which there were two king-
doms named Shu some seven hundred years
apart; the last rulers of both, as might be
expected, were noted for addiction to the plea-
sures of the flesh. The painting has thus been
published as illustrating ladies of the court either
of Liu Chan (207–267, r. 223–263) or of Meng
Chang (919–965, r. 934–965). Although the
expression *Shu Houzhu,* or "last ruler of Shu,"
seems to have been associated especially with Liu
Chan, it is most likely that the artist had Meng
Chang in mind when he painted the composition.
Like many young men of his day Meng Chang

loved to ride and play polo but he was equally
enamored of the Daoist sexual arts, for which he
acquired an enormous imperial harem. Meng
desisted from collecting girls only after being
admonished by one of his own officials. Meng's
court was also embellished by the creations of
such artists as Huang Quan (903–968), who in
925 had been given complete charge of the court
painting academy. Although Huang is known
today primarily as a painter of flower-and-bird
compositions, historical records attest his great

skill in figure painting as well. The delicate
washes, subtle color combinations, and elegant,
descriptive brushwork of the present painting are
precisely those characteristics of Huang Quan's
works noted by earlier critics; the lack of defining
environment and the creation of pictorial space
solely through placement of the figures also
characterize paintings from the time of Huang or
slightly earlier. In style as well as in subject the
painting may thus be taken as a reference to the
tenth-century court of Meng Chang.

Although Meng Chang in the end turned away form his "flowery willows," the courtesans so denoted continued to strive after the high position often symbolized by red robes and after the salaries connoted by the color green. "Reds and greens" often referred as well to both cosmetics and painting, so the range of possible bones of contention in the harem was wide indeed.

The inscription on the present painting is not dated, but another version of the composition, differing only in details such as the textile patterns, is dated to 1523 (Shanghai 1922). The recently deceased Zhengde emperor (1491–1521) had been even more avid than Meng Chang in collecting concubines. His generally dissolute life and inattention to the business of ruling almost cost him his throne in 1510, when a prince of the realm rebelled. Tang's painting may have been inspired by the Zhengde emperor's profligacy, or by another rebellion that nearly brought disaster to his own life. Tang had been invited in 1514 to the court of Zhu Chenhao, a Ming imperial prince enfeoffed as Prince of Ning. Just as Meng Chang's father came to the throne by revolting against his king, so too did the Prince of Ning rebel in 1519 against the Zhengde emperor, only to be defeated in a short campaign led by the philosopher-soldier Wang Yangming (1472–1529).

Though not wise enough to refuse the prince's invitation, as many of his artist-friends had done, Tang at least had sense enough to leave this dangerous patron long before he mounted his unsuccessful rebellion. In the last sentence of his inscription Tang may be indicating his regret that, unlike Meng Chang, he had not allowed good advice to turn him from bad company at critical junctures in his life (see cat. 298). H.R.

298 ࣺ

Tang Yin

1470–1523

CLEARING AFTER SNOW ON A MOUNTAIN PASS

early 16th century
Chinese
hanging scroll; ink and light color on silk
69.9 x 37.3 (27½ x 14⅝)
inscription with signature of the artist

National Palace Museum, Taipei

> When snow clears from blocked passes
> travelers crowd densely,
> Lightly loaded are the mules,
> heavily laden the oxen;
> In front of Tadpole Inn
> the mountains hoard iron,
> Beneath Frog Hill
> wine pours out like oil.
> Painted by Tang Yin of Jinchang.

Born the son of a Suzhou restaurateur, Tang Yin was a prodigy whose quick intellect and brilliant artistic talent earned him the respect of Shen Zhou (see cat. 311–315) and Wu Kuan (see cat. 286) and the lifelong friendship of Zhu Yunming (see cat. 285) and Wen Zhengming (see cat. 286, 317). Tang easily passed the lowest-level civil service examination and in 1498 took first place in the provincial examination held in Nanjing (failed several times by his friend Wen), creating almost universal expectations that he would do equally

well in the metropolitan examination in Beijing. There, however, Tang and a friend were accused and convicted of having obtained prior knowledge of the questions. In 1499, after a short term in prison, from which he was released on the intervention of friends, Tang returned home in disgrace, forever debarred from official position and status.

Although Tang had begun painting at least by the age of sixteen, it was not until about 1500 that his changed expectations led him to paint for his

livelihood and to associate himself with the ranking professional master in Suzhou, Zhou Chen (cat. 295). *Clearing After Snow on a Mountain Pass* is not dated, but the clear influence of Zhou Chen here would suggest that it was painted toward the end of the first decade of the sixteenth century. The monumental composition is conservative in its dynamically organized and complex structure and represents a revival of the twelfth-century mode of Li Tang. From that same source comes the characteristic brush schemata known as ax-cut strokes, which here texture and facet the surfaces of rocks and cliffs.

Despite those references to past styles and attitudes, however, the painting is very much up to date in its strong emphasis on the frontal picture plane. The size and prominent placement of the artist's inscription insist on the primacy of the two-dimensional arrangement of shapes, just as the construction of hills and mountains as a series of flat, overlapping stages carries little visual implication of continuous spatial recession. While the sense of deep pictorial space, monumentality, and awesomeness that characterized landscapes of the Northern Song era have been lost, the visual impact of Tang's picture is more immediate, more intimate, and also more revealing of a distinct creative personality at work. H.R.

299 🐦
Tang Yin
1470–1523

MYNAH BIRD ON OLD TREE BRANCH

Chinese
hanging scroll; ink on paper
121 x 26.7 (47⅝ x 10½)
inscription with signature of the artist; two colophons

Museum of Art and History, Shanghai

> In mountain hollows all is silent,
> Sequestered from the sounds of man,
> The roosting mynah calls
> To announce the end of the spring rain.
>
> Tang Yin

High on an elongated, vine-entangled tree branch perches a cawing mynah, its head raised and beak open. Free-flowing ink and the lack of crisp details suggest a moisture-laden atmosphere for this highly focused vignette of nature. While a formal stability is achieved by keeping the forms within the frontal picture plane and largely along the central vertical axis, the immediacy of a fleeting moment in time and space is yet captured through the precarious placement of the bird and through the spontaneous execution itself.

The degree to which this painted image evokes specific aspects of the reality of nature allies it with much of Song dynasty (960–1279) painting, when naturalistic values held sway over abstract ones. Yet Tang Yin's painting is very nearly as compelling when considered solely as brush strokes of varying intensities and textures organized into shapes which divide the format into visually stimulating patterns. Tang's ability to pursue pictorial and abstract goals simultaneously at such a high level of technical and descriptive competence is virtually unmatched during the middle Ming era and places him on a par with Zhao Mengfu (1254–1322), the great Yuan dynasty master who was one of the first to meld calligraphy and painting into one aesthetic whole.

At upper left is a colophon inscribed by the Qianlong emperor (r. 1735–1795) in 1755. A second colophon, on the mounting, was written by the official Zhang Ruogui in 1774, when this painting was presented to him by the emperor.

H.R.

300 🐦
Qiu Ying
died 1552

PASSING A SUMMER DAY IN THE SHADE OF BANANA PALMS

Chinese
hanging scroll; ink and color on paper
279.1 x 99 (109⅞ x 39)

National Palace Museum, Taipei

Qiu Ying's normally tight and disciplined brushwork is here somewhat relaxed and, as in calligraphy, more overtly focused on the process by which the forms are created. Pictorial space is limited, and the rocks and trees are arranged so as to create a shallow stage for the two scholars and their attendant. Textured surfaces and linear patterns play especially important roles in this painting, for the sound of music is suggested, indirectly but effectively, by the vigorous rhythms of arcing bamboo, angular fronds, and crystalline rock.

The subject as well as the manner of its presentation here embody values and attitudes held dear by literati of the middle Ming period. Making music was considered to be a complete experience only in the presence of a sympathetic and knowledgeable listener, and the two gentlemen-amateurs shown here were further linked by their appreciation of the ancient bronze vessels and scrolls laid out for later contemplation. Though the setting is rustic, the scene is unobtrusively elegant, revealing lives of privilege, sophistication, and—most prized of all—privacy.

The artist who so successfully evoked that rarefied life was himself a professional painter of no formal education; he seems to have acquired cultural literacy mostly through association with the Suzhou collectors and artists who were his friends, peers, and patrons. Probably born sometime in the 1490s, Qiu studied painting with Zhou Chen, and met such other Suzhou luminaries as Tang Yin, Wu Kuan, Zhu Yunming and, at least by 1517, Wen Zhengming. Qiu became especially famed for his paintings of classical subjects in a variety of styles, from facsimile copies of antique originals to, as here, freer and more creative transformations of traditional themes.

The present painting bears the collection seals of Xiang Yuanbian (1525–1590), a major patron and collector with whom Qiu often stayed during the final decade of his life. Xiang and his elder brothers were ardent collectors of earlier painting, and during the years Qiu lived with the family he was, according to Xiang's grandson, able to see more than one thousand Song and Yuan dynasty paintings. Xiang Yuanbian first mentioned Qiu in an inscription written in the year 1547, when he himself was twenty-two years of age, and the present work probably dates from about that time as well. The unusually large size of the painting, and the use of a paper ground rather than the silk that Qiu seems to have preferred for more technically polished large works, suggest that the painting was commissioned directly by Xiang and was intended to associate its owner with the literati class to which that businessman aspired.

By reason of virtually identical size, seals, mediums, subject, and style, *Passing a Summer Day in the Shade of Banana Palms* is paired with another hanging scroll in the National Palace Museum, entitled *Conversation in the Shade of Firmiana Trees*. The two are usually described as the extant half of a set of four paintings depicting different views in each of the four seasons. In such a set the present painting would have been the summer scene, and the *Firmiana Trees*—trees which lose their leaves each fall—would have represented autumn. The set must have been broken up some time before the late eighteenth century, for *Banana Palms* is recorded in the Imperial Collection catalogue of 1793, but *Firmiana Trees* does not appear in the Imperial Collection until the catalogue of 1816 and hence probably entered the palace at a somewhat later date. In neither catalogue are the paintings associated with one another or described as parts of a set. An intriguing question about the nature of the postulated set and the possible survival of the two lost scrolls is posed by a Qiu Ying painting now in the Shanghai Museum. Entitled *Wang Xizhi Inscribing a Fan*, that work measures 280.5 x 99.1 cm, was also painted in ink and color on paper, and bears the same collector seals of Xiang Yuanbian as the pair in Taiwan. If the very close similarity between these three paintings can be taken to indicate that they once belonged together, then the location of

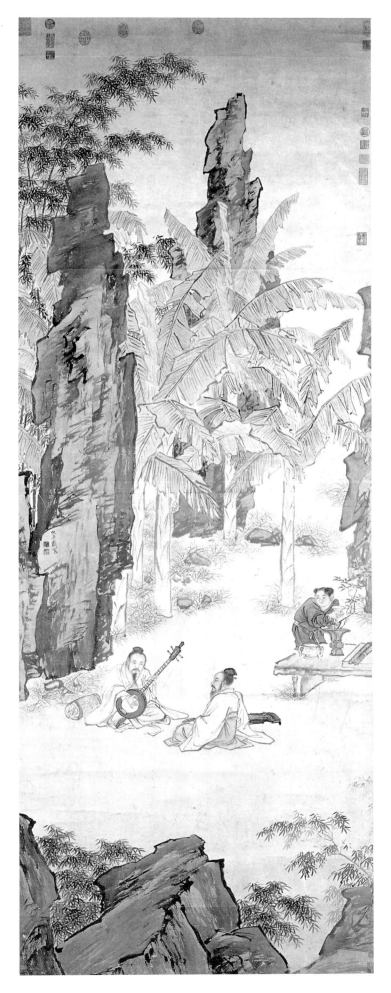

the signatures on the National Palace Museum pair suggests that they were the first and fourth in the set, with *Firmiana Trees* on the right and *Banana Palms* on the left. The composition and style of the unsigned *Wang Xizhi* blend best with *Banana Palms*, making that painting the third in the set, and leaving only the second still unaccounted for.

If this hypothesis is accepted, however, the modern idea that the set represented the four seasons must be discarded, for the *Wang Xizhi* painting seems to have no specific seasonal connotations at all. To the contrary, it suggests that each of the four original paintings illustrated a narrative subject embodying conservative cultural values. This is a plausible assumption, just as Qiu Ying's paintings remain visual affirmations of the worth of such classical ideals as rationality, harmony, and emotional restraint. H.R.

301 ॐ

painting by Qiu Ying
d. 1552

calligraphy by Wen Zhengming
1470–1559

THE GARDEN OF SOLITARY PLEASURE

dated to 1558
Chinese
handscroll; ink and color on silk
27.8 x 381 (11 x 150)
references: Sirén 1949; Cahill 1978, 201–210; Cleveland 1980, 206–209; Little 1985, 41–73; Young (date), 1:255–257

The Cleveland Museum of Art,
John L. Severance Fund

Superb technical mastery of brushwork, color, representation, and composition characterize the art of Qiu Ying. Though a professional painter, pupil of Zhou Chen (cat. 295), Qiu nevertheless moved in the circle of the Suzhou literati and was by late sixteenth century acclaimed one of the Four Masters of Suzhou, along with his fellow pupil and fellow professional Tang Yin (cat. 298) and the two great *wen ren* painters Shen Zhou (cat. 311–313) and Wen Zhengming (cat. 316–317), the last-named of whom wrote the essay and poems attached to this scroll. Qiu is usually associated with works even more colorful than this one, in the "blue-and-green" manner associated with landscapes of the late Six Dynasties (222–589) and the Tang dynasty (618–907). He is recorded as having colored one of Wen Zhengming's paintings at Wen's request. Qiu Ying's almost frightening facility in various styles is borne out by a comparison of this scroll, roughly in the style of Li Gonglin (c. 1049–1106) of the Northern Song dynasty, with the totally different hanging scroll *Passing a Summer Day in the Shade of Banana Palms* (cat. 300), in which he combined the brush technique of the Zhe school with the austere, pure flavor of the *wen ren* school.

Qiu's supreme ability both to copy and to create in various manners both ancient and modern, while maintaining the suppleness of original invention, put him much in demand by collectors scrupulous and unscrupulous. Of these the most famous was Xiang Yuanbian (1525–1590), who once owned this painting—as his fifty-nine seals on the scroll testify. At least two collectors besides Xiang patronized Qiu, who repaid their hospitality with commissioned copies and original works.

Wen Zhengming's son, Wen Jia, expressed in 1578 the feelings of Qiu's contemporaries and immediate successors before 1600:

Qiusheng [Qiu Ying] had superior talent,
He excelled at mastering the principles
 of painting.
Then, in his prime, he withered away,
Remaining are his landscapes,
 which he has deserted.
Until now his name in the garden of painting,
Was a fresh wind filling everyone's ear.

 (Translation by Stephen Little.)

The scroll shows the seven sections of a famous garden in sequence, ending with a distant view across water to mountains and forests. In this garden the shelters range from copses of live bamboo to substantial timber, tile, and thatch pavilions; the plantings from neatly subdivided rectangular plots, each growing a different plant, to "rustic" groupings featuring fantastically weathered garden rocks. Then and now Suzhou boasted the most famous gardens in all China, and Qiu Ying's familiarity with these "living specimens" added to the variety and convincing reality of this representation. It should be noted that Qiu has modified the continuity usual in handscroll composition to allow slight separation of the seven historic gardens here recreated in one. Hallowed precedent for this could be found in the most famous of all landscapes of the Tang dynasty—Wang Wei's (699–759) depiction of his own garden residence, the *Wang Chuan Villa* handscroll.

The following discussion and translations are by Ling-yün Shih Liu, Henry Kleinhenz, and Wai-kam Ho, in Cleveland 1980, pp. 206–209.

Colophon by Xiang Yukui (grandson of Xiang Yuanbian):

The painting of the *Garden of Solitary Pleasure* on the right by [Shizhou, Mr. Qiu, i.e., Qiu Ying], is in the style of Li [Gonglin]. Its mood is peaceful, as if meeting the ancient gentleman face to face among the brushes and silk; it lifts one above the sordid bustle of life. Formerly, my late father handed me this scroll which had only the painting without the written essay. I considered asking a good calligrapher to write the essay to add to it but was afraid that the quality of writing would not match the painting. Several years later, I saw at a friend's house this essay and poems [of Sima Guang] written by Heng-shan [Wen Zhengming], once owned by my grandfather; so I spared no expense to obtain it. I rejoiced at this and said, "The divine swords are finally united. How things are predestined." Now my friend [Zhang Gong-zhao] technique for mounting [painting and

calligraphy] is excellent. Therefore by daring to take them out and join them together, I can preserve this beautiful story of [a] singular reunion.

. . . recorded . . . two days before New Year's Eve in the [jiashen] year of the [Chongzhen] era [1644].

Remarks:

The subject of [Qiu] Ying's painting and the calligraphy following it by Wen [Zhengming] is the essay with poems of the great Northern [Song] statesman and historian [Sima Guang, 1019–1086], in which he memorializes his

Garden of Solitary Pleasure built in 1073. By that time [Sima Guang], the conservative leader of the Confucian political revival, had left his high office and retired to [Luoyang] in opposition to the new reforms brutully enforced under the sponsorship of Wang [Anshi]. His essay opens with historical references to the meaning of happiness and then continues with a description of the garden's topography.

In the poems following the essay, [Sima Guang] associates each of the seven divisions in the garden with a specific historical figure whom

he admires. He relates the *Reading Hall [Dushu Tang]* to the Western Han Confucian scholar [Dong Zongshu, 179–93 B.C.], who became so engrossed in his studies he never looked out on his garden for three years. *The Pavilion for Playing with Water [Longshui Xian]* is identified with the late [Tang] poet and statesman [Du] Mu (803–852) who washed his inkstone in the water next to his study pavilion. [Yan Guang], the childhood friend of the Eastern Han emperor [Guangwu], is the subject of the third poem, on the *Hut of the Angling Fisherman [Diaoyu An]*. When the emperor took power in A.D. 25, [Yan Guang] refused his

summons to serve, preferring a life of fishing and farming. Next, the *Studio for Planting Bamboo* [*Zhongzhu Zhai*] was inspired by Wang [Huizhi, d. A.D. 388], son of the famous calligrapher Wang [Xizhi, 303?–361?]. Wang [Huizhi] retired from the world and surrounded himself with bamboo.... The fifth poem, *Plot for Picking Herbs* [*Caiyao Pu*] discusses Han [Kang]. For thirty years this Eastern Han figure sold herbs in the [Changan] marketplace, charging the same honest price.... he fled to the mountains for fear that his virtuous reputation would bring him trouble. [Sima Guang] alludes to the bibulous [Tang] poet [Bo Juyi, 772–846] in his sixth poem, the *Pavilion for Watering Flowers* [*Jiaohua ting*]. Demoted to the position of magistrate of [Jiangzhou], [Bo Juyi] built a garden retreat at [Xiangshan] to grow flowers, make wine and poetize in the company of eight good friends.... *Terrace for Seeing the Mountains* [*Jianshan Tai*], the final poem, was inspired by a famous line, "I pluck chrysanthemums at the eastern hedge; easily the Southern Mountain comes into view," written by the [Jin] recluse [Tao Yuanming, 365–427], who gave up the imperial bureaucracy to nurture his soul in the mountains. Thus, as [Sima Guang] walked about his garden in retirement, each place he would stop to rest provided him with an example of Confucian virtue facing predicaments similar to his own.

...Qiu Ying followed [Sima Guang's] essay ...even though he [reversed] the order in the garden by placing the *Pavilion for Playing with Water* before the *Reading Hall*. Otherwise, he constructs each scene with remarkable fidelity to the literary description [for an English translation, see Sirén 1949, pp. 77–78]....

Written among [Xiang Yuanbian's] seals at the beginning of the painting in the lower right-hand corner is the character *shu*, part of a code of characters which frequently appear on paintings he owned. The meaning of the code remains unknown because no catalogue of [Xiang's] collection was published. However, since [Xiang Yuanbian's] cataloguing of his own collection was based on the system of the [*Qian Zi Wen*, Thousand-Character Classic], in which the character *shu* is numbered 681, the present painting should have entered [Xiang's] collection prior to the year 1547. S.E.L.

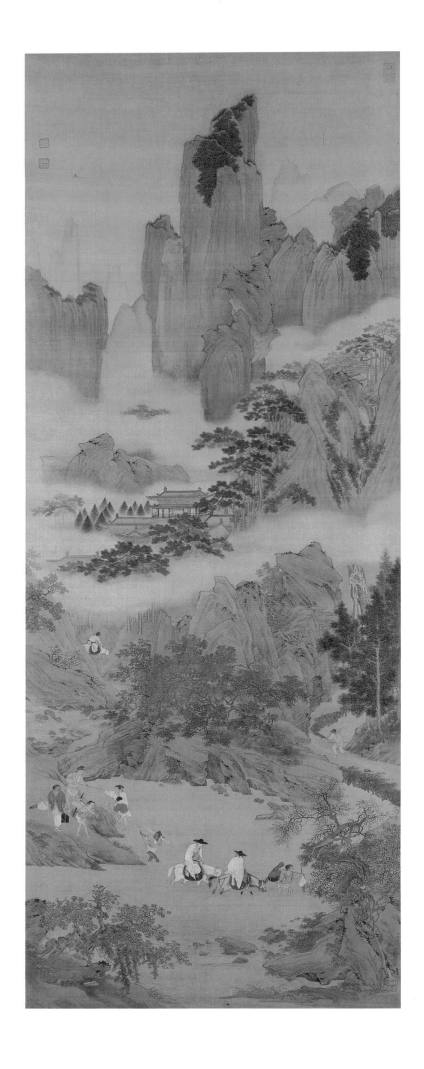

Qiu Ying

died 1552

EMPEROR GUANG WU OF THE EASTERN HAN DYNASTY AND HIS ENTOURAGE FORDING A RIVER

Chinese
hanging scroll; ink and color on silk
170.8 x 65.4 (67¼ x 25⅗)
signed by the artist; seal (at lower right): Shi Fu

The National Gallery of Canada, Ottawa

The four centuries of Han dynasty rule were broken at about midpoint by a fourteen-year usurpation (A.D. 9–23). After a bloody civil war Liu Xiu (6 B.C.–A.D. 57), a prince of the Han dynasty, regained the throne. As Emperor Guang Wu (Brilliant Martial Emperor, r. A.D. 25–57), he moved the capital from Chang'an (present-day Xi'an) eastward to Luoyang, center of his own power base. Retrospectively, therefore, the two periods of Han rule have been called Former and Later or Western and Eastern Han. Guang Wu proved an able ruler, and was particularly noted by later historians for his fostering of agriculture, a policy exactly consonant with ancient Chinese traditions of good and wise rule.

Presumably the painting was commissioned, its subject assigned to the artist rather than independently conceived. In any case, the subject was both historical and laudatory, and therefore its manner of depiction was governed by some ancient pictorial conventions. Although the incident depicted dates from the first century A.D., the conventions available to a professional artist such as Qiu Ying were basically those of the late Six Dynasties period and the Sui and Tang dynasties (spanning approximately the 4th to the end of the 9th century). Qiu Ying's painting reflects the landscapes of that period, with their characteristic preferred palette of blue, green, and gold and their tall, narrow mountain peaks. To artists and critics of the tenth and eleventh centuries this style was already archaic, and they described those mountains, graphically, as resembling the teeth of a court lady's comb. The costumes of the emperor (on a white horse) and his principal attendant (on a buckskin) resemble summer traveling dress of the Tang dynasty (618–907), and the saddle blankets on the horses also approximate those of Tang.

The superlative talents of Qiu Ying, however, could not be totally concealed behind such pious archaisms. The sure construction of the space embracing the foreground clearly indicates the emperor's intended path: across the river to the earth-covered wooden road on the far right, then along that road as it passes below a waterfall and veers left, then upward and to the right again, through a pine forest to the distant palace. The mineral colors (azurite, malachite, cinnabar) are

soft, the mists in the upland valleys sensitively depicted, and the whole is a complex blend of narrative realism, decorative color, and homage to both historical and artistic antiquity. The painting reveals a professional mastery equaling that of Qiu's Suzhou colleagues, Zhou Chen (cat. 295) and Tang Yin (cat. 297, 298).

The manifest excellence and importance of the picture are confirmed by two seals (at upper left) of the greatest of all Chinese collectors, Liang Qingbiao (1620–1691). S.E.L.

Sun Long

c. 1410–c. 1480

BAMBOO, BLOSSOMING PLUM, AND BIRDS IN SNOW

second half of 15th century
Chinese
hanging scroll; ink and color on silk
116.6 x 61.8 (45⅞ x 24⅜)

Palace Museum, Beijing

Four sparrows huddle on the snow-laden branch of a blossoming plum tree; another of the small birds hovers in the still air above, while a white pigeon stands motionless beneath the tree on the frozen ground. Especially noteworthy is the technique by which the densely muffling snow is manifested, for the snow-covered areas are not painted at all but rather blank silk around which a defining background has been painted. Since these "blanks" in fact represent the most substantial matter of the painting—the pigeon, the snow-covered rocks and branches, and the distant peak—there is a figure-ground reversal that engenders a visual tension in the otherwise quiet scene.

The absence of firmly drawn, discrete contours is referred to by Chinese writers as *mo gu*, "line-suppressed" or "boneless" painting. Although the technique appears already in Tang dynasty (618–907) paintings, traditional criticism associates it especially with the tenth-eleventh–century Song painters Xu Chongsi and Zhao Chang. During the thirteenth century the Buddhist priest Luochuang used a similar method for *Bamboo and White Hen*, and in the fourteenth century the literati master Huang Gongwang (1269–1354) painted an entire landscape, *Nine Peaks After Snowfall*, in reserve. The present artist thus did not originate his evocative technique, but he did use it in pursuit of pictorial, i.e., descriptive or narrative, goals, that were unusual in his day and closer in spirit to those of the early Song masters.

At least three artists named Sun Long were active during the Ming dynasty, but details of their varying lives and careers are sometimes con-

founded, yielding composite (and fictitious) biographies. The most easily distinguished of these men is the official and calligrapher whose work is recorded in the collection catalogue *Tingfanlou Shuhua Ji* (preface 1843). That work is a handscroll dated to the year 1600, and hence could not have been by either of the other artists named Sun Long, both of whom were active during the fifteenth century. Probably the earliest of them all was the Sun Long whose byname (*zi*) was Zongji; a colophon composed by him at the age of seventy-two is recorded in the collection catalogue *Shiqu Baoji Xubian* (preface 1793) as having been written for a painting by the artist Zhao Qi (1238–1306). This Sun Long, from Rui'an in Zhejiang Province, was active from the Yongle era (1403–1424) onward and served as prefect in Anhui Province during the Tianshun era (1457–1464). Sun's specialty in painting eventually earned him the name "Plum-Blossom Sun," and his paintings were valued equally with the much-prized bamboo paintings of his contemporary Xia Chang (1388–1470). Sun's daughter, who followed him in painting, eventually married another Rui'an artist-official, the calligrapher Ren Daoxun (1422–1503), who also continued Sun Long's style of painting.

The Sun Long who painted the present *Bamboo, Blossoming Plum, and Birds in Snow*

detail

was born in Wujin (present-day Changzhou), Jiangsu Province. His grandfather, Sun Xingzu (1338–1370), had been one of the young heroes who assisted Zhu Yuanzhang in overthrowing the Mongols and reestablishing a native Chinese dynasty in 1368. Following his death in battle, Xingzu was posthumously enfeoffed as the Marquis of Yanshan and awarded the title *Zhongmin*, "Loyal and Sympathetic"; the legends on several of Sun Long's seals declare him the "Grandson (or, sometimes, the Descendant) of the Loyal and Sympathetic Marquis at the Founding of the Realm." The local gazetteer of Wujin records that Sun was called "the little fool" and that he "was clever and quick from birth. He excelled in painting grass and insects and rabbits in snow. He was spontaneous in dotting and washing so his paintings had a lifelike flavor."

Perhaps during the 1440s or 1450s Sun was called to court; his byname *(zi)*, Tingzhen, means "raised or recalled to court" and his later nickname was Duchi, "the capital fool." Other evidence of his court service comes in the form of the legend on another of his seals: *Jinmen gongyu*, "Supplying the Emperor at the Golden Gate," this last being the location where, in the imperial palaces of old, the various attendants awaited summons. In the *Tuhui Baojian Xubian* of 1519 (a biographical dictionary of painters and calligraphers) Sun is described as "having the air and bearing of an Immortal. In painting birds, animals, grasses, and insects he developed his own style in what were called *mo gu tu*, 'boneless pictures.'" The present painting is a fine example of that style, based, according to Zhan Jingfeng

(1520–1602), "on the *mo gu* concepts of the Song dynasty masters but developed into an individual style—free and untrammeled images without the application of color. But his new ideas are not far distant from those of the ancients." H.R.

304 ஃ

Shi Zhong
1438–c. 1517

CLEARING AFTER SNOWFALL

dated to 1504
Chinese
handscroll; ink on paper
25 x 319 (9⁴/₅ x 125³/₅)
inscription and two seals of the artist
references: Cahill 1978, 128–153; Rogers, 1988, 123

Museum of Fine Arts, Boston

The two seals, *Wochi Lou* (Fool's Rest) and *Chi Weng* (Old Fool), are the artist's sobriquets for his home and himself. The poem is his own composition in his own hand:

> The sky is clear; snow covers mountain
> and river,
> The myriad trees tower high; this is
> nature's work.
> Alone and always happy to suffer poverty,
> This old man, moved to tears, records the
> divine pine.

In spring of the *jiazi* year of the Hongzhi reign [1504], when snow fell heavily, the Fool made this picture and added the poem to accompany it.
(Translation by Kojiro Tomita.)

Although Shi Zhong is not usually regarded as one of the Heterodox painters, his few extant works place him in this context. He came from Nanjing but was apparently known to Shen Zhou and well regarded by him. In childhood he is said to have been simple and (literally) dumb, which is doubtless a stereotypical "explanation" of his unknown origins.

Shi's major contribution to painting development is perfectly embodied in the present work. He was obsessed by the possibilities of "negative" images: creating forms in reserve from the play of ink on paper. Because snow scenes lend themselves so readily to this approach, they make up the major part of his extant works. The wild, "scribbly" (James Cahill) brushwork follows no school, as Shi himself asserted—hence his classification as "heterodox." As employed by Chinese critics, "heterodoxy" (*xie xue pai*) not only implied "beyond the two norms" of academic and *wen ren* style; it suggested perverseness—defiance of propriety—as well. Heterodox painting provoked real moral outrage; a critic writing in about 1550 railed: "I wouldn't even use them as dust rags for fear of disgracing my furniture" (translation by Howard Rogers). The drunken or willfully unorthodox works of disappointed professionals or failed scholar-artists found no ready acceptance in the evolving dichotomy of profes-

sional and amateur painting. By the late sixteenth and early seventeenth century, when Individualist painting triumphed, the Heterodox painters and their works had been largely forgotten.

<div align="right">S.E.L.</div>

305

Zhang Lu
c. 1490–c. 1563

HAWK PURSUING A RABBIT

Chinese
hanging scroll; ink and color on silk
158 x 97 (62⅕ x 38⅕)
signed: Pingshan

Nanjing Museum

A hawk plummets in pursuit of a wild hare that desperately leaps for cover in tall grasses, while two small sparrows near the ground fly out of harm's way to the right. Time and action are momentarily stayed, allowing us to comprehend the scene while anticipating its imminent transformation. The contrasting natures of predator and prey are emphasized by their forms, angular and sharp for the former, curvilinear and smooth for the latter, with the tremulous grasses providing appropriate notes of agitation and suspense.

The fierce hawk was a well-known symbol for a rapacious official; the white rabbit, a generalized emblem for good fortune, acquired during the Tang dynasty the more specific meaning of good governance owing to a benign imperial censor. Zhang's painting thus symbolically conjoins the potential extremes of political behavior.

Like Sun Long (cat. 303), Zhang Lu commanded a reserve technique of dazzling virtuosity. Here large areas were washed in first, creating an amorphous background for the narrative elements left starkly in reserve and then detailed with the "gossamer" line for which Zhang Lu was famous. The reserved forms, luminous against the ink wash of sky and earth, create an almost theatrical evocation of a moonlit hunt.

During his years as a professional artist Zhang Lu came to know many high officials and had sometimes to deal with those who regarded his work as craft rather than art. But as he himself put it: "How can one simply regard [painting] as a profit-making activity?" The eminent scholar-official Xue Hui (1489–1541) described Zhang's reception of those who approached him for a painting in what he deemed an insufficiently polite manner: "High officials fly about and spread his fame but do not easily get what they want; the visits of nobles with their requests are empty and without benefit." The marriage of Zhang's son to a member of the imperial clan directly descended from the Ming dynasty's

founder attests—and must have enhanced—the high status that permitted Zhang such independence in his dealings with court circles and powerful officials. The painting is signed *Pingshan,* which was Zhang Lu's byname.

<div align="right">H.R.</div>

306

Yin Shan (?)

ZHONG KUI AND DEMON ATTENDANTS

before 1503
Chinese
handscroll; ink on paper
24.2 x 112.8 (9½ x 44⅜)
references: Xu 1987; Huai'an 1988

Huai'an County Museum, Jiangsu Province

Very few portable Chinese paintings of premodern times can be absolutely and securely dated. Forgeries, copies, works "in the style of" abound. Therefore any scientific excavation that reveals portable works, usually handscrolls or hanging scrolls, arouses tremendous interest. In recent years a Liao dynasty (916–1125) tomb produced two tenth-century hanging scrolls of landscapes, and the tomb of a Ming prince (Zhu Tan, 1370–1390) in Shandong Province revealed a handscroll of *White Lotus* signed and sealed by the famous Qian Xuan (c. 1235–after 1301). The 1982 excavation of the tomb of Wang Zhen (1424–1496) and his wife, née Liu (d. 1503), in Huai'an County in northern Jiangsu Province, yielded twenty-five scrolls. Two of these were Ming copies (or forgeries) of works by famous painters—Ren Renfa (1254–1327) and Wang Yuan (c. 1280–after 1349). Most were landscapes, a few

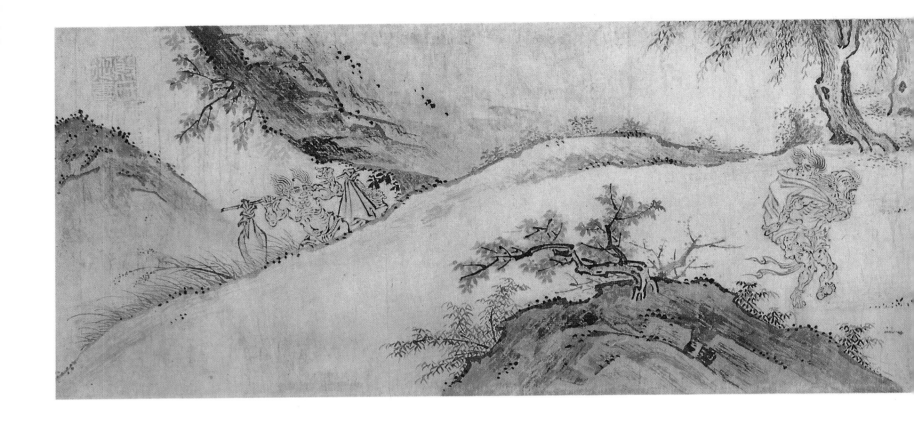

depicted flower or bamboo subjects; almost all were in *wen ren* taste and not of the highest quality. Wang Zhen evidently acquired some of these scrolls from a certain Zheng Jingrong who, according to inscriptions on some of the paintings, traveled south from Beijing in 1446. Presumably Wang Zhen acquired the works bearing Zheng's seals and inscriptions at that time or soon thereafter.

The two paintings in this exhibition from the Wang tomb are conservative works—one without signature, seals, or any other clue to attribution (cat. 307), and this one, bearing a seal (*Yin Shi Cong Shan*) which suggests that the name of the painter was Yin Shan, about whom nothing is currently known. Zhong Kui was a popular subject, and particularly meaningful for the scholar-official class (cat. 288), but this work has been executed in a mannered variation of the brushwork used by professional Buddhist painters of Ningbo to render Hell scenes. The profusion of nail-head strokes delineating the muscles and sinews of the demons are most characteristic of such icons. Although the landscape is basically Southern Song (1127–1279) in type, derived from Li Tang and the Ma-Xia adaptations of Li's type forms, it employs these conventions as modified by the Ningbo painters. In its decorative treatment the stream at the beginning of the scroll is comparable with the stream in the Kimbell Museum scroll by Yin Hong (cat. 292), a leading fifteenth-century court painter of decorative bird, flower, and "seasonal" paintings. s.e.l.

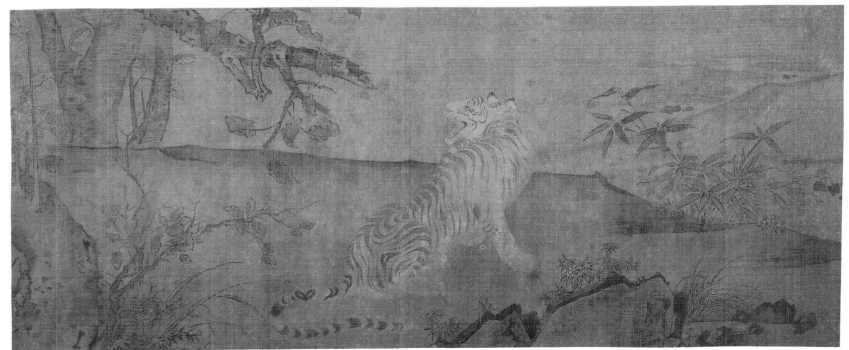

detail

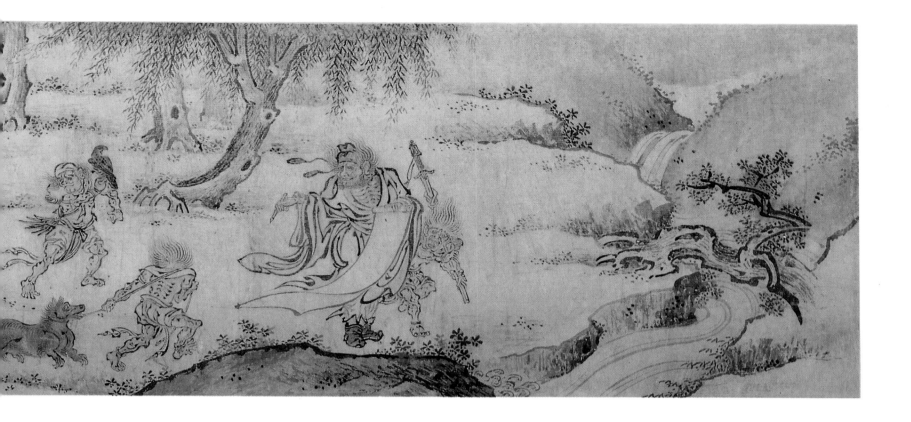

307

WHITE TIGER IN A FROSTY WOOD

before 1503
Chinese
handscroll; ink and color on silk
29.8 x 69 (11¾ x 27⅛)
references: Schafer 1963, 247; Xu 1987; Huai'an
1988
from a tomb excavated 1982 in Huai'an County,
Jiangsu Province

Huai'an County Museum, Jiangsu Province

The particulars of the tomb in which this painting was found have been summarized in catalogue 306.

The tiger entered Chinese art during the Bronze Age, appearing as a favorite motif on bronze ritual vessels and on jades of the Shang period (trad. 1766–1045 B.C.); its symbolic significance at that time, if it had any, is uncertain. As a symbol of the western quandrant of the compass, or indeed of the cosmos, the tiger appeared in Chinese art by the fifth century B.C. As governor—even divinity—of that quadrant, the tiger was confirmed, together with the other Animals of the Four Directions (*Si Shen*), during the Western Han dynasty (206 B.C.-A.D. 8). By the reign of Han Wu Di (r. 141–87 B.C.) the cosmic correspondence between symbolic creatures, directions, elements, colors, and moral qualities was firmly acknowledged: the tiger connoted the west, the element metal, the color white, and the Confucian virtue of righteousness (*yi*).

This symbolism was fundamental and has endured into the twentieth century, much embroidered over the millennia. Since at least the Eastern Han dynasty (A.D. 25–220) the tiger has been a potent guardian against demons, appearing widely in that role on clothing and household equipment. "The Chinese word for 'amber'... has been pleasantly explained as 'tiger's soul,'... and the etymology has been rationalized by the tale that the congealing glance of a dying tiger forms the waxy mineral" (Schafer, 1963, 247). Legend also had it that the tiger lived a thousand years, turning white at the midpoint of its life. In China the tiger (not the lion) was king of the beasts, often so identified in art by the character for "king" on its forehead, and its native power and ferocity recommended tiger skins and tiger motifs for military dress.

The tiger was also a favored subject in paintings of the Southern Song (1127–1279) dynasty, particularly in those with Daoist or Chan Buddhist themes. It is to these works that the present painting looks back for inspiration.

The auspicious beast is depicted at the center of the scroll, looking back over its left shoulder and apparently snarling. White opaque pigment colors his body and partly covers the ink stripes. In the landscape about him the artist has taken drastic liberties with relative scale. Bamboo leaves and red-tinged Japanese maple are huge, and the far tree trunk on the left is as large as the one in the nearest foreground. The result is bizarre, or perhaps "folkish," showing something of the nonchalant roughness found in much Korean painting of the early Chosŏn dynasty (1392–1910) (cat. 270).

But the boldly cut-off trees, rocks, and river bank, and the bold brushwork outlining the rocks, all relate to the professional painter's habits, as may be seen in the works of Zhang Lu (cat. 305). S.E.L.

308

THE LUOHAN VAJRĪPUTA

c. 1500
eastern Tibetan or Chinese
thangka (icon in hanging scroll format);
color and gold on cotton
81.3 x 50.8 (32 x 20)
references: Fong 1958; Gordon 1959, 104; Pal and
Tseng 1975; Pal 1984, 126, 127, 214, pl. 59; Tate
1989–1990, 196–206, fig. 10

Navin Kumar Gallery, New York

This image is more Chinese in character than most Tibetan representations of *luohan* (S: *arhat*, person who has attained Enlightenment by his own efforts). Except for the marked difference in scale between the *luohan* and his devotee, and the decorative emphasis on the colors of the robes, the painting is remarkably realistic, in the Chinese sense, and especially natural in its handling of the landscape environment. The pine, bamboo, and prunus behind the *luohan* are the "Three Friends"—symbols of incorruptibility and endurance and one of the favorite motifs of Chinese

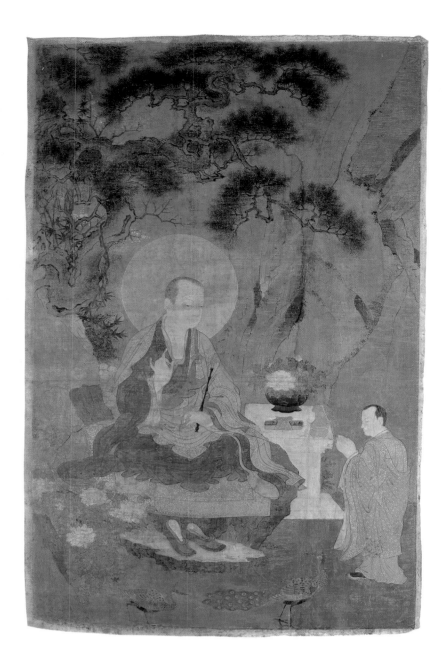
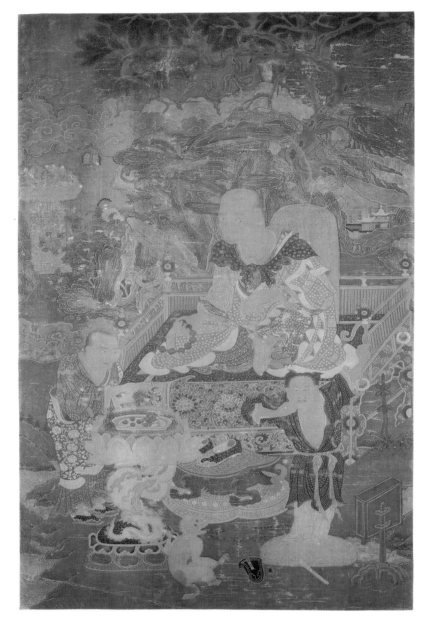

scholars. From the tradition of Chinese Buddhist painting centered in Ningbo since the Song dynasty (960–1279) comes the representation of peacocks and peonies, as well as the experienced ease in the handling of the twisting trunk and branches. In the famous set of *Five Hundred Luohan*, one hundred paintings by Zhou Jichang and Lin Tinggui painted some time in the late twelfth century, which are now divided among Daitoku-ji in Kyoto (88?), the Museum of Fine Arts in Boston (10), and the Freer Gallery in Washington (2), there are numerous figures whose heads prefigure that of Vajrīputa. An even closer prototype is *The Fourteenth Luohan with Attendant*, by Lu Xinzhong (act. mid-late 13th century) (also in the Boston Museum of Fine Arts), but quieter and simpler than the present work, reflecting Song taste.

The mountain landscape is even more traditional, harking back to the blue, green, and gold mode of the landscapes of the late Six Dynasties

period (222–589) and Tang dynasty (618–907), but filtered through the archaizing styles practiced by Qiu Ying (cat. 302) and his imitators and fashionable in the early sixteenth century. Qiu in turn was aware of the archaistic landscapes occasionally painted even by such literati paragons of the Yuan dynasty (1279–1368) as Zhao Mengfu, Qian Xuan, and Chen Ruyan. The manner was sensuous, decorative, and appealing to popular taste, and it became a staple way of representing landscape in *thangkas* made for Lamaist temples—whether in China or Tibet and whether painted by Chinese professionals or skillful priest-painters in eastern Tibet.

This *luohan* has previously been identified as Vanavāsi, the third in the Lamaist canon of Sixteen Luohan. Clearly, however, the figure here is making the gesture of teaching (S: *vitarka mudrā*) with his right hand while his left holds a fly whisk (S: *cāmara*), so he must be the fifth *luohan*, Vajrīputa, reputedly from Śri Lanka. s.e.l.

309 ❧

The Luohan Cūdapanthaka

15th century
eastern Tibetan or Chinese
thangka (icon in hanging scroll format),
now mounted as a panel; gouache on cotton
79.7 x 50.9 (31⅜ x 20)
reference: Pal and Tseng 1975, 25, 42

Museum of Fine Arts, Boston

Compared with the painting of *luohan* Vajrīputa (cat. 308), this image of a disciple of the Buddha who has attained Enlightenment seems deliberately obscured, even camouflaged by the rich surface patterns of the composition and the crowding and complexity of the staffage, with landscape background, throne, implements, and variously patterned textiles packed into relatively modest dimensions. The painting affords almost a sum-

mary of earlier Chinese inventions, both aesthetic and representational.

The *luohan* (S: *arhat*), attendant, and dancer are defined as Indian by their slightly dark and gray-toned skin, though the *luohan*'s meager beard and intensely meditative eyes are more Chinese, and he is seated on a raised Chinese platform (*kang*). Since Cūdapanthaka is the "meditation" arhat, his expression is appropriate, as is the tiny figure of a bodhisattva (in Nepalese style) meditating in a cave directly above the gold-roofed, multicolored palace in the distance on the left. The *luohan* wears a brilliantly colored, multi-patterned priest's robe and holds a large rosary in his left hand. Behind him is a plaited backrest, an essential for scholarly ease. His monkish attendant, also in colorful patterned garb, is holding an unhusked chestnut, which he is about to husk and place on a tray. This tray has a lotus base supported by a pedestal in the form of a Chinese dragon, which rises from a red and yellow lacquer base. On a red lacquer footstool are the *luohan*'s shoes. Nearly centered at the lowest point in the picture is a monkey. At lower left is an extraordinary attendant figure, dancing on a mat, with a flute lying half on and half off the mat. With left arm horizontal and right arm raised, the dancer echoes similar figures some seven hundred years earlier, dancing in Tang dynasty (618–907) representations of the Western Paradise of Amitābha Buddha. Even the monkey, both in pose and configuration, recalls works attributed to or in the style of early Song (960–1127) "fur and feather" paintings, such as those of Yi Yuanji (act. 1064–1067), the most famous of artists specializing in the genre. The patterns of the various textiles recall Tang and Song designs.

The setting, a rocky but verdant outlined landscape in lapis blue, turquoise green, and gold, is also indebted to Tang; the style began in China in the sixth century and continued as archaistic homage well into the Ming dynasty. Qiu Ying (cat. 302) made extremely sophisticated use of the "blue-green-gold style" at about the time this *thangka* was painted. By its interweaving of rocks, trees, and clouds the setting compounds the camouflaging density of the composition.

What we have here is a compendium of the copy-books inherited from generation to generation of traditional icon painters. The individual motifs, however, were woven into a thicket of obsessive design produced for a non-Chinese audience. Here the aesthetic wealth of China was placed at the service of the complicated theology of Tibet. S.E.L.

310

PORTRAIT OF SHEN ZHOU

dated to 1506
Chinese
hanging scroll; ink and color on silk
28 x 20.9 (11 x 8¼)
inscription with signature of the artist

Palace Museum, Beijing

The white-haired and bearded old man with angular face and piercing eyes appears shrunken in comparison with his peaked scholar's hat and undecorated literati robe. This contrast functions expressively to characterize the subject as a man of advanced age, just as the slightly asymmetrical placement of the body and head present him as a man of subtle depth.

Although some stylistic features of the painting are common in ancestor portraits, and some aspects of the face may have been emphasized to accord with general rules of physiognomy, the strong sense of a very specific personality here suggests that this is in fact a portrait painted from life. The identity of the artist responsible for this sensitive interpretation of character and personality is in some doubt; the painting has been published as a self-portrait by Shen Zhou and as the work of an anonymous artist. Though Shen Zhou is not remembered as a figure painter, it may be noted that the fixed, sidewise gaze of the sitter here would be natural for an artist concentrating on his own reflected image as he painted.

About the identity of the sitter there is no doubt, for the longest inscription is signed: "During the first year of the Zhengde reign-era [i.e., 1506] the old man of the Stone Field [Shen Zhou] inscribed this [portrait of] himself." Shen's

poem, acknowledging that he cannot see himself as others see him, asserts that spirit, not appearance, counts:

> Some people say my eyes are too small,
> while others say my jaw is too narrow;
> I myself have no way of knowing,
> nor do I know what is lacking.
>
> But why bother to judge appearance,
> when one should fear only loss of morality;
> Carefree for eighty years,
> I am now next door to death.

In a second inscription, added somewhat later, Shen suggests that beyond a certain point such philosophical speculation matters little in comparison with the sheer fact of survival:

> Is it like or not like, true or not true?
> From bottom to top it only reflects the
> exterior man.
>
> Death and life are both a dream,
> And heaven and earth are entirely dust.
>
> The stream endures within my breast,
> From spring it will be another year.

H.R.

311

Shen Zhou
1427–1509

LOFTY MOUNT LU

dated to 1467
Chinese
hanging scroll; ink and color on paper
193.8 x 98.1 (76¼ x 38⅝)

National Palace Museum, Taipei

The focal point of the painting is the small figure of a scholar, placed on the medial axis and further emphasized by his very isolation. Twisting forms constructed by constantly curling brush strokes fill the entire format, leaving the eye no place to rest save around that calm figure, who thus serves as the measure of this monumental and imposing vision of nature. Although remarkably complicated and dynamic, the composition is yet stable and coherently organized, just as the vibrant surface is clarified by means of texture and color.

Art-historical precedents for this style can be found in the works of Xu Ben (1335–c. 1379) and, most especially, Wang Meng (1309–1385). In common with the styles of those fourteenth-century masters are the extreme elaboration of surface, the richly tactile brushwork, and the localization of pictorial movement within stable units of form. The artist's student, Wen Zhengming (1470–1559), who became a major master in his own right, would later note that his teacher's

works before the age of forty were all small in scale, those after forty much larger; the present painting may well have been the original basis for that statement, for it was done when the artist was just forty and moreover is modeled on the style of Wang Meng, mentioned by Wen as his teacher's favorite source of inspiration during those middle years.

The artist's long inscription begins with the title, *Lu Shan gao*, "The loftiness of Mt. Lu," and then continues to describe the height, vast extent, and scenic beauties of that famous mountain located near Lake Poyang in Jiangxi Province. The mountain is then associated with the family of a scholar named Chen Kuan — a family which had lived at the foot of the peak for generations before moving to the Suzhou region. The artist then continues:

> I once traveled to the master's gate. After seeing the full extent of his loftiness, that of Mt. Lu was put to shame. Having retired to a hilltop garden at the age of seventy, he works hard at literary composition, his white hair tangled like autumn brambles.... This poem and painting were done by your disciple Shen Zhou of Changzhou, who respectfully submits them in hope of a long life for the venerable and virtuous Master Xing'an [Chen Kuan].

The painting was thus done to celebrate a major milestone in the life of the artist's literary teacher, Chen Kuan (1398–1467 or later), and both subject and style were chosen particularly for the occasion. As the ancestral home of Chen's family, Mt. Lu could function easily as metaphor both for the family and for the particular eminence of Chen himself. The artist's father and uncle had both studied with Chen Kuan's father, Chen Ji (1370–1434), and he in turn was the son of Chen Ruyan (c. 1331–c. 1371), himself a landscape painter of some note and a friend of Wang Meng, whose style so influenced the present painting.

Shen Zhou's family estate in Suzhou was founded during the early years of the Ming dynasty by his great-great-grandfather Shen Liangchen (mid–late 14th century), a collector and connoisseur of art who was also a friend of Wang Meng. Shen Zhou continued what had become a family tradition by declining to seek office and rather concentrating on scholarship, poetry, and collecting. He also became an excellent calligrapher, but it was as a painter that he achieved the ultimate accolade of history: recognition as the founder of a major school of painting, called the Wu school after the old name for the Suzhou region. Along with Tang Yin, Qiu Ying, and Wen Zhengming, Shen was also later celebrated as one of the Four Great Masters of Ming. Wang Shizhen (1526–1590), an important critic of the late Ming, rated Shen as "the best of our dynasty"; to Wen Zhengming, Shen's most illustrious pupil, Shen was "an immortal among men." H.R.

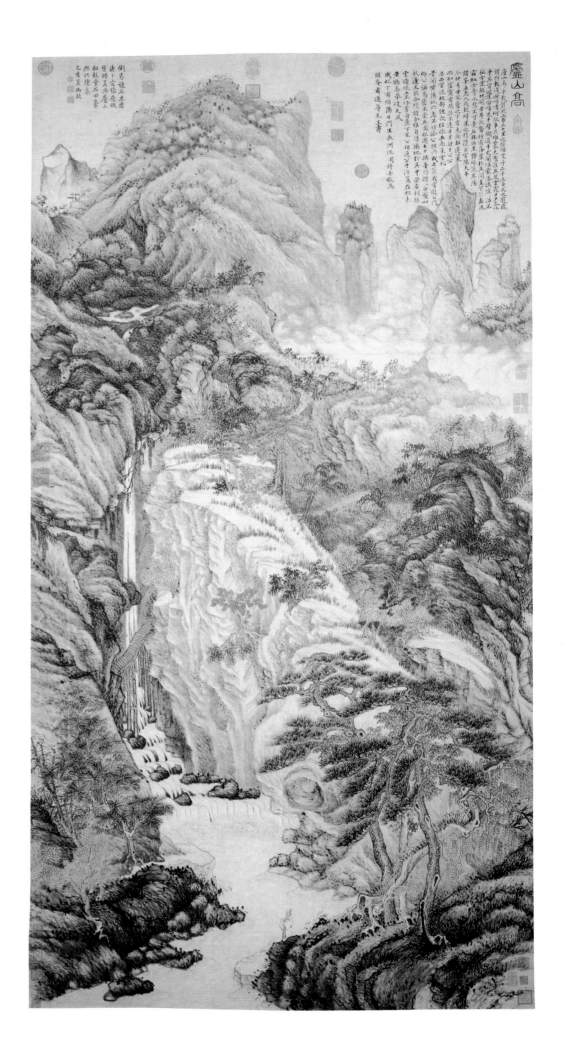

312

Shen Zhou
1427–1509

THREE JUNIPERS OF CHANGSHU

c. 1484
Chinese
three album sheets mounted as a handscroll; ink on paper
46.1 x 120.6 (18¹⁄₅ x 47½)
with artist's inscription and colophon by Wu Kuan (1436–1504) dated to 1484 and 1492
references: Tseng 1954, 22–30; Edwards 1962, 93; Cahill 1978, 95–96

Nanjing Museum

Some twenty miles northeast of Suzhou, home of Shen and birthplace of the Wu school, is Changshu. There, in the time of Shen Zhou, grew one of the remarkable sights of the region, the "Seven Stars," seven juniper trees of aged and hoary aspect. Of the seven originally planted by a Daoist priest of the Liang dynasty (502–557), four had been replaced by Shen Zhou's day but three had survived. Presumably these were the ones painted by Shen Zhou when he visited the compound in 1484 with his friend, the poet, statesman, and calligrapher Wu Kuan (1436–1504).

Old trees are most particularly honored by the Chinese scholar, partly for reasons of self-identification, since they connote incorruptible endurance through many an adverse season, but also because of their traditional connection with the world of myth and the powers of nature. Old trees were a favorite subject of the great early masters of Chinese landscape painting such as Li Cheng (c. 919–c. 967) and Guo Xi (c. 1001–c. 1090) of the Five Dynasties period and the Northern Song dynasty. But this subject received particular attention from Shen Zhou and his pupil Wen Zhengming.

The picture we now consider was probably the first major effort of its kind in Chinese painting — a depiction solely of old trees, without background or setting. As their branches twist and turn, and their twigs reach and gesture, these trees evoke dragons, those benign but awesome lords of water in all its aspects, anthropomorphic powers of rain and cloud and mist. What is tree? What is dragon? Here? There? The metamorphic character of this scroll, implied by the way in which the trees are represented, becomes explicit in later variations of the theme by other artists. Judging from a rather dry copy in the Honolulu Academy of Arts, Shen Zhou's pupil Wen Zhengming (1470–1559) attempted a handscroll of all seven of the junipers along with an inscription by the artist emphasizing their anthropomorphic, metamorphic, and dragonlike character. Wen was equally explicit in the inscription on his handscroll of an old pine (Cleveland Museum of Art):

"Constantly its form is changing, chances are it will never be captured; its dragon-whiskers bristle like lances, rank after rank."

Shen Zhou's Three Junipers needs no literary embellishment. Anyone who has seen and studied junipers recognizes the reality Shen produced. Careful and just observation guided his hand and guarded against the enemy of exaggeration. The ink is rich and the brush strokes subtly varied from full and fat to dry and lean, from pale to dark, and from sharp to a shaded wash. The quite free and easy delineation of the natural shapes and profiles gives the impression of a sketch "from life," although it is certain that the scroll was painted in the artist's study or workroom. Its perfect blend of strength, movement, solidity, and description is a major visual accomplishment. To write about this masterful scroll is a frustrating task. "I am a picture; do not ask me to speak!" (Heine) would be advice well taken here. S.E.L

313

Shen Zhou
1427–1509

NIGHT VIGIL

dated to 1492
Chinese
hanging scroll; ink and slight color on paper
84.8 x 21.8 (33³⁄₈ x 8⁵⁄₈)
signed: Shen Zhou; two seals of the artist: Qi'nan, Shi Tian
references: Edwards 1962, 56–58; Sullivan 1974, 52–55; Cahill 1978, 90–91

National Palace Museum, Taipei

In contrast to Three Junipers of Changshu (cat. 312), here the inscription, its content and implications, dominate the scroll. Words prevail over the image, even mold and magnify it. Since most scholars of wen ren painting consider this scroll a key monument, it is necessary to present the inscription in full, as translated and paraphrased by James Cahill (see References):

On a cold night, sleep is very sweet. I woke in the middle of the night, my mind clear and untroubled, and as I was unable to go to sleep again, I put on my clothes and sat facing my flickering lamp. On the table were a few folders of books. I chose a volume at random and began to read but, tiring, I put down the book and sat calmly doing nothing. A long rain had newly cleared, and a pale moon was shining through the window. All around was silence. Then after a long time absorbing the fresh brightness, I gradually became aware of sounds.

(He listens to sounds farther and farther off — the wind in the bamboo, the growling of dogs, the drumbeats that mark the hours, and finally, near dawn, the sound of a distant bell. His meditations turn to the difficulty of breaking through the constant operation of his own intellect, which seeks for knowledge more in books than in direct experience.)

My nature is to enjoy sitting in the night. So I often spread a book under the lamp, going back and forth over it, usually stopping at the second watch. Man's clamor is not at rest, and the mind is yet bent on bookish learning. Until now, I have never attained a state of outer tranquillity and inner stability [rest].

Now tonight all sounds and colors come to me through this state of tranquillity and rest; they serve thus to cleanse the mind, spirit, and feelings [instead of, as ordinarily, muddying them] and to arouse the will. (But this will, this central point of consciousness, cannot easily dissociate itself from attachment to sensory data.) It is not that these sounds and colors do not exist at other times, or that they do not strike one's ears and eyes. My outward form [body] is [usually] slave to external things, and my mind takes its direction from them. [True perception through] hearing is obscured by the sounds of bell and drum; [true perception through] seeing is obscured by patterns and beauty. This is why material things benefit people seldom, harm them often. (Once, however, he has arrived at a state of inner tranquillity, the effect of sensory stimuli is very different.) Sometimes it happens, though, as with tonight's sounds and colors, that while they do not differ from those of other times, yet they strike the ear and eye all at once, lucidly, wonderfully becoming a part of me [absorbed into my very being]. That they are bell and drum sounds, patterns and beauty, now cannot help but be an aid to the advancement of my self-cultivation. In this way, things cannot serve to enslave man.

(Physical sensations are ephemeral, while the will remains more constant.) Sounds are cut off, colors obliterated; but my will, absorbing these, alone endures. What is the so-called will? Is it inside me, after all, or outside? Does it exist in external things or does it come into being because of those things? In this [i.e., the realization I am now experiencing] there is a means of deciding these questions. Ah! I have, through this, decided them.

How great is the power of sitting up at night! One should purify his heart and sit alone, by the light of a newly trimmed, bright candle. Through this practice one can pursue the principles that underlie events and things, and the subtlest workings of one's own mind, as the

奇觀而未嘗
見也并寫歸
後
進所得詩于
石路迴老去登
燥虞仲祠前
昭明臺下芒難
臨誇健在舊
進山水喜重來
雨乾草受相
將發春淺梅
嫩忽縮開傳
取梁朝檜神
去袖中疑道
有風雷
成化甲辰人日
沈周

方雷
色日暮袖歸：不
得滿山風雨山靈
惜居此贈與卧
雲人長嘯寒風
生石壁於乎石
君詩畫天下知
此筆尤為天下
奇勸君風雷當
龍壁空去蛟
揚戶恐後化
吳興張淵

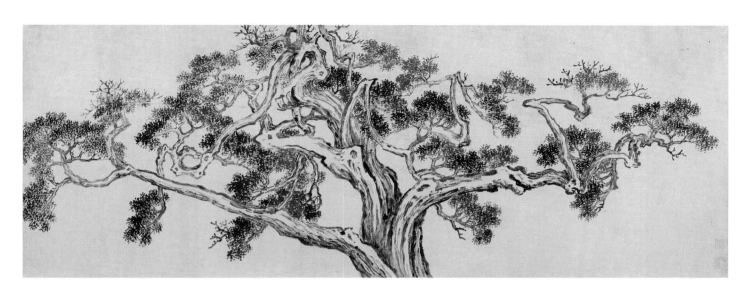

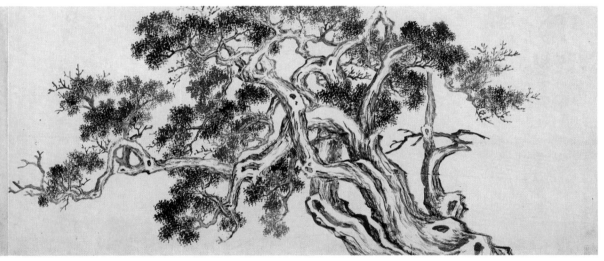

虞山至道觀有
所謂七星檜者相
傳為梁時物也
今僅存其三餘
則後人補植者
而三株中又有

虞山老檜三株青
斗壇半揸招捂
星道欠舟成仍鶴
去三檜天矯飛龍
形具一崖禾植經千
載昔見昭明讀書
在幾迴天上葉
神仙不獨人間
夔奈海古今人去
繞樹行古今人
樹長生乃知勁氣
合元化不與凡木爭
枯榮長洲老石好
奇者百里攜杯酒
樹下浩嗟天下有
此樹何人圖三日
經營雙眼力滿
空菴翠移真從

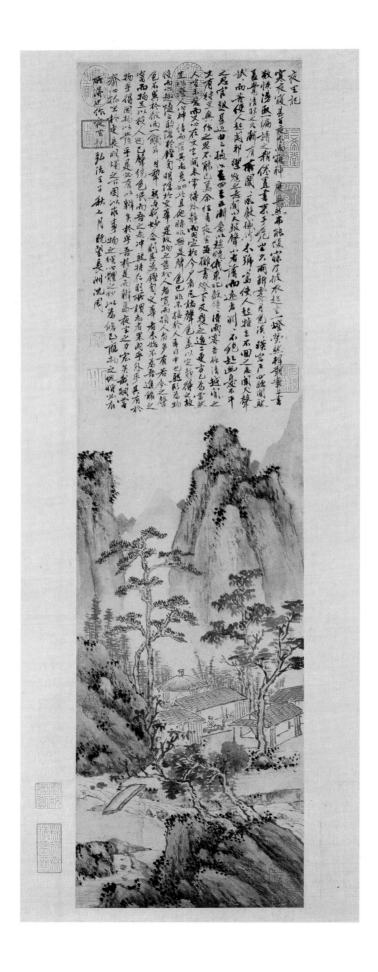

basis of self-cultivation and [a proper mode of] response to external things; through this, we will surely attain understanding.

I have composed this record of my night vigil in the [Hongzhi] era, [*renzi*] year [1492], fifteenth day of the seventh month.
[Shen Zhou of Changzhou.]

Contrary to Cahill's following comments, it seems that Shen *is* relating this meditation specifically to the nature of artistic creation. Ten times he mentions components of the arts dear to the heart of a literatus: sounds, colors, drum, bell, patterns, and beauty. Although characteristically rambling and vague, Shen's thoughts are discernible and his theme is refreshingly simple. The artistic process may occur in parts, or stages, but its successful realization — in the Confucian sense of "self-realization," since *wen ren* art is the expression of the character of the man — requires an intuitive achievement of wholeness.

Joining his Western peers in this intuition of the supremacy of intuition, the Chinese master also finds the night a sympathetic occasion for receiving these glimpses of real "reality." Between sleep and waking, in "outer tranquillity and inner stability," intuitions arise. In all this there are Buddhist overtones as well, less explicit than the Confucian ones, but implicit in the idea of contemplation as emptying oneself of a preoccupation with the things of this world.

The picture is not mentioned in this long colophon, unless "composed the record" includes the making of the image as well as the writing. It seems to be a kind of visual *aide-memoire*, echoing the rather unfocused, informal, and rambling nature of the inscription. A firmly and rapidly brushed mixture of dabs, strokes, and washes builds a convincing landscape setting for the not-so-convincing architectural elements, especially the stone slab bridge. Along a diagonal running from mid-left to lower right the picture divides between a dynamic and darkly brushed lower foreground and a paler, calmer middle and far distance. One thing seems certain from both text and image. Wine's creative assistance played no part in the making of *Night Vigil*, in contrast to other similarly informal and casual works by the artist, notably the *Landscape for Liu Jue*, also in the National Palace Museum, Taipei. The intuitions of night-long vigils can be comparable to those called forth by alcoholic exaltation, a constant theme in the history of later Chinese painting. Here the Chinese artist finds equivalents in the Western tradition.

In *Night Vigil*, inscription and picture combine to permit insights into the "literary man's" painting tradition. It is so particularly and deeply embedded in that tradition that it can enter a larger world of art only with difficulty. S.E.L.

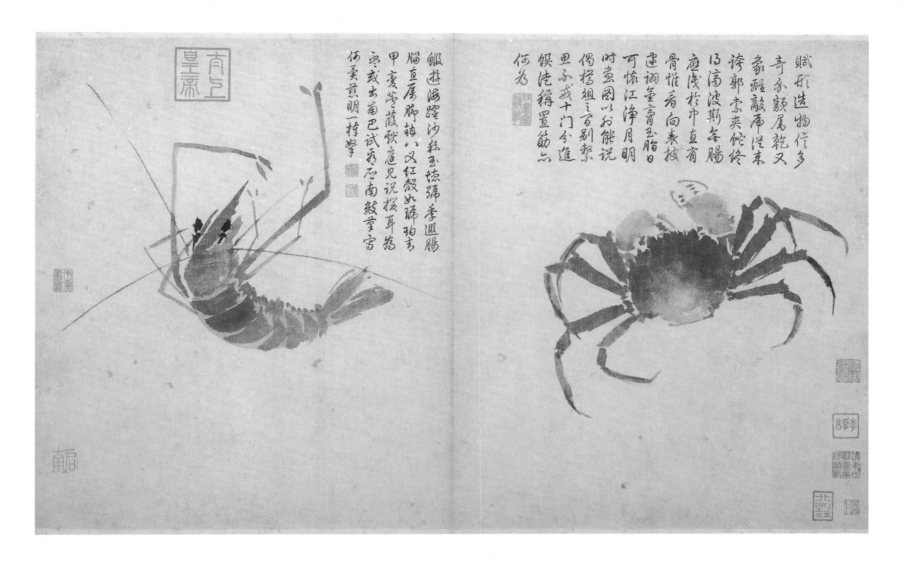

314

Shen Zhou
1427–1509

DRAWINGS FROM LIFE: PLANTS, ANIMALS, and INSECTS

dated to 1494
Chinese
album of 16 leaves, ink on paper
each leaf 34.7 x 55.4 (13⅝ x 21¾)
inscription with signature of the artist

National Palace Museum, Taipei

Accompanying the album is an inscription by the painter that clarifies the artistic process as well as the specific intent of Shen Zhou in this case:

> With wriggly things as well as those that grow,
> I can still manipulate my brush and plumb the
> wellsprings of the universe;
> On a sunny day by a small window I sit in
> a solitary place,
> Spring breezes fill my face and my heart
> grows subtle.

Playing with the brush I did this album, creating shapes in accord with the forms of the objects by depending on the inspiration from my own agreeable, leisurely, and well-fed existence. Those who seek me in my paintings will find me apart from the painting. Inscribed by Shen Zhou during the year [1494] of the Hong-zhi reign-era.

Shen Zhou first stated what has become a truism of painting: subject matter is no more than the starting point for what the artist wishes to communicate. Quite ordinary plants and creatures as well as their more exotic or rarefied relatives can provide the raw material on which the artist's imagination works. The natural forms of those subjects were not distorted for expressive purposes and are still easily recognizable—the painted shapes do correspond with the three-dimensional forms of the subjects—but verisimilitude was not the main point of any of these paintings. The limits in that direction were spelled out by Shen Zhou in another inscription written for a similar series of paintings in that same year: "All flowers, leaves, berries, melons, flying birds, and walking animals were brought forth within limits established by the operation of nature, and cannot be imitated through human effort."

Granting, then, the impossibility of exactly replicating the things of nature, the artist had no compelling need to limit the sources of his inspiration to nature and could draw on earlier paintings as well. The duck, for example, is very close in style and appearance to one painted by Chen Lin, a protégé of Zhao Mengfu (1254–1322). Like Chen and Zhao before him, Shen Zhou gives us in the leaves of this album a series of ink-plays, performances in ink using a variety of techniques, including the "boneless" (*mo gu*) mode. It is precisely because the subjects are so commonplace, so well known to all his audience, that viewer attention is focused rather on the means of representation than on the creative process itself. It is this last that reveals the genius of Shen Zhou, for, as he himself noted here, the paintings tell us on a superficial level only that he was conversant with the basic forms of cats, donkeys, frogs, crabs, shrimp, clams, birds, butterflies, flowers, fruit, and vegetables. It is in the penetrating insight, technical freedom, and humor with which Shen Zhou treated these subjects that something of his personality and the seemingly charmed circumstances of his existence is revealed.　　　H.R.

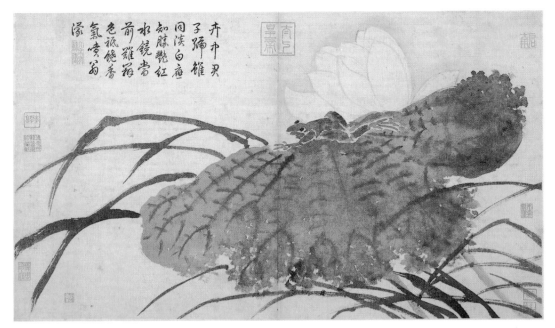

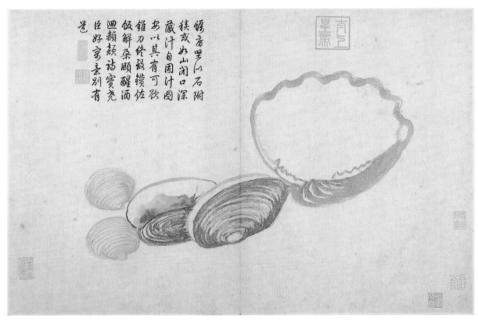

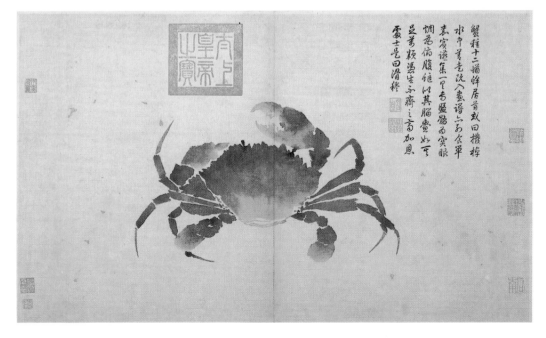

315–316 ✑

Shen Zhou
1427–1509

LANDSCAPES WITH FIGURES

Wen Zhengming
1470–1559

RAINY AND WINDY LANDSCAPE

c. 1490
Chinese
six album leaves mounted as a handscroll;
ink on paper; ink and light color on paper
38.7 x 60.2 (15¼ x 23¾)
signatures, seals, and inscriptions by the artists:
leaf 1, signature and two seals; leaf 2, signature,
two seals, and poem; leaf 3, signature, seal, and
poem; leaf 4, signature, seal, and poem; leaf 5,
signature, two seals, and poem; leaf 6 (by Wen
Zhengming), two seals and poem. Thirty-five
additional seals of collectors and two colophons,
one by Wen Zhengming dated to 1516, and one by
Xie Lansheng (1760–1831) dated to 1824.
references: Edwards 1962, 38–41, 95–96; Sullivan
1974, 48–51; Ann Arbor 1976, 28–34; Cleveland
1980, 185–187

The Nelson-Atkins Museum of Art, Kansas City,
Nelson Fund

This deservedly famous and much praised set of
album leaves reveals the art of Shen Zhou in his
old age, and at its highest level. Richard Edwards
has dated the scroll to about 1480, which seems to
this author a decade too early. The masterful ink
handling, differing for different subjects but sure,
strong, and predominantly wet, seems more com-
patible with the early 1490s, comparable with the
1494 album of *Plants, Animals, and Insects* (cat.
314). This dating accords well with Wen Zheng-
ming's statement, in his colophon of 1516, that the
"venerable" Wu Kuan (1436–1504) asked him to
paint four leaves following the six by Shen Zhou.
(Four of the album leaves have been lost, three by
Wen and one by Shen.) At sixty, Wu would have
qualified as venerable, but hardly at forty-five.

Leaf 1, the genre scene with gardeners, is the
only leaf without poem or inscription, and most
likely the omission was deliberate: workingmen
were not an approved *wen ren* subject (in contrast
to the subjects of the other four leaves), hence
unworthy of poetry. Nevertheless this composi-
tion is the most innovative of the set, matched in
quality only by leaves 2 and 3. Some elements in
leaf 1 are "conventional" in the sense of having
precedents — the right foreground with its catal-
pas (?) and bare willows recalls the "one-corner"
compositions of the thirteenth-century Ma-Xia
school and its early Ming descendant, the Zhe
school, and the rock platform under the bamboo
(?) fence had appeared in paintings for centuries.
But observation and inventiveness are manifest
in the way in which the fence is angled to divide

the pictorial stage, and in the diagonal recession, diminution in scale, and increasing atmospheric haziness that together suggest recession of the ground plane. Old Shen still had his eyes open to reality as well as to pictorial tradition.

Leaf 2 is a most unusual and bold composition, with its enormous, nearly central crag—a "stone ledge flying in space"—dominating both the solitary figure and the screen of trees and rocks to the right. The conceit of showing the figure (Shen himself?) looking at his poem hanging in the space between ledge and distant hills is a wonderful example of the unity of word and image in the best *wen ren* painting.

Leaf 3 is likewise a modified "one-cornered" composition, with the trees in the lower right foreground balanced by distant hills at upper left. The crisp clarity of ink and color convey the feel of a brisk fall day ("white clouds and red leaves"). On leaf 4 the poem refers even more specifically to autumn, while the image suggests a wind that not only fills the boats' sails but even seems to make the exaggerated ledge to lean in the same direction. Leaf 5 recalls the undramatic, even, "bland" look of *Night Vigil* (cat. 313) of 1492; its poem seems unfocused and only partly related to the image. The travelers do not "look back"; there is no "carriage wheel" in sight.

The sixth leaf, the only one remaining of the four painted by Wen Zhengming at Wu Kuan's request, must be a very early work by the artist—Edwards suggests a date before 1504, the date of Wu Kuan's death, when Wen was thirty-seven, a mere youth by Chinese scholars' standards. He refers to himself as "pupil" to Shen Zhou, and *Storm over the River*, though rendered in his more elegant and more miniature brushwork, clearly shows his debt to the older master. A comparison of leaf 6 with leaf 4 by Shen is instructive in this regard.

Of the following signatures and seals, poems, and colophons, those on leaves 1–5 are by Shen Zhou, leaf 6 and the colophon are by Wen Zhengming:

Leaf 1: Signed *Shen Zhou*; Seals: *Qi'nan*, *Shi Tian*

Leaf 2:
 White clouds like a belt
 encircle the mountain's waist
 A stone ledge flying in space
 and the far thin road.
 I lean alone on my bramble staff
 and gazing contented into space
 Wish the sounding torrent
 would answer to your flute.

Signed *Shen Zhou*. Seals: (below signature) *Qi'nan*; (lower right) *Boshi Weng*

Leaf 3:
 Carrying a crane and my [*qin*]
 homeward bound on the lake

White clouds and red leaves
 flying together
My home right in the very
 depths of mountains
The sound of reading within bamboo,
 a tiny couch, a humble gate.

Signed *Shen Zhou*. Seal: *Shi Tian*

Leaf 4:
 The red of autumn comes to river trees
 The mountain smokes freeze fast the
 purple evening.
 Are those who long for home,
 Returning from a thousand *li*?

Signed: *Shen Zhou*. Seal: *Qi'nan*

Leaf 5:
 Deep and dark, emerald trees of mottled green,
 Anglers' punts loll at the [Zha's] western shore.
 Travelers on the bank look back in vain,
 Each departing, by horse's hoof or
 carriage wheel.

Signed: *Shen Zhou*. Seals: (below signature)
Qi'nan; (lower right) *Shi Tian*

Leaf 6:
 The spring flood carried the rain,
 swifter by evening.
 And at the wild ford, no one—
 only the empty, lurching boat.

Seals: *Tingyun Sheng, Wen Bi yin*

Colophon by Wen [Zhengming]:

 Venerable [Shi, i.e., Shen Zhou] was lofty
 in spirit when wielding the brush;
 He was by nature placid as the
 languorous clouds.
 Do not think he follows
 [Yuanhui's, i.e., Mi Youren's] style,
 For he himself depicted [Suzhou's] mountains
 after rain.

 What [Suzhou] place did he portray in
 drippy wet ink?
 Pre-eminent were the western hills, so striking
 after rain
 Who can capture even one part of this
 scenery's mood?
 In a thousand years, only the painted poetry
 of [Mo-Qi, i.e., Wang Wei].

 Years ago his poetry was noted for
 its excellence;
 In later years greatness in painting all
 but obscured this earlier fame.
 Life's affairs are vast and uncertain,
 who knows what will obtain?
 Your old pupil, though white-headed now,
 is still inept and ashamed.

 Shen [Xiuwen, i.e., Shen Yue],
 that noble man, is no longer seen;
 And how many times since has the sun set on
 [Yuzisha]?

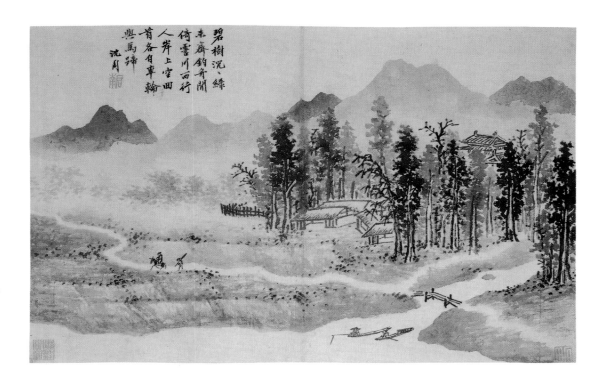

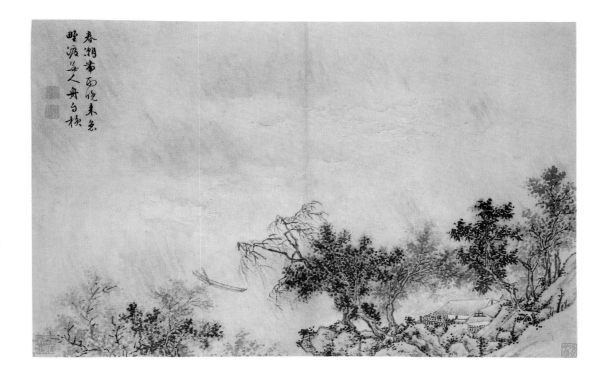

Looking, through tears, at the broken ink and
 remnants of his work;
Emerald peaks, rank on rank, melt into the
 sad clouds.

Shen [Zhou] was a man of the highest integrity.
His writings were perceptive and rich, and his
scholarship deeply grounded. Emerging during
odd moments of spare time, his paintings
afforded an amusing diversion. They are not,
indeed, something which indifferent artisans
or commonplace craftsmen can realize. In his
early years he followed Wang Meng [1309–
1385] and Huang [Gongwang, 1269–1354] and
proceeded on into the chambers of [Dong Yuan,
d. 962] and [Ju-Ran, act. c. 960–980], his crea-
tions becoming ever more profound. There is
no knowing what its genesis might be.

These six leaves were done for Wu [Kuan,
1436–1504]. In brushwork and compositional
placement especially do they surpass his usual.
Venerable old [Pao, i.e., Wu Kuan] bade me
fill in the extra leaves. I declined with thanks,
pleading inadequacy. However, I could not
brush aside his request. With four [Tang] cou-
plets casually in mind, I smeared and scribbled
in a desultory way. But how could such clumsy
and inferior skills as mine bear being attached
to a renowned brush? The disciple was sin-
cerely embarrassed.

By now it has been several years since the ven-
erable old [Pao] passed on, and the venerable
old [Shi], too, is dead. His [Wu's] nephew [Siye,
i.e., Wu Yi] brought the album to show me.
I cannot help sighing over the fact that the
[qin, a kind of zither] remains but the man is
gone. And so, I have composed four poems
and inscribed these remarks.

Written by the pupil Wen [Zhengming] in the
[Yuqing shanfang] during the eighth lunar
month in the autumn of the [bingzi] year of the
[Zhengde] era [1516].

(Translations from Cleveland 1980, 185–187.)

NOTES:

Mi Youren (1075–1151), a famous painter, was the son
of Mi Fu (1051–1107), an even more eminent painter,
calligrapher, and scholar, and one of the accepted cre-
ators of *wen ren* painting and aesthetics.

Wang Wei (699–759), the traditional patriarch of the
wen ren tradition, was famous as poet and as the first
artist to paint a particular landscape, his country villa
Wangchuan.

Shen Yue (441–513) was a scholar whose name was
used by Wen as a complimentary reference to Shen
Zhou. Yuzisha was Shen Zhou's villa.

Xie Lansheng's colophon of 1824 describes the scroll
as it is now: "Originally it had six leaves, with four
other leaves added by Wen Hengshan [Wen Zheng-
ming], based on couplets from Tang dynasty poems.
In the album now there are only five of Shen's and
one of Wen's left." S.E.L.

317 �

Wen Zhengming

1470–1559

SPRING TREES AFTER RAIN

dated to 1507
Chinese
hanging scroll; ink and color on paper
94.3 x 33.3 (37⅛ x 13⅛)
inscription by the artist

National Palace Museum, Taipei

The theme of this painting as well as the circum-
stances under which it was created are stated in
the artist's inscription:

> After rain spring trees produce green shade,
> I love best that on West Mountain toward the
> last light of day;
> There must be people's houses at the
> mountain's foot,
> Across the river one sees from afar where the
> white mists are born.

> I painted this picture for Laishi, who after
> several days requested me to add a poem. Laishi
> is about to leave for the north. When he looks
> at this on the boat, will he wonder if Tianping
> and Lingyan still exist?

The artist's poem specifies a season and a time
of day and hints at atmospheric conditions; these
particulars, combined with the names of three
specific famous scenic areas in Jiangsu Province,
might well create expectations of a painting
almost exactly opposite to what the painter has
given us. Rather than the immediacy of a particu-
lar place on a somewhat humid evening in spring,
we view a scene in which the formalized, warm-
cool color combination, the general lack of spatial
or atmospheric recession, and the meticulous,
very dry, and refined drawing all tend to evoke a
mood of nostalgia, a sense of a world far removed
in time and place from the present.

Much of this approach harks back to Zhao
Mengfu (1254–1322), who was one of the earliest
artists in China to self-consciously distort natural
forms and relationships for purely expressive
purposes. The sense of disengagement which
characterizes the present painting is particularly
appropriate to the purpose, for *Spring Trees After
Rain* was painted as a gift for a man who was
leaving the lush river and lake country of the
Yangzi River region for the drier, more austere
north. The artist suggests in his inscription that
as the physical environment changed, his painted,
dreamlike vision might well come to seem more
substantial than his friend's memory of the south-
ern scenery.

Wen Zhengming, mentioned above as the most
important pupil of Shen Zhou, was also a boyhood
friend of Tang Yin and a close artistic associate of
Qiu Ying. Wen originally aimed to be a scholar-

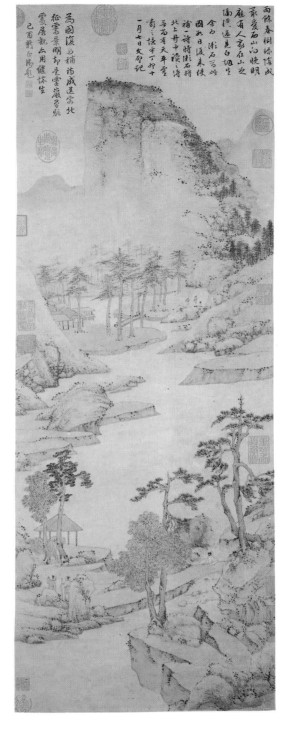

official like his father but failed time after time to
pass the district examination. In 1522, following
Wen's tenth failure, the governor of Jiangsu Prov-
ince recommended him for appointment at court;
after serving unhappily until 1527, he resigned
and returned home to pursue aesthetic rather
than political goals. Wen's unflagging productiv-
ity during his long life and his numerous disciples
and students were instrumental in the spread
and acceptance of the Suzhou style of painting
throughout the entire country by the end of
the sixteenth century. From then onward the
restraint, the refinement, and the discipline
already apparent in this early work of 1507
became hallmarks of literati painting. H.R.

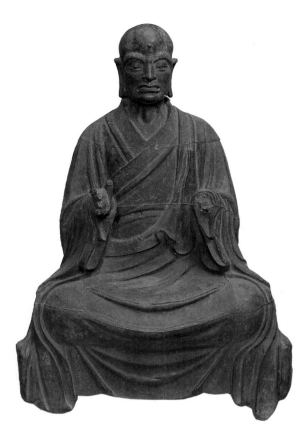

318 ᎒

LUOHAN

dated to 1497
Chinese
cast iron
height 112 (44⅛)
inscription

Palace Museum, Beijing

Shaven head and plain robes identify this figure as a Buddhist monk, seated with legs crossed in the posture of meditation, his hands extended in a gesture of revelation and his head slightly bowed. Beneath bushy brows the eyes are narrowed to slits, the mouth is set, and the neck tendons are strained, all being outward manifestations of inner resolve, strength, and concentration. Particularly striking are the elongated earlobes and the circular protrusion in the center of the forehead, both attributes of the Buddha himself but used here to manifest the Enlightenment, or Buddhahood, of one of his disciples, or *luohan* (S: *arhat*).

Entering the Buddhist record as sixteen disciples of Śākyamuni Buddha, the *luohan* increased in number as Buddhism moved eastward, first to eighteen, then to five hundred, ultimately totaling as many as twelve hundred. Since *luohan* attained spiritual perfection by their own efforts, they played a major role in the limited pantheon of Chan Buddhism, which emphasizes individual effort and responsibility, and which became one of the major Chinese schools of Buddhism from the tenth century onward. Images of these perfected

beings served in Chan temples as exemplars, patrons, and guardians of the faith.

Iron appears in Chinese art at least as early as the fourth century B.C., when it was used to make belt-hooks as well as tools and weapons. During the Han dynasty Emperor Gao Zu (r. 206–195 B.C.) instituted the practice of conferring iron tallies at enfeoffment ceremonies; these were inscribed in gold with a pledge of allegiance enduring "until the Yellow River becomes a belt and the Tai Mountains a whetstone" (see cat. 289). By the tenth century the tallies were also granted in recognition of meritorious service and carried with them such extraordinary privileges as legal immunity from the death penalty. The founder of the Ming dynasty, Zhu Yuanzhang (1328–1398, r. 1368–1398), often compared himself with Han Gao Zu and, probably to further the comparison, he revived the practice of granting iron tallies very early in his reign. Imperial iron foundries as well as imperial kilns were established, and iron as well as ceramics became important factors in international trade.

An inscription cast into the back of the *luohan* reads:

> Made during [the year 1497] of the Hongzhi reign-era [1488–1505] of the Great Ming dynasty for donation by eunuch Yao Jushi.

Other iron *luohan* images bearing dates include a set of four made in 1477 (Rösshka Museum, Göteborg), a single figure cast in 1482, and a figure with partially obliterated Chenghua reign-date (1465–1487; Kimbell Art Museum, Fort Worth, Tex.). The Kimbell sculpture was cast in Baoding District, near Beijing. Since Yao Jushi likely lived in Beijing, the present piece may have been made in Baoding as well. The observable popularity of iron images during the fifteenth century may be related to a well-known group of large-scale glazed ceramic images of *luohan* from Eight Luohan Mountain near Yizhou, immediately to the south of the capital. Although the clay figures were first dated to the Tang dynasty, they have more recently been ascribed to the eleventh or twelfth century, and an even later dating is far from impossible.

Its selection as capital of the Yuan dynasty greatly expanded Beijing's population and economy, which would surely have spurred local artists and artisans to greater and more ambitious efforts. This creative impulse continued into the Ming dynasty and was likely the impetus for the iron *luohan*.

The high degree of verisimilitude that characterizes this entire group of ceramic and iron *luohan* distinguishes them from pre-Song images, when *luohan* were portrayed with distinctly otherworldly, often grotesque, physiognomies. Creation of a more serene, humane image is usually credited to the literati painting master Li Gonglin (c. 1049–1106), and the present piece

derives from that lineage. With his plain robe connoting a simple life free from worldly vanity, and his sunken cheeks and lean neck suggesting a meager diet, the *luohan* sits with disciplined intensity, his moral and intellectual strength immediately apparent. While Yao Jushi may well have despaired of equaling such an exemplar, his meritorious donation must still redound to his credit. H.R.

319 ᎒

VIRŪPĀKṢA

15th century
Chinese Lamaist workshop
gilt copper, hollow cast, with silver, turquoise, coral, and lapis inlays
height 68.5 (27)
references: Gordon 1959, 3–7, 92; Von Schroeder 1981, 502–513, 524–525; Snellgrove 1987

Musée des Arts Asiatiques-Guimet, Paris

Virūpākṣa, one of the four Guardian Kings of the Four Directions (S: *lokapāla*), watches over the west. The architectural model of a stupa-pagoda, here held in his right hand, is one of his Lamaist attributes; as king of the *nagas* (serpent deities)

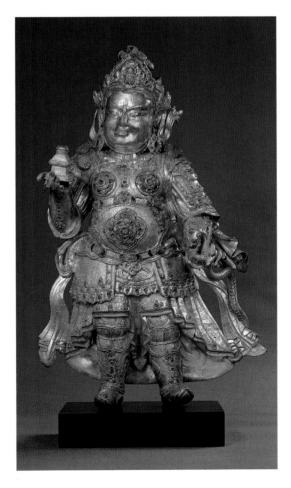

he holds a snake in his left hand. His complex armor and padding is of Chinese style, derived ultimately from Tang dynasty (618–907) representations of the Guardian Kings.

Its direct antecedents are to be found on the ceremonial marble gate called Juyong Guan, built north of Beijing between 1342 and 1345 by the Mongol rulers of Yuan dynasty (1279–1368) China. There the Four Guardian Kings dominate the reliefs decorating inner walls of the vaulted passage. The vigor of these reliefs, and the inscription repeated in six languages—Chinese, Mongolian, Uighur, Tibetan, Sanskrit, and Tangut—attest the extent of Mongol power and the complexity of the Mongol domain in the fourteenth century. In the service of their Lamaist form of Buddhism the Mongol rulers brought Nepali and Tibetan artist-craftsmen to their capital at Beijing, including the young Nepalese artist Aniko. Arriving in Beijing in the company of the distinguished Tibetan monk 'Phags pa (1235–1280), the young Aniko quickly became minister in charge of the imperial workshops producing religious art, and a major stylistic innovator.

Much of the iconography and representational conventions established in the Yuan dynasty for Lamaist paintings and sculpture continued to govern Lamaist art during the succeeding Ming dynasty—both the images intended for Chinese Lamaist temples and those exported to central Asia and Tibet. The close and mutually beneficial ties between Tibet and China in the early Ming period can be symbolized by the two-year visit (1406–1408) to the capital, Nanjing, by the fifth incarnation of the chief lama of the Karma-pa lineage, De-bzhin-gshegs-pa (1357–1419), who acted as spiritual advisor to the Yongle emperor. Many imperial reign-marked pieces—both images and implements—of fine quality are known from this time.

Lamaist works of middle Ming continued to show a creative mixture of Nepali, Tibetan, and Chinese stylistic elements. If the main images of Vajrayāna Buddhism (Tantric Buddhism with an admixture of pre-Buddhist Tibetan "Bön" worship of nature deities and demons), even those of Chinese manufacture, are strongly Tibetan in appearance, such secondary images as Guardian Kings (like Virūpākṣa) and *luohan* (cat. 308) are more indebted to Chinese modes of representing warriors and sages.

Inlays of semiprecious stones, uncommon on Ming Chinese artifacts, were more common in Tibet, perhaps indicating (according to Von Schroeder) that this image of Virūpākṣa was made for Tibetan use. 　　　　　　S.E.L.

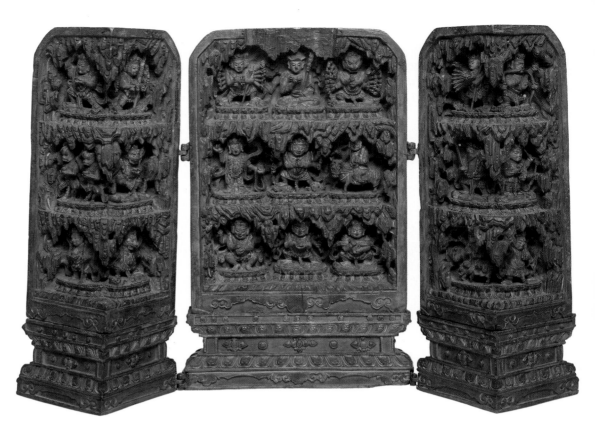

320 ⬧

PORTABLE SHRINE IN TRIPTYCH FORM

15th–16th century
Chinese
carved and engraved hardwood
height 25.4 (10)
references: Gordon 1959, 106; Sawa 1972, fig. 60; Paris 1977, 107–109; Snellgrove 1987, 2:397–408, 2:429–434, pls. 65, 72; S. Huntington and J. Huntington 1990, 218–395, 556–566

The Cleveland Museum of Art, Andrew R. and Martha Holden Jennings Fund

Identification of the twenty-one deities represented within the confines of this small folding shrine is beyond the competence of this writer. The central figure in the upper register of the central section is Padmasambhava (Lotus Born), and the rest are major deities of the Lamaist persuasion. Here the content is not as important as the context. Padmasambhava was a historical-legendary sage, founder of the Indo-Tibetan Lamaist tradition. He is reputed to have come from Nepal circa 779 at the request of the Tibetan ruler and to have quelled the gods and demons (Bön) of the region. He also founded the first monastery, bSam yas, and there installed the Indian version of Tantric Buddhism, which generated a rift in Tibet between sects looking south to India and those looking to powerful Tang China. Ironically, this later shrine extols Padmasambhava, champion of Indian Tantrism, although its manufacture and style are clearly Chinese. Probably by the sixteenth century the early sectarian divisions were no longer live issues.

Portable shrines, both diptychs and triptychs, played major roles in the dissemination of the faith and the popularization of certain deities. Ivory and wooden fragments exist of shrines of this type dating between the fifth and eighth century. One single example is perfectly preserved, and still emanates the magic that must have issued from all of these early material evidences of the new, true faith—the portable shrine at Kongōbu-ji, the Shingon Buddhist temple on sacred Mt. Kōya in Wakayama Prefecture, Japan. Legend has the shrine brought to Japan by Monk Kūkai (Kōbō Daishi, 774–835), who returned in 806 from study in China to establish the enormously influential Shingon (True Word) school of Esoteric Buddhism in Japan. It is not unlikely; who but a man of Kūkai's intellect and charisma could have commanded such a treasure? In form and size the Kongōbu-ji shrine is almost identical with the shrine exhibited here, but its iconography is quite different. The Kongōbu-ji shrine is a classic presentation of the historical Buddha Śākyamuni, flanked by two bodhisattvas, secondary figures, guardians, lions, and attendants. The present Lamaist shrine is centered on a quasi-historical founder of a complex faith who, by the time this shrine was made, had acquired wholly legendary status and attributes.

The refinement of the detailed carving and engraving suggests a Chinese craftsman accustomed to working in fine-grained hardwoods and a workshop producing the rosewood (*huanghuali*) or boxwood small sculptures fashionable among the scholar-official class of the Ming dynasty. 　　　　　　S.E.L.

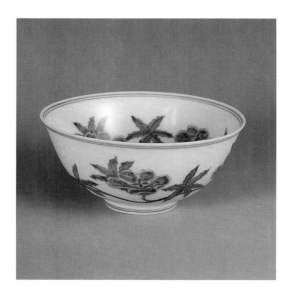

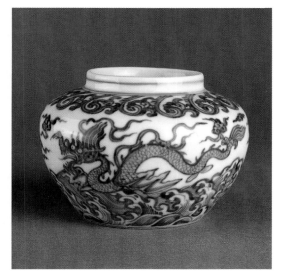

ated, form a band of scrolling decoration around the shoulder. The drawing of this piece is especially vigorous. Unlike the more schematic and, later, emblematic creatures of the later Ming and Qing, these dragons are convincingly full-bodied, their motion believably animated and undulating.

Over the white fabric of the jar the glaze has a particularly fine oily sheen. The base has a shallow ring-foot and, within its stepped underside, a six-character reign-mark in cobalt blue.　　s.e.l.

321 &

PALACE BOWL

Chenghua mark and period (1465–1487)
Chinese
white porcelain with underglaze blue decoration
height 6.8 (2⅝), diameter at mouth 14.7 (5¾)
references: Brankston 1938, 46, 47, pl. 26c; Jenyns
1953, 79–85, pls. 62–63; Medley 1963, A646

National Palace Museum, Taipei

The term "Palace Bowl," proposed by Brankston for bowls of this shape and size, seems to have been accepted almost universally. The shape is very simple, with little or no reflex curve from the side to the lip. The six-character reign-mark and the two fine-lined circles enclosing it are brushed in underglaze blue on the slightly convex, fully glazed base. Encircling the wall of the bowl inside and out is a hibiscus(?) scroll with five blooms and leaves; in the well of the interior is a five-leaf floral "whorl" enclosed in a single fine-lined circle. Double lines mark the lip inside and out, and on the exterior a double line encircles the foot. Characteristic of these Chenghua period bowls, the design is simple, elegant, and finely balanced, and the blue color is enhanced by the large area of white surround. As Brankston notes, the scrolling stem that links the blooms and leaves was not drawn with a single continuous brush stroke, unlike the scrolls of earlier imperial wares made at Jingdezhen. Pale blue wash alongside the darker blue in blossoms and leaves effects a subtle kind of shading, simply achieved.　　s.e.l.

322 &

JAR

Chenghua mark and period (1465–1487)
Chinese
white porcelain with underglaze blue decoration
height 8.7 (3⅜), diameter 12.8 (5)
reference: Medley 1962–1963, pls. 11a, 11b

The Asia Society, New York,
Mr. and Mrs. John D. Rockefeller 3rd Collection

On this small jar of squat form, with a high shoulder and rolled mouth rim, the principal decoration is of two fish-tailed dragons soaring above a raging sea. Hooked foliate scrolls, obliquely situ-

323 &

COVERED JAR

Chenghua reign (1465–1487)
Chinese
white porcelain with dou cai decoration
height 11.1 (4⅜), diameter at mouth 6.3 (2½),
diameter at foot 9.1 (3⅗)
references: Jenyns 1953, 77–93; Medley 1966;
Los Angeles 1989

National Palace Museum, Taipei

Perhaps the rarest of all Chenghua period porcelains, this jar has no counterpart in the West. Given the sybaritic life of the emperor, empress, and inner court, the compressed and softly swelling shape and wide, low-rimmed mouth suggest that it was used to hold small delicacies.

Dou cai decoration combined underglaze drawing in cobalt blue with overglaze enameling; separately the two techniques antedated the Chenghua

reign-era, and there seems to be evidence (cat. 326) that *dou cai* itself, formerly thought to be an invention of the Chenghua imperial kilns, was in use as early as the Xuande reign-era (1426–1435). Nevertheless, *dou cai* decoration is always primarily associated with the ceramic production of the Chenghua reign. Soft cobalt blue was used to outline the motifs and to wash in some of them, then transparent glaze was applied and the piece received its first, high-temperature, firing. Lead-based enamels were then painted within the remaining blue outlines and fused by a second, lower-temperature, firing. The result was a superb, delicate fabric, characteristically slightly ivory-tinged and with a distinctive oily sheen that was only partially achieved in the succeeding Hongzhi (1488–1505) and Zhengde (1506–1521) reigns, and hardly at all in later copies. An accidental effect of the firing also helps to identify genuine Chenghua pieces: the foot usually shows an ivory to pale cinnamon discoloration, an effect of the high-temperature firing on the glaze and body within the confines of the foot rim.

Dou cai, literally "competing colors," suggests a rather high degree of contrast. But in woodworking, fitting, or joinery, *dou cai* can also mean "agreeing" or "harmonious." With characteristic Chinese subtlety the term *dou cai* encompasses both meanings: "agreeable contrast" nicely describes the delicate sprightliness of *dou cai* color schemes.

Here the underglaze soft blue was used to outline the undulating dragons and to wash in the stylized clouds. Overglaze enamels color the green dragons and the two bands of yellow gadroons accenting the rim and foot. Floral arabesques on the lid repeat the green of the dragons on the jar. The only red is in a border of rosettes encircling the rim of the lid. Instead of a reign-mark, the glazed base bears the character *tian* (Heaven), brushed in underglaze blue.

The Chinese have always ranked the *dou cai* porcelains of Chenghua among the very finest works in their extraordinary ceramic tradition. Never spectacular, always subtle and delicate, they reflect the sensuous and hedonistic proclivities of the emperor, his formidable and pleasure-loving empress, and the eunuch-dominated court.

S.E.L.

324

"Chicken" Cup

Chenghua mark and period (1465–1487)
Chinese
white porcelain with dou cai *decoration*
height 3.5 (1⅜), diameter 7.6 (3)
references: Medley 1966, no. A749; Los Angeles 1989, no. 41

National Palace Museum, Taipei

On the fine white porcelain body of this wine cup, under a warm, transparent glaze, underglaze cobalt blue outlines leaves, flowers, and chickens and also fills in the shaded rocks. A double underglaze blue line marks the upper boundary of the design, below the slightly everted rim, and a single line marks the lower boundary, just above the base. On the recessed underside of the base cobalt blue also renders the six-character reign-mark and the double line that forms a rectangular cartouche around it. *Dou cai* (cats. 323, 325, 326) enamels of red, green, yellow, and aubergine color

in the outlines of lilies, peonies, leaves, chicks, hen, and rooster.

This elegant, tiny wine cup resonates with Chinese aristocratic and scholarly traditions. Wine was a time-honored accompaniment of elevated discourse and elegant gatherings. For the scholar-poet or scholar-painter wine was both inspiration and solace in times of trouble. The most famous Chinese wine party of all time was held in spring of the year 353 in the Shanyin District, near present-day Shaoxing in Zhejiang Province. There forty-one poets joined their host, the celebrated calligrapher Wang Xizhi, at the Lan Ting (Orchid Pavilion). The guests were seated along the banks of a small stream, down which wine-filled cups were floated. When a cup drifted to shore near one of the poets, he drank the wine and composed a verse. After the party the poems were copied out as the *Orchid Pavilion Collection* (*Lan Ting Ji*), to which a celebrated preface was added by the host. The earliest known representation of scholar-poet with wine cup (now in the Nanjing Museum) is found on a relief formed of molded

clay bricks from a fifth-century tomb at Xishan-jiao, Nanjing, where Ruan Ji (210–263), one of the Seven Sages of the Bamboo Grove, lifts his cup to his lips in company with his fellows.

Wine and its cup continued to be essential accouterments of the gentleman-scholar-artist's life. In addition, the motifs decorating this cup and others like it are emblematic of good fortune: the cock was a symbol of achievement and harbinger of fame and, combined with the peony, a rebus of riches and honors—presumably devolving on the imbiber.

Tradition has it that the Chenghua emperor's favorite concubine, Wan Guifei, had a voice in determining the wares produced at the imperial kiln at Jingdezhen. If this be true, then the exquisite beauty and fine quality of Chenghua porcelains reflect the sensitive and subtle taste of a sophisticated, pleasure-loving court. S.E.L.

325

WINE CUP

Chenghua mark and period (1465–1487)
Chinese
white porcelain with dou cai *decoration*
height 4.8 (1⅞)

The Cleveland Museum of Art,
John L. Severance Fund

This wine cup, shaped like the wider end of an egg on a low ring-foot, is made of fine white porcelain under a warm transparent glaze. Underglaze blue outlines the design and colors the rocks; the same blue bounds the design top and bottom, with a single line just under the rim and a double line encircling the ring-foot. On the faintly cinnamon-

tinged underside, cobalt blue also renders the six-character reign-mark within a double-outlined rectangular cartouche. Red, green, and yellow enamels fill in the costumes, flowers, and leaves of the subject—boys flying kites on a garden terrace. The complex composition required for this small wine cup attests the porcelain decorators' skill, as does the admirably controlled underglaze drawing in slightly violet cobalt blue. The warm oil-sheen white, perfectly even, seems particularly rich and unctuous.

The subject, which alludes directly to fertility and abundant progeny, had by Ming times become generally auspicious and congratulatory. It originated at least as early as Tang (618–907) times, when *bai zi* (one hundred, i.e., many, children) curtains were used in marriage ceremonies. During the Song dynasty (960–1279) children playing, whether few or many, became a common motif, rendered by painters of the imperial academy as well as by those lesser lights who painted auspicious subjects for restaurants, pleasure quarters, and affluent homes.

A mate to this cup is in the National Palace Museum, Taipei—the only other example of Chenghua date known to the author, although Zhengde (1506–1522) copies exist. In the Percival David Foundation, London, is an unpublished handscroll titled *Gu Wan Te* (Myriad Special Antiques), dated to 1728. It is one of at least eight and probably more scrolls (one is reported to be in the Victoria and Albert Museum) which together provide a visual catalogue of the Yongzheng emperor's (r. 1722–1735) collection. Depicted in the David scroll is a pair of wine cups, identified as Chenghua and appearing identical to the now

separated Cleveland and Taipei examples. The provenance of the Cleveland cup indicates that it probably came from the Palace Collection in the 1920s or 30s as collateral for loans by the Shanghai Salt Bank, a provenance shared by many of the imperial porcelains in the Percival David Foundation. S.E.L.

326

PAIR OF PLATES

Chenghua reign (1465–1487)
Chinese
white porcelain with dou cai *decoration*
height 3.8 (1½), diameter 16.6 (6½)
reference: Rogers 1990, 75–76

National Palace Museum, Taipei

Ornamenting each of these most unusual plates is a virtually identical lotus pond inhabited by a pair of mandarin ducks, rendered in a *dou cai* scheme of soft underglaze cobalt blue outlines colored in with red, yellow, and green overglaze enamels. In the well of each dish, bordered by a circular double outline in underglaze blue, this design was composed into a somewhat stiff, naively drawn pondscape, seen from above, with the lotuses and water weeds very large in scale compared with the ducks. The same motifs appear around the outside

of each dish, but here there was no attempt to organize them into a scene; they march around the cavetto in strict alternation, at eye level, the richness of the coloring emphasizing a certain resemblance to heraldic blazons.

Since mandarin ducks mate for life, since the Chinese character for lotus (*lian*) is homophonous with other characters meaning "to connect" and "to love," and since lotuses produce vast numbers of seeds, lotuses and ducks are frequently combined in Chinese applied arts to symbolize happy and fruitful marriage. It is not unlikely that these dishes were made to celebrate a marriage.

Encircling the inside rim is an inscription in Tibetan characters—further evidence for the often close connections in early and middle Ming between China and Tibet. The underglaze cobalt blue in which the characters were brushed is particularly vibrant, with a watery texture common to most Chenghua porcelains.

In the Sakya monastery, Tibet, is a bowl bearing the same *dou cai* design and a Xuande reign-mark (1426–1435), and apparently of the period. This would suggest that the *dou cai* technique, as well as this unusual design, originated as early as circa 1430. S.E.L.

327 🐿

DISH

Hongzhi mark and period (1488–1505)
Chinese
white porcelain with underglaze blue decoration and overglaze yellow enamel
diameter 26.4 (10¾)
references: Jenyns 1953, 66; Medley 1966, 42

National Palace Museum, Taipei

The spectacular decorative scheme on this dish was originated at the Jingdezhen potteries as early as the Xuande reign-era (1426–1435), continued popular during Chenghua (1465–1487), and was in great demand by the Imperial Household, as evidenced by its orders to the potteries, during the Hongzhi reign-era.

On the unfired white body the design was painted in cobalt blue before being clear-glazed and fired: inside, in the central roundel a vigorously drawn floral spray, possibly tree peony; around the cavetto evenly spaced fruiting sprigs of lichee, loquat(?), chestnut, and crabapple; evenly disposed around the outside wall of the dish are four identical floral scrolls, more stylized than those on the inside. Fine double lines encircle the rim inside and out, the central roundel, and the foot, setting off the motifs. The base is glazed and bears the Hongzhi reign-mark in underglaze blue.

In the Xuande period this type of design was probably rendered only in underglaze blue on white. But Chenghua and Hongzhi dishes of the type were painted with overglaze yellow enamel covering all but the blue motifs and the base, then fired a second time to fuse the enamel. Design and color combine to make these blue-and-yellow wares among the boldest imperial porcelains of the Ming dynasty. S.E.L.

328 🐿

TABLE SCREEN

Zhengde mark and period (1506–1522)
Chinese
white porcelain with underglaze blue decoration
height 45.8 (18)
references: Jenyns 1953, 98–105; Medley, 1963, #B687, 64

courtesy of the Percival David Foundation of Chinese Art, London

A single piece of porcelain forms this entire screen, though its base is designed to resemble the wooden mounting of a single-panel painted screen (J: *tsuitate*). In its center is a quotation from the Koran in Arabic script, set in a diamond-shaped cartouche with a double outline. Enclosing the diamond and touching it at its four corners is a double-outlined circle. A double line also traces the perimeter of the screen, which has cusped corners at the top echoing the cusps on the base. Cloud scrolls fill the spaces between the diamond and the circle, and floral scrolls the space between circle and perimeter. Save for a double-lined rectangle containing the six-character Zhengde reign-mark of the Ming dynasty, the lower edge of the screen is blank. Both inscriptions and all

the decoration are in underglaze cobalt blue. The back of the screen is unglazed.

The elegantly written Arabic text has been translated: "The words of [God] Almighty . . . and that the places of worship belong to God, so call on none along with God. And that when the servant of God (Sayyidua Muhammad) arose calling on Him they (the Jinn) were near to being too great an oppression for him. Say: I worship my Lord alone and associate none with Him" (*The Qur'an: Surat al Jinn* [LXXII] v. 18–20, trans. D. Cowan).

This highly unusual piece is one of the so-called Muhammadan wares—blue-and-white porcelains bearing inscriptions in Arabic or Persian against a background of distinctive, rather stiff scrolls outlined in dark blue and filled in with paler blue. Muhammadan wares, mostly accessories of the scholar's writing table, appeared during the Zhengde reign. They were produced for the Palace eunuchs, mostly Muslim, who by virtue of heavy influence over this emperor wielded vast power, corruptly, in the imperial administration. The Zhengde emperor himself was rumored to have converted to the Muslim faith, particularly after an edict late in his reign forbade the killing of pigs.

S.E.L.

329 🈂

DISH

probably Chenghua (1465–1487) or Hongzhi (1488–1505) reign
Chinese
porcelain with monochrome red (ji hong; sacrificial red) glaze
diameter 17 (6¾)
references: Brankston 1938; Hetherington 1948, 60–66, 75–78; Jenyns 1953, 52–56; Medley 1976, 211, 212; Cleveland 1990, nos. 44, 47

The Asia Society, New York,
Mr. and Mrs. John D. Rockefeller 3rd Collection

Cloaking this shallow dish is a deep and variable glaze ranging from blood red to cherry, with an "orange peel" texture resulting from many tiny

suspended bubbles. In shape this dish resembles a yellow-glazed dish in the Millikin Collection at the Cleveland Museum of Art, which bears a genuine Chenghua reign-mark; it is also like the one illustrated by Brankston (Brankston 1938, 86, table IVf) and ascribed by him to the Hongzhi reign.

The hue is remarkably like that of certain rare Xuande (1426–1435) porcelains, such as the reign-marked dish in the Cleveland Museum of Art. Copper oxide, fired in a reducing kiln, produces this red, which on porcelains of Ming date is called *ji hong* or *you li hong*. Before firing, a clear, untinted glaze was applied over the copper-charged glaze. Where this clear glaze ran down from the rim, leaving the copper glaze exposed during firing, the copper volatilized, and the white porcelain body color shows through.

Except for a few accidental or exceedingly crude examples, copper red first appeared in the ceramic decorator's palette during the Mongol Yuan dynasty (1279–1368). Yuan potters attempted to create underglaze red-and-white wares with the same decorative vocabulary as the more common underglaze blue-and-white wares, but found the underglaze red very difficult to control, particularly on larger pieces and on those with elaborate decoration. Most often such pieces emerged from the kiln with the red turned to gray, silver, even black, and often rather thin and "bleeding" in appearance. Small monochrome-glazed bowls and stem cups fared better, and this miniature mastery continued into early Ming, especially the Xuande period, and (as in this example) even to the end of the fifteenth century. Among Ming ceramics, however, copper reds are rare, because the potters had still not entirely mastered the high temperatures (exceeding 1500° C.) and carefully controlled reducing atmosphere necessary in the kiln. In the sixteenth century the underglaze red technique was abandoned in favor of the more easily controlled overglaze red enamels and was not attempted again until the seventeenth century.

The direct descendants of the early Ming copper reds are the technologically masterful productions of the imperial kilns at Jingdezhen, Jiangxi Province, during the Qing dynasty, especially the reign-era of the Kangxi emperor (1662–1722). The "oxblood" (*lang yao*) and peachbloom glazes of that time are justly famous for their range and brilliance of hues.

The precise use of the Ming red-glazed ceramics is not known, but their shapes—almost exclusively dishes, stem cups, and bowls—suggest luxury food services and small altar vessels.

S.E.L.

330 🈂

MEI-PING VASE

late 15th century
Chinese
white porcelaneous ware with fa hua decoration
height 36.8 (14½)
references: Jenyns 1953, 75–76; Medley 1976, 207–208

The Cleveland Museum of Art, Bequest of John L. Severance

Clearly outside the rarefied and intellectual realm of Imperial blue-and-white or monochrome porcelains is the vividly colored group of wares exemplified by this handsome *mei-ping* (plum-blossom vase). This decorative mode is called *fa hua*, a term that, as written by most Chinese authors, means "French" (or "Frankish") decoration. *Fa hua* ware falls within the more general classification of porcelain or porcelaneous ceramics clad in low-fired glazes applied over the biscuit (fired body). *Fa hua* wares are clearly distinguished by designs outlined in raised threads of slip and colored in a palette of deep aubergine, cobalt blue, turquoise, and yellow glazes, and white (in reserve). The technique, palette, and style of decoration resemble cloisonné enameling on metal, a medium associated with the Frankish countries as early as the Yuan dynasty (1279–

1368) and popular during the Ming and Qing dynasties. In this piece the lotus blossoms have been reserved in white under clear glaze, with the remainder of the design pale blue and yellow against a dark blue background.

Fa hua wares bear no reign-marks, but the author believes those with high-fired white porcelain bodies to be earlier than those with lower-fired, less homogeneous bodies. The high- and low-fired pieces employ the same cloisonné technique but are differentiated by size and shape. The presumably early, higher-fired porcelains are usually of substantial size and occur in shapes popular for Yuan and early Ming blue-and-white—the *mei-ping* vase and the *guan* jar. The lower-fired, ostensibly later pieces consist mainly of small vases and bowls related in shape to other late Ming and early Qing wares. On these pieces, because the firing temperature was too low, the glaze tends to be cracked and crazed, a flaw not usually found among the high-fired earlier examples.

The Cleveland *mei-ping* is one of a moderate number of remarkably similar pieces, all characterized by the "early" *mei-ping* shape, a hard white porcelain body flecked with iron impurities, and a decorative vocabulary of hanging cloud-collar motifs on the shoulders, a frieze of lotus on the body, and "rising gadroons" above the foot. All these motifs were in common use between 1350 and 1500. The precise use of these *mei-ping* is not known, but their decoration and color strongly suggest flower vases or perhaps decorative objects in their own right. Similar but not identical shapes may well have been wine bottles.

The rich and bold effect of *fa hua* designs pleased Western collectors of the late nineteenth and early twentieth centuries, and *fa hua* ware, rather than (or in addition to) Japanese design, may well have influenced Art Nouveau and Art Deco ceramics. Thereafter *fa hua* fell from popular grace in the West, but recent years have seen a clear revival of interest in the earlier, more striking shapes. Certainly *fa hua* colors and designs fit Western criteria for the decorative arts. They may also reflect the bold and "vulgar" pictorial qualities of Ming court and academic painting of the fifteenth century. S.E.L.

331 ❧

TWO-HANDLED *PAN* BASIN

second half of 15th century
Chinese
gilt bronze with cloisonné enamels
diameter 34.9 (13¾)
references: London 1958, 47–49, no. 303, pl. 81;
Feddersen 1961; Garner 1962; Jenyns and Watson
1980, 106, 113; New York 1989, 102, nos. 24, 27

Musée des Arts Décoratifs, Paris

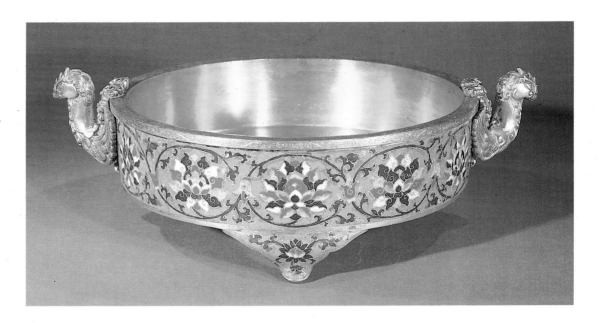

Although some evidence exists for enameling on metal in East Asia before the fourteenth century, there is little doubt that the Mongol Yuan dynasty (1279–1368), extending from China across Central Asia to Byzantium and into Europe, was the conduit through which cloisonné enamels and enameling were introduced into China. The necessary techniques were already known to the Chinese, having been developed to a very high level during the course of China's already three-thousand-year-old glazed ceramic tradition. Relatively low temperatures were required for enameling on metal, easily within the reach of Chinese technology. By the Xuande reign-era (1426–1435) reign-marked enameled bronzes were being produced by accomplished means wedded to a subtle and varied decorative tradition, especially that of the now dominant underglaze blue-and-white porcelains.

This *pan* basin is an unusual shape for so early a date. Its peony-scroll (*not* lotus) arabesque design occurs on numerous blue-and-white bowls of the Yongle (1403–1425) and Xuande reign-eras. The *pan* shape is archaistic: bronze *pan* originated in the Anyang period (13th century B.C.–1045 B.C.) of the Shang dynasty and were respectfully reiterated in bronzes and ceramics of later dynasties, especially from Song (960–1279) times on.

Many of the early Ming cloisonnés echo archaic bronze shapes: *gui* basins, *gu* beakers, and *ding* tripods may well have been used as altar offering vessels, but, being relatively small, seem more suitable to less formal, more domestic contexts. During later Ming large cloisonné vessels were common and conspicuous altar furnishings in important Buddhist temples, including imperial temples, in the form of beakers for liquid, containers for food offerings, lamps, candle-holders, and censers.

Technically the fifteenth-century works display a sound and forthright manufacture. The bronze bodies are heavy, the gilding is thick and deep-hued, and the enamel colors, principally red, pink, yellow and two different blues, are translucent and rich. The flowers and arabesque are natural and flowing, echoing the same elements in blue-and-white porcelain. On the present basin the winged-lion handles are particularly fine, heavily gilded and cast separately. The arabesque incised around the rim is also notable. Incidentally, the suggestion of Brinker and Lutz (New York 1989, 102) that the cloisonnés imitate *fa hua* porcelains (see cat. 330), reverses the relationship of the two wares. *Fa hua* ceramics do not seem to antedate the Xuande reign-era, nor are there pre-Ming precedents for the cloison technique in ceramics. It seems far more likely that the porcelain makers imitated the metal workers, changing their palette and adapting the cloison relief technique to porcelains. S.E.L.

332 ❧

LI DING TRIPOD

second half of the 15th century
Chinese
gilt bronze with cloisonné enamels
diameter at mouth 19.6 (7¾)
reference: New York 1989, nos. 31, 32, 34, 35

National Palace Museum, Taipei

The *li ding*, a trilobed container whose bulbous lobes narrow to form hollow feet, is one of the oldest vessel shapes in Chinese history. Ceramic prototypes exist from at least the third millennium B.C., bronze vessels of the type from at least 1600 B.C., found at the early Shang dynasty site of Zhengzhou. Like all ancient bronzes, including

the *gui, li ding* of Shang (trad. 1766–1045 B.C.) and Zhou (1045–256 B.C.) date served as ritual vessels and emblems of authority. It was only natural that the Chinese, profoundly historical-minded and revering precedent, should repeat the traditional shapes and treasure their historic resonance in later ceramics and jades and, after 1400, in cloisonné.

But the ancient Shang decorative repertory of "ogre masks" (*taotie*), "thunder patterns" (*leiwen*), and various birds and beasts, though it continued to be employed in later dynasties on archaistic bronzes (including some cloisonnés), gave way on most cloisonné vessels to the flora and fauna and spirited dragons found on the ubiquitous underglaze blue-and-white porcelains.

Precedents for the grapevine motif on this *li ding* are found on vessels as early as the late Six Dynasties period (A.D. 222–589), and grapevines were much used on metalwork of the Tang dynasty (A.D. 618–907). Thereafter they fell into desuetude until the early fifteenth century, when the grape and vine reappeared on rather splendid large white porcelain dishes with underglaze blue decoration. The luscious decorative effect of the design may seem to some traditionalists incongruous with the gravity of the ancient shape. But the combination of motif and medium must have appealed to some scholar-officials, for cloisonné grapevines appear on a brush holder and a seal box in the Uldry collection in Zurich. A *li ding* from the same collection is similar to the present vessel but has lost its gilding and lacks the engraved design of repeating "thunder pattern" around the rim. S.E.L.

333 ᗧᕯ

MEI-PING VASE WITH LOTUS DECORATION

c. 1500
Chinese
gilt copper and cloisonné enamel
height 52.1 (20½)
references: Jenyns and Watson 1980, 105–114, 134, 135; New York 1989, 102, no. 41

Musée des Arts Decoratifs, Paris

Although the *mei-ping* shape is rare in cloisonné enamel, it was often produced in glazed porcelains by the master potters of the Jingdezhen area in Jiangxi Province (cat. 330). The shape, literally "prunus vase," was particularly favored during the Northern Song dynasty (960–1127), but remained a standard vase form until modern times. The body of this vase is decorated with lotus blossoms, buds, and leaves, supplemented by peony and mallow motifs. In the shoulder and neck registers are aquatic flora, and encircling the base are rising leaf forms, which on later vessels became abstracted into "gadroons." S.E.L.

334 ᗧᕯ

PLATE
by Wang He

dated to 1489
Chinese
carved polychrome lacquer (ti cai)
diameter 18.8 (7⅜)
inscribed (over door): second year of Hongzhi [1489]; signed (on door jamb): Wang He
references: London 1958, 39, 73, pl. 66; Ch'en 1966, 62–66; Riddell 1979, 208; Jenyns and Watson 1980, 214

The Trustees of the British Museum, London

Technically and historically this dish is one of the most important of all carved lacquers of the Ming dynasty. Technically primitive carved lacquers have survived from as early as about 1200 B.C. (during the Anyang period of the Shang dynasty), but the earliest known complex and accomplished pieces are rectangular sutra containers decorated with Buddhist motifs. These were excavated from the Rui'an pagoda, not far from Hangzhou in northern Zhejiang Province, which is dated to A.D. 1043. Other carved lacquers in various collections are attributed to the Song dynasty (960–1279), but without full documentation. By the Yuan dynasty (1279–1368) artisans had certainly mastered the technique; surviving works of that time are fully developed, technically and aesthetically. Examples include boxes excavated from the Ren family tombs near Shanghai, dated to 1351.

This dish seems to be the earliest known example of carved polychrome lacquer. It is, moreover, a tour de force of carving, in which three different colored layers of lacquer were made to yield a highly detailed and complex pictorial representation. The technique, in brief, was as follows: the sap of the lac tree (*Rhus vernicifera*, C: *qi shu*), refined and pigmented, was applied in many thin coats over a wood or cloth base, each coat being allowed to dry before the next was added. For carved polychrome lacquers, such as this one, the colors were laid on in layers, each layer composed of several coats of that color. More than one layer of each color might be applied, so that each color could show up at various depths in the design. When the final coat of lacquer had dried, the carver created the design by cutting each element down to its predetermined color and depth. The technique is vastly time consuming, the lacquer is toxic, but the results are aesthetically unique. In addition, lacquer is highly resistant to liquids, even to some acids. The art was in its heyday probably from 1350 to 1550, and marked pieces made for the Yongle (r. 1402–1424) and Xuande (r. 1425–1435) emperors are much sought after. Signed pieces are reasonably common, though famous artisans' names are often forged.

The elegant and detailed carving on this dish depicts in cinnabar red, yellow, and green one of

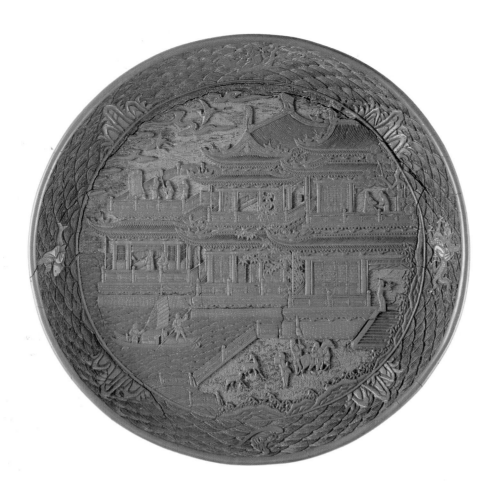

tal, floating in a small skiff; and the Immortal Qin Gao, who toured the world's oceans on the back of a giant magic carp.

The bracketing and tiling of the buildings are meticulously rendered, but the wealth of detail is controlled and dominated by the overall design of large units disposed within the circular frame.

<div style="text-align: right;">S.E.L.</div>

335 ❧

TABLE SCREEN
by Wang Yang (?)

Hongzhi reign (1488–1505)
Chinese
carved cinnabar lacquer (ti hong)
height 44.7 (17⁵⁄₈)
reference: Tokyo 1977

Tokyo National Museum

the most famous subjects of the gentleman-scholar (*wen ren*) tradition—the drinking-cum-poetry party at the Lan Ting (Orchid Pavilion). In April of A.D. 353 Wang Xizhi (303?–361?), the patriarch of Chinese calligraphy, received forty-one friends and relations at the Orchid Pavilion, situated in Zhejiang Province near Shaoxing, a city famous for its wine. When the wine had been drunk and the poems composed, Wang Xizhi compiled them into a handscroll and supplied a preface, the *Lan Ting Xu*, which became the most famous of all Chinese calligraphies.

This essay on life and history, produced in a state of physical and spiritual intoxication, was recognized by all as a work of inspired calligraphy, and its subsequent history of theft and loss, true or untrue, became a prime legend for the scholarly class. For the *wen ren*, the *Lan Ting Preface* surpasses in significance any comparable text in the whole history of China. The dish itself confirms the importance of this text by offering a fifty-six–character excerpt from the essay in a large square at the center of the underside, framed by arabesques of the *lingzhi* fungus, symbolic of

immortality. Around the rim of the underside auspicious dragons and phoenixes alternate with four cartouches, two containing pairs of scholars greeting each other and two showing a single scholar with an attendant or acolyte.

On the obverse of the dish we see the Orchid Pavilion with the guests gathering, beneath a sky full of clouds and cranes, the birds preeminently associated with scholars and immortality. Guests watch, talk, or take refreshments in various rooms of the three main wings of the pavilion. Two parties are arriving, one on horseback on the terrace, accompanied by domesticated deer (also associated with immortality), the other by boat. Around the rim flows a conventionalized sea of "fish scale" waves, out of which rise the triple-peaked Islands of the Immortals. These are repeated four times, evenly spaced, alternating with four figures of Immortals or wonder-workers. Clockwise from the top these appear to be: the explorer Zhang Qian (cat. 342, 343) in his log-boat from which hangs a double-gourd; a figure astride a dragon who may be the legendary emperor Fu Xi; another male figure, presumably a Daoist Immor-

In its original format this small screen undoubtedly had cusped top corners and two braces along the bottom edge that allowed it to stand vertically on desk or table. The multi-storied pavilion scene is elaborate but organized with a clear accommodation to the rectangular format. Although even more complex than Catalogue 334, it is not quite so convincing in detail, and the single color limits the possibilities for suggestion of depth.

The scene may be nocturnal; a servant girl at the lower left holds what may be a light or a censer. The welcoming entourage of ladies on the path at the lower edge recalls Southern Song fan paintings by the Ma family and others, celebrating the pleasure houses and barges of beautiful Hangzhou. The substantial buildings are surrounded by gardens and stone walls, the latter with reliefs of running *long-ma* (?) or some comparable dragon-headed, four-footed mythical animal. The lone guest proceeds to the left in procession with the servants. An empty chair and two servants await him just inside the entrance to the left, should his progress have overtired him. The host and perhaps one other guest wait on the second floor.

The ambience is all that the gentleman-scholar (*wen ren*) could desire. In the garden bamboo, plantain, pine, *wutong* (*Firmiana simplex*, sometimes called phoenix tree), and willow abound, along with the inevitable garden rock on its stone or bronze pedestal. Above (and thus, according to Chinese perspective, in the distance) are small, writhing clouds on a fine-textured cloud background. Distant mountains in "comb-tooth" shapes rise above the clouds. The most distant roof, for it is only that, is puzzling. At the crossing of its two wings is a finial resembling a Buddhist "precious jewel of the Law," but below there is no supporting structure. Is the base lost in the mist? Or is this an apparition, a holy and magical temple? S.E.L.

336 ᘓ

PLATE WITH PHOENIX AND DRAGON DESIGN

dated to 1522
Chinese
yellow and red carved lacquer (ti cai)
diameter 21.1 (8¼)
references: Schafer 1969, 110–114; Garner 1979

National Palace Museum, Taipei

On this most unusual piece of Ming carved lacquer, yellow has replaced the customary cinnabar red as the dominant color in a complex and intricately detailed design. The red background of the central design was divided between a geometric crisscross pattern representing sky or clouds and a "fish-scale" pattern representing water. In the

outer band of decoration four long panels feature yellow peony-scrolls against a dark red-brown plain background; between these panels are four symbols in yellow against a background of yellow intersecting circles on a red ground; the four symbols are: below, books for scholarship and protection; to the right, a coin for wealth and material success; to the left, a pair of rhinoceros-horn beakers for luck and the strong character of a scholar; and above, a parasol (?) for majesty. The strong central design shows a writhing five-clawed dragon and a phoenix (*feng-huang*) in flight. The dragon is the emblem of the emperor, represents the eastern direction and the season of spring, and lives in a vaporous, watery atmosphere embodying the masculine principle (*yang*). The phoenix's abode is in the south, and this magical bird contains the Five Cardinal Virtues, is the emblem of the empress, and embodies peace and the feminine principle (*yin*). Dragon and phoenix both pursue a flaming pearl at the center of the design, representing purity and the heart of the Buddha. Below the two are carved yellow waves lapping at the three Mountain-Isles of the Immortals in the Eastern Sea, the legendary home of Daoist spirits and source of the elixir of life. The only purely decorative element is the peony arabesque filling the panels, and even here a scent of symbolism remains, for the peony represents spring, wealth, and honor, and is empress among flowers.

The remarkable appearance and concentrated symbolism of the plate suggest a particular imperial commission; the date, 1522, the first year of the Jiajing reign-era, strengthens the suggestion. Perhaps the symbolism of the plate reflects the emperor's particular devotion to Daoist longevity magic, even in his youth (he ascended the throne at fifteen in 1521). So severely did the Jiajing emperor's devotion to Daoism distort his rule and deplete the imperial treasury that in the second year of his reign (1523) Grand Secretary Yang Tinghe (1459–1529) advised him not to take part in Daoist services. S.E.L.

337 ᘓ

BRUSH WASHER

15th century
Chinese
green jade with reddish brown markings
height 5.8 (2½), length 16.0 (6¼), width 12.3 (4⅞)

Hong Kong Museum of Art, Urban Council

All surfaces of this rectangular basin are carved, including the base, where swirling currents and breaking waves establish the conceptual foundation for the rest of the decoration. Three dragons emerge from those watery depths and climb exterior walls carved deeply with cloud formations to peer into the more oval interior, which is more lightly incised with clouds. Dragons have both seasonal and directional implications. Following their winter hibernation they rise from the eastern ocean to the heavens, where they begin the spring rains and sport with pearls (one of which appears at the right front corner), causing the thunder which accompanies the rainfall.

Potters, metalworkers, and painters of the thirteenth and fourteenth centuries all adopted and advanced the theme of dragons amidst waves and clouds, and James Watt has noted a Yuan dynasty (1279–1368) jade carving that is immediately precedent to the present piece: a black jade wine bowl over four feet in diameter carved with dragons and waves on its exterior surfaces. Close ceramic parallels to the design here can be found on the large globular "moon flasks" of the Yongle (1403–1425) and Xuande (1426–1435) reign-eras, which is also the period during which imperial workshops are known to have produced jades for use at court. Although this brush washer is not marked or inscribed, its magnificent design and superb execution indicate that it was intended for a client of exceedingly high status. H.R.

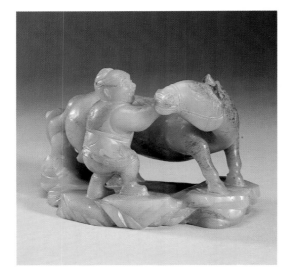

338

Man Grooming a Horse

14th–16th century
Chinese
light green jade with brown markings
height 9.5 (3¾), length 15 (6)

Asian Art Museum of San Francisco, The Avery
Brundage Collection

A squat but powerful groom in belted tunic and boots stands poised on an uneven rocky outcropping with his charge, a stocky Mongolian pony with short legs, thick body, and halter round his massive head. Their proximity to each other and the similarity of their expressions — the groom grinning, the horse turning to look at him with lips similarly drawn back — implies a close relationship between the two. Fine striations texture the tail and mane of the horse, and a patterned roundel decorates the back of the groom's tunic.

Comparable figure groups had appeared much earlier in painting and in ceramic sculpture, but the lighter mood and naturalism of this pair seem to have become common only toward the end of the Song dynasty (960–1279). Epochal changes in aesthetics and art theory occurred during the Yuan dynasty (1279–1368), making possible the greater expressiveness seen here, and that period too saw the use of roundels containing inscriptions in the Tibetan 'Phags pa script.

The present piece was clearly built on that late Song–Yuan stylistic foundation, and probably dates to the middle Ming period. Beautiful material, strong and skillful carving, and an interesting subject make this a most attractive object for display, a function for which the sculpted base was well designed. Possibly the groom, roundel, smiling face, and horse compose an auspicious visual pun, or rebus, of the type discussed in Catalogue 341. H.R.

339

Zhi Hu Wine Ewer

16th century
Chinese
green jade with brown and black markings
height 25.1 (9⅞)
reference: Weng and Yang 1982, 262

Palace Museum, Beijing

From the narrow sides of the flattened, gourd-shaped body extend the handle and spout, whose lines suggest a rectilinear frame for the body even while their curving contours provide contrapuntal accents to the dominant rhythms of the body itself. An oval foot is echoed in smaller scale by the mouth rim, which is surmounted by a removable lid. The swelling, undecorated surfaces of the piece set off by contrast the main areas of decoration: peach-shaped cartouches on the broad sides, each containing four figures, and, perched on the lid, three-dimensional figures of a sheep and a bearded old man.

The bald pate of this figure, plus the mushroom of immortality (*lingzhi*) held by his animal companion, identify him as the God of Longevity, who lives at the South Pole in a palace whose garden grows the aromatic and exotic herbs that contribute to long life. The peach-shaped medallions below are further references to him, for the peaches of immortality, which originated in the gardens of the Queen Mother of the West, are among the god's standard attributes. In like fashion the eight figures within the two medallions are the special group of Daoist saints known as the Eight Immortals. Individually identifiable by characteristic attributes, these transcendants are gathered here in joint celebration with the god above.

This iconography was held particularly appropriate for men's birthdays — women celebrated with the all-powerful Queen Mother at their head — and more specific anniversary wishes are indicated by the characters *jiu ru* appearing on the scroll held by the Immortal of the Southern Pole on the lid. Literally meaning the "nine similitudes," the allusion, according to Wan-go Weng, "is to a song dating to the first half of the first millennium B.C. in which listeners are offered health and happiness, and compared in turn to ageless mountains and mounds, ridges and hills, the swelling of a new stream, the constancy of the moon, the rising of the sun, the indestructibility of South Mountain, and the luxuriance of pines and cypresses." Since *yang* meaning "sheep" is homophonous with *yang* meaning "to look up respectfully," the whole forms a pictorial rebus for the phrase "the Eight Immortals offer up wishes for longevity."

The Eight Immortals figure prominently in art from the Yuan dynasty (1279–1368) onward, and

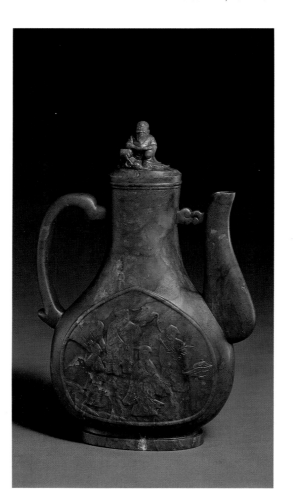

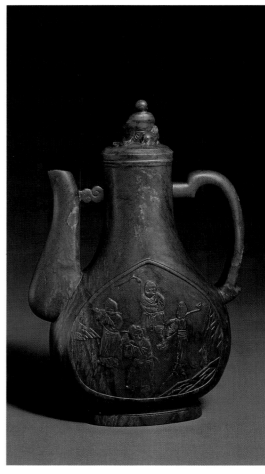

ceramic ewers in shapes comparable to the present one were produced at the imperial kilns by the early fifteenth century. It was, however, during the Jiajing reign-era (1522–1566) that Daoist iconography became all-pervasive, just as Daoism itself permeated all levels of contemporaneous society. This vessel, whose color approximates the patina on antique bronzes, appears to date no earlier than the Jiajing reign-era. When used to pour warmed wine at a celebration, the ewer would have contributed—not only functionally but symbolically and aesthetically—to the pleasure of the guests. H.R.

340 ᘓ

CYLINDRICAL CUP

late 16th-17th century
Chinese
white jade with brown markings
height 8.4 (3¼), outer diameter 6.7 (2⅝)
reference: New York 1980, 106

Quincy Chuang, Hong Kong

The simple cylindrical form, supported by three feet carved with animal masks, has been incised with profuse and complex decoration. On the ring handle with curved thumb-rest is a *taotie* animal mask, on the underside of the cup a horned dragon strides among clouds. In the central and widest decorative frieze on the body are zoomorphic motifs in low relief: a frontal animal mask bisected by the handle, and two mythical creatures set against a key fret pattern called *leiwen* (thunder pattern). Above and below this central band are borders filled with interlocking horizontal C-shapes. The creatures, one with phoenix head, the other perhaps a dragon, are both heraldically rampant; behind winged shoulders their bodies continue as rectilinear abstract designs that

suggest but do not describe their hindquarters and tails.

Almost all of these elements have much earlier prototypes, beginning with the shape of the cup itself, which appeared in both jade and lacquer about the third century B.C. Shang dynasty (trad. 1766–1045 B.C.) bronze workers pioneered the use of a *leiwen* background, and bronzes of the Zhou (1045–256 B.C.), and Han (206 B.C.–A.D. 220) dynasties reveal comparable abstraction of animal bodies and decorative use of *taotie* masks. The insistent archaism here represents an important trend in Ming dynasty jade carving—a trend which began with excavations of antique bronzes and jades during the Song dynasty (960–1279), and which was propagated from the eleventh century onward by publications, often illustrated, about these ancient treasures. The present example, however, does not simply replicate earlier designs but rather displays a knowing and exceedingly sophisticated manipulation of them, a general characteristic of the later Ming period, when scholarly interest in and appreciation of the past was at its height.

One of the most celebrated of the Suzhou craftsmen who catered to that antiquarian taste was Lu Zigang, active mainly during the second half of the sixteenth century. James Watt has noted that the present cup is very similar to two other cups, both of which have lids—presumably lost in this case—and also incised signatures of Lu Zigang. This cup may thus be dated to the late sixteenth–seventeenth century, when jade workshops abounded on Zhuanzhu Street in Suzhou, and it was boasted that "although the good jade is found in the capital, it's Suzhou for the good workmen." H.R.

341 ᘓ

THREE BOYS WITH LARGE JAR

16th century
Chinese
gray-green jade with brown markings
height 8.3 (3¼)

Asian Art Museum of San Francisco, The Avery Brundage Collection

Three nicely dressed lads, their eyes tightly closed, encircle a large storage jar (*guan*) and hold, respectively, a mouth organ (*sheng*), a scepter (*ruyi*), and a lotus (*lian*). The jar too is decorated, with a frieze of so-called lotus petals around its base and a border of *ruyi* lappets around its mouth rim. René-Yvon d'Argencé has suggested that the decoration and shape of the jar indicate a date within the Jiajing reign-era (1522–1566), a period during which children at play were a common

decorative theme on blue-and-white wares as well as enameled porcelains.

Given that their language is highly homophonous, it is natural that the Chinese have long enjoyed verbal puns. During the Ming they became increasingly fond of visual or pictorial puns, or rebuses, in which a word or phrase is indicated by objects whose names are similarly pronounced. For example, a monkey on a horse together with a bee is a rebus for the auspicious wish "May you immediately be enfeoffed as a marquis."

Here the key symbols are the lotus, the mouth organ, the jar, and the scepter. This last embodies in its name the idea "according to your wish," while its form resembles the mushroom of immortality (*lingzhi*), which connotes long life. The musical instrument *sheng*, consisting of varying lengths of bamboo pipes, is homophonous with two other characters pronounced *sheng*, one meaning "to rise in rank" and the other "to give birth to." The lotus has two names, *lian* and *he*; the first of these is homophonous with the character *lian* meaning "continuously," the second with the character *he* that denotes "peace and concord." *Guan* (storage jar) is also the pronunciation of the character meaning "official" as well as another meaning "string of cash." Obviously this sculpture has a wide range of connotations, all auspicious, and generally susceptible of the following benevolent summary: "May your many sons live long in peace and rise continuously in rank and status." That such matters rest primarily with fate may be the intended meaning of the shuttered eyes, which seem to increase the dependence of the children on their auspicious accouterments. H.R.

342 🐌

BOAT-SHAPED WINE CUP

15th–17th century
Chinese Ming period
gray-green jade with dark markings
length 10.8 (4¼)

Asian Art Museum of San Francisco, The Avery
Brundage Collection

A bearded old gentleman wearing scholar's robe and cap is conveyed within a hollowed log through water indicated by lotus blossoms and waves below; a gourd, hanging here from the rear of the boat, and a book are other characterizing attributes of the figure. For drinking, the cup was easily grasped by the protrusion at the rear. Its smooth yet richly tactile surface would have yielded additional pleasure as the cup was hoisted, just as the warm tones of the jade would have enhanced the natural color of the warm wine.

Boat-shaped wine cups made from a variety of materials seem to have been particularly popular from about the fourteenth through the seventeenth century. Those made by the famous silversmith Zhu Huayu (also known as Zhu Bishan, c. 1300–c. 1362 or after) bear dates ranging from 1345 to 1362, as well as poetic inscriptions which confirm their function: "Li Bo was crazy after one hundred cups, and old Liu Ling was always besotted; only when you know the pleasure of wine will you leave behind a good name." The poem by Du Ben (1276–1350) translated above, which was cast onto a cup made by Zhu in 1345, must have been inspired by the desire to claim kinship—at least during one evening's pleasure—with such "immortals of the wine cup" as Li Bo (701–762) and Liu Ling (3rd century). Yu Ji and Jiexi Si (1274–1344), scholar-officials who were Du Ben's contemporaries, likewise wrote inscriptions for and about Zhu's fabulous cups.

The precise identity of the figure and the full meaning of the boat are still uncertain because the evidence itself is ambiguous. Wai-kam Ho has

noted Yuan dynasty (1279–1368) references to "two well-known [Daoist] Immortals traveling separately to the fairy islands in a lotus boat and a raft in the form of a hollow tree stump." Tai Yi Zhen Ren (Great Monad Daoist), as the latter was called, was credited with many attributes and powers, but most pertinent here is his manifestation as spirit of the pole star, basic to navigation. Robert Mowry has called attention to a Yuan period wine-storage jar with painted decoration of a scholarly figure floating in a hollow log; hanging from a branch is a gourd (a Daoist emblem), and in the sky above appears a dipper-shaped constellation orientated with reference to the figure below. Other Yuan ceramics, especially Cizhou painted pillows, feature scenes with offering tables below and constellations above, a meaningful juxtaposition, since official offerings were made to Tai Yi throughout the Yuan and into the Ming period.

The boat in turn is no ordinary river conveyance but rather a sky boat which carried Daoist transcendants from either the ocean in the east or the source of the Yellow River in the west into the Sky River, or Milky Way. Even before the Tang dynasty (618–907) that identification was supported by identifying the figure as Zhang Qian (160–114 B.C.), army officer and explorer extraordinaire, who in the second century B.C. introduced into China from Ferghana the grapevine, alfalfa, and the prized "blood-sweating" horses. By Ming times the historical Zhang Qian had been thoroughly barnacled with legendary achievements like sailing the Sky River and was, in the Ming imagination, both explorer and wonder-worker. In one version of the tale Zhang's stellar destination was identified for him by the Daoist wonder-worker Dongfang Shuo (154–93 B.C.), who was held to have been an incarnation of the planet Venus, just as Li Bo would be many centuries later.

Why these partially overlapping identities and meanings should have been merged during the Yuan dynasty and been given visual form in the silver wine cups of Zhu Huayu is another perplexing question. Certain it is, however, that scholars at court had Zhang Qian's explorations very much in mind. In 1342 a magnificent horse arrived in Beijing from a Western country identified in dynastic records as Fulang, a name derived by the Chinese from the Persian *farang* and used to designate in general terms the European nations descendant from the Franks. Court records explicitly compare the Fulang steed with those brought to China a millennium and a half before by Zhang Qian.

European records show that the horse was shipped from Genoa on behalf of Pope Benedict XII, then in exile in Avignon in France. A close variant of the name Fulang occurs in the *Ge Gu Yao Lun* (Essential Criteria for Judging Antiques), written by Cao Zhao in 1387, in the course of the earliest Chinese account of cloisonné; Cao Zhao

noted the resemblance of Arabian cloisonné (*Da-shi yao*) to the inlay or champlevé enamels of "Folang." Recorded examples of cloisonné bearing reign-marks of the Zhiyuan (1335–1341) and Zhizheng (1341–1367) eras raise the possibility that some of the techniques of enameling were introduced by a tribute mission from Europe, which may have sparked on its return the visual and conceptual ideas that resulted in the startlingly innovative landscape setting for the "Good Government" frescoes commissioned of Ambrogio Lorenzetti in 1339 for the Palazzo Pubblico in Siena, an important enameling center in the fourteenth century.

While the enamels were disdained by such conservative critics as Cao Zhao, the horse was received with great wonder and enthusiasm. On the arrival of the auspicious steed such court artists as Zhou Lang, Chen Sheng, and Zhang Yanfu were commanded to paint the "heavenly horse," and many officials, including Yu Ji and Jiexi Si, wrote poems and inscriptions to commemorate the occasion. Most germane to our account among the painters was Zhang Yanfu, who was not only a friend of Du Ben, author of the poem on the silver boat-cup, but also an important priest of the Daoist Tai Yi Temple in Beijing.

These connections and interrelationships encourage speculation that the iconography of the boat-shaped wine cups was invented by that group of Daoists and scholars active in the capital during the late Yuan dynasty, and that it was they who commissioned the silver vessels from Zhu Huayu. These in turn served as models for later cups in other materials, such as the present example. We may be sure, however, that the obscure and seemingly arcane iconography of this drinking cup did nothing to diminish the pleasure of its users in its visual and tactile delights. Quite the contrary.

H.R.

343 🐌

BOAT-SHAPED WINE CUP
by Bao Tiancheng
active late 16th-17th century

late 16th century
Chinese
carved rhinoceros horn
height 9.7 (3⅞), length 25.5 (10)
signed: Bao Tiancheng
reference: Chapman 1982, 101–105

Museum of Art and History, Shanghai

Extant bronzes and jades in rhinoceros form show that the imposing creature was already known in China in the eleventh century B.C. Its seemingly impenetrable hide was valued early on for shields

and armor, and the horn eventually came to be used as a drinking vessel, one possessing prophylactic powers as well as the miraculous ability to reveal the presence of poison in the drink. And when the horn acquired further reputation as an aphrodisiac, the great and continuing popularity of such drinking cups was assured. The Shōsō-in in Nara, Japan, still preserves eighth-century examples of rhinoceros-horn cups, as well as plaques, girdles, ornamental pendants, scepters, rulers, and knife handles and sheaths made from the same material. Rhinoceros-horn cups bearing reign-era dates of the Song (960–1279), Yuan (1279–1368), and early Ming dynasties are not unknown, but it was from the middle Ming, or sixteenth century, onward that they flourished in general popularity.

The present example was first molded and then beautifully carved in the form of a hollowed-out log, festooned with vines and serving as a boat for the bearded scholar who reclines within an arbor of flowering branches. Despite the complex origins of the iconography (see cat. 342), by the late Ming period virtually everyone would have identified the subject as the intrepid traveler Zhang Qian of the second century B.C., in search of the source of the Yellow River.

Carved among the branches is the signature of Bao Tiancheng, a well-known carver from Suzhou. In addition to rhinoceros horn, Bao also worked in ivory and hardwoods; his carved incense sticks and containers, sandalwood boxes for scrolls, fan pendants, and hair and girdle ornaments were prized, and his skill was acclaimed as surpassing that of earlier craftsmen. Since Bao's work was well known to the Ming author Gao Lian (act. 1573–1581), he was probably active mainly during the later sixteenth century. H.R.

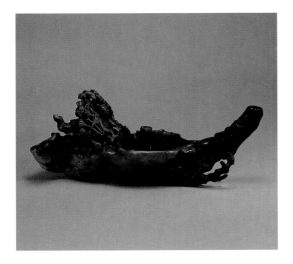

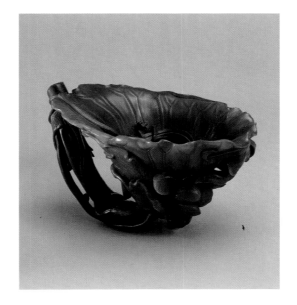

344 ❧

WINE CUP IN LOTUS FORM
by You Kan
active late 16th–17th century

late 16th century
Chinese
carved rhinoceros horn
height 9.5 (3¾), length 14.9 (5⅞),
width 11 (4⅜)
signed: You Kan
reference: Chapman 1982, 101–105

Museum of Art and History, Shanghai

The rhinoceros horn is not recalcitrant bone but rather a solidified mass of agglutinated hair, giving it a potential malleability that is evident in the form of this wine cup. The inner cavity, a natural depression shaped by a cranial protrusion of the animal's skull, was first bored through to the very tip. In a process described by Jan Chapman, the horn was then heated or immersed in water in order to soften it. Then the tip was bent upward, creating a stable base for the piece as well as a handle by which it could be grasped.

Sometimes described as a water dropper (for use in preparing liquid ink from an ink stick), this type of cup and also the boat-shaped cup (cat. 343) were clearly intended for display as well as use, and by late Ming times both types were high in literati esteem. The rhinoceros itself, despite its continuing reputation for irascibility and for dullness of sight and intellect, became an emblem of sound scholarly character, and the cups were associated with, and symbolic of, the prized status of gentleman-scholar.

Exquisitely carved details here include a praying mantis clinging to a lotus stalk on the interior of the cup, lotus blossoms complete with stamens and seed pods on the exterior, and organically intertwined stems on the handle—all in all a tour

de force of the carver's art. Toward the exterior base of the cup is carved in seal script (*zhuan shu*) the name of the artist, You Kan, whose signature appears on several other extant cups.

You Kan was almost certainly related to, and has been identified by some as identical with, a Suzhou carver active during the late seventeenth century and recorded as follows:

> He excelled in carving rhinoceros horn, ivory, jade, and gemstones into scholarly trifles, which in craftsmanship were the finest in the Wu district. When he was just a lad, a family relative owned a highly treasured rhinoceros-horn cup. You's father borrowed the cup and came home to enjoy it. It happened that there was a rhinoceros horn to hand, and You figured out how to make a copy of the other, exact as to form and style. The color being insufficiently glossy, You then pulped some balsam and dyed the copy as one would dye fingernails. There was then no difference at all between it and the original, and when he showed it to the relative, he too could not tell them apart. Thus it was that he came to be called "Rhinoceros-horn cup You." During the Kangxi era (1662–1722) You was summoned to enter the palace workshops...."

Although it is possible that this prodigy of carving was the You Kan who made the present cup, it also seems likely that only a professional in the trade would have had an uncarved rhino horn lying about the house for the boy to commandeer. If the carver of the present cup was the father of the boy described above, he would have been active during the late sixteenth–seventeenth century. H.R.

345 ❧

PAIR OF YOKE-BACK ARMCHAIRS

15th–early 16th century
Chinese
huanghuali (rosewood)
height 116.3 (45¾), width 56.4 (22¼),
depth 45.8 (18)
reference: Wang 1986, 15

Robert H. Ellsworth, New York

Of a type known as a *guan mao*, or "official's hat," armchair, because of the resemblance of its projecting ends to the profile of an official's hat, these particular chairs are characterized by an unusually tall back, gracefully curving S-shaped arms, a recessed seat in place of the original caning, and plain spandrels whose curves soften the otherwise rectilinear design. Spandrels and aprons are attached to the front surfaces of the two curving armrest supports, between the four legs beneath the seat, and beneath the foot rest,

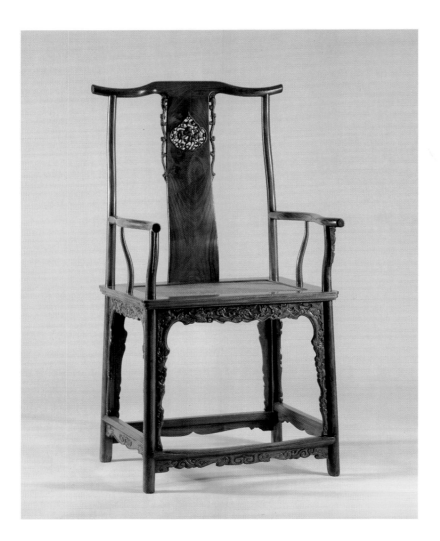

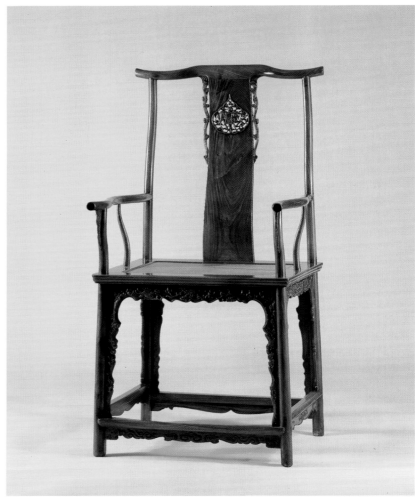

an amenity which raised the feet of the sitter off the cold stone floors of north China. Tongue-and-groove joins hold the one-piece aprons in place, wood-pinned mortise-and-tenon joins lock the thicker elements in place. As is usual, the back posts and legs of the chair were made of single, continuous pieces of wood to which the armrests, seat, and stretchers were attached.

From a single material, and using only a few elements in simple relationships, the craftsman fashioned a utilitarian piece of furniture whose aesthetic impact is yet strong and complex. First among the contributing factors is the *huanghuali* wood, from which a majority of fine Ming furniture pieces were made. Occurring in colors ranging from dark brown to light gold, and with a distinct and variable grain, this tropical hardwood is still to be found in Hainan and Southeast Asia.

The simple shapes from which this chair is formed are arranged in an upward taper so as to achieve an overall effect of stability. An alternating system of S-curves occurs in both the horizontal plane (top rail and armrests) and the vertical plane (back splat and armrest supports). This creates visual variety and a sense of movement, since each change in the observer's point of view reveals certain curves and conceals others.

The profile view is especially telling, for there one can see the perfect balance between the opposing curves of the posts and the splat. The balance, clarity, and harmony of this chair fully justify description of its style as classic, while the complex richness of its formal relations is sufficient to elevate it to the level of abstract, nonfigurative sculpture.

Given the preeminence of Suzhou's artists and craftsmen in nearly all areas of artistic endeavor by the middle of the Ming dynasty, it has long been assumed that fine furniture too was a specialty of that talent-rich region. Wang Shixiang has recently introduced literary evidence to suggest quite persuasively that the golden age of Chinese furniture began during the sixteenth century as a consequence of great urban prosperity coupled with the removal of legal restrictions on the free importation of the requisite hardwoods. And the late Ming writer Wang Shixing noted that this general phenomenon was especially marked in Suzhou:

> The people of Suzhou, being very clever and fond of antiques, were skilled at using old methods to make things . . . such as small treasures for the study, tables, and beds. Recently

they have liked to use *zitan* and *huali* [*huanghuali*] woods. They preferred plain to elaborately carved pieces; but if they used decoration it always followed the ancient patterns of the Shang, Zhou, Qin, and Han dynasties. This fashion spread all over China and was especially popular during the Jiajing, Longqing, and Wanli reigns (i.e., 1522–1619). H.R.

THRONE-LIKE ARMCHAIR

14th–16th century
Chinese
zitan *hardwood*
height 109 (42⅞), seat width 98 (38⅝), seat depth 78 (30¾)

Palace Museum, Beijing

Three pieces of *zitan*, the hardest, heaviest, and most prized of all the Chinese hardwoods, were used to make the sides and back of this thronelike armchair. The undecorated seat and waist are supported by a lower frame with continuous floor stretchers. Like most thrones, this chair has a matching footstool, lotus shaped. All surfaces save for the seat and waist are elaborately carved with lotus leaves, stalks, and blossoms, intertwined and overlapped as in nature itself.

Due largely to Buddhism, the lotus is of unique importance in Chinese thought. In the words of Wolfram Eberhard, "the lotus comes out of the mire but is not itself sullied; it is inwardly empty, outwardly upright; it has no branches but it smells sweet; it is the symbol of purity, and one of the eight Buddhist precious things." By extension, these carved emblems of ultimate rectitude became attributes of the exalted personage who was raised and supported by this chair.

Exactly when and how the chair came to be introduced into China remains obscure. It seems likely, however, that this occurred under the auspices of Buddhism, perhaps sometime late in the Tang dynasty (618–907). Even during the Ming dynasty chairs wide enough to sit in cross-legged were termed *chan yi*, "meditation chairs," and early pictorial representations of chairs do in fact depict monks with their legs drawn up in that posture. Another early term for the chair was *hu chuang*, "barbarian bed," presumably because it was believed that foreigners slept seated upright

on such contrivances. Portraits of various Song dynasty (960–1279) personages reveal that the chair came to be considered a symbol of status; abbots as well as emperors and empresses were depicted seated on textile-covered and ever more substantial chairs. By the fourteenth century raised chairs and footstools connoted high rank and authority, whether secular or religious.

The present chair, according to Wang Shixiang, is unique, the only extant example that is securely datable to the Ming period. Although its function—to exalt its occupant—was identical with that of later chairs, its relative simplicity argues for a fairly early date. In particular its naturalistic carving is comparable to carved lacquer work of the late fourteenth century, and the throne may thereby be dated to a period not far removed. Just as the lotus growing unsullied out of a murky pond provided an apt visual analogy for the enlightened soul unstained by the dust of the illusory world, so too does this throne-like chair characterize the political or religious sovereign for whom it was created as a man of strength as well as delicate sensibility. H.R.

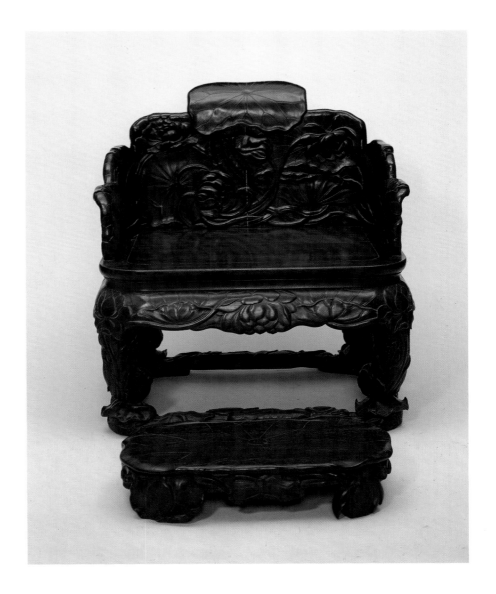

347 ❧

PĀRVATĪ

c. 1450
Indian, Vijayanagar
bronze
height 84.5 (33¼)
reference: New York 1985, 27–28, no. 2

Private Collection

Sprituality and sensuality meet in this image of Pārvatī, the *śakti* or female counterpart of Lord Śiva. The tangible and noblest form of cosmic divine power, she is also the benign aspect of Kālī, the destroyer. Although the image's stimulating womanliness might surprise those of us accustomed to unapproachably elevated statues and paintings of the Virgin Mary and other Christian saints, this blending of the otherworldly and the earthly is characteristic of Hinduism. Pārvatī, the mountain daughter, was a goddess of beauty, always admired for her voluptuousness. That her mere presence was enough to arouse Śiva's unbounded desire was fully understood by the sculptor, who endowed the image with a superbly lissome yet ample figure, luxuriantly sinuous jewelry and coiffure, and a costume vibrant with form-hugging folds.

This sculpture was created as a tool for meditation (*dhyāna*) according to the traditional canon of proportion known from earlier bronzes of the Chola period. Iconographically correct in configuration, its proportions conform to long-reckoned measurements, from the feet and ankles to the head. The master who created the image was a technical wizard, capable of the utmost refinements in modeling the original wax over an armature, building up the mold and fitting its carefully placed channels for draining the melted wax, and finally chasing the bronze to the perfected state seen here. But given that the sculptor had mastered such requirements, only his genius enabled him to breathe life into this piece, one of the most artistically moving of all later Indian bronzes.

Devotees sufficiently pure in heart to draw power from this image's supersensual beauty can through it achieve the spiritual goal of *samādhi*, the merging of the perceiver with the perceived.

s.c.w.

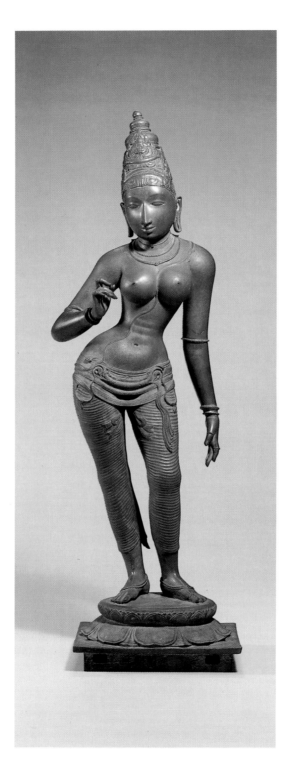
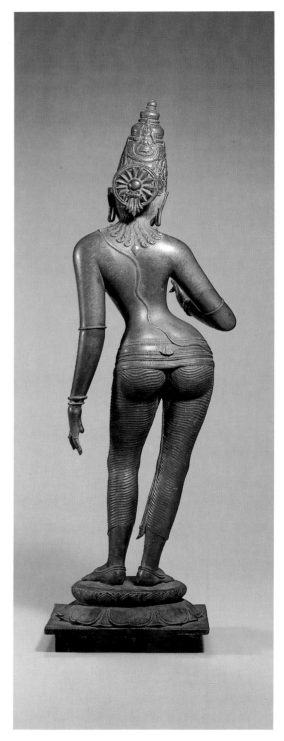

Yashodā and Krishna

15th century
Indian, Karnataka
copper
height 33.3 (13⅛)
references: Los Angeles 1977, 128–129; New York
1982–1983, 80–81; New York 1985, 33–34, no. 5

The Metropolitan Museum of Art, New York,
Purchase, Lita Annenberg Hazen
Charitable Trust Gift, in honor of Cynthia and
Leon Bernard Polsky

Probably the last very great South Indian metal sculpture, this deeply moving image of Yashodā and her foster son, the God Krishna, crosses the barrier that usually separates people from gods. The sculptor understood and sympathized with mothers and children and at the same time revered the divine. Yashodā is shown as a flesh-and-blood woman, probably observed from life, while Krishna gracefully ascends from human infancy to godliness. If his feet, legs, and left hand indicate a sensitively observed naturalism, his face conforms to the familiar South Indian typology and proportion known from many less extraordinary images.

The iconography is complex, demonstrating that the lives of the Indian gods were even more entangled than those of the Greeks. Here the human warmth of the image is appropriate, for Lord Krishna, whose name means dark, is the most humanly accessible of the Hindu deities—a god of youth who gradually emerged from ancient sacred mystery and legend. Scholars believe that in pre-Aryan times Krishna was worshiped by a tribe that deified cows, for in Vedic literature he is associated with cattle. In the Hindu epic *Mahābhārata* (*The Book of Wars*), he is described as a simple cowherd, one of whose wives is an untouchable. In the *Harivamśa* (*The Genealogy of Hari*) and the *Bhagavad Gītā* (*The Song of the Lord*), Krishna is the eighth incarnation or avatar of Vishnu, who took this form to slay the tyrant Kamsa.

When Kamsa was warned that he would be killed by one of the sons of Devakī, he ordered that Devakī's first six children were to be murdered at birth. But when Balarāma, the seventh son of Devakī and Vāsudeva, was conceived, Vishnu arranged for the fetus's miraculous transfer to the womb of Rohinī, Vāsudeva's second wife. When Devakī's eighth son, Krishna, was born, Devakī and Vāsudeva were imprisoned. Vishnu arranged for another miracle: their chains shattered, the guards fell asleep, and Vāsudeva carried the infant to Yashodā, wife of a cowherd, for nursing. Protected by her husband, Nanda, from Kamsa's murderous actions, Krishna grew up in the sacred groves of Vrindāvana, where he developed the talents of the Divine Lover. s.c.w.

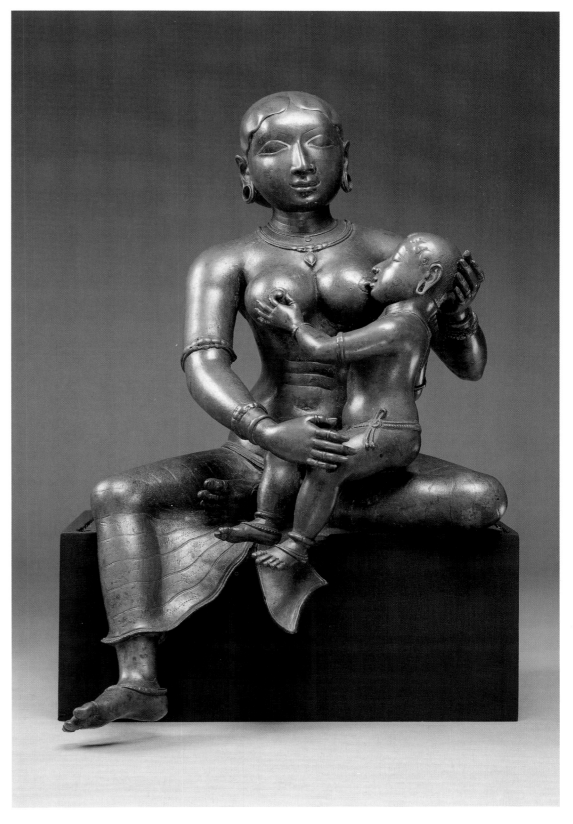

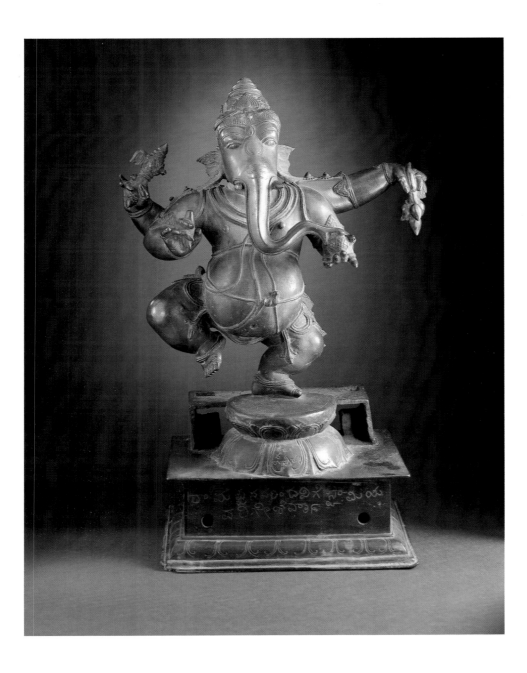

with only one tusk, and a snake encircling his torso. He is either yellow or red, and his four or more hands hold various attributes, including a shell or water lily, a discus, a club (or ax), and a ball of sweet rice (*modaka*), his favorite food, believed to contain the essences of his wisdom. His snake cincture is explained by a delightful tale: one day while riding his usual vehicle, the rat, the tired charger was terrified by a large snake and tripped. Ganeśa, who had crammed his belly with *modaka*s, fell off. His vast belly burst, and the sweets poured out. Unperturbed, Ganeśa stuffed them back in and sealed his paunch by wrapping it with the snake that had caused the accident. The single tusk resulted from a fight with Paraśurāma (known for ax-throwing) or with an angry *rishi* (holy man), who pulled out the other tusk when Ganeśa tried to keep him away from Śiva, who was meditating.

Here Ganeśa, also known as Ganapata (the lord of the Ganas, dwarflike troops of minor deities), is shown dancing on a lotus platform, with one hand free to maintain balance and his trunk reaching for a *modaka*. His infectious happy mood, as much as his other good qualities, accounts for his great popularity. In Indian thought, however, there is always ambivalence, perhaps because the vital monsoon rains are so fickle, sometimes bringing famine and pestilence as well as plenty. Happy is he who faces Ganeśa, but woe unto anyone on whom the god turns his back. From the front, Ganeśa spreads benevolence and geniality; from the back terror and destruction issue forth.

In this late but vital continuation of Chola period prototypes, tendencies toward metaphorical abstraction of form are apparent. Characteristically Indian are the full moonlike roundness of the belly, the fishtail leanness of the trunk, and the leaf-shaped eyes of this genial dancer. He seems to be spoofing Śiva's demonically powerful *tāndava* dance, symbolic of the world's unfolding, play, and destruction. We should remember, however, that Ganeśa may have originated not as a remover of obstacles but as a bringer of catastrophe, madness, and misfortune. Even now, he is worshiped by some through extreme antinomian meditations. In Hinduism, meanings are forever alive and changing; one never knows quite what to expect, and of course one's anticipations are always right as well as wrong. s.c.w.

349 ॐ

DANCING GANEŚA (NRITTA-GANAPATI)

15th century
Indian, Karnataka
bronze
50.3 x 32.9 (19⅞ x 13)
reference: Pal 1988, 156, 157, no. 134

Los Angeles County Museum of Art, Purchase, Harry and Yvonne Lenart Funds

Ganeśa is admired as the god of learning and good fortune, and as a destroyer of obstacles. His name is invoked at the beginning of all undertakings and is inscribed by devotees as the opening lines of literary and scholarly works. In Hindu temples, shrines, and households, his image is usually placed near the entrance to welcome visitors. Some believe that the elephant-headed son of the God Śiva and the Goddess Pārvatī was conceived when the divine couple saw a pair of elephants mating and decided to enjoy each other "in the elephant mode," as a result of which he was born with this unexpected head.

The legends of Ganeśa are infinite in number and vary somewhat: his pachydermic look is also ascribed to a crisis in infancy during which his human head was cut off, then replaced by the one closest at hand, which happened to be that of an elephant. According to another tale, Ganeśa was the son of Śiva and another wife, Durgā, whose name means "far" or "inaccessible" and who was noted as a slayer of monsters. Yet another tale maintains that Ganeśa was created by Pārvatī alone when Śiva had been persuaded by the other gods to beget no more children. He is invariably represented as a potbellied, elephant-headed god

ŚIVA AND PĀRVATĪ ON MOUNT KAILĀSA

15th century
Indian, Orissa
gneissic rock
32.1 x 36.2 x 7.9 (12⅝ x 14¼ x 3⅛)
reference: New York 1985, 38–39, no. 10

Los Angeles County Museum of Art, Purchase,
Harry and Yvonne Lenart Funds and
Museum Acquisitions Fund

In this spirited Orissan stone carving, Śiva and his divine consort, Pārvatī, attended by Nandi the bull, Hanumān the monkey chief, and another figure (possibly a holy man), loll animatedly, ready for eternal *maithuna* (cosmic lovemaking) atop Mount Kailāsa. The Himalayan mountain, in Tibet, is revered as one of the mountains of paradise, formed of crystals and used as a mirror by celestial beings (*apsarās*). Śaivite devotees consider it the penultimate *liṅgam*, the phallus symbolic of Lord Śiva, god of the unknown, of creation and destruction. A god of dread, Śiva, as the cosmic dancer, is also the embodiment of the ordered movement of the universe (*natarāja*). But his role as one of the three major gods of the Hindu pantheon, along with Brahma and Vishnu, includes that of the *Mahādeva* (Great God) and the *Mahāyoga* (Great Yogi, or ascetic).

Hanumān, son of the wind god (Pavana, Vāyu, or Marut) and an *apsarā* (celestial being), is regarded as almost divine. During the battle against demonic Rāvana in the *Rāmāyana* (Story of Rāma), he was sent by the monkey-physician Sushena to gather four healing herbs on Mount Kailāsa. If this explains his appearance here, Hanumān will have failed in his mission, but to set things right, he will swallow the entire mountain, leap with it to the monkey-physician, and disgorge it unharmed upon completing his task.

Nandi is omnipresent at Śaivite temples and shrines. Milky white, he is the chamberlain of the god, one of the *ganas* (attendants), and guardian of all quadrupeds. A musician as well, he accompanies Śiva during the cosmic *tāndava* dance.

Like many other examples of Orissan art, this work teems with swirling vegetation and sprightly animals. Sharing the heights of Mount Kailāsa with a holy man (*rishi*)—seated in the lotus position, staring into the sun—are delightful cockatoos, monkeys, elephants, boar, lions, and tigers. All of them occupy petal-shaped compartments, an Orissan characteristic found in several splendid ivory throne legs and probably traceable to lotiform bases for images.

Orissa, with its long coastline in eastern India, was protected from direct Muslim invasion. Like south India, it maintained ancient Hindu and animist traditions. Into the fifteenth century and

later, Orissa retained its indigenous flavor. By 1500, however, the brilliance of Orissan art known from the early medieval architecture and sculpture of Konarak, Bhubaneswar, and Puri had yielded to idioms touched with the earthier, less cerebral vitality of folk art. But the humble, less cosmopolitan Orissan sculptors and painters, always aware of the earlier masterpieces with which they lived and to which they prayed, never forgot their qualities. If they did not consciously turn to them as models, they understood their forms and meanings seemingly by osmosis and intuitively reinterpreted them. In this appealing sculpture, lively folkish elements combine with those of more intellectually and spiritually evolved precursors.

S.C.W.

A JAIN AID TO MEDITATION (SIDDHACAKRA)

c. 1500
western Indian
black ink and watercolor on fabric
49.5 x 48.9 (19½ x 19¼)

On Extended Loan to the Ackland Art Museum
from Gilbert J. and Clara T. Yager

This visually arresting schematic composition is in the form of a *mandala*, a circle within a square. These symbolical diagrams, believed to be universally present within the human consciousness from which they sometimes spontaneously emerge in dreams and visions, were first given form in ancient India, by Buddhists, Hindus, and Jains. Intended as "supports" or aids to meditation, these potent centers of psychic energy enabled devotees to master the cosmic process and to find their own spiritual centers.

Their use requires discipline and preparation. After ritual purification and adjustment of mood in a suitable place, the neophyte "enters" the *mandala* (or *yantra*), usually—though not here— through one of four directional gateways. Following the diagram step by step, he progresses towards the core or center by visualizing a succession of concepts, divinities, or instructive episodes in their lives. To facilitate this highly structured meditational quest, he usually intones prescribed *mantras* (magical syllables or words) specific to each of its stages. Fasting, vigils, incense, and the guidance of a religious preceptor further his progress through the symbolical diagram's increasingly elevated and elevating zones, a process that could go swiftly or consume a lifetime.

Although intended as tools or engines to stimulate inner visualizations, *mandalas* and *yantras*—which are also seen in three-dimensional

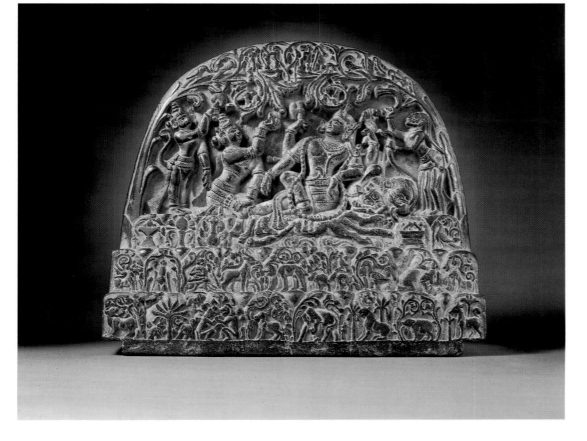

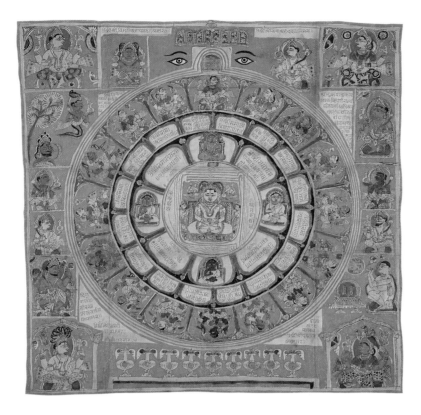

figures, animals, architecture, and landscape were outlined in black or red with reed pens, enriched with broad areas of red, green, blue, gold, and white. Their lively, wiry, often folkish formulas reveal few changes over the centuries, and regional styles are difficult to define. S.C.W.

352 ಇ

TWO MINIATURES FROM A *SHĀHNĀMA*

c. 1450
western Indian, Sultanate
opaque watercolor on paper
folio 73 a: 16.4 x 22 (6½ x 8⅝)
folio 112 a: 11.6 x 19.8 (4⅝ x 7⅞)
references: Goswamy 1988, pl. 2, pl. 11

Museum Rietberg, Zurich

Two miniatures from a copy of the Iranian poet Firdawsi's epic, the *Shāhnāma* (*Book of Kings*), underscore the impact of Muslim culture on fifteenth-century India. The epic was composed from earlier legends and histories by Firdawsi of Tus (c. 931–c. 1020) under the patronage of Sultan Mahmud of Ghazni, an Iranian ruler who made twelve expeditions to India. Although fragments of earlier *Shāhnāma* manuscripts illustrated in India are known, this generously illustrated copy, now dispersed, is the most purely Indian. Indeed, most of its miniatures are innovative reinterpretations in characteristically western Indian style of compositions traceable to subtler, less directly communicative Persian originals. Their ebullient mode seems pictographic, written rather than painted. Once we have learned the vocabulary of forms, simple as comic strips, they are so direct and persuasive that they remind us of Pavlov's button for making dogs salivate. Except for a few ballooning faces thus modeled for emphasis, compositions are flat, laid out in bold areas of cheerfully bright color with wire-thin, lively outlining. Sketchy, calligraphic, quick, and accomplished, such draftsmanship is the result of long training and constant practice. These miniatures can be assigned to a workshop, probably in Gujarat, that would have supplied manuscripts to diverse patrons, Muslim, Jain, and Hindu.

People, animals, mountains, vegetation, architecture, ornament, and still life all follow formulas in these good-humored, humble paintings. If this brings a certain similarity to the repertoire of faces, horse's masks, knees, and armor, monotony is avoided through witty variations. People are expressive but unportraitlike, with little differentiation between one or another pretty girl, handsome hero, or graybeard. Although the anonymous artists clearly derived pleasure from their

form—also serve as defenses against evil spirits, enemies, mental distractions, and temptations.

Jainism—derived from the Sanskrit *jina* or conqueror of the pains of worldly life—is claimed by its three million or so adherents to be the most ancient religion in India, older than Aryan Hinduism. It is usually considered to have been founded by Mahāvīra (d. 467 B.C.), the last of its twenty-four *tīrthaṅkaras* or *jinas,* a contemporary of the Buddha. Born under the name of Vardhamāna as the son of a local chieftain in modern Bihar, he renounced the world as a very young man and became a wandering ascetic. After attaining *kevala jñāna* (supreme knowledge), he wandered, taught, and founded an order of monks and nuns whose aim was to attain liberation from the cycle of birth and rebirth. Mahāvīra differed from the Buddha, who renounced asceticism, believing that this could only be achieved through extreme ascetic practices. He denied the existence of a creator god and the validity of sacrifices as well as of the caste system. At the age of seventy-two, Mahāvīra died, attaining *moksha,* or final liberation from the miseries of this life. His followers soon separated into two sects, the *Śvetāmbara,* or "white clad," initially centered in Karnataka, and the *Digambara,* or "sky-clad" (naked), of Maghada, in the south. To preserve Jain written and oral traditions, these were reconstructed and codified at a great council held at Pātaliputra. This work, however, was accepted only by the *Śvetāmbaras,* the *Digambaras* holding to the "former texts" (*Pūrvas*) and unreconstructed fragments.

To Jains, the principle of nonviolence (*ahimsā*) is greatly important. Lest they hurt or kill any living being (identifiable with the soul), they avoid such occupations as agriculture, animal husbandry, forestry, or even painting and sculpting, all of which endanger lives on one level or another. Paradoxically, Jain works of art, therefore, are commissioned from non-Jains. Most middle-class Jains, for the same reason, are money-lenders or businessmen, specializing in grains, textiles, machinery, paper, and cement. Others are bank clerks, accountants, jewelers, and grocers.

This spiritual diagram is one of the most popular of Jain *yantras,* the *Siddhacakra,* a wheel of the *siddha,* or liberated one, invoked for the destruction of sin and the promotion of prosperity and auspiciousness. In form, it consists of a stylized, flat lotus, the petals of which contain *mantras* and divine beings centered about the *arhanta,* who is a being lustrated by two elephants and is attended by fly-whisk bearers. He is surrounded by a riverlike rendering of the *mān-tirīkam* whose five letters [*a, h, r,* and *am*) connote the five venerable beings. Immediately above him is the *siddha,* or liberated soul, seated atop a crescent moon. The outer petals of the corolla contain depictions of the sixteen goddesses of magic (*mahāvidyādevī*), bracketed at top by two eyes symbolic of clairvoyance and omniscience, and below by nine vases, symbolizing the planets and intended, as *mallinatra,* to increase wealth and prosperity. Compartments at the corners contain the guardians of the four directions.

Jain painting follows traditional modes. Until the eighteenth century, when Mughal and Mughalized Rajput styles strongly influenced Jain art,

work, they scarcely attempted to represent moods by inventing gloomy palettes for tragedies or jolly ones for marriages.

Rustam Kills the White Div (folio 73a) is a particularly Indian version of a heroic subject. Rustam, the mighty Iranian paladin (knight), slays the White *Div* (Demon), a personification of evil and lieutenant of the *Div* King of Mazandaran. Not only do the cave, mountain, trees, and skyline conform to familiar Indian formulas, but the *div* is shown with unmistakably Hindu attributes. As B. N. Goswamy has pointed out, "His appearance is more like that of an ash-smeared ascetic wearing strings of rudraksha-beads and caste marks on his forehead than that of the scaly, animal-headed demon envisioned in Iranate work" (Goswamy 1988). To please a Muslim patron, moreover, the *Div* was endowed with an extra set of arms, bringing to mind poly-armed Hindu images. While the intent Rustam stabs, five junior *divs* shamble about anxiously, attempting ineffectually to aid and lend solace to their defeated master. Bound to a tree in the foreground is the potentially traitorous Owlad—rendered here as a dark-skinned Indian—a "marcher lord" captured earlier by Rustam, who promised to appoint him ruler of Mazandaran in exchange for guidance to the White *Div*.

Siyavush Enthroned with his Bride Farangish, Daughter of Afrasiyab (folio 112a) is an episode of rare and gentle poignancy in the heroic account of strife between Iran and Turan. Siyavush, son of the Iranian king, was not only welcomed by Afrasiyab, king of Turan, but offered his daughter Farangish in marriage. In this miniature of one of the happiest moments of Firdawsi's Iranian epic, the loving couple are enthroned beneath royal umbrellas.

Tragedy lay ahead; the seemingly endless war again turned bitter. Despite Farangish's tears and protests from wise Turanian advisers, Afrasiyab ordered Siyavush's execution. From the earth that had received the hero's blood grew flowers now known in Iran as Siyavush's Tears. Before long, Afrasiyab also lost his head—to the sword of the Iranian Shah Kay Khosrow.

Painted not in Iranian but in Indian terms, a musician plays an Indian instrument (*sarod*) and attendants are rhythmically disposed, recalling Jain and early Rajput groupings. Their skirts, visible through transparent muslin *duppattas* (long scarves), bring to mind the patterns of fifteenth-century Indian block-printed textiles excavated at Fostat, near Cairo. The gilt bronze animals of the lion throne resemble those that often support images of Jain saints. Among the assorted Indian metal objects is a salver of *pān* (betel nut and lime wrapped in a leaf). Most Indian of all, perhaps, are the portrayals of plump, dark-eyed Farangish and stout, black-mustached Siyavush, who bring to mind the heroes and heroines of current Indian films. S.C.W.

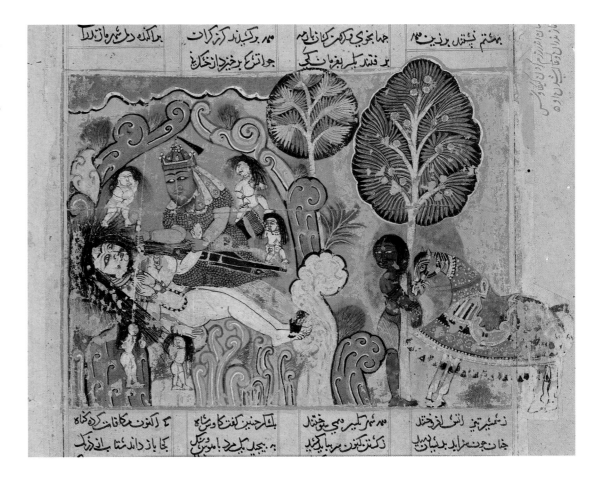

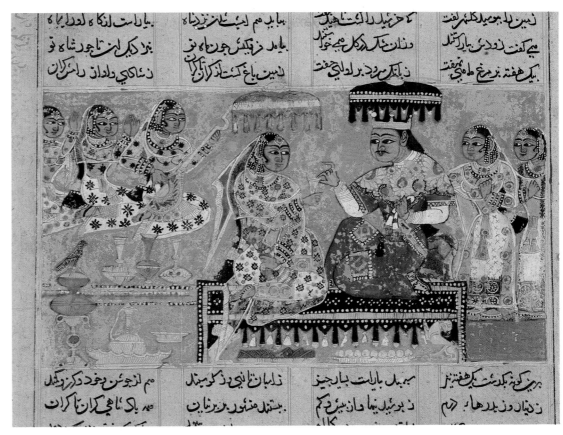

but as an entity in itself. What could be seen as a lack of classical perfection and harmony in Bihari and Maghribi texts is often more than offset by the vigor of the writing and the sometimes daring use of colorful decoration" (New York 1985, 123).

This unmistakably Deccani manuscript, with its Indian verve, is a very late example of Bahmanid art. It expresses the lingering might of its dynasty, centered at Gulbarga and later at Bidar, from which the other three major Deccani sultanates—Ahmednagar, Golconda, and Bijapur—broke away. At these highly creative Indian centers, lines between Muslim and Hindu were sometimes indistinct. Although the Deccani sultans were for the most part nominally Shi'ite rather than Sunni Muslims, several of their prime ministers were Hindus or converts from Hinduism. The sultans vied with one another to hire outstanding poets, musicians, artists, and scholars, some native born, others brought from various parts of the Islamic world. The prime requisite was talent, not birth, and outstanding creativity was awarded lavish patronage regardless of religious affiliation. s.c.w.

353 ❧

KORAN

dated to 1483
Indian, Deccan, Sultanate
opaque watercolor, ink, and gold on paper
47.6 x 31.1 (18¾ x 12¼)
reference: New York 1985, 123–126, no. 71

Archaeological Museum, Bijapur

Muslims are "people of the book," and the Koran is as fundamental to them as the Bible is to Christians and the Torah to Jews. Whether written and illuminated or printed, its creation is a reverential task. This noble copy is imbued with divine force.

Its typically Indian script in Bihari style, the substantial "feel" of its bound folios, and the architectural power of the illumination make this volume as impressive to behold as a great bridge or aqueduct.

Annemarie Schimmel has pointed out that Bihari script "has been used by calligraphers in India since the early Middle Ages. On the opposite fringes of the world of Islam, in North Africa and Spain, scribes also wrote in a style of their own, called Maghribi. In Bihari, the characters are wedge-shaped, more angular than the classical rounded forms, and writers of both Bihari and Maghribi depart from the rules by treating each word not as a carefully constructed sum of letters

354 ❧

DEDICATORY INSCRIPTION FROM A MOSQUE

dated to 1500
Indian, Bangla, Gaur, Sultanate
schist
41 x 115.3 (16⅛ x 45⅜)
references: London 1979, 30–31, no. 33;
Metropolitan Museum of Art 1983, 13–14, pl. 1;
New York 1985, 129–130, no. 74

The Metropolitan Museum of Art, New York, Gift of Mrs. Nelson Doubleday and Bequest of Charles R. Gerth, by exchange 1981

Islam spread rapidly from northwestern India southward to the Deccan and beyond and eastward as far as the Bay of Bengal. At Gaur and Pandua in Bengal, a major Islamic substyle developed, one best known—inasmuch as portable objects have not been identified—from its architecture, ornament, and architectural inscriptions.

Among extant inscriptions, the present example stands out for its masterfully organized processional rhythms. The composition brings to mind ships in full sail crossing choppy seas or an army of men, horses, and elephants on the march, waving high their spears and banners. Such designs were planned by masters of calligraphy, employing skills usually associated with painters or with sculptors of bas-reliefs. To them it was important that each element be as beautiful as the totality of the design. After envisioning the finished work—for which the calligrapher must have contrived an appropriate image such as the ships or army we have found—he would have refined the placement of the letters before writing the inscription full scale on paper or directly onto the already prepared schist slab. Having devoted so much attention to these initial stages, he undoubtedly must have supervised the stonemason who with utmost care chiseled, ground, and filed it until the majestic letters stood out in low relief from the neutral background.

In the Islamic world, calligraphers ranked higher than other artists or craftsmen, owing to their closeness to the inspired words of the Prophet Muhammad and to other sacred texts that virtually every calligrapher copied. Many shahs, sultans, and emperors were not only patrons of calligraphy but also practiced the art. Many different styles of writing were developed, some especially suited to monumental use, from the time of the Prophet until recent times. In fifteenth-century Bengal a special variant of the Tughra script known as "bow and arrow" was evolved, the style brilliantly represented here.

The text of this inscription begins with words taken from the *Hadith*, or prophetic traditions: "The Prophet, the blessing of God and peace be upon him, said, 'Whosoever builds a mosque for God will build him a palace the like of it in Paradise.' In the reign of Sultan 'Ala'ad-Dunya Abu'l-Muzaffar Husain Shah al-Sultan, may God perpetuate his rule and sovereignty. Prince Daniyal, may his honor endure, built this congregational mosque on the tenth of Dhu'l-Hijja of A.H. 905 [7 July 1500]."

Simon Digby, who first translated the inscription, has identified Prince Daniyal as one of Husain Shah's eighteen sons. The tomb of Shah Nafa at Monghyr, dated to 1497, also bears the prince's name. This piece was probably taken from a ruined building during the nineteenth century when Gaur and Pandua became a quarry for contractors from Calcutta. s.c.w.

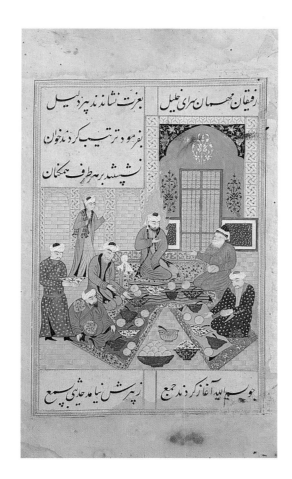

355 ❧

Haji Mahmud

THE PATRIARCH ABRAHAM PLAYS HOST TO A FIRE WORSHIPER, FROM THE *BUSTAN* OF SA'DI

c. 1500–1503
Indian, Mandu, Sultanate
opaque watercolor on paper
folio: 34.6 x 24.5 (13⅝ x 9⅝)
miniature: 19.4 x 16.2 (7⅝ x 6⅜)
references: New Delhi 1964, 94–95; London 1982, 67–68, no. 42; Ettinghausen 1985, 40–43; New York 1985, 134–135, no. 79

National Museum, New Delhi

In India, as in other parts of the Islamic world, remarkable variants developed from more central Islamic artistic traditions, inviting comparison with the changes rung on Italian Renaissance themes at Fontainebleau under the patronage of King Francis I. This copy of the thirteenth-century Persian poet Sa'di's *Bustan* (*The Orchard*), dating from the beginning of the sixteenth century and created in central India at the royal city of Mandu, exemplifies such cultural echoes. Although the paintings possess a unique character, specialists can detect adaptations from earlier Timurid or Uzbek work from Herat or Bukhara. The great creative force behind these pictures

is Master Bihzād of Herat, who with Sultan-Muhammad belongs at the peak of Persia's artistic hierarchy. Painting in Herat during the final quarter of the fifteenth century, Bihzād looked freshly and intently at nature, rarely depending upon artistic prototypes as his models. He was infinitely and painstakingly skillful, deeply concerned with human nature, and a lover of animals, trees, and flowers. His mind functioned with logical precision, and in his pictures every person, tree, fence, and wine cup is accurately and specifically located. Somehow these Bihzadian elements reached Mandu and were absorbed by the painter Haji Mahmud, probably Indian-born, whose name appears as illuminator as well as artist on folios 1 and 190 a.

Haji Mahmud can be assigned *The Patriarch Abraham Plays Host to a Fire Worshiper*, which describes one of Sa'di of Shiraz's characteristically witty yet moralistic tales. Abraham, an orthodox Muslim delighted by his own exquisite and lavish hospitality, once sighted a white-haired vagabond crossing the desert and invited him to dine. Eager to enjoy a delicious meal, Abraham said grace. While doing so, he noted the guest's silence and soon realized that he was a despised Zoroastrian! Outraged that his purity should be defiled by such a being, he forced the hungry old fellow back into the desert, whereupon an angel appeared and admonished him: "For a century God has provided this fire worshiper's daily bread, and now you presume to withhold the hand of bounty!"

This copy of the *Bustan* consists of 229 folios and 43 miniatures. It was written in bold but graceful *nasta'liq* script by Shahsuvar al-Katib (Shahsuvar the Scribe) for Nasir ad-Din Khalji of Malwa, who reigned from Mandu between 1501 and 1511. He was the second of two patrons of a slightly earlier manuscript, a cookery book entitled the *Ni'mat-nāma* (*Book of Delicacies*), in which the patrons' formula for the good life is delightfully outlined between recipes. This included a kingdom-within-a-kingdom in which, except for butchers, the sultan was the only male, his every need, from gastronomic and musical to military and administrative, attended to by beautiful women. s.c.w.

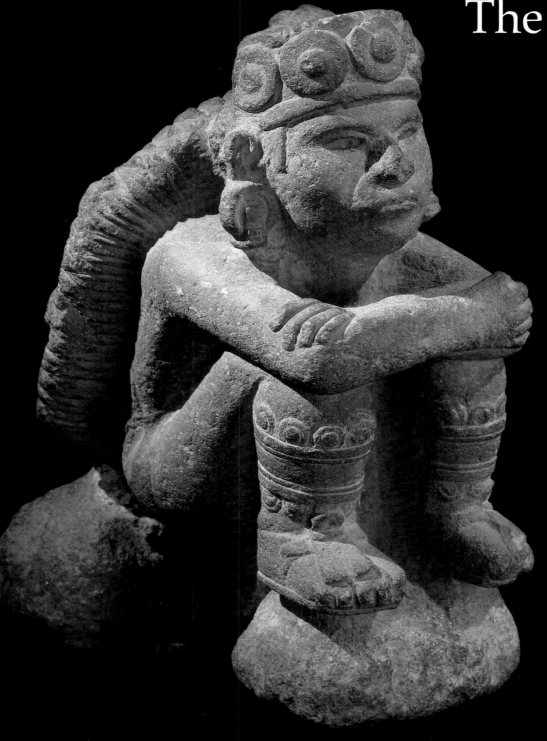

III

The Americas

THE AZTEC EMPIRE: REALM OF THE SMOKING MIRROR

Michael D. Coe

In 1566 Bernal Díaz del Castillo, one of Cortés' soldiers in the conquest of Mexico and then an old man, set down his recollection of that November day in 1519 when he and his hard-bitten comrades had crossed the pass between the volcanoes flanking the eastern side of the Valley of Mexico and beheld the heart of the Aztec Empire for the first time:

> The next day, in the morning, we arrived at a broad Causeway, and continued our march towards Iztapalapa, and when we saw so many cities and villages built in the water and other great towns on dry land and that straight and level causeway going towards Mexico, we were amazed and said that it was like the enchantments they tell of in the legend of Amadis, on account of the great towers and cues [temples] and buildings rising from the water, and all built of masonry. And some of our soldiers even asked whether the things that we saw were not a dream?[1]

But these strange and dangerous beings from another world were not there to wonder: they had come to destroy this civilization and claim an empire for their sovereign, Emperor Charles V.

For the reconstruction of the Aztec world that was obliterated by Spain, there is a wealth of information that is virtually unique for the indigenous societies of the Western Hemisphere. There are the eyewitness accounts of the conquistadors themselves, beginning with the politically motivated letters to his sovereign from Hernán Cortés.[2] There are the marvelous records and linguistic studies undertaken by the early Franciscan friars, above all the *Florentine Codex*, a stupendous, twelve-volume encyclopedia of Aztec life and history compiled by the remarkable man who was in effect the world's first field anthropologist, Fray Bernardino de Sahagún. It was so complete and controversial a work that it was suppressed at the order of Philip II.[3] Sahagún's great opus is the starting point for every study of Aztec thought and society on the eve of the conquest. In Mexico, he was followed by other scholars from the mendicant orders, but none of their reports were ever the match of Sahagún's in understanding and detail.

Some of our most valuable sources are native. Richest of all are the pictorial screen-fold manuscripts from central Mexico; except for the *Codex Borbonicus*, all predate the conquest. These are lengths of deerskin folded like an accordion or screen, coated with white gesso, and painted with ritual and mythological scenes. Although their exact provenance is still debated, these rarest of native American manuscripts represent indigenous thought in its purest form, untainted by European concepts.

According to their semilegendary history, the ancestral tribes that coalesced to form the Aztec nation had originated in western or northwestern Mexico, far beyond the confines of civilized Mesoamerica. Like all such migration tales, the accounts are mutually conflicting: some sources place Aztec origins in Aztlan (probably meaning "place of the white heron"), an island in a lake, while others have the Aztec nation emerging as seven distinct tribes from Chicomoztoc ("seven caves"). Led by four priests bearing the image of their tribal deity Huitzilopochtli ("hummingbird on the left"), the tribesmen are said to have departed Aztlan in A.D. 1111 on a trek toward their future destination, the Valley of Mexico, which they reached by the end of the thirteenth century.

Miraculous adventures befell the travelers along their way, particularly at a place called Coatepec ("snake hill"), where—somewhat illogically from our perspective, given his presence at the start of the migration—the god Huitzilopochtli was born. Within the mythology of the Aztec state this nativity story is central.[4] On Coatepec lived the Centzon Huitznahua ("four hundred southerners," the stars of the night) along with their mother Coatlicue

fig. 1. Huitzilopochtli. From *Codex Borbonicus*, p. 34 (detail). Bibliothèque de l'Assemblée nationale, Paris

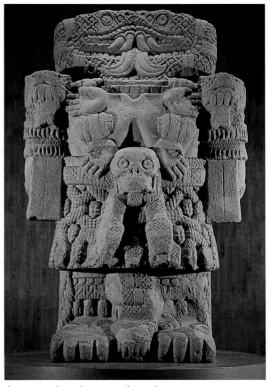

fig. 2. Colossal Statue of Coatlicue. Aztec, stone. Museo Nacional de Antropología, Mexico City

("she of the serpent skirt") and their sister Coyolxauhqui ("painted with bells"), the moon goddess (cat. 357). One day as Coatlicue was sweeping the temple on the top of the hill, a ball of feathers leaped into her womb and magically impregnated her with the future tribal deity. Her jealous and enraged offspring cut off her head, an act commemorated by the colossal Coatlicue sculpture in the Museo Nacional de Antropología in Mexico City, in which the mother goddess is depicted with two mighty gushes of blood in the form of snakes leaping from her severed neck.

Nevertheless Huitzilopochtli, now identified as the sun, came forth from his mother's womb fully armed and, in a cosmic struggle with his siblings the stars and the moon, slew them with his serpent staff. After beheading his sister Coyolxauhqui, he hurled her lifeless body to the foot of Coatepec and dismembered it.

When the Aztecs arrived at long last in the Valley of Mexico, they found it dotted with the cities and towns of long-settled, cultivated peo-

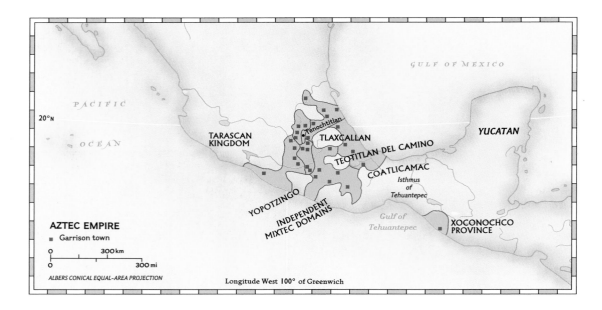

ples who had inherited the mantle of the old Toltec civilization, which had fallen in the twelfth century. These looked down upon the uncouth, warlike newcomers who by this time were calling themselves "Mexica," rather than "Azteca," their old name. Following a prophecy of the great Huitzilopochtli, and after a further period of poverty-stricken wandering, the Aztecs eventually settled on low islands in the midst of the huge, shallow lake that then filled much of the valley. There, the god had said, they would find an eagle perched on a prickly-pear cactus (*tenochtli*) and there they were to found their capital, Tenochtitlan—whence their destiny would lead them to rule the world. And so it happened.

The story of the rise to power of the Aztecs closely parallels in time that of the Ottoman Turks in the Old World and bears some resem-

blance to it: both represent the rapid progression from a collection of semibarbarian tribes to an empire. In 1427 the fourth Aztec ruler or *huei tlatoani* ("great speaker"), whose name was Itzcoatl, defeated the cruel Tepanec overlords on the mainland and took over their extensive domain in central Mexico. By the end of the fifteenth century the Aztecs controlled a loosely organized empire that reached to the Gulf and Pacific coasts and included most but not all of the Mesoamerican peoples situated west of the Isthmus of Tehuantepec. Lack of hard data makes it risky to estimate the number of people brought under the sway of Tenochtitlan by the Aztec military juggernaut, but the figure probably lies between ten and twenty million. Strictly speaking, the empire was a triple alliance of three polities of the Valley of Mexico: Tenochtitlan, Texcoco, and Tlacopan. However, this alliance was completely dominated by the Aztec capital itself, which claimed a lion's share of the tribute and war booty.

Although the political economy of the Aztec state is not fully understood, its main support seems to have been heavy tribute from the lands the Aztecs had conquered. Vast quantities of maize, beans, and other foodstuffs came into Tenochtitlan on a regular basis, along with more than a million cotton mantles, large numbers of war costumes, and other manufactured goods. There were daily markets in the towns and cities, the major ones so large that they required special market judges to settle disputes and ensure fair trade. Operating outside the market-vendor world were hereditary guilds of long-distance merchants, the *pochteca*, whose task it was to travel, often in disguise, to distant markets of peoples such as the Maya. There they traded for foreign luxury items, quetzal feathers, for example, to be brought back to the Aztec royal palace.

fig. 3. Colossal Relief of the Dismembered Moon Goddess Coyolxauhqui. Aztec, stone. Museo del Templo Mayor, Mexico City

The great island-capital itself, Mexico-Tenochtitlan as the Aztecs styled it, was connected to the mainland by three main causeways. In a sense it was a kind of double city, as the early Aztec polity had absorbed the once-independent Tlatelolco in the northern part of the island. Tlatelolco's great market, in a square described as larger than the one in Salamanca, was what had so impressed Cortés and Bernal Díaz. With its myriad canals thronged with canoe traffic, Mexico-Tenochtitlan reminded the conquistadors of Venice. In the absence of real census data, one can only guess the size of the population in 1519. Cortés[5] said the city was as big as Seville or Córdoba, neither of which accommodated more than seventy-five thousand souls in the early sixteenth century. The source known as the Anonymous Conqueror[6] assigned the city sixty thousand households, which would suggest a population of at least two hundred thousand. This latter estimate is probably too high: the comparable island-city of Venice had only one hundred fifty thousand inhabitants at that time, and it is unlikely that Tenochtitlan, which consisted largely of one-story houses, had more residents than this. Yet it was one of the world's largest cities.

The population was divided into four classes[7]: the nobility (*pipiltin*), including the royal household, with extensive private estates and rights to tribute; the free commoners (*mace-*

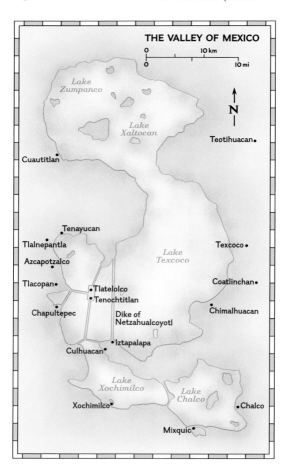

hualtin), with usufruct rights to land organized into localized wards called *calpultin*, each with a temple and schools; the serfs bound to the soil (*mayeque*), who worked the lands of the nobles; and the slaves (*tlacohtin*), most of whom toiled as domestic servants, farm laborers, and the like. Slavery was clearly defined under law, and ordinarily no slave could be resold without his consent. Slaves were generally persons who had been unable to meet their debt obligations, and some of them rose to become estate managers and enjoyed a degree of prosperity.

Religion and the calendar

As the early Spanish friars came to realize, there were few if any peoples in the world who could rival the Aztec in piety. They were compared favorably in this with the conquistadors. When Cortés had the temerity to suggest to the emperor Motecuhzoma (whose guest he was) that he be allowed to set up a statue of the Virgin Mary in the holiest of sanctuaries (the adoratory of Huitzilopochtli and Tezcatlipoca), the *huei tlatoani*'s measured reply was

> If I had known that you would have said such defamatory things, I would not have shown you my gods, we consider them to be very good, for they give us health and rains and good seed times and seasons and as many victories as we desire, and we are obliged to worship them and make sacrifices, and I pray you not to say another word to their dishonour.[8]

Everything the Aztecs did, from *huei tlatoani* to slave, from priest to warrior, was in some way religiously motivated, whether it be a prayer for good harvest, a father's advice to his son, or a human sacrifice. Permeating life, in fact energizing the entire Aztec nation and the universe itself, was a complex yet coherent system of beliefs nurtured and developed by the priesthood.[9] The Aztecs knew that it was their destiny to maintain the world in good order, and this structure guided them in every step along the way.

At once optimistic and deeply pessimistic, the Aztec world view justified all aspects of life, including the state and empire.[10] Its underlying premises were very different from those of European Renaissance civilization, and were not really understood by the invaders until long after the Aztec world had collapsed. Tezcatlipoca ("smoking mirror") was the real Aztec supreme deity: even Huitzilopochtli himself was but one of his aspects. This ancient, dread, and protean supernatural was both giver and destroyer of life and fortune. Through him the *huei tlatoani* and empire derived their legitimacy. The Aztec ethos embraced the principle of duality, the unity of opposites. The constant

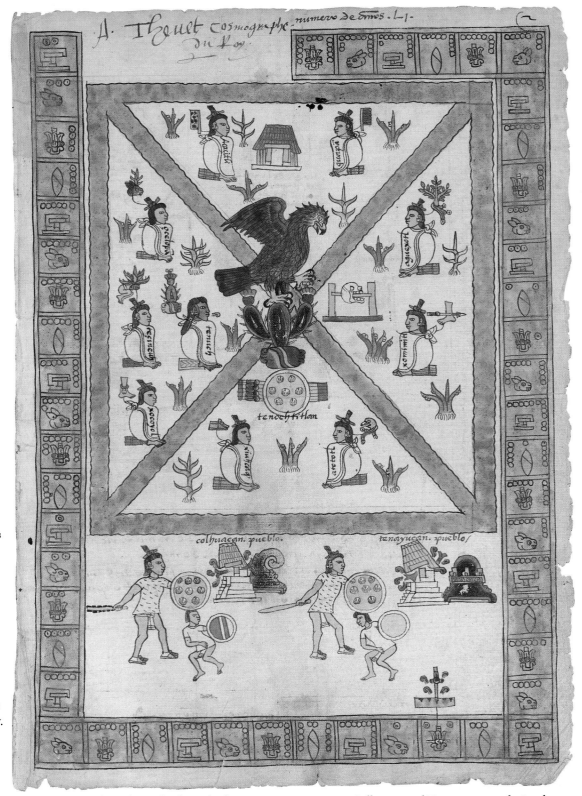

fig. 4. The Founding of Tenochtitlan. The first two Aztec conquests, Colhuacan and Tenayucan, are depicted at the bottom of the drawing. From *Codex Mendoza*, ms Arch. Seld. A.1. fol. 2r. The Bodleian Library, Oxford

struggle between Tezcatlipoca, the god of war and witchcraft, and his antithesis Quetzalcoatl ("feathered serpent"), lord of priests, produced the ages of the world and time itself.

In a universe both ordered and inherently unstable, with change and ultimate destruction implicit in all creation, the sacred calendar (*tonalpohualli*) integrated time with space. It was based upon the eternal permutation of the numbers one through thirteen with a count of 20 named days, producing an ever-repeating cycle of 260 days. Of great antiquity, with roots

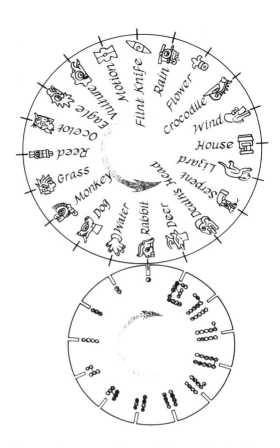

fig. 5. Schematic Diagram of the Sacred Calendar

going back into the Formative Period of Mesoamerican cultural history, the *tonalpohualli* was so fundamental that not only men but even gods were named by the day on which they had been born.

Each *tonalpohualli* day was assigned in a counterclockwise succession to a cardinal direction and to a specific color, thus describing a ritual circuit through space and time. Since each day sign and its corresponding coefficient had an augury—either favorable, unlucky, or neutral—the *tonalpohualli* provided the fortune of every individual Aztec and of the gods as well. The calendric machinery was extremely complex. The 260 days were grouped into 13-day weeks, each beginning with the coefficient *1* and each with its own prognostication and presiding deities. Those born under the sign 1 Dog, for example, would become rich, while those born under 1 Monkey would be brave but die in battle. Each night had its own supernatural patron in a succession of nine lords of the night; there were thirteen lords of the day as well.

All this knowledge was recorded in screenfold books kept under the care of the priests, who directed the *tonalpohualli* rituals. The grandest of the ceremonies were geared to the annual movements of the sun, which had its own god,

Tonatiuh, whose attributes had been usurped by the tutelary divinity Huitzilopochtli. The Aztec astronomer-priests used a solar year of exactly 365 days (rather than the true tropical year of 365¼ days), consisting of eighteen months of 20 days each, plus 5 extra nameless days on which it was extremely unlucky to be born. Although the *xihuitl* (365–day year) must always have run ahead of the true year, the monthly ceremonies, which took place on a vast scale in capital cities like Tenochtitlan, were closely related to the agricultural cycle and to the alternation of dry and wet seasons. From the terse accounts in the known sources there is no way to re-create the drama and magnificence of these festivals, with their communal dances, music, costumes, and sacrifices. It is clear that great celebrations, such as the springtime feasts in honor of the flayed god, Xipe Totec, must have involved tens of thousands of participants in the streets and plazas of the Aztec capital.

As in the rest of Mesoamerica, the *xihuitl* permutated with the *tonalpohualli* to produce a calendar round of fifty-two years.[11] Each of these years was named for a particular day in the *tonalpohualli*, and only four of the twenty day signs—Reed, Flint, House, and Rabbit—could be "year bearers." Unlike the Maya, the Aztecs lacked an unbroken day-to-day count from a single point in the past, so that all of their history and mythology was embedded in this recurrent fifty-two-year calendar, leading to much confusion among modern historians trying to deal with the Aztec past: we are told in which year an event occurred, but not in which calendar round it fell.

As the late Jacques Soustelle has observed, "At bottom the ancient Mexicans had no real confidence in the future,"[12] and this anxiety was nowhere so manifest as in the ceremonies marking the close of a calendar round (always in a year 2 Reed, the sign of Tezcatlipoca), when a symbolic bundle of reeds representing the old years would be buried like a dead man. All the fires throughout the empire were extinguished, and the fire priests gathered on the Hill of the Star to watch if the Pleiades crossed the zenith. If they did, the universe would continue for another calendar round; the new fire would be kindled in the breast of a slain captive, and the smoldering embers carried out into the world.

The Aztecs shared the color-direction concept with most other Mesoamerican groups and with many North American tribes. Each of the four directions had a color (among the Aztecs, east was white; north, the direction of death, was black; west was red; and south blue). There were also a host of other associations. Thus each cardinal point had a certain kind of tree, on the top of which perched a specified bird. The sur-

face of the earth had a fifth "direction," the center, the conceptual location of the three-stoned hearth in every woman's household and the domain of Huehueteotl, the old fire god. There were two additional directions, the above and the below.

In a way the Aztec universe was like the Ptolemaic, with the above being layered into thirteen heavens, and the below into nine underworlds. According to the *Codex Ríos*, a post-conquest book on European paper, each heaven was the abode and path of various celestial phenomena: the moon and the rain god Tlaloc inhabited the first heaven, the Milky Way the second, the sun god Tonatiuh the third, and so on. Over all, in the thirteenth heaven, was Ometeotl, the dual god of all creation.

The sun, either as Tonatiuh or his avatar Huitzilopochtli, was a major focal point of Aztec life; the right-hand or south side of the great temple in Tenochtitlan was dedicated to his worship. As the solar orb rose in the sky each dawn, it was conducted to its noontime position by a Xiuhcoatl (fire serpent), with upturned snout embellished with the seven stars of the Pleiades and back emitting flames (cat. 388). Thereupon the five sinister *cihuateteo* (goddesses), the souls of women who had died in childbirth, rose up from the western horizon to conduct the sun on its afternoon journey (cat. 370). Night marked the death of the sun and its voyage through the underworld; only the continued sacrifice of captive warriors would ensure that the fiery orb would rise again in the east.

As the sun represented maleness and the warrior principle, so the moon stood for everything female. The mythological underpinning for this belief was the Coatepec legend of the triumph of Huitzilopochtli over Coyolxauhqui, the moon. The Aztecs had an entire complex of female divinities with lunar attributes: young goddesses such as Xochiquetzal ("flower plume"), the goddess of love and Tezcatlipoca's mistress, represented the waxing moon, while aged goddesses stood for the waning one. Associated with this female pantheon were skills generally assigned in Mesoamerica to the female sex, such as weaving, curing, and midwifery. The breaking of the somewhat puritanical norms of Aztec behavior was considered the domain of these divinities. Drunkenness, for example, was often punished by death, yet the maguey wine itself was under the care of the goddess Mayahuel and closely associated with the rabbit, whose form the Aztec saw on the face of the moon.

Third in brightness among the heavenly bodies, the inner planet Venus was closely

watched by the astronomer-priests, especially during its heliacal rising as morning star every 584 days; ritual codices like the Borgia and Cospi (cat. 359) record this as a baneful event, the planet taking on aspects of the death god as it hurled its rays at various victims. Every 8 years, the Venusian and solar calendars coincided (8 x 365 = 5 x 584, the basis of the Venus tables in those books), and every 104 years (2 x 52) saw the meeting of the Venus count with the calendar round, a great and awesome event. Venus had strong associations with Quetzalcoatl, for the god, following his expulsion from Tula, the Toltec capital, was said to have thrown himself on his own funerary pyre to be apotheosized as the morning star.

Between the thirteen heavens and the nine underworlds was Tlalticpac, the earth's surface, with the world-direction trees at its four corners and the old fire god at its center, as seen on the first page of the *Codex Fejérváry-Mayer* (cat. 356). For most earth dwellers the destination after death was Mictlan, land of the dead. The exceptions were warriors who had died on the battlefield or under the sacrificial knife and women who had perished during childbirth, losing a battle with the warrior inside them, all of whom went to the paradise of the sun god; and those who had died by drowning, by lightning, or by water-connected diseases, who went to the delightful Tlalocan, the paradise of Tlaloc, the rain god.

The underground road to Mictlan was entered through the gaping jaws of Tlaltecuhtli, the earth monster. As the soul descended through each successive layer, it had to endure terrible tests and perils such as a place of bitter cold where there were winds as piercing as flint knives. At last it reached the bottommost hell, "where all the streets are on the left," presided over by the death god Mictlantecuhtli and his dread consort Mictlancihuatl. Four years after the death of the body, the soul ceased to exist.

One can think of an *axis mundi* passing vertically through these cosmic layers: at the nadir, the male-female ruler of the dead, in the center, the male-female old fire god, and at the zenith, residing in the ultimate heaven, Ometeotl, the androgynous dual divinity, the alpha and omega of Aztec religious thought. In his magisterial study of Aztec philosophy, Miguel León-Portilla[13] has demonstrated that to the Aztec wise men the entire universe with its multitudinous gods, lesser beings, and forces could be reduced to one ultimate reality: Ometeotl, embodying the ancient principle of the unity of opposites. All else was mere illusion.

Ometeotl was both male and female and existed before the creation of the universe. Out of the sexual opposition contained within his/her body came conception and the world's beginning: creation was thus equated with procreation. From this union there were born not one but four Tezcatlipocas, each assigned to a world-direction and color. To the north was the black Tezcatlipoca, the god of war and sorcery and the night sky; to the west the white one, Quetzalcoatl; to the south the blue Tezcatlipoca, Huitzilopochtli; and to the east the red one, Xipe Totec. A cosmic struggle for hegemony then ensued between Quetzalcoatl and the black Tezcatlipoca, and time began.

In Aztec thought the perpetual conflict between these two supernaturals—a kind of repeating Cain and Abel story—produced the world ages or "suns," each sun being dominated by one god or the other. In effect this was a mythic enactment of the structural opposition between the warriors, presided over by Tezcatlipoca, and the priests, for whom Quetzalcoatl was patron and beau ideal. The myth of the five suns was basic to the Aztec state religion, and it is exemplified by the greatest of the preserved Aztec monuments, the huge Calendar Stone. Ever since its rediscovery in the eighteenth century it has astonished visitors to Mexico City. It is in fact a view of the universe in space and through time. At the center of the disk is a face that is now generally thought to be that of the night sun, the dead sun in the underworld. Framing it is the sign 4 Motion, the day name of the present age or sun, someday to be destroyed by earthquakes; within the sign's four arms are the day-signs of the four previous ages, and the sign itself is encircled by the twenty named days of the *tonalpohualli*. Surrounding the disk are two gigantic fire serpents bearing the sun on its diurnal journey. And what is the message? That the sun itself, along with all of us, is to face certain destruction on some evil day.

The focal point of the cult of the sun and the conceptual heart of the empire was the Great Temple (*huei teocalli*) on the eastern side of the

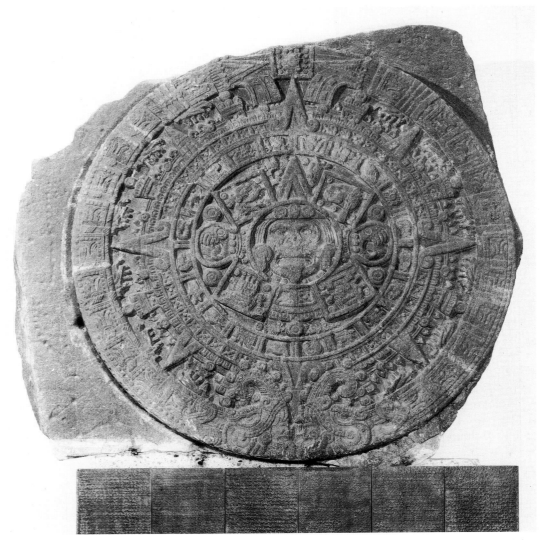

fig. 6. Aztec Calendar Stone. At the center is a representation of our own era, 4 Motion. Museo Nacional de Antropología, Mexico City

sacred precinct in the center of Tenochtitlan. Rebuilt and enlarged seven times since its founding in the early fourteenth century, this was a double temple, the north half dedicated to Tlaloc and the south half to Huitzilopochtli. Significantly, the Huitzilopochtli temple was known to the Aztec as "Coatepec," for in 1978, at the foot of the ruined stairway of its fourth stage, a colossal relief of the dismembered Coyolxauhqui was discovered by chance.[14] Subsequent excavations by Eduardo Matos Moctezuma in what remains of the Great Temple have provided a wealth of offerings and other materials related to the cults of Tlaloc and Huitzilopochtli through much of Aztec history.

In their religion the Aztecs never lost sight of the fact that they were a farming people who had once been hunters and gatherers. Tlaloc, the goggle-eyed rain god, was chief among the agricultural deities, and the Aztec multitudes held some of their greatest festivals in his honor, especially at the start of the rainy season, sacrificing even little children so that the crops might have their needed moisture. A verse from a hymn to Tlaloc points up the anxiety of a starving people in times of drought and scarcity:

O Lord, Beloved Lord, O Provider!
May it be in your heart to grant, to give,
 to bring comfort to the earth
and all that lives from it, all that grows
 on it.[15]

In late spring, just before the coming of the rains, the Aztec nation celebrated the festival of Xipe Totec ("our lord the flayed one"); for this event captives were slain and flayed. The celebrants put on the skins, which symbolized the new vegetation that was about to cover the land.

Maize was the staff of life in this agricultural civilization, and was deified as a goddess with the calendrical name Chicomecoatl ("seven serpents") and as the young god Centeotl. But the Aztecs were still proud of their ancestry among the hunting tribes of northwestern Mexico, so there were important gods of the chase, such as Mixcoatl ("cloud serpent," a Chichimec god) and Camaxtli, as well as an annual ritual hunt carried out in the hills above the Valley of Mexico.

There was a vast Aztec priesthood, since every major temple in the nation, from the Great Temple down to the smallest ones, had a sacerdotal staff. The priests were celibate and studied for the profession in a seminary (calmecac), where they learned the mythology and traditions, the rituals, and the workings of the books in which this knowledge was recorded. Because every priest owed his allegiance not only to the god to whom he was devoted but also to the divine patron of the clergy, Quetzal-

coatl, it is hardly surprising that the two high priests of the Aztec state were given the Quetzalcoatl title. Like their supernatural mentor, the priests practiced the most rigorous fasts and penitences, including the letting of their own blood in honor of the gods.

The antithesis of the clergyman was the sorcerer, the practitioner of the black arts under the patronage of Tezcatlipoca as the supreme wizard. Curers and necromancers, their most powerful medicine was an arm snatched from the corpse of a woman who had died in childbirth.

The omnipotent Tezcatlipoca, who could look into the hearts and thoughts of men with his magic mirror, also played a more positive role as patron of the royal house. The emperor ruled only by the capricious will of the great god, and on taking office he directed humble prayers of this tenor to the "smoking mirror":

O master, O our lord, O lord of the near, of the nigh, O night, O wind, thou hast inclined thy heart. Perhaps thou hast mistaken me for another, I who am a commoner.[16]

The ruler's office was thought to be a crushing burden laid on him by Tezcatlipoca, for he had total responsibility for the well-being of his people.

Notwithstanding the admonitions of the elders and councilors to conduct himself with all humility, the new emperor was to be surrounded with incredible pomp and even to be the subject of strict taboos to the end of his reign. He lived in a luxurious two-story palace adjacent to the sacred precinct; in it were his throne room, the royal arsenal, judicial courts, and a temple or hall devoted to the sciences and music. Bernal Díaz and Cortés were astounded by the royal zoo and aviary, by the botanical and pleasure gardens, and by the host of dancers, buffoons, and jugglers devoted to pleasing their sovereign. From the royal kitchens came every kind of savory dish and innumerable cups of well-frothed chocolate. None could watch while the emperor dined, nor could anyone ever gaze directly at his face.

Sumptuary laws were strict: fine cotton clothes and ornaments of gold, jade, and turquoise were restricted to the nobility, high-ranking warriors, and the royal family. From Sahagún's account and from the europeanized drawings of Texcocan lords in the Codex Ixtlilxochitl (cats. 372, 373) we have a good idea of what a ruler would wear: golden ear ornaments, a labret of cast gold, a cloak, perhaps tie-dyed and embroidered along the edge, a richly embroidered loincloth, and golden sandals. Everywhere the emperor went he was borne in

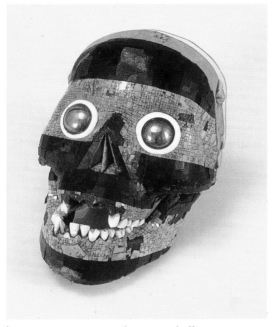

fig. 7. Mosaic-encrusted Human Skull Representing Tezcatlipoca. The eyes are convex pyrite mirrors. This was probably the skull of a sacrificed god impersonator. The Trustees of the British Museum, London

a litter and accompanied by the highest-ranking nobles of his court.

The lively arts flourished in these royal households and were generally held in high esteem among the population. Poetry—metaphorically known as "flowers, songs"—was highly developed and recited to the beat of the teponaztli (two-toned slit drum, cat. 378). Oratory was greatly elaborated; the ability to express one's thoughts in the Nahuatl tongue by employing metaphorical couplets and triplets, along with many honorifics, commanded great respect. There was a complex of gods devoted to the arts and to pleasure in general, chief of whom were Xochipilli ("flower prince"), the god of summertime (cat. 380), and Macuilxochitl ("five flower"), patron of music, dance, and gambling.

The real focus of Aztec life on the eve of the conquest was warfare. Every Aztec boy, unless he was of noble birth and thus qualified for entrance into a seminary, received military training in the telpochcalli under the divine aegis of Tezcatlipoca. Like the squires of medieval Europe, young cadets could accompany seasoned warriors into battle as arms bearers. The Aztec ethos extolled warfare and death on the battlefield or under the sacrificial knife, for the glorious soul of the dead warrior rose to accompany the sun as a beautiful hummingbird. The battleground itself was praised as the "field of flowers," for in Nahuatl metaphor flowers symbolized blood; moreover, a perpetual state of hostility between the empire and

the enemy states of Tlaxcallan and Huexotzinco was glorified as the "flowery war."

The usual proximate cause of a declaration of war was an attack by a foreign state on the long-distance merchants (*pochteca*). There were military orders similar to those into which European knights were organized in the age of chivalry, with eagle warriors (cat. 385) and jaguar warriors the most prominent. Each man-at-arms carried a round feather-covered shield of wood or reeds and either a *macuauhuitl* (a sword of wood edged with razor-sharp obsidian blades) or an *atlatl* (spearthrower, cat. 384) and handful of darts. Aztec armies were accompanied by semibarbarian Otomí bowmen, but no Aztec used this weapon. Attacks were signaled by war cries and accompanied by the din of blown conch shells and whistles; in the ensuing melee, high-ranking officers could be distinguished (as the Spaniards were quick to note) by their magnificent ensigns of reeds, feathers, and other materials that towered above the shoulders. Hand-to-hand combat was the rule, the goal of each warrior being to take and bind a captive for transport to the rear.[17]

While the actual number of captives (and slaves bought for the purpose) sacrificed each year in Tenochtitlan was surely far less than the Spaniards claimed, this was indeed the fate of all those taken in war; their heads ended up on the *tzompantli* (the great skull rack in the sacred enclosure). The ritual was perhaps most poignant in the case of the handsome young war prisoner who was selected to impersonate Tezcatlipoca. Presented with four lovely young women as his mistresses, he was revered as the god himself for one year, at the close of which he was taken to his own temple. There he bade farewell to his paramours and climbed the steps to the summit, where he was seized by four priests and stretched over the sacrificial stone. His heart was torn out and thrown in the *cuauhxicalli* ("eagle bowl"), in honor of the deity in whose place he had stood.

To the Aztecs, death by the obsidian or flint knife was perceived as a form of life, for it was the hearts and blood of brave humans that ensured that the universe would not end, that our own era—4 Motion—would continue for a while more, that Huitzilopochtli as the sun god would blaze forth on the eastern horizon each dawn to bring happiness and survival to his people.

But for the empire created by the lords of Mexico-Tenochtitlan, the universe did indeed end in destruction: on 13 August 1521, after seventy-five days of siege, the great city, bleeding and torn, capitulated to Hernán Cortés. Of all of its marvels and glories, as the veteran Bernal Díaz lamented in his old age, "today all is overthrown and lost, nothing left standing."[18]

NOTES

1. Bernal Díaz del Castillo, *The Conquest of New Spain*, trans. and ed. Alfred P. Maudslay, 6 vols. (London, 1908–1916), 2:37.
2. Hernán Cortés, *Letters from Mexico*, trans. and ed. Anthony Pagden (New Haven and London, 1986).
3. Fray Bernardino de Sahagún, *Florentine Codex, General History of the Things of New Spain*, 12 books (Salt Lake City, 1950–1969).
4. See Eduardo Matos Moctezuma and Felipe Ehrenburg, *Coyolxauhqui*, 2d ed. (Mexico City, 1980), 1–8.
5. Cortés 1986, 102.
6. Discussed in George C. Vaillant, *Aztecs of Mexico* (New York, 1941), 134.
7. For an overview of Aztec society, see Jacques Soustelle, *The Daily Life of the Aztecs* (London, 1961), 36–94.
8. Díaz 1908–1916, 2:78.
9. A succinct but very complete treatment of Aztec religion is Henry B. Nicholson, "Religion in Pre-Hispanic Central Mexico," in *Handbook of Middle American Indians*, ed. Robert Wauchope (Austin, 1971), 10:395–446. A more popular treatment is Alfonso Caso, *The Aztecs: People of the Sun* (Norman, 1953).
10. The best treatment of Aztec philosophy and cosmology is Miguel León-Portilla, *Aztec Thought and Culture* (Norman, 1963).
11. On Mesoamerican calendar systems and on the Aztec calendar in particular, see Alfonso Caso, *Los Calendarios Prehispánicos* (Mexico City, 1967).
12. Soustelle 1961, 101.
13. León Portilla 1963 has many references to the *tlamatinime*.
14. Many books and studies have emanated from the sensational excavations in the Great Temple, among which are Eduardo Matos Moctezuma, *The Great Temple of the Aztecs* (London, 1988); Elizabeth Hill Boone, ed., *The Aztec Templo Mayor* (Washington, 1983); and Johanna Broda, David Carrasco, and Eduardo Matos Moctezuma, *The Great Temple of Tenochtitlan* (Berkeley and Los Angeles, 1987).
15. Thelma Sullivan, "A Prayer to Tlaloc," *Estudios de Cultura Nahuatl* 5 (1965), 42–55.
16. Sahagún 1950–1969, bk. 6:41.
17. Ross Hassig, *Aztec Warfare* (Norman, 1988), is the only comprehensive treatment of the subject.
18. Díaz 1908–1916, 2:38.

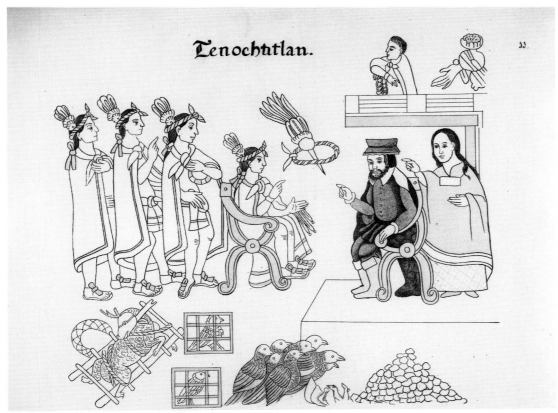

fig. 8. The First Meeting between Cortés and Motecuhzoma. Page from a map and historical record of the people of Tlaxcallan that was painted in early colonial times. Standing at the right is Cortés' interpreter-mistress, Doña Marína. From *Lienzo de Tlaxcala, Antigüedades Mexicanas* (1892)

THE AZTEC GODS—HOW MANY?

Miguel León-Portilla

Nearly all chroniclers of sixteenth-century Mexico—Indians, Spaniards, and mestizos alike—have pondered the great number of gods worshipped by the Aztecs. As if summing up what other chroniclers had declared, Francisco López de Gómara, chaplain of Hernán Cortés, stated in 1552 in his *Conquest of Mexico* that "They affirm there were more than two thousand gods, and that each one of them had his own name, attributes and signs."[1] Today most people who have visited the archaeological sites in Mexico or the museums where Aztec art and culture are represented will agree that there were, if not two thousand, at least more than a hundred Aztec gods. In one sense, this is true; in a contemporary study some hundred celestial, terrestrial, and other deities are identified.[2]

Nevertheless, the continuing study of the few extant pre-Hispanic codices and sacred texts of the indigenous tradition preserved in sixteenth-century sources has prompted questions about this widely accepted image of the "idolatrous" Aztecs, worshippers of gods of rain, wind, earth, sun, moon, harvest, wisdom, dance, death: more gods than man could possibly need. But the real question is whether the Aztec sages and priests ever made an attempt to explain or even to order that plurality of mysterious and powerful beings who received the name of *teotl*, a word curiously reminiscent of the Greek term *theos* (god). Upon closer observation, a hidden unity can be demonstrated behind the complex pantheon of the popular Aztec religion.

Tezcatlipoca, the smoking mirror, was to the Nahuatl-speaking nations, including the Aztecs, the true supreme deity. He was invoked as Ipalnemoani (he by whom there is life) and as Thoqueh, Nahuaqueh (the owner of being close, the owner of being near), or the lord who is everywhere. And Tezcatlipoca was also Yohualli, Ehecatl (night, wind), or invisible and intangible. And he, the smoking mirror, had his own counterpart, Tezcatlanextia (mirror who illumines things).

All this we know through the extant Nahuatl texts where the ancient word *(huehuehtlahtolli)* is preserved.[3] Tezcatlipoca was represented many times on the pages of the pre-Hispanic codices. He appears, for instance, in the *Codex Borgia* in paired form as one and a double, the black and the red Tezcatlipoca, the smoking

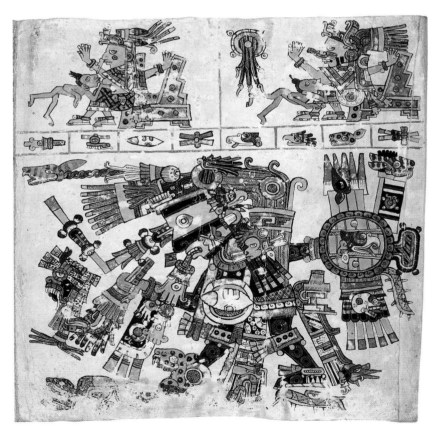

fig. 1. Tezcatlipoca. *Codex Borgia*, page 17. The lower two-thirds of the page shows the supreme deity with the twenty day-signs of the sacred calendar assigned to different parts of his body, clothing, and paraphernalia. In his right hand he grasps a shield and darts, symbolic of his position as god of war, while obsidian mirrors, which appear at his lower leg, over his chest, and at the back of the head, signify his role as the omnipotent magician who could look into the hearts of all who dwell on earth. Biblioteca Apostolica Vaticana

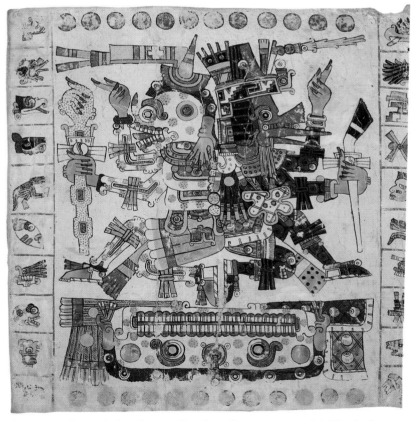

fig. 2. Mictlantecuhtli and Quetzalcoatl. *Codex Borgia*, page 56. The dualism so fundamental to Aztec philosophy can be seen in this image, which shows Mictlantecuhtli, the death god, back-to-back with Quetzalcoatl, the lord of life, over an inverted skull representing the land of the dead. Along the edges are the signs of the twenty thirteen-day weeks that made up the sacred calendar. Biblioteca Apostolica Vaticana

and illumining mirror. Moreover, as lord of the everywhere, he is depicted presiding over one or another of the four cosmic quadrants of the world.[4] As lord of the everywhen, he is present in the first and last pages of the *Codex Fejérváry-Mayer* (cat. 356), the book of destinies, as Tonalamatl consulted by the long-distance merchants *(pochtecas)*. There he appears surrounded by the different cycles of time: the days and the destinies.[5]

Lord of the everywhere and of the everywhen, one and double at once: Tezcatlipoca-Tezcatlanextia, smoking and illumining mirror, receives the same titles, Ipalnemoani, he by whom there is life, and Tloqueh Nahuaqueh, lord of the everywhere and everywhen, which refers to the ultimate reality. In the thought of the Aztec sages and priests he, the one and double at once, is Ometeotl the dual god, whose ultimate abode is Omeyocan, the place of duality. Several texts in the *Florentine Codex* (Biblioteca Medicea Laurenziana, Florence) and in other indigenous sources speak of him.

The dual god Ometeotl is Ometecuhtli, Omecihuatl, dual lord and dual lady, mother and father of whatever exists: Tonantzin, Totahtzin, our revered mother, our revered father, who through a portentous coition give origin to all reality. Thus She-He the supreme, the dual god depicted in the codices beyond the thirteen heavens, was invoked as the ultimate source of life, in the words of an Aztec midwife. After cutting the umbilical cord she washed the newborn and, while so doing, invoked in this manner:

Lord, Our Master,
She of the jade skirt,
He who shines like a sun of jade,
a baby has been born,
sent by Our Mother, Our Father,
Dual Lady, Dual Lord,
She-He who dwells
in the place of Duality.[6]

In popular religious belief all the gods are Her-His children. But the Nahuatl texts and the ancient codices also reveal that, in the thought of the sages, the *teteo*, appearing in pairs or at times even androgynous, are regarded as just as many presences of the supreme dual god. She-He is the mirror who illumines the world and produces the smoke that obscures reality at the end of a cosmic age. She-He, as several texts declare, is Quetzalcoatl, a name meaning feathered serpent and also precious twin, manifestation of the wisdom of the supreme Ometeotl, dual god. Cihuacoatl, feminine twin, our mother, is Quetzalcoatl's counterpart. She-He

appears, in the Aztec epic of creation, at the dawn of our present age, restoring life to the bones of humans who existed in previous cosmic ages.

The codices and texts, including the hymns and poems, provide the evidence. She-He can also appear as the god of the celestial waters, Tlaloc, and as the lady of the terrestrial waters, Chalchiuhtlicue, or as Mictlantecuhtli and Mictecacihuatl, lord and lady of the place of the dead, or as Cinteotl, Xilonen, god and goddess of maize, or as Ehecatl and Mictlantecuhtli, wind-life and death, their backs joined as if they were one person in *Codex Vaticanus 3773*,[7] or as Tlaltecuhtli, androgynous deity of the earth.[8]

As Ipalnemoani, Ometeotl, who is Tezcatlipoca, is fervently invoked by the Aztecs with the name of Huitzilopochtli. The Aztec tutelary god Huitzilopochtli indeed has the attributes of Tezcatlipoca—he is his Aztec alter ego. And it is he who causes the day to exist. So it is proclaimed in a sacred hymn:

Huitzilopochtli, the young warrior!
He who acts above, moving along his way.
Not in vain did I take the raiment of
 yellow plumage,
for it is I who makes the Sun appear.
The portentous One,
Who inhabits the region of clouds...
The Sun spreads out...
come adhere to us.[9]

Huitzilopochtli and Coatlicue, she of the serpent skirt, Tezcatlipoca and Tezcatlanextia, Omecihuatl, Ometecuhtli, dual lady and dual lord, are all manifestations of the supreme dual god, Ometeotl.

Indeed, as in today's Mexico, where the Virgin and Jesus are often invoked with many different names—Virgin of Guadalupe, Remedios, Pilar, Perpetuo Socorro, Salud, Señor de Chalma, de los Milagros, Jesus Nazareno—she, Tonantzin, and he, Totahtzin, in pre-Hispanic times were called and worshipped everywhere and everywhen, differently arrayed, but embodying the same ultimate and divine, dual reality.

The question "The Aztec gods—how many?" can in this manner be answered. The ancient texts of the native tradition give us ample evidence to accept the answer that these plural gods can be interpreted as various manifestations of a dual reality. Is not the ultimate reality our mother, our father, who give life everywhere and everywhen, indeed a beautiful form of approaching the mystery—that which is beyond the wind and the night?

NOTES

1. Francisco López de Gómara, *La Conquista de Mexico* (Madrid, 1986), 461.
2. This is the conclusion reached by Henry B. Nicholson in "Religion in Pre-Hispanic Central Mexico," in *Handbook of Middle American Indians*, ed. Robert Wauchope (Austin, 1971), 10:408–430.
3. One collection of *huehuehtlahtolli* is included in Fray Bernardino de Sahagún, *Florentine Codex, General History of the Things of New Spain*, 12 books (Salt Lake City, 1950–1969), book 6.
4. *Codex Borgia*, commentary by Karl Anton Novotny (Graz, 1976), 21.
5. This pre-Hispanic book has been published in facsimile under the title *Tonalamatl de los Pochtecas (Codex Fejérváry-Mayer)*, commentary by Miguel León-Portilla (Mexico City, 1985).
6. Sahagún 1950-1969, book 6, fol. 148 v.
7. *Codex Vaticanus 3773*, introduction by Ferdinand Anders (Graz, 1972), 75.
8. A more detailed and documented presentation of the multiple manifestations of the divine dual reality is found in Miguel León-Portilla, *Aztec Thought and Culture, A Study of the Ancient Nahuatl Mind* (Norman, 1982), 90-103.
9. Angel Ma. Garibay has published a translation, accompanied by a commentary, of these hymns in *Veinte Himnos Sacros de los Nahuas* (Mexico, 1958), 31.

THE TAÍNOS: PRINCIPAL INHABITANTS OF COLUMBUS' INDIES

Irving Rouse
José Juan Arrom

After a thirty-three-day crossing from the Canary Islands, Christopher Columbus' small fleet sighted land two hours after midnight on Thursday 12 October 1492. Following the coast until daylight, Columbus and his men observed people on land and went ashore to claim this territory for the Spanish crown. The island in the Bahamian archipelago on which they first set foot was called Guanahaní in the local language. Columbus renamed it San Salvador, and it was most probably the outlier that bears this name today.[1]

The landing was so momentous an event that Fray Bartolomé de Las Casas, whose abstract of Columbus' lost journal is our best source for the narrative of his first voyage, switched abruptly from the third person to "the very words of the Admiral in his book" to describe the meeting with the local inhabitants:

> In order that they would be friendly to us—because I recognized that they were people who would be better freed [from error] and converted to our Holy Faith by love than by force—to some of them I gave red caps, and glass beads which they put on their chests, and many other things of small value, in which they took so much pleasure and became so much our friends that it was a marvel.... But it seemed to me that they were a people very poor in everything.[2]

Columbus believed that he was greeting the natives of an island somewhere in the vicinity of Japan. In fact, he had encountered a people who have become known as the Taínos[3] and whose brief recorded history is intimately linked with his exploration of the islands that were to become known as the West Indies.

Recognizing the great importance to Ferdinand and Isabella of this first contact with the native population, Columbus recorded the appearance and character of these "Indians" in considerable detail:

> All of them go around as naked as their mothers bore them.... They are very well formed, with handsome bodies and good faces. Their hair [is] coarse—almost like the tail of a horse—and short.... Some of them paint themselves with black...and some of them paint themselves with white, and some

of them with red, and some of them with whatever they find.... They do not carry arms nor are they acquainted with them, because I showed them swords and they took them by the edge and through ignorance cut themselves. They have no iron.[4]

The nakedness of the Taínos who occupied the islands away from the Taíno heartland in Hispaniola evidently aroused great interest in Europe, as it is the only detail of Columbus' account that appears in the illustrations in the earliest printed editions of his letter to Ferdinand and Isabella in 1492.

Columbus must have been surprised and extremely disappointed by the utter absence on Guanahaní of the riches that Marco Polo's account of the Far East had led him to expect. Nevertheless he was clearly charmed by the Taínos' innocence. And yet, even at this first encounter, Columbus allowed himself to think ahead to the Taínos' possible utility to the crown and thereby, as we shall see, sealed their fate:

> I saw some who had marks of wounds on their bodies and I made signs to them asking what they were; and they showed me how people from other islands nearby came there and tried to take them, and how they defended themselves; and I believed and believe that they come here from *tierra firme* to take them captive. They should be good and intelligent servants, for I see that they say very quickly everything that is said to them; and I believe that they would become Christians very easily, for it seemed to me that they had no religion. Our Lord pleasing, at the time of my departure I will take six of them from here to Your Highnesses in order that they may learn to speak.[5]

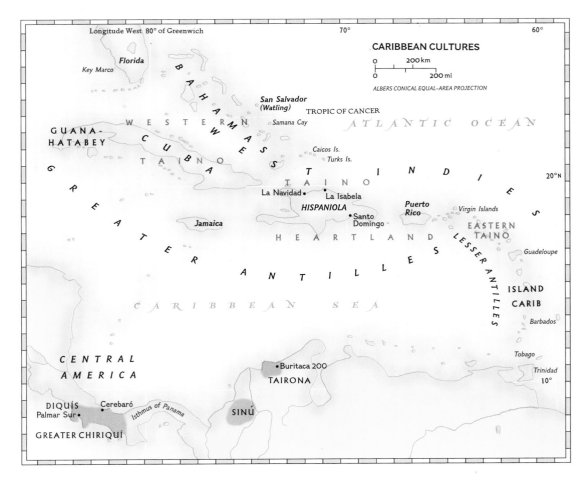

Two days later he noted in his journal, for the benefit of his sovereigns: "These people are very naive about weapons.... with 50 men all of them could be held in subjection and can be made to do whatever one might wish."[6]

Columbus' route led him right toward the more highly developed Taíno heartland. His itinerary was dictated by his pressing need to locate the gold which, from his researches, he believed was available in abundance in Japan, the island Marco Polo had called "Cipango." On 13 October he wrote:

I was attentive and labored to find out if there was any gold; and I saw that some of them wore a little piece hung in a hole that they have in their noses. And by signs I was able to understand that, going to the south or rounding the island to the south, there was there a king who had large vessels of it and had very much gold.... And so I will go to the southwest to seek gold and precious stones... I want to go to see if I can find the island of Cipango.[7]

This search for gold took Columbus from the Bahamas to eastern Cuba, which he believed to be a peninsula attached to the Chinese mainland, and thence to the island of Hispaniola.

Columbus would not abandon the misconception that he was somewhere off the coast of China, possibly in the China Sea that Marco Polo had described as dotted with 7,448 islands, most of them inhabited.[8] When his Taíno guides described their enemies, the Caribs, as the people of "Caniba," Columbus [11 December 1492] recognized them immediately as the subjects of the Chinese emperor: "And thus I say again how other times I said... that Caniba is nothing else but the people of the Grand Khan, who must be here very close to this place."[9] He was also aware that he might be in the spice

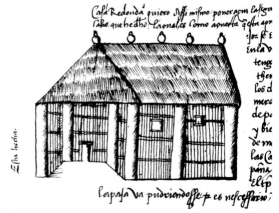

fig. 1. Gonzalo Fernández de Oviedo y Valdés, Taíno Dwelling. Drawing from *Historia general y natural de las Indias*, 1: fol. 4r, manuscript. Huntington Library, San Marino

islands or Indies, about which he had learned from classical literature and from medieval travel accounts.[10]

On Christmas Eve of 1492 Columbus' flagship, the *Santa María*, struck a reef and sank near the present city of Cap Haitien in northern Haiti. With materials salvaged from that ship he erected a fort, naming it La Navidad, and left there the sailors unable to crowd into his two remaining vessels. He returned to Spain by way of the northern coast of the Dominican Republic, where one of his captains had been able to verify the presence of gold.

His finds aroused great enthusiasm in Spain. He presented the six Taíno captives he had brought back with him to Ferdinand and Isabella when he first reported to them in Barcelona in April 1493. In the initial enthusiasm for Columbus' discovery, these Taínos were treated as celebrities: they were baptized, with the king, the queen, and the infante Don Juan acting as godparents, and one of them remained attached to the royal household until his death two years later. Peter Martyr d'Anghiera, a Milanese humanist at the Spanish court whose writings helped to spread news of the New World throughout Europe, immediately connected the Taínos with classical accounts of the Golden Age, in which early man lived in innocence, without property or social controls, in complete happiness.[11]

For his second voyage, in the fall of 1493, Columbus was provided by the crown with a large fleet manned by 1,500 men. This time he sailed a more southerly route to the Lesser Antilles, because his Taíno pilots had told him that its islands extended out into the Atlantic Ocean, making possible a shorter crossing. He stopped at Guadeloupe, which he found to be occupied by Island-Caribs, the southern neighbors of the Taínos.[12] Rescuing several Taíno women who were being held captive there, he took them back to their homeland in Puerto Rico and proceeded to La Navidad in Hispaniola, only to find that all the men he had left there had been killed by the local Taínos. He then turned his attention to the goldfield in the northern part of the Dominican Republic and established a base, which he named Isabela, from which to exploit the field, hoping, though as it turned out, vainly, that significant quantities of gold could be produced. Having thus fulfilled the crown's instruction to found a new colony, he resumed his search for a passage to the Chinese mainland, sailing westward to Cuba and exploring its south coast until he passed from Taíno territory into that of a people known as Guanahatabeys.[13] He halted shortly before reaching the far end of the island and returned to Isabela by way of Jamaica and the eastern tip

of Hispaniola, believing that he had shown Cuba to be a peninsula leading to China.

On his third (1498–1500) and fourth (1502–1504) voyages, this time seeking a more southerly passage through the islands to the Indies, Columbus reached Trinidad, just off the coast of South America and the southern part of Middle America including present-day Costa Rica and Panama, encountering Indians different from those he knew in the Antilles. He died in Valladolid, Spain, in 1506, never realizing that he had reached not the Far East, but a New World undreamed of by the classical geographers whose works provided the basis for his "enterprise of the Indies."

In the journal of his first Caribbean voyage Columbus left accurate descriptions of the landscape the Taínos inhabited, their physical appearance, and some of their customs. Wishing to know more about their culture, he commissioned Fray Ramón Pané, who accompanied him on his second voyage, to make a study of the religious rituals and beliefs on the island of Hispaniola. Pané spent four years among the Taínos, learning their language by listening to their stories and their songs, and prepared a report entitled *Relación acerca de las antigüedades de los indios* ("Report about the antiquities of the Indians"), which he submitted to Columbus around 1498. In it he faithfully recorded his observations and the statements that had been made to him, showing none of the prejudices that characterized the accounts of the more militant Christians.

Father Pané's report was read by three contemporary authors—Peter Martyr d'Anghiera, Fray Bartolomé de Las Casas, and Columbus' son Fernando, all of whom made use in their own writings of the information it contained. An inadequate Italian translation of the report was published in 1571, after which the original was lost. Arrom has reconstructed it by translating the Italian version back into Spanish, collating it with the information cited by Peter Martyr, Las Casas, and Fernando Columbus, correcting errors, and studying the meaning of the Indians' own words for the nature and attributes of their deities as recorded by Pané. Other sixteenth-century observers, such as Gonzalo Fernández de Oviedo y Valdés, have also contributed to our knowledge of Taíno culture.[14]

Further information about the Taínos has been difficult to obtain. They were not literate, and their culture disappeared by the mid-sixteenth century, too soon for their oral traditions, customs, and beliefs to be recorded in detail. Nevertheless, archaeologists and linguists have been able to confirm and correct the accounts of the conquistadors and to learn

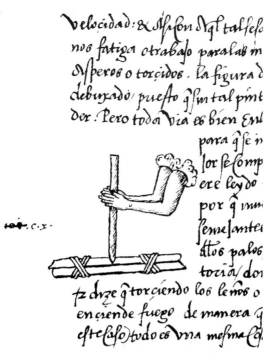

fig. 2. Gonzalo Fernández de Oviedo y Valdés, Loincloth. Drawing from *Historia general y natural de las Indias*, 1: fol. 5v, manuscript. Huntington Library, San Marino

fig. 3. Gonzalo Fernández de Oviedo y Valdés, Taíno Ax. Drawing from *Historia general y natural de las Indias*, 1: fol. 7v, manuscript. Huntington Library, San Marino

fig. 4. Gonzalo Fernández de Oviedo y Valdés, Firedrill. Drawing from *Historia general y natural de las Indias*, 1: fol. 9r, manuscript. Huntington Library, San Marino

more about Taíno lifeways. Until recently this research was concentrated in the Taíno heartland. Relatively little is known about conditions among the outlying Taínos, who inhabited the Bahamian Archipelago, most of Cuba, Jamaica, and the northern part of the Lesser Antilles. Efforts are being made to correct this lack of information.[15]

According to Pané, the heartland Taínos believed that they had emerged from a cave in a sacred mountain on Hispaniola and that their neighbors had come from a smaller cave nearby; there was evidently no tradition of a migration from another place. In fact, archaeologists have traced all the native West Indians back to the mainland. The first to arrive were the ancestors of the Guanahatabeys, consisting of two different groups who migrated from Middle America and South America into the Greater and Lesser Antilles during the fourth and second millennia B.C. respectively. The ancestors of the Taínos, known to archaeologists as the Saladoid peoples, migrated from South America to the Lesser Antilles and Puerto Rico during the first centuries B.C., replacing the earlier inhabitants, but did not continue through Hispaniola to Cuba until around A.D. 600, by which time they had evolved into a people whom archaeologists call Ostionoids. The Ostionoids gradually pushed the earlier inhabitants of Cuba back to the western end of the island. The origin of the Island-Caribs is uncertain. According to their traditions, they were descended from Carib warriors who had

left the South American mainland shortly before the time of Columbus and had conquered the southernmost Antilles.

There is reason to believe that both the Saladoids and their Ostionoid descendants spoke languages belonging to the Arawakan family, which is still widely distributed through northeastern South America.[16] The Saladoids were the first inhabitants of the West Indies to live in permanent villages, farm, make pottery, and worship the deities that the Taínos were later to call zemis. The Ostionoids, developing all these practices further, organized themselves into chiefdoms and evolved into the Taínos around A.D. 1200.

When Columbus reached the Taíno heartland he found its inhabitants living in large permanent villages, each composed of family houses grouped around a plaza. They practiced an advanced form of agriculture, growing two root crops, cassava and sweet potato, in large mounds known as *conuco*. They also cultivated corn or maize (the latter term in fact derives from the Taíno language), peanuts, pineapples, cotton, tobacco, and other indigenous plants, using irrigation where necessary. Ironically, while Columbus searched vainly through the Antilles for the precious spices and medicinal plants of the East Indies, which of course were not present, these humbler vegetables and plants, many of which the conquistadors took back to Spain from Hispaniola, turned out to be among the most important of the New World's agricultural gifts to the Old.[17]

The Taínos were expert potters, weavers, and carvers of wood, stone, bone, and shell. They created a distinctive form of art, combining motifs that their Saladoid ancestors had brought from South America with aspects of the art that the previous inhabitants of the Greater Antilles had developed from their Middle American background.[18] The Taínos of the heartland wore breechcloths or aprons and were fond of feather ornaments. They could not cast metals, but they were able to inlay their carvings with gold leaf and shell plates. Their chiefs obtained pendants made from a copper and gold alloy (*guanín*) through trade with South America.

Hispaniola and the rest of the Taíno heartland were ruled by hierarchies of regional, district, and village chiefs (*caciques*). They lived alongside the village plazas, generally in rectangular thatched houses (*bohío*), which contrasted with the round houses (*caney*) of the ordinary people. The *caciques* received visitors seated on carved wooden stools (*duhos*, cat. 411), while their attendants stood, crouched, or reclined in hammocks. Each village was also served by priests and medicine men (*behique*) and was divided into two social classes (*nitaíno* and *naboría*), which the Spaniards equated with their own nobles and commoners.

According to Pané, the Taínos worshiped deities called zemis. Foremost among them was Yúcahu Bagua Maórocoti ("giver of cassava," "master of the sea", "conceived without male intervention"). Arrom has connected this central deity with the distinctive three-pointed

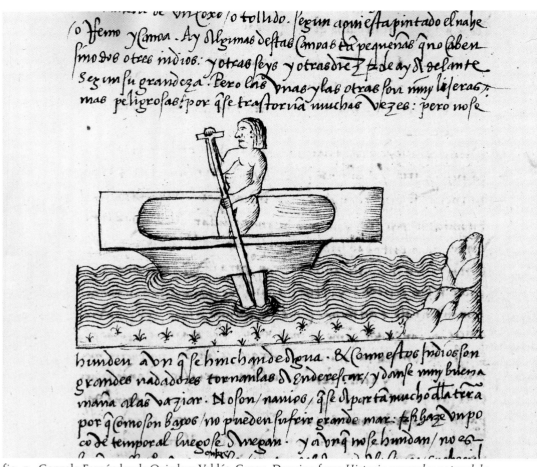

fig. 5. Gonzalo Fernández de Oviedo y Valdés, *Canoe.* Drawing from *Historia general y natural de las Indias*, 1: fol. 8r, manuscript. Huntington Library, San Marino

objects that are a mainstay of the Taíno art (cat. 412) and appear in simpler form as far back as Saladoid time. Yúcahu's mother, Atabey, was goddess of the moon, tides, and springs and protectress of women in childbirth.

The Taínos applied the term *zemi* to a number of other deities and to the objects they carved to portray them. For example, Boinayel and Márohu were twin gods of rain and fair weather, respectively. Another male zemi, Baibrama, presided over the production and consumption of cassava. The Taínos grated the fleshy roots of that plant and squeezed out their poisonous juice before processing them into a kind of bread, which they prized because it kept especially well in the hot and humid tropical climate.

Still another male zemi, Maquetaurie Guayaba, was lord of the land of the dead. He sent the owl to announce to a family that one of its members was soon to die, a belief that survives in the folklore of the Spanish West Indies. The zemis also included spirits that lived in trees, caves, or other features of the landscape.

Arrom has pointed out that some of the objects depicting zemis have features that can be related to the characteristics of specific gods.

For example, the threatening features of certain statuettes may be those of Baibrama in his role of enforcing the taboo against eating the cassava root before extracting its deadly juice. The cadaverous head with empty eye sockets and large leathery lips of another type of zemi may indicate that it depicts Maquetaurie Guayaba.[19]

The statuettes of the zemis were kept not only in homes but also in caves. Chiefs derived much of their power from their zemis. Some rulers owned so many of these statuettes that they had to erect separate buildings in which to house them. The Taínos believed that the spirits of the deceased were transported to the land of the dead whence they could return to their households and influence the welfare of the surviving occupants. Consequently, the Taínos worshiped their ancestors to ensure success and to avoid misfortune. They sometimes kept the bones of ancestors in elaborately decorated funeral urns or wrapped them in cotton cloth, but more often put them in baskets (*jaba*), which they hung in their homes. As time passed these receptacles decomposed and the bones were deposited in the refuse, leading some archaeologists to conclude that the Taínos practiced cannibalism.

Before worshiping, the Taínos induced vomiting to purify themselves (cat. 416–417). They inhaled narcotic powder (*cohoba*) through tubes of wood or bone (cat. 418) in order to induce hallucinations, which they interpreted as messages from their deities.[20] Vomiting spatulas and sniffing tubes were often carved with representations of zemis, as were many kinds of household furnishings and personal ornaments.

The Taínos danced and sang communally in their plazas, accompanying themselves with drums and rattles. They commemorated past events in the songs (*areítos*), thanked their gods, and prayed for success in future endeavors. Villagers in the heartland also held ceremonies in roadways and on more-or-less rounded courts, which they constructed by leveling fields, raising embankments, making stone pavements, and setting up stone slabs that were occasionally decorated with carvings depicting zemis.

The Taínos played their version of the ball game known throughout tropical America. In the heartland they built rectangular courts (*batey*) for the purpose, some of which appear to have been situated on the boundaries between chiefdoms. The balls made of rubber amazed the Spaniards, who had never seen such resilient material. Players wearing wooden or stone belts to protect themselves were allowed to hit the ball with any part of the body except the hands. The stone belts, also limited to the heartland, were elaborately carved with figures of zemis and geometric motifs (see cat. 420). As in Middle America, the thickest specimens are too heavy to wear and must have been purely ceremonial.[21]

The Taínos were the first native Americans to come into contact with the Europeans, and they bore the brunt of the early phase of the conquest. Relatively few died in military confrontations, for they soon realized that their simple wooden clubs (*macana*) and wood-tipped spears or arrows were no match for the steel swords and lances, the horses and dogs trained for warfare, and the firearms of the conquistadors.

The Taínos who submitted to Spanish rule were put to work in gold mines, ranches, or households. Most were assigned to individual Spaniards in a system of forced labor called *encomienda* in which they remained under the leadership of their village chiefs and were supposed to be allowed to return to their homes periodically for rest and relaxation. In practice, however, they were often overworked and poorly fed, and many died from exhaustion and malnutrition or committed suicide by hanging themselves or drinking cassava juice. They also suffered severely from European diseases, to which they lacked immunity. In 1518 an epi-

demic of smallpox killed almost half the remaining population.[22]

Assimilation also played an important role in the Taínos' disappearance. There was such a shortage of European women in the colony that its men married Taíno women, often in the church and with the approval of the authorities. These women were absorbed into the dominant Spanish society; their children were neither Indians or Spaniards but forerunners of a new *mestizo* population.[23]

Some Taínos escaped into the thickest woods, where they were able to survive for a time, but eventually became absorbed into the Spanish population. The escapees were called *indios alzados* and later *cimarrones*, a term which was shortened to *maroon* in English. Others fled to neighboring islands not yet controlled by the Spaniards, where they, too, were eventually engulfed by the wave of conquest. A few took refuge among the Island-Caribs, who were able to maintain their independence until the British, Dutch, and French subdued them during the seventeenth and eighteenth centuries.

With the conquest of the Aztec empire in the 1520s and the Inka empire in the 1530s, the Spanish crown lost interest in the West Indies. By that time, however, a viable colony had been established in Hispaniola, Puerto Rico, and Cuba. From this base the colonists depopulated the other Taíno islands, seeking workers to replace the dwindling number of *encomiendas* in their midst, and they further broadened their pool of labor by importing slaves from all parts of the Caribbean mainland and from Africa. By 1550 the remaining *encomiendas* had been absorbed into the new *mestizo* society, and the Taínos had ceased to exist as a separate people.

NOTES

1. Columbus and his companions did not record enough information for scholars to be able to identify his landfall precisely. The possibilities are summarized in Donald T. Gerace, *Proceedings, First San Salvador Conference, Columbus and His World, Held October 30–November 3, 1986* (Fort Lauderdale, 1987). We have used the version of Columbus' routes presented by Samuel Eliot Morison in *Admiral of the Ocean Sea: A Life of Christopher Columbus* (2 vols., Boston, 1942).

2. Oliver Dunn and James E. Kelley, Jr., *The Diario of Christopher Columbus' First Voyage to America, Abstracted by Fray Bartolomé de Las Casas* (Norman, 1989), 65.

3. The term *Arawak* is often inaccurately used in place of *Taíno*, especially in the British West Indies. The people who called themselves Arawaks were limited to the area around the mouth of the Orinoco River. See Irving Rouse, *The Tainos: Rise and Fall of the People Who Greeted Columbus* (New Haven, forthcoming).

4. Dunn and Kelley 1989, 65–67.

5. Dunn and Kelley 1989, 67–69.

6. Dunn and Kelley 1989, 75.

7. Dunn and Kelley 1989, 71–73.

8. Marco Polo, *The Travels*, trans. Ronald Lathem (Harmondsworth, 1958), 248.

9. Dunn and Kelley 1989, 217.

10. *Journals and Documents on the Life and Voyages of Christopher Columbus*, trans. and ed. Samuel Eliot Morison (New York, 1963), 21–23.

11. Antonello Gerbi, *Nature in the New World: From Christopher Columbus to Gonzalo Fernández de Oviedo*, trans. Jeremy Moyle (Pittsburgh, 1986), 53–54.

12. The Taínos employed the term *Carib* generically to refer to the inhabitants of all the small islands to the east and south of Puerto Rico, regardless of their cultural affiliation, and the Spaniards followed suit. Archaeological research has shown that the protohistoric people of the Virgin Islands and most of the Leeward group had the Taínos' culture, if not also their language. See Louis Allaire, "The Archaeology of the Caribbean," in *The World Atlas of Archaeology* (Boston, 1985), 370–371, and Rouse, forthcoming.

13. The Guanahatabeys are often called Ciboneys, but ethnohistorical research has shown that the latter term actually applies to a group of Taínos in central Cuba. See Ricardo E. Alegría, *El uso de la terminología etno-histórica para designar las cultures aborígenes de las Antillas* (Cuadernos Prehispánicos, Valladolid, 1981).

14. José Juan Arrom, *Fray Ramón Pané, Relación acerca de las antigüedades de los indios: El primer tratado escrito en América*, 8th edition (Mexico City, 1988).

15. For summaries of the archaeological and linguistic research see Rouse, *Migrations in Prehistory: Inferring Population Movement from Archeological Remains* (New Haven, 1986), 126–151 and Rouse, forthcoming.

16. Linguists have been able to identify the language spoken at the time and in the places occupied by the Saladoid peoples and to assign it to the Arawakan family. They have concluded that it diverged into Igneri in the southern part of the Lesser Antilles and into Taíno in the rest of the islands (Rouse, forthcoming, fig. 9).

17. Carl Ortwin Sauer, *The Early Spanish Main* (Berkeley and Los Angeles, 1966), 37–79; Alfred W. Crosby, Jr., *The Columbian Exchange: Biological and Cultural Consequences of 1492* (Westport, Conn., 1972), 165–207.

18. Rouse 1986, 116; Rouse, forthcoming.

19. For more information about the zemis and their worship, consult José Juan Arrom, *Mitología y artes prehispánicas de las Antillas*, segunda edición, corregida y ampliada (Mexico City, 1989).

20. The practice of inhaling *cohoba* powder goes back to Saladoid time (Rouse, forthcoming). The Taínos produced it from the seeds of a tree endemic to their heartland (Arrom 1988, 19–20).

21. Our knowledge of the Taínos' courts and their uses is summarized by Ricardo E. Alegría in *Ball Courts and Ceremonial Plazas in the West Indies*, Yale University Publications in Anthropology 79 (1983).

22. Sauer 1966, 203–204; Rouse, forthcoming.

23. Arrom makes these points in more detail and with ample documentation in *Las dos caras de la conquista: De las opuestas imágenes del otro al debate sobre la dignidad del indio* (Madrid, forthcoming).

fig. 1. Albrecht Dürer, Psalm 24, *Book of Hours of Maximilian.* Fol. 41r. Bayerische Staatsbibliothek, Munich

EARLY EUROPEAN IMAGES OF AMERICA: THE ETHNOGRAPHIC APPROACH

Jean Michel Massing

In the royal palace in Brussels Dürer saw the "jewels, shields and clothing" that had been sent, together with six Aztecs, by Hernán Cortés to Charles v in 1519. Dürer's reaction to the Aztec antiquities, which he saw between 27 August and 2 September 1520, is well known, as he recorded it at length in the diary of his journey to the Netherlands: "I saw the things which have been brought to the King from the new land of gold, a sun all of gold a whole fathom broad, and a moon all of silver of the same size, also two rooms full of the armour of the people there, and all manner of wondrous weapons of theirs, harnesses and darts, very strange clothing, beds and all kinds of wonderful objects of human use, much better worth seeing than prodigies. These things are all so precious that they are valued at a hundred thousand florins. All the days of my life I have seen nothing that rejoiced my heart so much as these things, for I saw amongst them wonderful works of art, and I marvelled at the subtle *Ingenia* of people in foreign lands. Indeed I cannot express all that I thought there."[1] Dürer's tone and the astonishment he found so difficult to express probably reflect a genuine admiration, not only for the exotic character and the monetary value of the objects, but also for their craftsmanship and their sheer beauty. After having been exhibited in the Casa de la Contratación in Seville and later in Valladolid, the Aztec artifacts had been brought to Brussels and displayed there at the time of Charles v's coronation in Aachen.

There can be no doubt that the gifts that Motecuhzoma had sent to Cortés had already aroused great attention among Europeans in both Mexico and Spain. A list of them was made before they were dispatched to Spain, and they are mentioned and described by Bernal Díaz del Castillo, Andrés de Tápia, Francisco de Aquilar, and various anonymous Spaniards who saw them before they left Mexico.[2] In Spain too they were widely praised. Like virtually everyone who saw them, Bartolomé de Las Casas, who was to become the great defender of the native Americans, was impressed by the golden and silver discs some two yards wide. Peter Martyr d'Anghiera, who viewed them in Seville, provided an interesting description as did Fran-

cisco López de Gómara in 1553, the latter writing of "two thin wheels, one of silver . . . with the figure of the moon [on it], and the other of gold . . . made like the sun, with many decorations and animals in relief, a very beautiful work. They hold these two objects in that land as gods, and make them of the colour of metal they resemble."[3]

The identification of the two discs as sun and moon seems to stem from the traditional relation between planets and metals found in Western astrological and alchemical writings: the Aztec objects, in short, were interpreted in European terms.[4] Similarly, Bartolomé de Las Casas identified Aztec textiles as "cloth of Aras or Verdure of marvelous workmanship."[5] And yet to Francisco Javier de Clavijero, writing some two centuries later, the two discs were unquestionably Aztec calendars,[6] the wheel in gold representing the image of their century, that of silver the figure of their year.[7] Dürer and his European contemporaries, without insight into Aztec culture, could not grasp the symbolic meaning of the objects presented to Cortés. Such knowledge was to come from Fray Bernardino de Sahagún that the various costumes handed over to Cortés were those of the god Quetzalcoatl in two aspects, Tezcatlipoca and Tlaloc.[8] For Dürer the "sun" and "moon" discs may even have appeared to be hieroglyphics, similar to those he had sketched with pen and ink in 1513 for Willibald Pirckheimer's translation of the *Hieroglyphica*, the original although spurious Greek treatise purporting to be a key to the Egyptian language written by an anonymous author, Horapollo, in late antiquity.[9] Dürer's drawing representing the sun, the moon, and a basilisk[10] illustrates the chapter *Quomodo aeuum designetur* (how time is shown); there Horapollo stated that when the Egyptians intended to symbolize eternity, they drew the sun and the moon because they are eternal elements.[11] The European reaction to the Aztec treasures is a typical response to objects outside their original context. Even the most sympathetic viewers — and Dürer was one of them — could only try to accommodate them to their own system of values. This same misunderstanding characterizes the first images of native Americans that appear in European art.

That Dürer was deeply interested in the exploration of America cannot be doubted. When he added marginal illustrations to Emperor Maximilian's *Book of Hours*,[12] he drew a native Brazilian on folio 41 to illustrate Psalm 24.1: "Domini est terra et plenitudo eius orbis terrarum et universi qui habitant in eo" (The earth is the Lord's and the fullness thereof; the world, and they that dwell therein).[13] The text of the prayer book, which was arranged according to Maximilian's specifications, was printed by Johannes Schonsperger in Augsburg, with colophon dated 13 December 1513. Of the six copies still extant, one, now divided between Munich and Besançon, has marginal drawings by various German artists, including Dürer, who set the pattern for the decoration and completed the first ten consecutive quires except the very first, which was left without decoration. These drawings were probably intended as a model for a prayer book with printed margins which, like many of Maximilian's ambitious artistic projects, was never completed. On folio 41 the border decoration in violet ink is signed with Dürer's monogram and dated 1515. The Brazilian Indian and the accompanying birds and snail symbolize the fullness of the earth, while the imperial coat of arms signifies the emperor's temporal power over it. The fish seem, like the American native, to have a special relevance, as the text of Psalm 24 continues on the next page: "quia ipse super maria fundavit eum: et super flumina praeparavit eum" (for he hath founded it upon the seas, and established it upon the floods).[14]

Brazil was discovered on 22 April 1500 by a Portuguese fleet commanded by Pedro Alvares Cabral. Already on this first visit the sailors collected natural artifacts and curios. Pero Vaz de Caminha, in a letter to King Manuel 1, reported how "The Indians traded bows for sheets of paper. . . . They brought back many bows and headdresses of birds' feathers, some green and some yellow."[15] At the time of the Portuguese landing, the Tupi-speaking tribes, which had moved from the Paraguay Basin, had progressively driven the Tapuya from the coastal areas inland. The Tupinikin and Tupinamba were bellicose peoples involved in constant vendettas, taking captives and killing

prisoners.[16] Tupinamba hunters fought with long bows and arrows. Dürer represented his Indian with another characteristic weapon, a ceremonial war club of hardwood with a long rounded handle decorated with feathers fastened in the knots of a cotton net and with a flattened, round or slightly oval blade with sharp edges. It is not known where or when Dürer may have seen Tupinamba artifacts, but we can establish that his rendition of the club is accurate on the basis of a surviving example that reached Europe later, though perhaps still in the sixteenth century. The club he drew is quite similar to a specimen now in the Musée de l'Homme in Paris, which is perhaps the club of the Tupinamba chief Quoniambec, a weapon brought back from Brazil by André Thevet in 1555 or 1556.[17] Dürer evidently had no idea of the function of this kind of club and lengthened it into a lance. This proves that he certainly never saw a Tupinamba warrior but that he was acquainted with the weapon only. His human model, in any case, has no native American features and poses in contrapposto, like a classical figure. He also wears a feather cloak as though it were a skirt (the Tupinamba, in fact, went practically naked).[18] Dürer derived his short feather skirts from German broadsheets.[19] Dürer also gave his figure necklaces and bracelets of feathers, with beads perhaps of wood, shell, or bone typical of Brazilian natives, as well as a round leather shield of non-European origin.[20] The cap, too, seems to be a real Tupinamba bonnet of small feathers fastened in the knots of a cotton net. Brazilian natives, however, wore no shoes nor did they have ladles carved of horn, the strange object on which Dürer's figure stands.[21]

Dürer's concern about people of foreign lands extended to the state of their souls. False rumors about Martin Luther's abduction and possible death prompted Dürer to comment in his diary that he hoped that Luther's example would be followed and "that we may again live free and in the Christian manner, and so, by our good works, all unbelievers, such as Turks, Heathen, and Calicuts, may of themselves turn to us and embrace the Christian Faith."[22]

Dürer's meticulous but not always accurate illustration in the emperor's prayer book can be compared to the Indians that Hans Burgkmair introduced into the *Triumph of Maximilian*, the woodcut pageant conceived by the emperor himself in 1512 and devised in detail by Marx Treitz-Saurwein, his secretary. Half the woodcuts were designed by Burgkmair, the others by Albrecht Altdorfer, Leonard Beck, Wolf Huber, Hans Schäuffelein, Hans Springinklee, and, of course, Dürer.[23] In this gigantic triumphal procession, which was never completed, the people of Calicut appear just before the baggage train: "After [the knights] shall come a man of Calicut (naked, with a loin cloth), mounted and carrying a verse inscription, wearing a laurel wreath; on the plaque shall be written these words: 'These people are subject to the previously shown praiseworthy crowns and houses.'" Verses were also planned:

> The Emperor in his warlike pride,
> Conquering nations far and wide,
> Has brought beneath our Empire's yoke
> The far-off Calicuttish folk.
> Therefore we pledge him with our oath
> Lasting obedience and troth.

The scheme continues: "Then shall come on foot the people of Calicut. (One rank with shields and swords. One rank with spears. Two ranks with English bows and arrows. All are naked like Indians or dressed in Moorish fashion). They shall all be wearing laurel wreaths."[24] In Maximilian's time the generic term Calicut was not restricted to India, but referred to the inhabitants of all the newly discovered lands, including native Americans. Until Magellan's trip around the world and even later, America was considered part of the Asian continent.[25]

The two woodcuts signed by Burgkmair show an oriental on his elephant followed by more or less exotic natives. No detail in the first print alludes to America. In the second, some of the men wear feather headdresses and one of them probably sports a feather bonnet as in Dürer's drawing.[26] The "skirts" in feather, too, are Indian, but are a misinterpretation of cloaks. Although American Indians sometimes did wear cotton garters trimmed with feathers under their knees, Burgkmair's version of them has a decidedly European appearance.[27] Such details of Burgkmair's woodcut as the knots of the bowstrings would suggest that he based his observations on European arms rather than upon the bows and arrows that were widely used by Brazilian natives, including the Tupinamba.[28] The steel ax is also European, as preconquest Indians only had axes of stone.[29]

Typically Indian however are the Tupinamba war clubs (*tacape*), with a round or oval flat head at the end of a long shaft and handle decorated with feathers and tassels.[30] More people from the newly discovered countries are found in a woodcut from the baggage train of the *Triumph*, also by Burgkmair. Two of them, one with a small ape and the other with a macaw, have feather skirts and headdresses. Undeniably American are the corn shafts.[31]

fig. 2. Tupinamba War Club. Musée de l'Homme, Paris

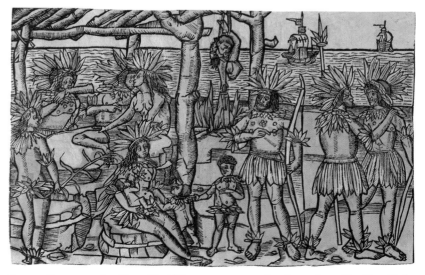

fig. 3. German artist, *New World Scene*. c. 1505, colored woodcut. The New York Public Library, Spencer Collection, Astor, Lenox and Tilden Foundations

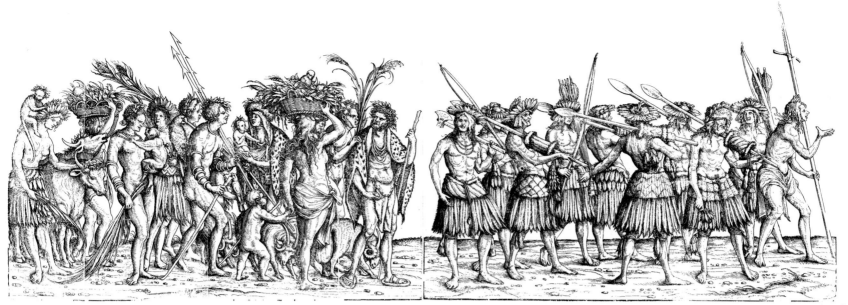

fig. 4. Hans Burgkmair, *The Triumph of Maximilian*. c. 1517–1518, woodcut. Graphische Sammlung Staatsgalerie Stuttgart detail

Dürer's and Burgkmair's approach reflects a transitional stage in the depiction of American natives in which artifacts are rendered more or less exactly but often without a proper awareness of their function. The effect is often composite, a mixture of elements from different cultural contexts. This is especially true for two drawings made by Burgkmair after 1519 that integrate Brazilian and Aztec elements (cat. 405).[32]

It is a pity that Dürer's and Burgkmair's drawings were done in monochrome,[33] as color would have helped us to identify more precisely the artifacts they sketched, especially the feather work. The earliest case we have of carefully recorded Indian objects in European art is found in a Portuguese Adoration of the Magi (cat. 32) probably made between 1501 and 1506 for the Capela-Mor da Sé in Viseu.[34] Instead of painting a traditional black magus, the anonymous artist showed a Brazilian native with a feather headdress. His nakedness is covered by a richly patterned shirt and breeches, presumably to make him presentable to the Holy Family.[35] Even this fanciful European costume is fringed with feathers. The shoes are clearly of European origin, but the earrings in white coral and the various necklaces, the golden anklets and armlets, and the coconut cup all have exotic overtones.[36] Most interesting is his arrow, typically Brazilian with its long shaft and, as here, black foreshaft. Even the red fore-end is clearly visible, as is the radial fletching bound at the end and in the middle of the feathering.[37]

Such careful but composite renderings contrast with most early European images of Indians, which are based merely on written descriptions, especially the more sensational passages. Most book illustrations and broad-sheets, in fact, caricatured the natives of America, stressing nudity and cannibalism.[38]

The first European sketches of real Aztecs were by Christoph Weiditz, a medal maker born in Strasbourg who worked in Augsburg from 1526 to 1528.[39] Perhaps because of the rivalry of local goldsmiths, he accepted an invitation from Johannes Dantiscus to come to Spain to secure an imperial decree protecting him from his opponents. He went to Spain in 1529 and after that to the Netherlands in 1531–1532. Weiditz seems to have followed the imperial court through Castile and Aragon to Barcelona in the spring of 1529. It is probable that he struck his medals of Charles v and Hernán Cortés at that time.[40] Most extraordinary is a manuscript he produced, the *Trachtenbuch*, in which he recorded Spanish society, from members of the imperial court to African slaves.[41] This volume of drawings is one of the earliest attempts to compile a costume book, a genre that flourished in the second half of the century.[42] The interest, both historical and ethnographic, of Weiditz's collection of drawings is enhanced by the presence of a portrait of Cortés[43] and no fewer than eleven drawings, two of them on double pages, of Aztecs. In 1528, when Cortés made his first return visit to Spain, he brought back with him a group of Aztecs, including acrobats and dwarfs. Weiditz's drawings must have been completed before 22 March 1529, when the Aztecs left Barcelona for Seville.[44]

In his album Weiditz drew three Aztec jugglers lying on their backs throwing and catching a log with their feet. The artist caught the kinetic progression of the action but in fact sketched three different Indians; this is confirmed by the variations in their dress and facial decorations.[45] In his *History of the Conquest of Mexico* López de Gómara described the jugglers who entertained Motecuhzoma, using "their feet as ours do their hands" and holding "between their feet a log as big as a girder, round, even, and smooth, which they toss into the air and catch, spinning it a couple of thousand times, so cleverly and quickly that the eye can hardly follow it."[46] López de Gómara also described another game, *tlachtli*, which Motecuhzoma used to watch at the *tlachco* (ball court): "The ball itself is called *ullamalixtli*, which is made of the gum of the *ulli*, a tree of

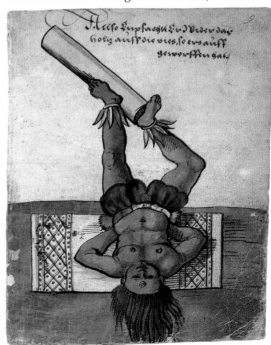

fig. 5. Christoph Weiditz, "Mexican Juggler." *Trachtenbuch*, 1529, pl. 9: "This is an Indian; he lies on his back and twirls a log-bole on his heels; it is as long as a man and as heavy; on the ground under him he has a leather [mat]; it is as large as a calfskin." Germanisches Nationalmuseum, Nuremberg

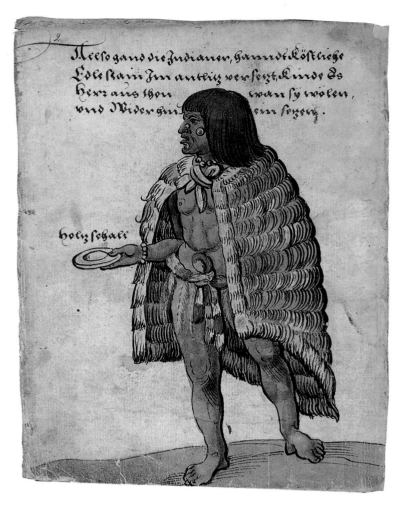

fig. 6. Christoph Weiditz, "Mexican Indian." *Trachtenbuch*, 1529, pl. 2: "Thus the Indians go, they have precious jewels inset in their faces; they can take them out and put them in again when they wish." Germanisches Nationalmuseum, Nuremberg

every European who discussed it.[53] Another more puzzling drawing shows an Indian holding a shield with a grayish-blue cross bordered with gray feathers who is armed with a tooth-edged steel-colored lance decorated with white and red tassels, clearly of European origin. He may be one of the Indian allies who helped Cortés in his fight against the Aztecs or may simply have been intended to illustrate how Indians were then subjected to the emperor's will.[54]

Weiditz drew the Aztecs with great care, recording their features and attending to their individual characteristics. His approach marks a new development in the European image of native Americans. This attempt to depict as carefully as possible the inhabitants of the newly discovered countries parallels the attempt of a few sympathetic scholars, such as Peter Martyr d'Anghiera, to collect historical and ethnographic information. It also looks forward to the much more ambitious efforts of several of the early friars in Mexico, such as Toribio de Motolinía, Bernardino de Sahagún, and Diego Durán, who actually learned the native languages and studied the indigenous cultures in detail.[55] Unfortunately other Europeans were more preoccupied with the plunder and enslavement of the American natives.

the hot country.... It is rolled into balls which, although heavy and hard to the hand, bounce and jump very well, better than our inflated ones.... The players may hit the ball with any part of the body they please, although certain strokes are penalized by loss of the ball. Hitting it with the hips or thighs is the most approved play, for which reason they protect those parts with leather shields. The game lasts as long as the ball is kept bouncing, and it bounces for a long time." The aim of this ritual game seems to have been, according to Juan de Torquemada, to shoot the ball through stone rings set into the side walls.[47] In Weiditz's drawing (cat 406) the players knock the rubber ball with their buttocks; they are nude but for the protective leather garment around their hips and leather gloves covering their hands.[48] Another double page shows the Aztecs at the game of *patolli*: "It is played," said López de Gómara, "with broad or split beans, used like dice, which they shake between their hands and cast upon a mat, or upon the ground, where a grid has been traced. They put pebbles down to mark the

place where the dice come to rest, removing and adding them [according to the cast]."[49] The Aztecs played for stakes, wagering according to their means. At times they would wager "all their goods in this game, and at times... even put their bodies to be sold into slavery."[50]

The costumes of the Aztecs in the *Trachtenbuch* match López de Gómara's description of the dancers of Motecuhzoma's court who performed "dressed in rich mantles woven of many colours, white, red, green, and yellow..., some of them carrying fans of feathers and gold."[51] Weiditz rendered with great care the idiosyncrasies of Aztec costume, drawing garments such as the *tilmatli*, a square cloak worn on one shoulder. One of the natives, identified as a nobleman, wears a breechcloth (the skirtlike row of feathers around his hips seems to be a later addition) and holds a fan of multicolored feathers, and on his right fist carries a large green parrot.[52] He also wears a necklace of red beads and, like most of the Indians sketched by Weiditz, has stones set into his nose, cheeks, and chin, a mutilation that shocked almost

NOTES

1. Hans Rupprich, *Dürer, Schriftlicher Nachlass*, 3 vols. (Berlin, 1956–1969), 1:155; see Jan Albert Goris and Georges Marlier, *Albrecht Dürer: Diary of His Journey to the Netherlands, 1520–1521* (London, 1971), 64.

2. The best account and the various early descriptions can be found in Marshall H. Saville, *The Goldsmith's Art in Ancient Mexico* (Indian Notes and Monographs) (New York, 1920), 20–39 and 191–206, n. 13; also Marshall H. Saville, "The Earliest Notices Concerning the Conquest of Mexico by Cortés in 1519," *Indian Notes and Monographs* 9, 1 (1920), 1–54. Interesting is also Jan Veth and Samuel Muller, *Albrecht Dürers Niederländische Reise*, 2 vols. (Berlin and Utrecht 1918), 2:100–108.

3. Francisco López de Gómara, *La istoria de las Indias y conquista de Mexico*, 2 vols. (Saragoza, 1552), fol. XXIV; see Saville *Art* 1920, 202–203.

4. For example Auguste Bouché-Leclercq, *L'astrologie grecque* (Paris, 1899), 315–316.

5. Saville *Art* 1920, 199.

6. Francisco Javier Clavijero, *The History of Mexico, Collected from Spanish and Mexican Historians...*, 2 vols. (London, 1787), 424, n.a.; also Diego Durán, *Book of the Gods and Rites and the Ancient Calendar*, translated and edited by Fernando Horcasitas and Doris Heyden (Norman, Oklahoma, 1971), esp. 383–411. See Alfonso Caso, "Calendrical Systems of Central Mexico," *Handbook of Middle American Indians* 11,1 (1921), 333–348.

7. For a different hypothesis, see Karl A. Nowotny, *Mexikanische Kostbarkeiten aus Kunstkammern der Renaissance im Museum für Völkerkunde Wien und in der Nationalbibliothek Wien* (Vienna, 1960), 10–12, who proposed that the discs represent the sun and moon, and that another in feather work also described by Cortés stands for Venus. For the Aztecs, the word for gold was *teocuitlatl* (excrement of the gods). The association with the sun, it seems, was made only by the Inkas: for them gold and silver were respectively the sweat of the sun and the tears of the moon. See André Emmerich, *Sweat of the Sun and Tears of the Moon. Gold and Silver in Pre-Columbian Art* (Seattle, 1965), XIX.

8. Bernardino de Sahagún, *Florentine Codex. General History of the Things of New Spain*, translated by Arthur J. O. Anderson, 13 vols. (Santa Fe, 1953–1982), 13:11–13 and 15.

9. For Pirckheimer's and Dürer's interest in hieroglyphics, see Karl Giehlow, "Die Hieroglyphenkunde des Humanismus in der Allegorie der Renaissance," *Jahrbuch der kunsthistorischen Sammlungen des allerhöchsten Kaiserhauses* 32 (1915), 1–232, and Erwin Panofsky, *Albrecht Dürer*, 2 vols. (Princeton, 1943), 177–179.

10. Campbell Dodgson, "Albrecht Dürer (1471–1528): Sun and Moon, with a Basilisk...," *Old Master Drawings* 7 (1933), 14–15, pl. 19; and Walter L. Strauss, *The Complete Drawings of Albrecht Dürer*, 6 vols. (New York, 1974), 3:1354–1355, no. 1513/9.

11. Horapollo, *Hieroglyphica*, I.1; for a translation, George Boas, *The Hieroglyphics of Horapollo* (New York, 1950), 57.

12. Walter L. Strauss, *The Book of Hours of the Emperor Maximilian the First*); (New York, 1974); for the most important studies, Karl Giehlow, *Kaiser Maximilians I. Gebetbuch mit Zeichnungen von Albrecht Dürer und anderen Künstlern (Munich, 1907)*; and Panofsky 1943, 182–190.

13. For folio 41r, Strauss *Dürer* 1974, 3:1536, no. 1515-31; Strauss *Maximilian I* 1974, 81. See also Hugh Honour, *The New Golden Land: European Images of America from the Discoveries to the Present Time* (New York, 1975), 13, ill.; William C. Sturtevant, "First Visual Images of Native America," *First Images of America*, edited by Fredi Chiappelli (Berkeley-Los Angeles-London, 1976), 423, ill., and Susi Colin, *Das Bild des Indianers im 16. Jahrhundert* (Idstein, 1988), 333–335, no. M.4.

14. The Vulgate has "Domini est terra et plenitudo eius orbis et habitatores eius quia ipse fundavit eum et super flumina stabilivit illum."

15. See for example John Hemming, *Red Gold: The Conquest of the Brazilian Indians* (London, 1978), 5.

16. For the fundamental studies of the material culture of Tupinamba Indians, see Alfred Métraux, *La civilisation matérielle des tribus Tupi-Guarani* (Paris, 1928); and Alfred Métraux, "The Tupinamba," in Julian H. Steward, ed., *Handbook of South American Indians 3, Smithsonian Institution. Bureau of American Ethnology. Bulletin 143* (Washington, 1948), 95–133.

17. For this war club, *La Renaissance et le Nouveau Monde* [exh. cat. Musée du Québec] (Quebec, 1984), 102 no. 35, ill. For such weapons, see A. B. Meyer and M. Uhle, *Seltene Waffen aus Afrika, Asien und Amerika, Königliches Ethnographisches Museum zu Dresden 5* (Leipzig, 1885), 5, pl. 9,4; Métraux 1928, 80–83, figs. 5–6, and Métraux 1948, 122, figs. 7b, 8, 9, and 13. For Tupinamba war clubs in European collections, Christian F. Feest, "Mexiko and South America in the European Wunderkammer," in *The

Origin of Museums*, edited by Oliver Impey and Arthur Macgregor (Oxford, 1985), 241.

18. Métraux 1928, 140–148. For Tupinamba feather cloaks in various European museums, Feest 1985, 242–243. For specific studies, Alfred Métraux, "Une rareté ethnographique du Musée de Bâle. Le manteau Tupinamba," in *Actes de la Société helvétique des sciences naturelles*, 108e session annuelle 2 (1927), 227–228; J.-S. Harry Hirtzel, "Le manteau de plumes dit de 'Montezuma' des Musées Royaux du Cinquantenaire de Bruxelles," in *Proceedings of the Twenty-third International Congress of Americanists* (New York, 1930), 649–651; Alfred Métraux, "A propos de deux objets Tupinamba du Musée d'éthnographie du Trocadéro," *Bulletin du Musée d'éthnographie du Trocadéro* 3 (1932), 3–11; M. Calberg, "Le manteau de plumes dit 'de Montezuma,'" *Bulletin de la Société des américanistes de Belgique* 30 (1939), 103–133; Annemarie Seiler Baldinger, "Der Federmantel der Tupinamba im Museum für Völkerkunde Basel," *Atti del ... Congresso Internazionale degli Americanisti* 2 (1974), 433–438; Berete Due, "A Shaman's Cloak," *Folk, Dansk etnografisk tidsskrift* 21–22 (1979–1980), 257–261; Karen Stemann Petersen and Anne Sommer-Larsen, "Techniques Applied to Some Feather Garments from the Tupinamba Indians, Brazil," *Folk, Dansk etnografisk tidsskrift* 21–22 (1980), 263–270; Laura Laurencich-Minelli and Sara Ciruzzi, "Antichi oggetti americani nelle collezioni del Museo Nazionale di Antropologia e Etnologia di Firenze: due mantelli di penne dei Tupinamba," *Archivio per l'antropologia e la etnologia* 111 (1981), 121–142.

19. Wilberforce Eames, "Description of a Wood Engraving Illustrating the South American Indians (1505)," *Bulletin of the New York Public Library* 26 (1922), 755–761, pl.; Georg Leidinger, "Die älteste bekannte Abbildung südamerikanischer Indianer," *Gutenberg Festschrift. Zur Feier des 25 jährigen Bestehens des Gutenbergmuseums in Mainz* (Mainz, 1925), 179–181, pl.; Rudolf Schuller, "Die älteste bekannte Abbildung südamerikanischer Indianer," in *A. Petermanns Mitteilungen* 71 (1925), 21–24, ill.; Rudolf Schuller, "The Oldest Known Illustration of South American Indians," *Indian Notes* 7 (1930), 484–497, ills.; F. W. Sixel, "Die deutsche Vorstellung vom Indianer in der ersten Hälfte des 16. Jahrhunderts," *Annali lateranensi. Annali del Pontificio museo missionario etnologico* 30 (1966), 89, fig. 2; Colin 1988, 186–187 no. B10, fig. 5. Native Americans did not have feather skirts: see Hugh Honour, "Science and Exotism: The European Artist and the Non-European World before Johan Maurits," in *A Humanist Prince in Europe and Brazil: Johan Maurits von Nassau (1604–1679)* (The Hague, 1979), 277.

20. For Tupinamba leather shields (*tapiroussou*), see Métraux 1928, 84; they were often painted or decorated with feathers. None seem to have survived.

21. Métraux 1928, 130–136; Métraux 1948, 105; for such a bonnet, see Bente Dam-Mikkelsen and Torben Lundbaek, *Ethnographic Objects in the Royal Danish Kunstkammer, 1650–1800* (Copenhagen, 1980), 28, no. and fig. EH5932. The sandals in Dürer's drawing are probably African as are those found in a woodcut by Hans Burgkmair (in *Allago*) based on Balthasar Springer's travel account first published in 1508. For this woodcut and early depictions of African sandals see Ezio Bassani and Letizia Tedeschi, "The Image of the Hottentot in the Seventeenth and Eighteenth Centuries," *Journal of the

History of Collections* 2 (1990), engr. 173, and 185 n. 21, figs. 8 and 13. See also the African in Burgkmair's woodcuts (fig. 4 in this essay).

22. Rupprich 1956, 1:171; Goris and Marlier 1971, 91.

23. For a good account, Panofsky 1943, 179–181. For the manuscript version, Franz Winzinger, *Die Miniaturen zum Triumphzug Kaiser Maximilian I. Faksimileband und Kommentarband* (Graz, 1973); for the printed work, Stanley Appelbaum, *The Triumph of Maximilian I* (New York, 1964).

24. Appelbaum 1964, 18–19, for the translation.

25. The German words meaning Indian (*indisch* and *indianisch*) were also ambivalent in the early sixteenth century: see Georg Friederici, *Amerikanistisches Wörterbuch* (Universität Hamburg. Abhandlungen aus dem Gebiet der Auslandskunde 53, Reihe B. Völkerkunde, Kulturgeschichte und Sprachen, 29) (Hamburg, 1947), 313–315.

26. For these woodcuts, see Appelbaum 1964, pls. 129–130. For a study of these works, Honour 1975, 14; Hugh Honour, *The European Vision of America* [exh. cat. Cleveland Museum of Art] (Cleveland, 1975), no. 5; Sturtevant 1976, 420–421; Colin 1988, 335–336 no. M.5.

27. For such garters see Métraux 1928, 178–179.

28. For Tupinamba bows see Métraux 1928, 71–73; E. G. Heath and Vilma Chiara, *Brazilian Indian Archery* (Manchester, 1977), 29–45; J. Peter Whitehead, "Pictorial Record of a 17th. Century Tupinamba Bow and Arrows," *Zeitschrift für Ethnologie* 110 (1984), 111–125.

29. For the rapid introduction of steel axes, Hemming 1978, 9. Indians are represented working with steel axes in various early maps of South America; see for example Honour in Cleveland 1975, no. 17 and Hugh Honour, *L'Amérique vue par l'Europe* [exh. cat. Grand Palais] (Paris, 1976–1977), 26–28, nos. 17 and 17a.

30. See note 17.

31. Honour in Cleveland 1975, 14, rightly observed that it is the first representation of corn in European art.

32. For these drawings, Colin 1988, 336–337, nos. M.6 and M.7; John Rowlands, *The Age of Dürer and Holbein. German Drawings, 1400–1500* [exh. cat. British Museum] (London, 1988), 187–188, nos. 158a and b, pl. XXIII.

33. These may have been preparatory drawings for prints that were never executed.

34. For this work, see Cleveland 1975, no. 4, ill.; Colin 1988, 331–332, no. M.1, with further references.

35. This sentence is borrowed from Honour 1975, 53. See Paul H. D. Kaplan, *The Rise of the Black Magus in Western Art* (Ann Arbor, 1985).

36. Coral in the early sixteenth century came mainly from the Mediterranean; see Wilhelm Heyd, *Histoire du commerce au Moyen-Age* (Leipzig, 1887), 609–610. The mounting of the earring is clearly European. For native American earplugs see Métraux 1928, 170–171. For coconuts and mounted coconuts, Rolf Fritz, *Die Gefässe aus Kokosnuss in Mitteleuropa, 1250–1800* (Mainz am Rhein, 1983).

37. For Brazilian arrows, see Heath and Chiara 1977, 59–66 and 142–164; also Whitehead 1984, 111–124.

38. For studies of early European images of American Indians see especially Honour 1975; Sturtevant 1976; Honour 1979 and more recently Colin 1988. Interesting material is also found in the following catalogues: Cleveland 1975; Paris 1976; and Karl-Heinz Kohl, ed., *Mythen der Neuen Welt. Zur Entdeckungsgeschichte Lateinamerikas* [exh. cat. Martin-Gropius-Bau] (Berlin, 1982). For American artifacts collected in Europe in the sixteenth century,

Feest 1985, 237–244; and Christian F. Feest, "Spanish-Amerika in Kunstkammern des 16. und 17. Jahrhunderts," in *Gold und Macht. Spanien in der Neuen Welt* (Rosenheim, 1987), 43–44, with further references.

39. Ulrich Thieme and Felix Becker, *Allgemeines Lexikon der bildenden Künstler von der Antike bis zur Gegenwart*, 37 vols. (1907–1950), 35:267–268; also Georg Habich, "Studien zur deutschen Renaissancemedaille, IV: Christoph Weiditz," *Jahrbuch der königlich preussischen Kunstsammlungen* 34 (1913), 1–35; and Theodor Hampe, *Das Trachtenbuch des Christoph Weiditz von seinen Reisen nach Spanien (1529) und den Niederlanden (1531/32)* (Berlin and Leipzig, 1927), 64–75.

40. For the medal of Cortés, Habich 1913, 11–13, pl. IV, no. 7; Paul Grotemeyer, "Da ich het die gestalt," *Deutsche Bildnismedaillen des 16. Jahrhunderts* (Munich, 1957), 50, figs. 29–30.

41. Hampe 1927; for a later copy, *Katalog der Freiherrlich von Lipperheide'schen Kostümbibliothek*, 2 vols. (Berlin, 1896–1901), 1:5–8; also Eva Nienholdt and Gretel Wagner-Neumann, *Katalog der Lipperheideschen Kostümbibliothek*, 2 vols. (Berlin, 1965), 1:1. For a group of drawings of American Indians done in the early 1550s see José Tudela de la Orden, "Las primeras figuras de Indios pintadas por Españoles," in *Homenaje a Rafael García Granados* (Mexico City, 1960), 319–329.

42. Heinrich Doege, "Die Trachtenbücher des 16. Jahrhunderts," in *Beiträge zur Bücherkunde und Philologie August Wilmanns zum 25. März 1903 gewidmet* (Leipzig, 1903), 429–444, for a survey of the field.

43. Hampe 1927, 70, 77, pl. IV; Howard F. Cline, "Hernán Cortés and the Aztec Indians in Spain," *The Quarterly Journal of the Library of Congress* 27 (1969), 78 and 80, ill.

44. Hampe 1927, 73, 78–81, pls. XI–XXIII; for a fundamental study, Cline 1969 (for the captions of my illustrations I have used his English translations). More recently Colin 1988, 340–344, described every scene. See also Benjamin Keen, *The Aztec Image in Western Thought* (New Brunswick, 1971).

45. Hampe 1927, 79, pls. XV–XVII; Cline 1969, 70–71, 75 and 72–73, ills.; Colin 1988, 342–343. Similar jugglers (but standing on their heads) are found in the view of Cuzco in Theodor de Bry, *Americae pars sexta* (Frankfurt, 1596); see Sturtevant 1976, 449.

46. López de Gómara 1552, 2: fol. 42; Francisco Cortés López de Gómara, *The Life of the Conquerer by His Secretary*, translated by Lesley Byrd Simpson (Berkeley and Los Angeles, 1964), 145. See also Cline 1969, 70–71, for further references.

47. López de Gómara 1552, 2: fols. 42r–42v; López de Gómara 1964, 145–146; see also Juan de Torquemada, *Los veynte y un libros rituales y monarchia yndiana*, 3 vols. (Madrid, 1615), 2:295. For this game, see also Cline 1969, 75.

48. Hampe 1927, 79, pls. XIII–XIV; Colin 1988, 343–344. The players were copied in reverse in the view of Cuzco in de Bry 1596; see above, note 45.

49. López de Gómara 1552, 2: fol. 42; López de Gómara 1964, 145. For further references see Cline 1969, 76–77.

50. López de Gómara 1552, 2: fol. 42; López de Gómara 1964, 145.

51. López de Gómara 1552, 2: fol. 43; López de Gómara 1964, 147.

52. Hampe 1927, 81, pl. XXII; Colin 1988, 342, pl. 59 [*recte* 1]. See for example the Aztec fans in the various codices.

53. See for example Vespucci's account on the *New gefunden menschen* broadsheet in *Die neue Welt in der Schätzen einer alten europäischen Bibliothek* [exh. cat. Herzog August Bibliothek] (Wolfenbüttel 1976), 44, cat. 3, ill. For early broadsheets, see note 19 above.

54. Hampe 1927, 81, pl. XXIII; Colin 1988, 343.

55. John Howland Rowe, "The Renaissance Foundations of Anthropology," *American Anthropologist* 77 (1965), 12–14; *Pietro Martire d'Anghiera (Secondo Convegno internazionale degli studi americanisti. Atti)* (Genoa, 1980); Donald Robertson, "The Sixteenth-Century Mexican Encyclopedia of Fray Bernardino de Sahagún," *Cahiers d'histoire mondiale* 9 (1966), 617–627; Fray Toribio de Benavente o Motolinía, *Memoriales o Libro de las cosas de la Nueva España*, edited by E. O'Gorman (Mexico City, 1971).

SIGNS OF DIVISION, SYMBOLS OF UNITY:
ART IN THE INKA EMPIRE

Craig Morris

In 1492 the Inka ruled the largest empire in the New World, rivaled only by the Chinese and Ottoman empires in the Old World. From its capital in Cuzco it ran southward to central Chile and included the northwestern part of Argentina as well as highland Peru and Bolivia. The empire extended for 2,600 miles from north to south. A recent and tentative estimate suggests that the population might have exceeded fourteen million.[1] The Inka had conquered the rich desert kingdoms of coastal Peru, such as Chimú and Chincha. They were still expanding northward in Ecuador when a small group of Spanish invaders under the command of Francisco Pizarro took Atawalpa, the Inka ruler, captive on 16 November 1532.

The genius of the Inka was the coordination of diversity. The resources of drastically different environments, many of them considered poor today, were put together to form such wealth that even the looting and disorder following the invasion took decades to dissipate it. Peoples of different customs and practices were combined to form an enormous patchwork polity in which human diversity matched the spectacular contrasts in the environment and the variety of the resources it provided.

The Inka called their empire Tawantinsuyu, "land of the four parts." The strategies they used to govern it varied somewhat from region to region, depending on the nature and organization of the incorporated peoples, on their amenability or resistance to Inka aims and policies, and on the local resources the Inka sought to exploit. Fundamental to understanding the enormous scale of the empire is the Inka perception and organization of space and of the people, settlements, and resources within it. While some of these ideas can be seen in religion and cosmology, it was their concrete realization in the physical and social world that is most important in understanding the political accomplishments. The Inka certainly produced many bold and beautiful objects. These notable artistic achievements are related to the Inka transformation of the landscape and society — to the ways they maintained diversity and at the same time brought together the constituent parts.

Political life in Tawantinsuyu seems to have involved an almost constant tension between unity and diversity, collaboration and conflict.

Its elaborate political and religious ceremonies encompassed rituals of peace and growth as well as of war and destruction. From deep in the history of the Andes came a concept of colonization as a means of access to the goods of distant and varied regions,[2] one that appears to have been very different from those the Europeans were to evolve in the Americas. While the Inka idea was certainly one of domination, it was also one of economic independence of individual groups and their responsibility for their own well being. Different groups shared and collaborated in certain circumstances and acted independently in others.

The empire was thus maintained through a careful balance between hierarchically organized groups. This balance required forces of division as well as of unification. Inka political ideology included a vision of space and planning on the most grandiose scale. It also recognized the inevitability of conflict and confrontation. The state and its rulers attempted to control the changing process by which this balance was achieved and maintained.

A hallmark of Inka administration was a vast road system connecting well-coordinated way stations, warehouses, and centers of government ceremonies. At the empire's height more than twenty-five thousand kilometers of roads were in use.[3] Archaeology has revealed that the towns, cities, and other installations built along the imperial roads were different in architecture and planning from the local settlements in the regions that surround them. The differences between state and local styles extended frequently, as in the Peruvian central highlands, to the ceramics and other objects used in the state installations.

These stylistic distinctions between objects made by the Inka and by those whom they ruled provide archaeological keys for the understanding of Inka society and art. Inka art has sometimes been characterized as rigid and standardized, uninspired and plain,[4] often considered a classic case of political authority exerting strong sway over creative output. Many objects made under state supervision for state use were indeed standardized. Because the Inka state did not extend its control to the lower, local levels in most of the realm, much of life and art continued under local traditions. And

some state-sponsored art escaped standardization. Thus the largest part of the archaeological inventory from Tawantinsuyu reflects these local traditions or an interplay between local traditions and those of the rulers from Cuzco.

As in most nonwestern societies there is no evidence that the Inka had a category of objects thought of as art. Most of the things beautiful to the modern eye had functions in Inka society. Some were utilitarian objects: pottery or metal vessels to hold food and drink or textiles for clothing. Others functioned mainly in the symbolic realm, such as figurines used as offerings or carved stones that related people and society to the natural and supernatural worlds. The aspects of these objects that we might call design or decoration almost always were intimately involved with identity and the communication of identity — personal, social, and cultural.

A maker of objects might identify with several different social and cultural strata. There were at least two: the level of local or regional society and that of the Inka state. In some cases the levels were more complex. Large regional societies might be divided into subgroups; towns might have their own identities and might be further divided into moieties. The extent to which these separate identities are reflected in ceramics, cloth, and metalwork varies considerably from one region of Tawantinsuyu to another.

The diversity in objects whose production was not under imperial control is thus related to the patchwork quality of the Inka empire. Sometimes local artisans combined elements of imperial style into local products, and in other cases they ignored the Cuzco style almost entirely. Some of these stylistic relationships, not surprisingly, are related to the extent of local resistance to Inka rule. Except for occasional imitations of an Inka form, Chimú ceramists continued with the basic black ware they made before they were conquered by the Inka. Subtle changes in shape denote the passage of time and allow Inka-period pottery to be distinguished from older material, but there is no clear rejection of earlier stylistic ideas.[5] In textiles the emphasis is also on stylistic continuity.[6] The Inka either did not or could not drastically change the principal features of Chimú art.

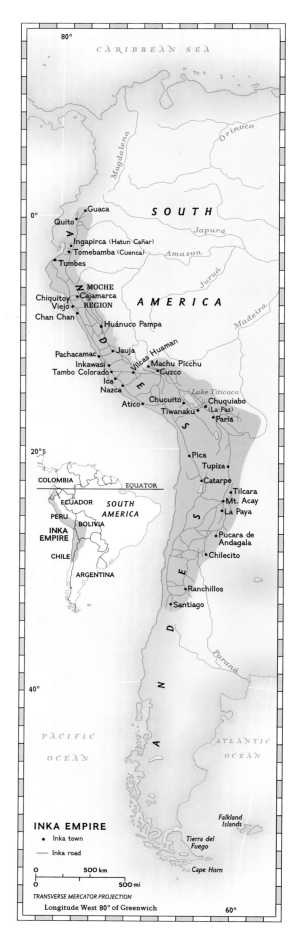

INKA EMPIRE

- Inka town
- Inka road

500 km

500 mi

TRANSVERSE MERCATOR PROJECTION
Longitude West 80° of Greenwich

The detectable changes are subtle, and the style remained more Chimú than Inka. Some accomplished Chimú artisans were taken to Cuzco where they probably made objects in the Inka style,[7] such objects apparently symbolizing the Inka state. Yet most of those artisans who continued to work on the Peruvian north coast continued to reflect local traditions, preserving a strong sense of the conquered Chimú state.

The situation of the south coast of Peru was somewhat different. The large kingdom of Chincha was eventually brought peacefully into Tawantinsuyu, and the more extensive local imitation of Cuzco elements in Chincha ceramics reflected the close and cooperative relationships between Cuzco and that region. Slightly farther south, in the regions of Ica and Nazca, the peaceful Inka conquest was marked by the appearance of innovative new styles that combined a strong degree of artistic independence with a liberal borrowing of Cuzco Inka elements. These new eclectic styles were most marked in ceramics and textiles. Among the most spectacular Inka-period objects from this area are ceremonial digging boards found in tombs. These objects were often decorated with red and yellow resin paint and sometimes sheathed in gold and silver. Their shapes were based on agricultural implements, and the iconography of their decoration featured sea birds eating fish (the process that led to the formation of the *guano* fertilizer basic to Andean agriculture).[8]

The influence of Cuzco and the Inka rulers on local art thus ran the gamut from almost total independence to very heavy borrowing of imperial motifs. At the fringes of the empire there was also a range of various kinds of polities, each with its own set of political, economic, and artistic relationships to Tawantinsuyu. One such was the lowland Pacific coast of Ecuador. There is no evidence of direct Inka control,[9] but highland regions near the northern frontier that were incorporated into the empire had particularly active traders who maintained commercial links with the Pacific littoral.[10]

Inka art, as usually defined, refers to those objects produced in the Cuzco style of the ruling elite beginning sometime toward the middle of the fifteenth century. It is a style characterized by the use of relatively simple, bold geometric designs with a strong emphasis on symmetry, particularly in textiles. It "is classic in its formal clarity, balanced proportion and clean outline. It is compact, integrated and simple."[11] The level of technical excellence is high, and the repetition of designs and motifs suggests mass production.[12]

The visual strength and clarity of Inka art, as well as its repetitiveness, can be understood as the result of its official nature. Most of the bold architecture, metalwork, ceramics, and textiles were produced by artisans working for the state.[13] The state apparently controlled production not just to provide itself with substantial quantities of necessary and valuable goods, but also in part because it wanted to stamp those objects and buildings with its own identity. It wanted to create an image of the state and its rulers as providers of hospitality and givers of valuable gifts. These gifts and hospitality were dispensed in settings of political and religious rituals intended to teach the populace a new, imperial level of social and political order.[14] To do that, state-sponsored artists designed a set of strong, clear symbols that the conquered peoples could easily identify, and perhaps identify with.[15] Inka-style architecture set the centers built by the state apart from existing local settlements; these state centers, in many parts of the realm, provided the settings for rituals, ceremonies, and administrative activities. In many such centers, inhabitants and visitors were served from ceramic, metal, and wood vessels made in the Inka style.[16] Garments and other items of cloth were also dyed and woven in state-dictated styles.

The beginnings of Andean art are recorded in textiles more than three thousand years old.[17] Andean cloth was among the world's finest centuries before the existence of Tawantinsuyu. In Inka times cloth was the most valued of all goods. It was given or exchanged to celebrate all of life's turning points; elaborate gifts of cloth to recently conquered peoples were but one of the measures of its political importance.[18] Designs on cloth were richly symbolic. Distinct patterns signaled differences in group membership.[19] Some patterns symbolized the twelve royal *panaqa* (organizational divisions of the ruling elite),[20] and certain garments were reserved for the ruler. Some of these were used only for special rituals and calendar events.[21] The description by Francisco de Jerez of the Inka ruler Atawalpa and his retinue entering the plaza of the Inka city of Cajamarca gives an impression of the brilliance and color of the Inka court. It also implies that people were dressed according to their status and duties.

Soon the first people began to enter the plaza; in front came a group of Indians in a colored uniform with checks. They came removing straw from the ground and sweeping the road. Another three groups came after them, all singing and dancing, dressed in a different way. Then many people advanced with armor, medallions, and crowns of gold and silver. Among them Atawalpa entered in a litter covered with colorful

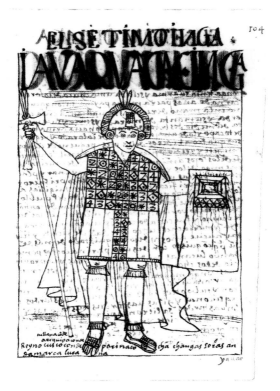

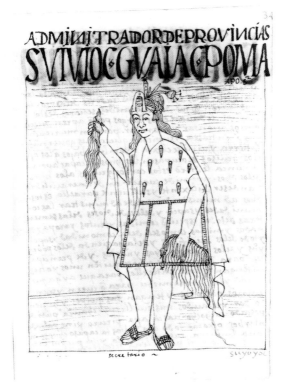

fig. 1. An early Inka ruler holding in his left hand what was probably a padded cloth shield. From Guaman Poma de Ayala, *El Primer Nueva coronica y Buen Gobierno* (cat. 441). The Royal Library, Copenhagen

fig. 2. The "administrator of provinces" holding *quipus*, stringed devices that were knotted in a decimal system and used in record keeping. From Guaman Poma de Ayala, *El Primer Nueva coronica y Buen Gobierno* (cat. 441). The Royal Library, Copenhagen

parrot feathers and decorated with gold and silver plaques. Many Indians carried him up high on their shoulders, and after this came two other litters and two hammocks in which two other important people rode. Then many groups of people entered with gold and silver crowns. As soon as the first entered the plaza, they went to the side and made room for the others. Upon arriving in the middle of the plaza, Atawalpa make a sign for silence.[22]

The exact meanings of the designs on Inka textiles will probably never be deciphered. Historical knowledge is scant because the early Europeans were more concerned with subjugating the New World and taking advantage of its great wealth than they were with recording the details of the cultures that had accumulated such riches. A few investigators have claimed that the meanings of some of the designs on Inka cloth are so specific as to make them signs in what was essentially a form of writing.[23] Most, however, do not believe that the system of signs was sufficiently complete or manipulable to approach writing in the sense of a system of codes for replicating spoken language.

There is, nevertheless, considerable standardization, particularly of *unqo*, the tunics worn by

men (cats. 449–453).[24] The standardization of design on these garments extends also to some technical features.[25] It seems probable that the designs of these tunics were related to the status of the wearers and, in some cases, to the situations in which they were worn. This would be consistent with the use of visual insignia of group membership as one of the essential functions of garments. The use of bright and highly visible designs would tell knowledgeable observers at a glance the ethnic identity and other essential social and political characteristics of the people they encountered. It would also allow them to quickly assess the composition of a large group, such as the functionaries and officials Jerez saw accompanying Atawalpa. This capacity to communicate social information rapidly was essential, given the variety of the components of the empire.

The textiles that appear so starkly modern should be thought of in their Inka contexts. They were garments moving from place to place as the people who wore them moved, helping define the status and positions of their wearers and determining the reactions of others toward them. By making these identifications possible, textiles were vital to the way the empire was held together and made to function. The Inka

state invested enormous resources in the production of cloth.[26] Part of the interest in cloth production by the state was related to the economic and symbolic value of textiles to the user,[27] but it was also related to the state's interest in creating and controlling a series of essential signs and symbols.

The artistic peak in Andean ceramics was reached centuries before the Inka with the achievements of Chavin, Moche, Nazca, and Wari potters. The tendency toward standardization already suggested in some of the earlier styles became especially pronounced in Inka pottery. Technical standards were high, and the clean geometric polychrome designs, though rather limited in range, are vibrant and appealing. Modeled ornaments frequently depict the heads of pumas; the handles on plates often take the form of the head of a bird. Rare pieces model the human form.

The role of pottery in the material culture of the state was relatively narrow. Of course its primary use was in the preparation, serving, and storage of food and drink. The brewing and storage of maize beer required great quantities of jars. Pottery was also used as containers for offerings of food and was common as grave furniture. Unlike some earlier Andean cultures, the Inka do not appear to have broken pottery ceremonially as part of religious rites. The materials honored by being sacrificed were mainly textiles.[28]

Ceramics in standardized Inka styles are found mainly in Cuzco and the centers built by the Inka along their road system. They are sometimes mixed with local styles in non-Inka sites that were of special political importance to the Inka.[29] The furnishing of state centers far from Cuzco with pottery in the style of the capital symbolically underscored the source of the food, drink, and hospitality prepared and served there.

Precious metals, specifically gold, were of primary interest to the invading Spanish. For the Inka, gold and silver had not become the universal measure of value that they had in Europe. The Inka had nevertheless accumulated vast quantities of precious metals and used them lavishly. The temple of the sun in Cuzco had walls sheathed in gold and a garden planted with golden plants.[30] Unfortunately, Spanish greed and insensitivity assigned most of these fabulous objects to the melting pots. One need name only a few of the objects from the long lists of destroyed treasure to get a notion of the inconceivable loss:

A golden sheep [llama or alpaca], assessed at 17cts., weighing one hundred and eleven marks, five ounces [about fifty-five pounds]

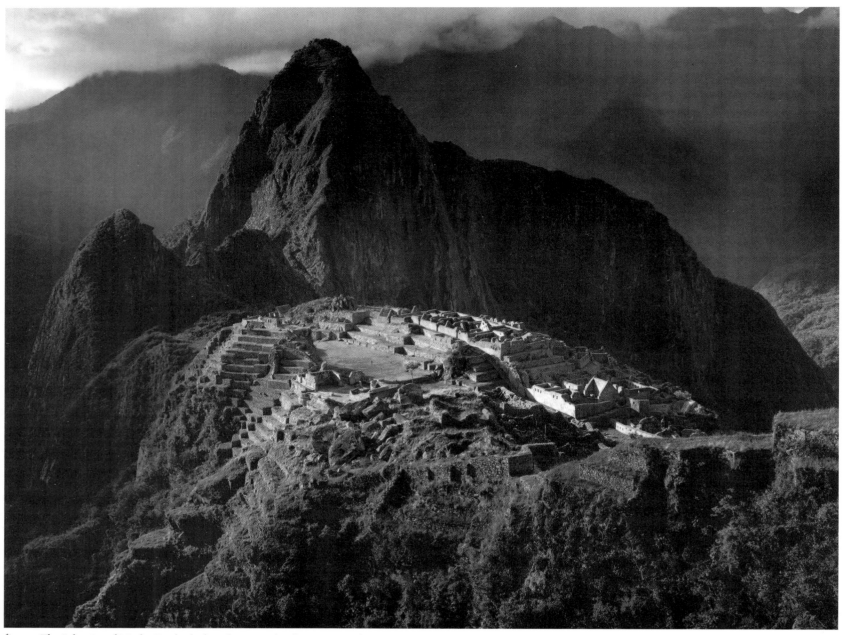

fig. 3. The Inka site of Machu Picchu before the pinnacle of Huayna Picchu

A golden sheep, assessed at 17cts., weighing one hundred and thirteen marks, four ounces

A golden woman, assessed at 18cts., weighing one hundred and five marks, five ounces, and seven ochavas.[31]

Francisco Pizarro was allowed by Spanish law and custom to select for his own an article from the spoils. He chose a golden litter, said to have weighed more than two hundred pounds.[32] No Inka work in gold or silver even remotely approaching these sizes is known today, although smaller figures indicate how some of the animal and human forms may have appeared. Pedro Sancho, one of Pizarro's scribes, gives a glimpse of the destruction that took place when Inka smiths in Cuzco were made to melt down most of the treasure:

It was a thing worthy of witnessing, this house where the melting was done, full of so much gold in plates of eight and ten pounds each, and in table service; jars and pieces of various forms with which these lords were served, among other singular things to be seen were ... ten or twelve figures of women, of the size of women of this land, all of fine gold and as beautiful and well made as if they were living.[33]

Objects of precious metals were major indicators of status and prestige. Their surface color is certainly one of the many qualities inherent in metals that lend themselves to this social role;[34] their brilliance is another. In addition, the colors of gold and silver had come to symbolize the light of the sun and the moon, forming an important way of linking cosmology and divine power to elites and rulership.

Early descriptions of the rulers and their ceremonies show the importance of gold and other metals.[35] Common among surviving Inka metal objects are the *tupu* pins, frequently in silver, used to fasten women's garments. Their counterparts for elite males were probably ear ornaments, although almost none have survived from the Inka period. The Spanish referred to men of high status as *orejones* ("big ears"), a reference to the elongation of their earlobes

fig. 4. The shape of the sacred rock at Machu Picchu echoes that of the mountain behind it

caused by large ear ornaments. The ear ornaments of the Inka rulers are said to have been of gold.[36]

Metal objects were frequent religious offerings. Gold and silver figurines of animals and people were often buried. Some of the most spectacular examples of these buried offerings were interred on snowcapped mountains in the southern Andes of Chile and Argentina (cat. 442).[37] It is interesting that the human figures were clothed, so that the metal surface was largely covered.

In pre-Inka times the quantities of silver and gold ornaments in the Cuzco area had not been nearly as great as those in the north. The Inka brought Chimú smiths to Cuzco, suggesting both the importance of the craft and the lack of sufficient local specialists to supply the rapidly expanding state.[38] These smiths were presumably asked to make objects in a new style. They apparently abandoned the elaborately ornamented surface detail of sheet metal characteristic of earlier Chimú art for an emphasis on the simple, more three-dimensional forms favored by the Inka.

The Inka had inherited one of the world's most sophisticated metallurgical technologies, and they clearly appreciated the malleability, durability, and reflective surfaces of metal. However, it was not the medium they chose for expressing their most complex ideas. The vocabularies for articulating their principal social and ideological concerns were most often seen in textiles and architecture.

Architecture built by the Inka state is easy to distinguish from the buildings of other times and cultures. It is based on simple forms with little adornment. In the highlands the Inka built mainly with stone, relying on relief provided by the joins for surface character. On the coast local adobe was the primary construction material. In both regions buildings were frequently covered with a thin layer of clay that was brightly painted. Walls were slightly tapered for stability. The trapezoid was a ubiquitous form, used for doorways, windows, and wall niches.[39]

In some of the most famous and monumental Inka architecture, retaining walls were used to

fig. 5. The sculpted grotto known as the royal mausoleum, below the Torreón at Machu Picchu

fig. 6. The Inti-watana, a carved natural stone at Machu Picchu

reshape topography. The temple-fortress of Saqsawaman and the terraces throughout the sacred Urubamba Valley are primary examples. The entire site of Machu Picchu is a landscape architecturally converted into a union of culture and nature. The sensitivity of detail in the site, such as the platform that calls atten-

tion to a stone echoing the shape of the mountains behind it, is as remarkable as the town's overall drama.

Characteristics of Inka architecture that make it so striking are relatively easy to list. Its construction techniques are also relatively well understood.[40] Knowing that the Inka had access

to battalions of corvée laborers even makes comprehensible the magnitude of this construction: dozens of cities and hundreds of way stations were built in less than a century. At one level the symbolic significance of the easily identifiable Inka architectural style also seems clear. The buildings signified the state, its rulers, and its activities. They identified entire settlements with the state, contrasting them with other settlements occupied by other groups in the same region.[41] In some cases they identified compounds or sectors of Inka occupation and activity within settlements built by other groups.[42] Just as textiles helped define people and groups, architecture identified towns and parts of towns.

Since architecture helps control and channel human activities, the symbols it encoded became part of the backdrop to the performance of rites that reinforced and legitimized the state to the people being incorporated into Tawantinsuyu. The way some Inka towns and cities were laid out mirrored certain principles of imperial organization.[43] Details of the rites and activities in Inka centers are sketchy at best, but the possibility of a correspondence between town plans and organizational principles is intriguing. Such plans could have placed groups of people in actual physical positions analogous to the positions the state envisioned for them in the new order of sociopolitical relations it was creating.

Although architecture was involved in critical ways with the identity of the state, it was less standardized than were textiles or, more particularly, pottery. Town plans included many common elements, but the combinations were quite distinct; no two Inka towns were the same.[44] Even the execution of individual structures could offer surprisingly fresh departures: the temple at Huaytará with its niches that are trapezoidal in elevation and triangular in plan,[45] the *kori kancha*, with its curved enclosure and extraordinary masonry,[46] the megalithic wall at Ollantaytambo.

Stone possessed special—in a sense sacred—qualities for the Inka.[47] This is seen in the unusual treatment of individual stones incorporated into the walls of buildings and terraces. It reaches its height in the treatment of living rock. In many cases living rock is incorporated as part of a structure. The buildings are adapted to natural features and the natural features are incorporated into the cultural environment.

Living rock also appears as freestanding sculpture. Visitors to the Cuzco region and other parts of the Inka realm have long admired these extraordinary stones. Whether strikingly simple or complex, almost all are enhanced by the landscapes in which they are

set. They have not received the attention and appreciation given to other native New World art because they must be seen in their remote contexts. Recent studies seek to redress this imbalance. "Inka monumental stone sculpture . . . should be seen as one of the major sculptural styles of the world. Like the most accomplished Egyptian, Greek, Mexican and Romanesque works of sculpture, it presents a unique intellectual achievement. Mass, volume and voids are its primary concerns. Its angular aspect and formal rigidity give it a distinctly 'modern' feel."[48]

Although more subtle and much less standardized than other manifestations of imperial art, these sculptures also served as markers and symbols of the presence of the Inka. Their uses and meanings, however, are probably much more far-reaching and complex. Frequently they marked boundaries or commemorated important events in myths and legends, for example, places of ancestral origin. Perhaps their most intriguing and powerful meaning is as instruments of mediation and communication between people and the natural and supernatural.[49] As objects fashioned from the realms of both culture and nature, they were ideal bridges between people, the natural worlds in which they lived, and the supernatural world, which was also populated by extensions of beings from nature.

Recognizing the pivotal role of Inka art in communication between people and groups and even between society and the cosmos does not detract from the artistic importance of the objects. Aesthetic strength is, in some sense, based in communication. The headdresses that served as insigniae of group membership, the tunics that may have signaled position in the hierarchy of state officials, the bright metal objects that indicated status or symbolized religious beliefs, the stones that helped mediate between earth and cosmos: all owed some of their artistic characteristics to the meanings attached to them.

The creation of an empire like that of the Inka depended on communication to link its numerous and varied parts; the dependence was perhaps even greater because of the lack of true writing. The creation of an empire also depended on motivation, inspiration, and persuasion. The use of strong, simple, understandable symbols in architecture, clothing, and objects of adornment was an important aspect of the means used by the state to achieve cooperation and participation in its political and economic activities. Objects in the imperial Inka style had become part of the means by which the empire was created and maintained. Some might argue that art and design had become

subservient to propaganda. In broader perspective, however, the sociopolitical dimensions of imperial Inka style can be seen as the participation of art and visual communication in an overall process of social growth that contributed to new political, economic, and aesthetic orders.

To understand fully the role of art in this process we need to know how the imperial Inka style developed. Unfortunately, both the historical and the archaeological records offer only fragmentary information on this topic. The incomplete archaeological evidence suggests that the style appeared quite suddenly in the mid-fifteenth century.[50] It was preceded in the Cuzco area by the Killke style, known only from ceramics.[51] While some elements of painted design on Inka ceramics can be traced to earlier Killke designs,[52] these seem insufficient to suggest a gradual evolution of the imperial Inka style from the earlier tradition. Rather, with its crisp new range of shapes, improved technical quality, and more controlled designs, the Inka style represents a marked break from the past. We can only speculate as to how these specialized weavers, smiths, and potters may have been related to the creation of the style associated with the state.[53] It seems clear, however, that these widespread designs were not simply the innovations of individual artists and designers, later freely copied by others as they became widely popular. For styles to become standardized and then broadly disseminated as these were, there had to be some direction from the governing elite almost from the outset.

The content of Inka art is thus intimately tied to the nature of the empire in which it was created and used. As we appreciate the beauty and social utility of the relatively standardized objects, we need also to seek a greater understanding of their creative source. It is important as well not to be so blinded by the boldness of the state styles that we fail to note the latitude for individual variation. Though the variety of regional styles is evident, some of the most innovative and unique Inka art is actually part of the imperial repertory. It occurs most notably in architecture and in sculptures carved in living stone. Seen in its totality the art of Tawantinsuyu is as grand and complex as the empire itself, a kaleidoscope of regional variation tied together by the strong and unmistakable style of objects created for the Cuzco rulers.

Most impressive about the Inka aesthetic world are the combinations, the way various arts and media were used together and incorporated into human activities and the natural landscape. In spite of its seeming modernity in many visual features, this was not art produced by individuals for purely aesthetic ends. It was art as practiced throughout most of history and

prehistory, communicating ideas and stamping a new vision of beauty on the physical world in which people lived. Its scale and effect varied from the subtlety of small, exquisitely cast metal figures dressed in textiles and feathers for offerings on high mountain peaks, through carved rocks that were also occasionally covered with textiles,[54] to the heroic dimensions of towns sculpted out of mountains. The careful ensemble, the combining of elements in the material world, matched attempts in the social, political, and economic realms to assemble complementary elements into a vast, balanced, and wealthy whole.

The remarkable economic, political, and artistic achievements of the Inka did not equip them to cope with a foreign world. They could not have envisioned the tragic consequences of the European invasion. Although many aspects of Andean creativity continue even today, the empire and its art were quickly destroyed during the first decades of outside domination. To the Inka the recently arrived representatives of that foreign world must have seemed uncivilized: people driven by greed and religious fanaticism to acts of brutality and ugliness.

NOTES

1. John Hyslop, *Inka Settlement Planning* (Austin, 1990), 291.
2. John V. Murra, "El 'Control Vertical' de un Máximo de Pisos Ecológicos en la Economía de las Sociedades Andinas," in *Visita de la Provincia de León de Huánuco*, vol. 2 (Huánuco, Peru, 1972).
3. John Hyslop, *The Inka Road System* (New York, 1984).
4. J. Alden Mason, *The Ancient Civilizations of Peru* (London, 1957), 231.
5. Dorothy Menzel, *The Archaeology of Ancient Peru and the Work of Max Uhle* (Berkeley, 1977), 26–29.
6. Ann P. Rowe, *Costumes and Featherwork of the Lords of Chimor* (Washington, 1984).
7. See discussion of smiths, below.
8. Dorothy Menzel, "The Inca Occupation of the South Coast of Peru," *Southwestern Journal of Anthropology* 15, no. 2 (1959), 125–142, provides a general review of the Inka occupation of the Peruvian south coast. For a more specific treatment of the Inka and Nazca areas see Menzel 1977, 8–18.
9. John Hyslop, "Las fronteras estatales extremas del Tawantinsuyu," in *La Frontera del Estado Inca*, ed. Tom Dillehay and Patricia Netherly (Oxford, 1988), 35–57.
10. Betty Meggers, *Ecuador* (London, 1966), 162–163; Frank Salomon, "Vertical Politics on the Inka Frontier," in *Anthropological History of Andean Polities*, ed. John V. Murra, Nathan Wachtel, Jacques Revel (Cambridge and London, 1986), 89–117.
11. Julie Jones, *Art of Empire: The Inca of Peru* (New York, 1964), 5.
12. John H. Rowe, "Inca Culture at the Time of the Spanish Conquest," in *Handbook of South American Indians*, ed. Julian Steward (Washington, 1946), 2:287.

13. The major discussion of state revenues is John V. Murra, *The Economic Organization of the Inca State* (Greenwich, Conn., 1980), especially ch. 5.

14. Craig Morris, "The Infrastructure of Inka Control in the Peruvian Central Highlands," in *The Inka and Aztec States: 1400–1800*, ed. George Collier, Renato Rosaldo, John Wirth (New York, 1982).

15. Archaeologists have argued that simple, bright designs that can be easily recognized at a distance are more effective at communicating behavioral meaning than complex designs that require time to analyze. See Christopher Carr, "Toward a Synthetic Theory of Textile Design," *Style, Society, and Person*, ed. Christopher Carr and Jill Neitzel (Cambridge, England, forthcoming); Margaret Hardin, "Design Structure and Social Interactions: Archaeological Implications of an Ethnographic Analysis," *American Antiquity* 35 (1970), 332–343.

16. Craig Morris, "State Settlements in Tawantinsuyu: A Strategy of Compulsory Urbanism," in *Contemporary Archaeology: A Guide to Theory and Contributions*, ed. Mark P. Leone (Carbondale, Ill., 1972).

17. Junius B. Bird, John Hyslop, Milica Dimitrijevic Skinner, "The Preceramic Excavations at the Huaca Prieta, Chicama Valley, Peru," in *Anthropological Papers of the American Museum of Natural History* 62, no. 1 (New York, 1985), 146–190.

18. John V. Murra, "Cloth and Its Functions in the Inca State," *American Anthropologist* 64 (1962), 717–722.

19. Bernabé Cobo, *History of the Inca Empire*, tr. Roland Hamilton (Austin, Texas, 1979).

20. Murra 1962, 719.

21. Tom Zuidema, "The Royal Whip in Cuzco: Art, Social Structure and Cosmology," in *The Language of Things: Studies in Ethnocommunication*, ed. Pieter ter Keurs, Dirk Smidt (Leiden, 1990).

22. Francisco de Jerez, *Las Relaciones de la Conquista del Perú* ([1534] Lima, 1917), 56, trans. Craig Morris.

23. Victoria de La Jara, *Introducción al Estudio de la Escritura de los Incas* (Lima, 1975).

24. John H. Rowe, "Standardization in Inca Tapestry Tunics," in *The Junius B. Bird Pre-Columbian Textile Conference*, ed. A. P. Rowe, E. P. Benson, A. L. Schaffer (Washington, 1979), 239–264.

25. Ann P. Rowe, "Technical Features of Inca Tapestry Tunics," *Textile Museum Journal* (1978), 5–28.

26. Craig Morris, "Reconstructing Patterns of Nonagricultural Production in the Inca Economy: Archaeology and Documents in Institutional Analysis," in *The Reconstruction of Complex Societies: An Archaeological Symposium*, ed. Charlotte Moore (Cambridge, Mass., 1974), 49–60.

27. Murra 1962.

28. Murra 1962, 720.

29. Craig Morris and Donald Thompson, *Huanuco Pampa: An Inca City and Its Hinterland* (London, 1985), 142.

30. Pedro Cieza de León, *Cronica del Perú, Segunda Parte* ([1653] Lima, 1985), 7.

31. In Miguel Mujica Gallo, *The Gold of Peru* (Recklinghausen, Germany, 1959), 288. See also S. K. Lothrop, *Inca Treasure as Depicted by Spanish Historians* (Los Angeles, 1938).

32. Lothrop, 1938, 52.

33. Pedro Sanchez, *Relacion de lo Sucedido en la Conquista del Peru* (Lima, 1917), 181.

34. Heather Lechtman, "Andean Value Systems and the Development of Prehistoric Metallurgy," *Technology and Culture* 25 (1984), 1–36.

35. Pedro Cieza de León, *The Incas of Pedro Cieza de Leon*, tr. Harriet de Onis, ed. Victor von Hagen (Norman, Okla., 1959), 35–37.

36. Cieza de León 1959, 36.

37. Grete Mostny, "La momia del cerro El Plomo," *Boletín del Museo Nacional de Historia Natural* 27 (Santiago, 1957).

38. Cieza de León 1985, 170.

39. Hyslop 1984, 285.

40. Jean-Pierre Protzen, "Inca Stonemasonry," *Scientific American* 254, no. 2 (1980), 94–103.

41. Morris 1972.

42. Hyslop 1990, 251–269.

43. Craig Morris, "Architecture and the Structure of Space at Huánuco Pampa," (ms. 1980) forthcoming in Spanish, in *Cuadernos del Instituto Nacional de Antropología* (Buenos Aires).

44. Hyslop 1990, 191.

45. Graziano Gasparini and Luise Margolies, *Arquitectura Inka* (Caracas, 1977), 266–269.

46. John H. Rowe, "An Introduction to the Archaeology of Cuzco," *Papers of the Peabody Museum of American Archaeology and Ethnology* 27, no. 2 (Cambridge, Mass., 1944); John Hemming and Edward Ranney, *Monuments of the Inkas* (Boston, 1982), 78–87.

47. Hyslop 1990, 106–108.

48. Maarten Van de Guchte, *"Carving the World": Inca Monumental Sculpture and Landscape* (Urbana, Ill., 1990), 1.

49. Van de Guchte 1990, 330–333.

50. J. Rowe 1944, 61.

51. J. Rowe 1944, 60–62; Brian S. Bauer and Charles Stanish, "Killke and Killke-Related Pottery from Cuzco, Peru, in the Field Museum of Natural History," *Fieldiana Anthropology* n.s. no. 15 (Chicago, 1990), 1–17.

52. Bauer and Stanish 1990, figs. 3, 4, 9, 12.

53. J. Rowe 1946, 269; Murra 1980, 89–115.

54. Hyslop 1990, 77, 107.

THE FALCON AND THE SERPENT: LIFE IN THE SOUTHEASTERN UNITED STATES AT THE TIME OF COLUMBUS

James A. Brown

After the conquest of Mexico and Peru led the Spanish to unexpected riches, their attention turned to what is now the southeastern United States as the next land of opportunity. Encouraged by his own success in the Andes, Hernando de Soto led a heavily financed expedition in a serious attempt to reveal this new land to European eyes. In so doing DeSoto and his men found a family of complex cultures spread over this enormous territory, land inhabited by farmers as well as many compact fortified towns led by exalted rulers. Political units of considerable size were based upon single towns. Advanced as these cultures were, the conquistadors were nevertheless disappointed by their discoveries. Native Americans were not sitting on the kind of liquid wealth the Spaniards had found in Mesoamerica and South America and which they had invested so heavily in locating.

By the end of the sixteenth century it was evident that La Florida, as this land was known to the Spanish, was too vast for easy domination. Many of its populous settlements were far from the coast, making effective control of some of the more promising areas all the more tenuous, particularly in the face of fierce native resistance. Both the problems and the opportunities were summed up in the Spanish account of La Florida completed in 1592 by the Peruvian historian Garcilaso de la Vega, known as "El Inca" because his mother was an Inka princess:

In addition to the brave deeds performed and the hardships suffered by the Christians both individually and generally, and the notable things discovered among the Indians, we present in this history a description of the many extensive provinces found throughout the great kingdom of Florida by the Governor and Adelantado Hernando de Soto.... Our purpose in offering this description has been to encourage Spain to make an effort to acquire and populate this kingdom (now that its unsavory reputation for being sterile and swampy, as it is along the coast, has been erased) even if, without the principal idea of augmenting the Holy Catholic Faith, she should carry forward the project for the sole purpose of establishing colonies to which she might send her sons to reside just as the ancient Romans did when there was no longer space in their native land. For Florida is fertile and abundant in all things necessary to human life, and with the seed and livestock that can be sent there from Spain and other places, it can be made much more productive than it is in its natural state.[1]

Despite El Inca's plea, the interior of La Florida remained poorly known to the Europeans for centuries. During the sixteenth century both exploration and missionary activity were limited. Colonization proved a disaster. Spanish penetration into the land was too expensive an undertaking. Although the crown retained nominal claim over the vast subcontinent, actual Spanish control over the destinies of the resident peoples extended only to small patches on promising parts of the coast. The problem was that distances were great and much of the vast interior was unoccupied. Although populations were concentrated in certain regions, these areas were not city-size, but towns of only several thousand inhabitants. Without population of sufficient density, labor-intensive projects such as mineral exploitation were not feasible. And without the political organization entailed in city-scale organizations, there was no potential for subjugation of native populations, as there had been in Mexico and Peru.

Thus the land was left on its own until the end of the seventeenth century, when other European powers quickened the tempo of exploration and enmeshed the area in the world economy. Because of European neglect of this area in earlier periods, however, we lack the variety of Spanish chronicles that describe the culture of the contact period in Mesoamerica and South America, and there is no parallel to the encyclopedic texts detailing Mexican culture that were produced by or under the supervision of the early Franciscan missionaries. Moreover, we cannot depend for our knowledge of the pre-Columbian southeast on the more specific accounts that began to emerge later, for these describe a very different land. By this time the cultural landscape of the area had been modified almost beyond recognition. Where direct European manipulation had been ineffective, Old World diseases had thinned the population, displaced the people, and increased the militancy of the surviving population.[2] It was in this dramatically different setting that the Europeans were able to undertake new initiatives in political manipulation, economic subjugation, and eventual colonization, initiatives that defined subsequent periods of native American history.

Archaeology and history combine to tell us that the high cultures of the pre-Columbian southeast were significantly different from the cultural landscape that emerged centuries later. At the end of the seventeenth century in the Memphis region of the Mississippi River Valley, where populations once were densest, few people were to be found. Tribes mighty in Soto's time had been reduced to small towns, which were forced to merge with others to compensate for their loss of population. Compact urban settlements were abandoned in favor of dispersed settlement. Once-powerful rulers were succeeded by chiefs holding largely empty titles. This shift away from the social and political features associated with large populations has led archaeologists to conclude that significant parts of the culture became simplified as well, the net result being general depauperization of native life. After two centuries of indirect European impact through disease, the residents of the southeastern interior were very different from their predecessors. New tribal entities replaced the fallen, and formerly powerful groups shrank to minor tribes. Native Americans faced Europeans on very different terms during the eighteenth century.

This background explains why the early culture of the native southeast does not have a well-defined image today. Native accomplishments have been reduced to stories about Powhatan and other major figures, bizarre practices, and conflicts with settlers on the expanding American frontier. These stories leave little room in the imagination for the real triumphs of pre-Columbian culture. During the early

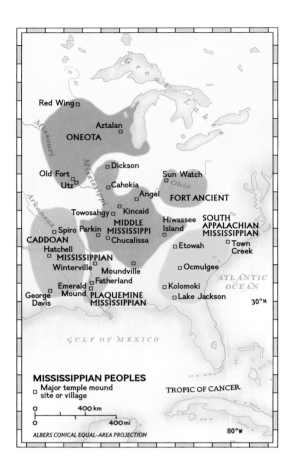

MISSISSIPPIAN PEOPLES
□ Major temple mound site or village

0 400 km
0 400 mi

ALBERS CONICAL EQUAL-AREA PROJECTION

period of contact, when native traditions were more or less intact, the obscurity of native southeastern life deprived the European chroniclers, who were in a position to record it, of a sense of native American lifeways. The evocative objects displayed in this exhibition offer a hint of these traditions, which have all too often been dismissed as derived from Mesoamerican culture and as a consequence having no bearing on North American achievements. However, archaeologists have amassed data that create a complicated and rich history of the southeast. This is one in which the highly refined beliefs, symbols, practices, and technology—of supposedly Mexican derivation—are actually the result of developments in high culture that were for the most part self-contained. Whatever connections had existed between Mexico and the southeast in the past, they only reinforced a preexisting southeastern cultural pattern.[3]

Contemporary expeditions were mounted by Coronado in the southwest and the southern Great Plains and by Cartier in the Saint Lawrence. Although, like Soto's, these helped bring the main outlines of native culture to the attention of the Old World, detailed knowledge of the interior of North America remained to be learned in the future.[4] Archaeology helps fill the gap in providing a conception of the range of North American cultural life in this period. From a combination of sources it is clear that

agriculturally based societies were confined within climatic limits. This limitation meant that a border zone of relatively complex cultures existed to the north of the southeast in the Lower Great Lakes and northwest along the fingers of well-watered valleys stretching out into the Great Plains. The other concentration existed in the arid southwestern United States where the pueblo towns were spotted along the few dependable watercourses. Otherwise, most of the population at 1492 was packed along the Pacific Coast from California to Alaska. Seafood provided the basis of settled life and complex culture in this area. Elsewhere, populations were sparse and scattered, and economic life was dependent upon hunting and gathering.

La Florida of the conquering Spaniards embraced the southeast broadly conceived. It lay roughly in the Old South, which in the nineteenth century was to realize an agricultural potential that had been established nine centuries earlier. The route that Soto took largely bracketed this territory.[5] His quest for wealth led his band to the main seats of political life. Along the way he met minor groups and traversed long stretches of wilderness. The geography of settled life provided by his march, coupled with our knowledge of the archaeology of the early sixteenth century, gives us a rough idea of the principal features of the cultural landscape.

From south to north the following picture emerges. The Gulf Coast proper contained few people. The immediate interior held far more. These were organized mainly into small chiefly societies divided into nobles and commoners and led by hereditary chiefs with limited powers. At present day Tallahassee, Florida, where he spent his first winter, Soto met the fierce Apalachee, a people who eventually lent their name to the mountain chain.[6] To the north, populations of similar political organization were clustered along a number of the major rivers whose valleys held the soils essential for farming. Within a broad, barren belt of southeastern pine woods these river valleys were the focus of settled life.[7] Not all valleys were occupied; there was a notable vacancy in the Savannah River Valley dividing present day Georgia and South Carolina. In the Piedmont zone many more named provinces (the Spanish term for native tribal territories) were to be found. Two among them stood out as particularly large, and were probably even in the process of expansion at the time of the visit. The Cofitachequi held sway in central South Carolina. At their main town the Spanish looted a mortuary shrine of its pearls, the first and only occasion of their finding significant wealth in European terms. The reports of silver that drew them to

this place turned out to be inspired by great sheets of mica. This and the native copper that were used to make precious objects conferring high prestige were found to be the closest things to reservoirs of value that were recognized by the native peoples. In what is now northwest Georgia the powerful leader of the Coosa held authority over subordinate chiefs in a wide swath of the intermontane valley.

In the Mississippi River Valley the largest and most compact of the towns were located north of the mouth of the Arkansas up to what is now the Missouri state line. Here the explorers found the most populous area of their journey. Territories were under the sway of large fortified towns nestled together, with few of the uninhabited zones that commonly separated settled provinces elsewhere. Settlements south of this section of the river valley appear to have been more dispersed, although two major chieftaincies occupied the lower valley; these were responsible for the expedition's final harassment on its journey homeward. North of the Memphis section settlement was sparse. West of the Mississippi Valley, settlements were dispersed with populations thinning out in east Texas.[8]

Along the way the expedition discovered peoples speaking most of the major languages of the historic southeast: Timucuan, Muskogean, Iroquoisan (Cherokee), perhaps Siouan, and Caddoan. In their wandering the Europeans traversed the domains of major provinces or chiefly polities. Although some of the peoples the Europeans encountered survived to develop into the major tribes of later times (Chickasaw), others (Coosa, Cofitachequi) subsequently dwindled in power and population to the point that they were forced to coalesce, to become the Creeks.

Soto found evidence of town life concentrated within defensive walls as well as distributed over scattered hamlets. He found rulers (albeit with limited power) over both small and large communities. The greatest potentate was the paramount chief (or grand cacique) of the Coosa, who commanded tributary relations over a large area. Among all of the tribes, warfare was entrenched. The importance of this fact of life had its impact on which personages were represented in art and the manner in which images were presented.

Even though the knowledge that archaeology has provided is incomplete, certain outlines have emerged to help provide a context for the Spanish narratives. This archaeological contribution makes it possible to define a cultural world of native North America at the time of initial European encounter that cannot be constructed from the Spanish narratives alone,

which are limited in their viewpoints toward native cultures. Although they are rich in action and adventure, missing are indications of religious life, town architecture, political organizations, crafts, trade, and the visual arts. With the help of archaeology these and other features of native life emerge to fill out our portrait of this high culture.

This cultural landscape goes back to around A.D. 1000, when a transformation took place in the social, economic, and political realities of native life. Broadly speaking, the scattered, independent, single-village social communities that formerly predominated were replaced by interdependent multivillage communities. The result was the development of the social and political means of integrating larger groups of people, which became the basis for cultural life of southeastern tribes established from then on. So marked was this change in many interdependent aspects of cultural life that archaeologists have distinguished pre-Columbian history after the year 1000 as the Mississippian period. Although some of this shift in organization was a consequence of local population growth, in certain places the change was accomplished by the political union of formerly autonomous villages. The result was a new institutional basis on which variations and elaborations could take place.

The principal architectural features of Mississippian towns were the platforms of earth erected to support the houses of chiefs, the shrines of the ancestors, and the sacred fires. Some of these towns achieved considerable size. As the period progressed many settlements were walled for defense. A shift toward increasing reliance on corn agriculture likewise characterized this period. This development was accompanied by the rise of distinct traditions in artifacts that continued until the sixteenth century.

From the perspective of material culture archaeologists have identified broad groupings of traditions. The more complex of these were the South Appalachian Mississippian (represented by the Apalachee, Coosa, and Cofitachequi), the Middle Mississippian, the Caddoan Mississippian, and the Plaquemine Mississippian (represented by the Natchez). Less complex social and cultural life to the north is divided into the Oneota and Fort Ancient cultures.

In place of a universal pantheon, each tribe had its own deities who defined their origin and social identity. Although there seemed to be great similarity among southeasterners with respect to worship and belief, the overwhelming authority of local custom prevented any drive toward syncretism. Therefore, one must look at the organization of social life to understand southeastern religion.

Settled village life centered around what has been loosely called a temple, but was in reality a shrine dedicated to the veneration of the town's ancestor-founder. Closed to all except the chief and his priests, the chosen few, this shrine occupied a conspicuous place in the center of the town. It frequently stood on a platform mound oriented in a ceremonially prescribed direction. Within burned the sacred fire, carefully nurtured by ritual guardians. Important objects kept there included the bones of the ancestors of the elite family, tokens of wealth, and sometimes even armaments. In generalizing about southeastern religion El Inca placed the temple squarely in the center of indigenous religious practice:

> The Indians are a race of pagans and idolaters; they worship the sun and the moon as their principal deities, but, unlike the rest of heathendom, without any ceremony of images, sacrifices, prayers, or other superstitions. They do have temples but they use them as sepulchres and not as houses of prayer. Moreover, because of the great size of these structures, they let them serve to hold the best and richest of their possessions. Their veneration for the temples and burial places, therefore, is not profound. On the doors of them they place the trophies of victories won over their enemies.[9]

The most spectacular ancestor shrine known was the temple of the Cofitachequi located in the center of present-day South Carolina.[10] According to the detailed description provided by El Inca, who relied on the direct testimony of members of Soto's expedition, carved wooden giants were stationed at the doorway, each brandishing different kinds of weapons. Inside were masses of marine shells and strands of pearl beads, headdresses of multicolored feathers and furs, and different kinds of armaments. In the center were wooden chests filled with the bones of the ruling family and carved images of individual dead. Although this account may be exaggerated or a fusion of separate instances, the kinds of objects described are ones that are known from archaeology and other historical accounts to have been important in native life. Pearls, marine shells, and copper beaten into shape were items of value in the southeast. Armaments were sometimes stored under the same roof as wealth and ancestral bones. Thus the essentials of this splendid example are objects that can be attested to independently from other sources. Furnishings that dominate the shrine are caskets and images. Images of this type have survived to provide a remarkable

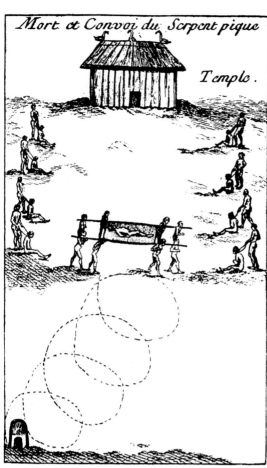

fig. 1. Funeral Procession for Tattooed Serpent in 1725. At rear is a mortuary shrine that stood on one of the mounds at the Grand Village of the Natchez

testimony of native American craftsmanship (cats. 428, 429).[11]

Clearly the ancestor shrine was the physical center of religious life. Two centuries later the Natchez espoused beliefs that once were probably more widely held in the southeast.

> The chiefs were regarded as spirits descended from a kind of idol which they have in their temple and for which they have a great respect. It is a stone statue enclosed in a wooden box. They say that this is not properly the great spirit, but one of his relatives which he formerly sent into this place to be the master of the earth; that this chief became so terrible that he made men die merely by his look; that in order to prevent it he had a cabin [shrine] made for himself into which he entered and had himself changed into a stone statue for fear that his flesh would be corrupted in the earth.[12]

The Natchez called this deity "The." He was the bearer of arts and technology as well as the tribal forefather. This founding deity gave direction and coherence to society. So imbued with life force were these stone (and wood) personifications that they were thought to be in

le transport du Grand Soleil

fig. 2. The Natchez Chief Great Sun Being Transported on a Litter

some sense alive. The contemporary Tukabahchee Creek, who no longer maintained a sacred shrine house, nevertheless brought their image out into the town square to consecrate important public affairs.[13] Although these images generally were of males, along the Mississippi River female figures were reported and among the South Appalachian cultures these images were paired, one male and the other female.[14] Differences in representation probably reflect differing conceptions regarding descent from the gods.

The ruling family held a preeminent social status through its genealogical descent from the town founder. As a consequence, the chief was the principal if not the sole person having access to the shrine's inner sanctum. From this privileged position he acted as mediator between the deity—the sun—and the general population. He held esoteric sacred knowledge shared only among a small group of priestly officials.[15] A group of "nobles" from second- and third-ranking families shared some of the prerogatives held by the ruling family. All of the elite were distinguished from commoners in deport-

ment and dress, particularly in their use of large and showy headdresses (cats. 438, 440). To signify their importance chiefs were sometimes carried over the heads of ordinary people in litter transports.[16] These ordinary individuals belonged to low-ranking families. Although enormous differences in wealth and privilege were associated with family rank, each society was bound together into two complementary family groups having reciprocal obligations to each other.

A small minority of carefully selected and trained individuals controlled the rites and paraphernalia belonging to the sanctified shrine. Rites were entirely secret. Typically, transgressions such as allowing the sacred fire to become profaned with ordinary fire were punished by death—an indication of the awful jeopardy into which the entire community was believed to be placed by this infraction. So bound up with the health and well-being of the community were these sacred flames that when calamity struck, the custodians of the fire were expected to take the blame.

The sacred fire was no ordinary fire since it was conceived as being kindled by the sun. As a representative of the sun on earth, for each town it defined the center of the universe. The four directions branched off this center, and a fifth was created by the ascent of smoke to the heavens of the upper world. The four directions were commonly represented by four logs set pointing to the center where the fire slowly burned. In keeping with the importance of the sacred fire as an embodiment of the life force, each town maintained its own fire under the care and protection of the highest ritual practitioners. The authority that the elite, as custodians of the town's power, took from this life

force presumably led to the frequent employment of solar disc and cross-rayed motifs as shorthand symbols of chiefly power. The fire was ritually renewed each year in order to replace with pure fire the old one, which had absorbed the pollution generated by the community over the preceding year.

The dead held such a potent place in the affairs of the living that certain objects were created to draw upon that power. Pottery versions of stone and wooden shrine figures, made in the Arkansas area, appear to be embodiments of the very dead whose remains were kept in the town shrines. Ceramic pots were modeled to resemble human heads, essentially those of dead men (cat. 435). Marine shell masks with thunderbolt markings descending from the eyes likewise have mortuary associations. These masks were widely employed in the sixteenth century, and from later testimony we know that they were the principal components of the sacred bundle, a kind of portable shrine carried on the warpath.[17]

In this context the commentary of El Inca describing the southeastern religions is quite understandable. Since the gods were connected with the most sacred forces relevant to social life, religious rites could be kept simple and guided entirely by the worship of the tribal leaders. Because these deities were extensions of tribal kinship, it was logical to expect the senior representatives of the tribe to arrogate to themselves the propitiation of their own ancestor gods.

The rites of the privileged minority were a special refinement on generally espoused beliefs about the powers of nature that impinge upon everyday existence. The task of ritual, whether under priestly control or not, was to maintain

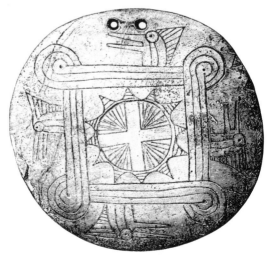

fig. 3. Neck Ornament. Engraved shell, c. 1400–1500. The looped square frame is a transformation of the litter in fig. 2

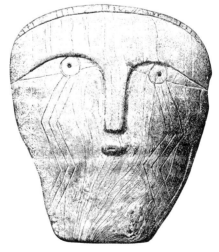

fig. 4. Mask of the Ancestor Spirit (?). Carved and engraved in marine shell, c. 1500–1600. Lightning bolts of the thunderers descend from the eyes

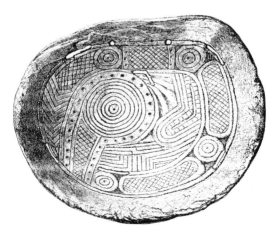

fig. 5. Gorget. Engraved marine shell, c. 1500–1600. The motif is a rattlesnake's head within its coils. The teeth in the jaws suggest the cougar

order in the face of the contending forces of the upper and lower worlds. These forces were conceived as opposites such as good/evil, order/chaos, and life/death that are present to varying degrees in all things and actions. They were connected with what were (and to an extent traditionally still are) regarded as polar forces in constant contention and counteraction. The middle ground, that of the earth, was the theater in which these cosmic forces played.[18]

The sacred fire was by origin and association a representative of the upper world having considerable power for good on this earth as long as it was properly tended. But proper care in a perfect sense was offset by the frailties of humankind. This is where management of the countervailing powers aligned with each of the worlds required dedicated ritual attention. The upper world was associated with the sun, the sacred fire, the thunderers, the falcon, and other powers. The underworld was associated with water from springs, the cougar, and the rattlesnake. Although life was believed to be conferred by powers from the upper world and death was a property of the underworld, various allied concepts of fertility were apportioned more subtly.

The leaders of the Natchez appropriated into their names the sun and the serpent as symbols of primal power. The "Sun," representing the upper world, was the preeminent ruler who was senior brother to the "Tattooed Serpent," representing the lower. As principal and second-ranking leaders of the tribe they encapsulated the cosmos. Together they controlled the fate of the society by representing these polar forces on earth.

Leadership in war and the organization of men into warrior societies drew upon the powers of the upper and lower worlds. The falcon constituted the symbol of elite control of success in war. This animal had most of its connections with the elite. Hawks, and more specifically duck hawks or peregrine falcons, were the epitome of the aggressive strike force, probably out of regard for their spectacular aerial hunting behavior.[19] But other birds possessed warrior qualities as well. The pileated woodpecker and the turkey represented warriors because of very different properties specific to each. The former was conventionally associated with the war hatchet that was shown in images with chiefly identifications. In contrast to these upper-world representatives, major warrior societies among Natchez and certain Creek towns drew upon the serpent. The cougar represented stealth in combat. This use of one or the other resembles the division of Creek towns into red and white sides, one representing war and the other peace.

In other underworld associations the cougar (or panther), sometimes as an aquatic monster, controlled the underworld. The snake had a connection with regeneration.[20]

The serpent was not always cast as the tutelary of the warriors or as a power controlled by the war chief. At a somewhat earlier point in time, the falcon had been the principal emblem of war leadership. Chiefs dressed in nose, headdress, and cloak of hawks impersonated this patron of stunning prowess in an effort to mimic in dance and dress the effects they sought to emulate in their deeds (cats. 437, 440).

Ideas about the place of individual animal powers were given greater scope for expression outside the ordered universe of the controlling and rationalizing chiefs, priests, and healers. These concepts are richly expressed in the many stories and remedies handed down through oral tradition. Most of these beliefs have to do with ceremonies that were public rather than exclusive to the initiates of the shrine. All adult society took part; professional masters of ritual were unnecessary. The principal cycle of public ceremonies was the green corn dance, a communal ritual honoring the first crop of corn, which was so essential to the local economy. This great ceremony enlisted many of the beliefs most fundamental to everyday existence.

Images chosen for subject matter in the ceramic arts appear to be subject to the same influences as public ritual. Most of the animals incorporated into effigy pottery could have been regarded as personal tutelaries accessible to everyone. Modeling of humans must have had another rationale, none of it having any particularly sacred aspect as far as we can tell (cats. 434, 439). Commonly held beliefs are thought to include the primal importance of caves within hills.[21] The large earthwork platforms that supported the shrines and chiefs' houses are interpreted as having drawn from this power.

In the years after 1000 a distinctive imagery became established, which lasted into historic times. This imagery centered around objects that were literal or metaphorical expressions of certain powers. Conspicuous among them were the animals connected with the ritual invocation of cosmological forces. Many of these mammals, birds, and insects, however, have less exalted, even playful associations as well (cat. 433). Images of man and animals were frequently combined in ways suggesting particular myths in which these creatures were central characters. Birds in particular represented specific positions in society. In this sense the bird kingdom was thought of as a metaphor for human society.[22]

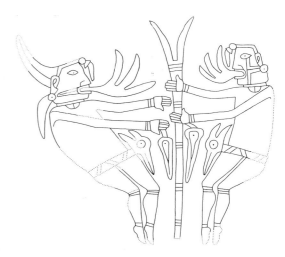

fig. 6. Paired Figures Confronting a Forked Pole. This motif is a serpent theme; the figures have woodpecker-headed hatchets in their belts. Drawing from pieces of engraved marine-shell cup, c. 1300

Artistic expression separated the female world from that of the male. In human images women are confined to the earliest period of artistic production and were the centers of mythic tableaux revolving around the origin of fertility and the gifts of the cult founder. They feature such elements as generation of squash plants from the body of magical cougar-serpents.[23] Males play an entirely different role in imagery that centered around warfare, spirit quest, divination, hunting, and the impersonation of magical forces.

Within this broad range of expression certain themes stand out for their connection with the chiefly ancestors, secular power, and warfare. The honored ancestors can be depicted as heads or mysterious figures. In more abstract fashion, hand and eye in certain contexts signify the gods (cat. 430). Litters become images of chiefly office. Associated with this theme of secular power are woodpeckers, specifically woodpecker-effigy war hatchets.

Warfare in general is a theme finding many expressions. Images of fierce warriors represent ideals of male prowess in battle and success in raiding. The falcon, pileated woodpecker, and turkey were employed to represent fierceness in combat and the other traits of the successful warrior. Serpents held a strong place in imagery, although their meaning changed over time (cat. 431). In later prehistory the imaginary piasa monster was the typical embodiment of the dangerous ruler of the underworld. This monster was depicted as a rattlesnake with cougar head, avian wings, and animal legs with talons.[24] The mixture brought together elements of certain creatures that played a role as tutelaries of warfare: cougar, serpent, and hawk.[25] It

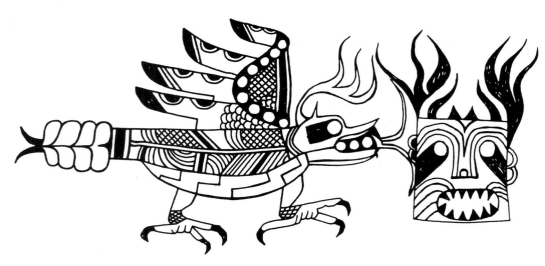

fig. 7. Piasa Monster. Drawing of side and front view of an image engraved on a pottery vessel

is primarily in this context that we have to interpret this fearful monster.

Much of this animal imagery can be interpreted as an evocation of the creature's power. Parts of animals are widely employed to these ends, as in the figure of speech known as synecdoche, in which the part stands for the whole.[26] The distinctive forked marking around the falcon eye was regularly used to stand for the bird. The crossed poles of the chiefly litter were used to stand for the chief's office itself.

In all, the overwhelming theme of southeastern imagery at the time of Columbus can be thought of as centering around men in their capacity to manage the powerful and often magical properties of both the upper and lower worlds. Men were depicted as either gods or captive foes. Animals were used for their symbolic value as representations of the most potent forces of the upper and lower worlds. Humans were more than ritual mediators with the powers of these two worlds. For certain purposes humans were divided into social groups that represented these worlds. Society was organized by cosmic principles.

In this the land of the Old South, a country so conducive to successful agriculture in a preindustrial world of America, a high culture arose around the year 1000 that produced a rich art that is only now becoming recognized. Upon this base a large population of interrelated communities arose that used this artistic expression as a means of placing humankind in proper order with potent cosmic forces. Both human and animal forms were used interchangeably with certain preferences being typical of particular periods. One enduring principle was the identification of certain animals as representatives of either the upper or lower worlds. Birds

were predominately aligned with the upper world together with the sun and heavenly sources of nurture. Serpents belonged to opposing, dangerous forces of the lower world. At the period of contact with the Europeans, the human form was used to represent overwhelmingly the gods, the ancestral dead, and possibly the living representative of this line of ancestors. Otherwise Mississippian art, which has contributed some remarkable images of human life, made use of the underworld monsters in its increasing preoccupation with the successful pursuit of war and survival through defense.

NOTES

1. Garcilaso de la Vega, *The Florida of the Inca*. Translated by John and Jeannette Varner (Austin, 1951), xxxviii. El Inca was a pseudonym.
2. The aftermath is well covered by David Hurst Thomas, ed., *Columbian Consequences, Volume 2, Archaeological and Historical Perspectives on the Spanish Borderlands East* (Washington, 1990). See also Peter Wood, Gregory A. Waselkov, and M. Thomas Hatley, eds., *Powhatan's Mantle: Indians in the Colonial Southeast* (Lincoln, 1989).
3. Malcolm C. Webb, "Functional and Historical Parallelisms between Mesoamerican and Mississippian Cultures" in Patricia Galloway, ed., *The Southeastern Ceremonial Complex: Artifacts and Analysis* (Lincoln, 1989), 279–293.
4. Carl Ortwin Sauer, *Sixteenth-Century North America* (Berkeley, 1971).
5. The baseline work that covers this route is that of the DeSoto Commission: John R. Swanton, *Final Report of the United States De Soto Expedition Commission* (1939, republished Washington, 1985, with a new introduction). Since that publication, archaeology has made great advances in identifying the towns and villages of the period with the help of

a sharpened knowledge of the articles of the Soto expedition. A handy guide to the contribution of archaeology to the identification of the route is Jerald T. Milanich and Susan Milbrath, eds., *First Encounters: Spanish Explorations in the Caribbean and the United States, 1492–1570* (Gainesville, 1989).
6. Close attention to documents provides details. See Charles Hudson, *The Juan Pardo Expeditions* (Washington, 1990); and John H. Hann, *Apalachee, The Land Between the Rivers* (Gainesville, 1988).
7. Lewis H. Larson, *Aboriginal Subsistence Technology on the Southeastern Coastal Plain during the Late Prehistoric Period* (Gainesville, 1980).
8. David H. Dye and Cheryl Anne Cox, eds., *Towns and Temples Along the Mississippi* (Tuscaloosa, 1990).
9. Garcilaso de la Vega 1951, 13–14.
10. Garcilaso de la Vega 1951, 316–322.
11. *Ancient Art of the American Woodland Indians* [exh. cat. Detroit Institute of Arts] (Detroit, 1985), pls. 95, 96, 139, 140, 141.
12. John R. Swanton, *Indian Tribes of the Lower Mississippi Valley* (Washington, 1911), 172.
13. James Adair, *The History of the American Indians* (London, 1775), 22–23.
14. Guy Prentice, "An Analysis of the Symbolism Expressed by the Birger Figurine," *American Antiquity* 51 (1986), 239–266.
15. Swanton 1911. A particularly rich body of information is available about the practices of the elite in the chiefly society reported by John M. Goggin and William C. Sturtevant, "The Calusa: A Stratified, Nonagricultural Society (with Notes on Sibling Marriage)" in *Explorations in Cultural Anthropology*, ed. Ward H. Goodenough (New York, 1964), 192.
16. Garcilaso de la Vega 1951, 15, 343.
17. Examples of pottery images and shell masks can be found in David H. Dye and Camille Wharey, "Exhibition Catalog" in Patricia Galloway, ed., *The Southeastern Ceremonial Complex: Artifacts and Analysis* (Lincoln, 1989), 321–378.
18. Charles Hudson, *The Southeastern Indians* (Knoxville, 1976).
19. Hudson 1976, 129.
20. These and other behavioral associations can be found in Hudson 1976, 146, 257; Webb 1989, 282; and Vernon James Knight, Jr., "The Institutional Organization of Mississippian Religion," *American Antiquity* 51 (1986), 675–687.
21. Knight 1986, 675–687.
22. Hudson 1976.
23. Prentice 1986, 239–266.
24. Phillip Phillips and James A. Brown, *Pre-Columbian Shell Engravings from the Craig Mound at Spiro, Oklahoma*, Peabody Museum of Archaeology and Ethnology, Harvard University, part 1 (Cambridge, Mass., 1978), 140–143.
25. The combination also plays on the snake's anomalous features: born from an egg but hated by birds; adept at swimming in water, crawling on land, and hanging from trees (Hudson 1976, 144–145).
26. Robert L. Hall, "The Cultural Background of Mississippian Symbolism," in Patricia Galloway, ed., *The Southeastern Ceremonial Complex: Artifacts and Analysis* (Lincoln, 1989), 239–278, and "Cahokia Identity and Interaction Models of Cahokia Mississippian," in *Cahokia and the Hinterlands: Middle Mississippian Cultures of the Midwest*, ed. Thomas E. Emerson and R. Barry Lewis (Urbana, 1991), 3–34.

EMBLEMS OF POWER IN THE CHIEFDOMS OF THE NEW WORLD

Warwick Bray

The first European contacts with the New World were not with Aztec Mexico or Inka Peru, but with the lands in between (the old "Spanish Main"), where the conquistadors encountered simpler forms of society ruled by local chiefs (*caciques*).[1] Each *cacique* controlled a group of villages. Most of these territories were small, with populations of ten to forty thousand subjects, nearly all of whom lived within a day's journey of the principal town. Since warfare was endemic, some of these towns were fortified.

The chiefdoms of the Americas were hierarchic, nonegalitarian societies in which power, status, and wealth were concentrated in the hands of a ruling elite.[2] At the top of the hierarchy was the chief himself, supported in office by contributions in goods and services from his subjects. The *cacique* was the ultimate political authority. He declared war, made diplomatic alliances, adjudicated quarrels and disputes, and controlled the production and distribution of certain goods. He also sponsored feasts and religious ceremonies at which he gave presents to his supporters and handed out food and drink to the populace at large. As possessor of sacred knowledge and "owner" or patron of essential rituals, the authority of the chief became sanctified, identified with important supernatural forces, and surrounded with religious ceremonialism.

This power brought its rewards. Chiefs received special titles and forms of obeisance, insignia of rank, the finest craft products, a retinue of slaves and servants, and all the trappings of influence and status. In death as in life these distinctions were maintained. Paramount chiefs were dressed for burial in gold from head to foot, and into the tomb were put all that was needed for the afterlife: food, serving vessels, regalia and weapons, and sometimes also wives and servants.

When we consider the products of the American chiefdoms we must abandon European attitudes about art and artistic values. In these societies, gold was not particularly valued as bullion or as precious metal. The son of a Panamanian chief pointed out to the Spaniards that raw gold had no more value than a lump of clay until it was transformed into something useful or pleasing.[3] In the pre-Hispanic New World, gold objects served a purpose as symbols of authority and prestige. Chiefs bedecked their bodies with gold. They competed for it, used it to bribe political allies, and with it paid ransoms for sons captured in war. They stole it from their rivals and, in times of danger, hoarded it in secret places. Gold ornaments functioned as insignia of rank and as amulets or talismans; they defined tribal or lineage identities and, indirectly, linked the real world with the supernatural. All these artifacts carried messages whose different layers of meaning could be decoded by all members of a particular society.

This area of lower Central America and northern South America, stretching between the Aztec and Inka empires, was the home of many different ethnic groups, each with its own culture. Notable works of art, in gold and other materials, were produced by the inhabitants of the Diquís and Chiriquí subregions of the isthmus, in the Sinú and Tairona archaeological zones of Caribbean Colombia, and also by the Muiscas of the Colombian highlands and the Manteño of Ecuador.

The subregions of Diquís and Greater Chiriquí included most of the frontier area along the present-day boundary between Costa Rica and Panama.[4] On the Pacific side it incorporated the Diquís region of southwest Costa Rica and the adjacent Panamanian provinces of Chiriquí and much of Veraguas. Finds of similar pottery and goldwork at the Caribbean end of the frontier extend this culture area to the coastal region visited by Columbus in 1502 during his fourth voyage.

In the sixteenth century the name Veragua was applied to the whole of Caribbean Panama from the Laguna de Chiriquí to Punta Rincón. The diary of Fernando Columbus describes a typical beach scene at Cerebaró, now known as Almirante Bay. The Spaniards found twenty canoes pulled onto the beach and "the people on the shore naked as they were born, except for a mirror of gold at the neck, and some with an eagle of guanín [gold-copper alloy]."[5] This is the first mention of the discs and eagle pendants found archaeologically throughout the isthmus.

The brief accounts by members of Columbus' expedition can be supplemented by later documents from Diquís.[6] Spanish chroniclers reported that the population was organized into a network of villages, the largest of which served as the residences of paramount chiefs who warred with each other for booty and

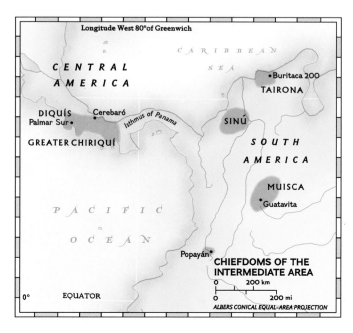

fig. 1. View of Lake Guatavita, Colombia

slaves. In 1562 Vázquez de Coronado noted that war captives were brought back as slaves for sacrifice, and these victims may have provided the trophy heads depicted on Diquís sculpture and gold work.

Archaeological sites in Diquís are of various sizes. They are made up of residential sectors surrounded by clusters of hilltop cemeteries, some of them marked by stone statues or huge spheres carved from granite. The difference between rich and poor graves mirrors the social hierarchy in life. Some tombs contain only a few simple pots or a single gold item; others (like the Huacal de los Reyes, discovered early in this century) held several pounds of gold ornaments. A single tomb, opened in 1956 at Palmar Sur,[7] yielded eighty-eight metal objects: round breastplates, human and animal pendants, bells,

crescents, head bands, and sheet-metal cuffs, precisely the kind of chiefly regalia listed in early Spanish accounts. At Coctú, a major Diquís town, one of the chief's sons was himself a goldsmith.

The subject matter of Diquís goldwork is mainly figurative: animals (especially the so-called eagle pendants), human beings, and mythological creatures, part human and part animal. Within the natural world, Diquís goldsmiths were selective. The most common creatures depicted are those that are dangerous or predatory, that sting, bite, or kill: jaguars, alligators, sharks, birds of prey, crabs, scorpions, spiders, bats, supernatural monsters.

Some clues to the belief system that underlies this selection may be deduced from the mythology of present-day Indian groups. In

historical times, for example, the Bribri and Cabecar Indians of Costa Rica had a single principal deity, called Sibo or Sibu, who was the creator of all things. It was Sibu who brought the seeds from which humankind sprouted; he taught people to dance and selected the clans from which shamans were drawn. He took the form of a kite or buzzard. In the words of a Bribri song:

> Sibu came in the form of a buzzard
> dressed as a man,
> collar on his neck.[8]

Collars or necklaces are a standard feature on the eagle pendants of Diquís and Greater Chiriquí, and there are other pendants with human bodies and the wings and heads of birds of prey. We can never be sure that the pre-His-

panic eagle pendants represent Sibu but, given the importance of predatory birds in indigenous beliefs, it is not too surprising that the last *cacique* of Talamanca, who died as recently as 1910, wore as his regalia a necklace of six large pendants of just this type.[9]

The Sinú archaeological zone, in the Caribbean lowlands of Colombia, is a land of savannas, great rivers, and lagoons: an aquatic landscape, much of which is flooded during the rainy season. In the sixteenth century it was one of the richest and most populated areas of Colombia, divided into chiefdoms ruled over by three great lords. When Pedro de Heredia visited the principal town in 1534 he found a settlement of large houses, with a temple capable of holding more than a thousand people and containing twenty-four wooden idols covered with sheet gold. These images were arranged in pairs, each pair supporting a hammock filled with gold offerings. Around this temple were the burial mounds of the chiefs, each mound topped by a tree whose branches were hung with golden bells.[10]

Another early chronicler, Juan de Castellanos, noted in 1589 that Sinú goldsmiths made "figurines of various kinds, aquatic creatures, land animals and birds, down to the most lowly and unimportant."[11] His account is especially important as an eyewitness description of the types of objects that were later to be recovered from archaeological finds. Sinú goldwork falls into two broad categories: personal jewelry (ear ornaments, nose pieces, penis sheaths, belts, helmets, and diadems) and representations of the natural world (birds, animals, and recognizable human beings). These latter are always true to life and depict the animals and birds of the savannas and rivers. Sinú metalwork lacks the obviously mythological and supernatural quality that is so marked in works from the Diquís region.

On the other hand the political elements of chiefdom society are well represented in Sinú culture and are encapsulated in another passage from Simón, who referred to three great lords, each of whom governed one of the chiefdoms (*zenúes*) into which the region was divided. Paramount among these chiefs was the ruler of Zenúfana, whose sister commanded in Finzenú. When she died, the lord of Zenúfana ordered

all the greatest lords of the other two Zenúes to be buried in the Zenú belonging to his sister, with all the gold belonging to them at the hour of their death . . . or at least that they should have their tombs in the cemetery of the great sanctuary and in the Bohío (dwelling) of the Devil that was in Finzenú. . . . But if they did not want to be buried there, but in their own land, they should at least send half of the gold in their possession at time of

death, so that the gold should be buried in their place in the tomb mentioned above. This law was so inviolable that nobody would dare to break it.[12]

As an account of the role played by gold in prehistoric politics, Simón's story is second to none.

The Taironas of the Sierra Nevada de Santa Marta and the adjacent coastlands possessed one of the most sophisticated cultures of Caribbean America. The largest towns served as the capitals of mini-states, each one with its own *cacique* supported by a class of noblemen and specialist priests.[13] One such town, Buritaca-200 (the "Lost City"), has well over a square mile of stone-built house foundations — residential and agricultural terraces with spectacular retaining walls — interspersed with tombs, staircases, roads, irrigation canals, and drains.

Tairona artifacts in all media are replete with symbolism, but all distinctions between the sacred and the profane are blurred; the real world and the supernatural world merge into an all-embracing philosophy. The gold (or gold alloy) "cacique pendants" illustrate this point. Some of them seem to represent individuals of high rank, dressed in a full set of Tairona jewelry. Other pendants, wearing identical regalia, are only part human, and have the heads of jaguars or bats. These human-animal transformations probably reflect the world of hallucinatory drugs, which enable shamans to leave their earthly bodies and to make journeys to the spirit world.[14]

Gold and other precious or sacred substances provide a link (with chiefs and shamans serving as intermediaries) between earthly power and the cosmic forces of life-giving energy. Among the modern Kogui, direct descendants of the Taironas, gold itself is charged with solar energy.[15] At certain times of year the Kogui priests bring out Tairona heirlooms of gold and gilded copper and place them on a special mat under the full rays of the sun. This act is believed to recharge the objects with their fertilizing cosmic energy, which is transmitted to the priests and, through them, to all the participants in the ritual. The sun itself is personified as a man in a golden mask, and the familiar animals of Tairona art have their places in Kogui mythology. The bat was a child of Mulkuxe, the sun, from an incestuous relationship; the frog or toad served as a seat when the sun received visitors, and was for a time his spouse. The Kogui regard themselves as jaguar people; their land is the territory of the jaguar, and their ancestors were jaguar men. This testimony from the Taironas' descendants is a compelling

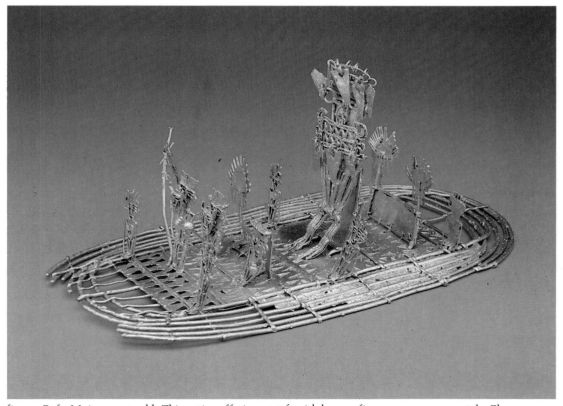

fig. 2. Raft. Muisca, cast gold. This votive offering, a raft with human figures, may represent the El Dorado ceremonies. Museo del Oro, Banco de la República, Bogotá

argument that Tairona goldwork is much more than a decorative art.

The archaeological remains of the Muiscas are unspectacular, but their society, like that of the Taironas, can be classified as an advanced chiefdom or an incipient state.[16]

Rich individuals wore jewelry made of imported gold or gold alloyed with locally available copper, manufactured by specialist craftsmen under the patronage of *caciques*. Castellanos remarked that the goldsmiths of the town of Guatavita were esteemed as specialists, traveling through the neighboring provinces and earning a living by their skills.[17] It is said, too, that anyone employing a Guatavita jeweler had to send two of his own vassals to work in Guatavita for the duration of the contract. Other goldsmiths were attached to the principal shrines and were perhaps responsible for making the *tunjos*, which are a uniquely Muisca contribution to native American metallurgy. These *tunjos* were not jewelry, but votive offerings, roughly cast in the shape of human figures, animals, snakes and dragons, weapons, insignia, and household utensils. The aim seems to have been to produce objects that were easily recognizable (with plenty of diagnostic detail) rather than merely beautiful, well finished, or correctly proportioned. *Tunjos* may have served much the same purpose as the *ex votos* offered in today's churches.

Muisca shrines were located in inaccessible places such as mountain peaks, caves, and lagoons, and they continued in clandestine use long after the Spanish conquest. They are described as small dark huts made of wood and straw, black with the smoke of incense. Inside were the idols and the offerings: uncut emeralds, seashells brought from the Caribbean coast, wooden items, and *tunjos* wrapped in cotton cloth and stored in jars or packed in mantles. The offerings were eventually buried outside the temple.

The most famous Muisca ritual, which has earned a permanent place in the legends of the New World, is the ceremony of El Dorado (literally the "gilded man") carried out at Lake Guatavita.[18] Each new ruler, when he took office, went to the sacred lagoon where his skin was annointed with a sticky earth onto which was blown gold dust until he was covered from head to foot. He was then placed on a raft, with piles of gold items and emeralds to be offered to the gods, and with him went four retainers, also with their offerings. To the sound of music and chanting the raft slowly moved to the center of the lake, where the gilded man made his offerings and (in some versions of the story) plunged into the lagoon to wash off his golden coating. In the words of Juan Rodríguez Freyle (who learned the details from the nephew of the last *cacique* of Guatavita): "From this ceremony came the celebrated name of El Dorado, which has cost so many lives."[19] No European ever witnessed the ceremony, but many like to believe that the raft of El Dorado is represented by the finest of the *tunjos* in the collection of the Museo del Oro in Bogotá.

NOTES

1. Carl Ortwin Sauer, *The Early Spanish Main* (Berkeley and Los Angeles, 1966).
2. Robert A. Drennan and Carlos A. Uribe, eds., *Chiefdoms of the Americas* (Lanham, 1987); Mary W. Helms, *Ancient Panama: Chiefs in Search of Power* (Austin and London, 1979).
3. Helms 1979, 79.
4. Doris Stone, *Pre-Columbian Man in Costa Rica* (Cambridge, 1977), 107–135; Elizabeth P. Benson, ed., *Between Continents/Between Seas: Precolumbian Art of Costa Rica* [exh. cat. Detroit Institute of Arts] (Detroit, 1981).
5. Sauer 1966, 131.
6. Luis Ferrero A., "Ethnohistory and Ethnography in the Central Highlands—Atlantic Watershed and Diquís," Detroit 1981, 93–103.
7. Samuel K. Lothrop, *Archaeology of the Diquís Delta, Costa Rica,* Papers of the Peabody Museum of Archaeology and Ethnology, Harvard University 51 (1963), 94.
8. Doris Stone, *The Talamancan Tribes of Costa Rica,* Papers of the Peabody Museum of Archaeology and Ethnology, Harvard University 43, no. 2 (1962), 64.
9. Ferrero in Detroit 1981, fig. 34.
10. Fray Pedro Simón, *Noticias Historiales de las Conquistas de Tierra Firme en las Indias Occidentales,* bk. 4 (Bogotá, 1892), 32-34.
11. Juan de Castellanos, *Elegías de Varones Ilustres de Indias* (Bogotá, 1955), 3:74.
12. Simón 1892, 26.
13. Gerardo Reichel-Dolmatoff, *Colombia* (London, 1965), 142–158.
14. Gerardo Reichel-Dolamatoff, *Orfebrería y Chamanismo: Un estudio iconográfico del Museo del Oro* (Medellín, 1988).
15. Gerardo Reichel-Dolmatoff, "Things of Beauty Replete with Meaning—Metals and Crystals in Colombian Indian Cosmology," in *Sweat of the Sun, Tears of the Moon: Gold and Emerald Treasures of Colombia* [exh. cat. Natural History Museum of Los Angeles County] (Los Angeles, 1981), 17–33.
16. Reichel-Dolmatoff 1965, 158–168.
17. Castellanos 1955, 4:142.
18. Warwick Bray, *The Gold of El Dorado* [exh. cat. The Royal Academy] (London, 1978), 18–23.
19. Juan Rodríguez Freyle, *El Carnero* (Medellín, n.d.), 66.

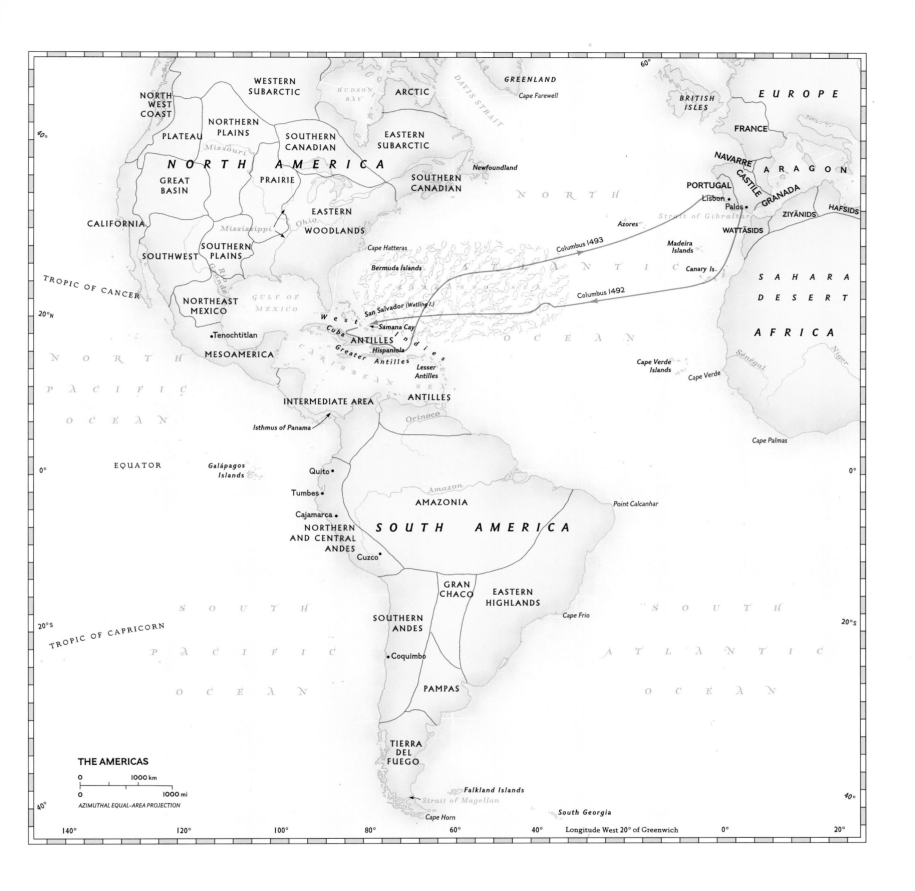

THE AMERICAS

EUROPE

GREENLAND
Cape Farewell

BRITISH
ISLES

FRANCE

NAVARRE
ARAGON
PORTUGAL
CASTILE
GRANADA
Lisbon
Palos
ZIYĀNIDS
HAFSIDS
WATTĀSIDS

WESTERN
SUBARCTIC

NORTH
WEST
COAST

ARCTIC

HUDSON
BAY

NORTHERN
PLAINS

PLATEAU

SOUTHERN
CANADIAN

EASTERN
SUBARCTIC

Missouri

NORTH AMERICA

Newfoundland

GREAT
BASIN

PRAIRIE

EASTERN
WOODLANDS

SOUTHERN
CANADIAN

Ohio

Mississippi

NORTH

Azores

Madeira
Islands

Columbus 1493

CALIFORNIA

SOUTHERN
PLAINS

Cape Hatteras

Bermuda Islands

ATLANTIC

Canary Is.

SAHARA
DESERT

TROPIC OF CANCER

SOUTHWEST

NORTHEAST
MEXICO

GULF OF
MEXICO

Rio Grande

Columbus 1492

OCEAN

West

San Salvador (Watling I.)

AFRICA

Tenochtitlan

Cuba
ANTILLES

Samana Cay

Indies

MESOAMERICA

Hispaniola
Greater
Antilles

NORTH

CARIBBEAN

Lesser
Antilles

SEA

ANTILLES

Cape Verde
Islands

Sénégal

Cape Verde

Niger

PACIFIC

OCEAN

INTERMEDIATE AREA

Orinoco

Isthmus of Panama

EQUATOR

Galápagos
Islands

Quito

Amazon

Point Calcanhar

Cape Palmas

Tumbes

AMAZONIA

Cajamarca

SOUTH AMERICA

NORTHERN
AND CENTRAL
ANDES

Cuzco

GRAN
CHACO

EASTERN
HIGHLANDS

SOUTH

Cape Frio

SOUTH

TROPIC OF CAPRICORN

SOUTHERN
ANDES

ATLANTIC

Coquimbo

PACIFIC

PAMPAS

OCEAN

OCEAN

TIERRA
DEL
FUEGO

Falkland Islands

THE AMERICAS

Strait of Magellan

South Georgia

0 1000 km

Cape Horn

0 1000 mi

Longitude West 20° of Greenwich

AZIMUTHAL EQUAL-AREA PROJECTION

THE AZTEC EMPIRE

By the late fifteenth century the Aztecs had created one of the most glittering civilizations of pre-Columbian America. Their achievement was of relatively recent origin in the long chronology of Mesoamerican culture. About two hundred years before, the tribe that called itself Mexica had arrived in the Valley of Mexico after a long migration from the north. The Aztecs established their capital of Tenochtitlan on the site of present-day Mexico City and, excellent soldiers from the start, gradually extended their control over a sizable empire. In the course of their march to power, they assimilated the deities of the cultures they conquered, and their religion attained a formidable complexity. A complicated system of tribute levied on their vassal states assured a constant flow of goods, including luxury items, into the capital. Tenochtitlan itself, built on a series of islands in a lake, was one of the world's greatest and most populous cities in 1492. It suggested the marvels of Venice to the band of provincial Spaniards who arrived there, led by Hernán Cortés, in 1519.

The city was demolished in the course of the struggle with the Spanish forces, who were joined by a number of the Aztecs' traditional enemies. Countless works of art were destroyed or buried forever beneath the modern Mexican capital. Nevertheless, enough has survived to provide us with a vivid picture of this extraordinary culture. As is the case in contemporary Europe, much of Aztec art is religious: sculptures of various deities, priestly paraphernalia, and pictographic manuscripts that can still be read. The function of the remarkably naturalistic representations of plants and animals is unclear; they may have been intended for public monuments or for private collections. Luxurious works in gold, exotic feathers, and turquoise mosaic were created for the use of the nobility and the royal house. In this very militaristic society an entire class of objects is associated with battle and with the cult of human sacrifice; it was believed that the blood of human victims—who in practice were principally war captives—was needed to nourish the gods and ensure the continuation of human life.

356 &

CODEX FEJÉRVÁRY-MAYER

c. 1400–1521
Aztec or Mixtec
paint on animal skin overpainted with gesso
each page 17.5 x 17.5, total length 404
(6⅞ x 6⅞ x 159)
reference: Léon-Portilla 1985

The Board of Trustees of the National Museums and Galleries on Merseyside, Liverpool Museum, 12014 Mayer

The *Codex Fejérváry-Mayer*, which received its title from the names of two of its former owners, is a pre-Hispanic book of forty-four pages made of folded strips of animal hide. Aside from its beauty and its excellent state of preservation, it is especially interesting because of its unique subject matter. Whereas most of the small number of pre-Hispanic codices that have come down to us appear to have been prepared for the use of priests, the *Codex Fejérváry-Mayer* reflects the special concerns of the *pochteca*, the Nahua long-distance merchants.

Since at least the classic period in Mesoamerica (the first to ninth centuries A.D.), wealthy merchants operated along permanent routes of trade. Some of them went back and forth with their goods from central Mexico to distant places in Oaxaca, Guatemala, and the fringes of the Yucatan Peninsula. Others traveled in their boats along the Caribbean shores. Their trade included both raw materials and manufactured objects: precious stones, amber, bundles of cacao, tiger skins, feathers, live birds and beasts, and also gold and silver and jewels, fine clothes, embroideries, ceramics, copper knives, other utensils, weapons, and musical instruments. The name of these long-distance traders was derived from *pochotl* (ceiba tree), as they "used to have places designated for their *tiangues* [markets], where they gather for transactions, fairs and exchanges, and they have there two, three or four ceiba trees to provide shade; and in several plazas two, three, four ceibas are sufficient to give shade to one or two thousand people" (Oviedo y Valdés 1851–1855, 1:345).

Several indigenous sources provide information about the *pochteca*, who operated in groups and had their headquarters in important Aztec towns such as Tlatelolco, Tochtepec in present-day Oaxaca, and Xicalanco on the Gulf coast. The *Florentine Codex* describes, in the Nahuatl language, the special feasts and ceremonies performed by the *pochteca*, both before they departed on commercial enterprises and when they returned.

Early texts also provide ample information about the titular gods of the *pochteca* and the way the merchants conducted their affairs, always consulting the special books they owned, known as the *tonalamatl* ("books of the days and destinies"), which were arranged in accordance with the 260-day astrological count. Consulting these books, the *pochteca* determined the most propitious days to depart on ventures, to celebrate and thank their gods for the profits they made, or to perform the funerary rites for their deceased colleagues, those who may have been attacked and murdered on the road.

The present work is such a *tonalamatl*. Its first page contains an image of the world. The four cosmic regions are represented with the glyphs denoting the east, north, west, and south. In the center is the old god of fire presiding over the whole *imago mundi*. Each of the cosmic regions has its corresponding color—red, yellow, greenish blue, and bluish green—and also its own gods, trees, birds, and other related attributes. The omnipresent Tezcatlipoca ("smoking mirror") is also visible. His attributes—head, one arm, one foot, and bones—are evident, associated with the four cosmic directions.

Tezcatlipoca is lord of the everywhere and also he who introduces motion, life, and time into the world. From his head, arm, foot, and bones issue four streams of blood, the source of life, converging toward the center of the image where the old fire god, also lord of time, resides. The four cosmic regions are the stage on which time, destinies, and life interact. The 260-day count of destinies is twice registered, encompassing everything that exists in the four cosmic regions. For the *pochteca*, who marched to distant parts of Mesoamerica, here was a complex message. To arrange one's affairs successfully, one had to learn the meanings of the days in their relation to the cosmic regions.

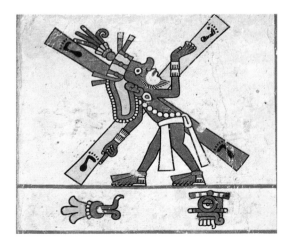

cat. 356, detail of p. 37: Yacatecuhtli Bearing Cross-roads

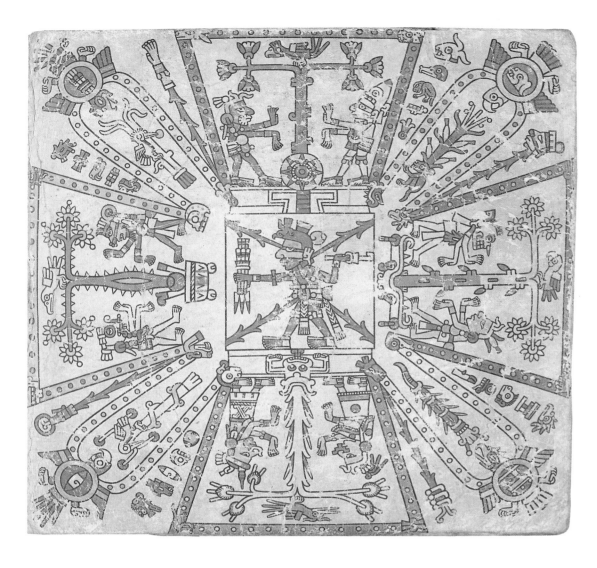

He is recognized as the one

Who does as He wishes,
He determines, He amuses Himself.
As He wishes, so will it be.
In the palm of His hand
He has us.
At His will He shifts us around.
We shift around
like marbles we roll,
He rolls us around endlessly.
(*Florentine Codex* 1979, 2: book 6, fol. 43 v).

Tezcatlipoca and Yacatecuhtli (lord of the nose) were the supreme dual counterparts among the patron deities of the *pochteca*. The merchants knew this fact well. Their book, not surprisingly, recalls it again and again.

Some specialists have claimed the style of this book is Mixtec, that is from the Oaxaca region. Comparisons with several extant Mixtec codices seem convincing on this point. Nevertheless the contents of the book correspond to the beliefs and practices of the people of central Mexico, especially to the *pochteca* from the Nahua region. It may well be that the wealthy *pochteca* for whom the book was created commissioned Mixtec scribes and painters to produce it. The *pochteca* were in frequent contact with the Mixtecs living in what are today the regions of Puebla and Oaxaca, and it would have been easy for them to turn to Mixtec artists for such work.

The splendid book they produced, relating the beliefs and wisdom of the *pochteca*, has in this century become familiar to scholars through facsimile editions produced in England, Germany, Austria, and Mexico. Not even the finest of these, however, can convey the beauty of the original, which has survived almost unscathed the destruction of the world that created it. M.L.-P.

Several pages (35–40) include representations of gods to be worshipped and of ceremonies to be performed in accordance with divine manifestations, well known to the Nahua peoples of central Mexico in Aztec times. Among them, six are especially important. They are Yacatecuhtli, lord of the nose; Chalmecacihuatl, lady of Chalma; Acxomoculi, an avatar of Tezcatlipoca; Nacxit, "four feet"; Cochimetl; and Yacapitzahua, associated with Quetzalcoatl, the feathered serpent. These six deities were the much-revered patron gods of the *pochteca*.

On other pages (5–22) one sees, related to different dates (days-destinies), series of numbers: bars meaning fives and dots for units. One might have guessed that these would indicate astronomical computations or perhaps something as mundane as profits and losses in transactions. However, it is now known through accounts provided in Nahuatl by *pochteca* in the sixteenth century, after the fall of Aztec Mexico, that these numbers, so carefully distributed, show how the offerings to the gods were to be presented.

The book also refers to several dates that were particularly meaningful to the merchants. One such date is 1 Death (page 5), which was propitious for them. On it they performed rituals honoring Tezcatlipoca. Associated with a scene of a dead body of a merchant who lost his life on the road is the day-sign 1 Water (page 17), which the *Florentine Codex* describes as particularly adverse to the merchants.

Many are the roads and crossroads depicted in the book. They can be found in at least eleven places in the codex; on one page (43) two crossroads are painted. In the upper one, several dates are indicated, which we know from the Nahuatl texts of the *Florentine Codex* are those on which the *pochteca* should choose to embark in order to ensure a propitious trading enterprise. The most advisable of these dates was *Ce coatl, melahuac ohtli* (1 Serpent, "straight way").

The last page of the book is devoted fully to Tezcatlipoca, the lord of everywhere and here also of everywhen, as he appears surrounded by the twenty day-signs with twelve dots added to each sign. A complete *tonalpohualli*, the 260-day count, thus encompasses "the smoking mirror," the supreme Tezcatlipoca. He appears as well on the first page and on several others of the codex.

HEAD OF COYOLXAUHQUI

Aztec
green porphyry
80 x 85 x 68 (31½ x 33¼ x 26¾)

CNCA—INAH—MEX, *Museo Nacional de Antropología, Mexico City*

This colossal sculpture was discovered in 1830 in the basement of the old convent of Santa Teresa, which is located near the National Palace of Mexico City. On learning of its discovery, a well-known historian of the time, Don Carlos María de Bustamente, convinced the nuns to give it to the Museo Nacional, where it remains part of this institution's collection. It was not until the turn of the century, however, that it was correctly identified by Eduard Seler as the head of the moon goddess Coyolxauhqui, Coatlicue's malevo-

lent, matricidal daughter, who was slain and dismembered by her half-brother Huitzilopochtli, the sun of war (Nicholson 1983, 49), in the Aztecs' extraordinary myth explaining the birth of the sun (see Coe essay in this catalogue).

In this masterpiece the Aztec artists concretized the symbolism of the goddess in a dense greenish stone, which when finished takes an exceptional

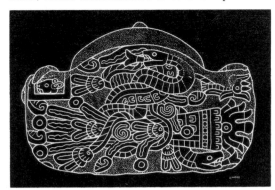

cat. 357, view of underside

polish. The deity's face occupies almost the whole front of the piece. Her closed eyelids show that she is dead. The bells on her cheeks, incised on top with a cross-and-four-dots motif that was a sign for gold among the Aztecs, are her principal ornament and give meaning to her name Coyolxauhqui ("painted with bells"). Her enormous earrings are circular disks with triangular pendants, which also adorn her nose and cover her mouth. These symbolize rays of light and indicate that she is the moon, the luminous star of the night.

The feather headdress resembles an enormous flower with an open corolla. A tuft of long feathers hanging to the side forms the characteristic adornment for outstanding warriors. Small circular feathers over the whole head identify military prisoners who would be sacrificed.

On the base of the sculpture, in fine relief, the artists represented currents of water and fire, which when mixed symbolized burnt water, the life-giving blood of the universe, the precious liquid that feeds the sun and the earth. Also on the base is the calendar date, 1 Rabbit, that is directly associated with the symbol of this goddess and other deities of darkness and the earth.

F.S. and M.D.C.

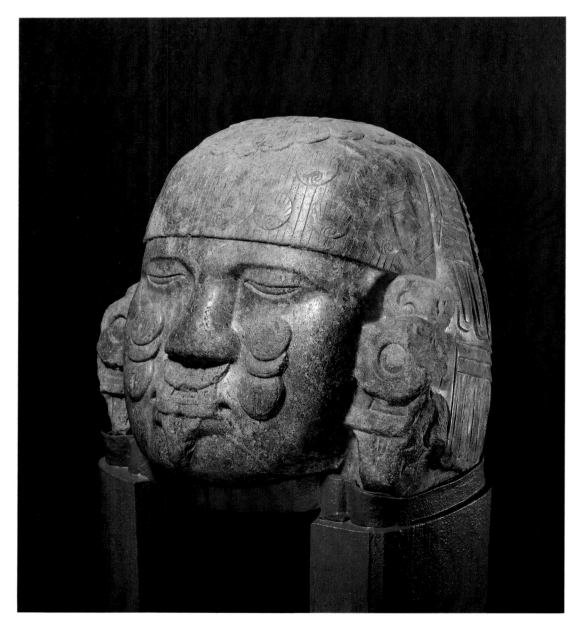

TONATIUH

Aztec
volcanic stone
30 (11¾)

Museum für Völkerkunde, Basel

This young god sits with crossed arms resting on drawn-up knees; disks with raised central bosses are found on the pillbox-like headgear and on decorative bands around the lower legs. The identity of the youthful deity is given by the feather-surrounded device placed on his back: this is the familiar sun disk with solar rays, marked by the sign for the fifth sun, 4 Ollin.

It is thus virtually certain that this is Tonatiuh, the vibrant, youthful solar deity worshiped in central Mexico long before some of his functions were usurped by the Aztec tutelary god Huitzilopochtli. A directly comparable image appears on page 71 of the *Codex Borgia*: Tonatiuh, his face and body painted red, with an identical headband and with the solar disk on his back, is enthroned with knees drawn up. He receives the blood from a beheaded quail. To complete the identification in the drawing, there is a 4 Ollin sign below the throne.

This sculpture may be the only three-dimensional carving of Tonatiuh to have survived the conquest; his cult may never have been a particularly popular one. On the other hand, statues of

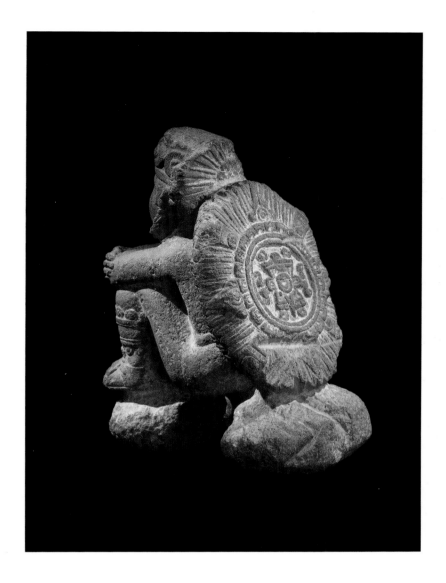

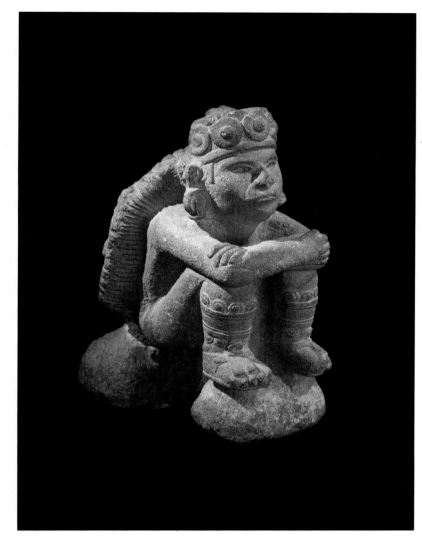

his solar rival, Huitzilopochtli, are nonexistent, perhaps because the Spanish troops and missionaries made every effort to obliterate the image of that deity wherever they found it.　M.D.C.

359 ⊛

Codex Cospi

c. 1430–1521
Aztec or Mixtec
screenfold manuscript
paint on animal skin overpainted with gesso
each page 18 x 18, total length 360 (7⅛ x 7⅛
x 141¾)

Biblioteca Universitaria di Bologna, MS 4093

The *Codex Cospi* is a ritual screenfold manuscript of a kind that must have existed in every temple and religious seminary within the Aztec empire. Its exact origin remains unknown. Eduard Seler (1902, 351), who made the first study of the manuscript, thought that it might have come from Aztec territory bordering on the land of the

Maya, but there is little evidence for or against this idea. There are strong iconographic ties between the Cospi and other members of the so-called "Borgia Group" of screenfolds, such as the *Codex Borgia* and *Codex Vaticanus B*.

Seven of the twenty pages of the obverse of the *Codex Cospi* were left blank, as were eight pages of the reverse. Different hands are evident on the two sides. The artist responsible for the obverse worked with thin and extraordinarily uniform black outlines, which he filled in with flat colors in a rich but muted palette. The reverse is carried out by a more hasty hand, with hesitant outlines and bright and somewhat clashing colors. This dichotomy extends to the completely different iconographic content of the two sides.

There are three thematic sections on the obverse. On pages 1–8, the *tonalpohualli* (the sacred calendar of 260 days) is laid out in fifty-two columns of five members each, each day being accompanied by the head or symbol of the ruling lord of the night, in a repeating succession of nine lords. Next, on pages 9 to 11, is the Venus calendar. Last, on pages 12–13, each of four gods stands, with a smoking, ladle-type incense burner,

before a temple; as Seler (1902, 344–345) recognized, the day-signs in a column to the left of each picture assign each of the deities to one of the four world-directions (the sun god Tonatiuh to the east, for instance). Both pages can be matched, in much fuller form, by pages 49–52 of the *Codex Borgia*. A comparison with pages 25–28 of the *Dresden Codex*, a fifteenth-century Maya screenfold manuscript, suggests that both the Cospi and Borgia sections represent New Year rituals through a succession of four years: Reed, Flint, House, and Rabbit.

There is yet no convincing explanation of pages 21 to 31 of the reverse of the *Codex Cospi*. Here eleven deities, some of them clearly female, are seated, each holding a shield with darts in the right hand and an *atlatl* (spear thrower) with dart in the left. Below each figure is a grouping of bar-and-dot numbers (6, 7, 8, 9, and 11)arranged in an *I*-shaped layout, which probably represents arrays of offerings to be made to the god. At the sides of each page are the figures of animals, insects, scorpions, and animal-headed hearts, which have not yet been interpreted.

The Venus pages are of the greatest icono-

graphic interest in the Cospi. As morning star, the planet was worshipped under the name of Tlahuizcalpantecuhtli (lord of dawn), and identified with the god Quetzalcoatl. The Mesoamericans knew that Venus rose heliacally (with the sun) on the eastern horizon every 584 days following a short period of disappearance during conjunction; consequently the Venus tables in the Cospi, Borgia, Vaticanus B, and Maya Dresden manuscripts are all based on the equation $5 \times 584 = 8 \times 365$, relating the Venus cycle to the approximate length of the solar year, and upon the fact that two Calendar Rounds or 104 approximate solar years are exactly equal to sixty-five Venus cycles.

The rising of Venus in the east just ahead of the sun was a decidedly baleful event to the Aztecs, as a passage in the *Anales de Cuauhtitlan* makes clear (Thompson 1971, 217):

> They (the old men) knew when he [Quetzalcoatl as Venus] appears, on what number and what particular signs he shines. He casts his rays at them, and shows his displeasure with them.

According to this source, on the day 1 Cipactli, Quetzalcoatl spears the old men and women, on 1 Acatl the great lords, on 1 Ollin the young men and maidens; and on 1 Atl there is drought.

All of the Mesoamerican codices with Venus tables reflect this belief, and all have five sections corresponding to the five Venus cycles that make up an eight-year period. In the Cospi, the morning star is fittingly depicted as a striding death god with shield and spear, hurling his weapon (the Venus ray) at a victim; in his headdress he wears the typical squared-off eagle feathers associated with the planet.

The Venus calendar in the *Codex Cospi* begins in the lower half of page 9, with Venus spearing Cinteotl, the maize god, who stands on a smoking *milpa* (cultivated field): crop failure is obviously the augury. This event takes place on 1 Cipactli (crocodile), the official beginning of the Venus calendar. Next, on the top of page 9, Chalchiuhtlicue, the water goddess, is speared 584 days later on the day Coatl (snake), an event that will result in drought. Since this day is given the coefficient *1*, as are all the other heliacal rising days, the five Venus pages are actually twenty-six cycles apart, and the entire Cospi scheme covers 2×104 solar years.

The third cycle can be seen in the top half of page 10, with the rising Venus spearing a mountain with snow-capped, twisted top, on the day 1 Atl (water). Although the meaning here is unclear, the water issuing from the base of the mountain suggests that the victim is the city as a whole, for in the Nahuatl language *altepetl* (water, mountain) was a metaphor for city. Below it is the start of the fourth cycle, on the day 1 Acatl (reed), with the morning star spearing a throne with a sun on it, surely a symbolic representation of the

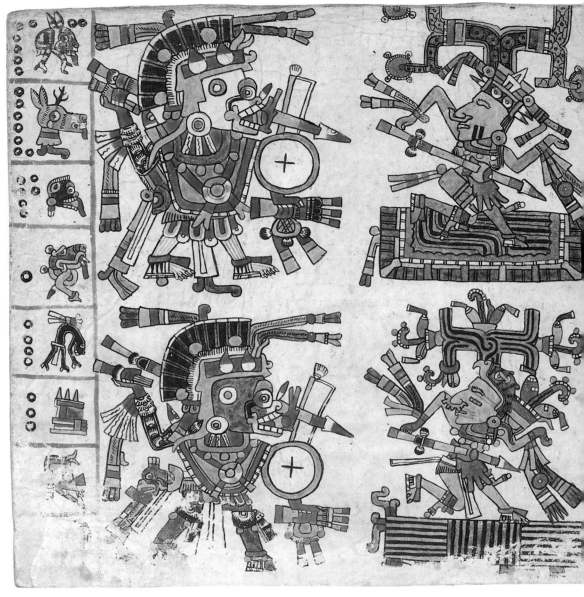

cat. 359, pages 9 and 10

rulers mentioned in the *Anales de Cuauhtitlan*; that these kings are earthly and not divine is underlined by the fact that the throne rests on a segment of Tlaltecuhtli, the earth monster.

The final scene in the *Cospi* Venus calendar is at the bottom of page 11. At heliacal rising on 1 Ollin (motion), the victim is a jaguar holding a bloody heart; all scholars agree that this creature stands for the warrior orders and therefore the young men mentioned in the passage from the *Anales de Cuauhtitlan*.

Other day-signs appear in the columns of days to the left of the pictures in the Cospi. These are the rest of the first twenty days of the *tonalpohualli* beginning with 1 Cipactli; they are also given in the *Codex Borgia*.

The *Codex Cospi* has one of the most venerable provenances of any Mexican manuscript. Its history constitutes a fascinating chapter in the collecting of American ethnographic objects in Italy and in the early history of museums. Nothing is

known of its whereabouts before 26 December 1665, when it was given by Count Valerio Zani to Marquis Fernando Cospi (1606–1686), a Bolognese who on his father's side belonged to an ancient senatorial family of that city and on his mother's side was kin to the Medici. The cover, in seventeenth-century parchment, is inscribed: "Libro del Messico donato dal Sig. Co. Valerio Zani al Sig. March. Cospi il di' XVI Dic. re MDCLXV" (book from Mexico given by Count Valerio Zani to Marquis Cospi the 16th day of December 1665). At the time he made the presentation Count Valerio Zani evidently thought the book was Chinese, since the inscription read "Libro della China," and was subsequently corrected to read "del Messico," as is indicated by the fact that the correction falls outside the lines the scribe had drawn on the leather of the cover as a guide to his lettering.

The codex then became part of the celebrated collection of the Marquis Cospi, also known as the

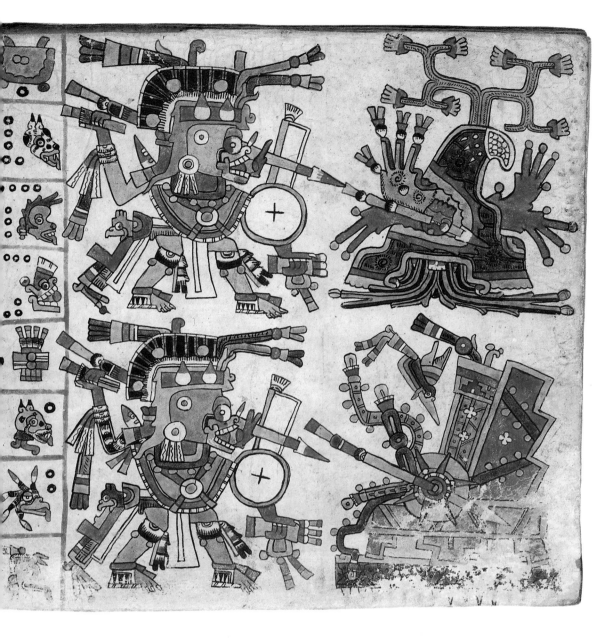

Count Zani himself had donated, after 1665 but before 1677, to the adjacent sixteenth-century museum left to the city of Bologna by the Bolognese *protomedico* Ulisse Aldrovandi (1522–1605) (see Laurencich-Minelli 1983 and Laurencich-Minelli and Filipetti 1983).

In 1680 the codex was again listed simply as a "book from Mexico" in the *Inventario semplice di tutte le materie descritte che si trovano nel Museo Cospiano* (Summary inventory of all the described materials found in the Cospi Museum), the slender anonymous inventory probably published to establish officially the number of objects that the Marquis Fernando Cospi had donated to the city of Bologna along with his museum (Bologna 1680). In 1742 the Aldrovandi and Cospi collections were transferred from the Palazzo Pubblico to the Istituto delle Scienze, and on 4 August of that year the Cospi museum was deposited temporarily in the house of a descendant of Marquis Fernando, the Marquis Girolamo Cospi, so that he could choose the materials to send to the science institute (Bologna 1743; Laurencich-Minelli 1983, 190; Laurencich-Minelli and Filipetti 1981).

On 6 June 1743 the book from Mexico, along with other objects from the Museo Cospiano, entered the Room of Antiquities of the Istituto delle Scienze (Laurencich-Minelli 1982, 190). In 1803 the library and entire institute became a part of the University of Bologna. The codex remained in the library known today as the University Library (Schiassi 1814).

One can speculate as to how it may have come into the possession of Count Valerio Zani, who was a man of considerable learning and a collector who was a generous benefactor of public museums. He gave to the Museo Cospiano a series of medals with the effigies of characters from the classical world as well as the *Codex Cospi*, and at about the same time donated to the Aldrovandi Museum the Aztec *atlatl* (Legati 1677, 192) that is now in the Museo Etnografico L. Pigorini in Rome (inv. no. 4212), as are all among the best American pieces from the Aldrovandi and Cospi collections.

Count Zani was a member of the Accademia Bolognese dei Gelati, of which he was prince in 1670–1671, and of which Cospi too had been prince. Zani was in contact with the great travelers of his epoch, and under the pseudonym of Aurelio degli Anzi wrote *Il Genio Vagante* (the wandering genius) (Parma, 1691–1693), a work in four volumes on the voyages and voyagers of the time. It may be that the *Codex Cospi* came into the possession of Count Zani from one of the many travelers with whom he came into contact in the course of his writing. However, we should not completely reject the idea that his uncle Costanzo Zani, bishop of Imola, through the international ties that the Church of Rome continued to protect even after the Council of Trent, could have been the intermediary. L.L.-M. and M.D.C.

Museo Cospiano, eight years after the collection had been transferred from Palazzo Cospi to the Palazzo Pubblico. It had been set up there in preparation for its formal donation to the city of Bologna, which took place in 1672. On 24 June 1660 the Marquis Fernando, in a "request" to the Bolognese senate, laid the foundation for the donation and promised also to have a "printed Inventory with identifying marks with many illustrations and eruditions..." drawn up (Laurencich-Minelli 1982). The two catalogues, prepared in 1667 and 1677 following Marquis Fernando's request by Dr. Lorenzo Legati, professor of Greek at the University of Bologna, give the most detailed information on the codex.

Lorenzo Legati may have been the first scholar to have recognized the American origin of the codex. In the 1667 catalogue he listed it in the chapter entitled "Miscellaneous" as "book... from India," "India" meaning at that time both the West Indies and the East Indies. In the more

definitive catalogue, compiled in 1677, he described it precisely as a book from Mexico and noted that it was kept in a square box with a crystal cover that has since been lost.

Legati (1677, 191–192), furthermore, gave the first accurate description of the codex and supplied measurements, in Bolognese feet, of the codex when fully opened. However, he did not seem to realize that leather had been used as a ground for the writing: he called the support "paper" and compared its thickness to the cardboard used by booksellers. He did affirm correctly that the surface was covered with a chalky paint, which, by making it smooth, rendered it suitable for writing. With this observation he anticipated by four centuries the results of the examination of the surface of the codex with an electron microscope (Gasparotto and Valdré in Laurencich-Minelli 1991). Legati also described the writing in the codex, relating it to other hieroglyphics including those incised on the Mexican *atlatl* that

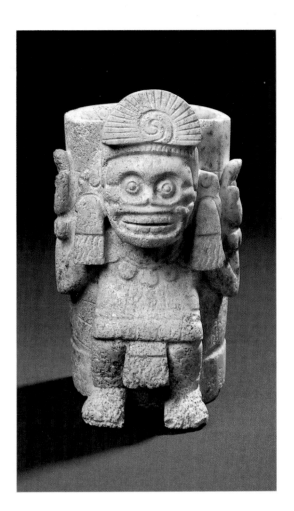

representation of the patron of the dead, Mictlan-tecuhtli, comes from offering no. 20. The container has vertical sides. It is decorated with unpatterned stripes on the base, the center of the body, and the edge. The image of the deity, the lord of the underworld, the living-dead who directs the fate of the inhabitants of his kingdom, Mictlan, is sculpted on the front of the vessel. He stands, dressed in a long tunic decorated with a string near the edge, while underneath the dangling strip of the *maxlatl* (breechcloth) is evident (see cat. 362). His necklace has hanging spheres that are probably stylized human hearts. His bent arms cling to the walls of the vessel in such a way that the palms of the hands face outward. Eyes bulge from the skull, looking straight at the spectator.

The headdress that identifies this representation as Mictlantecuhtli is an enormous semicircular feather, and the very large earrings made of textile strips are typical of the deities of death and the underworld. The color white identified the underworld and its principal gods. The artist chose the pale stone to highlight the symbolism of this vessel dedicated to the deity who received man in his final journey. F.S.

361 &

TLALTECUHTLI

Aztec
basalt
93 x 57 x 34 (36⅝ x 22½ x 13⅜)

CNCA—INAH—MEX, *Museo Nacional de Antropología, Mexico City*

During the construction of the first subway line in Mexico City, the southern section of the old Aztec capital was crossed in an east-west direction by a huge excavation that unearthed numerous constructions including temples and palaces. In 1967 a carved monolith weighing nearly a ton was found near the corner of Isabel la Católica and Calle Izazaga in downtown Mexico City (Martin Arana 1967). It represents a seated deity, Tlaltecuhtli (lord of the earth). It is one of the few three-dimensional images of this Aztec god who is better known from his images in codices and stone reliefs.

Tlaltecuhtli here sits with clawed crossed feet. The arms are bent and point upward as does the mouth, forming a horizontal plane encompassing the claws and the face in an altar-table. At first

360 &

VASE WITH THE EFFIGY OF THE GOD OF DEATH

c. 1469
Aztec
travertine marble
16.6 x 11 (6½ x 4¼)

CNCA—INAH—MEX, *Museo Nacional de Antropología, Mexico City*

Travertine marble was a material the pre-Columbian lapidaries have worked since the period of Teotihuacan. The Aztecs used this colorful rock in shades of white, green, yellow, and pink to tile the ceremonial floors of two lateral temples located on the platform of the main temple of Mexico-Tenochtitlan, in the so-called 4-B stage, which would correspond to the Axayacatl government, provisionally dated around A.D. 1469.

Many delicately worked masks and small sculptures of this same material have also been discovered; they were placed among the offerings dedicated to the principal Aztec gods Huitzilo-pochtli and Tlaloc. This vase with an impressive

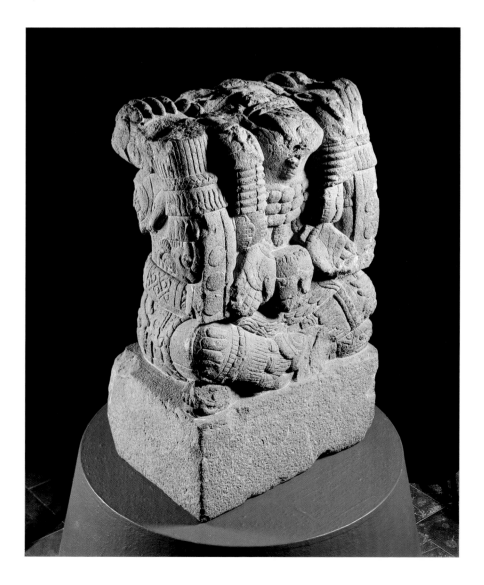

the figure was mistaken for the goddess Coatlicue, the female aspect of the earth. That goddess has a necklace of cut-off hands and hearts as well as a bracelet of dangling strips, which distinguish the great sculpture of the goddess whose best-known image was discovered in the Plaza Mayor of Mexico City in 1790 (see Klein 1988 for a discussion of Tlaltecuhtli's relationship with other deities).

In this sculpture, Tlaltecuhtli wears a kind of short skirt trimmed with crossed femurs and skulls in profile, which clearly allude to the earth as the covering of the world of the dead. The human skull pendant seen in the back has a similar meaning. Together with the cut-off hands and the heart, they indicate that human sacrifice, the death of an individual, will fertilize the gods and nature with blood, thereby giving continuity to life and death.

The face of the deity is decorated by a kind of make-up in the lower part of the face and two discs on the cheeks, which are directly related to the underworld. They also recall the face located in the central section of the famous "sun stone" (more popularly known as the Calendar Stone) that has been interpreted as the earth sun Tlalchitonatiuh, which is the moment of the day, at daybreak, when the king star emerges from a hole in the east of the universe after a journey through the inside of the earth.

In summary, Tlaltecuhtli is the male aspect of the earth and the great monster that carries all of creation on his back. In turn, he receives all beings that have reached the end of their existence. He has the underworld within him. F.S.

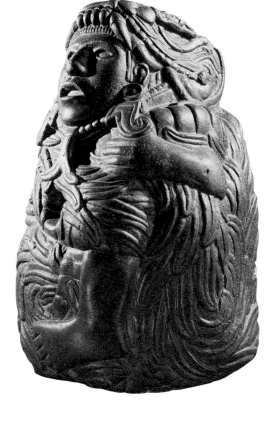

362 🐚

XIUHTECUHTLI AS AN OLD MAN

Aztec
volcanic stone
48.5 x 22 (19⅛ x 8⅝)

CNCA — INAH — MEX, *Museo Nacional de Antropología, Mexico City*

One of the characteristics of Aztec sculpture is that most figures represent a youthful adult. The Aztec people glorified youth, associating it with physical strength, audacity, and impulse. These qualities were fundamental to the success of a warrior society at a time of territorial expansion, when the Aztecs exercised dominion over many peoples far from Mexico-Tenochtitlan. This statue immediately draws attention because it has the face of an old man with many wrinkles. However, the seminude figure is well proportioned. His only attire is the distinctively male *maxlatl*, a piece of cloth covering the genitals that is knotted

in the front with hanging strips that form a kind of apron. The man is barefoot and raises both arms and hands forming a hollow for the placement of arms, insignia, or some other object. The expression on the face has great vitality, and the body is that of a vigorous person.

His physical strength contrasts with his old face not only because of his wrinkles, but also because he has only two side teeth. The wrinkles and the two teeth identify this figure as one of the most peculiar images of Xiuhtecuhtli, turquoise lord and the old fire god, an ancestral Mesoamerican divinity whose remotest origins are in the city of Cuicuilco, in the southern area of the Valley of Mexico. He was adopted as one of the most important gods of Teotihuacan. Since the Aztecs considered themselves the heirs of the cultures that preceded them, it was natural that they should adopt Xiuhtecuhtli yet give him their own peculiar character: a combination of youth and old age, the eternal and ancient fire that illuminated this dynamic society.

In most of the images that the Aztecs made of Xiuhtecuhtli, they eliminated the wrinkles and only showed the characteristic two teeth. This sculpture is therefore significant. The hollows of the eyes indicate that these were probably inlaid with shell, obsidian, or some other material, which would have made the figure very realistic.
<div align="right">F.S.</div>

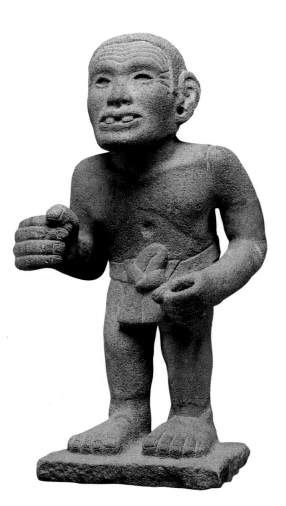

363 🐚

QUETZALCOATL

Aztec
porphyry
44 x 25 x 23 (17⅜ x 9⅞ x 9)

Musée de l'Homme, Palais de Chaillot, Paris

Quetzalcoatl was the god-king of the Toltecs, an earlier society whose heirs the Aztecs considered themselves to be. This great sculpture has become the best known of all the representations of Quetzalcoatl, who was also the patron deity of the Aztec priesthood. Preserving the irregular form of the porphyry boulder from which he carved the piece, the sculptor ingeniously combined the body of a rattlesnake covered with quetzal plumes with that of Quetzalcoatl as a human being. From the gaping jaws of the composite animal appears the face of the man-god, while his arms and right leg emerge from the feathered coils. That the face is that of "One Reed Topiltzin Quetzalcoatl" himself — ruler of the great city of Tollan (Tula) and culture hero of the Toltecs — is shown by his curved shell ear ornaments.

This is one of the supreme examples of the pan-Mesoamerican concept of the *nahualli*: the animal alter-ego into which powerful religious practitioners can transform themselves at will, and back

again into their human form. This concept, which can be traced to the ancient Olmec civilization and perhaps beyond, recognizes that the boundary between the human and the animal world is at most a very tenuous one, entirely permeable at times of religious ecstasy or, in some cases, under the influence of psychotropic substances. The spectator, in beholding this Aztec masterpiece, is in some doubt whether he is confronted by a man becoming a feathered serpent or a serpent turning into a man.

Such ambiguity pervades the whole subject of the god Quetzalcoatl as treated in Aztec sources (and, in some cases, reworked after the conquest by colonial historians anxious to recast Hernán Cortés as a Quetzalcoatl returned from exile, or Quetzalcoatl himself as a kind of Christlike figure). There is an ever-present contradiction between a god known as the feathered serpent, often wearing the wind-god mask, and a heroic leader of a former political power in central Mexico from whom the Aztec royal house drew its legitimacy, compounded by the confusion resulting from the cyclic nature of the Aztec reckoning of time.

As Nicholson (1983, 143) has shown, this sculpture has been known in Mexico since the mid-nineteenth century and arrived in Paris in 1883. Since that time it has become the most typical of all Quetzalcoatl images, and rightly so.　　M.D.C.

364 ᒣ

Mask of Tezcatlipoca

Aztec
stone
18.5 x 16.3 (7¼ x 6⅜)

Dumbarton Oaks Research Library and Collections, Washington

Because the eyes are not perforated and the back is flat, it is clear that this object was never actually worn as a mask. Three holes drilled near the top at back suggest that it might have been suspended over the head of a funerary bundle as a kind of stand-in for the deceased's face. Regardless of its function, it is one of the most sensitively carved depictions of the human countenance known in Aztec art (see Nicholson 1983, 105–106).

The iconography and the date carved in relief on the reverse make it certain that this is an idealized portrait of the great god Tezcatlipoca (smoking mirror), depicted as the eternally youthful warrior and patron of the *telpochcalli*, the military academy for young men and boys. His insignia is the stylized mirror above his left ear, edged with eagle-down balls and pierced by a bone tube from which smoke curls. The day-sign on the back is 2 Acatl (reed), the calendrical name of the deity in

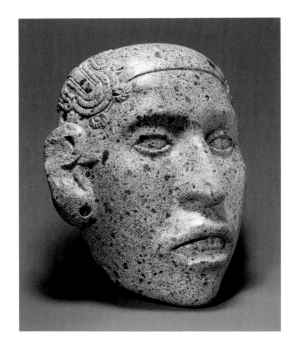

the *Codex Cospi* (cat. 359) and *Codex Nuttall* and given by the seventeenth-century source Jacinto de la Serna, perhaps the day on which he was born. Lothrop (in Lothrop, Foshag, and Mahler 1957, 243) thought that the year 2 Acatl, corresponding to 1507, was shown; however, missing here is the square frame that usually surrounds Aztec years.

If this was a mortuary mask it was for an extremely important person, perhaps a member of the royal family or even the *tlatoani* himself, for Tezcatlipoca was patron of the royal line.　　M.D.C.

365 ᒣ

Mirror

Aztec
obsidian with gilded wood frame
diam. 26 (10¼)

American Museum of Natural History, New York

The reflecting surface of this object is a horizontal section that has been struck off a very large obsidian core and carefully polished. This technique apparently continued well into the colonial period in Mexico, since a few examples of mirrors with wooden frames are surely later than the conquest.

This mirror probably predates 1521, but its function is unknown. On classic Maya pictorial pottery, lords often gaze admiringly at themselves in framed obsidian mirrors similar to this one, with the assistance of court dwarfs or servants. The obsidian mirror (*tezcatl*) was the supreme emblem of the great god Tezcatlipoca, patron of sorcerers, with whom mirrors were associated.

The frame has been simply carved with a repeated device that is perhaps a flower or conceivably a symbol representing the four directions of the universe.　　M.D.C.

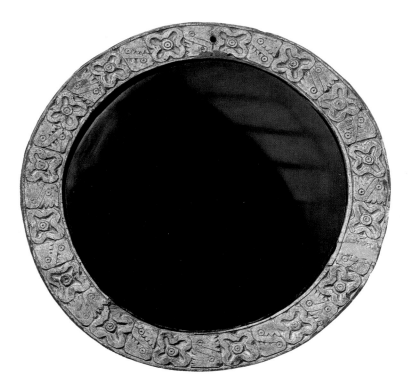

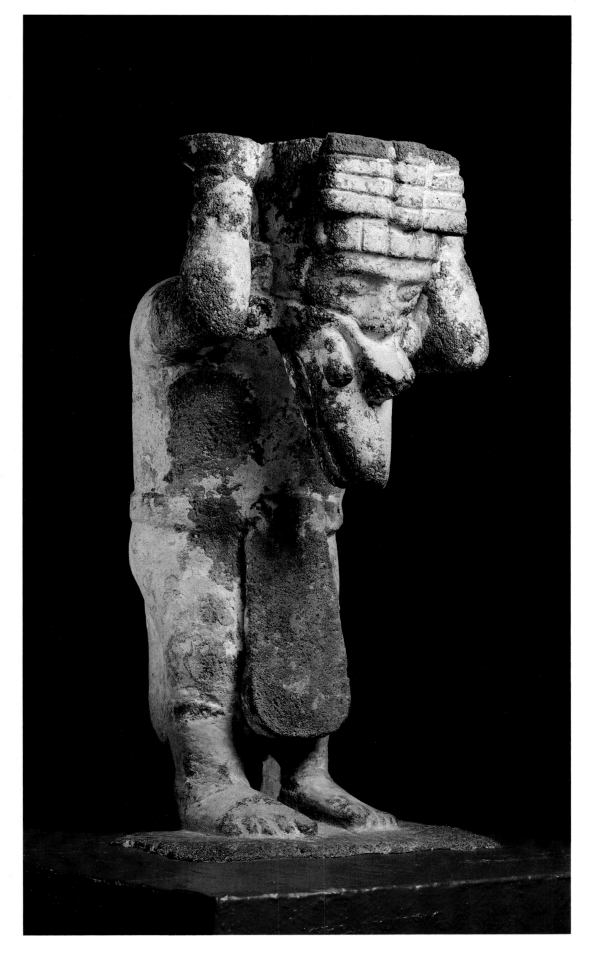

 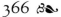

Ehecatl-Quetzalcoatl Atlantid

Aztec
volcanic stone
58 x 30 x 30 (22⅞ x 11¾ x 11¾)

CNCA—INAH—MEX, *Museo Nacional de Antropología, Mexico City*

As the Aztecs exercised territorial control over several areas of ancient Mexico, they added to their worship deities of their neighbors and of peoples whom they had recently conquered. Quetzalcoatl (the plumed serpent) was the most venerated deity for many indigenous peoples, since he symbolized one of the creative and regenerative elements of nature. Among other manifestations he was considered the civilizing god par excellence. In the later periods, however, the Aztecs worshipped a different god as the supreme deity, Huitzilopochtli (the young sun of the war). For the Aztecs, Quetzalcoatl had importance other than his ancestral preeminence. They worshipped him as the patron of the wind, and thus his complete name during the Aztec period is Ehecatl-Quetzalcoatl.

This deity was adored in temples with a special form. They had a circular floor, curved walls, and a cone-shaped ceiling, as we can see in sites such as Calixtlahuaca in the State of Mexico and in Cempoala, Veracruz.

The pioneering Mexican archaeologist Leopoldo Batres found this sculpture on 16 October 1900 during his excavations in the Calle de las Escalerillas near the ruins of the Great Temple in downtown Mexico City; four years later the German scholar Eduard Seler (1904) identified it and another very similar one found next to it as Atlantean representations of Ehecatl-Quetzalcoatl—Quetzalcoatl in his guise as wind god (see cat. 363). Seler also related the two Atlantids to the figure of Ehecatl-Quetzalcoatl on page 51 of the *Codex Borgia*. In the latter image, the god bears the eastern heavens on his shoulders.

Nicholson (1983, 79) further related these two figures (thus far the only Atlantids known in Aztec art) to non-Aztec sculptures from elsewhere in Mesoamerica; they are particularly prominent in the Toltec site of Tula, but have antecedents as far back as the Olmec civilization.

The Escalerillas sculpture is simply attired, with the familiar birdlike buccal mask of Ehecatl and the loincloth with paddle-shaped hanging ends typical of Quetzalcoatl. At the front of the headdress is a quadruple stack of knots, which is probably symbolic of blood sacrifice, in this case the penitential bloodletting with maguey spines practiced by the priesthood of which Quetzalcoatl was the patron.

The ultimate meaning of this object and its counterpart can be inferred from the Borgia

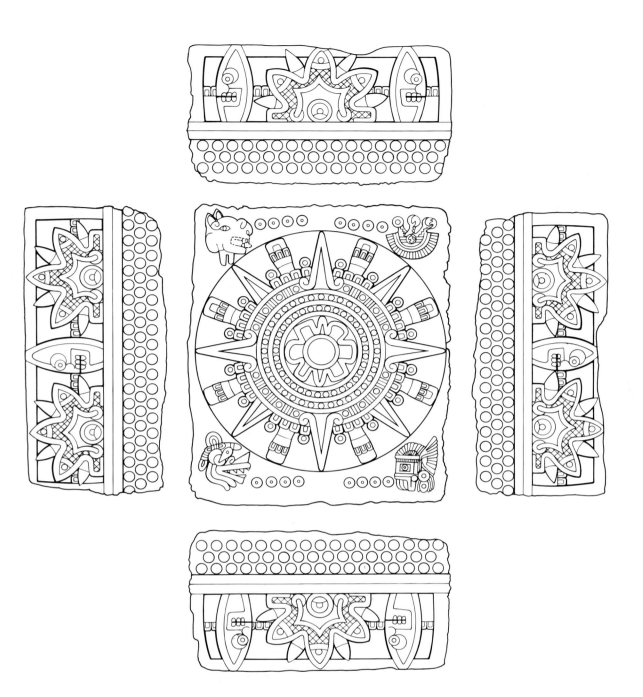

representation. In the Aztec creation legend preserved in the *Histoyre du Mechique* (de Jonghe 1905), floods had destroyed the universe at the end of the penultimate age; the sky had fallen upon the earth, and had to be raised for a new universe to take form. Tezcatlipoca and Ehecatl entered the earth goddess Tlaltecuhtli, the former through her mouth, the latter through her navel, and met in the heart of the goddess—the middle of the earth. The two gods then "made the sky very strong" and summoned the other gods to help them raise the heavens. This having been done, the stage was set for the creation of our own universe. The Escalerillas Ehecatl-Quetzalcoatl is the embodiment of this cosmic myth.

F.S. and M.D.C.

367 ❧

CREATION STONE

Aztec
basalt
54.6 x 45.7 x 25.6 (21½ x 18 x 10⅛)

Peabody Museum of Natural History,
Yale University, New Haven

Purchased in 1887 by Professor O. C. Marsh of Yale at a sheriff's sale in New Haven (MacCurdy 1910), this object has a close iconographical relationship to the famous Calendar Stone in Mexico City. The central perforation with a brass tube

was added in post-conquest times, perhaps to serve as a base for a flagpole.

The top surface (drawing, center panel) represents the ages into which the Aztec divided the history of the universe, each successive age being known as a "sun" symbolized by the day in the 260-day calendar (*tonalpohualli*) on which it ended. Our present age or sun is represented by the raised solar disk and will be destroyed by great earthquakes on the day 4 Ollin (motion), indicated by the Ollin day sign in the center of the disk. The four previous eras are indicated by the day signs in the four corners, to be read in a counterclockwise direction. The cycle of creations and destructions to which this representation refers

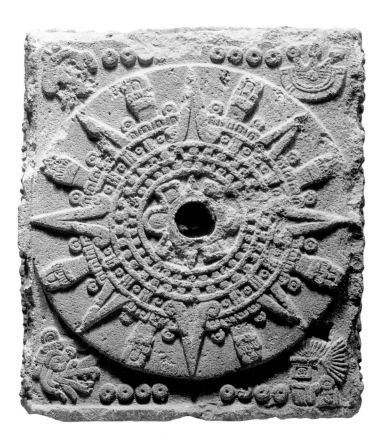

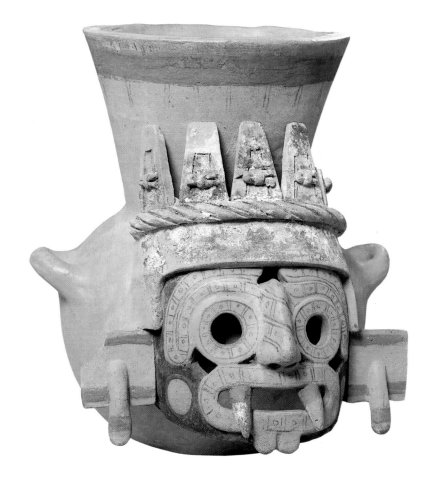

is fundamental to an understanding of the Aztecs' complex view of the world.

The first world age is signified by 4 Ocelotl (jaguar) in the upper left corner. In this age Tezcatlipoca ruled the universe but finally was hurled by Quetzalcoatl into the sea, where he became a jaguar and proceeded to destroy creation. Quetzalcoatl thus ruled the next era, 4 Ehecatl (wind), the sign of which is in the lower left corner. At the end of this sun, Tezcatlipoca, returning as a jaguar, threw Quetzalcoatl from his throne; a great wind arose and carried away Quetzalcoatl and the people, who were turned into monkeys. Tlaloc, the rain god, ruled in the third sun, 4 Quiahuitl (rain) seen in the lower right corner. At the end of this age Xiuhtecuhtli, the old fire god, descended to the earth and brought about a rain of fire, apparently at the command of Quetzalcoatl. In the fourth age, 4 Atl (water), shown in the upper right corner, the reigning deity was Chalchiuhtlicue ("she of the jade skirt," the water goddess, and Tlaloc's consort).

A great flood destroyed the fourth world and the sky fell on the earth, leaving the world in darkness. The gods met at midnight in Teotihuacan, the great city on the northeast side of the Valley of Mexico, and built a huge fiery pit. The lowliest among them, Nanahuatzin, leaped into the flames to become the sun of the fifth age, 4 Ollin, followed by Tecuziztecatl, who rose up as the moon. The midnight setting of this cosmic drama may be depicted by the four edges of the monument, which symbolize the night sky: beneath a band of stars are pendant sacrificial knives alternating with symbolic wings of Itzpapalotl ("obsidian butterfly"), a dreaded star goddess who descends to the earth during solar eclipses.

M.D.C.

368 🐿

TLALOC VASE

Aztec
earthenware
35 x 32.5 (13¾ x 12¾)

CNCA — INAH — MEX, Museo Templo Mayor, Mexico City

The Aztecs lived within a world of dualities. The change from a rainy season, in which the vital liquid made plants grow and have life, to a dry season, in which everything died, was central to their culture. The Mesoamerican calendar was established in accordance with these cycles, in which the gods of water and fertility prevailed in the first season, and the warrior deities in the second. These deities ruled the daily life of the Aztecs. Tlaloc was the god of water and rain, and he was frequently represented in the form of a clay pot that contained water. Many pieces with the face of this god were found in the excavations of the Great Temple. As one of the two sanctuaries of the upper part was dedicated to Tlaloc, and the other sanctuary to Huitzilopochtli, god of war, the life-death duality was present in the main Aztec temple.

E.M.M.

captors attired in jaguar and eagle costumes. The victims were then flayed and their skins donned by Xipe impersonators (*xipime*), who for the next twenty days went through the streets as mendicants begging food and presents and blessing the people and their children (Couch 1985, 41–48). At the end of this time the reeking skins were thrown into a ceremonial pit.

This sculpture is the standard representation of the god, shown as one of the *xipime*: the impersonator's own face looks out from the skinned face of the victim, tied in the back of the head with cords, while the skin of the body, complete with dangling hands but missing the feet, is similarly tied up on the back. A realistic touch is the sutures closing the horizontal cut through which the heart had been extracted. The body of the impersonator was painted red, and it is likely on the basis of representations of Xipe in the codices that the victim's skin was once painted yellow.

In the upper part of the body opening on the back can be seen the calendrical sign 2 Reed, the designation of the year in which the new fire ceremony was held, the last one having taken place in 1502. However, since the square or rectangular frame is lacking, it is unlikely that this was intended to represent a year. Though 2 Reed was the calendrical name of Tezcatlipoca, there is no clear connection with Xipe Totec. Therefore the presence of this inscription on the statue cannot be explained.

<div align="right">M.D.C.</div>

370 &

CIHUATEOTL

Aztec
volcanic stone
71 x 48 x 44 (28 x 18⅞ x 17⅜)

CNCA — INAH — MEX, *Museo Nacional de Antropología, Mexico City*

In Aztec religious thought, the *cihuateteo* (sing. *cihuateotl*, "goddess") were the deified spirits of women who had died during their first childbirth: they had nobly perished fighting the warrior who struggled within them, and they dwelled, like the

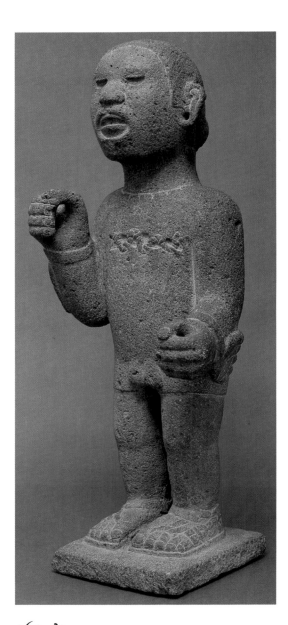

369 &

XIPE TOTEC

Aztec
volcanic stone
77.5 (30½)

National Museum of the American Indian, Smithsonian Institution

Xipe Totec was god of the springtime and of the renewal of vegetation by the coming of the rains. He was also patron of the gold workers. It was Xipe who afflicted people with skin ailments and diseases of the eyes and subsequently brought relief from these ills when prayers and vows were made in his honor.

Xipe's principal festival took place in April, at the end of the dry season, in the "month" called Tlacaxipehualiztli ("flaying of men"), and his own name means "the flayed one, our lord." In this, one of the most important celebrations in the annual cycle, gladiatorial sacrifices were staged in which the bravest of captives died, slain by their

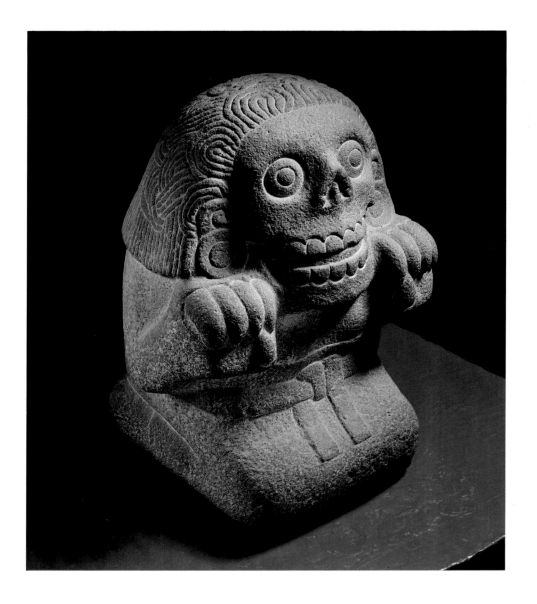

warriors who had fallen on the field of battle, in the heaven of the sun god. Their specific abode was on the western horizon, and their duty was to rise up at noontime from the west (called in Nahuatl *cihuatlampa*, "place of women") to the sun at zenith, and conduct the fiery orb toward its setting and entry into the underworld.

The *cihuateteo* were terrifying beings, as is evident in this sculptural representation. They were also called *tzitzimime*, which can be translated as a ghostly being. According to Aztec tradition, dead women shed their flesh bit by bit until the skeleton became visible. The left arm of a dead woman was a powerful weapon in sorcery, as can be seen in the depiction of page 44 of the *Codex Fejérváry-Mayer* of the archsorcerer Tezcatlipoca holding such an arm to his face.

Several sculpted figures representing these fantastic beings were discovered in the nineteenth century during the construction of a building in the center of Mexico City. This was probably the site of the Aztec sanctuary dedicated to these women who died in childbirth, which is known to have been located to the west of the sacred enclosure.

This sculpture is part of a group of four similar figures attired only in wraparound skirts (Nicholson 1983, 67–68). Instead of hands the sculptor gave them impressive eagle or jaguar claws that menace the spectator. Their breasts are displayed as a sign of their frustrated future maternity.

F.S. and M.D.C.

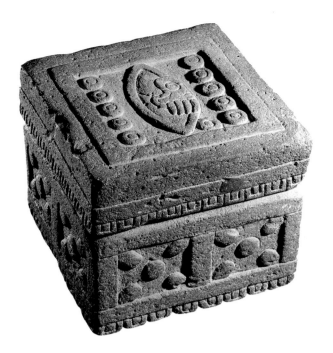

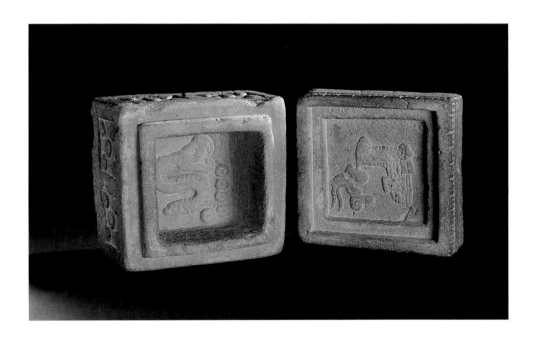

 371 &

Stone Box

Aztec
basalt or andesite
22 x 24 x 24 (8⅝ x 9⅜ x 9⅜)

CNCA — INAH — MEX, Museo Nacional de Antropología, Mexico City

Few archaeological remains relating to the rulers of Tenochtitlan and of the neighboring peoples have survived to our time. It seems that the royal burials were sacked and destroyed by the conquerors. This stone vessel is of a type thought by many scholars of Aztec culture (Seler 1904, 746–750) to have been a box for the ashes of one of the *tlatoanis* of Mexico-Tenochtitlan or of an allied kingdom.

The container, on which its original red and blue color is still evident, is in the form of a quadrangular prism decorated on each of its four outer surfaces with a pair of little squares with quincunxes. This symbol represents the cardinal points of the universe, which correspond to the number five represented by the five circles indicating the north, south, east, west, and center. Each side also has an even stripe finishing in the lower section with a row of short feathers.

The cover of the box also has the stripe and feathers motif. On the upper face is another numeral, the number eleven in the form of a flint knife, the sacred sacrificial instrument; because of its ritual character it is depicted with a fantastic face with eyes, eyebrows, and fangs. On the side eleven circles represent the date.

On the inside, the numeral five in the form of a rattlesnake can be found on the bottom of the box, accompanied by five discs or *chalchihuites* that depict the date. Inside the box also is the most important glyph, which is a mark of the vessel's royal character. This is the outline of a head of hair girdled with the *copilli* (royal crown) worn by the Aztec *tlatoanis*. The earrings of these noblemen are also present. Complementing the whole is the glyph for *tlatoa* (king); thus the iconography of the box derives from imperial power, the symbol of the *tlatoani*, leaders of discourse, commanders or rulers, and the insignia that distinguish them.

The identity of the nobleman for whom this vessel was made is uncertain. Some scholars associate it with Izcoatl (r. 1428–1440), and others with either of the two Motecuhzomas (Motecuhzoma Ilhuicamina [r. 1440–1469] or Motecuhzoma Xocoyotzin [r. 1502–1520]). However, only the latter two governors used the *copilli* specifically as a symbol of their name. F.S.

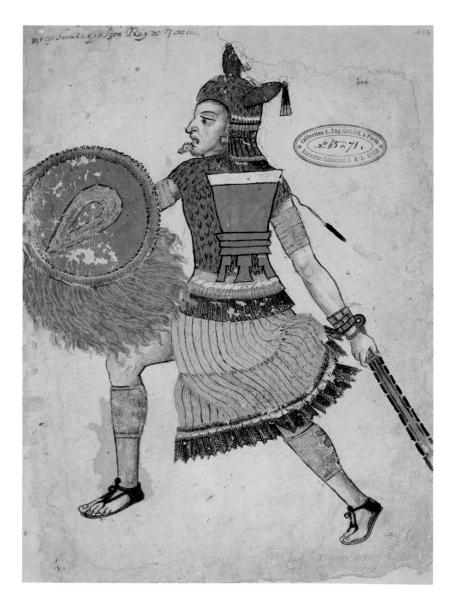

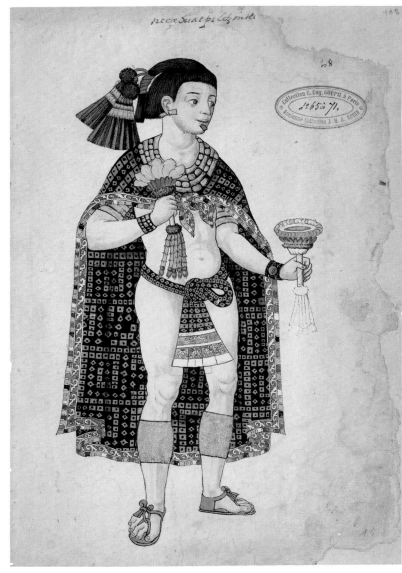

Nezahualcoyotl

late 16–early 17th century
colonial Mexican
fol. 106 of Codex Ixtlilxochitl
ink and watercolor on paper
31 x 21 (12⅛ x 8¼)

Bibliothèque Nationale, Paris

The *Codex Ixtlilxochitl* (see Durand-Forest 1976) is a booklike manuscript on European paper, apparently written by the native Texcocan historian Don Fernando de Alva Ixtlilxochitl (c. 1575–1658). There are three distinct parts to the manuscript, all of them in different hands: an illustrated account of the eighteen "months" of the solar year, drawn from the same lost original as the *Codex Magliabecchiano*; highly Europeanized portraits of four Texcocan lords including the present drawing, a schematic drawing of the Great Temple of Tenochtitlan, and a detailed watercolor of the god Tlaloc; and an unillustrated calendar again dealing with the festivals of the eighteen "months."

The subject of this drawing is the remarkable Nezahualcoyotl (or, to give him his honorific name, Nezahualcoyotzin), who had a long and distinguished career as *tlatoani* (ruler) of Texcoco. He was born in the year 1 Rabbit (1402), succeeded his father Ixtlilxochitl to the throne in 1431 or 1432, and reigned until he died in 1472. Among his many military triumphs, he defeated the Tepanecs and personally sacrificed their tyrannical ruler. Nezahualcoyotl ("fasting coyote") was also a famous lawgiver, student of the arts and sciences, and poet. The verses attributed to him (Davies 1980, 126) have a distinct air of sadness and pessimism, as can be seen in these lines:

Just as a painting
Our outlines will be dimmed,
Just as a flower
We shall become dessicated. . . .

Ponder on this,
Eagle and Jaguar Knights,
Though you were carved in jade,
Though you were made of gold,
You will also go thither
To the abode of the fleshless.
We must all vanish,
None may remain.

The artist who painted this section of the manuscript was probably a native who had been trained in the European tradition of three-dimensional illusion. The king is shown from the back as a warrior in action, but the execution is decidedly awkward. Nezahualcoyotl's feathered war costume may represent a kind of horned owl; he carries on his back a small *huehuetl* drum with drumstick to indicate his high military rank. In his right hand he wields a *macuauhuitl*, the terrible sword of Aztec warfare—a heavy flat club of wood with the edges set with razor-sharp obsidian blades, attached to the right wrist by a cord. On his left

arm he bears a feathered shield. Curiously, the device in the middle of the shield is an *oyohualli*, a stylized human vulva that symbolized the pleasure principle and is usually associated in Aztec iconography with music and dance; perhaps this indicates the *tlatoani*'s preoccupation with poetry.

Just below Nezahualcoyotl's lip may be seen a golden labret in the form of an eagle's head, virtually identical to the one in the Museo Civico, Turin (cat. 376). M.D.C.

373 🐜

NEZAHUALPILLI

fol. 108 of Codex Ixtlilxochitl
late 16th–early 17th century
colonial Mexican
ink and watercolor on paper
31 x 21 (12⅛ x 8¼)

Bibliothèque Nationale, Paris

When the aged Nezahualcoyotl died in 1472, he was succeeded by his seven-year-old legitimate son Nezahualpilli ("fasting prince"), who ruled until his own death in 1515. The latter thus was a contemporary and valued ally of every *huei tlatoani* of Mexico-Tenochtitlan, from Axayacatl to Motecuhzoma Xocoyotzin. The splendor of his vast palace in Texcoco was almost legendary; apart from his legitimate wives, he was said to have had more than two thousand concubines.

His portrait in the *Codex Ixtlilxochitl* (see Durand-Forest 1976) is, of course, imaginary, but there can be little doubt that this particular artist had actually looked upon a very high-ranking lord or *tecuhtli*, perhaps even a *tlatoani*, and remembered exactly what he had seen. This image is surely the most detailed and accurate representation in existence of the appearance and costume of an Aztec *tlatoani* during a festival. Two plumed tassels decorate his bound hank of hair, and he wears golden ear spools through his ears and a jade labret through the lower lip. Golden arm bands and greaves can be seen on his limbs, and a wide jade-bead collar is worn around the neck and jade bracelets on the wrists.

His cloak and loincloth are of the utmost sumptuousness: blue-and-black, tie-dyed cotton cloth edged with polychrome embroidery with repeated *xicalcoliuqui* designs symbolizing clouds.

In his right hand the *tlatoani* carries a fanlike bunch of tropical-bird feathers set in a tasseled handle, while the other hand holds a similar handle topped by what seems to be a circular nosegay of flowers. Nezahualpilli may be shown here as a participant in a dance, as identical objects are brandished in many dance scenes in early colonial illustrations, such as in the *Codex Tovar* (cat. 404). M.D.C.

374 🐜

SERPENT LABRET

Mixtec-Aztec
cast gold
6.6 (2½)

Lent through the courtesy of the Detroit Institute of Arts

Possibly made by Mixtec gold workers for an Aztec patron, this is perhaps the finest and most elaborate of the few golden lip plugs that escaped being melted down by the Spaniards during the conquest and in early colonial times.

The wearer of this object was certainly a local lord or perhaps a member of a ruling family. The bifid tongue of the serpent is actually movable; when the object was fixed into the lower lip it must have been a striking sight. Because of the weight, shape, and length of the labret, it was probably worn only on the most important occasions.

This ornament is a triumph of the lost-wax process, in which Mixtec craftsmen excelled. The gold objects found in Tomb 7, a Mixtec royal burial site at Monte Albán, Oaxaca, demonstrate that these artisans were capable of casting the most complex objects all in one piece, including even linked sections with bell dangles. A forked serpent tongue that moves would not have taxed their capabilities. M.D.C.

375 🐜

SERPENT HEAD LABRET

Mixtec
cast gold
6.5 x 6.5 (2½ x 2½)

National Museum of the American Indian, Smithsonian Institution

A Mixtec work from Ejutla, Oaxaca, this serpent labret is comparable to cat. 374, although not as elaborate; it probably adorned the lip of a lesser official. The iconography of gold labrets seems to be restricted to snakes and birds, at least in the examples that have survived.

In 1519 Cortés sent several Mexican Indians, probably Totonacs from Veracruz, across the Atlantic. The golden ornaments that these Indians inserted through holes in their cheeks and below their lips provoked astonishment and disgust in the Europeans who saw them. However, throughout Mesoamerica such ornamentation was an indication of high status among noble males, as well as a symbol of elevated military rank.

 M.D.C.

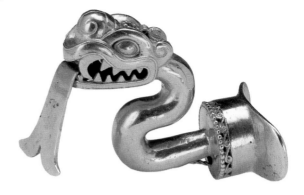

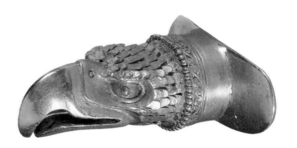

376 🐜

GOLD EAGLE LABRET

Mixtec-Aztec
cast gold
5.4 (2⅛)

Museo Civico, Turin

This is an unusually large and magnificent example of a *cuauhtenpilolli*, the eagle-head lip plug worn by only the very highest of state and military officials. Possibly made by Mixtec artisans, it is nevertheless in the purest Aztec style and is virtually identical to the eagle-head labret worn by Nezahualcoyotl in the illustration in the *Codex Ixtlilxochitl* (cat. 372). Its history is unknown before it became part of the important collection of Mesoamerican objects donated by Cav. Zaverio Calpini to the Museo Civico in 1876 (see Hildesheim 1987, cat. 250). M.D.C.

TURQUOISE MOSAIC MASK

Mixtec
wood with turquoise, jadeite, shell, mother-of-pearl
24 x 15 (9⅜ x 5⅞)

Museo Nazionale Preistorico e Etnografico Luigi Pigorini, Rome

In his meticulously researched study, Nicholson (1983, 171) suggested that this may be the mosaic mask listed in the 1553 inventory of the Guardaroba of Cosimo I de' Medici, duke of Florence. Its provenance, like that of most of the Mexican mosaics in early European collections, remains unknown; Juan de Grijalva collected mosaic masks along the Gulf Coast as early as 1518, but this object could have been obtained by the Spaniards anywhere in or outside the Aztec empire.

While the provenance of the mask may forever remain a mystery, the area of manufacture may be ascertained through the iconography. Although it has often been misidentified as a mask of the god Quetzalcoatl, knowledgeable scholars have recognized that the deity represented must be female: the snakes entwined in the hair or headdress are found throughout post-classic Mesoamerica in images of a number of goddesses, especially those with lunar associations (such as Ix Chel, patroness of childbirth and medicine among the Maya).

The stepped nose ornament of the goddess allows the identification to be even more specific. Following an original proposal by Beyer (1921), Nicholson (1983, 172) has shown that this is a goddess known by the calendrical name 9 Reed who appears often in Mixtec screenfold manuscripts as well as on carved bones found in the Mixtec royal Tomb 7 at Monte Albán, Oaxaca. Another Mixtec element can be seen in the fire-

serpent snake heads, which have tridentlike devices on the upturned snouts unlike the seven-star motif of central Mexican iconography. It seems reasonable to assume, therefore, that the mask was made by a mosaic craftsman somewhere in the Mixtec region of southeastern Mexico.

This does not preclude the possibility that the mask was actually collected in Tenochtitlan by the conquistadors, for many Mixtec luxury objects—of cast gold as well as turquoise mosaic—were crafted for the royal palace and major Aztec temples. While Nicholson conceived of 9 Reed as the Mixtec equivalent of the Aztec water goddess Chalchiuhtlicue, "9 Reed" was in fact the calendrical name of Tlazolteotl, goddess of childbirth and weaving (Caso 1967, 196); she can be found with this name on both page 47 of the *Codex Borgia* and page 26 of the reverse of the *Codex Cospi* (cat. 359) and is shown naked on page 17 of the *Codex Fejérváry-Mayer* (cat. 356). The chronicler Juan de Torquemada (1943–1944, 2:183) stated that at least some of the priests in the great temple in Tenochtitlan bore the name "9 Reed," presumably as impersonators of Tlazolteotl in her role as lunar goddess. Thus the present mask could well have been worn by one of these priests (the back, although flat, is nevertheless pierced so it can be worn).

What have not yet been explained are the reptilian or perhaps avian jaws between which the face rests. In the *Codex Borgia*, the love goddess Xochiquetzal (who as a young lunar deity is closely related to Tlazolteotl) is often shown looking out from the beak of a quetzal bird; she also has the fretted nose ornament, so that 9 Reed may have more general implications of sexual desire and fertility.
M.D.C.

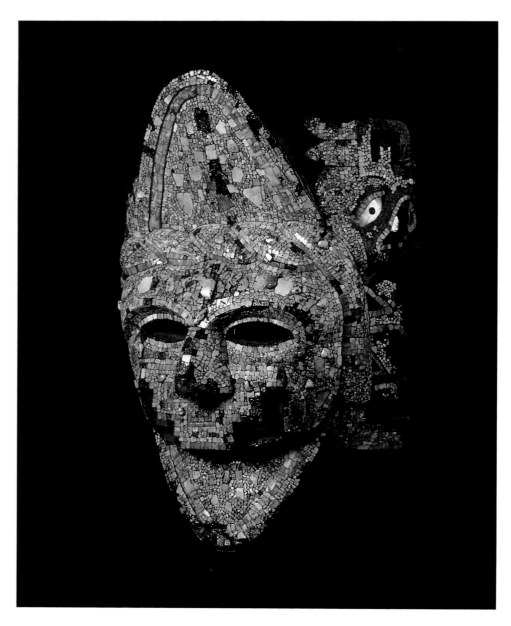

WOODEN DRUM (TEPONAZTLI)

Aztec
wood with shell inlay
14 x 12 x 60 (5½ x 4⅝ x 23⅝)

CNCA—INAH—MEX, Museo Nacional de Antropología, Mexico City

There were several kinds of percussion instruments used by the Aztecs, but only two wooden drums: the upright *huehuetl* covered on top with a skin drumhead and played with the hands (cat. 379) and the *teponaztli*, the horizontal slit drum beaten with rubber-tipped drumsticks. *Teponaztlis*, of which this is a fine example, were fashioned from a single small log and hollowed out on the inside, with an *H*-shaped slit on top leaving two tongues. These tongues were struck to pro-

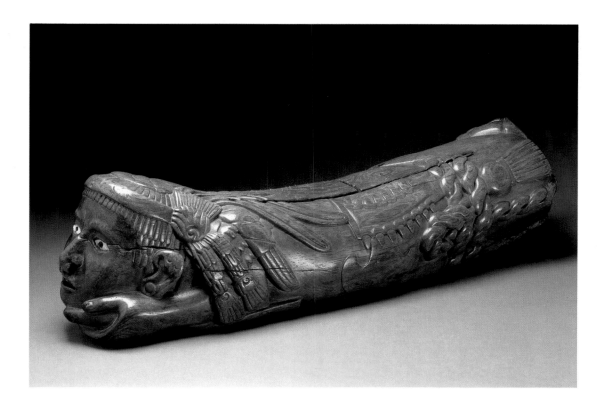

Huehuetl

Aztec
wood
84 x 50 x 50 (33⅛ x 19½ x 19⅝)

CNCA—INAH—MEX, *Museo Nacional de Antropología, Mexico City*

The name of this type of vertical drum in the Nahuatl language is *huehuetl* or *tlapanhuehuetl*. Two surviving *huehuetls* in particular are notable for the fine workmanship of their decoration. One of them comes from Malinalco (Nicholson 1983, 144–147), and the other from the village of Tenango (Castañeda and Mendoza 1933), both located in the State of Mexico. The drum shown here is the one from Tenango.

This drum was worked from a section of a tree trunk that was hollowed out and shaped like a cylinder; the upper part was covered with a skin to be struck with hands or hammers. The Tenango drum's three supports resemble the battlements of pre-Hispanic buildings turned upside-down.

duce a harmonious sound. This type of drum was the usual accompaniment for poetry recitals.

Of the many *teponaztlis* in the Museo Nacional's collection, this one, from Tlaxcallan, is certainly the most important. It represents a Tlaxcalteca warrior who, following the shape of the instrument, reclines on one side, while his head and arms are directed toward the front. He displays the headdress insignia of the great warriors and carries a flower in one hand. His skill in warfare is demonstrated by his handling of different arms.

There had long been antagonism between the Tlaxcaltecas and the Aztecs, and this became intensified from the time of Motecuhzoma Ilhuicamina's government (1440–1469), during which time both peoples agreed to the establishment of the *xochitlyaoyotl* (flowery war); this was a kind of military tournament, where the bravest warriors of the nations faced each other. Their purpose was neither territorial dominion nor plunder, but rather to capture the enemy alive, tie his feet and hands, and carry him to the victor's camp. Later the captives would be taken to Tlaxcallan, where they would be exhibited as war trophies. Eventually the prisoners would be sacrificed in honor of the gods. F.S.

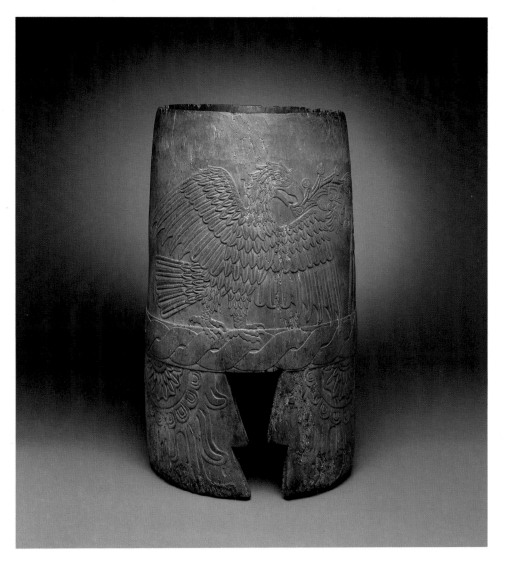

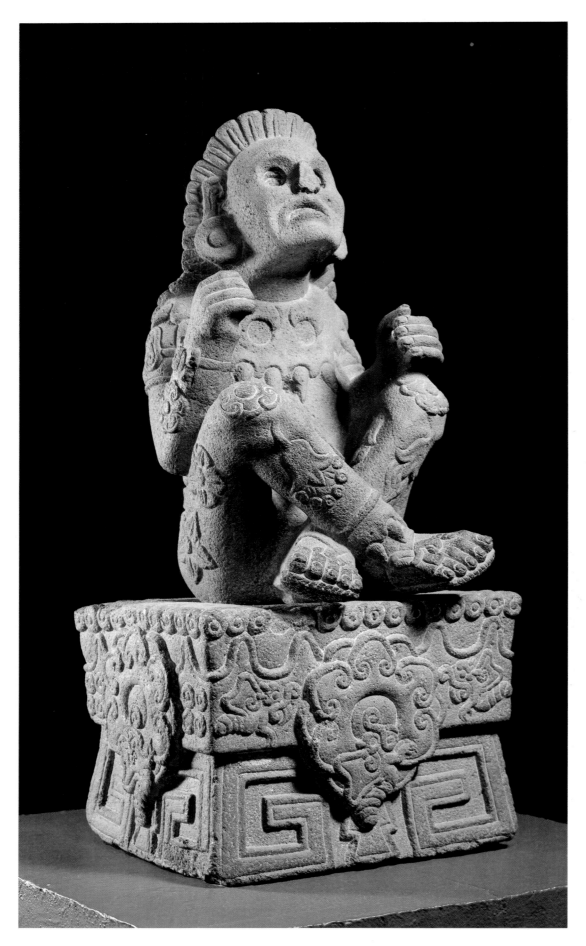

A kind of rope circles the lower section of the musical instrument, on top of which is the image of two birds of prey: a vulture is on the left, and facing it on the right is an eagle. Both birds have their wings spread as if about to fly. The symbols of fire and water mix as they flow out of their beaks. The union of these two elements forms the well-known symbol of *atl-tlachinolli* (water conflagration or flowery war). This was the supreme military ritual in which select corps of the Aztec army confronted their enemies to capture live prisoners for the sacrificial stones of Tenochtitlan or to achieve glorious death in battle.

From the decoration of this beautiful wooden piece we can surmise that it was used in the festivities associated with the wars of conquest and the sacrifice of prisoners. F.S.

380 ❧

XOCHIPILLI

Aztec
basalt
115 x 53 x 42 (45¼ x 20⅞ x 16½)

CNCA—INAH—MEX, *Museo Nacional de Antropología, Mexico City*

Xochipilli means "prince of the flowers" in the Nahuatl language, and this name clearly defines him as the supreme patron of the greenness of the fields, responsible for the opening of the flowers that bring butterflies and birds. For this reason nineteenth-century scholars called him the god of spring. Xochipilli was also the god of dances, of games (including the ball game), of gambling, and of love. He was the supernatural patron of pleasures and voluptuousness and of the arts, such as music, poetry, and song.

This celebrated sculpture is the most beautiful and complete representation of the deity. It was found in the final decades of the nineteenth century in the village of Tlalmanalco, situated within the mountain range where the twin volcanoes Popocatepetl (the smoking hill) and Iztaccihuatl (the white woman) are located. These two sentinels have identified the landscape of the Valley of Mexico for many centuries. This region was the home of an extraordinary school of sculptors who created this masterpiece and others that survive attest to their skill.

The figure of the deity reposes on a splendid platform. This throne is appropriate to the exalted position of Xochipilli by virtue of its fine detailing and iconography. The proportions of the figure were life-size by the standard of the people of that era, whose bodies were about seven times the length of their heads. The deity's legs are crossed and both arms are flexed. The fists have openings

for the placement of banners or banderoles, bags of resin, or natural flowers.

The dress of this god is the *maxtlatl* (loincloth) and a striking chest protector made of the skin of a feline head showing the hollows of the eyes, eyebrows, and fangs. The headdress is unique. It consists of a kind of short cloak covering the head and reaching the shoulders and is decorated with four circles combined with four vertical bars (*tonalli* and *tlapapalli*), which are associated with the heat of the sun and the color red and represent the spring climate. The headdress has a row of small feathers like short plumes. The god's face is covered by an impressive mask, which, in the original ritual, was probably made of wood with holes for the god's eyes to be seen. One scholar (Seler 1904, 821–822) has interpreted it as an attribute of Xochipilli in his role as the deity presiding over theatrical performances and dances during which the performers were masked. The mask with the line of the mouth curving down at the corners gives a hardness to the god's expression. Unfortunately the nose is broken. The figure wears earrings whose circular shape was probably intended to convey that they were made of gold or jade. The bracelets are in the form of knotted bands and jaguar skins with hanging teeth, similar to the adornments on his ankles. On one arm he wears cut shell jewelry.

The seat itself is a separate sculptural work. The legs adopt the form of a fret and the upper section of the throne is developed in the manner of a flower corolla that borders the whole piece and ends with a sequence of small discs that symbolize the stamen and pistils of the flowers. On this part of the seat there are also four circles like those of the headdress. At the center of each of the four faces of this almost cubic pedestal is a flower worked in a naturalistic manner with extended petals, and a butterfly drinks its nectar. The front part of the throne can be identified by two butterflies at the two sides of the central flower, waiting their turn to approach the plant.

The flowers and plant forms appearing in relief on the base and on Xochipilli's body have been the subject of a controversial analysis by the late R. Gordon Wasson (1980, 57–58), who proposed that the depictions include the powerful psychotropic mushroom *Psilocybe aztecorum*, known to the Aztecs as flesh of the gods, along with flowers of tobacco and the hallucinogenic morning glory *Turbina corymbosa*.

Despite the ravages of time the two separately worked pieces of this sculpture conserve their original red paint. F.S. and M.D.C.

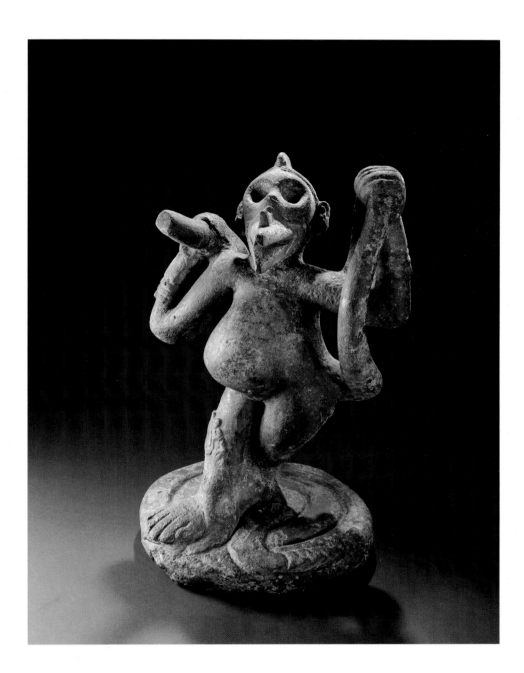

381 🐌

Monkey with Wind-God Mask

Aztec
andesite
60 x 37 x 33 (23⅝ x 14½ x 13)

CNCA—INAH—MEX, *Museo Nacional de Antropología, Mexico City*

This extraordinary and unique sculpture was discovered in 1969 during excavations for the Mexico City subway at the corner of Calles Izazaga and Pino Suárez; it had been broken up in pre-Hispanic times and placed as a buried offering in front of a circular temple to the wind god, Ehecatl-Quetzalcoatl (Gussinyer 1969).

The monkey was the main animal symbol of Ehecatl-Quetzalcoatl, patron god of the wind. As one of the most unpredictable animals, the monkey was naturally associated with the restless wind. The connection between the monkey and the wind god may also be related to the Aztec creation myth. At the end of the second or third age of mankind, depending on the source, the world was destroyed by a hurricane, and all mankind, with the exception of a single couple, became monkeys (see Nicholson 1983, 127). The direct association with the god Ehecatl is clear because the monkey wears the characteristic half-mask in the form of a bird's beak that identifies the wind god. What is extraordinary about this piece is its lively *contrapposto*, one that clearly indicates dance and probably reflects the association of a simian god with dancing and singing. There are two serpents present, one coiled on the base and ascending the right leg of the monkey, and the other forming its tail.

The sculpture was once highly polychromed: the body was painted black, with red used for the mask, part of the face, ears, and hands, and

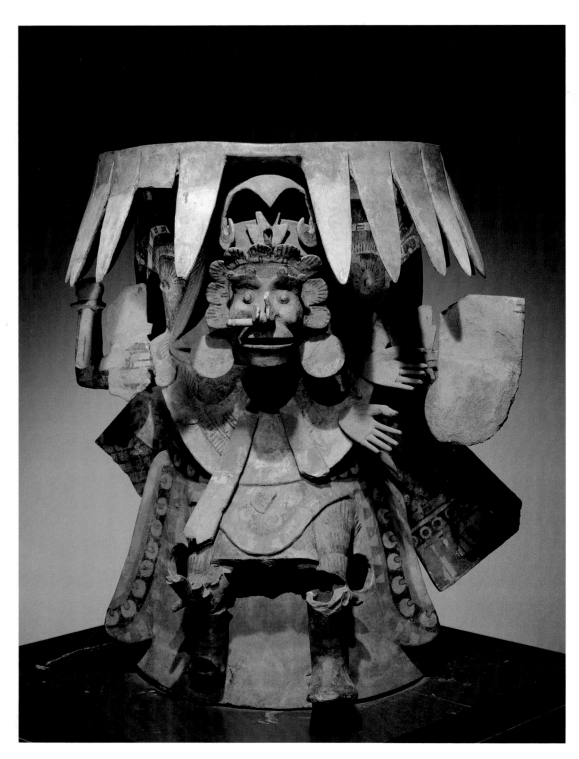

wears a red band, which is adorned with two blue crescents and a blue bird in the center. Her headdress takes the form of a diadem consisting of nine large, ocher-colored plates that symbolize feathers. She wears a nose ornament, in the form of a horizontal polychromed bar with two round blue plates, and large circular earrings. Her face is painted black, her eyebrows are blue and adorned with circles of different colors, and an ocher band appears near her mouth. She wears a polychromed *quechquemitl* with a border decorated with the motif of hands. Two red and blue ribbons fall from the garment's center, and from the rear emerge two bands with black rhombuses, circles, and tassels. Bird's claws spring from the figure's knees, and she wears sandals with tassels on the heels. Twenty-four triangular tassels adorn the brazier's upper edge.

Censers of this type were used to burn copal resin, the sacred incense of all the Mesoamerican peoples. Copal smoke was considered to be the medium through which humans communicated with the gods. E.M.M.

383 🐍

SHIELD

Mixtec-Aztec
wood, turquoise
diameter 31.8 (12½)

National Museum of the American Indian, Smithsonian Institution

According to Saville (1922, 47), who was the first to describe this shield, it was found somewhere in the Mixteca region of Puebla in a deposit of ceremonial objects of wood, seventeen of which were

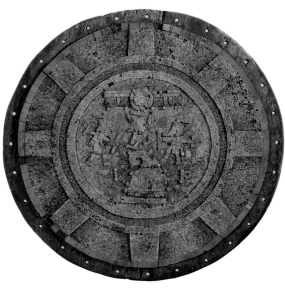

blue-green used for the wrists and eye cavities. Although it was found in pieces, the statue had been repaired at one time with a natural resin.

With one of his hands this monkey holds down its tail, and in the other it holds some object that unfortunately has broken off. The animal is a pregnant female, which curiously appears to be defecating. Pregnancy, childbirth, and excrement (which also symbolized gold) were traditionally associated with the wind that brings rain and thereby fertility to the earth. F.S. and M.D.C.

382 🐍

ANTHROPOMORPHIC BRAZIER

Aztec
polychromed earthenware
91 x 76 x 57.5 (35⅞ x 29⅞ x 22⅝)

CNCA — INAH — MEX, Museo Templo Mayor, Mexico City

This elaborate temple vessel is decorated with a figure in relief representing a mysterious standing female, whose extended arms and fleshless face emerge from the head of a bird. The figure

bought by the museum and brought to New York. One presumes from its excellent state of preservation that the site was a dry cave.

The piece is a wooden disk faced on the obverse with a finely made mosaic, by Saville's estimate consisting of fourteen thousand turquoise tesserae, most of which are tiny circular bits. Within and without the Aztec empire the art of turquoise mosaic was mainly in the hands of the Mixtec of Oaxaca and Puebla, although many of the surviving objects may have been made by order of the Aztec state as is probably the case with this shield. While the exact source of the turquoise has not yet been determined, there were apparently no pre-conquest mines in Mexico proper; it is generally believed that the people of central Mexico obtained their turquoise from the Pueblos of Arizona and New Mexico, in return for parrot and macaw feathers.

In inventories of Cortés' loot, 150 shields are enumerated, mostly decorated with feathers, but 25 are specified as being ornamented with turquoise mosaic (Saville 1922, 69); and we know from early colonial sources, for example Sahagún's, that images of specific gods carried such shields. Karl Taube (personal information) suggests that this piece might have been a back shield, worn on the small of the back by warriors and gods, and that the perforations were for suspending feathers.

The turquoise disk recalls Aztec solar disks, although the eight radial spokes in the outer band suggest the eight cycles of the planet in the five-year Venus calendar. In the center is a scene of great interest, since it alludes directly to the myth of the tribal origin of the Aztec rather than the Mixtec people. Below a celestial band with stars and a solar disk, a female figure, clad only in skirt, descends head down; she may be a Cihuateotl, one of the dread warrior-goddesses of the west, the souls of women who had died in childbirth, who were thought to descend during eclipses and at the end of the world ages (see cat. 370). Directly comparable images can be seen on the world-direction pages (49–52) of the *Codex Borgia*. She is flanked by two male figures, perhaps two of the Ahuiteteo (pleasure gods) who are found on the same Borgia pages.

Below is the "twisted mountain" place glyph of Colhuacan, most likely not the Colhuacan (or Culhuacan) in the Valley of Mexico whose princess was sacrificed and skinned by the Aztecs, but the original mythical Colhuacan, the *ur*-homeland of the Aztec, which was in an island in a lagoon in the land of Aztlan. This was a magic and enchanted place, in which the mother-goddess Coatlicue lived and which was reached by the migrating Aztec tribes, according to the *Codex Boturini*, in a year 1 Flint (A.D. 1168). The scene on the shield, therefore, recalls an episode of the Aztecs' great migration legend, perhaps an astronomical event of some sort. M.D.C.

384 ᣔ

ATLATL

Mixtec-Aztec
wood and gold leaf
length 57.5 (22⅝)

Museo di Antropologia e Etnologia, Florence

Aztec warriors held spear throwers, called *atlatls* in the Nahuatl language, to launch their darts with greater force, in effect lengthening the arm to provide greater impetus to the projectile. This weapon also has been documented in various other parts of the world and is generally thought to be an invention older than the bow and arrow. In the case of the piece shown here, two darts were placed in the pair of notches carved on the working face of the *atlatl*, and were fixed against the two hooked protuberances at one end. The rich carving and gilding decorating this *atlatl* suggest that it was used for ceremonial purposes rather than in actual warfare.

There are at least twelve Aztec ceremonial *atlatls* known. The present object is a particularly rare example, both because it allows two darts to be launched at the same time and because the carving on its back is so complex.

On the working surface, the two notches are decorated with incised motifs, one in a fishtail pattern and the other in a design recalling woven mats or *petlatl*. The two hooks are carved in bas relief with two standing warrior figures facing each other.

The back of the *atlatl*, worked in high relief on the first level and in bas relief in the second and third, is divided into three areas, with the central one occupying four-fifths of the entire carved surface. In the first area, at the top, are two figures with all the signs of their status: nose ornament, earrings, and feathered headdresses. They are seated on two ceremonial stools and stretch their arms out to shake hands. A third male figure, also of high rank, can be seen between the two with his hands on their outstretched arms, as though ratifying an agreement. This probably represents a pact between mythical ancestors, as is indicated by the fact that they are separated from the second area by the glyph for the rainy sky.

The second area, divided into six sections, describes the adventures of the noble warrior 1 Rabbit and his allies. This hero sits on the symbol of a house and rests his foot on the outstretched hand of 1 Grass while the latter points with his foot to a warrior seated on an alligator crouching on the glyph for water and holding a sacrificial knife. Behind the alligator is a warrior whose hand is covered by what appears to be a kind of knuckle-duster. This section evidently narrates 1 Rabbit's conquest of 1 Grass and the sacrifice, through the offices of the sacrificing god and his assistant, of a noble warrior who had

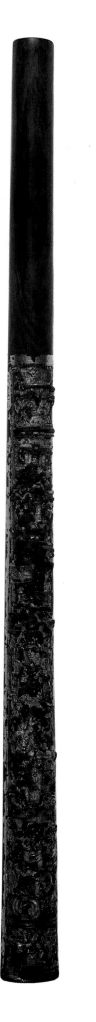

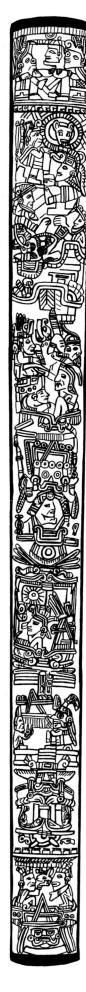

been defeated. The glyph for the place, which geographically lay close to a body of water, and a glyph for heaven with curls of flowers and reeds separate the first from the second sections. In the second section the bearded god 2 Wind, perhaps Quetzalcoatl-Ehecatl himself, dives from heaven onto a priest with tusks, while 1 Grass (indicated by his headdress shaped like the head of a macaw) and 3 Lizard (whose head and arm are all that are visible) make an offering to him. 3 Lizard and the tusked priest are seated on the symbol of the rain god, which separates the second section from the third. The third section is dedicated to the year 9 Rain. The god is portrayed with reeds, flowers, and feathers emerging from his hands and streams of water from his mouth and with a female head and right arm symbolizing the fertility of that year. This section is separated from the following one by the glyph for water and two symmetrical tufts of grass.

The fourth section is dedicated to the year 2 House and the noble 2 Grass seated on the glyph for Tlaloc and two alligators, perhaps the toponyms of the place where 2 Grass settled. The fifth section is dedicated to the year 2 Reed (?) as well as the conversation between the tusked priest shown above and an Aztec king or noble (as indicated by the classic *xiuhuitzolli* headdress) on the predella of an altar. The sixth section shows the rain god, who scatters his beneficial waters on a house, alternating with the warm rays of the sun placed at the base of the section. The roof of a palace with its roof ornaments separates and protects 1 Rabbit; the latter, having shed his battle clothes, sits on the glyph for the year 4 Rain and receives an offering from a person of rank.

The stories recounted on the back of this *atlatl* are, unlike those on other Aztec ceremonial *atlatl*s, more historical than ritual in nature. This fact, along with the frequent symbols for the year in distinct Mixtec style, the indication of the characters by their calendar names, and the liveliness of the carving and the gilding, suggest that this *atlatl* is the work of a Mixtec artist who was familiar with Aztec taste.

Nothing is known of its history before 1902 when the founder of the Museo di Antropologia e Etnologia of the University of Florence, Paolo Mantegazza, bought it along with a second *atlatl* from a Mr. Tosi, "merchant in artistic objects in Florence," for 500 lire, an enormous sum at that time. The two *atlatl*s were kept in a late seventeenth- or early eighteenth-century leather case and had been in the possession of "an old family resident in Florence for some time" whose name the antiquarian refused to divulge (Florence ms. n.d.). Research carried out by Sara Ciruzzi (1983) in the state archives of Florence on the inventories of the Medici Guardaroba and Armory yielded no information, thus providing no support for the Medici collection provenance proposed by D. Bushnell (1905). L.L.-M.

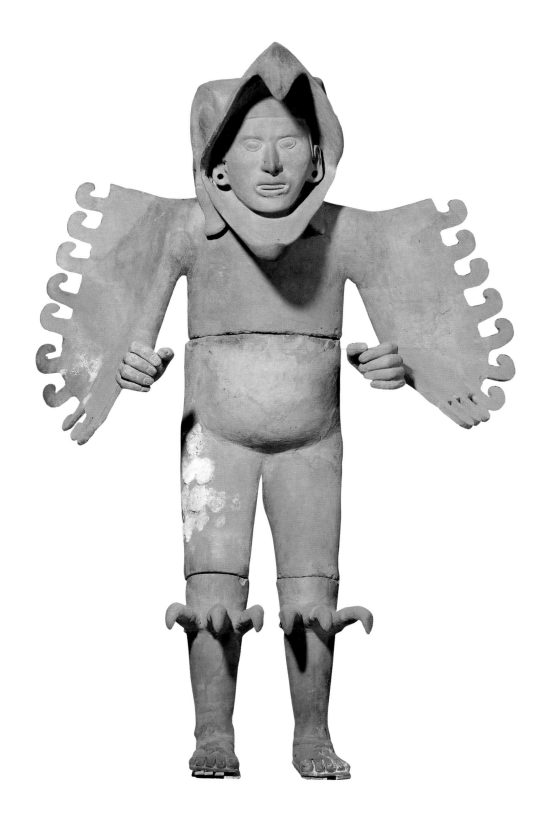

385 &

Eagle Warrior

Aztec
earthenware and plaster
170 x 118 x 55 (66⁷/₈ x 46¹/₂ x 21⁵/₈)
reference: Nicholson 1983, 85

CNCA—INAH—MEX, *Museo Templo Mayor, Mexico City*

The eagle warriors and the jaguar warriors were the elite soldiers of Aztec society. The former were the warriors of Huitzilopochtli, the god of the sun and of war. The eagle was a symbol of the sun, whose enclosure was found in the excavations at the northern end of the Great Temple in Mexico-Tenochtitlan. Two life-size sculptures representing these warriors were found on either side of the main door of this enclosure, on benches decorated with serpents and warriors in procession.

Each of the sculptures is formed of four sections. The first is the head, where, in the present

example, the face is enclosed in an enormous bird mask. The neck has a spike that fits into the next piece comprising part of the chest and the plumed arms. It is possible that the hands once held a wooden weapon. The third piece, forming the belly and the thighs, in turn fits into the two legs, each decorated with the claws of the bird and showing the warrior's feet with sandals.

This piece shows the great skill of the Aztec ceramists who gave an impressive appearance to the figure. The sculpture symbolizes the importance of the warrior in a society that depended to a great extent on military control over tributary regions. E.M.M.

386 ࣷ

COLOSSAL RATTLESNAKE HEAD

Aztec
basalt
103 x 108 x 157 (40½ x 42½ x 61¾)
reference: Nicholson 1983, 131

CNCA — INAH — MEX, Museo Nacional de Antropología, Mexico City

This enormous serpent head, which was discovered in the nineteenth century near the cathedral in Mexico City, probably formed part of the wall of the sacred enclosure at the very center of Mexico-Tenochtitlan. When the Spaniards arrived in the Valley of Mexico in the sixteenth century, this enclosure had a quadrangular floor like an enormous patio that probably measured four hundred meters (1,300 feet) per side. According to the descriptions of the conquistadors and early chroniclers, it was enclosed by a wall, both defensive and symbolic in function, decorated with sculpted stone serpent heads, the *coatepantli*. This walled enclosure had three entrances facing south, north, and west, which led to the paved causeways joining the city with the mainland. The wall of serpents marked the boundaries of the sacred land, where the Great Temple, representing the hill of the serpents in the Aztec creation myth, rose and where the sun was born. These menacing stone reptiles were also intended as the protectors and guardians of the deities.

The sculptors captured the power that emanates from the rattlesnake. The poisonous snake not only has a double pair of fangs at the sides, but also a row of four more in front and a forked tongue. The reptile has its nasal cavities marked, its head covered with scales, and enormous eyebrows over the circular eyes. F.S.

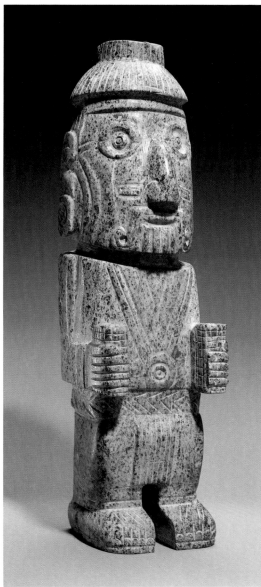

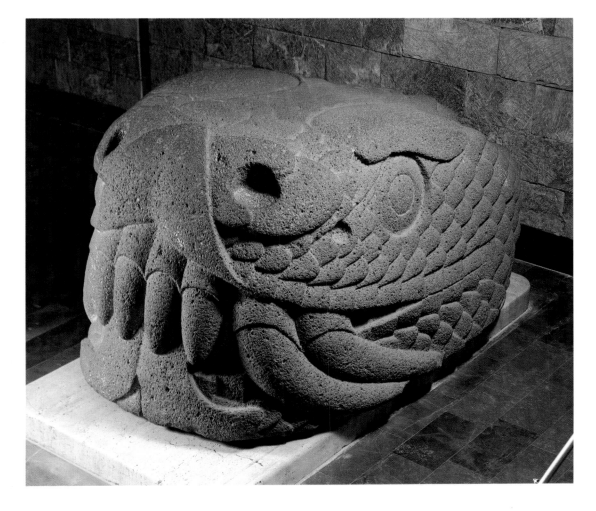

387 ࣷ

TLALOC

Mixtec
greenstone
39.5 x 11 x 10.5 (15½ x 4¼ x 4⅛)

CNCA — INAH — MEX, Museo Templo Mayor, Mexico City

This image of Tlaloc, god of rain, which was found in the Great Temple of Mexico-Tenochtitlan, comes from the Mixteca region of Oaxaca. This area was under Aztec military control, since it was rich in greenstone, which was so valuable in the pre-Hispanic world. It is therefore not surprising to find objects made of that stone in the Great Temple, where all the economic, political, and religious power of the Aztecs lay. E.M.M.

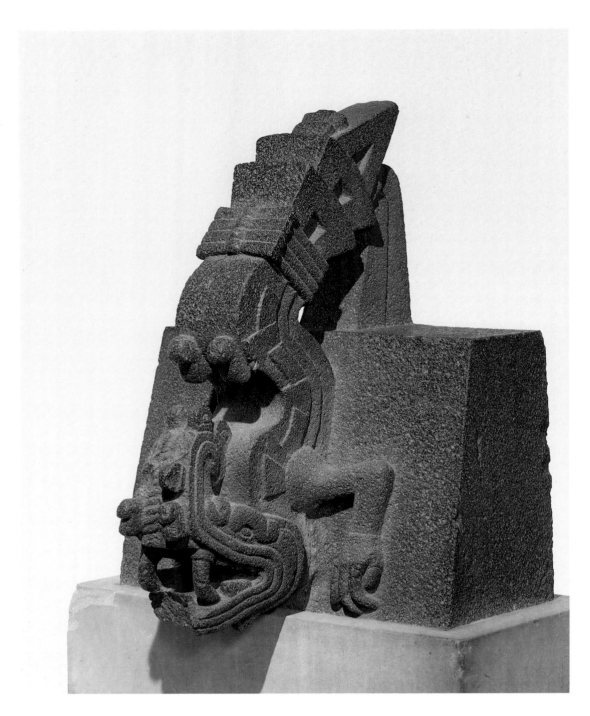

more open trapezoids, the final one inverted and showing only its spinelike apex. This trapezoidal device is the well-known year sign, standing for the solar year.

On almost all examples of the fire serpent there are two or more horizontal paper strips, each with a knot in the middle, arranged in a vertical stack and placed between the body and the "year-sign" tail. This device, which is also to be found on the exterior of several stone *cuauhxicallis* (containers for human hearts), has long puzzled Aztec specialists, but is now well known to Maya iconographers. It was David Joralemon (1974) who first identified this device as the preeminent sign of blood and blood sacrifice among the classic Maya, found on ritual bloodletters and elsewhere; the stack of knots symbol retained this function through the Maya-Toltec period at Chichen and in the late post-classic codices. It may well have been that the stack of knots was transmitted to the Aztecs from the Maya through the Toltecs, for it is also very common at the Toltec capital, Tula.

This symbol raises the question of just what is being portrayed on the present sculpture. The Xiuhcoatl is undulating down a trapezoidal stone, surely an unusual posture for a creature supposed to be traveling upward with the sun. But the base itself is surely intended to represent a sacrificial stone, over which victims were stretched face-up to have their chests opened by the obsidian or flint knife: it virtually duplicates the sacrificial stone found on the Huitzilopochtli side of the Great Temple during the recent excavations. The stack of knots symbol strongly suggests that the Xiuhcoatl had a sanguinary function during human sacrifice, namely to descend from the sky and receive the offering of the warrior's heart and blood as a representative of Huitzilopochtli-Tonatiuh, the fifth sun of our own creation. M.D.C.

389–393 ॐ

SACRIFICIAL KNIVES

Aztec

389: *silica, obsidian, copal*
22 x 6 x 3.9 (8⅝ x 2⅜ x 1½)

390: *silica, obsidian*
23.4 x 6.7 x 1.1 (9⅛ x 2⅝ x ½)

391: *silica, obsidian, copal*
17.5 x 6.7 x 1.5 (6⅞ x 2⅝ x ½)

392: *silica, obsidian, copal*
15 x 5.2 x 3.8 (5⅞ x 2 x 1½)

393: *silica, obsidian, copal*
19.5 x 7 x 3.6 (7⅝ x 2¾ x 1⅜)

CNCA — INAH — MEX, Museo Templo Mayor, Mexico City

388 ॐ

XIUHCOATL

Aztec
volcanic stone
75.5 x 60.5 x 56.5 (29¾ x 23⅞ x 22¼)
The Trustees of the British Museum, London

The Xiuhcoatl (fire serpent) was an avatar of Xiuhtecuhtli, the old fire god, with the task of conducting the sun on its daily journey from the eastern horizon to the zenith. The *coatl* (snake) designation in the name is somewhat misleading,

for in stone monuments and in representations in the codices the creature is more like a dragon, usually having forelimbs. The root *xiuh-*has many meanings in Nahuatl; derived from the noun *xihuitl*, it signifies fire, the year, grass, and comet. As seen here, on the Calendar Stone, and in codices like the Borgia, the Xiuhcoatl has gaping jaws and an upturned snout lined with stars; since the latter usually number between six and eight, it is quite probable that these represent the Pleiades, an extremely important star cluster in Aztec astronomical thought. The body of the creature is always segmented, ending with one or

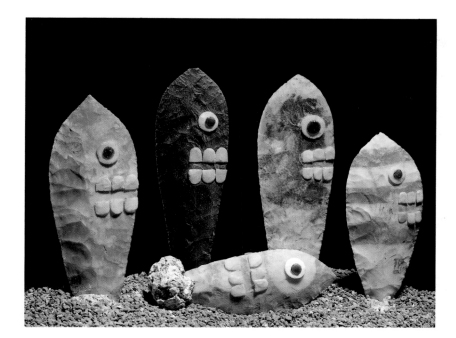

Aztec ritual was the center of attention during the
month of Izcalli, when ritual impersonators of
the god were burned in fires and then subjected
to the knife. M.D.C.

Such decorated sacrificial knives have been found
in many Aztec offerings. Sacrificial knives, called
técpatl in the Nahuatl language, were embellished
with shell and obsidian simulating eyes and teeth.
The flint knife was very important in Aztec cul-
ture. It symbolized the northerly course of the
universe, and was associated with cold and death.
It was also the name of a year. In view of their use
in sacrificial rites, it is not surprising that such
knives have been found in several offerings at the
Great Temple. E.M.M.

395 ᏋᏅ

HUMAN SKULL WITH KNIVES

Aztec
bone, pyrite, flint
16.5 (6½)

CNCA — INAH — MEX, *Museo Templo Mayor,*
Mexico City

Several skulls were found among the offerings in
the Aztec Great Temple. This mask-skull from
offering 57, with small perforations in the fore-
head, has eyes of bone and pyrite that can still be
seen. The skull has stone knives inserted into the
nasal cavities and another into the mouth, which
we interpret as the representation of cutting off
the flow of life-giving air. It is, therefore, a most
poignant expression of death. In pre-Hispanic
Mexico, death and life were united in a constant
cycle that man observed in nature. E.M.M.

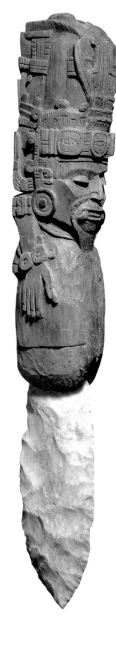

394 ᏋᏅ

SACRIFICIAL KNIFE

Aztec or Mixtec
wood and flint
19 (7½)

American Museum of Natural History, New York

This knife has been restored by adding an old flint
blade to the wooden handle, but there can be little
doubt that the original instrument was used to
extract hearts from war captives. Unless, as seems
unlikely, the handle comes from an old European
collection, it was probably found in a dry cave,
which would suggest a provenance in Puebla,
Oaxaca, or Guerrero, which have many such
caves. The style is late post-classic, but the handle
could be of either Mixtec or Aztec manufacture.

 The figure apparently represents a deity; the
beard along with the crooked fangs at the corners
of the mouth lead one to believe that it is Xiuhtec-
uhtli (see cat. 362), the aged fire god, who in

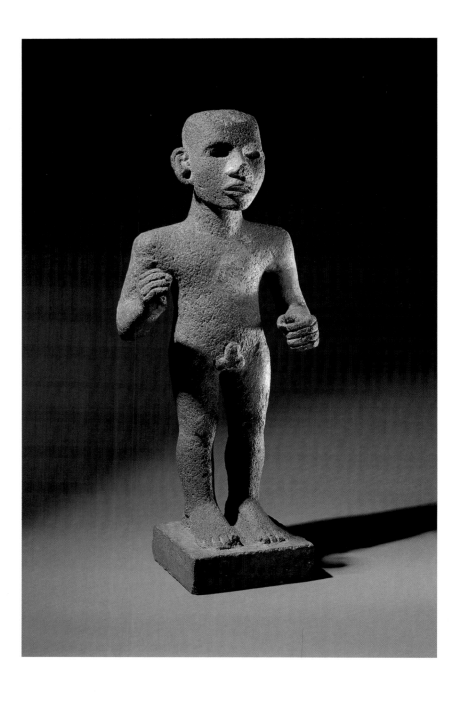

plex culture. If they were commoners they would attend the *telpochcalli* and learn the rudiments of their fathers' trade. They were also taught to control their sexual impulses by self-sacrifice.

Knowing this, the unusual nature of this sculpture, of which type no more than ten exist, becomes evident. The figure of a nude young man with an erect penis, a state that would have been considered antisocial in public, comes from the city of Texcoco, where this type of figure was probably placed in the interior of a temple and out of the view of the general public. The phallic imagery is associated with male puberty. The awakening of male sexuality is associated with the spring, bringing with it the heat of the sun and its rays which, like the penis, generate fertility.

Texcoco was one of the settlements in the Valley of Mexico that had a long cultural history. Its origins date back to at least the thirteenth and fourteenth centuries, when the group of hunters and warriors known as the Chichimecas of Xolotl entered the civilizing process. They intermarried with the ancient agricultural cultures that existed in this Mesoamerican region and founded a metropolis that was to become famous for its cultural development, Texcoco. This city was known for its libraries rich in codices, for the poet-king Nezahualcoyotl (cat. 373) who ruled there, and for its status as the center of activity for many craftsmen and artists.

The quality of this piece gives testimony to the excellent workshops of sculptors in Texcoco. The artist gave the figure a well-proportioned physique of great aesthetic quality. The youth has no hair and has perforations on the ear lobes, which indicate that human hair was placed on his head and that he was adorned with real ear ornaments.

F.S.

397

Young Woman Kneeling

Aztec
stone
32 x 20 x 15 (12⅝ x 7⅞ x 5⅞)

CNCA—INAH—MEX, Museo Nacional de Antropología, Mexico City

Aztec sculptures give us an insight into the traditions, social structure, and world view of these ancient peoples. This figure from the Valley of Mexico portrays a young girl seated in public on her legs, kneeling. It was the posture that women had to adopt socially and the position in which women carried out their work. The figure evidently represents an adolescent since her breasts have not grown.

She is dressed in the traditional skirt that covers the lower section of the body and the *quechquemitl*, a kind of rhomboidal blouse with

396

Nude Young Man

Aztec
stone
55 x 20 x 15 (21⅝ x 7⅞ x 5⅞)

CNCA—INAH—MEX, Museo Nacional de Antropología, Mexico City

The physical characteristics of the Aztec people can be recognized in their sculpture. Their skin color ranged from light to dark brown. They had straight black hair, little tendency to baldness, and hairless faces, with dark fairly wide eyes, high foreheads, broad noses, and very prominent cheekbones. Their average height was about 160

centimeters (5 feet 3 inches) for men and 148 centimeters (4 feet 10 inches) for women.

The Aztecs had a highly developed concept of restraint in dress and social conduct. The evidence collected by the sixteenth-century chroniclers abounds with examples regarding the control that each individual exerted over his acts, his dress, and his language. Respect for and obedience to the authorities, gods, elders, and traditions were especially exalted. At the age of puberty, it was compulsory for young men to attend public schools where they became interns for five years and were taught according to their social class. If they were noble they would attend the elite school known as the *calmecac* and learn about their deep and com-

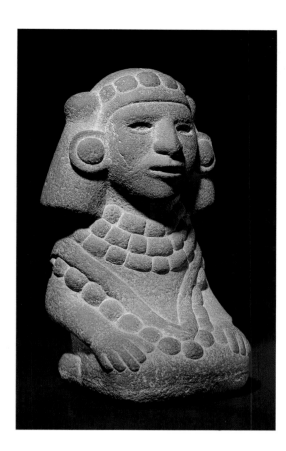

NUDE WOMAN

Aztec
stone
146 x 40 x 25 (57½ x 15¾ x 9⅞)

CNCA—INAH—MEX, *Museo Nacional de Antropología, Mexico City*

This figure is the best evidence of the great plastic quality achieved by the art of Texcoco during the Aztec era. Its proportions are almost perfect. The thighs and the lower part of the legs, the curve outlining the lower abdomen, and the marking of the female genitalia—very rare in the artistic tradition of that time—leave no doubt that this sculpture is intended to exalt female sexuality. It is one of the few Aztec sculptures that express sensuality.

The artist shaped the woman's waist as a thin line from which the torso builds to solid shoulders; although her arms are broken, we can imagine that they were flexed and directed toward the front. The breasts are very small, like half spheres that cling to the body. The quadrangular hollow between them would originally have contained a bead or a jade figure, the well-known "green stone heart" that imaginatively gave life to these images. The face has a stern expression. The hol-

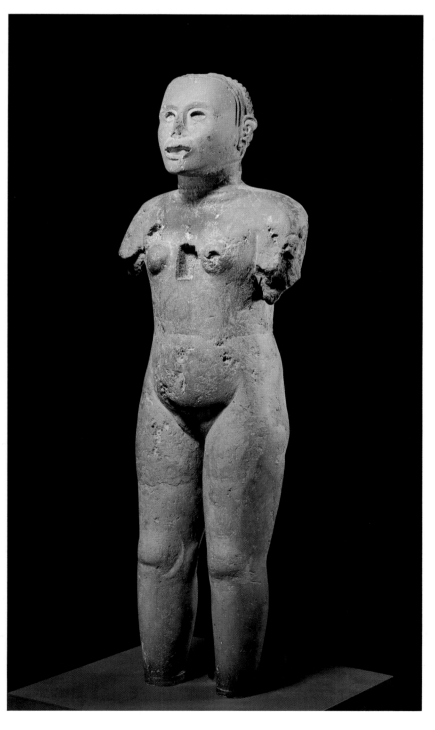

a hole in the middle for the head. This piece of clothing is still worn by some indigenous peoples of Mexico, but today it is short and almost ornamental, and a blouse with sleeves introduced after the Spanish conquest is worn underneath. In the pre-Hispanic period it covered the entire upper body. The garment on this figure, falling in a triangle in the front and back, is notable for its rich workmanship adorned by a fringe or border of small spheres or cloth tassels.

The young woman's status as a member of the elite is conveyed by her fine jewels: circular earrings possibly of precious metal and an elegant, naturalistic necklace of three rows of jade beads that is very similar to necklaces that have been discovered in archaeological excavations. The headdress is a band that girds the whole head. It too has a row of spheres as an adornment on the upper part and two large tassels hanging on both sides of the face. Above these the artist depicted earrings, which in reality were probably covered by the cloth adornments.

Some scholars consider this headdress to be characteristic of the goddess of food and water. Accordingly, despite her naturalism, this figure is probably a representation of the female power of nature, the generative principle. In this sculpture, this force is envisioned in the dry season of the year waiting for growth, maturity, and fertility through the action of heat and water. This is why it is represented as a young girl of the nobility, restrained and elegant.

Red color, which was characteristic of the goddess of food, still covers the figure's face. F.S.

lows of the mouth and eyes were evidently crafted so that they could be inlaid with shell, bone, and obsidian. The woman's hair is not represented; in its place, there are grooves that were perhaps used to insert real hair.

If one carefully observes the whole and then each part individually, one can see that sculptural work in Aztec Mexico was not the work of a single artist but of collective participation. It is evident that different hands worked on the legs, the torso, and the face of this figure. F.S.

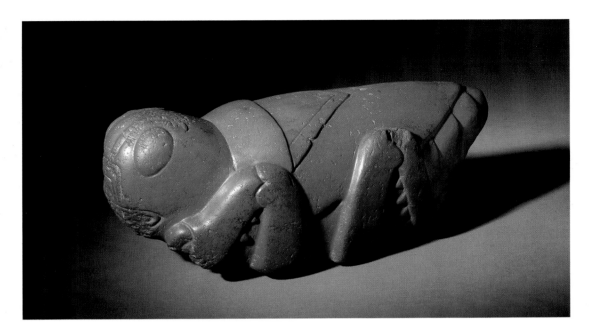

399 &

GRASSHOPPER

Aztec
carneolite
16 x 46 x 19 (6¼ x 18⅛ x 7½)

CNCA—INAH—MEX, *Museo Nacional de Antropología, Mexico City*

In the western part of the ancient Lake of Texcoco, there is a hill called Chapultepec, which gave its name to a beautiful forest. Chapultepec, now a park, it is one of the few green areas that survive in the modern city of Mexico.

The name of the mountain and the forest comes from the grasshopper, called *chapulin* in the Nahuatl language, which is the insect represented in this sculpture in a reddish-colored stone. We can see how the sculptor made use of the shape of the stone to depict the animal. The *chapulin* seems to be at the point of jumping, which is how these creatures swarm through the fields during the season when they are abundant. Other Aztec stone sculptures of grasshoppers are known (Nicholson 1983, 117–118), but none as beautiful as this masterpiece.

According to early legends, Chapultepec was a sacred place that welcomed the Aztecs when they reached the Valley of Mexico after having passed through many places in quest of the land, promised by their god Huitzilopochtli, where they would found Mexico-Tenochtitlan. The place was delightful and very green with abundant trees and vegetation, because in the eastern section of the mountain there was a permanent spring. Years after founding their capital, the victorious Aztecs channeled the spring's valuable water by constructing an aqueduct from Chapultepec to Tenochtitlan and also to Tlatelolco. For this purpose they constructed two parallel ducts, which entered the Aztec capital from the west through the paved road of Tlacopan. The two pipelines allowed them to have one in operation while the other was being cleaned.

According to tradition, Motecuhzoma Ilhuicamina, fifth lord of Tenochtitlan, ordered the construction of reservoirs in Chapultepec. It is believed that this sculpture comes from these reservoirs. F.S.

400 &

TOAD

Aztec
stone
19 x 51 x 34 (7½ x 20 x 13⅜)

CNCA—INAH—MEX, *Museo Nacional de Antropología, Mexico City*

Several pre-Hispanic cultures in Mexico considered batrachians as the animals that announce the rainy season, and these amphibians were therefore associated with Tlaloc, the patron god of this vital element. In the Great Temple of the Aztec capital, on the platform in front of the shrine of Tlaloc is a small altar whose insignia sculptures are two gracious toads. Besides being associated with water, toads were also related to the earth and the underworld, probably because they live underground.

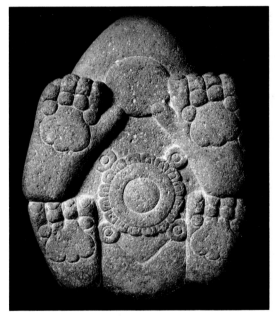

cat. 400, view of underside

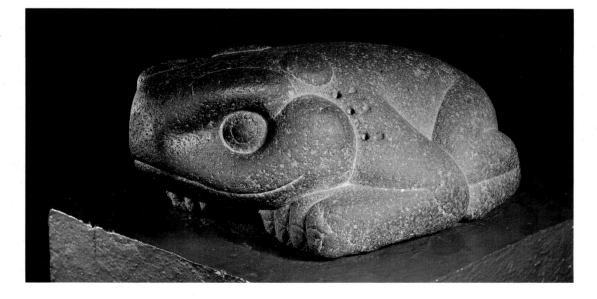

The figure of this toad was sculpted with great realism. It is in a crouching position. The head is pointed almost like a beak, giving it a birdlike profile. On the upper part, two semispherical protuberances identify the animal as one of the species *Bufo marinus*, which is characterized by the bags of poison on its head. According to the Spanish chroniclers of the sixteenth century, this substance was carefully extracted by the Aztecs and used to prepare a hallucinogenic drink.

On the sides of the head are three circular holes in sequence, probably used for placing ornaments of real feathers or textile on the sculpture. On the belly of the animal is the symbol of the center of the universe, consisting of a large circle with a feather border. There are also four small circles on the edge of this circle placed in a crosslike design. These are symbolic representations of *chalchihuitl*, the precious jade. Another Aztec sculpture of a toad in the Museum für Völkerkunde, Berlin, has an almost identical carving on its underside (Nicholson 1983, 115–116).

Many images of Tlaltecuhtli, the lord of the earth, have the same symbol on the belly. The Aztecs imagined Tlaltecuhtli in the crouched position of a large batrachian under the earth who held the universe on his shoulders. Therefore this sacred toad is like the center of the earth that supports us on his shoulders.　F.S.

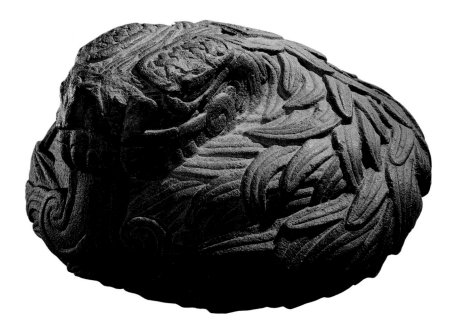

401 🐌

QUETZALCOATL

Aztec
gray stone
25, diameter 40 (9⅞, 15¾)

CNCA—INAH—MEX, Museo Nacional de Antropología, Mexico City

The pre-Hispanic peoples venerated a deity representing the fertility of the earth and positive changes in nature. This deity was given the form of a serpent, usually a poisonous one such as the rattlesnake, which was shown covered with feathers. The oldest known image of this type is on a ceramic vessel from Tlatilco, dated 900 B.C.

The Aztecs called this god Quetzalcoatl, "the feathered serpent," one of the deities of creation who, together with Tezcatlipoca, had participated in the successive generation of the world ages or "suns" (see further explanation in Coe essay in this catalogue). The feathered serpent was responsible for the second sun, the age of the wind, which brought light into the world.

The Aztecs often represented Quetzalcoatl. In general he is shown as a serpent whose body is rolled in a spiral, forming a sort of truncated cone; the animal is covered with feathers and generally has a large head. In some cases the calendar date 1 Reed, the date when Quetzalcoatl was born, is added in a small square.

This magnificent sculpture is one of the best-preserved and best-known specimens. The reptile is completely covered by the feathers, which extend in different directions as if the wind were moving them. The snake's head is striking: large brows appear over eyes that appear to be made of strips of interwoven textile. The nose is partially covered by a sort of triangular upper lip. There are more than the normal number of two fangs: a full row runs from one corner of the mouth to the other, exaggerating the serpent's ferocity. An enormous forked tongue, in the form of a broad band with a double tip that is curled up, falls heavily covering part of the body.

Unfortunately, a relief found at the base of the sculpture was erased intentionally when working the stone. Nonetheless some details of the representation remain, suggesting that the base was a figure of the god of earth, Tlaltecuhtli, whose characteristic position was crouching. On the back of the head it bears the date 1 Reed.

The significance of this sculpture of Quetzalcoatl on a base representing Tlaltecuhtli is that, for the Aztecs, Quetzalcoatl, based on the earth, in turn held up the universe.　F.S.

402 🐌

RECLINING JAGUAR

Aztec
volcanic stone
12.5 x 14.5 x 28 (4⅞ x 5⅝ x 11)

The Brooklyn Museum

The jaguar, the world's largest spotted cat, was absent from the mountainous region of central Mexico, the heart of the Aztec empire, except in the royal zoo. But this fearsome creature of the lowland forests played a vital role in Aztec thought: along with the harpy eagle, it was the symbol of war. In the Aztec creation myth the first world age was the era of jaguars; the great god Tezcatlipoca, who dominated the age, took the form of a jaguar; and, finally, the jaguar warriors were one of the two most powerful military orders in the Aztec army.

This small sculpture is a sympathetic rendering of the creature. The front paws are outstretched and the tail curves across the hind legs in a posi-

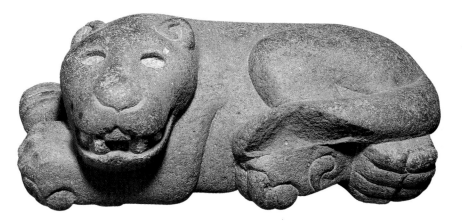

tion of repose. As is this case with many Meso-
american sculptures beginning with the ancient
Olmec civilization, the underside of this piece
is fully carved: the pads of the paws, although
invisible to the beholder, are depicted in detail.

As with almost all Aztec carved representations
of naturalistic animals and plants, it is not known
why they were carved or for whom. They could
have been placed in temples, in palaces, or even in
the homes of well-off people. It is quite possible
that this jaguar graced a military academy where
jaguar warriors were trained. M.D.C.

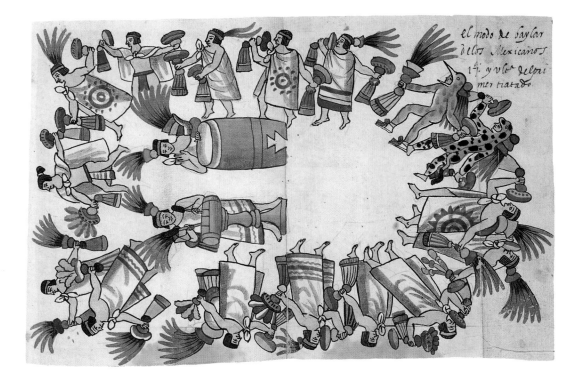

403

PUMPKIN

Aztec
porphyry with traces of feldspar
19.7 x 24.5 (7¾ x 9⅝)

private collection

The Aztec interest in the naturalistic rendering of
plant and animal forms is well represented in this
vividly realistic sculpture of a pumpkin (*Cucurbita
pepo*), a food plant first cultivated in Mexico
several millennia before the Christian era. Vari-
ous species of squashes, including the pumpkin,
were grown in Aztec gardens; both their flesh and
the dried seeds were a part of Aztec cuisine.

It is not known what function this sculpture
may have played. Nicholson (1983, 113) suggested
that it might have been on permanent display in a
temple dedicated to a fertility deity (perhaps Chi-
comecoatl, the maize goddess). But we know little
about Aztec connoisseurship, and it is also con-
ceivable that the work formed part of a private
collection in a noble Aztec home or palace.

M.D.C.

404

THE MEXICANS' MANNER OF DANCING

from the Codex Tovar
1583–1587
colonial Mexican
manuscript on paper
21.2 x 15.6 (8 ⅜ x 6⅛)

The John Carter Brown Library at Brown University,
Providence

According to Ignacio Bernal (in Durán 1964, xxi-
xxxii), the late sixteenth century was "a golden
age of chronicles written on ancient Mexico." Still
alive in Mexico were native survivors of the con-
quest, and many native communities still carried
on their own way of life. In the wake of the early
pioneer missionary-ethnologists, including
Olmos, Motolinia, and Sahagún, there followed a
new generation of historians, some of them born
in Mexico. This band of scholars included Her-
nando Alvarado de Tezozomoc; the Dominican
Diego Durán; and two Jesuits, José de Acosta
and Juan de Tovar. With the exception of Acosta,
whose knowledge of ancient Mexico seems
entirely based on that of Tovar, most of them
drew their information from living informants as
well as from old, indigenous chronicles that have
been lost. They also drew freely on each other,
providing many problems of attribution for
modern scholars.

Juan de Tovar was born in Mexico (New Spain)
around 1543–1546, either in Mexico City or
Texcoco, and was by his own account a relative
of Durán (Kubler and Gibson 1951, 11:12–13).

Ordained as a priest in 1570, he entered the Jesuit
order three years later and eventually gained
fame as a missionary preacher. He was fluent in
Nahuatl, Otomí, and Mazagua. Apparently basing
his studies on original sources, Tovar prepared
a history of pre-conquest Mexico that has since
disappeared. It is his second history that appears
in the Providence manuscript, along with other
material. His long life ended in 1626.

The *Codex Tovar* appeared in England in 1816
and came into the possession of Richard Heber.
On Heber's death in 1836 it entered the collection
of Sir Thomas Phillipps, remaining in the Phil-
lipps library until 1946 when it was acquired by
the John Carter Brown Library. The volume, with
a modern leather binding, consists of three parts,
the first being an exchange of letters between
Acosta and Tovar that is important because it
describes the first lost history. The second part of
the manuscript is a version of the historical text
entitled "Relación del origen de los Yndios,"
covering Aztec history and the great ceremonies
linked to the solar calendar. This is largely but not
entirely drawn from the historical part of Durán's
work; the Tovar version was copied in its entirety
as chapter 7 of José de Acosta's "Natural and
Moral History of the Indies," while the so-called
Codex Ramírez, preserved in Mexico City, is
another copy of Tovar. This section of the Tovar
is illustrated by watercolors very similar to those
accompanying Durán's work, but in a style that
is less European than that of Durán's artist (see
Lafaye 1972). The third section is the Tovar calen-
dar, a description of the rites and feasts of the

solar calendar including a correlation with the Christian calendar, illustrated by a hand different from the one in the second part. The entire manuscript is holograph, in the hand of Tovar.

Figure 17, one of thirty-two accompanying the second part, is spread across two facing pages and is captioned "The Mexicans' manner of dancing." It shows a large, counterclockwise dance of men, with the music provided by a horizontal drum (*teponaztli*) and a vertical drum (*huehuetl*) (cats. 378, 379). All the participants appear to be of very high rank, including the musicians who wear the headdress-insignia of the emperor on their shoulders. Each of the dancers is attired in a cloak knotted at the shoulder and carries a bouquet in one hand and a device topped with feathers in the other. These are very similar to the objects carried by Nezahualpilli in the *Codex Ixtlilxochitl* (see cat. 373).

Lafaye has suggested that this is the dance that took place in the month Toxcatl (1972, 273). However, the presence among the dancers of a jaguar knight and an eagle knight raises the possibility that this might be part of the rites for Tlacaxipehualiztli, held in honor of the god Xipe Totec; during these festivities these warriors not only engaged in gladiatorial sacrifices, but also participated in such dances. M.D.C.

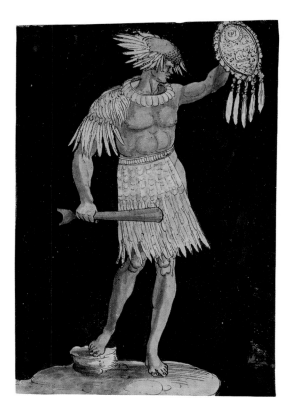
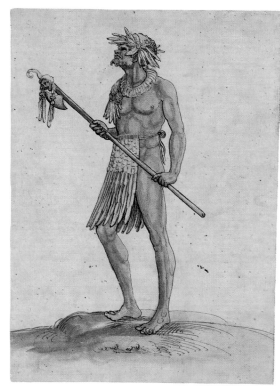

405

Hans Burgkmair
Augsburg, 1473–1531

Two Costume Studies

c. 1519–1525
pen and ink with washes on paper

405A: Black Youth Holding a Club and a Shield
23.5 x 16 (9¼ x 6¼)

405B: Black Youth Holding an Ax
24 x 16.1 (9⅜ x 6¼)
references: Halm 1962, 125–126, 161, figs. 62, 63; Honour in Cleveland 1975, 14, fig. 9b; Feest 1984, 11; Rowlands 1988, 187–188, nos. 158(a) and 158(b), pl. XXIII; Colin 1988, 336–337, nos. M.6, fig. 14, and M.7, fig. 15

The Trustees of the British Museum, London

Hans Burgkmair, like Dürer, never saw a native American. In these two drawings Burgkmair posed models with exotic artifacts. His "Indians" are blacks and one is even bearded, whereas American natives did not tolerate hair on their bodies.

The warrior of the first drawing is shown in contrapposto, a typical classical pose in which the weight of the body rests on one foot. The feather headdress and necklace are probably Brazilian, specifically Tupinamba. So is the strange ornament over the right shoulder, which seems to be a Tupinamba headdress made of a cotton bonnet with feathers hanging down at the back (Métraux 1928, 130–136; Colin 1988, 336). The feather skirt, which is open on one side, is an item of clothing that does not seem to have existed in America. Tupinambas, in fact, wore little except for long feather cloaks at festivals (see cat. 408). In this case, Burgkmair, probably relying to some extent on the depictions of Indians found in broadsheets and book illustrations, used either a Tupinamba feather cloak or an Aztec feather headdress to cover the nudity of his "Indian." The war club is probably Mexican, although no extant weapon provides an exact parallel. The mosaic shield, with a leather border from which feathers hang, is more clearly of Aztec origin. It can be identified with the famous wooden shield now in the Museum für Völkerkunde, Vienna (Feest 1984, 11), which may be one of the shields given by Motecuhzoma to Hernán Cortés and sent by him to Charles V (Saville 1922, 71–75, pls. XXI–XXII; Nowotny 1960, 38–41, pls. 4–7). In the sixteenth-century Vienna inventory these are described as having "pieces of colored featherwork hanging round the outside of them" (Cortés 1986, 43; see also Saville 1922, 10). The Vienna shield was recorded in the *Kunstkammer* in Schloss Ambras in 1596. As late as 1730 it still had a leather border to which the feathers must have been attached. Although the shield has lost many of its tesserae, the iconography can still be reconstructed: in the upper half are the sun and five zones of heaven, while below are the moon and various figures.

For the second drawing Burgkmair dressed a black bearded man with the same Indian artifacts. This time, however, the weapon the man holds is a battle ax with a hook at its end. Although no specimen with a carved head is known today, the "blade" is clearly an anchor-ax, a well-known South American type (see Rydén 1937 for Brazilian anchor axes and, for clubs in early European collections, Hochstetter 1885, 99–104, pl. V, and Feest 1985, 241–242). The head cannot be, as is sometimes claimed, a Jívaro shrunken-head (*tsanta*); such heads were distinguished by long white cotton threads hanging from the lips and often by red and yellow toucan-breast feathers hanging from the ears (Harner 1972, 187–193). In addition, shrunken heads were worn round the neck. In any case, Jívaro Indians came into contact with the European invaders only in 1549, when the Spaniard Hernán de Benavente came down from the Andes and reached the confluence of the Río Upano and the Río Paute. J.M.M.

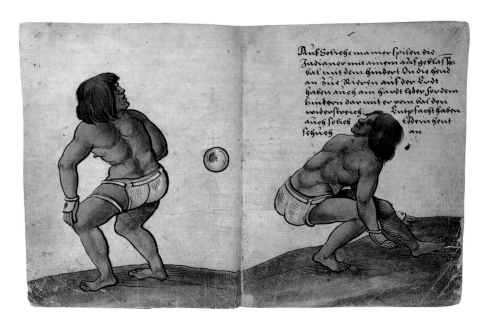

406 ❧

Christoph Weiditz
Strasbourg, c. 1500?–1559

Aztecs Playing Tlachtli

1529
from the Trachtenbuch
manuscript
each fol. 19.8 x 15 (7¾ x 5⅞)
references: Hampe 1927, esp. 79, pls. XIII-XIV; Cline
1969, 75–76, ill. p. 74; Honour in Cleveland 1975,
59–61, fig. 48; Colin 1988, 340–344 (esp. 343–344)

Germanisches Nationalmuseum, Nuremberg,
Hs 22.494

Christoph Weiditz is best known as a medallist, in which medium he portrayed both Charles V and Hernán Cortés. He is known as well for the *Trachtenbuch*, his famous costume book. This manuscript includes eleven representations of Aztecs, two of them on double pages. Weiditz was, in fact, the first European to portray native Americans; he sketched these Aztecs in Barcelona in 1529, more precisely before March 22, the date the Mexicans left for Seville. The Aztecs he saw had been brought back by Cortés in 1528, when he returned to Spain to justify himself before the emperor. Weiditz carefully recorded their appearance, showing some of them juggling and playing games like *tlachtli* and *patolli*. The ball game was explained in an inscription by Weiditz: "In this way the Indians play with the inflated ball, with their buttocks without raising their hands from the ground; they also have a hard leather over their buttocks to receive the impact of the ball; they are also wearing similar leather gloves." Because he was unfamiliar with rubber, Weiditz assumed from the ball's elasticity that it was inflated; in fact, it would have been made of solid rubber. The game of *tlachtli*, which the drawing

illustrates, is known from accounts first published by Francisco López de Gómara in 1552 and by Juan de Torquemada in 1615. Torquemada indicated that this game was played by teams of two or three players who hit the ball with their buttocks, the aim being to bounce it through a stone ring on a wall. In his *History of the Conquest of Mexico* (1552) López de Gómara gave an exhaustive description, specifying the particular type of ball used (*ullamalixtli*) and explaining that "the game is not played for points, but only for the final victory, which goes to the side that knocks the ball against the opponents' wall or over it." "Stones resembling millstones are set into the side walls, with holes cut through them, hardly big enough to allow passage for the ball. The player who shoots the ball through them (which rarely happens, because it would be a difficult thing to do even if one threw the ball by hand) wins the game and, by ancient law and custom of the players, also wins the capes of all the spectators" (López de Gómara 1964, 145–146; for the ball game, see also Durán 1971, 312–319, pl. 34). J.M.M.

407 ❧

Map of Tenochtitlan and the Gulf of Mexico

from H. Cortés, Praeclara de Nova maris Oceani
Hispania Narratio...*(Nuremberg, 1524)*
hand colored woodcut
31 x 46.5 (12⅛ x 18¼)
references: Toussaint 1938, 93–105, fig. 13; Palm
1951, 59–66, fig. 9; Marquina 1960, 25–26, fig. 1;
Nuremberg 1971, 360 no. 653, ill. p. 358; Budde
1982, 173–182, fig. 262; Nebenzahl 1990, 74–76

Newberry Library, Chicago

This map of Tenochtitlan was included in a book on the conquest of Mexico published by Friedrich Peypus in Nuremberg in March 1524. The text consists of a Latin translation, by Pietro Savorgnani, of Hernán Cortés' second and third letters from Mexico together with the *De rebus, et Insulis noviter repertis* by Peter Martyr d'Anghiera; the large woodcut of Tenochtitlan, the Aztec city, is based on a drawing supposedly made at Cortés' behest. The conquistador was deeply impressed by the Aztec capital, built on a lake and approached by four artificial causeways. The main streets were wide and straight and the town had many squares "where trading is done, and markets are held continuously . . . ; each kind of merchandise is sold in its own street without any mixture whatsoever," something about which the Aztecs were evidently very particular. Cortés described the variety of produce at great length. At the center of the city was the Great Temple, which he described as being "so large that within the precincts, which are surrounded by a very high wall, a town of some five hundred inhabitants could easily be built." The anonymous woodcut recording the city shows the central square (*Temixtitan* or *Tenochtitlan*) surrounded by the enclosure known as the *coatepantli* (snake wall), with the temples in which human sacrifices were held (*Templum ubi sacrificant*), and even the *tzompantli* or skull-rack altar where the heads of the sacrificed (*capita sacrificatorum*) were placed. The architecture is largely fanciful and accommodated to familiar European conventions, but the large pyramid and two towers probably represent the two shrines atop the Great Temple dedicated to Huitzilopochtli and Tlaloc on their giant pyramidal base. The headless idol (*idol lapideum*) is more symbolic than real and alludes to Cortés' destruction of the Aztec deities (for the Great Temple, see Matos Moctezuma 1988). The Aztec ruler had various residences in and around Tenochtitlan. In some of his houses he kept birds and animals (*domus animalium*) in cages made of strong, well-joined timber: "in most of them were large numbers of lions, tigers, wolves, foxes, and cats of various kinds" (Cortés 1986, 102–111).

Built as an island and with an inner ceremonial enclosure, Tenochtitlan was well defended. It has indeed been proposed (Palm 1951) that the 1524 woodcut was used by Albrecht Dürer for his scheme for an ideal city published in his treatise on fortifications (*Etliche underricht, zu Befestigung der stett, Schloss, und flecken* [Nuremberg, 1527], fol. E.1r). This town plan is perhaps the most original part of Dürer's treatise. The town itself is built in the form of a square; it is also fortified and clearly organized quarter by quarter. The connections with Tenochtitlan, however, are rather general, and no direct dependence can be proved. In any case Dürer could have arrived at his scheme simply by adapting the regular symmetrical layout of the Greek military camp, as described by Polybius, to a centralized city plan.

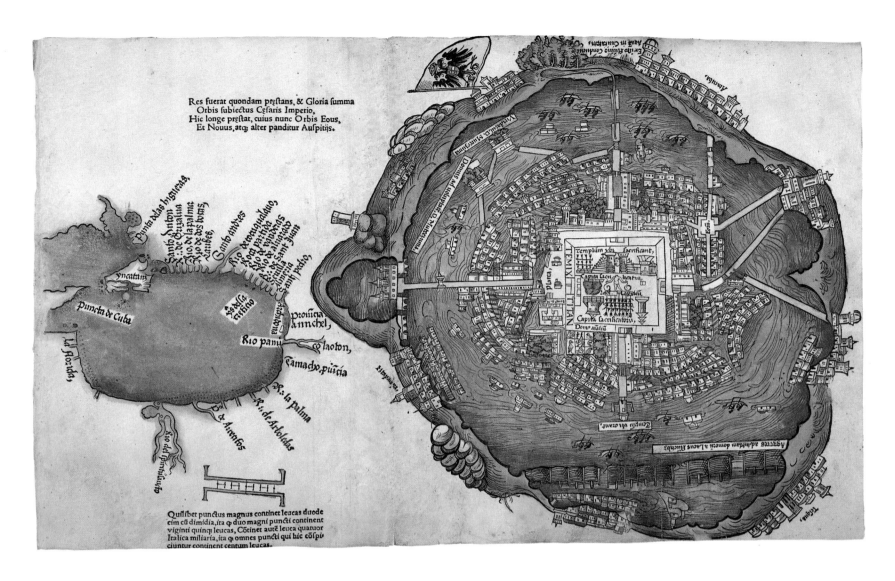

Res fuerat quondam præstans, & Gloria summa
Orbis subiectus Cæsaris Imperio.
Hic longe præstat, cuius nunc Orbis Eous,
Et Nouus, atq; alter panditur Auspitijs.

Quislibet punctus magnus continet leucas duode
cim cū dimidia, ita q̄ duo magni puncti continent
viginti quinq̄ leucas, Cōtinet autē leuca quatuor
Italica miliaria, ita q̄ omnes puncti qui hic cōspi
ciuntur continent centum leucas.

The 1524 woodcut influenced later illustrations
of the Aztec city, including that by Benedetto
Bordone in his *Libro, Nel qual si ragiana de tutte
l'Isole del mondo* (Venice, 1528) and that in Gio-
vanni Battista Ramusio's *Della Navigationi et
viaggi* of 1565. Best known, probably, is Franz
Hogenberg's map of Mexico in the famous *Civi-
tates Orbis Terrarum* of 1572.

The map of the Gulf of Mexico next to the plan
of Tenochtitlan in Cortés' work uses the place
name La Florida, which the Spanish gave to what
is now the southeastern United States, and shows,
for the first time ever on a map, the Mississippi
River (here called Rio del Spiritusancto).

J. M. M.

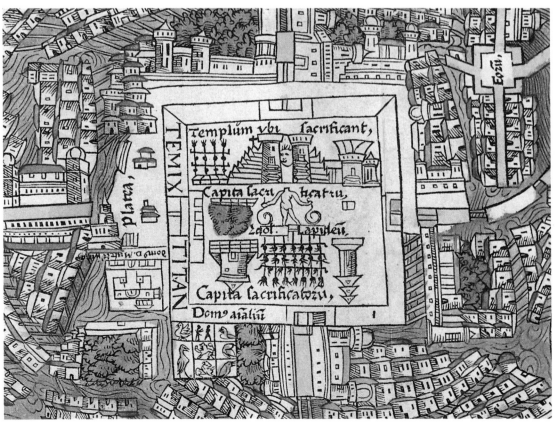

THE TUPINAMBA

The ancestors of the Tupinamba migrated to the coast of what is now Brazil from the interior. By the sixteenth century they occupied a long strip of coastline along the Atlantic. They were a warlike people, and the cannibalism that accompanied their victories was described in sensational detail in the accounts of early European explorers.

The Tupinamba are best known for their beautiful ceremonial capes made of tropical birds' feathers, a number of which have survived in Kunstkammer collections. Their arti-facts must have made a great impression when they arrived in Europe in the years following the first Portuguese landing in Brazil in 1500. The earliest European depictions of native Americans often show figures dressed in feather garments and holding war clubs that were clearly inspired by Tupinamba prototypes.

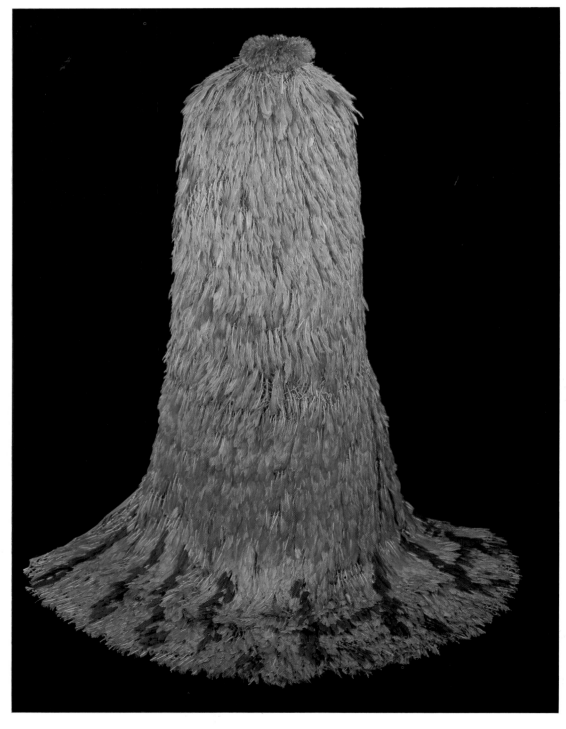

408 🦢

FEATHER CLOAK

16th or 17th century
Tupinamba
cotton or plant fiber, feathers, bird skin
200 x 180 (78¾ x 70⅞)
references: Hirtzel 1930, 649–651; Métraux 1932, 7; Calberg 1939, 103–133; Feest 1985, 243; Hildesheim 1987, cat. 357

Musées royaux d'Art et d'Histoire, Brussels

On special occasions the usually naked Tupinamba Indians in what is now Brazil adorned themselves with feathers, which they glued directly onto their bodies or wore as an ornament. An Indian cape was recorded in the *Kunstkammer* of the king of Denmark in an inventory of 1689, as was a long Indian cloak of red feathers. These two items are now in the Nationalmuseet in Copenhagen (see Dam-Mikkelsen and Lundbaek 1980, 27–28, nos. EHC52 and EH5931, ills). Several other Tupinamba cloaks are known: two in Florence and one each in Basel, Berlin (destroyed during the Second World War), Paris, and Brussels (Feest 1985, 242–243). The oldest reference to the feather cloak in Brussels is in an inventory (1781) of the collections in the royal arsenal made by Georges Gérard, a member of the Académie des Sciences et Belles-Lettres of Brussels. There under no. 70 is recorded "Une espèce d'habillement ou manteau composé de plumes rouges qu'on dit avoir appartenu à Montesuma (Empereur du Mexique)." However, this cloak is not Aztec but Tupinamba. Similar items of costume are well known from sixteenth- and seventeenth-century descriptions, the best illustrations being found in Hans Staden's *Warhaftige Historia . . . der wilden, nacketen, grimmigen, Menschfresser Leuthen* of 1557 and in Theodor de Bry's engravings. The cloaks were put on for ceremonies, including human sacrifices; according to Claude d'Abbeville (1614), the native Americans wore them not only as adornments, but also as encitements to bravery ("non pour cacher seulement leur nudité mais pour se parer et estre plus braves"), which implies a magical function (Due 1979–1980, 257–261). The mantle in Brussels is extremely wide as well as long, which means that it must have swept the ground. The backing of the cloak is a net made of cotton or vegetable fibers into which the feathers were very carefully fastened. The red feathers are those of the guara or red ibis (*Tantalus ruber L.* or *Ibis rubra*), the blue and the yellow feathers are those of the Ara (*Ara ararauna*), while the remainder come from Amazonian parrots. Both technical details (discussed by Calberg 1939) and the choice of feathers confirm a Brazilian and more specifically Tupinamba origin. J.M.M.

THE TAÍNOS

When Columbus made his first landfall in the Bahamian archipelago on 12 October 1492, he was greeted by a group of people from the culture we now call Taíno. Their ancestors had migrated to the Antilles from the South American mainland. If Columbus was puzzled by how little the relatively simple way of life of these people, whom he called "Indians," corresponded to Marco Polo's account of the splendors of Cathay, he did not betray his surprise in the journal of his first voyage. Instead, prompted by the small gold ornaments he saw some of the Taínos wearing, he set about searching for the abundance of gold that Marco Polo attributed to the Indies. He also noted the possibility that the docile islanders could be easily converted to Christianity and turned into laborers.

Early exploitation of the Taínos, as well as their assimilation into the Spanish population of the West Indies, led to the disappearance of their culture by the mid-sixteenth century. Much of our knowledge of their religion and customs comes from the report prepared for Columbus around 1498 by Fray Ramón Pané.

We know they worshipped deities known as zemis, whose characteristic features are preserved in carved stone and wooden statuettes. The paraphernalia of their religious ceremonies have also survived, as have carved stone belts associated with their version of the ball game popular in pre-Columbian Mesoamerica. Taíno works of art were among the earliest American artifacts to have entered European Kunstkammer collections.

409 ॐ

WEEPING MALE FIGURE

Taíno
wood
100 (39⅜)

The Trustees of the British Museum, London

This artifact was found in a cave in Jamaica, where it may have been put to hide it from the Spaniards. The Taínos normally kept such statuettes in their houses and worshiped them as deities

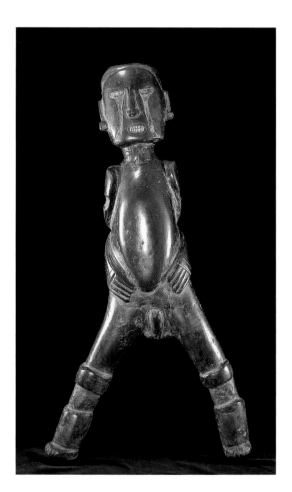

(zemis). They placed narcotic powder (*cohoba*) on the upper platform and inhaled it through tubes such as cat. 419. The resulting hallucinations were thought to be messages from the deity.

The Taínos believed that a pair of zemis were responsible for sunshine and rainfall respectively. They sometimes depicted them as twins joined together in a single piece of stone sculpture. In other cases, as in this piece, they carved them separately. This example portrays Boinayel the rain giver (Arrom 1989, 37–45). His most important feature is the grooves running down from his eyes, which symbolize the course of the magical tears that created rainfall. An incised piece of shell has been placed in his mouth to represent his teeth. Few such inlays are still in place.

I.R. and J.J.A.

410 ॐ

CROUCHING MALE FIGURE

Taíno
guayacán wood
61 (24)

Visual Equities, Inc., Atlanta

This piece is from the part of Hispaniola now in the Dominican Republic. Its threatening expression gives reason to believe that it portrays Baibrama, a zemi who embodied the Taínos' knowledge about the planting, growth, processing, and consumption of cassava, their principal crop. In that process they grated the tuberous root of the plant, extracted its poisonous juice, and converted its flesh into flour from which they baked bread. Baibrama's expression may have been intended to admonish people against drinking cassava juice before it had been boiled to evaporate its poison. Both the Taínos and the

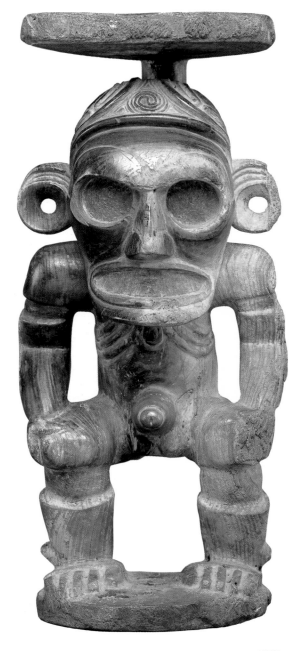

Spaniards prized cassava bread because it kept well in the hot and humid tropical climate of the West Indies (Arrom 1989, 67–73, pl. 46; Rouse, forthcoming). 　I.R. and J.J.A.

411 &

CHIEF'S STOOL (Duho)

Taíno
wood
78 x 40 (30⅝ x 15¾)

Musée de l'Homme, Palais de Chaillot, Paris

Chiefs, priests, and other important personages sat and reclined on stools crafted from single pieces of wood or, less commonly, stone. The Taínos called these objects *duhos*. Columbus likened them to the thrones he knew in Europe. The Italian humanist Peter Martyr d'Anghiera, as well as the Spanish chroniclers Oviedo and Las Casas, admired their beautiful designs and highly polished surfaces. Most examples are in the shape of hammocks, which the Taínos used in place of beds. Geometric figures are engraved on the backs of the more elaborate specimens, and heads of zemis are sculptured on their fronts, as in this example from Haiti (Arrom 1989, 107–108).
　I.R. and J.J.A.

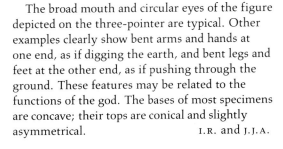

412 &

CARVED THREE-POINTER

Taíno
stone
17.5 (6⅞)

Museo del Hombre Dominicano, Santo Domingo

Three-pointers vary greatly in material, size, and decoration. The smaller and plainer specimens are said to have been buried in the fields in order to improve the growth of crops. Because larger stone pieces like this one from the Dominican Republic are so beautifully carved and exquisitely finished, they are thought to have been kept in their owners' houses and worshiped as zemis. Arrom (1989, 17–31) has shown that these objects represent the Taínos' supreme deity Yúcahu Bagua Maórocoti, god of agriculture, fishing, and seafaring.

The broad mouth and circular eyes of the figure depicted on the three-pointer are typical. Other examples clearly show bent arms and hands at one end, as if digging the earth, and bent legs and feet at the other end, as if pushing through the ground. These features may be related to the functions of the god. The bases of most specimens are concave; their tops are conical and slightly asymmetrical. 　I.R. and J.J.A.

413 &

HUMAN EFFIGY FIGURE

Taíno
ceramic
40.5 (15⅞)

National Museum of the American Indian, Smithsonian Institution

This piece, found in a cave in the Dominican Republic in 1916, has been repeatedly described as a "humpbacked clay idol." It is in reality a beautiful, brooding human figure with a mythical turtle on its back, which can be connected with the creation story related by Fray Ramón Pané in his account of Taíno mythology (Arrom 1988). According to Father Pané, a male quadruplet named Deminán asked his grandfather to teach

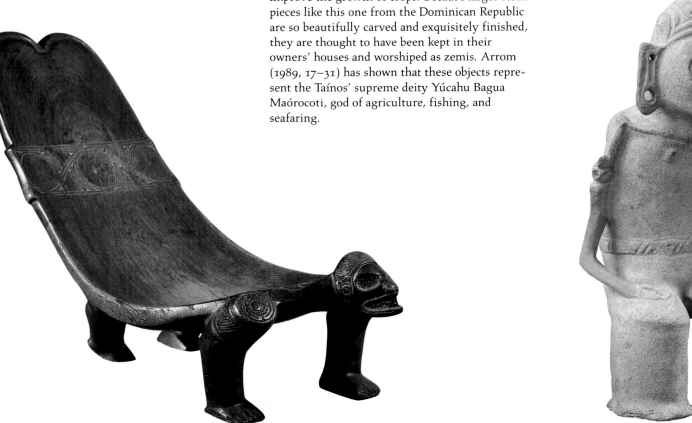

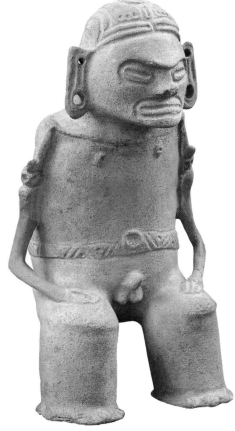

him the use of fire. The grandfather was so incensed by this petition that he spit freshly made cohoba, the narcotic powder used by the Taínos in the worship of zemis, on Deminán's back, causing a painful inflammation. His brothers cut the inflammation open and out came a living turtle. The four brothers built a house, cohabited with the turtle, and thus created the Taíno people (Arrom 1989, 84–89).

Having seen his grandfather's use of fire, Deminán could pass this knowledge on to his descendants. With it, the Taínos were able to clear the forests for agriculture, bake the bread they made from the cassava plant, and smoke tobacco. In this statuette, Deminán is portrayed with extended ear lobes and wearing a belt, both of which are typical Taíno features. I.R. and J.J.A.

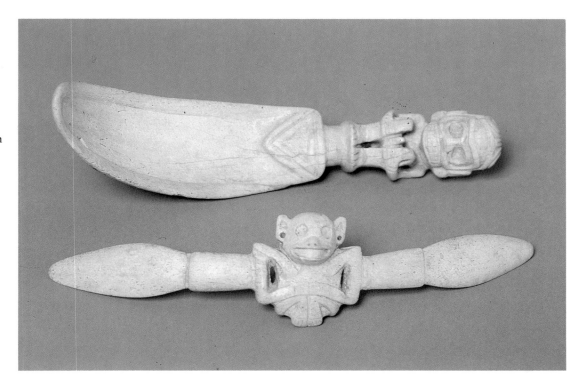

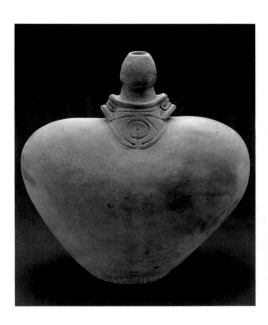

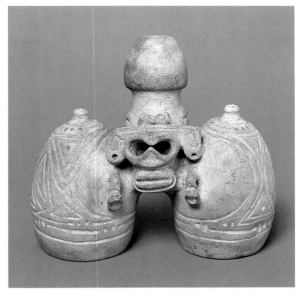

416–417 ଛ

Vomiting Spatulas

Taíno
bone
416: 23.6 (9¼)
417: 23 (9)

Collection of Fundación García Arévalo, Inc.

Before worshiping their idols, the Taínos purified themselves by tickling their throats with spatulas of wood or bone in order to induce vomiting. Some of the spatulas made during the Chican time (around A.D. 1200–1500, in the Taíno heartland) were elaborately carved; Dominican archaeologists have found examples of such pieces in the burials of elite persons (Rouse, forthcoming). The first of these examples is decorated with an anthropomorphic figure of a zemi and the second with a zoomorphic carving of a bat.
 I.R. and J.J.A.

414–415 ଛ

Ceramic Bottles

Taíno
414: 49.5 x 43.2 (19½ x 17)

Brian and Florence Mahony

415: 18 x 20.4 (7 x 8)

Collection of Fundación García Arévalo, Inc.

Inhabitants of the tropical forests found it convenient to store their beverages in gourds and to drink from them. The ancestors of the Taínos began to supplement gourds with clay bottles during the first centuries B.C., shortly after their arrival in the West Indies. This practice ended around A.D. 600, but was revived by the so-called Chican potters of Hispaniola A.D. 1200. The use of pottery bottles spread through most of the Taíno heartland during the following three centuries. The two examples shown here are in the Boca Chica style, which developed on the south coast of the Dominican Republic (Rouse, forthcoming, fig. 12, *a*). The more elaborate bottles were undoubtedly used in ceremonies. I.R. and J.J.A.

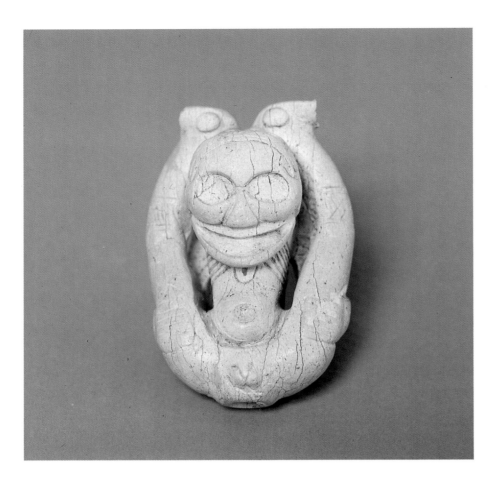

418 ◪

SNUFF INHALER

Taíno
bone
8.6 (3⅜)

Collection of Fundación García Arévalo, Inc.,

Taíno worshipers used tubes made of wood or bone to inhale cohoba powder, often sniffing it from platforms on the tops of figures of zemis (cats. 409–410). The conquistadors observed plain forked tubes being used for the purpose. This unique example has been exquisitely sculpted from a single piece of bone to represent a human figure. The walls of the tubes form its legs and are very thin, as can be seen in a fracture on its left side. The legs frame the features of the face, giving the appearance of a delicate cameo. The figure portrays Maquetaurie Guayaba, the Taíno lord of the underworld, who has also been identified in a number of other ritual objects (Arrom 1989, 112–113). I.R. and J.J.A.

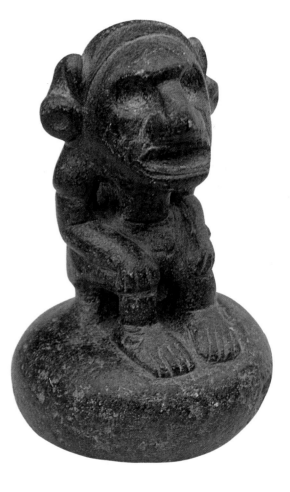

419 ◪

ANTHROPOMORPHIC PESTLE

Taíno
stone
24 (9⅜)

Museo del Hombre Dominicano, Santo Domingo

A figure of a zemi is carved on this conical stone pestle from the Dominican Republic. As early as the first millennium B.C., the Taínos' predecessors used plain conical pestles to grind wild vegetable foods. The practice of decorating them began in the Taíno heartland during the Chican period, between A.D. 1200 and 1500. I.R. and J.J.A.

with twenty-four incised teeth is solidly attached. The eye orbits and the large ears of the idol show traces of resin or vegetable glue; small discs of shell, mother-of-pearl, tortoise, or even gold plates may have been attached at one time.

The bent knees of the figure are common among Taíno zemis. The cotton bands that the Taíno used to decorate their arms and legs are here represented by two deep symmetrical cuts in the lower limbs.

Giglioli (1910) reported that this plate, like the Taíno necklace (cat. 422), reached Florence from Santo Domingo between the end of the seventeenth and beginning of the eighteenth centuries, suggesting that it would have been exhibited in the Medici collections. However, Ciruzzi (1983) did not find it listed in the inventories of objects belonging to the Medici. It is first found registered and described in the catalogues of 1820 and 1843 of the Regio Museo and the Museo Antropologico. D.Z.

420 🐌

STONE BELT

Taíno
black stone
47.3 x 30.2 (18⅝ x 11⅞)
references: Fewkes 1907; Ekholm 1961; Alegría 1982

Museum of History, Anthropology and Art of the University of Puerto Rico, Río Piedras

Decorated stone rings, often called "collars" in the literature, are the most characteristic archaeological objects from Puerto Rico. For many years their function among the Taínos was an enigma. Today it is known that, like the stone "yokes" from Mexico, they were used as belts and were part of the paraphernalia of the players in the ball game. They were never described in the early chronicles and have rarely been found in situ, although fragments have been found in the vicinity of Antillean ball courts (*bateyes*). It is possible that belts like these were originally made of bent branches, for in some cases the union of the branch and its binding is carefully represented in the stone carving. Stone belts are associated with another characteristic Puerto Rican archaeological object, the so-called elbow stone. These seem to have been the most important part of a belt, the rest of it being made of a branch tied to the ends of the elbow stone.

Approximately two hundred Taíno stone belts exist in collections in museums in Puerto Rico, the Dominican Republic, the United States, and Europe. Most are from Puerto Rico, as is this one, though a few are from the Dominican Republic and Saint Croix. These stone belts can be grouped into two types: the massive type, which is generally undecorated and weighs around thirty-five pounds, and the slender, which usually is highly decorated and weighs about ten pounds.

The present example, which was found in Juana Díaz, Puerto Rico, is one of the finest examples of the slender type. It has a beautifully decorated boss and side panels incised with an all-over chevron motif. It is skillfully carved and polished. The principal motif, on the decorated panel border, represents a humanoid head with batlike appendages. The piece is part of the museum's De Hostos Collection. R.E.A.

421 🐌

OVAL PLATE WITH ANTHROPOMORPHIC HANDLE

Taíno
wood (Guayacum officinale?) and shell (Strombus gigas)
51 (20); diam. 22.2 (8¾)

Museo di Antropologia e Etnologia, Florence

This beautiful wooden plate or tray shows traces of a reddish color at its center. The concavity of its internal surface was obtained by hollowing out a single piece of wood, and the final sanding down and polishing were executed with care. The plate is shiny, smooth to the touch, and light and easy to handle. The handle consists of an anthropomorphic idol; to its mouth, which is stretched out in a curved rectangular shape, a curved shell plate

422 ❧

Necklace with Central Idol

Taíno
shell (Tridalna gigas?)
length 24 (9⅜)

Museo di Antropologia e Etnologia, Florence

The care with which this necklace was made and the appearance of the small idol at its center suggest that its use was ceremonial. Comparison of the idol's features with other Taíno amulets reveals a common morphology, the face of a bat. In Taíno mythology bats were possibly associated with the spirits of the dead (García Arévalo 1988).

This necklace is one of a small number of Taíno pieces with an early provenance. According to Giglioli (1910), this necklace is originally from Santo Domingo and reached Florence and the Medici family "at the end of the seventeenth century or the beginning of the eighteenth century...." Sara Ciruzzi (1983) has noted that it was mentioned for the first time in the Inventory of the Medici Armory in 1696 (Guardaroba Medicea. 1091:229) and then in the Armory Inventory of 1715. It appears also in the last inventory of the Medici Armory from 1746–1747 (Guardaroba Medicea. 60 appendix: 139), passing to the Inventory of the Lorraine Armory of 1868 (MSS 97:115) and the Inventory of the Pieces in the

Armory Kept on the Occasion of the 1775 Sale and Existing in the Royal Gallery (MSS 103). The necklace was subsequently described in the 1820 and 1843 catalogues of the Regio Museo di Storia Naturale and then in the catalogues of the museum that is its home today (see Zanin 1991).

D.Z.

423 ❧

Beaded Belt

c. 1525–1550
Taíno
shell, seeds, cotton, convex mirrors, glass, brass
83.4 x 6.8 (32¾ x 2⅝), height of
central figure 10.3 (4)

Museum für Völkerkunde, Vienna

The vivid account given by Bartolomé de Las Casas has made it common knowledge that the conquest of the New World began with the massive depopulation of the West Indies. Equally affected by the destructive impact of European contact were the products of the art and craftsmanship of the indigenous Taínos. Since images of zemis, a class of supernatural beings revered by the Taínos, were an integral part of many if not most utilitarian artifacts, the destruction of thousands of these "idols" became a priority for zealous Christian missionaries.

Of those artifacts sent to Europe in the first decades after 1492, only five have survived in European collections. The oval plate (cat. 421) and shell necklace (cat. 422), which the present author believes is more likely to be a headband, are thought to have been preserved in the Medici collections in Florence (Giglioli 1910), although only the latter can actually be traced to the Medici

inventories. A very similar shell headband in Ulm was first described in 1909 (Andree 1914) as part of the seventeenth-century Weickmann collection of Africana, but does not appear in any of the Weickmann catalogues and may have an entirely different history.

The beaded belt now in Vienna has equally poor documentation. It first appeared in an 1877 inventory of the Ambras Collection and is identified as a transfer from the Vienna Schatzkammer, but cannot be traced to any earlier list or inventory. Before its identification as a Taíno work in 1952 (Schweeger-Hefel 1951/1952), it had been variously thought of as Malayan or Indonesian, and later as a Kongo mirror fetish. Its obvious and close relationship to the beaded zemi that has been preserved in Rome in the Museo Pigorini since 1878 (Laurencich-Minelli 1982) suggested a common origin and quite probably some shared history in European collections. Since the beaded zemi was first mentioned in 1680 as an "idol from the Indies" (not specifically from Santo Domingo as is sometimes reported) in the collection of Fernando Cospi of Bologna, any shared history must predate 1680 and may involve an Italian past of the beaded belt.

Early accounts describe Taíno belts, some of them with attached "masks," made of "fish bones, white and in between some red in the manner of seed beads," and cotton: they were four fingers wide and so tightly woven that "an harquebus would not have been able to pierce them, or only with difficulty" (Vega 1973, 212–214; Alegría 1983, 129–131). While this description fits the beaded belt, and iconographically its zemi is closely related to other pre-Columbian images of these supernaturals, the presence of glass beads and mirrors on the belt clearly proves its postconquest origin. In addition, the shells used for the teeth of the zemi have been identified as a West African species of *Marginella*. Similarly, the face of the Roman beaded zemi has recently been shown to be of rhinoceros horn (Vega 1989).

The kind of convex mirrors used as a substitute for shells in the zemi's eyes and in the ear spools of the Pigorini zemi date both pieces to no earlier than the second quarter of the sixteenth century (Schweeger-Hefel 1952, 226). At that time, however, the destruction of Taíno religion and the zemi cult may have been nearly complete. Peter Martyr d'Anghiera (1530, I. Dec., book IX), for example, reported that "they are now all subject to the Christians, all those who had stubbornly resisted having been executed. Nor remains there yet any memory of their *zemes*, for they have all been brought to Spain, so that we may be certified of their illusions of evil spirits and idols."

Among other Taíno objects recorded in sixteenth-century European collections but since lost, another larger beaded zemi appears on a 1598 inventory of the Munich Kunstkammer and was illustrated in Pignoria (1626, 563). Resembling in shape a cotton zemi now in the Museo di Antropologia in Turin, but covered on the outside "with small white and red interlocking rings, with big eyes of blue glass" (Heikamp and Anders 1970, 210), it was obviously related to the Rome and Vienna pieces. The Munich inventory reports that it had come from Mexico and had been part of the collection of Cardinal Francisco Ximenes Cisneros, the archbishop of Toledo (Feest 1986, 190–191). Although the cardinal had died in 1517 (and a Mexican origin would be precluded also for that reason), the provenance is possible as soon as a Taíno origin is recognized. Since the eyes were made of glass other than convex mirrors, there is no reason why it should not have dated from the first quarter of the sixteenth century.　C.F.F.

THE SOUTHEASTERN UNITED STATES

Beginning around A.D. 1000 a transformation took place in the area the Spanish were later to call La Florida. Large multivillage communities came to replace the simpler forms of social organization that had formerly predominated. Towns of considerable size developed, centered around earthen platforms, sometimes of immense size, that were erected to support the houses of chiefs, ancestor shrines, and sacred fires.

The cultures in the Southeast evolved a rich vocabulary of artistic expression, employing human and animal imagery in which changing meanings can be traced over time. Birds represented the upper world, associated with the sun and heavenly sources of sustenance; the serpent stood for the opposing dangerous forces of the underworld. At the end of this period, the time of contact with Europe, the human form could represent the gods, the ancestral dead, and, possibly, the living representative of the ancestral line.

Our knowledge of these high cultures depends heavily on the results of archaeological investigation. Contact between the Europeans and the indigenous peoples of this area was sporadic until the eighteenth century. Nevertheless, diseases introduced from Europe in the sixteenth century soon decimated the native populations and drastically changed their social structure. The culture that had previously prevailed in this area is only now becoming understood and appreciated.

424–427 ဆ

WOODEN ANIMAL FIGURES

c. 1000
Glades Culture (Key Marco)

424: DEER FIGUREHEAD
20 x 18 x 17.2 (7⅞ x 7 x 6¾)

425: WOLF FIGUREHEAD
37 x 24 x 15 (14½ x 9⅜ x 5⅞)

426: PELICAN FIGUREHEAD
11.2 x 6 x 8 (4⅜ x 2⅜ x 3⅛)

The University Museum of Archaeology and Anthropology, Philadelphia

427: CAT FIGURINE
15.2 x 7 x 4.4 (6 x 2¾ x 1¾)

Department of Anthropology, Smithsonian Institution, Washington

These four wooden sculptures from Key Marco, off the west coast of Florida, are part of an extraordinary archaeological find made in submerged muck in the 1890s (Gilliland 1975). The pieces were found together in the ruins of what is believed to have been a community shrine. The figureheads were probably part of a building. Similar carved posts have been found in a collapsed mortuary structure and shrine in the Lake Okeechobee basin to the east that dates from around A.D. 200 (Sears 1982). Although the Key Marco pieces are much more recent, they retain similar constructional details and carving style. While often described as fifteenth-century, their date has been more recently estimated, on the basis of carbon 14 tests, to about A.D. 1000 and thus at the beginning of the Mississippian period (Widmer 1988, 89–93). However, the subject matter of these carvings, which focuses on locally available animals (dolphin, marine turtle, crab, pelican, wolf, alligator, and duck), is more in keeping with the imagery of the period before that date. As the Mississippian period progressed, animals of pan-regional mythic signficance (hawk,

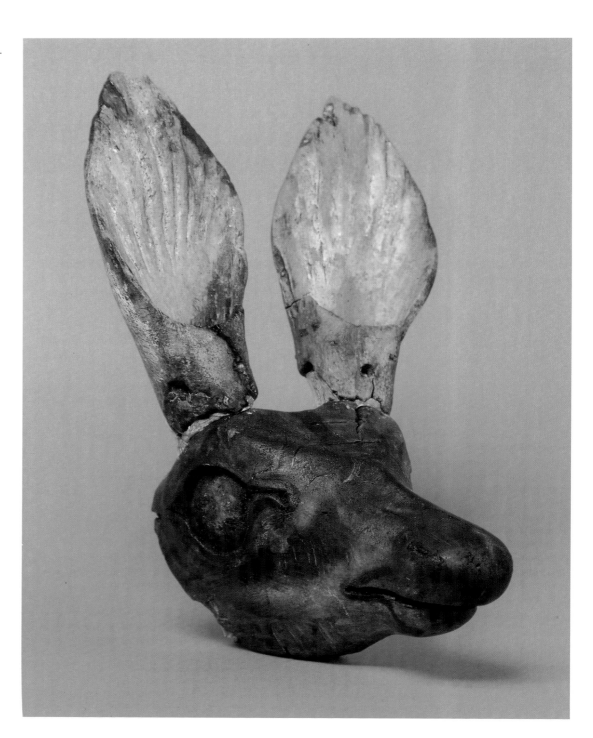

cougar, rattlesnake) became more important. The change in animals receiving artistic attention, from a broad range of animals having local prominence to a small set of regional ones, parallels the shift from less stratified to more stratified societies. Thus the Key Marco artwork belongs to a period much earlier than that of the historic Calusa, who later occupied the area.

The deer figurehead, which was made with detachable ears, was originally painted in blue, black, and white (Gilliland 1975, 85, pl. 64B). The wolf figurehead was found disassembled, with head and separate ear and shoulder attachments wrapped with green palmetto strips (Gilliland

1975, 85, pl. 64A). The piece, which has faded, was originally painted in white, black, and pink. The pelican figurehead evidently was part of a more complete bird carving, since fragments of wings were discovered alongside it (Gilliland 1975, 85, pl. 67). Its original paint colors were white, black, and a buff-gray.

The cat figurine (Gilliland 1975, 116, pls. 69, 70), perhaps a piece of shrine furniture, is stylistically similar to upright crouching cats from a site dated to A.D. 200 (Sears 1982). Those earlier cats were the carved terminals of posts that were found by archaeologists in similarly submerged sites (Sears 1982). J.A.B.

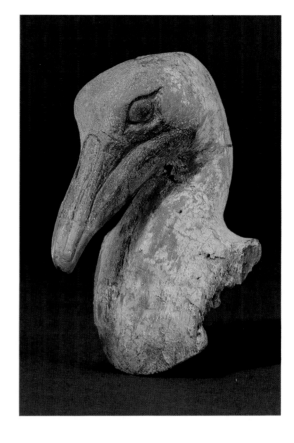

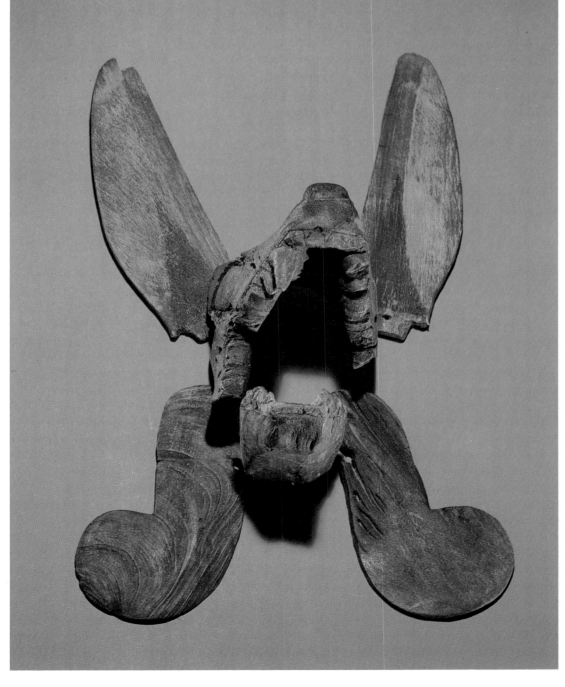

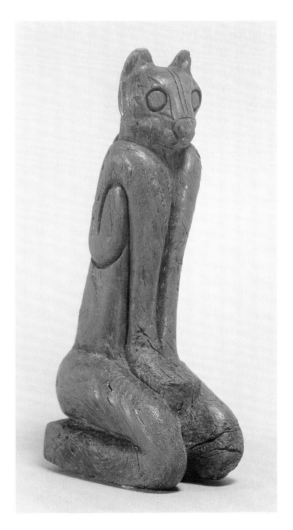

PAIR OF MALE AND FEMALE SHRINE FIGURES

1200–1350
South Appalachian Mississippian
culture (Wilbanks)
marble
each 61 (24)

Etowah Mounds State Historic Site—Georgia
Department of Natural Resources, Atlanta

These two painted marble shrine figures were discovered together in a tomb built into the side of a mound at the Etowah site in northwestern Georgia (Larson 1971). Pairs of male and female figures are a specialty of the South Appalachian Mississippian culture. These material representations of the ancestor gods were probably kept in a shrine building once located on the summit of the mound. This building appears to have burned, after which these figures were removed and lowered into a large grave. The human bones and miscellaneous objects also found in this grave probably were removed from the shrine at the same time. The male figure was broken when it was placed originally in the grave; the female figure was found upright on the floor. J.A.B.

ENGRAVED PALETTE

1080–1550
Middle Mississippian culture (Moundville)
stone
31.9 (12½)

Etowah Mounds State Historic Site—Georgia
Department of Natural Resources, Atlanta

Palettes were used to grind pigments for paint; they sometimes retain traces of color. The image on the face of this palette seems to portray the solar deity. The serpent border resembles the

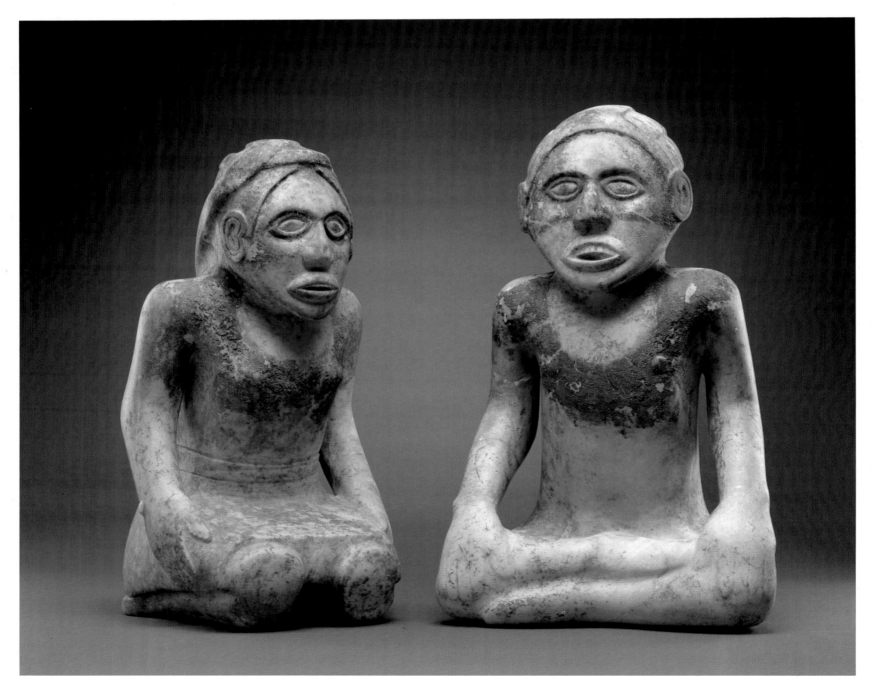

crown of snakes sometimes referred to as a head-dress of the cult-bringers, or emissaries of the solar deity. These serpents, which combine the rattlesnake with the horned cougar, have mythic roots in common with the piasa, but without the wings that are ever-present in later underworld monsters. The eye in the hand is conceivably part of the same theme. Since the eye is substituted for a rayed solar disc in many instances, it is reasonable to conclude that the eye here is an affiliated symbol with a meaning similar to the belief held by historic Choctaw that the solar deity watched them with a blazing eye (Hudson 1976, 126). The hand in this connection is presumably the medium through which gifts are conferred on humankind.　　　　　　　　　　　J.A.B.

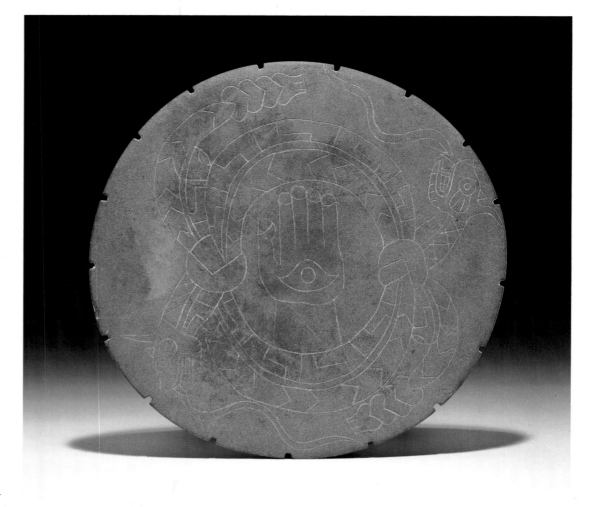

431 🐾

MONSTER EFFIGY BOWL

1440–1550
Middle Mississippian culture (Moundville III)
diorite
approx. 29 x 40 (11⅜ x 15¾)

National Museum of the American Indian,
Smithsonian Institution

This bowl was discovered, deliberately broken, among the grave goods of an elite burial from a cemetery at Moundville in central Alabama (Moore 1905, 237–240, figs. 167–170). It was interred with a piece of copper sheeting probably belonging to a headdress, marine shell beads, a cougar pipe of the late style, and a bottle in the Moundville engraved, *var. Wiggens* type. This burial can be dated between A.D. 1400–1550. Although its discoverer identified the animal as a male wood duck, certain details reveal that it is actually a representation of the monstrous bird-headed serpent. Body cross-hatching, trilobate body markings, and tear-drop eye markings are properties of the double-ended knotted snake monster found on engraved shell cups of the Braden School style, complete with a similar crest (Phillips and Brown 1978, 156, pls. 24, 69, 70). Since this monstrous form is more typical of the period before A.D. 1300, the handsome bowl may have been an heirloom at the time of its interment.　　　　　　　　　　　J.A.B.

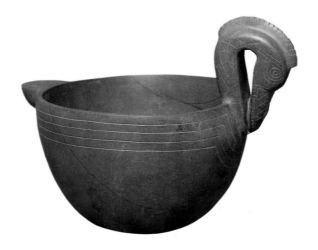

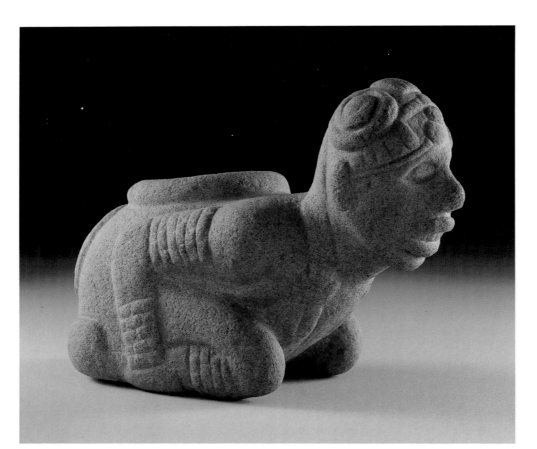

KNEELING PRISONER EFFIGY PIPE

1400–1600
Palquemine Mississippian culture
stone
12.2 x 17 x 8.5 (4¾ x 6⅝ x 3⅜)

The Brooklyn Museum

The theme of the conquered warrior-chief is represented in this human effigy pipe. The figure's dress indicates his status. He wears the warrior's beaded hair forelock, which is swept to the right side of the face. The hair is gathered into two buns on top of the head, and a long braid trails alongside the right shoulder in a manner reminiscent of the hair dressing of the figure on the Big-Boy pipe (cat. 440). Many strands of beads wrap the arms and legs, presumably marking this person as a warrior of high status, possibly a chief. This pipe is thought to have come from the Emerald site near Natchez. J.A.B.

433 ॐ

DOG EFFIGY BOTTLE

1350–1550
Middle Mississippian culture
earthenware (Nodena red and white)
19.5 x 25.6 (7⅝ x 10)

The Thomas Gilcrease Institute of American History and Art, Tulsa

This vessel was found in southeastern Arkansas, in the southern part of the area occupied by the Middle Mississippian culture (Penney in Detroit 1985, 209). J.A.B.

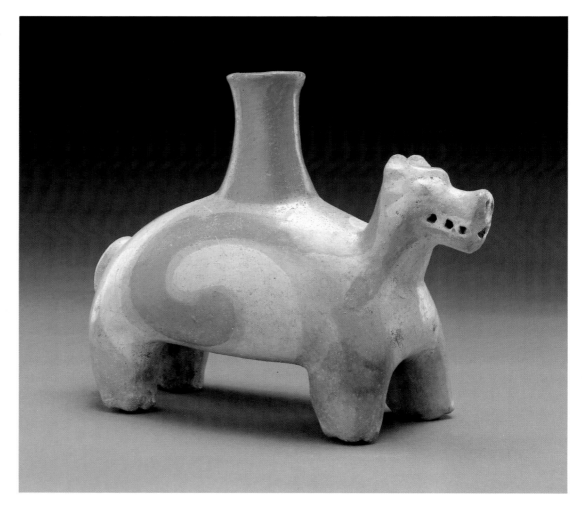

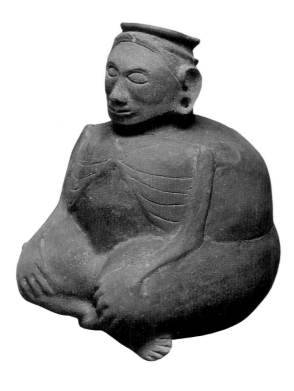

434 ᘍ

MALE HUMAN EFFIGY BOTTLE

1400–1550
Middle Mississippian culture (Walls)
pottery (Bell Plain)
approx. 24 x 18 x 18 (9½ x 7⅛ x 7⅛)

National Museum of the American Indian,
Smithsonian Institution

The hunchback is a subject frequently incorporated into this type of bottle. This vessel was found in Crittendon County, Arkansas, across the river from Memphis (Moore 1911). Black polished effigy vessels are a well-developed artform in the culture of this archaeological phase. J.A.B.

435 ᘍ

HUMAN HEAD EFFIGY JAR

1400–1650
Middle Mississippian culture (Nodena)
earthenware (Carson red on buff)
15.6 x 18.5 (6⅛ x 7¼)

National Museum of the American Indian,
Smithsonian Institution

Undoubtedly made in Arkansas, this Nodena-style head pot is reported to have been found near Paducah, Kentucky. These vessels were a specialty of the native Americans living in the Memphis area during the sixteenth and seventeenth centuries. The products of different cultural groups can be recognized by distinctive treatments of the head, the style of facial tattooing, and the manner in which this facial decoration is implemented. These vessels are depictions of the dead, in which closed eyes and curled-back lips mimic dried skin. They belong to a category of mortuary shrine heads and figures that could be produced locally without difficulty.

The rise of earthenware mortuary figures is presumably of some social and historical significance. Earlier mortuary figures were made of stone and wood and were carefully controlled in their number and disposition. The rise of these alternative pottery forms suggests a loosening of the elite's monopoly on the number of mortuary representations and access to them by a broader spectrum of the society. Hence, these vessels may have been used in inclusive, clan-based ritual contexts rather than in ceremonies confined to the elite. J.A.B.

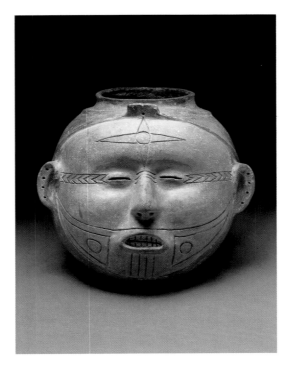

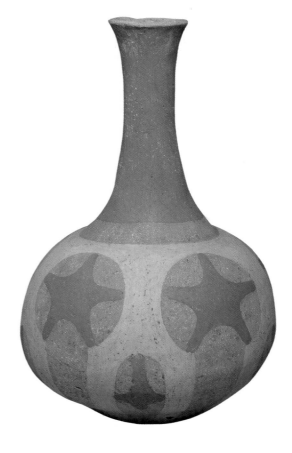

436 ᘍ

WATER BOTTLE

1400–1700
Middle Mississippian culture (Quapaw)
painted earthenware (Avenue polychrome)
24.1 (9½)

National Museum of the American Indian,
Smithsonian Institution

This bottle was found at the mouth of the Arkansas River in the eastern part of the state (Moore 1908, pl. 13). The vessel's color was applied with the assistance of dye-resist technique; a trace of the black, probably vegetable dye is visible (Ford 1961, 179). This vessel dates to the late seventeenth century, but the design is a scalp-lock motif that was developed at Moundville, Alabama, in the fifteenth century. The five-pointed star represents the solar disk painted on elite scalps. The star form and the *V*-shaped lock of hair falling from the disk can be found on painted vessels. They are also the subject of pendants made of stone and of beaten copper at Moundville between 1400 and 1550 (Moore 1905). J.A.B.

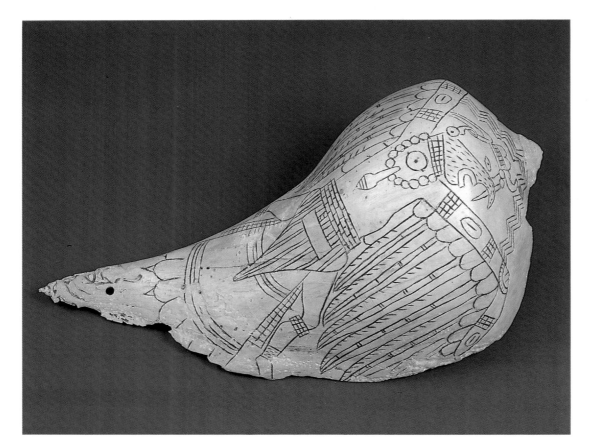

PLATE WITH WARRIOR'S HEAD

1000–1200
Cahokia culture?
repoussé copper
24 x 17.4 (9³⁄₈ x 6⁷⁄₈)

Ohio Historical Society, Columbus

This fragment of a larger copper plate is one of several that were found together, presumably from the great mortuary at the base of the Craig Mound at the Spiro site in eastern Oklahoma. This piece and most of the contents of the deposit were objects retrieved from old graves and placed in a massive ossuary around A.D. 1400. The present fragment was originally part of a large geometric copper tablet that was mounted as a frontlet in a headdress, a small version of which is sculpted in cat. 440 (Brown 1976). A burial at the Etowah site indicates that some of these copper headdresses achieved a length of 35 centimeters (13³⁄₄ inches) (Larson 1971, 62). Sometime in its history the central repoussé image of this example was cut free from its copper background, possibly at the time of reburial in the great mortuary ossuary. The details of dress and style of presentation of the warrior place this piece in the thirteenth century or earlier. J.A.B.

437 ॐ

ENGRAVED CUP

c. 1300
Caddo Mississippian culture
shell
approx. 13 x 30 x 18 (5¹⁄₈ x 11¹⁄₄ x 7¹⁄₈)

National Museum of the American Indian,
Smithsonian Institution

Plain sea shells found their way by trade to the interior of the continent, where they were fabricated and decorated in the style of their owners at the time. This cup was made by removing the interior columella or whorl of the shell of the lightning whelk (*Busycon sinistrum*). Two well-preserved perforations, at the tip and at the back of the spire, were made to attach a bail. It is one of hundreds of shell cups that were found in Craig Mound at the Spiro site in eastern Oklahoma (Burnett 1945). The exterior has been smoothed

and engraved with the figure of a bird-man. The style of engraving, which is indigenous to the Caddoan area of eastern Oklahoma and Texas, dates the cup to around 1300 (Phillips and Brown 1984, pl. 203).

The human figure is costumed as an impersonator of the falcon or some other hawk. This ritual role was important in the early centuries of the Mississippian period (Detroit 1985). The spread-eagle stance of the figure has more to do with the conventions of this artistic school than it has with the actual appearance of the costume or the performance of any ritual. The figure's hawk parts are mainly the beak, the stylized wing feathers, and the large hawk tail. The human elements of the costume include the gorget, columella pendant necklace, ear spool, beaded forelock, plume headdress, and large heart-shaped apron. Brickwork bead bands that adorn the headdress, neck, bird-arms, and legs are standard marks of wealth and indicate the elite status of the figure. J.A.B.

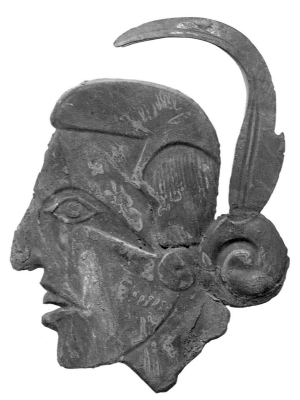

439

NURSING MOTHER EFFIGY BOTTLE

1250–1350
Middle Mississippian culture (Sand Prairie?)
earthenware (Bell Plain)
14.9 x 9.7 (5⅞ x 3¾)
Saint Louis Science Center

In ceramics, female figures were infrequently represented. The origin of this figure may have been a craft place in what is now Arkansas or Tennessee, and may have been brought by trade to Saint Clair County, Illinois, where it was found (Blake and Houser 1978, pl. 7). J.A.B.

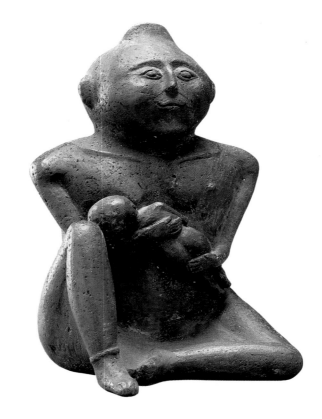

440

HUMAN EFFIGY PIPE

1100–1200
Cahokian culture (Stirling?)
stone (fireclay?)
27.5 x 23 (10¾ x 9⅛)
University of Arkansas Museum, Fayetteville

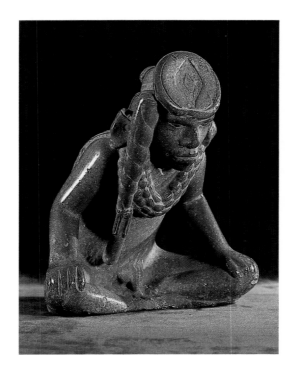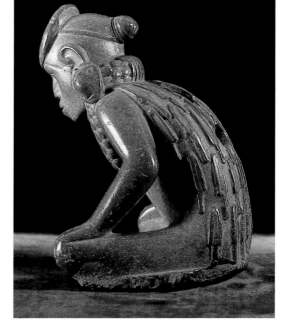

Because of its large size, this pipe has been dubbed Big Boy (Brown 1976). Although it was discovered in a deposit at the Spiro site in eastern Oklahoma dating around A.D. 1400, the piece was probably crafted in the Cahokia, Illinois, area at least a century earlier, when shrine figurines of this style were made (Emerson 1982). The red fireclay material was probably available nearby in Missouri. Originally this piece was crafted as a figurine and was later converted to use as a pipe.

The subject of this pipe, a falcon impersonator in a trance, can be identified from the figure's dress. A carved feather cloak, signifying the falcon, is draped over the figure's back. The headdress is a copper plate fitted into a frame held in place by a strap beneath the bun of hair. A long braid and a rope of beads complete the outfit. Another version of this theme can be seen in cat. 437. The "eye" in the headdress is probably a version of the eye in cat. 430. The ear ornaments are long-nosed god maskettes that identify the figure more precisely as the mythic Red Horn (Hall 1991, 30–33). Limitations of the material prevented the sculptor from providing the highly conventionalized face-mask ornaments with their characteristic Pinocchio noses. Red Horn bears the alternative name of "He-who-wears-human-heads-as-earrings" in historic Iowa and Winnebago mythology of the Oneota culture. An underlying theme of the Red Horn myth is the conferral of ritual kinship upon strangers in a function similar to that of the Calumet ceremony of historic times (Hall 1991, 31). J.A.B.

THE INKAS AND THEIR EMPIRE

The empire created by the Inkas constituted one of the most formidable political achievements in the world of 1492. With a highly developed government centered in Cuzco, the Inka rulers had extended their control over a number of diverse cultures during the preceding two centuries, bringing stability and prosperity to their vast realm. They created an impressive system of roads to unite their possessions and erected imposing stone cities in lofty Andean settings. The ruins of these monuments still attest to the splendor of the empire at its height.

Sadly, many Inka works of art disappeared at the time of the Spanish conquest or in its aftermath. What remain, for the most part, are votive figurines—miniature depictions of men, women, and animals in gold and silver—and beautifully woven tunics of vicuña and alpaca wool. The Inkas introduced their highly formalized artistic vocabulary to the peoples they ruled as a means of proclaiming their presence throughout the empire. Surviving works of art from some of these cultures, such as Chimú and Chancay, reveal the great cultural variety of the lands brought under Inka control.

441 ཟ

Felipe Guaman Poma de Ayala
late 16th–early 17th century

INKA RULER SURROUNDED BY THE ROYAL COUNCIL

fol. 364 of El Primer Nueva Coronica y Buen Gobierno
before 1615
manuscript on paper
14.5 x 20.5 (5⅝ x 8)

The Royal Library, Copenhagen, MS Gl., Kgl. Saml. 2232

The finding of this manuscript in 1908 among materials in the Royal Library of Denmark has been called "the most important discovery of the century for the knowledge of the Andean world, a contribution without equal among the primary sources" (Murra in Guaman Poma 1980, xiii). How it arrived in Copenhagen is not certain (Adorno in Guaman Poma 1980, xliii). The manuscript consists of 1,189 written pages, of which 400 are full-page, annotated illustrations of the conquest and Christianization of Peru and of indigenous persons and customs of the Inka period. A long letter to the Spanish king, it is believed to have been written in the years before 1615. The Inka state had been conquered decades before Guaman Poma completed his monumental work, and European priorities influence some of what he wrote. His intent was to convince authorities in Spain of the need for improvements in the ways the Andes were governed; to do that, he wanted to increase European understanding of the natives and their pre-Hispanic customs and system of governance. Because of the basically colonial intent, care must be used in interpreting the document, but under its veneer of European perceptions lies one of the strongest pictures of the Andean world, written and drawn by a native who had rich personal knowledge of local customs. As one of the few early Andean sources and the only one with rich visual material, the manuscript is immensely valuable as an aid in interpreting

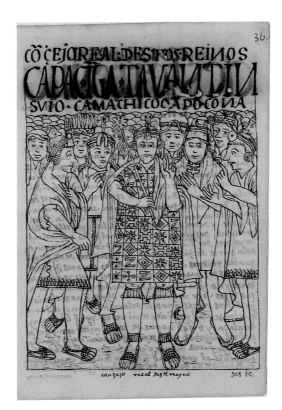

preconquest life and as a guide to Inka social structure, administration, religious ritual, the calendar, daily life, and dress. Some of the kinds of objects in the Inka section of this exhibition are illustrated in use in Guaman Poma's depictions of Inka rulers and their officials and in scenes of calendrical rituals, worship, and seasonal activities.

Nothing is known of the author except what can be learned from this manuscript. The "Carta del Padre del Autor," at the beginning of the manuscript, states that Guaman Poma's father was the son of a Spaniard named Ayala and the grandson of kings of the Inka past, a descendant of the sovereigns of Chinchaysuyu, the northern part of the Inka empire. *Guaman* (or *waman*) means "falcon" in the Quechua language in which the manuscript is mostly written, and *poma* (or *puma*) is the mountain lion of the Andes. In the manuscript Guaman Poma pictures himself in elegant Spanish dress.

The contrasts and contradictions between the native and the European worlds are evident in both the manuscript and its author. The Andean viewpoint is presented with force and sensitivity, but the medium of both writing and illustration is essentially European. It is the Andean pictorial source closest to the remarkable encounter between the Old World and the New. E.P.B.

442–448 ཟ

SEVEN HUMAN FIGURINES

Inka

442: hammered silver, wool, feathers
10 (4)

Museo Nacional de Historia Natural, Santiago

443: hammered silver, textiles, feathers
7.1 (2¾)

private collection

444: hammered silver
15.75 (6⅛)

The American Museum of Natural History, New York

445: hammered gold
14.6 x 3 (5¾ x 1⅛)

private collection

446: hammered gold
11 (4¼)

Museum Rietberg Zurich (Purchase funded by Credit Suisse)

447: silver with shell inlays
19.5 (7⅝)

Musée de l'Homme, Palais de Chaillot, Paris

448: hammered gold, wool, feathers

Museo Pachacamac, Peru

Inka metal figurines can be male or female, of gold, silver, or copper. Some small examples are solid and cast; the hollow ones are made of pieces of sheet metal soldered together. The usual pose is with hands at the chest. The female figurines have long, center-parted hair, ending with some sort of clasp in back near the bottom. The male figures usually wear a band wound around the head. Cat. 446 has an added cloth turban. Cat. 447 is shown wearing ear spools. The other figurines lack ear ornaments, but the lobes are elongated from having worn them; the figurines may at one time have been furnished with them. Throughout what is now Latin America, ear ornaments symbolized high status and often the ceremony in which the wearer was participating. In an important Inka initiation rite, boys of royal lineage were given their first breech cloths and ear ornaments (J. Rowe 1946, 308).

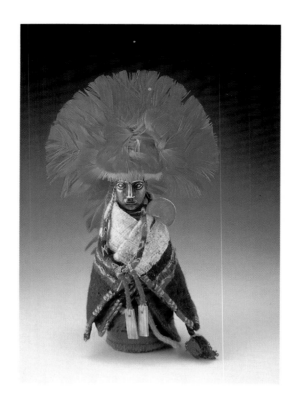

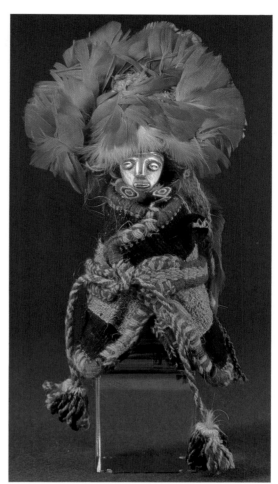

Some figurines are dressed in miniature garments. There was a tradition, probably widespread throughout pre-Columbian America, of dressing sculpted figures. A gold male figurine (cat. 448), from the important central coast site of Pachacamac, Lurín Valley, central coast of Peru, is wrapped in a mantle tied with a sling-like belt. Silver figurines without garments have also been found at Pachacamac (McEwan and Silva I. 1989, fig. 22).

The two female figurines here wear feather headdresses. Cat. 442, from Cerro El Plomo, Chile, wears parrot feathers, a silver chain around the neck, and, over a wrapped garment, a mantle of vicuña wool, fixed with a silver pin (tupu), a type of object used to fasten full-size mantles worn by Inka women. This figure was buried near the mummy of an entombed boy of eight or nine years—possibly the son of a local official—preserved in central Chile at the cold altitude of 5,400 meters (17,700 feet) (Mostny 1957; see also Besom 1991). A small shell figure, also wearing a headdress, was found with him, along with other offerings.

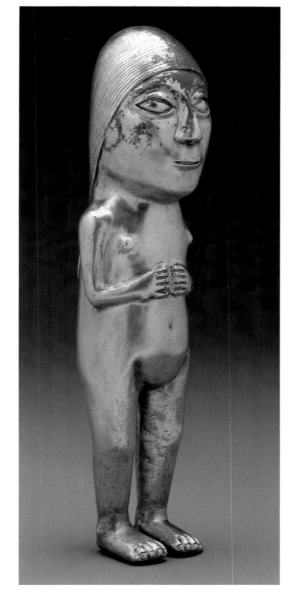

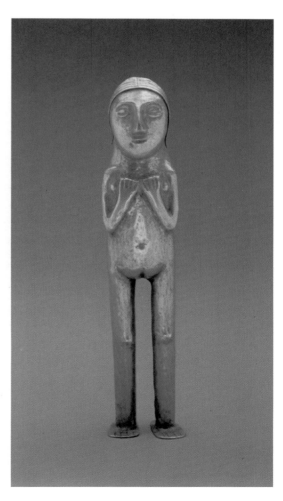

A child was a particularly precious sacrificial offering in the Andes. Such victims might be buried with oblations including small figures—humans and llamas—of metal and of the highly valued spondylus shell. Another child burial from the southern end of the Inka empire, at about the same altitude on a high mountain in Argentina, was that of a seven-year-old boy, accompanied by three small male figures: one of hammered gold, one of a solid alloy, and one of spondylus shell, all clothed and with plumed headdress, and three llama figures, one of gold and two of spondylus (Schobinger 1991). Perhaps there is an analogy between these dressed figurines and the human dead, who were also wrapped in layers of cloth garments. The silver, gold, and shell figures might be considered escorts to the other world.

The use of gold and silver was the prerogative of the Inka rulers, and the distribution of spondylus shell was carefully controlled (Davidson 1981).

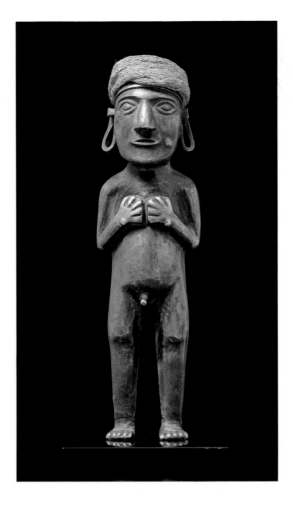

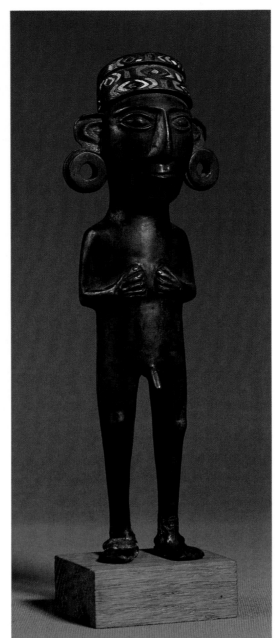

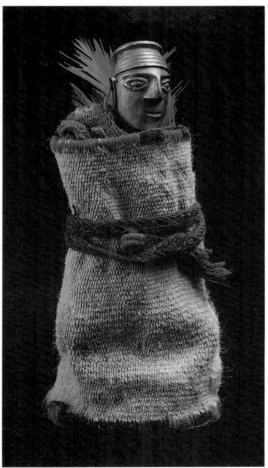

Burials with these materials were particularly sacred. These high-altitude burials may have been offerings to mountain gods and to the sun, possibly a means of acquiring higher status for the family making the offering.

Small gold or silver figures have been found in many parts of the Inka empire, sometimes associated with human sacrifice and perhaps always in sacred places (Bandelier 1910; Bray in Brussels 1990; Essen 1984, 384; McEwan and Silva I. 1989; Reinhard 1983, 50–54). There were also apparent sacrifices to the sea. In 1892 an Inka burial was discovered on Isla de La Plata, off the coast of Ecuador, at the approximate northern end of the Inka empire. Two skeletons were found accompanied by three female figures of gold and three others of silver, copper, and marine shell (McEwan and Silva I. 1989). The lighthouse keeper on the island at the time reported also finding a pair of figures, one of silver and one of gold.

In the highlands nearer the center of the Inka empire, gold and silver figurines have been found in and near Lake Titicaca, both with burials and as apparent offerings (McEwan and Silva I. 1989; Johan Reinhard, personal communication, 1991). Cat. 444 comes from Koati, in Lake Titicaca, an island dedicated to the moon (Bandelier 1910, pl. LVII). A burial found near Pacariqtambo, the place of origin of the Inka people, was accompanied by marine shells, a gold figure, and other objects of silver (McEwan and Silva I. 1989, 170).

According to the Spanish chroniclers, such sacrifices/offerings were made at solstice celebrations, on the accession of a new ruler, and on the death or the anniversary of the death of an Inka ruler (Bray in Brussels 1990, McEwan and Silva I. 1989). Although the burial patterns are not completely consistent, they often involve upper-class young people, gold and silver figures, and marine shell, usually spondylus, in natural form or as a figurine. The seeming consistency of the offerings may have been a means of confederating the empire through the type standardization that is evidenced in many Inka practices. E.P.B.

449 ઝ

TUNIC

Inka
cotton, wool, gold beads
96.5 x 80.5 (38 x 31⅝)

Staatliches Museum für Völkerkunde, Munich

The tunic, called *unqu* in the Quechua language of the Andes, was a knee-length men's garment, a sleeveless rectangle of cloth longer than it was wide. The loom length of these tunics is usually

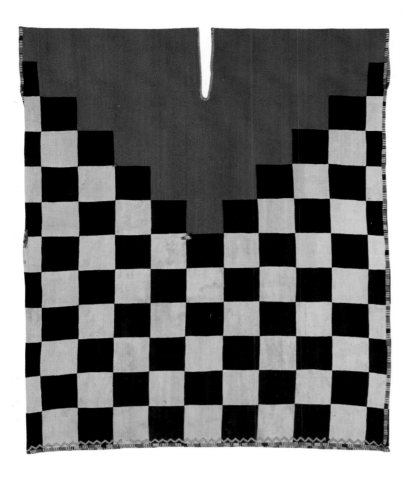 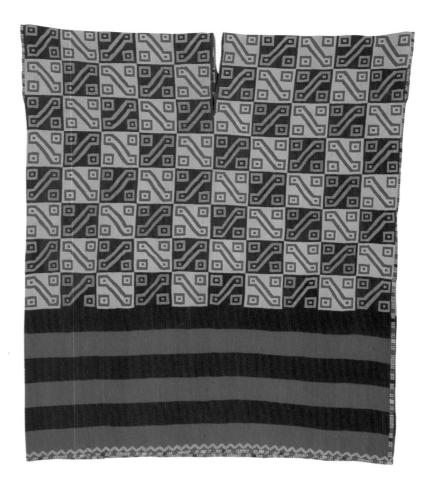

the entire width of the shirt—that is, they were woven sideways, with the warp in the short direction, and then folded over and bound up the sides, leaving spaces for the armholes (A. Rowe 1978, 5; J. Rowe 1979, 239–241). A slot at the neck was woven in with discontinuous warps. With the tunic, men wore a breechcloth and a cloak. Garments were not tailored but were woven to the form of the object desired.

Tunics with a checkerboard design were used by Inka army officers as military garments. Guaman Poma de Ayala illustrated these tunics on military officers and royal escorts of the conquest period (1980; see also J. Rowe 1979, 242–243; Zuidema, forthcoming). A tunic with a checkerboard lower half is worn in a September ritual (Guaman Poma 1980, 226 [ms 252]).

Checkerboard garments also appear in earlier cultures, not in scenes of warfare but in connection with specific rites or myths. The significance of the motif varied in different cultures. Tunics with checkerboard patterns incorporating Spanish colonial motifs remain from colonial times.

The checkerboard design was known in Quechua as *qolqanpata* ("hill of terraces with storehouses"); in an illustration in Guaman Poma's manuscript, the composition of the stone storehouses (*qolqas*) belonging to the Inka state resembles a checkerboard pattern (1980, 309 [ms 335]). *Qolqanpata* was also a name given to the hill above Cuzco and below the impressive stone fortress of Sacsahuaman was located (Zuidema,

forthcoming). Sacsahuaman was a sun temple as well as a military structure.

The *V*-shaped stepped yoke design, composed of squares and woven into the tunic, is known by the Quechua name *awaqui* (Zuidema, forthcoming). Like many other checkerboard tunics, this one has a zigzag design sewn at the bottom, a motif seen also in Guaman Poma's illustrations. The gold beads at the neck slit of this example may indicate that it was a royal garment.

Usually of interlocked tapestry, the checkerboard-patterned tunics have alpaca warps (see A. Rowe 1978, 7; J. Rowe 1979, 239–243). Some fifteen checkerboard-patterned tunics are known, most of them from the south coast.

This garment was found at Los Majuelos, Río Grande de Nazca. Preservation conditions are better on the dry coast than in the highlands, and virtually all extant Inka textiles have come from this region. E.P.B.

450 ᷡ

TUNIC

Inka
wool and cotton
92 x 79.2 (36¼ x 31⅛)

Staatliches Museum für Völkerkunde, Munich

The key-checkerboard motif is the major design on a number of Inka tunics (see A. Rowe 1978, 7; J. Rowe 1979, 248–251); it is a motif on cat. 451. Usually the key motif is repeated on the upper two thirds of the garment, while the lower third is plain or striped as is this one. Two examples are miniatures, perhaps made for offerings or as garments for small figures (see cats. 442, 448). In the Guaman Poma manuscript, only variant key-checkerboards appear (1980).

In the Andes special garments were worn on ceremonial occasions. Royal rites involved frequent change of dress; the Inka ruler was said never to wear the same garment twice (Garcilaso de la Vega 1966, 314; Murra 1962, 719). Cloth, woven into garments and accessories, was of extraordinary value and prestige. It was wealth; it was sacred; it was a major offering to the gods. Some images of the sun were made of thick blankets; other images were of gold, dressed in clothing of wool and gold thread. The mummy bundles of sacred ancestors were taken out on occasion and given new garments and offerings. Cloth was exchanged at royal wedding rites, and the royal couple walked through streets covered with colorful cloth. Cloth was a royal gift to create or reinforce bonds of loyalty, to reward those who had distinguished themselves in battle, or to be presented in diplomatic exchanges. Because tunics were widely disseminated in this way, they are unlikely to have been made in the area in which they were found (A. Rowe 1978, 6; Morris 1988,

237–247). This tunic came from the same tomb as cat. 449 at Los Majuelos, Río Grande de Nazca, but it is probable that neither was made on the south coast.

The early Spanish conquerors were astonished not only by the fineness of Inka cloth and the value placed on it by the native Americans, but also by the government warehouses throughout the empire that were filled to the ceiling with bundles of cloth (Cieza de León 1959, 177; Murra 1962, 717). Weaving was as important to the state as food production. The obligation to weave cloth for state and religious needs went along with the right to use community fibers for one's own purposes. Both the kinds of fibers used and the designs woven into the tunics were carefully controlled; the sizes are also very close, averaging 90–95 cm (35–37 in.) in height and 75–77 cm (29¼–30 in.) in width (A. Rowe 1978, 7; J. Rowe 1979). The standardization of designs in all media was a means of enforcing the coherence of the Inka empire, as was the use of a standard, official language, Quechua, throughout the empire, even where local languages prevailed for everyday use.

<div align="right">E.P.B.</div>

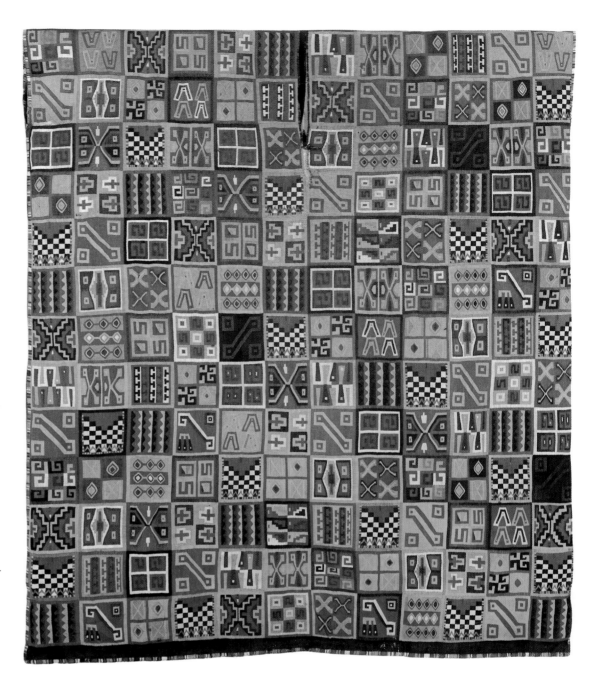

451

TUNIC

Inka
wool and cotton
91 x 76.5 (35⅞ x 30)

Dumbarton Oaks Research Library and Collections, Washington

This man's garment, which is probably from the south coast of Peru, is woven of interlocked tapestry. It is notable for its fine spinning, the excellent preservation of its brilliant colors, and its complex design. Such a design of small square or rectangular motifs is called, in the Quechua language of the Inka, *t'oqapu.* The present garment is the only known complete tunic with an allover design of these motifs. In his 1615 manuscript Guaman Poma illustrated similar allover designs on tunics worn by a number of Inka rulers and their descendants (1980). The motifs also appear in three rows at the waist of several existing tunics (J. Rowe 1979, 242, 257–259). In the Guaman Poma manuscript three-band tunics are shown being worn by rulers and members of the royal family, including women, commonly in ritual scenes. The motifs may appear also in one horizontal or two vertical stripes.

This *t'oqapu* tunic has twenty or more motifs, depending on how one defines an individual motif. These have been examined as a form of syllabic writing to be read as an incantation (Barthel 1971; de la Jara 1975). Most scholars, however, believe that the motifs are part of a symbolic language but not true writing, which early Andean cultures lacked. Associations have been found for some of the motifs. The four-part motifs may refer to the Inka empire, Tawantinsuyu (world of the four parts). One motif is a miniature checkerboard tunic (see cat. 449), and another is the key motif seen on cat. 450. The motifs on this and other surviving tunics are different from and more complex than those shown in the Guaman Poma manuscript, where the motifs are placed in a regular, diagonal repetition. Some of the *t'oqapu* motifs appear on wooden *qeros,* a form of tumbler used by the Inkas. Small

qeros made of gold were presented with tunics as ritual gifts to leaders of peoples newly under Inka rule or to successful captains of allies in conquest; these were later used or displayed in ritual (Cummins n.p.).

The warp of this tunic is Z-spun, S-doubled cotton; the weft is Z-spun, S-doubled wool (Lothrop, Foshag, and Mahler 1957, 284–285). The sides are reinforced with five multiple warps; the heading is all of interlocked loops. The striped binding is accomplished with a cross-knit loop stitch. This tunic may have been made shortly after the Spanish conquest.

<div align="right">E.P.B.</div>

452

TUNIC

early colonial Peruvian
cotton
92 x 81 (36¼ x 31⅞)

Museo de América, Madrid

Tunics continued to be made in the early colonial period, often by native craftsmen weaving tapestry on commission for the Spaniards, who greatly admired the work of Inka weavers (see A. Rowe 1978, 6). This tunic, probably woven shortly after the conquest, is no longer in a pure Inka style. It retains the preconquest *t'oqapu* waistband and the *V*-shape (*awaqui*) framing the neck area, but the borders of the *V* section and the lower edge are of a later style; some of the *t'oqapu* motifs are postconquest variants; and the plant that is the major design is not an Inka motif. It has been identified as datura or floripondio (*Datura arborea*), a plant with handsome flowers that grows in the Urubamba Valley near Cuzco, among other places, and is widely used as a psychoactive ritual drug (Cabello Carro 1989; Herrera 1941, 365).

This tunic was collected by Joseph Dombey at Pachacamac, in the Lurín Valley, south of Lima, in the course of a botanical expedition to Peru in 1777–1787. In pre-Inka times, Pachacamac had been a sacred place and a pilgrimage center with an important oracle. The Inka allowed the site to continue as a sacred place and built a temple to the sun there. Many Inka-style objects have been found there, including a silver figure (cat. 448) in this catalogue. Pachacamac was one of the most powerful *wacas* (sacred places) in the Inka empire (Cieza de León 1959, 334–337; Patterson 1985). Its oracle was consulted even by the Inka ruler himself. E.P.B.

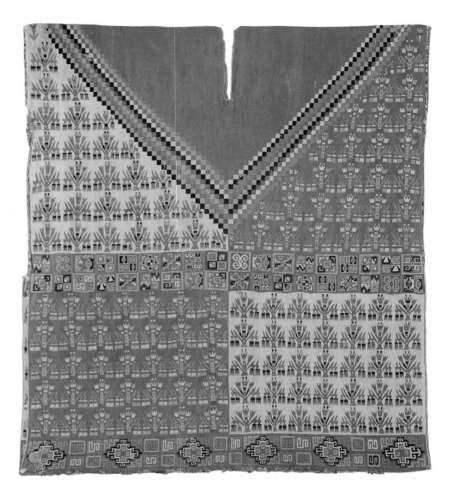

453

TUNIC

Inka
wool and cotton
88 x 71.8 (34⅝ x 28¼)

Staatliches Museum für Völkerkunde, Munich

The word *qompi* was used for fine, soft tapestry woven by cloistered women for religious purposes—offerings and cult images—and for the Inka ruler; it was also woven by the wives of provincial administrative officials and by men who specialized in weaving to meet their labor-tax obligation to the government. The wefts of *qompi* are invariably of two-ply alpaca; the warps are usually three-ply dark brown or black alpaca, or

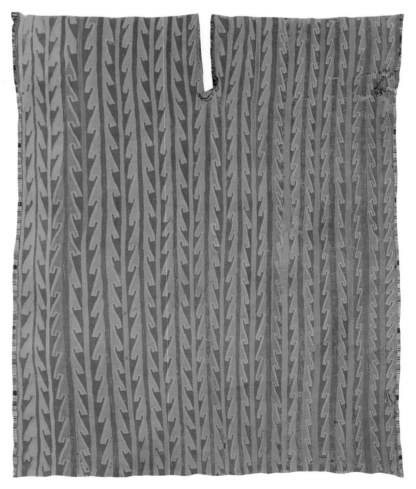

tan or white cotton (A. Rowe 1978, 6–7; J. Rowe 1979, 239–240).

Qompi garments and blankets were silky soft, often bright-colored, and decorated with feathers or shells. Religious statues were screened most of the time with *qompi* curtains (Murra 1962, 719). No one was permitted to wear a *qompi* garment unless it had been given by the ruler; the unauthorized wearing of such cloth was, apparently, a capital offense. Vicuña wool was carefully controlled and could be worn only by the royal family; llama wool was in common use. Ordinary weaving, rather thick and rough, was called in Quechua *awasqa*; it was woven on a different loom from that used for *qompi*.

Pre-Columbian Andean weavers were some of the finest in the preindustrial world. They used a backstrap or body loom, which had one end attached to a vertical object and the other end tied to the body of the weaver. The looms are depicted in the Guaman Poma manuscript (1980, 191 [ms 215], 193 [ms 217], 535 [ms 564], 611 [ms 645], 612 [ms 647]); they are still used in the Andes. Even today spinning and weaving are important occupations in the highlands for people of both sexes and all ages.

The motif of this tunic is unusual—it is not a standard design—but the sides are closed with typical Inka binding. E.P.B.

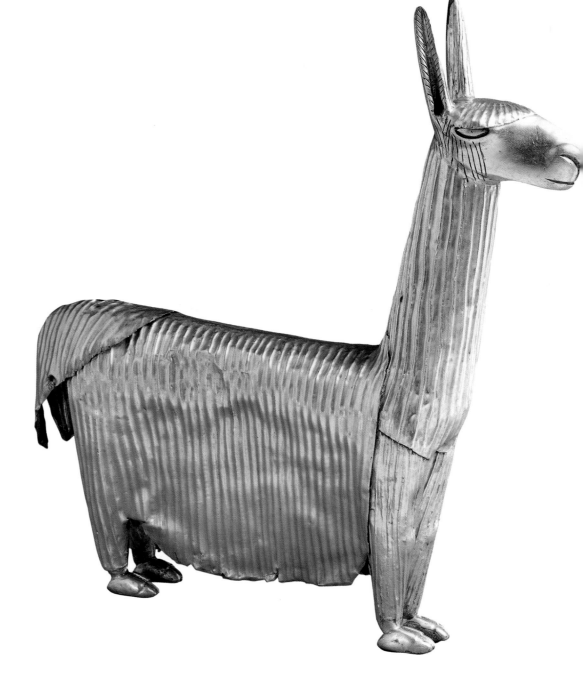

454 ◑

ALPACA

Inka
silver
23.8 x 20.6 x 5.2 (9¼ x 8⅛ x 2)

American Museum of Natural History, New York

The alpaca's fine long hair gives it great value as a wool-producing animal. When allowed to grow, alpaca hairs can reach 75 cm (29½ in.) in length; the animals are usually sheared regularly, however, producing shorter fibers. Alpacas are more restricted to high altitudes than llamas are; the ideal elevation for them is about 5,000 meters (16,000 feet) (Flores Ochoa 1982, 64). The alpaca, which is not used as a pack animal, has probably been domesticated in the Andes for some 6,000 years. There are no wild alpacas or llamas; the wild members of the family are the even finer-haired vicuñas and the larger, coarse-haired guanacos.

This silver piece and cat. 455 were found near the sacred rock on the island of Titicaca among offerings in a place that had been sacred to the Colla people before their conquest by the Inka. The place then became sacred to the Inka, who built a temple to the sun there and a temple to the

moon on a nearby island (Bandelier 1910, pl. LVIII). Like small gold and silver human figures, camelids of precious metal were used as offerings.

This object is fashioned of soldered sheet silver; details are accentuated with repoussé and chasing. E.P.B.

455 ◑

LLAMA

Inka
cast silver with gold, cinnabar
22.9 x 21.6 x 4.4 (9 x 8½ x 1¾)

American Museum of Natural History, New York

The llama was the prime sacrificial animal in the Andes. Early Spanish accounts describe the different quantities and colors of llamas sacrificed at

specific Inka calendrical rituals (Guaman Poma 1980, 228 [ms 254], 826 [ms 880]; see also J. Rowe 1946, 255, 308–311; Flores Ochoa 1982, 80). The heart, lungs, and entrails were used for auguries about crops. The animals were associated with rain and fertility. Their remains have been found in Inka-period burials.

A white llama was a symbol of royal authority. One was sacrificed every morning at the temple of the sun in Cuzco. At the April calendrical ritual in Cuzco, a pure white llama was dressed in a red tunic and gold ear ornaments. Other llamas were sacrificed in its name, and life-size camelids of gold and silver, wearing blankets, were carried in procession on litters. The white llama, representing the first llama on earth, had special human attendants; it sometimes accompanied the Inka ruler and it was allowed to die naturally (although its death may have been hastened by the

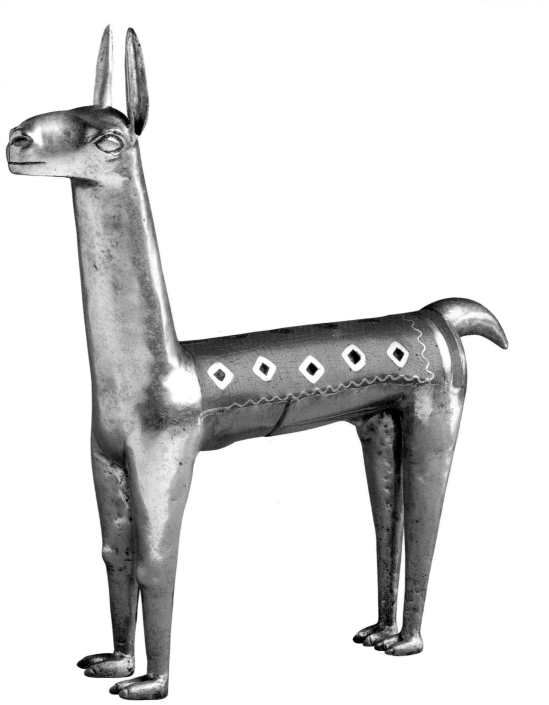

GROUP OF CARVED LLAMAS AND ALPACAS

Inka

456: *black stone with speckles*
6 x 11 x 4.5 (2³⁄₈ x 4³⁄₈ x 1³⁄₄)

457: *black stone*
6 x 11 x 4 (2³⁄₈ x 4³⁄₈ x 1¹⁄₂)

458: *white alabaster*
8 x 10 x 4.5 (3¹⁄₈ x 3⁷⁄₈ x 1³⁄₄)

459:
8.5 x 13 x 5.5 (3³⁄₈ x 5¹⁄₈ x 2¹⁄₈)

460: *wood*
5 x 7 x 3.5 (2 x 2³⁄₄ x 1³⁄₈)

461: *beige stone with black veining*
8.5 x 12 x 4.5 (3³⁄₈ x 4³⁄₄ x 1³⁄₄)

462: *black stone*
7 x 10 x 3.5 (2³⁄₄ x 3⁷⁄₈ x 1³⁄₈)

The Detroit Institute of Arts, Founders Society Purchase with funds from June and William Poplack

Stone vessels in the shape of camelids served as offering vessels to contain llama fat and blood to be presented to the gods. Placed in pastures, these vessels ensured the fertility of a herd.

Llamas, probably originally domesticated some 6,000 years ago in southern Peru, are essentially highland animals, associated with the sacred mountains. The llama also adapts well to differing altitudes and was used in interaltitude trade. There is a long history of llamas on the coast of Peru (Rostworowski 1981, 50–53; Shimada and Shimada 1985). During the Inka era the range of llama herding was widely and deliberately expanded, from Ecuador to Chile (Murra 1962, 711). Today llamas are relatively rare in the Andes, although they are becoming popular as

corn beer and coca leaves with which it was fed).

This silver llama may have represented the royal llama; it was found near a temple of the sun on the island of Titicaca, Bolivia, and wears the garments described by the Spanish chroniclers. Made by lost-wax casting, it has red color added to form the blanket; there were once inlays of chrysacola. The narrow zigzag line on the blanket is made of gold, as are the toenails. A similar zigzag motif appears on some tunics (see cat. 449).

A gold llama and one of spondylus (spiny oyster shell) were found in the burial with which cat. 442 was associated (Mostny 1957). Llamas of metal and spondylus also have been found with other sacrificial burials (Schobinger 1991).

Llama sacrifices are still performed in the Andes on certain occasions, and llama fertility rites are important festivals in many places in the highlands. E. P. B.

pets and mountain pack animals in the United States.

Herds of llamas were controlled by the Inka state. State-owned herds were used for military transport. Shrines and temples owned herds, as did the mummies of dead kings. Llamas served as royal gifts after successful military campaigns; one Inka general is said to have owned fifteen thousand llamas (Zarate in Flannery, Marcus, and Reynolds 1989, 114).

The llama was of critical importance to the Inka. It was, aside from man, the only beast of burden in the New World, carrying up to about forty-five kg (100 lbs.) on a short trip, less on a longer one; pack trains of five hundred or more animals transported goods on Inka roads (Flores Ochoa 1982, 64; Garcilaso de la Vega 1966, 513; J. Rowe 1946, 219, 239). The llama was also a source of wool for clothing, accessories, and weapons (the sling). Sandals, thongs, rope, and drums were made from its hide, and sometimes the dead were wrapped in hide for burial. Its bones were used for tools and ornaments, and its sinew for thread. Its meat was eaten fresh or dried—the English word "jerky" derives from the Quechua word *charqui*—and the dried meat could be traded for the foods of lower altitudes. Llama fat was burned for light and for offerings, and llama dung provided fuel. Pastoralism and agriculture developed together. The important high-altitude staple crop was the potato, which, like llama meat, can be dried through a process of alternately freezing and sundrying. Potato cultivation is dependent on llama-dung fertilizer.

Llamas were identified by threads or cloth in holes in their ears. Earmarking is still an important ritual in the highlands, and stone llama fetishes are still used in a number of ceremonies, especially fertility rites.

In this group the smaller, smooth-necked examples represent llamas, whereas the larger animals with hair at the neck are alpacas. E.P.B.

463 ঌ

SEVEN SEA BIRDS

Inka
cut and hammered gold
5 x 26 (2 x 10¼)

American Museum of Natural History, New York

Several sets of such objects from the Ica-Nasca region, on the south coast of Peru, exist, but their use is unknown. They appear to have been fixed in groups of six or seven on a base that was perhaps to be attached to some other object. One example has a cord (Lapiner 1976, pl. 683). The identification of these birds is not completely clear. They have been called ibises and may well be, although most of the birds have straight bills whereas those of ibises are curved. The birds appear to be searching for food in sand or shallow

water, as shore birds do. Water birds are important motifs in coastal Peruvian art.

The birds are made of several pieces of gold soldered together. The eyes have holes that were perhaps once inlaid with another material. E.P.B.

464 ঌ

HANGING OR MANTLE

c. 1470
Chimú
cotton, camelid fiber
222 x 346 (87⅜ x 136¼)

The Textile Museum, Washington

As the Inka state was rising to power, the kingdom of Chimor, that of the Chimú people, ruled the north coast of Peru from its capital at Chan Chan, a city of some six square kilometers in the Moche Valley. The kingdom of Chimor was the largest and most powerful of the coastal states and was also the richest polity taken over by the Inka. Nine huge, high-walled enclosures of adobe included, among other kinds of structures, burial platforms with rich stores of grave goods, among which were textiles and goldwork.

A seated spotted figure with a tail and an angular-crescent headdress is depicted twelve times on this mantle, each repetition being slightly different. Nine of them are accompanied by a small version of the creature. At the bottom appear four versions of a possibly lacertilian animal. The large figure has been called the moon animal, a mythical creature that appears in many variations in earlier Moche and Recuay art. This piece may have been made under Inka influence, for red and yellow were favorite colors of the Inka period. Textiles of this bold type come from the southernmost Chimú valleys on the north coast of Peru (Kajitani 1982, pl. 97 and trans. p. 48).

This is a complete fabric of tapestry weave, with cotton warps and camelid fiber wefts (A. Rowe 1984, 112–113, pl. 15). The warps are partly Z-plied and partly S-plied, but all are three-ply. An unusually large piece, it was made with a loom width of 78–79 cm (30½ in.); the side pieces were sewn on. There are fringed bands on the sides and tassels at the corners. E.P.B.

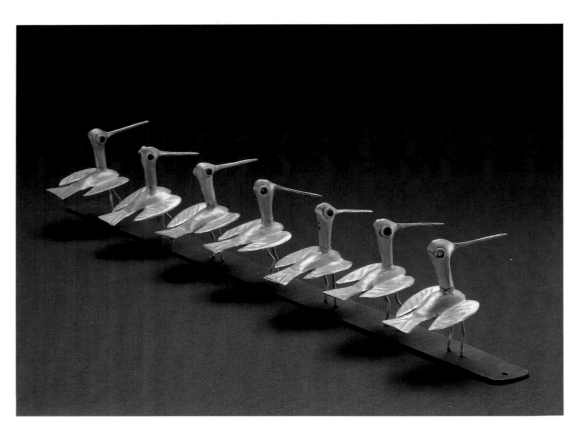

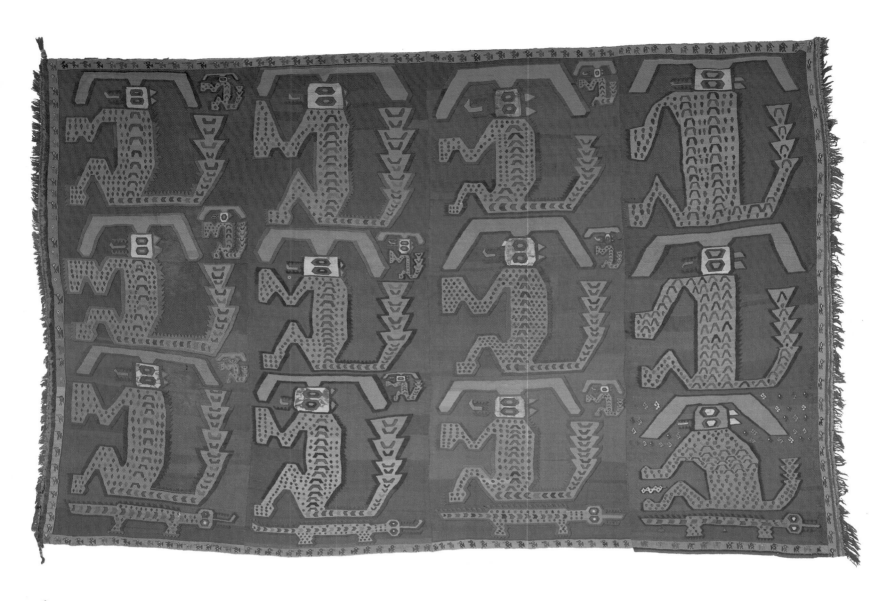

MANTLE

before 1470
Chimú
painted cotton
180 x 191 (70⅞ x 75⅛)

American Museum of Natural History, New York

On this mantle stylized felines alternate with a geometric variant of the step-fret motif that is common in art throughout the Andes. Each repeat of the two motifs is varied. Sometimes an apparent crescent moon is included in a corner of the square; some cats are clawed, some are not. The design presents a dynamic alternation of curving shapes with angular ones.

Felines are generally prominent subjects in pre-Columbian art and myth. The puma (mountain lion) was common in the Andes and the jaguar inhabited the Amazon Basin beyond. The spots on the feline on this textile from the central coast of Peru indicate that a jaguar inspired the motif.

The cloth is plain weave with paired warps; overcasting stitches join three loom products. E.P.B.

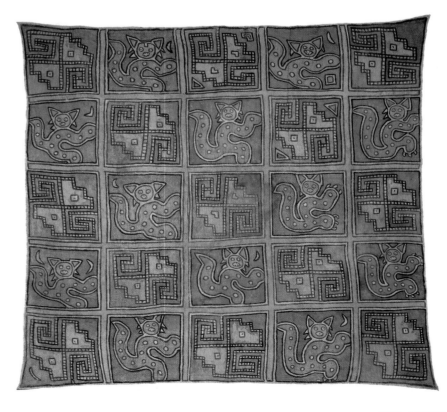

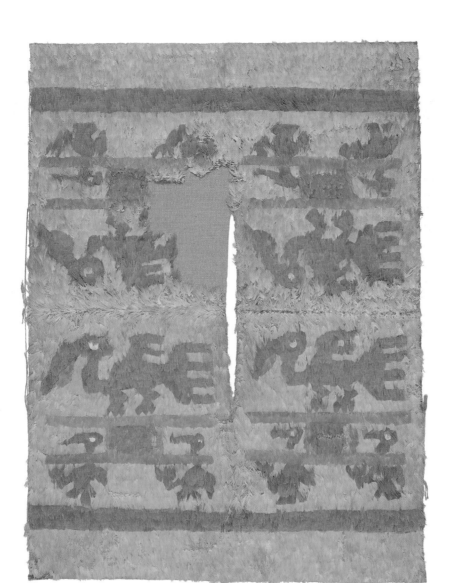

466 ᒍ

TABARD

c. 1465
Chimú
cotton with applied feathers
98 x 68 (38½ x 26¾)

The Textile Museum, Washington

Some of the finest extant American feather work
was that done by the Chimú people of the north
coast of Peru. After the Inka conquest of the king-
dom of Chimor, some Chimú artists and crafts-
men were taken to Cuzco, so impressed were
the Inka with Chimú workmanship. Later, pre-
Columbian feather work sent back to Europe
inspired European craftsmen who admired and

emulated it. The Chimú probably kept captive
birds such as macaws, parrots, and Muscovy ducks
(O'Neill in A. Rowe 1984, 146–150). Many birds,
alive or dead, would have been brought from the
Amazon region to the coast. The feathers on this
garment are mainly from the blue and yellow
macaw. The fabric is plain-weave cotton with
paired warps.

Important persons were carried in litters in the
Andes, and, in art, supernaturals are often litter-
borne. The motif of large pelicans carried in litters
by small pelicans on this tabard is not uncommon
in Chimú weavings.

Tabard is the name given to tunics with open
sides. Tabards were usually smaller than the
closed tunics. E.P.B.

467–468 ᒍ

TWO EFFIGY VESSELS

Chimú
before 1470

467: **DEER**
hammered silver
12.7 x 19 x 8.2 (5 x 7½ x 3¼)

468: **PANPIPER**
hammered silver with turquoise inlay
21 x 11 x 7 (8¼ x 4¼ x 2¾)

The Metropolitan Museum of Art, New York, The
Michael C. Rockefeller Memorial Collection, Gift of
Nelson A. Rockefeller, 1969

These two vessels were reportedly part of a large
group of silver effigy vessels and other offerings
found in a tomb or tombs in a pyramid at
Hacienda Mocollope in the Chicama Valley on the
north coast of Peru. They are made of separate
pieces of hammered silver soldered together.

The panpiper wears pendant disk ear ornaments
and a garment with a wave design made by
engraving and pecking. A stepped motif on his
hand may represent tattooing. Toenails and fin-
gernails are indicated by incising. Panpipes, usu-
ally made of reeds or pottery, were prevalent on
the coast and in other regions, but they do not
seem to have been an Inka instrument. Other
instruments included drums, flutes, trumpets,
whistles, and ocarinas. Panpipes were particularly
significant instruments; they are usually shown
played by figures of richer dress and higher status
than those playing other instruments.

The reclining deer vessel has a bowl on its back.
The deer was one of the most important motifs in
the art of the north coast of Peru in the pre-
Columbian era. The ancestors of the peoples
living in this region had hunted deer as a primary
food. Later, when there were populations of
settled farmers, the deer became an agricultural
symbol. The stag's antlers grow in synchroniza-
tion with the growing cycle of plants; the antlers
look like tree branches; deer eat vegetation,
including the farmer's crops; stags feeding from
trees may get leafage entwined in their woody
antlers. Deer-hunt scenes with vegetation are
one of the most common motifs of earlier north-
coast art. E.P.B

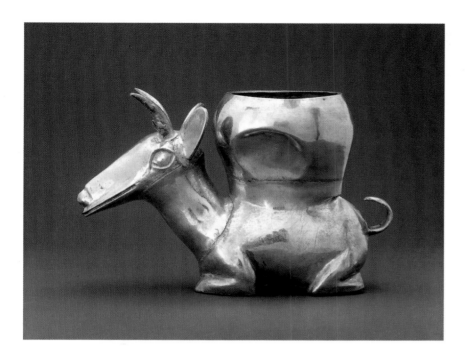

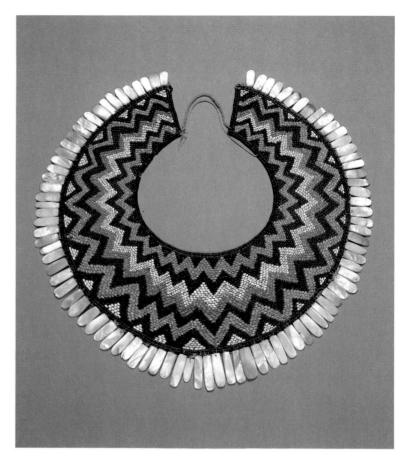

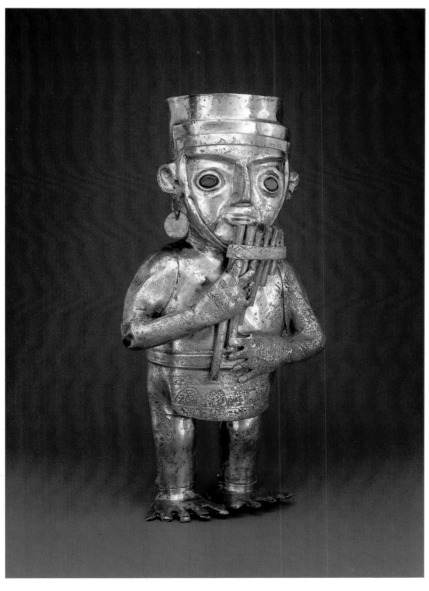

469 🐦

BEADED NECKPIECE

probably after 1470
Chimú
spondylus, mussel, jet, mother-of-pearl,
cotton string
35 x 34.5 (13¾ x 13½)

American Museum of Natural History, New York

This neckpiece, with a wavelike design, has two
pairs of ties for attachment. It is made without a
fabric backing (A. Rowe 1984, 165–167, fig. 173).
The beads are strung in an alternating alignment:
two threads pass through each bead; the threads
are then separated and grouped with adjacent
threads to hold the next row of beads.

The Chimú people, living on the coast, used the
resources of the sea. Especially valuable was the
shell of *Spondylus princeps,* one of the materials
used here. The black bead material has been iden-
tified as jet.

This piece is said to have been found at Chan
Chan with a group of other shell-bead objects.
It was presented to the American Museum of
Natural History by J. Pierpont Morgan in 1896.

E.P.B.

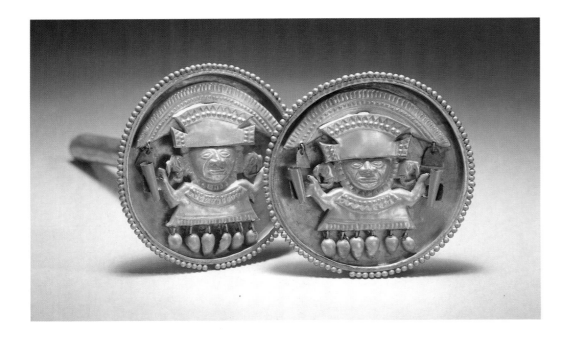

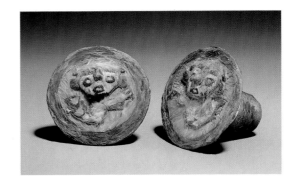

470 ◈

PAIR OF EAR ORNAMENTS

before 1470
Chimú
hammered and cut gold
diameter 13.5 (5¼)

Jan Mitchell and Sons, New York

Large ear ornaments with thick tubes were common adornments for the elite in the Andes as well as in Central and Middle America. Ear piercing was usually a ritual event, and the ornaments that were later worn bore symbolic motifs and often had a particular shape and decoration that identified the rank and ritual occupation of the wearer. This spool form of ear ornament was worn by prominent people on the north coast of Peru for at least a millennium. The beaded frame is typical.

In the scene on these ornaments, a central figure in an enormous, elaborate headdress with a step motif holds a beaker in one hand and a fan in the other (Jones 1985, no. 78). He stands on a snake-headed litter borne by two men in "sunrise" headdresses. All three figures wear ear ornaments. Under the litter a small, bird-headed figure holds a double-spouted vessel, a typical Chimú pottery form. Pottery was itself sacred and was used in rituals; it is often depicted in north-coast art.

Pre-Columbian peoples collected gold from placer deposits, although there was also mining from auriferous quartz veins (Lechtman 1980, 321). Silver was mined, but some may have been taken from surface outcroppings. There is some evidence for the smelting of silver ores or argentiferous lead ores. E.P.B.

471 ◈

PAIR OF EAR ORNAMENTS

c. 1470
Chimú
wood and feathers
diameter 6.4 (2½)

American Museum of Natural History, New York

These figures, which seem to be swimming in space, are abbreviated forms of the creatures seen on the large painted hanging from the Textile Museum (cat. 464). These ear-ornament figures lack lower limbs but have the same tail. The ornaments are probably fairly late in the Chimú sequence, perhaps after the 1460s (A. Rowe 1984, 171–172).

The wooden bases have been carved to make the face project from the surface. Chopped feathers of parrot (green), macaw (yellow and red), and tanager or honeycreeper (purple-blue) have been glued on. E.P.B.

FOOTED BOWL

c. 1470
Chimú
ceramic
15 x 23 (5⅞ x 9)

Linden-Museum, Staatliches Museum für Völkerkunde, Stuttgart

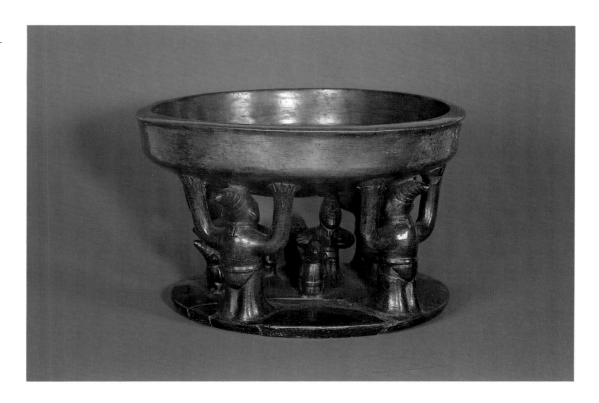

Four large Atlantean figures, standing on a base, support this large bowl. Beneath the center of the bowl stands a medium-size figure with a cup who is surrounded by a group of smaller figures. At the side, a figure pours from a jug. The scene seems to depict a water ritual or the offering of liquid, perhaps corn beer or even blood. The Atlantean figures suggest the four corners of the world or the four world directions and the gods that uphold them, a concept prevalent in pre-Columbian cosmology. All the figures have the flattened head affected by most pre-Columbian people of status; the peaked effect was a Chimú trait during the Inka period. The bowl comes from the north coast of Peru.

Chimú ceramics often have smoke-blackened, polished surfaces. E.P.B.

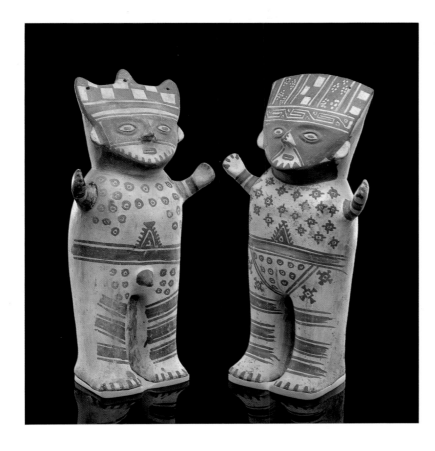

PAIR OF CERAMIC FIGURES

before 1470
Chancay

473: MALE FIGURE
50.5 x 24.5 (19⅞ x 9⅝)

474: FEMALE FIGURE
49.5 x 27 (19½ x 10⅝)

American Museum of Natural History, New York

These figures, one male, one female, are simply made with blocky bodies and legs and masklike faces. The simplified body as well as the short, outstretched arms are conventions of the Chancay ceramic style, as is the unpolished ceramic surface with simple painted designs (see de Lavalle and Lang 1982). Genitalia are rendered in relief, then clothing is painted around them.

Chancay ceramic figures, from the central coast of what is now Peru, were apparently made as grave goods. They were impressively large and were not finely made. They served a need for offerings but were not a major art form. E.P.B.

THE LANDS OF GOLD

Stretching between the Aztec and Inka empires were a series of prosperous chiefdoms that are best known today for the exquisite quality of their craftsmanship in gold. The Diquís culture flourished late in the period before European contact in what is today Costa Rica, and in present-day Colombia the principal gold-producing cultures included the Tairona, the Sinú, the Popayán, and the Muisca. Fortunately for us much of their artistic production in gold was entrusted to the earth soon after its creation, either buried with the chiefs who had commissioned it or, in the case of the Muiscas, hidden for the gods in secret offering caches.

Gold in these cultures was a material associated with temporal and religious power. While some of the objects—earrings, nose ornaments, necklaces, and so forth—clearly functioned as jewelry, many works in gold embodied a complicated religious iconography. Ethnographers working with the present-day descendants of these cultures have come across legends and myths that may shed light on the original meaning of some of these objects. A recurring theme is the ability of the priest or shaman to transform himself into animal guise during religious rituals, a popular belief in societies of this type throughout the pre-Columbian Americas. The Muiscas developed a special category of gold objects, the so-called tunjos. Somewhat like European ex-votos, these were small representations of humans and animals that were offered to the gods in the hope of having favors granted.

DIQUÍS

Diquís, a word deriving from an indigenous language, is still used to denote the southwestern quarter of Costa Rica, including the western slopes of the Talamanca Mountains (the highest of these in Costa Rica at 3,823 meters [12,500 feet]), the agricultural General Valley, and the dense lowland Pacific rain forests of the Osa Peninsula. Modern political divisions are differently named, and archaeologists usually group the zone with northwestern Panama, with which it shares many prehistoric and ethnohistorical traits, calling it the Greater Chiriquí Sub-Area. In general, Diquís has witnessed less scientific archaeology than the other zones of Costa Rica, although looting is endemic.

Among the objects excavated or collected scientifically by archaeologists in Diquís are ground and chipped stone tools more than seven thousand years old and, at the other extreme of the indigenous cultural sequence, quantities of glass beads of European manufacture found in tombs together with crude post-Hispanic local pottery (Quintanilla 1987). While pottery dating to at least 2000 B.C. is now known (Corrales 1985), most archaeological remains found date from c. 300 B.C. forward. Until around A.D. 500–800, the zoned red-on-buff pottery found in the rest of Costa Rica predominated, although with distinctive shapes and motifs. Notably, the emphasis on elite-oriented lapidary work in jade seen in the rest of Costa Rica at that time was almost absent, and there is good evidence that the tradition that produced the famous giant stone spheres began in the first centuries after Christ (Drolet and Markens 1981). Prehistoric settlement patterns of this time typically show small villages of twenty to two hundred inhabitants following the smaller streams of the uplands and foothills, always on agriculturally viable land.

The succeeding transitional period also echoed ceramic and stone sculptural traditions seen in the rest of Costa Rica, especially in the emphasis on human trophy-head symbols on carved stone metates (grindstones) and resist (batik-technique) decoration on ceramics almost identical to similar pottery from northern Colombia. As Diquís moved past A.D. 800–1000, there was an interesting local reflection of the polychrome pottery explosion in northwestern Costa Rica, the symbolism of which was strongly Mesoamerican. Diquís, like the Central Highland and Atlantic lowland traditions, produced pale imitations of the brilliant Greater Nicoya polychrome pottery, probably indicating coastwise trade networks.

Of the three major archaeological zones of Costa Rica, Diquís is that most clearly "southern," as opposed to Mesoamerican, in terms of cultural artifacts. The most obvious difference, other than style, is the early emergence of metallurgy in gold and gold-copper alloys (the latter have a melting temperature lower than that of gold or copper individually), a result of the diffusion of metallurgical technology from south to north, culminating in the adoption of, especially, the lost-wax casting technique, already developed in Colombia by 500–300 B.C. The fascination with cast metals set the Diquís region apart in Costa Rica, as did the production of caleros (containers for lime used in the chewing of the coca leaf, a singularly Andean tradition). Furthermore, effigies of American camelids, not native to Costa Rica, appear in ceramic types that continued into historic times. The natural range of the American camelid (llama or guanaco) at best reached southern Colombia, so the Costa Rican representations either show trade of clearly drawn objects or personal contact between Diquís and the Andes.

When the first Spaniards arrived in Diquís (they had crossed the Central American isthmus in Panama and come back up the Pacific Coast), they observed what they called palenques—stockades or palisaded villages protected by walls of cactus or other spiny plants. Juan Vázquez de Coronado (1964, 33–45) described a palenque of the Coto people in Diquís as oval in shape, built on a ridge with small entrances at the eastern and western extremes that could be raised or lowered from the inside like drawbridges; two steeply banked streams at the north and south provided protection. Two parallel walls surrounded the fort, with holes and trenches between them. Inside the walls were eighty-four circular houses, raised about half a meter off the ground on stilts and roofed with conical spires of thatch. The houses were arranged in groups separated by open streets, in such a way that an enemy could not take more than one group without exposing himself to mortal fire from the others. Each house was normally occupied by twenty-five men with their women and children.

Such detailed descriptions were corroborated in the 1970s (Snarskis 1978) and 1980s (Drolet 1984; Snarskis 1984) by controlled archaeological excavations that clearly revealed circular house foundations of river cobbles, with stone-paved walkways running between and around them, and many domestic activity areas defined by grindstones, hearths, and large clusters of broken pottery and stones. Both in Diquís and the Atlantic zone of Costa Rica, strategically located "city-states" or principal villages, the power bases of local chiefs, were able to dominate areas several hundred square kilometers in size. These polities seemed to be in a state of constant warfare, in which prisoners were often taken and later sacrificed. Warriors depicted in stone sculpture and other media are frequently shown holding an ax and a shrunken human head; such "trophy heads" are also seen as dominant motifs on elaborate ceremonial metates, suggesting that propitiation of agricultural deities was part of the rituals performed.

Most native gold in Costa Rica is found in Diquís, in the form of placer deposits, and prehistoric gold artifacts have been found with much greater frequency in Diquís than in the other archaeological zones of the country. This fits with the generally "southern" cultural affiliation of Diquís, as metallurgy originated in the Andes many centuries before Christ,

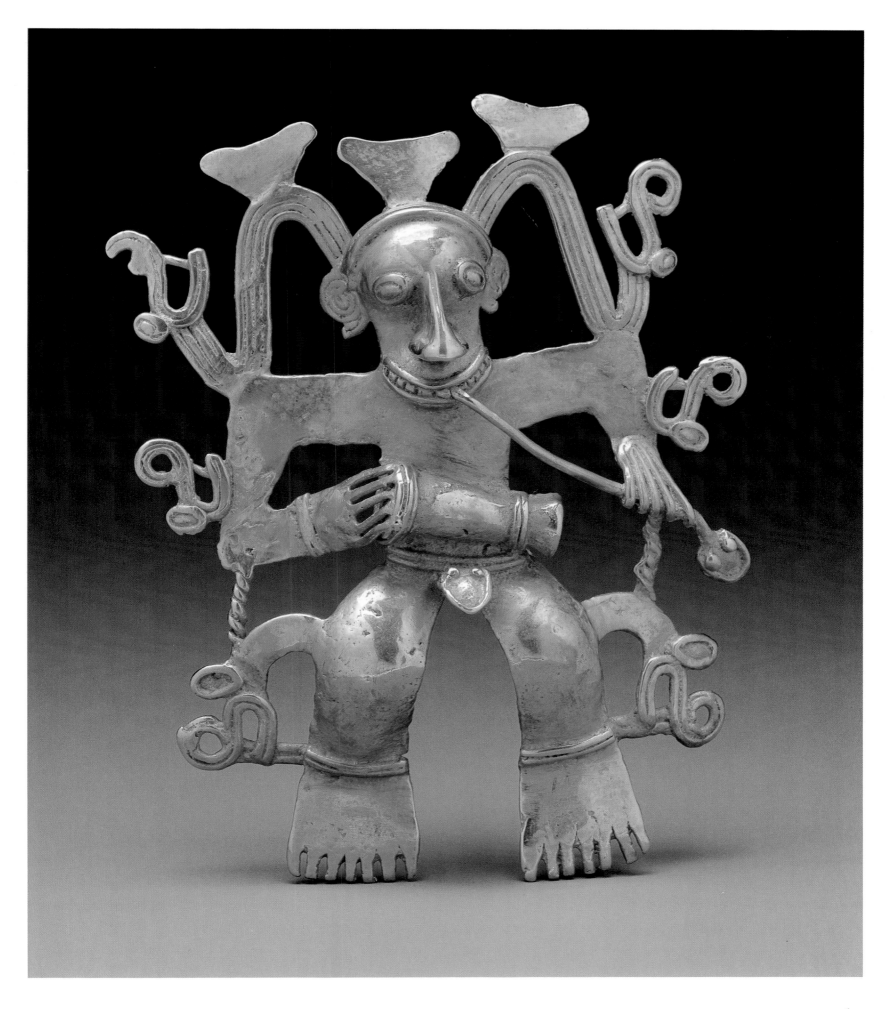

apparently reaching Costa Rica by diffusion around A.D. 300–500.

By the 1500s there was a highly developed social system, of the kind anthropologists call a chiefdom or rank society. Unlike the highly stratified political states or empires of the Inkas or Aztecs, for example, chiefdoms in Costa Rica, Panama, and Colombia did not have monumental stone edifices or cities with tens of thousands of inhabitants. This was probably because of their smaller population base and the ecology of slash and burn agriculture, which requires the moving of sites with some frequency. Instead the smaller chiefdoms developed highly sophisticated crafts with ritual significance, such as gold casting, stone and wood sculpture, and feather work. Although the Spaniards sometimes described groups of native peoples as if all or most wore gold adornment, archaeology suggests that the distribution of gold artifacts among the general population was much less democratic. Elite burials with fifty to one hundred gold objects of all kinds have been found (see Bray, this volume); such burials are often grouped together, as if in a special funerary precinct. On the other hand, archaeologists have excavated whole cemeteries of more than 150 well-made stone cist tombs and found only a single tiny gold avian pendant.

According to Spanish descriptions, those who possessed access to sumptuary goods such as gold were caciques, warriors, and shamans; an individual could hold more than one of these social positions. Bozzoli (1975) noted that historical native peoples still recalled that there were three warrior classes: the jaguars, the red monkeys, and the "two-headed" ones (bicephaly, and even twins, were historically regarded as symbols of impending doom). It is also remembered that the settlements of the jaguar and monkey clans, the only clans from which chiefs could be designated, were located systematically between the villages of other lesser clans so as to better control them. Cobble-paved causeways or "Indian roads" (now buried) crisscrossed Diquís, and the Spanish observed that some roads connected principal settlements with gold-bearing rivers and included vine suspension bridges over deep canyons. Each major chief had a symbol of his reign, which he frequently caused to be tattooed on all his subjects.

Bray (this volume) has provided a synthesis of Diquís mythology as known through historical indigenous peoples, especially as it relates to the symbolism contained in gold artifacts. It may be added that the circular house form (and general village layout) is a tradition shared with northern South America, suggesting a quite different cosmogony or "world view" than that of Mesoamerica, where squares and references to the four cardinal points were fundaments in the prevalent mythic structure. Similarly, the shaft and chamber interment and the stone cist tomb, a burial placed in an edifice of stone or wood including floor, walls, and lid, are also seen in many Colombian sites; the ethnographic explanation is a taboo against the deceased's body coming into contact with the earth.

Our view of Diquís at the time of the first European contact, then, is one of warring city-states, rising and falling over just a few generations; complicated, pantheistic religious systems that meshed with sociopolitical realities and that were embodied in many sculptural media, one of the most impressive being cast gold; and an ingrained custom of human sacrifice as part of the spoils of war, probably viewed as necessary for the maintenance of many deities and the viability of the ruling social strata. Today we see no pyramids, no evidence of a writing system or calendar: the real complexity of these indigenous societies is just beginning to be deciphered from an exuberant corpus of portable sculpture.

M.J.S.

475

PEG-BASE FIGURE

Diquís
stone
35.5 x 12.7 (14 x 5)
Alfonso Jiménez-Alvarado

The stone sculpture of the Diquís in protohistoric times was markedly different from that of the rest of pre-Columbian Costa Rica, sharing instead clearly South American styles, especially the sculptural tradition of San Agustín, Colombia, and that of Muisca gold work. Much Diquís statuary is stiff and highly stylized, almost giving a two-dimensional impression, with only a slight bow to realism in the depiction of anatomical features. The resulting formality recalls architectural embellishment, which the peg-base figures may have been, more than individual work.

This piece is carved in a more appealing fully round style, but as is the rule in most pre-Columbian sculptures, every element, every posture had sociopolitical or religious significance. Figures such as this one, carrying an inverted human-head trophy and, like many of the gold figurines, wearing a serpent belt and what is probably a feline mask, must represent warriors or shamans displaying their superiority over a vanquished enemy. The trophy head cult (commented upon by the first Spanish chroniclers) was reflected in all sculptural media, frequently on *metates*, indicating that human sacrifice formed part of the rituals used to propitiate agricultural deities.

The Spaniards also noted the presence of statuary around open plazas and elite residential or ritual centers; archaeological excavations in Diquís and the Atlantic zone have in fact revealed the cobblestone mounts for such sculptures, some with the broken bases of the sculptures still in place. It is true also that the famous stone spheres of Diquís were frequently arranged around an open plaza. As some smaller stone spheres found from Veracruz to Guatemala appear to be related to the Mesoamerican ball game and associated cosmological symbolism, it is possible that ritual decapitation of the losers after the ball game (or some other ceremony held in the zone surrounded by sculptures) is represented by figures like the present example (Graham in Detroit 1981, 127).

M.J.S.

476

FELINE

Diquís
stone
18 x 31 (7⅛ x 12¼)
Museo Nacional de Costa Rica, San José

This stone feline, which could represent any of the six wild cats known from Central America, has full, softly rounded contours that at first glance give it a benign, almost cartoon-character quality. Some other Diquís animal sculptures share this particular style. However, it should be recalled that the jaguar was one of the most important and frequently used symbols in pre-Columbian America. For the historic native peoples of southern Costa Rica, this feline was "hunter, killer, warrior, clansman, uncle, brother-in-law; symbol of strength and power; equivalent to eagles above, crocodiles in the water, and to the *Xanthosoma* edible root (*ñame*) in the vegetable world" (Bozzoli 1975, 180). In this region, the clan identified with the jaguar was one of only two that could provide caciques (ruling chiefs). This sculpture shows the *N*-shaped incisors or fangs characteristic of most pre-Columbian feline sculptures from South America.

M.J.S.

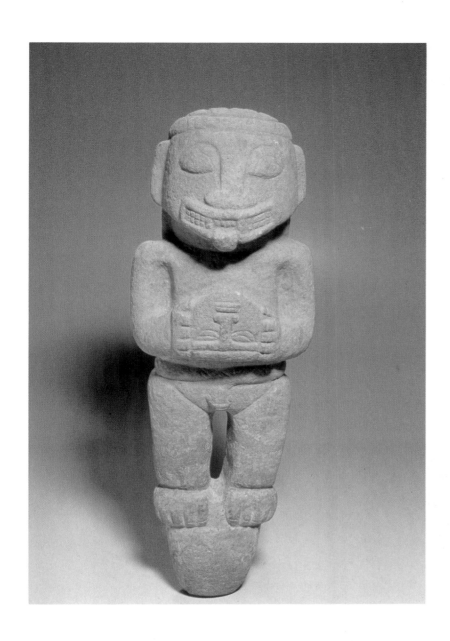

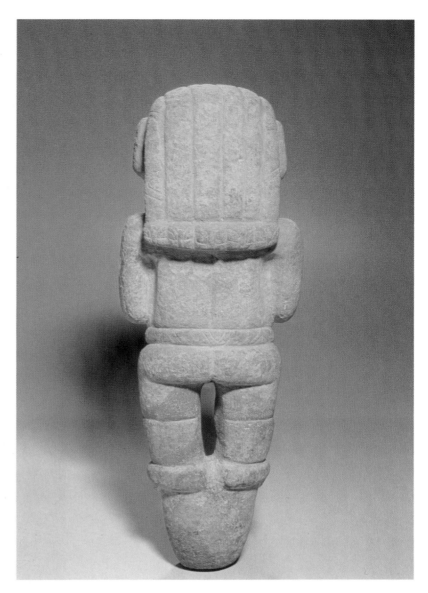

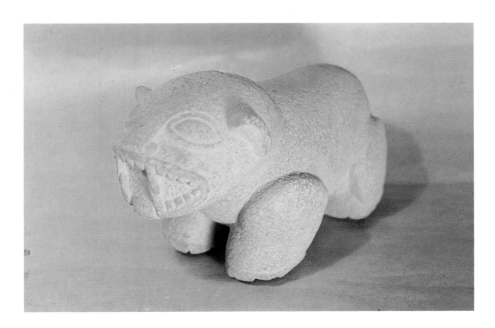

CROCODILE

Diquís
cast gold
5.5 x 15.8 (2⅛ x 6⅛)

Museos del Banco Central de Costa Rica, San José

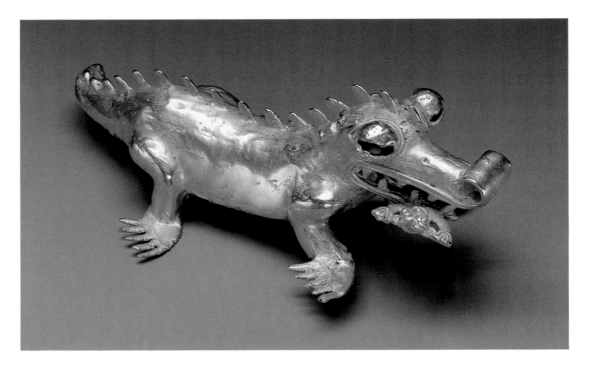

This striking piece shows a crocodilian reptile with a human in its mouth. Crocodiles, caymans, and alligators are all found in Central America; crocodile is used here as a generic term in describing Diquís artifacts. In this case the relative sizes of man and beast indicate that this is a mythological crocodile. There was a basic pan-American pre-Columbian belief in a giant saurian (sometimes a crocodile, sometimes a turtle) on whose back the world rested. In the hierarchy of deities in almost every major pre-Columbian culture, this creature symbolized the basic foundation of the universe. In Diquís and all of Costa Rica and northern Panama, the crocodile motif was probably the most frequently depicted (the next two being the jaguar and the eagle-vulture).

While the symbolism of this composition cannot be known with certainty, it is notable that another similarly proportioned gold figure from Diquís (Museos del Banco Central de Costa Rica, San José, no. 297) shows a deer holding a maize cob in its mouth. It may well be that the Diquís thought that the deer, a major indigenous protein source, was sustained in part by maize, a product of man's farming activities, whereas the crocodile, one of the principal deities, had to be propitiated by man's body itself, presumably through human sacrifice. M.J.S.

MAN WITH CROCODILE COSTUME

Diquís
cast gold
12.3 x 7.5 (4⅞ x 3)

Museos del Banco Central de Costa Rica, San José

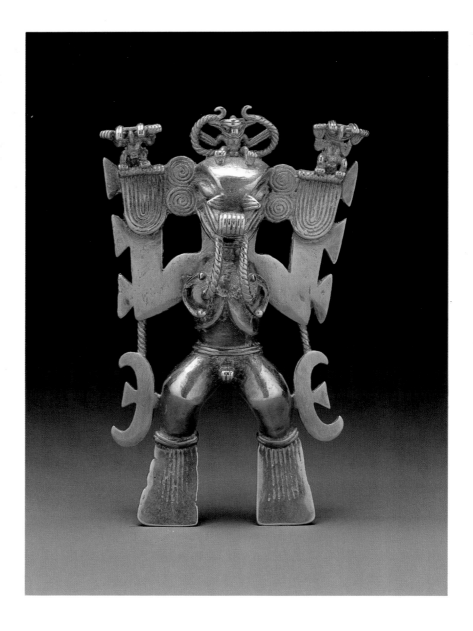

Some of the most impressive gold figurines from Diquís depict men costumed as crocodiles. They may represent shamans or warrior-chiefs. The spatulate hands and feet, recalling fins, accentuate the reflective glitter of the gold. The dynamic yet splendidly elaborate costume worn by this figure appears to cover his entire upper torso, and the triangular elements along each side of the body symbolize the scaly plates of crocodiles, or possibly feathers recalling the tail element in almost all avian pendants. The scrolls on the sides of the head either represent ear spools or denote the act of "hearing and understanding," both human traits. These scroll-shaped elements do not appear on realistic effigies of animals. The tiny figures

on top of this piece seem to be two humans costumed as birds (owls?) at either side and a person with a bat or monkey mask in the center. The principal figure holds a double-headed serpent in his mouth; his posture and realistically attired lower body, with ligature and penis sheath, reveal him to be a man. M.J.S.

479

HUMAN FIGURE WITH CROCODILE COSTUME AND INSET STONE

Diquís
cast gold
15 x 10.8 (5⅞ x 4¼)

Museos del Banco Central de Costa Rica, San José

Some of the features of this figure's crocodile costume echo those of cat. 478, among them the spatulate extremities, flattened arms, ear spools, and double serpent motif, this time circling the waist in place of a realistic ligature. However, in this piece a large curved flat element, using a minimum of gold to create the maximum reflection, crowns the head. The significance of this element is unknown; it could represent feathers. Its lower parts at the sides of the ears are missing.

The most striking feature of this piece is the flat black polished stone inlaid in the chest cavity. Similar pieces from Diquís have been found with inlays of emerald imported from Colombia, as well as stones of other colors. Some stone and pottery figures of the same date show empty thoracic cavities, most probably representing the opening of the chest to remove the heart in a sacrificial ritual. M.J.S.

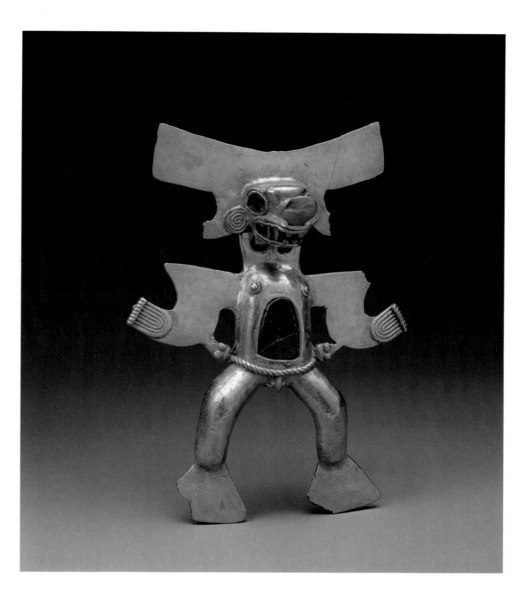

480

MAN WITH CROCODILE COSTUME

Diquís
cast gold
3.9 x 4.85 (1½ x 1⅞)

Museos del Banco Central de Costa Rica, San José

The motif of the shaman or warrior-chief in crocodile-god attire also appears in the elaborate Diquís substyle called Changuinoia. Here the small principal figure is almost obscured by a baroque array of elements, including jutting pairs of false filigree crocodile or bird heads to the side of the head and legs, a double-headed serpent held in the hands and mouth, a serpent belt, and stylized faces. These faces, possibly of birds, are composed of eye cavities on the chest, thighs, and lower legs. The penis sheath represents the beak element in one of these faces. This finely detailed piece, including the false filigree elements and the flattened arms, was produced in a single casting. M.J.S.

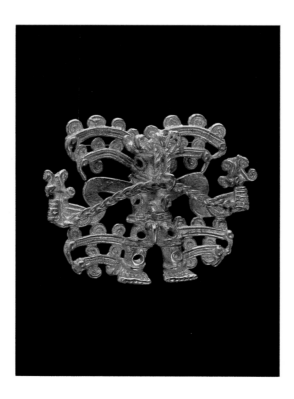

481 ॐ

SHAMAN WITH DRUM AND SNAKE

Diquís
cast gold
10.8 x 8.2 (4¼ x 3¼)

Museos del Banco Central de Costa Rica, San José

Like cat. 478, this piece is large and dynamic, a realistic portrayal of a shaman. His bodily proportions and anatomy are fairly naturalistic, and he wears no mask. Surrounding him, however, is an aura of deities that undoubtedly reflects his special powers. It must be kept in mind that psychotropic substances were an important part of shamanistic ritual, and the visions experienced by the participants in the rituals frequently achieve plastic expression in artifacts. Here two false filigree waves emerge from the shaman's head, topped by crocodile-scale or feather symbols, and

three pairs of crocodile heads—the upper two facing up, the lowest pair facing down—surround the body. Ligatures around the waist and ankles and a snake-head penis sheath complete the attire.

The pose is of great interest. Many authors have called such figures, especially smaller, more stylized ones, musicians, interpreting the thin element emerging from the mouth as a flute. While there is no question that the personage is playing a drum, this thin element is more likely to be a snake. It is probable that the shaman is shown holding a real snake in his mouth and hand, the hand being near the snake's head much like a similar ritual practiced by the Hopi of North America. By dancing, playing a drum, and holding a venomous snake, the shaman demonstrates his impunity to danger and his dominance of the physical and supernatural worlds. M.J.S.

482 ॐ

MAN WITH JAGUAR MASK AND CROCODILE MOTIFS

cast gold
7.7 x 8 (3 x 3⅛)

Museos del Banco Central de Costa Rica, San José

This shaman has a jaguar-crocodile mask and a human leg in his mouth. A tiny jaguar springs around his neck, and the familiar serpent penis sheath-belt, with scrolls symbolizing water instead of serpent heads, encircles his waist. Pairs of false filigree crocodile heads are at his head and feet. This interesting piece is one of several pendants found in Diquís and Chiriquí that show ornately costumed men placed between thin, usually curved plaques of sheet gold. The plaques have the obvious function of anchoring the plethora of elements between them. Perhaps they are

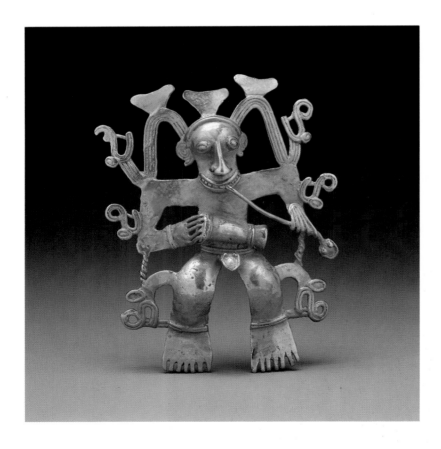

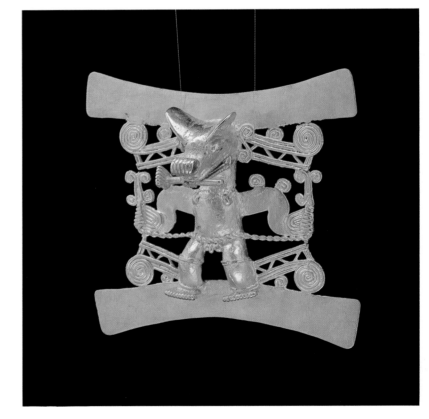

also symbolic of the mythological world view of some southern Costa Rican peoples, who conceived of a general "above/below" dichotomy that was mediated or synthesized by shamans to allow normal life on earth. Good and bad events could take place either above or below, but is was critical to know how the different forces, especially deities, interacted. Large birds, jaguars, bats, the creation force (also a large buzzard or vulture), and things male in general were above; snakes, crocodiles, water, and things female were below (Bozzolli 1975, 199–206). Shamans between the gold plaques on these pendants may represent powerful persons, fully aware of the complex dualities between the worlds above and below, who were thought to be able to mediate between them.

M.J.S.

483 ॐ

MAN WITH AVIAN COSTUME

Diquís
cast gold
10 x 9.9 (4 x 3⁷⁄₈)

Museos del Banco Central de Costa Rica, San José

Here a man, probably a shaman or warrior-chief, is costumed as a rapacious bird. This creature resembles a buzzard or a vulture, though the type is commonly called "eagle." The adornment includes dual false filigree crocodile heads on top, the ear spool or "understanding" scrolls along the side of the head, the penis sheath belt in the form of a serpent, and tiny bird heads on the feet. With his avian wings outstretched, the figure perches on a horizontal gold plaque.

M.J.S.

484 ॐ

DOUBLE HUMANS OR TWINS

Diquís
cast gold
5.7 x 7.3 (2¼ x 2⁷⁄₈)

Museos del Banco Central de Costa Rica, San José

This complex Changuinoia-style pendant anchors the principal elements between plaques of sheet gold above and below them (see cat. 482); these plaques, however, were part of a single cast for the piece as we see it today.

For some indigenous peoples of southern Costa Rica, twins and the concept of bicephaly were considered an ill omen, a threat to the lives of all. It is possible that the double-figure motif increased the power of gold pendants to inspire awe or fear, the purpose for which Diquís warriors and shamans wore massive quantities of gold.

M.J.S.

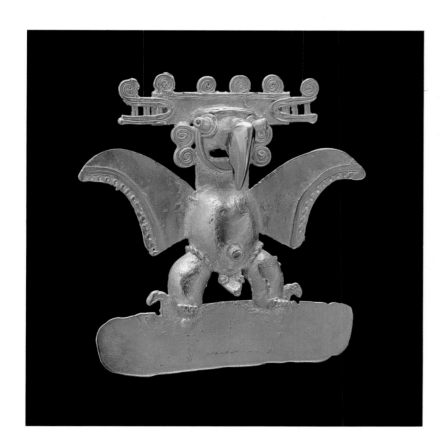

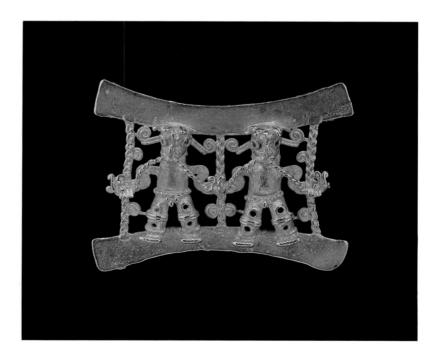

485 ᙏ

JAGUAR EFFIGY WITH BIFURCATED TAIL AND OCCLUDING PLAQUES

Diquís
cast gold
9 x 8.7 (3½ x 3⅜)

Museos del Banco Central de Costa Rica, San José

This piece portrays a fairly realistic jaguar, but its bifurcated serpent-headed tail betrays its supernatural or mythological aspect. Crocodiles are also occasionally shown with such tails, the meaning of which is still unclear. At the central Costa Rican site of Guayabo de Turrialba, a national park, there is a large boulder petroglyph with a jaguar on one side and a crocodile on the other, both with bifurcated tails.

Of special interest in this piece are the four large occluding plaques of hammered sheet gold, which were attached to the piece after it was removed from the mold. These pendants attracted attention, tinkling like bells as well as glittering. The plaques may have symbolized the shaman's or chief's ability to assume animal shapes and attributes at will. M.J.S.

486 ᙏ

MAN IN AVIAN COSTUME WITH FILIGRAM

Diquís
cast gold
11 x 9.6 (4⅜ x 3¾)

Museos del Banco Central de Costa Rica, San José

The central figure in this composition shares many traits with cat. 483, although it has the typically flattened human arms holding a serpent belt-penis sheath instead of wings. Four smaller human-avian figures surround him within an ornate square of false filigree. This piece, and very probably cat. 484 as well, originally possessed the occluding hammered plaques of gold still present in cat. 485. M.J.S.

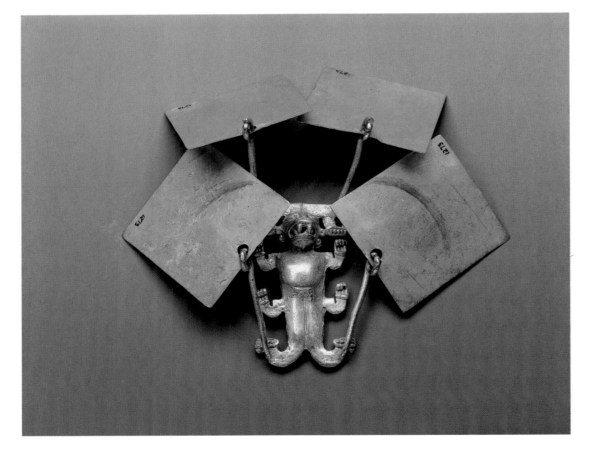

487 ᙏ

ANTHROPOMORPHIC AVIAN EFFIGY

Diquís
cast gold
9.6 x 10.7 (3¾ x 4¼)

Museos del Banco Central de Costa Rica, San José

Whereas this and cats. 488–490 appear to be "eagle" (really buzzard-vulture) pendants, their anthropomorphic essence is betrayed by human faces, however obscured by masks and headdresses, and the ear-spool/ "hear and understand" spirals that can usually be seen at the sides of the head. Other body features, either stylized or fantastically elaborated, are more avian than human.

Such variations on a bird with spread wings and flared tail make up a large percentage of all Costa Rican gold work. This motif represents an efficient use of the precious substance, creating a large reflective surface with a relatively small amount of metal (it should be remembered that the wings and tail were part of a single cast for the whole piece). Two reasons for the pervasiveness of this motif are suggested by the observable world. One is that, even today, large birds perch in the treetops in just this posture, feathers outspread, to dry themselves in the sun after a tropical rain.

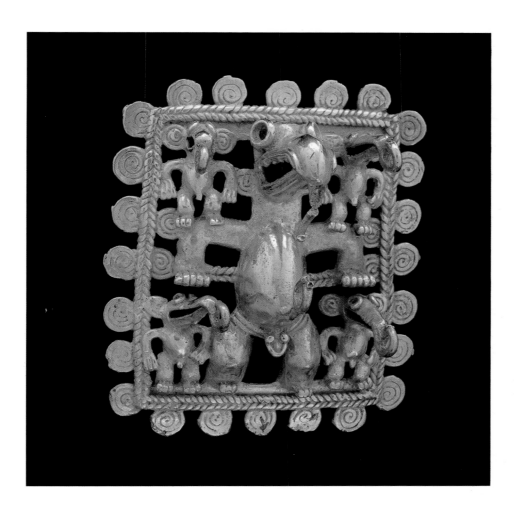

Another is that the king vulture, "upon its arrival at a carcass, terrifies the other carrion-feeding species with a foreboding expansion of its bicolored wings" (Cooke 1984). The large "eagle" or vulture was significant in the world of belief as part of the world above, and was the deity of creation among some native peoples.　M.J.S.

488 ࢠ

ANTHROPOMORPHIC AVIAN EFFIGY

Diquís
cast gold
13.1 x 13.3 (5⅛ x 5¼)

Museos del Banco Central de Costa Rica, San José

This primarily avian pendant, like other Diquís pendants (see cats. 486, 487, 489, 490), is characterized by the flared wing and tail. Dual crocodile heads in false filigree emerge from the head.

M.J.S.

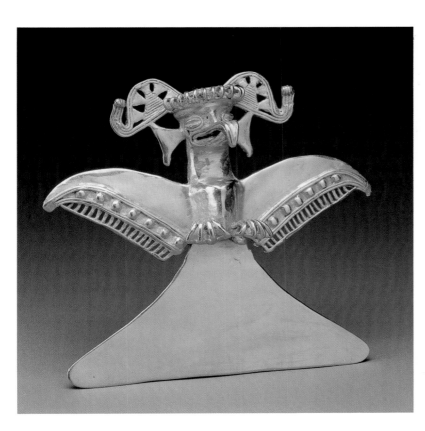

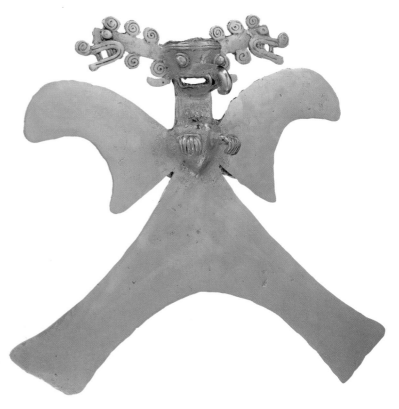

ANTHROPOMORPHIC AVIAN EFFIGY

Diquís
cast gold
7.4 x 8.2 (2⁷/₈ x 3¹/₄)

Museos del Banco Central de Costa Rica, San José

Another in the series of elaborate Diquís "eagle" pendants, this piece, in addition to large crocodile heads in false filigree emerging from the sides of the head, has other smaller versions of this motif facing forward, along with a more realistic human face just barely visible beneath the mask. The wings also seem to resemble the gaping mouths of snakes or sharks. At the front of this pendant are four hooks from which thin occluding plaques of hammered gold originally hung. M.J.S.

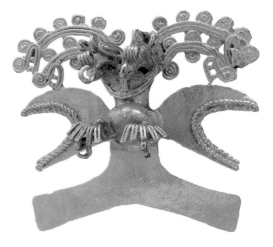

SHARK

Diquís
cast gold
2.8 x 4.9 x 10.45 (1¹/₈ x 1⁷/₈ x 4¹/₈)

Museos del Banco Central de Costa Rica, San José

Although Diquís gold artifacts are pendants and not freestanding figurines, a few are quite realistic. Here a nurse shark, a species that often cruises near the shoreline, is depicted. The animal species that the Diquís chose to portray in gold and that had no important mythological roles in their life frequently have the ability to sting, bite, pinch, poison, or otherwise harm man. M.J.S.

AVIAN-HUMAN EFFIGY WITH CROCODILE AND JAGUAR HEADS

Diquís
cast gold
10.4 x 12.5 (4¹/₈ x 4⁷/₈)

Museos del Banco Central de Costa Rica, San José

In this piece, only the forward-facing birdlike eyes suggest that a human face might be hidden under the elaborate mask. The hybrid creature is undoubtedly fantastic: a jaguar head emerges from the breast, the typical silhouetted crocodile heads in false filigree adorn the headdress, and the buzzard's carbuncles, true-to-life fleshy knots near the base of the hooked beak, have been pushed forward and made into tiny bells. M.J.S.

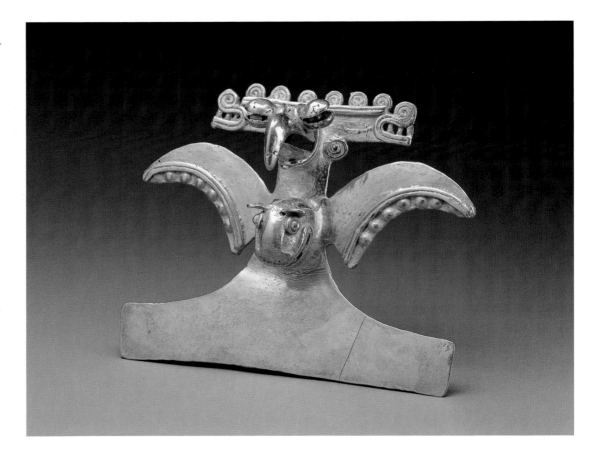

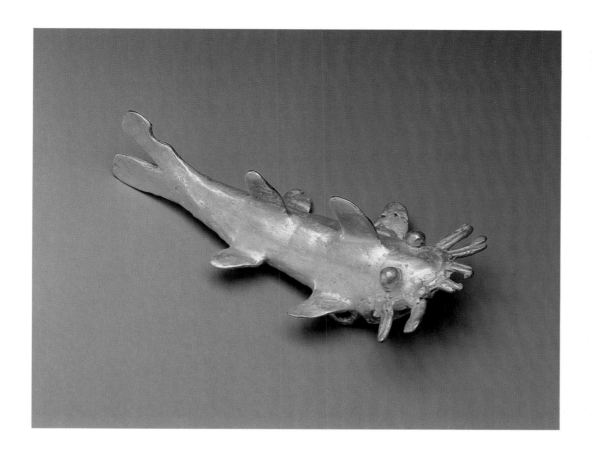

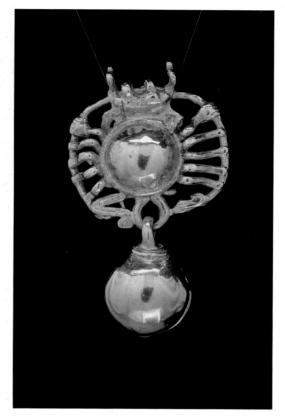

492 ₰

Double-Bell Spider Effigy

Diquís
cast gold
7.4 x 4.4 (2⁷⁄₈ x 1³⁄₄)

Museos del Banco Central de Costa Rica, San José

Except for suspiciously human forward extremities, this spider in the center of a web seems very realistic when compared to most Diquís gold artifacts. A bell hangs below the spider's body, which is itself also a bell. Perhaps the composite piece was inspired by a spider with its egg case on a web.

M.J.S.

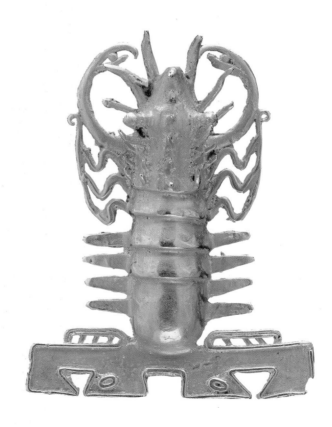

493 ₰

Lobster with Effigy Tail

Diquís
cast gold
10.7 x 8.3 (4¹⁄₄ x 3¹⁄₄)

Museos del Banco Central de Costa Rica, San José

This beautiful and very realistic tropical lobster, locally known as *langostina*, has been symbolically modified only at the tail, which has been transformed into stylized crocodile or parrot heads.

M.J.S.

494 🐌

FANTASTIC LOBSTER EFFIGY

Diquís
cast gold
12.5 x 7.8 (4⅞ x 3)

Museos del Banco Central de Costa Rica, San José

The basic form of this piece is recognizably a lobster, but other elements that transform it into a mythological creature (or one seen in a drug-induced hallucination) include the bifurcated upturned tail, the humanlike forward extremities, and the wavy lines and triangular motif emerging from the mouth, which are definitely crocodilian symbols. The meaning of the composition is unknown. M.J.S.

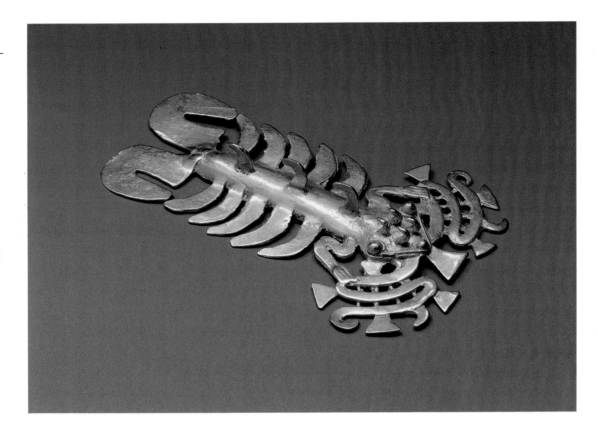

495 🐌

FANTASTIC FROG EFFIGY

Diquís
cast gold
3.2 x 6.8 x 9.1 (1¼ x 2⅝ x 3½)

Museos del Banco Central de Costa Rica, San José

The typical pose in gold frog pendants is a naturalistic one, showing the animal sitting on its haunches with hind legs flexed. The rear feet are usually represented by oversize rectangular or trapezoidal plaques cast integrally with the body, for the same reasons—economy in the use of metal and maximum reflectivity—that such techniques are used in avian pendants and other pieces. Like the crocodile, the frog was associated with the world below and with water. In the mythology of some indigenous peoples of southern Costa Rica, the frog is viewed as a burial helper, whose job it is to sit on a grave to prevent the deceased from rising to trouble the living. Thus the frog's ability to sit (the pose seen in all frog pendants) is critical. In this pendant, false filigree crocodile heads and attached spirals (water symbols) emerge from the mouth, converting a realistic effigy into a fantastic creature. M.J.S.

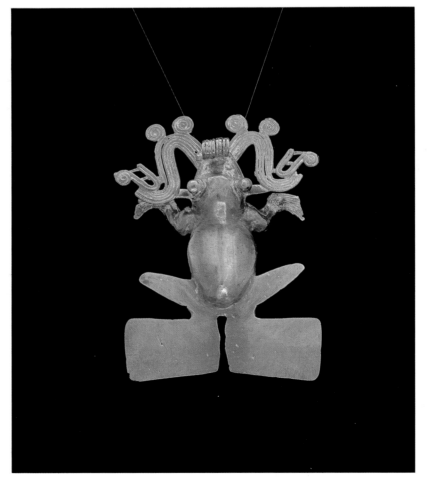

496 ॐ

Bat Bell

Diquís
cast gold
7.1 x 13 (2¾ x 5⅛)

Museos del Banco Central de Costa Rica, San José

What seems to be a realistic bat except for the ear-spool elements is mounted on a large bell representing the bat's body, forming a beautiful and impressive composition.　　　　　M.J.S.

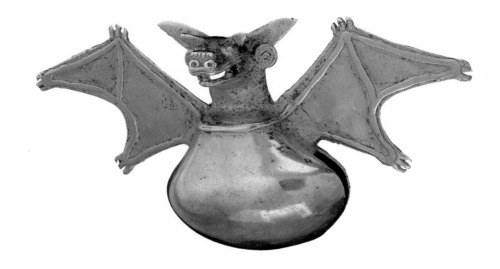

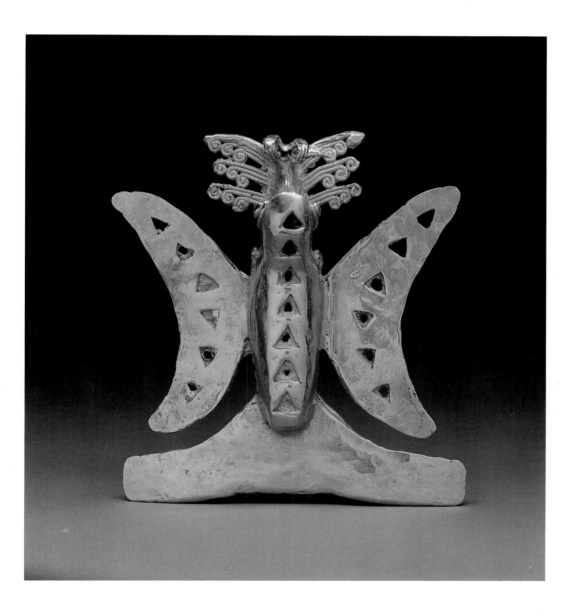

497 ॐ

Butterfly-Bird Effigy

Diquís
cast gold
12.2 x 10.9 (4¾ x 4¼)

Museos del Banco Central de Costa Rica, San José

Here a realistically portrayed butterfly or moth is adapted to the classic form of the avian pendant, and imaginary spreading tail feathers have been added. Among some native cultures of southern Costa Rica, butterflies, along with dragonflies and all waterbirds (Bozzoli 1975), were seen as intermediaries between the forces of the upper and lower worlds.　　　　　M.J.S.

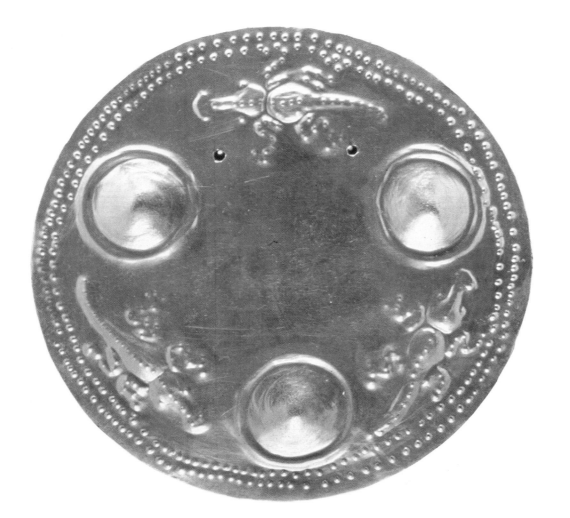

EMBOSSED DISK WITH
CROCODILE MOTIFS

Diquís
hammered gold
diameter 15.7 (6⅛)

Museos del Banco Central de Costa Rica, San José

Unlike other gold objects from Diquís, which were made by the lost-wax casting method, this disk and cat. 499 were formed by hammering out thin sheets of gold, which were then embossed and perforated. For many pre-Columbian peoples, including those of Diquís, there was a symbolic link between the sun and such shiny gold objects. It is not unlikely that the form of this and similar pieces represents the shape of the sun as seen in the sky. On this disk large embossed conical elements, perhaps intended as the cone-shaped roofs characteristic of Diquís houses at this time, alternate with realistic crocodilian effigies. Such disks were almost always perforated to hang as pendants or to be sewn onto a softer material such as cloth or leather. M.J.S.

499 ❧

DISK WITH FANTASTIC
CROCODILE MOTIF

Diquís
hammered gold
diameter 15.8 (6¼)

Museos del Banco Central de Costa Rica, San José

On this disk the open maw of a crocodile monster confronts the observer. Other stylized crocodilian motifs surround it. This unusual perspective may have been utilized to create double-aspect motifs as well, perhaps a humanoid face, on other such objects. The design was embossed on hammered gold, and the resulting piece was perforated to hang as a pectoral. M.J.S.

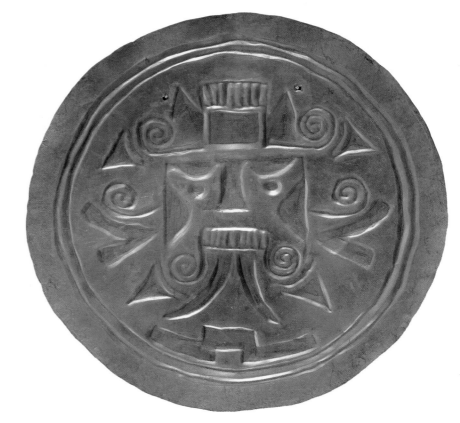

TAIRONA

The Taironas, the ancient inhabitants of the Sierra Nevada de Santa Marta in northern Colombia, began their consolidation into a political and social entity at the beginning of the modern era. The objects in metal that these people produced during the formative period of their culture, in the sixth and seventh centuries A.D. (Bischof 1968; Oyuela 1985), have a characteristically hybrid quality; some show the influence of the metallurgical traditions of the south, while others suggest subjects that would later become common in classical Tairona gold work. The advanced technology that they demonstrate was probably not developed locally; these techniques, most likely reflecting outside influence, were adapted and integrated in Tairona gold work, which was in the process of gradually acquiring its strength and coherence (Falchetti 1987).

The period of greatest development of Tairona culture in the coastal region and on the northern slopes of the Sierra Nevada is thought to have begun around the tenth century A.D.

and to have continued until the sixteenth century, when the Spaniards reported numerous densely populated urban nuclei (Reichel-Dolmatoff 1954; Bischof 1968). The remains of more than two hundred dispersed settlements have been found in the lowlands and in the mountains at altitudes up to two thousand meters (6500 feet; see Cadavid y Turbay 1985). This was the period of classical Tairona gold work, a quite distinct phenomenon within the panorama of pre-Hispanic Colombian metallurgy. Despite great variety in their decoration, the thousands of preserved objects form a coherent whole by virtue of their technology, their elaborate style, and the homogeneity of the themes and forms represented (Plazas 1987; Falchetti 1987). The Taironas used the lost-wax technique for casting their gold, in which the object was first modeled in wax and then encased in clay, forming a mold into which molten metal was poured. Each mold was original and very elaborate. The pieces have considerable volume and were perfectly finished: when extracted from the mold they were pol-

ished, gilded, and cleaned of residues. The objects were designed for intensive use. The diadems, nose ornaments, and necklaces show signs of surface wear, and the rings have lost some of their high relief.

In Tairona iconography, frogs, serpents, birds of prey, and felines are frequently combined into complex hybrid figures such as bat-men, jaguar-men, and bird-men. These motifs are closely related to the religion of the present-day Ijka and Kogui, indigenous communities consisting of about ten thousand people who inhabit the Sierra Nevada de Santa Marta. The iconography of the classical Tairona objects conveys a specific system of beliefs and a world-view that explains the use of these adornments in the society. The highly elaborate designs of the Tairona pieces indicate their emblematic function. These variegated representations of human beings with animal attributes appear to have identified specific social groups, mythically and ancestrally related to certain animals.

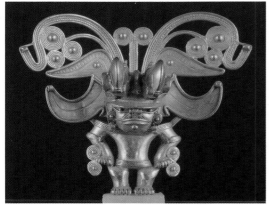

cat. 501

500–501 ⬥

Two Human Figure Pendants

Tairona
cast, gilded gold-copper alloy

500: 15.8 (6¼)

501: 7.8 (3)

private collection

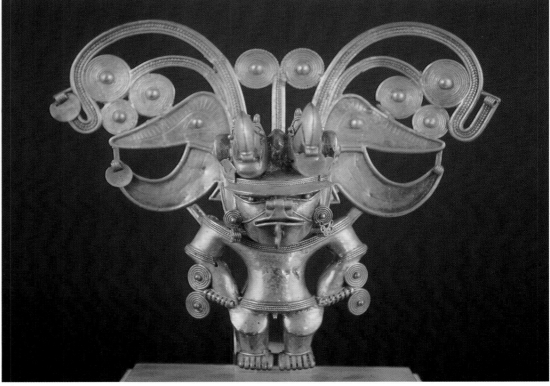

cat. 500

The so-called cacique pendants from Caribbean Colombia are among the finest and most detailed gold castings from pre-Columbian America. They are hollow cast by the lost-wax method, and much of the clay and charcoal core is left inside the heads and bodies to give weight and strength to the relatively thin metal. In their most typical form these pendants depict Tairona noblemen or

chiefs (caciques) dressed in full regalia. These figures wear enormous headdresses, each topped by a pair of large-beaked birds, with elaborate side pieces, a visor or diadem with two vertical projections, a set of tubes or a kidney-shaped ornament in the septum of the nose, a labret in the lower lip, disc-headed bars and crescent-shaped danglers through the ear lobes, necklaces, arm

bands, belt, and penis cover. These miniature gold ornaments are shown with meticulous accuracy, and are comparable to full-size examples found in Tairona tombs. The larger of the two pendants represents the cacique figure in its classic form. The smaller version is an exquisite piece of casting. The loops on the extremities of the headdress once held danglers. W.B.

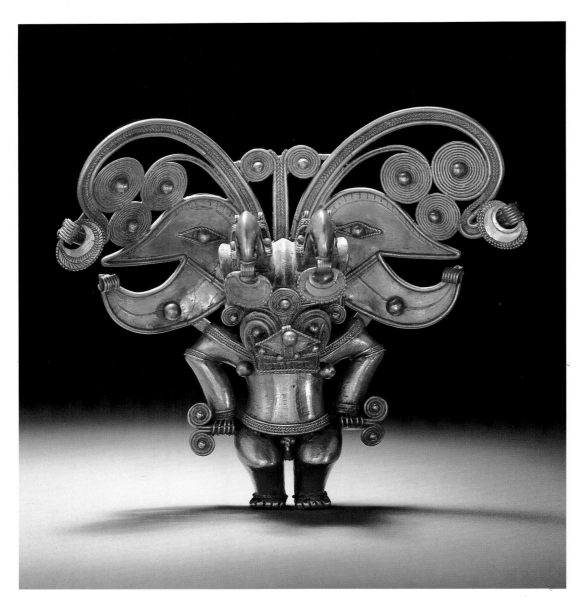

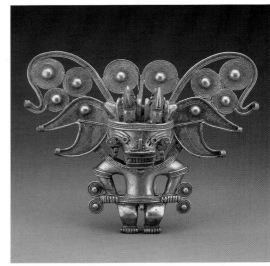

502 🐾

BAT-MAN PENDANT

Tairona
gold
13.3 (5¼)

Jan Mitchell and Sons, New York

In Tairona art there are two common versions of the cacique pendant: one represents a normal human figure; the other, though similar in most of its details, has the head of a bat instead of a human face. On small-scale figures, it is not always clear whether the goldsmith depicted a composite creature from the world of mythology or a masked human being engaged in ritual or ceremonial activities. On this large and splendid pendant, the wrinkles that define the face of the bat may also be meant to indicate the edges of a mask, similar to the wooden ones in use today among the Kogui Indians, the descendants of the prehistoric Tairona tribes. In Kogui mythology the bat is identified as the first animal in creation and, because of the blood-sucking habits of certain species, is linked with menstrual blood and female fertility.

This pendant was collected before 1894 by an engineer who worked in Colombia and was sold in Geneva by his daughter sixty years later, making it the earliest documented Tairona gold item to have survived until the present. W. B.

503 🐾

BAT-MAN PENDANT

Tairona
cast gilded gold-copper alloy
2.9 x 4.6 (1⅛ x 1¾)

Museo del Oro, Banco de la República, Bogotá

This figure also appears to be wearing a mask. On his head are two representations of birds, and the stylized representation of a serpent is distinguishable on his girdle, which he holds in his hands.
 A. M. F.

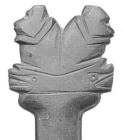

504 ᘐ

CEREMONIAL STAFF

Tairona
gray stone
55.7 x 7.4 (21⅞ x 2⅞)

Museo del Oro, Banco de la República, Bogotá

According to the mythology of the present-day
Kogui, before the sun appeared, the universe was
made of stone. Stone staffs, hatchets, and beads
were consequently used to protect man in the
rituals in which he returned to that mythical past.

A.M.F.

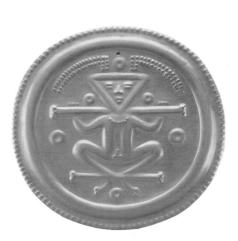

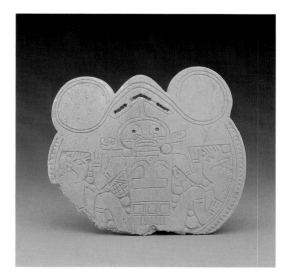

505–506 ᘐ

TWO PECTORALS

Tairona

505: hammered gold
diameter 14 (5½)

506: bone
10.1 x 11.4 (4 x 4½)

Museo del Oro, Banco de la República, Bogotá

These two pectorals represent Seránkua, the
humanized image of father sun (see Reichel-
Dolmatoff 1988). According to the mythology of
the present-day Kogui, "The sun is a man with
a golden mask. The mask emits rays beneficial
to planting and growth. The sun moves in the
sky, two *mámas* (shamans) carry it on their
shoulders." A.M.F.

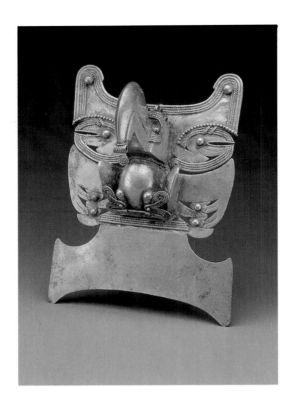

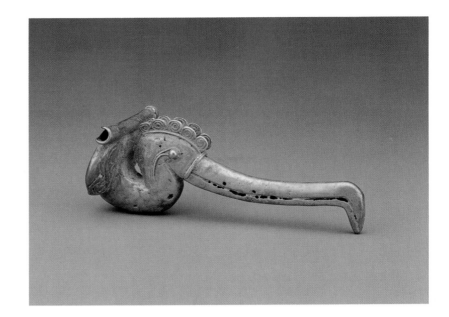

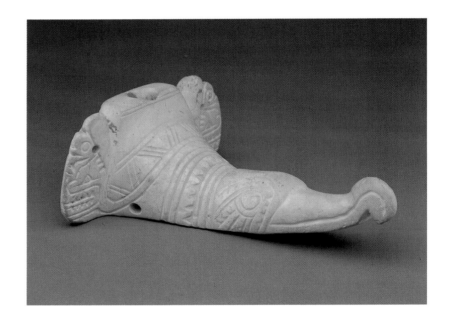

507–509 🐦

THREE BIRD PENDANTS

Tairona

507: BIRD OF PREY
cast gilded gold-copper alloy
12.3 x 9.3 (4⅞ x 3⅝)

508: BIRD'S HEAD
cast gold-copper alloy
3.5 x 8.4 (1⅜ x 3¼)

509: BIRD'S HEAD
shell
8.5 x 11.8 (3¼ x 4⅝)

Museo del Oro, Banco de La República, Bogotá

This iconography may be related to an idea
preserved in Ijka mythology that birds in human
form brought the seeds of the plants that society
needs for survival. The hummingbird brought
coca, the eagle brought yucca (*manioc*), the ani
brought the trees and the flowers, and the macaw
brought the first maize (see Tayler 1974).

A.M.F.

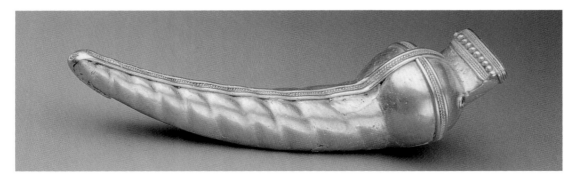

510 🐦

SNAIL PENDANT

Tairona
cast gold
20.4 x 4.9 (8 x 1⅞)
Museo del Oro, Banco de la República, Bogotá

The snail is a symbol of male genitals and fertili-
zation, as are the serpents that decorate this piece.

A.M.F.

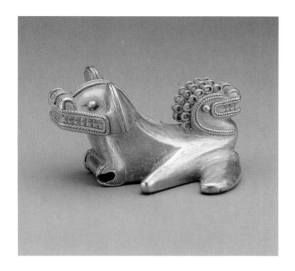

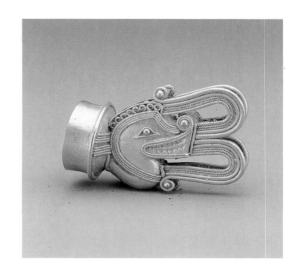

511 🐌

TOAD PENDANT WITH HEADS OF JAGUAR AND SERPENT

Tairona
cast gilded gold-copper alloy
5.6 x 5 (2⅛ x 2)

Museo del Oro, Banco de la República, Bogotá

For the inhabitants of the Sierra Nevada de Santa Marta, this group of animals represents basic conflicts. The rising sun, the east side of the universe, is dominated by the jaguar, which represents the positive side of human existence. The serpent, symbol of darkness, evil, and death, is master of the west, the side of the setting sun. In the middle, in the land of humanity, is a toad, the first spouse of the sun and a symbol of female sexuality (see Reichel-Dolmatoff 1985). A.M.F.

512 🐌

JAGUAR-MAN FINIAL

Tairona
bone
7.2 x 5.4 (2¾ x 2⅛)

Museo del Oro, Banco de la República, Bogotá

This carved bone finial depicts a jaguar-man carrying another being on his back. A bird of prey pecks at his skull. A.M.F.

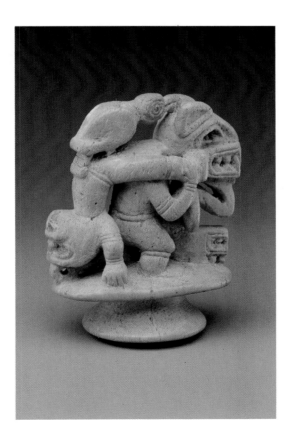

513 🐌

LIP PLUG WITH SERPENT'S HEAD

Tairona
cast gold
2.9 x 4.6 (1⅛ x 1¾)

Museo del Oro, Banco de la República, Bogotá

This type of adornment was made to be worn through a hole below the lip. This example is decorated with the head of a serpent with a forked tongue. A.M.F.

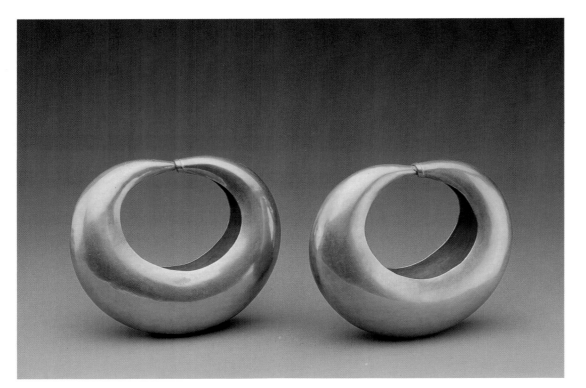

LARGE CRESCENT-SHAPED EARRINGS

Tairona
cast gold
each 8.1 x 9.4 (3⅛ x 3⅝)
Museo del Oro, Banco de la República, Bogotá

Hollow half-moon earrings, cast in gold or the gold-copper alloy known as *tumbaga*, are common in Tairona gold work, although this pair is unusually large.

A.M.F.

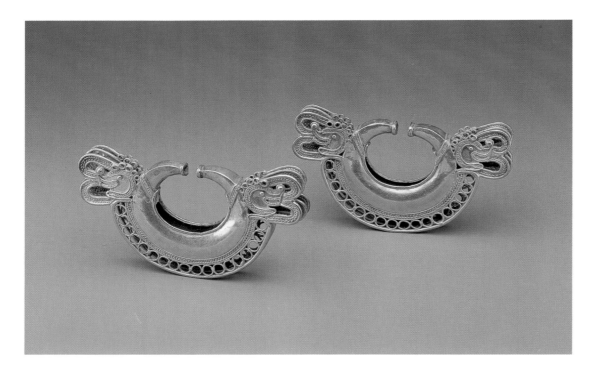

515 ᘑ

EARRINGS WITH SERPENTS

Tairona
cast gold
4.2 x 7.8 (1⅝ x 3)
Museo del Oro, Banco de la República, Bogotá

This pair of earrings is decorated with two serpents, facing in opposite directions, whose bodies are stylized as circles of false filigree. The serpent, in Kogui mythology an immortal animal associated with darkness and the west, is also a symbol of the movement of time.

A.M.F.

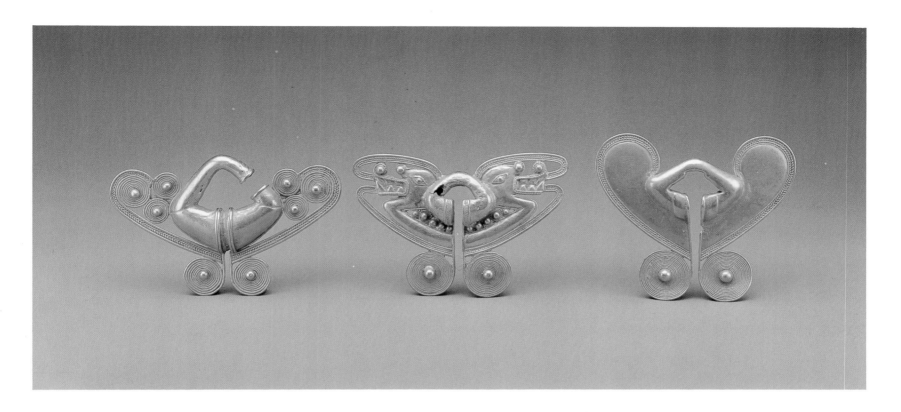

516–518

THREE NOSE ORNAMENTS

Tairona
cast gold

516: 5.7 x 8.9 (2¼ x 3½)

517: 5.7 x 8.2 (2¼ x 3¼)

518: 2.9 x 1.5 (1⅛ x ½)

Museo del Oro, Banco de la República, Bogotá

Tairona nose ornaments usually extended to the sides of the nose. They were cast in gold or in *tumbaga* and were frequently decorated with false filigree ornament or stylized serpents. These adornments emphasized the central part of the face and would have transformed the mouth into a brilliant snoutlike shape. It may be that the nose ornament identified the wearer with the jaguar-man. A.M.F.

519

NECKLACE

Tairona
cast gilded gold-copper alloy
each link 3.3 x 1.1 (1¼ x ½)

Museo del Oro, Banco de la República, Bogotá

This necklace is composed of links that represent stylized animals. A.M.F.

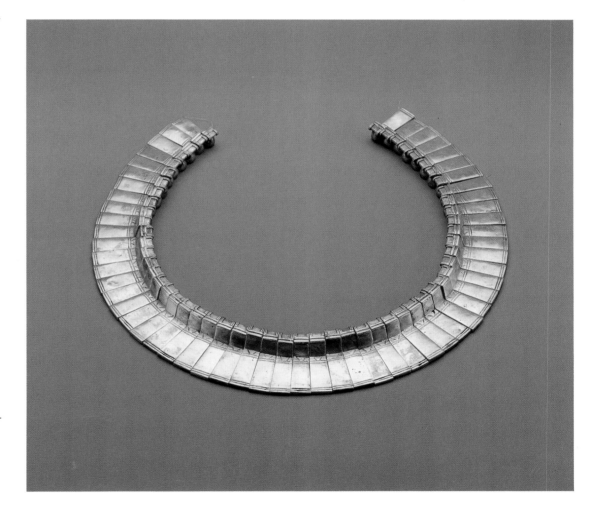

SINÚ

The gold work characterized as Sinú was produced on the tropical Caribbean plains of Colombia, which is traversed by the Sinú, San Jorge, Cauca, and Nechí rivers (Perez de Barradas 1966; Falchetti 1976). Gold was already being worked here in the sixth to tenth centuries A.D. This era was the zenith of the culture of the Zenú, a people who densely populated the low-lying plains of the San Jorge that were prone to flooding. There they constructed a complex network of artificial canals covering an area of 193,000 square miles of marshy lands (Plazas and Falchetti 1981). After the tenth century these plains were gradually abandoned, and the population inhabited the higher surrounding savannahs. According to an indigenous tradition recorded by the Spaniards in the sixteenth century, Finzenú and Yapel, on the rivers Sinú and San Jorge, were surviving chiefdoms of an older sociopolitical organization, when the Greater Zenú territory was divided into three provinces—Finzenú, Panzenú, and Zenufana—governed by caciques of the same lineage and fulfilling complementary economic and social functions. Finzenú was a land of specialists. Even during the sixteenth century there were communities of goldsmiths. Over the course of many centuries these artisans produced the gold objects that have since been found in tombs spread throughout the Greater Zenú territory.

The abundance of gold in this area is attested to by the considerable number of pieces made of fine gold hammered into sheets and then embossed from both sides to create designs. Zenú craftsmen also melted gold and mixed it with copper to produce works—including decorated finials—in tumbaga, whose surfaces were then gilded. They also used the "false filigree" technique to produce many earrings and to decorate larger pieces. False filigree is a casting technique, using a model built up from wirelike threads of wax. It has been given this name to distinguish it from true filigree, in which bits of coiled gold wire are soldered together or to a support. Sinú iconography includes the characteristic fauna of the savannahs and marshlands: deer, caymans, jaguars, and birds with beautiful plumage.

A large part of the production of the Zenú goldsmiths must have been in the service of the chieftains. Gold, of great emblematic importance for objects of adornment and for religious and funerary offerings, played a fundamental role in the ceremonial activi-

ties described by the early Spanish chroniclers, which were designed to enhance the Greater Zenú's social cohesion, reaffirming the prestige of the caciques and priests. These privileged individuals dominated the union between the sacred and the social; they had greater rights than did ordinary men to possess gold and to take it with them, in burial, to their tombs.

The influence of the Zenú was felt around the Serranía de San Jacinto, the mountain range that separates the plains from the Caribbean coast. In the sixteenth century

this area had a dense indigenous population that buried its dead in urns and produced gold work that shows some relationship with that of the earlier Zenú. Numerous finials in gilded tumbaga *were produced there. Cast filigree was also used to decorate the finials and for the various types of earrings. Filigree from the Serranía de San Jacinto is different from that of the Zenú in that the cast thread is finer and the designs more varied (Falchetti 1976; Plazas and Falchetti 1985).*

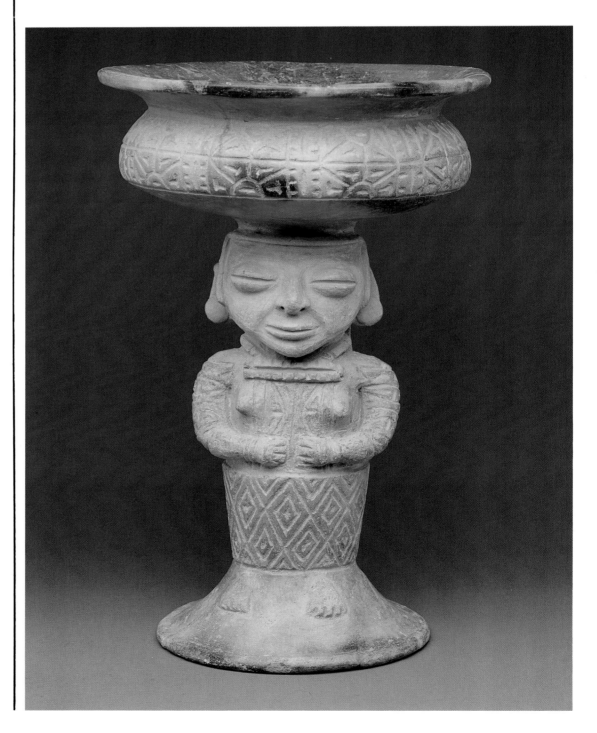

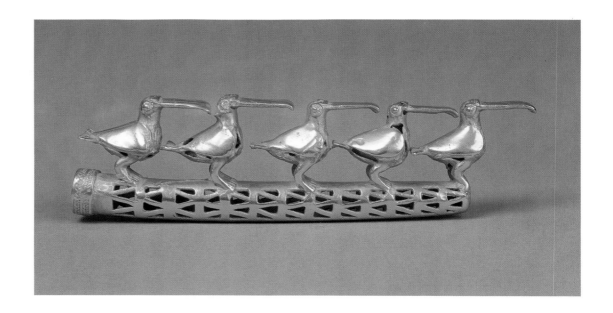

520 🐚

VESSEL WITH
ANTHROPOMORPHIC PEDESTAL

Sinú
ceramic
34 x 20 (13³⁄₈ x 7⁷⁄₈)

Museo del Oro, Banco de la República, Bogotá

Various types of ceramic vessels were made to be placed in the tombs of important persons. The frequency with which women are represented reflects their social and political importance in this culture. A.M.F.

521 🐚

FINIAL WITH FIVE BIRDS

Sinú
cast gold
5.4 x 20.32 (2¹⁄₈ x 8)

*National Museum of the American Indian,
Smithsonian Institution*

This is one of the largest lost-wax castings from the Sinú archaeological zone. It demonstrates the realistic manner in which Sinú goldsmiths depicted creatures of the natural world. The ferrule is designed to slip over the end of a wooden rod, which, because of the effect of climatic conditions in the Caribbean lowlands on organic materials, has disappeared from the archaeological record. This rod would have been too thin to take any serious weight. For this reason and because the birds are seen at their best with the object held horizontally, the finial may have served as the finger grip, more ceremonial than practical, of a wooden spear thrower. W.B.

522 🐚

FINIAL WITH DOUBLE-HEADED BIRD

Sinú
cast gold
11.43 x 12.70 (4¹⁄₂ x 5)

*National Museum of the American Indian,
Smithsonian Institution*

Like other Sinú finials, this double-headed bird appears to have been attached to the end of a wooden object that has not been preserved. The ferrule has holes for pins, which held the metal firmly in place. Although the birds' breast feathers and the crests on their heads are reduced to stylized spirals, the modeling retains the realism characteristic of Sinú art. W.B.

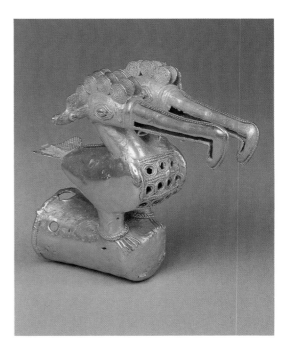

523 &

FINIAL WITH BIRD

Sinú
gold-copper alloy
16.2 (6³/₈)

George Ortiz Collection

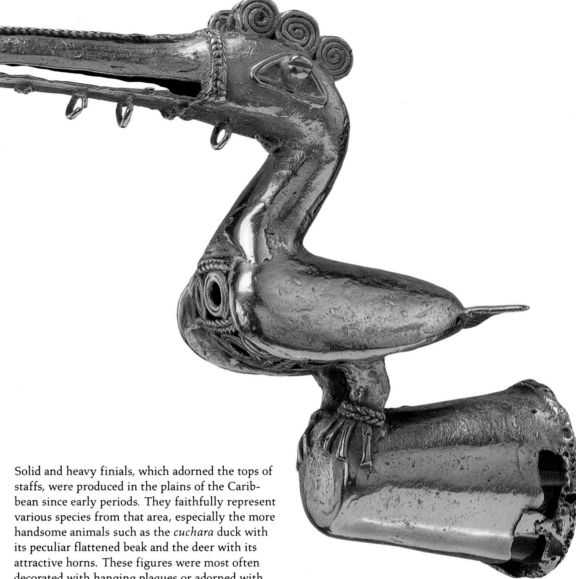

The bird appears to be a toucan. He has slit eyes, the head surmounted by a crest of spirals. Under his long beak are small loops from which gold pendants probably dangled. The bird perches on a socket that may have been attached almost horizontally to a ceremonial staff; it is possible, though unlikely, that it served as the hook of a ceremonial spear thrower.

This finial attests to the high degree of artistic and technical development achieved by Sinú goldsmiths. It was part of the collection of tribal and exotic art assembled by the sculptor Jacob Epstein.

<div align="right">G.O.</div>

524–525 &

TWO ANIMAL-EFFIGY FINIALS

Sinú
cast gold-copper alloy

524: 10.6 x 8.9 (4¹/₈ x 3¹/₂)

525: 9.9 x 7.8 (3⁷/₈ x 3)

Museo del Oro, Banco de la República, Bogotá

Solid and heavy finials, which adorned the tops of staffs, were produced in the plains of the Caribbean since early periods. They faithfully represent various species from that area, especially the more handsome animals such as the *cuchara* duck with its peculiar flattened beak and the deer with its attractive horns. These figures were most often decorated with hanging plaques or adorned with false filigree. Most are naturalistic, but occasionally they represent two-headed animals. A.M.F.

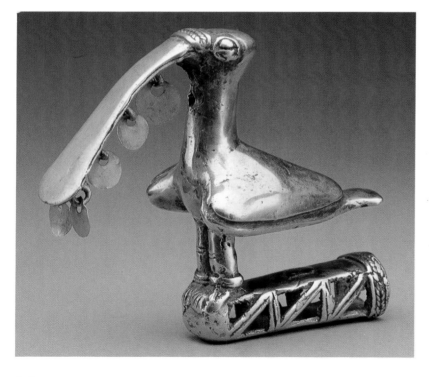

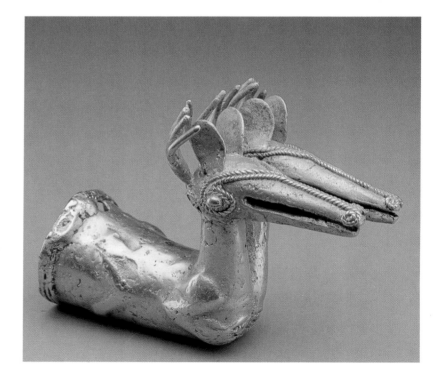

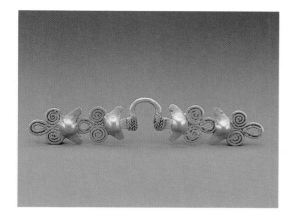

526–528 𝕤𝕒

THREE NOSE ORNAMENTS

Sinú

526: *hammered gold*
50 x 3.7

527: *cast gold*
9.3 x 1.6 (3⅝ x ⅝)

528: *hammered gold*
43.3 x 7.1 (17 x 2¾)

Museo del Oro, Banco de la República, Bogotá

Nose ornaments with lateral extensions, hammered or cast, are common in Sinú gold work of the earlier periods. A.M.F.

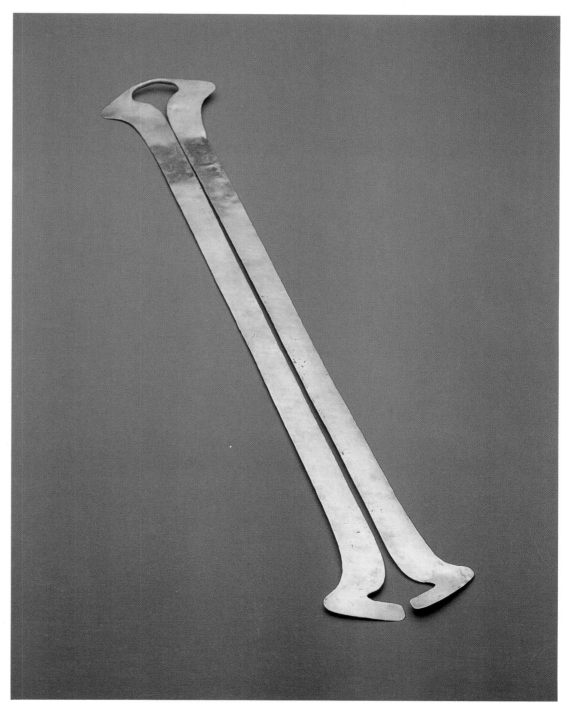

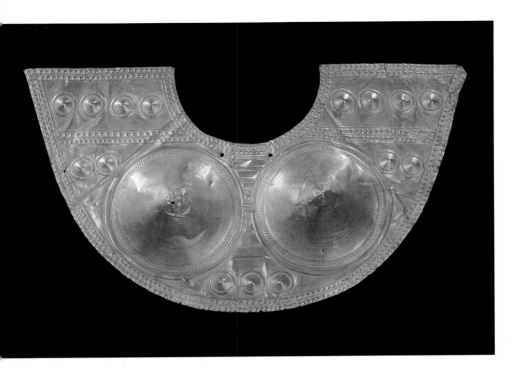

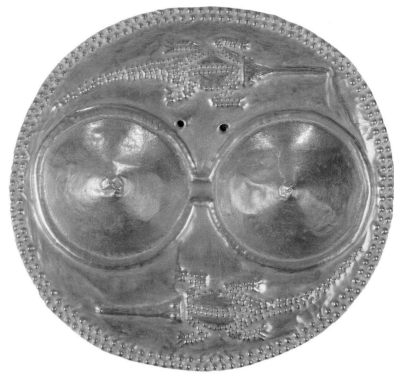

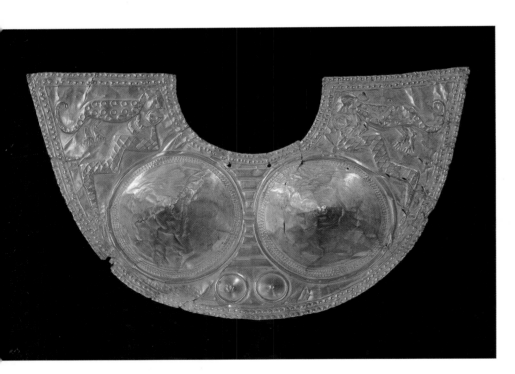

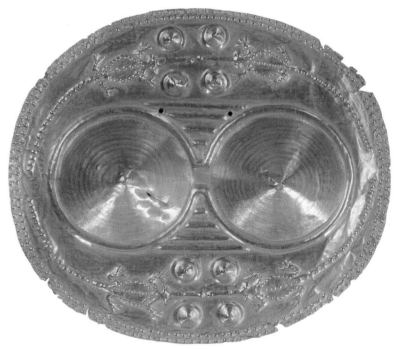

529–533 🐌

FOUR PECTORALS AND NOSE ORNAMENT

Sinú
hammered gold

529: NOSE ORNAMENT
8.89 x 15.88 (3½ x 6¼)

530: CRESCENT PECTORAL WITH GEOMETRIC MOTIFS
54.9 x 32.2 (21⅝ x 12⅝)

531: CRESCENT PECTORAL WITH ANIMAL MOTIFS
53.5 x 32 (21 x 12⅝)

532: ROUND PECTORAL WITH TWO ALLIGATORS
diameter 27.8 (10⅞)

533: ROUND PECTORAL WITH FOUR ALLIGATORS
diameter 33 (13)

University Museum of Archaeology and Anthropology, Philadelphia

These items were found in a burial mound excavated in 1919 in the region of Ayapel, Colombia, where the capital town of one of the most powerful Sinú chiefs at the time of European contact was located. The Ayapel tumulus yielded one of Colombia's richest archaeological treasures, all in gold: three crescent-shaped breastplates, five circular breastplates, six staff heads surmounted by birds or animals, four pairs of ear ornaments, twenty-six nose pieces, nine necklaces, a girdle

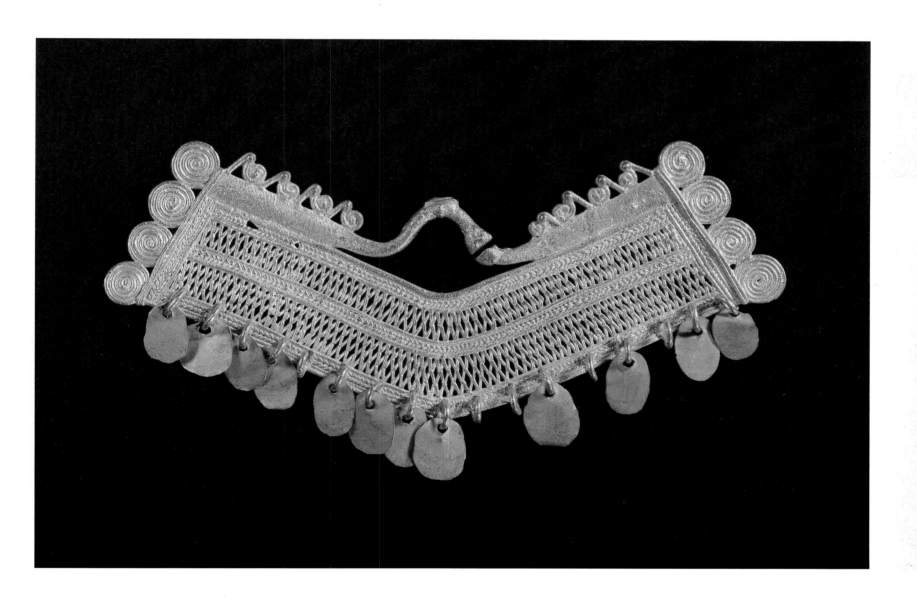

made of 138 solid gold bars, a golden helmet, six sheet-gold plaques, twelve disks, eight bracelets, an arm band, and a funnel-shaped object. All these offerings, which include both cast and hammered pieces, are of prime quality and may have been the property of a single lord. It is unusual that the contents of the tomb have been kept together, as in this case, rather than dispersed.

Both the crescent-shaped breastplates have two holes for suspension. The repoussé geometric design is based on the conical bosses that are characteristic of the Sinú style. The resemblance to female breasts may be fortuitous. Many of the finest Sinú hammered items have two (or more) large conical bosses, but there is no evidence that these objects were worn exclusively by women. The second crescent-shaped pectoral is similar, but with raised bosses and designs of jaguars attacking huge snakes. The two circular pectorals are smaller. They, too, have two holes for suspension

cords. The usual geometrical decoration is supplemented by repoussé alligators.

The nose piece (or ear ornament) is an unusual variant on the typical fan-shaped form from the Sinú. Made by the false filigree technique, the main body of the ornament was assembled from wax threads and then cast in a single operation by the lost-wax method. The design along the upper edge consists of a row of stylized birds, each with a spiral body and a straight beak. W.B.

534–536 ཥ

FALSE-FILIGREE EARRINGS

Sinú
cast gold

534: *pair, each 4.3 x 7.3 (1⅝ x 2⅞)*

535: *6.6 x 6.3 (2⅝ x 2½)*

536: *pair, 7 x 7 (2¾ x 2¾) and 7.2 x 7 (2⅞ x 2¾)*

Museo del Oro, Banco de la República, Bogotá

Earrings decorated in false filigree were produced
in the Sinú region for many centuries. The tech-
nique shows the influence of textile designs,
which were of great importance in this area in
pre-Hispanic times. In early periods the earrings
were produced with thick cast threads; this was
gradually replaced by a finer filigree design. The
decoration includes geometric designs and stylized
birds. In later periods round earrings were
common, frequently with decoration that com-
bines human beings and animals. A.M.F.

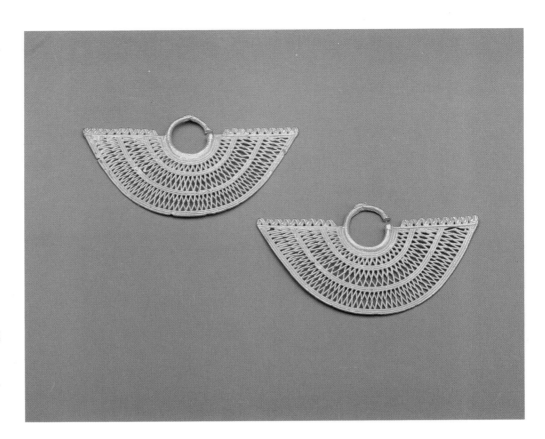

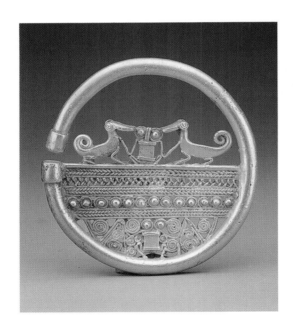

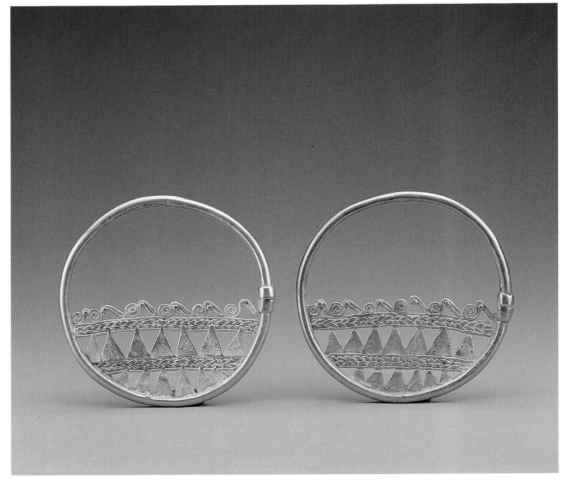

537 ଓ୶

NECKLACE

Sinú
cast gold
each bead 2 (⅞)

Museo del Oro, Banco de la República, Bogotá

This necklace is composed of barrel-shaped beads
worked in false filigree. A.M.F.

POPAYÁN (CAUCA)

This area is best known for representations of the bird-man, one of the most common images in pre-Hispanic Colombian gold work. The transformation of the shaman into a bird symbolizes his capacity to fly toward the supernatural world, the source of his knowledge (Reichel-Dolmatoff 1988).

In the large pectorals of gilded tumbaga that have been found in the region of the upper Cauca River, south of the city of Popayán, the man with a bird's beak occupies a central position. His hair is transformed into feathers that open above a pierced crescent recalling chullos, the cloth caps that are still worn to protect against Andean cold. The twisted nose ornament, necklace, belt, and ties under the knees give a human quality to these figures, which are nevertheless portrayed with the unfurled tail of a bird. The central figure is accompanied by two or more small bird-men and by auxiliary animals that assist him in his transformation (Reichel-Dolmatoff 1988).

None of the pieces of this type has been recovered from a controlled archaeological excavation, but it is known that they are associated with large ceramic figures of highly adorned personages seated on benches and carrying shields with pierced decoration (see cat. 540). The date of the pectorals is not known; however, the technique of casting in gilded tumbaga arrived late in the Colombian southwest, at the same time that the use of the twisted nose ornaments became common. These nose ornaments are associated with the sonsoide ceramic tradition, which lasted from approximately the tenth to the sixteenth centuries A.D.

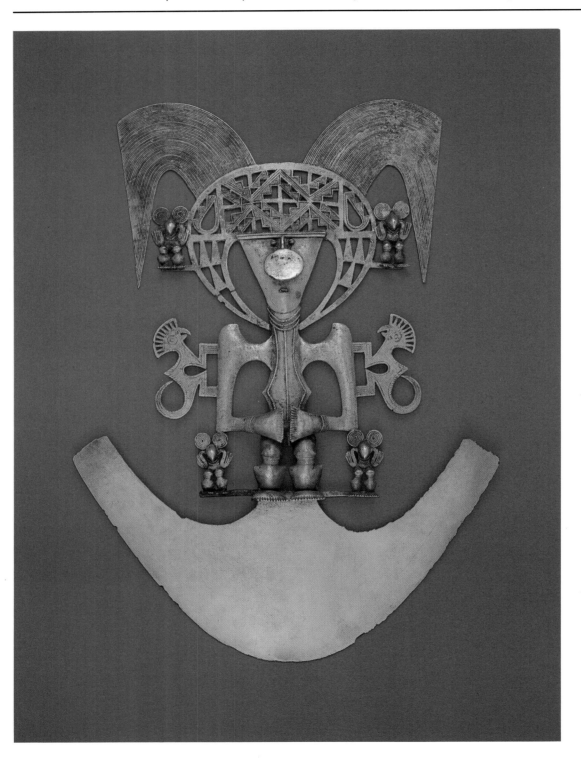

538 🐦

HUMAN FIGURE PENDANT WITH HEADDRESS

Popayán (Cauca)
cast, hammered, and gilded gold-copper alloy
29.8 (11¾)

The Trustees of the British Museum, London

The Popayán or Cauca style of gold work has two principal images: the human figure and a spread-winged bird of prey, perhaps a falcon or an eagle. These two icons merge into one another to produce intermediate forms (human-headed birds, winged humans, eagles wearing necklaces). These make clear reference to the themes of human-animal transformation, extracorporeal flights, and drug-induced visions that lie at the heart of shamanistic practices everywhere in the New World.

This pendant is one of the finest of the Popayán group. The central figure has a lizardlike body and wears a nose disc of the kind common in burials from the region. The main personage is accompanied by subsidiary creatures: two bird-headed quadrupeds and four bird-headed humans. These may represent the shaman's spirit helpers. The pendant is part of a collection of objects found by a treasure hunter in a cemetery of shaft and chamber tombs at the Hacienda de la Marquesa, Timbío, department of Cauca, Colombia. The tombs also yielded a necklace of gold frogs, a gold bird, two nose ornaments, and nine effigy pots (see cat. 540). W. B.

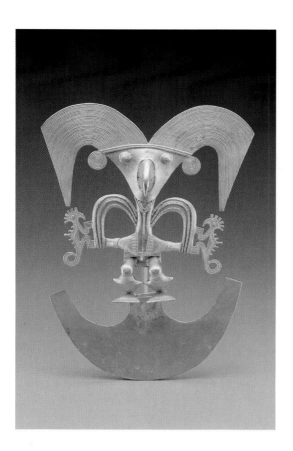

539 ❧

Pendant Figure with Headdress

Popayán (Cauca)
cast and hammered gold
16.5 x 12.1 (6½ x 4¾)

Museo del Oro, Banco de la República, Bogotá

This is one of the few pieces of this type that
is cast in highly refined gold. It was worked
in two parts that were then joined under the
figure's legs. C.P.

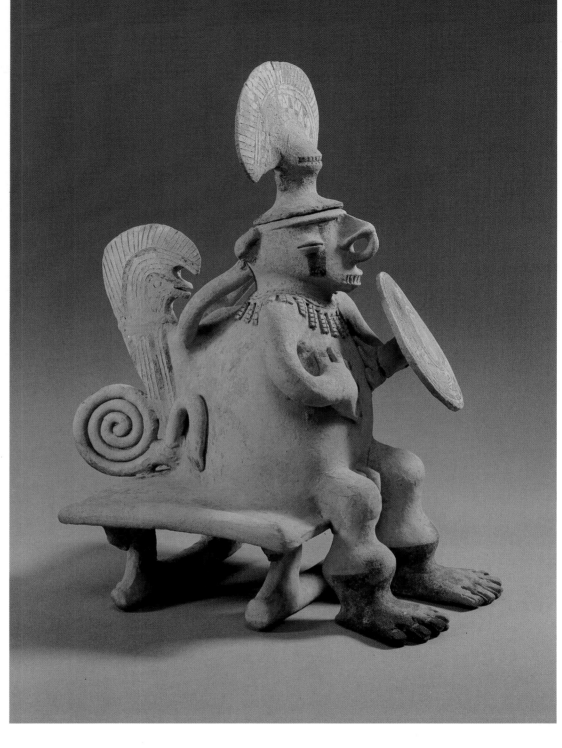

540 ❧

Effigy Vessel

Popayán (Cauca)
painted earthenware
38.1 (15)

Denver Art Museum

This object is from the same cemetery as the gold
pendant (cat. 538) and represents a warrior hold-
ing a shield and seated on a low stool. The head-
dress forms a removable lid, and the vessel may
have served as a burial urn. The geometrical,
triangular designs painted on the shield are re-
peated in the metalwork of the Popayán group and
are one of the defining characteristics of this style.
On the back of the human body is a strange crea-
ture with a coiled tail, an alter ego figure repre-
senting a shaman's animal soul or spirit-helper.

W.B.

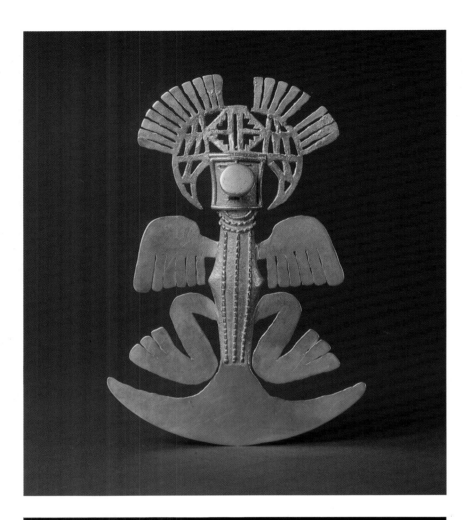

541 &

BIRD-MAN PENDANT

Popayán (Cauca)
cast and hammered gold or gold alloy
13.3 (5¼)

National Museum of the American Indian,
Smithsonian Institution

This Popayán pendant is closely related to cat. 538 and represents the bird-man variant of the form. The body and limbs are those of a lizard or crocodile; the wings and feathered crest belong to a bird; the human face is provided with a nose disc. This item is reported to have come from Manizales, in the department of Caldas, Colombia. If the provenance is correct, the pendant was found more than two hundred miles from its place of manufacture. W.B.

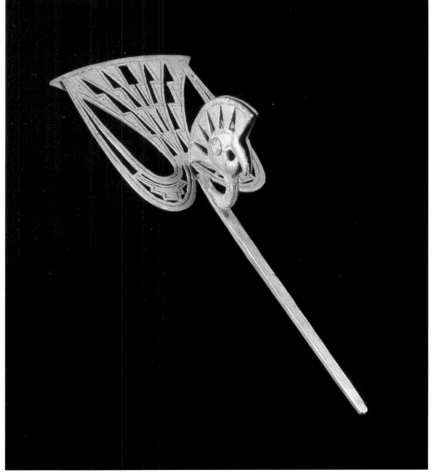

542 &

BIRD

Popayán (Cauca)
cast and hammered gold
13.65 (5⅜)

Jan Mitchell and Sons, New York

The crested bird is a recurrent image in Popayán metalwork (compare the head of this piece with those of the bird quadrupeds on cat. 538), but this example is unique in its treatment of the theme. The bird appears to be in motion, a falcon diving toward its prey, and the wings and body are reduced to an openwork plaque, which simultaneously gives the impression of feathers and repeats the triangular motifs characteristic of Popayán art. The whole effect is achieved with a beautiful economy. Seen from an oblique angle the object appears to be a three-dimensional bird, but when it is held vertically the bird head merges into an abstract geometrical pattern. The function of this item is uncertain; it may have been a lime spatula, a headdress ornament, or even the finial of a wooden staff. W.B.

MUISCA

The Muiscas, the last of the pre-Hispanic inhabitants of the central Colombian high plateau, created hundreds of works in gold and copper, the earliest of which date from the seventh century A.D., according to numerous carbon 14 tests of clay and carbon core materials (Falchetti 1989).

In Muisca society many works in gold were intimately linked to religious practices. Most of the pieces found on the plateau are objects of a type known as tunjos. These were not items of jewelry but rather offerings to the gods, created to be hidden away in sacred places. Most tunjos do not represent deities but rather the animals, people, and artifacts of the everyday world. They are often depicted with absolute accuracy.

The groups of votive objects that have been discovered consist of cast figurines, ranging in number from five to thirty. These votive objects were generally deposited in ceramic vessels that have been found concealed under stone slabs in open areas not associated with dwellings or burial places. They have also been found in caves or in settings of great natural beauty.

Most of the tunjos have a triangular or elongated form and were thus intended to be set directly on the floor or placed within the elongated ceramic vessels (London 1986; Plazas 1987).

The offerings were made through the chiefs or priests, who functioned as mediators between those making the offerings and the gods. When examined carefully, the tunjos appear to represent, within certain specified conventions, a sort of language for requesting divine assistance or giving thanks for such aid. The recognizable types include warriors, masculine figures in attire that probably identifies their rank, women holding their children or the objects associated with chewing coca, miniature versions of their various adornments, scenes of political and social life, and animals of religious significance such as condors, serpents, and jaguars. The specific type of figure was evidently connected with the benefit being requested from the gods.

Soon after production these objects were deposited in the place of offering and for this reason were not given the surface gilding common in other pre-Hispanic traditions of gold work. The votive function of the tunjos made the undisguised presence of copper in the images acceptable. Most of the Muisca pieces are flat and have no core. They were cast by the lost-wax process in individual molds, a means of production that was a consequence of the evident popular demand (Plazas 1975).

The tunjos are a curious expression of man's need to communicate. There is a tacit vocabulary of bodily adornment to which much pre-Hispanic gold work belongs; the tunjos, however, represent a different sort of language, one that is explicit and immediate. On the whole, the images follow an original and very specific aesthetic formula. The figures' large heads contrast with their minute extremities and belongings. The marked changes in scale that often differentiate participants in the same scene and the exaggeration of some of the figures' physical characteristics go beyond a merely descriptive function to express the deeper spiritual meaning of the offering. Even though the figures often seem naive and disproportionate, they achieve their objective very effectively.

543 🐍

CACIQUE ON A LITTER

Muisca
cast gold
8.3 x 22.6 (3¼ x 8⅞)

Museo del Oro, Banco de la República, Bogotá

The importance of the chief represented in this piece can be measured by his size and his complex headdress. This piece was found in a cave near Pasca (Cundinamarca), fifty kilometers (thirty-one miles) south of Bogotá, along with the famous Muisca raft that represents the ceremony of El Dorado. C.P.

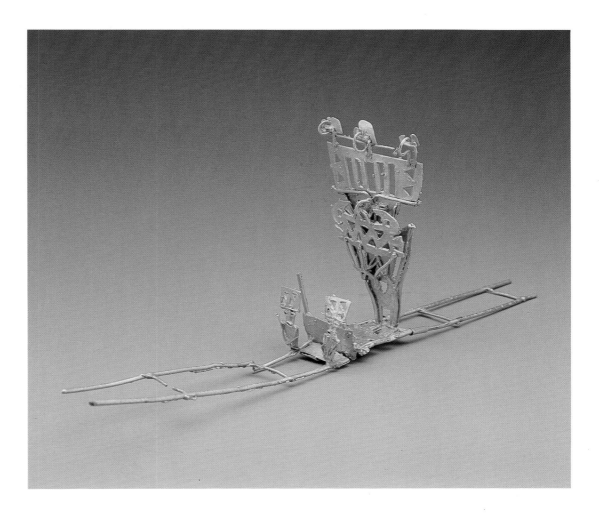

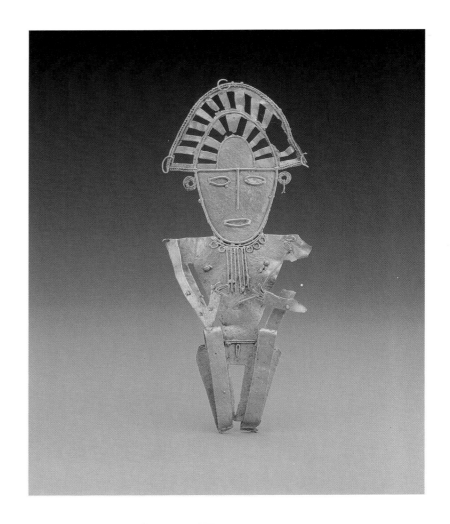

544 ᘓ

MALE FIGURE WITH LARGE HEADDRESS

Muisca
cast gold
15 x 6 (5⅞ x 2⅜)

Museo del Oro, Banco de la República, Bogotá

This obviously important personage, who also
wears necklaces of gold beads crossed on his chest,
carries a spear-thrower, a scepter, and a vessel
adorned with two birds. The goldsmith has
specifically emphasized the figure's genitals.

C.P.

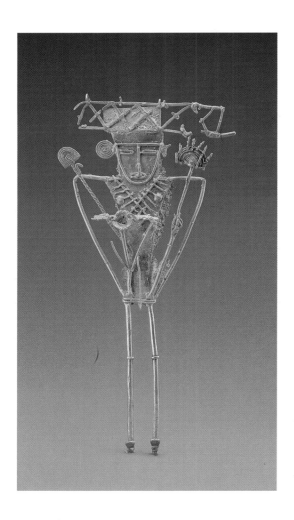

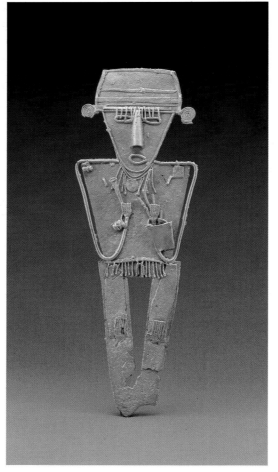

some of the scenes and their elaborate attire indi-
cate their important position in Muisca society.
Muisca leaders inherited power through maternal
lineage and lived in the homes of their maternal
uncles.

In her left hand this figure carries a stick with a
bird at the end, a device used for extracting lime
from a lime flask, used in coca chewing. C.P.

545 ᘓ

WOMAN WITH COMPLEX HEADDRESS

Muisca
cast gold
15.9 x 6.6 (6¼ x 2⅝)

Museo del Oro, Banco de la República, Bogotá

Representations of the female figure are common
among Muisca votive offerings. Their size in

546 ᘓ

WOMAN HOLDING A SCEPTER

Muisca
cast gold
19.2 x 6.5 (7½ x 2½)

Museo del Oro, Banco de la República, Bogotá

This figure, found at the border between the
Muisca region and the eastern plains, holds a
scepter in her left hand and has tiny bundles on
her shoulders. Fringes are repeated in her head-
band and skirt.

C.P.

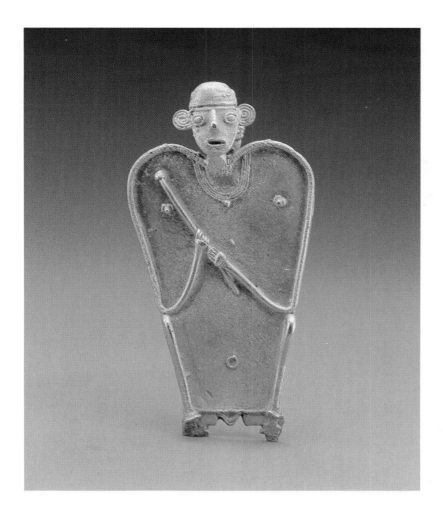

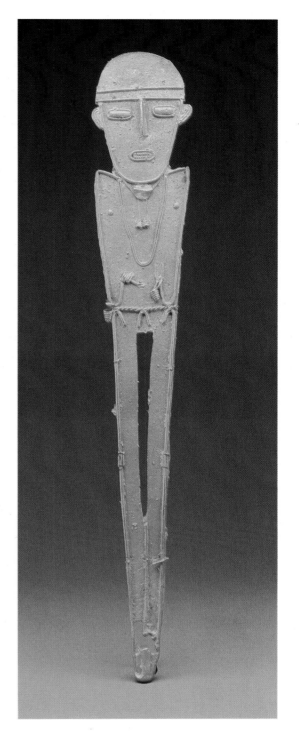

547

WOMAN HOLDING A CHILD AND A SCEPTER

Muisca
cast gold
9.2 x 4.6 (3⅝ x 1¾)

Museo del Oro, Banco de la República, Bogotá

This *tunjo* represents a squatting woman, carrying a child on her back and a scepter in her hands.

C.P.

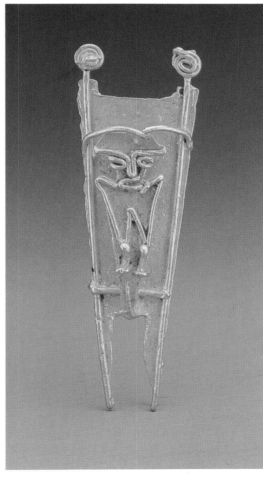

548 ཟ

BABY IN A CARRIER

Muisca
cast gold
5.5 x 1.8 (2⅛ x ¾)

Museo del Oro, Banco de la República, Bogotá

Babies in baby carriers can appear alone, as in this *tunjo*, or held by their mothers in their arms or on their backs.

C.P.

549 ཟ

LARGE FEMALE FIGURE

Muisca
cast gold
28.5 x 4.1 (11¼ x 1⅝)

Museo del Oro, Banco de la República, Bogotá

This figure's bulging eyes give her a mysterious appearance. She wears adornments on her neck and has small bundles hanging from her left shoulder.

C.P.

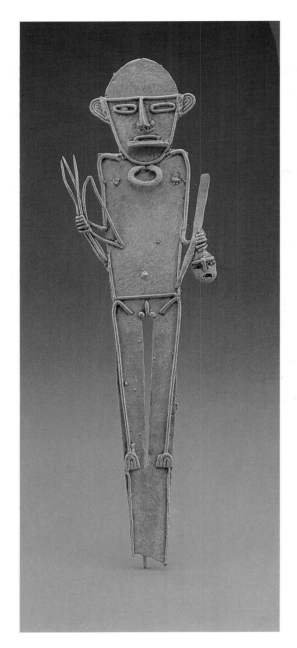

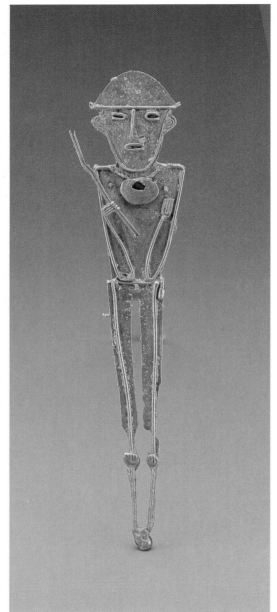

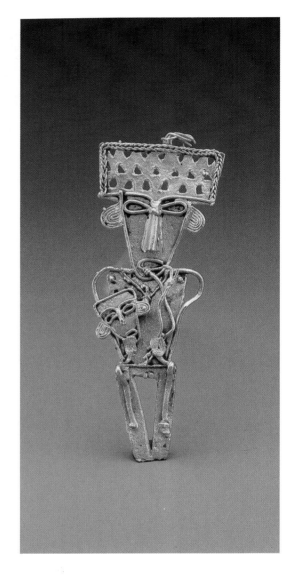

550–553 ᘐ

Four Warrior Figures

Muisca

550: Warrior Holding a Bow and Arrow
cast cold-copper alloy
11.9 x 3.2 (4⅝ x 1¼)

551: Warrior with Spear Thrower
cast gold
13.2 x 2.4 (5⅛ x 1)

552: Warrior with Head Trophy
cast gold
6.6 x 2.4 (2⅝ x 1)

553: Squatting Warrior
cast gold
8 x 4.2 (3⅛ x 1⅝)

Museo del Oro, Banco de la República, Bogotá

The early Spanish chroniclers described the fierce *güecha* warriors who protected the Muiscas from their hostile neighbors. According to Fray Pedro Simon: "Because these Panche Indians are so bellicose and the enmity between them and the Muiscas so inflamed, those of Bogotá had some Indians they called *güechas* in the villages bordering the Panches.... These [warriors] were men

with strong bodies, brave, agile, determined and valiant, who received wages and promotion for being the best soldiers. They had cropped hair and pierced ears and noses. Around the outer edges of their ears there were holes with many small tubes of the finest gold; the holes of the lips and nose were intended for the same purpose, but here they only placed small tubes when they killed Panche Indians, thus for each Panche they killed they wore a small tube of fine gold on their noses and lips" (Simon 1625).

These figures are characteristic of the *güecha*. They are generally portrayed with cropped hair and a plaque in the mouth. According to the

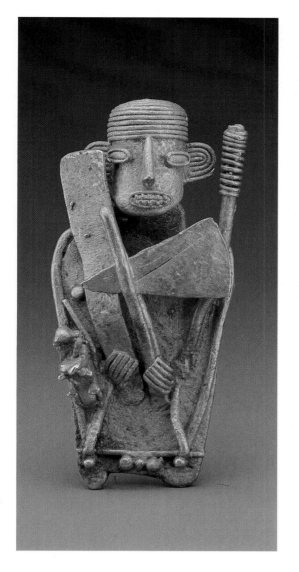

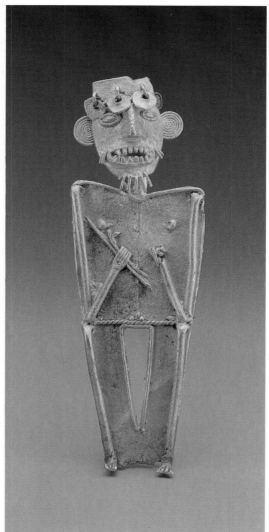

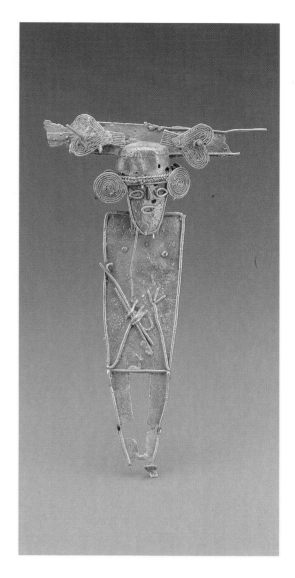

chroniclers Juan de San Martin and Alonso de Lebrija, "If the Panches capture Indians from Bogotá, they would kill and then eat them; and if those from Bogotá kill or capture any of them, they would take their heads to their land and place them in their places of worship" (San Martin and Lebrija 1539).

The squatting warrior is armed with a hatchet, a truncheon, and a club. His wounded prey is depicted to his right.　　　　　　　C.P.

554 ᘒ

STANDING WARRIOR

Muisca
cast gold
12 x 3.9 (4¾ x 1½)

Museo del Oro, Banco de la República, Bogotá

The spear thrower and dart in the right hand of this figure were the characteristic weapons of the Muiscas. The skin around his lips is perforated with gold wires. The figure's ferocity is also represented by his teeth, which are filed into triangles.　　　　　　　C.P.

555 ᘒ

DEAD WARRIOR

Muisca
cast gold
10.3 x 5.3 (4 x 2)

Museo del Oro, Banco de la República, Bogotá

This figure carries a spear thrower and darts in his right hand. On his featureless face is a mask with a headdress with two birds, whose flight symbolizes communion with the beyond.　　　　　　　C.P.

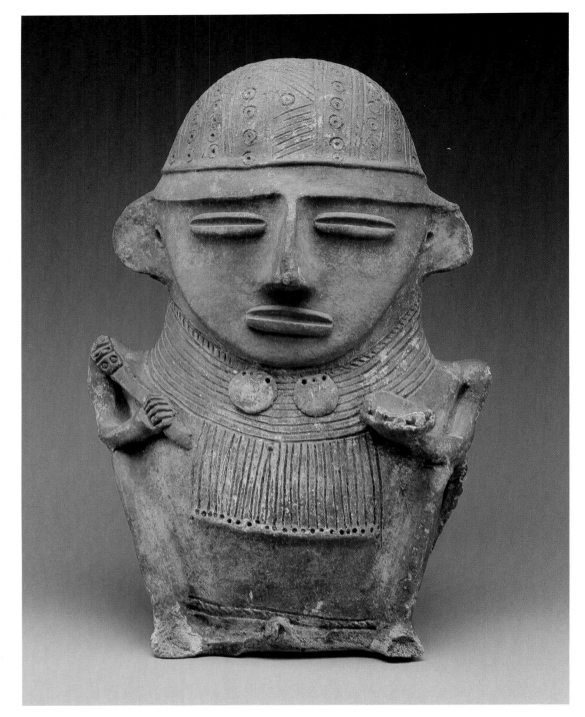

556 ða

FIGURINE HOLDING OFFERINGS

Muisca
earthenware
37.5 x 26.5 (14¾ x 10⅜)

Museo del Oro, Banco de la República, Bogotá

The ceramic figure, broad and generous like
Mother Earth, probably comes from a secret
offering place. These were holes in the ground
that were thought of as entry points for fertilizing
the earth with gold offerings, as were lagoons
and caves. C.P.

557–558 ða

TWO CAST-GOLD OFFERINGS

Muisca

557: CUP
0.9 x 3 (⅜ x 1⅛)

558: SCEPTER
7.9 x 0.9 (3⅛ x ⅜)

Museo del Oro, Banco de la República, Bogotá

These tiny gold votive offerings are similar to the
cup and scepter held by the earthenware figure
(cat. 556). C.P.

559–560 ≽

TWO JAGUARS

Muisca
cast gold
5.7 x 10 and 3.1 x 7.1 (2¼ x 4 and 1¼ x 2¾)

Museo del Oro, Banco de la República, Bogotá

The Muisca made votive images of the jaguar, the supreme golden animal whose power makes it comparable to the sun, and thus to gold itself. Yet Muisca jaguars are not aggressive in appearance. On occasion, as in the case of one of the present examples, their whiskers are exaggeratedly long, giving them the appearance of dragons, a confusion that is compounded by the fact that the excess metal remaining from the casting channel looks like a serpent's tail. C.P.

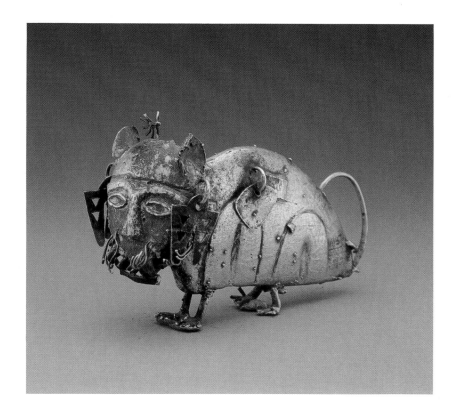

561 ≽

DEER

Muisca
cast gold
1.8 x 2.5 (¾ x 1)

Museo del Oro, Banco de la República, Bogotá

Among the Muisca, eating venison was a privilege reserved for the chieftains, as was wearing mantles hand-painted with designs similar to those that decorate this *tunjo*. C.P.

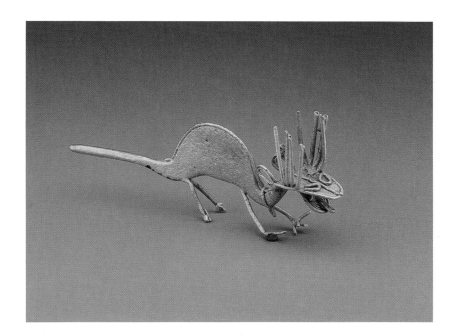

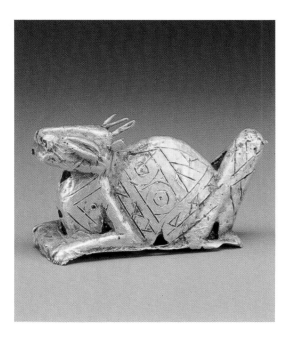

562 ⧉

TURTLE

Muisca
cast gold
8 x 3.9 (3⅛ x 1½)

Museo del Oro, Banco de la República, Bogotá

This creature is rarely represented in pre-Hispanic art from this part of the Americas, even though it was an essential part of man's diet in many regions, such as the Caribbean coastal plain. It may be that the turtle's flesh was reserved for the chieftains, as we know was the case with that of deer and birds of prey, a circumstance which would make the animal all the more appropriate as a subject for an offering. C.P.

563–564 ⧉

TWO SNAKES

Muisca
cast gold
11.43 (4½) and 11.11 (4⅜)

Jan Mitchell and Sons, New York

Unlike most *tunjos*, which depict their subjects with absolute accuracy, snake *tunjos* often have elements such as ears, limbs, or whiskers that are never found on living serpents. The offerings may therefore represent mythical creatures. One Muisca myth tells how the goddess Bachúe (beneficent female) emerged from a lake with her infant son, whom she married when the child came of age. The couple had many children. With these Bachúe populated the land; then, exhorting them all to live in peace, she and her son-husband reentered the lake in the form of snakes. In Muisca religion serpents were associated with sacred lakes, which were also places where offerings were deposited.

These two serpent *tunjos* are cast by the lost-wax process. The button at the end of each tail is the residue of metal left in the mold after pouring. The serpent with whiskers at the mouth has ears and a twisted braid design along the body. The underside is flat. The other snake *tunjo* has front legs with tiny toes. The head has round eyes, small ears, and whiskers. The lower jaw is formed by a semicircular element attached below the head, and the mouth is open. W.B.

565 ⧉

SNAKE

Muisca
cast gold
4 x 4.1 (1½ x 1⅝)

Museo del Oro, Banco de la República, Bogotá

To the present-day Chibcha, the serpent rolled up into a spiral is a symbol of life and movement. In mythology, the snake was the first wife of the sun, condemned to keep its serpentine shape for having committed adultery. C.P.

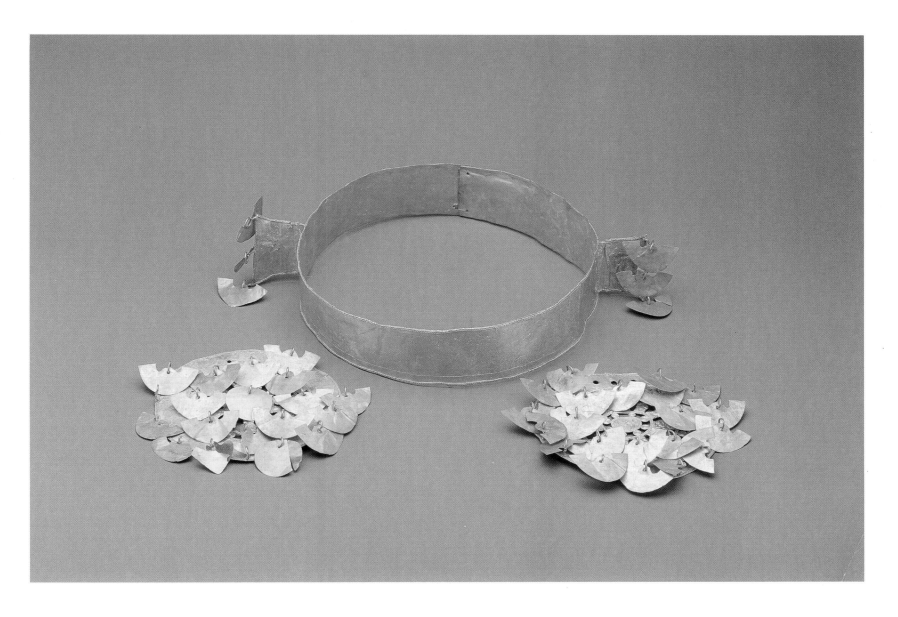

566–567 ❧

DIADEM AND EAR ORNAMENTS

Muisca
cast gold

566: *6.5 x 22.8 (2½ x 8⅞)*

567: *11.1 x 12.2 and 11.2 x 13.2*
(4⅜ x 4¾ and 4⅜ x 5⅛)

Museo del Oro, Banco de la República, Bogotá

Compared to the numerous *tunjos* that have been found, few gold ornaments exist today that were used by the elite of Muisca society for the display of power. However, among these objects of jewelry are a number of pectorals, nose ornaments, earrings, and headdresses of great beauty.

The large gold diadem with lateral projections and the two earrings, which formed part of the same funerary offering, were found in a tomb in the vicinity of Sogamoso (department of Boyacá), where the cacique of Tunja lived. These pieces were cast using the lost-wax process, and the anthropomorphic designs were imprinted with molds that had been carved in stone. The pendant plaques were hammered separately.　C.P.

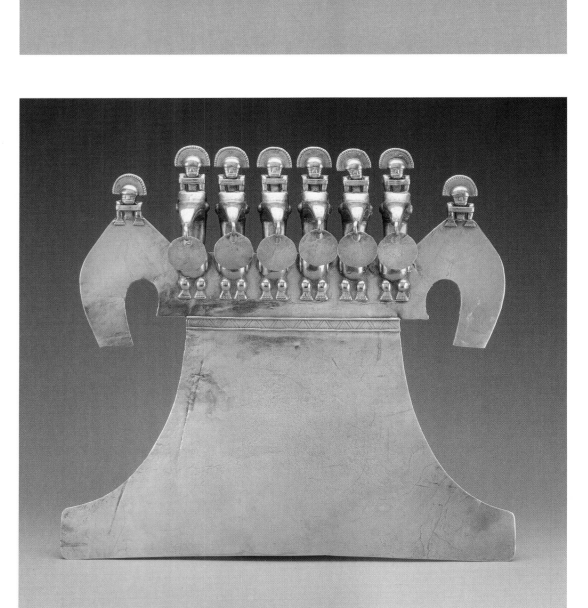

568

NOSE ORNAMENT

Muisca
cast gold
9.3 x 17.1 (3⅝ x 6¾)
Museo del Oro, Banco de la República, Bogotá

The decoration of this cast piece consists of two serpents with bird's heads at each end. C.P.

569

PECTORAL

Muisca
cast gold-copper alloy
21 x 22.5 (8¼ x 8⅞)
Museo del Oro, Banco de la República, Bogotá

This extraordinary pectoral, found in Guatavita (Cundinamarca), is composed of a stylized bird with the tail spread. Above are six bird bodies with six figures crouching on top and two others on the wings, making a total of eight human figures. These may represent political chiefs.

It appears that this work is an allegory of political power. Similar pendants are known from the Tairona area, where groups living today still speak dialects of the Chibcha language, which was spoken by the Muiscas and the Taironas. Like the present-day U'wa, who live in the Sierra Nevada del Cocuy, the Muiscas and Taironas conceived of their political and social power in the form of a single body, represented by the bird, headed by the different clan chiefs. C.P.

A WORLD UNITED

J.H. Elliott

On September 9, 1522, eighteen gaunt men, candles in hand, walked bare-footed to the shrine of Santa María de la Victoria in Seville to give thanks for their safe return. It was just over three years since they had commended themselves to the Virgin in that same shrine, on the eve of their departure as members of an expedition which was intended to reach the spice islands by sailing west, rather than east, and somehow finding a way around, or through, the great landmass of America. During the course of those three years they accomplished their mission, but at a terrible cost. Mutinous crews were struck down by cold, hunger and scurvy; their commander, the Portuguese-born Fernando Magellan, was killed by angry islanders on a Pacific beach; and, of the five ships which formed part of the original expedition, only one, the *Victoria*, limped home to Seville with its much diminished crew. But these lone survivors had done something that had never before been accomplished. In their battered little ship, under the command of a dour Basque captain, Sebastián Elcano, they had circumnavigated the world.

Thirty years separated the departure of Columbus from Palos, in Andalusia, and the return of the *Victoria* to Seville's port of San Lúcar de Barrameda. At the start of those thirty years, Europe was still largely confined between the twin barriers of an impassable Atlantic Ocean to the west, and of a remote and alien Asian landmass to the east. By the end of them, Europeans had rounded the coasts of Africa to reach India and the Moluccas; they had encountered lands and peoples, quite outside the realm of their preconceived ideas and expectations, on the far side of the Atlantic; and now, after navigating a storm-swept passage to the south of Patagonia, they had crossed the great expanse of the Pacific Ocean and found their way back home.

The immediate effect of these three decades of unprecedented achievement was to give those Europeans who were interested in such matters a new and overwhelming sense of the size of the world. Columbus, it soon became apparent, had grossly underestimated the distance between Europe and Cathay; and Antonio Pigafetta, the Italian Knight of Rhodes who had sailed aboard the *Victoria* on its epic voyage, recorded with awe that, after leaving the Strait of Magellan, "if we had sailed always westward, we should have gone without finding any island other than the Cape of the Eleven Thousand Virgins, which is the cape of that strait at the Ocean Sea."[1] The Europeans, in other words, had found space, and found it on an unimagined scale. But, paradoxically, even as their world expanded, it also began to shrink. A globe encompassed became a globe reduced.

Indeed the very attempt to map the lands and seas of the world through the device of the globe may have helped to reduce unmanageable space to manageable proportions. The first known terrestrial globe was that of Martin Behaim of Nuremburg, dating from 1492. The first globe to record Magellan's route was made, also in Nuremburg, around 1526, and appears in Holbein's famous painting of *The Ambassadors* (National Gallery, London) of 1533. In selecting as his device a globe surmounted by an eagle, the Emperor Charles v was paying unconscious tribute to this new European conceptualization of space—a conceptualization that became increasingly routine as the sixteenth century progressed. To see the world in terms of a globe was to hold it in one's hands. In 1566, when St. Francis Borja sent his son the gift of a sphere, the youth wrote back in his letter of thanks to his father: "Before seeing it, I had not realized how small the world is."[2]

A globe held in the hands is a globe controlled, and to be able to follow, with the twist of a sphere, the voyages of fellow-Europeans and see at a glance the lands they had settled was to participate, however vicariously, in that sensation of power already generated by the voyages themselves and by the conquests of peoples and territories. The arrogance of the European as he contemplated the newly mapped world was nicely caught in the engraved frontispiece to the *Milicia y descripción de las Indias* published in 1599 by a Spanish captain, Bernardo de Vargas Machuca, that portrayed him holding a pair of compasses over a globe, while the accompanying motto consisted of the immortal words: *A la espada y el compás / Más y más y más y más* ("To the compass and the sword, more and more and more and more"). Domination and expansion—these were to be the leading themes of the post-Columbus generations of Europeans as they moved to exploit the legacy of 1492.

These Europeans who moved out across the world during the course of the sixteenth century, trading, settling, evangelizing, and—all too often—killing, tended to see themselves as superior beings, providentially enjoying, and, where possible, diffusing, the supreme blessings of Christianity and civility. To the non-European peoples, on the other hand, into whose world they had trespassed, they naturally appeared in a very different light. Arriving in their curious high-prowed ships, they looked, with their pointed beards, their bulbous doublets and tall hats —the "hat men" as they were called in India[3]—like strange, and often sinister, intruders, unpleasantly prone to seize what was not rightfully theirs. Although, in the perspective of time, they can be seen as pioneers of global unity, breaking down the

fig. 1. Bernado de Vargas Machuca, frontispiece, *milicia y descripción de las Indias* (1599). The New York Public Library, Astor, Lenox, and Tilden Foundations

barriers of separation and bringing all the peoples of the world into contact with each other, they erupted into non-European space as if they already owned it, bringing untold misery, death and destruction in their train. Embarking all unaware on a process that would lead to the creation of one world, they gave every impression of wanting to mold that world in the image of themselves. An early sixteenth-century Spanish humanist said as much when we wrote of Columbus that he "sailed from Spain . . . to mix the world together and give to those strange lands the form of our own."[4]

Europeans were to prove less successful in giving those "strange lands" the form of their own in Asia than in the Americas, where the great organized empires of the Aztecs and the Inkas succumbed before their onslaught. However elaborate those empires, and however sophisticated many of their cultural and technical achievements, their isolation from other centers of civilization left them dangerously vulnerable to attack by peoples whose attitudes, behavior and technologies were a cause of mystification and astonishment. Europe and Asia, on the other hand, had a long-standing, if mutually wary, relationship, and the same was true for North Africa. For a long time the Portuguese, who were followed to Asia by the Dutch and the English, were able to do little more than establish coastal enclaves for themselves, from which they were forced to compete on roughly equal terms with peoples whose political, military and commercial skills matched or excelled their own.

Everywhere these sixteenth-century Europeans went, however, they created lesser or greater disturbances, setting up ripples that were liable to grow into whirlpools. Only Australasia would remain excluded, for the better part of three centuries, from these ripples of disturbance that marked the opening of a new and multiplying range of connections among peoples dispersed over wide portions of the globe. If, by 1600 or even 1700, this was still very far from being a European world, it was none the less a world in which Europeans, both by design and by accident, were acting as the precipitants of change.

European overseas expansion meant, in the first instance, a movement of peoples. During the sixteenth century some 240,000 men and women migrated from Spain to America, while roughly the same number of Portuguese (largely young men) migrated to Asia, the overwhelming majority never to return.[5] Europeans, however, even if still no more than a trickle of them, were not the only peoples to be caught up in the process of overseas migration. Africans, too, were involuntarily to be swept up in a movement generated by the settlement of growing numbers of Europeans on the farther shores of the Atlantic.

By the fifteenth century, Portuguese traders along the coast of West Africa had become aware of the profits to be made in purchasing Africans and shipping them abroad—either to Lisbon for domestic service in Spanish and Portuguese households, or to the newly settled Atlantic islands where sugar was being planted. By a process of natural extension this lucrative trade in African slaves spread across the Atlantic to those areas where, for one reason or another, the indigenous peoples of America proved unsuited to the kind of labor required by European settlers eagerly exploiting the mineral and agricultural resources of their newly occupied lands. As a result, during the sixteenth century a network was woven of commerce in human chattels—a network that bound together in mutual complicity chieftains and traders in the Kingdom of Kongo and the African interior with merchants in Seville and Lisbon, settlers in Mexico and Peru, and sugar growers in Brazil. Already by 1600 some 275,000 black slaves had been transported to Europe and America, and five times as many would be shipped in the century that followed.[6]

This great transoceanic movement of human beings meant the development of new racial mixtures as Europeans, Asians, Africans and indigenous Americans cohabited and intermarried, producing offspring of such a wide variety of colors that in eighteenth-century Spanish America there was a vogue for series of paintings depicting different racial combinations, each with its own particular name. The effect of the contact of peoples in this dawning Oceanic Age, however, was not confined to the transfer of genes. There was another and more sinister legacy, for the contact of peoples meant the spread of disease.

Europe and Asia, united by land, had for millennia shared each other's epidemics, and it was the Europeans who succumbed to disease when increasing numbers of them sought to make a life for themselves in an unfamiliar Asian climate and environment. In America, however, it was a different story. Isolated from the great pandemics that periodically swept the Euro-Asian landmass, the native peoples of America proved terrifyingly vulnerable to newly imported European diseases—smallpox, measles, influenza—to which Europeans had developed some degree of immunity. The consequence was that, within a century of Columbus' landfall, the indigenous population of mainland America had shrunk by about 90%, and the Taínos who populated the Antilles at the time of his arrival had become extinct. The Europeans may have carried back with them from the Americas the scourge of syphilis, but in exchange they wiped out a world.[7]

The union of peoples, therefore, meant a union of germs, as death danced its macabre dance around the globe. But death came in many forms, and not least by war. In their dealings with non-European peoples, Europeans displayed from the beginning a marked predisposition to seize their territories, and to back up their commercial ventures by force of arms. It was to the sound of gunfire that European merchants fanned out across the world. In the words of the Malay Annals describing the Portuguese attack on Malacca in 1511, "the noise of the cannon was as the noise of thunder in the heavens and the flashes of fire of their guns were like flashes of lightning in the sky: and the noise of their matchlocks was like that of groundnuts popping in the frying-pan."[8]

The superior military technology of the Europeans brought them immediate advantages, especially in America, where the shock effect of guns and horses played a significant psychological role in the early, and critical, stages of the Spanish conquest. But Asia already belonged to the gunpowder culture, and Europe's initial superiority in military technology soon showed itself to be a diminishing asset. The Ottoman armies rapidly adopted and mastered European hand guns and field guns; by the late sixteenth century many soldiers in the armies of the Mughals were armed with muskets; and, farther east, the Chinese possessed their own indigenous firearms, while the Japanese imported and successfully copied European cannon.[9] Guns, no less than germs, were spreading across the globe.

The aggressive behavior of these gun-carrying Europeans—described as "white Bengalis" by the astonished inhabitants of Malacca when the first Portuguese vessel arrived in port[10]—was a source of bewilderment and consternation everywhere they went. "What is it," the King of the Tartars is said to have asked a party of Portuguese, "that you are looking for in those other lands? Why do you expose yourself to such great hardships?" After the Portuguese spokesman had done his best to explain, the old Tartar shook his head and remarked: "The fact that these people journey so far from home to conquer territory indicates clearly that there must be very little justice and a great deal of greed among them."[11]

The greed of fifteenth- and sixteenth-century Europeans for gold, silver, spices, and subsequently for land, was indeed what had induced them, in the sage words of the Tartar, to "fly all over the waters in order to acquire possessions that God did not give them." It was an impelling force, and one that enabled them, as they

mastered the world wind system,[12] to develop a series of trading routes that came to span the globe.

One maritime route, pioneered by the Portuguese, ran around the coast of Africa and across the Indian Ocean to the South China Sea, to compete directly, and with increasing success, against the overland spice and silk routes that had long linked Europe to the markets of the East. Another, the monopoly of the Spaniards, ran from Seville to the Caribbean and thence to the ports of Vera Cruz in Mexico and of Cartagena in present-day Colombia. This was the route that supplied the American colonists with European goods, and made possible the return shipment, by way of exchange, of the Mexican and Peruvian silver needed to replenish the coffers of European princes and merchants, and to pay for the deficit trade between Europe and Asia. In the Indian Ocean as much as in Europe or America the Spanish silver *real*, minted in the mines of Zacatecas or Potosí, became a coveted unit of exchange. To the Spanish Atlantic, revolving around the regular annual flow of American silver to Europe, was joined a Portuguese Atlantic—the Atlantic of sugar and slaves— running from Lisbon to West Africa and the Azores, and thence to Brazil. Into this Iberian-dominated Atlantic the English, the Dutch and the French, arriving first as interlopers, would infiltrate with increasing success.

In 1565 the last remaining section of what was to be a global transoceanic trade was fitted into place when the first Spanish galleon sailed back across the Pacific from Manila to unload a cargo of cinnamon on the coast of Mexico. This voyage marked the beginning of the regular sailing of the ''Manila galleon'' between Acapulco and Manila. Outward bound from Mexico it carried the silver needed for the purchase of the products of China and the East—silks, porcelains and spices, jade and mother-of-pearl— which were brought by fleets of junks to the Philippines, and then shipped in the Spanish galleon to Acapulco, from where they would be dispatched to the luxury markets of America and Europe.[13] Saluting Acapulco in his poem of 1604 on the greatness of his native Mexico, the poet Bernardo de Balbuena wrote: ''In thee Spain is joined with China, Italy with Japan, and ultimately a whole world in disciplined commerce.''[14]

Balbuena's words vividly suggest how, with the development of these long-distance trading systems, all four continents—Europe, Asia, Africa and America—were moving into a closer reciprocal relationship as suppliers and recipients. Oriental luxuries—Persian carpets, Chinese porcelains, Javanese pepper and cloves

fig. 2. Lorenzo Vaccaro, *Allegorical Figure of America*, 1692, silver, The Cathedral, Toledo

—found their way in growing quantity into the homes of the European elite. African ivories, carved in ways that reflected the presence and the tastes of the Portuguese, who had penetrated far into the interior, and intermarried with Africans to form Afro-Portuguese communities, were brought back to Europe as prized curiosities (see cat. 63–71). European manufactures—textiles and firearms—penetrated the markets of Asia, where Portuguese was becoming the language of international maritime trade.[15] But Asia's appetite for commodities from Europe, other than silver, was much smaller than the insatiable European appetite for the products of the East. In spite of the arrival of Portuguese merchants in the Persian Gulf, the Indian Ocean and the Straits of Malacca, they and their fellow-Europeans in the sixteenth century were simply one more group of competitors, if outlandish ones, jostling in on long-established local trading networks, and buying and selling as best they could.

For all the dynamism and aggressiveness of the ''hat men,'' they were swallowed up in the vastness of Asia, with its teeming populations

and its long-established ways. To the extent that they were accepted there, they were accepted for their silver, and this silver would not have been available to them in such quantities without Spain's exploitation of the mines of Mexico and Peru. To the extent that the sixteenth century saw the inauguration of a ''world economy,'' it was the Spanish conquest and settlement of the silver-producing regions of Central and South America that made possible the beginnings of economic integration on a global scale.

Cruelly wrenched from its isolation by the arrival of the Spaniards, America—symbolized in the allegories of the four continents that began to appear from the 1570s, as a naked woman with feather headdress, seated on an armadillo, and sometimes surrounded by the exotic flora and fauna of a strange new world[16] —was tied hand and foot to Europe in ways that Asia could never be. Occupied, governed, evangelized and exploited by Europeans, the Antilles and the vast mainland regions of Central and South America were drawn inexorably into the orbit of a European world determined

to remake them in its own "superior" image. Native Americans were introduced to the technology of iron, and the wheel. New crops and animals were imported from Europe. For the settlers the absence of bread was tantamount to starvation, and wheat was planted where maize once grew. "The Indians," observed a Spanish official, "should not be made to grow wheat, for this causes them great hardship. They do not understand how wheat is grown, and do not have plows."[17] Little by little the Spaniards "improved" on American nature, with their sugar plantations, their vineyards, and their olive groves—nostalgic reminders of the world they had left. Similarly, they imported their own animals—horses, sheep, cattle, pigs, hens and goats—drastically upsetting in the process both the pattern of indigenous life and work, and the ecological balance of the conquered lands.[18]

The transfer, however, was not all one way. In opening America to the imports of Europe, Europe opened not only itself but the rest of the world to those of America—not merely precious metals, or emeralds from Colombia and Venezuelan pearls, but plants and foodstuffs which in the course of time would add enormously to the range, and nutritional value, of the European—and African—diet. None, except perhaps tobacco, had an immediately dramatic effect on the habits of the Europeans, but beans, maize, and—above all—the potato made the transatlantic crossing, with profound long-term consequences for the eating habits, and the demography, of a Europe that stretched from Ireland to the Urals.

By incorporating a hitherto isolated America into the beginnings of a global economic and ecological system, the Columbian voyages made a contribution of overwhelming importance to the creation of a single world. But if this was to be a world united, was the unity to be imposed on European terms? The expansionary character of European civilization, its lust for wealth, its desire to dominate and to convert, certainly pointed in that direction. Yet from the beginning there was resistance, sometimes open and sometimes concealed. Militant Christianity faced a formidable rival in militant Islam, championed in North Africa and on the fringes of Europe by an Ottoman empire which, in the sixteenth century, was at the height of its power. In the complicated religious world of the Indian sub-continent Christian teaching made only very limited headway, while China remained impervious and largely impenetrable to the West. Among the twenty million inhabitants of Japan, the Jesuits had made some 300,000 converts by the early seventeenth century, but the brief flirtation of the Japanese

with the western world ended in 1639 when the Portuguese were expelled and the country closed itself to westerners and their pernicious offerings.

Even in Iberian America, where an intense missionary effort was buttressed by the full weight of the secular power, there was in many regions a sullen resistance that took a thousand forms. While the new faith gained enthusiastic converts, especially in Mexico, the tendency among the indigenous populations was to appropriate those elements of the conquerors'

5 *Frumentum Indicum luteum.*
Yellow Turkie Wheate.

6 *Frumentum Indicum aureum.*
Gold coloured Turkie Wheate.

7 *Frumentum Indicum rubrum.*
Red Turkie Wheate.

8 *Frumentum cæruleum & album.*
Blew and white Turkie Wheate mixed

fig. 3. "Maize" from John Gerard, *The Herbal or Generall Historie of Plantes* (London, 1597). Cleveland Medical Library Association

religion that suited their needs. Old deities and old shrines still retained their sacred aura and were assimilated into new and distinctively American forms of Christianity with their own syncretic rituals and systems of belief. Worship of the Virgin Mary might replace that of Coatlicue, but this had always been a world that took the metamorphosis of the gods in its stride.

It would take a vastly superior European technology, and a capacity for the control of space far beyond sixteenth-century logistical possibilities, for a united world to become even superficially a European world. In so far as this was achieved at all, it would be achieved only in the nineteenth century. But—irrespective of the sheer technical difficulties in the way of global domination, whether political, cultural or economic—sixteenth-century European civilization itself possessed certain characteristics

that impeded its best efforts to "give to those strange lands the form of our own."

In the first place, this was a civilization that had grown accustomed to the idea of diversity. Divided into competing political units—and also, from the sixteenth century, into competing religious units —Renaissance Europe was a pluralist society, with none of the monolithic central control that characterized the contemporary Ottoman and Chinese empires. While having no doubt of the superiority of its own religion and way of life, it was less dismissive of the "barbarians" beyond its own borders than was the Chinese world. Debates within the medieval church had led to the conclusion that non-Christian societies legitimately enjoyed property and lordship, and that Christians could therefore claim no automatic right to dispossess non-believers of their lands.[19] When the Spanish occupation of America reopened the debate, the leading Spanish scholastic of the age, Francisco de Vitoria, reaffirmed this doctrine, and argued that the indigenous Americans, by demonstrating their capacity for social life, had proved themselves "citizens of the whole world, which in a certain way constitutes a single republic."[20]

Once it was accepted that these newly encountered peoples were entitled, at least in theory, to space of their own, they were simply added in the European mind to the wide variety of peoples with whom the globe was shared. The Italians, after all, were different from the French, and the French from the English, and they all spoke different languages. Therefore it was taken for granted that these peoples, living in different climes and conditions, would have their own peculiar characteristics and ways of life, however strange or repugnant they might seem to European eyes. Their form of dress (or undress), their sexual mores, their differing styles of worship made them exotic specimens to be added to the many already to be found in that encyclopedic compilation by Johann Boemus, *Omnium gentium mores*, first published in 1520 before the peoples of America had seriously impinged on the European consciousness.[21]

Given this acceptance of human diversity, which was put down to climate and geography, there were limits to the necessity, as well as the feasibility, of imposing European norms on the peoples of the world. Strenuous, and surprisingly successful, efforts might be made by Spanish friars in Mexico to persuade the male inhabitants to clothe themselves in trousers, but this was because the loincloth offended Christian ideas of decency.[22] In other areas of behavior, less offensive to Christian views of a proper way of life, there was less pressure to conform. Here the characteristic European re-

sponse of disapproval was liable to be accompanied by curiosity.

The curiosity with which Europeans approached the non-European world was reflected in the journals of voyagers like Pigafetta or Verrazano, who described with fascination the customs of the peoples whom they came across in their travels. This curiosity suggests a degree of openness in sixteenth-century European civilization. At times it showed itself willing to be impressed, as Dürer was impressed by the beauty of the objects brought back from Mexico in Motecuhzoma's treasure, and by the skill of native craftsmen in working gold and silver. Such reactions suggested that Europe would not remain immune to the cultural influences of the non-European world, even if the principal reaction in the sixteenth century was more often astonishment or wonder than the desire to emulate.[23]

This responsiveness to certain aspects of non-European culture was reinforced in some quarters by a growing sense of guilt. While the arrogance that sprang from an innate sense of superiority was liable to predominate in the dealings of Europeans with non-Europeans, there were some, both at home and overseas, whose scruples of conscience made them question the behavior and motivations of their fellow-Europeans. Above all it was a growing realization of the fate that was overtaking the inhabitants of the Indies at the hands of the Spaniards that provoked the first stirrings of conscience in European minds. These stirrings will be forever associated with the name of Bartolomé de Las Casas, the Spanish friar who, after witnessing in the Caribbean and mainland America the sufferings of the Indians, devoted the rest of his long life to denouncing the behavior of his compatriots, and expatiating on the social and cultural achievements of the people who, even as he wrote, seemed set for extinction.[24]

The combination of an awareness of diversity, an intense curiosity, and the growing sense of guilt that characterized sixteenth-century European thought at its best, was nowhere better represented than in the essays of that sceptical Frenchman, Michel de Montaigne, who was prompted by his reading of Gómara's account of the conquest of the Indies to reflect on Europe's record in its encounter with the non-European world: "So many goodly cities ransacked and razed; so many nations destroyed and made desolate; so infinite millions of harmelesse peoples of all sexes, states and ages, massacred, ravaged and put to the sword; and the richest, the fairest and the best part of the world topsiturvied, ruined and defaced for the traffick of Pearles and Pepper...."[25]

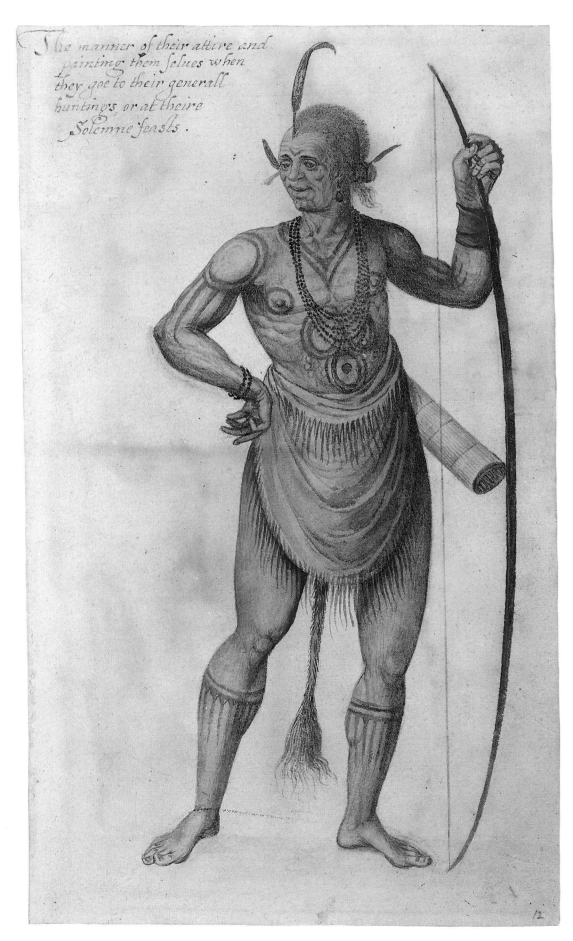

fig. 4. John White, *An Indian Painted for the Hunt*, c. 1585, watercolor, Trustees of the British Museum, London

651

As the silver of the Indies and the luxuries of the East flowed into a Europe which was growing accustomed to looking to worlds across the seas to minister to its appetites and needs, there could be no turning back to an earlier age of more limited, and less exploitative, contacts between European and non-European. For both good and ill, the age of European maritime expansion, so spectacularly inaugurated by the voyage of Columbus, had brought the world closer together in ways that would forever change it.

Montaigne's contemporary and compatriot, Henri de La Popelinière, asked why it was that the Europeans of his age should have chosen to risk their lives, riches, honor and conscience to "trouble the ease of those who, as our brethren in this great house of the world, asked only to live the rest of their days in peace and contentment."[26] La Popelinière's question is one that still haunts us today. Europeans would shake the "great house of the world" to its foundations as they ransacked it in the pursuit of what they perceived as their own best interests. Greed, arrogance, dogma—all these played their part. But there was a more generous spirit alive also in that European civilization which, even as it destroyed, began to build a new, and more interdependent, world. That spirit was best expressed in the declaration of Las Casas, which, along with the question of La Popelinière, reverberates down the centuries. "All the peoples of the world," wrote Las Casas, "are men; and there is only one definition of each and every man, and that is that he is rational."[27] That, too, was a legacy of 1492.

NOTES

1. Antonio Pigafetta, *Magellan's Voyage*, trans. and ed. R. A. Skelton, 2 vols. (New Haven, 1969), 1:58.
2. François de Dainville, *La géographie des humanistes* (Paris, 1946), 92, n. 3.
3. Bernard Lewis, *The Muslim Discovery of Europe* (New York, 1982), cited James D. Tracy, *The Rise of Merchant Empires* (Cambridge, 1990), 4.
4. Hernán Pérez de Oliva, *Historia de la invención de las Yndias*, ed. José Arrom (Bogotá, 1965), 53–54.
5. For Spanish America, see Woodrow Borah, "The Mixing of Populations," and Magnus Mörner, "Spanish Migration to the New World prior to 1800," in Fredi Chiappelli, ed., *First Images of America*, 2 vols. (Berkeley, 1976), 2:707–722 and 737–782. For the Portuguese in Asia, see G. V. Scammell, *The World Encompassed* (Berkeley, 1981), 292.
6. Eric R. Wolf, *Europe and the People Without History* (Berkeley, 1982), 195.
7. A recent overview of the impact of Europeans on the demography of the non-European world is to be found in Alfred W. Crosby, *Ecological Imperialism. The Biological Expansion of Europe, 900–1900* (Cambridge, 1986), ch. 9. For syphilis, see the same author's *The Columbian Exchange* (Westport, Ct., 1972), ch. 4.
8. *Sějarah Mělayu or Malay Annals*, trans. C. C. Brown (Oxford, 1970), 162.
9. See Geoffrey Parker, *The Military Revolution* (Cambridge, 1988), ch. 4, for a valuable brief survey of the military encounter between Europe and the non-European world.
10. *Malay Annals*, 1970, 151.
11. Fernão Mendes Pinto, *The Travels of Mendes Pinto*, ed. and trans. Rebecca C. Catz (Chicago, 1989), 254.
12. Philip D. Curtin, *Cross-Cultural Trade in World History* (Cambridge, 1984), 136.
13. See William Lytle Schurz, *The Manila Galleon* (1939; repr. New York, 1959).
14. Benardo de Balbuena, *Grandeza Mexicana*, cited in *El Galeón de Acapulco* (Instituto Nacional de Antropología e Historia, Museo Nacional de Historia, Mexico City, 1988), 78.
15. Curtin, 1984, 143.
16. See Hugh Honour, *The New Golden Land* (New York, 1975), 85–91.
17. Alonso de Zorita, *The Lords of New Spain*, trans. Benjamin Keen (Rutgers, 1963), 251.
18. See Crosby, 1972, ch. 3.
19. See James Muldoon, *Popes, Lawyers and Infidels* (Philadelphia, 1979).
20. Cited by J. H. Elliott, *The Old World and the New, 1492–1650* (Cambridge, 1970), 45–46.
21. For Boemus, see Margaret T. Hodgen, *Early Anthropology in the Sixteenth and Seventeenth Centuries* (Philadelphia, 1964; repr. 1971), 134–143.
22. Charles Gibson, *The Aztecs Under Spanish Rule* (Palo Alto, 1964), 336.
23. Nicole Dacos, "Présents Américains à la Renaissance. L'assimilation de l'exotisme," *Gazette des Beaux-Arts*, VIᵉ période, lxxiii (1969), 57–64.
24. For Las Casas and his writings see especially Lewis Hanke, *The Spanish Struggle for Justice in the Conquest of America* (Philadelphia, 1949).
25. "Des Coches," in *The Essayes of Michael Lord of Montaigne*, trans. John Florio (1603) (London, 1928), 3:144.
26. *Les Trois Mondes* (Paris, 1582), 38.
27. Cited in Elliott 1970, 48.

NOTES TO THE READER

Dimensions are given in centimeters followed by inches in parentheses. Unless otherwise specified, height precedes width precedes depth.

Short references in the text will be cited in full at the end of the catalogue.

TOWARD CATHAY:

Chinese is here transcribed according to the *pinyin* system; in quotations from texts using another transcription, the Chinese has been converted to *pinyin* and set in square brackets.

Japanese is here transcribed according to the Hepburn system.

Korean is here transcribed according to the McCune-Reischauer system.

All East Asian personal names are cited in traditional fashion, surname followed by given name. Chinese monastic names are hyphenated.

Emperors of Ming China are commonly referred to not by their personal names but by an auspicious era-name chosen for each reign — the Yongle (Perpetual Happiness) emperor, the Zhengde (True Virtue) emperor. The reign-era, however, was never precisely synchronous with the reign itself: it was usually proclaimed some months after the enthronement and continued in use until the succeeding emperor, some time after *his* enthronement, proclaimed a new reign-era. (Thus the Hongzhi emperor was enthroned in 1487 and died in 1505, but the Hongzhi reign-era began in 1488 and ended in 1506.)

Buddhist temples are called *Si* in Chinese. In Japanese they are *-ji* or *-dera*, with *-in* and *-an* denoting a subtemple and *-dō* an individual hall within a temple compound. Shinto shrines are *-gu*, *jinja*, and *taisha*, in ascending order of importance.

Dates are given according to the solar calendar.

Left and *right* mean viewer's left and right when referring to paintings, reliefs, and all objects *except* figural sculptures, for which they mean proper left and right.

With a few exceptions, the objects in this exhibition date between about 1450 and about 1550. During this time the Ming dynasty ruled China, under the reigns of emperors referred to by their auspicious era-names:

Jingtai (1450–1456) ⎱ Jingtai and Tianshun
Tianshun (1457–1464) ⎰ fall within the period
Chenghua (1465–1487) commonly called
Hongzhi (1488–1505) "interregnum"

Zhengde (1506–1521)
Jiajing (1522–1566)

In Japan the century between 1450 and 1550 falls within the Muromachi (or Ashikaga) period, the former name referring to the locale of the shogunal palace in Kyoto, the latter being the surname of the shogunal family.

Korea during this century was ruled by the Chosŏn dynasty (sometimes referred to as the Yi dynasty, after the surname of the ruling house).

THE AMERICAS:

Spellings of Aztec and Inka words are in the modern orthography of their languages, Nahuatl and Quechua respectively.

Dates of objects made in Central and South America are approximately as follows: Aztec, 1450–1521; Taíno, 13th–16th c.: Inka, c. 1400–1530; Diquís, 1430–1532; Tairona, 800–1600; Sinú, 600–1600; Popayán, 1000(?)–1600; Muisca, 700–1600.

Since the titles for objects that appear in this catalogue in the "Lands of Gold" section are not necessarily those used by the lending institutions, we include, for the reader's convenience, the following concordance of catalogue numbers and inventory numbers supplied by the lenders:

475	J001	496	975
476	14682	497	1287
477	1245	498	811
478	1250	499	612
479	1253	503	16584
480	1421	504	LT-697
481	963	505	16146
482	751	506	S.N.
483	1566	507	23820
484	962	508	16387
485	1273	509	ConT.388
486	456	510	21215
487	428	511	12563
488	1551	512	HT123
489	594	513	16388
490	976	514	20278
491	1289	514	20279
492	1297	515	13693
493	1246	515	13694
494	423	516	11683
495	1277	517	22819

518	26128
519	20289
520	CS12857
521	10/507
522	9/2106
524	6444
525	7504
526	32791
527	28952
528	33035
529	SA 2735
530	SA 2702
531	SA 2703
532	SA 2704
533	SA 2705
534	25805
534	25804
535	20291
536	21358
536	21359
537	6375
538	1938.7-6.1
539	6414
541	15/3168
543	11374
544	6266
545	78
546	1927
547	2022
548	11289
549	32867
550	296
551	2050
552	28695
553	6755
554	6365
555	1861
556	CM12799
557	28538
558	6918
559	1115
560	28513
561	33078
562	1116
563	SL85129
564	SL85153
565	32850
566	19535
567	19536
567	19537
568	124
569	125/3

REFERENCES

I. Europe and the Mediterranean World

Abiodun 1989
Abiodun, Rowland. "The Kingdom of Owo." In *Yoruba—Nine Centuries of African Art and Thought*. By Henry John Drewal and John Pemberton III. Edited by Allen Wardwell. New York, 1989, 93–115.

Aguas 1987
Aguas, Neves. *Roteiro da Primeira Viagem de Vasco da Gama*. Lisbon, 1987.

Aguiar 1962
Aguiar, António de. *A Genealogia iluminada do Infante Dom Fernando por Antonio de Holanda e Simão Bening: estudo histórico e crítico*. Lisbon, 1962.

Alexander and Kalus, forthcoming
Alexander, David, and Ludwik Kalus. *Catalogue of the Swords in the Topkapı Sarayı*. Forthcoming.

Alexander 1977
Alexander, Jonathan J. G. *Italian Renaissance Illuminations*. London, 1977.

Alldridge 1901
Alldridge, T. J. *The Sherbro and Its Hinterland*. London, 1901.

Almagià 1940
Almagià, Roberto. "I Mappamondi di Enrico Martello e alcuni concetti geografici di Cristoforo Colombo." *La Bibliofilia* 42 (1940), 288–311.

Alvarez de Almada 1946
Alvarez de Almada, André. *Tratado Breve dos Rios de Guiné do Cabo Verde*. Lisbon, 1946.

Alves 1985
Alves, Ana Maria. *Iconologie do Poder Real no Período Manuelino*. Lisbon, 1985.

Ameisenowa 1959
Ameisenowa, Zofia. *The Globe of Martin Bylica of Olkusz and Celestial Maps in the East and the West*. Translated by Andrzej Potocki. (Polska Akademia Nauk, Komitet Historii Nauki, Monografie z dziejów nauki i techniki 11). Wroclaw, Kraków, and Warsaw, 1959.

Andaloro 1980
Andaloro, Maria. "Costanzo da Ferrara. Gli anni a Costantinopoli alla corte di Maometto II." *Storia dell'Arte* 12 (1980), 185–212.

Angulo Iñiguez 1954
Angulo Iñiguez, Diego. "Pintura del Renacimiento." *Ars Hispaniae* 12 (1954).

Anzelewsky 1971
Anzelewsky, Fedja. *Albrecht Dürer. Das malerische Werk*. Berlin, 1971.

Anzelewsky and Mielke 1984
Anzelewsky, Fedja, and Hans Mielke. *Albrecht Dürer: Kritischer Katalog der Zeichnungen (Staatliche Museen preussischer Kulturbesitz)*. Berlin, 1984.

Ara Gil 1977
Ara Gil, Clementina Julia. *Escultura gotica en Valladolid y su provincia*. Valladolid, 1977.

Aragão 1974
Aragão, A. C. Teixeira de. *Descripção Geral e Historia des Moedas cunhadas em nome dos Reis, Regentes e Governadores de Portugal*. Vol. 1. Lisbon, 1974.

Arberry 1967
Arberry, Arthur A. *The Koran Illuminated. A Handlist of Korans in the Chester Beatty Library*. Dublin, 1967.

Arcangeli 1942
Arcangeli, Francesco. *Tarsie*. Rome, 1942.

Arnáez 1983
Arnáez, Esmeralda. *Orfebrería religiosa en la provincia de Segovia*. 3 vols. Madrid, 1983.

Arnould 1991
Arnould, Alain. "An Art Historical Context for the Library of Raphael de Mercatellis." Ph.D. dissertation. Ghent, 1991 (forthcoming).

Asselberghs 1968
Asselberghs, J. P. *La tapisserie tournaisienne au XVI siècle*. Exh. cat. Halle au ble. Tournai, 1968.

Aslanapa 1982
Aslanapa, Oktay. "Osmanlı devri cilt sanatı." *Türkiyemiz* 38 (1982), 12–17.

Atasoy and Çağman 1974
Atasoy, Nurhan, and Filiz Çağman. *Turkish Miniature Painting*. Istanbul, 1974.

Atıl 1973
Atıl, Esin. "Ottoman Painting Under Mehmed II." *Ars Orientalis* 9 (1973), 103–120.

Atıl 1981
Atıl, Esin. *Renaissance of Islam. Art of the Mamluks*. Washington, 1981.

Attali 1982
Attali, Jacques. *Histoire du Temps*. Paris, 1982.

Avery 1986
Avery, Charles. "Donatello Celebrations: A Major Exhibition at Detroit, Fort Worth and Florence." *Apollo* 123 (1986), 14–18.

Avril et al. 1982
Avril, François, Jean-Pierre Aniel, Mireille Mentré, Alix Saulnier, and Yolanta Zaluska. *Bibliothèque nationale. Manuscrits enluminés de la péninsule ibérique*. Paris, 1982.

Avrin 1979
Avrin, Leila. "The Spanish Passover Plate in the Israel Museum." *Sefarad* 39 (Madrid, 1979), 27–46.

Ayers 1985
Ayers, John. "The Early China Trade." In *The Origins of Museums*. Edited by Oliver Impey and Arthur MacGregor. Oxford, 1985, 259–266.

Azcárate 1958
Azcárate, José María. "Escultura del siglo XVI." *Ars Hispaniae* 13 (1958).

Babelon 1924
Babelon, E. *Les antiques et les objets d'art*. Paris, 1924.

Babinger 1951
Babinger, Fr. "Bajezid osman (Calixtus Ottomanus), ein Vorläufer und Gegenspieler Dschem-Sultâns." *La Nouvelle Clio* 3 (1951), 349–388.

Bacci 1976
Bacci, M. *L'Opera completa di Piero di Cosimo*. Milan, 1976.

Bagrow and Skelton 1964
Bagrow, Leo, and Raleigh Asblin Skelton. *History of Cartography*. London, 1964.

Baião and Azevedo 1905
Baião, António, and Pedro Azevedo. *O Archivo da Torre do Tombo. Sua História, Corpos que o compõem e organização*. Lisbon, 1905.

Baldass 1959
Baldass, Ludwig von. *Jheronimus Bosch*. Vienna-Munich, 1959.

Baldi 1724
Baldi, B. *Memorie concernenti la città di Urbino* (c. 1588). Urbino, 1724.

Baltimore 1952
The World Encompassed. An Exhibition of the History of Maps. Exh. cat. Baltimore Museum of Art. Baltimore, 1952.

Baltimore 1989
Wiech, Roger S., and Eric M. Zafran. *Splendor of the Popes*. Exh. cat. The Walters Art Gallery. Baltimore, 1989.

Baltimore Museum of Art 1949
Baltimore Museum of Art. *Illuminated Books of the Middle Ages and Renaissance*. Baltimore, 1949.

Bambach Cappel 1987

**Bambach Cappel, Carmen. "Michelangelo's Cartoon for the Crucifixion of St. Peter Reconsidered." *Master Drawings* 25 (1987), 131–143.

Bambach Cappel 1990
Bambach Cappel, Carmen. "Review of Michael Hirst's 'Michelangelo and His Drawings.'" *Art Bulletin* 72 (1990), 493–498.

Barelli 1964
Condivi, Ascanio. *Vita di Michelangelo Buonarroti* (1553). Edited by E. Spina Barelli. Milan, 1964.

Barga 1870
Barga, Teófilo. "Uma salva de prata cinzelada." *Era Nova* (1870).

Barişta 1981
Barişta, Örcün. *Osmanlı Imperatorluk Dönemi Türk işlemelerinden örnekler*. Ankara, 1981.

Barocchi 1962
Vasari, Giorgio. *La Vita di Michelangelo* (1550 and 1568). Edited by P. Barocchi. 5 vols. Milan and Naples, 1962.

Barreto 1880
Barreto, J. A. da Graça. *A Descoberta da India Ordenada em Tapeçaria por mandado de El-Rei D. Manuel, documento inédito do séc. XVI publicado em comemoração do 3° centenário de Camões*. Coimbra, 1880.

Barrett 1949
Barrett, Douglas. *Islamic Metalwork in the British Museum*. London, 1949.

Basel 1974
Koepplin, Dieter, and Tilman Falk. *Lucas Cranach: Gemälde, Zeichnungen, Druckgraphik*. Exh. cat. Kunstmuseum Basel. Basel, 1974.

Bassani 1975
Bassani, Ezio. "Antichi avori africani nelle collezioni Medicee." *Critica d'Arte* 143, 144 (1975), 69–80; 8–23.

Bassani 1981
Bassani, Ezio. "Due grandi artisti Yombe—Il Mº della maternità Roselli-Lorenzini e il Mº della Maternità De Briey." *Critica d'Arte-Africana* 178 (1981), 66–84.

Bassani and Fagg 1988
Bassani, Ezio, and William B. Fagg. *Africa and the Renaissance: Art in Ivory*. New York, 1988.

Bassani and Tedeschi 1990
Bassani, Ezio, and Letizia Tedeschi. "The Image of the Hottentot in the Seventeenth and Eighteenth Centuries. An Iconographic Investigation." *Journal of the History of Collections* 2 (1990), 157–186.

Battisti 1971
Battisti, Eugenio. *Piero della Francesca*. Milan, 1971.

Battisti and Ubans 1971
Battisti, Eugenio, and J. Ubans. "Note sulla prospettiva rinascimentale." *Art Lombarda* 16 (1971), 106–107.

Bax 1979
Bax, Dirk. *Hieronymus Bosch: His Picture-Writing Deciphered* (Translation of *Ontcijfering van Jeroen Bosch*. The Hague, 1948). Rotterdam, 1979.

Bayramoglu 1983
Bayramoglu, Fuat. *Haci Mayram-i Veli. Yasam-Soyu-vakfi*. Vols. 1, 2. Ankara, 1983.

Beckwith 1972
Beckwith, John. *Ivory Carvings in Early Medieval England*. London, 1972.

Behling 1975
Behling, Lottlisa. "Eine 'Ampel'-artige Pflanze von Albrecht Dürer. Cucurbita lagenaria L. auf dem Hieronymus-Stich von 1514." In *Zur Morphologie und Sinndeutung kunstgeschichtlicher Phänomene*. Cologne, 1975, 122–127.

Behling 1989
Behling, Lottlisa. "Zur Ikonographie einiger Pflanzendarstellungen von Dürer." *Albrecht Dürer und die Tier-und Pflanzenstudien der Renaissance. Symposium (Jahrbuch der Kunsthistorischen Sammlungen in Wien)*

82/83, 1986–1987 (1989), 43–56.

Bélard da Fonseca 1957–1967
Bélard da Fonseca, A. *O Mistério dos Painéis*. 5 vols. Lisbon, 1957–1967.

Belém 1750–1755
Belém, Frei Jerónimo de. *Chronica da Ordem Serafica de Santa Provincia dos Algarves*. Lisbon, 1750–1755.

Ben-Amos 1976
Ben-Amos, Paula. "Men and Animals in Benin Art." *Man* 2, 2 (1976), 243–252.

Ben-Amos 1980
Ben-Amos, Paula. *The Art of Benin*. London, 1980.

Bercham 1978
Bercham, Max van. "Notes 'd' archéologie arabe' III." *Opera Minora* 2 (Geneva, 1978), 1814–1815.

Berenson 1938
Berenson, Bernard. *The Drawings of the Florentine Painters*. 3 vols. London and Chicago, 1938.

Berg 1968
Berg, Judith F. "Un nuevo documento sobre Bartolomé Bermejo." *Archivo Español de Arte* 41 (1968), 61–62.

Bergasconi 1981
Bergasconi, John. "The Dating of the Cycle of the Miracles of the Cross from the Scuola di San Giovanni Evangelista." *Art Veneta* 35 (1981), 198–202.

Berlin 1989
Europa und der orient, 800–1900. Edited by Gereon Sievernich and Hendrik Budde. Exh. cat. Martin-Gropius-Bau. Berlin, 1989.

Bernardi and de Grunne 1990
Bernardi, Bernardo, and Bernard de Grunne. *Terra d'Africa, Terra d'Archeologia—La grande scultura in terracotta del Mali-Djenné VIII–XVI sec*. Rome 1990.

Bertolotti 1889
Bertolotti, A. *Le Arti minori alla corte di Mantu* Milan, 1889.

Bialostocki 1986
Bialostocki, Jan. *Dürer and His Critics, 1500–1971. Chapters in the History of Ideas Including a Collection of Texts*. Baden-Baden, 1986.

Bibliothèque Nationale 1955
Bibliothèque Nationale. *Les manuscrits à peintures en France du XIIIe au XVIe siècle*. Paris, 1955.

Blackmun 1991
Blackmun, Barbara Winston. "Who Commissioned the Queen Mother Tusks?" *African Arts* 24, 2 (1991), 55–91.

Blake 1940
Blake, John W. "The Organization of Portuguese Trade with West Africa During the Sixteenth Century." *Congresso do Mundo Português* 5, 3 (1940), 33–51.

Bober 1948
Bober, Harry. "The Zodiacal Miniature of the 'Très Riches Heures' of the Duke of Berry. Its Sources and Meaning." *Journal of the Warburg and Courtauld Institutes* 11 (1948), 1–34.

Bober and Rubenstein 1986
Bober, Phyllis Pray, and Ruth Rubenstein. *Renaissance Artists and Antique Sculpture*. Oxford and New York, 1986.

Bock 1921
Bock, Elfried. *Die deutschen Meister. Beschreibendes Verzeichnis sämtlicher Zeichnungen*. Staatliche Museen zu Berlin. Die Zeichnungen alter Meister im Kupferstichkabinett. 2 vols. Berlin, 1921.

Bode 1923
Bode, W. von. *Die italienischen Bronzestatuetten der Renaissance*. Berlin, 1923.

Boeheim 1888
Boeheim, Wendelin. "Urkunden und Regesten aus der k.k. Hofbibliothek." *Jahrbuch der kunsthistorischen Sammlungen des Allerhöchsten Kaiserhauses in Wien* 7, 1 (1888).

Boeheim 1889
Boeheim, Wendelin. *Führer durch die Waffensammlung*. Vienna, 1889, 25, no. 66.

Boeheim 1890
Boeheim, Wendelin. *Handbuch der Waffenkunde*. Leipzig, 1890.

Boeheim 1894
Boeheim, Wendelin. *Album herrvorragender Gegenstände aus der Waffensammlung des AH Kaiserhauses* 1 (1894).

Boeheim 1899
Boeheim, Wendelin. "Die Waffenschmiede Seusenhofer,

ihre Werke und ihre Beziehungen zu habsburgischen und anderen Regenten." In *Jahrbuch der Kunsthistorischen Sammlungen des AH Kaiserhauses in Wien* 20 (1899).

Boeheim 1899
Boeheim, Wendelin. *Führer durch die Waffensammlung*. Vienna, 1899.

Bologna 1988
Bologna, Giulia. *Illuminated Manuscripts. The Book before Gutenberg*. London, 1988.

Bonanni 1709
Bonanni, Filippo. *A. P. Philippo Bonanni Societatis Jesu Musaeum Kircherianum sive a P. Athanasio Kirchero in Collegio Romano Societatis Jesu Pridem inceptum Nuper restitutum auctum descriptum et iconibus illustratum*. Rome, 1709.

Born 1936
Born, Wolfgang. "Some Eastern Objects from the Hapsburg Collections." *Burlington Magazine* 69 (1936), 269–277.

Borsi 1989
Borsi, Franco. *Bramante*. Milan, 1989.

Botelho 1957
Botelho, Afonso. *Estética e Enigmática dos Painéis*. Lisbon, 1957.

Böttiger 1947
Böttiger, John. "Uma tapeçaria de Vasco da Gama no Museu Nacional de Estocolmo." *Revista de Guimãres* 1–2 (1947).

Boucher 1986
Boucher, Bruce. "Detroit and Fort Worth: Sculpture in the Time of Donatello." *Burlington Magazine* 128 (1986), 65–68.

Boudreau 1978
Boudreau, Linda C. Hults. "Hans Baldung Grien and Albrecht Dürer: A Problem in Northern Mannerism." Ph.D. dissertation. University of North Carolina, Chapel Hill, 1978.

Brachert 1970
Brachert, Thomas. "A Distinctive Aspect in the Painting Technique of 'Ginevra de' Benci' and of Leonardo's Other Early Works." *Report and Studies in the History of Art*. Washington, 1970, 84–101.

Brasio 1952
Brasio, Antonio D. *Monumenta Missionaria Africana, Africa Ocidental, 1471–1531*. Vol. 1. Lisbon, 1952.

British Museum 1882
British Museum. *Catalogue of Additions to the Manuscripts in the British Museum in the Years MDCCCLXXVI–MDCCCLXXXI*. London, 1882.

British Museum 1950
British Museum. *Italian Drawings in the Department of Prints and Drawings in the British Museum*. 5 vols. London, 1950.

British Museum 1967
British Museum, Department of Printed Books. Grenville Library. *Illuminated Manuscripts Exhibited in the Grenville Library*. London, 1967.

Brown 1990
Unpublished report of a close examination of the picture, made available to the author. National Gallery of Art. Washington, 19 April 1990.

Brown 1985
Brown, David A. "Ginevra de' Benci." *Leonardo. La Pittura*. Edited by P. Marani. Florence, 1985, 30–32.

Brown 1963
Brown, Jonathan. "Dos obras tempranas de Bermejo." *Archivo Español de Arte* 26 (1963), 269–279.

Bruhn de Hoffmeyer 1982
Bruhn de Hoffmeyer, Ada. "Arms and Armour in Spain II." *Gladius, Instituto de Estudios sobre Armas Antiguas, Tomo Especial*. Madrid, 1982.

Brummer 1970
Brummer, H. *The Statue Court in the Vatican Belvedere*. Stockholm, 1970.

Bull 1991
Bull, David. Unpublished report of a close examination of the portrait of Cecilia Gallerani (Lady with an Ermine). National Gallery of Art, Washington, 15 April 1991.

Burger 1950
Burger, D. "Old Tapestries Representing the Seven Liberal Arts." *Archives internationales d'histoire des sciences* 3, 13 (1950), 859–873.

Burgos 1496
Burgos Cathedral. Archivo Capitular. Registro 31, fol. 88r. Burgos, 1496.

Burgos 1500
Burgos Cathedral. Archivo Capitular, Cuadernos de Contabilidad. Burgos, 1500.

Burgos 1501
Burgos Cathedral. Archivo Capitular, Cuadernos de Contabilidad. Burgos, 1501.

Buser 1974
Buser, Thomas A. "The 'Pieta' in Spain." Ph.D. dissertation. New York University, 1974.

Buttin 1960
Buttin, François. "Anciennes Armes Marocaines, I. Les Adargues de Fès." In *Hseperis-Tamuda*. Vol. 1, 3. Fasc. Rabat, 1960.

Çağman and Tanındı 1979
Çağman, Filiz, and Zeren Tanındı. *Topkapı Sarayı Müzesi Islâm, minyatürleri*. Istanbul, 1979.

Caiger-Smith 1973
Caiger-Smith, Alan. *Tin-Glaze Pottery in Europe and the Islamic World*. London, 1973.

Caiger-Smith 1985
Caiger-Smith, Alan. *Lustre Pottery: Technique, Tradition and Innovation in Islam and the Western World*. London, 1985.

Cali 1967
Cali, Maria. "La 'Madonna della Scala' di Michelangelo, il Savonarola e la crisi dell'umanismo." *Bolletino d'arte* 52 (1967).

Camón Aznar 1980
Camón Aznar, José. *Alonso Berruguete*. Madrid, 1980.

Campbell 1990
Campbell, Lorne. *Renaissance Portraits*. New Haven and London, 1990.

Campbell 1983
Campbell, Marian. *Medieval Enamels*. London, 1983.

Campbell 1987
Campbell, Tony. *The Earliest Printed Maps, 1472–1500*. London, 1987.

Campos 1967
Campos, Ernesto de Sousa. *Livro de Horas. Iluminuras*. Lisbon, 1967.

Cantipratensis 1973
Cantipratensis, Thomas. *Liber de natura rerum*. Berlin and New York, 1973.

Capucci 1990
Capucci, Roberto. *Roben wie Rüstungen. Mode in Stahl und Seide*. Exh. cat. Vienna, 1990.

Carswell 1985
Carswell, John. "Blue-and-White in China, Asia and the Islamic World." In *Blue and White: Chinese Porcelain and Its Impact on the Western World*. Chicago, 1985, 27–35.

Castanheda 1924
Castanheda, Fern ao Lopes de. *História do Descobrimento e Conquista da India pelos Portugueses*. Bk. 1. Coimbra, 1924 (1st edition 1525).

Cavallo 1967
Cavallo, Adolph S. *Tapestries of Europe and of Colonial Peru in the Museum of Fine Arts, Boston*. 2 vols. Boston, 1967.

Cavalucci and Molinier 1884
Cavalucci, J., and E. Molinier. *Les Della Robbia. Leur vie et leur oeuvre*. Paris, 1884.

Chastel 1953
Chastel, André. "Marquéterie et perspéctive au XV siècle." *Revue des Arts* 3 (1953), 141–154.

Chastel 1965
Chastel, André. "Marquéterie, géometrie et perspective." In *Renaissance méridionale. Italie 1460–1500*. Paris, 1965, 244–263.

Cheles 1986
Cheles, Luciano. *The Studiolo of Urbino. An Iconographic Investigation*. Wiesbaden, 1986.

Chumovsky 1960
Chumovsky, T. A. *Trés Roteiros Desconhecidos de Ahmed Ibn-Màdjid. O piloto árabe de Vasco da Gama*. Lisbon, 1960.

Ciati 1980
Ciati, Bruna. "Cultura e società nel secondo quattrocento attraversato l'opera ad intarsio di Lorenzo e Cristoforo Lendinara." In *La Prospettiva rinascimentale*. Edited by Marisa Dalai Emiliani. Florence, 1980, 201–214

Çiğ 1971
Çiğ, Kemal. *Türk Kitab Kapları*. Istanbul, 1971.

Cinotti 1966
Cinotti, Mia. *L'opera completa del Bosch*. Milan, 1966.

Clark 1969
Clark, Kenneth. *Piero della Francesca*. 2d ed. London, 1969.

Clark and Pedretti 1968–1969
Clark, Kenneth, and Carlo Pedretti. *A Catalogue of the Drawings of Leonardo da Vinci at Windsor Castle*. 3 vols. London, 1968–1969.

Clarke 1986
Clarke, T. H. *The Rhinoceros from Dürer to Stubbs. 1515–1799*. London, 1986.

Clausse 1900–1902
Clausse, G. *Les San Gallo. Architects, peintres, sculpteurs, médailleurs XV e XVI siècles*. 3 vols. Paris, 1900–1902.

Cogliati Arano 1966/1980
Cogliati Arano, Luisa. *Disegni di Leonardo e della sua cerchia alle Gallerie dell'Accademia*. Venice, 1966, 1980.

Cohen 1988
Cohen, Evelyn M. "The Decoration of Medieval Hebrew Manuscripts." In *A Sign and a Witness: 2,000 Years of Hebrew Books and Illuminated Manuscripts*. Exh. cat. New York Public Library. New York and Oxford, 1988, 47–60.

Cole 1989
Cole, Herbert M. *Icons—Ideals and Power in the Art of Africa*. Washington, 1989.

Collection Spitzer 1890–1892
La Collection Spitzer. 6 vols. Paris, 1890–1892.

Cologne 1978–1980
Die Parler und der Schöne Stil, 1350–1400. Exh. cat. Schnütgen-Museum. 4 vols. Cologne, 1978–1980.

Concilium Basiliense 1896–1936
Concilium Basiliense. 8 vols. Basel, 1896–1936.

Conway 1889
Conway, William Martin. *Literary Remains of Albrecht Dürer*. Cambridge, 1889.

Coomans 1985
Coomans, Henry E. "Conchology Before Linnaeus." In *The Origins of Museums*. Edited by Oliver Impey and Arthur MacGregor. Oxford, 1985, 188–192.

Correia 1953
Correia, Vergílio. *Obras. Estudos de História de Arte*. Vol. 3. Coimbra, 1953.

Cortesão and Teixeira da Mota 1960
Cortesão, Armando, and Avelino Teixeira da Mota. *Portugaliae Monumenta Cartographica*. 6 vols. Lisbon, 1960.

Cortesão 1925
Cortesão, Jaime. *A História dos Painéis de S. Vicente*. Texto da conferência no MNAA (2 May). Lisbon, 1925.

Cortesão 1944
Cortesão, Jaime. *A carta de Pêro Vaz de Caminha, Cabral e as origens do Brasil*. Rio de Janeiro, 1944.

Cortesão 1979
Cortesão, Jaime. "A história nos painéis de S. Vicente." *Os Descobrimentos Portugueses*. Vol. 2, chap. 3, part 4. Lisbon, 1979.

Cortez 1968
Cortez, Russel. "Pedro Alvares Cabral e Viseu." *Panorama* 4, 27 (1968), 49.

Couto and Gonçalves 1960
Couto, João, and António M. Gonçalves. *A Ourivesaria em Portugal*. Lisbon, 1960.

Craven 1975
Craven, Stephanie. "Three Dates for Piero di Cosimo." *Burlington Magazine* (1975), 574.

De la Cruz 1976
De la Cruz, Valentín. *Arte Burgalés: Quince mil años de expresión artística*. Burgos, 1976.

Cunha 1642
Cunha, D.-Rodrigo da. *História Ecclesiástica da Igreja de Lisboa*. Lisbon, 1642.

Curjel 1923
Curjel, Hans. *Hans Baldung Grien*. Munich, 1923.

Cuttler 1957
Cuttler, Charles D. "The Lisbon 'Temptation of St. Anthony' by Jerome Bosch." *Art Bulletin* 39 (1957), 109–126.

Dalai Emiliani 1984
Dalai Emiliani, Marisa. "Figure Rinascimentali dei polie-dri Platonici. Qualche problema di storia ed autografia." *Fra Rinascimento Manierismo e Realtà. Scritti di storia dell'arte in memoria de Anna Maria Brizio*. Edited by P. Marani. Florence, 1984, 71–116.

Dalton 1907
Dalton, O. M. *Proceedings of the Society of Antiquarians* 2 ser., 21 (1907), 376–378.

Daly Davis 1977
Daly Davis, Margaret. *Piero della Francesca's Mathematical Treatises. The "Trattato d'abaco" and "libellus de quinque corporibus regularibus."* Ravenna, 1977.

Daly Davis 1980
Daly Davis, Margaret. "Carpaccio and the Perspective of Regular Bodies." *La Prospettiva rinascimentale*. Edited by Marisa Dalai Emiliani. Florence, 1980, 183–200.

Dam-Mikkelsen and Lundbaek 1980
Dam-Mikkelsen, Bente, and Torben Lundbaek. *Ethnographic Objects in the Royal Danish Kunstkammer 1650–1800*. Copenhagen, 1980.

Dapper 1668
Dapper, Olfert. *Naukeurige Beschrijvinge der Afrikaensche gewesten, van Egypten, Barbaryen, Libyen, Biledulgerid, Negroslant, Guinea, Ethiopiën, Abyssinie....* Amsterdam, 1668.

Dapper 1686
Dapper, Olfert. *Description de l'Afrique....* Amsterdam, 1686.

Dark 1973
Dark, Philip J. C. *An Introduction to Benin Art and Technology*. Oxford, 1973.

Davanzati 1986
Davanzati, Lorenzo. "La Venezia di Carpaccio. La ricostruzione computerizzata dello spazio pittorico." *Architettura* 32 (1986), 65–70.

Davidovitch 1975
Davidovitch, David. "Ceramic Seder Plates from Non-Jewish Workshops." *Journal of Jewish Art* 2 (Jerusalem, 1975), 51–54.

Deissmann 1933
Deissmann, Adolph. *Forschungen und Funde im Serai. Mit einem Verzeichnis der nicht-islamischen Handschriften im Topkapu Serai zu Istanbul*. Berlin-Leipzig, 1933.

Deluz 1988
Deluz, Christiane. *Le Livre de Jehan de Mandeville: Une 'géographie' au XIVe siècle*. Louvain-la-Neuve, 1988.

Derolez 1979
Derolez, Albert. *The Library of Raphael de Marcatellis, Abbot of St. Bavon's, Ghent. 1437–1508*. Ghent, 1979.

Destombes 1964
Destombes, Marcel. *Mappemondes, A.D. 1200–1500. Monumenta cartographica vetustioris aevi A.D. 1200–1500*. Amsterdam, 1964.

Destrée 1923
Destrée, Joseph. *Les Heures de Notre-Dame dites de Hennessy: Etude sur un manuscrit de la Bibliothèque royale de Belgique*. Brussels, 1923.

Deswartes 1977
Deswartes, Silvie. *Les enluminures de la Leitura Nova 1504–1552. Etude sur la culture artistique au temps de l'Humanisme*. Paris, 1977.

Devisse and Mollat 1979
Devisse, Jean, and Michel Mollat. "Africans in the Christian Ordinance of the World. Fourteenth to the Sixteenth Century." Vol. 2.2 of *The Image of the Black in Western Art*. Lausanne, 1979.

Dias 1982
Dias, Pedro. *A importação de esculturas de Itália nos séculos XV e XVI*. Porto, 1982 (2d edition, 1987).

Digby 1980
Digby, George Wingfield, assisted by Wendy Hefford. *Victoria & Albert Museum, The Tapestry Collection, Medieval and Renaissance*. London, 1980.

Dilke 1987
Dilke, Oswald Ashton Wentworth. "Cartography in the Byzantine Empire." In John Brian Harley and David Woodward. *The History of Cartography*, 1. Chicago and London, 1987, 258–275.

Dittmer 1967
Dittmer, Kunz. "Bedeutung, Datierung und Kulturhistorische Zusammenhänge der 'prähistorischen' Steinfiguren aus Sierra Leone und Guiné." *Baessler Archiv* N.F. 15 (1967), 183–238.

Dizionario biografico 1960–
Dizionario biografico degli Italiani. 36 vols. Rome, 1960–.

Dodgson 1922
Dodgson, Campbell. "Notes on Dürer III — The Unique Engraving at Amsterdam Attributed to Dürer." *Burlington Magazine* 40 (1922), 17–18.

Dorn 1830
Dorn, Bernhard. "Description of the Celestial Globe Belonging to Major General Sir John Malcom... Deposited in the Museum of the Royal Asiatic Society of Great Britain and Ireland." *Transactions of the Royal Asiatic Society* 2 (1830).

Dornelas 1926
Dornelas, Afonso de. *As Tapeçarias de Arzila foram para Castela por oferta deste Rei*. Lisbon, 1926.

Dornelas 1931
Dornelas, Afonso de. *Tratado Geral de Nobreza por Antonio Rodrigues principal rei de Armas "Portugal" de D. Manuel*. Porto, 1931.

Drechsler 1873
Drechsler, Adolf. *Der arabische Himmels-Globus angefertigt 1279 zu Maragha von Muhammad b. Muwajid elardhi zugehörig dem königlichen mathematisch-physikalischen Salon zu Dresden*. Dresden, 1873.

Duchâteau 1990
Duchâteau, Armand. *Benin—Tresor Royal—Collection du Museum für Völkerkunde Vienne*. Paris, 1990.

Dupré dal Poggetto 1983
Dupré dal Poggetto, Maria G. C. "La 'Città Ideale' di Urbino." *Urbino e le Marche prima e dopo Raffello*. Urbino, 1983, 71–78.

Dürer 1528
Dürer, Albrecht. *Hierin sind begriffen vier bücher von menschlicher Proportion*. Nuremberg, 1528.

Dürer 1918
Dürer, Albrecht. *Albrecht Dürers niederländische Reise*. Edited by J. Veth and S. Müller. Vol. 1. Berlin and Utrecht, 1918.

Eghareva 1953
Eghareva, Jacob A. *A Short History of Benin*. Ibadan, 1953.

Einhorn 1976
Einhorn, Jürgen Werinhard. *Spiritalis unicornis: Das Einhorn als Bedeutungsträger in Literatur und Kunst des Mittelalters*. Munich, 1976.

Eisler 1977
Eisler, Colin. *Complete Catalogue of the Samuel H. Kress Collection. European Paintings Excluding Italian*. Oxford, 1977.

El Atlas catalán 1975
El Atlas catalán de Cresque Abraham. Primera edición coimpleta en el sexcentésimo anoversario de su realización 1375–1975. Barcelona, 1975.

Elam 1981
Elam, Caroline. "Mantegna and Mantua." In London 1981, 15–27.

Elisofon and Fagg 1958
Elisofon, Eliot. *The Sculpture of Africa*. Text by William Fagg. London, 1958.

Ellis 1988
Ellis, Charles Grant. *Oriental Carpets in the Philadelphia Museum of Art*. Philadelphia, 1988.

Emison 1990
Emison, Patricia. "The Word Made Naked in Pollaiuolo's 'Battle of the Nudes.'" *Art History* (1990), 261–275.

Encyclopedia of Islam 1960–
Encyclopedia of Islam. 2d ed. Leiden and London, 1960–.

Enzo 1965
Enzo, Carli. *Il Duomo di Orvieto*. Rome, 1965.

Erginsoy 1980
Erginsoy, Ülker. "Turkish Metalwork." In *The Art and Architecture of Turkey*. Edited by Ekrem Akurgal. Fribourg, 1980, 208–221.

Estepa Diez 1984
Estepa Diez, Carlos. *Burgos en la edad media*. Burgos, 1984.

Ettinghausen 1967
Ettinghausen, R. *Treasures of Turkey*. Geneva, [1967].

Ettinghausen 1983
Ettinghausen, Richard. "Chinese Representations of Central Asian Turks." In *Beiträge zur Kunstgeschichte Asiens. In Memoriam Ernst Diez*. Istanbul, 1983, 208–222.

Ettlinger 1972
Ettlinger, Leopold. "Hercules Florentinus." *Mitteilungen des kunsthistorischen Instituts in Florenz* 16 (1972), 119–142.

Ettlinger 1978
Ettlinger, Leopold. *Antonio and Piero Pollaiuolo.* Oxford, 1978.

Eyo and Willett 1980
Eyo, Ekpo, and Frank Willett. *Treasures of Ancient Nigeria.* Detroit, 1980.

Ezra 1988
Ezra, Kate. *Art of the Dogon—Selection from the Lester Wunderman Collection.* New York, 1988.

Fabriczy 1903
Fabriczy, C. von. "Adriano Fiorentino." *Jahrbuch der K. Preussischen Kunstsammlungen* 24 (1903), 73–75.

Fagg 1957
Fagg, William. "The Seligman Ivory Mask from Benin." *Man* 57 (1957), 143.

Fagg 1959
Fagg, William. *Afro Portuguese Ivories.* London, 1959.

Fagg 1963
Fagg, William. *Nigerian Images.* New York, 1963.

Fagg 1968
Fagg, William. *African Tribal Images.* Cleveland, 1968.

Fagg 1981
Fagg, William. "Head (Mahen Yafe)." In *For Spirits and Kings—Art from the Paul and Ruth Tishman Collection.* Edited by Susan Vogel. New York, 1981.

Fahy 1965
Fahy, Everett. "Some Later Works of Piero di Cosimo." *Gazette des Beaux Arts* 54 (1965), 201–212.

Falke 1913
Falke, Otto von. *Kunstgeschichte der Seidenweberei.* Berlin, 1913.

Faraday 1929
Faraday, Cornelia Bateman. *European and American Carpets and Rugs.* Grand Rapids, Michigan, 1929.

Faria y Sousa 1680
Faria y Sousa, Manuel. *Europa Portuguesa.* Vol. 2, part 3, chap. 1. Lisbon, 1680.

Feest 1990
Feest, Christian F. "Vienna's Mexican Treasures." *Archiv für Völkerkunde* 44 (1990).

Fernandes 1951
Fernandes, Valentim. *Description de la Côte Occidentale d'Afrique (Senegal au Cap de Monte, Archipels).* Edited and translated by T. Monod, A. Teixeira da Mota, and R. Mauny. Bissau, 1951.

Fernández y González 1872, 1875
Fernández y González, F. "Espadas hispano-árabes." *Museo Español de Antigüedades* 1 (1872), 573–590; 5 (1875), 389–400.

Fernández Vega 1934–1935
Fernández Vega, P. "Dagas granadinas." *Anuario del Cuerpo Facultativo de Archiveros, Bibliotecarios y Arqueólogos* 3 (1934–1935), 360, 364–367.

Ferrandis Torres 1943
Ferrandis Torres, J. "Espadas granadinas de la jineta." *Archivo Español de Arte* 14 (1943), 142–166.

Ferrari 1939
Ferrari, Maria Cecilia. "La Geografia del Tolomeo fatta miniare del Cardinale Bessarione." *La Bibliofilia* 40 (1939), 23–37.

Figueiredo 1910
Figueiredo, José de. *O Pintor Nuno Gonçalves.* Lisbon, 1910.

Figueiredo 1926
Figueiredo, José de. *As Tapeçarias de Arzila e as Relações com os Painéis de S. Vicente.* Lisbon, 1926.

Figueiredo 1935
Figueiredo, José de. "A Natividade. Iluminura de Gregório Lopes (?) do Livro de Horas de D. Manuel." *Lusitânia* 8, 3 (1935).

Fiore-Herrmann 1972
Fiore-Herrmann, Kristina. "Das Problem der Datierung bei Dürers Landschaftsaquarellen." *Anzeiger des Germanischen Nationalmuseums* 1971–1972 (1972), 122–142.

Fischel 1913–1941/Oberhuber 1972
Fischel, Oskar. *Raphaels Zeichnungen.* Berlin, 1913–1941. Vol. 9 by Konrad Oberhuber. Berlin, 1972.

Fischer 1932
Fischer, Joseph. *Tomus prodromus to Claudius Ptolemaeus "Geographiae Codex Urbinas Graecus 82."* 3 vols. Leiden-Leipzig, 1932.

Fischer and Wieser 1903
Fischer, Joseph, and Franz Ritter von Wieser. *The Oldest Map with the Name America of the Year 1507 and the Carta Marina of the Year 1516 by M. Waldseemüller (Ilacomilus).* Innsbruck, 1903.

Fischer and Wieser 1966
Waldeesmüller. *Cosmographiae introductio* (1507). With translation by Joseph Fischer and Franz von Wieser. Ann Arbor, 1966.

Fite and Freeman 1969
Fite, Emerson David, and Archibald Freeman. *A Book of Old Maps Delineating American History from the Earliest Days down to the Close of the Revolutionary War.* First published in 1926. New York, 1969.

Fitzwilliam Museum 1967
Goodison, J. W., and G. H. Robertson. *Fitzwilliam Museum, Cambridge. Catalogue of Paintings, 1: Italian Schools.* Cambridge, 1967.

Flemming 1968
Flemming, Barbara. *Verzeichnis der orientalischen Handschriften in Deutschland XIII/1. Türkische Handschriften* 1 (1968), 36–40.

Fletcher 1989
Fletcher, Jennifer. "Bernardo Bembo and Leonardo's Portrait of Ginevra de' Benci." *Burlington Magazine* 131 (1989), 811–816.

Florence 1978
Bellosi, Luciano, and Fiora Bellini. *I Disegni antichi degli Uffizi. I Tempi di Ghiberti.* Exh. cat. Gabinetto Disegni e Stampe degli Uffizi. Florence, 1978.

Florence 1980
Firenze e la Toscana dei Medici nell'Europa del Cinquecento: La corte, il mare, i mercanti. La Rinascita della Scienza. Editoria e Società. Astrologia, magia e alchimia. Florence, 1980.

Florence 1986
Darr, Alan P., and Giorgio Bonsanti. *Donatello e i Suoi.* Exh. cat. Florence, 1986.

Fontes Ambrosiani 1956
Pacioli, Luca. *De Divina proportione.* Fontes Ambrosiani 21. facsimile edition. Milan, 1956.

Forman and Dark 1960
Forman, Werner, Bedrich Forman, and Philip Dark. *Benin Art.* London, 1960.

Fortini Brown 1988
Fortini Brown, Patricia. *Venetian Narrative Painting in the Age of Carpaccio.* New Haven and London, 1988.

França 1960
França, José-Augusto. "Nuno Gonçalves 1957." *Da Pintura Portuguesa.* Lisbon, 1960.

Fränger 1946
Fränger, Wilhelm. *Mathias Grünewald in seinen Werken.* Berlin, 1946.

Frankfurt-am-Main 1985
Türkische Kunst und Kultur aus osmanischer Zeit. Exh. cat. Museum für Kunsthandwerk. Frankfurt am Main, 1985.

Fredericksen and Zeri 1972
Fredericksen, Burton, and Federico Zeri. *Census of Pre-Nineteenth Century Italian Paintings in North American Public Collections.* Cambridge, Mass., 1972.

Freeman 1976
Freeman, Margaret Barss. *The Unicorn Tapestries.* New York, 1976.

Freisleben 1977
Freisleben, H.-C. *Der katalanische Weltatlas vom Jahre 1375.* Stuttgart, 1977.

Freitas and Gonçalves 1987
Freitas, Paula, and M. de Jesus Gonçalves. *Painéis de S. Vicente de Fora, uma questão inútil.* Lisbon, 1987.

Frey 1909
Frey, Karl. "Studien zu Michelangiolo Buonarroti und zur Kunst seiner Zeit." *Jahrbuch der königlich Preussischen Kunstsammlungen* 30 (1909), 113–137.

Freyer 1987
Freyer, Bryna. *Royal Benin Art in the Collection of the National Museum of African Art.* Washington, 1987.

Friedländer 1978
Friedländer, Max, and Jacob Rosenberg. *The Paintings of Lucas Cranach.* London, 1978.

Fritz 1982
Fritz, Johann Michael. *Goldschmiedekunst der Gotik in Mitteleuropa.* Munich, 1982.

Fritz 1983

Fritz, Rolf. *Die Gefässe aus Kokosnuss in Mitteleuropa, 1250–1800.* Mainz am Rhein, 1983.

Frothingham 1951
Frothingham, Alice Wilson. *Lustreware of Spain.* New York, 1951.

Fumi 1891
Fumi, Luigi. *Il Duomo di Orvieto e i suoi restauri.* Rome, 1891.

Fusco 1971
Fusco, Laurie. "Antonio Pollaiuolo's Use of the Antique." *Journal of the Warburg and Courtauld Institutes* 42 (1971), 157–163.

Fusco 1973
Fusco, Laurie. In *Early Italian Engravings from the National Gallery of Art.* J. Levenson, K. Oberhuber, and J. Sheehan. Washington, 1973.

Fusi 1977
Fusi, Maurizio. *Navi d'argento, Nefs, Silverships.* Milan, 1977.

Gambin 1989
Gambin, Marie-Thérèse. "L'île Trapobane: problèmes de cartographie dans l'océan Indien." In *Géographie du monde au Moyen Age et à la Renaissance.* Edited by Monique Pelletier. Paris, 1989, 191–200.

Ganong 1964
Ganong. W. F., with introduction and notes by Theodore E. Layng. *Crucial Maps in the Early Cartography and Place-Nomenclature of the Atlantic Coast of Canada.* Toronto, 1964.

Gasparini Leoporace 1956
Gasparini Leoporace, Tullia. *Il mappamondo di Fra Mauro.* Rome, 1956.

Gay 1887
Gay, Victor. *Glossaire Archéologique, du Moyen Age et de la Renaissance.* Vol. 1. Paris, 1887.

Gaya Nuño 1958
Gaya Nuño, Juan Antonio. "Sobre el retablo de Ciudad Rodrigo, por Fernando Gallego y sus colaboradores." *Archivo Español de Arte* (1958), 299–312.

Gerbi 1986
Gerbi, Antonello. *Nature in the New World—From Christopher Columbus to Gonzalo Fernández de Oviedo.* Translated by Jeremy Moyle. Pittsburgh, 1986.

Gibson 1973
Gibson, Walter S. *Hieronymus Bosch.* London, 1973.

Gibson 1983
Gibson, Walter S. *Hieronymus Bosch: An Annotated Bibliography.* Boston, 1983.

Globes 1968
Globes and Globe-Gores. The H. P. Kraus Private Collection. Ridgefield, Conn., [1968].

Godinho 1984
Godinho, Vitorino Magalhães. *Os Descobrimentos e a Economia Mundial.* Vols. 1 and 2. Lisbon, 1984 (1st edition, 1963–1971).

Góis 1566
Góis, Damião de. *Chrónica de El-Rei D. Manuel (. . .).* Lisbon, 1566.

Góis 1619, 1953
Góis, Damião de. *Crónica do Felicíssimo Rei D. Manuel.* Lisbon 1619. Reprint Coimbra, 1953.

Gökyay 1976
Gökyay, Orhan Şaik. "Tilsimli gömlekler." *Türk folkloru araştırmaları yıllığı* 3 (1976), 93–112.

Goldschmidt 1923–1924
Goldschmidt, A. "Früh-mittelalterliche illustrierte Enzyklopädien." *Vorträge der Bibliothek Warburg.* Hamburg, 1923–1924, 217.

Gombrich 1960
Gombrich, Ernst Hans. *Art and Illusion. A Study in the Psychology of Pictorial Representation.* London, 1960.

Gombrich 1984
Gombrich, E. H. *The Sense of Order.* Oxford, 1984.

Gómez-Moreno 1941
Gómez-Moreno, Manuel. *Las Aguilas del Renacimiento español.* Madrid, 1941.

Goris 1925
Goris, Jan Albert. *Etude sur les colonies marchandes méridionales (Portugais, Espagnols, Italiens) à Anvers de 1488 à 1567.* Louvain, 1925.

Goris and Marlier 1971
Goris, Jan Albert, and Georges Marlier. *Albrecht Dürer. Diary of His Journey to the Netherlands. 1520–1521.* London, 1971.

Gorle 1975
Claudii Ptolemaei Cosmographia. Edited by Lelio
Pagani. Gorle, 1975.
Gould 1966
Gould, Cecil. Michelangelo, Battle of Cascina. Newcastle upon Tyne, 1966.
Grayson 1972
Alberti, Leon Battista. 'On Painting' and 'On Sculpture'. Translated by Cecil Grayson. Harmondsworth, 1972.
Greenhill 1982
The National Maritime Museum. Edited by Basil Greenhill. London, 1982.
Gronau 1905
Gronau, Georg. "Per la storia di un quadro attribuito a Jacopo de' Barbari." Rassegna d'arte (1905), 28.
Grosjean 1977
Grosjean, G. Mappa mundi. Der katalanische Weltatlas vom Jahre 1375. Zurich, 1977.
Grosz and Thomas 1936
Grosz, A., and B. Thomas. Katalog der Waffensammlung in der Neuen Burg. Vienna 1936, 42.
Grote 1961
Grote, Ludwig. Die Tucher. Bildnis einer Patrizierfamilie. Munich, 1961.
Grottanelli 1975
Grottanelli, V. L. "Discovery of a Masterpiece: A Sixteenth-Century Ivory Bowl from Sierra Leone." African Arts 8 (1975), 14–23.
Grottanelli 1976
Grottanelli, V. L. "Su un'antica scultura in avorio della Sierra Leone." Quaderni Poro 1 (1976), 23–58.
Grube 1989
Grube, S. J. "Notes on the Decorative Arts of the Timurid Period." Islamic Art 3 (1989), 175–208.
Grunne 1980
Grunne, Bernard de. Terres Cuites Anciennes de l'Ouest Africain. Louvain-la-Neuve, 1980.
Guerlin 1914
Guerlin, Henri. Segovie, Avila et Salamanque. Paris, 1914.
Guiffray 1886
Guiffray, J. Histoire de la Tapisserie du Moyen Age jusqu'à nos jours. Tours, 1886.
Gusmão 1951
Gusmão, Adriano de. "Iluminura Manuelina." Arte Portuguesa. Edited by João Barreira. Lisbon, [1951].
Gusmão 1956
Gusmão, Adriano de. O Nuno Gonçalves de Phaidon. Lisbon, 1956.
Gusmão 1957
Gusmão, Adriano de. Nuno Gonçalves. Lisbon, 1957.
Guye and Michel 1970
Guye, Samuel, and Henri Michel. Mesures du Temps et de l'Espace. Horloges, Montres, et Instruments Anciens. Fribourg, 1970.
Hahnloser 1971
Il Tesoro di San Marco, 2: Il Tesoro e il Museo. Edited by Hans Robert Hahnloser. Florence, 1971.
Haines 1983
Haines, Margaret. The 'Sacrestia delle Messe' of the Florentine Cathedral. Florence, 1983.
Halm 1962
Halm, Peter. "Hans Burgkmair als Zeichner." Münchner Jahrbuch der bildenden Kunst Dritte Folge 13 (1962), 75–162.
Hammer-Purgstall 1836–1838
Hammer-Purgstall, Josef von. Geschichte der Osmanischen Dichtkunst. Pest, 1836–1838.
Hannsmann and Kriss-Rettenbeck 1977
Hannsmann, Liselotte, and Lenz Kriss-Rettenbeck. Amulett und Talisman. Erscheinungsform und Geschichte. Munich, 1977.
Harris 1985
Harris, Elizabeth. "The Waldseemüller World Map: A Typographic Appraisal." Imago Mundi 37 (1985), 30–53.
Harrisse 1892
Harrisse, Henry. The Discovery of North America. London-Paris, 1892.
Hartlaub 1961
Hartlaub. Hans Baldung Grien. Hexenbilder. Stuttgart, 1961.
Hartmann 1978
Hartmann, Wolfgang. "Hans Baldungs 'Eve, Schlange und Tod' in Ottawa." Jahrbuch der Staatlichen Kunst-

sammlungen in Baden-Württemberg 15 (1978), 8.
Hartner 1939
Hartner, Willy. "The Principle and Use of the Astrolabe." In A Survey of Persian Art. Edited by Arthur Upham Pope. Oxford, 1939. Reprinted in Oriens-Occidens. Ausgewählte Schriften zur Wissenschafts-und Kulturgeschichte. Festschrift zum 60. Geburtstag. Hildesheim, 1968.
Hartt 1968, 1969
Hartt, Frederick. Michelangelo: The Complete Sculpture. New York, 1968; London, 1969.
Hartt 1988
Hartt, Frederick. The Drawings of Michelangelo. London, 1971.
Heger 1899
Heger, Franz. "Alte Elfenbeinarbeiten aus Afrika in den Wiener Sammlungen." Mitteilungen der Anthropologischen Gesellschaft Wien 29 (1899), 101–109.
Heikamp 1960
Heikamp, Detlef. "Dürers Entwürfe für Geweihleuchter." Zeitschrift für Kunstgeschichte 23 (1960).
Hemming 1978
Hemming, John. Red Gold: The Conquest of the Brazilian Indians. 1500–1760. Cambridge, 1978.
Herklots 1921
Herklots, G. A. Islam in India or the Qānūn-i Islām. The Customs of the Musulmāns of India ...by Ja'far Sharif. Edited by William Crook. Oxford, 1921.
Hernmarck 1977
Hernmarck, Karl. The Art of the European Silversmith, 1430–1830. 2 vols. London and New York, 1977.
Hibbard 1985
Hibbard, Howard. Michelangelo. Harmondsworth and New York, 1985.
Hieatt 1983
Hieatt, A. K. "Hans Baldung Grien's Ottawa Eve and Its Context." Art Bulletin 65 (1983), 290–334.
Hildburgh 1941
Hildburgh, W. L. "A Hispano-Arabic Silver-gilt and Crystal Casket." The Antiquaries Journal 21 (1941), 211–231.
Hill 1926
Hill, George F. "Medals of Turkish Sultans." Numismatic Chronicle 6 (1926), 287–298.
Hill 1930
Hill, George F. A Corpus of Italian Medals of the Renaissance before Cellini. London, 1930.
Hill and Pollard 1967
Hill, George F., and Graham Pollard. Renaissance Medals from the Samuel H. Kress Collection at the National Gallery of Art. London, 1967.
Himmelheber 1985
Himmelheber, Georg. "Eine Truhe von Baccio Pontelli." Antologia di Belle Arti 27–28 (1985), 19–26.
Hind 1938
Hind, Arthur. Early Italian Engraving. Vol. 1. London, 1938.
Hirsch 1976
Hirsch, Rudolf. "Printed Reports on the Early Discoveries and Their Reception." In First Images of America. Edited by Fredi Chiappelli. Vol. 2. Berkeley, Los Angeles, and London, 1976, 537–552.
Hirst 1986
Hirst, Michael. "I desegni de Michelangelo per la 'Battaglia de Cascina' (ca. 1504)." Tecnica e stile: esempi di pittura murale del Rinascimento italiano. Edited by Eve Borsook and Fiorella Superbi Gioffredi. Villa I Tatti/The Harvard University Center for Italian Renaissance Studies 9. 2 vols. Milan, 1986.
Hirst 1988
Hirst, Michael. Michelangelo and His Drawings. New Haven and London, 1988.
Hollstein 1949–
Hollstein, F. W. H. Dutch and Flemish Etchings, Engravings, and Woodcuts, ca. 1450–1700. 24 vols. Amsterdam, 1949–.
Holanda 1984
Holanda, Francisco de. Da Pintura Antiga. Introduction and notes by Angel G. Garcia. Lisbon, 1984.
Honour 1976
Honour, Hugh. The New Golden Land. New York, 1976.
Horn and Born 1979
Horn, Walter, and Ernest Born. The Plan of St. Gall. A Study of the Architecture and Economy of, and Life in a

Paradigmatic Carolingian Monastery. 3 vols. Berkeley, 1979.
Horne 1908
Horne, Herbert. Alessandro Filipepi Commonly Called Sandro Botticelli, Painter of Florence. London, 1908.
Huidobro Serna 1949
Huidobro Serna, Luciano. La Catedral de Burgos. Madrid, 1949.
Humfrey 1991
Humfrey, Peter. Carpaccio. Catalogo completo. Florence, 1991.
Husband 1980
Husband, Timothy. The Wild Man. Medieval Myth and Symbolism. New York, 1980.
Huyghe 1949
Huyghe, René. "Nuno Gonçalves dans la peinture européenne du xvème siècle." XVI Congrés International d'Histoire de l'Art (Rapports et Communications). Vol. 1. Lisbon/Porto, 1949.
Hyman 1981
Hyman, Isabelle. "Examining a Fifteenth-Century 'Tribute' to Florence." In Art the Ape of Nature: Studies in Honor of H. W. Janson. New York, 1981, 105–126.
Iglesia 1659
Iglesia, Nicolas de la. Flores de Miraflores. Burgos, 1659.
Isemeyer 1964
Isemeyer, C. A. "Die Arbeiten Leonardos und Michelangelos für den grossen Ratsaal in Florence." Festschrift für L. H. Heydenreich. Munich, 1964, 84–120.
Istanbul 1983
The Anatolian Civilisations. Exh. cat. Topkapi Saray Museum. Istanbul, 1983.
Ivanov 1977
Ivanov, A. A. "Istoriya izucheniya Maverannakhrskoi (Sredneaziatskoi) shkoly miniatyury." In Srednyaya Aziya v drevnosti srednevekov'ye. Edited by B. G. Gafurov and B. A. Litvinsky. Moscow, 1977, 144–159.
Jackson 1911
Jackson, Charles James. An Illustrated History of English Plate. 2 vols. London, 1911.
James 1980
James, David. Qurans and Bindings from the Chester Beatty Library. A Facsimile Exhibition. London, 1980.
James 1981
James, David. Islamic Masterpieces of the Chester Beatty Library. Exh. cat. Leighton House. London, 1981.
Jane 1988
The Four Voyages of Columbus. Edited by Cecil Jane. New York, 1988.
Janitsch 1883
Janitsch, J. "Dürer's Türkenzeichnung." Jahrbuch der Königlich-Preussischen Kunstsammlungen 4 (1883), 50–62.
Janson 1963
Janson, Horst. The Sculpture of Donatello. Princeton, 1963.
Jirmounsky 1940
Jirmounsky, Myron Malkiel-. "Notes sur la composition des panneaux dits de S. Vicent au Musée de l'Art Ancien." Boletim do MNAA 7 (1940).
Joannides 1977, 1981
Joannides, Paul. "Michelangelo's Lost Hercules." Burlington Magazine 119 (1977), 550–554; and "A Supplement to Michelangelo's Lost Hercules." Burlington Magazine 123 (1981), 20–23.
Joannides 1983
Joannides, Paul. The Drawings of Raphael. Oxford, 1983.
Jones 1984
Jones, Peter Murray. Medieval Medical Miniatures. London, 1984.
Joubert 1987
Joubert, Fabienne. La tapisserie médiévale au Musée du Cluny. Paris, 1987.
Kaemmerer and Ströhl [1903]
Kaemmerer, Ludwig Joachim Karl, and Ströhl. Ahnenreihen aus dem Stammbaum des portugiesischen Königshauses: Miniaturenfolge in der Bibliothek des British Museum. 2 vols. Stuttgart, [1903].
Kahsnitz 1984
Kahsnitz, Rainer. "Veit Stoss in Nürnberg. Eine Nachlese zum Katalog und zur Ausstellung." Anzeiger des Germanischen Nationalmuseums (1984), 39–70.
Kamal 1926–1953
Kamal, Youssouf. Monumenta Cartographica Africae et

Aegypti. 5 vols. Leiden, 1926–1953.

Kaplan 1985
Kaplan, Paul Henry Daniel. *The Rise of the Black Magus in Western Art.* Ann Arbor, 1985.

Karabacek 1918
Karabacek, Josef von. *Abendländische Künstler zu Konstantinopel im 15. und 16. Jh.* Vienna, 1918.

Karling 1970
Karling, Sten. "Riddaren döden och djävulen." *Konsthistorisk Tidsskrift* 39 (1970), 1–13.

Karlsruhe 1959
Hans Baldung Grien. Edited by Jan Lauts. Exh. cat. Staatliche Kunsthalle Karlsruhe. Karlsruhe, 1959.

Kassel 1990
Staatliche Kunstsammlungen. *Porzellan aus China und Japan. Die Porzellangalerie der Landgrafen von Hessen-Kassel.* Kassel, 1990.

Katz 1968
Katz, Karl. "Jewish Tradition in Art." *From the Beginning.* Jerusalem and London, 1968.

Kauffman 1935
Kauffman, H. *Donatello.* Berlin, 1935.

Keele and Pedretti 1979–1980
Keele, Kenneth and Carlo Pedretti. *Leonardo da Vinci. Corpus of Anatomical Studies at Windsor Castle.* London and New York, 1979–1980.

Keil 1919
Keil, Luis. *Faianças e Tapeçarias.* Elvas, 1919.

Keil 1985
Keil, Robert. "Zu Dürers frühen Proportionszeichnungen des menschlichen Körpers." *Pantheon* 43 (1985), 54–61.

Kemp 1984
Kemp, Martin. "The Taking and Use of Evidence; with a Botticellian Case Study." *Art Journal* 44 (1984), 207–215.

Kemp 1985
Kemp, Martin. "Leonardo da Vinci: Science and the Poetic Impulse." *Journal of the Royal Society of Arts* 133 (1985), 196–215.

Kemp 1989
Leonardo on Painting. Edited by Martin Kemp. Translated by Martin Kemp and Margaret Walker. London and New Haven, 1989.

Kemp 1989a
Kemp, Martin. *Leonardo da Vinci. The Marvellous Works of Nature and Man.* London, 1989.

Kemp 1989b
Kemp, Martin. "Geometrical Bodies as Exemplary Forms in Renaissance Space." *World Art. Themes of Unity in Diversity.* Edited by Irving Lavin. 3 vols. University Park and London, 1989, 1:237–242.

Kemp 1990
Kemp, Martin. *The Science of Art: Optical Themes in Western Art from Brunelleschi to Seurat.* New Haven and London, 1990.

Kemp 1991
Leon Battista Alberti On Painting. Edited by Martin Kemp. Translated by Cecil Grayson. London, 1991.

Kemp and Massing 1991
Kemp, Martin, and Ann Massing. "Paolo Uccello's 'Hunt in the Forest.'" *Burlington Magazine* 133 (1991), 164–178.

Kendrick 1924
Kendrick, A. F. *Victoria and Albert Museum Department of Textiles. Catalogue of Muhammadan Textiles of the Medieval Period.* London, 1924.

Kerchache, Paudrat, and Stephan 1988
Kerchache, Jacques, Jean Louis Paudrat, and Lucien Stephan. *L'art Africain.* Paris, 1988.

Kern 1915
Kern, J. G. "Der Mazzocchio des Paolo Uccello." *Jahrbuch der Preuszichen Kunstsammlungen* 36 (1915), 13–38.

Kimball 1927–1928
Kimball, Fisk. "Luciano Laurana and the 'High Renaissance.'" *Art Bulletin* 10 (1927–1928), 125.

Kiparsky 1952
Kiparsky, Valentin. *L'histoire du morse.* Annales Academiae Scientiarum Fennicae, Ser. B.73,3. Helsinki, 1952.

Klemp 1968
Klemp, Egon. *Africa on Maps Dating from the Twelfth to the Eighteenth Century.* Leipzig, 1968.

Klemp 1976
Klemp, Egon. *America in Maps Dating from 1500 to*

1856. New York and London, 1976.

Klibansky, Panofsky, and Saxl 1964
Klibansky, Raymond, Erwin Panofsky, and Fritz Saxl. *Saturn and Melancholy. Studies in the History of Natural Philosophy, Religion and Art.* London, 1964.

Koch 1974
Koch, Robert. *Hans Baldung Grien: Eve, the Serpent and Death.* Ottawa, 1974.

Kohlhaussen 1939
Kohlhaussen, Heinrich. "Ein Drachenleuchter von Veit Stoss nach dem Entwurf Albrecht Dürers." *Germanisches Nationalmuseum. Anzeiger 1936–39* (1939), 135–141.

Kohlhaussen 1968
Kohlhaussen, Heinrich. *Nürnberger Goldschmiedekunst des Mittelalters und der Dürerzeit, 1240 bis 1540.* Berlin, 1968.

Koloss 1982
Koloss, Hans-Joachim. "Afrika." In *Ferne Wölker—Frühe Zeiten, Kunstwerke aus dem Linden Museum Stuttgart.* Recklinghausen, 1982.

Koreny 1985
Koreny, Fritz. *Albrecht Dürer und die Tier-und Pflanzenstudien der Renaissance.* Munich, 1985.

Koreny 1988
Koreny, Fritz. *Albrecht Dürer and the Animal and Plant Studies of the Renaissance.* Boston, 1988.

Koreny 1991
Koreny, Fritz. "A Colored Flower Study by Martin Schongauer and the Development of the Depiction of Nature from Van der Weyden to Dürer." *Burlington Magazine* 133 (1991).

Koschatzky 1973
Koschatzky, Walter. *Albrecht Dürer. The Landscape Water-Colours.* London, 1973.

Köseoğlu 1987
Köseoğlu, Cengiz. *The Topkapi Saray Museum. The Treasury.* Edited by J. M. Rogers. London, 1987.

Krahl and Erbahar 1986
Krahl, Regina, and Nurdan Erbahar. *Chinese Ceramics in the Topkapi Saray Museum, Istanbul. A Complete Catalogue. 2: Yuan and Ming Dynasty Porcelains.* Edited by John Ayers. London, 1986.

Krása 1983
Krása, Josef. *The Travels of Sir John Mandeville. A Manuscript in the British Library.* New York, 1983.

Krautheimer 1969
Krautheimer, Richard. "The Tragic and Comic Scenes of the Renaissance: The Baltimore and Urbino Panels." *Studies in Early Christian, Medieval and Renaissance Art.* Princeton, 1969.

Kress 1956
Paintings and Sculpture from the Kress Collection. Washington, 1956.

Krieger 1969
Krieger, Kurt. *Westafrikanische Plastik.* Vol. 2. Berlin, 1969.

Kris 1932
Kris, Ernst. *Goldschmiedearbeiten des Mittelalters der Renaissance und des Barock, I: Arbeiten in Gold und Silber.* Publikationen aus den kunsthistorischen Sammlungen in Wien 5. Vienna, 1932.

Kristeller 1902
Kristeller, Paul. *Andrea Mantegna.* Berlin and Leipzig, 1902.

Kristeller 1896
Kristeller, Paul. *Engravings and Woodcuts by Jacopo de'Barbari.* Berlin, 1896.

Kühnel 1950
Kühnel, Ernst. "Der Mamlukische Kassettenstil." *Kunst des Orients* 1 (1950), 55–68.

Kunsthistorisches Museum 1988
Kunsthistorisches Museum, Vienna. *Führer durch die Sammlungen.* Vienna, 1988.

Kury 1974
Kury, G. "The Early Work of Luca Signorelli." Ph.D. dissertation. Yale University, 1974.

Kurz 1937
Kurz, Otto. *Master Drawings.* 1937.

Kurz 1953
Kurz, Otto. "Huis nympha loci. A Pseudo Classical Inscription and a Drawing by Dürer." *Journal of the Warburg and Courtauld Institutes* 24 (1953), 171–177.

Kwiatowski 1955

Kwiatowski, K. *La Dame à l'hermine de Léonardo de Vinci. Etude technologique.* Warsaw, 1955.

Lach 1970–1977
Lach, Donald Frederick. *Asia in the Making of Europe.* 2 vols. Chicago and London, 1970–1977.

Laínez Alcalá 1943
Laínez Alcalá, Rafael. *Pedro Berruguete, pintor de Castilla.* Madrid, 1943.

Laking 1920–1921
Laking, O. F. *A Record of European Armour and Arms through Seven Centuries.* 5 vols. London, 1920–1921.

Lambert 1951
Lambert, Emile. "Remarques sur le Polyptyque dit de Saint Vincent au Musée de Lisbonne." *Boletim do MNAA* 3, 1 (1951).

Lamp 1983
Lamp, Frederick. "House of Stones: Memorial Art of Fifteenth-Century Sierra Leone." *Art Bulletin* 65, 2 (1983), 219–237.

Lane 1961
Lane, Arthur. "The Gaignières-Fonthill Vase; A Chinese Porcelain of about 1300." *Burlington Magazine* 103 (1961), 124–132.

Lane 1989
Lane, Barbara G. "'Requiem aeternam dona est': the Beaune 'Last Judgement' and the Mass of the Dead." *Simiolus* 19, 3 (1989), 166–180.

Laubenberger 1959
Laubenberger, Franz. "Ringmann oder Waldseemüller? Eine kritische Untersuchung über den Urheber des Namens Amerika." *Erdkunde* 13 (1959), 163–179.

Laurent c. 1577
Laurent, Jean. *Archivo Ruiz Vernacci.* c. 1577.

Laurenziana 1986
Biblioteca Medicea Laurenziana. Florence, 1986.

Lauts 1962
Lauts, J. *Carpaccio: Paintings and Drawings.* London, 1962.

Leber 1988
Leber, Hermann. *Albrecht Dürers Landschaftsaquarelle. Topographie und Genese.* Hildesheim, 1988.

Leeman 1984
Leeman, F. "A Textual Source for Cranach's 'Venus with Cupid the Honey-Thief.'" *Burlington Magazine* 124 (1984), 274–275.

Legner 1967
Legner, A. "Anticos Appollo vom Belvedere." *Städel Jahrbuch* N.F. 1 (1967), 103–118.

Le Goff 1984
Le Goff, Jacques. "Calendário." *Enciclopédia Einaudi.* Vol. 1 (Portuguese ed.). Lisbon, 1984.

Leguina 1898
Leguina, E. de. *Espadas históricas.* Madrid, 1898.

Levenson 1978
Levenson, Jay. "Jacopo de'Barbari and Northern Art of the Early Sixteenth Century." Ph.D. dissertation. New York University, 1978.

Levey 1961
Levey, Michael. "Minor Aspects of Dürer's Interest in Venetian Art." *Burlington Magazine* 103 (1961), 511–513.

Liebman 1968
Liebman, M. "On the Iconography of the 'Nymph of the Fountain' by Lucas Cranach the Elder." *Journal of the Warburg and Courtauld Institutes* 29 (1968), 434–437.

Lightbown 1978
Lightbown, Ronald. *Sandro Botticelli. Life and Work.* 2 vols. London, 1978.

Lightbown 1986
Lightbown, Ronald. *Andrea Mantegna.* London, 1986.

Lightbown 1978
Lightbown, Ronald William. *Secular Goldsmiths' Work in Medieval France: A History.* London, 1978.

Lisbon 1895
Ortigo, Ramalho. *Exposição de Arte Sacra Ornamental promivida pela Comissão do Centenário de Santo António de Lisboa no ano de 1895.* Exh. cat. Sala de Sua Magestade. Lisbon, 1895.

Lisbon 1963
The Collection of the Calouste Gulbenkian Foundation. Museo Nacional de Arte Antiga. Lisbon, 1963.

Llorente 1961
Llorente, María Josefa. "El Convento de Santa Cruz." *Estudios Segovianos* (1961).

Lomazzo 1584
Lomazzo, Giovanni Paolo. *Trattato dell'arte della pittura.* Milan, 1584.

Lomazzo 1974
Lomazzo, Giovanni Paolo. *Idea del tempio della pittura.* Edited by Robert Klein. 2 vols. First published 1590. Florence, 1974.

London 1933
Sotheby and Co. *Catalogue of the Renowned Collection of Western Manuscripts, the Property of A. Chester Beatty. The Second Portion.* Sale 9th May. London, 1933.

London 1960
Prince Henry the Navigator and Portuguese Maritime Enterprise. Exh. cat. British Museum. London, 1960.

London 1974
Ivory Carvings in Early Medieval England, 700–1200. Exh. cat. Victoria and Albert Museum. London, 1974.

London 1974
Sotheby and Co. *Catalogue of African, Oceanic, Eskimo, Pacific North-West Coast, American Indian and Pre-Columbian Art.* Sale 8th July. London, 1974.

London 1976
The Arts of Islam. Exh. cat. Hayward Gallery. London, 1976.

London 1980
Sotheby and Co. *Catalogue of a Collection of Benin Works of Art.* Sale 16th June. London, 1980.

London 1981
Splendours of the Gonzaga. Exh. cat. Victoria and Albert Museum. London, 1981.

London 1982
Losty, Jeremiah. *The Art of the Book in India.* Exh. cat. British Library. London, 1982.

London 1982
Raby, Julian. "Silver and Gold." *Tulips, Arabesques and Turbans.* Edited by Yanni Petsopoulos. Exh. cat. Leighton House. London, 1982, 17–33.

London 1983
The Genius of Venice. Edited by Jane Martineau and Charles Hope. Exh. cat. Royal Academy of Arts. London, 1983.

London 1983
Islamic Art and Design, 1500–1700. Exh. cat. British Museum. London, 1983.

London 1984
English Romanesque Art, 1066–1200. Exh. cat. Hayward Gallery. London, 1984.

London 1988
Rogers, J. Michael, and Rachel Ward. *Süleyman the Magnificent.* Exh. cat. British Museum. London, 1988.

London 1989
Leonardo da Vinci. Edited by Martin Kemp. Exh. cat. Hayward Gallery. London, 1989.

Longhi 1942
Longhi, Roberto. *Piero della Francesca.* 2d ed. Milan, 1942.

Lopes 1925
Lopes, David. *História de Arzila durante o domínio português.* Lisbon, 1925.

López Martínez 1961
López Martínez, Nicolas. "Don Luis de Acuña, el cabildo de Burgos y la reforma (1456–95)." *Burgense* 2 (1961), 309.

López Mata 1946
López Mata, Teófilo. *El Barrio e iglesia de San Esteban de Burgos.* Burgos, 1946.

López Mata 1950
López Mata, Teófilo. *La Catedral de Burgos.* Burgos, 1950.

Lorch 1980
Lorch, Richard. "The 'Sphera solida' and Related Instruments." *Centaurus* 24 (1980), 153–161.

Ludovici 1958
Ludovici, Sergio Samek. *Il 'De Sphaera' estense e l'iconografia astrologica.* Milan, 1958.

Luino 1974
Malazzani, G. *Sacro e profano de Bernardino Luini.* Exh. cat. Civico istituto di cultura popolare. Luino, 1974.

Lunsingh Scheurleer 1980
Lunsingh Scheurleer, Daniël François. *Chinesisches und japanisches Porzellan in europäischen Fassungen.* Braunschweig, 1980.

Luschan 1919
Luschan, Felix von. *Die Altertümer von Benin.* 3 vols. Berlin, 1919.

Lutz 1958
Lutz, Heinrich. *Conrad Peutinger. Beiträge zu einer politischen Biographie.* Augsburg, 1958.

MacDougall 1975
MacDougall, Elizabeth. "The Sleeping Nymph. Origins of a Humanist Fountain Type." *Art Bulletin* 57 (1975), 357–365.

Macler 1928
Macler, Frédéric. *L'enluminure arménienne profane.* Paris, 1928.

Madrid 1893
Exposición histórico-europea. 1892 a 1893. Madrid, 1893.

Madrid 1898
Don Juan, Valencia de. *Catálogo Histórico-descriptivo de la Real Armería de Madrid.* Madrid, 1898.

Madrid 1986
Junquera de Vega, Paulina, and Concha Herrero Carretero. *Catálogo de tapices del Patrimonio Nacional.* Vol. 1: *Siglo XVI.* Madrid, 1986.

Mancini 1979
Mancini, Fausto. "L'Opera di Leonardo sulla Pianta di Imola di Danesio Maineri." *Notizario Vinciano* 9 (1979), 37–52.

Mann 1933
Mann, J. G. "Notes on the Armour Worn in Spain from the Tenth to the Fifteenth Century." *Archaeologia* 83 (1933), 301–302.

Mannowsky [1931]–1938
Mannowsky, Walter. *Der Danziger Paramentenschatz. Kirchliche Gewänder und Stickereien aus der Marienkirche.* Berlin and Leipzig, [1931]–1938.

Marani 1984
Marani, Pietro. *L'Architettura fortificata negli studi di Leonardo da Vinci con il catalogo completo dei disegni.* Florence, 1984, no. 126.

Marani 1985
Marani, Pietro. "La Mappa di Imola di Leonardo." *Leonardo: il Codice Hammer e la mappa di Imola presentati da Carlo Pedretti.* Florence, 1985, 140–141.

Marchesi 1849
Marchesi, Jose Maria. *Catalogo de la Real Armería.* Madrid, 1849.

Marinoni 1988
Marinoni, Augusto. "Leonardo in Romagna." *Torricelliana (Faenza)* 39 (1988), 53–62.

Markl 1983
Markl, Dagoberto. *Livro de Horas de D. Manuel. Estudo introdutório.* Lisbon, 1983.

Markl 1988
Markl, Dagoberto. *O Retábulo de S. Vicente da Sé de Lisboa e os Documentos.* Lisbon, 1988.

Markl and Pereira 1986
Markl, Dagoberto, and Fernando A. B. Pereira. "O Renascimento." *História da Arte em Portugal.* Vol. 6. Lisbon, 1986.

Marques 1940
Marques, J. M. Silva. "Armas e Tapeçarias reais num inventário de 1505." *Congresso do Mundo Português.* Vol. 5, book 3. Lisbon, 1940, 555–603.

Martin 1912
Martin, Frederic R. *The Miniature Painting and Painters of Persia, India and Turkey.* London, 1912.

Martindale 1961
Martindale, Andrew. "Luca Signorelli and the Drawings Connected with the Orvieto Frescoes." *Burlington Magazine* (1961), 216–220.

Martín González 1985
Martín González, Juan Jose. *Catálogo monumental de la provincia de Valladolid* (XIV. part 1. Monumentos religiosos de la ciudad de Valladolid). Valladolid, 1985.

Martínez Sanz 1866
Martínez Sanz, Manuel. *Historia del templo catedral de Burgos.* Burgos, 1866.

Massing 1984
Massing, Jean Michel. "Schongauer's 'Tribulations of St. Anthony.' Its Iconography and Influence on German Art." *Print Quarterly* 1 (1984), 220–236.

Mateo Gómez 1979
Mateo Gómez, Isabel. *Temas profanos en la escultura gótica española. Las sillerías de coro.* Madrid, 1979.

Matos 1955
Matos, Luis de. "A propósito do 'Tríptico de Santa Auta.'" *Boletim do Museu Nacional de Arte Antiga* 3, 1 (1955).

Matoso 1983
Matoso, José. *Introduço ai Catálogo da Exposição Os Descobrimentos Portugueses e a Europa do Renascimento.* Lisbon, 1983.

Maximilian 1959
Maximilian I. Exh. cat. Österreichische Nationalbibliothek. Vienna, 1959, 230, no. 622.

Mayer 1956
Mayer, L. A. *Islamic Astrolabists and Their Works.* Geneva, 1956.

Mayer-Thurman 1975
Mayer-Thurman, Christa C. *Raiment for the Lord's Service.* Chicago, 1975.

Mazerolle 1897
Mazerolle, Fernand. "Un vase oriental en porcelaine orné d'une monture d'orfèvrerie du XIVe siècle." *Gazette des Beaux-Arts* 3e sér. 17 (1897), 53–58.

McClintock 1950
McClintock, Henry Foster. *Old Irish and Highland Dress.* Dundalk, 1950.

McClintock 1958
McClintock, Henry Foster. *Handbook on the Traditional Old Irish Dress.* Dundalk, 1958.

McCown 1922
Testamentum Salomonis. Edited by Charles Ch. McCown. Leipzig, 1922.

McGurk 1966
McGurk, Patrick. *Astrological Manuscripts in Italian Libraries Other than Rome.* Catalogue of Astrological and Mythological Illuminated Manuscripts of the Latin Middle Ages 4. London, 1966.

McIntosh 1988
McIntosh, Roderick J. "Middle Niger Terracottas before the Symplegades Gateway." *African Arts* 22, 2 (1988).

McLeod 1980
McLeod, Malcolm. *Treasures of African Art.* New York, 1980.

Meder 1932
Meder, Josef. *Dürer-Katalog. Ein Handbuch über Albrecht Dürers Stiche, Radierungen, Holzschnitte.* Vienna, 1932.

Medley 1985
Medley, Margaret. "Chinese Porcelain in the Istanbul Album Paintings." *Between China and Iran. Paintings from Four Istanbul Albums.* Ernst J. Grube and Eleanor Sims. London, 1985, 157–159.

Meiss 1968
Meiss, Millard. *French Painting in the Time of Jean de Berry: The Boucicaut Master.* London, 1968.

Meiss 1970
Meiss, Millard. *The Great Age of Fresco.* London, 1970.

Meiss 1976
Meiss, Millard. "*Ovum struthionis*: Symbol and Allusion in Piero della Francesca's Montefeltro Altarpiece." In *The Painter's Choice: Problems in the Interpretation of Renaissance Art.* New York, 1976, 105–129.

Melbourne 1990
The Age of Süleyman the Magnificent. Exh. cat. Melbourne, 1990.

Melikian-Chirvani 1987
Melikian-Chirvani, A. S. "The Lights of Sufi Shrines." *Islamic Art* 2 (1987), 126–131.

Melikian-Chirvani 1969
Melikian-Chirvani, Asadallah S. "Oeuvres inédites de l'époque de Qā'itbāy." *Kunst des Orients* 4, 2 (1969).

Melikian-Chirvani 1973
Melikian-Chirvani, Asadallah S. *Propyläen Kunstgeschichte, Islam.* Edited by Bertold Spuler and Janine Sourdel-Thomine. Berlin, 1973.

Melikian-Chirvani 1976
Melikian-Chirvani, Asadallah S. "Four Pieces of Islamic Metalwork: Some Notes on a Previously Unknown School." *Art and Archaeology Research Papers* 10 (December 1976), 24–30.

Meltzoff 1988
Meltzoff, Stanley. *Botticelli, Signorelli and Savonarola. Theologia Poetica and Painting from Boccaccio to Poliziano.* Florence, 1988.

Menavino 1551
Menavino, G. A. *La vita, et i costumi de' Turchi etc.* Florence, 1551.

Mendes Pinto 1983
Mendes Pinto, Maria Elena. *Os descobrimentos portugueses e a Europa do Renascimento — A arte na rota do*

Oriente. Lisbon, 1983.

Mendonça 1949
Mendonça, Maria José de. "Affinités du polyptyque de Nuno Gonçalves avec des tapisseries et fresques du duché de Bourgogne." *XVI Congrés International d'Histoire de l'Art. Rapports et Communications* 2. Lisbon, 1949.

Merchante 1923
Merchante, E. García. *Los Tapices de Alfonso V.* Toledo, 1923.

Meriç 1957
Meriç, Rıfkı Melûl. "Bayazid camii mimarisi." *Ankara Üniversitesi Ilâhiyat Fakültesi Yıllık Araştırmalar Dergisi* 2 (1957), 7–76.

Meriç 1963
Meriç, Rıfkı Melûl. "Bayramlarda Padişahlara hediye edilen san'at eserleri ve karşılıkları." *Türk Sanatı Tarihi Araştırma ve Incemeleri* 1 (1963), 764–786.

Meyer 1978
Meyer, Ursula. "Political Implications of Dürer's 'Knight, Death and Devil.'" *Print Collector's Newsletter* 9 (1978), 35–39.

Migeon 1903
Migeon, Gaston. *Exposition des arts musulmans au Musée des Arts Décoratifs.* Paris, 1903.

Milanesi 1878–1885, 1905–1915
Vasari, Giorgio. *Le Vite de' più eccellenti pittori, scultori ed architettori* (1568). Edited by G. Milanesi. Florence, 1878–1885. Reprint 1905–1915.

Miller 1895–1898
Miller, Konrad. *Mappaemundi. Die ältesten Weltkarten.* 6 vols. Stuttgart, 1895–1898.

Miner 1967
Miner, Dorothy. "More About Mediaeval Pouncing." In *Homage to a Bookman. Festschrift H. P. Kraus.* Berlin, 1967, 87–108.

Minorsky 1958
Minorsky, Vladimir. *The Chester Beatty Library. A Catalogue of the Turkish Manuscripts and Miniatures.* Dublin, 1958.

Moreira 1921
Moreira, Francisco de Almeida. *Museu Regional de Grão Vasco. Catálogo e guia sumário.* 1921.

Morgan 1960
Vitruvius. *The Ten Books on Architecture.* Translated by Morris H. Morgan. New York, 1960.

Morison 1942
Morison, Samuel Eliot. *Admiral of the Ocean Sea: A Life of Christopher Columbus.* 2 vols. Boston, 1942.

Morison 1974
Morison, Samuel Eliot. *The European Discovery of America: The Southern Voyages, A.D. 1492–1616.* New York, 1974.

Mota 1975
Mota, A. Teixeira. "Gli Avori africani nella documentazione portoghese dei secoli XV–XVII." *Africa* 30, 4 (1975).

Motta Alves 1936
Motta Alves, Artur. *Os Painéis de S. Vicente, num Códice da Biblioteca Nacionale do Rio de Janiero.* Lisbon, 1936.

Moule and Pelliot 1938
Polo, Marco. *The Description of the World.* Edited by Arthur Christopher Moule and Paul Pelliot. 2 vols. London, 1938.

Mullin Vogel 1985
Mullin Vogel, Susan. *African Aesthetics—The Carlo Monzino Collection.* Milan, 1985.

Munich 1910
Sarre, Friederich P. T. *Die Ausstellung von Meisterwerke Muhammedanischer Kunst in München.* Exh. cat. Munich, 1910.

Müntz 1888
Müntz, E. *Les Collections des Médicis au XVe siècle.* Paris, 1888.

Muraro 1977
Muraro, Michelangelo. *I Disegni di Vittore Carpaccio.* Florence, 1977.

Murray 1962
Murray, Peter. "Bramante milanese: the Paintings and Engravings." *Arte lombarda* 7 (1962), 25–42.

Nagy 1975
Nagy, Zoltán. "Ricerche cosmologiche nella corte umanistica di Giovanni Vitéz." In *Rapporti veneto-iungheresi dell'epoca del Rinascimento.* Budapest, 1975, 65–93.

Narkiss 1969
Narkiss, Bezalel. *Hebrew Illuminated Manuscripts.* New York, 1969.

Narkiss 1971
The Golden Haggadah. A Fourteenth-Century Illuminated Hebrew Manuscript in the British Museum. Introduction by Bezalel Narkiss. London, 1971.

Narkiss 1982
Narkiss, Bezalel, Aliza Cohen-Mushlin, and Anat Tcherikover. *Hebrew Illuminated Manuscripts in the British Isles.* Vol. 1: *The Spanish and Portuguese Manuscripts.* Jerusalem and London, 1982.

Naples and Rome 1983
"Ritratto di Luca Pacioli con Guidobaldo da Montfeltro." In *Leonardo e il leonardismo a Napoli e a Roma.* Edited by A. Vezzosi. Exh. cat. Museo nazionale di Capodimonte, Naples, and Palazzo Venezia, Rome. Florence, 1983.

National Gallery of Art 1941
National Gallery of Art. *Preliminary Catalogue of Paintings and Sculpture.* Washington, 1941.

National Gallery of Art 1973
Levenson, Jay A., Konrad Oberhuber, and Jacquelyn L. Sheehan. *Early Italian Engravings from the National Gallery of Art.* Washington, 1973.

Nebenzahl 1990
Nebenzahl, Kenneth. *Atlas of Columbus and the Great Discoveries.* Chicago, 1990.

Nepi Scirè and Valcanover 1985
Nepi Scirè, Giovanna, and Francesco Valcanover. *Gallerie dell'Accademia di Venezia.* Milan, 1985.

Neuss 1931
Neuss, W. *Die Apocalypse des Hl. Johannes in der altspanischen Bibelillustration.* Münster-in-Westphalen, 1931.

Nevadomsky 1986
Nevadomsky, Joseph. "The Benin Bronze Horseman as the Ata of Idah." *African Arts* 19, 4 (1986), 40–85.

New York 1956
Treasures of the Musée Jacquemart-Andre, Institut de France. Exh. cat. The Metropolitan Museum of Art. New York, 1956.

New York 1974
Souchal, Geneviève. *Masterpieces of Tapestry from the Fourteenth to the Sixteenth Century.* Exh. cat. The Metropolitan Museum of Art. New York, 1974.

New York 1980
Watt, James C. Y. *Chinese Jades from Han to Ch'ing.* Exh. cat. The Asia Society. New York, 1980.

New York 1984
The Treasury of San Marco, Venice. Exh. cat. The Metropolitan Museum of Art. Milan, 1984.

New York 1985
Ministerio de Cultura. *Tesoros de España: Ten Centuries of Spanish Books.* Exh. cat. New York Public Library. New York, 1985.

New York and Nuremberg 1986
Gothic and Renaissance Art in Nuremberg, 1300–1550. Exh. cat. The Metropolitan Museum of Art, New York, and Germanisches Nationalmuseum, Nuremberg. Munich, 1986.

New York Public Library 1990
Portugal-Brazil: The Age of Atlantic Discoveries. Exh. cat. New York Public Library. Lisbon, Milan, and New York, 1990.

Nicco-Fasola 1942
Piero della Francesca. *De Prospectiva pingendi.* Edited by Giustina Nicco-Fasola. Florence, 1942. Reprinted with notes by E. Battisti, F. Ghione, and R. Paccani. Florence, 1984.

Nickel 1958
Nickel, Helmut. "Der mittelalterliche Reiterschild des Abendlandes." Ph.D. dissertation, Freie Universität. Berlin, 1958.

Nicolle 1981
Nicolle, David. *Islamische Waffen.* Graz, 1981.

Nuremberg 1958
Aus dem Danziger Paramentenschatz und dem Schatz der Schwarzhäupter zu Riga. Exh. cat. Germanisches Nationalmuseum. Nuremberg, 1958.

Nuremberg 1971
Albrecht Dürer. 1471–1971. Exh. cat. Germanisches Nationalmuseum. Nuremberg, 1971.

Nuremberg 1983

Veit Stoss in Nürnberg: Werke des Meisters und seiner Schule in Nürnberg und Umgebung. Exh. cat. Germanisches Nationalmuseum. Nuremberg, 1983.

Oakley 1975
Oakley, Kenneth P. *Decorative and Symbolic Uses of Vertebrate Fossils.* Oxford, 1975.

Oakley 1985
Oakley, Kenneth P. *Decorative and Symbolic Uses of Fossils. Selected Groups, Mainly Invertebrate.* Oxford, 1985.

Oman 1963
Oman, Charles. *Medieval Silver Nefs.* London, 1963.

Oman 1968
Oman, Charles. *The Golden Age of Hispanic Silver, 1400–1655.* London, 1968.

Oman 1979
Oman, Charles. "The College Plate." In *New College, Oxford. 1379–1979.* Edited by John Buxton and Penry Williams. Oxford, 1979, 293–305.

Omont 1895–1896
Omont, Henri. *Bibliothèque nationale. Catalogue générale des manuscrits français.* 3 vols. Paris, 1895–1896.

Omont 1907
Omont, Henri. *Bibliothèque Nationale. Département des Manuscrits. Livre des Merveilles.* 2 vols. Paris, [1907].

Orlandini 1914
Orlandini, Umberto. *Il manoscritto estense "De Sphaera."* Modena, 1914.

Osório de Castro 1988
Osório de Castro, António. *Os Painéis do Museu de Lisboa e D. Carlos da Catalunha.* Barcelos, 1988.

Osten 1983
Osten, Gert van der. *Hans Baldung Grien. Gemalde und Dokumente.* Berlin, 1983.

Ottawa 1987
Catalogue of the National Gallery, Ottawa. European and American Painting and Sculpture and Decorative Arts I. Edited by M. Laskin Jr. and M. Pantazzi. Ottawa, 1987.

Ottino della Chiesa 1956
Ottino della Chiesa, A. *Bernardino Luini.* Milan, 1956.

Oudenburg 1984
Sint-Arnoldus en de Sint-Pietersabdij te Oudenburg. 1084–1984. Oudenburg, 1984.

Öz 1953
Öz, Tahsin. *Topkapı Sarayında Fatih Sultan Mehmed II'e ait eserler.* Ankara, 1953.

Pacheco Pereira 1905
Pacheco Pereira, Duarte. *Esmeraldo de situ orbis.* Edited and annotated by A. Epifanio de Silva Dias. Lisbon, 1905.

Pacioli 1494
Pacioli, Luca. *Summa de arithmetica, geometria, proportioni, et proportionalità.* Venice, 1494.

Pacioli 1509
Pacioli, Luca. *De Divina proportione.* Florence, 1509.

Pais da Silva 1986
Pais da Silva, J. H. "A arquitectura no retábulo de Santa Auta." *Páginas de História da Arte* 2 (1986).

Pallucchini 1966
Boschini, Marco. *La Carta del Navegar Pittoresco.* 1660. Edited by Anna Pallucchini. Civiltá Veneziana. Fonti e Testi 7. Venice, 1966.

Palomo Iglesias 1979
Palomo Iglesias, Crescencio. "El Padre Claudio Sancho de Contreras. Dominico Exclaustrado." *Estudios Segovianos* (1970), 89.

Panofsky 1915
Panofsky, Erwin. *Dürers Kunsttheorie, vornehmlich in ihrem Verhältnis zur Kunsttheorie der Italiener.* Berlin, 1915.

Panofsky 1940
Panofsky, Erwin. *The Codex Huygens and Leonardo da Vinci's Art Theory. The Pierpont Morgan Library Codex M.A. 1139.* London, 1940.

Panofsky 1943
Panofsky, Erwin. *Albrecht Dürer.* 2 vols. Princeton, 1943.

Panofsky 1948
Panofsky, Erwin. *The Life and Art of Albrecht Dürer.* 3d ed., 2 vols. Princeton, 1948.

Panofsky 1957
Panofsky, Erwin. "The History of Human Proportions as

a Reflection of Style." *Meaning in the Visual Arts* (1957), 55–107.

Panofsky 1967
Panofsky, Erwin. *Studies in Iconology*. Oxford, 1967 (Portuguese ed. 1986).

Panofsky 1972
Panofsky, Erwin. "The Early History of Man in Two Cycles by Piero de Cosimo." *Studies in Iconology*. New York, 1972.

Paris 1971
Les arts de l'Islam des origines à 1700. Exh. cat. Orangerie des Tuileries. Paris, 1971.

Paris 1973–1974
Chefs-d'oeuvre de la tapisserie du XIVe au XVIe siècle. Exh. cat. Grand Palais. Paris, 1973–1974.

Paris 1977
L'Islam dans les collections nationales. Exh. cat. Grand Palais. Paris, 1977.

Paris 1990
Adle, Chahriyar. "Entre Timurides, Mongols et Safavides. Notes sur un Chahname de l'atelier-bibliothèque royal d'Ologh Beg II à Caboul (873–907/ 1469–1502)." Etude Daussy-Ricquès *Art Islamique et orientalisme*. Sale catalogue Drouot-Richelieu. Paris, 15 June 1990, 136–142, lot 183.

Parker 1956/Macandrew 1981
Parker, K. T. *Catalogue of the Drawings in the Ashmolean Museum*. Vol. 3, *Italian Schools*. Oxford, 1956. *Supplement* by Hugh Macandrew. Oxford, 1981.

Parronchi 1964
Parronchi, Alessandro. "Paolo o Piero?" *Studi sulla dolce prospettiva*. Milan, 1964, 533–548.

Parry 1963
Parry, John Horace. *The Age of Reconnaissance*. London, 1963.

Parshall 1971
Parshall, Peter W. "Albrecht Dürer's 'St. Jerome in His Study': A Philological Reference." *Art Bulletin* 53 (1971), 303–305.

Pass 1989
Pass, Günther. "Dürer und die wissenschaftliche Tierdarstellung der Renaissance." *Albrecht Dürer und die Tier- und Pflanzenstudien der Renaissance. Symposium (Jahrbuch der kunsthistorischen Sammlungen in Wien 82/82, 1986–1987* (1989), 57–67.

Pastor 1959
Pastor, Ludwig von. *Storia dei Papi*. Vol. 3, rev. ed. Rome, 1959.

Pattie 1980
Pattie, Thomas Smith. *Astrology, as Illustrated in the Collections of the British Library and the British Museum*. London, 1980.

Pedretti 1975
Disegni di Leonardo da Vinci e della sua scuola alla Biblioteca Reale di Torino. Edited by Carlo Pedretti. Florence, 1975.

Pedretti 1982
Pedretti, Carlo. *Landscapes, Plants and Water Studies in the Collection of Her Majesty the Queen at Windsor Castle*. New York, 1982.

Pedretti 1987
Pedretti, Carlo. *Horses and Other Animals, Drawings by Leonardo da Vinci in the Collection of Her Majesty the Queen at Windsor Castle*. New York, 1987.

Pellegrin 1955
Pellegrin, Elisabeth. *La Bibliothèque des Visconti et des Sforza, ducs de Milan, au XVe siècle*. Paris, 1955.

Pelliot 1959–1973
Pelliot, Paul. *Notes on Marco Polo*. 3 vols. Paris, 1959–1973.

Peres 1988
Peres, Damião. *Viagens de Luis de Cadamosto e de Pedro de Sintra*. Academia Portuguesa de História. Lisbon, 1988. Reimpresso da ed. de 1948, com notas de D. Peres.

Phyrr and Alexander 1984
Phyrr, Stuart W., and David G. Alexander. "Parade Helmet (of 'Boabdil')." In *The Metropolitan Museum of Art. Notable Acquisitions 1983–1984*. New York, 1984, 21–22.

Pignatti 1964
Pignatti, Teresio. "La Pianta di Venezia de Jacopo de'Barberi." *Bollettino dei Musei Civici Veneziani* 9 (1964), 9–49.

Pignatti 1967

Pignatti, Teresio. *Mobili italiani del Rinascimento*. Milan, 1967.

Pignatti 1981
Pignatti, Teresio. *Le Scuole de Venezia*. Milan, 1981.

Pigouchet 1497
Horae Beatae Mariae Virginis. Philippe Pigouchet for Simon Vostre. Paris, 1497.

Pilz 1977
Pilz, Kurt. *600 Jahre Astronomie in Nürnberg*. Nuremberg, 1977.

Pina 1792
Pina, Rui de. "Cronica d'El Rey D. João II." In *Colecção de Livros inéditos da Historia de Portugal*. Vol. 2. Lisbon, 1792.

Pinacoteca di Brera 1988
Pinacoteca di Brera. Scuole lombarda e piemontese, 1300–1535. Milan, 1988.

Pinder-Wilson 1976
Pinder-Wilson, R. H. "The Malcolm Celestial Globe." *The Classical Tradition: British Museum Yearbook* 1 (1976), 83–101.

Pogatscher 1898
Pogatscher, Heinrich. "Von Schlangenhörnern und Schlangenzungen vornehmlich im 14. Jahrhunderte." *Römische Quartalschrift für christliche Alterthumskunde und für Kirchengeschichte* 12 (1898), 162–215.

Pollitt 1965
Pollitt, J. J. *The Art of Greece, 1400–31 B.C. Sources and Documents in the History of Art*. Englewood Cliffs, New Jersey, 1965.

Pope-Hennessy 1965
Pope-Hennessy, John. *Renaissance Bronzes from the Samuel Kress Collection: Reliefs, Plaquettes, Statuettes, Utensils and Mortars*. London, 1965.

Pope-Hennessy 1969
Pope-Hennessy, John. *Paolo Uccello*. London and New York, 1969.

Pope-Hennessy 1970
Pope-Hennessy, John. *Italian High Renaissance and Baroque Sculpture*. London and New York, 1970.

Pope-Hennessy 1971
Pope-Hennessy, John. *Italian Renaissance Sculpture*. London and New York, 1971.

Pope-Hennessy 1980
Pope-Hennessy, John. *Luca della Robbia*. Oxford, 1980.

Pope-Hennessy 1980
Pope-Hennessy, John. *The Study and Criticism of Italian Renaissance Sculpture*. Princeton, 1980.

Pope-Hennessy 1989
Pope-Hennessy, John. "The Study of Italian Plaquettes." *Italian Plaquettes*. Studies in the History of Art 22. Washington, 1989, 19–32.

Popham 1946
Popham, Arthur E. *The Drawings of Leonardo da Vinci*. London, 1946.

Post 1947
Post, Chandler Rathfon. *A History of Spanish Painting*, Vol. 9, part 1, *The Beginning of the Renaissance in Castile and Leon*. Cambridge, Mass., 1947.

Poulle 1983
Poulle, Emmanuel. *Les Instruments astronomiques du moyen âge*. Société internationale de l'Astrolabe, Astrolabica 3. Paris, 1983.

Primisser 1819
Primisser, A. *Die Kaiserlich-Königliche Ambraser-Sammlung*. Vienna, 1819.

Pudelko 1934
Pudelko, G. "Studien über Domenico Veneziano." *Mitteilungen des kunsthistorischen Instituts in Florenz* 4 (1934), 145.

Quarcoopone 1983
Quarcoopone, E. Nii. "Pendant Plaques." *The Art of Power, The Power of Art: Studies in Benin Iconography*. Edited by Paula Ben Amos and Arnold Rubin. Exh. cat. Museum of Cultural History, UCLA. Los Angeles, 1983.

Quinn 1961
Quinn, R. M. *Fernando Gallego and the Retablo of Ciudad Rodrigo*. Tuscon, 1961.

Raby 1982
Raby, Julian. *Venice, Dürer and the Oriental Mode*. The Hans Huth Memorial Studies I. London, 1982.

Raby 1985
Raby, Julian. "Mehmed II Fatih and the Fatih Album." In *Between China and Iran. Paintings from Four Istanbul*

Albums. Edited by Ernst J. Grube and Eleanor Sims. London, 1985, 42–49.

Raby 1987
Raby, Julian. "Pride and Prejudice: Mehmed the Conqueror and the Italian Portrait Medal." *Italian Medals*. Edited by J. Graham Pollard. Studies in the History of Art 21. Washington, 1987, 171–194.

Raby and Atasoy 1989
Raby, Julian, and Nurhan Atasoy. *Iznik. The Pottery of Ottoman Turkey*. London, 1989.

Raczynski 1846
Raczynski, Athanasius. *Les Arts au Portugal. Lettres Adressées à la Société Artistique et Scientifique de Berlin et accompagnées de documents*. Paris, 1846.

Rada y Delgado 1874
Rada y Delgado, Juan de Dios de la. "Sepulcro de Don Juan II en la Cartuja de Miraflores de Burgos." *Museo español de antigüedades* 3 (1874), 322.

Rapp and Stucky-Schürer 1990
Rapp, Bury, and Monica Stucky-Schürer. *Zahm und wild. Basler und Strassburger Bildteppiche des 15. Jahrhunderts*. Mainz, 1990.

Répertoire chronologique 1941
Répertoire chronologique d'épigraphie arabe 9 (1941).

Resende 1596
Resende, Garcia de. *Chronica que trata da vida e grandissimas virtudes (…) Dom João ho Segundo*. Lisbon, 1596.

Revuelta Tubino 1987
Revuelta Tubino, Matilde. *Museo de Santa Cruz, Toledo*. 2 vols. Ciudad Real, 1987.

Ricci 1935–1940
Ricci, Seymour de. *Census of Medieval and Renaissance Manuscripts in the United States and Canada*. 3 vols. New York, 1935–1940.

Richard 1989
Richard, Francis. "Dīvānī ou taʿlīq: un calligraphe au service du Mehmet II, Sayyidi Muhammed monşi." In *Les manuscrits du Moyen Orient. Essais de codicologie et de paléographie*. Edited by François Desroche. Istanbul, 1989, 89–93.

Richards 1968
Richards, Louise. "Antonio Pollaiuolo. Battle of the Naked Men." *Bulletin of the Cleveland Museum of Art* 55 (1968), 63–70.

Richter 1970/1977
The Literary Works of Leonardo da Vinci. 3d ed. Edited by Jean Paul Richter. 2 vols. London and New York, 1970; Oxford, 1977.

Rico Santamaría 1985
Rico Santamaría, Marcos. *La Catedral de Burgos*. Burgos, 1985.

Ringling Museum 1949
William E. Suida. *A Catalogue of Paintings*. John and Mable Ringling Museum of Art. Sarasota, Fla., 1949.

Robbins and Nooter 1989
Robbins, Warren M., and Nancy Ingram Nooter. *African Art in American Collections—Survey 1989*. Washington, 1989.

Roberts 1959
Roberts, Helen. "St. Augustine in 'St. Jerome's Study': Carpaccio's Painting and Its Legendary Source." *Art Bulletin* 12 (1959), 283–297.

Rodríguez Lorente 1964
Rodríguez Lorente, J. J. "The XVth Century Ear Dagger, its Hispano-Moresque Origin." *Gladius* 3 (1964), 68–70.

Rogers 1988
Rogers, J. Michael. "Two Masterpieces from 'Suleyman the Magnificent,' a Loan Exhibition from Turkey to the British Museum." *Orientations* (August 1988), 12–18.

Rohde 1923
Rohde, Alfred. *Die Geschichte der wissenschaftlichen Instrumente vom Beginn der Renaissance bis zum Ausgang des 18. Jahrhunderts*. Monographien des Kunstgewerbes 16. Leipzig, 1923.

Rome 1959
Bacou, R., and J. Bean. *Disegni fiorentini del Museo del Louvre dalla collezione di Filippo Baldinucci*. Exh. cat. Gabinetto Nazionale delle Stampe. Rome, 1959.

Römer 1917
Römer, E. "Materialien zur Dürerforschung." *Repertorium für Kunstwissenschaft* 40 (1917), 219–224.

Rose 1975
Rose, Paul. *The Italian Renaissance of Mathematics*. Geneva, 1975.

Rosenberg 1918
Rosenberg, Marc. *Geschichte der Goldschmiedekunst auf technischer Grundlage. Abteilung: Granulation.* Frankfurt am Main, 1918.

Rosi'nska 1974
Rosi'nska, Gra·zyna. *Instrumenty astronomiczne na Uniwersytecie Krakowskim w xv wieku.* Polska Akademia Nauk, Zaklad Historii Nauki i Techniki, Studia Copernicana 11. Wroclaw, Warsaw, Cracow, and Gdansk, 1974.

Ross 1963
Ross, David John A. *Alexander historiatus. A Guide to Medieval Illustrated Alexander Literature.* London, 1963.

Ross 1971
Ross, David John A. *Illustrated Medieval Alexander-Books in Germany and the Netherlands. A Study in Comparative Iconography.* Cambridge, 1971.

Rossacher 1962
Rossacher, Kurt. "Der verschollene Schatz der Erzbischöfe von Salzburg. Neue Entdeckungen in den Sammlungen des Palazzo Pitti in Florenz." *Alte und moderne Kunst* 58/59, 62/63, 64/65 (1962), 2–9.

Rossacher 1966
Rossacher, Kurt. *Der Schatz des Erzstiftes Salzburg.* Salzburg, 1966.

Rossi 1888
Rossi, F. "I Medaglisti del Rinascimento alla Corte di Mantova." *Rivista italiana di numismatica* (1888).

Rossi and others 1986
Rossi, Paolo, Celeste Soddu, and Carlo Ragghianti. "Il chalice di Paolo Uccello uno e senza limite." *Critica d'arte* 51 (1986), 85–92.

Roth 1964
Roth, Cecil. "Majolica Passover Plates of the xvi–xviii Centuries." *Eretz-Israel* 7 (Jerusalem, 1964), 106–111.

Rotondi 1969
Rotondi, Pasquale. *The Ducal Palace of Urbino.* London, 1969.

Roukema 1963
Roukema, Edzer. "Brazil in the Cantino Map." *Imago Mundi* 17 (1963), 7–26.

Rowlands 1988
Rowlands, John. *The Age of Dürer and Holbein. German Drawings, 1400–1550.* Exh. cat. British Museum. London, 1988.

Rücker 1973
Rücker, Elisabeth. *Die Schedelsche Weltchronik. Das grösste Buchunternehmen der Dürer-Zeit.* Munich, 1973.

Rückert 1965
Rückert, Rainer. "Das Nachlassinventar der bayerischen Herzogin Jacobäa." *Münchner Jahrbuch der bildenden Kunst* 14 (1965), 121–148.

Rudwick 1976
Rudwick, Martin J. S. *The Meaning of Fossils: Episodes in the History of Palaeontology.* New York, 1976.

Ruhmer 1958
Ruhmer, E. *Grünewald. The Paintings.* London, 1958.

Rupprich 1956–1969
Rupprich, Hans. *Dürers schriftlicher Nachlass.* 3 vols. Berlin, 1956–1969.

Ryder 1964
Ryder, Alan F. C. "A Note on the Afro-Portuguese Ivories." *Journal of African History* 5 (1964), 363–365.

Rykwert and others 1988
Alberti, Leon Battista. *On the Art of Building in Ten Books.* Translated by J. Rykwert, N. Leach, and R. Tavenor. Cambridge, Mass., and London, 1988.

Rzepinska 1985
Rzepinska, Maria. "La Dama dell'ermellino." *Leonardo. La Pittura.* Edited by Pietro Mariani. Florence, 1985.

Saalman 1968
Saalman, Howard. "The Baltimore and Urbino Panels: Cosimo Rosselli." *Burlington Magazine* 110 (1968), 376–383.

Sacken 1855
Sacken, E. von. *Die Ambraser Sammlung.* Vienna, 1855, 115.

Sacken 1859
Sacken, E. von. *Die Vorzüglichsten Rüstungen und Waffen der K.K. Ambraser-Sammlung.* Vol. 1. Vienna, 1859.

Salzburg 1967
Salzburgs Alte Schatzkammer. Exh. cat. Salzburg Cathedral. Salzburg, 1967.

Sampaio 1971
Sampaio, Luis de Melo Vaz de. "Subsídios para uma Biografia de Pedro Alvares Cabral." *Revista da Universidade de Coimbra* 24 (1971).

Sánchez Cantón 1930
Sánchez Cantón, F. J. "El retablo de la Reina Católica." *Archivo Español de Arte y Arqueología* (1930), 97–133.

Sandrart 1675
Sandrart, Joachim von. *Die teusche Akademie.* (1675). Edited by A. R. Peltzer. Munich, 1925.

Sangiorgi 1976
Sangiorgi, F. *Raffaello e i duchi di Urbino.* Urbino, 1976.

Santos 1946
Santos, Luís Reis. *Vasco Fernandes e os pintores de Viseu do séc xvi.* Lisbon, 1946.

Santos 1962
Santos, Luís Reis. *Vasco Fernandes.* Lisbon, 1962.

Santos 1925
Santos, Reynoldo dos. *As tapeçarias da tomada de Arzila.* Lisbon, 1925.

Santos 1932
Santos, Reynaldo dos. "Les principaux manuscrits à peintures conservés au Portugal." *Bulletin de la Société Française de Reproductions de Manuscrits à Peinture* (1932).

Santos 1950
Santos, Reynaldo dos. "Un Exemplaire de Vasari annoté par Francisco de Olanda." *Studi Vasariani* (1950), 91–92.

Santos 1955
Santos, Reynaldo dos. *Nuno Gonçalves.* London, 1955.

Santos 1964
Santos, Reynaldo dos. "As iluminuras da 'Crónica de D. João I' de Fernão Lopes em Madrid." *Colóquio* 24 (1964).

Santos 1970
Santos, Reynaldo dos. *Oito Séculos de Arte Portuguesa.* 3 vols. Lisbon, 1970.

Santos and Quilhó 1974
Santos, Reynaldo dos, and Irene Quilhó. *Ourivesaria Portuguesa em Colecções Particulares.* Lisbon, 1974.

Saraiva 1925
Saraiva, José. *Os Painéis do Infante Santo.* Leiria, 1925.

Sauvaget 1945–1946
Sauvaget, J. "Une ancienne Representation de Damas au Musée du Louvre." *Bulletin d'études orientales, Institut Français de Damas* 11 (1945–1946), 5–12.

Savage-Smith 1985
Savage-Smith, Emilie. "Islamicate Celestial Globes: Their History, Construction and Use." *Smithsonian Studies in History and Technology* 46 (Washington, 1985).

Saxl 1927
Saxl, Fritz. *Die Handschritften der National-Bibliothek in Wien. Verzeichnis astrologischer und mythologischer illustrierter Handschriften des lateinischen Mittelalters* 2. Heidelberg, 1927.

Saxl 1954
Saxl, Fritz. *English Sculptures of the Twelfth Century.* London, 1954.

Scalini 1984
Scalini, Mario. "Il 'Reuther' di Albrecht Dürer, Tipologia e Simbologia di un Armamento." *Antichità* 23 (1984), 15–18.

Scarpellini 1964
Scarpellini, P. *Luca Signorelli.* Florence, 1964.

Schiedlausky 1989
Schiedlausky, Günther. "Natterzungen: Ein Leitfossil in der Geschichte mittelalterlicher Giftfurcht." *Kunst und Antiquitäten* (1989, no. 6), 25–31.

Schmidberger 1990
Schmidberger, Ekkehard. "Porzellan aus China und Japan in Kassel. Zur Geschiche der ehemals landgräflichen Sammlung." In *Porzellan aus China und Japan.*
Die Porzellangalerie der Landgrafen von Hessen-Kassel. Berlin, 1990, 10–40.

Schönberger 1922
Schönberger, Guido. "Mathias Grünewalds 'Klein Crucifix.'" *Städel Jahrbuch* 2 (1922), 35–52.

Schönberger 1935–1936
Schönberger, Guido. "Narwal-Einhorn. Studien über einen seltenen Werkstoff." *Städel-Jahrbuch* 9 (1935–1936), 167–247.

Schulz 1978
Schulz, Juergen. "Jacopo de'Barbari's View of Venice: Map Making, City Views and Moralized Geography

before the Year 1500." *Art Bulletin* 60 (1978).

Scillia 1975
Scillia, Diane Grabowski. "Gerard David and Manuscript Illumination in the Low Countries, 1480–1509." Ph.D. dissertation. Case Western Reserve University, 1975.

Scotoni 1982
Scotoni, Lando. "Prime piante rilevate con le coordinate polari." *Scritti geografici in honore di Aldo Sestini* 2 (Florence, 1982), 985–999.

Sed-Rajna 1970
Sed-Rajna, Gabrielle. *Manuscrits Hébreux de Lisbonne.* Paris, 1970.

Sed-Rajna 1988
Lisbon Bible 1482, British Library Or. 2626. Introduction by Gabrielle Sed-Rajna. Tel-Aviv, 1988.

Segurado 1970
Segurado, Jorge. *Francisco d'Ollanda.* Lisbon, 1970.

Seitz 1965
Seitz, H. *Blankwaffen.* Vol. 1. Brunswick, 1965.

Servolini 1944
Servolini, L. *Jacopo de' Barbari.* Padua, 1944.

Shapley 1968
Shapley, Fern R. *Paintings from the Samuel H. Kress Collection. Italian Schools, xv–xvi Century.* Washington, 1968.

Shapley 1979
Shapley, Fern R. *Catalogue of the Italian Paintings. National Gallery of Art, Washington.* Washington, 1979.

Shearman 1975
Shearman, John. "The Collections of the Younger Branch of the Medici Family." *Burlington Magazine* 118 (1975), 18.

Shell 1991
Shell, Janice, and Grazioso Sironi. "Salai and Leonardo's Legacy." *Burlington Magazine* 133 (Feb. 1991).

Shestack, Talbot, and Hults 1981
Shestack, Alan, Charles Talbot, and Linda Hults. *Hans Baldung Grien. Prints and Drawings.* Exh. cat. Washington, 1981.

Shirley 1983
Shirley, Rodney W. *The Mapping of the World—Early Printed World Maps 1472–1700.* London, 1983.

Simões 1882
Simões, A. Filipe. *A Exposição Retrospectiva de Arte Ornamental Portuguesa a Hesoanhola em Lisboa.* Notas do Redactor do "Correio da Noite." Lisbon, 1882.

Smith 1983
Smith, Jeffrey Chipps. *Nuremberg. A Renaissance City, 1500–1618.* Austin, 1983.

Smith 1974
Smith, R. "Natural versus Scientific Vision: The Foreshortened Figure in the Renaissance." *Gazette des Beaux Arts* ser. 6, 84 (1974), 239–248.

Smith 1968
Smith, Robert. *The Art of Portugal, 1500–1800.* London, 1968.

Snyder 1973
Bosch in Perspective. Edited by James Snyder. Englewood Cliffs, 1973.

Sousa 1860
Castro e Sousa, A. D. de. *Noticia de alguns Livros iluminados que se guardam no Archivo Real, ou cartório de todo o Reino, de iluminadores até ao séc. 18º e do estabelecimento em Portugal da Torre do Tombo.* Lisbon, 1860.

Sousa 1868
Castro e Sousa, Abbade de. "Baixos-Relevos em Barro cozido e colorido do século xiv." *Archivo Pittoresco* 9 (1868).

Sousa 1739
Sousa, António Caetano de. *Historia Genealógica da Casa Real Portuguesa. Provas.* Vol. 2. Lisbon, 1739.

Sousa 1960
Sousa, J. M. Cordeiro de. "Os Medalhões Della Robbia no Museu das Janelas Verdes." *Boletim do Museu Nacional de Arte Antiga* 4, 2 (1960).

Spallanzani 1978
Spallanzani, Marco. *Ceramiche orientali a Firenze nel Rinascimento.* Florence, 1978.

Spitzer and Wiener 1875
Spitzer, Frédéric, and Ch. Wiener. *Portulan de Charles-Quint, donné à Philippe II, accompagné d'une notice explicative.* Paris, 1875.

Sterling 1968
Sterling, Charles. "Les Panneaux de Saint Vincent et leurs 'Enigmes.'" *L'Oeil, Revue de l'Art* 158 (1968).

Stevenson 1921
Stevenson, Edward Luther. *Terrestrial and Celestial Globes. Their History and Construction Including a Consideration of Their Value as Aids in the Study of Geography and Astronomy.* 2 vols. New Haven, 1921.

Stevenson 1932
Geography of Claudius Ptolemy. Edited by Edward Luther Stevenson. New York, 1932.

Strauss 1972
Strauss, Walter L. *The Complete Engravings, Etchings and Drypoints of Albrecht Dürer.* New York, 1972.

Strauss 1974
Strauss, Walter. *The Complete Drawings of Albrecht Dürer.* 6 vols. New York, 1974.

Strauss 1976
Strauss, Walter L. *The Intaglio Prints of Albrecht Dürer. Engravings, Etchings and Drypoints.* New York, 1976.

Strauss 1980
Strauss, Walter L. *Albrecht Dürer. Woodcuts and Wood Blocks.* New York, 1980.

Strieder 1982
Strieder, Peter. *Albrecht Dürer, Paintings, Prints, Drawings.* Translated by Nancy M. Gordon and Walter L. Strauss. New York, 1982.

Strika 1978
Strika, Vincenzo. "La Cattedra di S. Pietro a Venezia." *Annali dell'Istituto Orientale di Napoli* 38 (1978), Supplemento n.15.

Strömberg 1965
Strömberg, Elisabeth. "'Astonomie,' en fransk medeltidsgobeläng." *Röhsska Konstslöjdmuseets Årsbok* 1963–1964 (1965), 14–28, 46–47.

Tagliaferri 1989
Tagliaferri, Aldo. *Stili del potere — Antiche sculture in pietra della Sierra Leone e della Guinea.* Milan, 1989.

Tagliaferri and Hammacher 1974
Tagliaferri, Aldo, and Arno Hammacher. *Fabulous Ancestors: Stone Carvings from Sierra Leone and Guinea.* New York, 1974.

Tanındı 1985
Tanındı, Zeren. "Cilt Sanatında Kumaş." *Sanat Dünyamız* 11, 32 (1985), 27–34.

Tarín y Juaneda 1896
Tarín y Juaneda, Francisco. *La Cartuja de Miraflores (Burgos), su historia y descripción.* Burgos, 1896.

Taviani 1986
Taviani, Paolo Emilio. *I viaggi di Colombo: la grande scoperta.* Novara, 1986.

Teixeira da Mota 1975
Teixeira da Mota, Avelino. "Gli avori africani nella documentazione portoghese dei secoli XV–XVII." *Africa* 30, 4 (1975), 580–589.

Tescione 1965
Tescione, Giovanni. *Il corallo nella storia e nell'arte.* Naples, 1965.

Thieme and Becker 1907–1950
Thieme, U., and F. Becker. *Allgemeines Lexikon der bildenden Künstler.* 37 vols. Leipzig, 1907–1950.

Thomas 1949
Thomas, B. "Konrad Seusenhofer Studien — Zu seinen Spätwerken 1511 und 1517." *Konsthistorisk Tidskrift* 18 (Stockholm, 1949).

Thomas 1963/1964
Thomas, Bruno. "Orientalische Kostbarkeiten aus der Waffensammlung zu Wein." *Bustan.* 4–5. Vienna, 1963/1964.

Thomas and Gamber 1954
Thomas, B., and O. Gamber. *Die Innsbrucker Plattnerkunst.* Exh. cat. Tiroler Landesmuseum Ferdinandeum. Innsbruck, 1954.

Thomas, Gamber, and Schedelmann 1963
Thomas, B., O. Gamber, and H. Schedelmann. *Die schönsten Waffen und Rüstungen.* Heidelberg-Munich, 1963.

Thomas, Gamber, and Schedelmann 1974
Thomas, Bruno, Ortwin Gamber, and Hans Schedelmann. *Armi e Armature Europee.* Milan, 1974.

Thomas and Gamber 1976
Thomas, Bruno, and Ortwin Gamber. *Katalog der Leibrüstkammer.* Part 1: *Der Zeitraum von 500 bis 1530.* Kunsthistorisches Museum. Vienna, 1976.

Thompson 1980
Thompson, F. Paul. *Tapestry. Mirror of History.* Newton Albot, 1980.

Thompson 1854
Thompson, G. *Thompson in Africa.* New York, 1854.

Tietze and Tietze-Conrat 1935
Tietze, Hans, and E. Tietze-Conrat. "'The Sultan and His Mistress' by Albrecht Dürer." *Print Collector's Quarterly* 22 (1935), 213–223.

Tietze and Tietze-Conrat 1937–1938
Tietze, Hans, and Erika Tietze-Conrat. *Kritisches Verzeichnis der Werke Albrecht Dürers.* 3 vols. Basel, 1937–1938.

Toledo 1958
Carlos V y su ambiente. Exposición homenaje en el IV Centenario de su muerte (1558–1958). Toledo, 1958.

Tolnay 1943–1960
Tolnay, Charles de. *Michelangelo.* 5 vols. Princeton, 1943–1960.

Tolnay 1975–1980
Tolnay, Charles de. *Corpus dei disegni di Michelangelo.* 4 vols. Novara, 1975–1980.

Tosti et al. 1982
Tosti and others. "Due interventi di Conservazione." *Istituto Statale d'Arte di Gubbio.* Perugia, 1982.

Trionfi 1983
Trionfi, Honorati M. "Prospettive architettoniche a tarsia: le porte del Palazzo Ducale di Urbino." *Notizie di Palazzo Albani* 12 (1983), 38–50.

Trizna 1976
Trizna, Jazeps. *Michel Sittow: Peinture revalais de l'école bourgeoise (1468–1525/1526).* Brussels, 1976.

Turner 1987
Turner, Anthony. *Early Scientific Instruments. Europe 1400–1800.* London, 1987.

Uluçay 1960
Uluçay, M. Çagatay. *Osmanlı Sultanlarına aşk mektupları.* Istanbul, 1960.

Ünal 1969
Ünal, Ismail. "Çini cami Kandilleri." *Türk sanatı tarihi. Araştırma ve incemeleri.* Vol. 3. Istanbul, 1969, 74–111.

Underwood 1949
Underwood, Leo. *Bronzes of West Africa.* London, 1949.

Ünver 1958
Ünver, Ahmed Süheyl. *Fatih devri saray nakkaşhanesi ve Baba Nakkaş çalışmaları.* Istanbul, 1958.

Unverfehert 1980
Unverfehert, Gerd. *Hieronymus Bosch. Die Rezeption seiner Kunst im frühen 16. Jahrhundert.* Berlin, 1980.

Urbino 1978
Bernini, Dante, and Grazia Pezzini Bernini. *Il Restauro della Città Ideale di Urbino.* Exh. cat. Urbino, 1978.

Urrea Fernández 1982
Urrea Fernández, Jesús. *La Catedral de Burgos.* León, 1982.

Uzunçarşılı 1986
Uzunçarşılı, I. H. "Osmanlı Sarayında ehl-i hiref 'sanatkarlar' defterleri." *Belgeler* 15 (Ankara, 1986), 23–76.

Vadillo
Vadillo, Alfonso. *Archivo Municipal de Burgos.* Sec. fotográfica, 927–951.

Valladolid 1988
Las edades del hombre. El arte en la iglesia de Castilla y León. Exh. cat. Cathedral of Valladolid. Salamanca, 1988.

Vandenbroeck 1987
Vandenbroeck, Paul. *Jheronimus Bosch, tussen volksleven en stadscultuur.* Berchem, 1987.

Vandenbroeck 1987
Vandenbroeck, Paul. *Over wilden en narren, boeren en bedelaars. Beeld van de andere, vertoog over het zelf.* Koninklijk Museum voor Schone Kunsten. Antwerp, 1987.

Vandevivère 1967
Vandevivère, Ignace. *La Cathédrale de Palencia et l'église paroissale de Cervera de Pisuerga.* Brussels, 1967.

Vascáno 1892
Vascáno, Antonio. *Ensayo Biográphico del Célebre Navegante y Consumado Cosmógrafo Juan de la Cosa.* Madrid, 1892.

Vasconcelos 1882
Vasconcelos, Joaquim de. *Ensaio Histórico sobre a Ourivesaria Portuguesa, Sécs XIV–XVI.* Porto, 1882.

Vasconcelos 1895
Vasconcelos, Joaquim de. "Taboas da pintura portuguesa no século XV — Retrato Inédito do Infante D. Henrique." *O Comércio do Porto* (27–28 July 1895).

Vasconcelos 1896
Vasconcelos, Joaquim de. "A Pintura Portuguesa nos séculos XV e XVI." *Arte, Revista Internacional* 1, 3 (1896), 151–162.

Vasconcelos 1904
Vasconcelos, Joaquim de. *Arte Religiosa em Portugal.* fasc. 13. Porto, 1904.

Vasconcelos 1929
Vasconcelos, Joaquim de. *Albrecht Dürer e a sua influência na Península.* Coimbra, 1929.

Vasconcelos 1951
Vasconcelos, Joaquim de. *A Ourivesaria Portuguesa nos séculos XV e XVI.* Porto, 1951.

Venice 1968
Cento codici Bessarionei. Exh. cat. Biblioteca Nazionale Marciana. Venice, 1968.

Veth and Muller 1918
Veth, Jan, and Samuel Muller. *Albrecht Dürers Niederländische Reise.* 2 vols. Berlin and Utrecht, 1918.

Vieira Santos 1959
Vieira Santos, Armando. *Os Painéis de São Vicente de Fora.* Lisbon, 1959.

Vienna 1936
Grosz, August, and Bruno Thomas. *Katalog der Waffensammlung in der Neuen Burg, Schausammlung.* Kunsthistorisches Museum. Vienna, 1936.

Vienna 1964
Katalog der Sammlung für Plastik und Kunstgewerbe. Mittelalter. Vienna, 1964.

Vienna 1976
See Thomas and Gamber 1976.

Vienna 1982
Matthias Corvinus und die Renaissance in Ungarn 1458–1541. Exh. cat. Schloss Schallaburg. Vienna, 1982.

Villacampa 1928
Villacampa, Carlos G. "La Capilla del Condestable, de la Catedral de Burgos." *Archivo Español de Arte y Arqueología* 4 (1928), 25–44.

Villain-Gandossi 1985
Villain-Gandossi, Christiane. *Le navire médiéval à travers les miniatures.* Paris, 1985.

Viterbo 1882
Viterbo, Sousa. "A Exposição de Arte Ornamental. Notas ao Catálogo." *Boletim da Sociedade de Geografia de Lisboa* (1882).

Viterbo 1899
Viterbo, Sousa. *Dicionário Histórico e Documental dos Arquitectos, Engenheiros e Construtores Portugueses.* Lisbon, 1899.

Viterbo 1920
Viterbo, Sousa. *Artes e Artistas em Portugal.* Lisbon, 1920 (1st edition 1892).

Voss 1943
Voss, Wilhelm. "Eine Himmelskarte vom Jahre 1503 mit den Wahrzeichen des Wiener Poetenkollegiums als Vorlage Albrecht Dürers." *Jahrbuch der preussischen Kunstsammlungen* 64 (1943), 89–150.

Wagner 1985
Wagner, Franz. "Beschlagene Straussen-Ayer. Ungewöhnliche Trinkgeschirre des Spätmittelalters und der frühen Neuzeit." *Kunst und Antiquitäten* (1985), no. 2, 32–42.

Wagner 1986
Wagner, Franz. "'Halt veste uns komen Geste': Greifenklauen als festliche Trinkgeschirre." *Kunst und Antiquitäten* (1986), no. 3, 64–70.

Wagner 1931
Wagner, Henry Raup. "The Manuscript Atlases of Battista Agnese." *Papers of the Bibliographical Society of America* 25 (1931), 1–110.

Wagner 1947
Wagner, Henry Raup. "Additions to the Manuscript Atlases of Battista Agnese." *Imago Mundi* 4 (1947), 28–30.

Waldseemüller 1507
Waldseemüller, Martin. *Cosmographiae introductio.* Saint-Dié, 1507.

Walker 1967
Walker, John. "Ginevra de' Benci by Leonardo da Vinci." *Report and Studies in the History of Art.* Washington, 1967, 1–38.

Walker 1975

Walker, John. *National Gallery of Art, Washington.* Washington, 1975.

Ward 1883–1910
Ward, Henry Leigh Douglas. *Catalogue of Romances in the Department of Manuscripts in the British Museum.* 3 vols. London, 1883–1910.

Wardwell 1988–1989
Wardwell, Anne. "*Panni tartarici*: Eastern Islamic Silks Woven with Gold and Silver (13th and 14th Centuries)." *Islamic Art* 3 (1988–1989), 95–173.

Warner 1889
Warner, George Frederick. *The Buke of John Mandevill, being the Travels of Sir John Mandeville.* London, 1889.

Warner and Gilson 1921
Warner, George, and Julius P. Gilson. *British Museum. Catalogue of Western Manuscripts in the Old Royal and King's Collections.* 4 vols. London, 1921.

Washington 1966
Art Treasures of Turkey. Exh. cat. Smithsonian Institution. Washington, 1966.

Washington 1971
Dürer in America: His Graphic Work. Edited by Charles W. Talbot. Exh. cat. National Gallery of Art. Washington, 1971.

Washington 1986
Leithe-Jasper, Manfred. *Renaissance Master Bronzes from the Collection of the Kunsthistorisches Museum, Vienna.* Exh. cat. National Gallery of Art. Washington, 1986.

Washington 1988
Hirst, Michael. *Michelangelo Draftsman.* Exh. cat. National Gallery of Art. Washington, 1988.

Wattenberg 1980
Wattenberg, Diedrich. "Johannes Regiomontanus und die astronomischen Instrumente seiner Zeit." In *Regiomontanus-Studien.* Edited by Günther Hamann. Vienna, 1980, 343–362.

Watts 1924
Watts, William Walter. *Old English Silver.* London, 1924.

Weil-Garris Posner 1970
Weil-Garris Posner, Kathleen. "Notes on S. Maria dell'Anima." *Storia dell'arte* 6 (1970).

Weise 1925
Weise, George. *Spanische Plastik aus sieben Jahrhunderten.* 4 vols. Reutlingen, 1925.

Welliver 1973
Welliver, W. "The Symbolic Architecture of Domenico Veneziano and Piero della Francesca." *Art Quarterly* 26 (1973), 1–30.

Welsh 1904
Welsh, James. "A journey to Benin beyond the countrey of Guinea made by Master James Welsh, who set forth in the yeere 1588." *The Principal Navigations Voyages Traffiques and Discoveries of the English Nation.* Edited by R. Hackluyt. London, 1904.

Wethey 1936
Wethey, Harold E. *Gil de Siloe and His School.* Cambridge, Mass., 1936.

White 1973
White, Christopher. "'An Oriental Ruler on His Throne' and 'The Entombment': Two New Drawings by Albrecht Dürer." *Master Drawings* 11 (1973), 365–374.

Whitehouse 1973
Whitehouse, David. "Chinese Porcelain in Medieval Europe." *Medieval Archaeology* 16 (1973), 63–78.

Wickhoff 1882
Wickhoff, F. "Die Antike im Bildungsgange Michelangelos." *Mitteilungen des Instituts für Oesterreichische Geschichtsforschung* 2 (1882), 408–435.

Wieser 1876
Wieser, Franz. "Der Portulan des Infanten und nachmaligen Königs Philipp II von Spanien." *Sitzungsberichte der philosophisch-historischen Classe der Kaiserlichen Akademie der Wissenschaften* 82 (1876), 541–561.

Wilde 1944
Wilde, Johannes. "The Hall of the Great Council of Florence." *Journal of the Warburg and Courtauld Institutes* 7 (1944), 65–81.

Willett 1971
Willett, Frank. *African Art.* London, 1971.

Willett 1986
Willett, Frank. "A Missing Millennium? From Nok to Ife and Beyond." *Arte in Africa — Realtà e prospettive nello studio delle arti africane.* Edited by Ezio Bassani. Flor-

ence, 1986, 87–100.

Wilson 1976
Wilson, Adrian. *The Making of the Nuremberg Chronicle.* Amsterdam, 1976.

Winkler 1925
Winkler, Friedrich. *Die Flämische Buchmalerei des XV. und XVI. Jahrhunderts.* Leipzig, 1925.

Winkler 1932
Winkler, Friedrich. "Dürerstudien III Verschollene Meisterzeichnungen Dürers. Einige berufssmässige Kopisten (Meister der 1520er Jahre, Hans Hoffmann usw)." *Berliner Jahrbuch* 35 (1932), 68–89.

Winkler 1936–1939
Winkler, Friedrich. *Die Zeichnungen Albrecht Dürers.* 4 vols. Berlin, 1936–1939.

Winter 1981
Winter, Patrick M. de. "A Book of Hours of Queen Isabel la Católica." *Bulletin of the Cleveland Museum of Art* 67, 10 (1981), 342–421.

Winterberg 1899
Winterberg, C. *Pictor Burgensis de Prospectiva pingendi.* Strassburg, 1899.

Wirth 1979
Wirth, J. *La Jeunne fille et la mort.* Geneva, 1979.

Wittkower 1942
Wittkower, Rudolf. "Marvels of the East: A Study in the History of Monsters." *Journal of the Warburg and Courtauld Institutes* 5 (1942), 159–197.

Wittkower 1977
Wittkower, Rudolf. "Marvels of the East: A Study in the History of Monsters," "Marco Polo and the Pictorial Tradition of the Marvels of the East," and "*Roc*: An Eastern Prodigy in a Dutch Engraving." In *Allegory and the Migration of Symbols.* London, 1977, 45–74; 76–92; 93–96.

Wohl 1980
Wohl, Helmut. *The Paintings of Domenico Veneziano.* New York and London, 1980.

Wohl 1976
Condivi, Ascanio. *The Life of Michelangelo.* Edited by H. Wohl. Translated by A. Sedgwick Wohl. Baton Rouge, La., 1976.

Wolf 1960
Wolf, Siegfried. "Afrikanische Elfenbeinlöffel des 16. Jahrhunderts im Museum für Völkerkunde Dresden." *Ethnologica* 2 (1960), 410–425.

Wolfe 1962
Wolfe, Philippe. *Le Temps et sa Mesure au Moyen-Age.* Paris, 1962.

Wolff-Metternich 1967–1968
Wolff-Metternich, Franz Graf. "Der Kupferstich Bernardos de Prevedari um 1481. Gedanken zu den Anfängen der Kunst Bramantes." *Römisches Jahrbuch für Kunstgeschichte* 11 (1967–1968), 7–108.

Woodward 1987
Woodward, David. "Medieval *Mappaemundi*." In *The History of Cartography I.* Edited by J. B. Harvey and David Woodward. Chicago and London, 1987, 286–370.

Yörukan 1965
Yörukan, Beyhan. "Topkapı Sarayı Müzesindeki albümlerde bulunan bazi rulo parçalari." *Sanat Tarihi Yilligi 1964–1965.* Istanbul, 1965, 188–199.

Young 1975
Young, Eric. *Bartolomé Bermejo: The Great Hispano-Flemish Master.* London, 1975.

Yücel 1988
Yücel, Ünsal. *Al-suyūf al-islāmiyya.* Translated by Tahsin Amratoğlu. Kuwait, 1988.

Yüksel 1983
Yüksel, İ. Aydın. *Osmanlı mimarisinde II. Bâyezid Yavuz Selim devri (886–926/1482–1520).* Istanbul, 1983.

Yule 1875
Yule, Henry. *The Book of Ser Marco Polo.* 2 vols. London, 1875.

Zammit-Maempel 1975
Zammit-Maempel, George. "Fossil Sharks' Teeth: A Medieval Safeguard against Poisoning." *Melita Historica* 6,4 (1975), 391–410.

Zeiler 1659
Zeiler, Martin. *Exoticophylacium Weickmannianum.* Ulm, 1659.

Zeri 1976
Zeri, Federigo. *Italian Paintings in the Walters Art Gallery.* Baltimore, 1976.

Zink 1968
Zink, Fritz. *Die Handzeichnungen bis zur Mitte des 16. Jahrhunderts.* Kataloge des Germanischen Nationalmuseums Nürnberg. Die deutschen Handzeichnungen 1. Nuremberg, 1968.

Zöllner 1987
Zöllner, F. *Vitruvs Proportionsfigur. Quellenkritische Studien zur Kunstliteratur im 15. und 16. Jahrhundert.* Worms, 1987.

Zorzi 1988
Zorzi, Marino. *Biblioteca Marciana, Venezia.* Florence, 1988.

Zülch 1938
Zülch, W. K. *Der historische Grünewald: Mathis Gorthart-Neithardt.* Munich, 1938.

Zurla 1806
Zurla, Placido. *Il mappamondo di Fra Mauro Camaldolese.* Venice, 1806.

Zygulski 1969
Zygulski, Zdzislaw Jr. *Contribution aux etudes sur la Dame à l'hermine. Le style du vêtement et les noeuds de Leonardo.*

II. Toward Cathay

Acker 1954
Acker, William R. *Some T'ang and Pre-T'ang Texts on Chinese Painting.* Leiden, 1954.

Ann Arbor 1976
Edwards, Richard. *The Art of Wen Cheng-ming.* Exh. cat. University of Michigan Museum of Art. Ann Arbor, 1976.

Barnhart in Bush and Murck 1983
Barnhart, Richard. "The 'Wild and Heterodox School' of Ming Painting." In Bush and Murck 1983.

Beijing 1983
A Selection of Ming Dynasty Court Paintings and Zhe School Paintings. Exh. cat. Palace Museum. Beijing, 1983.

Beijing and Hong Kong 1990
The Wumen Paintings of the Ming Dynasty. Exh. cat. Palace Museum. Beijing and Hong Kong, 1990. With English suppl.

Born 1936
Born, Wolfgang. "Some Eastern Objects from the Hapsburg Collections." *Burlington Magazine* 69 (1936), 269–277.

Boston 1970
Fontein, Jan, and Money Hickman. *Zen Painting and Calligraphy.* Exh. cat. Museum of Fine Arts, Boston.

Brankston 1938, 1970
Brankston, A. D. *Early Ming Wares of Chingtechen.* Peking, 1938, reprint Hong Kong, 1970.

Brewitt-Taylor 1925
Brewitt-Taylor, C. H., translator. *Lo Kuanchung's Romance of the Three Kingdoms.* Shanghai, 1925.

Bush and Murck 1983
Theories of Art in China. Edited by Susan Bush and Christian Murck. Princeton, 1983.

Bush and Shih 1985
Bush, Susan, and Hsiao-yen Shih. *Early Chinese Texts on Painting.* Cambridge, Mass., and London, 1985.

Cahill 1978
Cahill, James. *Parting at the Shore.* New York and Tokyo, 1978.

Cambridge 1988
Cambridge History of China. Edited by Frederick W. Mote and Denis Twitchett. Vol. 7: *The Ming Dynasty, 1368–1644: Part One.*

Castile 1971
Castile, Rand. *The Way of Tea.* New York, 1971.

Ch'en 1966
Ch'en Chih-mei. *Chinese Calligraphers and Their Art.* Adelaide, 1966.

Chan 1982
Chan, Albert. *The Glory and Fall of the Ming Dynasty.* Norman, Okla., 1982.

Chapman 1982
Chapman, Jan. "The Use of Manipulation in Chinese Rhinoceros Horn Cups." *Arts of Asia* 12 (July–August 1982), 101–105.

Chiang 1954, 1973
 Chiang Yee, *Chinese Calligraphy*. London, 1954, reprint Cambridge, Mass., 1973.
Chicago 1985
 Carswell, John. *Blue and White: Chinese Porcelain and Its Impact on the Western World*. Exh. cat. Smart Gallery, University of Chicago. Chicago, 1985.
Cleveland 1977
 Japanese Screens from the Museum and Cleveland Collections. Exh. cat. Cleveland Museum of Art. Cleveland, 1977.
Cleveland 1980
 Ho, Wai-kam, Sherman E. Lee, Laurence Sickman, and Marc F. Wilson. *Eight Dynasties of Chinese Painting*. Exh. cat. Cleveland Museum of Art and Nelson-Atkins Museum of Art, Kansas City. Cleveland, 1980.
Cleveland 1983
 Lee, Sherman E., and others. *Reflections of Reality in Japanese Art*. Exh. cat. Cleveland Museum of Art. Cleveland, 1983.
Cleveland 1990
 Catalogue of the Severance and Greta Millikin Collection. Exh. cat. Cleveland Museum of Art. Cleveland, 1990.
Cort 1979, 1981
 Cort, Louise A. *Shigaraki: Potters Valley*. Tokyo and New York, 1979, 1981.
Covell 1941, 1974
 Covell, Jon C. *Under the Seal of Sesshū*. New York, 1941, reprint New York, 1974.
Covell and Yamada 1974
 Covell, Jon, and Sobin Yamada. *Zen at Daitoku-ji*. Tokyo, New York, and San Francisco, 1974.
David 1971
 David, Sir Percival. *Chinese Connoisseurship: The Ko Ku Yao Lun*. London, 1971.
DeWoskin in Bush and Murck 1983
 DeWoskin, Kenneth. "Early Chinese Music and the Origins of Aesthetic Terminology." In Bush, and Murck 1983.
Driscoll and Toda 1935, 1964
 Driscoll, Lucy, and Kenji Toda. *Chinese Calligraphy*. Chicago, 1935, reprint New York, 1964.
Edwards 1962
 Edwards, Richard. *The Field of Stones: A Study of the Art of Shen Chou*. Washington, 1962.
Edwards 1976
 Edwards, Richard. "Shen Chou." In *Dictionary of Ming Biography*. Edited by L. Carrington Goodrich and Chaoying Fang. New York, 1986, 2:1173–1177.
Ellsworth 1971
 Ellsworth, Robert H. *Chinese Furniture*. New York, 1971.
Faulkner and Impey 1981
 Faulkner, R. F. J., and Oliver R. Impey. *Shino and Oribe Kiln Sites*. Oxford, 1981.
Feddersen 1961
 Feddersen, Martin. *Chinese Decorative Art*. New York, 1961.
Fong 1958
 Fong, Wen. *The Lohans and a Bridge to Heaven*. Washington, 1958.
Fukuyama 1976
 Fukuyama, Toshio. *Heian Temples: Byōdō-in and Chūson-ji*. New York and Tokyo, 1976.
Garner 1962
 Garner, Sir Harry. *Chinese and Japanese Cloisonné Enamels*. London, 1962.
Garner 1979
 Garner, Sir Harry. *Chinese Lacquer*. London, 1979.
Gompertz 1968
 Gompertz, G. St. G. M. *Korean Pottery and Porcelain of the Yi Period*. London, 1968.
Goodrich and Fang 1976
 Goodrich, L. Carrington, and Chaoying Fang, editors. *Dictionary of Ming Biography*. New York, 1976, 2 vols.
Gordon 1959
 Gordon, Antoinette. *The Iconography of Tibetan Lamaism*. Rutland, Vt., 1959.
Goswamy 1988
 Goswamy, B. N. *A Jainesque Sultanate Shahnama and the Context of Pre-Mughal Painting in India*. Zurich, 1988.
Hall and Toyoda 1977
 Hall, John W., and Takeshi Toyoda, editors. *Japan in the Muromachi Age*. Berkeley, 1977.

Harada 1937
 Harada, Jiro. *A Glimpse of Japanese Ideals*. Tokyo, 1937.
Hayashiya, Nakamura, and Hayashiya 1974
 Hayashiya Tatsusaburo, Nakamura Masao, and Hayashiya Seizo. *Japanese Arts and the Tea Ceremony*. Tokyo and New York, 1974.
Hetherington 1948
 Hetherington, A. L. *Chinese Ceramic Glazes*. South Pasadena, Cal., 1948.
Hong Kong 1988
 Paintings of the Ming Dynasty from the Palace Museum. Exh. cat. Chinese University of Hong Kong. Hong Kong, 1988.
Huai'an 1988
 Huai'an County Museum. *The Wang Zen [sic] Tomb of the Ming Dynasty at Huai'an*. Huai'an, 1988. With English summary.
Huntington 1990
 Huntington, Susan L., and John C. Huntington. *Leaves from the Bodhi Tree*. Seattle and London, 1990.
Ienaga 1973
 Ienaga, Saburo. *Painting in the Yamato Style*. New York and Tokyo, 1973.
Jenyns 1953
 Jenyns, Soame. *Ming Pottery and Porcelain*. London, 1953.
Jenyns 1971
 Jenyns, Soame. *Japanese Pottery*. London, 1971.
Jenyns and Watson 1980
 Jenyns, Soame, and William Watson. *Chinese Art: The Minor Arts II*. New York, 1980.
Kanazawa 1979
 Kanazawa, Hiroshi. *Japanese Ink Paintings: Early Zen Masterpieces*. Tokyo and New York, 1979.
Kates 1948, 1962
 Kates, George N. *Chinese Household Furniture*. New York, 1948, reprint, New York 1962.
Keene 1971
 Keene, Donald. *Landscapes and Portraits*. Tokyo, 1971.
Kim 1990–1991
 Kim, Kumja Paik. "The Introduction of the Southern School Painting Tradition to Korea." *Oriental Art* 36, no. 4 (Winter 1990–1991), 186–195.
Kim and Gompertz 1961
 Kim, Chewon, and G. St. G. M. Gompertz. *The Ceramic Art of Korea*. London, 1961.
Kim and Lee 1974
 Kim, Chewon, and Lena Kim Lee. *Arts of Korea*. Tokyo, New York, and San Francisco, 1974.
Lach 1970
 Lach, Donald F. *Asia in the Making of Europe*. Vol. 2: *A Century of Wonder*. Chicago, 1970.
Lee 1963
 Lee, Sherman E. *Tea Taste in Japanese Art*. New York, 1963.
Lin in Bush and Murck 1983
 Lin, Shuen-fu. "Chiang K'uei's Treatises on Poetry and Calligraphy." In Bush and Murck 1983.
Little 1985
 Little, Stephen. "The Demon Queller and the Art of Qiu Ying." *Artibus Asiae* 46, 1/2 (1985).
Loehr 1980
 Loehr, Max. *The Great Painters of China*. New York, 1980.
London 1958
 Oriental Ceramic Society. *The Arts of the Ming Dynasty*. Exh. cat. Arts Council of Great Britain. London, 1958.
London 1982
 Losty, Jeremiah P. *The Art of the Book in India*. London, 1982.
London 1984
 Goepper, Roger, and Roderick Whitfield, editors. *Treasures from Korea: Art Through 5000 Years*. Exh. cat. The British Museum. London, 1984.
Los Angeles 1977
 Pal, Pratapaditya. *The Sensuous Immortals: A Selection of Sculptures from the Pan Asian Collection*. Exh. cat. Los Angeles County Museum of Art. Los Angeles, 1977.
Los Angeles 1984
 Light of Asia. Exh. cat. Los Angeles County Museum of Art. Los Angeles, 1984.
Los Angeles 1985
 Miyajima, Shin'ichi, and Yasuhiro Satō. *Japanese Ink Painting*. Edited by George Kuwayama. Los

Angeles County Museum of Art. Los Angeles, 1985.
Los Angeles 1989
 Kotz, Suzanne, editor. *Imperial Taste: Chinese Ceramics from the Percival David Foundation*. Exh. cat. Los Angeles County Museum of Art. Los Angeles, 1989.
Matsushita 1961
 Matsushita Takaaki. *Suiboku Painting of the Muromachi Period*. Tokyo, 1961.
Matsushita 1974
 Matsushita Takaaki. *Ink Painting*. Translated by Martin Collcutt. Tokyo and New York, 1974.
McCune 1962
 McCune, Evelyn. *The Arts of Korea, an Illustrated History*. Tokyo, 1962.
Medley 1962–1963
 Medley, Margaret. "Re-grouping 15th Century Blue and White." *Transactions of the Oriental Ceramic Society* 34 (1962–1963).
Medley 1963
 Medley, Margaret. *Illustrated Catalogue of Porcelains Decorated in Underglaze Blue and Copper Red*. London: Percival David Foundation of Chinese Art, 1963.
Medley 1966
 Medley, Margaret. *Illustrated Catalogue of Ming Polychrome Wares*. London, Percival David Foundation of Chinese Art, 1966.
Medley 1976
 Medley, Margaret. *The Chinese Potter*. Ithaca, N. Y., 1976, rev. ed.
Metropolitan Museum of Art 1983
 Schimmel, Annemarie. In *Notable Acquisitions 1981–1982*. New York, 1983.
Mikami 1983
 Mikami, Tsugio. *The Art of Japanese Ceramics*. 5th printing, New York and Tokyo, 1983.
Munakata 1974
 Munakata, Kiyohiko. *Ching Hao's Pi-fa-chi: A Note on the Art of the Brush*. Ascona, 1974.
Murck 1976
 Murck, Christian, editor. *Artists and Traditions*. Princeton, 1976, esp. Wai-kam Ho, "Tung Ch'i-ch'ang's New Orthodoxy and Southern School Theory," 113–129.
Nara 1973
 Korean Paintings of the Koryŏ and Yi Dynasties, Exh. cat. Yamato Bunkakan. Nara, 1973.
Nara 1979
 The Arts of the Lotus Sutra. Exh. cat. Nara National Museum. Nara, 1979.
Nara 1985
 Arts Treasures of Mountain Religion. Exh. cat. Nara National Museum. Nara, 1985.
New Delhi 1964
 Manuscripts from Indian Collections. Exh. cat. National Museum of India. New Delhi, 1964.
New Haven 1977
 Fu, Shen C. Y. *Traces of the Brush: Studies in Chinese Calligraphy*. Exh. cat. Yale University Art Gallery. New Haven, 1977.
New York 1968
 Griffing, Robert P., Jr. *The Art of the Korean Potter*. Exh. cat. The Asia Society. New York, 1968.
New York 1980
 Watt, James. *Chinese Jades from Han to Ch'ing*. Exh. cat. The Asia Society. New York, 1980.
New York 1981
 Lee, Sherman E., and others. *One Thousand Years of Japanese Art*. Exh. cat. Japan Society. New York, 1981.
New York 1982–1983
 Metropolitan Museum of Art: Notable Acquisitions 1981–1982. New York, 1983.
New York 1983
 Murase, Miyeko. *Emaki: Narrative Scrolls from Japan*. Exh. cat. The Asia Society. New York, 1983.
New York 1985
 Welch, Stuart Cary. *India: Art and Culture 1300–1900*. Exh. cat. The Metropolitan Museum of Art. New York, 1985.
New York 1989
 Brinker, Helmut, and A. Lutz. *Chinese Cloisonné: The Pierre Uldry Collection*. Exh. cat. The Asia Society. New York, 1989.
New York 1991
 Kim, Hongnam. *The Story of a Painting*. Exh. cat. The Asia Society. New York, 1991, esp. 22–23.

Okazaki 1977
 Okazaki, Jōji. *Pure Land Buddhist Painting*. Tokyo, New York, and San Francisco, 1977.
Okudaira 1962
 Okudaira, Hideo. *Emaki: Japanese Picture Scrolls*. Rutland, Vt., and Tokyo, 1962.
Pal 1984
 Pal, Pratapaditya. *Tibetan Paintings*. Vaduz and Basel, 1984.
Pal 1988
 Pal, Pratapaditya. *Indian Sculpture*. Vol. 2: *700–1800*. Los Angeles, 1988.
Pal and Tseng 1975
 Pal, Pratapaditya, and Hsien-ch'i Tseng. *Lamaist Art: The Aesthetics of Harmony*. Boston, 1975.
Paris 1977
 Dieux et Demons de l'Himālaya. Exh. cat. Musées Nationaux. Paris, 1977.
Philadelphia 1971
 Ecke, Tseng Yu-ho. *Chinese Calligraphy*. Exh. cat. Philadelphia Museum of Art. Philadelphia, 1971.
Princeton 1976
 Shimizu, Yoshiaki, and Carolyn Wheelwright, editors. *Japanese Ink Paintings from American Collections*. Exh. cat. The Art Museum, Princeton University. Princeton, 1976.
Princeton 1984
 Fong, Wen. *Images of the Mind*. Exh. cat. The Art Museum, Princeton University. Princeton, 1984.
Rhee 1978
 Rhee, Byung-chang, editor, and Ikutarō Itoh, managing editor. *Masterpieces of Korean Art*. Vol. 3: *Yi Ceramics*. Tokyo, 1978.
Rhodes 1970
 Rhodes, Daniel. *Tamba Pottery*. Tokyo, New York, and San Francisco, 1970.
Riddell 1979
 Riddell, Sheila. *Dated Chinese Antiquities, 600–1650*. London, 1979.
Rogers 1988
 Rogers, Howard. *Masterworks of Ming and Qing Painting from the Forbidden City*. Exh. cat. International Arts Council. Lansdale, Pa., 1989.
Rosenfield in Hall and Toyoda 1977
 Rosenfield, John M. "The Unity of the Three Creeds." In Hall and Toyoda, 1977.
Sadler 1962
 Sadler, Arthur L. *Cha-no-Yu: The Japanese Tea Ceremony*. Reprint, Rutland, Vt., and Tokyo, 1962.
San Francisco 1979
 Five Thousand Years of Korean Art. Exh. cat. Asian Art Museum of San Francisco. San Francisco, 1979.
Sanford 1981
 Sanford, James H. *Zen-Man Ikkyū*. Boston, 1981.
Sansom 1958
 Sansom, Sir George. *A History of Japan*. Vol. 1: *To 1334*. Vol. 2: *1334–1615*. Stanford, 1958, 1961.
Saunders 1960
 Saunders, E. Dale. *Mudrā: A Study of Symbolic Gestures in Japanese Buddhist Sculpture*. New York, 1960.
Sawa 1972
 Sawa Takaaki. *Art in Japanese Esoteric Buddhism*. New York and Tokyo, 1972.
Sayer 1951
 Sayer, Geoffrey R. *Ching-Te-Chen T'ao-Lu* or *The Potteries of China*. London, 1951.
Schafer 1963
 Schafer, Edward H. *The Golden Peaches of Samarkand*. Berkeley, 1963.
Schafer 1969
 Schafer, Edward H. *Shore of Pearls*. Berkeley, 1969.
Seattle 1972
 Ceramic Art of Japan. Exh. cat. Seattle Museum of Art. Seattle, 1972.
Seoul 1972
 Ancient Arts of Korea. Exh. cat. National Museum of Korea. Seoul, 1972.
Sirén 1958
 Sirén, Osvald. *Chinese Painters: Leading Masters and Principles*. London, 1958.
Sirén 1963
 Sirén, Osvald. *The Chinese on the Art of Painting*. New York, 1963.
Snellgrove 1987

Snellgrove, David. *Indo-Tibetan Buddhism*. 2 vols. Boston, 1987.
Soper 1958
 Soper, Alexander C., translator. "T'ang Chao Ming Hua Lu" [Celebrated Painters of the T'ang Dynasty], by Zhu Jingxuan [9th century]. In *Artibus Asiae* 31 (1958), 204–230.
Speiser, n.d.
 Speiser, Werner. *Meisterwerke Chinesischen Malerei aus der Sammlung der Japanischen Reichsmarschalle Yoshimitsu und Yoshimasa*. Berlin, n.d.
Sullivan 1974
 Sullivan, Michael. *The Three Perfections: Chinese Painting, Poetry, and Calligraphy*. London, 1974.
Taipei 1974
 An Exhibition of Works by Ch'iu Ying. Exh. cat. National Palace Museum. Taipei, 1974.
Taipei 1975
 Ninety Years of Wu School Painting. Exh. cat. National Palace Museum. Taipei, 1975.
Tanaka 1972
 Tanaka Ichimatsu. *Japanese Ink Painting: Shūbun to Sesshū*. New York and Tokyo, 1972.
Tanaka 1978
 Suiboku Bijutsu Taikei. Ichimatsu Tanaka, editor. Vol. 6: *Josetsu, Shūbun, and the Three Ami*. Tokyo, 1978.
Tanaka and Nakamura 1973
 Suiboku Bijutsu Taikei. Vol. 7: *Sesshū, Sesson*, by Ichimatsu Tanaka and Tanio Nakamura. Tokyo, 1973.
Tate 1989–1990
 Tate, John. "The Sixteen Arhats in Tibetan Painting." *Oriental Art* 35 (Winter 1989–1990).
Tokyo 1977
 Commemorative Catalogue of the Special Exhibition, Oriental Lacquer Arts. Exh. cat. Tokyo National Museum. Tokyo, 1977.
Tokyo 1985
 Japanese Ceramics. Exh. cat. Tokyo National Museum. Tokyo, 1985.
Tseng 1954
 Tseng Yu-ho. "'The Seven Junipers' of Wen Chengming." *Archives of the Chinese Art Society of America* 8 (1954).
Valenstein 1989
 Valenstein, Suzanne. *A Handbook of Chinese Ceramics*. New York, 1989.
Vanderstappen 1956, 1957
 Vanderstappen, Harrie. "Painters at the Early Ming Court (1368–1435) and the Problem of a Ming Academy." *Monumenta Serica* 15, no. 2 (1956) and 16, nos. 1–2 (1957).
Von Schroeder 1981
 Von Schroeder, Ulrich. *Indo-Tibetan Bronzes*. Hong Kong, 1981.
Wang 1986
 Wang Shixiang. *Classic Chinese Furniture*. Bangkok, 1986.
Willetts 1958
 Willetts, William. *Chinese Art*. Vol. 1: jade, lacquer, and silk. Vol. 2: ceramics. Baltimore, 1958.
Xu 1987
 Xu Bangda. "Huai'an Ming mu Chu-tu shu-hua jian xi." *Wenwu* 1987, no. 3.
Yamada 1964
 Yamada, Chisaburoh, editor. *Decorative Arts of Japan*. Tokyo, 1964.
Yashiro 1960
 Yashiro Yukio, editor. *Art Treasures of Japan*. 2 vols. Tokyo, 1960.
Yonezawa 1956
 Yonezawa Yoshio. *Painting in the Ming Dynasty*. Tokyo, 1956.

III. The Americas

Alegría 1983
 Alegría, Ricardo. "Aspectos de la cultura de las indios taínos de las Antillas Mayores en la documentación etnohistórico." *La Cultura Taína*. Madrid, 1983, 123–140.

Andree 1914
 Andree, Richard. "Seltene Ethnographica des städtoschen Gewerbe-Museums zu Ulm." *Baessler-Archiv* 4 (1914), 29–38.
Anghiera 1530
 Anghiera, Petrus Martyr d'. *De Orbe Novo*. Alcalá, 1530.
Arrom 1988
 Arrom, José Juan. *Fray Ramón Pané, Relación acerca de las antigüedades de los indios: El primer tratado escrito en América*. 8th edition. Mexico City, 1988.
Arrom 1989
 Arrom, José Juan. *Mitología y artes prehispánicas de las Antillas*. 2d edition. Mexico City, 1989.
Bandelier 1910
 Bandelier, Adolf F. *The Islands of Titicaca and Koati*. New York, 1910.
Barthel 1971
 Barthel, Thomas S. "Viracochas Prunkgewand (Tocapu-Studien 1)." *Tribus* 20 (1971), 63–124.
Besom 1991
 Besom, Thomas. "Another Mummy." *Natural History* (April 1991), 66–67.
Beyer 1921
 Beyer, Hermann. *El llamado "Calendario Azteca."* Mexico City, 1921.
Bischof 1968
 Bischof, Henning. "Contribución a la Cronologia de la Cultura Tairona (Sierra Nevada de Santa Marta, Colombia)." *Verdhandlungen des xxxviii Internationalen Amerikanistencongresses*. Munich, 1968.
Blake and Hauser 1978
 Blake, Leonard W., and James G. Hauser. "The Whelpley Collection of Indian Artifacts." *Academy of Science of St. Louis, Transactions* 32, 1 (1978).
Bologna 1660
 Supplica del senatore Marchese Fernando Cospi al Senato di Bologna. Fondo del Senato, series F, Bologna, Archivio di Stato, 24 June 1660.
Bologna 1680
 Inventario semplice di tutte le materie descritte che si trovano nel Museo Cospiano. Non solo le notate nel libro già stampato e composto dal Sig. Dottore Lorenzo Legati ma ancora le aggiuntevi dopo la Fabrica. Bologna, 1680.
Bologna 1743
 Inventario delle Cose del Museo Cospiano spettanti alla Stanza delle Antichità. MS 273, Fondazione dell'Istituto delle Scienze di Bologna, fasc. 5. University Library, Bologna, 6 June 1743.
Bozzoli de Wille 1975
 Bozzoli de Wille, Maria Eugenia. "Birth and Death in the Belief System of the Bribrí Indians of Costa Rica." Ph.D. dissertation, University of Georgia, Athens, 1975.
Bray 1990
 Bray, Warwick. "Le travail du métal dans le Peru prehispanique." Brussels in 1990, 292–315.
Brown 1976
 Brown, James A. *Spiro Studies Volume 4: The Artifacts*. Norman, Okla., 1976.
Brussels 1990
 Inca—Peru: 3000 ans d'histoire. Edited by Sergio Purin. Exh. cat. Musées royaux d'Art et d'Histoire. Brussels, 1990.
Budde 1982
 Budde, Hendrik. "Gross Venedig, die Residenz Vitslipitsli. Graphische Visionen der aztekischen Hauptstadt Tenochtitlá." *Mythen der Neuen Welt. Zur Entdeckungsgeschichte Lateinamerikas*. Exh. cat. Martin-Gropius-Bau. Berlin, 1982, 173–182.
Burnett 1945
 Burnett, E. K. *The Spiro Mound Collection in the Museum*. Contributions from the Museum of the American Indian—Heye Foundation, vol. 14. New York, 1945.
Bushnell 1905
 Bushnell, D. I. "Two Ancient Mexican Atlatls." *American Anthropologist* 7 (1905), 218–221.
Cabello Carro 1989
 Cabello Carro, Paz. *Coleccionismo americano indígena en la España del siglo XVIII*. Madrid, 1989.
Cadavid and Turbay 1985
 Cadavid, Gilberto, and Luisa Fernanda Herrera de Turbay. "Manifestaciones Culturales en el Area Tairona." *Informes Antropológicos*, no. 1. Instituto Colombiano de Antropología. Bogotá, 1985.

Calberg 1939
Calberg, M. "Le Manteau de plumes dit 'de Montezuma.'" *Bulletin de la Société des américanistes de Belgique* 30 (1939), 103–133.

Caso 1967
Caso, Alfonso. *Los calendarios prehispánicos.* Mexico City, 1967.

Castañeda and Mendoza 1933
Castañeda, Daniel, and Vicente T. Mendoza. "Los huehuetls en las civilizaciones precortesianas." *Anales del Museo Nacional de Arqueología, Historia y Etnografía* (Mexico City) 4a, época, t.8 (1933), 287–310.

Cieza de León 1959
Cieza de León, Pedro de. *The Incas.* Translated by Harriet de Onis. Edited by Victor Wolfgang von Hagen. Norman, Okla., 1959.

Ciruzzi 1983
Ciruzzi, Sara. "Gli antichi oggetti americani nelle collezioni del Museo Nazionale di Antropologia e Etnologia di Firenze." *Archivo per l'Antropologia e la Etnologia* 113 (1983), 151–165.

Cleveland 1975
Honour, Hugh. *The European Vision of America.* Exh. cat. Cleveland Museum of Art. Cleveland, 1975.

Cline 1969
Cline, Howard F. "Hernán Cortés and the Aztec Indians in Spain." *The Quarterly Journal of the Library of Congress* 27 (1969), 70–90.

Cobo 1979
Cobo, Bernabé. *History of the Inca Empire.* Translated and edited by Roland Hamilton. Austin, 1979.

Colin 1988
Colin, Susi. *Das Bild des Indianers im 16. Jahrhundert.* Idstein, 1988.

Cooke 1984
Cooke, Richard G. "Archaeological Research in Central and Eastern Panama: A Review of Some Problems." *The Archaeology of Lower Central America.* Edited by F. W. Lange and D. Z. Stone. Albuquerque, 1984, 263–302.

Corrales 1985
Corrales, Francisco. "Prospección y Excavaciones Estragráficas en el Sitio Curré (P-62-CE), Valle del Diquís, Costa Rica." *Vínculos* 11 (1985), 1–17.

Cortés 1986
Cortés, Hernán. *Letters from Mexico.* Translated by Anthony Pagden. New Haven and London, 1986.

Cortés Hernández 1982
Cortés Hernández, Susana. *Dos series de tapices flamencos en el Museo de Santa Cruz de Toledo.* Madrid, 1982.

Couch 1985
Couch, N. C. Christopher. *The Festival Cycle of the Aztec Codex Borbonicus.* Oxford, 1985.

Cummins, n.p.
Cummins, Tom. "Representation and the 16th Century: The Image of the Inca." Manuscript.

Dam-Mikkelsen and Lundbaek 1980
Dam-Mikkelsen, Bente, and Torben Lundbaek. *Ethnographic Objects in the Royal Danish Kunstkammer 1650–1800.* Copenhagen, 1980.

Davidson 1981
Davidson, Judith. "El 'Spondylus' en la cosmología chimú." *Revista del Museo Nacional—Lima* 45 (1981), 75–87.

Davies 1980
Davies, Nigel. *The Aztecs.* Norman, Okla., 1980.

Detroit 1981
Between Continents/Between Seas: Precolumbian Art of Costa Rica. Exh. cat. Detroit Institute of Arts. New York, 1981.

Detroit 1985
Brose, David S., James A. Brown, and David W. Penney. *Ancient Art of the American Woodland Indians.* Exh. cat. Detroit Institute of Arts. New York, 1985.

Drolet 1984
Drolet, Robert. "A Note on Southwestern Costa Rica." *The Archaeology of Lower Central America.* Edited by F. W. Lange and D. Z. Stone. Albuquerque, 1984.

Drolet and Markens 1981
Drolet, Robert, and Robert Markens. "Informe final, rescate arqueologico, Proyecto Bornca." Manuscript. Museo Nacional de Costa Rica y el Instituto Costarricense de Electricidad. San Jose, Costa Rica, 1981.

Due 1979–1989
Due, Berete. "A Shaman's Cloak." *Folk. Dansk Ethnografisk Tidsskrift* 21–22 (1979–1980), 257–261.

Durán 1964
Durán, Fray Diego. *The History of the Indies of New Spain.* Introduction by Ignacio Bernal. New York, 1964.

Durán 1971
Durán, Fray Diego. *Book of the Gods and Rites and the Ancient Calendar.* Translated and edited by F. Horcasitas and D. Heyden. Norman, Okla., 1971.

Durand-Forest 1976
Durand-Forest, Jacqueline. *Codex Ixtlilxochitl.* Graz, 1976.

Easby and Scott 1970
Easby, Elizabeth K., and John F. Scott. *Before Cortes: Sculpture of Middle America.* New York, 1970.

Emerson 1982
Emerson, Thomas E. *Mississippian Stone Images in Illinois.* Illinois Archaeological Survey, Circular 6. Urbana, 1982.

Essen 1984
Peru durch die Jahrtausende. Exh. cat. Villa Hügel, Essen. Recklinghausen, 1984.

Falchetti 1976
Falchetti, Ana María. "The Goldwork of the Sinú Region, Northern Columbia." Ph.D. dissertation. Institute of Archaeology, University of London, 1976.

Falchetti 1987
Falchetti, Ana María. "Desarrollo de la Orfebrería Tairona en la Provincia Metalúrgica del Norte Colombiano." *Boletín Museo del Oro* 19 (1987).

Falchetti 1989
Falchetti, Ana María. "Orfebrería Prehispánica en el Altiplano Central Colombiano." *Boletín Museo del Oro* 25 (1989).

Feest 1984
Feest, Christian F. "Review of Susi Colin, 'Das Bild des Indianers....'" *American Indian Workshop Newsletter* 19 (1984), 11.

Feest 1985
Feest, Christian F. "Mexico and South America in the European Wunderkammer." *The Origins of Museums.* Edited by Oliver Impey and Arthur MacGregor. Oxford, 1985.

Feest 1986
Feest, Christian F. "Zemes Idolum Diabolicum." *Archiv für Völkerkunde* 40 (1986), 181–198.

Fernández 1959
Fernández, Justino. "Una aproximación a Xochipilli." *Estudios de Cultura Nahuatl* 1 (1959), 31–42.

Ferrero 1981
Ferrero A., Luis. "Ethnohistory and Ethnography in the Central Highlands—Atlantic Watershed and Diquís." In Detroit 1981.

Flannery, Marcus, and Reynolds 1989
Flannery, Kent V., Joyce Marcus, and Robert G. Reynolds. *The Flocks of the Waimai.* New York, 1989.

Florence ms.
"Catalogo delle collezioni etnografiche." Manuscript, vol. 3. Museo di Antropologia e di Etnologia dell'Università di Firenze. Florence.

Florentine Codex 1979
Codice Florentino. Manuscrito de la Colección Palatina, Biblioteca Medicea Laurenziana, Florence. 3 vols., facsimile. Mexico City, 1979.

Flores Ochoa 1982
Flores Ochoa, Jorge A. "Causas que Originaron la Actual Distribución Espacial de las Alpacas y Llamas." *El Hombre y su Ambiente en los Andes Centrales.* Edited by Luis Millones and Hiroyasu Tomoeda. Osaka, 1982, 63–92.

Ford 1961
Ford, James A. "Menard Site: The Quapaw Village of Osotouy on the Arkansas River." *Anthropological Papers of the American Museum of Natural History* 48, 2 (1961).

García Arévalo 1988
García Arévalo, Manuel A. "El murciélago en la mitología y el arte Taínas." In *El Murciélago y la Lechuza en la Cultura Taína.* By José Juan Arrom and Manuel A. García Arévalo. Ediciones Fundación García Arévalo Inc., Serie Monográfica. Santo Domingo, 1988, 24:29–56.

Garcilaso de la Vega 1966
Garcilaso de la Vega, El Inca. *Royal Commentaries of the Incas and General History of Peru.* Translated by Harold V. Livermore. Austin, 1966.

Giglioli 1910
Giglioli, E. H. *Intorno a due rari cimeli precolombiani molto probabilmente de Santo Domingo, conservati nel Museo Etnografico di Firenze.* Atti del XVI Congresso Internazionale degli Americanisti, Vienna, 1910.

Gilliland 1975
Gilliland, Marion Spjut. *The Material Culture of Key Marco, Florida.* Gainesville, 1975.

Guaman Poma 1980
Guaman Poma de Ayala, Felipe. *El Primer Nueva Corónica y Buen Gobierno.* Translated by Jorge L. Urioste. Edited by John V. Murra and Rolena Adorno. Mexico City, 1980.

Gussinyer 1969
Gussinyer, Jorge. "Una escultura de Ehecatl-Ozomatli." *Boletín del Instituto Nacional de Antropología e Historia* 37 (1969), 27–31.

Hall 1991
Hall, Robert L. "Cahokia Identity and Interaction Models of Cahokia Mississippian." *Cahokia and the Hinterlands: Middle Mississippian Cultures of the Midwest.* Edited by Thomas E. Emerson and R. Barry Lewis. Urbana, 1991, 3–34.

Halm 1962
Halm, Peter. "Hans Burgkmair als Zeichner." *Münchner Jahrbuch der bildenden Kunst.* Dritte Folge 13 (1962), 75–162.

Hampe 1927
Hampe, Theodor. *Das Trachtenbuch des Christoph Weiditz von seinen Reisen nach Spanien (1529) und den Niederlanden (1531/32).* Berlin and Leipzig, 1927.

Harner 1972
Harner, Michael J. *The Jívaro, People of the Sacred Waterfalls.* Berkeley and Los Angeles, 1972.

Heikamp and Anders 1970
Heikamp, Detlef, and Ferdinand Anders. "Mexikanische Altertümer aus süddeutschen Kunstkammern." *Pantheon* 23, 3 (1970), 205–220.

Hernández Rodríguez 1952
Hernández Rodríguez, Rosaura. *El Valle de Toluca.* Mexico City, 1952.

Herrera 1941
Herrera, Fortunato L. *Sinopsis de la Flora de Cuzco.* Vol. 1. Lima, 1941.

Hildesheim 1987
Glanz und Untergang des Alten Mexiko. Exh. cat. Roemer-und Pelizaeus-Museum, Hildesheim. Mainz am Rhein, 1987.

Hirtzel 1930
Hirtzel, J.–S. Harry. "Le manteau de plumes dit de 'Montezuma' des Musées Royaux du Cinquantenaire de Bruxelles." *Proceedings of the Twenty-third Annual Congress of Americanists.* New York, 1930.

Hochstetter 1885
Hochstetter, Ferdinand von. "Über mexikanische Reliquien aus der Zeit Montezumas in der K.K. Ambraser Sammlung." *Denkschriften der kaiserlichen Akademie der Wissenschaften, Philosophisch-historische Klasse* 35 (1885), 83–104.

Hudson 1976
Hudson, Charles. *The Southeastern Indians.* Knoxville, 1976.

de la Jara 1975
Jara, Victoria de la. *Introducción al estudio de la escritura de los inkas.* Lima, 1975.

Jones 1985
The Art of Precolumbian Gold: The Jan Mitchell Collection. Edited by Julie Jones. London, 1985.

de Jonghe 1905
Jonghe, E. de. "Histoyre du Mechique: manuscrit français inédit du XVIe siècle." *Journal de la Société des Américanistes* n.s. 2 (1905), 1–41.

Kajitani 1982
Kajitani, Nobuko. "The Textiles of the Andes." *Senshoku no Bi (Textile Arts)* 20 (1982), 9–99.

Klein 1988
Klein, Cecilia F. "Rethinking Cihuacoatl: Aztec Political Imagery of the Conquered Woman." *Smoke and Mist: Mesoamerican Studies in Memory of Thelma D. Sullivan.* Edited by J. K. Josserand and K. Dakin. Oxford, 1988, 237–277.

Klor de Alva, Nicholson, and Quiñones 1988
The Work of Bernardino de Sahagún. Edited by J. Jorge Klor de Alva, H. B. Nicholson, and Eloise Quiñones. Institute of Mesoamerican Studies, Studies on Culture and Society, vol. 2. Albany, 1988.

Kubler and Gibson 1951
 Kubler, George, and Charles Gibson. "The Tovar Calendar." *Memoirs of the Connecticut Academy of Arts and Sciences* 11 (1951), 12–13.
Lafaye 1972
 Lafaye, Jacques. *Manuscrit Tovar*. Graz, 1972.
Lapiner 1976
 Lapiner, Alan. *Pre-Columbian Art of South America*. New York, 1976.
Larson 1971
 Larson, Lewis H., Jr. "Archaeological Implications of Social Stratification at the Etowah Site, Georgia." *Approaches to the Social Dimensions of Mortuary Practices*. Edited by James A. Brown. Memoir of the Society for American Archaeòlogy, vol. 25, 1971, 58–67.
Laurencich-Minelli 1982
 Laurencich-Minelli, Laura. "Dispersione e recupero della collezione Cospi." *Deputazione di Storia Patria della Provincia di Romagna* 32 (1982), 185–202.
Laurencich-Minelli 1983
 Laurencich-Minelli, Laura. "Oggetti americani studiati da Ulisse Aldrovandi." *Archivo per l'Antropologia e la Etnologia* 113. Florence, 1983. 187–206.
Laurencich-Minelli, forthcoming
 Il Codice Cospi. Edited by Laura Laurencich-Minelli. Milan, forthcoming.
Laurencich-Minelli and Filipetti 1981
 Laurencich-Minelli, Laura, and Alessandra Filipetti. "Il Museo Cospiano. Alcuni oggetti americani ancora a Bologna." *Il Carrobbio* 7(Bologna, 1981), 220–229.
Laurencich-Minelli and Filipetti 1983
 Laurencich-Minelli, Laura, and Alessandra Filipetti. "Per le collezioni americaniste del Museo Cospiano e dell'Istituto delle Scienze. Alcuni oggetti ritrovati a Bologna." *Archivio per l'Antropologia e la Etnologia* 113 (Florence, 1983), 207–226.
de Lavalle and Lang 1977
 Lavalle, José Antonio de, and Werner Lang. *Arte precolumbino*. Introduction by Luis G. Lumbreras. Arte y tesoros del Peru. Lima, 1977.
de Lavalle and Lang 1982
 Lavalle, José Antonio de, and Werner Lang. *Culturas precolumbinas: Chancay*. Arte y tesoros del Peru. Lima, 1982.
Lechtman 1980
 Lechtman, Heather. "The Central Andes: Metallurgy without Iron." *The Coming of the Age of Iron*. Edited by Theodore A. Bertime and James D. Muhly. New Haven and London, 1980, 267–334.
Legati 1667
 Legati, Lorenzo. *Breve descrizione del Museo de F. Cospi*. Bologna, 1667.
Legati 1677
 Legati, Lorenzo. *Museo Cospiano annesso a quello dell'Illustra Ulisse Aldovrandi*. Bologna, 1677.
León-Portilla 1958
 Sahagún, Bernardino de. Ritos, Sacerdotes y Atavíos de los Dioses. Edited by Miguel León-Portilla. Mexico City, 1958.
León-Portilla 1985
 León-Portilla, Miguel. *Tonalamatl de los Pochtecas, Códice Fejérváry-Mayer*. Mexico City, 1985.
López de Gómara 1552
 López de Gómara, Francisco. *La istoria de las Indias y conquista de Mexico*. 2 vols. Saragoza, 1552.
Lothrop, Foshag, and Mahler 1957
 Lothrop, S. K., W. F. Foshag, and Joy Mahler. *Robert Woods Bliss Collection of Pre-Columbian Art*. New York, 1957.
MacCurdy 1910
 MacCurdy, George Grant. "An Aztec 'calendar stone' in Yale University Museum." *American Anthropologist* n.s., 18 (1910), 481–496.
Madrid 1893
 Las joyas de la Exposicion histórico-Europea de Madrid 1892. Madrid, 1893.
Marquina 1960
 Marquina, Ignacio. *El templo mayor de México*. Mexico, 1960.
Martín Arana 1967
 Martín Arana, Raul. "Hallazgo de un monolito en las obras del S.T.C. (Metro)." *Boletín del Instituto Nacional de Antropología e Historia* 30 (1967), 19–23.
Matos Moctezuma 1988

Matos Moctezuma, Eduardo. *The Great Temple of the Aztecs. Treasures of Tenochtitlan*. London, 1988.
McEwan and Silva I 1989
 McEwan, Colin, and María Isabel Silva I. "Que fueron a hacer los Incas en la costa central del Ecuador?" *Proceedings, 46th International Congress of Americanists, Amsterdam, Netherlands 1988: Relaciones interculturales en el área ecuatorial del Pácifico durante la época precolombina*. Edited by J. F. Bouchard and M. Guinea. Oxford, 1989, 163–185.
Menzel 1959
 Menzel, Dorothy. "The Inca Occupation of the South Coast of Peru." *Southwest Journal of Anthropology* 15 (1959), 125–142.
Menzel 1977
 Menzel, Dorothy. *The Archaeology of Ancient Peru and the Work of Max Uhle*. Berkeley, 1977.
Métraux 1928
 Métraux, Alfred. *La civilisation matérielle des tribus Tupi-Guarani*. Paris, 1928.
Métraux 1932
 Métraux, Alfred. "A propos de deux objets Tupinamba du Musée d'éthnographie du Trocadéro." *Bulletin du Musée d'éthnographie du Trocadéro* 3 (1932), 3–18.
Moore 1905
 Moore, Clarence B. *Certain Aboriginal Remains of the Black Warrior River*. Philadelphia, 1905.
Moore 1907
 Moore, Clarence B. *Moundville Revisited*. Philadelphia, 1907.
Moore 1908
 Moore, Clarence B. *Certain Mounds of Arkansas and Mississippi*. Philadelphia, 1908.
Moore 1911
 Moore, Clarence B. *Some Aboriginal Sites on Mississippi River*. Philadelphia, 1911.
Morris 1988
 Morris, Craig. "Progress and Prospect in the Archaeology of the Inca." *Peruvian Prehistory*. Edited by Richard W. Keatinge. Cambridge, England, and New York, 1988, 233–256.
Mostny 1957
 Mostny, Grete. "La Momia del Cerro el Plomo." *Boletín del Museo Nacional de Historia Natural* (Santiago de Chile) 27, 1 (1957).
Murra 1962
 Murra, John V. "Cloth and Its Functions in the Inca State." *American Anthropologist* 64 (1962), 710–728.
Nebenzahl 1990
 Nebenzahl, Kenneth. *Atlas of Columbus and the Great Discoveries*. Chicago, 1990.
Nicholson 1971
 Nicholson, Henry B. "Religion in Pre-Hispanic Central Mexico." *Handbook of Middle American Indians* 10 (1971), 396–451.
Nicholson 1983
 Nicholson, Henry B. *Art of Aztec Mexico*. Exh. cat. National Gallery of Art. Washington, 1983.
Nowotny 1960
 Nowotny, Karl A. *Mexikanische Kostbarkeiten aus Kunstkammern der Renaissance im Museum für Völkerkunde Wien und in der Nationalbibliothek Wien*. Vienna, 1960.
Oviedo y Valdés 1851–1855
 Oviedo y Valdés, Gonzalo Fernández. *Historia general y natural de las Indias*. 4 vols. Madrid, 1851–1855.
Oyuela 1985
 Oyuela, Augusto. "Las Fases Arqueológicas de las Ensenadas de Nahuanje y Cinto." Thesis. University of the Andes, Bogotá, 1985.
Palm 1951
 Palm, Erwin Walter. "Tenochtitlan y la cuidad ideal de Dürer." *Journal de la Société des Américanistes* n.s. 40 (1951), 59–66.
Patterson 1985
 Patterson, Thomas C. "Pachacamac—An Andean Oracle Under Inca Rule." *Recent Studies in Andean Prehistory and Protohistory*. Edited by Peter Kvietok and Daniel Sandweiss. Ithaca, 1985.
Pérez de Barradas 1966
 Pérez de Barradas, José. *Orfebrería Prehispánica de Colombia Estilos Quimbaya y otros*. Madrid, 1966.
Phillips and Brown 1978
 Phillips, Philip, and James A. Brown. *Pre-Columbian*

Shell Engravings from the Craig Mound at Spiro, Oklahoma. Part 1, Cambridge, Mass., 1978.
Phillips and Brown 1984
 Phillips, Philip, and James A. Brown. *Pre-Columbian Shell Engravings from the Craig Mound at Spiro, Oklahoma*. Part 2, Cambridge, Mass., 1984.
Pignoria 1626
 Pignoria, Lorenza. "Seconda parte delle Imagini de gli dei Indiani." In Vicenzo Cartari, *Seconda Novissima Editione delle Imagini de gli dei delli Antichi*. Padua, 1626.
Plazas 1987a
 Plazas, Clemencia. "Función Rogativa del Oro Muisca." *Maguaré* 5, 5 (1987).
Plazas 1987b
 Plazas, Clemencia. "Forma y Función en el Oro Tairona." *Boletín Museo del Oro* (1987).
Plazas and Falchetti 1981
 Plazas, Clemencia, and Ana María Falchetti. *Asentamientos Prehispánicos en el Bajo río San Jorge*. Fundación de Investigaciones Arqueológicas Nacionales, Banco de la República. Bogotá, 1981.
Plazas and Falchetti 1985
 Plazas, Clemencia, and Ana María Falchetti. "Cultural Patterns in the Prehispanic Goldwork of Colombia." In Jones 1985.
Quintanilla 1987
 Quintanilla, Ifigenia. "Paso Real: Un Sitio Into-Hispánico en el Valle del Diquís." *Vínculos* 12, 1–2 (1987), 121–134.
Reichel-Dolmatoff 1954
 Reichel-Dolmatoff, Gerardo. "Investigaciones Arqueológicas en la Sierra Nevada de Santa Marta, parts 1, 2, 3." *Revista Colombiana de Antropología* 2, 3 (1954).
Reichel-Dolmatoff 1988
 Reichel-Dolmatoff, Gerardo. *Orfebrería y Chamanismo*. Medellín, 1988.
Reinhard1983
 Reinhard, Johan. "Las montañas sagradas: Un estudio etno-arqueológico de ruinas en las altas cumbres andinas." *Cuadernos de Historia* 3, Departamento de Ciencias Historicas, Universidad de Chile (July 1983), 27–62.
Romero Quiroz 1963
 Romero Quiroz, Javier. *Teotenanco y Matlazinco*. Toluca, 1963. ·
Rostworowski de Diez Canseco 1981
 Rostworowski de Diez Canseco, María. *Recursos naturales renovables y pesca, siglos XVI y XVII*. Lima, 1981.
Rouse, forthcoming
 Rouse, Irving. *The Tainos: Rise and Fall of the People Who Greeted Columbus*. New Haven, forthcoming.
A. Rowe 1978
 Rowe, Ann Pollard. "Technical Features of Inca Tapestry Tunics." *Textile Museum Journal* 17 (1978), 5–28.
A. Rowe 1984
 Rowe, Ann Pollard. *Costumes & Featherwork of the Lords of Chimor: Textiles from Peru's North Coast*. Washington, 1984.
J. Rowe 1946
 Rowe, John Howland. "Inca Culture at the Time of the Spanish Conquest." *Handbook of South American Indians* 2, Smithsonian Institution Bureau of American Ethnology Bulletin 143 (1946), 183–330.
J. Rowe 1979
 Rowe, John Howland. "Standardization in Inca Tapestry Tunics." *The Junius B. Bird Pre-Columbian Textile Conference*. Edited by Ann Pollard Rowe, Elizabeth P. Benson, and Anne-Louise Schaffer. Washington, 1979, 239–264.
Rowlands 1988
 Rowlands, John. *The Age of Dürer and Holbein. German Drawings, 1400–1550*. Exh. cat. British Museum. London, 1988.
Rydén 1937
 Rydén, Stig. "Brazilian Anchor Axes." *Ethnologiska studier* 4 (1937), 50–83.
Sahagún 1950–1982
 Sahagún, Fray Bernardino de. *Florentine Codex: General History of the Things of New Spain*. Salt Lake City, 1950–1982.
San Martin and Lebrija 1539
 San Martin, Juan de, and Alonso de Lebrija. "Relacion del descubrimiento y conquista del Nuevo Reino de Granada." *Relaciones historicas de America* (1539). Modern publication, Madrid, 1916.

Saville 1922
Saville, Marshall H. *Turquoise Mosaic Art in Ancient Mexico.* New York, 1922.

Schiassi 1814
Schiassi, Filippo. *Guida del Forestiere al Museo delle Antichità della Regia Università di Bologna.* Bologna, 1814.

Schobinger 1991
Schobinger, Juan. "Sacrifices of the High Andes." *Natural History* (April 1991), 62–69.

Schweeger-Hefel 1951/1952
Schweeger-Hefel, Annemarie. "Ein rätselhaftes Stück aus deralten Ambraser Sammlung." *Archiv für Völkerkunde* 6, 7 (1951/1952), 209–228.

Sears 1982
Sears, William H. *Fort Center, An Archaeological Site in the Lake Okeechobee Basin.* Gainesville, 1982.

Seler 1902
Seler, Eduard. "Codex Cospi. Die mexikanische Bilderhandschrift von Bologna." *Gesammelte Abhandlungen zur Amerikanischen Sprach-und Altertumskund* 2 (1902), 341–351.

Seler 1904
Seler, Eduard. "Quauhxicalli. Die Opferflutschale der Mexikaner; Uber Steinkisten, Tepetlacalli, mit Opferdarstellungen und andere ähnliche Monumente; Die Ausgrabungen am Orte des Haupttempels in Mexico." *Gesammelte Abhandlungen der Amerikanischer Sprachund Alterthumskunde* 2 (1904), 704–904.

Shimada and Shimada 1985
Shimada, Izumi, and Melody Shimada. "Prehistoric Llama Breeding and Herding on the North Coast of Peru." *American Antiquity* 50 (1985), 3–26.

Simon 1625
Simon, Fray Pedro. *Noticias historiales de las conquistas de Tierra Firme en las Indias Occidentales* (1625). Modern publication, Bogotá, 1981, vol. 3.

Snarskis 1978
Snarskis, Michael J. "The Archaeology of the Central Atlantic Watershed of Costa Rica." Ph.D. dissertation. Columbia University, 1978.

Snarskis 1984
Snarskis, Michael J. "Central America: The Lower Caribbean." *The Archaeology of Lower Central America.* Edited by F. W. Lange and D. Z. Stone. Albuquerque, 1984.

Soustelle 1961
Soustelle, Jacques. *Daily Life of the Aztecs.* London, 1961.

Tayler 1974
Tayler, D. B. "The Ika and Their System of Beliefs." Ph.D. dissertation. Oxford University, 1974.

Thompson 1971
Thompson, J. Eric S. *Maya Hieroglyphic Writing. An Introduction.* 3d edition. Norman, Okla., 1971.

Torquemada 1943–1944
Torquemada, Juan de. *Los veynte y un libros rituales y monarchia yndiana.* 3 vols. 3d ed. Mexico City, 1943–1944.

Toussaint et al. 1938
Toussaint, Manuel, Federico Gomez de Orozco, and Justino Fernández. *Planos de la cuidad de Mexico: siglos XVI y XVII. Estudio histórico, urbanistico y bibliográfico.* Mexico, 1938.

Vázquez de Coronado 1964
Vázquez de Coronado, Juan. *Cartas de Juan Vázquez de Coronado, conquistador de Costa Rica.* Edited by Ricardo Fernández-Guardia. Academia de Geografía e Historia de Costa Rica, San José, 1964.

Vega 1973
Vega, Bernardo. "Un cinturón tejido y una careta de madera de Santo Domingo, del período de transculturación taíno-español." *Boletín del Museo del Hombre Dominicano* 3 (1973), 199–226.

Vega 1989
Vega, Bernardo. "Nuevas revelaciones sobre el zemí taíno del Museo Pigorini de Roma." *Isla abierta/Hoy* (9 December 1989), 8–9.

Wasson 1980
Wasson, R. Gordon. *The Wondrous Mushroom.* New York, 1980.

Widmer 1988
Widmer, Randolph J. *The Evolution of the Calusa.* Tuscaloosa, 1988.

Zanin 1991
Zanin, Daniela. "Due oggetti Taíno conservati nel Museo Nazionale di Antropologia e Etnologia di Firenze." *Museologia Scientifica* 7 (1991), 111.

Zuidema, forthcoming
Zuidema, R. Tom. "Guaman Poma and the Art of Empire: Towards an Iconography of Inca Royal Dress." *Transatlantic Encounters: Europeans and Andeans in the Sixteenth Century.* Edited by R. Adorno and K. Andrien. Berkeley, forthcoming.

Picture Credits

Photographic materials have kindly been supplied by lenders or owners of works of art except as noted.

Alinari/Art Resource, NY: Raby fig. 2; Kemp fig. 17

Amplicaciones y Reproducciones "MAS": Jonathan Brown figs. 1–5, 7–10; cat. 20

Antoine S. Le Page Du Pratz, *Histoire de la Louisiane*, 3 vols. (Paris, 1758), 2:368: James A. Brown figs. 1, 2

Dirk Bakker: Bassani fig. 2; Bray fig. 2; cats. 59, 61, 64, 65, 428–430, 432, 435, 438–439, 503–520, 524–528, 534–537, 539, 543–562, 565–569

Dean Beasom: cats. 5, 132

Marcello Bertoni: cat. 145

Dennis Brack, Black Star: cats. 80, 81, 84–85, 88, 100

Photo Bulloz: cat. 180

Mario Carrieri: Bassani fig. 1; cats. 13, 377, 382

Francesc Catalá Roca: Kagan figs. 2, 3; cats. 20, 33, 35, 38–42, 44, 46, 47, 49–51, 111

Philip A. Charles: cat. 340

Martin Collcutt: Collcutt figs. 2, 3

Lorene Emerson: cats. 415–418

Valentim Fernandez, *Reportório dos Tempos* (Lisbon, 1563), 140: Maddison fig. 1

Gabriel Ferrand, *Introduction a l'Astronomie Nautique Arabe* (Paris, 1928), 26: Maddison fig. 3

Mark Fiennes: Rogers fig. 2

Photographie Giraudon: Kemp fig. 11

©1978 and 1984 President and Fellows of Harvard College, Courtesy Peabody Museum Press. Philip Phillips and James A. Brown, *Pre-Columbian Shell Engravings from the Craig Mound at Spiro, Oklahoma*, part 2 (Cambridge, Mass., 1984): James A. Brown figs. 3, 4

courtesy Felica Hecker: Mote fig. 4

William H. Holmes, "Art in Shell of the Ancient Americans," *2nd Annual Report of the Bureau of American Ethnology* (Washington, 1883), 185–305: James A. Brown figs. 5–7

Martin Kemp: Kemp figs. 3, 5

Justin Kerr: cats. 451, 470, 502, 542, 563, 564

Salvador Lutteroth Lomeli: cats. 396, 401

Pedro de Medina, *Regimiento de navegación* (Seville, 1563), fols. 16, 36: Maddison figs. 2, 4

Andrea Medri: drawing cat. 384

J. B. Metzler, Stuttgart. Erich Pllaschek, "Ptolemaios als Geograph," *Paulys Realencyclopädie die der classischen Altertumswissenshaft*, ed. August Pauly, Beorg Wissowa, and others (1894—), suppl. 10 (1965): Woodward, fig. 2

Kim Nielson: cat. 58

Olivetti, Direzione Relazioni Culturali, photo Antonio Quattrone: Kemp fig. 8

©Edward Ranney: Morris figs. 1–4

©PHOTO Réunion des musées nationaux: Massing "Dürer and the Exotic..." fig. 2

Robert D. Rubic, NYC: Massing "Early European Images..." fig. 3

Scala/Art Resource, NY: Raby fig. 1; Argan fig. 1; cats. 150, 168, 170, 175

Shin Hada: cat. 239

Selamet Taskin: cats. 83, 85, 90–92, 95, 97–99, 101

John Bigelow Taylor: cats. 79, 357, 360–362, 365, 366, 370–371, 378–382, 385–387, 389–395, 397–400, 414, 444, 445, 454, 455, 463, 465, 469, 471, 473, 474, 477–499

©1987 by The University of Chicago Press. *History of Cartography: Cartography in Prehistoric, Ancient, and Medieval Europe and the Mediterranean*, ed. J. B. Harley and David Woodward, 1:187, 188: Woodward figs. 2, 3

Fernando Urbina: Bray fig. 1

This book is a coproduction of the editors office, National Gallery of Art, and Yale University Press, New Haven and London. ❧ The editing of this book was supervised by the editors office, National Gallery of Art. Editor-in-chief, Frances Smyth. "Europe and the Mediterranean World" edited by Mary Yakush, with assistance from Julie Warnement. "Toward Cathay" edited by Naomi Noble Richard. "The Americas" edited by Jane Sweeney. Copyeditors, editorial consultants, and editorial support staff for this project include Stephen Alee, Margaret Alexander, Nazan Armenian, Kathleen Emerson-Dell, Lee Johnson, Elizabeth McGrath, Deborah Del Gais Muller, Clea Ramea, Lys Ann Shore, Maria Tsoumis, Abigail Walker, and Janet Wilson. Translators include Dorothy Alexander, Susan Scott Cesaritti, Charles Roberts, Kyoko Selden, Stephanos Stephanides, and Robert Erich Wolf, and the Columbia University Tutoring and Translation Agency. ❧ The production of this book was supervised by John Nicoll, managing director, Yale University Press, London, with assistance from Gillian Malpass and Marina Cianfanelli. ❧ Composed in Aldus, a typeface based on Renaissance forms, by Paul Baker Typography, Evanston, Illinois, with assistance from U.S. Lithograph, New York. It was printed and bound by Arnoldo Mondadori Editore, Verona, Italy, with color separations by Evergreen, Hong Kong. Mechanicals prepared by BG Composition, Baltimore, and Bruce Campbell Design, Stonington, Connecticut. Computer drawing of the Vitruvian Man and title page display type prepared by James Campbell. Designed by Bruce Campbell with assistance from Lisa Tremaine.